JOSEF MARIA EDER

350
41

HISTORY OF
PHOTOGRAPHY

By JOSEF MARIA EDER

TRANSLATED BY

EDWARD EPSTEAN

HON. F. R. P. S.

DOVER PUBLICATIONS, INC.
NEW YORK

Published in Canada by General Publishing Company, Ltd., 30 Lesmill Road, Don Mills, Toronto, Ontario.
Published in the United Kingdom by Constable and Company, Ltd., 10 Orange Street, London WC2H 7EG.

This Dover edition, first published in 1978, is an unabridged and unaltered republication of the work originally published by Columbia University Press, N. Y., in 1945. The present edition is published by special arrangement with Columbia University Press.

International Standard Book Number: 0-486-23586-6
Library of Congress Catalog Card Number: 77-88114

Manufactured in the United States of America
Dover Publications, Inc.
180 Varick Street
New York, N. Y. 10014

Preface to the Third Edition (1905)

WHAT IS PROBABLY the earliest authoritative source of the history of our knowledge and appreciation of the physics of light and its action reaches us through Priestley in his *History and Present State of Discoveries Relating to Vision, Light and Colours* (1772; German edition, 1775). In its pages we find some scant observations on the chemical action of light. Ebermaier's *Versuch einer Geschichte des Lichtes und dessen Einfluss auf den menschlichen Körper* (1799), as well as Horn's *Über die Wirkungen des Lichtes auf den lebenden menschlichen Körper mit Ausnahme des Sehens* (1799), contains many historical notes which, however, are chiefly of interest to students of physiology.

Concerning other early theories of light in general, as well as regarding its chemical action, much of importance may be found in Johann Carl Fischer's extensive work *Geschichte der Physik* (1801-6, 8 vols.), upon which I have drawn largely in the preparation of the present work. Gmelin's *Geschichte der Chemie* (1799) and Fischer's *Physikalisches Wörterbuch* (1801-25, 9 vols.) are valuable works of the same character. The prize essays of Link and Heinrich, *Über die Natur des Lichtes* (1808), deservedly distinguished by the Academy of Sciences of St. Petersburg, have furnished very excellent and valuable contributions, not only giving their own personal observations but also reporting with painstaking care the earlier contributions on this subject. This work was included, almost in its entirety, in Landgrebe's excellent collected works *Über das Licht* (1834). Landgrebe brought to us, in a general way, the same early sources and added other enlarged literary contributions up to 1833, and gave us a detailed index containing numerous early references and notes on the subject. A valuable contribution to the literature of photochemistry is offered in G. Suckow's *Commentatio physica de lucis effectibus chemicis* (Jena, 1828), which bears the motto "nihil luce obscurius" (nothing is darker than light) and is dedicated to Döbereiner. This work was awarded a prize by the University of Jena. Later than Suckow we have independent essays on the early sources by J. Fiedler, whose Latin dissertation *De lucis effectibus chemicis in corpora anorganica* (1835) is edited with careful skill worthy of the highest commendation. This author relies much more on Priestley, in his *History and Present State of Discoveries Relating to Vision, Light*

and Colours (1772; German ed., 1775), than on those who preceded him, and in some parts of his historical treatment far excels his predecessors. Another important contribution to the study of photochemistry in the nineteenth century is Karsten's "Literaturbericht der Photochemie," which appeared in the *Fortschritten der Physik pro 1845*. At this point I feel compelled to remark that the existing textbooks were quite inadequate and of little service in my researches among the early sources. Thus the celebrated works of Hunt, *Researches on Light* (1844), and Becquerel's *La Lumière* offer little of value in their historical notes, while W. J. Harrison's *History of Photography* (1888) is concerned in a superficial way with the years preceding Daguerre, while it is well known that Fouque's history, *La Vérité sur l'invention de la photographie* (1867) confines itself entirely to the inventions of Niépce.

Facing this deficiency of material for the formation of the groundwork for my *Geschichte der Photochemie*, I was compelled to search through book after book and innumerable periodical publications, covering subjects with the oddest titles, in order to find the existing references to photochemical subjects. I published the first fragment of my researches into the historical source of information in the *Photographische Korrespondenz* (1881). This was followed, in 1890, by the first edition of my *Geschichte der Photochemie*, which appeared as the first part of my complete and specialized *Handbuch der Photographie*, presenting for the first time these studies as a connected and coherent unit. With this work I may safely claim to have traced the history of photography in the pre-Daguerre period. How much more complete my studies of the historical sources of this period are than those of my predecessors is proved by a simple comparison. It may be noted here that all later writers on the history of photography base their works on my studies of the sources of information.

Major General J. Waterhouse (London, 1901-3), pursued a series of further studies of these sources, following my basic publication. These included: "Notes on the Early History of the Camera Obscura" (*Photographic Journal*, Vol. XXV, No. 9); "Notes on Early Tele-Dioptric Lens-Systems and the Genesis of Telephotography" (*Photographic Journal*, Vol. XXVI, No. 1); "Historical Notes on Early Photographic Optics" (*Journal of the Camera Club*, September, 1902); and "The History of the Development of Photography with the Salts of

Silver" (*Photographic Journal*, Vol. XLIII, June, 1903), all of which embody extremely serious and exact investigations.

There were others who made use of my studies of historical sources, but without mentioning whence their information was derived. Writing at second-hand in many other cases, without a fundamental knowledge of the subject, they mixed facts and falsehoods without discrimination or judgment, as I proved in the *Photographische Korrespondenz* (1891, pp. 148, 254). I think it best not to concern myself any further with them. On the other hand, the books of W. Jerome Harrison, *A History of Photography* (Bradford, 1888), and John Werge, *The Evolution of Photography* (London, 1890), are well-written and conscientious efforts, at least as far as concerns the participation of England and America in the invention of photography in the nineteenth century. Interestingly written, but limited to a very small group of the inventors of photography, is the work of R. Colson, *Mémoires originaux des créateurs de la photographie* (Paris, 1898). In this work only the biographies and experiments of Joseph Nicéphore Niépce, Daguerre, Bayard, Talbot, Niépce de Saint-Victor, and Poitevin are dealt with in considerable detail, and no mention is made of other inventors. It is unfortunate that the share of German and Austrian inventors in the development of photography seems to have been largely unknown to these English and French historians. Therefore, in this present work I have given special attention to the development of the history of photography from an international viewpoint, especially later than Daguerre, having first devoted myself to a minute study of the sources of information in order to obtain the greatest objectivity in the conception and writing of my *Geschichte der Photographie*.

There were three stages in the development of my *Geschichte der Photographie*. The first was the period to the beginning of the eighteenth century; this fragment, as was mentioned above, was published in 1881. In 1890 I published (see above) the development of photochemistry up to Daguerre and Niépce. Then followed the first authoritative and exhaustive treatment of the general field of photography, with accurate references to the literature and historical sources, in my *Ausführliches Handbuch der Photographie*, which served as the groundwork for my history of the modern photographic processes. With this material in hand, I was enabled for the first time to attempt, in this (third) edition of my history, to present the history of the in-

vention of photography up to the end of the nineteenth century. I undertook also to include in this work careful reproductions of many incunabula and portraits of importance to the history of photography. The originals of most of these are fast disappearing and have become very rare and difficult to obtain. They can now be found in only a few places, particularly in Paris, London, and Vienna. The collections of the Graphische Lehr- und Versuchsanstalt in Vienna, the Photographische Gesellschaft, and the Technical Institute in Vienna contain highly valuable material, in part collected since 1839, most of which has not yet been sufficiently studied and is quite unknown in circles outside these institutions. I am greatly obliged to the president of the Paris Photographic Society, the Paris Photo-Club, the London Photographic Society, Major General J. Waterhouse and Mr. George E. Brown, of London, Professor Vidal, M. J. Demaria, and M. Davanne, of Paris, and Herr Braun, of Dornach, as well as to many other respected colleagues who have assisted me and expedited my historical researches and investigations in a most appreciative way.

Although I believe my *Geschichte der Photographie* to be the most complete work of its kind thus far attempted, I realize that it cannot be entirely exhaustive, since the space allotted to me does not suffice for a broader treatment. The pursuit of too-minute detail, however, would doubtless have affected my plan of presenting a general view such as I have striven for in the treatment of the whole subject.

THE AUTHOR

Vienna
March, 1905

Preface to the Fourth Edition (1932)

THE THIRD EDITION of my *Geschichte der Photographie* (1905) has been out of print for many years. It was impossible for me to accede to the many requests for a new and enlarged edition during the confusion of the War and the consequent interruption of international scientific intercourse. Only within the past few years has it become possible for me to gather and evaluate the foreign historical researches, which in the meantime had greatly increased, and to incorporate them into my earlier work after personal studies of their sources and origin. The previous edition of this work dealt with the history of photography only to the end of the nineteenth century. The present new edition gives the reader a complete survey of the history down to the end of the first quarter of the twentieth century.

In the endeavor to present more than a narrow technical history of photography, I have tried to record the development of photography in relation to the events of the time and its application. In addition I have taken great pains to hold fast to impartial, objective historical statements, not permitting myself to be influenced by chauvinistic tendencies, so that I might do full justice to the international history of the advance of the science. The objectivity of my book is in no degree diminished by the fact that as an old Austrian I have stressed the contributions of my compatriots more generously than we find in other works on this subject. The notable influence which Austrian workers exerted on the development of photography during the earlier years of its history amply justified my course. At that time Austria still was the predominating great power in Europe; Vienna was acknowledged as the guardian of the sciences and was held in high repute as a seat of learning and patroness of arts. To record these facts is not only the duty of historical truth and objectivity; it is the more justified because all studies, particularly several of recent German origin, of the technical literature show lamentable gaps where the participation of Austrians in the development of photography is concerned. At a time when the tragic fate of my sorely tried Fatherland meets with so little understanding and sympathy in the world, it seems only right and just to give a place to these important and outstanding contributions, which will bear the scrutiny of the most searching historical inquiry, before the

memory of these early workers and their notable contribution to the advance of photography are forgotten and sink into oblivion.

It seemed indispensable to an objective historical record of the subject that some account of the fortunes and personal experiences of the pioneers in photography should be included, since these were often of vital influence on the development of the art. As early as 1875 I had begun to acquire, by active participation, a practical knowledge of photography and the photomechanical processes. I also came into personal contact with many scientists and inventors, thus gaining an insight into their ideals, purposes, and, often, the tragedies of their lives. Through these contacts I obtained and fixed in my memory many details of the history of the development of photography which have great authentic value and deserve to be rescued from oblivion. Hence, as far as possible I have followed my plan to delineate those personages whom I thought important in the evolution of photography and to give a record of their work in relation to their times and background. This called for biographical data and portraits, many of which were often difficult to obtain. Many notable workers in that bygone period of the growth of photography ended their lives misunderstood by their contemporaries, often in tragic circumstances, without having reaped the reward of their inventions. Their lives and work, nevertheless, were not spent in vain. More fortunate, gifted men of a later generation, coming from different callings, have raised the art of photography to the high place it occupies today in every sphere of human activity. However, all modern writers have had to rely on and to build their works on the foundations provided by their predecessors.

It was also essential to the completeness of my work to consider the many valuable historical papers which have appeared during recent years in various foreign publications, even though these presented a purely national view, because despite this limitation they contributed, in important details, to our knowledge of the history of photography.

For instance: the history of photography in France is portrayed by Georges Potonniée, in his *Histoire de la découverte de la photographie* (Paris, 1925), in a manner worthy of recognition. Interesting, however, as is this original study of the sources with regard to the French claims, it can hardly be said to present an objective exposition of the collective international contributions to the domain

of photography. I do not reproach M. Potonniée because he ignores the German literature on this subject, presumably owing to his lack of acquaintance with it, but his *Histoire* betrays a one-sided view, even though he had German literary sources at his disposal. A perusal of the list of authors given in this work will show these points, and criticism of them is recorded in their respective places.

The early history of photography was greatly advanced by valuable research documents contributed by Professor E. Stenger, of Berlin, as well as by the publication of Wilhelm Dost's *Vorläufer der Photographie* (Berlin, 1931).

I have received very generous and most welcome assistance in the work of compilation and revision for this new edition of my history from many sides. Thus, I am indebted to the Société Française de Photographie, Paris, for valuable information and communications concerning French scholars; to the Royal Photographic Society of Great Britain and its secretary, Mr. H. H. Blacklock; to the Eastman Kodak Research Laboratory in Rochester, New York; to Herrn Regierungsrat Tippmann, the Oberstaats-Bibliothekar of the technical high school of Vienna; to the director of the Austrian Technical Museum of Trade and Industry, Vienna; to Herrn F. Paul Liesegang, Düsseldorf, Dr. Lüppo-Cramer, Schweinfurt, Professor Leopold Freund, University of Vienna; Hofrat Professor E. Valenta, Vienna; Professor E. Stenger, Berlin; Dr. Helmer Bäckström, Stockholm, and Professor Y. Kamada, Tokio. To these gentlemen, to these institutions, and to all the experts in the art who have aided and advanced the achievement represented by this work—my heartiest thanks and appreciation are here offered.

The presentation of the history of photography necessarily touches so many departments of the technical arts and sciences that an extraordinary variety of different but related subjects has been brought into discussion. As a basis for the further study of the material and also to make my books more useful to the reader and research student, I have added a list of the authors and subjects. This was furnished by Herrn Oberbaurat Fritz Schmidkunz, of Vienna, and deserves my sincere appreciation.

My special thanks are due to the publisher, Wilhelm Knapp, Halle a.S., who spared neither trouble nor expense in providing the best of workmanship and material in the production of the books. The considerable enlargement evident in this fourth edition of the *Geschichte*

der Photographie made it desirable to issue the work in two parts in order to facilitate the binding in two volumes. In each part of the Halle 1932 edition is found a list of contents and illustrations; a complete index to authors and subjects is at the end of the second volume.

J. M. EDER

Vienna
November, 1931

Translator's Preface

IT WAS IN 1932 in Dr. Eder's beautiful villa at Kitzbühel in the Austrian Tyrol that at his request I promised to translate his work *Geschichte der Photographie* (4th ed., 1932) for the benefit of the English-speaking student of the subject. The demands of the German publishing house and the changed political conditions in Germany which followed put a stop to the chance of publication at that time. Notwithstanding its seeming Chauvinism, the work is unique, and it is a monument to Dr. Eder's long years of study and an eloquent witness to his accomplishments.

The illustrations appearing in the German work are omitted since most of them have only an ornamental value and are of little practical use to the student.

My original translation was edited by Mr. John A. Tennant, of New York City. The typescripts were read and edited by Mr. George E. Brown, of London, for twenty-nine years editor of the *British Journal of Photography*; by Mr. William Gamble, editor of *Penrose's Annual*, London; by M. Louis-Philippe Clerc, of Paris; and by Dr. Eder, who furnished me with additional notes. Any deviations from the original text are due to him or to these collaborators. I am also indebted for kind assistance to Dr. C. E. Kenneth Mees and Dr. Walter Clark, of the Eastman Kodak Co., and to Dr. Fritz Wentzel, of Ansco Co., for English translations of some of the German photochemical terms. The final reading of the text was done by Mr. Charles M. Adams, Assistant to the Director of Libraries, Columbia University.

Any profit resulting from this publication will be paid by the publishers to the Columbia University Libraries of New York City.

I apologize in advance for whatever errors and omissions may appear in my translation and can only plead in extenuation, *ut desint vires, tamen est laudanda voluntas.*

<div align="right">

EDWARD EPSTEAN
HON. F. R. P. S.

</div>

New York City
January 2, 1945

Contents

I. From Aristotle (Fourth Century before Christ) to the Alchemists 1

II. Influence of Light on Purple Dyeing by the Ancients 8

III. Thought and Teaching of the Alchemists 15

IV. Experiments with Nature-Printing in the Sixteenth and Seventeenth Centuries 33

V. The History of the Camera Obscura 36

VI. Stereoscopic (Binocular) Vision 45

VII. The Invention of Projection Apparatus in the Seventeenth Century 46

VII. (Rewritten). The Invention of Projection Apparatus 51

VIII. Studies of Photochemistry by Investigators of the Seventeenth Century up to Bestuscheff's Discovery in 1725 of the Sensitivity of Iron Salts to the Light and the Retrogression of Processes in Darkness 55

IX. Phenomena of Phosphorescence: Luminous Stone; Discovery of the Light-Sensitivity of Silver Salt; the First Photographic Printing Process by Schulze, 1727 57

X. The Life of Johann Heinrich Schulze 64

XI. Photochemical Research in the Eighteenth Century until Beccarius and Bonzius (1757), Together with a Digression on the Knowledge at That Time of the Instability of Colors 83

XII. From "Giphantie" (1761) to Scheele (1777) 89

XIII. From Priestley (1777) to Senebier (1782); Together with an Excursion into the Application Made in Those Days of Light-Sensitive Compounds to Magic Arts 99

XIV. From Scopoli (1783) to Rumford (1798) 107

XV. From Vauquelin (1798) to Davy (1802) 119

XVI. The Studies of Sage (1803), Link, and Heinrich on the
Nature of Light (1804-8) up to Gay-Lussac and Thénard
(1810) 142

XVII. From the Discovery of Photography in Natural Colors
by Seebeck (1810) to the Publication of Daguerre's Process
(1839) 153

XVIII. Special Investigations into the Action of Light on Dye-
stuffs and Organic Compounds (1824-35) 186

XIX. Joseph Nicéphore Niépce 193

XX. Relationship between Niépce and Daguerre 207

XXI. The Life of Daguerre 209

XXII. The Agreement between Nicéphore Niépce and Da-
guerre (1829) 215

XXIII. Daguerre Discovers the Light-Sensitivity of Iodized
Silvered Plates 223

XXIV. Joseph Nicéphore Niépce's Death in 1833; His Son Isi-
dore Takes His Father's Place in the Contract of 1829 with
Daguerre; Daguerre Discovers Development with Mercury
Vapors 226

XXV. Daguerre and Isidore Niépce Attempt Unsuccessfully in
1837 to Sell Daguerreotypy by Subscription; They Offer
Their Invention to the Government; Arago's Report to the
Academy on January 7, 1839; Agreement Arrived at June 14,
1839 230

XXVI. Bill for the Purchase of the Invention of Daguerreotypy
by the French Government, Which Donates It to the World
at Large 232

XXVII. Daguerre's Activities after the Publication of Daguer-
reotypy; Report on Daguerreotypy to the Emperor of Austria 246

XXVIII. Success of Daguerreotypy and Its Commercial Use; the First Daguerreotype Cameras, 1839 248

XXIX. Commercialization of Daguerreotypy; Description of the Process 250

XXX. First Use of the Word "Photography," March 14, 1839 258

XXXI. Scientific Investigation of the Chemico-physical Basis of Photography 259

XXXII. The First Daguerreotype Portraits; Exposures Reduced to Seconds 271

XXXIII. The Daguerreotype Process in Practice 279

XXXIV. Petzval's Portrait Lens and the Orthoscope 289

XXXV. Daguerreotypy as a Profession, 1840-60 313

XXXVI. Colored Daguerreotypes 315

XXXVII. Invention of Photography with Negatives and Positives on Paper and Its Practical Development by Talbot 316

XXXVIII. Reaction of the Invention of the Daguerreotype, the Talbotype, and the Earlier Photomechanical Processes on the Modern Processes of the Graphic Arts 331

XXXIX. Bayard's Direct Paper Positives in the Camera and Analogous Methods 334

XL. Reflectography (Breyerotypy) by Albrecht Breyer, 1839 336

XLI. Photographic Negatives on Glass (Niepceotypes) 338

XLII. The Wet Collodion Process 342

XLIII. Beginning of Photography as an Art by Daguerreotypy, Calotypy, and the Wet Collodion Process 348

XLIV. Portable Darkrooms; Theory and Practice of the Wet Collodion Process 357

XLV. Direct Collodion Positives in the Camera 369

XLVI. Chemical Sensitizers for Silver Halides 371

XLVII. The Dry Collodion Process and the Invention of Alkaline Development 372

XLVIII. Invention of Collodion Emulsion 376

XLIX. Invention of Collodion Layers for the Production of Stripping Films on Spools 380

L. Stereoscopic Photography 381

LI. Microphotography 385

LII. Photomicrography and Projection 388

LIII. The Solar Camera 391

LIV. Balloon Photography 393

LV. Photogrammetry 398

LVI. Modern Photographic Optics 403

LVII. Further Development of Photochemistry and Photographic Photometry 412

LVIII. Photoelectric Properties of Selenium 420

LIX. Gelatine Silver Bromide 421

LX. Gradual Increase of Sensitivity of Photographic Processes from 1827 until the Present Time 439

LXI. Gelatine Silver Bromide Paper for Prints and Enlargements 439

LXII. The Discovery of Gelatino-Silver Chloride for Transparencies and Positive Paper Images by Chemical Development (1881); Artificial Light Papers 443

LXIII. Calculation of Exposure, Determination of Photographic Speeds, Sensitometry, and the Laws Governing Density 449

LXIV. Discovery of Color-Sensitizing of Photographic Emulsions in 1873; Professor H. W. Vogel Discovers Optical Sensitizing 457

LXV. Discovery of Desensitizing 478

LXVI. Film Photography and the Rapid Growth of Amateur Photography 485

LXVII. The Stroboscope and Other Early Devices Showing the Illusion of Movement in Pictures 495

LXVIII. Eadweard Muybridge's Motion Picture Photography 501

LXIX. Photographic Analysis of Movement by Janssen and Marey 506

LXX. Ottomar Anschütz Records Movement by Instantaneous Photography and Invents the Electrotachyscope (1887) 512

LXXI. Development of Cinematography 514

LXXII. Photographing Projectiles in Flight and Air Eddies 524

LXXIII. Artificial Light in Photography 528

LXXIV. Printing-out Processes with Silver Salts 534

LXXV. Mordant-Dye Images on a Silver Base; Uvachromy and Allied Processes 539

LXXVI. Printing Methods with Iron Salts; Photographic Tracing Method (Blue Prints, etc.); Platinotype 542

LXXVII. Fotol Printing (1905) and Printing Photographic Tracings [Blueprints, Brown Prints, and Others] on Lithographic Presses (1909) 549

LXXVIII. Photographic Printing Methods with Light-Sensitive Diazo Compounds: Diazotypy, Primuline Process, Ozalid Paper 550

LXXIX. Discovery of the Photographic Processes with Chromates by Ponton (1839), and of the Light-Sensitivity of Chromated Gelatine by Talbot (1852) 552

LXXX. Gum Pigment Method 560

LXXXI. Pigment Images by Contact; Marion (1873); Manly's Ozotype (1898); Ozobrome Process (1905); Carbro Prints 561

LXXXII. Oil Printing 562

LXXXIII. Bromoil Process 564

LXXXIV. Photoceramics, Enamel Pictures with Collodion, and Dusting-on Methods 566

LXXXV. Electrotypes; Auer's Nature Prints 568

LXXXVI. Electrotypes and Galvanic Etchings 574

LXXXVII. Photogravure with Etched or Galvanically Treated Daguerreotype Plates 577

LXXXVIII. Invention of Photoelectrotypes for Copperplate Printing and Typographic Reproduction 581

LXXXIX. Production of Heliogravures by Means of the Asphaltum Method; Beginning of Halftone Steel Etching 591

XC. Heliographic Steel and Copper Etching with the Chromated Glue Process; Klič's Photogravure; Printing with the Doctor; Rotogravure 593

XCI. Photolithography; Zincography; Algraphy 608

XCII. Collotype 617

XCIII. Photographic Etching on Metal for Typographic Printing, Zincography, Copper Etching, and the Halftone Process 621

XCIV. Three-Color Photography 639

XCV. Photochromy; Color Photography with Silver Photochloride; Lippmann's Interference Method and "Photographie Intégrale"; Kodacolor; Bleaching-out Process 664

XCVI. Photographic Technical Journals, Societies, and Educational Institutions 676

XCVII. Supplement to the Chapters on Daguerreotypy and Cinematography 717

Biography of Josef Maria Eder, by Hinricus Lüppo-Cramer 720

Notes 729

Index 819

Chapter I. FROM ARISTOTLE (FOURTH CENTURY BEFORE CHRIST) TO THE ALCHEMISTS

LIGHT, which makes all things visible, this common and blessed property bestowed on all beings of the universe, has such an important object and place in nature that its character and qualities have not escaped studious investigation by the most gifted and ingenious nation of antiquity. We are indebted to the Greeks not only for the discovery of those laws which light observes when in motion through homogeneous and heterogeneous media and when reflected by polished surfaces; but they alone of all ancient people realized, from the nature of these laws, that optics is a mathematical discipline. They were also the first to attempt to bring within the domain of mathematics that infinitely subtle nature of light which appears to our senses so nonmaterial. [Translator's note: To my mind the shortest and most satisfying definition of light is that of the physicist, namely, light is that form of energy (radiant energy) which, acting on the organs of sight, makes visible the object from which it proceeds.]

Instructive in this respect is E. Wiedemann's *Geschichte der Lehre vom Sehen.*[1] According to Wiedemann, there were two main schools of thought among the Greeks regarding the nature of vision. One, represented by Plato (427?-347? B.C.), held that sensitive threadlike rays are emitted from the eye and that the objects perceived are touched by these rays. The other school, led by Aristotle (384-322 B.C.) and Democritus (d. 370 B.C.), taught that the objects themselves emitted the light rays which meet the eye. Avicenna (A.D. 980-1037) offered as a compromise the theory that light rays emitted from the eye function as organs of vision after they have united with the luminous air. As is well known, the opinion of Aristotle prevailed; Euclid (fl. c. 300 B.C.) and Ptolemy (fl. A.D. 127-141) accepted it.

The generally accepted view, until recently to be found in various histories of physics, is that Ibn al Haitam (Al Husen, d. 1038) was the first to revive the correct view of Aristotle. As a matter of fact, this Arabian savant discussed and firmly established the theory that vision is created by the agency of light rays. Ibn al Haitam, however, had predecessors and contemporaries who were of the same mind.

These were the Arabian philosophers and physicians who supported the Aristotelian theory and as medical men were led to the correct solution of the problem.

According to the "Lautere Brüder" (Ichwân Al Safâ, tenth century), light emanates from the body, penetrates and is absorbed in part by the transparent matter or the permeable substance of the object, the unabsorbed light rays conveying the color of the object by reflection to the eye. The other theory, that rays are projected from the eye, was rejected as folly.

When convenient, however, the Arabs referred to rays that proceed from the eye—for instance, Ibn al Haitam, who, as he tells us, follows Ptolemy in his writings concerning the configuration of the universe.

Moreover, Averroës (Ibn Ruschd, 1126-98) states quite appropriately in his commentary on the meteorology of Aristotle (Lib. III, cap. II): "Since one arrives at the same result in the study of perspective, one may accept either view; but as writings concerning the soul demonstrate that vision is not produced by rays proceeding from the eye, it is more fitting to adopt this last (i.e., the correct) theory" (*Jahrbuch f. Phot.*, 1893, p. 318).

The knowledge of convex lenses and spectacles is also related to the theory of vision. Convex lenses were well known to the ancients, examples of quartz crystal or glass lenses having been found at Nineveh, Pompeii, and elsewhere. It is supposed that they were used as magnifiers or burning glasses, as is indicated in the writings of Pliny and Seneca. A quartz crystal found at Tyre and preserved at Athens, at first thought to be a magnifier or eyeglass, was probably nothing more than a knob or button. The emerald through which, according to Pliny, the Emperor Nero viewed the gladiatorial combats, was not used as a spectacle or device to aid vision, but undoubtedly (contrary to the oft-quoted opinion) as protection against the glare of sunlight. This view is accepted by E. Bock, for various reasons. The first indisputable mention of spectacles is presented by Roger Bacon in 1276 (Emil Bock, *Die Brille und ihre Geschichte*, 1903; Emil Wilde, *Geschichte der Optik*, 1838, p. 92).

The development of the theory of vision and the history of the development of geometrical optics, so admirably dealt with by Wilde in his history above mentioned,[2] will not be further considered here, because I desire to emphasize the early concepts of the Greek philosophers as to the action of light on matter (organic substances).

The theories of Plato, Epicurus, and Hipparchus concerning light and vision postulated that vision is produced by the emanation of image-bearing light rays from the eyes, analogous to the sense of touch; that light emanates from the eye as from a lantern. These propositions, obviously, were unfavorable to any discovery of facts leading to the realm of photochemistry.

The Greek philosopher Empedocles (483-424 B.C.) defined light as matter (corpuscles), but this was later contradicted by Aristotle, who held that light and color were not bodily emanations from luminous objects and explained vision as a motion of the transparent medium existing between the eye and the visible object.

There can be no doubt that Aristotle concerned himself more than did any other philosopher of the ancient world with the intimate study of the nature of light. His teaching as to the transmission of light has been affirmed in modern times. How far he was in advance of his time in the difficult field of optics (light, vision, and color) is evident from the fact that even today, with our highly developed technique, his teachings dealing with light still attract admirers and followers.

Aristotle sets forth his researches dealing with light in three tracts—"On Light," "On the Senses," and "On Colors"—of which the last named is the most important for us. This treatise "On Colors" is sometimes attributed to Theophrastus,[3] a pupil of Aristotle, or to the peripatetic school, but it is the decision of those who rely on the judgment of Plutarch[4] that it was unquestionably the work of Aristotle.

It may be taken for granted that the earliest observations of the influence of sunlight in affecting a change of matter (changes in organic substances) were made on plants. Knowledge of the fact that sunlight is necessary to the formation of the green coloring matter of plants is probably as old as the human race.

Aristotle indicates his view on this matter in various parts of his writings. He expresses himself very clearly in his book "On Colors," chap.v, as follows:

Those parts of plants, however, in which the moisture is not mixed with the rays of the sun, remain white Therefore all parts of plants which stand above ground are at first green, while stalk, root, and shoots are white. Just as soon as they are bared of earth, everything turns green Those parts of fruit, however, which are exposed to sun and heat become strongly colored."[5]

He was also familiar with the action of light on the coloring of the human skin. To be sure, he goes too far when he attributes the blackness of the Negro to the intensity of sunlight. His view is, however, original, as is shown by comparison with Herodotus (484-425 B.C.), who, as is well known, accepted the explanation that "the black emanations of the body" of the Ethiopian are responsible for his color, while Onesicritus, much later, inclined to the opinion that the black color is the result of hot rain water falling from the skies.[6]

<div align="center">
EARLY ANTICIPATIONS OF THE EFFECT

OF LIGHT ACTION
</div>

A closer search among the writings of the ancients brings to light many anticipations of modern thought and theory, as *Gaea* (1908, p. 125), the popular German scientific journal explains. For example, Sophocles (495-406 B.C.) mentions in his poem "Trachinierinnen" a light-sensitive substance which required the employment of a dark room (verse 691) and was to be kept away from sunlight in a light-proof box (verse 692). Dejanira prepared from Nessos' blood a love philter for her husband Hercules, by anointing a woolen undershirt. She was instructed by the dying centaur to make her preparations in the dark, fold the garment, and place it carefully in a chest. She cast aside carelessly, however, some of the wool left over. As soon as these were struck by the rays of the sun, they disintegrated into a mass of flakes and emitted fumes.

The author asked Dr. Edmund Hauler, professor of classic philology at the University of Vienna, for more detailed information. He replied that in the above note the situation is in general correctly reproduced. In verse 555 of the "Trachinierinnen" we find an address by Dejanira to the chorus: "I had of old a gift given by the centaur, before this time kept secret in a brazen kettle, which I received once on a time while yet a girl from shaggy Nessos, when he was stricken to death."

According to his instructions, Dejanira used the blood of Nessos, poisoned by dragon's blood in which Hercules had dipped the deadly arrow which he had sent to Nessos. She had preserved the tincture carefully away from the fire and kept it always untouched by sunlight, deep in the recesses of the house, until her jealousy was aroused by Hercules, when she anointed an undergarment with it and sent it as a pretended love gift. Sophocles tells it as follows:

I smeared it in the house at home secretly with wool, having plucked the fleece from a lamb of our own herd, and, folding up the gift, I laid it untouched by the sunlight, in a hollow chest, as you saw. But coming in I see something which is puzzling to hear, unintelligible for a man to understand: For I happened to throw the tufts of wool from the lamb, with which I had done the rubbing into the blaze of the hot rays of the sun. But as they grew warm the whole mass dissolved, so as to be unrecognizable, and crumbled away on the ground, in appearance most like when one sees sawdust while wood is being cut; so it lies there crumbled away. But out of the earth where it lay, bubbles of foam sizzle up in masses, as when one pours the rich drink of the vintage upon the earth from Bacchus's vine.

The "magic" effect of the poisonous love philter manifested itself in the crumbling of the fabric and the hissing noise of the vapors which issued from it on exposure to sunlight, but especially in the terrible tortures endured by Hercules when the poisoned garment touched his warm body.

The narrative is so realistic that one cannot but feel that Sophocles knew something of the destructive effect of sunlight on wool. It is, however, useless to indulge in further speculation in this, since the description is simply a creation of the poet's fancy.

It is easier to connect the fancies of the Roman poet Publius Papinius Statius (A.D. 40-96) with photography, in anticipation of the daguerreotype process.

Statius was a contemporary of the emperors Vespasian and Domitian and a favorite of the latter. Among his fanciful poems still extant is a collection under the title "Silvae," and in iii. 4, of the collection we find a poem entitled "The Hair of Earinus." The *Frankfurter Nachrichten* in 1928 reported that this poem mentions an image formed by light on a mirror of gold. I quote from the report: "The youth Earinus, of Pergamus, in Asia Minor, was a great favorite of the Emperor Domitian. It is reported that his image, by magic, was permanently fixed on a small silver plate,[7] into which he had gazed for a period of time. His counterpart, Statius continues, was fixed merely by placing himself opposite— an image fixed on a silver plate. The picture was made on the seventeenth birthday of Earinus, when, according to custom, he was dedicated to one of the gods by having his locks cut off. Both the image fixed on the small silver mirror and the locks traveled to the Temple of Aesculapius at Pergamus."

Again the author consulted Professor Edmund Hauler, of Vienna, in

order to obtain more details of the quotation by reference to the original text in Statius: "Silvae," (iii. 4, Capilli Flavi Earini).

> Tunc puer e turba, manibus qui forte supinis
> nobile gemmato speculum portaverat auro:
> "Hoc quoque demus," ait, "patriis nec gratius ullum
> munus erit templis ipsoque potentius auro;
> tu modo fige aciem et vultus huc usque relinque."
> Sic ait et speculum reclusit imagine rapta.

These Latin verses may be rendered in English as follows:

Then a boy from the throng, who, it chanced, had brought on his upturned hands a splendid mirror of gold studded with jewels, said: "This also let us give to the temples of our fathers; no gift will be more pleasing, and it will be more powerful than gold itself. Do you only fix your glance upon it and leave your features here." Thus he spoke and showed the mirror with the image caught therein.

There is no mention of a silver plate, but gold is twice spoken of as the material. The mirror is described as having the form of a shield and was probably a hand mirror; at that time such mirrors were often embellished with a pictorial representation. The poet probably thought that Cupid, by his divine power, had quickly engraved a portrait of Earinus on the surface of the mirror as he gazed on it. Professor Hauler adds: "It is to be noted that this quotation is referred to by Henry in the *Neuen Jahrbüchern für klassische Philologie* (1863, XCIII, 643) as anticipating Daguerre's invention."

The picture of Earinus, formed by light, a bold dream of classical poetry, touches the imagination of today as a prophecy.

KNOWLEDGE OF THE ANCIENTS CONCERNING
THE ACTION OF LIGHT ON MATTER

Two thousand years ago the destructive effect of light on certain colors used in painting, especially on cinnabar, was well known. Vitruvius (first century B.C.), a celebrated Roman architect under both Caesar and Augustus, writes in his "De architectura" (vii.9), the only work of this kind which has come down to us from antiquity, about cinnabar (minium): "When used for trimming draperies in rooms not open to sunlight, it will keep its color unchanged; but in public places (peristyles, auditoriums), and in similar places where the light of sun and moon has access, it spoils immediately when exposed to their rays

and the color loses its vividness and brilliancy, turning black." Another writer, Faberius, who desired to decorate his house on the Aventine, had a similar experience. He covered the walls of the peristyle with cinnabar, but after four weeks they were so unsightly and spotty that he had to cover them with another color. However, if one wishes to bestow more care on the coating of cinnabar, in order to render it permanent, this may be done by first allowing the painted wall to dry and then, using a bristle paint brush, covering the wall with a mixture of molten Punic wax and oil, known to the Greeks as "kausis." This wax coating permits no penetration by the rays of sun or moon. Vitruvius (vi. 7) discusses in detail the question toward which point of the compass a building should be erected and remarks that picture galleries, textile workrooms (plumariorum textriniae), and the studios of painters should face northward, in order that the colors used in such places should remain unchanged.

It is very doubtful whether Pliny (first century A.D.) intended, as many authors report, to refer to the darkening of silver chloride in light when he states that "silver changes its color in mineral waters as well as by salt air, as, for instance on the Mediterranean shores of Spain" (*Historiae naturalis* xxxiii. 55, 3). I believe this reaction was undoubtedly assisted by the presence of hydrogen sulphide. Elsewhere (xxxvii. 18) he says: "It is curious to note that many emeralds deteriorate in time; they lose their green color and suffer a change under sunlight." On the other hand, a knowledge of the change of colors by light is clearly indicated in the following quotation from Pliny (xxxiii. 40): "The effect of the sun and moon on a coat of minium (cinnabar?)[8] is injurious." This statement is copied almost verbatim from the work of Vitruvius. Similarly, in his statement about the wax covering as preventive of destructive light action, Pliny (xxi. 49) closely follows Vitruvius. He speaks of bleaching wax "in the open air by the light of sun and moon" and discusses those methods of encaustic painting which use wax melted by heat and applied with the paint brush: "a method of painting which, when applied to ships, does not suffer the least change from sun, salt water or the weather" (xxxv. 41).

No further statements about the change of other colors are to be found in the early accounts, which is perhaps explained by the fact that they made little use of colors other than red. According to Pliny xxxii. 7, 117), red paint was for long the only color employed in the execution of old pictures called monochromata, and it was especially

minium (Pb_3, O_4, red lead oxide) and rötel (mixture of ferrous oxide) which were used. Even at a later period, when the primitive method of painting had been abandoned, the use of luminous colors, red and yellow, still predominated, though now painters employed four colors, as Pliny relates (xxxv. 7, 50): white, black, red, and atticum, a color similar to ocher.[9] Dioscorides describes, in chap. xxxii of the first book of his work *De materia medica*, the process of bleaching oil of turpentine: "Take some of the lighter kind, place it in the sun in an earthen vessel, mix and stir it violently until scum is formed, whereupon add resins and, if necessary, expose it again to the sun.

However, new researches have been made respecting the colors used by the ancient Romans; the material for these researches was found at Pompeii.[10] Their constituent parts were mostly yellow and red ocher, vermilion, minium, massicot (lead oxide), mountain green (basic copper carbonate), some kind of smalt, carbon, and oxide of manganese. Of all these colors, cinnabar was, perhaps, particularly suited to demonstrate a change in color when exposed to light. It is not easy to understand why these writers failed to investigate and record further their observations of the changes in dragon's blood and indigo blue, which colors, however little used, were undoubtedly known at that time.

Chapter II. INFLUENCE OF LIGHT ON PURPLE DYEING BY THE ANCIENTS

THE EARLY WRITINGS and observations concerning purple dyeing deal chiefly with the photochemical properties of light to effect changes in or decompose colors. The ability of light to produce dyes was recognized then only in the case of the green coloring matter of plants. But occasionally during the early practice of purple dyeing it was noticed that light possessed the remarkable quality of not only influencing and originating beautiful colors but also enriching their vividness of hue.[1]

The purple of the ancients was the most beautiful and costly dye of antiquity. The snails (*purpura*) which yielded the dye used in purple dyeing were found on the coast of the Mediterranean, but the beauty and durability of the color varied greatly with the place of their origin and with their quality. The red and violet varieties of purple produced at Tyre won world-wide renown and were well known as early as the

time of Moses. The two species of snails most favored by the ancients were *Murex brandaris* and *Murex trunculus*. Their glands secrete a yellow, pus-like mucus, which develops under the influence of sunlight into a purple-red or violet dye.

For centuries the Phoenicians alone possessed the secret of the manufacture of purple. The coloring matter manufactured from these snails quickly gained general favor, and purple garments were esteemed a mark of distinction for rulers and high dignitaries. The use of purple garments increased with the wealth of nations, notwithstanding the extremely high price which was demanded for clothes of this sort. The Roman emperors transferred the manufacture of purple to Italy and conducted it as a monopoly. The art of purple dyeing, which, like many other arts, had reached a high level at this time, was lost almost completely in the stormy period which marked the migration of nations. For a short time the art was still preserved in the Byzantine Empire, only to become extinct even there in the twelfth century. Important imperial decrees were written in purple ink, and today one may still find valuable manuscripts, written on purple-colored parchments in the libraries at Upsala and Vienna. The latter has in its possession two such examples of religious manuscripts.

A noteworthy piece of silk, dyed in antique purple, is found in the state robe produced for the Saracen court at Palermo, in Sicily, which after curious vicissitudes became the coronation robe of the German emperors. It is now preserved among the exhibits of the former imperial jewel room in Vienna. Incidentally, it is well to record that the hue of purple was never bright red, but showed rather a violet shade, and there are numerous examples of shades running toward the blue.

The purple dyeing process deserves much consideration in the history of photochemistry. Sunlight plays a great role in the manufacture of these beautiful purple-dyed materials, because they are made possible only through the effect of sun rays on the light-sensitive secretion of the Purpura snail. Although many early authors have much to say about Purpura snails and purple dyeing, the references made by Greek and Latin writers are scattered; they treat them only as of secondary importance. Only rarely do they refer to the necessity of the presence of sunlight in the creation of the splendor and radiance of colors. The fundamental investigation of this subject was reserved for Alexander Dedekind, formerly director of the Egyptian Department of the Imperial Museum of the History of Art, Vienna, whose research clarified

the history of the subject. Dedekind is the outstanding authority on the subject of purple, and his works form the basis of our knowledge (Dedekind, *Ein Beitrag zur Purpurkunde*, Berlin, Verlag von Mayer und Müller, Bd. I, 1898; Bd. II, 1906; Bd. III, 1908).

The oldest accounts, as Dedekind proves, are those of Aristotle, who relates, in his work on colors, the advantageous influence of light in purple dyeing. Julius Pollux (latter half of the second century A.D.) writes in a similar manner in his dictionary *Onomasticon*, and Philostratos, a Greek Sophist from Lemnos, who lived in Rome about the middle of the third century A.D., writes in his book *Imagines*: "The purple of Tyre looks dark and derives its beauty from the sun, which gives it the shade of a pomegranate blossom."

Until very modern times priority for the recognition of the influence of light in purple dyeing was attributed, in ignorance of the ancient authors, to the celebrated Eudoxia Macrembolitissa, because of an old historic-mythological dictionary, called "Ionia," an interesting Greek manuscript which it is alleged was reported as composed by her. Until quite lately this manuscript was said to be dated about the eleventh century. It is preserved in a library at Paris, and in it the alleged Eudoxia describes how the material to be dyed is dipped into the purple dye. She continues: "The purple color becomes first class only if the material is exposed to the sun, because the rays of the sun add great fire which darkens the color, and the brilliancy is brought to its greatest perfection by the fire from above."

Bischoff, in his *Versuche einer Geschichte der Färbekunst* (1780, p. 19), was the first to call attention to this clear and explicit description of the part played by light in the formation of purple colors.[2] The citation quoted in the third edition of the author's book was taken from the work by Bischoff. The book with which Eudoxia is credited, entitled "Ionia," was published by Villoison in the first volume of the *Anecdota Graeca* (1781), where on pages 53-58 the purple snail is described (new edition by Flach, Leipzig, 1850).

Eudoxia was the daughter of a respected Byzantinian, who during the reign of Emperor Michael IV, the Paphlagonian, occupied an important official position in Byzantium. She was famous for her beauty, erudition, and Hellenic culture. She became the second wife of Constantin Ducas, who later ascended the throne of Byzantium (1059) as Constantin X. He appointed her Regent, and she reigned alone after his death (1067) for a time, then married General Romanos, who was

captured in the war with the Seldshooks, a Turkish tribe, and after being set free, was persecuted by his own people. These internal struggles over the sovereignty ended when her brother-in-law Johs. Ducas had her arrested and imprisoned as a nun in the Convent of St. Mary on the Bosphorus, which she herself had built. The gifted empress, who now devoted all her time to the pursuit of learned studies, lived for twenty-five years after being dethroned. Therefore it is quite plausible that the manuscript which has been ascribed to her, entitled "Ionia" or "Violarium" (Garden of Violets), may have originated with her. The authorship of this book, although conceded to Eudoxia by many until quite recent times,[3] is absolutely denied to her by modern critics.

According to Karl Krumbacher this work is to be ascribed, not to Eudoxia, but to the Greek Constantin Palaeokappa, who recompiled it from different sources. The authenticity of "Ionia" as the work of Eudoxia was passionately defended by Flach, but in a vain controversy, and according to Dedekind there remains no doubt that "Ionia" did not originate with the purple-born Eudoxia.

Krumbacher[4] also declares it to be apocryphal and concludes that very likely it was put together by the Greek Constantin Palaeokappa from various sources. Almost half the work is copied from a book by Phavarinus (a Latin author of the times of Hadrian, second century A.D.), and printed at Basel in 1538; the Greek writer also made use of the Basel edition of Palaephatos and Cornutus of 1543. The principal statements dealing with the spuriousness of Eudoxia's claim originate from Pulch ("Die Pariser Handschriften des Honnus Abbas und Eudoxia," *Philologus*, 1882, pp. 341, 346, and his treatise *Konstantin Palaeokappa*). Pulch was also the author of *Jonia der Eudokia* (Hermes, 1882, pp. 177, 192). Also see the discussion by Wilamowitz-Möllendorf in *Die deutsche Literaturzeitung* (1880, p. 228, and 1881, p. 319). Flach replied to this with a pamphlet which is not convincing: *Herr Wilamowitz-Möllendorf und Eudokia; eine Skizze aus dem byzantinischen Gelehrtenleben*, added to the second part of Jahn's *Jahrbuch* (1881).

Whoever may be the author of the book "Ionia," it is without doubt the most lucid and important of early contributions to our knowledge of the photochemical change of colors in the dyeing with purple.

It was not until the seventeenth century that further research added to our knowledge of purple snails. Here we are indebted to William Cole, of Minehead, England, who discovered on the shores of Somer-

setshire and South Wales shellfish (*Buccinum*) containing purple. He observed that their juice, when spread on linen or silk, produced first a greenish color, which changed rapidly to dark green and light purple, which turned in a few hours under bright skies to a deep purplish red. Cole discovered also that every one of these shades of color remained fixed when the dyed material was kept in a dark room. He also noted an odor of garlic during the decomposition of the juice while exposed to sunlight. In November, 1684, Cole sent some samples of such dyed linen material to the Royal Society of London, with a description of his experiments.[5]

In the beginning of the eighteenth century the celebrated French scholar of natural sciences and inventor of the thermometer which is named after him, René Antoine Ferchault de Réaumur (1683-1757), occupied himself with the study of the purple snails. Several of his important works deal with the domain of zoology. He studied especially the life of insects and crustacea, investigating the formation of the shells of this species.

Réaumur found a great many *Buccina* on the coast of Poitou and published in 1711, in his treatise *Sur une nouvelle pourpre*, his observations of the important part which light plays in the formation of red color.[6] He observed that the animal secretion when fresh was yellowish and turned violet only when exposed to the sun and finally to purplish red. The air alone did not affect the color in the dark, nor did the light emanating from a hot fire prove effective in the process of turning the color red, although the fire was much hotter than sunlight. However, when sunlight was concentrated on it through a burning glass, the reddening was greatly accelerated. His experiments led him to the conclusion that "in order to produce the same changes in the juice which can be affected by the warmth of sunlight, it is necessary to employ a much higher degree of heat in the fire."

These studies by Réaumur inspired, in 1736, General Inspector of the Marine and French Academician Duhamel du Monceau (1700-1782) to new experiments with the purple dye indigenous to certain shellfish.[7] In his dissertation *Quelques expériences sur la liqueur colorante que fournit le pourpre, espèce de coquille qu'on trouve abondamment sur les côtes de Provence*[8] he describes, in much the same manner as did his predecessors, a similar change in color (reddening) which takes place when the white secretion of certain mollusks is exposed to sunlight. He satisfied himself that dark heat does not effect a change of

color, that fire does so only to a very small degree,[9] while sunlight in a few minutes changes the color of the secretion or that of linen dipped in purple. Reddening by light took place also when the material was enclosed in glass, but not when covered with the thinnest tin plate. He was astonished to find that the reddening process proceeds more quickly and more intensively in sunlight if the experimental material is covered with opaque blue paper, and in greater degree than under proportionately more transparent yellow and red paper. This is the earliest (though indefinite) record of the different chemical reactions of radiation of colors.

In the nineteenth century H. de Lacaze-Duthiers, of Paris, during a sojourn in Mahon, the capital of the Balearic Island, Minorca, studied various species of purple snails (*Purpura haemastoma* and *Murex trunculus*) which are found there in the sea. He made exceedingly interesting experiments with the secretion of these snails and their sensitiveness to light. These results have been preserved for us. He published his work in a treatise "Mémoire sur la pourpre," in the *Annal. des sciences naturelles, Zoologie* (Paris, 1859). Lacaze-Duthiers coated linen and silk with the yellow secretion of the purple snails and exposed them for two days to strong sunlight, thus forming purple dye. He used the secretion of the purple snail to make drawings of snail shells and reproduced their images by exposing them to the sun. A drawing of this kind, made with the juice of *Purpura haemastoma* in 1858, was published by Alexander Dedekind in his *Ein Beitrag zur Purpurkunde* (Berlin, 1898). Collotypes in color were inserted, which the author (Eder) had reproduced at the Graphische Lehr- und Versuchsanstalt, in Vienna, from the original linen images. Other images made with the secretion of *Murex trunculus* show a blue-violet shade. As late as the time of Lacaze the fishermen of the Balearic Isles used the juice of these snails (*Purpura haemastoma*) to mark their laundry, and this marks the end of early purple dyeing. Nor is it likely that the industry will be revived, since modern color chemistry can undoubtedly produce much more brilliant purple dyes.

Later Augustin Lettelier studied the mussel *Purpurea capillus*, which is found abundantly along the British coast. He observed that the purple dye yielded by this bivalve consisted of a yellow substance which was not sensitive to light, and of two other substances which were sensitive to light and turned carmine red or violet under the action of light ("Comptes rendus," Eder's *Jahrbuch*, 1890, p. 279).

The chemical properties of the purple dye were first investigated in 1905 by the highly gifted chemist P. Friedlander, who was called at that time by W. Exner to the Department of Chemistry of the Technological Museum for Industry at Vienna. His pioneer investigations of sulphur derivatives of indigo (thioindigo, etc.) pointed in entirely new directions in the chemistry of indigo (1905). In the research which resulted in his discovery of indigo red he arrived at the assumption that purple dye might be an indigo derivative, like the red indigo. Through the courtesy of the Imperial Zoological Experiment Station in Triest he obtained about 11,000 snails (*Murex brandaris*). He isolated the purple dye by coating filter paper with the secretion of the glands and developed the dye by a short exposure to sunlight. Friedlander found that the purple was free from sulphur, chlorine, and iodine, but contained nitrogen and, what particularly surprised him, was also rich in bromine.

Analysis showed that the purple dye was to be considered as a dibromo derivative of indigo or an isomer indirubine. Theoretically, there can be no less than fifty isomeric dibromindigotines and dibromindirubines. According to Friedlander the purple of the ancients is indentical with the artificially manufactured 6:6 dibromindigo, which possesses, of all isomers which have hitherto been investigated, by far the deepest shade of red. However, it was still necessary to prove by spectroanalysis that the artificial purple was identical with nature's product. This led Professor Friedlander, in 1909, to request his colleague Dr. Eder to make a spectroscopic comparison of the brominated indigo derivatives (6:6 dibromindigo) in question with the orginal purple of *Murex brandaris*. Dr. Eder found that equally strong solutions of both dyes were identical, both in the qualitative absorption spectrum as well as in the quantitative spectral analysis. These experiments by Eder are published as a supplement to Friedlander's essays in the reports of the proceedings of the Akademie der Naturwissenschaften.[10] Thus, it was Friedlander who raised the veil which for centuries had hidden the true nature of the purple of antiquity.[11]

Chapter III. THOUGHT AND TEACHING OF THE ALCHEMISTS

AMONG THE ALCHEMISTS there prevailed confused ideas about the influence of sunlight. Their views were formed probably less from actual observation of nature, than through astrological speculations. At any rate, it is these ideas from which sprang the science of photochemistry, and this is our reason for occupying ourselves with this interesting subject.

The alchemist endeavored to find not only a substance which could transmute baser metals into gold but also an elixir that would heal sickness and prolong life. It was because of this that the term "philosopher's stone" was used. Many alchemists believed that the stars and their conjuctions influenced the success of "the great work."

Julius Firmicus Maternus (fourth century), who is supposed to be the first to use the word "alchemy," deemed it important that an alchemist be born under the influence of a good star (for example, Saturn) that would endow him with the talent: "If he proceeds from the house of Mercury, he brings the gift of astronomy; from the house of Venus, he brings song and laughter; from the house of Mars, the love of arms and instruments; from the house of Jupiter, comes the talent for theology and jurisprudence; and from the house of Saturn, the science of alchemy is achieved."[1]

Kallid Rachaidibis, in his work on alchemy "The Book of the Three Words," relates in the sixth chapter "On the Observation of the Planets in the Work of Alchemy,"[2] states that only when the sun is in certain positions in the heavens,[3] which are there more clearly explained, "the work of alchemy is achieved." It follows therefore that the author did not take into consideration in any way the direct coöperation of sunlight.

G. Clauder considered as very important the extremely punctilious observance of the proper season when preparing the philosopher's stone. In his "Treatise on the Philosopher's Stone,"[4] published in 1677, he mentions that the "World Spirit" was most propitious during the equinoctial periods; particularly favorable was the spring equinox, in April and May, also the summertime, when the sun is in Leo. However, the constellation of the stars must be considered.

Petrus de Zalento[5] also states: "Much of the success of your work will depend on its beginning being made under the proper auspices of the stars."

Perhaps one might search among the dark secrets of Hermes Trismegistos for the root from which sprang the belief of many alchemists that the stars influence chemical processes. This document, composed about 4,000 years ago by the "decimal magnitudes," which according to the myth was engraved on an emerald tablet, was highly esteemed by the mystics of all times, and many have attempted to solve its meaning.

The interpretation of the quotation in question is vague. At any rate it is written:

The father of all things is the sun, the moon is the mother, the wind has carried in its belly, and the earth has matured it Mount with all the ingenuity of your senses from the earth to the heavens, then return to earth and force together into one the upper and lower powers; thus the honor of the whole world can be achieved, and man will no longer be despised [after Wiegleb].

In many of the old collections there is still found the conclusion of Hermes: "The foregoing is entirely the work of the sun."[6]

The writings imputed to Hermes are very obscure, and their interpretation difficult. He attributes all chemic power to the sun, "the father of all things." The alchemists interpreted the words "sun" and "moon" as gold and silver and meant " the making of gold" when they spoke of the "work of the sun."[7] There were many other comments on the subject.[8] This quotation of astrological superstition, as well as a similar one equally ancient, is perhaps from Ostanes, whose manuscript in Coptic characters was found within a column in the ruins of the Temple of Memphis. The English translation of the Latin text (via the German translation by Kopp)[9] runs as follows: "Heavens above, heavens beneath; stars above, stars beneath; seize these, and you will be lucky."

In a similar manner the later alchemists often prescribe the coöperation of the sun; for instance, the exposure of mixtures, compounds, and such like to the rays of the sun. However, since almost invariably there are added to the direction[10] for this purpose the words "or in a warm place," among others the burying in a warm dunghill—where light, of course, is entirely shut out—one must conclude that they were to use the strength of the sun's rays merely for their mild, heating energy.

This so-called sun distillation was very common in the sixteenth and seventeenth centuries, especially in the warm southern countries. The

distillation apparatus, consisting of distilling flask, condenser, and receiver, was placed in the sun in the heated sand. They sought to increase the effect of sunlight by properly placed mirrors, which caused the rays of the sun to be reflected upon the distilling bulb. A preparation made in this manner was called "aqua rubi," which was used as an eye wash and was very common in Italy at that time.

The alchemist Geber (eighth century) mentions the influence of the stars in alchemic processes in the first part of his "Chemical Writings":

Likewise all being and all perfection comes from those stars, as the initial and perfecting matter of all that is born and dies, to one entity and not to a multiplicity For everything obtains at once for the time of its existence from a definite constellation of the stars, that which serves them best . . .[11]

A little less mystic and confused is this quotation from Chapter XXIII "On Gold":

And therefore we perceive in the work of nature, that copper can also be changed into gold through skill, for we have seen in copper ore, over which water flowed, that it carried with it the thinnest and most minute copper flakes and that it washed and cleansed them by a current constantly running over the ore; when after a while the water stopped running, we observed that these same flakes having been cooked in the dry sand for three years, there was then found under them traces of genuine gold. Therefore, we believed that the water cleansed and refined it, but that the warmth of the sun and the dryness of the sand digested and worked the change of substance.[12]

It appears from this passage that Geber attributes to the rays of the sun, "the warmth of the sun"—the power to transmute base metals into precious metals as, for instance, copper into gold, if not directly, at least in combination with other agents. Geber also refined "cerussa" (white lead pigment) by "congealing in sunlight or moderate fire."[13] There are still other scattered astrological references to the influence of the stars on the success of alchemic labors, but I find no mention of the effect of light.

The Silesian physician Hans Heinrich Helcher, in his *Aurum potabile* or "Tincture of Gold," writes that this preparation together with the excellence of gold and its analogy with our body is certainly a curative in effect and use as well as a preservative. In Chapter II, "On the Excellence of Gold and Its Use in Medicine . . ." he says,

For none of the metals is purer, more stable, heavier or more perfect than gold . . . which may be dissolved in spirits and contains the life principle in itself, like a fire which was imparted to it by the heavens. For this reason, perhaps, philosophy looks upon the sun as flowing gold or even as containing the great tincture[14] and on that account uses the sign of sun-heavens as symbol of gold in its books, to indicate that even as the sun in the heavens exercises its influence on the great world, more particularly in the growing, noble metal,[15] so gold acts, in the most powerful manner, as a concentrated light and as the sun's son, in the small world of man; when well dissolved, precipitated and active, it shows great efficacy, like the sun. It is unnecessary to prove this by citations, because there are so many books at hand, full of marvelous cures.

Moreover, there is a like quotation from Brandau's *Universal Medicine* (ch. i, p. 3):

In gold there are the most precious principia and mineralia . . . namely, the magnificent, fertile warmth of the sun, the moisture of the moon . . . resident . . . gold is a son of the heavenly sun; whatever good the sun does in the great world with its true, mystical rays, that also can his son gold perform with his subtle, fiery sulphur in the small world, which is MAN Where there is light, there is warmth; where warmth is, there is life also; and where there is life, there are all kinds of power, forces, blessings, and fruitfulness.

It is noteworthy that one is cautioned now and then to set out of doors the "philosophic salt," viz.; the gold-containing mixture (the salt) required for the production of the quintessence. It was to be set out of doors for drying at night, but in daytime it was to be placed in an airy room or in a place shielded from the sun.[16] There may be a connection between this statement and the light-sensitiveness of gold salts, which may have been known to the alchemists.

However, many alchemists undoubtedly express their opinion that the effect of light rays upon the elixir are favorable. Henricus de Rochas[17] states that the "heavenly spirit of the universe," which animates the elixir, could be incorporated into the matter, especially through the "warmth and rays of the sun, moon, other planets, or through dew . . . etc." Pater Spies, of Cologne,[18] mentions that the strength of the elixir and its natural fire are augmented by the rays of the sun. Sendivogius[19] writes that the primary matter of metals, the "philosopher's mercurium," was "governed by the rays of the sun and moon" He also differentiates (following Hermes) between the "heat" of the sun and that "heat" which is hidden in the center of the

earth; heavenly and earthly heat, salt, and water must be combined, and then "all things on earth are created."

In conclusion, I wish to mention a mystic utterance of an alchemist who lived at the end of the eighteenth century. I found this hand-written note of an adept in the *Handschriften für Freunde der geheimen Wissenschaften*, von M. J. F. v. L** (1794) in the library of the well-known spiritualist and author, Lazar Freiherr von Hellenbach, who also interested himself a great deal in alchemy and who owned several manuscripts by alchemists. There we find light praised as the primal source of things in the following words: "God lives and acts in light; light acts in spirit; and spirit in salts, salts in the air, air in the water, and water in the earth." Thus, the alchemists furnished few positive data about the nature of the effect of light on matter, or as to the nature of silver salts in particular, but directed attention to sunlight.

In this respect we obtain the most interesting insight into the opinions of the alchemists of olden times through the iconographs and medals preserved to us, which represent symbolically the ideas and works of the alchemists. It is interesting to note that in these repro-ductions the image of the sun, which is also that of gold, plays an important role; but at the same time other symbols are found which refer to other metals known to the alchemists. For a better understand-ing of the symbolical representations found on such alchemic gold and silver medals, I give here an abstract of the more important and most applied symbols for the materials and agents employed by them:[20]

Iron: Mars			Salt	
Tin: Jupiter			Alum	
Gold: Apollo or Sun			Salpeter: Saltpeter	
Silver: Diana or Moon			Vitriol	
Lead: Saturn			Ash	
Mercury: Mercury			Sulphur	
Copper: Venus			Materia prima	
Air			Arsenic	
Earth			Antimony	
Water			Caustic potash	
Fire			Cinnabar	

A crown: in general, the conclusion of the great work

To Professor Alexander Bauer, of Vienna, we are indebted for the most exhaustive investigations into alchemic coins and medals. He describes in several works the rich Austrian possessions of exceeding rarity and prominence.[21] Two of these medals, in the numismatic collection of the Ferdinandeum at Innsbruck, are, according to Bauer, of gold and have come down to us from 1647; among other marks they contain the sign of the sun. The face and reverse of one of these medals no doubt has an alchemic origin; it was coined for a particular occasion, perhaps for a wedding which celebrated at the same time a political coalition.

The outer inscription reads: Lilia cum niveo copulantur fulva leone (Lilies of fiery yellow unite with the snow-white lion); the inner inscription: sic leo manuescet sic lilia fulva virescent 1647 (Thus will the lion become tamed, the yellow lilies strengthened).

Reverse: in the inner circle, a man striding, in his left hand the symbol of iron (Mars), in the right a sword (at that time the alchemic sign for fire) and the inscription: Arma furens capiam rursusque in praelia surgam (Furious, I shall take up my weapons and rise again to battle). The inner circle is surrounded by six other small circles and by the planetary signs of the metals: gold, silver, mercury, copper, lead, and tin. The legends to these symbols read as follows: for gold (sign of the sun): A marte obscuror (I am obscured by iron); for silver: Martis horrore deficio (I am wasted by the horror of war); for mercury: Pedibus Mars abscidit alas (Iron has cut away the wings of Mercury's feet); for copper: Marti conjungor (By iron I am united); for tin: A marte defendor (I am defended by iron); for lead: A marte ligor (I am bound by iron).

The other medal shows an alchemic taler of the alchemist Baron v. Kronemann, who maintained that he was able to make gold and silver out of mercury. He made silver coins for special occasions (c.1679), which are preserved in the Imperial Numismatic Cabinet at Vienna. Kronemann, who was exposed as a swindler and hanged,[22] engraved on one of these original coins the picture of a radiant sun, added the word "tandem" (finally) and in the direction of the rays the words "per me" (through me). Perhaps he meant to indicate the necessity of sunlight for the great work, perhaps the sign of the sun is merely to indicate the symbol of gold. The reverse of the medal carries again the sun and the symbols of the three basic principles.

Another noteworthy alchemic medal of gold, weighing 16½ ducats,

is kept in the former Imperial Numismatic Cabinet at Vienna and comes down to us from 1716. The inscription on this medal relates that in this year the transmutation of lead into gold was successfully accomplished in the presence of a number of trustworthy witnesses. Here, also, the medal carries a symbolic figure of the sun with the inscription: "A golden progeny sprung from a leaden father." An illustration may be found in Bauer's work *Die Adelsdokumente österreichischer Alchimisten und Abbildungen einiger Medaillen alchimistischen Ursprungs* (1893).

The reverse of this medal carries a Latin inscription which reads in English:

The chemical change of Saturn to sun, i.e., of lead into gold, was observed at Innsbruck December 31, 1716, in the presence of His Highness, the Rheno-Bavarian Count Palatine Carl Philipp, High Steward of His Holiness the Roman Emperor, Great Elector of Bavaria, Duke of Jülich, Cleve and Bergen, Governor of Tirol, etc. etc., and this medal was coined to the everlasting memory of the castle Ambras and posterity [Schmieder, *Geschichte der Alchimie*].

Later works are: *Collection d'ouvrages relatifs aux sciences hermétiques Albert Poisson théories & symboles des alchimistes le grande-œuvre suivi d'un essai sur la bibliographie alchimique du XIXe siècle; ouvrage orné de 15 planches, représentant 42 figures, Bibliotheque Chacornac,* (Paris, 11, Quai Saint-Michel, 1891), and *Cosmology; or, Universal Science, Cabala, Alchemy, Containing the Mysteries of the Universe Regarding God Nature Man, the Macrocosm and Microcosm, Eternity and Time, Explained according to The Religion of Christ, by Means of The Secret Symbols of the Rosicrucians of the Sixteenth and Seventeenth Centuries; copied and translated from an Old German manuscript and provided with a dictionary of occult terms by Franz Hartmann, M. D.* (Boston; Occult Publishing Company, 120 Tremont Street, 1888).

The alchemists, as we have seen, had only hazy, mystic conceptions of the influence of the all-animating sun and of astrology on the successful working out of the chemical processes by which they endeavored to change base metals into gold and silver. Nevertheless, their ideas were the starting point for a number of chemical experiments, which led to the discovery of phosphorescent bodies in the seventeenth and eighteenth centuries and to the discovery of the light sensitiveness of the silver salts, as is shown in a later chapter.

SILVER AND GOLD SALTS

The chemical properties of the salts of silver and gold with their reactions to light remained unknown for a long time. We shall mention here only the most important facts from the history of chemistry and the gradual growth of the chemical knowledge of silver and gold combinations as far as the history of photography is concerned with them.

We quote from the author's *Quellenschriften zu den frühesten Anfängen der Photographie bis zum 18. Jahrhundert* (Vienna, 1913).

The earliest record of the production of nitrate of silver by dissolving silver in aqua fortis (nitric acid) and its subsequent crystallization is attributed to the half-mythical Geber (Gâbir, Dschâbir ibn Hajjam), the most renowned of the Arabian alchemists, who is said to have lived in the eighth century. He spread the ancient teachings and ideas about the transmutation of base metals into noble metals. The latter-day alchemists venerated Geber as their master.

If we disregard these ideas and concentrate upon the practical, chemical knowledge of the early alchemists, it must first be stressed that old Geber was credited with extraordinary chemical knowledge and with having, among other matters, first mentioned nitric acid. Modern historical research, however, points to many writings attributed to Geber as apocryphal; they were probably written by different Latin writers under assumed names, about the fourteenth to the sixteenth century and foisted upon Geber's name. But they report the experiences of the occidental alchemists of their time.

The passage relating to silver nitrate in the work attributed to Geber; *De inventione veritatis*, which was printed in 1545,[23] reads as follows: "Next dissolve glowing silver in aqua fortis as before, then boil it for a day in a long-necked phial with the opening corked, until the water is reduced to one-third its volume; then put it in a cool place, and little stones are formed like fusible crystals." Silver nitrate is thus well described, but at that time a specific name was not conferred upon the crystals.

We owe exact and authentic information about silver nitrate to the celebrated physician Angelo Sala (seventeenth century), born in Vincenza. He lived most of his life in Germany and in Switzerland, and in his last days was physician-in-ordinary to the Duke of Mecklenburg. He spent a good deal of time in compounding drugs and medi-

cines and deserves credit for the development of chemistry and its application. He introduced the name "magisterium argenti," or "crystalli Dianae," and described in his book *Opera medica chimicae* (1st ed., 1647; 2d ed., 1682) the manufacture of the so-called *Hollenstein* (caustic stone) by smelting silver nitrate. As Felix Fritz discovered, a pamphlet by Sala was published under the title *Septem planetarum terrestrium spagirica recensio* (1614) in which he reported that powdered silver nitrate turns a deep black in sunlight. He called silver nitrate at that time "lapis lunearis" and wrote: "Si lapidem lunearem pulveratum ad solem exponas instar atramenti niggerimus" (When you expose powdered silver nitrate to sunlight, it turns black as ink). He also established the effect on paper, because he saw that silver nitrate wrapped in paper for a year colored it black.

The well-known alchemist Johann Rudolf Glauber (1604-68), the discoverer of "Glauber salt," named after him, mentions in his *Explicatio miraculi mundi* (1653; later ed., 1658):

If an aqua fortis is distilled from saltpeter and vitriol and a little silver is dissolved in it, if then is added common rain water to break up the aqua fortis, there is produced a fluid which dyes coal black, like ebony, not only all the hard woods, but also furs and feathers [Glauber, *Opera chymica*, 1658, p. 190].

The first intimation of the property of silver nitrate to turn black when in contact with organic substances is attributed by the old writers to Count Albert von Bollstädt (Bollstädt is near the small Bavarian town Lauingen), who was called Albertus Magnus (1193-1280). He was one of the most learned men of the Middle Ages and was looked upon as one of the oldest and most renowned alchemists.[24] He was born in Suebia, entered the Dominican order, taught in several monasteries in Cologne, Hildesheim, Regensburg, was professor of theology at the University of Paris, and finally returned to Cologne, where he devoted the last years of his life entirely to science. Albertus Magnus died in 1280, at Cologne, where he is buried in the church of St. Andrew. Owing to his many-sided education and culture, he was honored with the surname Albert the Great, also as "Doctor universalis." His works on chemistry and mineralogy were valued very highly during the Middle Ages, and his views on chemistry, clad in the garb of Aristotelian philosophy, although naturally highly uncertain, disclose a profound penetration. Of the metals, he knew only mercury, lead, tin,

silver, copper, and gold, and he pronounced the alchemic gold which was brought to his attention a fraud. In his writings he mentions silver nitrate, and he was familiar with the separation of silver from gold by means of aqua fortis. In the pamphlet attributed to him, *Compositum de compositis*, the celebrated "Doctor universalis" reports the following about a solution of silver in nitric acid: "It discolors the human skin with black color which is difficult to remove" (Kopp, *Geschichte der Chemie*, IV, 203).

The authorship of this pamphlet has been denied to old Albertus, according to later investigations of H. Kopp (*Beiträge zur Geschichte der Chemie*, 1875, III, 77), and is said to have come down to us from an early unknown alchemist.

THE DISCOVERY THAT CHLORIDE OF SILVER (HORNSILVER) EXISTS AS A MINERAL IN NATURE, BY FABRICIUS, 1565

Chloride of silver, the "luna cornea" of the alchemists, occurs in the mineral kingdom as "hornsilver" and is found in the upper levels of the silver lodes in Freiberg (Saxony) and in other silver mines. It was recognized as rich in silver ore in the sixteenth century and was first described by Georg Fabricius in 1565. This happened at the same time as the reawakening of the descriptive natural sciences in the sixteenth century, in which period Konrad Gesner especially stands out as a student of natural sciences and an extensive writer on the subjects of zoology, botany, mineralogy, and various other departments of science. This versatile historian, who after many travels settled down in Zurich as professor of philosophy and as physician, was also called the "German Pliny" on account of his versatility. Although most of his efforts were devoted to botany and zoology, he published also a collective work on fossils, precious stones, minerals, and metals under the title *De omni rerum fossilium genere, gemmis, lapidibus, metallis . . .* (1565). Several scholars of the natural sciences, including Fabricius, collaborated with Gesner in this work. The part "Über Metalle Verwendung und ihre Namen" was edited by Georg Fabricius. Fabricius (1516-71) was born in Chemnitz, became rector of the *Fürstenschule* at Meissen, after he had previously lived a long time in Italy as private tutor; he died in Meissen in 1571.

Fabricius was greatly influenced in his studies by the earlier works of the well-known mineralogist and chemist Georg Agricola (1490-1555). He acknowledges Agricola's influence in the Preface of his

work *De metallicis rebus* (Zurich, 1565), which is of special interest to us, as follows: "Various and learned observations concerning metallurgy and metallurgical terms, from the papers of Georg Fabricius; by which especially are explained certain matters which Georg Agricola omitted." This work, which discloses an astounding knowledge of the different silver-bearing ores, was regarded by his contemporaries as less important than his other philosophical and poetical writings.

The reputation of Fabricius as a poet was so great that he was appointed poet laureate by Emperor Maximilian II in 1570 and was raised to the rank of nobility. His poems have long since faded away and been forgotten, but his work *De metallicis rebus* has won from posterity its well-earned recognition. In it we find mentioned for the first time a kind of translucent silver ore under the name "Argentum Cornei coloris translucidum," viz., hornsilver, which is nothing else than our silver chloride. While Fabricius states that hornsilver is of the color of leather, soft as lead, and that it melts so easily that the flame of a candle will melt it—he knows nothing of any change by exposure to light. This point must be stressed, because the French physicist Arago, in his report on the daguerreotype presented in 1839, adds the following: "This substance changed under the influence of light from a yellowish gray to violet." The words caused many who copied them thoughtlessly to believe that Fabricius himself knew and expressed his opinion on this reaction, which was and is not true. This misunderstanding led many to repeat Arago's remarks (with or without mentioning the source), thus attributing to Fabricius, until modern times, a discovery with which he had nothing whatever to do. As early as 1881 I corrected this erroneous opinion that Fabricius knew of the sensitiveness of silver chloride to light, which correction has been repeated for many years in the literature of the subject (1st ed. of my *Geschichte der Photographie*, 1881; 3d ed., 1905). Nevertheless, this erroneous view persists and is contained in the work of Colson, *Mémoires originaux des créateurs de la photographie* (p. 7), as well as in Ludwig Darmstädter's *Handbuch zur Geschichte der Naturwissenschaften und Technik* (2d ed., 1908, p. 1559).

This protracted uncertainty about the origin of photography is evidently to be traced to the fact that the works of Fabricius have become very rare and therefore difficult of access. For this reason I added the Latin context of Fabricius about silver to the German translation in my *Quellenschriften zu den frühesten Anfängen der Photographie*

(1913). The title and tail pieces of that work are exact photoengraved reproductions of the woodcuts from the orginals printed in 1565 and preserved in the Court Library at Vienna.

The portrait of Georg Fabricius can be found in the Saxonia collection of the Royal Cabinet of copperplate engravings in Dresden. The print is probably an engraving dating from the second half of the seventeenth century, therefore a copy of an older print or of a painting. Professor Robert Luther was kind enough to have a negative made from this print in his laboratory for scientific photography in Dresden, from which the reproduction in rotogravure was made for my fourth edition. Another picture of Fabricius, a lithograph, is given in his biography by C. G. Baumgarten Crusius, *De Georgii Fabricii vita et scriptis* (1839).

Ever since the discovery of the daguerreotype the writing of the history of photography has been dominated by the erroneous opinion, caused by Arago; evidently none of the "history writers" was acquainted with the very rare Latin booklet of Fabricius. Georges Potonniée refers to this matter in his *Histoire de la découverte de la photographie* (1925, p. 60) in a manner which distorts the true circumstances. Potonniée denies the originality of Dr. Eder's explanations. He relates that the French physicist Ed. Becquerel did not share Arago's view and indicated this in his book on physics, *La Lumière* (1868). Becquerel, however, substantiated his assertion by references to the early original sources; it is therefore hardly surprising that all later writers on the history of photography (even the French) trusted rather the authority of Arago than the vague utterances of Becquerel, to whom nobody paid any attention. The author opposed this confusion of facts first in 1881, and his view was accepted thereafter by the literature of the profession. Mr. Potonniée commits an error when he writes: "The same information is given by Fabre" in his *Traité encyclopédique de photographie* (1889-90).

It is evident that Potonniée had before him only the second and third editions of Eder's *Geschichte*, dated 1892 or 1905, and did not take the trouble to refer to Eder's decisive first publication of 1881 in order to confirm the historical chronology. Had he done this, he could not have overlooked the fact that C. Fabre wrote eight years later than Eder. Eder corresponded with this distinguished author in the department of scientific photography, and it is gratifying to note that Fabre supported Dr. Eder in his conclusions. Of course Fabre never

TEACHING OF THE ALCHEMISTS 27

claimed any priority. Waterhouse also supported Eder's statement
(*Phot. Journal*, June, 1903).

THE PRODUCTION OF CHLORIDE OF SILVER BY THE WET PROCESS BY ALCHEMISTS IN THE SIXTEENTH AND SEVENTEENTH CENTURIES

BASILIUS VALENTINUS

The wet process of producing silver chloride from a solution of
silver nitrate with sodium chloride, which afterward became so impor-
tant in photography, was certainly known very early. This discovery
was credited for a long time to the mysterious old alchemist and analyst
Basilius Valentinus, who was alleged to be a Benedictine monk and
lived about 1413 in St. Peter's Monastery in Erfurt. Modern research
has proved this story to be untrue, since such an individual never
existed. The writings published under his name are said to have been
collected and published long after his death. There were many editions,
in which were set down many very important chemical discoveries
by different anonymous alchemists.[25]

In the writings of this so-called Basilius Valentinus, then, are gathered
the observations of several authors.[26] Many parts dealing with chemis-
try and alchemy were purloined from Paracelsus, some of them from
analytical chemistry. The whole style of the so-called "Basilius
Valentinus-Schriften" is Paracelsic, showing the effort to imitate
Paracelsus, while copying him all the time. These writings date from
the second half of the sixteenth century and carry the names of several
authors and compilers. Modern research has ascertained that Nikolaus
Soleas, a Bohemian, was the author of at least part of the "Letzte
Testament." It is certain that Johann Thölde, the publisher of this
so-called "Basilius Valentinus-Schriften," is not the author. Thölde's
works are entirely different in presentation and style of thought. The
first pamphlet which was published under the name "Basilius Valen-
tinus" bears the title: *Ein kurtz summarischer Tractat Fratris Basilii
Valentini des Benedicter Ordens, von dem grossen Stein der Uralten*
(Eisleben, published by Johann Thölde 1599).

Thölde is the publisher of the following works: two reprints of the
above book (Leipzig and Frankfurt, 1601); *Von den natürlich und
obernatürlichen Dingen* and *De occulta Philosophia; oder, Von der
heimlichen Wundergeburt der 7 Planeten* (Leipzig, 1603); *Halio-
graphia* (Leipzig, 1603); *Triumph-Wagen Antimonii Basilii Valentini*
(Leipzig, 1604), which is one of the most famous works. In the latter

work there is found a remark, erroneously credited to Roger Bacon, which speaks of the fusibility of artificial silver chloride.

Later, George Claromontanus, in Jena, published *Das letzte Testament des Basilius Valentinus* (1626?; 2d ed., 1651, by C. Dietzel, Strassburg). This is the most important and earliest printed matter.

The main sources, as we have shown, of the "Basilius Valentinus-Schriften" are taken from Paracelsus, and some parts are taken from the metallurgical-alchemistic works of Nikolaus Soleas; indeed, the latter is absolutely the author of several parts of the "Basilius Valentinus-Schriften." The other authors remain unknown.

The title of the pamphlet about mines (Zerbst, 1600) by Nikolaus Soleas reads as follows: *Ein Büchlein von dem Bergwergk wie man dasselbig nach der Rutten und Witterung bawen soll sehr dienstlich und zu wissen nötig durch Nicolaus Soleam Boemum zu Kauff getragen Jtzt durch Eliam Montamum, Fürstlichen Antaltisten Leib-Medicum zum Briege. Erstlich an Tag geben.*

Recently Felix Fritz (Berlin) made researches into this so-called "Basilius Valentinus" and published his valuable investigation in the *Zeitschrift für angewandte Chemie* (1925 XXXVIII, 325), which was edited by Günther Bugge, Franz Strunz, Ernst Darmstädter, Lippmann, and other historians of natural sciences.

The *Chymischen Schriften des Basilius Valentinus* were not printed until 1677, which was several centuries after his death. In Book IV of *Chymischen Schriften*, called "Handgriffe," is a remark that sodium chloride, or cooking salt, in a silver solution produces a precipitate, while it is suggested there that "copper as well as common salt precipitates silver." Of course, in the first case metallic silver is formed, while in the latter it is silver chloride.

Although a pseudonymous author wrote under the name Basilius Valentinus about silver salts, it is plain from the surrounding circumstances that the preparation of silver chloride by the wet process was known to a wide circle of alchemists. This is established by the widespread and celebrated writings of the German physician and alchemist Oswald Croll (Crollius). He taught, in his essays printed in 1608, how to deposit silver chloride by a solution of silver nitrate in cooking salt, how to purify by water, and how to produce hornsilver artificially, which he called "luna cornea," according to the alchemistic symbol for silver, which was expressed by the sign "luna," the moon. It is remarkable that Crollius did not claim priority for all his statements,

since he writes in the memorial Preface to his *Basilica chymica*[27] that he communicates to the public use:

What I have learned in nearly twenty whole years in my many different perilous and laborious travels in France, Italy, Germany, Hungary, Bohemia, and Poland from the most celebrated alchemists and learned men, partly through great gifts and exchange of my secrets (not mentioning my own practice and inventions), learned and experienced through untiring diligence and careful investigation . . .

The first edition of the *Basilica chymica* of Crollius was published in 1608, a year before his death. It went through eighteen editions; a German edition appeared in 1657 at Frankfurt a.M. Crollius is representative of the school of thought and research of his time in the sphere of alchemy, theosophy, and medicine; that is why the author reproduced in his *Quellenschriften* large parts of the text as well as the highly interesting front page of this first edition of Crollius. The title page displays the portraits of those masters of alchemy whom he esteemed among his predecessors—the mythical Hermes Trismegistos, Geber, Morienus, Roger Bacon, Raimundus Lullius, and Theophrastus Paracelsus. The name Basilius Valentinus is not among them, therefore it is questionable whether Crollius derived the preparation of silver chloride from earlier sources or discovered it through his own experiments. At any rate, he contributed most, among all the alchemists of his time, to the spread of the knowledge about the production of silver chloride by the wet process.

ROBERT BOYLE'S RESEARCHES IN 1667 CONCERNING SILVER CHLORIDE AND OF ITS PROPERTY OF TURNING BLACK IN THE AIR

From the excerpts given above of the general condition of chemistry until the beginning of the seventeenth century, it must be evident that the conception of the chemical processes of nature was permeated by mystic and cabalistic errors. About the middle of this century, however, exact natural science gradually forced its way to the front, and especially Robert Boyle (born at Lismore, Ireland, 1627, died in London, 1691, where he lived for a few years) insisted on exact knowledge based on experiments in chemical and physical phenomena. Boyle was one of the founders of the celebrated English scientific body The Royal Society and one of the directors of the powerful East India Company. He combated many of the alchemic superstitions of his

time, as well as the old theory of the four basic elements, and he defined the term "element" as a substance which cannot be further decomposed. He also studied the laws governing gases and was one of the first to give a good deal of time to experiments leading to the knowledge of chemical affinities.

Among his most important writings are *Experiments and Considerations upon Colours* (1663), published in Latin at Geneva, 1667, with the title *Experimenta et considerationes de coloribus.* They are also contained in the English collection of Boyle's works (London, 1772), which is adorned with Boyle's portrait.

Boyle represented the viewpoints that light was of a material nature and that heat could be weighed. He also described, among other things, many chemical reactions and resulting changes of color. He communicated his experiments to a friend, whom he called Pyrophilus, in the form of letters. Pyrophilus is a name by which he addressed himself in the third person. He described also the effect of acids and bases on vegetable dyes (for instance, the change of color in litmus, the juice of buckthorn berries, *Rhamnes cathartica,* violets, etc.). In a lengthy series of experiments he mentions chemical changes of color of all kinds, and he arrives through this investigation at the mention of chloride of silver. In "Experimentum XXXVI" of this book we find a very important passage relating to the history of photography, where he describes the deposit of the white chloride of silver and the phenomenon that it turned dark under exposure "in the air." It is true that he did not realize the cause of the darkening, which is an effect of light, but attributed it to the action of air. At any rate, it was through his experiments that the knowledge of silver chloride was greatly enlarged, which prompted the author to include in his work *Über die frühesten Anfänge der Photographie* the text of the "Experimentum XXXVI" from Boyle's Latin edition *Experimenta et considerationes de coloribus,* together with a German translation. The sober and pointed observations of Boyle differ strikingly from the confused mystic and extravagant statements, not only of his predecessors but also of many of his successors (for instance, Balduin). However, the road, beginning with the discovery of silver chloride and leading to an explanation of the true causes of its darkening by light, was still a very long one.

At that time Boyle's conception of that theory was not carried any further. For instance, Lémery in 1675 writes in his *Cours de chymie*

(9th ed., Paris, 1698, p. 1) about chloride of silver: "the precipitate deposits simultaneously with the salt or with the copper, drying, and even in the shadow it turns brown which is no doubt because of the small amount of copper which it contains." This proves that Lémery noticed that silver chloride would darken even in the shade. Instead of pursuing these investigations further, however, he presumes that the discoloration was caused by the presence of a trace of copper (Felix Fritz, *Phot. Industrie*, 1925, p. 586).

It is interesting to note that the old scholars, even those who specialized in the theory of light, gave us such extremely meager suggestions of its chemical effects. This applies not only to the ancient Greeks but also to the Arabs.[28]

Celebrated scholars of a later era, like Roger Bacon (1214-94), Porta (1538-1615), Kepler (1571-1630), Huyghens (1625-95), Newton (1642-1727), who prepared the way for new advances in the science of optics, overlooked the influence of light on the intricate nature of matter.

In the sixteenth and seventeenth centuries there emerged the invention of the camera obscura and of nature prints, both of which are of such importance to the history of the invention of photography that we shall enter upon this discussion subsequently more closely.

HOMBERG'S EXPERIMENTS WITH STAINING AND BLACKENING OF BONE BY EXPOSURE TO SUNLIGHT, 1694

In 1694 the German advocate Wilhelm Homberg (b. 1652, in Batavia) offered noteworthy communications about silver nitrate. He was induced to study chemistry in 1674 by Otto von Guericke of Magdeburg and traveled in Italy, France, England, Holland, Sweden, and Hungary in order to pursue his studies in the department of the natural sciences and medicine. He visited Paris several times, where he was elected a member of the Academy (1691) and where he died in 1715.

On September 4, 1694, Homberg delivered, at a meeting of the Academie Royale des Sciences, in Paris, several communications on his various experiments.[29] In the *Histoire de l'Académie Royale des sciences à Paris, depuis 1686 jusqu'à son renouvellement en 1699* (II, 129, point 7) he gives a note on the etching of bone by a solution of nitrate of silver and having blackened it in sunlight. The quotation reads: "Homberg has shown a small marbled box made of beef bone

which had been soaked in dilute aqua fortis in which silver had been dissolved. This bone was then exposed to the sun to be blackened; then it was put in a lathe to give it a marbled appearance."

From this account it appears that Homberg showed at the Academy in Paris, in 1694, a small marbled box made of beef bone. He had dipped the bone in a solution of nitrate of silver and had blackened it by exposing it to sunlight. He then mounted the bone in a lathe and, by the process of turning it, laid bare portions of the whitish bone below the blackened surface, thus giving the box a grained or marbled appearance.

Thus, the result of Homberg's experimenting was no more than the marbling of bone previously dipped in silver solution and blackened by exposure to light. It never occurred to him to differentiate between the action of light and heat in the process of blackening, and he made no attempt to place a stencil or string over the silver-impregnated bone to produce a photographic silhouette, as Schulze did later. Schulze knew well the difference between the effect of light and of heat and used light for the production of his stencil images. This made him the first to discover the chemical action of light on silver salts and their use in the photographic process.

Whereas in the seventeenth century sunlight and heat, celestial light and atmospheric air, were not kept apart as agents, it seems the somewhat belated dragging in of an idea, which Homberg did not express anywhere in his publications, when an author (Fritz) insists that "he [Homberg] discovered the change of silver nitrate by light in the presence of organic substances." It is difficult for us to appreciate what reads today as seemingly naïve reports of the individual experiments of the old natural philosophers, although they appeared generally quite proper and interesting to them. If, for instance, one reads what Homberg writes in another place, that a cat died under the bell glass of an evacuating air pump, on the exact fourth stroke of the piston, and so forth, one would expect that Homberg would have stated at least that the silver-impregnated bone would turn black on the surface, exposed to sunlight, and not on the under side; which is what Homberg would have been compelled to state, if he had been conscious of the effect of light and shade.

Homberg did not realize the correct nature of the phenomena which entered into the staining and blackening of the bone. He believed, no doubt, that he faced the effect of sun heat and that is why he failed

to connect the demonstration of his little blackened and turned bone box, impregnated with silver salts, with the discovery of the effect of light action on silver. Consequently, despite the great interest awakened by Homberg's experiment (sensitizing of bone in silver nitrate and blackening through exposure to sun) his work had no influence worthy of remark on the advancement of photochemistry in his time, and his contributions in no way interfere with Schulze's claim to priority.

Closer and more careful observation would have shown that the bone impregnated with silver nitrate darkened first on the side exposed to the sun, while the side not so exposed to light action darkened much more slowly.

Chapter IV. EXPERIMENTS WITH NATURE-PRINTING IN THE SIXTEENTH AND SEVENTEENTH CENTURIES

Subsequent to the invention of the printing art in the fifteenth century the method of illustrating printed matter with engraved wood blocks (wood engraving) achieved great importance, as did also the art of copper-plate engraving. Numerous works of the sixteenth century are illustrated in this manner. Even at this early period naturalists and publishers of works on botany were compelled, owing to the great cost of wood and copper-plate engraving, to investigate the possibility of using plants, leaves, and so forth, for making impressions directly. The earliest works of this kind, no matter how bad or primitive, seem to have been accepted as sufficiently satisfactory. This is borne out by the fact that such prints were frequently and favorably mentioned and that the process was recommended for imitation.

Leonardo da Vinci was, it appears, the first to experiment in the fifteenth century with the making of copies from plants.[1] He writes in his great atlas-shaped manuscript "Codex Atlanticus," which he probably began in 1490 and which he continued until the end of his life (1519), on page 72, as follows:

The paper must be coated with lampblack, mixed with sweet oil, and then the leaf of the plant must be colored with white lead, dissolved in oil, as is done with type on the printing press. It is then printed as usual,

and so the leaf (i.e., the impression from it) will appear dark in the low parts and light in those parts which are high . . .

Leonardo attached an impression of such a nature print from a Salvia leaf (*Salvia officinalis*) to his manuscript.

The subsequent history of nature printing was investigated in detail by Karl Kampmann at the request of the author at the Graphische Lehr- und Versuchsanstalt (Eder, *Jahrbuch für Photographie*, 1899, p. 133). His treatment of the subject is adopted in the following pages. The writings of Leonardo da Vinci did not become known until the eighteenth and nineteenth centuries, so that the first printed description of nature printing from plants must be dated earlier. These products of nature printing were described under the name "Ectypa plantarum" in the work on art of Alessio Pedemontese (Alexis Pedemontanus, as others called him), Milan, 1557, which was translated into German in 1593 by Hans Jacob Wecker, city physician at Colmar. In 1665 M. de Monconys (*Journal des voyages*, Lyon, Vol. II) described the method of printing from plants, which he had learned in Rome from a Dane by the name of Walgenstein (Welkenstein).

In the Court Library (now National Library) at Vienna, there is a work by the French professor De la Hyre which contains nature prints from the seventeenth century. This was shown to his Majesty the King of Sweden, on his visit to the library, as the earliest work produced by nature printing (*Neues Wiener Abendbl.*, February 26, 1904, p. 3), but this was an error, because, as mentioned above, there are earlier claims for priority extant.[2]

In the book *Nützlicher und curieuser Künstler* (Nuremberg, 1728), we find the recipe, "To print a natural leaf with all its veins," very much on the same lines as advised by Pedemontese. Many similar descriptions are to be found in this period. Even the apothecary's assistant at the court pharmacy at Mayence, Ernst Wilhelm Martius, published, in 1785, a small work of his own under the title *Neueste Anweisung, Pflanzen nach dem Leben abzudrucken*, Wetzlar; and J. Conr. Gütle offers in his work *Über die Kupferstecherei* (1793, p. 119) a description of how plants can be printed, according to the book by Martius.

In 1798, at Brandenburg, was published J. H. A. Dunker's *Pflanzenbelustigung oder Anweisung, wie man getrocknete Pflanzen auf eine leichte und geschwinde Art sauber abdrucken kann* with five black-and-white and five color illustrations; this ran to a second edition.

As late as 1809 Graumüller published in Jena his *Neue Methode von natürlichen Pflanzenabdrücken in- und ausländischer Gewächse.*

The process for the production of these impressions consisted at first, according to the reports of the authors quoted above, in holding the dried plant in the smoke of an oil lamp or candle until it had become completely and evenly blackened with soot. It was then put between two pieces of soft paper and rubbed with a folder or by hand until the soot had been transferred to the paper, whereby two impressions were produced simultaneously. In later years in place of lampblack, either the ordinary printing inks used in type printing or that used for copper-plate engravings was employed. Sometimes a color ink (red, brown, etc., according to taste) was used, which was mixed with sticky varnish, and less perishable impressions were obtained by this method. These Ectypa were generally very defective and imperfect, and the process was a very slow one, because the inking of the plants with printers' ink-balls took a great deal of time. The requirements of larger editions also necessitated that many plants of the same species had to be prepared, to yield the necessary number of impressions, since, of course, a single plant would permit of only a very limited number of copies, no matter how carefully is was handled.

The nature prints produced by this method were in one color, either black, brown, or red; these prints were then painted in by hand in their respective full colors. However, the epidermis of most species of leaves was often so thick that the delicate veins (the skeleton) did not show in sufficient relief. This led to the reduction of the leaves to their skeletons by maceration, that is, by stripping away the upper and lower skin of the leaves either in water or with an acid, thus leaving only the perfectly clean framework of the leaf. Antonio Mizaldi (1560) was supposed to have been the first to do this skeletonizing, and Marc Aurel Severin (Nuremberg, 1645) succeeded even in preparing the leaf of an Opuntia (genus cacti) so that "all flesh was away and nothing remained but the hard fibers."

Early books illustrated by this method are not rare and may be found in most of the larger libraries. Especially rich in such works, however, is the Hofbibliothek in Vienna. A noteworthy example is a manuscript dating from 1685, the work of a Cistercian monk, Silvio Boccone. "Disegni naturali et originali consacrati Alla Sua Maesta Cesarea di Leopoldo Primo usw. Monaco Cisterciense."[3] (Folio, 42 tables with 82 illustrations of plants. Wiener Hofbibliothek, No.

11,102). The title and dedication run: "Eurer Kaiserl. Majestät unter-
tänigster ergebenster Diener im Herrn Don Silvio Boccone, Zister-
ziensermönch." The oldest examples of these nature prints extant were
reproduced for the first time in the author's *Geschichte der Photo-
graphie*, in 1905.

Among other noteworthy examples, the works of Professor Kniphof
must be mentioned. It is known that Professor Joh. Hieron. Kniphof
carried on nature printing (1728-1757) in a business way and in-
stalled his own printing establishment, for which purpose he allied
himself with the printer and bookseller C. R. Funke, of Erfurt.
Many works illustrated by this method originated there and are
accessible in the Hofbibliothek at Vienna. Worthy of mention, also,
are the publications of Seligmann[4] (1748) and others. All these impres-
sions are produced by coloring the plant and pressing it against paper.
This procedure did not afford a real graphic printing process, for
it did not supply a firm and sufficiently uniform printing surface.

From these early efforts, however, sprang the germ which devel-
oped, in 1852, into the process of nature printing invented by Hofrat
Auer, director of the Government Printing Office at Vienna. This
process is based on the use of intaglio printing plates produced by
mechanical casts of the natural objects, mostly from subsequent
galvano-plastic molds. This yielded prints of superior quality and
was of importance for the beginning of the photochemical proc-
esses (see Pretsch, *Photo-galvanography;* see also the material on
Woodburytype).

Chapter V. THE HISTORY OF THE CAMERA
OBSCURA

THE CAMERA OBSCURA[1] in the form of a box with a small hole through
which the eye could view the scene is the predecessor of the photo-
graphic camera. Mention of the formation of pictures projected through
a small aperture is found in the words of Aristotle (384-322 B.C.).
More exact accounts of the observation of eclipses with a species of
pinhole camera are mentioned by the old Arabian scholars and their
followers, as may be seen in the comprehensive studies of Eilhard
Wiedemann. Wiedemann (Eder, *Jahrbuch für Photographie*, 1910,

p. 12), dates the first mention of such a camera from 1038 and publishes a dissertation of the Arabian savant Ibn al Haitam (d. 1039) which is of importance in the history of the camera obscura. The learned Arab writes in his essay "On the Form of the Eclipse" that he had in this way observed the sickle-like shape of the sun at the time of an eclipse. Abridged, the introduction to his exposition reads as follows:

The image of the sun at the time of the eclipse, unless it is total, demonstrates that when its light passes through a narrow, round hole and is cast on a plane opposite to the hole it takes on the form of a moonsickle (Hilâl).

The image of the sun shows this peculiarity only when the hole is very small. When the hole is enlarged, the picture changes, and the change increases with the added width. When the aperture is very wide, the sickle-form image will disappear, and the light will appear round when the hole is round, square if the hole is square, and if the shape of the opening is irregular, the light on the wall will take on this shape, provided that the hole is wide and the plane on which it is thrown is parallel to it.

He then presents as illustrating the sun-sickle, a proof, which as a whole is correct and is supported by numerous diagrams, together with a discussion of the possibility of varying the size and shape of the picture by increasing the distance between the aperture and the projection wall.

Some historians assert that Roger Bacon, an English Franciscan friar (1214-94), invented the camera obscura. They support this with the following remark by Bacon concerning the projection of aerial images. "The images appear at the point of contact of the light rays with the perpendicular plane, and things appear there, where there was nothing before." Bacon was one of the most ingenious philosophers and scientists of his time, and to him is ascribed not only the invention of the camera obscura but also of the telescope, of spectacles, a self-propelled wagon, a flying machine, gunpowder, and so forth. He was suspected of practicing sorcery, and he had to send his pupil Johannes to Rome in 1266 in order to purge himself of this accusation. Although there are passages in Roger Bacon's writings which are looked upon by some as possibly referring to the camera obscura, it cannot be proven as a fact that he invented it.

Goethe, who concerned himself with Bacon exhaustively in his *Farbenlehre* (1810, Vol. II), expressed the opinion that many statements issuing from the far-seeing and mentally active, brilliant man were only conclusions, perhaps only daydreams, which were in antici-

pation of what both he and his time could offer. Goethe remarks:

Those who are familiar with the ability of the human mind to rush ahead, before technique can overtake it, will find here nothing unheard of. Roger Bacon claims that through glasses which he describes one can perceive with his own eyes not only the most distant objects as quite near but also the smallest, enormously large. He asserts, also, that images can be thrown into the air, into the atmosphere, so that they may be seen by a crowd of people. Even that is not without reason. Many natural phenomena which are based on refraction and reflection—the camera obscura, which was invented much later, the magic lantern, the solar microscope and their different applications—have established almost literally his predictions, because he foresaw these results. But the manner in which he expresses himself concerning these matters indicates that his apparatus worked only in his brain and that therefore many imaginary results may have originated there.

Levi ben Gerson (d. 1344), alias Leon de Bagnois (see the *Jewish Encyclopaedia*, VIII, 26) who was versed in Arabic literature, described the camera obscura in his work, written in Hebrew and translated in 1342 by Petrus de Alexandria under the title "De sinibus, chordis et arcubis." He employed the camera obscura in a manner similar to that of his predecessor Ibn al Haitam in his investigations of the eclipses of sun and moon.

A quotation, perhaps more intelligible, but still not quite clear, which might be considered to be the description of a camera obscura, appears in a work of the architect Caesare Caesariano, who published, in 1521, at Como, a commentary on Vitruvius's *Treatise on Architecture*. He makes a remark, in elucidation of a misunderstood statement by Vitruvius, which would indicate that the Benedictine monk Dom Papnuzio, or Panuce, was familiar with the camera obscura. Caesariano writes that Papnuzio had fastened a concave glass screen, through the center of which he had bored a hole, in a closed window of a dark room, and so obtained colored images of exterior objects on a piece of paper. It is established that this happened before 1521. At any rate, the description is so vague that several historians[2] refuse to accept it as a true presentation of the camera obscura.

LEONARDO DA VINCI IS THE FIRST TO GIVE AN ACCURATE DESCRIPTION OF THE CAMERA OBSCURA

The first clear description of the camera obscura, which projected images of exterior objects of all sorts through a small wall opening

upon the opposite wall of a darkened room, is found in the manuscripts of the celebrated genius of the Renaissance, Leonardo da Vinci (1452-1519),[3] who was a pioneer not only in the arts but also in the natural sciences, engineering, and anatomy. In his "Codex Atlanticus" (see MSS L. da Vinci's Vol. D, fol. 8, in the Bibliotheque Nationale, at Paris; E. Müntz, see footnote 3) Leonardo writes:

If the facade of a building, or a place, or a landscape is illuminated by the sun and a small hole is drilled in the wall of a room in a building facing this, which is not directly lighted by the sun, then all objects illuminated by the sun will send their images through this aperture and will appear, upside down, on the wall facing the hole.

In another place Leonardo da Vinci reports his observation of the significance of the eye as a camera obscura, for he says:

The experience which demonstrates how objects send their reflex images into the eye and into its lucid moisture is exhibited when the images of illuminated objects enter through a small round opening into a very dark room. You will then catch these pictures on a piece of white paper, which is placed vertically in the room not far from that opening, and you will see all the above-mentioned objects on this paper in their natural shapes or colors, but they will appear smaller and upside down, on account of crossing of the rays at the aperture. If these pictures originate from a place which is illuminated by the sun, they will appear colored on the paper exactly as they are. The paper should be very thin, and must be viewed from the back; the aperture must be bored through a small, very thin piece of metal.

This clear description by Leonardo da Vinci and the documented explanation of the principle of the camera obscura stand out so vividly against the vague descriptions of his predecessors that one must agree with E. Müntz, who states:

Accordingly there can be no doubt that Leonardo da Vinci not only knew the principle of the camera obscura but also, with his usual penetration, probably discovered it. His genius is worthy of the honor of this and many other inventions and discoveries. But it is a question whether his discovery really was of any use to his own or the succeeding generation; whether these, like so many other observations of Leonardo, did not remain hidden in obscurity. His writings, for which, as is well known, he used mirror writing, and which were therefore very difficult to read, have appeared in print, in complete form, only within the last few years. Undoubtedly he demonstrated the marvels of the camera obscura to some

of his acquaintances, but we do not know whether these persons disseminated the information; for instance, had B. Papnuzio heard of it, or was the discovery started anew by others independently of Leonardo's first achievement?

In the first half of the sixteenth century we find the camera obscura employed on several occasions for the observation of astronomical phenomena. In Germany, Erasmus Reinhold (1540) and his pupils Gemma Frisius, Moestlin, and others made observations of the eclipse of the sun with the aid of a pinhole camera. Girolamo Cardano published in 1550, on page 107 of his book *De subtilitate,* a process which was intended to improve the camera obscura by inserting a glass screen into the shuttered panel carrying the aperture of a camera obscura ("orbem e vitro," by which presumably a lens is meant).

JOHANN BAPTISTA PORTA, IN 1553, WAS THE FIRST TO MAKE MORE
GENERALLY KNOWN THE CAMERA OBSCURA (PINHOLE CAMERA)

The Italian Giovanni Baptista della Porta was born in Naples (1538) and died there (1615). He was the first who described in clear, universally comprehensible language the pinhole camera (camera obscura) in his widely read book, which reached numerous editions, *Magiae naturalis; sive, De miraculis rerum naturalium,* 1st ed., 1553, and thus made it known in the widest circles. At that time the manuscripts of Leonardo da Vinci, which were written in cipher (mirror writing), were unknown; they were not printed until several centuries later. It is highly probable that Porta knew nothing of Leonardo da Vinci's invention, and he, as well as the historians of subsequent centuries, therefore believed himself to be the first to have invented the camera obscura and the first to have described its marvelous properties. Although it was shown by later investigations that other scholars were entitled to claim priority in the invention of the pinhole camera, this does not in any way minimize the fact that Porta merits the distinction of having issued the first publications respecting the camera obscura.

In addition, Porta actually announced in the first edition of his book a novelty, namely, the use of a concave mirror for the production of images in the camera obscura. He states:

Now I want to announce something about which I have kept silent until now and which I believed that I must keep secret, how one can see everything in its colors as desired: place opposite the aperture a mirror which

does not disperse the rays, but unites them and move it forward and back until you recognize that the picture is in its proper size . . .

Porta projected a reversed picture on a paper screen fastened on top of the aperture. The aperture which acted thus as diaphragm could be proportionately larger; according to a remark in the second edition the aperture was the size of the small finger (see F. Paul Liesegang's "Ausführungen" in *Mitteilungen zur Geschichte der Medizin und der Naturwissenschaften*, 1919, XVIII, No. 1). At any rate, it is remarkable that the chapter in which Porta describes the camera obscura is entitled "On Other Actions of the Concave Mirror."

Porta is one of the most interesting figures of the sixteenth century. He paints a true picture of the conditions prevailing at that time with regard to the knowledge of physics in his *Magiae naturalis*, the first edition (1553) of which he wrote in his fifteenth year. He dealt, in no less than twenty volumes, with the most varied subjects with a strange mixture of superstition and knowledge.

He had written, among other things, of the witches' ointment (*lamiarum unguentum*), was denounced by a Frenchman, and incurred the suspicions of the Roman court, before which he was accused as a magician and a poison mixer. Porta was summoned to Rome to defend himself. He protested that he undertook his investigations only for the purpose of exposing the fraud which had been carried on with the matter in question. Although he was acquitted of the charge, the Academia degli Secreti, which he had founded in his own house, was closed by order of the Pope. He made many journeys through Italy, France, and Spain, in order to perfect his knowledge of the natural sciences and to make his published works, which followed each other very fast, ever more and more perfect.

A portrait of Porta is to be found in his work *La fisonomia dell' huomo et la celeste*; I have before me the edition printed in 1668 in Venice, in which a comparison is shown of human and animal physiognomy, with numerous illustrations. The constellations of the stars are also discussed in this work.

After Porta's description of the camera obscura had made it widely known, this apparatus was often employed by pseudo-magicians for shows of all kinds, especially for conjuring up the devil, and all kinds of variations were devised, which would offer still more wonderful performances. It is worthy of notice that considerably enlarged copies

of pictures were made even then with the camera obscura. In later years the magic lantern replaced the camera obscura for this purpose. A detailed and exhaustive description with indication of the sources is found in F. Paul Liesegang, "Schaustellungen mittels der camera obscura in früheren Zeiten" (*Opitische Rundschau*, 1919, Nos. 31-33).

THE USE OF A CONDENSING LENS IN THE CAMERA OBSCURA BY BARBARO (1568) AND PORTA (1588)

The Venetian nobleman Daniel Barbaro must be credited with the first description of the use of a biconvex lens in the camera obscura, for he describes on page 192 of his work *La prattica della perspettiva* (1568) the combination of the lens and the camera obscura.[4] He used the spectacles of a man who had grown far-sighted and described clearly the effect of the lens and its application in perspective drawing. He also discussed the effect of the use of the diaphragm to improve the definition of the image. This publication was issued twenty years before the second edition of Porta's *Magiae naturalis*, in which he seems to describe the use of the camera obscura with a convex lens as if it were his own invention. A portrait of Daniel Barbaro, found by Major General J. Waterhouse, in London, is a reproduction from a copper plate engraved by Hollar from the painting by Titian (*Phot. Jour.*, 1903, No. 8). Another portrait of Barbaro, by Paolo Veronese, is in the Dresden Gallery, where also a copper plate engraving by Houbraken can be found.

Giovanni Battista Benedetti, a Venetian patrician (1585), also knew of the use of the lens in a camera obscura. It was much later that Porta described the camera obscura with a lens—in the second edition of his *Magiae naturalis*, published in 1588.[5] It is extraordinary that he now wants to announce the secret so carefully kept for a long time. There is no doubt that Porta knew of the work of his predecessors, for he stresses in the Preface how he had increased his knowledge extensively by travel, by his study in many libraries, and by his personal intercourse and correspondence with the most eminent scientists and artists. According to an investigation by F. Paul Liesegang[6] this seemingly contradictory statement is explained when one compares the wording of the second edition with that of the first. One finds that Porta has interjected the reference to the lens in the portion of the text cited above, at the end of the first sentence in which he announces his secret,

so that it appears that the secret refers erroneously to the lens. He was probably so pressed for time when he made this addition that he did not realize that thereby he injected a deceptive meaning.

Porta also occupied himself here in a more detailed manner with the experiments to right the reversed picture by means of a mirror, and he mentions that the light images projected on white paper could be traced or drawn over; the usefulness of a portable camera obscura as an aid in drawing and painting was quite evident to him.

The second edition of Porta's *Magiae naturalis* was translated into German, and this translation was published at Nuremberg (1715) under the title *Magiae naturalis, oder Hauss-, Kunst- und Wunderbuch* . . .

The priest Franciscus Maurolycus (1494-1575), a renowned teacher of mathematics in Messina, concerned himself with the direction of light rays in the camera obscura and states in his *Photismi de lumine et umbra* (1575), the solution to the question which had troubled the students of optics since Aristotle, why the image of the sun projected into a darkened room appeared round, although the aperture through which the rays passed was rectangular.[7]

Caspar Schott also describes, in his work *Magia universalis naturae et artis* (Würzburg,1677), the camera with and without a lens and presents theoretical and optical comments.

THE PORTABLE CAMERA OBSCURA

In the time of Porta a whole room was usually adapted for use as a camera obscura, but later portable cameras were manufactured.

The first mention of a small portable camera is found in the extensive work of the Praemonstratensian monk Johann Zahn, devoted to optics, *Oculus artificialis teledioptricus; sive, Telescopium ex abditis rerum naturalium et artificialium . . . adeoque telescopium* (Herbipoli, 1665). Zahn describes the camera obscura which he provided with lenses mounted in a tube; moreover, he took into consideration the influence of focal length of the lens employed on the size and scale of the image and gives us exact designs of his apparatus. On page 180 of the above-cited work he illustrates several types of cameras with lenses and a slanting, reversible mirror. By this arrangement the image was projected upward in perpendicular position, as in the modern reflex camera.

Another very interesting illustration of such a portable camera

obscura is found in a work written by the Jesuit scholar Father
Athanasius Kircher, who was well versed in optics. This camera was
built with the object of setting it up in the open air and of facilitating
the drawing and painting of landscapes. The title of the book was
*Ars magna lucis et umbrae, in X. libros digesta, quibus admirandae lucis
et umbrae in mundo, atque adeo universa natura, vires effectus, que uti
nova, ita varia novorum reconditiarumque speciminum exhibitione,
ad varios mortalium usus manduntur* (Amsterdam, 1671).

Athanasius Kircher (1601-80), one of the most versatile scholars
in mathematics and natural science of his time, was born near Fulda.
He studied mathematics first at Würzburg and later at the Jesuit
College at Rome. The first edition of his *Ars magna lucis et umbrae*
appeared in 1646, at Rome, and was looked upon at that time as a
masterpiece, although largely devoted to the discussion of unim-
portant matters from beginning to end. Kircher did not discover any
of the properties of light. Nevertheless, the science of optics is indebted
to him for a great deal—among other things, distinctive descriptions
and illustrations of cameras and magic lanterns (see below). Thus in
the second edition of his *Ars magna*, Chapter IV, p. 709, "De parastasi
per specierum in obscurum locum immissiorem," we find described
how to copy different objects and produce a likeness. The illustration
shows an opening in the floor of the camera through which the artist
entered; also it is explained how the reversed picture of the different
objects in nature are produced on paper or canvas in the interior of
the camera obscura.

As regards the invention of the camera obscura the following appears
in *The Photographic Journal* (London, 1857, IV, 129): In a letter
from Sir Henry Wooton to Lord Bacon it is stated at length that the
celebrated astronomer and mathematician Johannes Kepler (1571-
1630) set up a revolving tent which had on one side a hole of about
1½ inches in diameter, through which he put a tube holding a convex
glass, and that he drew with a pen on paper the images projected by
this lens. Major General Waterhouse also calls attention to the writings
of Robert Boyle, who mentions in his *The Systematic Cosmos or
Cosmical Qualities of Things* (1669) a portable camera obscura, and
he believes that according to the language of the passage cited the
invention should be credited to this Irish scholar (*Phot. Jour.*, 1903,
XXXIII, 333). Zahn's publication of his invention, however, is dated
four years earlier.

Another portable camera obscura was described by Robert Hooke in 1679. Marco Antonio Cellio designed in 1687 a portable camera, which was to serve particularly for the rapid copying of copperplate etchings, paintings, and silhouettes. Georg Büsch observed in 1775 that the image in the camera obscura always reproduced nature exact in detail, but that it was distorted by perspective.

W. Hooper, in his *Rational Recreations, in Which the Principles of Numbers and Natural Philosophy Are Clearly Elucidated* (London, 1st ed., 1755; 2d ed., which I have before me, 1782, in II, 36, Table 3) described an original design for a camera obscura in the form of a table with reflecting mirrors. This demonstrates how widely known and popular, for instruction or entertainment, the various types of camera obscura had become. Interesting details on the development of the camera obscura are given by M. von Rohr in the *Zentral-Zeitung für Optic & Mechanik*, 1925, XLVI, 233, 255.

The literature of that period shows conclusively that after the camera obscura had been invented essential improvements in the optical apparatus were negligible during the seventeenth and eighteenth centuries. Whatever modification we find during this period relates usually to the improvements on the mechanical side of the camera. Progress in optical apparatus seems to have come from England, where in 1812 W. H. Wollaston made public his lens in the shape of a meniscus and definitely stressed the importance of an exact focus. Fifteen years later G. B. Airy published his classical work on the theory of astigmatism for the single lens in the camera obscura.

Chapter VI. STEREOSCOPIC (BINOCULAR) VISION

As EARLY as two thousand years ago Euclid studied the phenomena of binocular vision and enunciated the principles pertaining to them. He demonstrated that each eye sees a slightly different image in looking at an object and that it is by the union, merging or fusing together, of these two dissimilar images that the two eyes perceive the object as a whole, with the appearance of relief and solidity obtained in ordinary vision. Five hundred years later the celebrated physicist and physician

Galen treated this subject of binocular vision more exhaustively than had Euclid.

Leonardo da Vinci, in his treatise on painting, which was published in Milan in 1589 from his posthumous manuscripts, indicated quite plainly the dissimilarity of the images which each eye beholds, and he cites this as the reason why finished paintings never give the effect of that relief in natural objects which we perceive by binocular vision.

Jacopo Chimenti, a Florentine painter of the sixteenth century, also concerned himself with experiments to produce stereoscopic pictures by means of the art of drawing; such drawings by Chimenti are preserved in the Musee Wicar, at Lille (see *Phot. Jour.*, April, 1862, p. 29,[1] and *Bull. Soc. franc. de phot.*, 1922, p. 206, with table).

Porta repeats in his *Magiae naturalis*, in the chapter "Über die Strahlenbrechung" (Vols. V—VI), the propositions of Euclid and the opinions of Galen and so fully illustrates the details of these two theories that we recognize not only the fundamental principles but also his anticipation of the modern stereoscope.[2] After Porta's time the subject of binocular vision attracted little attention, and it was not taken up again until the first half of the nineteenth century.

Chapter VII. THE INVENTION OF PROJECTION APPARATUS IN THE SEVENTEENTH CENTURY

USUALLY, but erroneously, the Jesuit Athanasius Kircher is named the inventor of the apparatus for projection, or magic lantern.[1]

J. B. Porta is said to have projected not only images of natural objects into his dark room by sunlight but also designs drawn on thin paper, which were strongly illuminated by the sunlight allowed to shine through them. At the same time he made the drawings movable, and therefore he could give the picture any motion desired—a clever device, which must have seemed supernatural at that illiterate time. In this manner, Porta writes, he produced to the surprise of his audience presentations of hunting scenes, battles, and so forth. Kircher relates that he once saw an excellent performance of the Crucifixion made by Porta's method, and in a similar manner the Emperor Rudolph was

entertained by his mathematicians by a procession of all the emperors, from Julius Caesar down to himself.[2]

The invention of the magic lantern as an apparatus for projection is to be credited to the celebrated Dutch physicist Christian Huygens (1629-95). He is noted as the founder of the undulatory theory of light and of the theory of probabilities. He improved the telescope and discovered the rings of Saturn. He also laid down the principle of centrifugal force and invented, in 1656, the pendulum clock.

The earliest information about a magic lantern dates from 1656. We learn the fact that Christian Huygens made a·magic lantern—the oldest of which we know—from the correspondence of Huygens with his brother Ludwig. After publishing in a previous work (*D. opt. Wochenschrift*, 1919, pp. 152, 163; compare Eder's *Jahrbuch*, XXX, 34) the investigations concerning the magic latern, the whole procedure is fully described in this correspondence.

This is reported by F. Paul Liesegang, writing on Christian Huygens (at the time of the tercentenary birthday of the scholar, on April 14, 1929) and the magic lantern ("Uber Christian Huygens und die Zauberlaterne," in *Centralztg. f. Opt. u. Mech*, 1929, L, 167).

Huygens's attention was diverted by his many more important inventions, and subsequently he paid no more attention to this trifle ("bagatelle"). When his father, then ambassador from the Netherlands to the court of France, requested that he should make a magic lantern for him, he used every pretext to avoid discharging this commission. He was afraid of losing his reputation if it became known that he had made an apparatus evidently intended for the production of ghostly apparitions (*D. opt. Wochenschrift*, 1919, pp. 152, 165; VI [1920], 337, 355; VII, 20). About 1665 the renowned scholar worked on a device for projection, but we have no details of its construction.

Thomas Walgenstein, a Dane, who in 1658 studied at the University of Leyden and was acquainted with Huygens, improved the magic lantern in shape and form and introduced it commercially. We know of demonstrations at Paris, 1662, Lyons, 1665, Rome, before 1670 (perhaps even in 1660), and later at Copenhagen, 1670. Walgenstein's magic lantern was fitted with a concave mirror condenser and double lens to intensify the illumination. Huygens's magic lantern was introduced into England in 1663, in which year there is mentioned such a lantern in use by the London optician John Reeves, who was an acquaintance of Christian Huygens.

For an earlier description and illustration of the magic lantern with artificial illumination, we are indebted, as stated above, to the German Praemonstratensian monk Johann Zahn.

He described a portable projection apparatus in his above-mentioned *Oculus artificialis teledioptricus* (1665, p. 256), and elucidated it by drawings. It can be seen from these that the construction of his magic lantern is the same as that adopted in the projection apparatus of today.

Athanasius Kircher also described the magic lantern, although somewhat later, and popularized the art of projection among wide circles, repeating and supplementing the experiments of Porta and others by exhibiting with his magic lantern at night and in many ways more effectively than Porta had done by daylight.

In the second edition of his work *Ars magna lucis et umbrae*, 1671, Kircher gave two illustrations of his magic lantern.[3] Kircher adds the following description:

Make and finish a wooden box and put on it a chimney, so that the smoke of the lamp in the box is on a level with the opening, and insert in the opening a pipe or tube. This tube must contain in the front a very good lens, but at the end of the tube, i. e., in the opening of the box (*"in foramine vero seu in fine tubi"*), it is necessary to fasten the small glass plate, on which is painted an image in transparent water colors. Then the light of the lamp, penetrating through the lens and through the image on the glass, which is to be inserted, vertically, i. e., upside down) will throw an upright, enlarged colored image on the white wall opposite. In order to increase the strength of the light, it is necessary to place a concave mirror behind the illuminant of the lamp.

It is obvious that in the illustration the engraver made the error of placing the slide or small transparency outside of and in front of the projection lens. A projection of the image would not be possible with the slide so placed. Its proper position is behind the projection lens and in front of the condenser.

From this fact Professor Reinhardt, to whom we owe a profound study of the history of projection lanterns,[4] concludes that Athanasius Kircher lacked a clear conception of the action of light rays in the projection lantern and that probably he only saw the magic lantern somewhere and so could not rightly claim its invention. Indeed Kircher claims also the credit of having brought about the construction of the magic lantern by his description, in the first edition of his *Ars magna lucis et umbrae*, of the mode of operation of lenses in the optical

apparatus. In this passage, as Reinhardt was the first to point out, he hands down to us an interesting historical note, which I have failed to find mentioned elsewhere. Kircher narrates (p. 768 of the 2d ed.) that, based on his description, a Danish mathematician of repute, Thomas Walgenstein, had constructed an "improved" magic lantern and had demonstrated it in various places in Italy. Certainly one cannot easily recognize from Kircher's description or illustration what the Walgenstein lantern looked like, but we receive a helping hand here from another author of the seventh century.

In his work *Cursus seu mundus mathematicus* Claude François Milliet Dechales (1st ed., 1674; 2d ed., 1690), particularly in the third volume of the second edition (p. 696), reports that in 1665 a learned Dane introduced at Lyons a lantern through which could be produced "at night, from a small drawing (prototypus), a very clear image on the wall" and that this was done, as is generally presumed, through two lenses (that is, condenser and projecting lens). This Dane, well known in the history of optics, is no doubt the Thomas Walgenstein mentioned by Kircher.[5] It seems that Walgenstein traveled everywhere in Europe with his magic lantern, but he never explained the inner construction of it to the public in his demonstrations. Reinhardt believes that this is the reason for Kircher's fanciful picture and his haziness about the optics of the apparatus. Dechales also includes in his work a drawing. He describes, however, in a conclusive manner the formation of the enlarged light image. According to the drawing the object is placed within the focal distance of the lens,[6] which forms a virtual image and brings it to a focus within the lens system (at a diaphragm not shown in the diagram), after which it is projected by the front element of the projection lens in the form of an enlarged real and inverted image on the screen. This lens tube, or barrel, could be, as Dechales expressly emphasizes, made longer or shorter in order to obtain a distinct and sharply defined image, regardless of the distance between it and the projection screen. Even for that Dechales had the proper explanation. He also discusses the effect of the mirror and the required focal lengths of the lenses, of which the former was to be shorter than the latter. He also showed that the flame of itself could not produce either a correct or a reverse image, if the optical lens system of the lantern is properly designed, and that a properly restricted disk of light must appear on the projection screen. Only after he had discovered all this by himself, Dechales relates, was he permitted by the

inventor to view and take measurements of the interior of the lantern.

Reinhardt credits Walgenstein with the invention of the magic lantern and the art of projection. In this, however, he went too far in his appreciation of Walgenstein. The oldest English description of the magic lantern is found in the book on optics by Molyneux (1692); by that time the apparatus had already become an article of trade.

THE LAW OF REFRACTION AND THE WAVE THEORY OF LIGHT

Snellius (Willebrord Snell van Roijèn), professor of mathematics at the University of Leyden, in Holland, discovered (1626) the law of the refraction of light and states it as follows: "The sine of the angle of refraction is in constant exact proportion to the sine of the angle of incidence." That it was he, not Descartes, who discovered this law is proved by the testimony of Huygens and others; Snellius worded the law in his lectures somewhat differently from the present form given to it by Descartes.

The wave theory of light was laid down by Huygens (1690) in opposition to Newton's (1678) emission or "corpuscular" theory. The telescopes of that time all showed colored fringes around the images projected from them. This chromatic aberration of lenses was first corrected by the Englishman John Dollond (1706-61).

Dollond was a silk weaver for many years and devoted much study to mathematics and optics. In 1758 he discovered the different behavior of colored light rays in media of different refractive power and concluded that it should be practicable to construct telescopes capable of giving images without colored marginal fringes. In 1757 he produced compound lenses, made of flint and crown glass, which showed no chromatic errors (achromatic lenses). He also eliminated spherical aberration, but all this only by means of empirical practical experiments. It was not until 1814 that Fraunhofer arrived at a method of calculating a spherically and chromatically corrected objective.

Chapter VII (REWRITTEN*). THE INVENTION OF PROJECTION APPARATUS

THE PROJECTION APPARATUS developed from the magic lantern and also the magic lantern, it is believed, came out of the earlier camera obscura. This can be traced to an erroneous interpretation of parts of the writings of J. B. Porta and of the Jesuit Father Caspar Schott (1608-66) who was professor of mathematics in Würzburg (Bavaria). It was the mistaken opinion that Porta in his presentations with the camera obscura had already produced at that time transparent images.[1] Notwithstanding the close connection between both apparatus, the development proceeded along an entirely different road, although the magic lantern had assumed the work originally assigned to the camera obscura, namely, the presentation of light images in a dark room.

According to the investigations of F. Paul Liesegang the magic lantern originated from an ancient process of throwing shadows with the aid of a mirror.[2] This was described first by Porta in 1589; but a legend points to the fact that this method was evidently kept secret and was known as magic art in the early ages. Writing, to be projected, was painted on a mirror which was held against the rays of the sun and thus reflected on the opposite wall a hazy shadow picture. Athanasius Kircher, in Rome, endeavored to improve the method, because he desired to project writing at the greatest possible distance. He succeeded in this by inserting in the course of the rays, reflected in the mirror, a condensing lens which acted as an objective and produced a much sharper picture of the writing. Thus originated the first primitive projection arrangement. Kircher described this in the first edition of his *Ars magna lucis et umbrae* (1646). He used this arrangement for the projection of figures, too, and also presented them in the evening by candlelight.

As Kircher wrote later (2d ed. of *Ars magna*, 1671), there were many who devoted themselves to the improvement of his method. A very interesting case of the application of his method has come down to us. In 1653 or 1654 the Jesuit Father Andreas Tacquet, in Leyden (Belgium), arranged with Kircher's apparatus a regular projection presentation of a trip to China.[3] Undoubtedly by that time he was using pictures on glass. But it was hardly possible to paint during the

*This rewritten chapter has never before been published. The original typescript, sent by Dr. Eder in 1933 to the translator for inclusion in the American edition, is in the Epstean Collection, Columbia University Libraries.

presentation the series of pictures on the concave mirror. It was only a step from this to the magic lantern.

The invention of the magic lantern as a projection lamp must be credited to the famous Dutch physicist Christian Huygens (1629-95). He is known as the founder of the theory of undulation of light and of the theory of probabilities. He also improved the telescope and discovered the Ring of Saturn. He laid down the law of centrifugal force, invented the pendulum clock, and designed the magic lantern, which he had constructed by his friend Tacquet.[4]

Huygens himself considered it beneath his dignity to bother further with this "trifle," because other more important and serious inventions engaged his time. But he must be called the creator of the magic lantern.

Thomas Walgenstein, a Dane, acquainted with Huygens, studied at the University of Leyden, took up the magic lantern, and developed it to a practical form, making it known by presentations, particularly in France and Italy.

The earliest information about the scare lantern (*Schreckenlaterne, Lanterne de Peur*) of Walgenstein is found in a letter addressed by the Parisian Petit to Huygens, in 1662.[5] The first publication about the apparatus, with lengthy geometric optical details, appeared in 1668 in a little-known optical textbook *Centuriae optical pars altera* by the Italian priest Francesco Eschinardi.[6] Here appears for the first time the name "magic lantern," which Kircher evidently gave to the apparatus. A more detailed description, however, is given by a sketch which the mathematician Dechales published (1674) from a book on optics at Lyons in 1665.[7] The illumination of the glass picture was brought about by a large concave mirror; a condenser lens was not used. The first lens of the double-lens objective was placed near the glass picture; the second could be moved for the purpose of sharpening the pictures. The well-known illustration of the magic lantern furnished by Kircher in the second edition of his *Ars magna* (1671) is faulty. The tube containing the lenses of the objective is erroneously shown between the lamp and the glass picture.[8]

In Germany the magic lantern became known through Johann Christoph Sturm, who was professor at the University of Altdorf, near Nuremberg.[9] He introduced the magic lantern (1672) in his experimental lectures as a novelty and gave an exact description of it in his *Collegium experimentale sive curiosum* (1676). At this time the Nurem-

berg optician Franciscus Griendel exhibited for sale magic lanterns of different sizes.[10] Joh. Zahn devoted himself exhaustively to the magic lantern in his optical textbook *Oculus artificialis teledioptricus sive telescopium*, published in Würzburg (1685-86). Zahn and Sturm also described projection clocks,[11] which later came into general use.

In England[12] the optician John Reeves occupied himself as early as 1663, in London, with the production of a magic lantern. In 1668 the scientist Robert Hooke reported on a universal projection arrangement. The first detailed publication in England was given in 1692 by Molyneux in the book *Treatise of Dioptrics*. The magic lantern described by him differs from Walgenstein's apparatus in that it contained a condenser lens.

Noteworthy is the later magic lantern of the Dutch professor s'Gravesande, of Leyden, described in his *Physices Elementa Mathematica* (1720-21). This apparatus was equipped with an oil lamp and a four-flame burner placed in the center of curvature of a concave mirror and had a double objective with a central diaphragm. Ehrenberger, at Hildburghhausen (1713), occupied himself in particular with the development of movable magic-lantern pictures.

The magic lantern served particularly for the amusement of children. As early as 1685 Joh. Zahn proposed the use of this apparatus for anatomical lectures, and in 1705 Creiling, at Tübingen, recommended the light image for all educational purposes.[13] All this without success, however. Indeed, the magic lantern fell more and more into the hands of adventurers for the presentation of spirits with which to dupe the superstitious. Georg Schröpfer, in Leipzig, about 1770, is particularly noted for this art. The climax of ghost projections was, however, the phantasmagoria which Robertson presented in 1798 in Paris and other cities with great refinement.[14]

From these phantasmagoria, which a German by the name of Philipsthal introduced into England (1802) and which gradually lost in their subsequent exploitations their gruesome character, developed the famous "dissolving views," which remained for nearly half a century the principal exponents of the practical art of projection.[15] The "dissolving views" method, improved particularly by the Englishman Childe, who perfected it first in 1839, consisted in the application of two, three, or even more projection apparatus, which were put into action alternately or simultaneously. Of greatest importance to this dissolving-view equipment was the calcium light, invented in 1822 by

the London physician Gurney,[16] which, owing to its greater power of illumination, displaced the weak oil lamp and permitted large sensation-creating projections.

Birckbeck, in London, used calcium light for projection apparatus in 1824,[17] and in 1832 Cooper and Carry (?), in London, constructed a projection microscope with calcium light (oxyhydrogen-microscope), which Pritchard perfected in 1837 by employing a triple condenser in a cooling vessel. Donné and Foucault introduced, at Paris, in 1844, the art of projection and used their projection microscope ("photoelectric microscope") as a source of illumination. Foucault and Duboscq, in 1849, constructed automatic projection arc lamps. The latter perfected at that time a projection apparatus for scientific use which remained the model for decades. In America the art of projection was later particularly promoted by Professor Martin.[18] The essential improvement was made in the projection apparatus by the use of an objective calculated for portrait photography by Professor Petzval, of Vienna, in 1840.

The projection with calcium light as well as with electric arc lights was at that time very involved, because it was necessary to prepare oxygen and hydrogen gases for the former, and for the latter it was necessary to produce an electric current by means of a large battery of galvanic lamps. Therefore, in most cases one continued to rely on the primitive oil lamp. It was really a progressive step when optician Marcy of Philadelphia, in 1872, replaced the oil lamp by a very practical kerosene lamp with flat wicks.[19] The "sciopticon" created a revolution in the art of projection and assisted greatly in its spread. The method owes its large growth, however, to the electric light of modern times, because, since the model of the 90's, most towns were equipped with electric power stations, in which the use of all electric arc lamps for projection apparatus can be adequately employed. Its greatest impetus came with the substitution of a metal wire in place of carbon in the electric incandescent lamp and strong lamps with concentrated filaments have been manufactured since 1912.

The episcopic projection apparatus for paper pictures was described in its earliest primitive form by the famous mathematician Leonhard Euler, in 1750, and they were constructed, if not then, at least a very few years later. The invention was lost and was made anew several times, until in 1867 Krüss, in Hamburg, brought his wonder camera into the market and found many sales. At the same time wonder cameras

with calcium lights were made in both England and America. Episcopic projection was also greatly improved by employing electric arc lamps, of which the first practical apparatus was the epidiascope of Zeiss, in Jena, in 1898.[20] Incandescent electric light was first employed in 1911 by Schmidt and Haensch in their spherical episcope as well as by Liesegang in his globoscope employing the then new strong metal filament lamps.

Chapter VIII. STUDIES OF PHOTOCHEMISTRY BY INVESTIGATORS OF THE SEVENTEENTH CENTURY UP TO BESTUSCHEFF'S DISCOVERY IN 1725 OF THE SENSITIVITY OF IRON SALTS TO THE LIGHT AND THE RETROGRESSION OF PROCESSES IN DARKNESS

NATURAL PHILOSOPHERS in the seventeenth century were the first to take up the changes caused by light in plant life. Ray was one of the first who, in 1686, attributed the green color of leaves to the influence of sunlight and thus called attention to the difference between the action of light and air.[1] Other writers before Ray, like Grevius, in his *Anatomia plantarum*, and Scharroc, in his *Histor. propagat. vegetabilium* . . . considered air the cause of the green color, and according to J. Vossius, in his *De lucis natura et proprietate* (1662), it was warmth which caused the vivid coloring of animals and plants in sunny climates.[2]

The fact that the bleaching of linen and other materials was greatly hastened by light was well known to the ancients, not only to the Greeks and Romans but also in Egypt and India. The French academician Ed. Mariotte (1666-84) made conclusive observations of the phenomena which occur in the process. In his *Traité de la nature des couleurs* (Paris, 1688) he states: "There are many yellow or dark materials which are bleached when they are alternately dampened and then dried in the sun. When they are then white and are left in the light without being dampened again for a long time, they will turn yellow."[3]

In 1707 the French royal physician, Nicolas Lémery (1645-1715), called attention[4] to the crystalline structure of plants growing out of salt solutions in general. Petit notices, in 1722, that solutions of nitrate of potash in ammonia would produce prettier vegetation in sunlight than in the shade.[5]

Count Bestuscheff (1693-1766), Lord High Chancellor and later Field Marshal of Russia, invented, in 1725, his "Tinctura tonico-nervina," asserting that he employed in its production the assistance of light. This "tincture" was formerly very highly esteemed and was sold in Russia at a very high price as a secret remedy, because the liquid was supposed to contain gold; later the prescription came through a laboratory assistant into the hands of Lamotte, who sold it in France; this is the reason this solution is also known as "Lamotte's Gold Drops." The Russian Empress Catherine bought the secret from Bestuscheff's heirs and ordered the preparation of the tincture of iron to be made public. For detailed statements of the history of this preparation see Trommsdorff's *Journal der Pharmazie* (1881, p. 60) and Kerner's *Annalen der Chemie und Pharmazie* (XXIX, 68). Bestuscheff's original directions, as generally followed, consisted in heating iron sulphide, sulphur, and bichloride of mercury, subliming the iron chloride formed and allowing it to liquify and then dissolving it in four times its weight of alcohol. This deep-yellow solution was exposed to sunlight in hermetically closed flasks until it became colorless. (Reduction of ferric chloride to ferrous chloride.) It was also known even then that the solution decolorized in light and regained its yellow color in the dark or when air had access to it.

Bestuscheff, therefore, was not only the first to discover the light sensitiveness of iron salts and to observe the reduction of ferric to ferrous salts, but he also recognized a light reaction which after a while, up to a certain degree, reversed itself in the dark.

Chapter IX. PHENOMENA OF PHOSPHORES-CENCE: LUMINOUS STONE; DISCOVERY OF THE LIGHT-SENSITIVITY OF SILVER SALT; THE FIRST PHOTOGRAPHIC PRINTING PROCESS BY SCHULZE, 1727

WE LEARN from the writings of Aristotle and Pliny that the Greeks and Romans knew of several substances which were luminous in the dark. Aristotle mentions the sea, meat, and some fungi (or rotting wood), and Pliny tells of shining precious stones. That diamonds shone in moderate warmth was known to Albertus Magnus and probably to others before him.[1] But it was not until the seventeenth century that phosphorescent bodies, "the marvelous light-absorbing and light-emitting luminous minerals," were discovered. The beginning was made, in 1602-4, by the shoemaker Casciorolo, in Bologna (Bononia), who devoted a great deal of time to the study of alchemy and was the first to discover that barium sulphide, which is found in the vicinity of Bologna, when put between red hot coals became luminous. It was also called "Bologna stone" or "lapis solaris."[2] From this time on there was an almost maniacal zeal for making new discoveries of these luminous minerals, which led many writers on the history of physics to observe as Heinrich does, "One might well call the second half of the seventeenth century the phosphorus epoch of natural science." Efforts tended toward increasing the phosphorescence of those luminous minerals which were known and to find new ones.[3] Every new discovery created an enormous sensation.

Toward the end of the seventeenth century the invention of a peculiar artificial "luminous stone," a phosphorescent mass, materialized by Christoph Adolph Balduin, attracted general attention. His real name was Baldewein, and he was born in 1623, at Döbeln, near Meissen, and died in 1682, at Grossenhain, in Saxony, where he was magistrate.

In 1674 Balduin took a different and entirely novel course from Casciorolo. He was the first to produce calcium nitrate by a solution of chalk in nitric acid. He realized that this salt absorbs moisture very quickly in the open air and intended to apply this knowledge for the marvelous alchemic purpose of imprisoning the "universal Weltgeist." He set out in the open air all manner of things in which to catch the *Weltgeist*. He supposed that this solution of chalk in nitric acid, which

when dried absorbs moisture rapidly, would be of great use for this purpose. As soon as the salt became liquid he drew off the *Weltgeist* by distillation and set the residue again in the air. On one occasion it happened by accident that everything in his glass retort, after being highly heated, dried up, and he found that the dry matter which had been deposited on the inner side of the retort was luminous.

This phosphorescent fused stone was variously named: "Balduin's luminous stone," "Balduin's phosphorus," "phosphorus hermeticus," or "magnes luminaris" (light magnet or light sponge).

Balduin describes his luminous stone, which he called "phosphorus" (carrier of light), in the *Miscellanea curiosa medico-physica Academiae naturae curiosorum; sive, Ephemeridum medico-physicarum annus quartus et quintus*, 1673 and 1674 (Frankfurt and Leipzig, 1676). In the "Appendix," p. 167, Balduin writes of the qualities of his "phosphorus hermeticus," which filled one of his friends with such enthusiasm that he wrote an extravagant madrigal, which we quote here.

Madrigal

The new world still would be hid behind the sea had not the wise hero Flavius of Cosen discovered the magic of the magnet stone and its glorious wonders. But one thing more is wanted wherewith the voyage hard to Colchos may be eased through further miracles. That is, Oh, Hermes's Son, thy fiery magnet stone, thy self-invented phosphorus that rules with radiant light the destiny of Jason's ship. Here sparkles another star; we progress clear and fast and lo! from far away we see the golden fleece!

This is written with dutiful devotion and with everlasting memory to his highly respected friend Johann Engelhart, Medic. C.

This curious book is, in its manner and style, characteristic of the method of writing employed by the alchemists of that time. Balduin believed that he had discovered in his phosphorus, which glowed in the dark, the philosopher's stone, and renewed his efforts to improve it, but in vain. He intended at least to help others along the road of his discovery, and so published the supposition that his light-gatherer had some relation to the philosopher's stone.

Of course Balduin is quite silent in the first treatise which refers to this matter concerning the manner and means used in the preparation of his light-gatherer. He states only that the residue in the glass retort in which he distilled the "alkahest" glowed after the distillation was completed. However, the preparation of Balduin's *Leuchtstein* (Bologna stone) was subsequently disclosed, and very soon Kunckel von

Löwenstjern, Robert Boyle, Lémery, and others worked along the same lines and described the production of this phosphorus.

The phenomena exhibited by and through these phosphorescent minerals attracted great attention and led to the most absurd speculations. Balduin even declared the moon to be a huge phosphorescent mineral which absorbs the rays of the sun during the day and emits them again at night time. Since these minerals were stimulated to phosphorescence by a preceding exposure to radiation or sunlight and emitted a fairly bright light, they were looked upon as a magnet or a kind of sponge, which could suck up the light and give it out again, and so forth.

The study of the phenomena of phosphorescence directed the attention of scientists to the phenomena of light. The chemist Johann Kunckel von Löwenstjern (1638-1703), informed of Balduin's experiments, commenced new investigations and described the procedure in such a manner[4] that "Balduin's phosphor" could be produced without any difficulty.

Some weeks after Balduin's phosphorus had become publicly known, Kunckel (as he writes) made a trip to Homburg and took with him a luminous fragment of it. When he showed it there, he was told that a bankrupt merchant, who also dabbled in medicine and was called Dr. Brand, had also produced a material which became luminous at night. Brand, in 1674-75, in order to repair his lost fortune, had turned to the production of the philosopher's stone and chemical remedies. Among other experiments, he attempted to distil human urine by heat, and in this manner he discovered phosphorus. After Kunckel had inspected the small amount of phosphorus which Brand had accidentally obtained, he imparted the news by letter to Kraft, in Dresden. Kraft immediately journeyed to Homburg, without informing Kunckel, bought Brand's process secretly for 200 thalers, promising him that he would not teach it to anyone. This defeated Kunckel's attempts to make a deal with Brand, and he departed without having learned anything about Brand's method for the production of phosphorus. But Brand had mentioned at some time to Kunckel that he had made use of urine in his experiments, which led Kunckel to work along these lines, and he was fortunate enough to discover, for the second time, the production of phosphorus.[4]

The discovery of the production of phosphorus was of the greatest importance to chemistry, but has not as yet had any reaction on photo-

chemistry. However, the studies of the phenomena of phosphorescence shown by certain mineral compounds, especially the stimulation given by Balduin (1675) with his Bologna stone, in conjunction with Homberg's discovery (1693) of *Leuchtstein* from lime and muriatic acid gave an impetus, indirectly, to the discovery of the first photographic processes with silver salts in the beginning of the eighteenth century.

The first description of luminous minerals was printed in Venice in the work of Ad. Jul. Caesar la Galls: *De phenomenis in orbe lunae*, (Venice, 1612). It is related there that it is not necessary to expose the minerals to strong sunlight, for mild light would suffice (H. Kayser, *Handbuch der Spektroskopie*, 1908, IV, 603; Felix Fritz, *Phot. Indust.*, 1925, p. 487). Another of the very earliest works on the subject was that by Peter Poterius, *Pharmacopoea spagirici* (Bonon., 1622, p. 272).

Lémery, in Paris, describes Homberg's experiments with phosphorus minerals, many of which he contributed himself in his *Cours de chymie* (9th ed., Paris, 1689). He mentions that heat is injurious to luminous minerals, and therefore advises that they should not be exposed to light when hot (both citations by Felix Fritz, *Phot. Indust.*, 1925, p. 487).

This would indicate that a heat effect, contrary and antagonistic to the action of light, was known to exist as far as luminous minerals are concerned. This does not apply to chemical processes, in which heat, on the contrary, not only is not detrimental to the reaction of light but even assists it if both act at the same time, while heat alone in pure photochemical processes in general cannot take the place of the action of light. But all this was unknown to the physicists of that time; it was not until very much later that Schulze recognized the difference between the effect of light and of the dark heat rays.

JOHANN HEINRICH SCHULZE DISCOVERS, IN 1727, THE SENSITIVITY TO
LIGHT OF SILVER SALTS; EMPLOYS THEM IN THE FIRST PHOTOGRAPHIC
PROCESSES; DIFFERENTIATES BETWEEN LIGHT AND HEAT IN PHOTO-
GRAPHIC PROCESSES AND DISCOVERS PHOTOGRAPHY

I pointed out as early as 1881 that we must consider as the first discoverer of the sensitiveness to light of the silver salts Johann Heinrich Schulze (born May 12, 1687, in Colbitz, in Magdeburg; died 1744, in Halle). He was appointed, in 1720, professor of medicine, and, in 1729, also professor of Greek and Arabic at the University of Altdorf. In 1732 he was called to the University of Halle as professor

of medicine, of rhetoric, and of archaeology. In addition to all these activities, he devoted much time to chemical experiments, attempting to reproduce the luminous stone of Balduin. Schulze was still in Altdorf when he occupied himself with the production of this stone. He employed, at one time and quite by chance, nitric acid containing nitrate of silver for dissolving chalk. When he exposed this silver nitrous mixture of chalk and nitrous lime accidentally to light, he discovered that silver salts were sensitive to light.

Much to his surprise he noticed that the surface of the chalky sediment which was turned toward the light had darkened, while the side turned away from the light remained unchanged. Schulze continued his investigation of this phenomenon, demonstrated by unquestionable experiments that this darkening was caused by light, not by heat, and thus became the discoverer of the sensitiveness to light of the silver salts. He found that the compound mentioned above turned a violet black, "a tro-rubentem et in coeruleum vergentem" and satisfied himself that this result must be attributed to light, not to heat , for when he exposed the mixture in a bottle to the dark heat of an oven, the color did not become darker. In order to make certain whether only those parts of the silver-impregnated chalky sediment turned dark which were directly affected by light, he tied a thin thread from the mouth to the bottom of the bottle and observed that the silver sediment remained white where the string kept the light from shining on it. He also pasted paper stencils on the glass, on which words and whole sentences were cut out. Before long those parts of the silver sediment which were not protected from light turned dark in the sun, and the words and the sentences were perfectly delineated in the sediment.[5] He showed this experiment to his friends; to those who were not familiar with the procedure it seemed very marvelous. A mere shaking up of the sediment caused the writing produced by light to disappear entirely, and the sediment was ready for another light impression. Schulze also cites in his essay the observation that sunlight concentrated through a burning glass would immediately blacken the silver-impregnated chalk sediment and that a pure (i.e., not containing chalk) solution of nitrate of silver would turn dark gradually.[6]

Judging from these statements, there can be no doubt that Schulze, as early as 1727, not only knew definitely that silver salts were sensitive to light, but that he applied this knowledge to inscribe, or copy

("inscribere"), written characters by the aid of light. It follows that Schulze, a German, is to be credited with the invention of photography, which was pointed out for the first time by this author. Even this phrase, that one can "write" by the aid of light on silver salts, anticipates the later word "photography." Schulze's essay was almost entirely forgotten or not very highly esteemed in his time, which may have been due to the difficulty of access to the record of his work. Beccarius, Scheele, Senebier, Davy, Heinrich, Link, and Landgrebe seem to have known little or nothing of Schulze and his work; even Priestley, who lived closer to the time of Schulze, while citing Schulze's experiments in his history of optics (1772), places them in an erroneous chronological position, since he gives to Beccarius a place before Schulze; in addition, no dates are cited by Priestley.[7] Fiedler, in his *De lucis effectibus chemicis* (1835), also falls into the same error or anachronism. None of the modern authors seems to have known the work of Schulze, and the present writer was the first, basing his statement upon the study of the original sources, to point out the German scientist Schulze as the inventor of photography in its first inception.[8] With Johann Heinrich Schulze, in 1727, begins a new epoch in the history of the invention of photography.

REJECTION OF THE ERRONEOUS PRESENTATION OF SCHULZE'S MERITS BY POTONNIÉE IN HIS "HISTOIRE DE LA PHOTOGRAPHIE," 1925

Inadequate and incorrect accounts of Schulze's part in the invention of photography by Potonniée must be corrected in the interest of historical truth. Potonniée has treated the invention of the first photographic printing process by Schulze in 1727 with malicious and derogatory remarks; he is silent on the fact that Schulze was the first physicist who distinguished between the chemical action of light and the effect of heat, although the chapter in which Potonniée deals with this matter is headed "Chimistes et photochimie," which would seem to demand a correct and complete treatment of the subject.

Why does Potonniée deny Schulze's indisputable achievement, which can be established by documentary evidence of the silhouettes which he copied in 1727 in sunlight and on silver-salt layers, or by the positives he made from stencils, after having made negatives of a string? Why does he ignore the general scientific recognition, so important to the consideration of the history of photochemistry, that here is presented a specific photographic action of light which has no con-

nection whatever with the rays of heat and is produced as well in direct sunlight as in reflected light? This narrow viewpoint of some French and English authors is not in conformity with the spirit of objective scientific and historical investigation.

Evidently Potonniée was not sufficiently acquainted with this author's works, in which the lines are definitely drawn between the claims of Schulze to the discovery and the inventors of new lines of thought. Potonniée never mentions these works in his book, although they contain conclusive documentary proof of Schulze's priority, which this author proved in his book *Johann Heinrich Schulze, der Lebenslauf des Erfinders des ersten photographischen Kopierverfahrens* (1917). See also Dr. Eder's *Quellenschriften zu den frühesten Anfängen der Photographie* (1913), in which both the original Latin and a German translation are given.

It is necessary here, also, to correct a misleading statement of Hellot's invention (1737) made by Potonniée in his *Histoire*, 1925. Potonniée states that Hellot, who had invented a sympathetic ink with silver nitrate which turned black under light, "had made his experiments about the same time as Schulze"; he creates on the reader a false impression, unfavorable to Schulze, with this statement, since in fact Hellot did not publish his information until ten years later.

With greater fairness than Potonniée displayed and with typical scientific objectivity, the English scholar Charles R. Gibson has acknowledged in his chapters on the history of photography in the collective work *Photography as a Scientific Implement* (1923) the unquestioned merits of Schulze. Gibson writes: "Schulze's experiment, published in 1727, proved a real stepping-stone in the evolution of photography . . . [even though] Schulze had no idea whatever of making a permanent record." Gibson states correctly that the direct route of the invention of photography led in a straight line from Schulze, via Wedgwood and Davy, to Talbot, who, as inventor of modern negative photography in the camera and of the subsequent copying process, must be called the inventor of modern photography.

Chapter. X THE LIFE OF JOHANN HEINRICH SCHULZE

SCHULZE was born on May 12, 1687, in Colbitz, Grand Duchy of Magdeburg. His father, Mathäus Schulze, supported himself and his numerous family by tailoring and keeping bees. The preacher of that time in the village of Colbitz had been suspended for many years and was finally transferred to another place. In his place Andr. Albr. Corvinus was appointed pastor. He tried diligently to improve the condition of the neglected congregation, cared for the education of the children, and visited the school as often as the inefficiency of the schoolmaster demanded. The bright six-year-old boy Schulze attracted the pastor's attention; he became fond of him and placed him under the private tutor who taught his own children. During these private lessons the older scholars were taught the rudiments of Latin and Greek, but little Schulze learned only religion and calligraphy. He was very attentive to the teacher's instructions and the recitals of the scholars, and his eager mind and precociousness helped him to grasp things quickly. Often on leaving school he borrowed the books of his comrades in order to learn surreptitiously by himself what others had to learn laboriously by public instruction. His teacher, noticing this, visited his father in order to learn how the boy spent his time at home and found him in a corner of the garden, behind the beehives, with a Greek New Testament in his hands, laboring over the abbreviation of the Greek words. When he learned of the boy's remarkable thirst for knowledge, he gave him a better edition of the Testament, which greatly assisted his advancement. He had the instruction of several teachers in this manner until he was sixteen years old, when they returned to the newly erected Friedrich University, at Halle.

The university in Halle was founded by the Great Elector of Brandenburg, Friedrich III, who later (1701) became Friedrich I, the first king of Prussia; it was dedicated and opened in 1694 and named the "Friedrichs-Universität" after its founder. King Friedrich I bestowed upon this institution his special attention; his son, King Friedrich Wilhelm I, continued it after the death of his father (1713), although in general he took no great interest in higher education.

At that time there lived at Glaucha, a suburb of Halle, the celebrated pastor and professor August Hermann Francke.

Pastor Francke (born 1663, in Lubeck; died 1727, in Halle) was an

eminent philanthropist and theologian. He had spent an eventful youth. As lecturer and teacher at the University of Leipzig (1695) he had difficulties, owing to his lectures, which were delivered in a free-minded though sanctimonious manner. In 1692 Francke was made professor of Oriental languages at the University of Halle, a chair which he later exchanged for that of theology at the same university. In the same year he became pastor at Glaucha, which he made the center of his endowments and bequests.

In 1698 he erected there an orphan asylum, as well as schools for all classes, and admitted the talented, orphaned students to the higher institutions of learning. He added a large institute for Bible study, named after Freiherr von Canstein, a printing establishment, a book-seller's shop, and a pharmacy. This Francke Foundation gradually enlarged the scope and usefulness of its philanthropic work for all who came under its influence.

In 1697 Pastor Corvinus brought young Schulze to the attention of his friend Francke, with the result that Mathäus Schulze brought his son to Halle in that year, where Francke took the boy's education in hand, placing him in the Latin school attached to the orphanage.

At that time, in 1701, Salomon Negri, a very learned Arab, came from Damascus to Halle. Francke induced him to remain there for more than a year and teach the Arabic language in the "Oriental College," which Francke had founded, to the students of the university, and to six pupils of the orphanage; Schulze was among the latter.

In 1704, for the first time, some of the young men were sent from the orphanage to the University at Halle. Schulze was one of them, and he devoted himself to the study of medicine. Francke recommended him to D. Richter, at that time physician of the Königliche Pedagogium. This learned medical man had a large practice and carried on an extensive correspondence, and he employed young Schulze, dictating letters to him and sending him to patients in order to bring him reports of their condition; all these duties, however, were not permitted to shorten the time allotted to him for his studies. In addition, Schulze attended lectures by the world-renowned chemist and physician Georg Ernst Stahl (1660-1734), who was professor of medicine at the University of Halle from 1694 to 1716. Schulze, introduced by Francke's recommendation, acquired from Stahl the first rudiments of chemistry; he also studied under Christopher Cellarius, whose original perfectly good German name was Keller and who was from 1693 to 1707

professor of history and rhetoric at the University of Halle. Cellarius was the author of *Liber memorialis*, an elementary Latin primer which was generally used as the basic textbook in teaching Latin until late in the eighteenth century and which Goethe, as he relates in his *Dichtung und Wahrheit*, had to memorize diligently.

After Schulze had carried on these studies for two years a friend persuaded him to give up medicine and devote himself to the study of theology and philology. So Schulze was transferred to the theological school. At first he majored in philology under the guidance of Professor Michaelis, under whom he read the Bible in Hebrew; then he studied Syrian, Chaldaic, Ethiopic, Samaritan, and Rabbinical literature, all of which connected up ingeniously with his previously acquired knowledge of Arabic. These studies in philology were not permitted to interfere with his work in theology and philosophy at Halle.

SCHULZE IS APPOINTED, IN 1708, TEACHER OF BOTANY, ANATOMY, GEOGRAPHY, AND PHILOLOGY AT HALLE

In recognition of his varied and thorough scholarship, Hieronymus Treyer, the head of the Königliche Pedagogium, in Halle, with the consent of Francke, offered Schulze a professorship. He taught elementary courses in botany, anatomy, Greek, Latin, Hebrew, geography, and in the highest class "poetry and philosophy." In 1716 Schulze edited, on the basis of his lecture notes for the teaching of Greek, the third edition of the *Erleichterte griechische Grammatik*, by Johann Junker, which subsequently ran into several editions. For seven years he was active in the profession of teaching. Meanwhile, although he had not yet made up his mind to follow medicine, he attended the lectures of Heinrich Heinrici, then professor extraordinary for anatomy and surgery.

SCHULZE, IN 1715, UNDER THE INFLUENCE OF THE CELEBRATED PHYSICIAN FRIEDRICH HOFFMANN, TURNS TO MEDICAL SCIENCE

In 1712 the famous chemist Hoffmann (1660-1742), physician in ordinary to King Friedrich I of Prussia, was called to Halle as professor of medicine. Next to Boerhave, Hoffmann was the best-known physician of his time. Born in Halle, February 19, 1660, he studied at the University of Jena, 1678, at Erfurt, 1679, returned to Jena, 1680, and then made a journey to Holland and England. He went to London and Oxford, where the studies, libraries, and pharmacies of the most

learned were opened to him; he especially attracted the good will and friendship of the great scholar and philosopher Robert Boyle.

Hoffmann's connection with Boyle's pioneer work in the methods of exact investigations into chemistry and physics is well documented. Boyle was at that time president of the Royal Society of London, and their association is interesting to us because Boyle was the first to publish, in his essay *Experimenta et considerationes de coloribus* (1680), the observation that silver chloride will become dark in color when left exposed to the air. Boyle did not attribute this change to the action of light, but considered it as an effect of air and moisture.

Hoffmann certainly knew Boyle's published works and would be influenced by the course of his researches, which added so much to the advance in natural science. He was a colleague of the chemist Stahl at the Halle institution, from whose scientific theories he often openly dissented. Hoffmann wrote many valuable chemical and medical essays. Among his accomplishments, he was the first to classify mineral waters as bitter, alkaline, and ferruginous waters and correctly to indicate their medicinal properties. His name survives today in the medicine he introduced—"Hoffmann's drops," the "Ätherweingeist" (ethyl acetate) of our present pharmacopoeia.

In all the many chemical essays by Hoffmann there is but one incidental remark on the gradual darkening of a silver nitrate solution: "particularly when it is exposed to the open air and the rays of the sun." Felix Fritz, who has devoted special studies to the works of Hoffmann (*Photographische Industrie*, 1916, p. 193), tried to connect this communication of Hoffmann's with Schulze's later discovery of the light sensitivity of silver salts, to which we shall refer later. Hoffmann's remark quoted above is found in the collection of Hoffmann's physico-chemical observations (*Friderici Hoffmanni observationum physico-chymicarum*, Lib. III, Halle, 1722). The Latin text of the original reads: "Argentum, ab omni contagio venero immune adeoque purissimum, videtur omni colore esse orbatum, sed tamen si solvitur in aqua forti, et ejus solutio affunditur cretae, eaque solvitur, tunc amethystino eleganti imbuitur colore, praesertim si aeri libero et radiis solaribus exponitur. Idem color etiam fit, si solutio argenti in vase aperto paulo diutius stet et aliquid chartae bibulae adjiciatur." This may be translated, "Silver which is free from copper, and therefore quite pure, is colorless, but when dissolved in aqua fortis and this solution is poured on chalk and again dissolved, the liquid will be imbued with the color

of amethyst, especially when exposed to open air and rays of the sun. The same color is obtained when the silver solution remains for a long time in an open vessel and a piece of blotting paper is added."

This would indicate that Hoffmann attributes the darkening of the solution of silver nitrate neutralized by chalk from free nitric acid (a solution of nitrate of silver and calcium nitrate) partly to the action of air and partly to the sun's rays, and he adds that the same result is obtained, after some time, by throwing a piece of blotting paper into the solution (even without sunlight). There is no evidence of a scientific conception of the specific action of light on silver salts.

It seems, therefore sufficiently proved that Hoffmann in no way influenced the subsequent discovery by Schulze of the light-sensitivity of silver. That Hoffmann exerted a great influence on Schulze's education and career is unquestionable.

The author treated Hoffmann's part in the history of photography exhaustively in *Photographische Industrie* (1925, No. 37), while Felix Fritz, in the same publication (1925, No. 18), places Hoffmann in advance of Schulze, to the latter's detriment, and attributes the discovery of the light sensitivity of silver salts to Hoffmann. On this matter the author remarks:

It is proven by documents which are still accessible that Schulze was in no way influenced in his discoveries by the statements of Hoffmann, which at their best were only vague; Schulze himself writes clearly that he set out to make a "luminous stone," from a solution of nitric acid containing silver salts, by adding to it an excess of chalk; he set the bottle with the muddy mixture on a window ledge, and thus observed the formation of images by light (silhouettes and photographic prints from stencils) which resulted from both direct and reflected sunlight.

Whether Schulze was inspired in this by Hoffmann or not is immaterial as far as the subject is concerned, but it is of consequence in an estimate of his character. Why should Schulze keep silent on Hoffmann's influence, if he had been inspired by him? It certainly would not have been honorable to hide his knowledge of earlier experimental work, which had paved the way for him, by his fatherly friend, teacher, and benefactor; particularly since Hoffmann taught in a neighboring town and was in constant communication with him on scientific subjects.

It is well to recall the method followed in the preparation of dissertations and learned theses in those times. A thorough knowledge of the

early literature of the subject, preferably back to classic antiquity, was essential. All findings and conclusions from the often meager experiments had to be traced back and built up genetically on the works of earlier authors; a lack of familiarity with the literature of the subject or silence on a known priority would have been severely criticized.

All one needs to do is to look into the numerous dissertations which were carried on under Schulze at the university to make it apparent at once that he stressed the importance of the citation of sources. There can be no doubt that he would have stated the fact precisely had he recognized any connection which Hoffmann's publication might have had with his discovery; following Hoffmann's experiment he (Schulze) had found the darkening, and so forth, to be the result of light action, which Hoffmann had not differentiated.

Schulze's silence on Hoffmann's experiments with the coloring of a silver solution, which is mentioned by Fritz, is decisive proof that at that time Hoffmann's note was not regarded as having any reference to the photochemical action of light, as Schulze described it.

Considering these circumstances, we come to the following conclusions: (1) Hoffmann made a vague observation concerning the darkening of a silver solution, without indicating a particular action of light; (2) Schulze probably knew of this work of his teacher; (3) Schulze could not have regarded this work of Hoffmann as having any connection with his own discovery of the sensitivity of silver salts to light and their use in a photographic copying process, otherwise the introduction to his treatise would have been worded differently; (4) Hoffmann had no part in the discovery of the darkening of silver salts by light.

THE JENA AFFAIR OF INVOKING THE DEVIL IN 1716

In 1716 Schulze was drawn into a remarkable dispute about a conjuration of the devil in which two of the parties lost their lives. This case created an enormous sensation, so that the theological, legal, and medical faculties of the university interested themselves in it. It occasioned the first independent scientific work of Schulze, then twenty-nine years old, in the realm of medicine.

This early work of Schulze had for its background an event of great interest in the cultural history of the country, which is known in the literature of the Faust saga, or legend, as the Jena Christmas

Eve tragedy. On Christmas Eve, 1715, a queer trio spent the night at a winegrower's hut near Jena (at that time there were still vineyards in Thuringia). They were the medical student Johann Gotthard Weber, the shepherd Hans Friedrich Gessner, and the peasant Hans Zenner. They proposed nothing less than to invoke or conjure up "the prince of the realm of the sun, Och, that he produce at their behest the spirit Nathael, who owed obedience to him, in visible and human form, so that he might be of assistance to them in the raising of treasures." When the owner of the vineyard, the tailor Georg Heichler, who was acquainted with their plans and had stipulated that part of the treasures come to him, visited the hut the next day (Christmas), he found Gessner and Zenner dead and Weber unconscious. On the table was an open copy of the *Clavicula Salomonis* and of Dr. Faustus's *Höllenzwang*, which dealt with the exorcising or conjuring up of spirits and the ability to make the devil subservient. On the roof of the hut had been drawn a circle together with all kinds of magic symbols. There could be no doubt: Satan, whom the three bold men had conjured up, had appeared in person and had departed, taking with him their souls. The student Weber, who recovered shortly, was arrested, while the bodies of the two peasants, escorted by two executioner's assistants, were publicly carried on a hangman's dray through the town to the gallows and there buried in the presence of a great number of people. For final judgment the legal documents of the case were sent to the University of Leipzig. The theological, legal, and medical faculties of the University of Leipzig declared, in their unanimous opinion, delivered in April, 1716, that death was not caused by any supernatural agency, but was brought about by the fumes of the charcoal which the peasants, in order to keep warm on that cold December night, had lighted in a pot, the remains of which were found by the court commission. Nevertheless, the student Weber was dismissed from the University of Jena and exiled from the country, because "contrary to his baptismal vows, by which he renounced the devil and all his works, he had dealings with and placed his faith in the devil's black art and so had profaned the honor of God."

The incident created great popular excitement, and many were inclined to regard the affair as a direct influence of the devil. For that reason Hoffman, Schulze's teacher, published a small dissertation, entitled *Eines berühmten Medici gründliches Bedenken und physikalische Anmerkungen von dem tödtlichen Dampf derer Holtz-*

Kohlen, auf Veranlassung der in Jena beym Ausgang des 1715 Jahres vorgefallenen traurigen Begebenheit. Now, Hoffmann had more than ten years earlier published a dissertation *De diaboli potentia in corpora* (Halle, 1703; 2d ed., 1712), which in no way denied the domination of the devil in the material world. Thereupon followed a long controversy. Friedrich Andreas Erdmann, a practicing physician at Jena, asserted in his *Gründlicher Gegensatz auff das Gründliche Bedencken und physikalische Anmerckungen von dem tödtlichen Dampfe der Holtz-Kohlen* that the death of the two peasants must by all means be attributed to Satan. Schulze published a new edition of this polemical pamphlet, with a Preface and comments by himself in which he defended the opinions of his teacher Hoffmann. It bore the title Erdmann, Friedrich Andreä, *Gründlicher sogenannter Gegensatz auff das in Halle herausgegebene gründliche Bedencken von dem tödtlichen Dampf der Holtz-Kohlen mit Anmerckungen von Johann Heinrich Schulzen* (Halle, 1716). However, it was a long time before the last word was written in this controversy; as he dealt with his predecessors, so it happened to him: a third reprinted Schulze's Preface and comments under the title *C. A. T. Med. Cult. Unpartheyische Prüfung der Vorrede und kurtzen Anmerckungen Herrn Johann Heinrich Schultzens* endeavored to maintain that in some cases even results that can be explained by natural causes must be attributed to evil spirits and their extraordinary powers and that the incident at Jena "was largely attributable to Satan's power over bodily matter." This controversy dragged along until 1720, with new pamphleteers constantly entering, but Schulze successfully maintained his point, and it was acknowledged finally that the charcoal fumes (carbonic oxide poisoning) were the cause of death of those who had conjured up the devil. Throughout this controversy Schulze played a strong and meritorious role, defending the viewpoint of science with great skill and the depth of his convictions, based on his thorough knowledge of chemistry and medicine, against ignorance and superstition, never a light task.

SCHULZE ATTAINS HIS DOCTORATE AT HALLE IN 1717 AND BECOMES PROFESSOR AT ALTDORF, 1720

Schulze received the degree of Doctor after writing the thesis *Dissertatio inauguralis de athletis veterum, eorum diaeta et habitu,* dealing with the physical training and diet of boxers and prize fighters (athletes) of early times. In the year that Schulze received his doctorate

and his *Venia legendi* (license to teach) in Halle, he left Hoffmann's house. His lectures on physiology, anatomy, history of medicine and chemistry were attended by large audiences, but had scarcely started when disturbances arose at the university which caused him to lose all but five of his students. These disturbances interfered greatly with the lectures, and many students abandoned their classes at the university and left Halle.

Some of his students, when taking their departure, advised Schulze to move to Altdorf, and they probably caused his being called there several years later. After the loss of most of his students he held private lectures and devoted himself to writing books, especially since the bookseller Johann Christ. Francke had founded a new Halle publishing house. He also collaborated with other scholars on the *Vermischte und abgesonderte akademische Bibliothek*.

In June, 1719, he married Johanna Sophie, daughter of the above-mentioned Pastor Corvinus, and when Professor Heister left Altdorf, in 1720, for Helmstedt, Schulze was appointed his successor at the University of Altdorf, in the district of Nuremberg.

The University of Altdorf attained high repute and sent out many famous men. Gottfried Wilhelm Leibnitz, the celebrated scholar and philosopher, who subsequently founded the academies of sciences at Berlin and St. Petersburg, held debates in Altdorf and attained his doctorate there. In 1806 the imperial city of Nuremburg, with its surrounding territory, was ceded to Bavaria, and the University of Altdorf was merged with the University of Erlangen in 1809. The history of the University of Altdorf was written by Will in a monograph published at Altdorf (1808).

Schulze commenced his lectures at Altdorf on anatomy and surgery, on Dec. 13, 1720, with a discourse relating to the subject of his teaching, a correct survey of anatomical studies.

In the following year he delivered there his first academic lecture on the history of anatomy. The title reads; "Historiae anatomicae specimen primum." The excellent scholarship shown in it was the occasion of his admission to the Imperial Leopold-Caroline German Academy of Natural Sciences in 1720. This academy was accustomed to bestow upon its initiates an epithet, selected from the world of classical antiquity. Schulze received the surname "Alcmäon" after one of Pythagoras's pupils. Alcmäon (about 500 B.C.) belonged to the school of medicine founded by Pythagoras and because of his dis-

coveries in the domain of anatomy and physiology he occupied a very important place in the history of medicine among the old Greeks. In the caption to the oldest known portrait of Schulze, the surname "Alcmäon" is included. The appreciation with which the above-mentioned study of the history of anatomy was received in professional circles induced Schulze to write an elaborate work on the history of medicine, which was published several years later (1728) in Leipzig. He also dealt with the study of applied medicine, published several dissertations, and lectured diligently and with success on anatomy and pharmacology. He engaged his pupils in practical anatomical studies, which seemed particularly curious to his contemporaries, since the dissection of human bodies was rarely undertaken at that time. Therefore a public announcement of the dissection of a male or female body at the university was an event to which attention was called by printed invitations. In the bibliography printed at the end of Dr. Eder's book *J. H. Schulze* (1917) several such announcements of postmortem examinations by Schulze are cited.

He also conducted chemical experiments along the lines and in the spirit of Stahl and Hoffmann. It was one of these experiments which led him, in 1727, to the discovery of the sensitivity of silver salts to light and thus to the discovery of photography.

DISCOVERY OF PHOTOGRAPHY BY SCHULZE, AT ALTDORF, 1727

In 1725 Schulze commenced experiments for the production of phosphorescent or luminous minerals and bodies, which he concluded in 1727 and published in the *Acta physico-medica Academiae Caesareae Leopoldino-Carolinae Naturae Curiosorum exhibentia Ephemerides* (Nuremberg, 1727). Schulze relates in this memoir that he found something quite different from what he expected. He remarks: "often we discover by accident what we could scarcely have found by intention or design." At the outset he intended to produce the artificial luminous stone of the alchemist Balduin by bringing calcium nitrate to a red heat. Balduin, who had invented this luminous stone in 1674, was a member of the Imperial Leopold-Caroline German Academy of Natural Sciences. Schulze, who was a member of the same academy and was familiar with Balduin's writings, aimed to produce the luminous stone by himself.

He searched for a luminous stone which absorbs light from the rays of the sun and so becomes luminous, but instead he discovered a

mixture which becomes darkened by the sun; that is why he called the light-sensitive silver-impregnated mixture a "carrier of darkness" (Dunkelheitsträger; Latin, scotophorus), which he had discovered instead of the sought-for phosphor "carrier of light" (Lichtträger; Latin, phosphorus). Schulze expressed this very concisely in the title of his memoir relating to this subject, as follows: "Scotophorus pro phosphoro inventus; seu, Experimentum curiosum de effectu radiorum solarium" published in *Acta physico-medica Academiae Caesareae Leopoldino-Carolinae Naturae Curiosorum exhibentia Ephemerides* (Nuremberg, 1727).

The author published the complete original Latin text, together with a faithful German translation (Halle, 1913). The particular passage of Schulze's memoir that is especially important for the history of the invention as far as it concerns the identification of the action of the sun's rays and the lack of action of the strong heat of an open fire on the darkening of the silver impregnated paste reads as follows:

Such aqua fortis (diluted nitric acid), containing a very moderate quantity of silver particles, was used by me for moistening the chalk, as required by Balduin's experiment. I carried on this work by an open window, which admitted the brightest sunshine. I was astonished at the change in color of the surface to deep red inclining toward violet blue. But I wondered still more, when I saw that the part of the dish which was turned away from the sun did not take on any color whatever.

Having noticed this phenomenon, I regarded it worthy of further investigation. I discontinued my work with Balduin's phosphorus and concentrated my attention upon the so-called "scotophor" experiment, in order to clear up the causes underlying the change in color. Doubtful what procedure to follow, I divided the saturated chalky mass into two parts, of which I put one part into a long tube, such as is customarily used for compounding medicines and, in order to make it easier to pour this doughy mass into the tube, I added more dilute nitric acid. This, however, caused too violent ebullition, and the chalk began to dissolve; in order to check this vehement reaction, I added water. I then put the tube down in a place where the sun shone brightly. In a few minutes I noticed that the solution showed a similar change in color, namely, deep red, tending toward a shade of blue, on that side of the tube which was turned toward the sunlight. The residue in the dish I left exposed to the sunshine until it was entirely dried up. During this period I observed that the surface became colored and remained so for several days, until the residue was exhausted in further experiments.

I placed this new experiment before my friends, in order to learn their

opinion; some of them thought that the change of color was due to the effect of heat. At first we held the tube so close to the glowing fire that it became more than sufficiently warm. But we placed it so that the part which was previously not reached by the sunlight and had remained un-colored, was now turned toward the fire. We confirmed the fact that there was no change of color, although the tube had become so hot from the fire that it was almost impossible to hold it in the hand.

This was sufficient to demonstrate that heat played no part in the change; I therefore pass over the other experiments made along these lines. But for the purpose of assuring myself and to be able to prove to others that it is not heat but sunlight which brought about this deep color, I shook up the precipitate of chalk in the tube until it was thoroughly mixed with the supernatant water, so that the mixture showed no difference in color in any of its parts. Then, dividing the liquid, if I may be permitted so to call the mixture, I filled a glass with one part and put it in a dark spot where no sunlight could reach it, while I kept the remaining portion for further experiments. I exposed the first portion to sunlight, suspending a thin string perpendicularly from the mouth of the center of the glass, so that the part exposed to the sun was divided almost in half, and left it exposed for hours to the strongest sunlight, undisturbed and untouched in any way. When we returned to inspect it, we found the liquid thoroughly imbued with the color. When the string was slowly withdrawn, we noticed to our delight that the part covered by the string showed the same color as the back of the glass which was not reached by the sunlight; we tested the same result with horsehair, with human hair, and with a very fine silver wire; so that there was no doubt that the change of color resulted solely from sunlight, and that it was not in any way dependent on warmth, not even the heat of the sun.

I began further experiments in reverse. Whenever I intended to make a new test by mixing and shaking the solution well in order to restore to it a colorless state, I covered the larger part of the glass with opaque bodies or patterns which permitted the light access to only a small portion of the vessel's contents. In this manner I frequently wrote names and whole sentences on paper and carefully cut out with a very sharp knife the parts covered with ink. The paper perforated in this manner I fastened with wax on the bottle. Before long one could see the sun's rays write through the perforations in the paper, through which they could reach the glass, these very words and sentences on the chalky sediment. The light wrote so plainly and exactly that those not familiar with the experiment were tempted to attribute the matter to I know not what kind of trick or dodge.

In addition, Schulze determined by a counter experiment that pure calcium nitrate is not sensitive to light by itself, that on the contrary

it was the particles of silver which the solution contained that caused the phenomenon. He found that magnesia, burnt hartshorn, or similar substances could be substituted for chalk.

Schulze also mentioned that sunlight reflected from a mirror or from a white wall caused the color to darken and that the action of sunlight discussed above was much more rapid when a convex burning glass was focused on it. Finally, Schulze expressed the opinon "that his experiment could be applied in the examination of minerals and metals, to ascertain whether they contain any silver, because up to now this phenomenon had not been observed when other metals or minerals were tested in the same manner," and he continues "I do not doubt that this experiment will lead chemists to other means of application and use."

Considering the chemical side of Schulze's experiment, we are able to determine exactly the composition of his light-sensitive compound by following his supplementary directions. It was not easy at that time to procure pure nitric acid free of chlorine, which was used as a solvent for the separation of silver from gold. It was customary to dissolve a small quantity of silver in nitric acid, allow the deposit of silver chloride to settle, and pour off the clear solution of nitric acid which contained some silver. If this acid mixture is poured on calcium carbonate or magnesium carbonate, the nitric acid will then be neutralized through the formation of calcium or magnesium carbonate, whereupon the excess chalk, through partial metastasis (double decomposition) forms some silver carbonate as a white precipitate, which settles from the silver nitrate solution and which, similar to silver chloride, darkens in the light. However, since Schulze diluted the liquid with ordinary well water, which always contains some chloride, chloride of silver was also formed in this experiment. From this we must conclude that Schulze's light-sensitive mixture, which he used either as a paste or dry, was made up of chloride or carbonate and of nitrate of silver, together with an excess of white chalk or magnesia. This substance, just as in our modern printing-out paper, for example, a silver chloride emulsion on a substratum of white baryta, serves as a white background, thus considerably enhancing the clear visibility of the color change during the light reaction and the legibility of the design so obtained. Schulze was also aware of the fact that one could intensify the photographic action of light on silver salts by means of optical instruments, particularly by convex condensing lenses.

Because of these facts Schulze must be declared without doubt the inventor of photography with silver salts. He is also the first scholar in natural sciences who drew a sharp and distinct line between the peculiar chemical action of light rays as compared with the effect of heat rays and confirmed his views by experiments.

SCHULZE DECIPHERS THE CHARACTERS ON THE CORONATION ROBE OF THE GERMAN EMPERORS

In 1728 Schulze, who was deeply versed in the Arabic language, received a copy of the inscription of the age-old coronation robe of the German emperors. This inscription was supposed to be in unknown Oriental characters, because they could not be correctly deciphered at that time. Schulze recognized that the writing in question was of Coptic origin (old Arabic decorative), and he succeeded in deciphering them, although not quite correctly.

The coronation robe of the German emperors was kept, in Schulze's time, together with the other imperial insignia, in the city of Nuremberg, and is at present preserved in the former imperial treasure chamber at Vienna; it is an extremely valuable treasure. The mantle, richly embroidered with gold and pearls, was added to the imperial regalia on the passing of the last of the line of Hohenstaufens. The lining is silk woven and dyed with purple; on top is a gold clasp. The edge is bordered with three rows of pearls and bears the Coptic inscription mentioned. The Nuremberg patrician Hieronymus Wilhelm von Weber became interested in these gold embroidered characters, had exact copies made of them, and showed them to different scholars, among whom was Schulze. He recognized that he had to deal with an Arabic inscription written in the Coptic manner and that the handwork was an expensive example of Sicilian-Arabic art. He furnished a translation which on the whole was fairly correct, although a hundred years later it was much improved. He gave the date of the production of the mantle as A.D. 1126, while later investigations fixed the date as 1133—surely a matter of small importance. Expensive festival garb such as this was made at the Saracen court in Palermo and was worn by emirs and caliphs on holidays at court ceremonies. After the defeat of the Saracens of Sicily, the Saracenic industry which flourished at Palermo was taken under the special protection of the Norman kings. Thus the highly artistic and elaborate coronation robe made in Palermo by the Saracenic art embroiderers for Roger II, king of Sicily, came

then into the possession of the German emperors and was worn by them as early as the first half of the thirteenth century at the coronation ceremonies.

Schulze wrote, in 1727, in addition to his memoir on the light sensitivity of silver salts, many other essays which were published by the Imperial Leopold-Caroline German Academy of Natural Sciences, as well as various dissertations relating to medicine. Subsequently he gave little attention to physical and chemical research, but turned with all his energy to anatomy and surgery.

The first part of his *Historia medicinae a rerum initio* ... (Leipzig) appeared in 1728. This basic study of the history of medicine in antiquity, which had reached only to the time when the science of medicine was transplanted to Rome, was unfortunately never completed; it was regarded as the first scientific history of medicine. In 1729 Schulze was appointed to the chair of Greek at the University of Altdorf. Finally, after the departure of Zeltner from Altdorf, Schulze also added the teaching of Arabic to his other lectures, which probably had never before been connected with the science of medicine at any university.

A vacancy existed at the University of Halle when Nikolaus Hieronymus Gundling died, in 1729, who since 1708, as successor to the celebrated Cellarius, had held the chair of rhetoric and archaeology and since 1712 also lectured on jurisprudence. But it was three years after Gundling's death before Schulze, in 1732, was called to the University of Halle as professor of medicine and philosophy. His salary was five hundred thalers, of which one hundred thalers were to be paid from the funds of the university and four hundred thalers from the Royal Prussian Treasury. Unfortunately, Schulze seems to have quite neglected the remunerative practice of medicine and, having fallen in debt to the extent of about one hundred thalers, he feared that his creditors might prevent him from leaving Altdorf. When King Friedrich Wilhelm I of Prussia learned of this, he granted Schulze a loan for the payment of his debts in addition to the traveling expenses to which he was entitled; the larger part of this debt was later remitted.

This indicates the great confidence which the king had in Schulze, for Friedrich Wilhelm I was well known as excessively parsimonious; he reduced the salaries of many state employees and the remuneration of a minister down to two thousand thalers.

It is this economical trend of the king that makes it so remarkable that he helped Schulze in his financial embarrassment, probably only temporary, and enabled him to enter on his duties at Halle.

In the list of the university courses for the years 1732 to 1736 the only lectures announced as by Schulze are on early literature. His Latin lectures were not very well attended, which caused him to reduce his activities in this branch of philosophy. On the other hand, his lectures on archaeology attracted a great many students; this led him to the study of numismatics, when in 1734 a student presented him with a well-preserved *tetradrachma Thasiorum*, an old Greek four drachma coin. This study stimulated him to investigate not only everything he could discover concerning these Thasian coins, but to consult all the literature bearing on the subject. The first fruit of this study was a dissertation: *De nummis Thasiorum* (1737).

While engaged in this special study, his collection of coins grew considerably, numbering two thousand in four years, and soon after, three thousand. He used this important collection often in his lectures on archaeology and stressed their importance in the historical studies of all times. In 1738 we find him giving a special course of lectures on numismatics.

In recognition of his numerous and outstanding scientific works Schulze was elected a member of the Imperial Leopold-Caroline German Academy of Natural Sciences and the Royal Prussian Society of Scientists at Berlin, which was presided over by Leibnitz, and the Imperial Russian Academy of Sciences, of St. Petersburg.

Schulze's reputation as a scholar of Oriental languages and the history of art grew in importance, owing to his numerous and learned works on these subjects; he had also gathered around him a circle of earnest students who devoted themselves to these branches of knowledge. Among the names of these pupils of Schulze shines out one which was celebrated later in the realm of the history of art as one of its pioneers, Johann Joachim Winckelmann (1717-68). He entered the University of Halle at Easter, 1738, and at once became one of the most eager of Schulze's hearers. It was Schulze who introduced Winckelmann into scientific circles. This student of archaeology

later became celebrated for his studies of ancient art and its history and is considered the founder of this branch of science.

Schulze continued his studies in the history of medicine among the ancient Greeks and Romans and published a concise textbook *Compendium historiae medicinae a rerum initio ad excessum Hadriani Augusti* (Halle, 1742) and *Dissertationum academicarum ad medicinam ejusque historiam perbinentium* (fasc. i, Halle, 1743).

After Hoffmann's death, in 1742, Schulze joined the medical faculty, where he tried to continue the life work of his great master. He contributed a biography of Hoffmann to the Geneva edition of his works, but this is not identical with the *Commentarius de vita Friderici Hoffmanni*, mentioned earlier in this chapter.

Schulze often held debates on scientific subjects and supervised the academic theses of those who studied for the doctor's degree in medicine; he took part in nearly one hundred of these debates, over which he presided.

He constantly studied, read, wrote, worked, and taught, retiring more and more to his study. He became estranged from society, occupied himself in teaching and with his books rather than with his patients, and soon renounced all gains from his medical practice. He preferred to live on the modest income from his professorship so that he could devote himself entirely to his scientific researches and collections. He overworked, however, and his health was weakened to such an extent that he had to be led home from an inaugural debate, in which he participated as the dean of the faculty. After this incident he withdrew from the staff and sought to regain his health by taking the iron baths at the neighboring town of Lauchstadt, in Merseburg. His illness, however, had progressed too far, and Schulze died October 10, 1744, aged 57 years, deeply mourned by the scientific world, by the students of the university, and by his family.

Hirsch, in his *Biographisches Lexicon der hervorragenden Ärzte aller Zeiten und Völker* (1887, Vol. V), mentions the fact that after Schulze's death a commemorative medal was coined in honor of his memory. This medal has become very rare, and none is in the collection of the University of Halle or at the Imperial Leopold-Caroline German Academy of Natural Sciences. There is, however, a cast of it in lead, preserved at Vienna in the large collection of medals of great medical men, which, gathered by Sanitätsrat Dr. J. Brettauer, in Trieste, was left in his will to the University of Vienna, under the title: *Medicina in nummis.*

Schulze's library, which was very comprehensive and valuable, was sold at public auction in May, 1745, by his heirs; the introduction to the catalogue of the auction was written by Jakob Baumgarten, a friend of the Schulze family.

Schulze had spent a part of his professor's salary on his library and on his hobby of collecting coins and medals, and he left, besides a number of manuscripts, a very valuable numismatic collection. This was sold to Privy Councillor Eichel by the heirs for about two thousand thalers. The collection finally reached the University of Halle, where it served as the nucleus of the larger collection now in the archaeological museum of that university.

Among the papers found in Schulze's estate is a complete work on subjects of chemistry, which was to serve as an introduction to the study of chemistry, with special consideration of medicine, and is of great interest to us. The manuscript carries the title "Chemische Versuche." It was edited by Strumpff a year after Schulze's death and was published by the printing office of the Halle orphanage.

Schulze made extensive use in this booklet *Chemische Versuche* of the customary signs and symbols used by chemists, physicians, and pharmacists in the first half of the eighteenth century; these symbols had originated with the alchemists and had undergone many variations (see J. M. Eder, *Quellenschriften zu den frühesten Anfängen der Photographie*, 1913, p. 51). At the end of the book Schulze gives a list of the signs used, knowledge of which is quite necessary to the reader of the booklet.

This work attracted favorable attention and went through several editions. The first edition appeared in Halle, 1745; the second, in 1757. In this book Schulze again referred with emphasis to his *scotophorus* experiment.

Below is a copy of the title in the original text of the first edition, which is dated 1745, not 1746, as Fritz erroneously mentions. An example of this very old and rare edition is in the library of the University of Erlangen, whose management kindly sent it to the author for inspection. The title page reads: *D. Joh. Heinr. Schulzens/weiland der Artzney-Kunst, wie auch der/Beredsamkeit, Alterthümer und Welt-Weis-/heit Professorius auf der Königl. Preussischen Universität Halle,/Mitglieds der Kayserlichen-Carolinischen, Russi-/schen, und Königl. Preussischen Societaten/der Wissenschafften/Chemische/Versuche/nach dem eigenhändigen/Manuscript des Herrn Verfassers/*

zum Druck befördert/durch/D. Christoph Carl Strumpff./Halle,/in Verlegung des Waysenhauses, 1745.

Strumpff states in the Preface that he "attended to the printing, according to the handwritten manuscript of the author, of blessed memory, without making the slightest change." Schulze intended, in his *Chemische Versuche,* to present a guide and aid to the teaching of chemistry, and he based his view on the phlogiston theory of Stahl. He described the salts, antimony, mercury, and other metals, acids, and so forth. In this work Schulze states, in paragraph 148, that raw nitric acid could be purified of its chlorine contents by dissolving some silver in it and this would form a white sediment (silver chloride); if the clear nitric acid was then poured off, it would still contain, Schulze says, some silver (silver nitrate), but it will be then quite adapted for the separation of silver from gold; he called nitric acid solution "präzipitiertes Scheidewasser" (water of separation or separating solvent).

In paragraph 151 Schulze refers with emphasis to his discovery in 1727 of the sensitiveness of silver salts to light, which we translate as closely as possible in the words of the original text:

Par. 151. When dissolved silver touches the skin, wood, or bone and they are placed in sunlight, a black color forms. One can dilute the precipitate *aq. fort.* (separating solvent) in ordinary water, then mix it with chalk and expose it to the rays of the sun, so the change of color will show visibly, during which two things are noticeable. 1. That this is not effected by heat, because even the strongest kitchen fire works no change in color. 2. That the sun's rays do this not only when they fall upon it directly, but also when they are thrown upon it through a mirror or even from a white wall.

This scotophorus experiment seems very serious to my eye. At least it serves for a handy proof that sunlight as light has an action which is independent of its warmth, on which, as far as I know, the physicists have not reflected up to now.

The passage cited above is of great interest in that it demonstrates once more that Schulze recognized the value of his discovery. As far as Schulze's claim to priority in the discovery of the light-sensitivity of silver salts and the development of photography are concerned, this statement contained in the posthumous publication in 1745 is, however, of lesser importance than his first original communication concerning the scotophorus experiment in 1727, because the first mentioned merely confirms, eighteen years later, his previous discovery.

Schulze's publication of the scotophorus experiment, in 1727, secures for him the priority of the discovery of the sensitiveness to light of silver salts, and of the invention of photography in its first beginning or original conception. His continual repetition and reiteration of it in his posthumous *Chemische Versuche* proves that Schulze was fully aware of its importance. Physicists neglected this for many years, and it was not until the end of the nineteenth century that rights to priority of the invention were accorded to this celebrated German scholar.

In Dr. Eder's *Johann Heinrich Schulze* (1917) can be found elaborate literary proofs, a complete list of Schulze's writings, several portraits of him, and facsimile reproductions of handwritten letters.

Chapter XI. PHOTOCHEMICAL RESEARCH IN THE EIGHTEENTH CENTURY UNTIL BECCARIUS AND BONZIUS (1757), TOGETHER WITH A DIGRESSION ON THE KNOWLEDGE AT THAT TIME OF THE INSTABILITY OF COLORS

ABOUT THIS TIME—certainly before 1737—the first observation, as far as I can discover, of the light sensitivity of mercury salts was published by Professor Kaspar Neumann (1683-1737), at Berlin. I quote from his posthumous works on chemistry,[1] where he states, "It is worth considering that mercury dulcis (calomel) becomes black in the sun." He does not seem to have followed up this change effected by light, since he merely mentions, in discussing silver solutions, that they blacken the skin, without stating that light action has any part in it.

In Neumann's day every pharmacist and chemist was familiar with the preparation of calomel by sublimation, by mixing mercury with corrosive sublimate, as well as its behavior when heated—that it remains white and then volatilizes, but never turns black under heat. Therefore, there is no room for misunderstanding when Neumann remarks that the blackening of calomel in the sun deserves consideration. He meant to convey to the chemists of his time that he had found something new and noteworthy, and his statement leaves no doubt about his recognition of the particular action of light on this mercury compound.

HELLOT APPLIES, IN 1737, NITRATE OF SILVER TO PAPER
AND USES CHLORIDE OF GOLD FOR SYMPATHETIC INK

In 1737 Jean Hellot (1685-1766) communicated to the Académie des Sciences de Paris, of which he was a member, a paper giving his experiments with a new sympathetic ink. In his study of the chemical basis of sympathetic ink, he found that cobalt salts were used in the production of invisible writing (on paper), which, when heated, became blue or green, and disappeared gradually after cooling; he also observed (1737) the change of color of nitrate of silver as well as of chloride of gold on paper, when exposed to sunlight. He published this experiment, *Sur une nouvelle encre sympathique*, and informs us that characters written or drawn on white paper with a dilute solution of chloride of gold became, after a few hours, quite deep violet ("violet foncé presque noir") when placed in the air. (He does not say "in light.") When, however, he enclosed this prepared paper in a metal box, the writing did not appear even after several months had elapsed; but after that it became gradually visible. It is of great historical value that he also referred to the use of a dilute silver nitrate solution. Writing on white paper with such a solution was invisible and did not become apparent until after three or four months when the paper was enclosed in a metal box, but it appeared in the course of an hour, in a sort of slate color, when the paper was placed in the sun.

It was Hellot who points out for the first time that paper coated with silver nitrate remains white in the dark, but turns deep grey after an hour's exposure to sunlight; also, that such paper, even in the dark, undergoes a gradual decomposition and its color deepens in the process. While this remark is correct, the explanation given for it offers very little satisfaction. Hellot presumed that the sun merely promoted the evaporation of nitric acid, which always contains some sulphur, and for this reason the silver becomes dark after the evaporation of the nitric acid, because silver is blackened by all sulphur compounds.[2]

While Hellot, therefore, must be credited with the discovery of the sensitivity to light of paper treated with silver nitrate, he had no idea of any other use for it than to produce secret writing. The idea of producing an image made up of light and shade in the sense of a photographic silver formation never dawned upon him.

THE ACTION OF LIGHT ON COLORED SUBSTANCES

The property of light to effect a decomposition of colored fabrics

was dealt with by Captain Dufay (1698-1739) in the Memoirs of the Paris Academy in 1737:

Among the examples which I could cite is one that I wish to mention, of a crimson colored taffeta curtain which hung for a long time before a window; all parts which had hung exactly opposite the windowpanes were entirely decolorized, while those parts opposite the window frame were not bleached nearly so much. In addition, it was quite evident that in the parts which were decolorized the silk was destroyed, and in those parts the silk was very much more apt to tear; while in the other portions one had to exert the usual force to tear them.[3]

It is obvious that the early painters must also have gathered many experiences about the change of colors through light. This is supported by a dissertation of Heraclius which comes down to us from the middle of the thirteenth century, *Von den Farben und Künsten der Römer*. He mentions various organic dyestuffs among the paints used by artists,[4] such as madder lake, litmus, dragon's blood, carmine, gum of Brasilwood, lac of violets, and in Cennino Cennini's book *Buch von der Kunst; oder, Traktat der Malerei*,[5] which was published as early as the middle of the fifteenth century, we find, indeed, a warning against the use of dragon blood: "let it stand, do not worry too much about it." In regard to shellac it is said that "air was its enemy"; of saffron, "See to it that it is not exposed in the open air, as it then quickly loses its color." Michael Angelo Buonarotti Biondo no longer quotes any of the mentioned vegetable colors[6] besides lac and indigo in his *Traktat von der hochedlen Malerei* (1549), when he enumerates the colors commonly used in painting. Further explanations on this subject are given in the French work by the Jesuit Father Castel (1688-1757), published in 1740 and translated into German in 1747 (Halle): *Die auf lauter Erfahrungen gegründete Farbenoptik*.

There it is stated, on page 127:

I know a painter whose taste and ability in painting portraits I value highly. He showed me his palette, where he had few colors, and he told me that he used neither carmine nor lac nor cinnabar for his red, nor did he use a fresh yellow; but he used for blue and green only prussian blue, and for all red and violet he used a brown red with a certain yellow of medium quality, the name of which I have forgotten.

Referring to the custom of well-known painters of those times of permitting red and green to predominate in their paintings. We read on p. 128:

He, the aforesaid painter, called my attention, however, to those that are

stable and permanent. These colors (the yellow and the red) are false . . . He added that lake, carmine, cinnabar and other very conspicuous colors had not enough body, nor were they permanent, and that he who used them in his work did not think of posterity.

Castel writes of gamboge on p. 97: "Painters do not think much of it, because the color is not sufficiently permanent."

That Castel realized the bleaching action of the sun is shown by the citation, p. 171: "What is called linen is bleached by air, by sun, by dew and by lye. The same thing happens with wax, wool, and many other things."

Castel was so throughly convinced of the extraordinarily great force of light that he was moved to express himself in words which seem to me rather daring for a Jesuit Father of the eighteenth century, p. 169:

For, God, who is pure light without an addition of darkness, was and existed as himself before all things were created. Whereas all things were created by that light and in it have their being, they have their origin from light and therefore from God, who has created light: their bodies and shapes, however, come straight from the darkness, because they are composed of matter; matter in itself is dark and lifeless.

About the nature of the action of light the physicists of those days had a very vague idea. For instance, J.J. Scheuchzer (1672-1733), professor of mathematics and physics at the Gymnasium of Zurich and academician, wrote in his *Physica; oder, Naturwissenschaft* (1st ed., 1703; 4th ed., 1743), from the latter edition we quote here, Chapter XXVIII, p. 239, on the bleaching of colored stuffs:

From frequent washing and drying linen becomes white in sunlight, because wetting it causes all kinds of impurities to be absorbed by the water, which are driven away together with the water through the small interstices of the linen, which necessarily makes the linen cleaner and whiter, because of the ensuing loss of the earthly impurities clinging to the linen. The vivid and bright colors of silk and taffeta are easily lost in the open air and still sooner in the sun, by which, as it is commonly said, they are extracted, in fact, that is what happens, so that through the powerful action of the sun's rays the smallest color particles which cling to the threads of silk or of other materials are in time bleached out, so that broadly speaking they are, in a way, scraped off.

BECCARIUS DESCRIBES THE SENSITIVENESS OF SILVER CHLORIDE TO LIGHT, 1757

The work of Réaumur and Duhamel called forth new investigations

by the Italian physicist Giacomo Battista Beccaria. He wrote in Latin and always signed himself "Beccarius." His work is important to the history of photography, owing to his discovery of the sensitiveness of chloride of silver to light. Born in Mondovi, Italy, in 1716, Beccarius was a member of a religious order, taught rhetoric and philosophy at Rome and Palermo and physics at the University of Turin from 1748 until his death there, in 1781. He interested himself almost entirely in the study of artificial and atmospheric electricity. Benjamin Franklin esteemed the work of Beccarius so highly that he had an English edition of it published, *Treatise on Artificial Electricity*, tr. from the Italian (London, 1766). Beccarius also participated in the surveying in Piedmont, where he proved in 1774 the influence of the Alps on the deviation of the pendulum. Among his physical investigations we find some on the action of light on various substances, and in 1757 one about the effect on chloride of silver. This essay is printed in the original Latin text and with a German translation in the author's *Quellenschriften zu den frühesten Anfängen der Photographie* (1913), in which there is reproduced a picture of Beccarius.

The dissertations of Beccarius and Bonzius, which were published at the same time by the Academy of Sciences of Bologna, have the common title which reads in translation, "On the art, which light possesses of itself, of changing not only the colors, but also the structure of things, sometimes without detriment to the colors.[7]

To Beccarius (Beccaria) belongs the priority of discovery with respect to the light sensitivity of silver chloride. Freshly precipitated hornsilver (cerargyrite, Ag Cl.), he states, is white; but gradually it becomes almost violet blue. A specimen kept in a glass turned blue only on the side toward the light, but the opposite side was still whitish; it also turned violet, however, when one gave the glass a half turn. This convinced him that it was the light, not the air, as he previously believed, which had effected the change of color. In order to convince himself finally, he covered the side of the glass which was turned toward the window and the light with a strip of black paper. The next day he found that the parts on which the light could shine were violet; those, however, covered by the paper were still whitish. The procedure of Beccarius's experiment seems quite analogous to that of Schulze, which the latter employed thirty years earlier in his experiment with "kreidehaltigen Silvermagna" (chalky mass saturated with silver).

Evidently Beccarius was not acquainted with Schulze's works, or he would probably have mentioned them. He expressed the opinion that there resided in light a certain force which could change colors. He determined that it was not air, but light which blackened silver chloride, and further stated that one must have a thorough knowledge of the three causes, light, air, and heat, in order to study the change of colors.

In order to appreciate Beccarius's publication to its full extent, it is necessary to consider the significance of chloride of silver in comparison with Schulze's silver-salts sludge and with the silver nitrate paper of Hellot, since modern photography is built on the light sensitivity of silver halide compounds.

CHANGES OF PIGMENTS BY LIGHT

Bonzius carried out various experiments on the action of light on colored ribbons, and so forth, which he published at the same time that Beccarius published his. We learn from Bonzius's experiments that many colors are greatly changed by light, regardless of the effect of heat or air. When different-colored ribbons were exposed to the rays of the sun for several days, the violets faded first, then the rose colors, and lastly blue and green. In the dark, in a much higher temperature than that of the sun's rays, the colors remained unchanged; although they lost their brilliancy, Bonzius concluded that air did not contribute anything to the change, because the bleaching proceeded just as well in an air-tight receptacle. Light from torches focused through a burning glass had no effect. The supposition that sunlight merely destroyed the colored particles was disproved by Bonzius's experiment, in which he placed the ribbons on white paper before exposing them to sunlight. The colors faded on both sides, but no particles remained on the paper in the place from which the ribbons were removed.

That this last-mentioned experiment, which may seem to us superfluous, was nevertheless quite necessary is shown by the following passage in A. D. Richter's *Lehrbuch einer für Schulen fasslichen Naturlehre* (Leipzig, 1769), where on p. 134, referring to dyeing, it is taught: "Those materials which are so coarse in their pigments that they cannot penetrate the spaces between the fibers of the fabric give color which will not last and which will easily fade away in the open air and sunlight." Even J. Bischoff utters a similar crude conception in

his *Versuche einer Geschichte der Färberkunst* (1780), although Bonzius long ago had disproved this theory. Anticipating the chronological sequence, we should note here that Bischoff declares that only those colored materials were genuine which could be exposed for twelve days to air, rain, and sunshine without suffering a noticeable change. These are requirements which are quite justified.

Supplementing this chapter, as it were, we feel inclined to add some remarks on the degree of knowledge at that time concerning the changes which artists' colors underwent.

Pernety states in his work, published 1760, in Paris, *Dictionnaire portatif de peinture*, that many colors are very impermanent; thus, "Dutch pink" disappears in a short time, especially when the painting is freely exposed to the air or to sunlight; prussian blue turns greenish in time; colombium lac changes gradually; cinnabar does not last in the open air (!) and "fine lac" (?) (madder) behaves similarly. We must conclude that they were pretty well aware of the alterability of vegetable pigments and had observed the influence of light on the process of decomposition.

Chapter XII. FROM "GIPHANTIE" (1761) TO SCHEELE (1777)

TIPHAIGNE DE LA ROCHE wrote, in 1760, a work, *Giphantie*, which is "a view of what has passed, what is now passing, and during the present century, what will pass in the world." The transposed letters of his name formed the word in the title "Giphantie." It contains certain fanciful allusions to the possibility of producing photographic images and provoked even very recently a great deal of discussion. These chimerical dreams were greatly admired, owing to their genius. We observe here basically the same fantastic ideas which we found expressed a thousand years earlier by the Roman poet Statius. We can place no more value upon these than on the modern imaginative novels of Jules Verne, based on the natural sciences. Tiphaigne, probably using the discoveries of Schulze or Beccaria, which could hardly have remained unknown to him, enlarged them into this fantastic tale, employing the alchemic jargon of the time. This fantastic tale and the satirical writings were taken altogether too seriously, because the sources from which he

obviously drew his information were not then known. It was there-
fore assumed that in his book the first appearance of an original idea,
namely, the production of images by light, was met.

Mayer and Pierson lay considerable stress on this *Giphantie* in their
work *La Photographie considérée comme art et comme industrie, his-
toire de sa découverte, ses progrès, ses applications—son avenir* (Paris,
1862). The following quotation from *Giphantie* is taken from the
English translation, published 1761:

You know that the rays of light, reflected from different bodies, produce
an image and that the objects appear delineated on all polished surfaces,
as on the retina of the eye, in water and on mirrors. The elementary spirits
have studied how to fix these fugitive images. They have composed a most
subtle substance which is very viscous and prepared so as to dry quickly
and harden; by the help of which a picture is produced in a few moments.
They coat a piece of canvas with this stuff and hold it before the objects
which they wish to depict. The first result apparent on the canvas is ex-
actly that of a mirror, all objects, near or far, from which the light can
throw a picture, are seen on it. But what the mirror cannot do, the canvas
does by fixing the images by means of its sticky coating. While the mirror
reproduces for us the objects faithfully, it retains none; our canvases repro-
duce them no less faithfully, but also hold them permanently. This impres-
sion of the images is the work of the first moment they are received on the
canvas, which is immediately carried away into a dark place. An hour
later the viscous coating has dried, and you have a painting which is the
more precious, because no art can attain its reality and time cannot damage
it in any way. We take from their purest source, in the luminous bodies,
the colors which painters must extract from different materials, which
time never leaves unchanged. The faithful rendering of the design, the
truth of expression, the strokes of the brush more or less strong, the grada-
tions of shading, the rules of perspective—all these we leave to nature, who,
with a sure and never-erring hand, paints pictures on our canvas which
deceive the eye and make one's reason to doubt, whether the so-called real
objects are not phantoms of the imagination which deceive not only eyes,
ears, and feelings, but all the senses together The elementary spirit
then entered upon some physical discussions: first, on the nature of the
glutinous matter which intercepts the rays and retains them; second, on the
difficulties of its preparation and use; third, on the struggle between the
rays of light and this dried substance; three problems which I submit to
the physicists of my time and leave to their discernment.

When we turn again to serious works on the subject, we find an
interesting description of the action of light in the work of Jos. Fr.

Meyer, an apothecary in Osnabruck (1705-65), *Chymische Versuche zur näheren Erkenntnis des ungelöschten Kalches, der elastischen elektrischen Materie, des allerreinsten Feuerwesens und der ursprünglichen allgemeinen Säure* (Hannover-Leipzig, 1764). In this work (ch. xx, p. 119) Meyer investigates "what causticum is and of what it is composed," and the opinion is expressed that the corrosive mordant in lime and other caustic substances consists of pure fire particles. He continues:

that the fiery part of the caustic might be the substance of light, which perhaps could be made more plausible by a few not unknown experiences . . . a greyish-black color is acquired by the precipitated Luna cornea when it is placed in the sunlight in a tightly closed glass. If one causes a solution of mercury in sulphuric acid to become crystallized, this "vitriolum mercurii" will turn black in the sun even in a closed vessel; the white sublimate which results from the solution, when it is finally separated by a strong fire, will also turn black in the sun.

These changes of color by light are contrasted by Meyer with those which nitrate of silver and calomel undergo when limewater is poured over them and both become black. Then he concludes: "the substance of the light penetrates the transparent glass and darkens these (i.e., the light-sensitive matter) just as the causticum does." It is, of course, quite unnecessary to emphasize that the blackening of the above-mentioned chemical compounds by limewater is to be attributed to an entirely different cause than the blackening by light, namely, the formation of silver oxide and mercurous oxide, and that it is a mere coincidence that the product in both cases is blackish. This view, erroneous as it is, is at any rate original and represents one of the earliest theories of the chemical action of light.

From these remarks of Meyer it is evident that a knowledge of the instability of silver and mercury salts had been pretty generally disseminated before 1764. It also seems to follow that photochemical decomposition of mercurous sulphate was known before Meyer; I did not succeed, however, in finding an earlier reference to this subject.

LEWIS MENTIONS (1763) THE APPLICATION OF SILVER NITRATE IN THE
 PRODUCTION OF DESIGNS ON BONE, MARBLE AND WHITE AGATE, WITH-
 OUT MENTIONING HIS PREDECESSORS; HE FORMS THE CONNECTING LINK
 WITH WEDGWOOD'S EXPERIMENTS

Curiously enough, we encounter as early as the sixties of the eighteenth century a practical use of silver nitrate for producing draw-

ings on all kinds of objects and for dyeing hair with the assistance of the sun. Dr. William Lewis writes, in his "History of Colors," Part 6 of his *Commercium philosophico-technicum* (London, 1763):

A solution of silver in aqua fortis, of itself colorless as water, dropped upon white bone or other like animal substances, produces at first no stain. In some time, sooner or later according as the subject is more or less exposed to the sun and air, the part moistened with the liquid becomes first of a reddish or purplish color, which by degrees changes into a brown, and at length deepens to a black.

Lewis made his experiments entirely according to the methods followed in the earlier efforts of Homberg and Schulze. Consequently, it seems as if Lewis would not have any special claim to having shared in the advancement of photography, if it were not for the peculiar accident that his writings came into the possession of the Wedgwood family. Their attention was called through this for the first time to the possibility of the production of light images. Charles R. Gibson points out, in the collective work already mentioned, *Photography as a Scientific Implement*:

We have seen that Dr. William Lewis (1763) repeated Schulze's experiments and extended them to ivory and wood. It so happened that upon the death of Dr. Lewis (1781), his notebooks relating to these experiments were bought by the famous English potter, Josiah Wedgwood, who also took Dr. Lewis's assistant into his own service as secretary and chemical assistant.

This secretary, whose name was Chisholm, seems to have acted also as tutor to Wedgwood's young son, Tom, who was delicate and who developed a liking for chemical experiments.

Young Thomas Wedgwood would doubtless receive much inspiration from the scientific friends who gathered at his father's house among whom was Dr. Joseph Priestley

There is no doubt that young Thomas Wedgwood would hear of Schulze's experiments in connection with some of the discussions at the meeting . . . for Dr. Priestley was conversant with Schulze's experiments, which he described in his *History . . . of Discoveries, Relating to Vision, Light and Colours*. Then there were also Dr. Lewis's notebooks, which were in Wedgwood's house, also the tuition from Lewis's assistant, so that there is a real link between the work of Schulze and that of Thomas Wedgwood.

This idea fell upon fertile ground with young Thomas Wedgwood, because it led him to the well-known work with Davy (1802) with which we shall deal later in detail.

Some photochemical notes by Johann Gottschalk Wallerius in his *Chemia physica* (1765, Vol. II, chap. xxv, par. 4) deal quite exhaustively with silver salts.[1] J. G. Wallerius (1709-85) was profesor of chemistry at Upsala. Among other things, he relates that hair is blackened by silver nitrate and that it is very difficult to wash away the black dye. He used silver nitrate to draw on marble, agate, jasper, and so forth, and also employed a dilute silver solution (aqua graeca) to turn red hair black.[1] Wallerius was acquainted with Schulze's investigations and quotes him with the words "Scotophoricum Schultzii." He repeated his experiments, but with chloride of silver, in which, however, he was anticipated by Beccarius (1757). Wallerius, therefore, contributed nothing new to the history of photography.

WORKS OF MARGGRAF (1771), PRIESTLEY, AND INGENHOUSZ, WHO IN 1786 DISCOVERED THE DECOMPOSITION OF CARBONIC ACID BY PLANTS IN SUNLIGHT

In 1771 Marggraf mentions, in the *Mémoires de Berlin* (1771, p. 3), that a red lac produced from a decoction made from dyer's madder (rubia tinctoria) in alum and potassium carbonate is much more permanent and does not fade so easily as that made from "Fernambuk" (Brazilwood).[2] In 1771 and 1772 the influence of Priestley made itself felt in the development of photochemistry. This great scholar presented in his *History and Present State of Discoveries Relating to Vision, Light and Colours* (1772)[3] the first comprehensive description of the chemical action of light; it was, however, not complete, referring only to Duhamel, Beccarius, Schulze, and Bonzius. There is no separate chapter devoted to this subject; for it is only mentioned in a description of chemical actions in the second chapter of the sixth period, "On the Bolognian Phosphorous." Priestley concluded from the observations at his command:

The view that light is a real substance, consisting of particles of matter emitted from luminous bodies, is farther favored by those experiments which demonstrate that the color, and inward texture of some bodies are changed, in consequence of their being exposed to light. The first observation of this kind appears to have been made by Duhamel, who found that the juice of a certain shell fish in Provence contracted a fine purple color when it was exposed to the light of the sun, and that the stronger the light, the more splendid the color.

As early as 1774[4] Priestley had observed that the green matter of

plants was developed out of carbon dioxide, without, however, recognizing the part played by light in this change of color, that is, that sunlight is necessary for the decomposition of carbonic acid in plants. This was first observed by Ingenhousz in 1786.

Jan Ingenhousz (1730-99), a Dutch physician who was for some years physician-in-ordinary at the imperial court in Vienna, spent his last years in England. The work of this scholar is of the greatest importance because of his discovery that the green plant liberates oxygen in sunlight and absorbs carbonic acid (carbon dioxide), which it gives off in the shade—the breathing of plants. He is the real founder of plant physiology. Until the most recent times Horace Benedict de Saussure (1740-99) was called the discoverer of the breathing of plants. However, the work of Ingenhousz, in which he pointed out the breathing of plants in light, had appeared a year before Saussure's publication on this subject. Only very much later did the discovery of Ingenhousz obtain the recognition it deserved. We are indebted to him also for important physical investigations and various pieces of scientific apparatus which are described by Julius Wiesner in *Jan Ingenhousz: sein Leben und Werken als Naturforscher und Arzt* (1905).

Wiesner explains why Ingenhousz's work was not properly appreciated until so late. Influenced by Senebier, Saussure never gave him (Ingenhousz) proper credit; on the contrary, in his writings Senebier is overestimated, to Ingenhousz's disadvantage. Later writers, especially Liebig, used Saussure as their source of information, and thus it is easily understood why before the last third of the nineteenth century this scholar was not justly dealt with until Julius Sachse called attention to the great importance of his work.

HOOPER PLAGIARIZES SCHULZE IN 1774

When Hooper published his *Rational Recreations, in Which the Principles of Numbers and Natural Philosophy Are Elucidated by a Series of Easy, Entertaining and Interesting Experiments* (editions 1774, 1775, 1787, 1794), he gave as "Recreation XLIII" (IV, 143) a method of "writing on glass by the rays of the sun," which runs as follows:

Dissolve chalk in aqua fortis to the consistence of honey, and add to that a strong solution of silver. Keep this liquor in a glass decanter well stoppered, then cut out from a paper the letters you would have appear, and paste the paper on the decanter, which you are to place in the sun, in such a

manner that its rays may pass through the spaces cut out of the paper, and fall on the surface of the liquor. The part of the glass through which the rays pass will turn black, and that under the paper will remain white. You must observe not to move the bottle during the time of the operation.

Doubtless many readers of this apparently popular work, not familiar with the literature of the subject, believed that in this "Recreation XLIII" Hooper offered something new and original. As the description of the method shows, however, Hooper plainly plagiarizes Schulze's famous experiment of 1727, as described in his memoir "Scotophorous pro phosphoro." Possibly he was inspired by or took his information from the account given by Priestley, a year or two earlier, of the Schulze experiments. The credulity of those modern writers who ascribe priority to Hooper may be dismissed without comment.

BERGMAN DISCOVERS THE LIGHT SENSITIVENESS OF SULPHATE AND OXALATE SILVER AS WELL AS MERCURY OXALATE (1776)

Torbern Olof Bergman, the successor of Wallerius at the University of Upsala (1735-84), published in 1776 the results of his experiments on oxalic acid obtained by oxidation of sugar, in a pamphlet entitled *De acido sacchari*. Here is mentioned for the first time the sensitivity to light of metal oxalates; he describes his observation that sunlight will turn black the difficultly soluble white powder (hydrargyrus saccharatus), as precipitated by means of oxalic acid from a solution of mercury in sulphuric or nitric acid.[5] We are also indebted to Bergman for the observation that silver sulphate and silver oxalate darken in light.

Bergman's complete observations on related subjects are collected in his work *Opuscula physica et chemica*[6] (1779). He states: "The rays of the sun darken the oxalate of silver." He goes on to describe how mercuric oxide with oxalic acid forms a "salty white powder which hardly dissolves and which turns black in sunlight." He obtained the same salt by precipitation from mercuric sulphate or mercuric nitrate by oxalic acid, and he noticed that the mixture of oxalic acid and mercuric chloride is sensitive to light. "Also by this method (addition of oxalic acid to the solution) the sublimate forms a powder, which only slightly and slowly will turn dark in the sun." This statement was afterward much more clearly defined by Planté (1815), but Bergman is, at any rate, to be credited with the discovery of the light-sensitiveness of numerous compounds of oxalic acid.

He was acquainted with silver sulphate and knew that it blackened more slowly than chloride of silver: "A solution of silver in nitric acid will give a white precipitate when sulphuric or hydrochloric acid is added. In the first case, however, the particles precipitated will not cohere so well, remain grainy rather than flaky, and will not darken as quickly. Bergman adapted his ideas on the nature of light to the phlogiston theory. The following passage characterizes this more closely:

It is well known that plants droop and lose their color, but when exposed to sunlight they soon recover. Because light consists of a matter of heat with an excess of phlogiston . . . unequal results must form, according to the different positions of the plants in respect to light, and their varying capability to decompose light and heat.

SCHEELE RECOGNIZES (1777) THE REACTION OF SILVER CHLORIDE IN LIGHT; HE INTRODUCES THE PRISMATIC SOLAR SPECTRUM FOR THE INVESTIGATION OF COLOR SENSITIVENESS AND DISCOVERS THAT AMMONIA IS AN AGENT FOR SEPARATING SILVER CHLORIDE AND METALLIC SILVER FROM PHOTOCHLORIDE

Basing his work directly on Schulze's investigations that were published in 1727, the eminent Swedish chemist Carl Wilhelm Scheele wrote his famous dissertation: *Aeris atque ignis examen chemicum*[7] (1777, p. 62), which is of the greatest importance to the history of photochemistry.

Scheele (born 1742, at Stralsund; died 1786, at Koping) started as apothecary's assistant in Gothenburg, and worked later in Malmö, Stockholm, and Upsala. He came to Koping in 1775 as manager of the pharmacy there, and bought it in 1777. He spent his time untiringly on broadening his knowledge of chemistry, notwithstanding the very modest resources at his command. The science of chemistry is indebted to him for many very important discoveries. He discovered oxygen independently of Priestley and Lavoisier, also many other organic substances (oxalic acid, citric acid, malic acid, gallic acid, glycerine), and extended the knowledge of inorganic chemistry, for instance, by the discovery of molybdic acid and tungstic acid; he was the first to prepare hydrofluoric acid and to isolate chlorine, which he described as dephlogistonized hydrochloric acid, and so forth. For our purpose Scheele's works in photochemistry, particularly those on silver chloride, are of special interest.

Scheele's experiments on the chemical action of light, as described in his book mentioned above, are often cited, and this much more frequently, because the beginning of photochemistry is ascribed to him.[8] I have endeavored to throw light on this subject, proving that this is an error, since there were a considerable number of photochemical processes known before his time. At any rate, he is undoubtedly entitled to recognition for his services in carrying out his experiments in a more systematic and clear-sighted manner than his predecessors. He must also be credited with having originated the chemical conception of the reaction of silver chloride to light and the photochemistry of the solar spectrum. He made his experiments for the purpose of demonstrating that light is composed of and contains phlogiston. He found that silver oxide, gold oxide, and mercurous oxide, when in the focus of a burning glass, are superficially changed to metal (take up phlogiston); he adds that heat probably plays a role in this. Scheele also observed that nitric acid will turn red in sunlight in three hours, while in dark heat it would take four weeks.[9]

Scheele gave us the first definite statements on the photochemistry of silver chloride and used silver chloride paper in his experiments. He knew the different reactions of silver chloride. He recognized the difference in behavior of silver chloride blackened by light, and the unchanged silver chloride with respect to ammonia. This gave us the knowledge of a fixative for silver chloride images, which unfortunately remained unnoticed for many decades.

On chloride of silver Scheele expresses himself as follows:

I precipitated a solution of silver by means of ammonia chloride . . . the white dry precipitate turned superficially black in sunlight Then, I poured some caustic spirit of ammonia on this black-looking powder and put it aside for digestion. This liquor dissolved a good deal of the chloride of silver, but a velvet-black powder remained. The washed powder was largely taken up in pure nitric acid, which volatilizes in this way[10] Consequently, the black substance which results from light action on silver chloride is nothing but reduced silver.

He verified that chloride of silver remained unchanged in the dark. It did not escape the keen observation of this ingenious chemist that during the blackening of chloride of silver "in light, muriatic acid" must form. "Since, however, no silver can combine in metallic form with muriatic acid, it follows that as many single particles of the silver chloride as are changed on their surfaces to silver, so much muriatic

acid must also separate." He also noted that washed silver chloride, when exposed to light under water, will give off muriatic acid to the water; he adds that it will remain unchanged in sunlight when submerged in nitric acid. He noticed that after two weeks particles of metal separated from a solution of chloride of gold.[11]

Scheele first sprinkled powdered chloride of silver on paper and allowed the solar spectrum to act on it. He found that the silver chloride blackened much more easily in the violet of the spectrum than in the other colors, "because the silver chalk liberated the phlogiston sooner from the violet light than from any other rays."[12]

If he painted a glass black and put silver chloride into the glass and exposed it to sunlight, it did not turn black, although the glass became quite hot. Heat rays alone, for example, those of a fire, did not succeed in producing the blackening even after two months.

These phenomena he explained by assuming that light is probably not pure phlogiston (principium inflammabile), but contains phlogiston along with heat as a constituent, and this combines with the "silver chalk." According to this view, light was decomposed by silver chloride—not, as it is expressed today, the silver chloride by light—and by this, one of the constituents is withdrawn from the light. This view coincided with the spirit of Newton's theory of emission, which was prevalent at that time and was used by Scheele in connection with the phlogiston theory.

And so we can trace manifestly the history of the development of the beginnings of photography directly from Schulze (1727) through Beccaria (1757) to Scheele, and we find in paragraph 60 of Scheele's writings (1777), mentioned above, the indubitable evidence:

It is known that the solution of silver in nitric acid, when poured on a piece of chalk and when exposed to sunlight, turns black. The same result is obtained, but more slowly, by sunlight reflected from a white wall. Heat, however, without light, produces no change whatever in this mixture. Could it be that this black pigment is real silver?

Based on his later experiments he answered this question in the affirmative.

Richard Kirwan, who added some explanatory notes to Forster's English translation of Scheele's work, expressed grave doubts regarding the opinion that light consisted of phlogiston and fire and gave as his reason "that combustible matter ordinarily does not penetrate solid matter as does light; that, on the other hand, light does not reduce

generally metal oxides or manganese dioxide." Richard Kirwan, F.R.S., was one of the most brilliant and versatile of the Irish men of science and the author of several reputable works: *On Phlogiston and on the Constitution of Acids, Geological Essays,* and so forth. Kirwan inclined more to the view that the light sprang from a strong motion of the elementary fire, whereby the combustible matter was expelled from the objects exposed to light, for instance: "drive out the light combustible matter from the muriatic acid in chloride of silver, which combines with silver oxide" (*Chemical Observations and Experiments on Air and Fire,* by Carl Wilhelm Scheele, with Introduction by Torbern Bergman; translated from the German by J. R. Forster, F.R.S., with notes by Richard Kirwan, F.R.S., with a letter to him from Joseph Priestley, F.R.S., 1780. Also in extract by Crell, in *Neueste Entdeckungen in der Chemie,* 1782, V, 231).

Chapter XIII. FROM PRIESTLEY (1777) TO SE-NEBIER (1782); TOGETHER WITH AN EXCURSION INTO THE APPLICATION MADE IN THOSE DAYS OF LIGHT-SENSITIVE COMPOUNDS TO MAGIC ARTS

DURING THE LATTER HALF of the century in which Scheele made his experiments on the photochemical action of light (1727), the Englishman Joseph Priestley (1733-1804), occupied himself in investigating the causes of the spontaneous reddening of nitric acid. He described his experiments later in great detail.[1] The results of his tests demonstrated that nitric acid turned red slowly, but more quickly in sunlight, and kept its color unchanged after several days in the dark, even though subjected to a considerable degree of heat. Since Priestley was a zealous partisan of the phlogiston theory, he concluded that light acted here similarly to phlogiston; how this happened could not as yet be stated definitely, but it was proved by many chemical experiments that light contained phlogiston, or as we say today, acted as a reducing agent.

Joseph Priestley was a remarkably versatile man. As a youth he mastered several ancient and modern languages and studied philosophy and theology. From 1755 his activities were divided in the work of a

dissenting preacher, the writing of liberal theological tracts, and scientific studies. In 1761 he taught languages and belles-lettres at Warrington. About this time he visited London and met Franklin, who lent him books which enabled him to publish his *History and Present State of Electricity* (1767). In the same year he took charge of a chapel at Millhill, near Leeds, where the proximity of a brewery turned his mind to the study of the chemistry of gases, and this branch of chemistry is indebted to no other scientist in a greater degree than to Priestley, for it was through him that this science assumed a new form. In 1772 he published his *History and Present State of Discoveries Relating to Vision, Light and Colours*, and in 1773 he was appointed librarian to Lord Shelburne, with him he traveled in Holland, Germany, and France, meeting Lavoisier at Paris, to whom he communicated his experiments with "dephlogisticated air," now called oxygen (1774). He also discovered hydrogen chloride, ammonia, sulphurous acid, nitrogen oxide, and so forth.

His works on chemistry contributed greatly to the construction of the system of chemistry by the great French chemist Lavoisier. He also wrote many theological tracts, which brought him into conflict with the "fundamentalists" of his day, for he inclined to the materialistic side of spiritual life and, as he said, "generally embraced the heterodox side of every question." He also antagonized through these writings his protector, Lord Shelburne, who parted (1780) from him as friend after they had lived together for seven years and granted him a yearly pension of £150. Priestley moved to Birmingham in 1780, where he became acquainted with Boulton, Watt, Dr. Darwin, and Josiah Wedgwood, the potter, who assisted him in his experiments by financial contributions. Here he again turned to the ministry, but he became involved in severe theological disputes. His sympathies with the French Revolution caused him to be attacked by a mob in 1791; his house, library, manuscripts, and apparatus were all consumed in flames, and he scarcely saved his life. With his family he left England in 1794 for America, where he bought a farm at Northumberland, Pa., and resumed his studies. He died there on February 6, 1804.

Opoix, a Frenchman, supplemented in 1777 the earlier statements of Dufay (1737) as well as those of Bonzius (1757) and demonstrated that the colors of materials, ribbons, and so forth, do not become bleached by the simple effect of the air, but that light is the cause;[2] he adds "because it loses the combustible" element "phlogiston," that is, it oxidizes.

The opinion that light contained a complex, combustible "something" aroused doubt as early as 1782 in the mind of Selle,[3] but no better explanation of the chemical action of light could be found to replace this view. Even Lavoisier, who was well aware of the importance of the role which light played in nature and praised it in extravagant terms,[4] had only highly imperfect conceptions of it. He believed in a material luminous matter, which combined with some plant particles and thus formed the color of the plant. Guided by Berthollet's experiments with chloride of silver, he expressed the opinion "that the matter of which light is made up has a great affinity for the acid-forming substance, so that the first combines with the latter, and by the addition of matter of which heat is composed can be changed into a gaseous state."[5]

A peculiar statement is made by Göttling, in *Taschenbuch für Scheidekünstler und Apotheker auf das Jahr 1781* (p. 189): "It is said that the observation has been made that silk, hair, cotton, and the like, in manner similar to the green leaves of plants under a bell glass in water when exposed to the sun, will give off living air (oxygen) (! ?)."

The proper preparation of Bestuscheff's tincture for the nerves and of the golden drops of De la Motte from iron chloride and alcohol was made known to large circles by Professor Murray, at Göttingen, in an extract from a letter dated at St. Petersburg, April 19, 1780.[6] This gave the impetus to further modifications in the preparation of this liquid.

Martin Heinrich Klaproth changed, in 1782, the prescription for Bestuscheff's tincture of iron, using ether instead of alcohol, which yellow solution he also "blended in light"; he obtained by this method a stronger tincture than with alcohol. He also observed that the solution of iron chloride in ether lost color more quickly in light than did the alcohol solution.[7] He offered the explanation for the action of light, "that this tincture really decomposes the rays of the sun, separates the phlogiston from it, and combines with it."

An anonymous writer remarked[8] that iron chloride, even when not sublimated, will produce a yellow, though turbid, etherized tincture which will not change color in the sun(?).

Wenzel, who was one of the most reputable chemists of the eighteenth century, published in 1782 *Lehre von der Verwandtschaft der Körper*, in which there are many prescriptions for solutions; for instance, on page 436 he states that nitrate of silver is soluble in spirits

of wine in the proportion 100:240, which is of interest for the later photography with collodion.

In 1782 A. Hagemann published his *Zufällige Bemerkung, die blaue Farbe des Guajacgummis betreffend*.[9] He contributes the observation that if this gum, pulverized, was placed in a glass vessel near a window it turned blue after a few weeks on the outer surface which faced the window and was exposed to the light, while the part facing the wall and the "inside" powder retained its natural color. When some of the powder was spread on paper and was exposed, it soon changed its color and became muddy, ash gray, with a slight greenish hue, but not blue. In a vacuum, however—for instance, in a barometer tube—it took on a blue color, which was much more beautiful in the shade than in the sun. "What could be more natural than to fall back on hornsilver for the explanation of this phenomenon?" asks Hagemann, and explains the phenomenon by following Scheele's theory. He states that gum-guaiacum extracts the phlogiston from the light and then turns blue, but that it loses the blue color when exposed to air, "durch die Feuerluft" (through the fiery air), since "das Brennbare wieder entzogen werde" (the combustible parts will be again withdrawn—oxidation).

This statement of Hagemann is of considerable historical importance, when we consider that Niépce at the beginning of his experiments, according to his own admission, used guaiacum. At any rate it is certain that the sensitiveness to light of resinous substances dates from Hagemann. Senebier admits this priority, and undoubtedly was stimulated by it to further studies of resins. Directly or indirectly Niépce also used the same source and arrived at the epoch-making photographic asphalt process.

The experiments of Jean Senebier, published in 1782,[10] were received with justified appreciation, owing to their rare thoroughness and great importance in the development of photochemistry, as well as their value in plant physiology. J. Senebier (1742-1809) studied theology and was pastor of a church at Geneva, which post he resigned in 1773 and became chief librarian of Geneva. At first he wrote stories, but with little success; later he published, in a prize competition given by the Academy at Haarlem, his classical work *Essai sur l'art d'observer et de faire des expériences* (2 vols., Geneva, 1775). He also contributed an article on plant physiology to the *Encyclopédie méthodique*. His most important contributions dealt with the application of the laws

of chemistry and physics to animal and plant life. He paid particular attention to the action of sunlight. We owe to him the data on the color change of the different woods in light, which turn darker in it, such as pine, linden, rosewood, oak, barberry, brazilwood, and so forth. He described the continued darkening of lignum vitae in light, as it turned blue in diffused light, grayish green in sunlight; but in this Senebier conceded the priority of discovery to Hagemann.[11] Also we are indebted to Senebier for the first knowledge of the changes effected by light in many other resins. Some fade, as mastic, sandarac, gummi animae (gum of hymenaea Courbail), incense. Others become darker, as gamboge, gum ammoniac,[12] guaiacum. It is quite possible that Niépce was guided by these statements, together with the earlier ones of Hagemann, and that the discovery of the light sensitivity of asphalt may have some direct connection with the knowledge of the facts established by Senebier. Unfortunately the recognition of this honor has not been accorded to Senebier or to Hagemann.

Senebier verified the fact that the alcoholic extract from green vegetable matter (chlorophyll) will fade in only half-filled bottles in sunlight within twenty minutes; while in completely filled and hermetically closed bottles, the tincture withstood the action of strongest sunlight perfectly throughout four months. The green liquid with nitrogen showed the same behavior when exposed to light. He discovered also that alcoholic tinctures of blossoms of jonquils, roses, buttercups, saffron became more or less bleached in sunlight; this also happened with solutions of dragon's blood, cochineal, fustic, henna root, safflower, kermes, gum-lac, and so forth. The red alcoholic solution of dragon's blood lost its color entirely, the alcoholic solutions of henna root, safflower, kermes, cochineal changed the red to yellow. The aqueous solution in water of henna, kermes, and cochineal in contrast with the alcoholic ones suffered no change in sunlight. The blossoms of the damask rose gave alcohol a brick red color; this tincture changed first to violet in the light, then the color was entirely destroyed; a few drops of acid stopped the decomposition of the color in the sun. Rose blossoms which had turned white, when extracted in alcohol, regained their color when they were spread out in a dark airy place, and the process was accelerated by light. This regeneration of the color did not occur over mercury in an atmosphere of nitrogen, not even in sunlight. This same behavior was observed in the red skin of plums and peaches.

The necessity for the action of light in these color changes was proved, especially in the case of the tinctures of blossoms, by the fact that they did not fade when the heat of a stove was substituted for sunlight. Even at 60°C. the leaf green did not fade when light was excluded.

Senebier saw that oils became viscous in light, and at the same time were bleached, that yellow ivory, yellow silk, and wax faded in the sun. He also discussed the changes of artists' colors and mentioned that cinnabar under water turns muddy in the sun in a short time.[13] He adds that artists' water colors withstand the action of sun's rays far better when covered with isinglass and then varnished than when varnished without isinglass.

White nitrous ether, according to Senebier, turns yellow in light and becomes still more volatile, forming nitrous acid. He is very explicit about the changes of chloride of silver in light.[14] Hornsilver sealed in a transparent glass started to turn violet after a few seconds; after a minute this color became intensified, but it did not penetrate deeply into the mass of the silver; after an hour had passed, the color changed to umber and no further change could be noticed. Sunlight alone produced this result, for the silver remained absolutely white when sunlight was completely excluded—and the silver was then exposed to heat and cold, to moisture or to very dry air—yes, and even when placed in a Toricellian tube. When placed in a dimly lighted room, however, where one could hardly see to read, the silver began to darken only after eight or ten days. When light was concentrated on it through a convex lens the silver colored instantaneously. When from one to three pieces of thin paper were laid on top of the silver and the sun was allowed to shine on them, the silver changed color in a few minutes; under four sheets it darkened no longer. In these experiments one may discern the beginning of the paper scale photometer (1782).

A piece of walnut half a line thick (a line = 1/12 inch) prevented the silver which it covered from changing, but a piece of pine of the same thickness permitted the coloring, undoubtedly on account of its larger pores, when compared with walnut. Twelve panes of glass, three-quarters of a line thick, only retarded the coloring without preventing it. Even two inches of water between two pieces of glass did not keep the silver from turning violet after three minutes.

In regard to the action of the solar spectrum Senebier found, mak-

ing his experiments in a darkened room, that the change of color in silver took place as follows:

Under violet light	Within	15	seconds
" purple-colored light	"	25	"
" blue light	"	29	"
" green light	"	37	"
" yellow light	"	5½	minutes
" orange-colored light	"	12	"
" red light	"	20	"

The three last-mentioned lights never produced as intensive a color as violet. Senebier also noted that while the colors produced by the prism imparted a violet color to the silver, it had more of a shade of violet in it and that this color became lighter in the proportion in which the rays are refrangible (toward red). This statement gave the first indication that silver chloride assumes various colors in the spectrum, and Senebier thus appears as the earliest forerunner of Seebeck's discovery that the spectrum reproduced itself on chloride of silver in its own natural colors. He also noted that light projected through red and violet-colored fluids lost a great deal of its effect on chloride of silver. These phenomena Senebier explained by stating that light acted like the "Brennbare" (combustible), namely, analogous to "the fumes of liver of sulphur and of coal." In other words, he considered the chemical action of light as a reduction.

The serious study on the chemical action of light in the eighteenth century reached its climax with Senebier; his works contain many valuable original observations which have kept their full importance up to this day, but which, for the most part, were not followed up later, so that Senebier's works must be considered as a rich source of knowledge, a veritable treasure trove of little-known facts.

What had happened to the earlier studies of Schulze, Hellot, and others? About the end of the last century these subjects were bandied about, here and there, among the most remote branches of literature, but from the sphere of chemistry and physics they had entirely disappeared. On the other hand, magic and legerdemain had appropriated these phenomena, and along these lines I propose to give a few examples.

Wiegleb prescribes in his *Natürliches Zauberlexikon* (3d ed., 1784, p. 458), that one should proceed to the manufacture of "sympa-

thetischer Tinte von Silber" (sympathetic silver ink) in the following manner:

In a small quantity of aqua fortis as much silver is dissolved as possible; then this solution is mixed with from 2 to 3 times its volume of distilled water. The characters written with this ink on paper remain invisible after they are dry, but when the paper is placed in sunlight they will appear soon after an hour in a blackish color.

The method "to blacken the face" cited on page 42 of Wiegleb's work is worthy of note owing to its originality: "The face is moistened with aqua fortis in which fine silver is dissolved, after the solution has previously been diluted with at least 100 times the quantity of water; then the sun is allowed to shine upon the face, thus one becomes for some time a black man." "To imitate ebony" one wets the wood with a silver solution, allows it to dry by placing it in the open air, making sure of sunlight, and polishes it with wax.

Who would not recognize immediately in this description the previous statements of Glauber, in 1658, and of Hellot, in 1727? Joh. Sam. Halle, in his *Magie; oder, Die Zauberkräfte der Natur* (1784, I, 148), recommends using "the magic forces of the sun to produce black writing inside a glass of water" as especially suited for amusement; one finds almost verbal reprint of Schulze's discovery, of course. without mention of the author.

This same experiment was described also in Poppe's *Neuer Wunder-Schauplatz*, (1839, I, 323), under the caption "How One Can Make Writing Appear by a Peculiar Method in a Fluid, Which Is Contained in a Glass."

Hellot's sympathetic ink, which becomes visible in light, has been described in similar books innumerable times. Among others Accum found as a welcome contribution to his *Chemische Unterhaltungen* (1819, p. 9) the coloring of ivory in the sun by a silver solution. He also recommends as a source of amusement the experiment, mentioned later, of the reducing gold by discoloring it in the sun through carbon. The original experiment is to be attributed to Rumford (1798).

I shall have to content myself with these examples, despite the temptation to pursue our investigations into the farthest corners of literature in the most extensive manner, in order to follow step by step the gradual development of photochemistry from so many angles.

Notwithstanding all these bypaths coming from and going toward

all directions, the road of the history of the development of photography led directly from Schulze (1727) via Scheele (1777) and his followers, and particularly in England through Dr. Lewis, in a straight line toward Wedgwood and Davy, and from them to Talbot in the thirties of the nineteenth century.

Chapter XIV. FROM SCOPOLI (1783) TO RUMFORD (1798)

It was in 1783 that the mining engineer Giovanni Antonio Scopoli,[1] of the University of Pavia, made, as far as I can ascertain, the first observations of the change of potassium ferrocyanide in light.[2] He mixed a solution of ferrocyanide with some acetic acid and exposed it to light: "the fluid soon turned green, and after fifteen minutes some Prussian blue separated." When the experiment was continued a part of the Prussian blue settled firmly on the glass, "where it was touched by the sun." In the dark there was no precipitation at 37-66°C. Scopoli concludes that "the effect of the entity which is light upon the coloring matter of substances is readily seen, and no doubt it represents one of their constituents."

THE PHOTOCHEMICAL EXPERIMENTS OF BERTHOLLET; DISCOVERY OF THE REACTION TO LIGHT OF CHLORINE WATER (1785)

Science owes the discovery that chlorine water is light sensitive (decomposition of water under liberation of oxygen) to Comte Claude Louis Berthollet, (1748-1822). He studied in Turin and Paris, where he was elected a member of the Academy of Sciences in 1780. He followed Bonaparte to Egypt and had at one time the commission to select the works of art which were to be removed to France. On his return to France, Napoleon made him a count and grand officer of the Legion of Honor. He was especially active in organizing French scholastic education.

One of the most distinguished theoretical chemists of his time, he discovered the constituents of ammonia and experimented with chlorine and fulminate of silver.

Berthollet made an important discovery in 1785 in the field of photochemistry. He noted that from chlorine water which was standing in the light little bubbles arose, which he identified as "vital air"

(oxygen). In the dark he could not effect this decomposition, not even at 100°C.[3] This discovery led Saussure, eleven years later, to the construction of the first chemical photometer.

In his dissertation *De l'influence de la lumière* (1785) Berthollet states this: "All these effects of light, that is, on vegetation, on nitric acid and on hornsilver, were attributed to phlogiston; but with later advances in chemistry this hypothesis was found insufficient and unnecessary." In order to make sure of just what the action of light consisted, he tried several experiments:

I have exposed to light a bottle, totally filled with chlorine water (dephlogistonated hydrochloric acid), the neck of which bottle was connected by a tube with a pneumatic apparatus; soon after I noticed a great number of small bubbles being liberated from the liquid everywhere, and after several days I found on the tube which was connected in the apparatus, a certain quantity of gas, which was nothing but "vital air." As the air was disengaged from the acid, it lost also its yellow color, so that finally it appeared completely like pure water.

In this state it did not bleach the blue vegetable colors (litmus) but only turned them red, and in general retained very little of its odor; it effervesced with alkalis, in short, the chlorine water (dephlogistonated hydrochloric acid) was now nothing more than muriatic acid (hydrogen chloride). By this experiment Berthollet also endeavored to determine how much muriatic acid and oxygen were formed. When a bottle was filled with the same liquid and was covered with black paper, it underwent no change and "no air was developed." At 100°C., it is true, chlorine gas escaped, but this was entirely absorbed in cold water and gave off "no air"; the residue remaining in the retort did not show the property of effervescing with fixed alkali (potash, etc.). In another distillation bulbs containing chlorine water, when heated directly above glowing coals, formed also a little oxygen in addition to chlorine gas and a residue, which effervesced with alkaline carbonate (showing presence of muriatic acid).

"This experiment proves definitely," concluded Berthollet, "that light not only acts entirely differently from heat but also possesses the quality of 'vital air' which exists in the combined state, namely, to give elasticity (to liberate combined oxygen as gas), and it is this which gives it its excellent action."

This Berthollet confirmed by his experiments with nitric acid, from

which after a few days, when exposed to sunlight, a considerable amount of oxygen developed, while under heat, he thought, only nitrous gas escaped.

In 1786 Scheele supplemented his former statement, as well as that of Priestley, on the decomposition of nitric acid in light.[4] He noticed the development of oxygen, which fact had hitherto escaped his notice. For when he lifted the stopper from a bottle which was not quite filled and had been standing in the sun, a gas blew out violently, and he identified it as oxygen. The date of this experiment was 1786, the year of Scheele's death.

Berthollet[4] repeated this experiment in the same year and reached the same result; he also found that phosphorus "turns red in light and is oxidized by chlorine water."

Of great interest is his observation that silver chloride, exposed to light under water, formed gas bubbles "to all appearances vital air." Thus he recognized the fundamental photochemical reaction of the blackening of silver chloride. But the silver is said to be not reduced to its metallic state, "but still retains some vital air."[5]

The particular passage reads: "When hornsilver over which water has been poured is exposed to light, the surface will quickly turn black and a number of small bubbles will escape from the bottom, which are to all intents vital air . . . for these are not bound tight to the silver chalk. The silver chalk has meanwhile not returned to its metallic state; it still retains some vital air . . . because the complete reduction of the metal oxides to metal was always difficult to attain."

According to these statements Berthollet was the first who expressed the opinion that on exposure to light chloride of silver changes, not into metallic silver, but into argentous chloride or argentic oxychloride, which view often turns up in later years.

From these experiments he concluded not only that light acted entirely differently from heat, but that it possessed also the property to impart elasticity to "vital air" (when in a combined state) and that this represents its chief effect (i.e., that it liberates oxygen from its combinations and changes it to a gaseous state). The theories of phlogiston he declared inadequate and antiquated. However, he later modified his views on this subject considerably.[6]

Bindheim informs us (1787) that a silver solution filtered through gray paper precipitates metallic silver faster than ordinarily.[7]

Robison sought to discover by experiments whether nitric acid be-

came fuming (i.e., yellow and vaporous) through the same "elementary matter of light" which blackened silver salts. He caused sunlight to fall on a glass filled with colorless nitric acid and then on nitrate of silver (-paper?), presuming that the sunlight would have no effect at all on the silver salt, or at least a weaker effect, since it had already produced one of these effects. He found, indeed, a considerable decrease in the action of light due to the interposition of the nitric acid. Unfortunately, Robison had to interrupt his experiments in 1787, owing to his shattered health.[8]

It cannot be denied that Robison already had a clear conception of the idea which later caused Draper, among others, to lay down the principle that when light is employed in the chemical process, some of its rays are absorbed and this part is robbed partially or entirely of its capability to produce any further chemical effects.

In 1788 Chaptal[9] investigated the salt "vegetations" and stated that the metallic salts (sulphate of iron, sulphate of zinc) promote vegetation especially well on the side turned to light. Chaptal stated:[10]

It is really an astonishing manifestation to a chemist when he sees the various dissolved saline substances creep up the sides of the vessel and, having reached the top, throw themselves over the sides. This phenomenon, which differs widely from crystallization and does not operate in the liquid state, becomes visible only after the salts have formed and have lost the water of crystallization, which phenomenon I call saline vegetation.

This caught his attention and excited his desire to make his own investigations of the subject. For this purpose he took several glass bowls and half covered the upper and lower parts with black taffeta. These vessels he filled with salt solutions and placed on a table in a completely darkened room, except for the light coming through a small hole in the curtain. The vessels were arranged so that only the uncovered parts could catch the light, while the covered portions were in almost total darkness. Air currents were carefully excluded, for he selected both the rooms and their chimneys for the installation of his apparatus with care and filled up all cracks in doors and windows. Chaptal made more than two hundred tests and verified that the vegetation appeared nowhere but on the side exposed to light. This result was so apparent that in nearly all solutions the salts vegetated in a few days, often in twenty-four hours, some distance above the surface of the fluid, but only on the lighted side, while on the dark side, not even the smallest trace of any kind of a crust or anything

similar showed. Iron sulphate and zinc sulphate kept strictly within such boundary lines and showed usually the strongest vegetation in those parts which were most intensely illuminated. Along these lines many species of salts were examined. (Metallic salts, alkaline earth salts, and alkaline salts; iron, copper and zinc sulphates, soda, potassium sulphate, alum, acetate of lime, saltpeter, seasalt, tin salt, etc.) The form which each of these salts assumed during this vegetation offered very curious differences; sometimes crusts or small leaves and in other instances needles, which formed nets and meshes, or which united in concentric form or formed tassels, etc.

That light alone does not create these results, that air must be added, and that evaporation must be made possible is a matter of course, but all this Chaptal carefully demonstrated in his experiments.

Finally, Chaptal proposed these questions: "Is it, perhaps, a kind of affinity among air, light, and the saline substances which lifts the latter and enables them to overcome the force of gravity? Is this a kind of real vital energy, which is aroused and ferments by the admission of air and light?" But Chaptal did not risk an answer to these questions.

Dizé, on the contrary, saw no influence of light on the salt vegetations when examined in a vacuum.[11] He published several criticisms on Chaptal's dissertation in February, 1789, mostly of a historical nature. He called attention to the younger Lémery, who presented to the academy in 1707 observations on salt vegetation, and also to two dissertations dealing with the same subject published by Petit, in 1722. Petit arrived at the same conclusions as Chaptal, namely, that air and light were indispensable to this operation, and he found that these kinds of vegetations were not different from those that took place by an imperceptible evaporation of liquids. Dizé states that this vegetation takes place just as well in the dark. But these experiments in no wise contradict the fact that this vegetation of the salts proceeds faster and better in those parts exposed to light than in the dark.

Priestley, in 1789, referred once more to the decomposition of nitric acid.[12] He found that nitric acid became colored in heat without light and made further studies concerning this, which are of no interest here.

Dorthes found, in 1790, that the vapors of water, alcohol, ether, and especially of camphor will settle on the side of a glass vessel most abundantly where the vessel is struck by light.[13]

INVENTION OF THE FIRST CHEMICAL PHOTOMETER BY SAUSSURE,
IN 1790, AND HIS OTHER DISCOVERIES

Berthollet's statements on the behavior of chlorine water in light urged Saussure to construct the first chemical photometer.[14] Horace Bénédict de Saussure (1740-1799), Swiss physicist, interested himself early in the natural sciences and was appointed professor of philosophy in Geneva when he was only twenty-two years old. He explored particularly the Alps, acquired the highest merit in geology and geophysics, invented the hair-hygrometer (1783), and made barometric measurements, particularly among the Alpine summits. Senebier wrote his biography, *Mémoires historiques sur la vie et les écrits de H. S. de Saussure* (1801), and continued to some extent his works. In commemoration of his services in the exploration of the Alps, a monument to Saussure was erected at Chamonix, Mont Blanc, France. He was the second who made the ascent of this "Monarch of the Alps."

Saussure experimented with measurements of the sun's rays at high altitudes, using chlorine water, which liberates oxygen gas in light; this was discovered by Berthollet in 1785. Saussure noticed that the ratio of development of the quantity of gas was proportional to the intensity of light and proposed the construction of a photometer based on this reaction. The decomposition of chlorine water took place much faster, on account of the greater intensity of the light, on Mont Blanc than in the valley. Wittwer, as is well known, revived later (1855) the use of chlorine water for photometry, but the priority of the idea belongs to Saussure, a fact to which the author of this history was the first to call attention.[15] Saussure, who deserves the title of father of chemical light measurement, also investigated the action of light on colored materials, which he made on the Géant and at Chamonix (1788). He chose, on the advice of Senebier, the materials enumerated below. They were exposed to the sun from 11 o'clock to 2 o'clock. The fact is, differences were conspicuous, which Saussure noted in figures, guided by the principles of the construction of his cyanometer and diaphanometer.

Saussure's "cyanometer" is a device for determining the intensity of the blue color of the clear sky. Saussure painted fifty-three strips of paper in colors ranging from white to pure Prussian blue. To a series of such mixtures from the palest to the most intense blue, he added also black, in order to make the blue still darker. With these colored strips

he compared the blue of the sky under various meteorological conditions. This is historically interesting, for Professor Ostwald, in his modern color theory, establishes a system of color tabulations in his *Farbenatlas* which also starts from pure hues; to these are added variable proportions of white and black. Thus it seems justifiable to consider Saussure in this respect the predecessor of Ostwald.

The "diaphanometer" of Saussure is a device for acertaining the transparency of air, that is, the diminution of the intensity of light as effected by the air. On a disk 2 m. (6½ ft.) in diameter there is drawn a black circle 60 cm. (23½ in.) in diameter. On a second circle 20 cm. (8 in.) in diameter there is a black circle 6 cm. (2½ in.) in diameter. Supposing the two disks are illuminated equally and that the air does not absorb any light, then the distances at which the circles vanish from the eye of the observer must be proportional to the diameters of the circles. The larger circle becomes invisible earlier if at a greater distance the contrast between the black disk and the white disk becomes less, due to absorption of light.

	VARIATION OF BLEACHING EFFECT	
	At Chamonix	On the Géant
Pale rose-red silk ribbon	2.45	2.73
Deep rose-red silk ribbon	6.43	8.86
Violet silk ribbon	0.61	2.05
Blue silk ribbon	1.16	. . .
Green silk ribbon	0.93	. . .
Green paper	1.43	7.68
Sky-blue paper	0.61	0.61
Barberry wood	5.46	9.11
Average figures	2.83	5.17

All colors faded; only barberry wood and green paper turned brown. Again, on the mountain the action of light was decidely more energetic than on the lower levels. That the color change in all examples, under the same conditions, was not alike (for instance, green paper 5-6 times more; blue, on the contary, the same in both cases) Saussure believed could be traced to the fact that the moisture content of certain colors played a greater role in some than in others.

Senebier now devoted himself again to photochemical experiments and investigated[16] the role which air plays in the change noted in oils when exposed to light. On April 26, 1790, he placed pure olive oil so that light could act on it in part by excluding air and in part by

admitting it. The oil soon turned brown, then white again, and became very rancid and viscous after about a month; later it underwent no further change. When air was shut out, hardly any change was evident after almost a month; then a green substance formed; still later a distinct change took place. He concluded: "Light favors the combination of oxygen with oil, because it thickens faster when light and air are both admitted than in air alone in a dark place. It seems that light alone will not cause oil to become rancid, so long as air does not touch it." He also remarks: "I noticed that fat oils, those that easily freeze, especially sweet oil, which freezes at 7°-8°R, did not freeze at 50°R after it had been exposed to the action of air and light during the summer; in this detail it resembled the dry oils, which freeze very slowly."

In 1791 Berthollet published his important work on dyeing and bleaching under the title *Eléments de l'art de la teinture* (Paris).[17] It is there demonstrated, with respect to the bleaching process with chlorine, that in the bleaching-out of organic coloring matter oxygen plays a great role, since it combines with the particles of the coloring matter and, so to speak, burns and bleaches them.[18] Berthollet also continued Senebier's experiments and tried to ascertain whether oxygen is absorbed or not during the decomposition of the coloring matter in light. He half filled a bottle with an alcoholic solution of chlorophyll and placed it upside down in mercury. When he exposed it to sunlight, the color became decomposed and at the same time the mercury rose in the bottle. This showed that "the oxygen had been absorbed and combined with the color particles." He continues:

When there is no oxygen in the glass which contains the fluid, then the light shows no effect upon the coloring matter, the nitrogen suffers no diminution . . . I placed tincture of litmus in contact, both in the dark and in the light, over mercury with oxygen gas; the first remained unchanged for a long time and did not reduce the quality of gas; the second, however, lost a great deal of its color, turned red and the oxygen was largely absorbed. He believed that some carbonic acid formed, which no doubt caused the change from blue to red.

Therefore Berthollet concludes that it is demonstrated "that light promoted the absorption of oxygen through coloring matter."

FURTHER ADVANCES IN PHOTOCHEMISTRY UP TO 1798

The knowledge of light-sensitive mercury salts was greatly enlarged

in 1786 through Hahnemann's discovery of "soluble mercury" (Mercurius solubilis Hahnemanni). In order to retain its black color, it is necessary to dry the black precipitate in darkness, this precipitate being formed by mixing nitric acid and mercurous oxide solution with ammonia. While Hahnemann saw that his preparation was partly reduced in the sun to a metallic state, he did not know that this does not happen in the dark. Therefore, it seems that he was not really aware of the light-sensitivity of this combination.[19]

Further details concerning the chemical decomposition of mercury salts are pointed out by A. F. de Fourcroy, in 1791.[20] He found that the gray precipitate formed by dissolving sulphuric mercurous oxide in a small quantity of ammonia was in sunlight reduced partly to metal, while another part changed into a dark powder, soluble in ammonia and capable of further reduction. When much ammonia was used, however, in the precipitation of the mercury salts, Fourcroy states, a darker precipitate formed which could be reduced completely in the light.[21]

In 1792 Vasalli presented to the Royal Academy of Sciences of Turin his investigations on silver chloride.[22] First, he determined quite definitely that not only sunlight but also light from candles and lamps has a chemical property, namely, the ability to effect a change of color in silver chloride, even though very slightly.[23] He stated, in a supplemental note, that moonlight concentrated through a convex lens also colored silver chloride within four hours and that for the process of bleaching wax water was not needed.[24] He further stated that potassium nitrate or sodium chloride crystals always crystallize on the side exposed to light.

In the *Journal für Fabrik, Manufaktur und Handlung* (August, 1792, p. 65) can be found a contribution by an unknown author, entitled "Versuch einer kurzen Einleitung in die Farbenlehre und Färberei." In this there are several mentions of the remarkable effect of light on different substances, and among others that it was "well known" that wool, when dyed in a woad vat or in an indigo vat, looked green at first, but when it was struck by light, turned dark blue. Also:

The leaves from two species of varnish or lacquer trees (toxicodendron triphyllum. Folio sinuato rubescente and T. triphyllum glabrum) contain a milky sap which, when exposed to light, turns a beautiful black; it colors the canvass without attacking and corroding it and also resists the action

of alkali Orseille acquires, in a solution of stannous chloride, a more permanent color proportionally as the solution changes into scarlet The orange color of Orleans (bixin) or Rocou (annato) and the beautiful yellow of Avignon berries and Curcuma fade very rapidly under the influence of light.

J. R. Trommsdorff declared, in 1793,[25] that benzoate of silver "remains unchanged in the air, but turns brown in sunlight."

Interesting is the opinion published by Buonvicino, in 1793, that basic mercuric sulphate turns black in light and is even said to increase in weight when enclosed in a hermetically sealed tube.[26] The phlogiston theory may have led him astray in his belief as to this increase (phlogiston absorption?). Trommsdorff, who seems to have had no knowledge of these statements, stated also, in 1796, that the yellow precipitate "which forms when one precipitates a solution of mercury in nitric acid with sodium sulphate" (that is, turbith) will turn a "dirty greenish gray" on the surface in the light; he does not mention an increase in weight. It was not until 1799 that Humboldt contradicted this statement of Buonvicino relative to the increase of weight and found that mercuric sulphate does not become heavier under light.[27]

Göttling, in 1794, advanced the strange opinion that oxygen by sunlight was not only degenerated, but that it was almost completely changed into nitrogen.[28] He forgot that in such a case our whole atmosphere would have been transformed long ago into nitrogen. Gren,[29] and later Böckmann,[30] contradicted this false statement and disproved it completely.

The property of metals to precipitate when in the state of solution by reducible substances gave an English woman, Mrs. Fulhame, the idea of employing this in the manufacture of gilt and silver cloths, inciting her to a series of interesting experiments on this subject. After the activity, although disputed, of Princess Eudoxia, we see for the second time within several centuries a woman interesting herself in the development of photochemistry.

In her meritorious work *An Essay on Combustion; with a View to a New Art of Dying and Painting, wherein the Phlogistic and Antiphlogistic Hypotheses Are Proved Erroneous* (1794), Mrs. Fulhame describes,[31] along with a number of other experiments, the different media to be used in order to reduce metals by the wet process and how the salts contained in silk material after having been soaked in a solution of chloride of gold or nitrate of silver are reduced to metal in light.

In the eighth chapter she deals with the reduction of metals by light. First, she points out that water alone cannot effect the reduction of the gold or silver solution and that light alone, in the absence of water, reduces the gold and silver salts; on the other hand, water and light together inevitably produce this effect. In this experiment a piece of silk material was dipped in a solution of chloride of gold or nitrate of silver and exposed to sunlight, the material being in the meantime soaked in water. The material which had been impregnated with the gold solution soon changed its color to a weak green; then followed a purple; and finally, after fifteen to sixty minutes, a crust of reduced gold formed. In the case of the silver solution, the material turned reddish brown, and finally, after about four hours, grayish black. But when the experiment was made by wetting the silk with alcohol instead of water, the reduction which took place was very weak in the case of silver and none at all in gold, which was ascribed to the moisture of alcohol and air. In another experiment the silk soaked in silver nitrate was dried by heat and exposed to sunlight; the stuff turned reddish brown after less than an hour, and on the third day, black. This effect as well was attributed to the moisture in the atmosphere.

Mrs. Fulhame drew the following conclusions from her experiments: "That water is absolutely necessary to the reduction of metals by light . . . that light acts in this reduction just like hydrogen, sulphur, and carbon . . . that light could accomplish this only through the decomposition of water." Mrs. Fulhame's statements are original and important. They led to Rumford's investigations and were indirectly responsible for serious attacks on the followers of the theory of the chemical effects of light.

Meanwhile, the hypothesis had developed that light consists of a modified heat substance. Girtaner was the first to express this view, in his *Anfangsgründe der antiphlogistischen Theorien* (1795, p. 14), and Link followed, in his "Beobachtungen and Betrachtungen über den Wärmestoff" (II, 7), of his *Beiträge zur Physik und Chemie* (1795). Scherer went even farther and in his *Nachträge zu den Grundzügen der neuen chemischen Theorie* (Jena, 1796, p. 18) denied every individual chemical influence of light even on plants; he sought to trace back all these phenomena to the effect of heat. He declared erroneous all observations not in harmony with this hypothesis and all experiments carried on for their substantiation fallacious.[32]

Count Rumford also sided with this opinion and tried to support

it with his experiments, which, however, were not original, but were to a great extent those of Mrs. Fulhame.

He writes:

In the second part of my seventh essay, *On the Propagation of Heat in Fluids*, I have mentioned the reasons which had induced me to doubt the existence of those chemical properties in light that have been attributed to it and to conclude that all these visible changes which are produced in bodies by exposure to the sun's rays are effected, not by any chemical combination of the matter of light with such bodies, but merely by the heat which is generated or excited by the light that is absorbed by them.

He then details at length a host of experiments he made in silvering and gilding cloths and other materials, saying that he did this because Mrs. Fulhame's experiments suggested it—and finally comes to the "conclusion" he gave in the first paragraph of his essay as given above. He does not, however, in any part of the essay refer to the "conclusion" given in the first paragraph, but simply details eighteen experiments and states that they may "induce others to pursue these interesting investigations."

Among his experiments, the one of special interest is that which tells of silvering a piece of ivory in dilute nitrate of silver solution. This was

suffered to remain in a dark closet till the ivory had acquired a deep or bright yellow color . . . then immersed in a tumbler of pure water and immediately exposed in the water to the direct rays of the bright sun. The instant the sunbeams fell on the ivory it began to change color and in less than two minutes . . . it became quite black.

He refers to this discoloration as a coaly substance (oxidation) which could be rubbed off, and when the ivory was again put in water and again exposed to sun the discoloration began again—"the oxide of the metal penetrating the ivory to a considerable depth."

Juch repeated, in 1799, Rumford's experiments with very slight changes and arrived, as might be expected, at the same conclusions: the action of light does not differ from heat.[33]

However, these mistakes had no injurious effect on the development of photochemistry.

Chapter XV. FROM VAUQUELIN (1798) TO DAVY (1802)

IN 1798 the celebrated French chemist Louis Nicolas Vauquelin (1763-1829) discovered chromium during his work on the analyses of minerals. Vauquelin was one of the best-known chemists of his time. First he was a pharmacist at Rouen, and later, in Paris, an inspector of mines. He became assistant in chemistry at the Ecole Polytechnique, and professor at the Collège de France and, after the death of Fourcroy in 1808, at the medical faculty in Paris. His labors covered the whole field of chemistry, but he specialized in the analysis of minerals. It was while making an analysis of the then newly-found mineral, Siberian red lead ($PbCrO_4$), that Vauquelin discovered chromium and investigated its compound, particularly the chromates. The new metallic element he called "chrome" after the Greek word *chromos*—color. Vauquelin observed that chromic acid forms with silver a carmine red salt ("un précipité du plus beau rouge de carmin") which turned purple ("pourpre") when exposed to light.[1] Thus he discovered the light-sensitivity of one of the chromium compounds. But this compound was a silver salt, and therefore this reaction really belonged to the photochemistry of silver compounds. It was Suckow who found, in 1832, the light-sensitivity of bichromate of potassium in the presence of organic salts, that is, by itself without silver salts. He must be recognized as the first discoverer of this light reaction. The first application of printing on paper treated with potassium bichromate was made by Mungo Ponton (1839) after the publication of the daguerreotype process.

Vauquelin also investigated more exhaustively citric acid, which was first produced by Scheele, in 1784, and described its salts, among them the silver salt, concerning which he states that citrate of silver, exposed to light, takes on "a color similar to black ink."[2] We must not overlook the fact that citrate of silver played an important role in the manufacture of printing-out paper.

FURTHER PROGRESS IN PHOTOCHEMISTRY

Giovanni Valentino Mattia Fabroni (1752-1822)[3] observed in 1798 that aloe leaves contain a juice which in the air—"light may strike it or

not"—turns gradually to a purple-violet color, which pigment he considered very permanent. Of other organic colors, scarlet, he found, belongs to the fast colors, "since it suffers almost no change from the effects of light or air"; that the safflower (bastard saffron) was erroneously included among the fast colors, since it bleached quickly under the influence of both light and air; and that orseille and the other mosses rapidly change their violet color to blue in sunlight.[4]

In the meantime sufficient empirical observations on the chemical actions of light were collected so that their conformity to the various hypotheses of the nature of light could be demonstrated. In the main the dispute hinged on the point whether light had as basis a particular matter (Newton's theory) or was caused only by vibrations of the ether (Huygens's theory). The prevalent view of the time is very well expressed in Gehlen's *Physikalisches Wörterbuch* (Leipzig, 1798, II, 902):

It seems, however, that a closer acquaintance with chemistry must incline everyone toward the system of emanation, because most chemists not only accept a "light substance," but are accustomed to consider it for their best theories as an essential ingredient In fact there are phenomena where the light displays an affinity to other substances and creates changes in the combination and decomposition of matter which are difficult to ascribe to mere vibrations of the ether.

As proof, he adduces the effect of light on chlorophyll, on silver salts, on dyestuffs, etc.

This view agrees with that of Kries, the editor and commentator of Euler's letters, who had laid down the precise hypothesis some years earlier, which also declares: "One had observed the action of light which cannot possibly be explained by simple vibrations and which makes it more than probable that light in very many of nature's processes co-operates as something material."[5] The proof for this Kries sought in the photochemical phenomena known at that time.

Davy proposed, in 1799, the idea that light is a particular form of matter which reacts simultaneously with oxygen to form oxides, that is, that oxygen gas was a combination of oxygen and light.[6] He himself later declared this statement to have been too hasty (1802).

The year 1800 was rich in investigations and experiments in the field of chemistry. Buchholz observed the blackening of silver carbonate in light.[7] He found that the blackening of this compound always took place only on the surface and that even after three months, having stirred the mixture thrice daily, he did not succeed in blackening the

entire material through and through; there was also no loss of weight.

Abildgaard, a physician in Copenhagen (1740-1801), mentioned as early as December 14, 1797, in a letter to Hermstadt, that half an ounce of red oxide of mercury, when placed in the Torricellian vacuum of a glass globe, turned brown or gray after three months. He published this in 1800 and demonstrated that red mercury oxide blackens superficially in the sun, that this process occurs even in a vacuum, and that along with it a gas (oxygen) is liberated, the nature of which, however, he did not recognize.[8]

Böckmann experimented with the influence of light on phosphorus,[9] and observed the formation of a red powdery deposit on the side of the glass vessel exposed to the sun, in which he usually found ordinary phosphorus in a nitrogen or hydrogen atmosphere. The precipitation was accelerated by the simultaneous effect of heat and light, was retarded in the cold, and did not occur when light was excluded. Parrot applied himself to this subject almost at the same time; he found that phosphorus in the air, as well as under water, turns yellow in the sun and that phosphorus in a tincture of blue litmus changed faster than in a solution of yellow saffron.[10]

Girtaner, in a letter to Trommsdorff,[11] opposes the statement that "light substance" was nothing but an "excited heat substance," because on the basis of this belief it could not be explained why chloride of silver was more rapidly changed by violet rays than by red ones and why chlorine water yielded more oxygen when exposed to light at a temperature below the freezing point than in a warm place when the sky was cloudy.

The first, although not very distinct, mention of the light-sensitivity of molybdic acid I found in 1800. Daniel Jäger described many experiments with different colors in the *Anzeigen der Kurfürstlichen ökonomischen Gesellschaft zu Leipzig, von der Michaelismesse des Jahres 1800*,[12] and he mentions, among other tests, that he impregnated a strip of calico with a solution of potassium molybdate, which he then dipped into a cold solution of a tin salt and found that it "took on a light blue color of dull and somewhat dirty appearance ... which in sunlight and air, instead of fading and becoming duller, gained in intensity. The green shades usually changed to blue, but after awhile regained their former appearance completely in the shade and in damp cold air."

Kasteleyn found that ferriferrous salammoniac sublimate crystals change color in sunlight and become darker.[13]

In the *Handbuch für Fabrikanten, Künstler, Handwerker ...*[14] for

1800 the remark is found that brazilwood and campeachy wood (logwood) lose their strength completely when they are exposed for a long time to light, air, and the rays of the sun and that they then give a poor brown color. "If they are to be preserved in good shape, they must be carefully kept from air, light, and the rays of the sun."

THE ESSAYS ON LIGHT BY JOHANN CHRISTOF EBERMAIER AND ERNST HORN, IN 1797

These very important dissertations, which dealt with the action of light in nature and particularly with its effect on the human body, resulted from a prize competition offered by the medical faculty at Göttingen in 1796. The question proposed was "What is the efficacy of light on the living human body, not only the noxious efficacy, but that useful and salutary efficacy which is over and above that concerned in vision?" According to Professor Placidus Heinrich, Dr. Johann Edwin Christof Ebermaier received the prize for a dissertation which was published first under the title *Commentatio de lucis in corpus humanum vivum praeter visum efficacia, praemio ornata* (Göttingen, 1797). Later he published a German edition under the title *Versuch einer Geschichte des Lichtes in Rücksicht seines Einflusses auf die gesamte Natur und auf den menschlichen Körper, ausser dem Gesichte, bosonders* (Osnabrück, 1799).

Respecting his career, it may be stated that Johann Edwin Christof Ebermaier was born April 19, 1769, at Melle, near Osnabrück. At first he followed his father's profession of pharmacist, then studied medicine at Göttingen. While studying there, he followed the Hanover troops as surgeon to Brabant and lived for some time in Leyden. He received his doctor's degree after his return to Göttingen in 1797. He settled first in Rheda, later in Osnabrück, was appointed court physician and councillor at Tecklenburg, and in 1805 became departmental physician of the Ruhr Department in Dortmund in 1810, government and medical councillor at Cleve in 1816, was transferred, in 1821, to Düsseldorf, where he died on February 21, 1825.

Among several prize essays he published two dissertations on medicinal plants; he was also contributing editor to several medical encyclopedias and collected works (see A. Hirsch, *Biogr. Lexicon*, II, 259).

Another contribution by Dr. Ernst Horn to the prize competition in June, 1797, which received the first prize, was one with the motto

"In disputation one must seek no authorities but the force of reason," which by unanimous decision was deemed worthy of publication. It was printed in both Latin and German.

Horn was born in Braunschweig, August 24, 1774, and received his doctor's degree in 1797 at Göttingen. According to the custom of those days he traveled extensively, studying in Germany, Switzerland, and France. In 1800 he became professor at the clinic for military surgery at Braunschweig; in 1804 he received a call as professor in ordinary for medicine at Wittenberg, and in the same year served at Erlangen in a like capacity. In 1806 he became professor at the medical and surgical military academy and second physician at the Charité Hospital in Berlin. While holding this position he was forced to defend an exciting criminal process due to a denunciation, from which he emerged thoroughly vindicated. He died September 27, 1848. His biography indicates that he acquired special merits in scientific and applied psychiatry.

Both of these dissertations demonstrate that medical studies at the end of the eighteenth century did not neglect the consideration of the biological effects of light and that as early as this a beginning was made toward a practical light hygiene and light therapy, all, unfortunately, neglected and forgotten. Professor Leopold Freund, Vienna, first called attention to this in his dissertation *Vergessene Pioniere der Lichttherapie* (*Strahlentherapie*, 1928 XXX, 595).

The writings of Ebermaier and Horn epitomize the knowledge and speculation of that time concerning the action of light on organic matter and on the human body. It was not customary, nor was it the intention of the authors, to demonstrate the correctness of the prevailing view by experiments on human bodies or animals or by eliminating all other elements entering into the results. Both authors, however, adduced a series of facts which reveal excellent gifts of observation and acumen; the conclusions which they drew from their experience, as well as the incitement to a practical light therapy which they urge, also prove a splendid training in logical thinking.

The question of the nature of light Horn leaves open. It is true that he mentions both Newton's theory of emission and Euler's polemic against it. The investigations of Young, which strongly supported the wave theory of Huygens, were evidently unknown to him. Ebermaier believed that the most satisfying and natural explanation for all effects of light is the acceptance of and the belief in a peculiar, ex-

tremely fine, elastic and expansible light substance. Horn did not consider it proven to his satisfaction that light produces chemical action on the human body. He could only accept the possibility of such action as at most a hypothesis, considering the state of the experience at that time, while Ebermaier had no doubt that the light substance could enter into chemical combinations with the human body. The property of light, which, according to De Lucs, possessed in itself no warmth, to create heat in the body, was explained by both authors by the assertion that light liberates a heat substance which is combined in the body—"fire matter," which is contained in varying degrees in different bodies. Horn also mentions, however, the theory of Fourcroy that the rays of the sun create warmth through the impact and friction on bodies which impede their progress. References to experiments tending toward a distinction between effects of light and heat are deficient. Ebermaier recommends that investigations into the effect of light by the abstraction of heat be made on the summit of high mountains. He also differentiates between the heat of a hot, but dark, stove and that of a flaming fire.

According to Horn, physical and chemical forces act differently on living bodies and on dead bodies. The cause is the existence of a basic force (vital force) in the first, which modifies those forces. Their effects, however, are not to be traced solely to the irritability of the body. Horn does not hesitate to draw comparisons between the effect of light on plants and that on animals, since many analogies may be established from both regarding origin, growth, maturity, and propagation, as well as their reactions to the influence of the different forces of nature. In both essays there are full details of the effects of light: the generation of green color in plants, the development of "vital air" (oxygen) from plants, the advancement of the cultivation and full growth of plants, and on their photo-tropism and nutations. Horn attributes particular importance to Senebier's *Mémoires physico-chimiques de la lumière solaire, pour modifier les êtres des trois règnes de la nature, et sourtout ceux du règne végétal* (3 vols., 1782), which state that light retards the decomposition and decay of organic substances of plant and animal nature. He even speaks directly of the antiseptic effect of light.

In Sotheran's (1926) catalogue the annotator says of this work of Senebier's:

The author confirmed the discoveries of Ingenhousz and discovered the fact that chlorophyll is bleached by the action of light. He also made important investigations on the action of light on resins and essential oils and found that some of the former, on exposure to light, lose their solubility . . . in fact later utilized in the halftone process.

All the authors mentioned agree that light acts as a stimulant on living organic bodies, which is particularly apparent on the surface of the body, and this without taking into consideration the function of the eyes, as is shown by the conduct of sightless animals in the light. Where light is most intense on the earth, there the color of men and animals is darkest. The color of many animals changes not only with geographical latitude, but also with the seasons and the intensity of the sun's rays. Animals living in darkness are white.

Blumenbach explained the black pigment as hydrogen gas. The hydrogen combines with the "vital air" (oxygen) of the atmosphere, which on the one hand forms water, while on the other hand the carbon is precipitated in the malpighian layer below the epidermis.

According to Link the animal pigments are developed by vital forces to which light contributes nothing, inasmuch as it acts as stimulant. He noticed that desires increased the color of frogs and toads even in the dark, while anger and fear, on the contrary, made their color fade. Compare the celebrated experiments of E. Brucke with chamelions. Heinrich calls attention to the fact that it is light, not heat, which produces the dark pigmentation of the skin, and refers to the accounts of the celebrated English philosopher Francis Bacon, Baron Verulam, who determined that workmen in glassworks and furnaces remain white (*Sylva sylvarum; seu, Historia nat.*, Cent. iv, p. 399). This was a posthumous work of Francis Bacon, Baron Verulam, published in 1627, a year after Bacon's death.

The warmth of the skin effects an afflux of liquid secretion to the vessels of the skin and increases their activity (the inspiratio and exspiratio sanktoriana); light awakens and increases the vital energy, elevates the frame of mind, and increases the pleasure for work. It is interesting to determine, with reference to experiments lately published, that Heinrich already differentiates between the heat sensation which is caused in the body by the rays of the sun and the feeling which the artificial heat of an oven creates in the body. Horn traces the stimulating influence of light as properly due to the agency of the eye, and he describes in detail the conjunction of the nerves of the

eye with other nerve systems. The detrimental consequences of the lack of light on men and animals are discussed thoroughly, and the weakness and sickliness of albinos are traced back to their lack of coloring, which causes them to be abnormally sensitive to light, and therefore they prefer to live in darkness. Ebermaier quotes an interesting statement by the celebrated physicist Lichtenberg that life on earth depends on the changes of the light intensity of the sun, its spots and torches.

Horn and Ebermaier describe in detail the pathology of the effect of light rays. Ebermaier knew of the following kinds of effect of light rays: (1) redness of the skin, either painless or connected with itching, freckles; (2) inflammatory stage, sometimes with heat blisters (these manifestations are the more intensive, the lighter the skin); (3) thickening and drying of the skin, which is inclined to stasis and the formation of tumors; (4) sunstroke, due to the burning heat of sun rays; (5) pellegra. Horn mentions injuries of the retina of the eye (black cataract) and the increased irritability of the body (convulsion of children) as consequences of excessive insolation. Ebermaier contends that the exacerbations in certain diseases which take place in the evening (exacerbatio vespertina) in wounds, abscesses, fever, inflammation of the eyes, fluxus coeliacus, dysentery, spastic conditions, periodic vertigo, pain in the bones in scorbut and lues are due to the absence of light. He quotes an old explanation of the morning "well being": "with the rising of the sun, disease itself takes flight."

If the recitation of these numerous and interesting observations and thoughts is fascinating, though they are not always expressed in the sense of modern science, the hygienic and therapeutic expositions of the two authors certainly must arouse our admiration. We find almost completely outlined in these publications, which appeared one hundred and thirty years ago and deserve a page of glory in the annals of the University of Göttingen, the sphere of action in modern light therapy, indications of results at which we have arrived with the aid of apparatus and appliances for research which did not exist in those days.

Horn advanced the opinion that lack of light promoted much stronger virulence in contagious diseases. He applied himself zealously to the fight against living quarters which lacked light and air, quarters under ships' decks, rooms in hospitals, prisons, or convents, against narrow streets, with high houses and small windows—all of which impair the state of health of whole classes of people, and he traced the high

mortality in cities to these evils. According to Ebermaier, the moderate altitudes of the mountains are the most advantageous to health, partly on account of the prevailing great light intensity, partly owing to the high oxygen content of the air, qualified by the influence of light on the vegetation, which is there so luxuriant. It is true that on the highest levels the air is lacking in water vapor and the light intensity is greatest, but the air there is too rarified and proportionally lacking in oxygen. In the lower levels there is a good deal of vegetation, but the oxygen content is, nevertheless, low on account of the small light intensity. This is caused by the absorption of light by the vapors in the atmosphere, which also contaminate the air. Although Ebermaier and Horn, in attributing to light so great a hygienic importance, follow largely the footsteps of Hufeland and other prominent physicians of the time, it is certain that their recommendations of light as a curative treatment for disease were greatly in advance of their era. Horn recommends exposure to light, and quite explicitly to full sunlight, for all diseases which have their origin in a weakened condition and in the inability to create sufficient stimulation of energy, especially in the case of scrofula. Ebermaier mentions a cure of old abscesses in 1776, and particularly that of a cancer of the lower lip, where La Payre applied concentrated sun rays through a burning glass to the lip. He reports that Le Comte, after repeating these operations, noted that it was not the burning (heat) which was to be considered of such great importance, because the procedure gave better results in the winter, when the sun was not so hot as in the summer (*Histoire de la Société Royale de Médecine, 1776*, Paris, *1779*, p. *298*).

Since light increased the secretions, he recommended it for the treatment of gout, podagra, and advanced cases of rheumatism. Its use is indicated for hypochondria and its attendant atonic conditions of the stomach and intestines and for symptoms due to age and consumption. The treatment of rickets by light therapy, believed to be an achievement of research in most recent years, was already expressly indicated by Ebermaier in a special chapter. For many psychoses this treatment seems to deserve consideration. On the contrary, Horn warns against the use of light treatment in cases of generally aggravated irritability and sensitiveness.

And so one finds—as Professor Leopold Freund stresses—in these forgotten publications rich and valuable material which will abundantly repay our study.

SIR WILLIAM HERSCHEL DISCOVERS (1800) THE INFRARED SPECTRUM;
J. W. RITTER DISCOVERS (1801) THE INVISIBLE ULTRAVIOLET RAYS
AND THEIR ACTION ON CHLORIDE OF SILVER AND IS THE FIRST TO OB-
SERVE THE ANTAGONISTIC EFFECT OF RED AND VIOLET RAYS

At the turn of the eighteenth century the celebrated English astron-
omer Friedrich Wilhelm Herschel (1738-1822) occupied himself with
experiments on the unequal proportion of heat in the prismatic solar
spectrum and discovered the invisible infrared heat rays (*Philosophical
Transactions*, 1800, pp. 2, 255; also Gilbert's *Annals*, 1801, p. 137). This
correct observation, which was at first disputed, gave great stimulus
to a further study of the spectral properties of light.

On the other hand, J. W. Ritter discovered (1801) the ultraviolet
rays. Ritter (1776-1810), when fifteen years old, came to Liegnitz
as apothecary's assistant, he remained there for five years. He lived then
in Jena, Gotha, and Weimar, where he made important investigations
in the field of galvanic electricity, during which he discovered gal-
vanic polarization and invented the storage column (predecessor of
the accumulator) and so forth. Worthy of notice is his essay *Beweis,
dass ein beständiger Galvanismus den Lebensprozess im Thierreich
begleitet* (1798). For us his discovery of the ultraviolet rays is of
special importance.

Ritter first published his discovery of the invisible violet rays on
February 22, 1801, in the *Intelligenzblatt der Erlanger Literatur-
zeitung* (1801), No. 16.[15] When he covered paper with damp, freshly-
prepared chloride of silver and let the solar spectrum act on it in a
dark room, he saw that the action began first beyond the ultraviolet
and only then proceeded toward the violet. He not only discovered
the decomposition of silver chloride in ultraviolet but also noted that
silver chloride paper, which previously in diffused daylight had turned
dark but slightly, became darker in the violet end of the spectrum,
but lighter in the red end, which observation first pointed to the
antagonism of the chemical effect of violet and red lights. He found
"that the darkening did not occur beyond the green and that the light-
action in the orange and red produces a true oxidation of the already
reduced silver chloride or, what amounts to the same thing, in retard-
ing or suspending the reduction." The violet and red of the spectrum,
when mixed under a burning glass, reduce the silver chloride, "which
demonstrates that the reducing rays must be present to a far greater
degree in white light than those which oxidize." From this follows the

classification of the more or less refrangible regions of the spectrum into a "reducing region and an oxidizing region." This, however, was later contradicted.

FURTHER ADVANCES IN PHOTOCHEMISTRY—WOLLASTON INTRODUCES, IN 1802, THE NAME "CHEMICAL RAYS" FOR THE MORE REFRANGIBLE RAYS

In the same year Leroux made the statement—it seems, without having had knowledge of Abildgaard's publication—that a bottle filled with red oxide of mercury would turn black on the side facing the light because of deoxidation.[16] At exactly the same time Robert Harup also published his results.[17] He claimed to have studied as early as 1797 the influence of light on mercury compounds. He stated that mercury oxide and calomel were reduced on exposure to sunlight and that this phenomenon also took place in a hermetically sealed glass tube. Both Leroux and Harup, however, must cede the priority for this statement to Abildgaard, who had published his work a year earlier.[18]

In 1801 appeared a booklet, which has now become very rare, by Christian Samuel Weiss: *Betrachtung eines merkwürdigen Gesetzes der Farbenänderung organischer Körper durch den Einfluss des Lichtes* (Leipzig, 1801). He points out that the change of color which organic matter suffers in light is opposite to that which is observed in inorganic bodies.[19] Weiss also proposes a peculiar view on colors. He assumes that light is composed of several basic light substances which specifically differ from each other; colored matter reflects light with which it "has no chemical (!) affinity"; for instance, red bodies, which show no affinity for red light, reflect red light, but absorb all other light (rays). Weiss thus traces back all pure optical color phenomena to chemical affinities of light and so oversteps the mark in the exposition of his chemical theory of light. The color change of a body in light Weiss regarded as the change of its chemical affinity to the free incident light.

Therefore, when a substance, which has been exposed to light, thereby changes its affinity for the free substance of light, there can be no other change than that of the further penetration of the light-substance according to chemical laws, that is to say, greater saturation of the light-substance— in so far as the substance does not undergo other condition of mixture. An inorganic substance (without vitality) will, when it changes nothing but its color through light, necessarily show less affinity to free

light after it has been exposed to light for a while than before. Consequently, it will reflect more light than before, that is, its color will grow lighter, it will bleach [bleaching of linen, bones, etc.]. . . . It is entirely different in living organic nature. . . . The laws are opposite to those of dead matter. Here the affinity is increased by the influence of light. The more the living body of animal or plant is exposed to light, the more its color deepens, the more it is able to absorb the substance of light. . . . Light acts as an exciter on the vital forces of the organs and, as a consequence, the secretions of the pigment show changes on the surface. The pigment receives a special mixture, which increases its affinity to free light substance. . . . This stimulus may be of a mechanical nature—either according to Newton's or Euler's system—always the illuminated substance will be moved. Light can also influence living organisms by chemical stimulus, so that the "light stuffs" can combine also with organic matter.

I have reproduced Weiss's views extensively here, because one may discern perfectly from them the spirit of the theories prevailing at that time. We find on the one hand that they adhere strictly to the view of "light matter," which can combine or separate and, in itself, is already explained as combined matter; on the other hand, we find prophetic anticipations of later scientific results, which present the opinion that light action can be both mechanical and chemical. This rigid classification, with which the scholars of those days insisted that dead matter be treated separately from living matter (the dissertation on "vital force" which cancels or reverses all chemical laws on matter), appears precisely expressed in Weiss's theory.

It is interesting to note the discovery of Desmortiers,[20] also made in 1801, that Prussian blue loses its color and turns white when air is excluded, that is, when stirred up together with nut oil and covered with water, but regains its color immediately in the air.[21] He proposed the following conclusions: (1) The loss of color does not result from the decomposition of the oil, but from a change in the surface, and is caused by the matter sinking to the bottom and the extinction of the light corpuscles in the small leaves and between the interstices of the coloring substance. (2) For the recovery of the color neither air nor any of its component parts nor an outside admixture is necessary; it can be achieved equally as well in an air-tight chamber. (3) Heat in the absence of light impedes and even destroys the color. A slight internal motion of its particles, no matter how effected, restores the color faster or slower, in proportion to the strength of light and the force of motion

applied. This discovery is often credited to Chevreul (1849), although Desmortiers made this statement forty-eight years earlier.

Scheldracke purified the fat oils (linseed oil, nut oil, poppy oil) of their mucilage by the action of sunlight, to which he exposed them in long-necked bottles.[22]

Shortly after Ritter's publication, William Hyde Wollaston announced, in 1802, certain observations regarding the chemically active but invisible rays of the solar spectrum, which are here quoted from his "Method of Examining Refractive and Dispersive Powers by Prismatic Reflection" in Royal Society, *Philosophical Transactions* (1802, p. 379).

Although what I have described above comprises the whole of the prismatic spectrum that can be rendered visible, there also pass on each side of it other rays, whereof the eye is not sensible. From Dr. Herschel's experiments (*Philosophical Transactions*, 1800), we learn, that on the one side there are invisible rays occasioning heat, that are less refrangible than red light; and, on the other, I have myself observed (and the same remark has been made by Mr. Ritter), that there are likewise invisible rays of another kind, that are more refracted than the violet. It is by their chemical effects alone that the existence of these can be discovered; and by far the most delicate test of their presence is the white muriate of silver.

To Scheele, among other valuable discoveries, we are indebted for having first duly distinguished between radiant heat and light (*Traité de l'air et du feu*, pp. 56-57); and to him also we owe the observation that, when muriate of silver is exposed to the common prismatic spectrum it is blackened more in the violet than in any other kind of light. In repeating this experiment I found that the blackness extends not only through the space occupied by the violet, but to an equal degree, and to about an equal distance, beyond the visible spectrum; and that by narrowing the pencil of light received on the prism, the discoloration may be made to fall entirely beyond the violet.

It would appear, therefore, that this and other effects, usually attributed to light, are not in fact owing to any of the rays usually perceived, but to invisible rays that accompany them; and that, if we include two kinds that are invisible, we may distinguish, upon the whole, six species of rays into which a sunbeam is divisible by refraction.

He then called for the first time the most refrangible rays of the spectrum "chemical rays," which designation they retained later, and he insisted on this characterization emphatically, particularly because he did not agree with Ritter's classification of oxidizing and reducing

rays.[23] Wollaston knew in 1802 that gum guaiacum was strongly affected by violet rays and suffered an oxidation from their action, while according to Ritter the violet rays merely exerted a reducing action. Wollaston's statements made at that time are in no manner so exhaustive as those of Ritter, and it was not until several years later that Wollaston came forward with additional details.

William Hyde Wollaston, M.D., F. R. S. (1766-1828), was an eminent English chemist and physicist. He studied medicine at Cambridge, received his doctor's degree, went to London, gave up the practice of medicine in 1800, and devoted himself with great success to chemistry and physics. His discoveries were of great importance not only to science but also to industry and the arts. He found the malleability of platinum, discovered the elements palladium and rhodium in platinum ore, made investigations in the field of galvanic electricity, perfected the microscope and "camera lucida," and invented the improved chromatic meniscus lens named after him, July 12, 1812, the concave side of which faced the object. This was of great advantage and was probably the reason why Niépce as well as Daguerre made use of this type of lens, manufactured by the Paris optician Chevalier (Eder's *Handbuch*, Vol. I, Pt. 4, *Photo. Objektive*, 1911). Wollaston was also the first to observe the dark lines in the solar spectrum, which were later more definitely determined by Joseph von Fraunhofer.

After many years of painstaking attempts to mark exact measurements of the refraction and dispersion of prisms which he had under consideration, Fraunhofer employed successfully, about 1814-1815, the dark lines of the solar spectrum which were observed first, more that a dozen years earlier by Wollaston, for the purpose of determining the refractive and diffractive powers of prisms, without confining himself to the complicated and precise method of his experiments. The importance of this method was tacitly recognized by the leading opticians everywhere, by calling these lines, not after their first discoverer, but after the scientist who first applied them in a practical way. This complete solution of the problem for the measurement of prisms was used by Fraunhofer in a twofold way (M. v. Rohr).

Joseph von Fraunhofer (1787-1826) was to have become a glazier. At the age of twelve he entered the employment of the glass cutter Weichselberger in Munich, who also made mirrors, as an apprentice. The fact that young Fraunhofer was luckily saved from underneath the debris when his master's house collapsed in 1801 attracted the

attention of King Maximilian Joseph of Bavaria, who, after he had recovered, made him a present of eighteen ducats. With this money Fraunhofer purchased a glass-grinding machine, which he used for grinding optical glasses. He studied optical and mathematical literature with particular attention to the laws of refraction of light. In 1807 he became assistant in, and later partner of, the important optical workshop of Georg von Reichenbach, J. Utzschneider, and J. Liebherr in Benedictbeuern, in Bavaria. From 1818 Fraunhofer conducted the optical works, which had become very famous, and he moved it to Munich, where, in 1817, he became a member of the Akademie der Wissenschaften and was knighted in 1818. Unfortunately, he died at the age of thirty-nine from an old lung trouble.

Fraunhofer's greatest achievements are the improvement of the telescope and other optical instruments. At first he invented a machine for polishing large, mathematically accurate, spherical surfaces; he began, in 1811, the manufacture of a flint glass which by far surpassed in quality and usefulness the English flint glass. During the years 1814 to 1817 the fixed dark lines in the solar spectrum were first accurately determined by him and used for the measurement of the refraction and dispersion of his optical glass. These "Fraunhofer lines" became of particular importance for spectroanalysis. He further discovered the grating spectrum by the use of parallel lines ruled in glass and deduced its laws. His investigations made possible the calculation of almost completely achromatic lens combinations. His dioptric telescopes laid the foundation for the world-wide reputation which his optical institute at Munich enjoyed. He also invented the heliometer which made possible the measurement of the diameters and of the distances between the sun and the planets. Fraunhofer was one of the greatest mathematical and practical opticians the world has produced.

Rumford's statement[24] "that all those visible changes which are produced in bodies by exposure to the action of the sun's rays are effected, not by any chemical combination of the matter of light with such bodies, but surely by the heat which is generated, or excited, by the light that is absorbed by them" encouraged Harup, in 1802,[25] to experiment with mercury salts, and he satisfied himself that sunlight effects the blackening of mercuric oxides when they are placed in a transparent glass vessel, but not in an opaque glass. He found also that when air is admitted, and in the presence of moisture, the change in light was not noticeably advanced and that light (not heat) acted always only on

the surface. Harup, in order to further clarify Rumford's assertions, attempted to reduce in light minium and acetate of lead (pure, as well as mixed with carbon), but without success. He concluded from these experiments that light has a specific action which differs from the effect of heat.

THE LUNAR SOCIETY IN LONDON AT THE TURN OF THE EIGHTEENTH
CENTURY AND THOMAS WEDGWOOD

The statement that photography had been supposedly invented at the end of the eighteenth century (about 1791) by Watt and his collaborator Boulton attracted a great deal of attention in 1863. It was recalled that a society existed at that time in Birmingham, called the "Lunar Society," which numbered among its members Josiah Wedgwood, Watt, Priestley, and others (Kreutzer's *Zeitschr. f. Phot.*, 1863, VII, 129; *Phot. News*, 1863, VII, 407; *Bull. Soc. franç d. phot.*, 1864, XIII, 81). The Birmingham *Daily Post* printed the news on April 16, 1863, that photographs were found there of the nearby factory town of Soho, which showed the buildings as they appeared at the end of the eighteenth century. This seemed from the start improbable and very unlikely of proof, since, as a matter of fact, neither Josiah Wedgwood, the potter, nor his son "Tom" Wedgwood was familiar in 1802 with the fixing of photographic printing process, nor could James Watt have known very much of a photographic printing process, or he would not have cited the common use of copying ink when he described, about 1802, the method of copying letters (*Das Neueste und Nützlichste in der Chemie* . . . 1802, V, 124). In fact, these supposedly old pictures later proved to be daguerreotypes and Talbotypes of later date.

This statement originated in a curious misunderstanding arising from ignorance of the purpose and proceedings of this "Lunar Society." The society had nothing whatever to do with the study of light or photographic processes; it consisted of a small but select number of prominent scholars and engineers interested in the natural sciences.[26] The "Lunar Society" derived its name from their meeting, which took place on the Monday of each month after the full moon "in order to partake of the joy of going home in daylight." At that time there were only eight or ten members, among them, it is interesting to note, Josiah Wedgwood, the potter, the Reverend Joseph Priestley, celebrated gas analyst, James Watt, inventor of the steam engine, Matthew

Boulton, a partner of Watt, Dr. Erasmus Darwin, grandfather of Charles Darwin, William Murdoch, inventor of coal-gas lighting and financial backer of Watt and Boulton, William Herschel, the founder of stellar astronomy.

The meetings of the "Lunar Society" were held at the home of Josiah Wedgwood (1730-1795), at Etruria, England, and we know that young Thomas Wedgwood was keenly interested in the discussions of the society. It is probable that there he first learned of the chemical action of light on silver, since the chemist Priestley was familiar with the experiments of Schulze and others, as related in his *History and Present State of Discoveries Relating to Vision, Light and Colours* (1772).

There were also, as mentioned on an earlier page, the notebooks of Lewis on the blackening of nitrate of silver on leather, and so forth, which were owned by the Wedgwood family, and finally there was Chisholm, the former assistant of Lewis, the tutor and teacher of Thomas Wedgwood, son of Josiah. This gives a perfect picture of the bond which connected the work of Schulze and Thomas Wedgwood. It may be supposed that Thomas Wedgwood began his photographic experiments in 1790, at nineteen; we shall report these later. Many writers suppose that his father, Josiah Wedgwood, made experiments of his own in photography; but this is contradicted by the fact that he died in 1795, seven years before the publication by his son of the work discussed above.

THOMAS WEDGWOOD PUBLISHED IN 1802 HIS INVENTION OF THE METHOD OF REPRODUCING DRAWINGS ON GLASS WITH SILVER NITRATE OR SILVER CHLORIDE; HE PRODUCED IN SUNLIGHT PHOTOGRAPHIC PROFILES AS SILHOUETTES; DAVY MAKES PUBLIC IN THE SAME YEAR THE METHOD FOR THE PRODUCTION OF PHOTOGRAPHIC ENLARGEMENTS BY THE AID OF THE SOLAR MICROSCOPE

Thomas Wedgwood (1771-1805), fourth son of the potter Josiah Wedgwood, was from early childhood disposed to infirmity and illness. He traveled a great deal, interested himself in different scientific investigations, and astonished the learned society in 1802 by the publication which later became so important to the history of photography.

A family history of Wedgwood appears in R. B. Litchfield's work *Tom Wedgwood, the First Photographer; an account of his life, his discovery and his friendship with Samuel Taylor Coleridge, including*

the letters of Coleridge to the Wedgwoods . . .[27] (London, 1903).
In 1802 Thomas Wedgwood, together with Humphry Davy, published the dissertation "An Account of a Method of Copying Paintings upon Glass and of Making Profiles by the Agency of Light upon Nitrate of Silver, invented by T. Wedgwood, Esq., with observations by H. Davy," *Journal of the Royal Institution,* London (I, 170). Tom Wedgwood was at that time twenty-nine; Davy[28] only about twenty-three years old.

White paper, or white leather, moistened with solution of nitrate of silver, undergoes no change when kept in a dark place; but on being exposed to the daylight, it speedily changes colour and, after passing through different shades of grey and brown, becomes at length nearly black.

The alterations of colour take place more speedily in proportion as the light is more intense. In the direct beams of the sun, two or three minutes are sufficient to produce the full effect. In the shade, several hours are required, and light transmitted through different coloured glasses acts upon it with different degrees of intensity. Thus it is found that red rays, or the common sunbeams passed through red glass, have very little action upon it: Yellow and green are more efficacious, but blue and violet light produce the most decided and powerful effects.*

The consideration of these facts enables us readily to understand the method by which the outlines and shades of paintings on glass may be copied, or profiles of figures procured, by the agency of light. When a white surface, covered with solution of nitrate of silver, is placed behind a painting on glass exposed to the solar light, the rays transmitted through the differently-painted surfaces produce distinct tints of brown or black, sensibly differing in intensity according to the shades of the picture, and

*The facts above mentioned are analogous to those observed long ago by Scheele, and confirmed by Senebier. Scheele found that in the prismatic spectrum the effect produced by the red rays upon silver muriate was very faint, and scarcely to be perceived; while it was speedily blackened by the violet rays. Senebier states that the time required to darken silver muriate by the red rays is twenty minutes; by the orange, twelve; by the yellow, five minutes and thirty seconds; by the green, thirty-seven seconds; by the blue, twenty-nine seconds; and by the violet, only fifteen seconds.—Senebier, *Sur la lumière,* III, 199.

Some new experiments have been lately made in relation to this subject, in consequence of the discoveries of Dr. Herschel concerning the invisible heat-making rays existing in the solar beams, by Dr. Ritter and Bockmann in Germany and Dr. Wollaston in England.

It has been ascertained by experiment upon the prismatic spectrum that no effects are produced upon the muriate of silver by the invisible heat-making rays which exist on the red side and which are least refrangible, though it is powerfully and distinctly affected in a space beyond the violet rays, out of the boundary. See *Annalen der Physik* (VII, 527.—D).

where the light is unaltered, the colour of the nitrate becomes deepest.

When the shadow of any figure is thrown upon the prepared surface, the part concealed by it remains white, and the other parts speedily become dark.

For copying paintings on glass, the solution should be applied on leather; and in this case it is more readily acted upon than when paper is used.

After the colour has been fixed upon the leather or paper, it cannot be removed by the application of water, or water and soap, and it is in a high degree permanent.

The copy of a painting, or a profile, immediately after being taken, must be kept in some obscure place. It may indeed be examined in the shade, but in this case the exposure should be only for a few minutes; by the light of candles and lamps, as commonly employed, it is not sensibly affected.

No attempts that have been made to prevent the uncoloured part of the copy or profile from being acted upon by light have as yet been successful. They have been covered with a thin coating of fine varnish, but this has not destroyed their susceptibility of becoming coloured; and even after repeated washings, sufficient of the active part of the saline matter will still adhere to the white parts of the leather or paper, to cause them to become dark when exposed to the rays of the sun.

Besides the application of this method of copying that has just been mentioned, there are many others. And it will be useful for making delineations of all such objects as are possessed of a texture partly opaque and partly transparent. The woody fibres of leaves and the wings of insects, may be pretty accurately represented by means of it, and in this case, it is only necessary to cause the direct solar light to pass through them, and to receive the shadows upon prepared leather.

When the solar rays are passed through a print and thrown upon prepared paper, the unshaded parts are slowly copied; but the lights transmitted by the shaded parts are seldom so definite as to form a distinct resemblance of them by producing different intensities of colour.

The images formed by means of a camera obscura have been found too faint to produce, in any moderate time, an effect upon the nitrate of silver. To copy these images was the first object of Mr. Wedgwood in his researches on the subject, and for this purpose he first used the nitrate of silver, which was mentioned to him by a friend, as a substance very sensible to the influence of light; but all his numerous experiments as to their primary end proved unsuccessful.

In following these processes, I have found, that the images of small objects, produced by means of the solar microscope, may be copied without difficulty on prepared paper. This will probably be a useful application of the method; that it may be employed successfully, however, it is necessary that the paper be placed at but a small distance from the lens.

With regard to the preparation of the solution, I have found the best proportions those of one part of nitrate to about ten parts of water. In this case, the quantity of the salt applied to the leather or paper will be sufficient to enable it to become tinged, without affecting its composition, or injuring its texture.

In comparing the effects produced by light upon muriate of silver with those produced upon the nitrate, it seemed evident that the muriate was the most susceptible, and both were more readily acted upon when moist than when dry, a fact long ago known. Even in the twilight, the colour of moist muriate of silver spread upon paper slowly changed from white to faint violet; though under similar circumstances no immediate alteration was produced upon the nitrate.

The nitrate, however, from its solubility in water, possesses an advantage over the muriate; though leather or paper may, without much difficulty, be impregnated with the last substance, either by diffusing it through water, and applying it in this form, or by immersing paper moistened with the solution of the nitrate in very diluted muriatic acid.

To those persons not acquainted with the properties of the salts containing oxide of silver, it may be useful to state that they produce a stain of some permanence, even when momentarily applied to the skin, and in employing them for moistening paper or leather, it is necessary to use a pencil of hair, or a brush.

From the impossibility of removing, by washing, the colouring matter of the salts from the parts of the surface of the copy which have not been exposed to light, it is probable that, both in the case of the nitrate and the muriate of silver, a portion of the metallic acid abandons its acid to enter into union with the animal or vegetable substance, so as to form with it an insoluble compound. And, supposing that this happens, it is not improbable, but that substances may be found capable of destroying this compound, either by simple or complicated affinities. Some experiments on this subject have been imagined, and on account of the results of them may possibly appear in a future number of the *Journal*. Nothing but a method of preventing the unshaded parts of the delineation from being coloured by exposure to the day is wanting, to render the process as useful as it is elegant.

Davy remarks, at the end of his report, that he will refer again to this subject in one of the following issues of the above-mentioned journal; but neither Wedgwood nor Davy published any other statement about this matter.

The invention of the production of photographic copies of drawings on glass and of silhouettes in sunlight on silver nitrate paper is often

attributed to the joint work of Wedgwood and Davy, although the credit for it belongs to Wedgwood alone.

The fundamental importance of Wedgwood's work lies in the fact that he was the first to visualize the possibility of obtaining a permanent image with the aid of the camera obscura, but his efforts remained unsuccessful. Sir Humphry Davy (1778-1829) was president of the Royal Society in London from 1820 to 1827. He is the founder of electrochemistry, discoverer of potassium, sodium, the alkaline earths metals (barium, strontium, calcium), and magnesium. He discovered in 1810 that chlorine is an element and that muriatic acid is a compound of chlorine and hydrogen, and he studied the reaction to light of chlorine with hydrogen and carbon monoxide. As inventor of the miner's safety lamp, named after him, his name became known everywhere. For the history of photography, his initial production of iodide of silver and the recognition of its sensitiveness to light (1814) are of particular interest, because both Daguerre and Niépce worked with silver iodide, and Talbot learned of Davy's discovery in 1834, as he recounts in his book *The Pencil of Nature* (1844).

The immortal fame of Thomas Wedgwood rests on his invention of the idea and method of reproducing designs on glass, on silver nitrate paper, and on silver chloride paper, that he was the first photographer in the world, and that he copied silhouettes on paper in sunlight. Davy was the first to give out a statement, in 1802, on the production of enlarged images by means of the solar microscope. In this publication is also found for the first time accounts of the production of silver chloride paper by successive applications of silver nitrate and of chloride solutions on leather and paper, all of which served as a starting-point for the later method of Talbot. True, neither Wedgwood nor Davy found a medium for fixing these light images on silver-paper, and it is probable that they made no efforts in that direction. Thomas Wedgwood's ill health seems to have interfered with his further labors; but he never allowed anything to be known about his illness, and he died three years after the publication of his record-making invention. Humphry Davy seems to have paid no further attention to the matter, but had withdrawn entirely from the field of photography, owing to his electro-chemical experiments and discoveries, which were so extraordinarily important in the development of chemistry. Had the gifted Davy interested himself in the fixation of silver images, he would surely have found the point of contact in the publication of Scheele,

which he himself had quoted, where it is stated clearly and precisely that ammonia liberates the silver chloride from the photochloride, blackened by light, and that it precipitates the black metallic silver formed by the action of light. Thus, an efficient fixative would have been found; but no one paid any attention to it.

The publication of Wedgwood and Davy of 1802 was soon lost in obscurity. It was not until thirty-seven years later that Arago uncovered it in his presentation of the report on the daguerreotype process before the French Académie des Sciences in 1839; at that time the two Englishmen were proclaimed the forerunners of photography.

It is impossible, however, for the impartial historian to award the priority for the first invention of photography to these two gentlemen, notwithstanding the full appreciation of their enormous services, and they must be placed in the ranks of those pioneers in the field of photo-chemistry who developed and practically applied, after more or less intensive preparatory studies, facts already known.[29]

The sensitiveness to light of silver-nitrate-chalk paste was discovered by Schulze in 1727; that of silver chloride by Beccarius in 1757. Hellot learned of the changes effected by light on paper impregnated with silver nitrate in 1737, and Scheele of light action on paper coated with chloride of silver (1777). Senebier, in 1782, continued like his predecessor Scheele to differentiate between the action of colored light. Schulze and Beccarius demonstrated that writing and designs could be copied on silver chloride, by allowing light to proceed through the stencils made from opaque materials, and Wedgwood found that leaves and designs on glass could be employed as well as stencils, while Davy inserted microscopic objects in a solar microscope, and projected them on sensitized paper some distance away, and thus invented (1802) the projection of images by photography, which includes the photographic enlarging process.

The application of the light-sensitive silver-salt papers to the copying of leaves, silhouettes, and designs on glass, and Wedgwood's idea of copying images in the camera were ingenious, but they could not carry their ideas to full realization. Notwithstanding these and the illustration of the enlargements of the solar microscope by Davy, services for which we must ever preserve a grateful memory, we must not conceal the fact that both Wedgwood and Davy forgot or did not know of that important discovery of old Scheele, namely, that white chloride of silver is completely soluble in ammonia, which is difficult

to understand, because Scheele's writings were widely distributed, and an English translation had been published. From Scheele they could have learned of a fixative for the silver chloride images, which Davy expressly declared had not been discovered. This neglect of his predecessor's labors on the part of Davy had serious consequences for the development of photography. Davy's announcement that he would deal more exhaustively with the question of the fixation of light images and his failure to produce results of any sort discouraged his contemporaries from trying to seek the solution of a problem which a scientist of Davy's rank found to be beyond his ability, and so years passed before the fixation of silver images was accomplished.

THE SILHOUETTES OF THE PHYSICIST CHARLES

In Arago's first report on the daguerreotype, which he presented to the Académie des Sciences on August 19, 1839, we find the statement that the first traces of the art of reproducing light images as silhouettes on light-sensitive paper are met with in the first years of the nineteenth century.

About this time [Arago continues:] our countryman Jacques Alexandre César Charles made use of a coated paper in order to produce silhouettes by the aid of sunlight. Charles died without describing the preparation he used, and since the historian must support his statements with printed and authentic documents, it becomes necessary in all fairness to trace back to Wedgwood the basic invention of the new art.

Another reason for protesting against the mention of Charles in connection with this invention is our inability to discover anywhere the year in which Charles's experiments took place. For many years Charles delivered private lectures on experimental physics in Paris; he died in 1823. Unfortunately, Arago made his statement in such an ambiguous manner that one is involuntarily led to the conclusion that Charles had photographed his silhouettes before Wedgwood, at any rate, one is kept completely in the dark on the point of time of his experiments. It is true that Gaston Tissandier states, in his *Les Merveilles de la photographie* (Paris, 1874, p. 15), that Charles, "about 1780," employed the camera obscura for rudimentary photography, projecting silhouettes of persons on paper coated with silver chloride. Tissandier presents an illustration on page 14 of his *Les Merveilles*, in order to demonstrate how the procedure may have been enacted.

It must be expressly stated here, however, that this illustration has its

origin in the imagination of Tissandier and that the year 1780, alleged to be that of the demonstration by Charles, is not supported by any mention of the source; it probably originated also in a dream of the author, just as did the illustration. I beg leave to propose the following presumption: Charles simply had read Davy's account of Wedgwood's experiments, followed them, and from them delivered a lecture on the subject, accompanied by an experiment, "in the first years of the nineteenth century." This explanation at once does away with all secrets concerning Charles's proceedings. His connection as member and librarian of the Paris Académie des Sciences excludes the acceptance of any secret mongering.

Jacques Alexandre César Charles (1742-1822) was a French physicist and popular lecturer on experimental science in Paris about 1780; professor of physics at the Conservatoire des Arts et Métiers, Paris, member and for some years librarian of the Institut de France, in the library of which institution he doubtless had access to the *Journal* of the Royal Institution of London, wherein Wedgwood and Davy reported (1802) their experiments in photography on silver chloride paper. After Montgolfier's discovery of ballooning, Charles was the first to use hydrogen to inflate balloons (1783), and he was actually the first man who ventured to ascend alone in a free balloon. In literary circles he was well known as the husband of "Elvire," the heroine of some of Lamartine's poems.

Chapter XVI. THE STUDIES OF SAGE (1803), LINK, AND HEINRICH ON THE NATURE OF LIGHT (1804-8) UP TO GAY-LUSSAC AND THENARD (1810)

BALTHAZAR GEORGE SAGE (1740-1842) was apothecary at the Hotel des Invalides, Paris, 1778, professor of assaying and metallurgy in the Paris Mint and member of the Academy of Sciences in Paris. He worked a great deal on chemical analysis, the chemistry of metals and mineralogy in general. He lost his eyesight in 1805.

The light-sensitivity of natural realgar (arsenic disulphide) was first noted by Sage in 1803. Sage observed this phenomenon on one of those miniature pagodas which the Chinese make from this mineral for export as decorative novelties; when polished, they show a beautiful

blood-red color. He noticed that the tiny pagoda lost its luster and brilliant red color in the parts directly touched by light, and took on an orange-yellow coating which fell off easily (so-called weathering); where the light did not strike it, the original vivid coloring remained unchanged. Realgar is found at Solfatara in octahedric crystals, a ruby red orpiment which takes on an orange-yellow coating in light.[1] This phenomenon belongs to the domain of physics, being a change of the molecular state, not a photochemical reaction proper.

In 1803 the apothecary Pierre François Guillaume Boullay described the decomposition of bichloride of mercury in light. A concentrated solution of this salt in water decomposed after exposure to sunlight for several days, the liquid giving off some oxygen and taking on the red color of litmus, which indicated the formation of free acid (muriatic acid); some of the bichloride of mercury crystals lost their transparency and were no longer completely soluble in water. After prolonged light action a gray precipitate settled.[2]

In the same year Johann Quirin Jahn, member of the Kais. Akademie der bildenden Künste, at Vienna, published a dissertation on "The Bleaching and Purification of Oils for Oil Painting" (1803), in which he states that linseed oil clarifies in sunlight and is bleached still more by the heat of the sun. There is no specific light action mentioned anywhere, but sunshine is identified with warm weather.

Berthollet, in 1803, renewed his interest in the development of photochemistry. In his celebrated *Essay de statique chimique* various photochemical reactions are mentioned, and new hypotheses are offered for their explanation.

"The heat substance" Berthollet states, "differs from light in that it is much lighter in weight and also absorbed by any matter which transmits light There are several chemical compounds which seem to be effected differently by heat and by light, which leads to the conclusion that these are to be considered as dissimilar." As proof, Berthollet cites chlorine water and nitric acid; concerning yellow prussiate of potash he remarks that it decomposes in the sun with formation of hydrocyanic acid and separation of a blue precipitate.

He published also new experiments on silver chloride. This compound, when exposed to light under water, imparted an acid reaction to the water and contained muriatic acid, but no chlorine. The gas which escapes at first is not oxygen, as he had stated in 1786, but simply air. "My assumption," he continues, "was unfounded that in this case

the oxygen, by action of light, is disassociated from the metal and re-assumes the gaseous state." Observing that when heating darkened silver chloride only muriatic acid vapors were liberated, but no chlorine, he concluded "that light produced merely a separation of that part of the muriatic acid which is tied up in the muriate of silver and that heat alone seemed to achieve the same result." He asserted that silver chloride would blacken as well in the dark from a draught of air as it does in the light, but this was an erroneous observation.[3]

At the beginning of the nineteenth century the considerably widened knowledge of chemistry and optics and, specifically, the opposed hypotheses on the nature of light attracted the attention of the learned world to this subject. There existed for some time the antagonistic hypothesis of Newton, who describes light as a material emanation of luminous particles, and that of Euler, according to whom light originates from the oscillations of the ether produced by luminous bodies. The founder of the new school of chemistry, Lavoisier, assumed that there existed in nature a particular substance which was the generating cause of the phenomenon denoted by the name of "light." Lavoisier supposed that this light substance was subject to chemical affinities and therefore combined with other substances or separated from them and produced noticeable modifications.

In general Berthollet asserted that light became apparent only in so far as it entered into a compound, that it yielded the quantity of heat substance which was lacking in the developed gas, and that it increased its expansibility by a rise in temperature. From these statements it seemed to him that the identity of the substance of light with that of heat is proven.

At this time (1802) Thomas Young,[4] the celebrated English physicist and mathematician, published his discovery of the law of the interference of light, which, though at first unfavorably received, finally established the now generally accepted undulatory theory of light, as stated by the Jesuit Francesco Mario Grimaldi (Bologna, 1665), Christian Huygens (1690), and Leonhard Euler (1746), as against the molecular theory proposed by Newton, according to which light was thought to consist of concrete particles emitted by luminous bodies.[5] Young found that even the invisible ultraviolet rays showed interference phenomena. In his *Experiments and Calculations Relative to Physical Optics* (1804)[6] he wrote:

Experiment 6.—The existence of solar rays accompanying light, more refrangible than the violet rays, and cognizable by their chemical effects,

was first ascertained by Mr. Ritter; but Dr. Wollaston made the same experiments a very short time afterwards, without having been informed of what had been done on the Continent. These rays appear to extend beyond the violet rays of the prismatic spectrum through a space nearly equal to that occupied by the violet. In order to complete the comparison of their properties with those of visible light, I was desirous of examining the effect of their reflection from a thin plate of air, capable of producing the well-known ring of colors. For this purpose I formed an image of the rings, by means of the solar microscope with the apparatus which I have described in the *Journal of the Royal Institution*, and I threw this image on paper dipped in a solution of nitrate of silver, placed at a distance of nine inches from the microscope. In the course of an hour portions of the three dark rings were very distinctly visible, much smaller than the brightest rings of the colored image, and coinciding very nearly in their dimensions, with the rings of violet light that appeared upon the interposition of violet glass The experiment . . . is sufficient to complete the analogy of the invisible with the visible rays, and to show that they are equally subject to the general law (i.e., that fringes of color are produced by the interference of two portions of light) which is the principal subject of this paper.

PRIZE COMPETITION BY THE ACADEMY OF SCIENCES AT ST. PETERSBURG
FOR INVESTIGATION OF THE NATURE OF LIGHT (1804) AND THE AWARD
TO LINK AND HEINRICH (1808)

In order to clarify the different views on light the Imperial Academy of Sciences of St. Petersburg announced (August 22, 1804) a prize of 500 rubles, to be awarded to the scientist who presented to the academy by 1806 the best dissertation on "the most instructive series of new experiments on light as matter; on the properties properly attributable to this substance; its relationship to other organic or inorganic bodies, and the modifications and phenomena which result in such bodies due to their combination with the light substance."

The prize was awarded to two German scientists: Heinrich Friedrich Link (1767-1854), professor of natural sciences, botany, and chemistry at Rostock, director of the University Botanical Garden and member of the Academy of Sciences at Berlin. The second prize winner was Placidus Heinrich (1758-1825), Benedictine monk in the seminary of St. Emmeran at Regensburg; professor of philosophy, natural sciences, and physics at Regensburg, where he was later made a member of the chapter of the cathedral.

The essays of Link and Heinrich appeared simultaneously in one volume bearing the title, *Über die Natur des Lichtes* (St. Petersburg,

1808). Both essays particularize their treatment of the chemical side of light action and are therefore of great importance to photochemistry.

Link repeated many of the earlier experiments on the light sensitivity of silver compounds and found also new facts—for instance, that silver chloride darkens more slowly in light under concentrated sulphuric acid or in strong alcohol than under water and that even at a temperature of −50° the blackening does not cease. He studied the sensitivity to light of silver carbonate, which Buchholz had discovered in 1800 and which is deoxidized equally by heat and light. He confirmed the phenomenon, observed by Sage in 1803 (Scherer's *Journal*, X, 115), that sulphide of arsenic bleaches in light; as well as Desmortiers's statement, 1801, on the supposed light sensitivity of Prussian blue, and he found that zinc oxide darkens in light.

Without communicating any essentially new observations, Link cleverly assembled the available experimental material and found that light deoxidizes many bodies (silver, mercury, and gold compounds), but oxidizes others (guaiacum lac, Dippel's animal oil, chlorophyll). He states that "light which combines with the substance during the photochemical action" ("das verbundene Licht") cannot be recognized through chemical phenomena; that the wave theory is in no manner contradicted by chemical experiments, but, on the other hand, this theory cannot be proven by chemistry.

Concerning the action of light on organic matter Link tells us no more than Ebermaier had published in 1799 in his *Versuch einer Geschichte des Lichtes*. Referring to the chemical effect of colored light, Link starts from the works of Herschel and Ritter, previously mentioned, the first of whom identified many heat rays at the red end of the prismatic spectrum, whereas the latter discovered invisible chemical rays (ultraviolet) beyond the violet end. Link expresses the opinion that the blue and violet rays, as such, act more strongly, and perhaps not because they contain special chemically actinic rays of a different nature. He concludes from the fact that silver carbonate darkens under red glass more quickly than behind blue glass that in this case the "heat rays" effect the decomposition more thoroughly. He states verbatim: "The expression 'chemical rays' therefore is not quite logical in its appellation to the rays adjacent to the violet, since those rays lying beyond the red act likewise and in a perfectly analogous manner." Link formulates precisely, although supported by wholly inadequate experiments, an important law of photochemistry

with remarkably keen vision. This law has been substantiated only in the most modern times through numerous experiments, since up to the middle of the nineteenth century the erroneous opinion prevailed that chemical action could be attributed only to the blue, violet, and ultraviolet rays.

Heinrich's discussion of the action of light is based on the body and the spirit of man and on plants, and he treats later the chemical effects of light in a manner similar to that of Link. He also attributes to light the property of oxidation and deoxidation, but arrives at the untenable statement that "when light combines with a substance, the acid principle is liberated." That acids are liberated in the photochemical processes (for instance, in chloride of silver in the presence of water, etc.) is quite correct; but Link was careful not to generalize from isolated cases, a mistake for which Heinrich became a victim.

Especially remarkable also seems the statement of Heinrich on the light-sensitivity of potassium ferrocyanide, or yellow prussiate of potash, which decomposes in sunlight, giving off hydrocyanic acid as gas, and precipitating "Berlin blue." Later this statement of Heinrich, as well as still earlier statements by Scopoli and by Berthollet, was lost sight of, and similar observations were published as new, without respecting Heinrich's priority.[7]

Even though, undeservedly, the work of Link and Heinrich is today[8] entirely neglected, and although the results did not justify the expectations awakened by the prize essays, we must not underestimate the influence of these dissertations upon subsequent photochemical research. For in them there was gathered for the first time all the available experimental data on the subject, in a manner fairly exhaustive and easily comprehensible.

GEHLEN STUDIES THE SENSITIVITY TO LIGHT OF METAL CHLORIDES

In the meantime the experiments on photochemical reactions were continued on many sides. Campeel showed in 1804 that light is not as necessary for crystallization as many believed, since the best crystallization of Glauber salts was achieved on darkest nights.[9]

We are indebted to the pharmacist and chemist Adolph Ferdinand Gehlen (1775-1815)[10] for thorough investigations on the decomposition by light of metal chlorides in alcohol and ether solutions. He summed up the results of his experiments (1804) on the action of light as follows:

1. A solution of sublimed chloride of iron in a mixture of alcohol and ether in light forms a colorless ferrous chloride and ethyl chloride.

2. A solution of anhydrous uranium chloride in absolute alcohol forms a beautiful "lemon yellow solution," which "when exposed to sunlight changes within a few seconds; it turns greenish and turbid and precipitates a muddy green sediment (soluble in water) on continued exposure." The ether is discolored and gives an acid reaction with only a trace of metal. Gehlen concluded that "here, then, reduced muriate of uranium is formed, which proves insoluble in ether; on heating with nitric acid it regains its yellow color under development of nitric acid fumes."

3. The solution of cobaltous chloride in ether is stable in light.

4. Cupric chloride dissolves in ether and forms a light yellowish green liquid. The solution bleaches very readily and passes through brownish yellow to yellow and finally arrives at a completely colorless state. The solution gives a white precipitate in water. He recognized this substance as "muriate of copper of a minimum of oxidation," namely, a reduction phenomenon of cupric chloride to cuprous chloride.

5. Anhydrous platinum chloride dissolves in a mixture of ether and alcohol and turns lighter in sunlight. The glass becomes coated under the action of light on the side directly exposed to the rays of the sun, with an extremely thin layer of the reduced metal in the form of bright metallic platinum which consisted of microscopic reguli of platinum. In the end the original dark brown-red liquid turns to a straw-yellow; that is as far as the color change went. A solution in ether alone acted similarly. The solution decomposed by light contained platinous chloride, as Gehlen quite correctly assumed.

Gehlen concluded:

From the foregoing it follows that all color changes of metal salts solutions in ether depend upon deoxidation by sunlight. The question therefore arises, what becomes of the oxygen which is liberated by the oxide? According to my observation the oxygen throws itself upon the ether (combines readily) and brings about a change in it. The latter takes on the odor of nitric acid I thought at first that in the process of bleaching carbonic acid gas would form, but I could not substantiate this assumption.

We must stress the fact that Gehlen was the first to make known the light-sensitivity of the compounds of uranium, copper, and platinum.

In 1805 Theodorus von Swindern published a lengthly dissertation *On the Atmosphere and Its Influence on Colors*,[11] in which are to be found the following statements regarding the action of light on colors:

1. The yellowish green solution of indigo-white from indigo pigment turns blue in the air, but upon exclusion of air (in a completely filled bottle) does not undergo any change in sunlight.

2. The green tincture which is obtained by extraction of spinach leaves in alcohol does not change color in wholly filled and sealed bottles, even after six weeks' exposure. In bottles filled only partially, the green color changes in greater proportion, as air is contained in proportion to the liquid.

3. Dippel's animal oil turned black only in sunlight when air was present, but when the air was excluded or in a nitrogen atmosphere it showed no change in light, even after fourteen days.

4. White wine did not change color in light, in the presence either of oxygen or of nitrogen.

5. Decoctions of the bark of holly and of Peruvian bark undergo a greater change of color in the presence of oxygen than in that of nitrogen, and this change was still more pronounced when the bottles were exposed to light.

6. Berberry wood (*Berberis vulgaris*), when exposed to light in an oxygen atmosphere, showed a far greater change in color than under similar conditions in an atmosphere of nitrogen (agreeing with Senebier).

7. In the process of bleaching linen, the effect of oxygen is greatly intensified by sunlight. Every expert knows that linen bleaches more thoroughly and quickly, the stronger the light acts on it; even moonlight is effective.

8. A mixture of ferrocyanide and iron vitriol, to which is added chlorine water, turns at once a beautiful blue. When the liquid is exposed in half-filled bottles, a blackish green sediment forms; in fully filled bottles the usual beautiful blue sediment is precipitated.

9. Ammonia dissolves metallic copper in the presence of air, taking on a blue color. This reaction occurs much faster in sunlight than in the dark.

Additional and very interesting statements on the behavior of iron chloride solutions in ether were made by Christian Heinrich Pfaff, 1805.[12]

RITTER ACHROMATIZES THE CHEMICAL AND OPTICAL RAYS (1805)

The observation that by combining certain kinds of glass the refracted "chemical" and "optical" rays may be made to coincide was recognized by the German physicist Johann Wilhelm Ritter, who

lived at that time in Munich, where he was a member of the Bayerische Akademie der Wissenschaften. Ritter was in communication with other scientists and corresponded also with Jean Baptiste van Mons (1765-1842), who was at that time professor of chemistry and physics in Brussels, later at the university at Leyden, and was considered one of the foremost chemists of his time in Belgium.

In September, 1805, Ritter wrote to Van Mons:[13] "I have found, when using achromatic prisms, that the chemical rays of light follow precisely the same laws of diffraction and dispersion as those rays of which the largest part appears luminous to us . . ."

There is no doubt that this discovery led, after more than thirty years, to the construction of photographic lenses in which the optical and chemical foci coincide.

In 1808 Ritter entered into a controversy with Professor Christian Ernst Wünsch of Frankfurt am Main,[14] who disputed the separation of light in the rays of the sun from heat (1807) in a short article: "Remarks on Wünsch's Dissertation on Herschel's Experiments with the Separation of Light Rays." Ritter states that it was known that thoroughly dry cerargyrite (hornsilver) does not change color (??) either in violet or white light or in the heat from a stove (Scheele). On the contrary, moist cerargyrite or that kept under water blackens early. He also states that in winter the reduction, everything else being equal, proceeds faster than in summer (?). At that time he had not considered the very probable influence of different times of day, although these undoubtedly could be expected to cause differences.[15] Furthermore, it would be of interest to compare experiments made on days as bright as possible, simultaneously and under equal conditions, on the action of light on cerargyrite and other light-sensitive substances, at great altitudes and at great depths. The results would no doubt differ greatly from those obtained at the same level under an air pump producing compressed and rarified air.[16] Otherwise the necessity for the presence of air in the darkening of cerargyrite in light is of the same value, since it is required for the operation of a galvanic circuit; at least that was Ritter's view at that time. The chemical action of light is then reduced to nothing but a decomposition of water by electricity. Just as a proportionately strong electrical current can decompose water independently of the presence of air, so also primarily a light intensified by condensing lenses can blacken cerargyrite in the absence of all free oxygen.

When Ritter leaves the domain of experimental research and invades the territory of speculation, he is not rewarded by good fortune. Hasty and ill-founded electrical hypotheses led him astray. It must be stressed, however, that Ritter, in his observations, had a distinct notion in his mind of the influence of great height on the power of the chemical action of light, namely, the law of absorption of chemical light rays, which Robert W. Bunsen later observed and investigated.

FURTHER ADVANCES IN PHOTOCHEMISTRY

On the action of light on fresh lard Henri August Vogel first published in 1806 some statements in his "Dissertation on Lard and Some Medicinal Preparations Which Are Produced from It."[17] He states:

It is known that fresh lard properly cleansed has no odor and an insipid, mild taste. When it is exposed to sunlight for two months, it takes on a rancid, penetrating odor and a pungent taste which irritates the throat for a long time; it changes its color from white to yellow, without taking up any acid. Exposed to sunlight and the action of air simultaneously, the same phenomenon occurs, but in that case the fat also turns acid.

We find an article in Hermbstädt's *Bulletin des Neuesten und Wissenswürdigsten aus der Naturwissenschaft* (1809, II, 130) on the bleaching of bones and ivory which is of interest to us. It is stated here that animal bones and ivory, when stored for a time in the open air and in dark places, turn yellowish and even brown, but that they become gradually bleached in the sunlight. It is therefore recommended to bleach ivory, etc., in weak caustic potash solution, then in chlorine, and to expose it to sunlight in order to complete the bleaching process. The action of the light, it is claimed, operates "by liberating the oxygen which creates the yellow color."

DISCOVERY OF THE SENSITIVITY TO LIGHT OF CHLORINE AND HYDROGEN (CHLORINE DETONATING GAS) AND RELATED LIGHT REACTIONS

The combination of the hydrogen-chlorine mixture had been discovered in 1801 by W. Cruickshank, but he did not investigate the problem very thoroughly. In 1809 appeared an important publication in photochemistry, namely, a description of the reaction to light of the mixture of chlorine gas and hydrogen gas. We are indebted for this experiment to the celebrated French chemists Joseph Louis Gay-Lussac (1718-1850) and Louis Jacques Thénard (1777-1857), a pupil of Vauquelin, who were the first to conduct investigations on the advance

of the chemical reaction by light of chlorine gas on hydrogen gas and on ethylene (oil-forming gas), which led to many experiments on similar reactions between chlorine and organic substances. These experiments furnished the starting point for the construction of the chlorine detonating gas photometer of Bunsen.

Gay-Lussac and Thénard published on February 27, 1809, their dissertation: "De la nature et des propriétés de l'acide muriatique et de l'acide muriatique oxigené," in *Mem. de phys. et de chimie de la Société d'Arcueil*, 1809, II, 339; Gilbert's *Annal.* (1810, XXXV, 8). They also repeated Berthollet's experiments on the light sensitivity of chlorine water. A. Fr. de Fourcroy (1755-1809) demonstrated that chlorine gas was not decomposed by light or heat. Gay-Lussac and Thénard state:

We have, then, discovered a substance which is not decomposed by light or heat, but by addition of water is easily disintegrated by either, namely, as steam under mild red-heat When the actions of light are compared with those of heat, it must be conceded that in general both produce the same effect. This conclusion had been already arrived at by Rumford. . . . We made two mixtures, each of which consisted of equal amounts of oxygenated hydrochloric acid gas (chlorine) and hydrogen gas One was put in a completely dark place, the other in sunlight which was rather weak on that particular day. After a few days the color of the former was still green and the mixture did not seem to have undergone any change. The latter, on the contrary, was completely discolored in less than a quarter of an hour and was almost completely decomposed We made further mixtures of oxygenated hydrochloric acid gas, partly with hydrogen and partly with ethylene gas . . . and exposed both mixtures to the sun; this was hardly accomplished when they suddenly ignited with an extremely loud detonation and broke the bottles into pieces which were strewn all over the place. Fortunately, we were rather dubious about these experiments, and we had taken precautions against accidents Carbon oxide has no reaction on chlorine (?) Light seems to act on dyestuffs in the same manner as heat of 150-200 degrees It is possible that light acts on plants only as heat does, but with the important difference that heat increases the temperature, but light, on the contrary, produces an inequality of temperature (just as in chlorine water), because it affects some parts sooner than others, which seems to be of great advantage to the scope and play of the organic forces.

Joseph Louis Gay-Lussac (1778-1850) was an eminent French physicist and chemist. He lectured as professor of physics at the Sor-

bonne and as professor of chemistry at the polytechnic school. He was
a member of the Chamber of Deputies from 1830 and was elected to
the House of Peers in 1839. We owe to him a lengthy series of impor-
tant discoveries in physics and chemistry, which space does not permit
us to consider here. We must, however, record those discoveries which
are connected with photochemistry and photography, especially his
works on detonating chlorine gas, iodine, and iodide of silver (1814).
Alkalimetry, acidimetry, and chlorometry are his inventions, and his
instruction on the volumetric examination of silver was used not only
in mints and analytical laboratories but also later in photography. Much
of his scientific work was carried on with Thénard, who was associated
with Gay-Lussac and others on the commission appointed to study
the value of Daguerre's invention. Gay-Lussac made a report on this
subject to the Chamber of Peers in 1839, recorded in our chapter on
daguerreotype.

Chapter XVII. FROM THE DISCOVERY OF PHOTOGRAPHY IN NATURAL COLORS BY SEEBECK (1810) TO THE PUBLICATION OF DAGUERRE'S PROCESS (1839)

THE DISCOVERY of photography in natural colors on silver chloride
was made by the famous German physicist Johann Thomas Seebeck
during his experiments with the solar spectrum. He was induced to do
this work by Goethe, who lived in Weimar while writing his *Geschi-
chte der Farbenlehre* and was on friendly terms with many scholars,
among whom was Seebeck. He was born in Reval, Estonia, studied
medicine at Berlin and Göttingen, and lived in Jena from 1802 to
1810 as a well-to-do scholar.[1] He spent his time with chemistry and
optics and discovered thermoelectricity; he was elected a member of
the Academy of Sciences at Berlin, where he died in 1831.

Goethe, during his studies on the science of color, devoted special
attention to Newton's theory of the solar spectrum. He delved deeply
into the historical side of the science of color, from the ancient Greeks
to modern times, and endeavored to support his teachings about color
by means of new optical experiments. This brought him into contact

with Seebeck, who lived not far away, in Jena. Seebeck investigated the chemical action of the solar spectrum, and these studies resulted in his sending a dissertation, *Wirkung farbiger Beleuchtung*, to Goethe, who added it to the appendix of his *Geschichte der Farbenlehre*, which was published in 1810.

Seebeck described therein the action of the solar spectrum on luminous minerals, and on that phenomenon is built a further dissertation by Seebeck of great importance in the history of photography: *Von der chemischen Aktion des Lichtes und der farbigen Beleuchtung.*

Seebeck writes[2]

that when he projected a solar spectrum upon paper prepared with still moist white hornsilver[3] and the light action was allowed to continue for a quarter of an hour or a little longer, the following results were observed: in the violet band of the spectrum the chloride became reddish-brown, sometimes tending to violet. This coloring extends all through and a little beyond the violet. In the blue part of the spectrum the chloride of silver becomes clear blue; the tint becoming fainter in the green. In the yellow no action took place, or only a faint yellow tint was produced; but in the red and ultra-red a rose or lilac coloration resulted. In the case of some prisms this reddening fell entirely outside the red zone of the spectrum When hornsilver, which had turned gray in light and is still moist, is exposed for the same length of time to the prismatic spectrum, it changes in the blue and violet, as above; in the red and yellow, however, the silver chloride will be found lighter in color than before, that is, perhaps not just lighter, but sharper and unmistakably more distinct. A reddening in or immediately below the prismatic red will also be observed Silver chloride turned gray under violet, blue, and blue-green glass, just as in sunlight or daylight, exhibited different characteristics according to the varieties of glass . . .

Thus, we note that apart from Senebier, who made far less detailed statements on the photochromy of silver chloride, Seebeck was the first who discovered that chloride of silver was capable of absorbing all natural colors of the solar spectrum and of colored glass; he recognized the property of silver chloride, which had turned gray under light (the so-called "silver subchloride"), becoming lighter (yellowish) in yellow light and reproducing also all other colors. That he also observed color sensitivity in the presence of "white silver chloride" can probably be traced to the fact that his spectrum was mixed with diffused white light, so that silver subchloride could form, which reproduces the colors; pure white chloride of silver in a pure spectrum

turns dark only in the more refrangible end, without reproducing the action of the colors. This was not observed by the earlier physicists, including Scheele and others, in similar experiments, nor did C. H. Pfaff later succeed in it. Seebeck also discovered the chemical action of infrared rays, which gave him enduring fame, although his contemporaries paid very little attention to his discovery.

In 1819 he called attention in great detail to the fact that the spectrum produced by various kinds of glass differed with regard not only to the action of heat but also to chemical action on silver chloride, which could be traced to the varying light-absorption ability of crown and flint glasses in the violet and ultraviolet spectrum.[4]

Seebeck made numerous other experiments in the interest of Goethe's studies on color.[5] We shall mention here only his observation, also contained in Goethe's work, that red oxide of mercury under blue glass is reduced in sunlight (changes into gray, imperfect oxide), but does not so react behind yellow glass, and that nitric acid and Bestuscheff's nerve tincture behave in an analogous manner under colored glass. In the following year (1811) Seebeck connected his experiments with those of Thénard and Gay-Lussac on chlorine-hydrogen gas,[6] and states: "I filled a yellow-red and a dark blue glass bell with these kinds of gas (Cl + H) and exposed them to sunlight. In the dark blue bell decomposition set in at once, but without an explosion, and it was quite finished in less than a minute In the yellow-red vessel the decomposition proceeded very slowly."

Seebeck was also the first to observe, in 1812, that the flame from Bengal lights caused an explosive combination of chlorine and hydrogen and caused a detonation.[7]

In 1813 a polemical pamphlet was published by C. H. Pfaff, professor at Kiel, on *Newton's Farbentheorie, Herr von Goethe's Farbenlehre und der chemische Gegensatz der Farben*, Leipzig, in which the author quite properly remarks that he cannot comprehend how Seebeck, after discovering that silver chloride assumes different colors in the spectrum, could be satisfied with the mere accidental colors (according to Goethe) of the color science. Pfaff remarks that he was unable to attain the natural colors of the spectrum on silver chloride, but he never doubted the correctness of Seebeck's observations. He also made experiments with sulphate of mercury, tincture of litmus, and so forth, and found: "In most cases it seems that violet and blue light have a deoxidizing effect, while red light mostly effects oxidation

(silver chloride, sulphate or mercury, litmus, Bestuscheff's tincture); on the contrary, however, the violet rays caused oxidation on guaiacum tincture and phosphorus."

Gay-Lussac and Thénard collected their observations as early as 1811 in their *Recherches physico-chimique* (1811, II, 186), on the comparative effects of light and heat during chemical processes, stating their conclusion in the following statements:[8]

1. Gold and silver solutions brought into contact with oils, ether, and carbon are decomposed by light; this occurs also by heat of 100° C., as Rumford demonstrated.

2. The dry oxidized hydrochloric acid gas (chlorine) is not decomposed by the strongest light or by greatest heat.

3. Aqueous oxidized hydrochloric acid (chlorine water) is decomposed by comparatively weak light, as well as by heat at dark-red heat.

4. Concentrated nitric acid is decomposed by very intense light, also by red heat.

5. Oxidized hydrochloric acid gas with hydrogen gas or hydrogenated carbon oxide gas[9] detonates when the sun's rays touch it; it is also detonated by heat 125-160° C.

6. Oxidized hydrochloric acid gas mixed with hydrogen gas is decomposed only slowly by diffused light. These two kinds of gas affect each other only slowly or not at all under 120° C.

7. Black mercury oxide changes in light into mercury and red mercury oxide; this change is due to heat.

8. Brown oxide of lead and no doubt also the oxides of silver, gold, and platinum decompose in light as well as in heat.

9. The rose color of safflower is decomposed by light and becomes dirty white; this same change takes place in heat of 160° C. in one hour.

10. The violet color of logwood (campeche) is decomposed by light and becomes reddish yellow and dull; in one and a half hours at 180° C. of heat it also turned reddish yellow and dull.

11. Light decomposed the red color of brazilwood and turned it almost white; heat did the same in two hours under 190° C.

12. The orange color of curcumine is decomposed by light and turns a rust color; a rusty color also appears in one and a half hours under 200° C. of heat.

13. Finally, the yellow color of woad became ochre in light; the same change took place in two and a half hours at 210° C. heat.

In conclusion Gay-Lussac and Thénard made the assertion that light produced no chemical action which was not generated by more or less heat.

This statement afterward started a series of lively controversies which showed that their views were correct in many, but not all, cases, which was also demonstrated by Davy in the following year.

The opinion previously expressed by Link and Heinrich that light acts by sometimes oxidizing, sometimes reducing was confirmed by Wollaston (1811) in experiments with guaiacum and paper coated with an alcoholic tincture of guaiacum. An interesting account of these experiments is to be found in the 1831 edition of Brewster's *Optics* (p. 91). Wollaston concentrated the various spectral rays on the card prepared with guaiacum by means of a lens. In the violet and blue rays it acquired a green color; in the yellow no effect was observed. Pieces of the prepared card which had become green in the violet or blue rays were restored to their original tint by exposure to the red rays. In an atmosphere of carbonic acid the violet and blue rays did not make the prepared card green; but the restoration of the original tint by the red rays took place in an atmosphere of carbonic acid. Heat also was found to destroy the green color.[10] He therefore termed the refrangible rays "chemically active rays" and opposed the term "reducing rays," which Ritter at that time used.

Ruhland also states in his "Fragmente zu einer Theorie der Oxydation"[11] that it had been found that sunlight accelerates the weathering of crystals containing water of crystallization and that light often oxidizes: "Thus oxidation in the galvanic pile, according to Buchholz (and with it, its efficiency) is increased by light, and thus iron oxidizes more rapidly in light than in the dark."

In 1811 the development of the wave theory of light was renewed by Thomas Young,[12] which was of great importance for mathematical optics, but caused no advances in photochemistry.

A new genius, Fresnel, appeared in the field of science in 1815 and, supported by Arago, won after a hard fight the splendid victory of establishing the wave theory over the theory of emission.[13] This effectually banished the earlier view that "a part of the light substance" (*ein Teil des Lichtstoffes*) combines with chemical substances. According to the Fresnel-Arago view it was distinctly expressed that in the chemical action of light on silver salts, and so forth, no combination takes place between "light particles" (*Teile des Lichtes*) with

those of the substances on which it acts. The decision in this case, therefore, was not established by chemical experiments, but as a consequence of the wave theory of light substantiated by mathematical-physical methods.

The general consideration of the nature of the chemical processes which cause the more refrangible rays of the solar spectrum, and also the less refrangible rays, was continued on many sides. Davy published in 1812 his *Elements of Chemical Philosophy*. He opposed the theory of Gay-Lussac and Thénard that the chemical action of light was similar to that of heat; he points out:

"Of the effects of radiant matter in producing chemical changes. Fourth observation: I have found that a mixture of chlorine and hydrogen acted more rapidly upon each other, combining without explosion, when exposed to the red rays than when placed in the violet rays I have found that the black oxide of mercury exposed in red rays concentrated by a lens gradually became red; in which case oxygen was probably absorbed; but the same oxide, exposed in the violet rays concentrated in the same manner was not changed; and these rays produced no effect upon dry red oxide of mercury, but upon moistened red oxide occasioned the same effect as a current of hydrogen gas The facts that I have stated above sufficiently demonstrate that the rays producing heat are capable of assisting certain species of chemical action, and there seems no more reason for asserting that the rays producing no heat are the rays most efficacious in occasioning chemical changes than for asserting, with MM. Gay-Lussac and Thénard, that light produces all its chemical effects by producing heat And from the observations of M. Berthollet, it appears that muriatic acid gas is formed when hornsilver is blackened by light, so that they may be called hydrogenating rays . . . [pp. 155, 211, etc.]

Davy also endorsed the opinion, which was later often stressed, that refrangible rays reduced (hydrogenated), while the less refrangible ones oxidized, which view, according to the state of photochemical knowledge of the times, was not wholly unreasonable, but was opposed by Wollaston and others. In modern times it has been contradicted by new experiments.

In 1812 Davy also found that carbonic oxide and chlorine gas combine in sunlight.[14] A. Vogel, in Paris, thoroughly investigated the behavior of phosphorus (see Böckmann, ch. xv, note 9) and its compounds toward light; Böckmann discovered the sensitivity to light of phosphoreted hydrogen[15] and later studied the action of sunlight on phos-

phorus.[16] He observed that it changes phosphorus to red, even under water, in a vacuum as well as in an atmosphere of nitrogen and hydrogen, wherein the violet rays of the spectrum acted more rapidly than the red.[17] Ruhland's observations are similar, as may be seen in a dissertation *Über den Einfluss des Lichtes auf die Erde*, which he submitted in 1813 to the Akademie der Wissenschaften of Munich.[18]

Vogel made further experiments with a watery blue infusion of violets, to which a little alcohol was added, which loses its color rapidly in blue light, slowly in red light, which is also the case of a poppy infusion. He also found[19] that "copper oxide-sodium oxalate has the peculiar property of turning in sunlight very rapidly and in the shade gradually, green, then dark brown, without losing any weight, shape, and as it appears, none of its luster."

Ruhland described further experiments of Vogel in Schweigger's *Journal*[20] (1813, IX, 236). Vogel found:

1. Fresh crystals of sodium phosphate, sodium sulphate (Glauber's salt), iron sulphate effloresce more rapidly under blue than under red glass.

2. Phosphorus in "pure nitrous gas" (nitrous acid?) is stable in light.

3. An alcoholic tincture of red carnations turned white in a few days behind blue glass, while behind red glass it was still purple after about the same length of time. Cotton and paper colored with this tincture showed the same differences. The petals of a corn poppy (papaver rhoeas), mounted behind a blue glass, turned whitish after a few days; behind a red glass the color remained unchanged.[21] The fatty oils turned gradually acid in light.

4. Phosphorus and caustic potash exposed under blue glass developed considerable gas and dissolved; behind red glass the same action took place, but much weaker and more slowly.

5. A solution of iron chloride in ether loses its golden yellow color in a few minutes behind blue glass, while behind red glass it remains unchanged for a whole day. Since this solution is extremely light-sensitive, "It may some day become a good measure for the intensity of light."

6. A solution of copper chloride presents the same phenomenon behind colored glass.

7. A saturated solution of mercuric chloride in ether shows no change in light behind red glass; behind blue and clear glass a mass of small crystals formed. The precipitate turned black in caustic potash, "which proves that the precipitate was mercurous chloride (calomel)." A solution in pure alcohol behaves similarly, but decomposes more slowly.

8. Ammonium sulphide exposed to light in blue and red glass bottles undergoes a change only in the blue containers; after two months the sides are coated with a crust.

It is worth mentioning that the chemist Doebereiner, of whom we shall speak later, found in 1813 that alkaline hypochlorite (Javel solution) and chloride of lime (bleaching powder) change more rapidly in the light than in the dark. (Schweigger's *Jour.*, 1813, IX, 18).

FISCHER DISCOVERS THE LIGHT SENSITIVITY OF SILVER ALBUMINATE AND CONTINUES THE STUDY OF SILVER CHLORIDE (1812)

The sensitivity to light of silver albuminate, which is important in the production of albumenized photographic paper, is mentioned for the first time in 1812 in an article "Kritik der von dem Herrn Professor David Hieron Grindel fortgesetzten Versuche über die künstliche Bluterzeugung," by N. W. Fischer.[22] He was the first to call attention to the light-sensitivity of silver albuminate, so important in photography as a well-known phenomenon:

When animal fluids, i.e., albumen, are mixed with a silver solution and are exposed to light, the silver combines in a mild oxidizing, but not definite, condition with the animal substance and turns black, as is well known; however, this color is at first brownish-red and changes later, often only after several days, to dark brown or black.

He adds a footnote:

As everyone may observe who stains his hands with a silver solution. But the silver solution, or at least the acid, must not be too strong, for when that is the case the stains will soon turn black, although a dirty black.

This shows that Fischer already knew that the blackening process in photography was influenced by the presence of free nitric acid.

The knowledge of the sensitivity to light of silver compounds was greatly enlarged by the special study of Fischer published under the title *Über die Wirkung des Lichtes auf Hornsilber*[23] (Nuremberg, 1814). This pamphlet contains a valuable historical review, with detailed descriptions of his own experiments. Since this booklet has become extremely rare, I record below the most important conclusions:

1. (a) The blackening of muriate of silver is due exclusively to the action of light. Link stated the same. Scheele, Senebier, Vasalli, Heinrich, and Buchholz held that heat co-operated. According to Ritter, silver chloride does not change color at 0° C. Berthollet states that a current of air causes blackening; but according to Ritter only after it had been heated by fire and gave out carbon.

(b) Chloride of silver changes color even at 16° to 18° R. Increase of heat alone effects no color change, and light does not act on dissolved silver chloride.

2. The color of silver chloride proceeds from bluish gray to red brown. According to the condition, namely, the purity of the compound, a different kind of color change takes place. In a compound in which there was excess of muriatic acid and which was dried quickly in large pieces, sunlight effected no change in color until the preparation was moistened.

3. Water, while facilitating and hastening the color change in silver chloride, is not absolutely necessary to this phenomenon, because it occurs in any colorless liquid and in dry air. Fischer demonstrated this with dissolved silver chloride, which when exposed by him in sulphuric acid, nitric acid, alcoholic ether, nut oil, was colored up to red-brown in all these cases; although most rapidly in water and most slowly in nut oil. Silver chloride also changed color in air dried over calcium chloride Scheele found that silver chloride did not change color in nitric acid. (Fischer remarks that he must have used red nitric acid.)

4. (a) The nature of this phenomenon (color change) is the decomposition of silver chloride by light, and that one constituent, the oxidized muriatic acid, is liberated, which escapes in a gaseous state or communicates itself to the liquid.

(Gilbert was the first to express this view: that chlorine is set free and forms with the hydrogen of the water, hydrochloric acid; Scheele, Senebier, Berthollet, Heinrich, Buchholz confirm simply the solution of hydrochloric acid.)

Fischer found that silver chloride in light yields chlorine not only to water but also to alcohol, ether, nitric acid; these liquids then react with silver nitrate.

During the time that dry silver chloride blackens in sunlight, an odor of chlorine develops. Silver chloride + water gives off the odor of chlorine after eight to fourteen days; it bleaches vegetable dyes (litmus, curcuma). Dry molten silver chloride also generates chlorine gas, although more slowly. Alcohol gives off the odor of chlorine ether. Therefore it is chlorine (not muriatic acid) which is set free.

(b) Pure molten silver chloride lost 1/500 in weight after four weeks' exposure (0.02 g. out of 10 g.).

5. The change which chloride of silver undergoes in the blackening process is "that it passes from the state of a neutral compound to that of a basic salt. The portion of silver liberated by the muriatic acid combines with the undecomposed muriate, forming a salt with excess of the base" (namely, silver subchloride!!!).

He supported this statement by the following experiments:

(a) Blackened silver chloride is not made lighter by muriatic acid or sulphuric acid, which shows that no silver oxide could have been liberated (as Berthollet, Buchholz, Gilbert assumed).

(b) If nitric acid is added to completely blackened silver chloride, a silver solution forms, but only when the muriate (silver chloride) is completely blackened; particularly when the color change takes place in the beginning under water was the change not entirely completed; the nitric acid dissolved no silver. In no case was the silver chloride decolorized, even if the nitric acid absorbed some silver; in which case, it is true, the color became somewhat lighter.

(c) The darkened silver chloride is no longer entirely soluble in ammonia like the uncolored; the residue is silver gray, completely soluble in nitric acid (as Scheele assumed, contrary to Berthollet's view). This does not prove, as Scheele believed, that ammonia simply liberates the silver formed by light, "but that ammonia itself has a decomposing action on the muriate and liberates silver." The product of the color change cannot be considered as a mere mechanical combination of undecomposed muriate and free silver, for otherwise the nitric acid would dissolve the free silver and thereby be able to produce the white color, which does not happen. The chemical union between the decomposed and undecomposed muriate is so intimate that nitric acid is not able to separate them.

6. On the difference between the oxidation in the red and the reduction in the violet, Fischer adopted a doubtful and reserved position.

7. All kinds of light produce these effects (color change and reduction) more rapidly in sunlight than in daylight; blue and violet act rapidly, red less, then comes the light from flames, and last moonlight.

Other works of Fischer which are of interest to us followed in 1818, when he wrote "Über die Ausscheidung des Silbers aus dem Chlorsilber durch Zink" (Schweigger's *Jour.*, 1818, Vol. XX). This method afterward was often employed for the recovery of silver from silver waste (also see *ibid.*, 1826, p. 222).

THE DISCOVERY OF IODINE (1814)

Iodine was discovered in 1814 by Bernhard Courtois (1777-1838) a manufacturer of saltpeter in Paris. Courtois used for the decomposition of the calcium nitrate the alkaline lyes of varec or kelp and observed in the process a strong corroding action on the copper vessels. Careful investigations (1812) led to the determination that the corrosion of the metal was caused by a combination of the copper with a substance heretofore unknown, but then isolated by Courtois—it was iodine. Although Courtois received a prize of 6,000 francs for his discovery from the Academy of Sciences (1831), he died in poverty and want, having lost all the capital invested in his factory, owing to the

subsequent admission of saltpeter from India free of duty. Courtois sent samples of the new element to Desormes and Clément for further study, and they reported in detail on the properties and behavior of iodine to the Imperial Institute of France, on November 29, 1813. On December 6, 1813, Gay-Lussac also reported his experiment on "iode," as he designated the element, and a short time later Davy, who was passing through France, received a sample of the element from Ampère. He was able to support Gay-Lussac's statements, especially as to the elementary nature of iodine, so-called by Davy in order to conform with the endings of chlorine and fluorine[24] (D. Chattaway, *Chem. News*, 1909, XCIX, 193-95; *Chemiker-Zeit.*, 1909, *Repert.*, p. 261).

Davy[25] reported to the Royal Society of London, on January 20, 1814, on the different properties of iodine. In this extremely interesting report of his "Some Experiments and Observations on a New Substance Which Becomes a Violet Coloured Gas by Heat," for which he proposes the name "iodine," Davy briefly summarizes the earlier experiments of Gay-Lussac, Desormes, and Clément, and continues:

The first experiments that I made on this substance, were to ascertain whether (argentane) muriate of silver could be formed from its solution in water or alcohol, and for this purpose it was purified by distilling it from lime. Its solution I found, when mixed with solution of nitrate of silver, deposited a dense precipitate of a pale lemon colour; this precipitate, when collected and examined, proved to be fusible at a low red heat, and then became of a red colour. When acted upon by fused hydrate of potassa, it was rapidly decomposed, and a solid substance, having all the characters of oxide of silver, was formed. The matter soluble in water separated by a filter, and acted upon by sulphuric acid, afforded the peculiar substance.

A solution of potassa, after being boiled on the precipitate, afforded the peculiar substance, when treated by the same acid.

The precipitate was much more rapidly altered by exposure to light than the muriate of silver, and was evidently quite a distinct body.

Davy perhaps prepared his iodide of silver with an excess of silver nitrate, since his preparation changed rapidly in light, which, as is well known, occurs only in that case.

Worthy of mention also are the investigations of Steffens, Link, and Fischer, who were first given the opportunity to engage in experiments with iodine and silver iodide by the courtesy of Gay-Lussac. Henrik

Steffens (1773-1845) received his degree as doctor of medicine and philosophy at Kiel, taught there and at Copenhagen, was professor of physics at Breslau from 1804 to 1832, and later in Berlin. He occupied himself with geology, geognosy, anthropology, and physical subjects. While at Paris, early in 1814, he visited Gay-Lussac, who gave him a small quantity of iodine, at that time a great rarity. With this he made experiments, together with H. F. Link and N. W. Fischer, with iodide of silver. The results, published by all three authors in Schweigger's *Journ. f. Chemie und Physik* (1814, XI, 133) did not coincide with those presented by Davy. The three chemists observed that silver solutions are precipitated by iodine and that the precipitate greatly resembles silver chloride, but they stated: "The precipitate (light greenish-yellow) compound as well as the melted compound (iodide of silver) retain their color under light."[26] This observation, contrary to that noted by Davy is probably explained, by the supposition that the last-named chemists evidently precipitated the silver iodide with excess of potassium iodide; it did not occur to the scholars of those times to observe the different behavior toward light of the melted and precipitated iodide of silver. The fact that silver iodide turns dark in light much less rapidly than does silver chloride, diverted the attention of physicists from the former, and it was considered of little importance in photochemistry until used by Daguerre. Boullay had discovered in 1827 the double salt of silver iodide with potassium iodide and had observed that in light it assumed a pale blue color (*Annal. d. Chemie u. Physik*, XXXVII, 37). However, the photochemical decomposition of this double salt is very limited.

From then on iodine and iodides were of importance only in medicine, but not in photochemistry. When Dr. Coindet of Geneva recommended, in 1820, that iodine be used as a cure for goiter, it received wide dissemination and increased considerably in price.

The physicists, on the other hand, occupied themselves in those days more with silver chloride, which in light turns black more rapidly than silver iodide.

PROGRESS IN PHOTOCHEMISTRY UNTIL THE DISCOVERY OF BROMINE

Subsequently separate observations accumulated on the light sensitivity of various substances. In his "Experiments on the Reciprocal Action of some Ammonia Salts and Oxidized Mercuric Chloride ($=HgCl_2$)" L. A. Planche[27] described in 1815 the action of light on

a mixture of ammonium oxalate and mercuric chloride solution. He mixed equal volumes of a cold saturated aqueous solution of ammonium oxalate and sublimate, filled with it a small Woulf jar (tube de Welter) nine-tenth parts, and attached a gas-delivery tube. When he exposed the jar to strong sunlight, the mixture became turbid after two minutes. Gradually it became milky, and then it deposited a certain quantity of "mercuric chloride in minimum" (calomel). Now "the surface of the liquid began to boil," and by a retarded motion of it, bubbles of carbonic acid were disengaged. This separation of gas continued for several hours, and then the liquid became clear. That these two salts actually decompose under the influence of light, Planche proved by putting aside in a dark place a sample of the solution; even after eight days not the slightest change could be noticed. The access of light, he concluded, seemed necessary to the reciprocal decomposition of the caustic sublimate and the ammonium oxalate.

Dr. Eder afterward based his photometer with mercury salts on this reaction.

ON THE LIGHT SENSITIVITY OF MANGANIC SALTS

Friedrich Brandenburg (1781-1837), a German pharmacist and honorary member of the Imperial Academy of Sciences at St. Petersburg, was the first to record the light sensitivity of manganic salts. Although long domiciled in Russia, most of the results of his investigations were published in German chemical journals. He reported in 1815[28] "that a reddish, clear solution of manganese, prepared with pure sulphuric acid and containing much free acid, when kept undisturbed, under exposure to light and in the open air, became at first turbid but soon after lost its color completely, after one or more days."

Schweigger adds[29] that he also observed that a beautiful red solution of sulphate of manganese[30] was discolored only in light and that the solution which had lost its color did not regain it in the dark. Fromberg, who investigated manganic acid later (1824),[31] states that an aqueous solution of it was light-sensitive, that is, loses color.

The behavior of organic substances toward light also attracted more attention. J. Pelletier and Cavetou,[32] in 1817, made detailed investigations of the green coloring matter of plants, the "grüne Pflanzenharz" (green vegetable resin) as extracted by alcohol, ether, and so forth. The alcoholic solutions of the green substance produced with lime, alumina, magnesia salts, and so forth, green pigments on which the

light manifested in general no deleterious influence; only the green matter of spruce and pines suffered a change. Johann Andreas Buchner, in a note commenting on this, states that he also had investigated this subject several years earlier and had found that the green pigment of various water plants, extracted in alcohol and laid on paper, linen, cotton, and silk, faded very quickly in sunlight and changed to a pale yellow or dirty brown.[33]

In 1818 Luigi Gasparo Brugnatelli, at the University of Pavia, investigated purpuric acid formed from uric acid and found that the colorless crystals containing water turn red in sunlight, also when heated. When, however, they have lost their entire water content, sunlight no longer changes their color and heat decomposes them, without their assuming a red color.[34]

GROTTHUSS EXPRESSES THE LAW OF PHOTOCHEMICAL ABSORPTION IN 1817
AND EXTENDS THE THEORY OF PHOTOCHEMICAL REACTIONS

With the beginning of 1817 we must turn our attention to the activities of Theod. Freiherr von Grotthuss, born in Leipzig, January 20, 1785, where, as well as in Paris, he received his training in the natural sciences. In Paris he attended the Polytechnic Institute and studied under Vauquelin, Berthollet, Fournier, and others. When the Franco-Russian war began, in 1804, he was forced to leave Paris and went to Rome and Naples, where he turned his attention to electrolysis. In 1805 he proposed a remarkable theory of the galvanic decomposition of water. In 1806 he returned to the estate inherited from his father in Russia. There he engaged in the cultivation of his estate and continued his scientific works.

Although Grotthuss only reached the age of thirty-seven, his works are important, particularly in photochemistry. It was he who in 1817 expressed for the first time the opinion "that only the absorbed light rays are active in the production of chemical changes" (Gilbert's *Annals*, 1817, LXI, 50). Thus, he formulated the important basic law of photochemistry, which is named after him, "the Grotthuss law of photochemical absorption."

The publication of this law received little notice at that time, although there existed some previous works on the subject by Christian Weiss, in 1801, and by A. Vogel, 1813. This important Grotthussian thesis was in time so completely forgotten that John William Draper, two years after the invention of the daguerreotype, discovered the

same law anew and entirely independently of Grotthuss (*Phil. Magaz.*, 1841, p. 195). For a long time it was known as "Draper's law of absorption," in ignorance of Grotthuss's priority (Eder's *Photochemie*, 3d ed., 1906, p. 41). Draper also recognized that in every chemical change in a substance caused by light, certain rays of definite wave-length are absorbed, which absorption produces the photochemical change.

This basic photochemical law, however, originated with Grotthuss; but he and Johann Heinrich Schulze suffered the same tragedy, that about a century passed before as pioneers in the field of photochemistry they received due recognition.

Not until the end of the nineteenth century was attention again drawn to the work of Grotthuss and the "Grotthuss law," universally accepted under his name. In the twentieth century it was formulated again and made to conform with modern theories[35] by van't Hoff, Plotnikow, and others.

Let us return to Grotthuss's work of 1818. In that year he found that sulphocyanide of silver is blackened by light, but less so than silver chloride.[36] In October of the same year he presented to the Kurland Society for Literature and Art a dissertation *Über die chemische Wirksamkeit des Lichtes*,[37] in which he set forth photochemical propositions[38] which were original.

Grotthuss tried to connect photochemical action with galvanic action, because Davy and Berzelius (1810) had pointed out the connection between chemical and electrical forces. Starting with Berzelius's electrochemical theory, Grotthuss held that positive electricity $(+E)$ negative electricity $(-E)$ are the true elements of light, and expressed the view that light separates the constituent parts of many combinations and forces them into combinations with electrical matter.

He endeavored to bring together under four laws the photochemical phenomena known in his time, and made many new experiments for the demonstration of his theory, which greatly enlarged our knowledge on the light sensitivity of chemical substances.

The four laws of Grotthuss are:

1. In certain solutions, especially those which dissociate, the light separates the nearest constituent, so that the new compound formed by the separation shows under the given conditions the greatest possible difference in solubility. Example: Stannous chloride dissolved in water and covered with oil is said to turn turbid more rapidly in sunlight than in the dark, "whereby basic stannous oxychloride separates, while the acid salt remains in solution."

2. In oxygen and chlorine compounds which are decomposed by light, the light usually deoxidizes or dechlorizes the ponderable electropositive constituent, or prevents its oxidation or chlorination; simultaneously it oxidizes or chlorinates the electronegative or other indifferent element. Example: Silver chloride forms in light first free chlorine; this, by action on water, forms muriatic acid, "since the oxygen contained in water combines with the $+E$ of light and the silver with the $-E$ of light," for instance, loss of color in the tincture of iron.

3. On compounds the constituent parts of which are capable of hydrogenation or dehydrogenation, the light acts in such a manner that the electronegative constituent is hydrogenated, while the electropositive constituent is dehydrogenated, because it transfers at the same time its imponderable elements ($\pm E$) chemically to the newly formed compounds. Example: Aqueous starch iodide turns colorless in light, since hydrogen iodide forms.[39]

4. When light acts on oxygen and solutions of certain salts which already have themselves undergone a change by light or have suffered a similar reaction, the light will deoxidize the imponderable $+E$ of the oxygen gas and oxidize the next electropositive constituent of the salts, and so forth. Example: The blood-red solution of iron sulphocyanide becomes discolored by light alone, but resumes its red color again in the presence of both air and light.

These laws of Grotthuss found little appreciation among his contemporaries; they were entirely forgotten, just as the dualistic electrochemical theory of Berzelius was afterward abandoned.[40] Still we must recognize the fact that the basic ideas which Grotthuss laid down in his photochemical theses were not far removed from the most modern views of physical chemistry, since the chemical forces of affinity are essentially of an electrical nature.

The fundamental principle that fugitive dyestuffs fade behind colored glass only by the action of those color light rays which they absorb (complementary colors), but are preserved by the rays of their own color (which they reflect), led later to the numerous photographic bleaching processes or color adaptation processes;[41] they furnished the possibility of photography in natural colors.

It will be seen that Grotthuss did not consider the law of absorption which he had found of great importance, for otherwise he would have laid more stress on it. At any rate, he paid no more attention to this subject in the subsequent years, but devoted his time to numerous other chemical and physical subjects. For instance, a year before his

death he wrote on the theory of Davy's safety lamp and on his investigation of a meteorite. His many-sided and strenuous scientific labors seem to have shattered his nervous system; in addition, he suffered from a progressive abdominal disease, became dejected, and shot himself on his estate, January 14, 1822.

THE INVENTION OF A SELF-RECORDING PHOTOMETER WITH SILVER
CHLORIDE PAPER BY LANDRIANI IN VIENNA (1818)[42]

At the beginning of the nineteenth century the light sensitivity of silver chloride paper was well known, especially through the works of Tom Wedgwood and Humphry Davy. We are indebted to Count Marsiglio Landriani, of Vienna, who was Lord Chamberlain to the Archduke Albert of Saxony-Dresden, for the first use of silver chloride paper in the production of an automatic recording photometer with a clock movement. Count Landriani devoted his leisure time to physics, wrote on the thermometer, constructed self-recording machines for the measurement of wind velocity, and so forth. He traveled a great deal and lived in turn in Vienna, Italy, and France, published his writings in both German and Italian, and was also correspondent of the Academy in Paris. This versatile, learned gentleman died in 1818.

His last publication was "Di due termometri, di cui uno in assenza dell'osservatore indica il massimo e l'altro il minimo di colore e del lucimentro," which appeared in the *Giornale di fisica*, Dec. 2, 1818, Vol. I.

During some of his experiments he used silver chloride paper, about which he spoke to Professor Traugott Meissner, in Vienna. Meissner was an old Austrian, born 1778, who had worked as apothecary's apprentice and studied chemistry under Jacquin, in Vienna, about 1797. He was pharmacist from 1800 to 1814, then came to Vienna as an assistant in chemistry at the Polytechnikum. He soon achieved his full professorship. He was the inventor of heating with hot air and wrote, among other books, a manual on general and technical chemistry (5 vols., 1819-33). This work is one of the last to be published in the nineteenth century in which a chemist supported the antiquated phlogiston theory. He was succeeded in his professorial office in 1845 by the chemist Professor Anton Schrötter (1802-75), the discoverer of red phosphorus, and died in Neuwaldegg, near Vienna.

In Meissner's *Handbuch der allgemeinen und technischen Chemie* (1820, II, 280, "Chemie der nichtmetallischen Stoffe, Abteilung A") mention is made of "the application of light." Meissner writes:

The property of light which causes different color substances to become decomposed under development of heat furnishes us with a means of measuring the intensity of light. On this is based the arrangement of the photometer invented by Sir John L. Leslie (1766-1832). It consists of two thermometers of equal size, the bulb of one having been blackened . . .

Landriani proposed another photometer based on the decomposition of hornsilver (silver chloride) by light, which consists of a round disk coated with chloride of silver, covered by another opaque disk which is pierced. It is covered in such a manner that the second disk is turned a little by clockwork every half hour, which exposes at each turn a new portion of the lower disk to the action of the light. In sunlight, different portions undergo in this manner an unequal darkening, by which the difference in the intensity of the light at different hours of the day can be measured.

This is undoubtedly the first description of a self-recording daylight photometer using light-sensitive silver chloride paper, and Meissner evidently learned of it directly from Landriani and recognized its value. The invention of the recording photographic photometer, therefore, must be accorded to Landriani not later than 1818; the first publicity about it was given by Meissner in 1820.

The Swedish inventor Georg Scheutz used chloride of silver paper in 1832 for the recording of sunlight for maps (*Nord. Tidskr. f. Fotogr.*, 1925, p. 70).

HERSCHEL DISCOVERS (IN 1819) THE PROPERTY OF HYPOSULPHITES AS FIXATIVES FOR CHLORIDE OF SILVER

Sir John Herschel discovered hyposulphites and described their properties in *Edinburgh Philosophical Journal* (1819, I, 8, 396). For us the fact of particular interest is the statement that "muriate of silver, newly precipitated, dissolves in this salt (hyposulphite), when in a somewhat concentrated solution, in large quantity and almost as readily as sugar in water." It is curious to note that this observation of Herschel was not utilized by his contemporaries or by later scholars who studied the light sensitivity of silver compounds for the fixation of light images on silver paper. Neither Daguerre nor Niépce knew of the fixative property of the hyposulphites at the time of the publication of daguerreotypy in 1839, although Daguerre adopted its use in that year; even Herschel's contemporary, the scientist Talbot, experimented with different salts for the fixation of his images on silver chloride paper, but it never occured to him to try sodium hyposulphite. But when, in 1839, the whole world discussed Daguerre's invention and Herschel

learned of Talbot's experiments, he published the announcement that hyposulphite was an excellent fixative for chloride of silver.

In 1821 Faraday discovered that iodine in combination with oil-forming gas (ethylene) forms a crystallizing compound when both are exposed to sunlight.[43] He gives an account of

a triple compound of iodine, carbon and hydrogen. It was prepared by exposing iodine in olefiant gas to the solar rays Crystals were gradually formed; no hydriodic acid appeared to exist in the vessel, so that the olefiant gas had not been decomposed, but merely absorbed by the iodine. The triple compound of iodine, carbon and hydrogen was purified by potash, which dissolved the uncombined iodine Mr. Faraday considers this substance analogous to chloric ether. He proposes to call it hydrocarburet of iodine.

This permitted the production of carbon perchloride direct from ethylene and chlorine gas, if the resultant oil is exposed with excess chlorine gas to the solar rays.[44]

In the same year William Henry[45] found that marsh gas (methane) is not decomposed by chlorine in the dark, but only in the presence of light.

Kastner mentions, referring to Robison's earlier statement, that light rays which have penetrated water turn silver chloride blackish purple, while light passing through nitric acid in the same time and under identical conditions will scarcely turn the hornsilver gray, that is, the latter absorbs much more of the chemically acting rays than silver—a confirmation of Robison's opinion (1787).[46]

Witting and Zimmermann made experiments on the decomposition of aqueous silver nitrate solutions. Ernst Witting (1800-1861) studied the behavior of silver nitrate solutions toward some of the gases and found[47] that carbonic-oxide, hydrogen, and phosphoreted hydrogen gas effect a color change and precipitate even in the shade, while, on the contrary, an aqueous solution of silver nitrate saturated with carbonic gas did not change color in the shade even after several days, although in light a violet coloring showed after a short time—at first without precipitate.[48]

In 1823 Rudolf Brandes (1795-1842) investigated camphoric acid salts more exhaustively and found that silver salts are white, but turn brownish under light.[49]

In 1821 a so-called "blood rain" fell near Giessen, Germany, which caused Wilhelm L. Zimmermann (1780-1825) to investigate these

aqueous meteors. He found in them a small salt content and organic substances. He speaks in the course of his investigation of a curious difference which the meteoric waters show toward nitrate of silver. Sometimes the waters decomposed in a nitrate of silver solution became turbid, at other times they did not. In the first case the turbidity darkened by sun or daylight to bluish gray, violet, and finally formed a blackish sediment. Zimmermann concludes that the chlorides predominated; the color changed to yellow-red, wine-red, and ended with purple. Finally a violet-brown precipitate formed (chloride and organic substances were present).[50]

In the second case the waters mixed with silver salt run through the same cycle, from yellow-red to purple (predominance of organic substances), or they remain unchanged and show only a suggestion toward red (the water was deficient in organic substances and in chlorides).

For further experiments in photochemical processes we are indebted to Johann Wolfgang Doebereiner, whose biography will be found later in this chapter. In his *Pneumatischen Chemie* (1825, V, 103), he states that a mixture of iodine, alcohol, and sulphuric acid loses color rapidly only in sunlight and sets free long sulphur crystals.

In 1826 Doebereiner succeeded in reducing platinic chloride from its solution by light, mixing this solution with another of neutral tartrate of soda until it became turbid and then exposing it to sunlight. The platinum was reduced almost entirely and deposited on the inner surface of the tube in the shape of thin, greyish-black lamellae. When he emptied the tube and then filled it with hydrogen, the reduced metal assumed a beautiful silver color. In this process of reduction, according to Doebereiner, the tartaric acid is changed into carbonic acid and formic acid. He continued his labors in photochemistry later with the greatest success.

DISCOVERY OF BROMINE (1826)

Bromine was discovered about 1826 by Antoine Jerome Balard (1802-76), at that time lecturer in the school of pharmacy at Montpellier. The incident which directed his attention to the mother liquor left after salt had been crystallized out of the concentrated waters of the neighboring salt marshes[51] is thus related by Karl Adolph Wurtz:

About 1824, when botanizing one spring morning near the edge of a salt marsh, Balard noticed a deposit of sodium sulphate, which the coolness

of the night had caused to crystallize out in a basin where someone had left a quantity of mother liquor after separating common salt. The idea of studying these mother liquors immediately took possession of his mind and occupied it during the greater part of his life. In the course of his subsequent experiments he was impressed by the peculiar coloration which certain reagents developed in such mother liquors. He made the most of this observation, and, following it up with a tenacity amounting to genius, he had the good fortune to discover bromine. It was a great discovery. Balard isolated a new simple body, not an insignificant rare metal hidden in some little-known mineral, but a highly important substance destined to rank between chlorine, which we owe to Scheele, and iodine, which we owe to Courtois. Thus, the name of this young man of twenty-four was placed at the outset of his career by the side of these illustrious names, and there it has become immortal.

Bromine ("bromos," Greek for bad odor), was the name Balard gave to the new element on the advice of his teacher, Anglada, and with respect to the behavior of the substance (*Chem. News*, 1909, LXXXXIX, 205).

Balard[52] describes in his report, mentioned above (*Annal. chim. phys.*, 1826, XXXII, 361), different bromates, like potassium bromide: "Nitrate of silver produces in hydrobromides a cheese-like precipitate of silver bromide. This compound, which has a pale greenish-yellow siskin color, turns black when it is exposed to light while still moist, but less so than silver chloride." Bromate of silver he found fairly constant in light.

The use of silver bromide, however, was not introduced into photographic processes until after the publication of Daguerre's process.

Balard's life passed more quietly and he achieved greater honors than Courtois, the discoverer of iodine. He was called from Montpellier to the faculty of sciences in Paris and became a member of the Institute of France.

FURTHER PROGRESS IN PHOTOCHEMISTRY

N. W. Fischer[53] was the first to publish, in 1826, the observation that silver nitrate is reduced in light with varied color, according to the nature of the admixed organic substances; in the presence of india rubber the change is toward red-brown and dark violet; with sugar it turns entirely black; with starch it shows a gray color. This supplemented Grindel's observation on the photochemical properties of silver albuminates.

In 1826 J. L. Casaseca, of Salamanca, a pupil of Thénard, investigated the action of nitrate of silver oxide on vegetable substances, particularly on solutions of rubber, sugar, starch, flour, wine, alcohol, nutgalls, coffee, tea, licorice root. He found that especially tea, coffee, and nutgall infusions rapidly reduce metallic silver from silver solutions, and that ammonia, potash and soda promote this reduction.[54] "Moreover, light plays no role in this reaction, of which I have convinced myself by a direct experiment."

R. Brandes and Reimann carried on Zimmermann's experiments with silver nitrate solutions which contained one percent silver nitrate. In these experiments water remained for a prolonged period in contact with the respective organic substances, in order that it might absorb the soluble ingredients, and was then treated with the silver salt. The result of these experiments is recorded in the table on the following page.[55] Brandes and Reimann conclude that silver nitrate is decomposed by most organic substances when exposed to light and that the different colored cloudiness and precipitates might be made useful for reactions.

SUCKOW'S WORK ON PHOTOCHEMICAL ACTION (1827)

Dr. Gustav Suckow published, in 1827, a prize essay, *De lucis effectibus chemicis in corpora organica et organis destituta*, in which he discussed especially the processes of disassociation by light in organic bodies (plants, etc.) and chiefly referred to earlier investigations by other scholars of natural science. It was not until the enlargement of this work in its second edition (1832) that the important and original discoveries of Suckow were published.

GUSTAV WETZLAR DESCRIBES SILVER CHLORIDE AFTER BLACKENING IN LIGHT AS SILVER SUBCHLORIDE (1828); OTHER WORKS ON SILVER AND MERCURY SALTS

Gustav Wetzlar published, in 1828, his *Beiträge zur chemischen Geschichte des Silbers*,[56] in which he concentrated his attention on subchloride of silver. He was a practicing physician at Hanau (1799-1861) and director of the Wetterau Society of Natural Sciences. Since his investigations on silver chloride and its behavior toward light were regarded as authoritative on the subject for many years, it is necessary for us to describe them here in detail. In discussing the different formations of subchloride, he mentions the action of light on silver chloride. He states that until then blackened silver chloride

CHANGE IN DAYLIGHT

Substance Which Was Put in the Silver Solution	After 12 Hours	After 24 Hours	After 3-4 Days	Change in the Dark after Two Weeks
Green leaf	Reddish coloration	Full red coloration	Dark violet precipitation in the clarified solution	Slight violet precipitation
Pollen of camomiles	Do.	Do.	Yellowish red cloudy solution	Slightly brownish sediment
Lycopodium	No change	Slight wine yellow coloration	Brownish flocculance in the yellow solution	Yellowish coloration
Cork	Reddish opalescent	Brownish red opalescent	Reddish opalescent without precipitation	No change
Paper	No change	Weak violet coloration	Purple colored flocculance	Hardly noticeable change
Sugar	Weak brown coloration	Strong brown	Purple sediment from a clear solution	Violet coloration without precipitation
Rubber	No change	Violet coloration	Gray-violet	No change
Glue	Do.	Reddish coloration	Reddish brown precipitate from the clarified liquid	No change
Ether, alcohol, or essential oils	Do.	No change	Reddish color and separation of some blackish flocculance	No change
Leather	No change	Slight yellowish red coloration	Brown sediment from the decolorized liquid	Very slight sediment
Raw vinegar	Slight reddish turbidity	Increased turbidity	Purple precipitation	No change
Raw acetic acid from wood	Weak grayish brown turbidity	More greenish turbidity	Slight precipitation in the weakly greenish liquid	Slight greenish sediment

was held to be a mixture of metallic silver with silver chloride, which
theory was started by Scheele's experiment according to which am-
monia dissolved the silver chloride and precipitated metallic silver.
Wetzlar observed, after twenty-four hours of action by sunlight on
aqueous silver chloride, a strong odor of chlorine (this, however, had
been established by Fischer in 1814); he found that silver chloride
blackened in light did not become lighter in nitric acid, which, accord-
ing to his opinion, would have to happen if the blackening were
brought about by metallic silver. He called the dark silver chloride
formed by light "silver subchloride." This splits up not only in am-
monia but also when cooked in a strong solution of common salt. Iron
chloride and copper chloride also restored the white color of chloride
of silver. To this treatise of Wetzlar, Fischer replied in his *Über die
Natur der Metallreduktionen* (1828), in which he asserted his just
claim to priority with regard to his article published in 1814.

Wetzlar had earlier, on October 26, 1827, published the fact that
silver chloride-sodium chloride crystallized from aqueous solutions,
is not sensitive to light.[57] "It is curious that while hornsilver (silver
chloride) is the most sensitive of all silver salts to the action of light,
its compound with sodium chloride is not affected in the least by the
most intensive sunlight. The solution of the double salt suffers also
no change whatever in light." This statement is of interest, because
Daguerre used a solution of silver chloride in sodium chloride at first,
in order to fix his photographs on metal with a solution of common
salt.

Eilhard Mitscherlich, born in 1794, in East Friesland, found in 1827
that ammonium nitrate of silver and sulphate remain unchanged in
the air by exclusion of light, but turn black in daylight.[58] Following
upon each other the sensitivity to light of several compounds was
discovered, namely: silver nitrite, by Germain Henri Hess,[59] professor
of chemistry at St. Petersburg; quinate of silver, by Etienne Ossian
Henry and Peisson;[60] borate of silver, by Heinrich Rose;[61] pyrophos-
phate of silver, by Friedrich Stromeyer;[62] perchlorate of silver, by
G. S. Sérullas;[63] pyro-acetate of silver, by Berzelius;[64] lactate of silver,
by Pelouze and Gay-Lussac.[65]

Löwig found that a solution of mercury bromide disintegrates in
sunlight into mercurous bromide and hydrobromic acid, "without
doubt under liberation of oxygen." When sal ammoniac was added,
no decomposition was noticeable.[66]

Carbonell also wrote on the light-sensitivity of mercuric salts, particularly regarding potassium mercuric tartrate.[67] Harff wrote on acetate,[68] oxalate-tartrate, pyro-tartrate, malate, benzoate, and citrate of mercury.[69] E. G. Burkhardt also investigated these salts.[70] Willibald Artus, professor at Jena, studied especially the mercurous iodides (1836). It is worth noting that these authors do not mention the work of their predecessors which we have cited, men who had earlier described the light-sensitivity of some of these mercury salts.

DISCOVERY BY DOEBEREINER OF THE SENSITIVITY TO LIGHT OF THE OXALATE OF IRON OXIDE AND MANGANESE OXIDE

The researches of the celebrated chemist Johann Wolfgang Doebereiner on photochemistry are of the greatest importance. He occupied himself at first with the platinum salts and tincture of iodine, and these studies were followed later by many important discoveries, among them the greater light-sensitivity of ferric and manganic oxalates. Doebereiner was born near Hof, Bavaria, in 1780; studied pharmacy, practiced it from 1799 on at Karlsruhe, and devoted himself to the study of natural science, especially chemistry. He established a chemical factory at Hof, but was compelled to abandon the venture after two years. He continued his studies privately and was called to the university at Jena in 1810 as professor of chemistry, pharmacy, and technology, where he taught until his death, in 1849. He stood in friendly relations with Goethe and the Archduke Karl August of Weimar; his correspondence with them was published by Schade (Weimar, 1856). At that time his invention of the ignition of hydrogen by platinum sponge created the greatest kind of a sensation. We have already reported in this chapter his earlier and less considered photochemical studies. He continued them in 1828.

In 1828 Doebereiner described the light sensitivity of platinum chloride in an alcoholic solution and the sodium platinum chloride mixed with alcohol and caustic potash.[71] In 1831 Doebereiner also communicated numerous valuable observations in his dissertation *Zur chemischen Kenntnis der Imponderabilien in der anorganischen Natur*.[72] He found that the purple-red oxalate of manganese oxide decomposes rapidly in light (as well as in heat).

Of still greater importance is his discovery of the light-sensitivity of ferric oxalate, published in the same article (1831); this photochemical process was of lasting consequence in the subsequent inven-

tion of cyanotype, platinum papers, and so forth, as well as for use in numerous photometers.

Doebereiner observed that a solution of ferric oxalate remained unchanged when kept for a long time and after being heated for several hours. In sunlight, however, many bubbles of carbonic acid formed in a very short period. The liquid gradually became turbid and deposited, under the constant generation of gases, small, shining, lemonyellow crystals of ferrous oxalate (he called the product "Licht-Humboldtit"). He also determined that for one equivalent of carbonic acid, two equivalents of ferrous oxalate are separated.[73]

At the same time Doebereiner stated that platinum chloride with oxalic acid in light forms metallic platinum, besides carbonic acid and muriatic acid; also that chloride of gold and oxalic acid decompose more rapidly in the light than in the dark; further, that the brown solution of sal-ammoniac of iridium is light sensitive when mixed with oxalic acid.

BRACONNOT DISCOVERS THE REDUCTION OF SILVER NITRATE BY PYROGALLIC ACID (1831)

Pyrogallic acid, which later became so important in photography as a developer, was produced in a pure state by Henry Braconnot, professor of natural history at Nancy, in 1831,[74] who also found that it rapidly reduced metallic silver from silver nitrate solutions, while gallic acid, on the contrary, reduced it only very gradually.

SUCKOW'S DISCOVERY OF THE LIGHT SENSITIVITY OF BICHROMATES ON ORGANIC SUBSTANCES (1832)

In 1832 was published a photochemical work which, similar to that of Link and Heinrich, had for its object a general survey of the chemical effect of light: *Die chemischen Wirkungen des Lichtes* (Darmstadt, 1832), by the German scholar of natural science, Dr. Gustav Suckow, who was professor at the University of Jena, as was Doebereiner. Gustav Suckow was born at Jena, 1803, received his doctorate in philosophy at the University of Jena, where he settled and became eventually professor. His first publication was a dissertation on the chemical effects of light on organic and inorganic bodies: *De lucis effectibus chemicis in corpora organica et organis destituta* (1827), which had a second edition in German under the title *Die chemischen Wirkungen des Lichtes* (Darmstadt, 1832). We cannot consider here

his numerous analyses of minerals, his works on chemical mineralogy, on tests with blow pipes, or his textbooks on chemistry and mineralogy. But still greater is the importance for the history of photochemistry and photography of his experiments with potassium bichromate. He divided the substance according to the phlogiston theory: "On the phlogistic processes effected by light, which can be directly related to mixtures of substances," for instance, compound of chlorine and hydrogen, and so forth.

Professor Suckow was the first to discover that potassium bichromate, when mixed with an organic substance, is sensitive to light, while it is admitted that the light-sensitivity of chromate of silver was found by Vauquelin as early as 1798. The discovery of Suckow that chromates are light sensitive even in the absence of silver when organic substances are added is of special importance in photography. The reference in question in Suckow's book is, in effect:

When a solution of potassium bichromate and potassium bisulphate is exposed to sunlight and the effloresced salt is sprinkled in different places with powdered sugar, the most beautiful colored moss-like vegetation forms. In this process the exposure separates a part of the oxygen of the chromic acid, so that thereby the green (!) potassium chloride is formed.

Incidentally, he mentions the fact that this phenomenon occurs only under blue and violet glass, not under yellow glass.

This discovery of Suckow was entirely lost sight of by the historians of photography until this author recalled it to memory in 1880. According to Suckow (*Die chemischen Wirkungen des Lichtes*, 1832, p. 35) nitrate of silver is reduced in solid form as well as in solution by light, especially by violet, blue, and green light; after prolonged action by light, small particles of metallic silver are deposited. He also mentions that the use of an aqueous silver nitrate solution mixed with gum and india ink as a marking ink on linen, and so forth, is based on this decomposition in light.

Concerning silver iodide Suckow writes elsewhere:

A partial reduction of the silver in silver iodide occurs after continuous exposure to light, but more slowly than in silver chloride under the same conditions and by simultaneous decomposition of the water. This takes place by the action of colorless as well as of some colored lights, particularly violet and blue, but not red and yellow; it turns at first to a brownish shade and ends with the blackening of the salt.

Jermesite loses, Suckow states elsewhere, its transparency in sunlight; the turbidity commencing on the surface and gradually extending to the inside. The other portion of Suckow's book is devoted to the action of light on plant and animal organisms, and has no special interest for us.

LIEBIG'S PROCESS FOR THE REMOVAL OF SILVER STAINS

Liebig, in 1833, had come so close to the discovery of a fixative for silver chloride images that he could have answered without hesitation the precise question: "How can the undecomposed silver chloride be removed from a photograph on silver chloride paper so that the coated paper will not darken further after the removal of the chloride of silver?"

He described a "process for the removal of designs or stains made with so-called indelible ink, nitrate of silver.[75] The process consisted in treating the black parts with chlorine water until they became white and then applying ammonium hydroxide. If one forgot to remove the formed silver chloride by ammonia, Liebig added, the stains would reappear, after drying, as black as before.

LANDGREBE'S AND DULK'S COLLECTED WORKS "ON LIGHT" (1834)

George Landgrebe, born in 1802, at Cassel, published in 1834 the splendid collective work *Über das Licht, vorzugsweise über die chemischen und physiologischen Wirkungen desselben* (Marburg, 1834). He lectured at that time (1826-37) without salary at the University of Magdeburg, and later owned a chemical factory at Cassel. We have quoted Landgrebe's book extensively in this history.

In the same year F. P. Dulk published his dissertation, which is now very rare, on photochemical actions: *De lucis effectibus chemicis; commentatio, qua vira illustratissimo Trommsdorff ad festa doctoratus semisecularia condecorundo gratulata ordo philosophorum in universitate Regimontana, interprete F. P. Dulk* (1843).

Friedrich Philipp Dulk (1788-1851) was pharmacist and professor of chemistry at the University of Königsberg, East Prussia. His work is worthy of particular notice, because he deals chiefly with the chemical action of colored light. He pointed out that there was a movement to prove an opposite effect of the light action at both ends of the spectrum (see Ritter, and others, above). Dulk tried to approach the subject by a careful investigation of the behavior of various substances under

colored glasses, which lasted for three months. His experiments disclosed the result that mercuric oxide under colorless glass (turning black) had lost 0.9 percent of its weight, under violet glass 0.5 percent, under green 0.2 percent, under red 0.1 percent. Chloride of silver did not change color behind red glass, but under glass of other colors it turned dark, without loss of weight. When Dulk found that his silver chloride, which had turned dark in light, became white in a silver solution of nitric acid (contrary to Fischer and Wetzlar), he concluded that metallic silver is formed in light. Silver oxide was reduced only under white, violet, and green glass, not under red. Dulk's conclusion, the most important part of which is recorded here, is as follows: "The action of white light is strongest, then follows that of violet and green." He did not accept the theory of a different action of the opposite ends of the spectrum on chemical compounds.

ALLEGED INVENTION OF PHOTOGRAPHY BY HOFFMEISTER (1834)

There must also be recorded the publication in 1834 of a visionary scheme by the Reverend Philipp Hoffmeister for the production of light tracings by means of "a varnish" (?). He was, however, unable to produce any kind of proof or to approach as near the authenticated production of light images at which Wedgwood or Niépce had arrived. We would not mention this publication here, had not Hoffmeister, in 1863, made the inexplicable claim that he was "inventor of photography," for which he had not the slightest justification.

This alleged invention of Hoffmeister excited only passing attention. Hoffmeister wrote an autobiography, which is included in the continuation of Strieder's *Gelehrtenlexikon* (1863, I, 61), to which the Cassel daily newspaper *Kasseler Tageblatt* (Oct. 19, 1887), and some photographic trade journals (*Phot. Korr.*, 1887, p. 518; *Phot. Nachrichten*, 1890, p. 387) called attention. In this biography Hoffmeister claimed to be the inventor of photography; he states that to him, not to Daguerre, belonged the priority to the invention, and Hofrat Hennicke, the publisher of the *Allgemeinen Anzeiger und Nationalzeitung der Deutschen*, vigorously supported his claims.

Hoffmeister's original communication was published in the *Allgemeiner Anzeiger und Nationalzeitung der Deutschen* (1834, No. 303) under the title "Von den Grenzen der Holzschneidekunst, sowie auch einige Worte über schwarze Bilder." He states:

Permit the undersigned, Hoffmeister, to give a few hints how by sunlight

even paintings and copper engravings may be produced. Everybody knows how some . . . colors are bleached by sunlight; imagine then a board painted with such a color, upon which certain objects throw a shadow, and expose the board to the solar rays; soon a monochromatic painting will appear, which needs only to be varnished to be made permanent. Further, one could coat a tablet with a varnish which dries at once in the sun, but in the shade is not yet dry enough to take on a colored powder, and so without much trouble a multicolored painting could be produced. . . . Finally, the sun could be used as a tool to engrave on a copper plate or in lithography, since the sun rapidly absorbs every moisture and either accelerates a mordant (etching fluid) or destroys its strength; thus promoting or not the taking up of the blackening by the stone (lithography), according to whether certain parts are dry or not However, it is quite probable that the same effects (as by sunlight) may be produced by an intense fire, so that not every dull day would become also a holiday.

Professor Bezzenberger justly estimated the value of the claims in his article "Ein angeblicher Vorgänger Daguerres" (*Phot. Nachrichten*, 1890, p. 397), in which he stated that to the Reverend Hoffmeister belonged only a minor place in the history of photography. Personally, I believe the cited statement of Hoffmeister to be more the expression of an ideal wish than the result of experiments. At any rate, there is no mention of any practical result of his ideas. It was not until 1863, twenty-four years after the publication of the daguerreotype process, that Hoffmeister, in his autobiography, mentions that he had used an unsized paper coated red with cochineal in his experiments, which (ostensibly in the camera obscura?) was bleached in the light parts. By immersing them in size (glue), he had fixed the pictures. A critical consideration of the merits of this invention discloses that: (1) Hoffmeister gave no indication whatever in 1834 of the use of the camera obscura; he did so many years later and, therefore, cannot prove any claim to priority. (2) Cochineal papers are too insensitive to light to give images in the camera; that fixation by sizing is entirely insufficient and that Nicephore Niépce had tried unsuccessfully the use of colored paper. (3) Hoffmeister's idea to employ "a varnish" which would dry instantly in the sun has evidently no real background, otherwise he would have explained in his autobiography the details of his experience with this varnish, as he did in the case of the cochineal paper. Hoffmeister's claim has therefore no practical value and can compete as little with Wedgwood's claim to priority as with those of Daguerre and Niépce; indeed, Hoffmeister hoped even to achieve from a great fire

the same action as from sunlight, which shows that he had not reached the level of experience of numerous earlier physicists who were working in the same direction.

FIEDLER'S DISSERTATION (1835)

In 1807, at Adlersbach, Bohemia, was born Johannes Fiedler, who published in 1835 the dissertation, written with such great profoundness, *De lucis effectibus chemicis in corpora anorganica*, which carries the ingenious motto "Nihil luce obscurius" (nothing is darker [more unknown] than light). In this work there is gathered a discriminating digest of the material which had become known up to the year of its publication concerning the chemical action of light on inorganic bodies. The following tables, reproducing from the dissertation the photochemical processes there reviewed, gives a faithful picture of Fiedler's work.

I. CHEMICAL ACTIONS WHICH ARE CAUSED SOLELY BY LIGHT

Substances Which Were Used for the Experiments	*Result*
1. Carbon oxide + chlorine	
2. Ethane chloride + chlorine	Combine
3. Ethylene + iodine	
4. Ethylene + bromine	
5. Methane + chlorine	Combine to carbonic acid and hydrochloric acid, respectively, to ethane chloride and hydrochloric acid
6. Ethylene + chlorine	
7. Chlorine water	
8. Starch iodide	
9. Prussic acid + chlorine	Decompose
10. Oxalic acid + hydrochloric acid (?)	
11. Uranium chloride (+ organic substance)	Is changed to uranous chloride
12. Iron chloride (+ organic substance)	Is changed to ferrous chloride
13. Copper chloride	
14. Gold chloride	
15. Platinum chloride	Give up part of the chlorine
16. Mercury chloride	
17. Mercurous chloride	Forms metallic mercury
18. Potassium or sodium chloroplatinate	Is reduced to platinum
19. Iron sulphocyanide	Is decomposed

Substances Which Were Used for the Experiments	Result
20. Ferric oxalate	Is decomposed and ferrous oxalate is formed
21. Manganic bioxalate	Is decomposed
22. Platinum chloride + oxalic acid	Is reduced to platinum
23. Iridium chloride + oxalic acid	Is reduced to iridium
24. Silver oxalate	Is reduced to silver
25. Silver carbonate	Is partly reduced
26. Silver borate	Partial boric acid is liberated
27. Silver chloride	Is changed to silver suboxide
28. Red mercury oxide	Is changed to mercurous oxide
29. Mercurous oxide	Is reduced
30. Gold oxide	Loses oxygen
31. Antimony sulphide and oxide	Lose oxygen
32. Sulphurous acid	Quickly decomposes tincture of iodine in sunlight
33. Combustion	Is retarded in light

II. Chemical Actions Which Are Caused by Light and Heat

Substances with Which the Experiments Were Carried Out	Result
1. Mixture of chlorine and hydrogen	Combines with detonation
2. Bromine and hydrogen	Combine to hydrogen bromide
3. Ferrocyanide of potassium and sodium	Are decomposed
4. Gold chloride and oxalic acid	Reduced to gold
5. Silver phosphate	Loses one part of phosphoric acid
6. Silver nitrate	Gives off oxygen
7. Brown peroxide of lead	Loses oxygen
8. Chloroxide	Are decomposed into chlorine and oxygen
9. Chlorous acid	
10. Sulphuric acid	Gives off oxygen (?)
11. Nitric acid	Loses oxygen
12. Gold- and silver-salts mixed with essential oils	Are reduced

Fiedler took little notice of the chemical effect of colored light, stating only that violet light exercises the greatest effect, which follows

closely on that of white light, after which follow blue, green, and red lights.

ACTION OF LIGHT ON MEDICINE

Theodor von Torosiewicz published, in 1836, at Lemberg, a very remarkable article on the preservation of medicines in colored bottles.[76] He pointed out that for some time the necessity had been discussed in chemical pharmaceutical journals of disposing of the glass receptacles in the chemist's shop and in the storage room in such a manner as to protect their contents from the changing influence of sunlight.

It is well known to every pharmacist [continues Torosiewicz] that not only the preparations which lend themselves easily and quickly for mixtures such as chlorine water, hydrocyanic acid, animal Dippel-oil (bone oil), etc., but also most of the vegetable powders, when kept in transparent vessels, will suffer in time considerable change To obviate this evil, wooden containers were preferred to ordinary glass vessels, and it was recommended that the bottles in which liquids were kept be painted black or that so-called hyalite (glass-opal) bottles be used for the storage of medicines. Physicians always ordered that bottles be pasted with black paper if the medicinal compound contained hydrocyanic acid. The homeopaths also must, according to prescription, preserve their globules made potential with hydrocyanic acid in bottles completely covered with black paper The black paint on glass vessels, however, rubbed off very soon, and the black bottle was repugnant to the patient; hyalite bottles were too costly, and their opacity was inconvenient.

Therefore, Torosiewicz, following the declarations of Scheele, Bérard, and Suckow that the color of silver chloride under red and orange yellow glass is not changed, recommended the use of transparant, golden-yellow, orange, or red colored glass vessels for the preservation of all light-sensitive substances. On account of their lesser cost, he used yellow bottles and started a series of experiments, during which he observed the behavior of various substances exposed to light and their changes when contained in white and yellow glass vessels.

Chlorine water behind white glass became clear as water in eight days and contained no trace of free chlorine; behind yellow glass it remained still greenish after twelve days and retained all its original properties. A solution of iron chloride in ether became discolored behind white glass in twenty-four hours; behind yellow it remained unchanged after twenty days.

Hydrocyanic acid became yellowish under white glass after twenty days; under yellow, no change appeared after a month. Animal oil, which among all the essential oils changes most rapidly when exposed to light and air, remained as clear as water in a completely filled yellow bottle.

Mercurous iodide mixed with lard, much used in medicine at that time, turned dark on its surface in a minute behind white glass, and in the course of fifteen minutes became almost grayish-black. Under yellow glass, the salve assumed a somewhat darker, greenish color on the side which was turned to the light after a full day's exposure (the yellow glass therefore did not protect it completely). Doebereiner's compound of platinum chloride and lime water remained unchanged under yellow glass for several hours; under white glass, it became turbid within three minutes.

Chapter XVIII. SPECIAL INVESTIGATIONS INTO THE ACTION OF LIGHT ON DYESTUFFS AND ORGANIC COMPOUNDS (1824-35)

IN JACOB ROUX's *Die Farben, ein Versuch über Technik alter und neuer Malerei* (1824) it is demonstrated that the cause for the darkening, fading, and cracking of oil paintings is partly the use of artificially prepared oils and partly the selection and combination of the coloring matter. Roux considered carmine not very durable, while he regarded madder lake as the most permanent among vegetable colors.

He regrets that painters, with the exception of Rubens and a few others, do not trouble themselves to acquire an exact knowledge of paints and that even in many paintings by later artists, for instance, in the portraits of Graff (1736-1813), the paints had become cracked, faded, and darkened. On the change in painters' colors effected by light various statements are made by later authors.

Montabert found gamboge, chrome-yellow, indigo, and so forth in wax perfectly stable, but not in oil (*Traité complet de la peinture*, Paris, 1829, Vol. VIII). According to Knirim in his *Die Malerei der Alten* (1839, p. 166), cinnabar in wax colors and dragon's blood are durable in air and light. George Field states that carmine and cochineal, which change rapidly in light and air, remain unchanged for a half century

when light and air are excluded (*Chromatographie*, 1836). Of chrome yellow he writes elsewhere that it will keep unchanged a long time in sunlight, but will darken in impure air; he also mentions many other pigments.

Jean Boussingault writes, 1825, from Santa Fe de Bogota, where a great deal of orellin (bixin) was prepared, some details concerning the chemical behavior of this pigment. He relates that, while the Indians and Caribbeans paint their skins with a mixture of fat and orellin, they prefer chicha, a pigment made from Bignonia chicha, not only because the latter is a more vivid red, but because it does not fade so quickly in sunlight.[1]

Schubler and Frank wrote, 1825, on vegetable pigments;[2] Decourdemanche, pharmacist at Caen, recommended in 1826 that dried herbs and flowers be preserved by exclusion of moisture, tightly packed and kept from exposure to light. Vegetable powders, also, should be stored in a dark place, in fully filled bottles which had been painted black, because without these precautions the light would cause a change.[3] In Buchner's *Repertorium für die Pharmacie* (1826, XXIV, 287) there is a postscript to this article, in which Decourdemanche remarks that the action of light on thoroughly dried substances is not so energetic as is generally supposed. The principal causes of the spontaneous decomposition of organic substances are undoubtedly moisture and heat (referring to herbaria). In sealed vessels and in completely dry air (dried by quicklime) flowers keep for a very long time even under the action of light. Professor Georges Sérullas found that chlorine and hydrocyanic acid combine in sunlight.[4]

Dr. C. Sprengel, of Göttingen, experimented in 1828 with the probable action of light on the soil of tillable land.[5] He states that by the violet and the blue rays of sunlight the deoxidation of some of the constituent parts is promoted, especially in the presence of organic compounds, "so that, for instance, ferrous oxides form from ferric oxide when (exposed to light) they come into contact with humus and such like." At any rate, sunlight plays an important role in the growth of plants, which Sprengel investigated. He mentions that as a rule vegetables grown in sunlight are more nutritious than those grown in the shade because, he claimed, the action of sunlight promoted the formation of a larger starch, albumen, gluten, and sugar content.

Later Sprengel dealt more fully with this subject, in his *Chemie für Landwirte Forstwirte und Kammeralisten* (1830).[6] He stated that the

presence of ferrous and manganous oxides in the soil were due to the action of light, and he made the following assertion, but did not prove it: "When light has unobstructed access to humus, carbonic acid and water form on account of the retarded combustion of the fallen leaves; when, however, the access of light has been checked by thick layers of leaves in the forest, a more rapid combustion takes place with formation of humus acid (??)." Apart from these hardly exact statements, Sprengel offers many very interesting and valuable observations on the dependence of the growth of plants on light.

Professor W. A. Lampadius collected in his small essay published in 1830,[7] *Über die durch Imponderabilien bewirkte Veränderung des chemischen Verhaltens der Körper*, among other matters, some observations on the action of light:

1. Kastner's observations that lime exposed for a time to sunlight possesses a stronger force to promote the growth of plants than lime not acted on by the sun. He published this observation in his *Gewerbefreunde*. It would certainly be worth while to repeat this experiment . . .

2. The use of minerals decomposed by long exposure to the sun is preferable to those reduced to small pieces mechanically. Lampadius hesitates to attribute a great role to light with full certainty.

3. The bleaching of several fatty oils, which takes place when they are exposed to sunlight in completely filled bottles.

4. The sudden formation of fatty acid which can be observed, for instance, when fresh thoroughly washed butter is kept melted by sunlight for fifteen minutes under the air-exhausted receiver of an air pump.

In 1831 Pierre Jean Robiquet investigated a light bluish-gray, very durable colored substance and found that its color was due to silver chloride blackened in light. He attempted to reproduce this color by soaking some fabric in a solution of silver nitrate and then dipping it, when dry, in a solution of calcium chloride or in chloride of lime and exposing the surface covered with silver chloride to the action of light, whereupon the color developed.

A dyer tried this experiment on a large scale, but failed for the following reasons: "If the color is to develop evenly in all parts, it is necessary that all of the surface of the stuff be exposed to light at the same time. The dyer in question could not accomplish this in his workroom. He exposed only portions of the stuff one after the other to light, and that caused the uneven appearance. Under favorable circumstances, Robiquet states, the experiment would be quite successful."[8]

Konrad Zier investigated, in 1832, among other matters, the behavior of orange-red palm oil in light[9] and found that:

When palm oil is pressed into a narrow clear-glass tube, which is then hermetically sealed at both ends and exposed to sunlight, the color of the oil will scarcely be changed in the course of several weeks. The change takes place more rapidly if water is added to the oil and it is shaken from time to time after the heat of the sun has liquified it. When, however, light and at the same time air are allowed to act on a very thin film of oil, the bleaching will take place more rapidly, and the oil will finally turn entirely white.

Lampadius repeated this experiment in the same year[10] and found that a layer of palm oil, about one line high, in a glass dish was bleached completely white under the action of the direct rays of the July sun after scarcely twelve hours and that it had also lost its odor of violets. The heat of the solar rays had completely liquified the palm oil during the bleaching. In a heavier layer or in a not quite melted condition the bleaching takes longer.

C. Merck presented, in 1833, a simpler formula for the production of santonin, and found that its white crystals turned yellow in sunlight.[11]

In 1834 Herman Trommsdorff, Jr., after a searching investigation of santonin, confirmed the findings that the colorless crystals do not change in the air on exclusion of light, but turn yellow in a few minutes when exposed to the solar rays.[12]

In their investigation "Über das Berberin" the Buchners, father and son, discussed its usefulness for dyeing.[13] They stated:

A disadvantage of berberine yellow, as of most yellow vegetable colors, is its rapid bleaching in sunlight. When a piece of paper coated with a solution of berberine[14] is exposed to the rays of the sun for only a few hours, its color will appear perceptibly faded, and this is also the case with colored fabrics Contrary to all expectations those fabrics mordanted with tin crystals faded still more than those colored only with berberine. Those mordanted with copper vitriol faded rapidly; in those stuffs mordanted with tannin acid the fading was less apparent, in fact, we would say that they gained in beauty of color, at least silk and wool. Generally speaking, silk, and often wool, retain their color for the longest time, and if they change somewhat in sunlight, the color does not on that account become more disagreeable.

Landerer, of Athens, reports that phosphorus containing oil did not

liberate any red phosphorus even after a year and a half in the dark, while after three months' exposure to light, much red phosphorus had deposited on the sides of the glass vessel.[15]

C. Henry and A. F. Boutron-Chalard found, in 1836, that light acts quickly on nicotine and turns the colorless liquid to brownish yellow.[16] Berzelius found, in 1836, that the yellow and red coloring matter contained in the leaves of the trees in autumn is a dark yellow, sticky oil, a solution of which is easily bleached by light.[17]

Of great value are the experiments in the art of dyeing made by Michel Eugène Chevreul (1786-1889).[18] In his youth Chevreul studied chemistry under Vauquelin, was professor of chemistry at the Lycée Charlemagne; member of the Académie des Sciences, Paris, and of the Royal Society, London, director of the Royal Gobelins tapestry factory, and died at the age of 103 years, a foremost authority in the field of the chemistry of fats and colors.

In these researches Chevreul made a close study of the changes which the principal agents, such as pure water, air, sunlight, and heat produce under certain circumstances on the dyestuffs fixed on fabrics. He investigated especially the part played by oxygen in the air and by moisture in the decomposition of colors when exposed to light.

Chevreul describes his experiments as follows:

Cotton, silk, and wool yarns and fabrics which had been dyed in curcuma, safflower, orseille, indigo sulphate, indigo, and prussian blue were attached to cardboard and exposed to direct sunlight under the following conditions:

1. In a bottle from which the air had been exhausted and which contained calcium chloride.
2. In a bottle which contained air dried by calcium chloride.
3. In a bottle which contained air saturated with water vapor.
4. In the open air.
5. In a bottle containing pure water vapor.
6. In a bottle containing hydrogen gas dried with calcium chloride.
7. In a bottle containing hydrogen saturated with moisture.

The general results which were attained by these experiments are as follows:

1. The indigo contained in the cotton, silk, and wool remains unchanged when exposed to light in an air-tight chamber, while prussian blue in the same fabrics under similar conditions turns white. Curcuma fixed in these fabrics is changed in an air-tight chamber by the action of light, while orseille remains constant.

2. It is commonly believed that wool has the greatest affinity for pigments, while cellulose (cotton, linen, hemp) has the least. This view, however, is not correct in a general way, as is shown by the following: In a dry, air-tight chamber the light has no effect on orellin when fixed in cotton and silk, while when fixed in wool the effect of light-action is considerable. In moisture light changes safflower in wool and silk after prolonged exposure, while cotton dyed with it retains its rosy-red color; the only change which it then suffers is a shade toward violet. In moisture wool and silk dyed with orseille are not changed by light, while cotton dyed with it fades. Indigo-sulphate on silk exposed to light in an air-tight dry chamber remains unchanged, but on wool and cotton it changes color. In dry air and in the atmosphere silk treated with this acid changes, but not nearly so much as other fabrics. Indigo fixed on fabrics shows under the influence of light, dry air, and in the open air exactly the opposite behavior from indigo-sulphate; the first is less stable on silk than on cotton and wool.

3. In an air-tight chamber sunlight does not seem to affect indigo, orseille and safflower. In dry air, however, the action of light produces entirely different changes, but they are not equally noticeable in all pigments. The change in prussian blue on cotton is hardly noticeable, but more so in silk and wool dyed with indigo. Wool and cotton dyed with it change little, silk, more. Silk dyed with indigo-sulphate fades, while wool and cotton dyed with it change considerably. Orseille loses its color on cotton, while on silk and wool it leaves a reddish trace. Orlean on cotton remains very red, but is completely decolorized on wool. Curcuma yellow and safflower red are totally decolorized on all three fibers. Light and moist air, on the contrary, have little more effect on fabrics dyed with prussian blue than light and dry air; the same is the case with wool dyed with indigo; this also applies to the three fibers dyed with orseille and silk, but to orlean only on wool and silk, to curcuma in all three. Light and moist air, on the contrary, change much more than light and dry air, indigo-dyed cotton and indigo-sulphate dyed oil on all three fabrics; particularly striking is the difference of effect in silk and wool. Curcuma and orlean on cotton are much more subject to change by light-action in moist than in dry air. The action of light and of the atmosphere is about the same as that of light and dry air on prussian blue, indigo, wool, and safflower. It is greater, however, with indigo dye on cotton and silk, on indigo-sulphate on silk, orseille, orlean, and curcuma. The effect is almost similar to that of light and moist air on indigo-sulphate, on cotton and wool, on indigo, on cotton and silk, and on orlean. The effect is stronger on orseille, safflower, orlean, and especially on curcuma. Light and moisture bleach stuffs dyed with prussian blue more rapidly than light alone. In addition there forms a

brown precipitate in a bottle filled with moisture, which does not form in a bottle from which air has been exhausted and dried. Light and moisture change curcuma, cotton, and wool dyed with orlean; the orseille dyed cotton, while they bleach the safflower on cotton very little and the orseille on silk and wool hardly at all. Fabrics dyed with curcuma, orlean, safflower, and orseille behave in hydrogen the same as in an air-tight chamber. Light, hydrogen gas, and moisture together show results similar to those of light and moisture.

Regarding the theory of bleaching, it is demonstrated by this experiment that, with the exception of the fabrics dyed with prussian blue, none of the stuffs mentioned above can be bleached completely by light and that only cotton dyed with curcuma, orlean, safflower, and orseille could be bleached completely white in the open air.

In 1849 Chevreul investigated the action of light on prussian blue and found that in an air-tight chamber it liberates cyanogen by the action of the sun, but it turns blue again in the dark, absorbing oxygen.

In 1839 the celebrated French chemist Jean Baptiste Dumas observed the formation of trichloracetic acid in the action of chlorine on acetic acid under the influence of direct sunlight. He found that dry chlorine gas in a bottle with glacial acetic acid will not act in the dark, but reacts slowly in daylight and rapidly in sunlight. On very sunny days the reaction sometimes results in an explosion, when upon opening the bottle the gas which had formed escaped with force (*Annal. chim. phys.*, LXXIII, 75; *Jour. f. prakt. Chem.*, XVII, 202). This discovery gave the impetus to a series of photosyntheses.

RETROSPECT

When we review the efforts and tendencies of the experimenters who devoted their time in the epoch just covered to the chemical actions of light, we must conclude that the utilization of photochemistry for the production of light images, either by contact or in the camera obscura, had been relegated to the background and almost completely neglected. Photochemical processes were studied, sometimes in the interest of the theory of light, sometimes in the realization of their use in pharmacy or chemistry. Regardless, however, of the numerous highly important observations on the nature of photochemical effects, their full significance was not recognized until much later. The production of photographs and their fixation had not advanced beyond the early experiments of Schulze or Wedgwood. Indeed, in the writings

of the scientists of those days there is no indication of an earnest effort for the solution of these problems.

So much the greater, therefore, is the merit of the two French experimenters Niépce and Daguerre, who for decades quietly worked with astonishing persistence toward the production of light images in the camera obscura and their fixation, as well as on the production of printing plates by a photographic process. The world was indeed surprised to the utmost by the publication of the daguerreotype process in 1839. How the invention of Niépce and Daguerre developed from unimportant beginnings is told in the following chapters.

Chapter XIX. JOSEPH NICEPHORE NIEPCE

JOSEPH NICÉPHORE NIÉPCE (1765-1833)[1] may be named the inventor of photography in the camera and the inventor of heliogravure, owing to his having etched asphalt-covered metal plates. It was he who contributed the actual photographic part of the procedure when he joined with Daguerre in labors which led to the invention of the daguerreotype process, named after the latter. This process produced positive images in the camera by relatively short exposures to light. Niépce came from a rich bourgeois family of good standing which owned several estates and also a town house at Chalon-sur-Saône, where he was born.[2] His father was a lawyer and king's counsel. His firstborn child was a daughter. Then followed Claude Niépce (1763-1828) and Nicéphore Niépce, who was two years younger. Nicéphore and Claude lived in intimate fellowship, not only in their youth, but also throughout their later years. A portrait of Joseph Nicéphore Niépce drawn by his son Isidore was reproduced from a line etching in *La Lumière* of July 6, 1851.

A portrait of Claude was found only recently by Potonniée and published in the *Bulletin de la Société française de Photographie* (1929, p. 195). The youngest brother Bernhard (1773-1807) plays no part in the history of photography.

Nicéphore and Claude received a thorough education in the Catholic Seminary of the "Pères de la Congrégation de l'Oratoire." Nicéphore was destined by his father for the priesthood, and taught at the Seminary after having finished his studies. Then came the French Revolution; the order was dispersed. His family, rich and suspected of royalist

sympathies, had to leave Chalon. The National Convention at Paris decreed (September 28, 1791) that all French citizens between the ages of sixteen and twenty-five were to report for military duty in order to attain the rank of sublieutenant. When his father died, in 1792, Nicéphore tried to avoid the suspicion connected with his family by joining an infantry regiment. He became lieutenant on May, 1793, in the army sent to Italy and took part in the Italian campaign of 1794. He contracted typhoid fever, then very prevalent, which forced him to resign his commission and which ended his military career. Returning to France, he lived in Nice, where he married and became, in 1795, a member of the district administration. His brother Claude entered the French navy. Both brothers returned to their paternal home at Chalon in 1801, where they constructed a machine to be used as a motor for large boats. The motive power was derived from the ignition of lycopodium powder mixed with air. They called their machine "pyréolophore" and obtained a patent for the invention by a decree of Napoleon, dated Dresden, July 20, 1807. The brothers Niépce also occupied themselves with the production of indigo blue from dyer's woad (isalis tinctoria), to which the French government gave recognition; but they were unable to produce a sufficient quantity to satisfiy the demand for this dye extract.

Meanwhile, the invention of lithography was attracting much attention in Germany and France. Lithography was invented in Munich, 1797, by the Bohemian Alois Senefelder (1771-1834) and is fully described in his celebrated *Lehrbuch der Lithographie,* which appeared in 1818. He obtained the lithographic stones at Solnhofen, Bavaria, where later a monument to Senefelder was erected.

In 1802 Senefelder took his invention to France, but he met with no success. It was not until 1812 that Count Charles Philibert de Lasteyrie-Dussaillant, a well-known French agriculturist and son-in-law of General Lafayette, interested himself in lithography and won for it success. The Count traveled to Munich in that year to study the new art, but had to return to France, owing to Napoleon's unfortunate campaign in Russia. After the Restoration (1814) he again visited Bavaria, engaged workmen, purchased lithographic utensils, and returning to Paris started a lithographic establishment. The process was this time received with great enthusiasm, and many persons exploited the method.

Nicéphore Niépce interested himself in lithography and experimented with the use of a local limestone for this purpose, as his son,

JOSEPH NICEPHORE NIEPCE 195

Isidore Niépce, related many years later;[3] he coated the stone with varnish, engraved designs on it and etched them with an acid. The stones at his disposal lacked the required fine and regular grain. He therefore substituted pewter plates for the stones. It is only through the later communications by his son that we learn that Nicéphore Niépce coated plates with a varnish of his own composition and exposed them at the window under designs which he had made transparent to light. Since Nicéphore took only his brother and son into his confidence concerning his experiments, there are no documents of any kind extant for our study. It is certain, however, that the brothers spent more of their time from 1813 to 1815 on their mechanical inventions, particularly with the pyréolophore, than with heliographic experiments. Claude Niépce moved to Paris in 1816. This restricted Nicéphore in his experiments to his own endeavors, and he returned to the development of lithography. The progress of his work is found in the correspondence with his brother Claude, which contains important documents for the history of photography.[4] In his letter of April 1, 1816, he expressed the hope that he would be able to fix the colors of a picture; on April 12, 1816, he spoke of a kind of an artificial eye, which is nothing but a camera; on April 22, 1816, he wrote that he had accidentally broken the lens on his camera; on May 5 he complained of the difficulties he had in procuring a new lens. Fortunately, he found a solar microscope of his grandfather's with a lens of focal length suitable for his camera.

We learn from his letter of May 5, 1816, of his first exposure with a miniature camera he had constructed. He obtained "with the process of which Claude knew" a negative image on white paper, which he could not fix. Most likely he worked with silver chloride. In his letter of May 9, 1816, he wrote that it was not necessary to have sunshine for exposures.

On May 19 Nicéphore wrote: "I inclose in my letter two etchings made by the process which you know." According to Fouque this should be recorded as the first mention of a heliographic etching, but the following contents of the letter indicate that the reference is to photographic silver chloride images which were not fixed (Potonniée, p. 89).

F. Paul Liesegang writes to the author of this work:

Niépce speaks in his letter of May 19 actually of "gravures" (Fouque, pp. 67-68). But I am certain that he deals with images on paper. At the close of the letter he calls the pictures "retines" and advises his brother to

place them in a book between two pieces of blotting paper, since the images were not fixed. In his letter of May 18 Niépce speaks of paper as the picture carrier. He enclosed in this letter what he called "epreuves" (proofs) of four exposures (pp. 69-70 in Fouque, in which letter paper is mentioned). It must be remembered that the subject was a new one, and terms were not yet established. The word "gravure" was adopted by Niépce, probably because he compared the negative impression of his fledgling exposure with a print which had already furnished him with this method of reproduction (Fouque p. 65). In his letter of June 2, 1816, Niépce refers again to the four proofs which he sent on May 28 and again calls one of the pictures on this occasion "gravures" (Fouque p. 72). He explained to his brother the peculiarities of the images, on account of their unusual appearance, for they were negatives, i. e., the position of objects was reversed as to right and left. The exposures were made by Niépce from the window of his laboratory opposite a low-roofed outbuilding on which was a dovecot.

On June 2 Niépce writes that it was impossible to find a substance of greater light sensitivity. He had tried to fix images on metal plates by the aid of certain acids, but the light did not noticeably influence the action of the acids. He therefore treated the metal plates in the camera during the exposure with acids, hoping that the images would be etched by the action of light. He expected a great deal from such a process, which would produce plates from which reproductions could be obtained. It appears from his letters of June 16 and July 12, 1816 (Fouque, pp. 80-81) that he continued these experiments on stone, but without success.

The nature and method of Niépce's experiments are indicated in his letter to his brother Claude, dated June 16, 1816. He writes:

I have read that an iron chloride solution in alcohol, which is beautifully yellow, bleaches in sunlight and recovers its original color in the shade. I coated a piece of paper with this solution, which I allowed to dry; the portion exposed to daylight bleached, while the parts protected against the light remained yellow. But this coating absorbed too much moisture from the air; I did not continue to use it, because accident furnished me with a better substance. When a piece of paper is coated with a layer of Mars yellow—yellow iron oxide—and is exposed to chlorine vapors, it turns a beautiful yellow and bleaches more rapidly than the above (iron chloride). I have placed both in the camera obscura . . . but could not produce a light image; perhaps I did not wait long enough.

Niépce also tried to bleach manganese peroxide by light. He wrote, April 20, 1817, that he had given up the use of silver chloride and intended to use another substance. It appears from the same letter that he had read in a work on chemistry that guaiacum, which is yellowish gray,

turned beautifully green by exposure to light. It took on new properties, and in this condition a stronger rectified alcohol was required for dissolving it than in its original state. He coated paper with guaiacum and produced, certainly, a light image; but his efforts to fix it with alcohol were fruitless. He also read in the French edition of Klaproth's *Dictionnaire de chimie* that A. Vogel described in detail the light-sensitivity of phosphorus.[5] He hoped that by the use of "Alcohol de Lampadius," namely, carbon disulphide, he could fix the image. Niépce stated that in such a solution only the white phosphorus was soluble, not the red phosphorus which is formed by light.[6]

He worked indefatigably to produce a thin layer of phosphorus on stone; he expected to attain with this substance what he failed to accomplish with the acids, namely, to etch an image on stone by light in the camera obscura. On this experimenting, which evidently kept him very busy, he reports in letters dated April 20, April 30, May 30, and June 7, 1817 (Fouque, pp. 89-94). He now gave up these experiments, in the course of which he had burned his hands, and applied himself to the use of guaiacum, with which he had previously dealt in the letter of April 20, 1817.

This seems to indicate that Niépce was influenced by the photo-chemical investigations of his time and that his idea in using asphaltum as a light-sensitive substance may be traced to the German chemist Hagemann, who was the first to investigate guaiacum in 1782, and to other scientists who favored the continued investigation of its light-sensitivity.[7] Niépce had tried, according to his letters, to fix light pictures on guaiacum with alcohol, although unsuccessfully; the apparent change of color in the guaiacum, however, permitted no doubt of the evident action of light which had occurred. That numerous other resins were sensitive to light had been already demonstrated in 1782 by Senebier. In his experiments Niépce probably happened on asphaltum, which he undoubtedly had on hand, because lithographers use asphaltum varnish for coating the stone, and, as is well known, most of the varnishes used as etching grounds then, as now, contain asphaltum.

NIÉPCE'S OPTICAL INSTRUMENTS[8]

Niépce constructed three small cameras when, in the spring of 1816, he began his experiments in heliography; one camera six inches long with a sliding lens barrel, a miniature one, the size of a matchbox, and another between these two sizes. In the museum at Chalon five large

cameras are preserved, which undoubtedly date from a period after 1826. Noteworthy among them are one with a leather bellows and another with an iris diaphragm. It seems that Niépce is entitled to the claim of priority for both accessories.

Uninformed concerning the experiences and advances of the preceding few decades in the field of optics as applied to the camera obscura, Niépce used simple condensing lenses as objectives in his first experiments. He learned to control the objectionable lack of sharpness in the picture images to some extent by the use of a diaphragm. Unable to overcome the excessively long exposures, which he had hoped to surmount by the use of a condensing lens, he decided that it was impossible to find a useful process of greater light-sensitivity and for a time abandoned further experiments with the camera. He returned to the use of the camera in 1826, using the meniscus prism of the Parisian optician Chevalier, which was a total-reflection prism, the cathetal faces being curved, that is, ground hollow. Evidently dissatisfied, he passed on to experiments with the "megascope," an apparatus which was also made by Chevalier, a kind of a camera obscura which was to serve him for the reproduction of copper engravings, and so forth. This also brought him no success. He was not discouraged, however, and realized that

among the principal means for improving the process, those concerning optics must be put in the first rank. I was deprived of these resources in the few essays I made with the camera, although I strove to do my best by means of certain combinations. But it is with apparatus of this kind, perfected as much as possible, that a faithful image of nature may be obtained and conveniently fixed ["Mémoire" of his process which Niépce left with Francis Bauer—written and dated Kew, December 1827].

He investigated the possibilities offered by Chevalier's lenses of all kinds. He experimented with a lens of 24 inches focal length, also with four lenses of 3 inches diameter and 12, 18, 30, and 36 inches focal lengths; he seems to have worked with many combinations of lenses. In 1828 he ordered from Chevalier two Wollaston periscopic lenses, of which he undoubtedly learned during his stay for several months in England. Chevalier also furnished him with an achromatic lens. While the periscopic lenses furnished markedly better results than his previous appliances, he still had to be content with exposures lasting all day. He even used two lenses of 6 inches diameter and 24 inches focal length in biconvex form, according to Chevalier's recommenda-

tion, and from these expected to achieve success, by restricting himself to a small field, but in this also he failed to obtain satisfactory images.

His last hope was Daguerre, who, as he had known for some time, had worked on the improvement of the optics for the camera obscura. It appears from a letter of Niépce to the Paris engraver Lemaître that Daguerre had offered to collaborate with him. In the hope of overcoming his difficulties with the exposure by the aid of Daguerre's lens, Niépce accepted and this brought about the contract of December 14, 1829, which is discussed later in detail. All Daguerre had to offer, however, was an achromatic periscopic lens, undoubtedly made for him by Chevalier, such as he used later on his cameras. The discovery of this secret must naturally have been extremely disappointing to Niépce. Daguerre himself affirmed in a footnote to his paper of 1839 that Niépce's hopes were not fulfilled. The road to further development was not clearly indicated; it was necessary to find a material of greater light-sensitivity.

In 1817 Claude Niépce went to London in order to sell the "pyréolophore." Very little is known about the progress of heliography during this time. There are no letters of Niépce preserved from July, 1817, to May, 1826,[9] only some letters from Claude to Nicéphore, which are contained in Fouque's *La Vérité*. Claude, in his letter dated December 31, 1818 (Fouque, p. 101) speaks of a new substance from which Nicéphore expects much, but as to the nature of this substance he (Claude) cannot guess. He writes in a similar manner on August 24, 1819 (Fouque, p. 102). On January 22, 1819, Claude writes (Fouque, p. 104) that the new process seemed to have the advantage, if it succeeded, that it would give permanent images (fix them). It appears from Claude's letter of March 17, 1820, that Nicéphore used a varnish and treated it with an oil (asphalt process). From the letter of April 21, 1821 (Fouque, p. 106): "The main point was to find a means by which, once the image was obtained, it could be retained unchanged." In that lay the greatest difficulty. This establishes the fact that in 1821 Niépce could not produce fixed photographic images (Paul Liesegang).

At this time Niépce worked diligently in his country house at Gras, near Chalon-sur-Saône, on his photographic experiments. Niépce's town residence at Chalon was later converted into a museum for his works and adorned with a tablet commemorating his invention.

DISCOVERY OF PHOTOGRAPHY IN THE CAMERA; NICÉPHORE NIÉPCE PRO-
DUCED IN 1822 THE FIRST PHOTOGRAPH ON GLASS IN THE CAMERA,
FROM NATURE, BY THE USE OF THE ASPHALT PROCESS

A letter from Claude Niépce in London, dated July 19, 1822, to his brother Nicéphore in answer to one of Nicéphore's, expresses his joy at the good news of Nicéphore's success in the production of light images in Chalon-sur-Saône. Claude's letter reads:

General Poncet must be equally enthusiastic about the beauty of your discovery, of which your renewed success has given me the greatest satisfaction. I have read and re-read with admiration the interesting details which you had the kindness to send to me; I see you before me, also my dear sister and my dear nephew, attentively following with your eyes the wonderful work of the light, and I believe that I also saw the same picture which I recall with pleasure. How much I hope, my dear friend, that an achievement so beautiful and so interesting for you and for science may have a full and lasting result.

This letter contains in the first place the definite indication of the successful photograph of Pope Pius VII (the copy of a copper engraving) and speaks obscurely of a "point de vue"; the correspondence of the brothers shows their great concern about the necessity for secrecy, which tends to ambiguity. Potonniée urged the year 1822 as the birth year of photography in the *Bull. Soc. franç. d. phot.* (1921, p. 312) and his *Histoire* (1925, p. 102), pointing out that Niépce distinguished in his letters between printing from transparencies and the "veritable photographs," that is, made in the camera, which latter he was accustomed to call "points de vue." Now, Claude writes in his letter of July 19, 1822, of "points de vue." This letter was considered by Potonniée "irrefutable evidence" to prove that the invention of an exposure from nature was produced with the aid of the asphalt process by Nicéphore Niépce in 1822. He disputed the views of Fouque and other older historians, who, in their earlier reading of this letter, were misled because they saw in the letter a definite explanation of the Pope's portrait reproduced from a copper engraving by the printing process. According to Potonniée, the "points de vue" were the veiled reference to a camera exposure by Niépce of his courtyard in Chalon, which was reproduced by the asphalt process through a window on which a birdcage, and so forth, rested; this picture was supposed to have been taken in the camera and to have been fixed in the known manner. It should be pointed out here that Isidore Niépce, the son of

Nicéphore Niépce, many years later made the following remark from memory: "The pictures mentioned were produced by the asphalt process, and in the family the tradition existed that the year 1822 was the year of the invention of photography by Niépce." Other proofs, besides the letter cited above in this chapter, are, however, not available. The year 1822 was the date inscribed on the tablet on Niépce's home in order to establish the date of the invention. Lemaître, the engraver, who was later in frequent contact with the Niépce-Daguerre Company, also accepts 1822 as the year of the invention (*Bull. Soc. franç. d. phot.*, 1856, p. 41). And so the author of the present history will also assign 1822 as the year in which the brothers discussed between them secretly the first successful "photography in the camera"; but the element of doubt as to this conception cannot be entirely suppressed, the establishment of 1822 as the year of the invention of photography in the camera being chiefly based on the statements of Niépce's son, Isidore, whose recollections were not published until many years later.

The result of this exposure in the camera of 1822 has never been found, and Potonniée bases his statement on the philological interpretation of the letter, dated July 19, 1822, which after all has some claim to plausibility. In any event, the asphalt images or pictures were permanent and fixed. The copies of copper engravings produced in 1822 on light-sensitive asphaltum-coated plates were certainly very beautiful and sharp, as every expert knows who has used this process. Therefore, it is easy to understand why General Poncet was so enthusiastically impressed with the beauty of Niépce's discovery; he had before him the reproduction of an outline drawing, which no doubt represented the heliographic process discovered by Nicéphore Niépce and which was based on the asphaltum process. The mysterious phrase "point de vue" in Claude's letters Potonniée endeavored to explain by a philological interpretation, as is stated above. Other earlier competent historians read into this letter, the contents of which are so veiled and nebulous, an entirely different meaning. The most eminent of Niépce's biographers was Fouque, who was the librarian of the library at Chalon. He defended fanatically Niépce's claim to priority for the invention and published the result of his investigation in his now rare book *La Vérité sur l'invention de la photographie* (1867). He arrived at an entirely different conclusion. He read one hundred and one letters in the course of his studies—some written by Niépce,

others addressed to him. For all the details known about Niépce's life we are indebted to Fouque, which is emphasized also by Potonniée (*Histoire*, p. 74). Ninety-three of these letters are preserved to us; therefore Fouque had examined the majority of them. He also printed the letter of July 19, 1822, which we have quoted.

But Fouque, the most eminent of Niépce's biographers, read into this letter which is still extant, something entirely different from Potonniée. The letter in question is nebulous and secretive; it shows a carefulness not to divulge anything. But it plainly indicates that the beauty of the discovery and the novel successes elated General Poncet. Fouque, as well as many other historians, recognized in this remark an allusion to a photographic copy (that is, contact print) from a transparent engraving, representing Pope Pius VII, not a photograph produced in the camera. This furnishes us, then, with a very authoritative view of the most notable student of Niépce's history. Claude writes nothing in 1822 about the method of production. But Isidore, the son, in an unpublished manuscript, writes, as Potonniée quotes, that his father used at that time asphaltum on glass plates, and he adds: "It is by the use of this substance that he (Nicéphore) obtained in 1822 the admirable reproduction of Pope Pius VII, which he presented as a gift to his relative General Poncet de Maupas" (Potonniée, p. 104). He says nothing of an exposure from nature. It is very important to note that Isidore was quite clear on the point that the letter of July 19, 1822, refers to this reproduction (copy) in the form of an image on glass, not an exposure from nature in the camera. Potonniée differs from this, but it is possible that Fouque's view is correct and that would not contradict the opinion of Isidore. It is interesting to note that the conscientious physicist Arago in his great historical introduction (1839) to the report on the year of invention of daguerreotypy evades this question.

Whether the half-successful trial of an exposure in the camera in 1822 took place is not quite certain. Arago, in his report of 1839, established generally Niépce's claim to priority for the production of photographic pictures by the asphaltum process. He stated that Nicéphore Niépce invented photography with the asphaltum process and that he was the first to produce pictures by the aid of a camera. He also records, however, that exposures in the brightest sunlight required twelve hours and that the process was not fit for practical use.

It should be noted that every photochemist who has experimented with Niépce's process knows that such asphaltum images on glass could have produced only crude results compared with an exposure from nature, producing, as is known, a negative. No one more clearly than Niépce himself recognized that the road he took in making exposures in the camera could not lead to practical results; for the reason stated above, therefore, he turned to new researches on the light sensitivity of silver iodide plates, which afterward led, with the work of Daguerre, to the perfection of the invention of photography. At this time it must be remembered that Wedgwood and Davy were the first to recognize the fact that silver papers yield gradations according to the different intensity of the exposure to light, and to realize the possibility of the reproduction of middle or half tones, although both Wedgwood and Davy failed to accomplish their object—to produce images in or by the camera.

CELEBRATION OF THE CENTENARY IN HONOR OF THE INVENTION
OF PHOTOGRAPHY BY NIÉPCE

Marking the year 1822 as that in which photography was invented, a centenary celebration in honor of the inventor Nicéphore Niépce was held in Paris, on which occasion the memory of Daguerre also was highly honored.

The Société française de Photographie decided, in connection with the historical significance of the year 1822, to honor Niépce and Daguerre during the International Congress of Photography held at Paris in 1925 by a celebration. At a festival session at the Sorbonne, July 2, 1925, under the patronage of the French President Doumergue, the memory of Niépce and Daguerre, who have laid the basis for the photographic art, was commemorated. The official speaker of the day, Potonniée, said: "Niépce's experiments led in 1822 to the photographic reproduction of his own house on a tin (or pewter) plate, and thus the art of photography was invented." The city of Paris contributed a commemorative tablet with the inscription: "Here stood, from 1822 to 1839, the diorama of Daguerre, with his laboratory, where he, in collaboration with Niépce, discovered and perfected daguerreotypy." The underground railway necessitated the tearing down of this building, and a marble tablet was affixed to the wall of the barracks of the Garde Republicaine in the Place de la République.

THE FATE OF THE SUCCESSFUL ASPHALTUM COPY ON GLASS
OF THE YEAR 1822

General Poncet, a cousin of the brothers Niépce, was so well pleased with the asphaltum portrait of Pope Pius VII (a print from an engraving which had been made transparent), which had been made in his presence at Gras, near Chalon, that he asked for it as a gift from Nicéphore Niépce. He took it with him on his travels, and when one day an admirer of the glass plate accidentally dropped it, it broke. Thus was lost to us the first permanent photograph made by Niépce, which had passed into other hands.[10]

NICÉPHORE NIÉPCE DURING THE YEARS 1823-26; ETCHINGS
ON METAL BY HELIOGRAVURE IN 1826

Three years, from 1823 to 1825, inclusive, were spent by Nicéphore Niépce in experimenting with the production of asphaltum photographs on glass and on metal. In the Niépce Museum there is preserved a tin (or pewter) plate with the heliographic reproduction of Christ on the Cross, by the asphaltum process, which is inscribed "Dessin héliographique, inventé par J. N. Niépce 1824." This date should more correctly read "1826." The inscription is due to his son Isidore, who affixed it long afterward.

From 1826 dates the production of a heliographic pewter plate representing Cardinal Georges d'Amboise, Minister of Louis XII. Niépce had etched this heliographic plate in the summer of 1826 and sent it on February 2, 1827, to the engraver Lemaître, in Paris, who returned printed proofs of the plate to Niépce on March 5, 1827. The size of the original, preserved in the collection of the Société française de Photographie, in Paris, is 13.2 × 16.2 cm. (5.2 × 6.3 inches).

The date 1824 was erroneously written on the heliogravure by the keeper of the Chalon museum, Chevrier, instead of 1826, and this mistake was carried over into the collection of the Conservatoire des Arts et Métiers, as well as into the collection of the Paris photographic society. Fouque established the date 1826 as correct (see *Bull. Soc. franç. d. phot.*, Sept. 1919, 3d ser., VI, 299-302).

We learn from a communication of his son Isidore Niépce[11] the method used by his father at that time; it was a solution of asphalt in Dippel's animal oil[12] with which the pewter plate was coated, fixed by a "solvent" and then etched. Niépce sent this plate to Lemaître, a clever Parisian engraver, to be re-engraved (deepened by hand beyond the

depth attained by etching). This is undoubtedly the oldest photographic reproduction (heliogravure), and it was afterwards presented by Nicéphore Niépce's son Isidore to the Chalon museum. It was exhibited at the Paris Exposition in 1900 and is reproduced in the report of the Exhibition Committee.[13]

On January 1, 1827, Niépce sent to Lemaître two copper plates, prepared for etching, and shortly afterward five pewter plates slightly etched with acetic acid. He writes that he is busy producing gravures directly in the camera.

Regarding the use of pewter plates F. Paul Liesegang reports as follows: On May 26, 1826 (Fouque, p. 122), Niépce wrote to his son: "I have just received new pewter plates. This metal lends itself better to my purpose, especially for exposures from nature, since it reflects the light strongly, and the image appears sharper. I congratulate myself on this idea." The use of pewter plates was at this time evidently something new. This is important for the fixation of the dates of Niépce's work. His work on pewter plates cannot antedate 1826.

On January 17, 1827 (Fouque, p. 124), Niépce wrote to Lemaître in Paris, who did etching for him, that he had sent him two copper plates to etch eighteen months previously, that is, in the middle of 1825. Niépce was not adept at etching, as he states in his "Mémoire" written in England (Fouque, p. 149).

February 2, 1827, he sent Lemaître five pewter plates for etching; among the subjects were the Holy Family, a landscape, and a portrait. Lemaître inquired in his reply of February 7, 1827 (Fouque, p. 128), why Niépce changed from copper plates, and he was told that pewter was not so well adapted for this work. He returned the five plates which he had worked upon March 5 together with proofs, and wrote that they had "turned out" better than he had expected.

On March 17, 1827, Niépce requested Lemaître to send him six or eight proofs of copper engravings on thin paper, which he intended to use in his experiments with copying. He received them March 28, 1827.

Meantime Claude, who resided in London, fell ill, and Niépce traveled to London via Paris. He remained in Paris for a few days and visited (1827) not only Daguerre but also Lemaître. At this period he speaks enthusiastically of Daguerre's diorama and writes to his son Isidore on September 4, 1827, that Daguerre caught the images in the camera obscura on a phosphorescent substance, "which substance

eagerly absorbs light, but cannot retain it long."

NICÉPHORE NIÉPCE EXHIBITS ASPHALTUM PHOTOGRAPHS ON SILVERED PLATES IN ENGLAND IN 1827

When he arrived in London Nicéphore found his brother Claude seriously ill. On a chance visit to Kew he made the acquaintance of Francis Bauer, who was secretary to the Royal Society of London, and Niépce wanted him to submit to the Royal Society a "Mémoire" on his methods accompanied by proofs. This "Mémoire," dated at Kew, December 8, 1827, was, however, never printed in the proceedings of the society, since the method was not disclosed, and the society therefore declined to listen to the lecture on the invention. We learn of it first through Fouque, who published the "Mémoire" elsewhere.

Niépce then attempted to send, through Mr. Aiton, proofs of his process to the king, but with no more success. He lived not far from Kew, and during his stay he produced a picture of a church in Kew, which has since disappeared.

Here must be noted that in the "Mémoire" which Niépce wrote in England he calls attention to the shortcomings of images on pewter plates, that is, weakness of tone and poor contrast; he believed that he could get a better effect with highly polished silvered plates (Fouque, p. 149); which shows that at that time he had not yet used silvered plates (F. Paul Liesegang).

The first mention of his work on silvered plates is contained in his letter to Lemaître, August 20, 1828 (Fouque, p. 153). He writes there of the resumption of his work after his return from England, which was delayed by the nondelivery of silvered plates which he had ordered. On October 4, 1828, he wrote to Lemaître that he had sent an image on a silvered plate to Daguerre (Fouque, p. 153); Daguerre later speaks of this as an asphaltum image.

During his sojourn in England (1827) Niépce gave a Mr. Cussel at Kew one of his prints. The latter wrote on the back of the picture: "This prototype (undoubtedly erroneously meant for "phototype") was given me at Kew, in 1827, by Mr. Niépce, to whom we owe the invention of this art." As late as the end of the fifties Joseph Ellis, at Brighton, saw the print in the hands of Cussel, and he desired to acquire it. Cussel refused to part with it, because he himself placed a high value on its possession. After this Ellis never lost sight of the picture, and after Cussel's death, about the beginning of the sixties, and the sale of

his property, he started a search for it and found the picture in the hands of a second-hand dealer who thought it was a silvered plate. He scratched off the back to convince himself of that and so acertained that the metal was pewter, not silver, which circumstance alone is probably the reason why this specimen, so historically important, did not meet destruction in the melting pot of a smelter. Ellis bought the picture and preserved it with care. It was an asphaltum-coated pewter plate produced in a camera obscura and the reproduction of an engraving (*Phot. News,* July 11, 1862, VI, 336; Horn's *Phot. Jour.,* XIX, 4).

The Museum of the Royal Photographic Society, London, acquired, in 1924, three original plates by Niépce showing experiments in making light images by the aid of light-sensitive asphaltum coatings, which Niépce brought to London in 1827 on the occasion of his proposed lecture before the Royal Society, and presented to F. Bauer the secretary of the society; they passed into the possession of H. P. Robinson, and finally his son, Ralph W. Robinson, presented these rare objects to the above-mentioned museum, which is rich in historical documents. These plates represent: the often-cited portrait of Cardinal d'Amboise, originating from 1827, size 13.5 × 16.5 cm. (5.3 × 6.5 inches); Christ carrying the Cross, from 1826, the picture short of 7.5 × 10 cm. (3 × 4 inches) on a plate 13 × 19 cm. (5.1 × 7.5 inches); a landscape (reproduction) dated 1827, plate 12 × 15 cm. (4.7 × 6 inches). There was no exposure from nature among them.

Nicéphore returned to France in January, 1828; Claude died at Kew Green on February 10 of that year.[14]

Chapter XX. RELATIONSHIP BETWEEN NIEPCE AND DAGUERRE

COLONEL NIÉPCE, a cousin of Nicéphore Niépce, on January 12, 1826, visited the celebrated opticians Vincent and Charles Chevalier of Paris to buy optical equipment, particularly a camera obscura equipped with a "prisme ménisque"[1] which Niépce had asked him to purchase. This "prisme ménisque" was a meniscus lens invented by the Chevaliers. It was of glass, ground concave on one side and convex on the other. In the course of the conversation the colonel mentioned that his cousin Nicéphore was occupied with experiments leading to

the fixation of images produced by the camera obscura, and he showed them a proof of a heliogravure made by Niépce, which surprised them. In reply Charles Chevalier told him that a painter by the name of Daguerre, in Paris, was at that time working along the same lines, with the same purpose.

The famous opticians at the time of Niépce and Daguerre were Jacques Louis Vincent Chevalier (1770-1840) and his son Charles Louis Chevalier (1804-59), who especially devoted himself to the development of photographic optics in Daguerre's time. Charles Louis Chevalier wrote on the camera obscura (1829), on microscopes (1839), and *Sur une modification apporté au doublet de Wollaston* (1841), *Nouvelles instructions sur l'usage du daguerréotype* (1841), *Mélanges photographiques* (1844), *Sur quelques modifications apportées à des instruments optiques* (1841), and also other articles on microscopes. He also wrote *Photographie sur papier, verre et metal* (1856), *Méthodes photographiques perfectionnées* (1859). The third generation of the Chevalier family, Louis Marie Arthur Chevalier (1830-72), continued the business, having become associated with his father in 1848. He wrote *Méthode des portraits des grandeur naturelle et des agrandissements photographiques* (1862) and other articles on the subject.

Now a very curious incident happened, which Arthur Chevalier relates in his work *Etude sur la vie et les travaux scientifiques de Charles Chevalier* (Paris, 1862). A few days after the visit of Colonel Niépce an unknown young man called at the place of business of the opticians Chevalier and bought a cheap camera obscura, remarking, "I am sorry that my means do not permit me to buy a better camera equipped with a lens (appareil à prisme), for with such a one I might hope to fix the image on the ground glass of the camera better." At the same time he showed positive images on paper, which he stated were produced by the action of light. Later he brought to Chevalier a small bottle containing a brown liquid which he claimed was sensitive to light. Chevalier was unable to obtain a result with it, neither could Daguerre, whom Chevalier told of it; they awaited the return of the stranger without result—he never came back.

This incident led Chevalier to speak to Daguerre of Nicéphore Niépce's experiments with heliography. He gave Daguerre Niépce's address and advised him to communicate with him. At first Daguerre rejected this proposal, but he changed his mind and wrote a few days later, about the end of January, 1826.

Chapter XXI. THE LIFE OF DAGUERRE

LOUIS JACQUES MANDÉ DAGUERRE was born November 18, 1787, at Cormeilles-en-Parisis, France.[1] His father was a court attendant there,[2] but he moved to Orleans as an official of the royal government domain. Young Daguerre, who showed a talent for drawing, entered, when sixteen years old, the studio of the well-known scene painter Degotti. He there attained great proficiency in perspective and lighting and later collaborated with Prévost on many panoramic paintings in Rome, Naples, and elsewhere.

As an artist Daguerre showed astonishing ingenuity in the handling of light and lighting effects, and he supplied the scenic and lighting effects for a number of operas on the stages of Paris theaters. About 1820 he conceived the idea of improving the panorama (devised by the German Breysing and executed by Robert Barker, of Edinburgh, about 1793), realizing it in his invention of the "diorama," a variety of the panorama, which might be called the precursor of the modern picture theater. The first one shown in Paris was built by the American engineer Robert Fulton,[3] in 1804, and drew great audiences. In 1822 Daguerre associated himself with the painter Bouton in the construction of an improved panorama, which he called "Diorama." He opened it on July 11, 1822, at 4 Rue de Sanson, in a spacious showroom. A garden and main building on the adjoining corner of the Rue de Marais were connected with this establishment. Here Bouton lived, and later Daguerre, who conducted the business. The house was plain and included a studio. Today the barracks of the Garde Republicaine occupy the corner of the Rue de Marais,[4] and a tablet commemorating the discovery of photography by Niépce and Daguerre, affixed to the wall of the building, recalls its historic interest.

In addition to Bouton and Daguerre, other artists worked on the diorama, Hippolyte Sebron and Charles Arrowsmith (both pupils of Daguerre). Daguerre married Arrowsmith's sister.

Potonniée, in the *Bull. Soc. franç. de phot.* (April, 1920, 3d ser., VII, 80-85), cites a list of the changing pictures, (*tableaux changeants*) shown in the diorama.

The diorama was one of the main attractions of the city and achieved great popularity. The ticket of admission to the diorama for the year 1836 which was presented by Dr. O. Prelinger of Berlin, through Dr. Eder, to the collection of the Graphische Lehr- und Versuchsanstalt, Vienna, was first published in the *Phot. Korr.* (1918, LV, 309). It

shows that the diorama was open between 11 A.M. and 4 P.M. and that the price of admission was one franc, a considerable fee for those days. Of interest are Daguerre's autograph and the validity of the ticket for only a limited period.

One of the scenes of the diorama showed a catastrophe which occurred at Goldau, in the Swiss canton Schwyz, where in 1806 a tremendous landslide buried several villages and filled part of the Lowerzer Lake. Daguerre reproduced this in a painting, showing the rural scenery with artificial lighting effects. Another picture showed a midnight mass at the Church of St. Etienne du Mont, Paris. The interior of the church appeared at first in daylight, and gradually, by means of lighting effects from the rear, it "dissolved" to an evening view, passing eventually to a scene showing the midnight mass.[5]

Although at this time he was already quite busy with his experiments on the production of light images, he carried on the business affairs of the diorama. The original of the following letter of Daguerre, written in 1830, is in the collection of the Vienna Photographic Society.

Paris, July 1, 1830

My dear Mr. Dauptain:

Being unable yesterday to pay the last note of 548 francs, I called on Messrs. Camus and Cotu and requested them to give me until tomorrow, Friday, which they will gladly do on a word from you. Will you oblige me and give it to bearer.

Yours very devotedly,

[Signed] Daguerre

Messrs. Camus and Cotu, Rue des Arcis, No. 17.

It appears from this letter that Daguerre at that period was sometimes pressed for money, although he was considered well-to-do. His income from the diorama and from his painting incident to it furnished Daguerre with the means for his photographic experiments. The diorama continued to prosper until 1839, when a fire caused by the carelessness of a machinist destroyed the building and its interior fittings, including all his early works. The building was later reconstructed nearby by Bouton (1842-43), but Daguerre was no longer interested in it. An illustration of an exhibition in Daguerre's diorama in 1822 may be found in Tissandier's *Les Merveilles de la photographie* (Paris, 1874, p. 21).

The esteem in which Daguerre's diorama and his paintings were held is attested by the honor bestowed upon him in his appointment in 1824

as Chevalier of the Legion of Honor; in 1839 he became Officer of the Legion.

Daguerre's diorama consisted of paintings in which the change from daylight to evening light was realistically imitated; in some cases figures appeared and disappeared. The effects were produced by painting the picture on both sides of the thin linen, which was lighted now from the front and then from the back. The onlookers therefore saw the picture of the same subject under changed conditions; for instance, Vesuvius was shown in day by light concentrated upon it, and as seen at night by dim effects of light penetrating from behind.

DAGUERRE'S WORKS OF ART

We cannot go into detail here concerning the numerous paintings and the small number of lithographs, and so forth, by Daguerre. The *Bull. Soc. franç. d. phot.* (1894, 2 ser., X, 590-93) contains a gravure reproduction of one of his paintings.

Another well-preserved panoramic painting by Daguerre is found in the church at Bry-sur-Marne, the little town to which Daguerre retired after disposing of his invention in 1839. We owe this to the initiative of Mlle de Rigny, who lived in Bry at that time. This learned lady, who died at the age of 82 in her castle at Bry, in 1857, studied science and astronomy with Laplace and Bouvard. She induced Daguerre to paint a picture for the interior of the church. In order to find a place for it, she had built at her own expense an annex behind the altar. Daguerre worked diligently for six months, often fifteen hours a day, on this picture, which represents the nave of a Gothic cathedral and recalls the perspective effects of his diorama.[6]

THE DIORAMA AS SEEN BY HIS CONTEMPORARIES

It is interesting to read a view of a contemporary of Daguerre's picture show. August Lewald (1792-1871), German author and actor, who traveled a great deal, visited Daguerre at his Paris diorama in 1832, then called "Salle de miracle," and described his experience in his *Gesammelte Schriften* (Leipzig, 1845, p. 348). Dr. O. Prelinger called the attention of the present author to the publication. The chapter reads as follows:

A Breakfast at Daguerre's

We sat in a pleasant circle in the house of a friend at Neuilly. It was a beautiful evening; we inhaled the air perfumed by thousands of blossoms,

filling our lungs and giving us a feeling of infinite pleasure. Since we were in happy mood, our conversation was enlivened by friendly jests. A beautiful young English lady, who was leaving in a few days for Geneva and Chamonix and in whom I became interested, seemed to be the only one who did not take part in the entertainment. Jokes of all kinds were not scarce, but although they were kept within the strict limits, the young lady did not appear to enjoy them. I noticed her ill humor, winked at my host, and we left her severely alone.

After a while she told us, without being asked, the cause of her dejection. She came from one of the romantic sections of her country, where verdant hills change into rocky scenes, seeming like the work of an artist. She recalled the quiet solitude, comparing it with the noise and the hustle of the city and even of the countryside, and this produced the melancholy sadness in her.

"And do you suppose that you cannot find again right here your mountains, your rural scenes, in short, everything which you miss so sorrowfully?" I asked.

The author, Lewald, then relates how the small company went to Daguerre's diorama.

Here was no theater, no wings, we found ourselves under the eaves of a Swiss peasant's home. Farm tools were strewn about here and there; it looked as if our unannounced arrival had scared away the bashful tenants. Below us we saw a small courtyard surrounded by buildings. On our right an open window from which hung some clothes for drying; there was a sawhorse and an axe and some wood that had been cut lay about under the stable doors; at our left a goat bleated, and not far away the melodious bells of the herd faintly sounded.

But a little farther on, what a view! The valley, covered with snow, was protected by the mountain giants. There could be no further question of what we saw before us. I extended my hands and explained that before us was Chamonix, more than three thousand feet above sea level; at our left Montanvert, lifting his white head above the green night of the fir forests; in the middle of the valley the majestic hump of the Dromedar, that highest point of the Mont Blanc group, 14,700 feet high; on the right, still hidden by the clouds, the Dom du Gouter; below Mont Blanc the glorious Bosson glacier, whose icy foot is rooted in the valley itself; and not far away the Breven. On the left the giant granite needles reach up to the dark sky, and in the center the Arveyron gurgled its way through ice and snow. Beaten paths showed in the snow, a few houses slumbered peacefully surrounded by grave firs covered with snow.

"It is April," I concluded, "which, of course, is warmer here than there.

We can transcend space, but it is not within the power of man to drive forward the wheels of time. A month later, and this lovely valley would have presented itself more pleasantly in the finery of its green meadows."

Everyone stood still with astonishment, but one surprise follows another.

Behind us wooden plates, spoons, and glasses clattered. We turned around and saw a young girl in the costume of the mountain folks serving a country breakfast consisting of milk, cheese, dark bread, and sausage, while a footman poured Madeira, port wine, and champagne into crystal glasses.

"I am enchanted!" said the young woman, pressing my hand as I escorted her to the nicely arranged table.

We were seated at breakfast when the Alpine horns sounded a short festival ritornello, after which a strong male voice in the valley sang a national song "The Chamois Hunter" in the dialect of the Chamonix Valley.

We were all wonderfully touched; the young lady had tears in her eyes.

"That cannot be painting, so far your magic cannot extend," she said finally; "there is here an extraordinary combination of art and nature, producing an overwhelming effect, and one is unable to discern where nature ceases and human skill begins. That house is built, those trees are natural, and further—yes, further," she said hesitatingly, "one is lost. Where is the artist who created this?"

"My friend Daguerre," I exclaimed enthusiastically, "long may he live!"

All clinked their glasses and Daguerre approached, thanked them, and expressed his pleasure at having been able to give them this pleasurable surprise in his diorama.

"Many art critics wanted to indict me for the crime of mixing art and nature; they say that my live goat, my real pines, and the peasant's hut are artifices prohibited to the painter. Be that as it may! My only aim was to effect illusion at its greatest height; I wanted to rob nature, and it was therefore necessary to become a thief. If you visit Chamonix, you will find everything substantiated; the hut, these eaves, and all the stage properties you see here, even the goat down there I imported from Chamonix."

"Then it is the diorama I am visiting?" asked the young lady.

"Yes."

"But the singers; the breakfast?"

"We are in Paris. Our boulevards furnish dancers, singers, costumes, and breakfasts according to the taste of all nations."

"Extraordinary! This kind of surprise can only be achieved in Paris."

"And a breakfast like this could only be served by Daguerre, the greatest living artist in his class. Let us ascend the stairs and admire the smaller paintings of the diorama."

We were standing under a gorgeous cupola, and the platform on which

we stood revolved. There passed before our enchanted eyes glorious Edinburgh, illuminated by a fire, and the tomb of Napoleon at sunset.

August Lewald added the note that this was written as early as 1832, when no one knew that Daguerre was busy with photographic experiments or dreamed that he was to be so great an inventor.

SPREAD OF THE DIORAMA TO OTHER COUNTRIES

Bouton went to London in 1832, painted several pictures for dioramas in England, and shipped some of them to America. He returned to Paris after the destruction of Daguerre's diorama (1839) and built a new show place in the neighborhood (1842-43).

In Germany the diorama found its first home in Breslau, but the only important one, modeled after the Paris diorama, was built at Berlin in 1826 by Carl Gropius, who learned personally from Daguerre the details of construction and equipment. It continued its operations until the fifties and then succumbed, like its Paris predecessor, with all its painted scenery, to a conflagration.

Erich Stenger has reported on this in his booklet *Daguerre's Diorama in Berlin; ein Beitrag zur Vorgeschichte der Photographie* (Berlin, Union deutsche Verlagsanstalt, 1925). This is written with a great deal of technical knowledge and shows intensive research.

Without going into details of the later popularization of the diorama, we must mention a Swedish diorama on which Helmer Bäckström, in *Nord. Tidskr. f. Fot.* (1920, IV, 17), reports: "In the autumn of 1843 a small diorama painted by C. A. Dahlström opened in Stockholm; in 1846 the decorative painter of the Royal Opera House, G. A. Müller, started a new diorama, soon followed by other installations."

DAGUERRE'S STUDIES OF PHYSICS, HIS EXPERIMENTS WITH THE CAMERA OBSCURA, AND HIS CONTRACT WITH NIÉPCE FOR JOINT WORK (1829)

Along with his artistic labors, Daguerre constantly applied himself to his physical studies, especially concerning light and its action. However, at that time he seemed to have experimented only with phosphorescent substances, and his studies covered mainly the camera obscura. His improvement of the camera obscura consisted in causing Chevalier to improve the periscopic lens by achromatizing it, a lens which had been introduced by Wollaston (1812). The well-known optician, Charles Chevalier, at the Palais Royal, in Paris, furnished the optical accessories. We have already mentioned how Chevalier offered

an opportunity for the coming together by correspondence and in person of Daguerre and Niépce.

At first their relations were very constrained, owing to the mutual reluctance to divulge too much concerning the results each had achieved. Nicéphore Niépce brought the matter to a head in 1829 by accepting Daguerre's offer to join him in the further improvement of the heliographic processes.

Chapter XXII. THE AGREEMENT BETWEEN NICÉPHORE NIEPCE AND DAGUERRE (1829)

ON DECEMBER 14, 1829, a contract was drawn up by a notary between Nicéphore Niépce and Daguerre. The latter came specially to Chalon for this purpose. The first paragraph of the agreement signed by them stated: "Between Niépce and Daguerre, formed to co-operate for the further improvement of the invention of Niépce which was perfected by Daguerre."

Owing to the historic importance of this contract, we give here a literal translation of the original:

Basis of the Preliminary Agreement

between the undersigned M. Joseph Nicéphore Niépce, landowner, residing at Chalon-sur-Saône, Department Saône-et-Loire, party of the first part, and M. Louis Jacques Mandé Daguerre, artist-painter, member of the Legion of Honor, Director of the Diorama, residing at Paris at the Diorama, party of the second part, who propose to establish a company planned by them, have set down the following preliminaries, to wit:

M. Niépce, in his endeavor to fix the images which nature offers, without assistance of a draughtsman, has made investigations, the results of which are presented by numerous proofs which will substantiate the invention. This invention consists in the automatic reproduction of the image received by the camera obscura.

M. Daguerre, to whom he disclosed his invention, fully realizing its value, since the invention is capable of great perfection, offers to join with M. Niépce to achieve this perfection and to gain all possible advantages from this new industry.

According to this arrangement the contracting parties have set down their agreement to the preliminary and basic articles in the following manner:

Art. 1. Under the name of the firm Niépce-Daguerre a company is founded between Messrs. Niépce and Daguerre for the joint work on the further perfection of the above mentioned invention made by M. Niépce and perfected by M. Daguerre.

Art. 2. The term of this contract is to be fixed for ten years from December 14 of the present year; the partnership cannot be dissolved before the end of this term without the mutual consent of the interested parties. In the case of death of one of the associates his assignee takes his place for the unexpired period of the ten years; further, in the case of death of either partner, the above-mentioned invention may only be signed by the two names designated in Art. 1.

Art. 3. Immediately following execution of this contract M. Niépce must communicate to M. Daguerre, under the seal of secrecy, which is to be protected by a penalty covering costs, damages, and interest, the principle on which his invention is based and to place at his disposal the exact and fully detailed documents on the nature, the use, and the different ways of manipulation which are referred to in order that by complete co-operation the research and experiments may be directed to the perfection and exploitation of the invention.

Art. 4. M. Daguerre binds himself at the risk of the above-mentioned penalty to preserve absolute secrecy, not only in regard to the basic principle of the invention but also regarding the nature, application, and use of the processes which will be communicated to him, and in addition to co-operate as much as possible in the improvements deemed necessary, contributing his knowledge and talents.

Art. 5. M. Niépce contributes to the company and transfers to it his invention, which represents the value of half of the returns capable of attainment, and M. Daguerre contributes a new design for the camera obscura, his talents, and his ability, which are considered equal to the other half of the returns mentioned.

Art. 6. Immediately following the execution of this contract M. Daguerre must communicate to M. Niépce under the seal of secrecy, which is to be protected by a penalty covering costs, damages, and interest, the principle on which the improvement is based which he has added to the camera obscura and is to place at his disposal the most fully detailed documents describing the nature of the improvement mentioned.

Art. 7. Messrs. Niépce and Daguerre are each to contribute one half of the cash capital necessary for the starting of the business.

Art. 8. If the partners deem it appropriate to apply the above-mentioned invention to practical use by the process of engraving, i. e., to employ the advantages which may arise for the use of the above-mentioned process by an engraver, Messrs. Niépce and Daguerre pledge themselves to choose

no other person but M. Lemaître for the execution of the mentioned use.

Art. 9. On the execution of the final agreement the partners nominate from among themselves the director and the treasurer of the company, which has its place of business in Paris. The duty of the director is to manage the enterprises stipulated by the partners, and that of the treasurer to collect the outstanding debts assigned to him by the director for the benefit of the company and to settle all bills payable.

Art. 10. The term of service of the director and the treasurer run for the term of the present contract. Re-election is permissible. A compensation for their services cannot be demanded by either the director or the treasurer, but there may be allowed to them a participation in the profits as compensation, if it is so agreed at the time of execution of the final contract.

Art. 11. The treasurer is to submit to the director every month his accounts and the trial balance of the company, and the profit is to be divided every half year among the partners in the manner stipulated below.

Art. 12. The accounts of the treasurer and the trial balance are to be examined, ratified, and discharged semiannually by the partners.

Art. 13. The improvements and perfections to the above-mentioned invention, as well as those added to the camera obscura, are and remain the property of both partners who, when they have attained the object which they desire, will execute a final contract on the basis of the present agreement.

Art. 14. Half the profits of the company from the net proceeds of the company are to be paid to M. Niépce as inventor, and half to M. Daguerre for his improvements.

Art. 15. All controversies which may arise between the partners from this present agreement are to be decided finally, without recourse to the courts, by arbitrators who are to be called in by both sides in friendly agreement, according to Art. 51 of the Code of Commerce.

Art. 16. In case of the dissolution of the company, the liquidation is to be executed by the treasurer, by mutual agreement, or by both partners together, or finally by a third person on whom they agree, or who is appointed by the competent tribunal on the application of the partner in charge of the business affairs.

Approved and attested

[Signed] J. N. Niépce

Approved and attested

[Signed] Daguerre

Recorded in the Register at Chalon-sur-Saône, March 13, 1830. f. 32 V. C. 9 and ff. Received 5 fcs. 50 ctms., including the tax.

[Signed] Decordeaux

The signatures and acknowledgment to this important agreement are reproduced in facsimile by a line etching which shows the autographs of Niépce and Daguerre in Eder's *Geschichte der Photographie* (4th ed., 1932, p. 282).

In Article 3 of the contract Niépce is pledged to describe exactly the principle underlying his invention. Since this document has been preserved to us, we know that Niépce was perfectly familiar with the heliographic asphalt process.

This "Notice sur l'héliographie," by Nicéphore Niépce, written as a supplement to the above agreement in 1829, was published by Daguerre himself in his *Historique et description des procédés du daguerréotype et du diorama* (Paris, 1839). Fouque also prints this in his book. Niépce writes:

The invention which I made and to which I gave the name "heliography" consists in the automatic reproduction, by the action of light, with their gradations of tones from black to white, of the images obtained in the camera obscura.

Basic Conception of This Invention

Light in the state of combination or decomposition reacts chemically on various substances. It is absorbed by them, combines with them, and imparts to them new properties. It augments the natural density of some substances, it even solidifies them and renders them more or less insoluble, according to the duration or intensity of its action. This is, in a few words, the basis of the invention.

First Substance: Preparation

The first substance which I use, the one which makes my process most successful and which contributes more directly to the production of the effect, is asphaltum, or the so-called bitumin (pitch) of Judea, which is prepared in the following manner:

I fill half a glass with this pulverized pitch and then pour, drop by drop, lavender oil on it until the pitch will absorb no more and is entirely saturated with it. Then I pour more of this essential oil on it until it stands three "lignes"[1] above the mixture, which is then covered and set in a place of moderate temperature until the oil is saturated by the coloring matter of the pitch. If this varnish is not of the proper consistency, it is allowed to evaporate in a dish, protecting it against moisture which would modify and finally disintegrate it. This unfortunate result is particularly to be guarded against in the camera during the cold damp season.[2]

If a highly polished metal plate plated with silver is coated with a small amount of this cold varnish, using a very soft leather ball, it gives the plate a beautiful red color and spreads over it in a very thin uniform coating. Then the plate is placed on a hot table which is covered over with several layers of paper, from which the moisture previously has been removed, and when the varnish is no longer tacky, the plate is withdrawn to allow it to cool and permit it to dry completely in a moderate temperature, protected from the influence of the moisture in the air. I must not forget to mention that this precaution is indispensable principally when the varnish is applied. In this case, however, a thin disk is sufficient, in the center of which a short peg is fixed, which is held in the mouth to keep away the moisture of the breath and condense it.

A plate prepared in this manner may be exposed immediately to the action of light; but even after prolonged exposure nothing indicates that an image really exists because the impression remains imperceptible.

It is therefore a question of developing the picture, and this can only be accomplished by the aid of a solvent.

Preparation of the Developer

Since the developer must be regulated according to the result that is to be obtained, it is difficult to determine the proportions of its composition with exactness; but all things being equal, it is desirable that it be a little weak rather than too strong; that which I prefer consists of one part lavender oil and six parts of white mineral oil or petroleum. The mixture, which at first is quite milky, becomes perfectly clear after two or three days. It can be used several times in succession, losing its solvent property only when it approaches the saturation point, which is indicated by the liquid's becoming turbid and dark in color; but it may be distilled and made as good as before.

When the plate or varnished tablet is taken out of the camera, it is placed in a white metal dish an inch deep, and longer and wider than the plate, and a plentiful quantity of this developer is poured in it, covering the plate entirely. When the plate is observed under an oblique light at a certain angle, the image can be seen to make its appearance, slowly and gradually developing, although still darkened by the oil which, saturated more or less with varnish, flows over it. The plate is then taken from the liquid and placed in a perpendicular position, in order that it may be entirely drained of all developer, after which we proceed to the last operation, which is no less important.

Washing the Plate

A very simple arrangement is required, consisting of a board four feet long and a little wider than the plate. Two strips are nailed on lengthwise,

which form a border two inches high. On top is a hinged handle which makes it possible to move the board up and down in order to give the water which is poured on it the required speed. At the bottom is a vessel which receives the liquid flowing off.

The plate is placed on the inclined board and is kept from sliding off by two small nails or hooks, which, however, must not protrude above the face of the plate. At this time of the year (winter) it must be remembered to use lukewarm water. The water is not to be poured upon the plate itself, but on the board, somewhat above the plate in order to obtain a fall sufficient to carry away the last of the oil adhering to the varnish.

The picture is now fully developed and appears perfectly and completely defined if the operation has been successful, especially if one has a perfect camera obscura at one's service.[3]

Uses of the Heliographic Process

Since the varnish can be used with equal success on stone, metal, and glass without necessitating any change of procedure, I shall confine myself to the method of application to silvered plates and glass, calling attention once for all to the fact that in printing on copper a little wax, dissolved in lavender oil, may be added to the varnish mixture without damage.[4]

Until now silvered plates seem to me best suited for the production of pictures, owing to their white color and their nature. It is certain that after washing, assuming that the image is quite dry, the result is satisfactory. It would be desirable, however, to obtain all gradations of tone from black to white by blackening the plate. I therefore occupied myself with this subject, using at first a solution of potassium sulphide (sulfure de potasse); but if a concentrated solution is used it attacks the varnish, and if diluted with water it turns the metal red. This twofold defect compelled me to give up this medium. The substance which I am now using with greater expectation of success is iodine,[5] which has the property of evaporating at ordinary temperatures. In order to blacken the plate by this method, it is only necessary to place the plate against the inner side of a box that is open at the top and to put a few grains of iodine into a groove cut into the opposite side on the bottom of the box.

It is then covered with a glass, in order to observe the result, which, although it shows less rapidly, is all the more certain in its effect. The varnish can then be removed by alcohol, and not a trace will remain of the original impression. Since this process is still quite new for me, I confine myself to this simple description until experience has allowed me to collect more precise details.

Two experiments showing views on glass exposed in the camera obscura have furnished me with results which, although still faulty, seem to me

quite remarkable, because this mode of application can be more easily perfected and therefore may become of special interest.

In one of these experiments the light, which had acted with less intensity, had dissolved the varnish in such a manner that the gradations of tones showed more clearly when viewed by "transmission" (i. e., transmitted light), so that the picture reproduced, up to a certain point, the well-known effects of the diorama.

In the other experiment, however, where the action of the light was more intense, the lightest parts, which were not affected by the developer, remained transparent and the gradations of the tones depended entirely and solely on the density of the more or less dark layers of the varnish. If the image is viewed on its varnished side by reflection in a mirror, and held at a certain angle, the effect is greatly enhanced, while if viewed by transmitted light, it appears confused and colorless, and, what is still more remarkable, it seemed to differentiate the separate tones of certain objects. When I considered this curious phenomenon, I believed that I might draw certain conclusions from it, which permitted a connection with Newton's theory of colored rings. It would be sufficient to assume that any prismatic ray, the green for instance, in acting on the substance of the varnish and combining with it, gave it the necessary degree of solubility, so that after the double operation of the developer and the rinsing, the layer which had formed by this method would reflect the green color. Whether this hypothesis is well founded is a matter for future investigation, but the subject seems to me of itself so interesting that it may well deserve further experiments and more exact proof.

Remarks

Although the application of the necessary media described above undoubtedly offers no difficulty, it may happen (when the procedure is not carefully followed) that in the beginning the operation will not turn out well. I believe, therefore, that it is advisable to start in a small way by copying copper engravings in diffused light according to the following very simple method. Varnish the engraving only on the reverse side to make it thoroughly transparent. When the paper is completely dry, place it face down on the coated plate under a glass, the pressure being modified by inclining the plate at an angle of 45 degrees. By this method it is possible to make several experiments in the course of a day, using two engravings properly prepared and four small silvered plates. This can be done even in overcast weather, providing that the workroom is protected against cold and especially against moisture, which, I repeat, deteriorates the varnish to such an extent that it will float off in layers when the plate is immersed in the developer. It is for this reason that I ceased using the camera obscura

during the inclement season. If the experiments which I have described are continued, one will soon be well able to carry out the details of the whole process.

In the matter of applying the varnish, I must call attention again to the fact that it can be used only in a consistency which is thick enough to form a compact yet thin coating, in order that it might resist better the action of the developer and become at the same time more sensitive to the action of light.

In respect to the use of iodine for blackening the images produced on silvered plates, as well as regarding the acid for etching the copper, it is essential that the varnish after washing be used exactly as described above in the second experiment on glass; because it becomes thus less permeable, both in acid and under the iodine vapors, particularly in those parts where it has retained full transparency, for only under these conditions can one hope, even with the best apparatus, to obtain a completely successful result.

Additions

When the varnished plate is removed for drying, it must be carefully protected not only from moisture but also from any exposure to light. In speaking of my experiments in diffused light, I have not mentioned any of these kinds of experiment on glass. I add this in order not to omit a specific improvement which relates to them. It consists simply in placing a piece of black paper under the glass and in putting between the metal plate on its coated side and the copper engraving a border of cardboard on which the engraving has been tightly stretched and glued. This arrangement has the effect of making the image appear much more vivid than on a white background, which helps to accelerate the action, and, furthermore, of avoiding damaging the varnish by rubbing it against the copper engraving as in the other method, a mishap which is very hard to prevent in warm weather, even when the coating is quite dry. This disadvantage is counterbalanced, however, by the advantages offered by the experiments with silvered plates, which withstand the action of the washing better, while it is rare that the images on glass are not more or less damaged by this operation, for the simple reason that the varnish can adhere less easily to the glass, owing to its nature and its smooth surface. It would be necessary, therefore, in order to overcome this disadvantage, to improve the varnish by making it more sticky, and I believe that I have succeeded in doing this at least in so far as I may be permitted to pass judgment on this matter, although the experiments are still new and not numerous enough.

This new varnish is composed of a solution of bitumen of Judea in Dippel's animal oil, which is allowed to condense at the ordinary temperature of air to the degree of consistency required. This varnish is more

greasy, tougher, and more strongly colored than the other, and it can be exposed to light as soon as the plate is coated, because it seems to solidify more rapidly, owing to the great volatility of the animal oil which causes it to dry more rapidly.

[Signed] J. N. Niépce

Issued in Duplicate
December 5, 1829

We call attention to the fact that as early as 1829 Niépce exposed silvered metal plates to the fumes of iodine, although only for the purpose of darkening the bare portions of the silver on which an asphalt photograph existed, in order to reproduce the shadows of the image more strongly; these light portions were formed in those places which had been protected by the asphaltum made insoluble by light and from which the asphaltum coating had been removed by more active solvents.

This "Notice sur l'héliographie" of N. Niépce is the earliest exact description of a photographic process. It is so elaborate that quite satisfactory heliographic etchings can be produced by following the directions. The production of pictures in the camera is of course possible only after several hours' exposure. The process is therefore not practical for taking pictures from nature in the camera. It is worthy of notice that Niépce acquainted Daguerre with his really new invention, but that Daguerre had no important photographic contribution whatever to offer.

Chapter XXIII. DAGUERRE DISCOVERS THE LIGHT-SENSITIVITY OF IODIZED SILVERED PLATES

FOLLOWING THE AGREEMENT of December 14, 1829, both Niépce and Daguerre worked assiduously on the improvement of the process. The immediate problem was to find a light-sensitive material which would give a more perfect light image with a shorter exposure than was possible with the bitumen and other agents hitherto employed by Niépce. By a "fortunate accident" Daguerre was led to the discovery of the light-sensitivity of iodide of silver.[1] Louis Figuier, in his *Exposition et histoire des principal découvertes scientifiques modernes* (I, 15), relates the incident as follows:[2] "One day a silver spoon was by chance

lying on an iodized silver plate and left its design on the plate by light perfectly." Observing this Daguerre wrote to Niépce, on May 21, 1831, suggesting the use of iodized silver plates as a means of obtaining light images in the camera. It appears from the letters of Niépce to Daguerre, dated June 24 and November 8, 1831, that Niépce was unsuccessful in obtaining satisfactory results in following Daguerre's suggestion, although he had produced a negative on an iodized silver plate in the camera.

It is also shown, in Niépce's letters of January 29 and March 3, 1832, that the discovery and use of iodized silvered plates as a light-sensitive material are due, not to Niépce, who did not use iodine as a means of blackening certain parts of his light images, but to Daguerre. Daguerre was thus the first to employ iodized silvered plates as the light-sensitive coating by which he obtained pictures photographically.

The following anecdote appeared in 1906 in French periodicals. The wife of a poor painter called one day on the celebrated French chemist and member of the Academy of Sciences J. Dumas to ask for his advice. "My husband," she complained, "is about to lose his reason. He has given up his art and carries on fruitless chemical experiments. At present he has the obsession to retain images fixed on metal plates. He has sold our possessions to buy chemicals and to build an apparatus." Dumas replied that he did not see what he could do in the matter, and the lady explained her hopes that he, owing to his reputation as an authority on chemistry, could convince her husband of the futility of his experiments. Dumas actually visited the painter the next day. But it turned out contrary to the wife's expectations, for after a short conversaton with the painter-inventor he said: "Continue with your experiments, and if you lack the funds I shall assist you myself." The painter was Daguerre, who a few years later completed his invention "of fixing images on polished metal plates" and presented to the astonished world his "daguerreotype." The story may be true; the circumstances tally with those of about 1831. J. Dumas himself related this story in 1864, in a lecture before the Société d'Encouragement pour l'Industrie Nationale. Dumas placed his laboratory at Daguerre's disposal at this time and gave him advice, which was undoubtedly of great service, since Daguerre was not at all versed in chemistry.

Daguerre himself, as early as 1839, the year of the publication of his process by the Paris academy, apprehended the doubts which might later arise in regard to the identity of the person to whom the distinc-

tion of the discovery of the light-sensitivity of iodized silver plates was due. On this account he presented Niépce's letters to him to the academy in 1839, had them attested by Arago, and published that year. Extracts from this correspondence are printed in many early publications dealing with the process, also in English translations.[3]

EXTRACTS FROM THE LETTERS OF NIÉPCE TO DAGUERRE

St. Loup de Varennes, June 24, 1831

Dear Sir and valued associate:

I have awaited news from you with great impatience. I have now received and read your letters of the 10th and the 21st of last month with the greatest pleasure. For the present I confine myself to answer yours of the 21st because I have occupied myself since its receipt with your experiments with iodine, and I hasten to report to you the results which I achieved. I had dealt with this same experiment before having become associated with you, but with no hope of success, because I considered it an almost impossible matter to fix the exposed images in a lasting manner, even if we should succeed in keeping light and shade in their proper arrangement. My experiments along these lines had quite the same success which I obtained with silver oxide, and the rapid action was the only real advantage which these two substances seemed to offer. In the meantime I made new experiments with iodine last year, after your departure from here, but according to another procedure; after I had reported the results to you and received your unsatisfactory reply I decided to discontinue my experiments. It seems that you meanwhile regard this question from a more hopeful point of view, and I have therefore no hesitation in granting your request addressed to me, etc.

[Signed] J. N. Niépce.

True copy:
 Arago. Daguerre.

St. Loup de Varennes, Nov. 8, 1831.

Dear Sir and valued companion:

. . . Referring to my reply of June 24, 1831, to your letter of May 21, I have made a great number of experiments with iodine in combination with silvered plates, without at any time obtaining the results which the deoxidation medium would have lead me to expect. Notwithstanding all changes to which I subjected the procedure and all various combinations of different methods of tests, my success was no more fortunate. I am now, on my part, thoroughly convinced of the absolute impossibility of reproducing negatives with light and shade effects in their natural sequence and also, particularly, to attain anything more than a fugitive image of objects.

At any rate, my dear Sir, this unsuccessful result is quite the same as those which I obtained in my tests with metal oxides long ago and which induced me to discontinue them. I finally decided to combine iodine with pewter, a process which at the start seemed to promise a favorable result. I had made, however, only once the astonishing observation during an experiment in the camera that light acts on iodine in the reverse manner, i.e., that the shades or, rather, light and shade, appear as in nature. I do not know how and why this result happened, and I could not produce it again by a careful repetition of the same procedure. However, this practice, as far as the fixation of the image obtained is concerned, would be as inadequate as before. After some other trials I remained at this point, and I must confess that I am exceedingly sorry to have pursued for so long a time a wrong direction, and what is worse, without any profit, etc.

[Signed] J. N. Niépce

True copy:
 Arago. Daguerre.

Chapter XXIV. JOSEPH NICEPHORE NIEPCE'S DEATH IN 1833; HIS SON ISIDORE TAKES HIS FATHER'S PLACE IN THE CONTRACT OF 1829 WITH DAGUERRE; DAGUERRE DISCOVERS DEVELOPMENT WITH MERCURY VAPORS

UNFORTUNATELY Nicéphore Niépce was taken from his labors as early as July 5, 1833; he died from apoplexy of the brain at his home in Gras, near Chalon, without reaping the benefits of his efforts. In 1885 a statue of Niépce, for which the funds were publicly subscribed, was erected in front of his birthplace in Chalon.[1] His residence there is adorned with a memorial tablet, and in the museum now occupying his house are preserved the apparatus and earliest photographic proofs of Niépce.

After Niépce's death his son Isidore, as heir, took his place in the contract with Daguerre, who thereafter carried forward the technical work alone. However, in 1835 Daguerre insisted on an "addition" to the first contract of 1829, in which he stated that his new process was not based on the principle mentioned in that contract. The company

changed its name by mutual consent; it was no longer Niépce-Daguerre, but was called "Daguerre et Isidore Niépce."

Addition to Original Contract

Between the undersigned Louis Jacques Mandé Daguerre, artist-painter, member of the Legion of Honor, director of the diorama, residing at Paris, and Jacques Marie Joseph Isidore Niépce, landowner residing at Chalon-sur-Saône, son of the late M. Nicéphore Niépce, sole heir, according to Article 2 of the provisory agreement of December 14, 1829, do stipulate as follows:

1. That while the invention has attained great perfection by the collaboration of M. Daguerre, the copartners recognize that the invention has reached the point which it was intended to attain and that further improvement seems to be almost impossible.

2. That since M. Daguerre, after numerous experiments, has realized the possibility of accomplishing a more advantageous result regarding the speed of operation by the aid of a new process discovered by him, which (with the anticipation of certain success) would supplant the basis of the discovery set forth in the provisory agreement of December 14, 1829, which discovery is explained there in detail, now therefore Article 1 of the mentioned provisory agreement is hereby canceled and the following is substituted in its place.

Art. 1. A company is to be organized between MM. Daguerre and Isidore Niépce, under the name "Daguerre and Isidore Niépce," for the exploitation of the invention made by M. Daguerre and the late Nicéphore Niépce.

All the other articles of the provisory agreement remain unchanged by the preceding.

Executed in duplicate for the undersigned at Paris, May 9, 1835.

Approved and acknowledged by our signatures

[Signed] I. Niépce. Daguerre.

As Isidore Niépce reports in his *Historique de la découverte improprement nommée daguerréotype* (Paris, 1841)[2] that Daguerre had shown him in 1837 proofs of light images which he had produced by the use of iodine and mercury, it is, thus, in that year that photography on iodized silvered plates with the development of the latent light image by mercury vapors was invented. For the invention of the development process Daguerre is said to have been indebted to a curious accident. Daguerre exposed his silvered plates to the action of iodine vapors, and in this way coated them with an extremely fine film of iodide of silver; but on these plates no picture was produced in the

camera obscura. His experiments, carried on for months and varied in manifold ways, gave no result. Chance, however, in the most proper sense, assisted him. A number of plates he had previously experimented upon in the camera obscura had been put aside in an old cupboard and had remained there for weeks without being further noticed. But one day, on removing one of the plates, Daguerre to his intense astonishment found on it an image of the most complete distinctness, the smallest details being depicted with perfect fidelity. He had no idea how the picture had come, but he felt sure there must be something in the cupboard which had produced it. The cupboard contained all sorts of things: tools and apparatus, chemical reagents, and among the other things a basin filled with metallic mercury. Daguerre now removed one thing after the other from the cupboard, with the exception of the mercury, and still he regularly obtained pictures if the plates which had previously been submitted to the action of images in the camera obscura were allowed to remain for several hours in the cupboard. For a long time the mercury escaped his notice, and it almost appeared to him as if the old cupboard were bewitched. But at last it occurred to him that it must be the mercury to whose action the pictures were due. A drawing made with a pointed piece of wood on a clean pane of glass, remains invisible even to the most acute sight, but comes to light at once when breathed upon. The condensation of the watery vapor (deposited in small drops) differs in the parts touched with the wooden point and those left untouched, in the same manner as took place in Daguerre's pictures (Liebig, *Cornhill Magazine*, XII, 303; Vogel's *Lehrbuch der Photographie*, 1878, p. 4).

A definite agreement was concluded on June 13, 1837, between Isidore Niépce and Daguerre, giving Daguerre the right to call the new process by the name "Daguerre" alone. This final contract reads:

I, the undersigned, declare by this present writing that M. Louis Jacques Mandé Daguerre, painter, member of the Legion of Honor, has communicated to me a process of which he is the inventor. This process has for its object the fixation of images obtained in the camera obscura, not with colors, but with perfect gradations of tone from white to black.

This new process has the advantage of reproducing objects from sixty to eighty times more rapidly than that which my father, M. Joseph Nicéphore Niépce, invented, and M. Daguerre had perfected. For the exploitation of that process a provisional agreement which is before us had been drawn December 14, 1829, in which it is stipulated that the process men-

tioned above is to be made public in the following manner: "process invented by M. Joseph Nicéphore Niépce and improved by M. L. J. M. Daguerre."

After this communication had been imparted to me, M. Daguerre consented to transfer the new process—of which he is inventor and which he has perfected—to the partnership founded according to the abovementioned provisory agreement, under the condition, however, that this new process shall carry the name of Daguerre alone; but it can only be made public simultaneously with the first process, in short, the name of M. Joseph Nicéphore Niépce figures always, as is right, in this invention.

By this present agreement it is and remains established that all the articles and underlying principles of the provisory contract of December 14, 1829, remain in force.

After this new agreement between MM. Daguerre and Isidore Niépce, which forms the final contract which is spoken of in Article 9 of the provisory contract, the said parties having decided to make public their various processes, the manner of publication by subscriptions has been given.

The announcement of the publication of the processes appears in the daily papers. The subscription list will be opened on March 15, 1838, and closed on April 15 of the following year. The price of subscription will be 1,000 francs. The list will be in the hands of a notary, to whom the payment is to be made by the subscribers, whose number is limited to four hundred.

The terms of subscription will be as favorable as possible. The processes, however, cannot be made public until at least one hundred individual subscriptions are received; if this number is not completed, the partners will consider another method of publication.

If before the subscription opens an offer is received for the sale of the process, the price accepted must not be less than 200,000 francs.

Executed in duplicate, accepted and signed at Paris, June 13, 1837, at the residence of M. Daguerre in the diorama.

[Signed] Isidore Niépce. Daguerre.

Chapter XXV. DAGUERRE AND ISIDORE NIEPCE ATTEMPT UNSUCCESSFULLY IN 1837 TO SELL DAGUERREOTYPY BY SUBSCRIPTION; THEY OFFER THEIR INVENTION TO THE GOVERNMENT; ARAGO'S REPORT TO THE ACADEMY ON JANUARY 7, 1839; AGREEMENT ARRIVED AT JUNE 14, 1839

AFTER the final papers had been signed on June 13, 1837, the two partners made an appeal to art lovers and capitalists for the purpose of disposing of the four hundred shares; but their appeals met with no response, and the subscription which was opened on March 15, 1838, did not meet with success.

When the attempt to exploit the process of daguerreotype was unsuccessful, Daguerre and Niépce decided to offer their method to the government. Daguerre approached François Jean Arago, to whom he imparted, under the seal of secrecy his processes and those of Nicéphore Niépce. It was fortunate that Arago possessed such a great insight into the invention, which he received enthusiastically. He reported the invention of the daguerreotype to the Academy of Sciences on January 7, 1839. The secrecy, however, was not observed very carefully, for the *Gazette de France* published a notice about it on January 6, 1839, although without printing any details.[1] Through the intervention of Arago and other influential persons Daguerre and Isidore Niépce were able to meet the Minister of the Interior, Duchâtel, with the result that a preliminary agreement was drawn on June 14, 1839, which read:

Louis Philippe, King of the French, to those present and to come, greetings!

We have commanded and do command that the draft of a bill, the contents of which follow, be submitted in our name to the Chamber of Deputies by our minister, Secretary of State for the Department of the Interior, whom we order to explain the underlying motives and to support the negotiations.

First Article

The provisional agreement made on June 14, 1839, between the Minister of the Interior, acting for the State, and MM. Daguerre and Niépce, Junior, is made a part of the present law and approved.

Second Article

To M. Daguerre is granted an annual pension for life of 6,000 francs; to M. Niépce, Junior, is granted an annual pension for life of 4,000 francs.

Third Article

On the passage of this present law these pensions shall be recorded in the book for civil pensions of the public treasury. They are to be paid in half to the widows of MM. Daguerre and Niépce.

Given at the Palais de Tuilleries, June 15, 1839.

[Signed] Louis Philippe.

For the King:
The Secretary of the Department of State

[Signed] Duchâtel.

The following agreement was entered between M. Duchâtel, secretary of the State Department on one side and MM. Daguerre (Louis Jacques Mandé) and Niépce, Junior (Joseph Isidore), as parties of the second part:

Art. 1. MM. Daguerre and Niépce pledge themselves to place in the hands of the Ministry of the Interior a sealed package containing the history and most detailed and exact description of the invention mentioned.

Art. 2. M. Arago, member of the Chamber of Deputies and of the Academy of Sciences, who is already acquainted with the methods of procedure mentioned, will meanwhile examine all parts of the said deposition and prove their correctness.

Art. 3. The deposition is not to be opened and the description of the process is not to be given publicly until the draft of the law here discussed is accepted. After the acceptance of the bill M. Daguerre must, on demand, in the presence of a commission appointed by the Minister of the Interior, operate the process.

Art. 4. M. Daguerre, in addition, pledges himself to give in the same manner the details of his process of painting and the physical apparatus which characterizes his invention of the Diorama.

Art. 5. He is obliged to make public all improvements of his inventions whatsoever, which he may accomplish in the future.

Art. 6. As remuneration for the present agreement the Minister of the Interior pledges himself to request from the Chambers for M. Daguerre, who herewith signifies his acceptance, an annual pension for life of 6,000 francs.

For M. Niépce, who also joins in the acceptance, an annual pension for life of 4,000 francs.

These pensions will be recorded in the register of Civil Pensions of the Public Treasury. Half of these pensions will revert to the widows of MM. Daguerre and Niépce.

Art. 7. In the case that the Chambers in their full sessions do not pass the proposed bill for these pensions, the mutual agreement with all rights will be declared null and void and the sealed package will be returned to MM. Daguerre and Niépce.

Art. 8. This present agreement is to be registered with a stipulated fee of one franc.

Executed in triplicate, Paris, June 14, 1839.

Attested signatures:

[Signed] Duchâtel
[Signed] Daguerre
[Signed] I. Niépce

For the attest of the copy corresponding with the original and attached to the draft of the bill.

The Secretary of the Ministry of State
[Signed] Duchâtel

Chapter XXVI. BILL FOR THE PURCHASE OF THE INVENTION OF DAGUERREOTYPY BY THE FRENCH GOVERNMENT, WHICH DONATES IT TO THE WORLD AT LARGE

AFTER THE PRELIMINARIES arranged at the meeting between the Minister of the Interior, Duchâtel, and MM. Arago and Daguerre and the preparation of the mentioned bill by Duchâtel, the King appointed a joint commision, composed of members of the Chamber of Peers, headed by Gay-Lussac, and members of the Chamber of Deputies, headed by Arago, to examine and report on the bill to their respective Chambers.[1] These reports follow:

Report

of the Commission of the Chamber of Deputies charged with the examinnation of a proposed bill granting, first, to M. Daguerre an annual and life pension of 6,000 francs and, second, to the son of M. Niépce, an annual life pension of 4,000 francs for the assignment to the State of their process for the fixation of images obtained in the camera obscura.

Presented by M. Arago, Deputy of the East-Pyrénées, in the French Chamber of Deputies, on July 3, 1839.

Gentlemen:

The interest aroused in this invention recently made public by M. Daguerre in this circle and elsewhere has been keen, enthusiastic, and unanimous. In all probability the Chamber awaits from its Commission no more than the approval of the proposed bill which the Minister of the Interior has presented. After careful consideration, however, the mandate with which you have charged us seems to impose upon us other duties.

We believe, however, that, while heartily approving the happy idea to grant a national reward to inventors whose interests cannot be adequately protected by the ordinary patent laws, we must furnish proof in the beginning of the cautious and scrupulous care with which this Chamber proceeds.

To subject a work of genius, such as that upon which we have to pass today, to a critical examination will serve to discourage ambitious mediocrity which might aspire to bring before this assembly its common and ephemeral productions. This will prove that you place upon a high plane the rewards which may be asked of you in the name of the national glory and that you cannot consent to lower your standards or dim their luster by a too lavish disposal of them.

These few words will serve to explain to the Chamber the lines we followed in our examination.

1. Is the process of M. Daguerre unquestionably an original invention?

2. Is this invention one which will render a valuable service to archaeology and the fine arts?

3. Can this invention become practically useful? And, finally,

4. Is it to be expected that the sciences may derive any advantage from it?

Arago proceeded to sketch earlier attempts with the camera, citing historical notes on the work of Wedgwood and others, which, however, were not at all exhaustive, and briefly outlined the early labors of Niépce and Daguerre. Arago continues:

The partnership agreement registered between Niépce and Daguerre for the joint exploitation of their photographic methods was dated December 14, 1829. The later agreements between M. Isidore Niépce, the son, as heir, and M. Daguerre mention first improvements which the Parisian painter added to the method invented by the physicist of Chalon and, secondly, entirely new processes discovered by M. Daguerre, capable of (in the language of the original document) "reproducing images sixty to eighty times more rapidly than the earlier process." This will explain the several articles of the contract between the Minister of the Interior on the

one hand and MM. Daguerre and Niépce, Junior, on the other, attached to the proposed bill. It will be noted that we have just spoken when discussing the labors of M. Niépce the qualifying words: "for the photographic printing from copper engravings." As a matter of fact Niépce, after numerous fruitless experiments, had almost given up the hope of being able to fix images obtained directly in the camera obscura. The chemical preparations which he used did not darken rapidly enough under the action of light, for he required ten to twelve hours to produce the image and during the long time of exposure the shadows of the objects represented changed from one side to the other, so that the resulting pictures were flat and monotonous in tones, lacking all the pleasing effects which arise from the contrast of light and shade; and, furthermore, even apart from these difficulties, one was never certain of a successful result, because after taking innumerable precautions, inexplicable and accidental occurrences intervened, and there was sometimes a passable result, or an incomplete image resulted which showed here and there empty spaces, and, finally, when exposed to sunlight, the sensitive coating, if it did not refuse to darken, would become brittle and scale off.

When all these imperfections are enumerated and the nature and manner of their elimination is explained, an almost complete account is obtained of the credit which M. Daguerre deserves for the discovery of his method, achieved after endless laborious, delicate, and costly experiments.

Even the feeblest light rays change the sensitive substance of the daguerreotype plate. This change is effected before the shadows thrown by the sun have time to move appreciably. The results are assured if one follows certain simple rules. Finally, the effect of sunlight on the finished pictures does not diminish, even after years, either their purity, their brilliancy, or their harmony.

Your commission has made the necessary arrangements, so that on the day when the proposed bill is discussed all those Deputies who desire to examine the examples of the daguerreotype process may form their own opinions of the usefulness of this discovery. While these pictures are exhibited to you, everyone will imagine the extraordinary advantages which could have been derived from so exact and rapid a means of reproduction during the expedition to Egypt; everybody will realize that had we had photography in 1798 we would possess today faithful pictorial records of that which the learned world is forever deprived of by the greed of the Arabs and the vandalism of certain travelers.

To copy the millions of hieroglyphics which cover even the exterior of the great monuments of Thebes, Memphis, Karnak, and others would require decades of time and legions of draughtsmen. By daguerreotype one person would suffice to accomplish this immense work successfully.

Equip the Egyptian Institute with two or three of Daguerre's apparatus, and before long on several of the large tablets of the celebrated work, which had its inception in the expedition to Egypt, innumerable hieroglyphics as they are in reality will replace those which now are invented or designed by approximation. These designs will excel the works of the most accomplished painters, in fidelity of detail and true reproduction of the local atmosphere. Since the invention follows the laws of geometry, it will be possible to re-establish with the aid of a small number of given factors the exact size of the highest points of the most inaccessible structures.

These reflections, which the zealous and famous scholars and artists attached to the army of the Orient cannot lightly dismiss without self-deception, must without doubt turn their thoughts to the work which is now being carried on in our country under the control of the Commission for Historic Monuments. A glance suffices to recognize the extraordinary role which the photographic process must play in this great national enterprise; it is evident at the same time that this new process offers economic advantages which, incidentally, seldom go hand in hand in the arts with the perfecting of production.

If, finally, the question arises whether art in itself may expect further progress from the study of these images drawn by nature's most subtle pencil, the light ray, M. Paul Delaroche will answer us.

In a report, made at our request this celebrated painter states that Daguerre's processes "are so far-reaching in the realization of certain essential requirements of art that they will be the subject of observation and study, even by the most able painters." What he stresses most about photographic images is their "unimaginable precision" of detail, which does not disturb the repose of the masses and does not detract in any way from the general effect. "The accuracy of the lines," Delaroche continues, "the nicety of form, are as perfect in Daguerre's pictures as could be desired, and at the same time one recognizes a broad and vigorous modeling as rich in tone as it is in effect. . . . The painter finds in this process an easy way of making collections for after-study and use which otherwise are obtainable only at great expense of time and labor, and yet less perfect in quality, no matter how great his talent may be." After having opposed with excellent arguments the opinions of those who imagined that photography would be detrimental to our artists and especially to our skilled engravers, M. Delaroche concludes his report with the remark: "In short the remarkable invention of M. Daguerre is a great service rendered to the Arts."

We will not presume to add anything to such testimony.

It will be recalled that among the questions which occupied us at the beginning of this report was whether this invention can become of practical use? Without disclosing anything that must remain secret until the

passage and promulgation of the bill, we can say that the plates on which light produces the admirable picture images of M. Daguerre are plated tablets, i. e., copper plates which have been coated with a thin deposit of silver. Doubtless, it would have been more advantageous not only for the comfort of travelers as well as from an economic point of view, if paper could be used. Paper impregnated with silver chloride or silver nitrate was indeed the first substance chosen by M. Daguerre, but the lack of sensitivity, the confused image, the uncertainty as to results, and the accidents which often happened during the operation of reversing lights and shadows could not but discourage so skilled an artist. Had he pursued this direction, his pictures would probably be shown in collections as experimental results among the curiosities of physics, but assuredly would never have become a subject for the consideration of this chamber. Finally, if it be said that three or four francs, the cost of a plate such as M. Daguerre uses, seems too costly, it is but fair to state that the same plate may serve successively for the taking of a hundred different pictures.

The extraordinary success of M. Daguerre's present process can be attributed in part to the fact that he uses an extremely thin coating, a veritable film. We need not concern ourselves here with the cost of the material employed; in fact the price is too small for evaluation. Only one member of the commission has seen the artist at work and has himself operated the process. It is, therefore, due to the personal responsibility of this Deputy that we can present to the members of the Chamber daguerreotype from the standpoint of practicability. Daguerreotype calls for no manipulation which anyone cannot perform. It presumes no knowledge of the art of drawing and demands no special dexterity. When, step by step, a few simple prescribed rules are followed, there is no one who cannot succeed as certainly and as well as can M. Daguerre himself.

The rapidity of the method has probably astonished the public more than anything else. In fact, scarcely ten or twelve minutes are required for photographing a monument, a section of a town, or a scene, even in dull, winter weather.

In summer sunlight the time of exposure can be reduced to half. In the southern climate two to three minutes will certainly be sufficient. We must note, however, that the ten to twelve minutes exposure in winter, the five to six minutes in summer, and the two to three minutes in the South express only the actual time during which the sensitive plate receives the image projected by the lens. To this must be added the time occupied by the unpacking and mounting of the camera obscura, preparing the plate, and the short time necessary for protecting the plate from the action of light after the exposure. For all these manipulations perhaps a half to three quarters of an hour may be required. Those who fondly imagine when

about to start on a journey that they will employ every moment when the coach is climbing slowly uphill in taking the scenes, will be therefore disappointed in their expectations. No less will be the disappointment of those who, astonished by the success obtained by the copying of pages and illustrations of the most ancient works, would dream of the photographic images for the reproduction and multiplication of the daguerreotype by means of lithographic print. Not alone in the moral world has every quality its defects; this principle applies also to the Arts. The perfection, delicacy, and harmony of the picture images are the result of the perfect smoothness and incalculable thinness of the coating on which M. Daguerre operates. If such a picture is rubbed or even lightly touched, or subjected to the pressure of a roller, it is destroyed past redemption; but, who could imagine anyone pulling apart a fine piece of lace or brushing the wings of a butterfly? The member of the Academy who has known for several months the preparations on which the beautiful designs submitted for our examination are produced deems it inadvisable to utilize his knowledge of the secret which had been entrusted to him by M. Daguerre, who had honored him with his confidence. He felt that before entering upon further research, thrown open to physicists by the photographic process, it would be more delicate to wait until a national award had placed in the hands of all observers the same means for further study. If we therefore discuss the scientific advantages of the invention by our compatriot, we can only hazard a conjecture. The facts, however, are clear and obvious, and we need not fear that the future will discredit our statements. The preparation used by M. Daguerre is a reagent, much more sensitive to the action of light than any heretofore known. Never have the rays of the moon, we do not mean in its natural condition, but focused by the greatest lens or the largest reflector, produced any perceptible physical effect. The plates prepared by M. Daguerre, however, bleach to such an extent, by the action of the same rays, followed by a subsequent treatment, that we may hope to be able to make photographic maps of our satellite. In other words, it will be possible to accomplish within a few minutes one of the most protracted, difficult, and delicate tasks in astronomy.

An important branch of the science of observation and calculation, that which deals with the intensity of light, photometry, has so far made little progress. The physicist has no difficulty in determining the comparative intensities of two lights, one next to the other and both simultaneously visible; but there are only imperfect means for making such a comparison when the condition of simultaneity is lacking, as when a light which is now visible is to be compared with another light, which will not be visible until after the first light has disappeared.

The artificial lights available to the observer for the purpose of com-

parison in the above-mentioned case are rarely permanent or of desirable stability; and seldom, especially when we deal with stars, do our artificial lights possess the sufficient whiteness. This is the reason for the great discrepancies between the determinations of the comparative light intensities of the sun and moon and the sun and stars, as given by equally able scientists; for the same reason the most important conclusions are surrounded by certain reservations, when they refer to the last-mentioned comparisons concerning the humble position which our sun occupies among the milliards of suns with which the firmament is bespangled; this, even in the works of the least timid authors.

We do not hesitate to say that the reagents discovered by M. Daguerre will accelerate the progress of one of the sciences, which most honors the human spirit. With its aid the physicist will be able henceforth to proceed to the determination of absolute intensities; he will compare the various lights by their relative effects. If needs be, this same photographic plate will give him the impressions of the dazzling rays of the sun, of the rays of the moon which are three hundred thousand times weaker, or of the rays of the stars. He can compare these impressions, either by dimming the strongest lights with the aid of the excellent media which only lately have been discovered, a description of which would be out of place here, or by allowing the most intense rays to act only for a second, while continuing the action of the other rays to half an hour, as may be necessary.

Moreover, when the observer applies a new instrument in the study of nature, his expectations are relatively small in comparison to the succession of discoveries resulting from its use. In a case of this sort it is surely the unexpected upon which one especially must count.

Does this sound like a paradox? A few citations will prove its accuracy.

Some children accidentally placed two lenses each in opposite ends of a tube. They thus produced an instrument which enlarged distant objects and represented them as if approached. Astronomers accepted this instrument with the hope of being better able to observe stars, which had been known for ages, but which up to that time could be studied only imperfectly. Pointing this new instrument toward the firmament, they revealed myriads of new worlds. Penetrating the inner formation of the six planets of the ancients, one finds them similar to our own world, with mountains the height of which can be measured, atmospheric disturbances which can be followed, with the phenomena of formation and fusion of polar ice, analogous to the terrestial poles and to the rotating movement which corresponds to that which creates the succession of our days and nights. Pointed toward Saturn, the tube of the Middelburg spectacle maker's children reveals a phenomenon more wonderful than any dream of the most fanciful imagination.

Could anyone have foreseen that when turned so as to observe the four moons of Jupiter it would reveal luminous rays, traveling at a speed of eighty thousand miles (300,000 km.) per second; that, attached to graduated measuring instruments it would demonstrate that no stars exist whose light reaches us in less than three years; and, finally, that if the instrument be used in certain observations one may conclude with reasonable certainty that the rays by which we perceive at any given moment were emitted by certain nebulae millions of years ago; in other words, that these nebulae, owing to the continuous propagation of light, would be visible to us several millions of years after their complete destruction?

The glass for near objects, the microscope, gives occasion for similar observations, because nature is no less admirable, no less varied in its smallness than in its immensity. When the microscope was first used for the observation of certain insects whose shapes the scientists desired to see in an enlarged size in order to delineate them more accurately, it revealed subsequently and unexpectedly in air, in water, in short in all liquids, these animalcules, these infusoria, through which it is hoped to find sooner or later a reasonable explanation for the beginning of life. Recently directed to minute fragments of different stones of the hardest and most solid variety, of which the crust of our earth is composed, the microscope revealed to the astonished gaze of the observer that these stones once lived, that they are in reality a conglomeration of milliards and milliards of microscopic animalcules closely cemented together.

It should be remembered that this digression was necessary in order to dispel the erroneous opinion of those who would mistakenly limit the scientific application of M. Daguerre's processes to the outline we have given; indeed, the facts already justify our expectations. We could, for instance, cite certain ideas, for the rapid method of investigation, which the topographer could borrow from the photographic process, but we shall reach our goal more quickly by mentioning here a singular observation, of which M. Daguerre spoke to us yesterday. According to him, the hours of the morning and of the evening, which are equally distant from the noon hour, and at which times the sun is at the same altitude, are not, however, equally favorable for the taking of photographs.

Thus, a picture is produced, regardless of the season and under similar atmospheric conditions at seven o'clock in the morning somewhat more rapidly than at five o'clock in the afternoon; at eight o'clock faster than at four o'clock, at nine faster than at three. Supposing this result is to be verified, the meteorologist will have a new element to record in his tables, and to the ancient observations as to the state of the thermometer, barometer, and hygrometer and the visibility of the air they will have to add another element, which these early instruments do not indicate. It will be necessary

to take into consideration an absorption of a peculiar character which cannot be without influence on many other phenomena, perhaps even on those belonging to the fields of physiology and medicine.

We will endeavor, gentlemen, to set forth everything which the discovery of M. Daguerre offers of interest under four aspects: its originality, its usefulness in the arts, the speed of execution, and the valuable aid which science will find in it. We have striven to make you share our convictions, which are vivid and sincere, because we have examined and studied everything with scrupulous care, in keeping with the duty imposed by your suffrage, because, if it were possible to misjudge the importance of the daguerreotype and the place which it will occupy in the world's estimation, every doubt would have vanished at sight of the eagerness with which foreign nations pointed to an erroneous date, to a doubtful fact, and sought the most flimsy pretext in order to raise questions of priority and to try to take credit for the brilliant ornament which photography will always be in the crown of discoveries. Let us not forget to proclaim that all discussion on this point has ceased, not so much on account of the incontestable and authenticated authority of title on which MM. Niépce and Daguerre base their claims, but chiefly because of the incredible perfection which M. Daguerre attained. If it were necessary, we would not be at a loss to present here the testimony of the most eminent men of England and Germany, in the face of which everything we have said, however flattering, concerning the discovery of our compatriot would pale completely. France has adopted this discovery and from the first moment has been proud that it can present it generously to the entire world.

We were not at all surprised by the public sentiment awakened by the exposure, due to a misapprehension of motives, which seemed to indicate that the government had bartered with the inventors and that the pecuniary conditions of the contract proposed for your sanction represented a bargain. It becomes necessary, gentlemen, to re-establish the facts.

The member of the Chamber who had full power given him by the Minister of the Interior did not haggle with M. Daguerre. Their negotiations were concerned solely with the point whether the recompense which the able artist had so well merited should be a fixed pension or a single payment. M. Daguerre at once remarked that the stipulation of a lump sum might give the contract the character of a sale. It would not be the same with a pension. It is with a pension that you reward the soldier, crippled on the field of honor, the official, grown gray at his post; and thus you have honored the families of Cuvier, Jussieu, De Champollion.

Such memories must have affected the noble character of M. Daguerre; he decided to ask for a pension. At the request of the Minister of the Interior, M. Daguerre himself set the amount of the pension at 8,000 francs,

which was to be divided equally between him and his partner, M. Niépce's son. M. Daguerre's share was later increased to 6,000 francs, partly because of the special conditions imposed on this artist, namely, to reveal the process of painting and lighting of the canvasses of the diorama, now reduced to ashes, and especially because he has pledged himself to make public all improvements with which he may enrich his photographic methods. The importance of this pledge will certainly not seem doubtful to anyone when we state that only a little progress is required to enable M. Daguerre to make portraits of living persons by his process. As far as we are concerned, instead of fearing that M. Daguerre might delegate to others the labor of adding to his present success, we rather sought to moderate his ardor. This we frankly admit is the motive which induced us to desire that you declare the pension free from the laws of restraint and attachment, but we have found that this amendment will be superfluous according to the law of 22d Floréal of the VII year and according to the decree of the 7th Thermidor of the X year.

The commission therefore unanimously proposes that you adopt the bill of the government without change.

In the House of Peers the celebrated chemist Joseph Louis Gay-Lussac reported in equally warm words, as follows, at the session of July 30, 1839.

Report

made to the Chamber of Peers by M. Gay-Lussac in the name of the special commission[2] charged with the examination of the bill relating to the acquisition of a process invented by M. Daguerre to fix the images of the camera obscura.

Gentlemen:

Everything which contributes to the progress of civilization, to the physical or moral well-being of man, must be the constant object of solicitude to an enlightened government, always alert to the duties with which it has been entrusted; those who, by their fortunate effort aid this noble task must find their honorable recompense in their success. Hence protective laws apply to literary and industrial property and assure to the author benefits proportional to the importance of the services rendered to society; a mode of remuneration which is so much more just and more honorable, because it is a purely voluntary contribution in return for services rendered and a shelter from the caprice of favoritism. While, however, this mode of encouragement is best suited to most circumstances, there are some where it cannot be applied or is impracticable or inadequate, and others where great discoveries demand more conspicuous and distinguished rewards.

It seems to us, gentlemen, that the discovery of M. Daguerre belongs to this category, and thus it has been regarded by the Royal Government, which has made it the subject of the present bill laid before you for your approval, and by the Chamber of Deputies, which has already given legislative sanction to the bill.

M. Daguerre's discovery is known to you by the results which have been presented to you and by the report to the Chamber of Deputies of the illustrious scientist to whom the secret was confided. It is the art of fixing the image obtained in the camera obscura on a metallic surface and conserving it.

Let us hasten, however, to remark, without intending in any way to belittle the merits of this beautiful discovery, that the palette of this painter is not very rich in colors; black and white alone comprise it. The image with its natural and varied colors will for a long time, perhaps for ever, remain a challenge to human ingenuity. We shall not venture, however, to confront him with unsurmountable barriers; M. Daguerre's success opens the way to a new order of possibilities. Called upon to give our opinion on the importance and future of M. Daguerre's invention, we have based it on the very perfection of the results, on the report of M. Arago to the Chamber of Deputies, and upon new communications received from this scientist and from M. Daguerre. Our conviction as to the importance of the new process is confirmed, and we should be happy, indeed, to have the Chamber share it with us.

It is certain that through M. Daguerre's invention physics is today in possession of a reagent extraordinarily sensitive to the influence of light, a new instrument which will be to the study of the intensity of light and of luminous phenomena what the microscope is in the study of minute objects, and it will furnish the nucleus around which new researches and new discoveries will be made. Already this reagent has recorded a very distinct impression of the dim light of the moon, and M. Arago has expressed the hope for a map of this satellite traced by the moon herself.

The Chamber had the opportunity to convince itself from the exhibits that bas-reliefs, statues, and monuments, in one word, inanimate nature, are reproduced with a perfection unattainable by the ordinary methods of drawing and painting, equal to nature itself, because in fact M. Daguerre's pictures are nothing other than the veritable images.

The perspective of the landscape and of each object is delineated with mathematical exactness; each incident, each detail, even if imperceptible, cannot escape the eye and the brush of this new painter, and since three or four minutes suffice for the work, a battle scene may be recorded in its successive phases with a perfection unattainable by any other means.

The industrial arts will certainly make general use of M. Daguerre's

process for the representation of forms, for designing perfect examples of perspective, and for the study of light and shade; the natural sciences, for the study of the species and their organization. Finally, the problem of its application to portraiture is almost solved, the few difficulties yet to be overcome leave no doubt as to success. However, we must not overlook the fact that colored objects are not reproduced in their natural colors and that, since the different luminous rays do not act uniformly on M. Daguerre's reagent, the harmony of the light and shade effects of the colored objects necessarily is altered. Here is the point of arrest, nature herself imposing her limitations on the new invention.

Such, gentlemen, are the advantages already assured, and the expectations of immediate fulfillment of M. Daguerre's discovery. Meanwhile, further information regarding the manipulation of the process was necessary, and the commission thought that no one would be better qualified to obtain it in a manner more certain and authentic than the honorable Deputy himself, in whom M. Daguerre had placed his confidence, and later the Minister of the Interior and the other Chamber. M. Arago, on the invitation of the president of the commission, attended their session and confirmed with new additional details what he had stated in his interesting report. It is established that the practicable working of M. Daguerre's process will require only a very short time and a negligible expense after the initial investment of approximately four hundred francs for the apparatus. Everyone is sure of success after a few trials. M. Arago himself, after having been initiated, produced a successful result which we would undoubtedly have been anxious to see; unfortunately, it was destroyed by the flames which consumed the diorama.

If further testimony were needed, the reporter of your commission may add that M. Daguerre offered to make him also acquainted with the secret of his process and that he described to him the complete procedure. The speaker can affirm that the process is inexpensive and that it can be operated by persons entirely inexperienced in the art of drawing, if they follow the instructions which M. Daguerre has undertaken to publish and to demonstrate. In his own interest, as well as in that of his process, success is essential, and there can be no doubt that M. Daguerre is anxious to insure it.

Your reporter adds that although he did not make a practical test of the process himself as did his respected friend M. Arago, he can judge from the descriptions which were offered him that its discovery involved many difficulties at a great expense of time and innumerable experiments in particular, that it called for a perseverance, not to be discouraged by failure, such as is possessed only by great souls. The process is, in fact, composed of successive operations which do not necessarily relate to each other, and their effects are not recognized immediately after each single step, but only

in their combined result. Surely, if M. Daguerre desired to carry on his process by himself or to confide only in wholly trustworthy persons, he would not need to fear that he would be robbed of the fruits of his labors. The questions may be asked and have already been put: Why, if the process is so difficult to discover, did he not exploit it himself? And why, under our wise laws, which secure the interests of the inventor as well as those of the public, did the government decide to acquire the invention and donate it to the public? We shall answer both questions.

The principal advantage of M. Daguerre's process consists in obtaining rapidly and accurately images of objects, either to preserve them as such or to reproduce them by means of engraving or lithography; and this being so, it will be easily understood that the process in the hands of a single individual could not reach its full development.

On the other hand, made available to the public, the process will find manifold applications in the hands of the painter, architect, traveler, and scientist.

Finally, if held closely by an individual, the process would remain where it is for a long time and perhaps fade from the scene. As public property, it will develop and be improved by the co-operation of the many. Thus from various aspects it is desirable that the process should become public property. In these circumstances it became the duty of the government to show its interest in Daguerre's process and to provide adequate compensation for its author. To those who are not indifferent to national glory, and who know that a people excels in achievement over other peoples only in proportion to their respective progress in civilization, to those we can say that the process of M. Daguerre is a great discovery. It is the beginning of a new art in an old civilization; it means a new era and secures for us a title to glory. Shall we pass it on to posterity accompanied by the ingratitude of its contemporaries? Should it not come rather as a brilliant testimonial of the protection accorded to great inventions by the Chambers, the July Government, and by the whole nation?

In reality, it is an act of national munificence expressed by the proposed bill in favor of M. Daguerre. We have given it our unanimous approval, but not without remarking the importance and honor attaching to a national reward. We call attention to this to remind ourselves, not without regret, that France has not always been so grateful and that only too often have beautiful and useful works earned for their inventors nothing but empty glory. This should not be interpreted as an accusation; errors should be deplored in order to avoid their repetition.

Gentlemen, having appraised to the best of our ability, the importance of M. Daguerre's invention, we reaffirm our conviction that it is new, rich in interest and possibilities, and, finally, well worthy of the high honor

of the national reward which has already been granted by the Chamber of Deputies. The commission voted unanimously in favor of the pure and simple adoption of the bill, and I, as its reporter, have been charged to propose that you do likewise.

The bill was passed in the Chamber of Deputies on July 3, 1839, and in the upper Chamber on July 30, with two hundred and thirty-seven votes against three. Thereupon Arago reported an exact description of the photographic processes of Niépce and Daguerre at the session of the Paris Academy of Sciences on August 19, 1839, and this presentation was received with enthusiasm by an enormous crowd.

On August 14, 1839, Daguerre's invention was granted a patent in England.

At the time of the publication of daguerreotypy, Hofrat von Ettingshausen, professor of physics at the University of Vienna, was present in Paris, under orders from the Austrian government, and interested himself keenly in Daguerre's invention. Earlier the Austrian chancellor, Prince Clemens Metternich, had received reports about Daguerre through Count Apponyi, who was the royal and imperial Austrian ambassador at Paris from 1826 to 1849. It seems that he invited Professor Ettingshausen to report to him personally and that he promoted his studies and interests. Ettingshausen was able to study Daguerre's method under him, reported to Prince Metternich at his Johannisberg castle on the Rhine, and brought the daguerreotype process to Vienna. When detailed descriptions of the process became known through the scientific journals, the assistant in the faculty of physics at the Polytechnikum and later the librarian, A. Martin, also Dr. J. J. Pohl, who was then a student, the apothecary Endlicher, Regierungsrat Schultner, as well as Wawra (father of the art dealer), busied themselves with the production of daguerreotypes. From this circle came A. Martin's *Repertorium der Photographie* (1846), the first book in Germany which discussed unselfishly the experiences and experiments of these workers and published detailed information on the publications of other scientists relating to the progress of daguerreotypy.

Chapter XXVII. DAGUERRE'S ACTIVITIES AFTER THE PUBLICATION OF DAGUERREOTYPY; REPORT ON DAGUERREOTYPY TO THE EMPEROR OF AUSTRIA

DURING THIS WHOLE PERIOD Daguerre resided in Paris. Until 1839 he lived at 15 Rue de Marais, the premises of the diorama from which he derived his income. In 1839 the house was burned to the ground, and with it the irreplaceable first results of Daguerre's work. Among these was the experimental picture which Daguerre made with Arago in order to instruct the latter in the method and importance of his invention. In the summer of 1839 Daguerre, who was married, lived at 17 Boulevard St. Martin, where he liked to spend his time in the circle of his friends;[1] but he did not neglect the further development of his invention and accepted the honors conferred upon him with joyful gratitude.

Daguerre had sent two daguerreotypes to Prince Metternich even before the detailed publication of his process. These incunabula of daguerreotypy were preserved for many years in the physics collection of the imperial residence of the Palace in Vienna, where Crown Prince Rudolph received his practical instruction. After the death of the Crown Prince the collections were divided among many schools and were lost. The subjects of the daguerreotypes, however, are known from the reports of contemporaries.

Emperor Ferdinand I of Austria was probably the first monarch, except the French sovereign, who manifested a particular interest in Daguerre's invention after it became known. He treated him with marked distinction on account of a report, dated August 24, 1839, by the Chancellor Prince Metternich, whose keen insight grasped the importance of photography for the future. Through the courtesy of Freiherr Dr. von Weckbecker, Vienna, the author was privileged to study other, hitherto unknown documents referring to Daguerre in the imperial archives. The Emperor had received early in August one of Daguerre's first specimens, for which he ordered a valuable honorarium to be transmitted in return to Daguerre.

The Emperor's letter to the Lord Chamberlain, Count Czernin, dated September 2, 1839, is signed by him. The text is as follows:

Dear Count Czernin.

Through my Embassy at Paris, M. Daguerre has sent a specimen picture of his invention, fixing by the action of light the images obtained in the

camera obscura, for which I grant him an artist's medal, 18 ducats in weight, and an initialed snuffbox valued at 1,200 florins. You are ordered to expedite both to my House, Court and State Chancellor, Prince Metternich, that he may present them to M. Daguerre.
Schönbrunn, September 2, 1839.

[Signed] Ferdinand.

It is interesting to note the following sentence from the instructions for the engraving of the medal:

Since according to the specifications the name of the party is to be engraved, and the office of the Chancellor has been unable to procure any knowledge of his Christian name, the office of the Lord Chamberlain deems it proper to employ the expedient used previously on similar occasions and to entrust the commission to the Imperial Royal Embassy at Paris, requesting that Daguerre's name be ordered engraved on the said medal, in order that the early acknowledgment of this gracious act, which the Court and State Office hereby requests, be not delayed.

This shows the high esteem in which Daguerre's invention was held at the Austrian Court and how his first daguerreotypes were appreciated—in a manner in which only distinguished artists were honored.

The first daguerreotypes sent to Vienna were exhibited at the Wiener Maler-Akademie, in 1839. The academy proposed to the government, in 1840, that Daguerre be made an honorary member of the Vienna Academy. This proposal, however, was not honored until 1843.

It is unfortunate that the pictures which Daguerre sent to the Emperor of Austria and to Prince Metternich have been lost, but an exact description of them is preserved in the Vienna journals of that time. For instance, *Der österreichische Zuschauer*, September 20, 1839, No. 113, writes as follows:

Both pictures are framed, under glass. One of them, a view of Notre Dame, Paris, presents the view of a whole section of the town. In the middle foreground one sees the Gothic Church (Notre Dame). Alongside is a bridge crossing the Seine, on each side the embankments, and in perspective rows of houses. The scale is probably 1/1000 of the natural size. It is necessary therefore to use a magnifying glass in order to view the details of the picture. And then the tiny pointed arches of the church windows, the smallest architectural ornament, hardly perceptible to eye in reality, every brick, the iron railing on the bridge, the stones of the pavement, in short, the smallest trifle is shown in such perfection that any other image is poor in comparison. It is the same with lights and shadows. The draughtsman

must lay down his pencil, the engraver his tool and confess that he cannot now or ever equal this result. The second picture, representing the studio of M. Daguerre, falls short of the first in point of sharpness and perfection, presumably because the light in the closed room was not as strong as that in the open air. We see in the foreground a plaster of Paris statue of Hercules, which shows very bright and therefore most distinctly. On the floor next to it is a sphinx, and several plastic objects—casts of hands, feet, etc.—fill the intermediate space. In the background on the left stand the Three Graces, carrying an entablature as Caryathides. In all the statues, particularly in that of Hercules, every muscle, every shadow, and every halftone is expressed in detail. The coloring is like that of a copperplate engraving, only translating gray into gray, but there are found here effects which are indescribable, and everyone was obliged to confess that he had never seen anything like it.

This demonstrates the overwhelming impression which the first daguerreotypes made in Austria.

Chapter XXVIII. SUCCESS OF DAGUERREOTYPY AND ITS COMMERCIAL USE; THE FIRST DAGUERREOTYPE CAMERAS, 1839

THE SUCCESS of Daguerre was extraordinary in every respect. In 1839 he became an Officer of the Legion of Honor, was elected an honorary member of the Royal Society of London (August, 1839), of the National Academy of Design, New York (May, 1839), and of the Vienna Academy (1843). In the spring of 1843 King Frederick William IV of Prussia bestowed on Daguerre at the request of Humboldt the order "Pour le Mérite," which was seldom given to foreigners. He received many other honors; but regardless of these rewards he did not neglect the financial side of his invention. He drew large profits from the sale of daguerreotype cameras and auxiliary apparatus.

THE YEARS PRECEDING DAGUERRE'S DEATH[1]

In the early forties of the last century Daguerre retired from business, greatly respected and amply rewarded. He made his home at his country place in Petit-Bry-sur-Marne, where he received visitors from all countries; there he died, suddenly, July 10, 1851. Daguerre left no will, but he had adopted his niece, Eulalia Daguerre, later Madame Courtin, who inherited his objects of art and his estate.

PORTRAITS AND MONUMENTS

There are several portraits of Daguerre in existence, and we refer only to those which seem most interesting. [These are reproduced in the fourth edition, 1932, of this *History*.] Potonniée, in his *Histoire*, reproduces a miniature by Millet de Charlieu, painted in 1827 and preserved in the Louvre.

A good portrait of Daguerre is shown in a lithograph by Aubert, dating from the late twenties. It was exhibited at the Paris Exposition in 1900. Especially valuable is the portrait ascribed by the editors of *The Year Book of Photography* to Mayall of London (1846), but according to George E. Brown (*The Photogram*, 1903, p. 323; *The Photo-Miniature*, March, 1904) it is a daguerreotype by Charles Meade, of New York, who visited Daguerre at Bry in 1848; it certainly dates from Daguerre's last years[2] and presents him as a country gentleman in robust health. Another good portrait appears in Nadar's *Paris-Photographe* (1891, No. 1, p. 23) a heliogravure reproduction of a daguerreotype.

In a print in a Dutch textbook on photography by Idzerda, *Leerbock der algemeene Fotografie* (1909, p. 101) Daguerre is pictured as a photographer, seated at a table on which rests a camera, probably illustrating the earliest form of the Daguerre-Giroux camera of 1839-40.

A monument adorned with a medallion portrait of Daguerre was erected in the cemetery at Petit-Bry-sur-Marne by the Société Libre des Beaux Arts, of which Daguerre was a member, on November 4, 1852, a year after his death. A larger bust in bronze, by Elsa Bloch, was unveiled on the Place Carnot at Bry-sur-Marne on July 27, 1897, donated by international subscriptions.[3]

America also possesses its monument of Daguerre, erected at Washington in 1890 by the Photographers' Association of America (*Anthony's Photographic Bulletin*, Feb. 8, 1890, XXI, frontispiece).

A number of commemorative medals, presented by various photographic societies for meritorious services in the field of photography, display the portraits of Niépce and Daguerre. Especially worthy of mention is the beautiful Peligot medal of the Société française de Photographie, at Paris, executed by E. Soldi. This medal was instituted by the celebrated chemist Eugene Melchior Peligot and is considered one of the coveted prizes of the Paris Photographic Society. The Klub der Amateur-Photographen, in Vienna, also had a Daguerre medal stamped, by Jauner of Vienna.

Many controversies have arisen as to whether Niépce or Daguerre deserved the greater share of the merit for the invention of photography. The author of this history is convinced that the credit unquestionably belongs to Nicéphore Niépce, for having been the first to produce photographs in the camera and to have fixed images on asphaltum. He is also without doubt the inventor of heliography, which made possible the photomechanical reproduction of pictures by the printing press. Daguerre had attempted to produce light images since 1824, but without success. It was not until he was made familiar with Niépce's new ideas and experiments and after he had changed, developed, and modified them successfully that images were obtained in the camera obscura with a relatively short time of exposure. After all, in both Niépce's and Daguerre's methods silvered plates were used as a basis. Both used iodine, but as shown above, in an entirely different manner. The great achievements were the first use of silver iodide as a light-sensitive substance in the camera obscura, the discovery of the development of the scarcely visible image by mercury vapors, and the discovery of the fixation of silver images. These rightly belong to Daguerre alone. The similarity of the methods of the two inventors would lead us to suppose that without Niépce's ideas it would have been difficult for Daguerre to have discovered the art named after him; but it is equally probable that the valuable discovery of Niépce would have been in vain without Daguerre's collaboration. In the history of science they must in justice be named jointly, and Niépce and Daguerre have equal claims on public gratitude.

NOTE

An alleged predecessor of Daguerre, the Greek monk Panselenus, whose writings a Dr. Simonides is supposed to have discovered, is dealt with exhaustively in the *British Journal of Photography* (1865, XII, 73, 194), by Carey Lea, who rejects this claim as quite unjustified.

Chapter XXIX. COMMERCIALIZATION OF DAGUERREOTYPY; DESCRIPTION OF THE PROCESS

DAGUERRE was not only a successful inventor and artist but also a clever business man. In 1839 he joined Giroux, manufacturer of cameras in Paris, for the commercial introduction of his camera. This camera

had affixed to it, as a guarantee, the signature of Daguerre and the seal of Giroux. A label on the wooden box of the camera read: "Each apparatus is guaranteed only if it carries the signature of M. Daguerre and the seal of M. Giroux. Equipment for daguerreotypy furnished, under the direction of its author, in Paris by Alph. Giroux et Cie., Rue de Coq. St. Honoré, No. 7."

Illustration No. 58 in the German edition (*Geschichte der Photographie*, 4th ed., 1932, p. 329) shows an orignial Daguerre camera,[1] as supplied by Giroux in September, 1839, at a price of 400 francs. One may recognize the movable telescopic wooden box and the diaphragmed lens which could be closed by a simple metal cover, an achromatic lens manufactured by Charles Chevalier in Paris.

Chevalier's lens consisted of a simple achromatic lens which combined a biconvex and a biconcave flint glass. (See the reference to Wollaston's meniscus, used earlier by Niépce). This lens was achromatized to optical rays as John Dollond had indicated and as Fraunhofer had taught. It was very slow, but it sufficed for the early period of daguerreotypy, being employed chiefly for exposures of architectural subjects and landscapes. The achromatization for the optical and chemical rays was perfected much later, when Petzval discovered his epoch-making portrait lens, concerning which more can be found in my *Handbuch* (1893, I (2), 56).

John Dollond (1706-61) was born in London and became a silk weaver by trade. He also studied mathematics, optics, and astronomy. In 1768 he discovered the unequal dispersion of colored light rays in various refracting media and deduced from this the possibility for the construction of telescopes, which did not produce colored rings. In 1757 he constructed an achromatic telescope of flint and crown glass (Kelly, *Life of John Dollond*, 3d ed., 1908). Dollond's lenses, however, were corrected by empirical tests. Fraunhofer was the first one to teach the exact calculation for the correction of color errors.

It is characteristic of Daguerre's well-developed business acumen that on August 14, 1839, a few days before the daguerreotype process was made public at a meeting of the Paris Academy, Miles Berry applied for an English Patent (No. 8,194, 1839) for daguerreotypy, "Being a communication from a foreigner residing abroad," I quote from the patent, "I believe it to be the invention or discovery of MM. Louis Jacques Mandé Daguerre and Joseph Isidore Niépce, Junior." These patent rights were bought by Claudet, who utilized them in his en-

deavor to shorten the time of exposure. He introduced important improvements into daguerreotypy. Claudet succeeded by his clever services in bringing the process into high public esteem and was appointed court photographer to the Queen and the Prince-Consort Albert (1855).

THE FIRST DESCRIPTION OF THE PRODUCTION OF DAGUERREOTYPES

The first report on the discovery of Daguerre was made by Arago on January 7, 1839, to the Royal French Academy of Sciences. The complete public report, entitled "La Daguerréotype, origine et histoire de cette découverte," was delivered on August 19, 1839, and may be found in *Comptes rendus.*

The first official description of the daguerreotype process made accessible to the general public was published in the handbook *Historique et description des procédés du daguerréotypie et du diorama,* by Louis Jacques Mandé Daguerre (pp. iv, 79, with six plates illustrating the apparatus used; Paris, Susse Frères, 1839). A second edition, corrected and enlarged, with a portrait of Daguerre as frontispiece, was published by Giroux, and a third edition, with the imprint of F. Mollet, Paris, appeared in the same year. An English edition, *Historical and Descriptive Account of the Various Processes of the Daguerreotype and of the Diorama,* by an unnamed translator, was published in 1839 by McLean and Nutt, London, with portrait and six plates. The first original German edition was published in 1839, by Schlesinger, in Berlin. W. Knapp, in Halle, also published in 1839 a booklet by F. A. W. Netto, entitled *Vollständige Anweisung zur Verfertigung daguerrescher Bilder.*

These were followed by a great output of literature, some of which has become very rare. An exhaustive list is given in the treatise of Eder and Kuchinka, *Die Daguerreotypie und die Anfänge der Negativphotographie auf Papier und Glas (Talbotypie und Niepçotypie)* (*Handbuch,* 1927, Vol. II, Part 3). Most of these pamphlets and books appeared in the early forties—until about 1847.

A very complete and valuable collection of early publications dealing with photography was gathered by the author of this history for the library of the Graphische Lehr- und Versuchsanstalt, of Vienna. The library of the Technical College at Vienna also, by the efforts of the late librarian, A. Martin, possesses an important collection, and there are notable collections in the libraries of the principal French, German, English, and American photographic societies.

The publication of the daguerreotype process aroused great interest throughout the world. It was introduced into use before the end of 1839 in many countries outside of France; the demands for its accessories therefore grew tremendously. A complete apparatus, including camera with lens, silvered plates, chemicals, and so forth, cost 400 francs. Original daguerreotypes made in Paris brought in Germany and elsewhere at the end of 1839 from 60 to 120 francs. The first pupils of Daguerre sold their own daguerreotypes at this time for about twenty to twenty-five marks.

DESCRIPTION OF DAGUERRE'S PROCESS

The original camera of Daguerre consisted of a plain wooden box with a simple Chevalier lens[2] of flint and crown glass cemented together. By means of a mirror fixed at an angle of 45° behind the ground glass (focusing glass) of the camera, the spectator viewed the picture image from above, seeing the subject (reversed by the mirror) in its original upright position, that is, "right side up," as in the reflex cameras of today. A light-sensitive silvered copper plate,[3] usually 6.5 x 8.6 inches, carefully polished and previously subjected to the vapors of iodine at normal temperature, this forming a very thin coat of silver iodide, was used to receive the picture image. In the camera these silvered plates treated with iodine vapors, were exposed to light for such a long time that at first one had to be satisfied with "taking" inanimate objects, such as architectural subjects, those of the plastic art, and landscapes. The first daguerreotypes were reversed as to position, but soon (1841) Chevalier attached to the front of the lens tube a reversing prism with a silvered hypothenuse and offered this apparatus for sale.

For the development of the invisible camera image the iodized silvered plates were subjected to the vapor of mercury, slightly heated. This was done in a wooden mercury box with a saucer-like hollow iron bottom in which the mercury was placed. An alcohol lamp on a shelf below heated the mercury, and a thermometer on the inside of the box indicated the correct temperature. After the exposure, the plate was inserted in the box diagonally, the cover closed and the image gradually became visible (developed) through the action of the mercury vapor.[4]

Daguerre himself and his numerous pupils produced many daguerreotypes, and they soon became known all over the world. Only a few of those made by Daguerre personally, and vouched for as such,

are preserved. One of these was exhibited at the Paris Exposition in 1900 and was later published in the official report.[5] The early daguerreotypes were generally preserved in paper wrappings, which injured the delicate images. As early as 1839 Daguerre protected his pictures by inserting them in frames or cases under glass.

In his early practice Daguerre knew only of the imperfect fixation of the daguerreotype with a warm common salt solution, which gave them a mottled appearance. One of the greatest improvements of the daguerreotype process consisted in the introduction by Sir John Herschel[6] of hyposulphite of soda as a fixative. This scientist discovered the salts of the hyposulphurous acids in 1819 and had already called attention to the solvent action of hyposulphite of soda on silver chloride[7] (see *British Journal of Photography Almanac*, 1931, p. 156).

At that time Herschel associated a great deal with Talbot, who in the beginning could fix his silver chloride images on paper only very imperfectly with a solution of common salt. It was Herschel who called Talbot's attention to the advantages of hyposulphite of soda and enabled him as early as May 1, 1839, to acknowledge the benefits of this improved fixation. Daguerre soon learned of this and, abandoning his imperfect method of fixation with a warm solution of salt, immediately adopted for use hyposulphite of soda, in 1839.

Daguerreotypes were greatly enhanced in beauty and improved in permanence by being toned in a bath of hyposulphite of soda containing gold chloride. The invention of this gilding process was made by the French physicist Fizeau, in 1840.[8] This advance was generally adopted and largely increased the public demand for daguerreotypes.

Fizeau's fixing bath contained 300 parts of hyposulphite of soda, 1,000 parts of water, and one part of chloride of gold. The pharmacists Mathurin Joseph Fordos and Amadée Gélis, manufacturers of chemical products at Paris, analyzed the double salt formed by this process, determined its composition, and called it "hyposulphite of gold and sodium," later known as "sodium auro-thiosulphate. In the trade it was called "Sel d'or de Fordos et Gélis," and subsequently it became the basis for many of the combined toning-fixing baths of modern silver printing papers.

In the early years of daguerreotypy, according to the statement of the inventor, silver-plated copper plates were used and pure iodine vapors, that is, silver iodide, which confined the art to taking of inanimate objects, owing to the necessity for long exposures. Notwithstand-

ing this limitation, the public took an unprecedented interest in the art of photography.

In 1841 Alexis Gaudin made a very small and handy camera with a very short focus lens; he also affixed to it a kind of exposure shutter permitting instantaneous exposure by means of a cloth flap covering the lens.

The introduction of the tripod for the camera is attributed to Baron Armand Pierre de Seguier (1803-76) as early as 1839. The announcement of this accessory is found in an annotated edition of the original pamphlet by Daguerre, published by Susse and Lerebours, October, 1839 (G. Cromer, *Revue française de photographie*, 1930, p. 154). Chevalier equipped his camera with a tripod in the same year.

Baron Seguier was the first to recommend, in 1839, a leather bellows to make the camera more portable. With the same purpose in mind Friedrich Voigtländer, at Vienna (1841), gave the daguerreotype camera the shape of a truncated cone. This was one of the first more convenient daguerreotype cameras built entirely of metal, easily carried, readily taken apart and assembled. The sensitive plate was inserted in the wide section; in the front was the Petzval portrait lens, and in the back a focusing lens. The plates were round. The directions for the use of the Voigtländer small metal camera are interesting. They read:

Directions for the use of the new daguerreotype apparatus for the making of portraits, executed according to the calculations of Professor Petzval by Voigtländer and Son, Vienna, printed by J. P. Sollinger, August 1, 1841.

The person to be photographed must be seated in the open air. For an exposure by overcast, dark skies in winter 3½ minutes is sufficient; on a sunny day in the shade 1½ to 2 minutes are enough, and in direct sunlight it requires no more than 40-45 seconds. The last, however, is seldom employed on account of the deep shadows necessarily obtained. [See 5th number of the *Verh. d. n. ö. Gew. Verein*, Vienna 1842, p. 72.]

This was followed by a variety of differently constructed cameras.

In 1845 Friedrich von Martens, a copperplate engraver in Paris, invented the first panoramic apparatus for curved daguerreotype plates, which had a visual angle of 150° (*Compt. rend.*, 1845). The apparatus was called "Megaskop-Kamera" or "Panorama-Kamera." A great disadvantage of Martens's apparatus was the difficulty in the handling of

the cylindrically curved plate. The lens was capable of being turned. Notwithstanding this and other difficulties, some results were obtained, and one specimen was preserved and was exhibited at the celebration of the centenary of photography by the Photographic Society of Paris. The picture represented an extensive view: "Panoramic view of the banks of the Seine in the direction of the Institute at Paris, 1844." This invention had no significance either for daguerreotypy or the collodion process.[9] It was not until the invention of the flexible silver bromide films that the invention achieved the great success which it merits. The prototype of the Kodak Panoram camera, introduced with commercial success in 1900, is easily seen at first sight. The Kodak Panoram camera permits an instantaneous exposure over an extensive field of vision by an analogous turning of the lens and by a slit shutter passing in front of the film. It was first shown at the Exposition in Paris, 1900 (*Jahrbuch f. Phot.*, 1901, p. 159).

As a matter for curiosity we mention that the daguerreotypist Netto constructed, in 1842, a studio in which the front part of the camera with the lens was built into the wall between the workroom and the adjoining darkroom. An illustration of this will be found in *Nord. Tidskr. f. Fot.* (1920, p. 119).

DAGUERREOTYPY CARICATURED

The degree of enthusiasm awakened by daguerreotypy in the whole world is shown in a caricature by Maurisset in Paris, published 1839-40, having as its subject "Daguerreotypomania." This was reproduced in Nadar's *Paris-Photographe* (1893, p. 486), as well as in *Phot. Rund.* (1889, p. 101). The latter journal remarks:

This French pamphlet expresses the accumulated wrath of the artist, worried over his bread and butter, against the new invention of photography. In the center is a great bustle and tumult of the crowd from all walks of life around a studio of adventurers: "Maison Susse frères," which advertises portraits in thirteen minutes without sun, "Epreuve retournée," "Etrennes daguerreotypiennes pour 1840," and "Fenêtres à louer." On the first platform we see a real detective apparatus in imaginary action, and beside it proofs are shown. On the second platform is a larger camera, with an umbrella and a clock—object doubtful. On the left a pupil of Daguerre's is in the act of photographing a dancing girl in a hazardous position, about to leap onto a tightrope—music and gas lamps, which were a novelty then, serve to accentuate the effect. In the left foreground a photographer, with

a portable traveling apparatus under his arm, photographs a struggling child held by mother and nurse. In the right foreground one sees the system of Dr. Donné, copies on paper, accessories for taking portraits, such as a headrest, a knee guard, and other imaginable contrivances for keeping the person from moving. Alongside stands the famous doctor with his magic wand and directs the ensemble with remarkable dignity.

In the foreground are disposed photographic accessories, such as vapor boxes and phials, and so forth. For the gentlemen who make their living from copperplate engraving a stately row of gallows are for hire, and some of them are occupied. A countless procession of curiosity seekers, as well as a steam boiler, are reproduced on the upper right of our page. Whether the circle of dancers pirouetting in front of the steam camera are a prophecy of the instantaneous pictures of modern times, remains unsolved. Humanity is divided, according to the picture, into "daguerreomaniacs" and "daguerreotypolators," let us say, "daguerreocrazed" and "daguerreo-amazed." Railroads, novel then, and steamships are not omitted from the drawing; we see a train and a boat loaded—with cameras only. Factory numbers 200, 250, and 300 are especially emphasized in the picture, even the balloon photographer is here.

Indeed, photography from a balloon in the air, prophesied by the caricaturists, was successfully executed by Nadar, in Paris, in 1858. Many of the other dreams were fulfilled, but photography proved itself an advantage rather than a detriment to the fine arts.

A caricature of Daguerre is found in the much-sought-after work *Musée Dantan; galerie des charges et croquis des célébrités de l'époque* (Paris, Delloye, 1838-39). The drawing is by Dantan, Jr.; the woodcut, white on black, by Grandville. The bust of Daguerre is on a pedestal which represents the diorama, and its name is on the pedestal as a picture puzzle.

Another harmless caricature, dating from the early days of daguerreotypy (end of 1839) is a lithograph printed by Aubert & Co., Paris, and published by them. One may see in this a Daguerre-Giroux camera in which the picture is looked at from above, reflected by an inclined mirror on a ground glass.

These caricatures give an idea of the hold daguerreotypy had on the popular mind.

Chapter XXX. FIRST USE OF THE WORD "PHOTOGRAPHY," MARCH 14, 1839

FOR A LONG TIME the date when the word "photography" was first used remained obscure. Through the efforts, however, of Dr. Murray, editor of the *Oxford Dictionary* and one of the greatest contributors to the history of the English language, the question was cleared up in 1905. As far as can be ascertained the first use of the word "photography" was made by Sir John Herschel in a lecture before the Royal Society of London, on March 14, 1839. He used there the terms "photographic" and "photography," in the present meaning of these words, in his article "On the Art of Photography; or, The Application of the Chemical Rays of Light to the Purpose of Pictorial Representation." Niépce used the term "heliographic"; Talbot the word "photogenic." Evidently it seemed more appropriate to Herschel to coin the general term "photography." In France it was not until May 6, 1839, that the term "art photographique" appeared in the *Compt. rend.*, VIII, 714.

Arago used the word as a matter of course in his report on Daguerre's process to the Chamber of Deputies, July 3, 1839. The term is constantly employed in later issues of the *Compt. rend.*, from July to September, 1839, and became universally adopted. We must therefore call March 14, 1839, the literary birthday of the word. It is quite certain that Niépce, Daguerre, and Talbot did not know or use the word. Talbot lectured on his invention six weeks earlier than Herschel, when he reported his own investigations, but the word "photography" did not occur; he spoke only of photogenic drawing. He called his photographs "Talbotypes" and "calotypes."

It was found out later that the word "photography" had been used a few days earlier than by Herschel in a German newspaper.

Professor Erich Stenger has called attention to this (*Brit. Jour.*, 1932, p. 577; also *Phot. Rund.*, 1932, p. 353). In the *Vossische Zeitung* of February 25, 1839, the word "photography" was first used by a contributor in an article on Talbot's inventions. The writer seemed to have placed very little value upon the use of this new word, because he did not sign his full name, but only his initials, "J. M." He writes that he used the word "photography" on account of brevity for the inventions of Daguerre and those of Talbot. This use of the word remained unnoticed for ninety years, until Eduard Buchner, the editor, called attention to it in the Festival Edition, "Zweihundert Jahre Kul-

tur im Spiegel der *Vossische Zeitung*." The writer of the original article, "J. M.," remained unknown until Professor Stenger succeeded in determining that it was written by the Berlin astronomer Johann von Maedler (1794-1874). Maedler studied natural sciences and specialized in astronomy. In 1842 he induced the banker Wilhelm Beer (the brother of the composer Meyerbeer) to equip a private observatory in Berlin, where they collaborated in producing a large map of the moon (1834-36).

In 1836 Maedler became observator at the observatory in Berlin, and in 1840 director of the observatory in Dorpat. He wrote many articles on astronomy and published, in 1872, a *Geschichte der Himmelskunde*. He wrote a good many articles on the natural sciences for the *Vossische Zeitung* and interested himself greatly in the publications of Daguerre and Talbot. His article on February 25, 1839, in that newspaper, therefore, establishes the birthday of the word "photography" and that Johann von Maedler was its author.

Of course, it must not be forgotten that the use of the word by an unknown and anonymous newspaper contributor was not noticed by anyone, while Sir John Herschel's mention of it made the word known to the whole world.

Chapter XXXI. SCIENTIFIC INVESTIGATION OF THE CHEMICO-PHYSICAL BASIS OF PHOTOGRAPHY

As soon as daguerreotypy became generally known, scientific investigations concerning it began everywhere. The earliest theory of the origin of the ability to develop the latent light image[1] on the daguerreotype plate was expressed by Arago in 1839 with the publication of the process in that year. He assumed that silver iodide is reduced in light to metallic silver which absorbs the mercury vapor, forming the lights of the image in amalgam, while the unchanged silver iodide is eliminated by the subsequent fixation. N. P. Lerebours reports on this in his *Historique et description de la daguerréotypie* (1839).

This chemical theory was opposed in the same year by Al. Donné, who offered another physical theory. He observed that a silvered plate subjected to iodine vapor is physically changed under the action of

light, suffering a change of structure on its surface and becoming powdery so that the powder can be removed by gentle rubbing (*Compt. rend.*, 1839, XI, 376). He assumed that the mercury vapor penetrates the exposed silver iodide layer (which has become powdery in its consistency) to the metallic silver plate, while the nonexposed and still coherent silver iodide layer resists the action of the fumes. Claudet, as well as Gaudin, made similar observations, as Schultz-Sellack noted later (*Handbuch*, 3d ed., 1927, II (3), 6).

In 1842 Ludwig Ferdinand Moser (1805-80), professor of physics at Königsberg, brought the so-called breath pictures ("Hauchbilder") into prominence. If a coin is placed on a clean glass plate for a few hours, a picture remains after the coin is removed if one breathes on the spot. He applied this to daguerreotypy. This demonstrates that many of the later theories (Hunt and Knorr) were discussed even then, and this refers also to the subject of "electrography" (Karsten).

Moser found that the well-polished surface of a glass or metal plate, when brought into contact with another body, attracts moisture (steam or breath). Moser assumed that the condensation of mercury vapor on the exposed daguerreotype plate revealed (developed) a breath picture ("Hauchbild") and made the interesting discovery that a fully exposed daguerreotype plate could be developed with steam; an image brought out by steam disappears, however, in a very short time. He did not agree with the theory of a chemical change in silver iodide (as assumed by Arago), but with a physical action, according to Donné. Moser supported his theory with an experiment made by Draper, who exposed an iodized silvered plate together with moist starch paper to sunlight; but no trace of liberated iodine could be proven (Pogg., *Annal.*, LXV, 190).[2]

Very important was the recognition that the latent image on the daguerreotype plate is destroyed by the fumes of iodine, bromine, or chlorine and that the developability is thereby lost (Gaudin, *Compt. rend.*, 1841, I, 1187). This was thoroughly investigated two years later by G. Shaw and Percy (*Phil. Mag.*, Dec., 1843). They found also that a daguerreotype plate on which the latent image had been destroyed by iodine or similar agents was capable of giving a developable image after re-exposure (*Handbuch*, 3d ed., 1927, II (3), 8).

Subsequently scientists abandoned the theory of the physical action of light, owing to the investigations of Choiselat and Ratel in 1843,[3] and turned to still another theory in favor of photochemical action.

These experimenters assumed that the silver iodide loses at first a part of the iodine in light, forming the hypothetical subiodide of silver (Ag_2J), while the iodine photochemically liberated is absorbed by the underlying silver of the plate. The mercury vapor decomposes not only the silver iodide (AgJ) but also the subiodide (Ag_2J) in a different manner; the parts of the silver iodide not acted upon by the light are changed into mercurous iodide and metallic silver by the action of mercury vapor. The silver subiodide formed during the exposure forms in contact with the mercurous iodide resulting from the above-mentioned reaction, metallic mercury and silver, according to the following equation: $2Ag_2J + 2Hg_2J_2 = 3HgJ_2 + Hg + 4Ag$. The silver and mercury combine in a white amalgam (*Handbuch*, 2d ed., 1898, II, 11, 32, 112). In fixing with hypo the mercuric iodide dissolves completely, leaving behind a white silver amalgam in the light parts; in the shadows it dissolves the mercurous iodide, and only dark, finely divided silver remains.

We shall not go further into these complicated theories, but will only point out the historical fact that in 1843 Choiselat and Ratel established for the first time the theory that the latent image consists of silver subhalide.

The latent image on the daguerreotype plate disappears gradually when it is kept in the dark, as John W. Draper was probably the first to observe. This retrogression was investigated by Carey Lea (*Phot. Korr.*, 1866, III, 129; 1867, IV, 53; *Philadelphia Photographer*, April, 1866, III, 97), also in pure silver iodide, which was produced by iodizing silvered glass mirrors (*Handbuch*, 1898, II, 85).

And so as early as 1840 all these theories of the latent light image obtained with silver halide salts were advanced which kept the photochemists of the nineteenth century busy and are not finally determined today. In order to complete the record it must be added here that August Testelin assumed in his *Essai de théorie sur la formation des images photographiques, rapportée a une cause électrique* (Paris, 1860) that the silver iodide molecules acquire an electric polarity during the exposure which brings about the precipitation of the mercury vapor on those parts affected by light.

The procedure during iodizing and developing the daguerreotype plate was very carefully and scientifically investigated.

Already Daguerre had noticed that the silvered plate, while being iodized, changed in surface hue to yellow, red, violet, and greenish

blue and that, if the exposure is prolonged, the change of color repeats itself in the same sequence (layers of the first, second, and third order). Daguerre iodized to gold-yellow (1839) or up to the violet-rose red of the first order.[4] Jean Baptiste Dumas measured the thickness of the gold-yellow iodide layer (1839) and found it no thicker than one millionth of a millimeter. The development of the daguerreotype is effected, in practice, by the vapors of mercury heated to about 50-60° C. The microscopically small mercury "drops" which deposit on the parts of the picture were measured by Brongniart (Paris), who found they had a diameter of 0.04 millimeter.

The physicist Karl August Steinheil, of Munich, introduced, in 1842, the use of cold mercury fumes for the development of exposed daguerreotype plates, by placing an amalgamated copper plate close to the daguerreotype plate. The development required much more time—several hours—but the result was good, and the mercury particles on the plate were much smaller than those deposited by hot vapors.

It was found that on pure copper plates (not plated with silver) which had been subjected to the vapor of iodine, bromine, or chlorine, light images could be obtained which could be developed by mercury vapor. Talbot seems to have been the first to discover this, and he, characteristically, applied in 1841 for an English patent on it (*Abridgements Br. Pat.*, 1861, p. 4; Dingler's *Polyt. Jour.*, LXXXII, 192). At the same time and independently Kratochwila of Vienna made the same observation (Dingler's *Polyt. Jour.*, LXXXI, 149).

Wells also applied for a patent on this (*Abridgements Br. Pat.*, 1872, II, 121). Talbot also stated that such images on iodized copper plates could be developed with hydrogen sulphide, without mercury (*Handbuch*, 2d ed., 1898, II, 56, where other notes on this subject will be found). It is worthy of notice that Prechtl, director of the Vienna Polytechnikum, fixed daguerreotype plates which had been normally developed with mercury vapor in a very dilute solution of ammonium sulphide, which caused the parts not amalgamated to turn gray (Dingler's *Polyt. Jour.*, LXVII, 318). None of these modifications, however, equaled the results obtained by the original daguerreotype process.

Sir John Herschel broadened the knowledge of photochemical actions; the results of his investigations were of the greatest importance in applied photography. In 1840 he examined the behavior of nitrate and bromide of silver papers toward the solar spectrum. He found that the image of the chemical spectrum on silver nitrate paper was 1.57

times longer than the visible spectrum; on silver chloride paper it was 1.8 times, and on silver bromide paper as much as 2.16 times longer. After observing this extended sensitivity range of silver bromide, he declared, even as early as 1840, "we must create a new photography, of which silver bromide will form the basis." These important new publications by Sir John Herschel were entitled: "On the Chemical Action of the Rays of the Solar Spectrum on Preparations of Silver and Other Substances, Both Metallic and Nonmetallic, and on Some Photographic Processes" (*Phil. Trans.* of the Royal Society of London, Part 1, p. 1, February 20, 1840) and "On the Action of the Rays of the Solar Spectrum on Vegetable Colours and on Some New Photographic Processes," with Postscript "On Certain Improvements of Photographic Processes Described in a Former Publication and on the Parathermic Rays of the Solar Spectrum" (*Phil. Trans.*, June 16, 1842, XII (2), 181, and Postscript on p. 209, August 29, 1842). In these dissertations Herschel reported the action of the rays of the solar spectrum on various silver and iron salts and on vegetable dyes. There is also mentioned the bleaching action of light on pigments.

HERSCHEL EFFECT

Sir John Herschel published in the *Philosophical Transactions* (1840), an observation which he had made on August 27, 1839, in which he made known for the first time that silver chloride paper turns dark in the concentrated light of the solar spectrum, but bleaches under the oxidizing action of red light. He states that red light, which is considered inactive, exercises an opposite action to that of blue and violet light.

Later Draper (1842), Lerebours (1846), and Claudet (1847) found that this effect of red light also applied to the latent light image on iodized silver daguerreotype plates and to the development with mercury vapor. The later evolution of these early experiments in this direction, which extended to collodion and gelatine silver bromide plates, is dealt with exhaustively in the author's *Handbuch* (1891, Vol. I, Part 2) and has passed into technical literature. Later investigations of the Herschel effect are described by Lüppo-Cramer in his "Grundlagen der Negativverfahren" (*Handbuch*, 1927, Vol. II, Part 1) and in his report at the seventh International Congress of Photography, London, 1928. Another interesting study on the subject by A. P. H. Trivelli is given in "Communication No. 383," of the Kodak Research Labora-

tories, 1929. Also see the dissertation of Johannes Narbutt, *Über den Herschel-Effekt* (Giessen, 1930).

The name "Herschel effect," which was originally used only for the direct blackening and bleaching process of silver chloride paper, was subsequently applied in researches on the latent image and the developing process. The importance of the phenomenon lies in its application to photography with infrared rays, to the production of direct positives and duplicate negatives, and to the theory of the latent image.

In 1840 Herschel stated: "Immerse an ordinary silver print in a solution of mercuric chloride. The picture image is completely bleached out, leaving clean, white paper. If now you immerse this piece of clean, white paper in a solution of fixing salt (hypo), the picture image reappears in all its original intensity." This is the principle of the so-called magic photographs,[5] as well as that underlying the intensification of negatives.

In the second paper mentioned above (1842), Herschel described for the first time the discovery of the iron printing processes with ammonio-citrate of iron by both methods, namely, with blue lines on a white background and white lines on a blue ground (cyanotypy, blueprint—iron process; *Handbuch*, 1929, Vol. IV, Part 4). He also invented the "chrysotype process," which depends on the exposure to light of ferric salts and the development of the ferro-image with gold and silver solutions (*Handbuch*, 1929, Vol. IV, Part 4).

Herschel did not obtain photographically the Fraunhofer lines of the solar spectrum. The first to photograph these was E. Becquerel on daguerreotypes in 1842-43. Draper also worked along these lines and discovered in 1843 the action of the infrared rays. Stokes, employing fluorescent substances in 1852, found that quartz transmits most ultraviolet rays, which led Crookes (1854) to the spectrography of the ultraviolet with wet collodion plates.

Edmond Becquerel (1820-91) came from a family of celebrated French physicists. His father, Antoine César Becquerel (1788-1878) successfully devoted himself to physical and chemical studies. His son Edmond was born in Paris, March 24, 1820, and died there on March 13, 1891. He worked at the Conservatory of Arts and Trades in Paris and was an outstanding scientific scholar in the field of photography; his works are often referred to. His investigations cover many fields and are important (electric light, galvanism,[6] magnetism, diamagnetic

properties, phosphorescence, and so forth). In photographic science his book *La Lumière, ses causes et ses effets* (2 vols., Paris, 1867-68) is of particular importance.

Edmond's son, Antoine Henry Becquerel (1852-1925), became in 1892 professor at the Museum for Natural Sciences, Paris, in 1894 Chief Engineer of Roads and Bridges, and in 1895 professor at the Polytechnic School. His work included among other subjects that on infrared light and phosphorescence, and he discovered the rays named after him (uranium rays, Becquerel rays), which are invisible rays continually emitted by pitchblende that act on silver bromide gelatine plates or films through the carton and black paper. Further investigation of this phenomenon led M. and Mme Curie to the discovery of radium. They found that pitchblende contained substances from which rays emanate with properties similar to those of the Roentgen rays, namely, radioactivity. In 1903 M. and Mme Curie, with Henry Becquerel, received the Nobel prize for their investigations of radium.

INCREASE IN THE SENSITIVITY OF DAGUERREOTYPE PLATES
BY THE INTRODUCTION OF BROMINE

The most important advance in the progress of daguerreotypy regarding their sensitivity to light was made with the discovery that the complex combinations of silver iodide with silver bromide or silver chloride, in the form of silver iodo-bromide or iodo-bromo-chloride of silver, were much more sensitive to light than pure silver iodide; a discovery of the greatest value, not only in daguerreotypy, but for the Talbotype and the wet collodion processes of earlier years, as well as for the gelatine emulsions of today.

The introduction of iodo-bromide by John Frederick Goddard, London, and Dr. Paul Beck Goddard, Philadelphia (1840), as well as that of iodine bromo-chloride at the same time, or perhaps somewhat earlier, by Kratochwila, in Vienna, is described in the next chapter.

BECQUEREL'S "CONTINUING RAYS"; SECONDARY EXPOSURE
WITH RAYS OF LONG WAVE LENGTH

The discovery of the partly equivalent and partly antagonistic action of the colored rays of the solar spectrum on photographic silver salt layers was theoretically, and in some degree practically, important.

Edmond Becquerel seems to have been the first person to observe, in 1840 (*Compt. rend.*, II, 702), that the latent daguerreotype image

which had been underexposed could be intensified if re-exposed to the yellow and red rays of the spectrum and then developed with mercury. The secondary exposure under red glass supplements the original exposure (Becquerel, *La Lumière, ses causes et ses effets*, Paris, 1868, II, 76, 90, and 176; see also the bibliography). Explaining this phenomenon, Becquerel called the yellow-red rays continuing rays ("rayons continuateurs") in contrast to the primary rays, which excited or produced the light image and which he called exciting rays ("rayons excitateurs").

These phenomena are usually called the "Becquerel phenomena" in photochemistry; they are dependent on the wave length of the light.[7] It is very curious that Moser, who, like all other investigators mentioned here, concerned himself only with daguerreotypy, opposed the theory that the red and yellow rays were called "continuing," and the blue and violet rays "exciting" in the photographic process. Moser pronounced this classification erroneous and advocated the theory that all rays, that is, rays of every wave length, are capable of commencing as well as of finishing the action of the light; and within certain limits he is correct.

Edmond Becquerel was not alone in his observation, as Eder indicated in 1884 (*Handbuch*, 1884, I, 53).

Antoine Gaudin, in 1841, attempted to use the "continuous action" of the red rays in photography for the purpose of shortening the exposure (*Compt. rend.*, XII, 862, 1060); Fizeau also recommended a short exposure for the brominated daguerreotype plates for portraits, followed by another exposure to the action of "continuous" rays (Stenger, *Wissensch. Zeitung f. Phot.*, 1930, XXIX, 45).

Fizeau and Foucault[8] described the so-called negative action of certain light rays very accurately, having placed in the hands of the Paris Academy a sealed letter on December 9, 1844, containing their report on this subject. In their experiments they caused the light of a lamp to act on a bromo-iodized daguerreotype plate, until it was covered by the mercury vapor with a uniform white layer. However, before they subjected the plates to the vapor, they exposed them to the solar spectrum. When the plates were subjected to the mercury vapor, two distinctly different parts of the spectrum were visible. On the one side of the orange, up to the most refrangible or "actinic" rays, a strong condensation of the vapor accrued, while, on the other side of the less refrangible rays, and indeed far beyond the red, no condensation was

noticeable. It follows that these rays had neutralized the effect of the lamp. Foucault and Fizeau therefore call this action negative in contrast to the positive action of the stronger refrangible rays. If the time of exposure is lengthened during which the spectrum acts on the plate, the precipitate extends to the maximum of the negative action. Moreover, it is observed that between the decidedly positive and decidedly negative acting rays, there exists a class of rays which have sometimes one and sometimes the other effect, according to the intensity and length of their action. These rays which are found particularly in the orange, act negatively when they are weak or when the exposure is short, but under opposite conditions they give positive results.

Claudet also, in 1847, demonstrated that the red and yellow rays of the spectrum prevent the action of the other (blue) rays on bromine, iodine, or silver chloride (daguerreotype plates) and destroy the action, if it has taken place, so that the image is not developed by the mercury vapor; later he found[9] that red and yellow rays always exercise a negative or destructive effect on bromo-iodide or bromo-chloride plates, but on pure iodine plates they act sometimes in the same ways as do blue rays and sometimes negatively. Concerning the relative action of the respective rays, according to Claudet, to destroy the action of white light which acted for the unit time, red light requires an exposure of the relative time of 50, orange colored, 15, yellow, 18.

Draper obtained solarization phenomena from G up to the infrared, with the positive appearance of Fraunhofer's lines, when he exposed daguerreotype plates to the spectrum and simultaneously to weak, diffused daylight.[10]

Very important is the discovery of photogalvanic and photoelectric currents by Becquerel in 1839 and subsequent years. He observed that when light falls on one of two plates of platinum, gold, or silver that are immersed in an acid or alkaline bath, a galvanic current will at once circulate between them. The current is greatly increased when the silver plates are coated with chloride, iodide, or bromide of silver.

In 1841 Becquerel constructed his "electro-chemical photometer," based on the above-described phenomenon; by the use of silver subchloride he accomplished with this apparatus photometric readings which correspond to the sensation caused by light on the retina in the human eye.

The generation of photogalvanic currents has since become of great importance in the study of physics and photochemistry. The "photo-

galvanic effect" has been usually abbreviated to "Becquerel effect" (B. E.). This distinct, circumscribed electrode Becquerel effect must not be confused with the above-mentioned photographic "Becquerel phenomenon," which deals with the opposite light action of various wave lengths on silver halide layers—exciting and continuing action ("Über den Becquerel-Effekt," by Chr. Winter, *Zeitschr. f. physikalische Chemie*, 1827, CXXXI, 205).

The action of electricity on daguerreotype plates was investigated by Daguerre in 1839, by conducting an electric current through the plate during exposure. He believed the sensitivity would be augmented by it, but the experiment was without success. Becquerel found, in 1841, that electricity reduces a layer of silver chloride, similar to light, which was verified by Pinaud. He continued his experiments until 1851 and found that a weak electric spark striking a daguerreotype plate produced a result which could be developed with mercury vapor (electrography).

For electrographic moisture pictures by Karsten (1842) and Grove (1857) and electrographic reproductions of medals on iodized daguerreotype plates by Volpicelli in 1857 see Eder, *Photochemie*, 1906, p. 419.

DISCOVERY OF "ATMOGRAPHY" ON DAGUERREOTYPE PLATES BY J. J. POHL, VIENNA

Dr. J. J. Pohl, late professor of chemical technology at the Technical High School at Vienna, made, in 1840, an accidental discovery which may be regarded as anticipating atmography (*Handbuch*, 1922, Vol. IV, Part 3).

He writes: "Finally, I cannot but add the following remarks. In February, 1840, that is, five years before Moser published his discovery of the so-called 'invisible light'[11] I worked in daguerreotypy, which at that time was hardly known in Vienna, without, however, being able to obtain favorable results, owing to my extremely limited apparatus. For the sake of simplicity, I tried the method of iodizing, which, if I am not mistaken, was only a short time before proposed by Steinheil, using a wooden slab impregnated with iodine vapors in place of the bulky iodine box commonly employed. The daguerreotype plate was placed for this purpose on the board (which had been subjected to iodine vapors for the usually sufficient length of time), but remained by mistake exposed more than half an hour to the action of the iodine. When

the daguerreotype plate was removed, it showed, much to my surprise, instead of the normal uniform gold-yellow coloration, a perfect and sharp picture of the fibrous structure (skeleton) of the wood of which the board was made, in a dark violet color. I took the opportunity to show this picture, which appeared in the manner related above, to several persons, but in vain, for none could give me a satisfactory explanation of the circumstances surrounding its origin; the picture remained almost unchanged for three months, kept in a dark place, and was finally deliberately destroyed."

DISPARITY OF OPTICAL AND CHEMICAL LUMINOSITY

While making photometric researches with various sources of light (electric arc light, calcium light, and sunlight) using daguerreotype plates, the French physicists Fizeau and Foucault observed that the chemical action of light is in no manner proportionate to its optical brightness (*Annal. chim. phys.*, 3. ser., XI, 370).

PONTON, TALBOT, AND HUNT

In order to complete the record of the position of photography at this time, it is necessary to state that Ponton discovered the sensitivity to light of paper impregnated with potassium bichromate in 1839 and that Talbot discovered that a mixture of glue and bichromate became insoluble by the action of light (*Handbuch*, 1926, IV (2), 359).

We must not forget to record R. Hunt's numerous investigations of light-sensitive substances in the solar spectrum and his work, *Researches on Light* (London, 1844; 2d ed., 1854), in which he described the results of his experiments and recorded many new observations.

We conclude this article dealing with the painstaking observations of the experimenters of that period, by pointing out that these results obtained in the studies of daguerreotypy have in a large measure been found to apply to the collodion process and to the modern emulsion plates.

PHOTOGRAPHING THE SUN, MOON, AND STARS

Dr. John W. Draper (1811-82) was an indefatigable investigator in the field of scientific photography. While Daguerre, in 1839, recognized the photographic action of moonlight on his iodized silver plates, as Arago emphasized in his report, it was Draper who was the first to produce distinct photographs of the moon in America (1840).

Draper obtained this photograph, measuring about 25 millimeters (0.98 of an inch), by exposing for twenty minutes. (A previous trial by Daguerre was unsuccessful). His son, Dr. Henry Draper (1837-82) was later one of the pioneers in the field of astrophotography. He occupied himself especially with the photography of the Orion nebulae and produced a photograph of it on September 30, 1880, on collodion plates. A better result was obtained by him March 14, 1882, by exposing 137 minutes.

Fizeau and Foucault photographed the sun on a daguerreotype plate April 2, 1845, at the request of Arago.[12] In 1845 Fizeau and Foucault endeavored to make exposures of the eclipse of the sun; in 1851 Dr. Busch, in Königsberg, made daguerreotypes of the total eclipse, in which the protuberances were indistinctly visible.

The first photographs of stars were produced by W. C. Bond, in Cambridge, Mass., on July 17, 1850, when he obtained a photograph of some of them.

Later, Warren de la Rue, in particular, occupied himself with celestial photography. This prominent man, who started as a bookbinder, from 1862 was one of the largest paper manufacturers in London and owned large electrogalvanic works. He was the first to produce vegetable parchment, and he practiced celestial photography with extraordinary success. In 1852 he made exposures of the moon on collodion plates; in 1856 he photographed the sun by instantaneous exposure, followed in 1858 by Jupiter's photographs. Foye also used a similar apparatus with an instantaneous shutter, such as De la Rue employed when photographing a solar eclipse (*Revue des sciences phot.*, 1905, p. 240). Here must also be mentioned the American physicist Lewis Morris Rutherford (1816-92), who in 1864 made photographs of the Pleiades with wet collodion plates and a specially corrected lens. Rutherford constructed in 1864 the first telescope (11¼ inches aperture) corrected for photographic rays and made the finest diffraction gratings obtainable prior to those of Rowland.

He photographed, in 1848, an eclipse of the moon, and later turned to astronomy and spectroscopy. In 1866 he made a report to the Vienna Academy on the photography of the moon and on the solar spectrum (also Pogg., *Annal.*).

Gould, Pickering in his *Stellar Photography* (Boston, 1886), and others also interested themselves in astrophotography.

ENLARGEMENTS

The first mention of an enlarging process is probably to be ascribed to Professor Draper, who wrote in 1840, in the *American Repository of Arts*, "Exposures are made with a very small camera on very small plates. These are subsequently enlarged to the required size in a larger camera on a rigid stand. This method will probably contribute very much to the practice of the art" (*Phot. Archiv*, 1895, p. 297; compare with Draper's collected works). The daguerreotype was, however, much less suitable for the enlargement process than the invention of Talbot.

Chapter XXXII. THE FIRST DAGUERREOTYPE PORTRAITS; EXPOSURES REDUCED TO SECONDS

THE COMPARATIVELY feeble light-sensitivity of the pure silver iodide which Daguerre used in his process demanded lengthy exposures, and the slow lenses available in France at that time offered no help in shortening the exposure. It was on account of the prolonged exposures necessary that portraits were not at first attempted, even Daguerre confined himself to pictures of landscapes, architectural subjects, and the like.

In Arago's report the taking of portraits was not mentioned, nor were there any portraits among the early daguerreotypes sent by Daguerre to the heads of European governments. Elsewhere, however, especially in America, where the keenest enthusiasm was aroused by this new method of taking pictures, many attempts were made to apply the process in portrait photography. In 1839 the improvements afterward introduced into the daguerreotype process, permitting of shorter exposures, were unknown, but in the autumn of that year Professor John W. Draper, in New York,[1] made the first photographic portrait on a daguerreotype plate, giving an enormously long exposure. The subject of the portrait, Draper's assistant, powdered his face with flour and sat in front of the camera for a half hour facing the sunlight.[2]

Sir David Brewster, in the *Edinburgh Review*, January, 1843, states his belief that Draper was the first to take portraits by Daguerre's pro-

cess, which no one considered possible, since portraiture was not mentioned in the reports of Arago and Dumas on the invention of dagurreotypy.

A portrait made in New York with wet collodium showing the customary style of posing at that time, pictures Professor John W. Draper twenty years after he made the first daguerreotype portrait of his assistant. A portrait of Draper from an etching was procured by Eder for the Graphische Lehr- und Versuchsanstalt in Vienna (Inventory No. 538).

In 1839, at the same time when Draper was there, there lived in New York a gifted gentleman—one who had a remarkable career. This was Samuel Finley Breese Morse, who had already achieved fame by the invention of the Morse telegraph and the telegraph alphabet named after him; he also took an interest in daguerreotypy. [Dr. Eder wrote to the translator in his 25th letter, March 21, 1932,]

I am very much interested in your historical study on page 359 and 360 [of my *Geschichte*] regarding Draper. You have evidently found in New York better sources than I possessed. Your remarks are very exact and appropriate. Please work up the whole matter regarding Morse, Draper, etc., as well as Cornelius, independently and add to the American edition the results of your own investigation.

[The section immediately following has been rewritten by John A. Tennant, New York City.]

Morse visited Paris in 1838 to introduce his system of telegraphy in France. During the winter of 1838-39 he met Daguerre, who invited him to his Diorama studio and there exhibited and explained his invention of the daguerreotype, at that time held secret and known only to Arago, with whom Daguerre was negotiating the sale of the invention to the French government. The probable date of this meeting of Morse and Daguerre was January or February, 1839, and the two inventors became warm friends.

Writing to his brothers in New York on March 9, 1839, Morse reports Daguerre's discovery to them and in explanation of his great interest in it says: "You may recall experiments of mine at New Haven (Yale College) many years ago, when I had my painting room next to Professor Silliman—experiments to ascertain whether it were possible to fix the images of the camera obscura. I was then able to produce different degrees of shade on paper dipped into a solution of nitrate of

silver, by means of different degrees of light, but finding that light produced dark, and dark light, I presumed the production of a true image to be impracticable and gave up the attempt. M. Daguerre has realized in the most exquisite manner this idea."

In this remarkable passage, hitherto unnoticed by historians of photography, we learn that the American Morse had conceived and experimented in the idea of fixing the camera obscura images by the action of light about 1812—in the same year that Nicéphore Niépce began his experiments and twenty years before Fox Talbot first attempted to fix the images of the camera obscura on his return from Italy in 1834.

Morse returned to America April 15, 1839. In May of that year he wrote Daguerre concerning his (Daguerre's) election as an honorary member of the National Academy of Design, at New York, and offered to promote an exhibition of the daguerreotype in that city if Daguerre would co-operate. To this Daguerre replied, acknowledging the honor conferred upon him by the National Academy, but regretting that his negotiations with the French government, then proceeding, made it impossible for him to attempt an exhibition in New York as proposed.

As soon as the publication of the process of daguerreotypy became known in America (August or September, 1839) Morse had the necessary apparatus constructed and began experimenting with the process.[3] His first attempt was to secure a picture of the Unitarian Church visible from the window of his room at the University of New York, where he was professor of drawing at the time. This was in September, 1839, and the exposure required to secure the picture was about fifteen minutes. Immediately thereafter Morse associated himself with Dr. John W. Draper, then professor of chemistry in the university, who was experimenting with daguerreotypy with considerable success. It seems that both Morse and Draper attempted photographic portraiture in those early days, having a studio together for that purpose on the roof of the university. The dispute as to whether Morse or Draper made the first portrait, often mentioned in the photographic literature of that period, seems to be conclusively settled in the life of Morse by his son (1914), where we read (page 146), "It was afterwards established that the honor must be accorded to Professor Draper, but I understand it was a question of hours only."

In 1840 Morse made the first group photograph, the subject being his class of 1810 at the reunion at New Haven (Yale) in that year.

Soon after this time Morse abandoned his photographic experiments, to give his remaining years to the telegraph.

The historically documented description of the first portrait photographs by Draper became confused when, at the Chicago World Fair in 1893, the portrait of Dorothy Catherine Draper, the sister of John W. Draper, was exhibited. The lady, eighty-seven years old, was alive at that time (*Jahrb. f. Phot.*, 1894, p. 384). This portrait was labeled: "This is the first sun picture of a human countenance ever made, taken by John W. Draper, in 1840, on the roof of the New York University." It is also reported that it was produced in 1840 (J. F. Sachse, *Jahrb. f. Phot.*, 1894, p. 257). This must be an error, because the proofs can be adduced that Draper, in the autumn of 1839, took the portrait of his assistant in full sunlight,[4] and it is said that this daguerreotype is still in existence (J. Werge, *The Evolution of Photography*, 1890, p. 108).

About the same time (Sachse claims it was even before Draper, which, however, is incorrect), namely, in the autumn of 1839, Joseph Saxton, in Philadelphia (with the assistance of Robert Cornelius), made experiments in daguerreotypes (*Jahrb. f. Phot.*, 1894, p. 257). He was employed at the U. S. Mint and was a member of the American Philosophical Society, in Philadelphia. The first daguerreotype made in America by Joseph Saxton, from the window of his workshop in October 16, 1839, is reproduced by Julius F. Sachse, "Philadelphia's Share in the Development of Photography," in *Journal of the Franklin Institute*, April, 1893, Philadelphia.

Cornelius attempted to take his own picture in November, 1839, with the lens of an opera glass as objective. He placed the camera on a chair in bright sunlight. After focusing sharply and having inserted the iodized silver plate, he removed the lens cap and quickly seated himself on a chair in front of the camera. After about five minutes he jumped up and covered the lens. The developed plate showed the image of a man.

This is not only the first self-portrait, but also one of the earliest portraits of a human being made by the action of light. The body is portrayed off the center of the plate, because Cornelius did not seat himself properly on the chair. This picture was submitted to the American Philosophical Society on December 6, 1839, as is recorded in the proceedings of that society. That this self-portrait was the same picture that was exhibited at the meeting is certified by Cornelius himself (who

died in 1893, at the age of 85), as well as by several living witnesses who were present at the meeting.

Cornelius was also the first to open a studio for portrait photography, in 1840. The light was concentrated by a series of reflectors, and blue glass was interposed to soften it. The exposure was one minute, and the price was five dollars for each portrait. Portraits were made only on bright days. The work of Cornelius is described in the *Proceedings of the American Philosophical Society*, March 6, 1840.

[End of section by Mr. Tennant.]

FURTHER DEVELOPMENT OF PORTRAIT PHOTOGRAPHY BY INCREASED SENSITIVITY OF DAGUERREOTYPE PLATES

Under the conditions described, the time of exposure in the beginning of daguerreotypy was prolonged, and this delayed the progress of the art of photographic portraiture. There was need for further basic inventions, both in physics and in chemistry. The only way to increase the sensitivity of daguerreotype plates was by departing from the pure silver iodide coating of Daguerre and introducing combined halide compounds of silver, for example, bromide or iodo-chloride of silver. The credit for these investigations belongs to J. F. Goddard, in London, Fr. Kratochwila and the Brothers Natterer, in Vienna.

For the increased luminosity of the photographic lens we are indebted to the gifted mathematician Professor Petzval, in Vienna, the inventor of the portrait lens. The success of portrait photography is closely interwoven with the name of Petzval; it was he who stimulated its progress almost within a year or two after daguerreotypy was made public.

It was John Frederick Goddard, lecturer at the Adelaide Gallery in London,[5] to whom is due the discovery that the sensitivity of daguerreotypes is increased by the use of bromine in combination with iodine in place of chemically pure iodine vapor.

He was the first to publish the use of bromine in daguerreotypy, as he did in a short letter, dated December 12, 1840, addressed to the *Literary Gazette*. He therein reported a considerable increase in the sensitivity of daguerreotype plates by the combination of bromine and iodine. The honor of the introduction of bromine in photography Goddard must share, however, with Franz Kratochwila, who, in Vienna, September, 1840, invented the same process[6] and published it in the *Wiener Zeitung* on January 19, 1841.

Kratochwila's observation showed that an iodized silver plate gained at least five times in sensitivity if subjected to a mixture of bromine and chlorine vapors containing at least 50 percent bromine. He obtained daguerreotypes by exposures of a few seconds and showed them in September, 1840, to Professors Liebig and Wöhler, who expressed their approval. By the use of Petzval's lens he was able to make portraits on cloudy days in eight seconds. He expressed the hope that "the boldest dream of producing an instantaneous photograph of even a crowded street might one day be fulfilled."[7]

The contribution Kratochwila made by introducing bromine into photography seems to have remained unknown to my predecessors in the writing of the history of photography. For instance, W. J. Harrison, in his *History of Photography* (Bradford, 1888), mentions only Goddard. Without doubt Kratochwila had shown his iodo-bromo-chloride plates to prominent experts earlier than Goddard showed his, but the latter made the subject public earlier in the journals. Therefore, to Goddard is due the merit for the first publication, although Kratochwila carried out his experiments with bromine earlier and had demonstrated to a closer circle that not only bromo-iodide and bromo-iodo-chloride but also iodo-chloride was used to make daguerreotype plates more sensitive than is possible with iodine alone. Iodo-chloride was first mentioned by Claudet in May, 1841 (Dingler's *Polytechn. Jour.*, LXXXI, 149), but he did not recognize the sensitivity of bromo-iodide in daguerreotypy. On June 10, 1841, Claudet read a paper before the Royal Society (*Phil. Mag.*, 1841) in which he emphasized the greater sensitivity of bromo-iodide and gave the exact composition of these preparations, on which so much depends.

The brothers Johann and Joseph Natterer, in Vienna,[8] in 1840-1841, increased the sensitivity of daguerreotype plates by using a mixture of iodine, bromine, and chlorine to such an extent that with a Petzval lens they obtained photographs in less than a second, as confirmed by Berres (Dingler's *Polytechn. Jour.*, 1841, LXXXI, 151).

Joseph Natterer, born in Vienna May 23, 1819, showed his love for the natural sciences, which was prominent in the whole Natterer family, and with his brother Johann worked experimentally with daguerreotypy. In the memorable year 1849 he earned the right to lasting memory, when by his energetic interference with the fanatic Viennese mob, misled by emissaries, he saved the statue of the Emperor Francis, in the inner court of the palace, and the Museum of Natural Sciences

from destruction. In 1855 he traveled to Nubia and Central Africa, and in 1858 returned, bringing with him a number of wild animals for the imperial menagerie. After some time he returned again to Africa, where he became Austrian consular agent at Khartoum. He accumulated a considerable fortune there and expected to return to Europe to devote himself entirely to science, but he died in Khartoum on December 17, 1862, where in 1867 his brother erected a monument in the cemetery.

One of the original daguerreotypes[9] taken by the Brothers Natterer in the summer of 1841 shows a crowd assembled in the Emperor Joseph Place, Vienna. The second one, taken near by, shows a rather poorly-defined picture of mounted police who were standing still; the exposure was probably not more than one second. These two specimens, not-withstanding their shortcomings, were probably the first photographs of street scenes obtained with an exposure of one second or less. The opinion that these views, dating from the beginning of photography, represent the first instantaneous exposures is supported by the fact that the earliest example of "instantaneous photography" which could be procured by the "Committee of Installation" for exhibition at the "Musée Retrospectif (Photographie)," at the Paris Exposition of 1900, to which committee all early photographic documents of the history of photography in France were accessible, was dated October, 1841.[10] It was a daguerreotype of the "Pont Neuf." This denies all claims to priority to those publications which deal with halogen mixtures of iodine, bromine, and chlorine.[11]

Professor Berres of Vienna, in his publication of the Natterer process in the *Wiener Zeitung* (March 24, 1841, p. 610), reports that the Brothers Natterer had photographed a copperplate engraving by the light of two oil lamps after an exposure of thirty-five minutes on iodo-chloride daguerreotype plates, while this could not be accomplished with iodide plates. This seems to indicate that the Brothers Natterer also made the first photographic reproduction by ordinary lamp light.

CORRECTION OF FAULTY STATEMENTS ON THE INVENTION OF THE USE OF BROMINE, IODINE, AND CHLORINE VAPORS FOR DAGUERREOTYPE PLATES

Potonniée, in his *Histoire de photographie* (1925), prints a chronology of the use of vapor for daguerreotype plates, but it is incorrect and has been criticized by this author (*Jahrbuch f. Phot.*, XXX, 50).

Potonniée, on page 220 of his book, gives the following chronology

of the invention of sensitizing of daguerreotype plates: Goddard introduced bromine, December, 1839. (This should read December, 1840, Eder.) Claudet used "iodo-chloride" at the end of 1840. Potonniée omits documentary evidence. Biot used iodo-bromide, January, 1841. Gaudin made instantaneous exposures of the Pont Neuf in Paris on daguerreotype plates in October, 1841.

Now, it has been pointed out that the Austrian amateur Franz Kratochwila is entitled to a large share of the merit for the important introduction of bromo-chloride, since prior to Goddard he had presented effective results of this sensitizing method, in September, 1839 to Professors Liebig and Wöhler,[12] in the shape of portraits he had obtained in a room with a Petzval lens, although it was not until January 19, 1840, that he wrote of it in the *Wiener Zeitung*, that is, of the fuming of iodized plates with iodine and bromine.

In December, 1840, Goddard published his observation of the favorable effect of bromine alone on the sensitivity of daguerreotype plates, as pointed out in the above-mentioned report.[13]

Kratochwila was also the first to introduce the use of chlorine vapor in addition to that of bromine. Potonniée's statement that iodo-chloride was first introduced by Claudet "at the end of 1840" is not documented; it seems, moreover, incorrect, because Claudet's publication on iodine chloride did not take place until May, 1841.

The Brothers Natterer, who in 1841 made instantaneous exposures with daguerreotype plates in Vienna and in the summer months, as is quite evident from the position of the sun, are also thrust aside by Potonniée in favor of Gaudin, who made an instantaneous exposure in Paris, October, 1841. In justice, at least equal credit should have been accorded. In addition, Potonniée passes over in silence the fact that Gaudin was able to obtain his instantaneous exposures only with the aid of Petzval's portrait lens.

Errata which should be corrected in Potonniée's text: "Natterer" instead of "Matterer," on pp. 220 and 240, and on pp. 225 and 259; "Le Gray" instead of "Legray"; "Balard' instead of "Balart," p. 220; "Reisser" instead of "Reiser."

Chapter XXXIII. THE DAGUERREOTYPE
PROCESS IN PRACTICE

In the early days of daguerreotypy, according to the instructions of the inventor, the work was done with silvered copper plates and pure iodine vapors and with only the slow single Chevalier lenses at that time available. The photographer of 1839 was limited to taking pictures of inanimate objects, owing to the necessity for long exposures (see photochemical advances in shortening of exposures). Notwithstanding this limitation, the interest of the public was unprecedented.

As early as the end of 1839 traveling daguerreotypists could be encountered, making photographs of architectural subjects and of landscapes. One of the first of these traveling photographers was the French painter of battles, Horace Vernet (1789-1863), who as early as November, 1839, made photographs in Malta and Smyrna, together with Adolphe Goupil (1806-1893), and who in 1840 made professional photographs for the illustrated book of travels *Excursions daguerriennes,* which among other illustrations contained prints from etched daguerreotype plates.[1]

Baron Gros, a successful amateur in the new art, took a complete daguerreotype outfit on a diplomatic mission to Greece and returned with a rich collection of views of the ruins of classic antiquities. At about the same time a certain Titereon photographed the nomadic life of the Mexican Indians, as reported by Ernest Lacan in his *Esquisses photographiques à propos de l'Exposition universelle et de la Guerre d'Orient,* Paris, 1856, (Fr. Wentzel, *Phot. Ind.,* 1926, XXIV, 1219).

It is easily understood that professional photography developed especially in Paris. The first daguerreotype of a crowned head is that of King Louis Philippe of France, which Daguerre himself made in 1840. It was not until many years later that the historian Esnault recovered it in the Touraine and presented it to the Paris Museum.

A great number of French daguerreotypes, up to the largest sizes, were exhibited in Paris at the time of the Centennial Celebration of Photography, of which a record is given in the *Bull. Soc. franç. d. phot.* (October, 1925, 3 ser., XII, 285).

As a natural consequence it was Paris that applied photography in the arts and crafts, and the manufacture of apparatus and accessories of all kinds was evolved and largely developed there. As early as the

forties Paris became the Mecca for photographers and the center of the photographic industry. Large and luxurious portrait galleries were opened, industry applied photography in all its branches, and technical experts devoted themselves to the development of the new science.

DAGUERREOTYPE STUDIOS IN ENGLAND

The first daguerreotype studio was opened in London, in 1840, by Beard and Claudet (*Brit. Jour.*, 1912, LIX, 930).

INTRODUCTION OF THE DAGUERREOTYPE PROCESS IN VIENNA

Daguerreotypy was publicly made known in Vienna earlier than in any other German-speaking country. Daguerre's gift to the Emperor of Austria and Prince Metternich of two of the first daguerreotypes has been mentioned earlier. In order to make the public acquainted with this new and marvelous invention, these two pictures were exhibited in 1839 at the Austrian Imperial Academy of the United Fine Arts in Vienna. We have also related how fully the Emperor and his chancellor appreciated the invention and the honors conferred upon Daguerre.

AUSTRIA AND OTHER GERMAN-SPEAKING COUNTRIES

In the German-speaking countries it was Vienna which developed as the center of progress in daguerreotypy. This applies as well to the increase in sensitivity of daguerreotype plates as to the epoch-making invention of the Petzval lens. The latter excelled the products of opticians everywhere and made portrait photography possible.

When Daguerre's discovery was reported at the public session of the Paris Academy of Sciences on February 7, 1839, the eminent Austrian physicist Andreas Freiherr von Ettingshausen (1769-1857) happened to be in Paris. He became professor of mathematics and physics at the University in Vienna and was instructed by Daguerre in his invention. On his return to Vienna he was therefore in a position to discuss intelligently the new sensation that agitated the scientific world and to lecture before the government, his friends, and others interested in the new invention. The *Wiener Zeitung* and other German journals printed the Paris sensation two weeks later. The director of the Polytechnic Institute in Vienna, Johann Joseph Ritter von Prechtl (1778-1854),[2] ordered practical tests to be made and advised Anton Martin (1812-1882), of the Polytechnic Institute, to investigate the new proc-

ess further. Martin succeeded, in the summer of 1839, in producing satisfactory daguerreotypes.

Anton Martin devoted himself to the study of physics and chemistry, became assistant in the department of physics at the Polytechnic Institute in Vienna, transfered later to the library of the institute, was elected a member of the trade association, founded in 1839. In the same year he took up the work of daguerreotypy, in which he used an apparatus constructed by the optician Plössl along the lines of Daguerre's camera. In 1839-1840 he confined himself to photographing inanimate objects. He was in constant contact with Ettingshausen and Petzval, and at the request of Professor Petzval he produced, in May, 1840, the first portraits with the double lens invented by Petzval. He was also the author of the first German textbook of photography and published numerous articles on photography and electrotypy, as well as a textbook on physics. He was the first president of the Photographic Society of Vienna.

A small edition of Martin's biography by Dr. A. Bauer and J. M. Eder was printed at the Graphische Lehr- und Versuchsanstalt in 1921. Other biographies in this series have dealt with Schulze, Kampmann, and Klič.

At the same time other Viennese took up daguerreotypy, among them Endlicher, Beck, August Neumann, and others; they generally used cameras constructed by themselves. The well-known optician Simon Plössl, in Vienna, was of great assistance; he constructed lenses for Daguerre's camera, with improved radius of curvature of the lens, without, however, attaining a greater light intensity. Following the invention of the rapid portrait lens by Petzval (1840), an enormous boom started everywhere, especially in Vienna, where Voigtländer made the first double objective of this kind. It was the possibility, created by this lens, of making daguerreotype portraits with short exposures from which the increased interest by the general public in photography may be dated. In September, 1839, several of the original daguerreotype cameras, with accessories, were sent to Vienna by Giroux et Cie., of Paris, and quickly sold.

The *Oesterreichische Zuschauer* of December 16, 1839, announced that the Parisian apparatus, which at first was sold for 400 francs, "now costs only 80 francs." Several advertisements indicate how the photographic industry grew there. It was announced that the apparatus constructed in Vienna was perfect, and it was stated that the price of a

camera, with both iodizing and mercurizing boxes, in addition to two silver plates and chemicals, was 45 "Gulden Conventionsmünze,"[3] while the price of the Paris apparatus, with duty, would be 60 florins. There are also advertised the names of a "mechanicus" and a university technician who made equipment and sold it direct to the user, with the advertisement of a firm furnishing silvered copper plates.

As in other large cities, there soon appeared in Vienna studios for daguerreotypy, but the real advance started with the invention of the Petzval portrait objective; daguerreotypes had been made in courtyards, in the open streets, but very seldom in a professional studio. One of these studios was opened by Karl Schuh at his residence, and there congregated from 1840 to 1842 a circle of scientists and others interested in daguerreotypy, such as Ettingshausen, Petzval, Dr. Berres, the Brothers Natterer, Kratochwila, Voigtländer, Waidele, Prokesch, Reisser, Schultes, and, of course, Martin. Regular meetings were held there, and Martin relates that each participant brought with him practical proofs of his experiments, which furnished abundant subjects for discussion. These meetings were the beginning of the Photographic Society of Vienna.

Schuh was well acquainted with the professors of the university, who offered him the opportunity to give experimental demonstrations of the hydro-oxygen microscope of Plössl in the large hall of the university during 1840 and subsequently. These demonstrations were advertised regularly in the official *Wiener Zeitung*. Schuh's versatile enterprise afterwards led him to erect a factory for galvanotypy. He died in 1863.

Another well-known daguerreotypist of those days was Martin Theyer, who, with his son, was interested in painting, daguerreotypy, and copper-plate engraving. A daguerreotype by Martin Theyer (size 5¼ x 7¼ inches; subject, landscape) was bought for 15 florins C.M. and is preserved in the collection of the Technical High School, Vienna (*Phot. Korr.*, 1911, XLVIII, 639).

The Vienna opticians Rospini and Waldstein[4] took up the exploitation of stereoscopic photography, which was first applied to daguerreotypy about 1845 in France, and made it commercially useful. These stereo-daguerreotypes were often colored. The stereo-daguerreotype was fastened on one of the inside covers of the case, while the opposite cover had placed in it the two small lenses through which one observed the picture. The author was fortunate in being able to acquire examples

of these stereo-daguerreotypes, and he added them to the collection of the Graphische Lehr- und Versuchsanstalt (see Eder and Kuchinka, "Die Daguerreotypie," *Handbuch*, 1927, Vol. II, Part 3).

The intensive pursuit of and the great public demand for photographs brought into being, about 1840-1842, a horde of itinerant photographers, who, equipped with a camera and a Petzval-Voigtländer portrait objective, set out on their travels.

One of these itinerant photographers, Reisser, a Viennese, when passing through Linz (capital of Upper Austria) photographed (1841 or 1842) the festival presentation of the colors to a regiment. In this picture the regiment standing in square formation, the crowds of onlookers, windows and balconies decorated with rugs and bunting, and every window occupied by people, as well as the brilliant, uniformed reviewing party in the center of the square, were all reproduced perfectly. In a very short time Reisser made fourteen exposures of the scene. This number of exposures in so short a time was possible only because Reisser used two cameras and had prepared and kept at hand the required number of ground, polished, and iodized plates in separate tightly closed brass holders. His exposures lasted one second in good light, three to ten seconds when it was cloudy, and he also made successful photographs indoors. His pictures met with such general approval that he was permitted to photograph the Royal Bavarian family at Munich, the Queen of Greece, and several celebrated artists and scientists. Reisser made daguerreotypes on an extended student trip in Germany, France, and England (*Frankfurter Gewerbefreund*, 1842, p. 177; *Phot. Korr.*, 1911, p. 639).

The Viennese painter and daguerreotypist Josef Weninger was the first itinerant photographer to travel to Dresden, Leipzig, Hamburg, and into the northern countries. Wherever he went, he spread the news of the new invention and gained pupils for it. Weninger's missionary trip in Sweden and Norway on behalf of the new art is described by Helmer Bäckström (*Phot. Korr.*, 1922, p. 6).

According to Dr. Friedrich Schulze, director of the Historical Museum of the City of Leipzig (*Phot. Chronik*, 1918, p. 75), Weninger produced his pictures in the shade with very short exposures, presumably in a closed room. This is apparent also from his advertisement of January 23, 1842, which emphasizes his independence of the weather. That the photographer of those early years could not resist the temptation to surround himself with the glory of having to combat the

difficulties of the process is easily understood; but Weninger kept within the bounds of truth and plausibility when he remarked, after having given a demonstration of daguerreotype exposures during an explanatory lecture before the Society of Arts and Trades, that it was necessary for a successful result with his apparatus to possess "not alone extraordinary knowledge and experience in chemistry, owing to the peculiar conditions surrounding the use of chlorine and iodine, the use of mercury vapors, and the manipulation necessary for the washing of the plates in the solution of common salt, but also an appreciation of the art of portrait painting in order to bring out the natural pose and facial expression of the sitter." In consequence of having met these indispensable requirements, Weninger selected for himself the title "portrait painter and chemist of Vienna."

In the *Tageblatt* of January 23, 1842 (No. 23, p. 174) appears the following advertisement:

Portraits by Daguerre's Process
in 20-40 seconds, according to the latest and improved method!

Josef Weninger, portrait painter and chemist of Vienna, has the honor respectfully to announce that he is ready to produce during his stay here portraits after the manner of Daguerre, and in fact, according to the latest Viennese inventions. The weather in no way interferes with the production, and a most striking likeness is guaranteed. Price one Louis d'or (20 gold francs).

PHOTOGRAPHY IN GERMANY

Karl August Steinheil, the celebrated physicist and expert in electricity of Munich, who was the founder of the optical establishment named after him, is said to have been the first who produced daguerreotypes in his laboratory, as soon as the process became known in Germany.

We have a very detailed account of the beginning of photography in Berlin in Fritz Hansen's report *Die ersten Anfänge der Photographie in Berlin*, published on the occasion of the fiftieth anniversary celebration of the Berlin Photographic Society, in 1913. He referred in this report chiefly to the papers written on the subject by Beer and Sachse in the *Photographische Mitteilungen*, in 1865, and covered the most important technical events of the introduction of photography in Berlin.

Another important work on the subject is the book by Wilhelm Dost and Dr. Erich Stenger, *Die Daguerreotypie in Berlin 1839 bis 1860; ein Beitrag zur Geschichte der photographischen Kunst* (Berlin,

1922). This richly illustrated work deals with the beginning of photography in Berlin and its progress up to the general introduction of photographs on paper. The newspapers printed a great deal about daguerreotypy. The *Vossische Zeitung* published, August 26, 1839, a full report of the session of the Paris Academy of August 19. But the report was not accepted everywhere in Germany as credible. "The details of the process had scarcely become known in Berlin, when immediately some persons arose and designated the whole matter as a humbug and a Paris swindle" (see Dost and Stenger).

But soon a different view appeared, to which especially L. Sachse, the well-known art dealer and proprietor of a lithographic establishment, contributed. He had visited Paris in April, 1839, had become acquainted with Daguerre, and had ordered from Giroux, in Paris, several pieces of apparatus in order to be the first to introduce them into Germany (Berlin). It was not until September 6, 1839, that he received the apparatus, with accessories and printed directions, but, unfortunately, everything arrived in a broken condition and quite useless. Thus, he had the disappointment of seeing others precede him in the first trials with apparatus that they had constructed themselves. The optician T. Dorffel, of Berlin, anticipated him with a self-constructed camera, which he exhibited in his store on the Unter den Linden, September 16, 1839. Dorffel also made the first daguerreotypes in Berlin, which he exhibited on the same day. Sachse was unable to produce his pictures made with French apparatus until a few days later. On September 30, 1839, Sachse explained the daguerreotype process to King Friedrich Wilhelm III, at the Charlottenburg Palace, and made some exposures of the architecture of the place then and there. Like all other early daguerreotypists, he worked without a reversing mirror, but his work met with such great approval that he had no difficulty in disposing of it commercially at a good price (up to 2 Friedrichs d'or). The daguerreotype apparatus sold by him brought about 400 francs.

Sachse also brought to Berlin the first Petzval lens, October 6, 1841, with which he made portraits with short exposures. The goldsmith to the court, Hossauer, also occupied himself with daguerreotypy at the same time as Sachse. A silver polisher employed by him, Kannegiesser, opened a studio at the end of 1840 and reduced the price of the popular sizes, so-called ¼ and ⅙ plates, to respectively 2 and 1½ talers, doing a splendid business.

Apart from the professional undertaking by Kannegiesser, daguerreotypy was pursued only as a side line, usually only on Sundays. Oehme & Graff exhibited to public view the first showcases with photographic specimens in Berlin in 1841. By 1852 there were a great number of photographic studios in Berlin, when the knowledge of the collodion process introduced a great revolution in photography.

A scholarly research work, written with conscientious thoroughness, is the illustrated monograph by Wilhelm Weimar *Die Daguerreotypie in Hamburg 1839-1860* (Hamburg, 1915). Weimer enumerates there the former occupations of the Hamburger daguerreotypists. Thirteen of them were artist-painters, two lithographers, three mechanics and opticians, and one each a master painter, art dealer, actor, watchmaker, chemist, teacher of languages, sea captain, manufacturer of gilt moldings, and a dealer in leeches (E. Stenger, *Atelier d. Phot.*, 1931, XXXVIII, 34).

The first report of Daguerre to the Academy of Sciences at Paris, January 7, 1839, was printed in German newspapers ten days later.

Kobell of Munich asserted that he, with Steinheil, made exposures and fixed silver chloride images on paper (*Allgemeiner Anzeiger, Nationalzeitung*, February 1, 1839; see also a more detailed description in the issue of April 9, 1839). But this has no more to do with daguerreotypy than does the claim of the Reverend Hoffmeister.

ITALY

According to the late Philippo Zamboni, professor of Italian at the Technical High School at Vienna, who spent his youth at Rome, a Jesuit father, Della Rovere, studied daguerreotypy very intensively. He made photographs of several of the papal institutions. He was considered the best daguerreotypist in Rome; he pursued the art passionately, spared no expense in procuring the best obtainable apparatus, and delved deeply into the relevant chemical studies. Unfortunately, as a priest he could not attempt to portray the beauties of Roman womanhood. Della Rovere stands out as the first photographer who confined himself to the portraiture of men only.

In addition to the resident daguerreotypists, there were also the itinerant artists, who traveled from place to place; according to Zamboni, in the forties there appeared at the Fair of Sinigallia, such a traveling daguerreotypist, who plied his trade in the market place, as one finds photographers producing portraits on postcards at the annual fairs of today (*Phot. Korr.*, 1911, XLVIII, 638).

SPAIN

In the *Wiener allgemeine Theater-Ztg.*, December 19, 1839, (No. 254, p. 1245) is a report by Adolf Bauerle:

No one could have dreamed of the great sensation which daguerreotypy created in Barcelona. A short time ago, when this new process was introduced to public use, a sort of festival was celebrated. A huge crowd assembled in the square where the first trial was to be held, and the instrument was set up, while bands played and flags were flying. The demand for the first picture made was so great that it had to be disposed of by drawing tickets in a lottery.

SWEDEN

Dr. Helmer Bäckström has made comprehensive studies on the introduction of photography into Sweden, which he published in *Nord Tidskr. f. Foto.* (1919, pp. 85, 113, 155; 1922, p. 1). The first specimen of daguerreotypy was sent by the Swedish Minister at Paris, Count Gustav Löwenhielm, and was exhibited, February, 1840, at the Royal Museum, Stockholm; it was received with great enthusiasm. A Swedish translation of the original handbook by Daguerre was published in 1839, together with a description of the diorama and Arago's report to the French Academy of Sciences. Some months later a small Swedish textbook on photography was printed in Stockholm, which also contained a description of Talbot's process. In September, 1840, the Frenchman Neubourg exhibited and sold daguerreotypes. In July, 1843, the Viennese photographer Weninger made photographic portraits in which he used the latest Viennese methods; in the autumn of the same year the Frenchman "Derville de Paris, élève de Daguerre" came to Stockholm and became very famous as a portrait photographer. The new coin showing the portrait of King Oscar I was modeled after the picture by him. Lieutenant Benzelstierna made a panoramic daguerreotype of Stockholm, which was reproduced by lithography. He lectured on the subject and gave demonstrations daily, from January to May, 1841. The first public portrait studio was opened in August, 1841, by J. A. Sevén, who, together with J. W. Bergström, was numbered among the best daguerreotypists in Sweden. Daguerreotype portraits by amateurs were, of course, made earlier. One such amateur, Benzelstierna, had the misfortune to cause his sitter, the actor Georg Dahlzwist, almost to lose his eye, owing to the long exposure in sunlight, lasting five minutes. In the summer of 1844 Julius Wagner,

of Berlin, introduced colored daguerreotypes, and he was followed by Reinhold, of Saxony. and others. Several photographers who later emigrated from Germany remained in Sweden and became residents.

AMERICA

At the beginning of Chapter XXXII we reported America's share in the early development of daguerreotypy. Alfred Rigling, librarian of the Franklin Institute, Philadelphia, writes in the *Journal* of the institute, March 12, 1908,[5] as follows:

In the autumn of 1839, accounts began to appear in the newspapers and magazines of the United States of the achievements of Louis Jacques Mandé Daguerre, in the field of photography.

One of the earliest notices of the advance in this art was communicated to the editor of the *United States Gazette*, by Alexander Dallas Bache, and reprinted in the *Journal* of the Franklin Institute for September, 1839. This was followed in the October number by a brief note extracted from the *Mechanics' Magazine*, London, and in November there appeared a translation by Prof. John F. Frazer, of the original article of Daguerre.

This contained a very full description of the process with illustrations of the apparatus necessary to carry out the various stages of the operation.

Soon after news reached Philadelphia of the latest developments in the art of picture-taking Joaquim Bishop, a chemical-instrument maker, then living at 213 Cherry Street, and assistant to Dr. Robert Hare, Professor of Chemistry at the University of Pennsylvania, constructed three cameras from the description of Daguerre.[6] One of these came into the possession of Dr. Paul Beck Goddard, an associate of Dr. Hare at the University, another was turned over to Justus Saxton, a mechanic connected with the United States Mint, and the third became the property of Robert Cornelius, a sheet metal worker, who was in business at 176 Chestnut Street.

The report of Alfred Rigling, however, contains a number of gross misstatements. For instance, he confuses Dr. Paul Beck Goddard, who was an amateur photographer in Philadelphia and had nothing whatever to do with the invention of the bromo-iodized plates, with the real inventor of this sensitizer, John Frederick Goddard, of London.

It is said that Rigling made the first daguerreotype portrait in Philadelphia. But this claim is untenable, since the exact date is not given, while Cornelius's portrait of himself in November, 1839, is well documented. Rigling's undated assertion that the instrument maker A. Mason was the first to make a photographic copy by artificial light is also not justified. The priority right for the first daguer-

reotype made under artificial light belongs to the brothers Natterer, of Vienna, as of March 24, 1841.

The Petzval-Voigtländer lens was introduced in the United States by Cornelius and Friedrich and Wilhelm Langenheim (1842-43), Draper and Morse having used a simple meniscus in their practice. The Langenheims emigrated from Germany and were related to Friedrich Voigtländer. Together with another German immigrant, G. F. Schreiber, they opened in the early forties a portrait studio in Philadelphia (Rohr, *Theorie und Geschichte des photographischen Objektivs*, 1899, p. 14); they enlisted as officers and fought in the Mexican War. The brothers Langenheim made six daguerreotypes of Niagara Falls in 1846 and sent one each to the heads of European governments, for which they received gold medals (*Photographer*, 1906, VI, 265).

Chapter XXXIV. PETZVAL'S PORTRAIT LENS AND THE ORTHOSCOPE

AT THE TIME OF Daguerre's invention single lenses, such as Chevalier's were used exclusively; they were not fast, nor did they give sufficiently sharp images at full aperture.

Simon Plössl, a Viennese optician, constructed in 1839 a daguerreotype camera and also made lenses with improved radii of curvature, without, however, obtaining an appreciable increase in relative aperture. A great number were sold in place of Chevalier's lenses, which were difficult to obtain.

Simon Plössl (1794-1868) was an optician not only of local fame, but also of wide reputation. He was one of the first to construct achromatic microscopes, and subsequently he manufactured good opera glasses for Petzval.

He entered the optical firm of Friedrich Voigtländer in 1812 as an apprentice and remained with it for many years. Here he became acquainted with the celebrated botanist Jacquin, for whom he made certain changes in his microscope and by whom he was introduced to the astronomer Von Littrow. These two scientists induced him to establish his own firm in 1823. In 1831 he bought a home of his own, where, according to custom, his business was also located. It was in this

house that the first lens of the Wollaston-Chevalier type was constructed (in the German-speaking countries). A street in Vienna is named after him. He competed successfully with the manufacturers of French and Italian microscopes, who had monopolized the market until 1829 through Chevalier in Paris and Amici in Modena. Even Fraunhofer, in Munich, was unable to compete with them, but his successor, George Merz (1829), made better progress, and Simon Plössl was crowned with success in 1830, when at a Congress of German scientists at Heidelberg he received the prize for the best-constructed achromatic microscope. The scientists present at this meeting spread his name and fame to the four corners of the world.[1]

Plössl executed for Littrow new dialytic telescopes in which the crown- and flint-glass lenses were separated. Plössl seems to have been the first to perfect the achromatic microscope objectives, and he also introduced them into England, where afterwards they were made by Ross (1832), Powell and Lealand (1843), Smith and Beck, though not for some time, of a quality equal to those of Plössl.

The old optical family of Waldstein played a great role in Vienna. The firm, which is still in existence, owned its own glass furnaces a hundred years ago. This "crown- and flint-glass factory" at Ottakring, a suburb of Vienna, produced such a fine quality of optical glass that, in the middle of the last century, Waldstein received the gold medal of the Lower Austrian Trade Society for its excellence. Unfortunately, the factory was financially unsuccessful and was closed about the year 1858.

A portrait of Simon Plössl, from a lithograph, was modeled by Professor Hujer for the "Plössl-Medaille" of the Society of Opticians.[2]

The small aperture of Chevalier's lenses with which Daguerre equipped his camera was generally deplored. Professor Ettingshausen recognized at once, when daguerreotypy was first made public, the insufficiency of the ordinary Chevalier lens, which was exported from Paris all over the world. As a colleague and friend he was acquainted with Petzval's genius for mathematics and optics and induced him to make a closer study of the problems involved in the construction of better photographic lenses, to which Petzval responded enthusiastically.

Potonniée writes in his *Histoire* (1925) that Ettingshausen and Petzval calculated the construction of a portrait lens which reduced the exposure to one-third. This is incorrect, for Ettingshausen himself never calculated a lens, it was Petzval alone who did so.

Petzval examined the lenses sent from Paris and found himself compelled by the result of his studies to abandon entirely the Chevalier type of lens and to start new calculations for the construction of large aperture objectives.

Josef Max Petzval[3] was born January 6, 1807, in Hungary, of German parentage. His father was a school teacher. After studying engineering at the University of Budapest, he taught there and became professor of higher mathematics in 1835. Two years later he was called to the University of Vienna, in the same faculty, and became a member of the Vienna Academy of Sciences. He died September 17, 1891. Biographical data on Petzval are scarce. He was very secretive about his personal affairs. In the records of the academy he inserted a dot in the column for "date of birth." He lived a secluded life and as a rule rejected all attempts to discuss himself or his inventions. Introduced to him by mutual scientific friends, I succeeded in getting some personal data for my *Ausführliches Handbuch der Photographie* (1893, Vol. II, Part 2) which I have collected above. A halftone reproduction of a lithographic portrait which Petzval presented to me is printed in the German edition (p. 385).

As early as 1839 Petzval devoted himself earnestly to the intensive investigation and profound calculation[4] necessary for the construction of a large aperture photographic lens, which resulted in his celebrated portrait lens and a rapid lens for landscapes, later called orthoscope. The manufacture of these new lenses he entrusted to the optician Peter Friedrich Voigtländer, of Vienna, giving him designs and the radius curvatures, without making a contract or guarding his property rights in the construction and sale. This lack of business foresight he later regretted, for it caused serious disputes between them. Voigtländer completed the construction of the first lens in May, 1840, and delivered it to Petzval. The lens was screwed on to an extremely primitive cardboard camera. It is preserved in the collection of the Museum of Austrian Handicraft, in Vienna (Eder, *Phot. Korr.*, 1896, XXXIII, 470). Subsequently the whole Petzval-Voigtländer collection was sent to the Technological Museum in Vienna.

The activity of Petzval extended in 1840 to two types of lenses, one of which, the portrait lens had a large aperture, about sixteen times as large as that of Chevalier's single lenses; the other had a small aperture (orthoscope), but a larger and sharper area of definition and was for use on landscapes and architectural subjects. It was still more rapid than

the Chevalier lens and was also a doublet. Both types consisted of a single achromatic landscape lens and another lens, slightly separated from the front lens, which itself consisted of two separate lens elements. The designs for the construction and the radii of curvature for both types are preserved, and the present author recorded them in his *Handbuch* (1893, Vol. I, Part 2).

From the mathematical conditions calculated by Petzval there resulted three systems of achromatic lenses, which could be combined into two types of double lenses. The amount of work involved in these calculations was considerable and required a number of assistants in order to expedite the result.

To this end Archduke Ludwig put at his disposal several soldiers of the Engineering Corps, trained in mathematics, who worked with Petzval and his assistant Reisinger. The portrait lens was offered to the public in 1840. A theoretical study of the subject by Petzval was published under the title: *Bericht über die Ergebnisse einiger dioptrischer Untersuchungen* (September, 1843).

Petzval's calculations for the portrait lens and for a second one (afterwards called the orthoscope) were ready in the early days of May, 1840, and Voigtländer's optical establishment found no difficulty in their successful manufacture and introduction. Petzval disclosed the radius of curvatures, the particular kind of glass, the lens distances only to Voigtländer, his manufacturing optician, keeping them strictly secret otherwise.

The original figures and working directions for the construction of Petzval's first lenses would have been lost to posterity, had not Voigtländer disclosed an attested copy of the designs and description, with the radius of curvature measurements of both systems of lenses, in the legal proceedings which ensued between them.[5] These were Petzval's 1841 figures. These documents containing a diagram are published in Eder's *Handbuch* (1893, I(2), 114) and in his work *Die photographischen Objektive* (3d ed., 1911).

The glasses used for the first portrait lens were "hard crown and light flint." The relative aperture was f/3.6; the first Petzval-Voigtländer lenses had only a tube diaphragm, which admitted the full volume of the light; later came the central diaphragm. The achromatism was limited, according to Fraunhofer's system of calculation of the optic rays; therefore there was a "chemical focus," to which at that

time little attention was paid, because of the short focal length of the lenses.

Early in the eighteen-fifties about eight thousand portrait lenses had been made from Petzval's design. The specimen Petzval portrait lens constructed in 1840 was entrusted shortly afterwards to Anton F. C. Martin, assistant to Professor Johann Philipp Neumann, of the faculty for physics at the Polytechnikum, in Vienna, for practical experiments in photography.

Ettingshausen had discussed the interesting discovery of Daguerre with Director Prechtl, and the latter had recommended young Martin for further practical investigation of the daguerreotype process.

It was therefore natural that Petzval should entrust Martin, after the completion of his first specimen lens by Voigtländer, with the experimental exposures in May, 1840. Martin was well equipped to make portraits on iodized daguerreotype plates and succeeded in doing so with exposures of 1¼ minutes by means of the new portrait lens. These plates excited the greatest interest at the first photographic exhibition at Vienna, in 1864.

The Petzval-Voigtländer portrait lens exhibited in its original form a much larger aperture than the apertures in the French lenses used by Daguerre, and this lens was the first which made portrait photography practical, so that later on, with the aid also of iodo-bromide or iodo-bromo-chloride plates, portraits could be produced in fifteen to thirty seconds in a favorable light. Specimen photographs from those times are preserved in the Technical Museum, at Vienna.

The first lectures on the Petzval lens were given by Professor Ettingshausen on November 2 and December 8, 1840, at the Lower Austrian Trade Association, at Vienna.

THE FAMILY OF VOIGTLÄNDER[6]—OPTICIANS

The family of Voigtländer, the opticians to whom Petzval entrusted the manufacture of his lenses, originated in the Harz mountains and settled in Vienna in the middle of the eighteenth century. The firm of Voigtländer was founded in 1756 by Johann Christoph Voigtländer (1732-1797), originally for the manufacture of fine mechanical instruments. His successor, Johann Friedrich Voigtländer (1779-1859), started the optical works in 1815. They were continued by Peter Friedrich von Voigtländer (1812-1878), who was succeeded by Fried-

rich von Voigtländer (1846-1924). Johann Friedrich Voigtländer introduced Wollaston's spectacle lenses first into Germany and later into Austria. His son Peter Wilhelm Friedrich Voigtländer constructed the first of the portrait lenses according to Petzval's calculations. In addition to the Vienna factory, he erected another at Brunswick in 1849, and he was knighted by Emperor Franz Joseph in 1866. He directed the factory at Vienna until 1868, when this establishment was discontinued.. The factory at Brunswick was carried on by his son Friedrich along the lines of modern developments in the science of optics.

Friedrich Ritter von Voigtländer advanced the interests of photography by the foundation in 1868 of the "Voigtländer" medal of the Vienna Photographic Society, which was conferred in bronze, silver, and gold for prominent achievements in the field of photography. The medal shows his portrait modeled by C. Radnitzky.[7]

PRIZE COMPETITION BY THE SOCIÉTÉ D'ENCOURAGEMENT IN PARIS FOR THE IMPROVEMENT OF PHOTOGRAPHIC LENSES; COMPETITION BETWEEN THE VOIGTLÄNDER AND CHEVALIER LENSES IN 1841

The shortcomings of the first Chevalier-Daguerre lens were well known to Charles Chevalier (1804-1859), as well as to all experts. The master opticians of Paris, London, Edinburgh, and Philadelphia labored in vain at the time of the discovery of daguerreotypy to produce a serviceable and large-aperture lens for portrait photography. They failed, because improvements could only be made by opticians who had also command of the higher mathematics.

The optician Chevalier, in Paris, and the mathematician and physicist Petzval, in Vienna, were both experimenting about the year 1840, independently of each other, to produce a large-aperture lens, which led them to the so-called double-lens. Both used an achromatic single lens (similar to Wollaston's meniscus), and in addition another pair of achromatic lenses, some distance apart. These latter consisted of two lenses separated from each other in Petzval's lens and two lenses cemented together in Chevalier's lens. The basic idea was the same, but the execution and the final result were different. There followed in 1841 a prize competition proposed by the Société d'Encouragement, of Paris, for the improvement of photographic lenses. Both Voigtländer, of Vienna, and Chevalier, of Paris, entered the competition. Voigtländer sent his Petzval portrait lens with excellent specimen por-

traits. We have already described this lens, which became known all over the world.

The Chevalier double-lens was made in two varieties, one for landscape and another for portrait photography. For the latter purpose the front lens was retained in its place, and an additional lens was inserted behind it in the lens barrel. The "stopping down" was accomplished by a diaphragm placed in front.

Chevalier had also employed glass prisms with a mercurized hypotenuse to reverse the image in the place of the earlier reversing mirrors. Chevalier's double-lens demonstrated as a novel idea the possibility by changing the rear lens, thus offering a combination of lens positions which made it suitable for both portraits and landscapes. These lenses were very faulty, however, from the optical and photographic standpoint, especially for portrait photography, and did not afford the clearness and brilliancy of the image in the center of the field given by Petzval's lens when sharply focused.

Chevalier was awarded the first prize, a platinum medal, for his double-lens with variable focal length, in which spherical aberration was minimized, thus permitting also a variation in the size of the picture by exchange of the lenses. Voigtländer had to be satisfied with the silver medal. Historical development subsequently showed that the facts did not justify the award of this jury, and as early as 1842 the superiority of the Petzval portrait lens was acknowledged by photographers everywhere.

Although Chevalier won a higher prize at this contest, he soon learned from the world-wide success of the Petzval-Voigtländer lens that his type of lens could not compete with it. All French opticians imitated the Petzval type, since it was not under patent protection, and their products were named "Système allemand," but they never mentioned Voigtländer's name or that of the inventor, Petzval. The success of the Petzval lens could not be retarded, and this aroused the opposition of Chevalier. He seemed to believe at first that the Petzval lens was an imitation of his production, which caused him to enter a protest in the same year before the Paris Academy of Sciences. The subsequent unbiased examination of the optical construction of both lenses proved conclusively that the types were entirely different and that Petzval's lens was an independent and typical invention. Moreover, a scientific controversy arose over the respective merits of the two types, from which Petzval emerged victorious.

Notwithstanding these facts and the unprecedented success of the Petzval-Voigtländer lens and despite the fact that the history of the Petzval invention became the common property of the scientific world, Potonniée, in his *Histoire*, sets himself up as the defender of the angry Chevalier and gives an incorrect picture of the history relating to portrait lenses. He writes:

The lens (Petzval-Voigtländer) constructed of four glasses, of great speed and sufficiently corrected for portraits, enjoyed great popularity, which was assisted by the fact that it was of foreign origin, because people prefer those things which come from abroad. They were expensive (450 francs), but the high price also was a factor in their success. Our opticians protested vigorously that their work was just as good and that the Voigtländer lens offered nothing extraordinary other than its price; but their recriminations were unavailing and nothing was left for them to do but to name their products "Système allemand."

Eder remarks in a review of this book: "Potonniée does not mention a single word about the fact that the French opticians simply imitated the lenses invented by Petzval and constructed by Voigtländer, because the Austrian patent protection did not extend to France. Contemporary opticians, however, preferred the original to the imitation." This loss of business seems to have aroused the ire of Chevalier, who was otherwise a very distinguished optician, and he wrote in 1844 that Ettingshausen had seen his lens on a visit to him in Paris. This was the well-known landscape lens. "Although they did not copy the curvature of my glass," says Chevalier, "they exploited my idea, but they exploited it badly." Potonniée takes this childish assertion and sets it up as a fact, claiming that Moigno (1847) and Valicourt (1862) confirm his position in the matter. "However that may be," says Potonniée, "one has seen the prices for the lenses of Chevalier and Voigtländer. According to Lerebours's catalogue of 1842, a lens 'Système allemand' cost 200 francs." Potonniée presents the history of the invention of photographic lenses solely from the standpoint of the price list of the French opticians, without the slightest recognition of or scientific comment on the invention of Petzval.

It is in this one-sided manner that this historian describes the revolutionizing of photographic optics by the great exploit of the ingenious Petzval, who made portrait and instantaneous photography possible for French as well as for German daguerreotypists, from all of which the French opticians reaped great profits, owing to their business acumen and their capacity to imitate and copy.

SUCCESS OF THE PETZVAL-VOIGTLÄNDER PORTRAIT LENS
PETZVAL BREAKS WITH VOIGTLÄNDER IN 1845

As early as the first half of the forties the commercial success of the Voigtländer firm with the Petzval lens was extraordinary. The careful production of the precise functioning Viennese optical works earned the highest reputation for these lenses; this is demonstrated by the fact that before the end of the forties many hundreds of these portrait lenses were shipped from this factory. But Petzval, who had turned over to the Voigtländer firm his invention without a contract, did not derive any satisfactory financial return from this success. Personal differences between Petzval and Voigtländer arose, their relationship became strained and in 1845 was completely broken off. Petzval refused to have anything more to do with Voigtländer and no longer used his workshop, but ground and polished the experimental lenses for his further work in his own shop and with his own hands. He became very efficient and sold several of these "one man" lenses to private persons, but never sold them publicly. In 1846 he made specifications for a new and specially fast lens intended for a projection apparatus. In 1843 he made calculations for the improvement of field glasses and microscopes. Voigtländer was the first to produce the Petzval double field glass; its principle is still in use today in opera glasses and in marine telescopes.

In 1846 Petzval calculated a new type of photographic lens which was four times faster than his original portrait lens; it was produced for several years and then disappeared from the market. Later such a Petzval lens was found in the possession of the optician Voigtländer in Brunswick and was submitted to Dr. H. Harting for testing and recalculation. It consisted of two cemented triplets, from which a lens was assembled with an aperture of f/2 (Rohr, *Theorie und Geschichte des photographischen Objektivs*, 1899). Only then did Voigtländer acknowledge the correctness of Harting's supposition that this lens was a forgotten type, different from the usual construction. Another Petzval lens of the same type was found in 1870. This lens was useful only in very small sizes; it was extremely fast and sharp, but it was not achromatic; its value was largely historical. Another Petzval construction was a symmetrical lens consisting of two air-spaced doublets, according to Voigtländer's documents, which have only lately become known. It was constructed in 1872 as a single model and was examined in 1878 by H. W. Vogel. The lens itself was lost, but the written notes

of Petzval were found among the papers of Voigtländer. The aperture was f/6.3. Harting found this type practical; it could be made of larger aperture and might be adapted for the production of motion pictures. Voigtländer's stepson, Zinke-Sommer, who worked in the Brunswick establishment, mentioned that the quadruplet objective of Petzval was capable of further improvement, but he could not induce Voigtländer to accept his advice. If the symmetry is not considered, one arrives at extraordinarily wide aperture lenses as von Rohr demonstrated long afterwards; The biotar constructed by von Rohr had an aperture of f/1.61 (H. Harting, *Phot. Ind.*, 1924, XXII, 1032).

IMPROVEMENT OF ACHROMATISM
ELIMINATION OF FOCAL DIFFERENCE

At the time of the invention of daguerreotypy the view prevailed that a lens achromatized to the human eye possessed sufficient achromatism for photographic purposes. Therefore the first lenses of Chevalier and Petzval were achromatized only according to Fraunhofer's specifications. The first to observe that the optical focus of such lenses was not identical with the focus of the "photochemically active rays" was Townson, who in 1840 recorded this in the *Phil. Mag.* (XV, 381). Anton Martin also observed during his first tests of the Petzval lens, in 1840, the focal difference, to which, however, little attention was paid by the professional photographers of his time. Claudet, in Paris, dealt with this exhaustively (*Compt. rend.*, May 20, 1844, XVIII, 954), and so did Cundell. Claudet gave exact information on the various positions of the "foyer optique" and the "foyer photogènique ou chimique" and returned to the research of these phenomena in 1849 and 1851.[8] Claudet's investigations encouraged the Paris optician Lerebours (1807-1873) to construct, in 1840, lenses without focal difference, and he associated himself later with Secretan, an officer in the Engineers Corps, for the purpose of the manufacture of such "actinically corrected" lenses (Rohr, *Theorie und Geschichte des photographischen Objektivs*, 1899, p. 101).

DIAPHRAGMS

The favorable effect of diaphragms (stops) in lenses on sharpness and depth was well-known long before the invention of photography. Niépce knew of this effect as early as 1816. Daguerre-Chevalier, in 1839, used diaphragms fixed at some distance from the lens. When

double-lenses were introduced, a blackened metal plate with a round opening was inserted between the two lenses. On the first Petzval-Voigtländer double objectives (1840) it was necessary to unscrew the front lens every time, insert the stop and replace the lens. But it was not long before the well-known loose or curtain stops were introduced.

Frederick Scott Archer made his wet collodion exposures in 1853 with such diaphragms and then followed Waterhouse's recommendation in 1857 (that of a slot for the diaphragm in the lens barrel); in England they were called Waterhouse stops. In 1859 Voigtländer fitted all portrait lenses in this manner.

On smaller lenses, that is, wide-angle lenses, so-called rotating or revolving diaphragms were used, which consisted of a blackened metal disk which could be turned and had apertures (stops) of various sizes cut in it.

Ch. Chevalier used rotating stops first for his microscope and in 1841 also for his lenses (see Rohr, *Zeitschr. f. Instrumentenkunde*, 1909, p. 138). The Englishman John Benjamin Dancer also proposed rotating stops on photographic lenses, in 1856; this is described in the English patent granted on September 5, 1856 (No. 2064).

The iris diaphragm was used by Niépce in 1816 on his camera obscura, this being the first diaphragm of its kind employed in photography; it differed very little from those in use today. It is preserved in the Niépce Museum at Gras, near Chalons.

The iris diaphragm was first made public by Charles Chevalier, who presented it before the Paris Société d'Encouragement in 1840. Nottone, in 1856 (*Phot. Jour.*, III, 165), Jamin (*Bull. Soc. franç. d. phot.*, 1857, p. 178), and Quinet (*ibid.*, 1860, p. 31) recommended similar iris diaphragms.

Karl Pritschow of the Voigtländer firm discusses at length the history and theory of iris diaphragms in *Phot. Ind.* (1926, XXIV, 222).

PETZVAL DESIGNS A LENS FOR LANDSCAPE AND REPRODUCTION PHOTOG-
RAPHY, ALLIES HIMSELF WITH THE OPTICIAN DIETZLER (1854), TAKES
OUT A PATENT FOR "PHOTOGRAPHISCHEN DIALYTEN" (ORTHOSCOPE)
1857, AND ENTRUSTS DIETZLER WITH THE MANUFACTURE OF HIS
LENSES

With the invention of the wet collodion process the demand for larger sizes developed in the photography of landscapes, architecture,

and for photomechanical reproduction. This demanded larger lenses. The Imperial Military Geographic Institute of Vienna, as well as the Government Printing Office in Vienna, called this to Petzval's attention in the fifties and directed his studies along these lines.

Petzval recalculated his figures of 1840, which were subsequently embodied in the "orthoscope" lens. He revised his figures, ground and polished in his own shop models according to this formula, and obtained with them pictures of large size, sharp at the edges, with a proportionally small aperture and fairly even illumination. In 1854 he secured the assistance of the optician Dietzler, of Vienna.

As early as 1856 he had finished the construction of his "Photographischer Dialyt" (dialytic photographic lens), and he exhibited in that year some of the exposures made with these lenses at the meeting of German physicists and members of the Society for Natural Sciences, which was held that year at Vienna. He also made a group photograph of those present at his lecture.

In order to protect the construction of this lens, he applied on October 6, 1857, through Dietzler, for an Austrian license, which was granted a few months later. The description of the apparatus in the application for the license is signed by Joseph Petzval.

This lens was put on the market in 1857 and met all requirements of the governmental departments mentioned above. It was used for more than ten years almost exclusively for reproduction purposes, but it was also by far the best landscape lens of its time, so that many lenses of this type were sold to professional photographers. Petzval used this type also in his terrestrial telescope, which he described in 1858 to the Vienna Academy of Sciences. The first of these telescopes constructed by Dietzler was sent to London by Petzval.

PETZVAL'S FIRST ORTHOSCOPIC LENS

The orthoscope No. 1 of Petzval-Dietzler was presented by the author of this history to the collection of the Graphische Lehr- und Versuchsanstalt, in Vienna. It was brought to him in the late nineties by Dr. Adam Pollitzer, to whom Petzval gave it as a souvenir when Dr. Pollitzer, in the fifties, refused to send him a bill for curing him of a disease of the ear.

PETZVAL-DIETZLER'S PORTRAIT LENSES

Petzval entrusted to Dietzler also the manufacture of his portrait

lenses and personally supervised the construction of the first hundred. These undoubtedly are the best type of Petzval lenses in existence.[9]

Dietzler and Voigtländer exhibited their competing lenses at the International Exhibition, in 1862, in London, and both received equally high awards. Dietzler's business prospered, sales were good, and his price lists appeared in rapid succession until 1862. After this Dietzler failed rapidly.

The business was badly conducted, lenses were sold at cut prices, the management was unreliable, and the sales diminished. Dietzler gradually became insolvent, and finally all his stock of lenses was sold by auction. At this sale lenses which were faulty and untested were sold, and this further confirmed the bad reputation of the firm. Petzval had separated from Dietzler in time, and deeply discouraged, refused any longer to have any connection with lens making.

Voigtländer retained his position in business and applied his energies in the years following with continued zeal to the making of Petzval-Voigtländer lenses. At the Paris Exposition of 1867, only Voigtländer exhibited, Dietzler had disappeared.[10] After having been supported by contributions from members of the Vienna Photographic Society, he died in poverty on October 21, 1872.

For his tests with the new "orthoscope" Petzval required a portable camera with a large plate-holder for landscapes and for reproduction. He contructed such a camera with his own hands and gave a description of it to the Academy of Sciences, Vienna, in 1857 (*Akademie der Wissenschaften*, Vienna, 1857, XXVI, 66).

A solidly constructed tripod carries on top a triangular bar of wood 4-inch thick, laminated with several pieces to avoid warping, and heavily varnished. To this bar two cameras, a large and a smaller one joined together, were fastened.

Petzval was fully alive to the importance of camera construction, and in his report, mentioned above, made this characteristic statement: "It is essential that the camera obscura should be made with the greatest accuracy, because it must be closely adjustable to the peculiarities of the lens if the lens is to function at its highest efficiency."

CONTROVERSY BETWEEN PETZVAL AND VOIGTLÄNDER OVER THE MANUFACTURING RIGHTS TO THE ORTHOSCOPE

As soon as the great success of the Petzval-Dietzler "dialytic lens," which later became the "orthoscope," became known, the Voigtländer

firm in Brunswick took up the manufacture of the new Petzval lens. Voigtländer recognized in this lens the construction earlier designed by Petzval for a landscape lens, to which he had paid no attention at the time. Even Petzval had forgotten that he had turned over to the Voigtländer firm the design and radii of curvature figures of this lens. Voigtländer now pushed the manufacture of this type and placed them on sale under his own name, as the "Voigtländer orthoscope." This name (but only this) was invented by Voigtländer, whereas Petzval intended to call this type "Photographischer Dialyt." Voigtländer's keen competition made itself felt on the Petzval-Dietzler business and forced Petzval to give his lens also the name "orthoscope." Voigtländer substantiated his rights to the construction by asserting that in 1840 he had already made a model of it and that he therefore had acquired the proprietary rights which the inventor had now given to Dietzler. Petzval opposed what he called the arbitrary manufacture by Voigtländer, but the latter insisted on his claim, and the long and acrimonious dispute disclosed that Petzval in the course of the years had entirely forgotten that he had actually turned over to Voigtländer, at Vienna, in 1840, the first data for the construction of this lens, as well as those of his portrait lens. Although this controversy disclosed that Petzval doubtless was the inventor of both types, he derived no pecuniary returns from them, because he had not protected himself by making a contract that would assure him of his share in the financial returns from his inventions; so both Dietzler and Voigtländer "orthoscopes" were placed on the market for sale.

The American opticians Harrison and Schnitzer, in New York, also manufactured "orthoscopes" fitted with iris diaphragms in the center, while in Voigtländer's orthoscope the diaphragm was inserted behind the rear lens (*Handbuch*, 1893, I(2), 139).

PETZVAL'S LAST YEARS

Until 1858 Petzval made an exhaustive study of the science of dioptrics (refractions of light). His reports to the Vienna Academy of Sciences in 1857 and 1858 show how earnestly he devoted himself to the problems of optics, and that he looked forward with confidence to their solution. But the prolonged disagreement with Voigtländer and the failure of Dietzler depressed him greatly. He made use of his masterly knowledge of grinding and polishing lenses and constructed,

without assistance and with his own hands, a newly invented and improved lens. We have the solitary model of that lens, preserved by an accident from total destruction. A burglary of his summer residence on the Kahlenberg, near Vienna, in 1859, during which the completed manuscript dealing with his theory of optics was destroyed, caused him to turn from optics entirely and to devote himself to acoustics.[11] In 1862 he terminated also the lectures on dioptrics, which he had delivered since 1853.

He married his housekeeper in 1869; the marriage was happy, but without issue. His wife died in 1873. On his seventieth birthday he retired from his professorship, greatly respected and decorated by the emperor. He now withdrew himself from everybody and became more and more misanthropic and lonesome. He was embittered by his quarrel with Voigtländer, by the failure of his enterprise with Dietzler, by the lack of reward for his life's work in applied optics, and by the ill will of his colleagues, with whom he was in constant contention; thus he passed his last years. He received the visits of a few old friends, but retired more to himself and died of infirmity due to old age on September 17, 1891.

In his last years the caretakers of the house looked after him and nursed him, and his will made them his heirs; but, of course, they had no appreciation of the heritage that had fallen into their hands.

Dr. Erményi, of Vienna, arranged Petzval's carelessly kept papers, which were partly ruined, giving his report of them in a pamphlet entitled, *Dr. Josef Petzvals Leben und Verdienste* (1903).[12]

Petzval was a member of the Academy of Sciences in Vienna, founded in 1846. He was made an honorary member of many scientific societies. He was also one of the founders of the Photographic Society of Vienna. Immediately after his death the society decided to erect a monument to his memory in the hall of the university, which was presented to the rector of the university on November 6, 1901, by the president of the society, at that time the author of this work.[13] A monument at his grave, erected by contributions from a circle of artists and scientists engaged in photography, was dedicated on October 17, 1905 (*Phot. Korr.*, 1905, XLII, 535, 547; 1907, XLIV, 107, 155). A street in Vienna was named Petzvalgasse, and finally the Minister of Education caused a Petzval medal to be stamped, to be awarded to those contributing meritorious service in the field of photography.[14]

PETZVAL'S PORTRAIT LENS

The librarian of the Graphische Lehr- und Versuchsanstalt, in Vienna, Eduard Kuchinka, reports in the *Phot. Korr.*, (1921, LVIII, 261) as follows, on large Petzval lenses:

In the beginning Voigtländer made only small portrait lenses of the Petzval type. In 1851 they were producing lenses four zoll (1 zoll=2.61 cm.) in diameter. The five-inch Voigtländer came on the market in 1856 (Martin *Neuestes Repertorium der Photographie*, 1856) and cost 450 talers. In the same year we find a six-inch lens offered by Dietzler for twelve hundred florins.

From a remark printed in the catalogue of the Berlin Photographic Exhibition of 1865 (p. 39) we note that there existed six-inch lenses in 1856; there is also announced, as exhibited by Leonhard Bülow, of Moscow, "the portrait of a Russian general of the cavalry, taken from life nine years ago with a large instrument."

In 1860 (Horn, *Phot. Jour.*, 1860, XIV, 36) Voigtländer brought out two types of the six-inch diameter lens with long and short focus, a good-sized, heavy lens weighing 14.3 kilograms (31 1/5 lbs.). Others who made six-inch lenses were Hermagis, in Paris, Busch, in Rathenow, and others. These models can be found today in such museum collections as the Graphische Lehr- und Versuchsanstalt, in Vienna.

The optical establishment of Busch, in Rathenow (Prussia), started in active competition with Voigtländer (Rohr, *Zeitschr. f. Instrumentenkunde*, XLV, 477) and brought a seven-inch diameter lens on the market, which Voigtländer answered with the production of an eight-inch lens in 1864. This is first mentioned in the report of the Vienna Photographic Society, October 18, 1864 (*Phot. Korr.*, 1864, I, 143).

Ludwig Angerer, who was a member of the executive committee of the Photographic Society of Vienna at the same time as Anton Friedrich[15] manager of the Voigtländer branch establishment in Vienna, probably learned from him of this lens, bought it, and worked with it considerably.

We find two examples of this lens in Voigtländer's exhibit at the International Photographic Exposition, Berlin, 1865 (the first in Germany), one of them loaned by Angerer. These two eight-inch lenses flanked the comprehensive exhibit, the arrangement of which was photographed and was later awarded the prize medal. There were three six-inch lenses exhibited, one attached to a camera with two tripods, owing to the weight of the lens. There is no mention of the eight-inch

lenses in the catalog of the exhibition, probably due to the printing of the catalog before the lenses arrived. One of the exhibits was a large photograph taken by Döbbelin & Remelê[16] with a thirty-six millimeter spherical Busch lens.

In the *Phot. Korr.* (1865, II, 168) we find the following report:

Ludwig Angerer exhibited portraits, busts, and three-quarter lengths, taken with an eight-inch Voigtländer lens. From the technical standpoint these were highly successful and vigorous without retouching, but, unfortunately, they were not as much appreciated as the difficulty of their production made them deserve. The pictures measure 16¼ by 22 inches; but, of course, this size has neither the freedom of arrangement nor the sharpness and delicacy of a portrait the size of a visiting card. The nucleus of his exhibit were the portraits, size 13 x 16 inches, taken with a six-inch Voigtländer lens.

H. W. Vogel also mentions the exhibit of the eight-inch lenses in *Phot. Mitt.* (1865-66, II, 68). Since the considerable weight of this lens excluded the use of the customary tripods, Angerer ordered a tripod constructed from his own design, which permitted the raising and lowering of the camera, as well as its inclination upwards or downwards, by the operation of levers. The camera, with lens and tripod, weighed 200 lbs.

The price of the eight-inch lens was 1,000 talers, according to Martin's *Handbuch* (6th ed., 1865, p. 519); of the six-inch lens only 420 talers. The latter was offered as late as 1884 by a Vienna firm for 1,260 marks.

Hermagis, in Paris, also constructed an eight-inch achromatic double portrait lens (price list of Oskar Kramer, in Vienna, March, 1865, and Hermagis's list, 1867); it was sold for 4,000 francs. There is no proof that the lens was ever manufactured; while in Kramer's catalog a camera is mentioned for Hermagis's eight-inch lens, but no details are given of the camera stand, bellows, or of the price.

In 1868, at the third German Photographic Exposition at Hamburg, photographs by L. Angerer, taken with the six- and eight-inch lenses, were exhibited.

The finished eight-inch lens, which marked an epoch in the history of the Voigtländer firm, was given the nice round number of "16,000." If we did not know, as mentioned above, the exact date of its production, we might yet guess approximately the number of the lenses produced annually, because at the end of 1861 there had been produced

in Brunswick the 10,000th lens, which was celebrated on February 22, 1862, by a special holiday (*Zeitscht. f. Phot.*, 1862, V, 38). There were constructed in Vienna and Brunswick 2,000 lenses yearly, and the probable number 16,000 would lead to August, 1864. And for all these Voigtländer had paid Petzval in 1840 about 2,000 florins ($1,000).

After Angerer's death his son-in-law Winter took over the management of the well-known establishment and found both the six- and the eight-inch lenses in the attic. The latter was procured by the author for the collection of his institute; the eight-inch lens, known in Vienna technical circles as the "1,000 florins lens," reached the university astronomical observatory at Vienna, whose director had long desired a large lens in his astro-photographic studies. The eight-inch lens No. 16,000 is preserved in the same institution. Such is the history of the largest lens produced at the Voigtländer works.

This, however, is not the end of the construction of these colossal lenses. Emil Busch, of Rathenow, continued the race by producing a ten-inch lens. This lens was an attraction at the International Photographic Exhibition in Paris in 1867. R. J. Fowler in the *Brit. Jour.* (1867, XIV, 366) described it as a "mammoth lens" ten inches in diameter, which is capable of taking a picture about 30 x 30 inches. The focus is about 34 inches, and it is asserted that a photograph was made with it on a collodion plate in 2 minutes.

From the *Phot. Mitt.* (1867, III, 312) we learn that Karl Suck exhibited a portrait at the February 15, 1867, session of the Photographic Society at Berlin, which was taken with the colossal lens made by Emil Busch, of Rathenow, destined for the Paris Exposition. The size of the picture was 64 x 80 cm. (25 x 31½ in.), and portrayed a lady whose head was 10 cm. (about 4 in.) high, while the size of the entire figure seated was 54 cm. (21¼ in.). The picture was sharp in all parts and full of detail. Suck exposed under a "rather dark sky for two minutes and obtained a fully exposed negative; the distance of the sitter from the lens was fourteen feet.

Busch did not produce more than this solitary example, which was and remained a showpiece; it was returned to its home, preserved until 1902, and then lost. It seems that is was accidentally damaged and was then destroyed.

This history would be incomplete without mention of the French opticians, who, long before the German opticians, produced giant lenses (from Petzval's type and radii of curvatures). Horn's *Phot. Jour.* (1855, IV, 8) reports:

A lens of ten-inch diameter. Very interesting demonstrations were made quite recently by Disdéri at Paris in the presence of a large audience of scientists, artists, journalists, and amateurs, among whom attended Messrs. Chevreul, president of the World Exposition jury, Leon Cogdiet, Dantan, Girod, Count Olympe Aguado, Edouard Delessert, Vicomte Vigier, etc. The object of the gathering was the demonstration of a lens with composite glasses, newly constructed by Messrs. Lebrun and Maës, and of a diameter of not less than 270.7 mm. (10⅝ in.).

Four portraits were obtained during the session with this gigantic apparatus with a diaphragm opening of 10 cm. (4 inches) and from a distance of three meters (10 feet), Dantan's portrait, two-thirds life-size, Count Aguado's somewhat smaller, and two of Ed. Delessert, life-size. These four positives on collodionized glass were wonderfully successful. The exposures varied from two to fifteen seconds. The portraits showed very little distortion, good lighting, and great detail. While these results proved that Messrs. Lebrun and Maës had constructed a good instrument, notwithstanding its extraordinary dimensions, they also gave new proofs of the well-known skill of M. Disdéri. The glass plates with which he operated were at least 60 cm. wide by 80 cm. high (23⅝x31½ in.).

Such a lens cost in Paris, with camera and plate holders of polished walnut, 20,000 francs (Horn, *Phot. Jour.*, IV, 48). The complete lens consisted of four glasses 27 cm. (10⅝ in.) in diameter (Kreutzer, *Jahresber. d. Phot.*, 1856, II, 146).

A few months later a short note was printed in *La Lumière* (June 30, 1855, p. 103) that W. Thompson and Bingham had taken life-size portraits on collodion plates, 80 cm. high (31½ in.), with a twelve-inch (33 cm.) lens by M. Plagniol and a camera four meters long (15¾ ft.) made by A. Gaudin et Frères.

We add a chronology of the genesis of large-size portrait lenses, in order to make the foregoing easier to follow:

Four-inch lens	1851, Voigtländer	
Five-inch lens	1853, Waibl	1856, Voigtländer
Six-inch lens	1854, Waibl	1856, Dietzler
Six-inch lens	1857, Busch	1860, Voigtländer, Dallmeyer, Ross
Seven-inch lens	1857, Busch	
Eight-inch lens	1864, Voigtländer	1865, Hermagis
Ten-inch lens	1855, Lebrun & Maës	1866, Busch
Twelve-inch lens	1855, Plagniol	

VIENNA IN THE FIELD OF PRECISION OPTICS

Moritz von Rohr gives a detailed account (*Phot. Korr.*, June, 1926, LXII, 57-67) of Vienna's place in the development of precision optics

before 1848.[17] It is mentioned that the optical works established by Fraunhofer in Munich surpassed all similar establishments in Germany and Austria. Voigtländer senior had learned in England the grinding and polishing of optical lenses. He constructed double telescopes of the type made in Holland and opera glasses (1823); he employed an apprentice by the name of G. Simon Plössl, who later went into business for himself. Von Rohr continues:

There were others in Vienna, who followed with interest the growth and results of the Munich output, which was astonishing in its enormous volume, considering the circumstances of the times surrounding industrially inferior Germany. These were the scientists connected with the Polytechnical Institute founded in 1841, especially those engaged in the field of optics, Director J. J. Prechtl (1778-1854) and his subordinate, the scientist S. Stampfer (1792-1864). They maintained the best of relations with the Bavarian establishment, which they admired, and were on the friendliest footing with Fraunhofer. Their relations with George Reichenbach (1772-1826) were so intimate that he himself installed, in 1819, the mechanical workshop in their training school at the Polytechnikum. The workshop was supervised by the able mechanic Starke, who assisted Fraunhofer in the construction of the Dorpat telescopic lens.[18] Prechtl, two years after Fraunhofer's death, was able to report his remarks on the molding of large sheets of optical glass. The practical workers were given an opportunity of keeping in touch with new developments by Prechtl's *Jahrbüchern des Kais. kön. polytechnischen Institutes*, in Vienna, which furnished periodical reunions with those whom he cherished even after they had left the institution and entered practical pursuits. Prechtl's *Technologische Encyclopädie*, published in 1831, demonstrates the comprehensive manner in which the technical sciences were taught at this institution.

During Fraunhofer's life no attempt was made to enter into competition with the enterprise which he directed, but this evidently changed soon after his death, in June, 1826. After Fraunhofer's successor was appointed, Prechtl and Stampfer changed their position, because they recognized now the possibility of assisting the Vienna opticians, for whom they felt they had a mandate of guardianship in scientific progress—of course, unfortunately, to the detriment of the orphaned Munich establishment.

In order to familiarize the two principal Viennese opticians, Voigtländer and Plössl, with the design of Fraunhofer's lenses, Stampfer published in 1828—about eighteen months after the master's death—two illustrated reports on his study of these lenses. The first of these reports dealt with an accurate method of measurement to determine the radii of curvature of Benediktbeurener[19] lenses, while the second dealt with an

attempt to discover the fundamental thought which had guided this excellent expert in their construction. Even today Stampfer's works are still worth reading, though one may not wholly agree with him.

Since it was intended, of course, to make their protégés in Vienna capable of properly grinding and polishing lenses, Prechtl published in his book *Praktische Dioptrik* (1828), a process for testing, grinding, and polishing which, according to E. Voit,[20] was very similar to the methods used by Fraunhofer. The exceedingly sensitive Newton's rings' test, to be sure, remained unknown to the Viennese instructor; it seems to have been carried on secretly in Munich.

It is certain that Prechtl also had to look after the supply of glass which could be furnished to some extent again, since 1818, by the reopened glassworks of P. L. Guinand, at Les Brenets. It was advantageous for Vienna that the Swiss glass manufacturer, as we learn from his statements in 1814 and 1816, had as his confidential representative the well-known Vienna optician A. Schwaiger. We may presume that active scientists like Prechtl and Stampfer would keep themselves informed about these matters. It is certain that Prechtl, in 1834, was well informed about the most capable of the small Swiss glassworks, since he discloses an accurate knowledge of the prices at which Guinand flint- and crown-glass plates were sold there. This factory was at that time under the management of a company formed from former individual enterprises by Guinand's widow, Rosalie, Th. Daguet, and A. Berthet. We may surely assume that Prechtl even then either himself advised or caused to have advice given to his Viennese protégés in the manipulation of the optical glass which they bought in western Switzerland. This opinion is strengthened by the reports of H. Harting on the different kinds of glass used by W. Fr. Voigtländer, which probably relate to this period, because we can find no other good reason for a combination between the two smelters Daguet and Berthet. The date is not documented, but we would assign about the year 1834 for this association.

Presumably the giving of counsel to the native opticians fell to S. Stampfer, whose name appears frequently in the Voigtländer papers referring to such matters.

It is certain that in 1829 he designed, at the request of A. Rogers,[21] new distance lenses (dialyte) for celestial telescopes, which, in fact, were soon executed by Plössl, who in later years sold this now-abandoned type of telescope on a large scale. The diameter of the aperture is given as up to $27\frac{1}{2}$ cm. (about $10\frac{1}{8}$ in.). It is probable, although the evidence is debatable, that Stampfer also assisted this same master craftsman in the construction of his lenses for microscopes. The requirements for these particular constructions, as we know, refer back to the respected scientist J. Fr. v. Jacquin, who, experienced in microscopy, gave to the Vienna op-

tician the advice of a specialist, which Fraunhofer lacked in this field. It seems as if the progress made in the combination of several achromatic lenses by the Paris opticians V. and Ch. Chevalier (father and son) in 1824-25 should also be credited to Plössl, and one may conclude that Stampfer also collaborated, since, probably after January, 1841, he furnished Voigtländer accurate directions for the radii of curvature and lens distances for microscopes.

It is certain that young Wilhelm Friedrich Voigtländer owed his technical education to Stampfer, presumably during the early thirties of the last century and, what is important, also studied under him the processes of determining the refraction factors of certain prisms under consideration.

Beneficial as the activity of Prechtl and Stampfer was for the establishments conducted by the Vienna opticians, one cannot help but think that their services were offered almost too liberally. These manufacturers probably became so accustomed to receiving this gratuitious co-operation as due to them that they soon suppressed any feeling of appreciation; they do not anywhere mention Stampfer's work on the theory of spectacles, published in 1831, of which they were certainly cognizant. In another place I have pointed out that, to my surprise, none of these Vienna firms deemed it advisable to express in its catalog their appreciation of Stampfer's mathematical contribution. This erroneous appraisal of the relative importance of the designing and making of lens units indicated increasing difficulties in any lasting collaboration of scientists and lens makers. As the event proved, this was perhaps the principal reason for the decline of applied optics as an industry in Vienna.

If we have followed Stampfer's guardianship, it is easily understood that he chafed under the disadvantages of being obliged to obtain his glass supply from abroad, and his joy may be imagined when he seemed to have reached the nationalization of the art of making optical glass through the efforts of Jacob Waldstein (1810-1876). He, no doubt, did everything in his power to procure a favorable reception for the first experimental meltings made in 1840-42. In fact, 1844 saw the opening of the first works for the production of optical glass in Vienna. We also know from the report of Harting that Stampfer tested melting specimens which were produced at the Waldstein glassworks. This enterprising business man was enabled to start these works with the assistance of workmen whom he had induced to leave Benediktbeurn and who brought with them the training received there. This loss crippled the older institution, which, while continuing in existence, no longer played any role in the world trade.

It must at this time be pointed out briefly that the whole scientific world was thrown into a turmoil by Arago's report on January 7, 1839,

in which he made the first announcement of daguerreotypy. The supply
of photographic lenses—at that time only for landscape subjects—came for
the moment from Paris; but the alertness of the Vienna optician is best
indicated by the fact that at that time Plössl was experimenting with his
own construction of a new type of double lenses.

The problem to be solved, if the prospectively profitable field of pic-
ture making opened by the new invention was to be made accessible, con-
sisted, in modern terms, of the manufacture of a camera lens of high
relative aperture and of medium-sized field. The technical opticians were
therefore faced with an entirely novel problem, and it seems quite im-
possible today that a solution could have been obtained by the amateurish
experiments of the purely rule-of-thumb-trained optical workers of that
time. They naturally attacked the problem in the manner with which we
are familiar in the detailed reports obtained from Paris, London, Edin-
burgh, and New York. The great difficulties in the way of the solution of
this problem seem to have become popularly known in the late summer
of 1839, when the details of the process were made public at the
Academy in Paris. It can be pointed out that the first experiments were
unsuccessful, although very efficient and ingenious technical experts
(Prechtl and Stampfer) occupied themselves with the problem.

Among those familiar with this difficult problem was the Viennese
physicist A. v. Ettingshausen, at that time on a visit to Paris, charged by
his government with the duty of attending the delivery of Arago's report,
who after his return to Vienna brought the subject to the attention of
the young professor of mathematics Joseph Petzval (1807-1891). Al-
though we have no details today of the relationship between Stampfer
and Petzval, it may be set down with certainty that Petzval was acquaint-
ed in a general way with this problem, which scientists worthy of repute
had passed on to the Viennese master opticians, and that undoubtedly the
unique photographs of Fraunhofer and his tremendous performance had
both attracted and stimulated him. His colleague advised him to procure
the necessary information—the indices of refraction and dispersion for
crown- and flint-glass—from the young optician W. Fr. Voigtländer.
Thus began between these two men a chance relationship for which
neither was fitted and which could not result in a successful collabora-
tion. Aided by this information pertaining to the species of optical glass
used, Petzval advanced his work in the analytical development of the cor-
rection of errors in general so diligently that as early as 1840 he had cal-
culated three lenses, after which, following his figures, two double com-
binations with new and desirable properties could be produced.

Petzval could not arrive at a satisfactory conclusion without more de-
tailed information of the results which had been obtained with the lenses
in use up to that period, and the assistance of the amateur photographer

A. Martin (1812-1882) was necessary before the great advance made by Petzval could be fully appreciated. Naturally, Voigtländer immediately put the new lens combination constructed in his works on the market. It is to be regretted that Petzval declined, it seems, the opportunity then offered of a business alliance with the respected and competent businessman and optician. Apparently unable to appreciate the financial value of the Prechtl-Stampfer achievement, he may have made a present of his invention to his optician.

Its commercial success was immediate and extraordinary; and because the portrait photographers, like eagles watching for their prey, kept their eyes wide open for rapid lenses, the fame of this new lens, Petzval's portrait lens, spread with unexpected rapidity. Neither W. Fr. Voigtländer nor his father, experienced in business affairs, took any steps for the methodical exploitation of the prize which had fallen into their laps, more surprising than a lottery prize; even the safeguards necessary for the protection of the property rights in Austria and abroad were neglected. Although the opticians of western Europe showed their appreciation of this new lens series by way of imitation, which imposed on them no further return, there was still enough left in the brisk demand for the original product to satisfy the most exorbitant claims.

It is clear that in these circumstances, where at least there was no lack of approval, Petzval required no urging to continue in the direction in which he so fortunately advanced. He calculated now another lens combination, still more rapid, as well as the lenses for an efficient telescope, by the Holland method, and a special lens for projection apparatus by transmitted light, and turned them over to his business associates. Still he seems to have felt a disposition to be discontented as the economic value of the portrait lens became known, so that when Petzval realized more clearly the commercial value of his "gift" to his optician friends, he naturally regretted his lack of foresight. Unfortunately, Voigtländer did not make use of this change of mind in his worthy collaborator by binding Petzval to his enterprise with a fixed contract, but thought that he could adequately remunerate him for his work up to that time with the sum of 2,000 florins ($1,000). We cannot go far wrong, if we explain this action of a businessman who, as is positively proved by later reports, thought very highly of Petzval's work as optician, by the pampering attitude towards the Viennese opticians adopted generally by the old directors of the Polytechnic Institute. It will be recalled that Stampfer's working out the results of separation (dialyte) met with no better appreciation from the Plössl works, although scientific circles recognized in his work a very remarkable performance. The young head of the Voigtländer firm probably never considered the necessity of taking a different position towards Petzval. How far his prejudiced conceit in his own performance extended,

is best shown by his request that his own determination of the indices of dispersion and refraction be included in the scientific report which Petzval published in 1843 on the elements of his calculation. The denial of his request seems to have hurt him more than his personal disputes with the sharp-tongued professor.

The historian of today cannot sufficiently regret this separation after so short a time, hardly two years of extraordinary success, of two notable men whose joint efforts ought to have continued. We are led to believe that Petzval would have been able to accomplish important results had he remained in closer touch with the requirements of an optical workshop.[22] He would thus have realized and improved the defects in the design of his landscape lens (orthoscope), as well as the qualities needed to fulfill his desire to produce faster lenses. Examples of these later productions are at hand and present a great contrast with the perfect design of his portrait lens. When we consider the fervent spirit with which he, in the middle fifties, solved the achromatism of his portrait lens, and if we attribute to him also the double lens which became known as "cemented dialyte," which at least is probable, we cannot help but deplore the misfortune which cut short so suddenly the progress of scientific optics in Vienna.

And so it happened, that a clever merchant and conscientious craftsman could enjoy for many years great reputation as producer of perfect photographic lenses, although he contributed hardly anything to the further development of these instruments.

After 1848 the optical trade in Vienna became smaller and smaller. The removal of Voigtländer's activities to Brunswick and the closing of the factory which was so excellent in its production robbed Vienna of its leadership in the optical industry. The activities of the English amateur photographic societies, following Petzval's second period of photographic activity in the development of a serviceable wide-angle lens, were not participated in by any Viennese optician. When at this time K. A. Steinheil began his memorable career, Vienna had lost its claim to scientific superiority in this field.

Chapter XXXV. DAGUERREOTYPY AS A PROFESSION, 1840-60

THE MORE the application of daguerreotypy was perfected chemically and optically, the more amateurs, artists, and scientists studied photography for their respective purposes. Everywhere it became the subject of endless experiments. More especially, professional photography as

a business enterprise grew with extraordinary rapidity. In the forties they were satisfied to take portraits in the open air, in an open corridor, or on a balcony, and no one paid any attention to the surroundings. The iron railing of a balcony shown in daguerreotypes of 1844 demonstrates the absence of elaborate settings. One of 1848 shows a daring forward step by including a restless child in the picture. Later studies added curtains and draperies.

French daguerreotypists achieved wide reputation, especially daguerreotypists Lerebours and Secretan, opticians to the observatory and to the navy in Paris. Before the end of 1839 N. P. Lerebours had constructed large daguerreotype cameras which produced pictures of 12 x 15 (French) inches. He worked at first with Gaudin,[1] then established himself in Paris as manufacturer of optical, physical, and mathematical instruments at Place du Pont-Neuf 13,[2] and later associated himself with Secretan.[3] They conducted a photographic studio at the Rue de l'Est 23, in addition to their shop, where they sold optical apparatus and accessories for daguerreotypes. Their studio was opened about 1845, and it flourished for several years. In 1850 Lerebours and Secretan made one of the most excellent panoramic daguerreotypes of a view of Paris ever made. This was preserved in the technological collection of the Polytechnic Institute in Vienna and was later placed on exhibition in the Technical Museum there.

In England one of the first professional daguerreotypists was A. Claudet, who had purchased from Daguerre a license for England immediately after the publication of the process and had moved from France to England. He was a practical photographer in London and experimented with photochemistry and optics. The English photographer J. E. Mayall also had a good reputation, and his daguerreotypes of 1850 achieved recognition at the London Exhibition of 1862, where they were exhibited. In addition to the few daguerreotypists here named, there were many others too numerous to mention. [Dr. Eder reproduced for the fourth edition, 1932, of his *Geschichte* a few interesting examples, because they demonstrated in connection with the other daguerreotypes illustrated there the status of photographic production in the middle of the last century.[4]]

The first attempts to portray the human body by daguerreotype as an aid in the fine arts or for attractive subjects for sale were made in the forties of the last century in Paris. The earliest daguerreotypes of this class which I have seen date from 1844-1849 and represent the

most technically perfect daguerreotypes which have been preserved from that time. They bear only the name and age of the model and were undoubtedly made for erotic purposes, for the collection comprises, among others, pictures of two persons which could not be reproduced.[5] It is difficult to determine who took the first group pictures by daguerreotype, since the idea of making portraits of one person and the natural progress to group photography followed each other too closely. In the *Photographic Journal* (1905, p. 218) we find the reproduction of a group picture said to be "the first one taken by Daguerre, March, 1843." It was probably photographed with a Petzval lens. It was no particular feat to produce pictures of groups with this instrument; the German and Austrian daguerreotypists achieved equally good results in this field.

Chapter XXXVI. COLORED DAGUERREOTYPES

THE COLORING of daguerreotypes seems to have been known as early as 1840 and the knowledge had spread by 1841. Lerebours, in Paris, seems to have occupied himself greatly with it.[1]

One of the first who colored daguerreotypes was the painter Isenring, of St. Gallen, Switzerland, who exhibited daguerreotypes in one and more colors on a trip to Augsburg in November, 1840. He was one of the first of his countrymen who took up daguerreotypy as a profession and one of the first to retouch daguerreotypes, by trying to improve unsharp portraits by laying bare or scratching out the silver in the eyes. In July, 1841, he opened a daguerreotype studio in Munich; at that time the production of colored daguerreotypes was no longer unusual. He did not disclose his process, but it undoubtedly consisted in the application of powdered pigments, as A. Martin records.[2]

In December, 1842, Beard published a method for the technical simplification of coloring daguerreotypes "by the application of stencil and powder colors."[3] Etienne Lechs took out a license in December, 1842, in France (No. 8925) for a "daguerreotype water color process by means of powders."

At this time daguerreotype portraits of ladies were not uncommon in which the gold ornaments and perhaps the delicate fresh coloring of the cheeks were suggested by the aid of dry colors.

About 1850 stereoscopic daguerreotypes were colored in Paris. The coloring was done by dusting-on exceedingly fine powdered pigments.

The Reverend Levi Hill (d. February 17, 1865) sold in America licenses for the use of a process, invented by him, of daguerreotypy in natural colors, the Hillotype, which turned out to be nothing but painting over the daguerreotype.

Colored daguerreotypes did not meet with general approval, since the coloring was not always done with discretion. Protests were heard that the coloring of daguerreotypes was not an improvement; it did not give a painting of the subject and was not a daguerreotype.

For additional information see Eder and Kuchinka, *Die Daguerreotypie und die Anfänge der Negativphotographie auf Papier und Glas*, Vol. II (3) of the *Handbuch*, 1927.

Chapter XXXVII. INVENTION OF PHOTOGRAPHY WITH NEGATIVES AND POSITIVES ON PAPER AND ITS PRACTICAL DEVELOPMENT BY TALBOT

DAGUERREOTYPY suffered from a fundamental disadvantage. It could furnish in the camera only a single photographic image, which was not capable of multiplication by simple photographic printing methods. It was not until the invention of so-called photographic negatives, at first produced on paper which had been made sensitive to light, from which in turn any number of positives or prints could be made, that photography took its place among the graphic arts and crafts as a method of reproduction.

FOX TALBOT

The honor of being the first to introduce a practical and workable method of photography which gave, in the camera, a negative image on light-sensitive paper from which positive images or prints could be obtained by contact printing—as in today's practice—belongs to the Englishman William Henry Fox Talbot, a country gentleman of means who was devoted to scientific pursuits.

Fox Talbot was born in February, 1800, the son of William Davenport Talbot. He was educated at Harrow and Trinity College, Cambridge, where he devoted himself in particular to the study of mathematics and physics.[1] Talbot lived on his family estate, Lacock Abbey near Chippenham (Wiltshire) in England,[2] was a member of Parliament 1832 to 1834 and a Fellow of the Royal Society in London from 1831. He died September 17, 1877.

Fox Talbot used the camera obscura on a trip to Italy in 1823 and 1824 as an aid in sketching by tracing the light pictures of the camera with pencil, on transparent paper, but he was not satisfied with results thus obtained. During another visit to Lake Como, in October, 1833, he again attempted to make sketches with the aid of a Wollaston camera lucida, but this method also presented difficulties and he failed to obtain satisfactory results.

Without knowledge of the analogous endeavors of Niépce and Daguerre, the idea ripened in Talbot's mind that it might be possible to fix the images obtained in the camera obscura by chemical means. Being well versed in chemistry and possibly acquainted with the earlier work of Schulze, Scheele, and Wedgwood with light-sensitive silver salts, he commenced experiments on the subject after his return to England in January, 1834. He investigated, first, the action of light on paper coated with nitrate of silver, and then with chloride of silver.

This description of his first experiments Talbot himself reports in the Preface of his work, now exceedingly rare: *The Pencil of Nature* (London, 1844). The illustrations for this work Talbot made with his calotype process, printing from the negatives so obtained on silver chloride paper.

The best copy of Talbot's *Pencil of Nature*, according to Charles R. Gibson, is in the possession of Glasgow University; the prints in the British Museum copy are much faded, several of them show hardly a trace of the image. A few years later, Talbot published a second collection of prints, entitled *Sun Pictures in Scotland*. A copy of this book, produced by Talbot, in 1845, is in the library of the Patent Office, London. One of the pictures is quite faded out, but the others are excellently well preserved. The variations in the state of preservation of the pictures may be traced to the differences in the fixation, and doubtless atmospheric conditions were in part responsible.

A survey of the historical development of photography presented by G. H. Rodman in *The Photographic Journal* (1921, p. 435, and

1924, p. 523) discusses in full Talbot's life and work, with illustrations of the instruments used by him at Lacock Abbey.

Quite unexpectedly, in 1930, a rather large collection of the first photographs by Talbot was discovered among the effects of the late Prince Metternich. This Austrian chancellor, while ambassador in Paris and later, took a great interest in daguerreotypy. He requested Talbot to send him the report of any new developments pertaining to the invention of photography and entered into correspondence with him. Talbot sent to Metternich in 1839-1840 a number of light tracings of ferns, stained glass, etc., on silver chloride paper, which were fixed. There were also some photographs of ceramics, which were probably produced in the camera after exceedingly long exposures. Then followed some silver chloride prints from negative images made in the camera by the process, invented by Talbot, of developing with silver iodide and gallic acid; the subjects were a portrait and several buildings, the prints being still in fairly good condition. These light images made by Talbot are in chronological order until 1841, but the earliest calotypes are dated after the granting of Talbot's English patent. This collection remained for some years unknown in Metternich's library until a portion of it was sold by his heirs. Together with some books the Talbot prints were bought by Count Hugo Corti, of Vienna, whose son, the historian Count Egon Corti, recognized their historic value. He showed them to the author of this history in August, 1930. The genuineness of these incunabula is indisputably attested by Talbot's autograph.

Talbot relates in his *Pencil of Nature* that he became acquainted in 1837 with the experiments of Wedgwood and Davy dating from 1802. He states:

The reports of Wedgwood and Davy are undoubtedly original and interesting, and certainly give these gentlemen a certain claim to be considered as the inventors of photography, although the effectively specific progress is inconsiderable. They actually succeeded in obtaining chemical reactions of sunlight, but only from featured objects, placed on a piece of paper suitably prepared ... they also made experiments to accomplish the principal purpose of the art, i.e. to produce images of distant objects with the aid of a camera obscura, which, however, they failed to accomplish, notwithstanding very long exposures. We must, therefore, recognize Wedgwood and Davy, as the first to initiate experiments which later led to the success of Talbot and others, but they have no claim to the discovery or

invention of a practical process for the production of photographic images in the camera.

It is quite evident that the way leads from Schulze to Scheele, from Wedgwood and Davy directly to Talbot, which Talbot himself declares and other English scholars, such as Charles R. Gibson, confirm.

In his first experiments Talbot coated the paper with the moist precipitate of silver chloride. Then he discovered a better way; he saturated the paper first with a strong solution of common salt, dried it, and then immersed it in a solution of silver nitrate. Adapted as this silver chloride paper was for contact printing in a printing frame, it was not sensitive enough for exposures from nature in the camera obscura, even after hours of exposure.

He succeeded, in 1835, in making his silver chloride paper more sensitive by repeated baths in a solution of common salt and nitrate of silver, and in that year he produced a picture of his residence at Lacock Abbey in the camera obscura on a bright sunny day. The size of the picture was very small and it has not been preserved or published by Talbot.

Talbot then used silver chloride paper to copy drawings, engravings, and manuscripts, and he was the first to apply the method to what was later called the process of making tracings by light, reported to the Royal Society in London, January 31, 1839. He also mentions there that leaves and flowers may be easily reproduced in this manner in sunlight. He states precisely that silver chloride with an excess of silver nitrate is more light-sensitive than with an excess of sodium chloride (common salt). His early use of a solution of common salt for fixing his prints gave imperfect results, of doubtful permanency; but when he learned of Herschel's "hypo" fixing salt, he adopted it, thus improving their appearance and ensuring their permanency. In 1834 Talbot's attention was called to the report of Sir H. Davy of twenty years earlier, stating that he had found that silver iodide was more sensitive to light than chloride of silver. Talbot's experience in his experiments, however, much to his surprise, was just the opposite. The silver iodide paper became less dark in light than the paper coated with silver chloride. He observed that even an excess of potassium iodide annuls the light-sensitivity of the silver salt, and he consequently concluded to fix photographic silver chloride images with a solution of potassium iodide, a fixative which he found as satisfactory as common salt.

During this whole period photographic experiments were merely a side issue with Talbot, who was then particularly interested in mathematical and physical investigations, especially in the study of optical phenomena in certain crystals and the phenomenon of light interference.

When on January 6, 1839, a preliminary general account of Daguerre's invention was published in the journals, Talbot, without any knowledge of the details of Daguerre's process, which were not published until August, made public his work in the photographic field and wrote a letter to the Royal Society in London, January 30, 1839, in which he described his method of production for light images on silver chloride paper and that of an approximate fixation with an excess of a strong solution of common salt.

This report was published under the title, *Some Account of the Art of Photogenic Drawing; or, The Process by Which Natural Objects May Be Made to Delineate Themselves without the Aid of the Artist's Pencil* (London, 1839).

On February 20, 1839, Talbot wrote to Biot, member of the French Academy, that he fixed his silver chloride images with a solution of iodide of potassium or a strong solution of common salt, or an entirely different, effective preparation given him by Herschel, which was to be kept secret for the present. It was the "hypo." On March 1, 1839, Talbot disclosed the fact[3] that potassium ferrocyanide is a fixative,[4] although an uncertain one. At the same time he revealed that the above-mentioned excellent fixative, given him by Herschel, was sodium thiosulphate (hypo).

On March 15, 1839, he wrote a letter to Biot, which was read before the French Academy, in which is contained the statement that he had discovered the great light-sensitivity of silver bromide paper (*Compt. rend.*, 1839, VIII, 409). He saturated paper with silver nitrate, then with a solution of potassium bromide, and then once more with nitrate of silver. He found this paper very sensitive in weak light, and with it he succeeded in making, in his camera, the picture of a window after an exposure of six to seven minutes.

Talbot therefore laid the foundation for our photographic printing methods with bromide and chloride of silver, and Herschel completely solved the question of perfect fixation with sodium thio-sulphate (hypo). (On the investigations of Herschel, Becquerel, and others on the action of the solar spectrum on these photographic papers, see

Chapter XXXI). All these inventions of Talbot's dealt, however, only with the method of making pictures direct in the camera, and this could not compete in light-sensitivity with the daguerreotype.

Talbot also discovered later, as mentioned below, the light-sensitivity of bichromated glue; also heliographic steel etching, as well as copper etching on light-sensitive bichromated glue coatings. He was an extraordinary, prolific, many-sided, active scientific discoverer and inventor of photographic processes, which were of far-reaching importance in the practice of photography.

Talbot took out patents on all his inventions and insisted on his rights as inventor; he prosecuted all who used his processes without his permission. These severe measures were not helpful to the advancement of photography. Lord Rosse, then president of the Royal Society, and Sir Charles Eastlake, the president of the Royal Academy, intervened in 1852 and tried to induce Talbot to take a less severely obstructive attitude in the interest of the arts and sciences. Talbot consented, publicly renounced his patent rights and presented them gratuitously to the public, with the single exception of the commercial use of his invention; he thus separated the exploitation of his inventions in trade from their application in the arts and sciences, which enabled anyone to work with Talbot's patented processes without being liable to suit for patent infringement (*Phot. News.*, October, 1877; Colson, *Mémoires*, p. 82).

DISCOVERY OF THE DEVELOPMENT OF THE LATENT IMAGE ON SILVER IODIDE WITH GALLIC ACID BY TALBOT (1840)—PAPER NEGATIVES (CALOTYPY)

The obtaining of the latent image on silver iodide paper and with it the method of developing photographs were discovered by Talbot on September 20 and 21, 1840. In an appendix to Tissandier's *A History and Handbook of Photography* (London, 1878) Talbot states:

This discovery immediately changed my whole system of work in photography. The acceleration obtained was so great, amounting to fully one hundred times, that, whereas formerly it took me an hour to take a pretty large camera view of a building, the same now only took about half a minute; so that instead of having to watch the camera for a long period and guard against gusts of wind and other accidents, I had now to watch for barely a minute or so [*Brit. Journ*, Sept. 15, 1905, p. 727; *Phot. Wochenblatt*, 1905, XLVI, 432].

During his numerous experiments Talbot turned back (in connection with daguerreotypy) again to silver iodide, introduced by Daguerre into photographic practice, but in all Talbot's work he held to the practical importance of his discovery: *that a slightly or not visible (latent) silver iodide image can be developed and intensified by gallic acid*. Talbot arrived at this method to some extent by accident. In order to test the degree of their sensitivity, he exposed several pieces of coated paper, treated in various ways, in the camera for only a short time, and one of these, which showed no trace of an image, he laid aside. When he took up this specimen again, he saw to his surprise that a perfectly finished negative design had appeared. Fortunately, he remembered perfectly the treatment given to this particular piece of paper, and thus was enabled to follow up his discovery by retracing the antecedent steps. He named the process "calotype" (after the Greek word "kalos," meaning "beautiful") on account of the surprising beauty of the results.[5]

The word "calotype" was first used by Talbot in a letter to the *Literary Gazette* of February 19, 1841. The particular passage, according to Charles R. Gibson in *Photography as a Scientific Implement*, is as follows:

I may as well begin by relating to you the way in which I discovered the process itself. One day, last September, I had been trying pieces of sensitive paper, prepared in different ways, in the camera obscura, allowing them to remain there only a very short time, with a view of finding out which was the most sensitive. One of these papers was taken out and examined by candlelight. There was little or nothing to be seen upon it, and I left it lying on a table in a dark room. Returning some time after I took up the paper, and was very much surprised to see upon it a distinct picture. I was certain that there was nothing of the kind when I had looked at it before, and, therefore (magic apart), the only conclusion that could be drawn was that the picture had unexpectedly developed itself by a spontaneous action. Fortunately I remembered the particular way in which this paper had been prepared and was therefore enabled immediately to repeat the experiment. The paper, as before, when taken out of the camera, presented hardly anything visible; but this time, instead of leaving it, I continued to observe it by candlelight, and had soon the satisfaction of seeing a picture begin to appear, and all the details of it come out one after another.

In this experiment, the paper was used in a moist state, but since it is much more convenient to use dry paper if possible, I tried it shortly afterwards in a dry state, and the result was still more extraordinary. The

dry paper appeared to be much less sensitive than the moist, for when taken out of the camera after a short time, say a minute or two, the sheet of paper was absolutely blank.

But nevertheless, I found that the picture existed there, although invisible; and by a chemical process analogous to the foregoing, it was made to appear in all its perfection. . . . I know few things in the range of science more surprising than the gradual appearance of the picture on the blank sheet, especially the first time the experiment is witnessed.

Fox Talbot applied for an English patent on his "Calotype Process,"[6] on February 8, 1841 (No. 8842). Talbot treated the paper with nitrate of silver and then with potassium iodide, which forms a less sensitive silver iodide. Just before using, he coated it with a compound solution of acetic acid with silver nitrate and added gallic acid (gallo silver nitrate), which made it more sensitive to light. After the paper was rinsed in water and dried, he exposed it in the camera (with lens diaphragm f/30, for nine to ten minutes) which, during the relatively short exposure resulted in no, or almost no, visible image; this appeared only after an additional brushing over with gallo silver nitrate solution.

At first Talbot employed potassum bromide solution as a fixative, later (June 1, 1843) a hot solution of hypo; he took out an English patent on this, as well as on making paper negatives transparent with wax[7] and on increasing the sensitivity of calotype papers by placing a warm iron plate under them (June 1, 1843, No. 9753).

Having obtained a negative image, i. e., an image in which the white portions of the subject photographed were reproduced in black, he proceeded to make from it positive prints on silver chloride paper. By this invention Talbot brought photography on paper to such a stage of perfection that the art was in a position to compete with daguerreotypy. This process was considerably improved later, in the hands of many skilled operators (*Handbuch*, 1927, Vol. II, Part 3).

The indisputable priority of the invention of a photographic process for obtaining transparent negative images direct in the camera which could be multiplied (as positives) in any desired quantity by printing on silver chloride paper, must be accorded within this description to Fox Talbot. It is he, who is the creator of the modern "negative photography."

A selection of the paper negatives obtained by his calotype process were used in the illustration of his work *The Pencil of Nature* (1844), with silver chloride prints. One of the illustrations is a view of a Paris Boulevard. A yellowed original is preserved in the Graphische Lehr-

und Versuchsanstalt, Vienna. This photograph, notwithstanding its several imperfections, is one of the earliest examples of photography with paper negatives and one of the rare incunabula of photography.

Talbot also published the first book in which the text is illustrated with photographic paper pictures. It is entitled: *Sun Pictures in Scotland* (1845). "The plates of the present work are impressed by the agency of light alone, without any aid whatever from the artist's pencil." It was the first book illustrated with photographs.

The first application of the calotype process to the production of enlargements Talbot mentioned in his patent specifications, June 1, 1843. He stated that it is possible, by the use of lenses, to obtain from a small calotype positive an enlarged paper negative, which is printed from in the usual manner. This was the beginning of the modern enlarging process.

In 1842 Talbot received the Rumford medal of the Royal Society in London for his inventions (*Phot. Journ.*, 1855, p. 84).

Talbotypy met with an enthusiastic reception in both professional and amateur circles. Queen Victoria and the Prince Consort practiced the art of Talbotypy and ordered (according to Gibson) a photographic darkroom constructed in Windsor Castle.

Miss M. Talbot, the great-granddaughter of Fox Talbot, presented to the Museum of the Royal Photographic Society, in London in 1921, a great number of cameras and accessories which Talbot had used— for instance, a solar microscope, seven calotype cameras of different sizes, a large daguerreotype camera with a single lens made by Alph. Giroux & Co., Paris, another similar camera with a lens by Lerebours, Paris, one of the first tripods by Charles Chevalier, Paris, iodizing and developing boxes, specimens of Talbot's etching process, daguerreotypes, and a manuscript by Talbot. Of special interest is a camera in which, through an opening in the front panel, the object could be observed up to the time of the exposure, when the opening was closed by a cork (*Brit. Jour. Phot.*, 1921, p. 565).

Rodman took a photograph of the vault at Lacock Abbey, which Talbot used as a darkroom (see "Exhibition Catalogue," of the *Phot. Jour.*, 1922, p. 48).

For the use of photography on porcelain Fox Talbot and Malone were granted a patent in 1849 (*Brit. Jour. Phot.*, 1865, p. 326).

Fox Talbot occupied himself in his last years with unsuccessful experiments to obtain photographs in natural colors. He died September

17, 1877 (77 years old)[8] on his estate at Lacock Abbey, Wilts (England), where a monument was erected to his memory (*Phot. Korr.,* 1921, p. 236).

J. B. READE

The accelerating influence of tannin on the blackening process of silver paper, seems to have been discovered by an English clergyman, the Reverend J. B. Reade, in 1839. His work was extremely deficient, however, in that he saturated writing paper first with a decoction of nutgalls, coated it with silver nitrate, and then used the moist paper at once to photograph nature or historical objects in the solar camera. He exhibited pictures thus obtained at the Royal Society in April, 1839.[9]

To attribute to Reade the discovery of the development of latent images, as many writers have done,[10] would be to overestimate his work. Reade saw nothing in the action of the tanning substance but the quickening of a photographic blackening process, without recognizing in the least the reaction of the latent light image to development by silver halides.

LINOGRAPHY

Photographic reproductions (mostly enlargements) were produced on linen, to be afterwards colored, by a variation of Talbotypy (silver chloride or silver bromo-iodide on linen with gallic acid or pyrogallic development). J. Lüttgens, in Hamburg, states that he used this process in 1856. In 1863 Disdéri practiced a process in France, which had been imported from America, in which the portrait was enlarged direct and colored on linen. Conte Bentiviglio also exhibited, in 1863, life-size photographs on linen, which were finished in oil colors. Enlargements by electric light on linen were produced especially by Winter, in Prague (later in Vienna) ("Linographie," in *Jahrbuch,* 1889, pp. 72, 421).

ROBERT HUNT DISCOVERS (1844) DEVELOPMENT WITH PROTOSULPHATE OF IRON

The publication of the processes of Daguerre and Talbot excited the desire for further study of the action of various developers on the silver iodide coating, and attention was drawn to photographic developers acting in aqueous solutions, a process which gradually supplanted Daguerre's development with mercury vapors. The discovery by Robert Hunt (1844) that iron sulphate (vitriol) was suitable for the development of light pictures on iodide, bromide, and chloride of silver was

of great importance for the future. It is well known that it was just this iron sulphate developer which brought "wet collodion" photography, invented several years later, to such efficiency.

Robert Hunt (1807-1887) was librarian and keeper of mining records at the Museum of Practical Geology and professor of mechanical engineering at the Royal School of Mines, at London. He carried on numerous photographic and photochemical experiments and he was one of the founders of the London Photographic Society. These experiments with organic and inorganic light-sensitive substances, which, with characteristic unselfishness, he made public during the early forties of the last century, were extremely useful in the study of photochemistry, which was then in its infancy, and were of great service for years to those who came after him and used his researches for the basis of their studies. His most important publications are: Robert Hunt, *Researches on Light; an Examination of All the Phenomena Connected with the Chemical and Molecular Changes Produced by the Influence of the Solar Rays* (1844, 2d ed., 1854); *A Popular Treatise on the Art of Photography*, (1841, 2d ed., 1847); *A Manual of Photography* (1851, 1853, 1854, 1857); *The Practice of Photography* (1857); and *Poetry and Science* (1849), which contains chapters on "Actinism," "Chemical Radiations," and so forth.

In the development of his discovery (1844) that protosulphate of iron had many advantages over gallic acid as a developing agent for all papers sensitized with the halide salts of silver, Hunt proposed several processes. In one of these, which he called "energiatype" or "ferrotype," the paper was first floated on a solution of pure succinic acid, common salt, and gum arabic, dried, and sensitized with nitrate of silver solution. After exposure, the image was developed with iron sulphate. Another process he called "fluorotype," in which potassium bromide and sodium fluoride were employed. He also improved the process by Dr. Woods, in which the paper was iodized with syrup of iron iodide and sensitized with silver nitrate solution, to which process he gave the name "catalysotype" (*Handbuch*, 1898, II, 129).

Although development with iron salts for paper prints and albumen prints was not very successful, the iron sulphate developer later proved itself highly useful, after the discovery of the collodion process, by shortening the time of exposure, which compels us to pay particular attention to its introduction into photography.

FURTHER APPLICATION OF CALOTYPY OR TALBOTYPY

In France there was at first very little attention paid to Talbotypy. A few haphazard experiments, in which the details of the photograph were destroyed, owing to the roughness of the paper, created the impression that the process had an inherent defect. As a matter of fact, the daguerreotypes of that time were far superior in detail to the Talbotypes. Nevertheless, and justly, Talbot maintained his conviction that the future of photography must depend upon perfecting a process for making negatives in the camera, for only thus could the possibility of multiplying the picture be attained.

The Scottish painter David Octavius Hill devoted himself, in 1843, to the production of large photographic portraits by calotypy, which he used as such only or as an aid to portrait painting. Most of his work was in proportionately large sizes and shows good artistic conception. Hill's photographs were held in high esteem in England and Scotland, which was proved at the Photographic Exposition at Edinburgh, in 1857, where calotypes of Hill and his assistant R. Adamson were exhibited and acclaimed for their artistic conception and execution (*Brit. Jour. Phot.*, December, 1924), and at Manchester Exhibition (*Brit. Jour. Phot.*, 1841, p. 346).

A monument to David Octavius Hill was erected in his native town, Perth, in 1914, and a monograph *David Octavius Hill*, by Dr. Heinrich Schwarz, was published, with eighty reproductions of Hill's calotypes (Leipzig, 1930).

BLANQUART-EVRARD'S IMPROVEMENTS

An amateur in Lyon, Blanquart-Evrard, pursued the idea of improving Talbot's invention and introducing it into practical photography. While Talbot added the developer (gallic acid) right at the beginning to the sensitized coating and poured it over for a second time following the exposure in order to insure full development of the image, Blanquart-Evrard[11] realized that silver bromo iodide with silver nitrate (without gallic acid) furnished a more sensitive coating for the negative process and that shorter exposures and clearer images could be obtained by postponing entirely the application of gallic acid as developer until after the exposure.

Blanquart-Evrard exposed the wet silver bromo iodide paper with nitrate solution (without gallic acid) between two glass plates in the

camera and developed immediately with gallic acid.[12]

Instead of coating the paper with iodide salts alone, mixtures of salt were mainly used, mostly iodo-bromine salts; or, according to Cundell, iodo-chlorine salts;[13] or, according to Le Gray, iodo-cyanide and fluorite of potassium.[14] Parr added sodium acetate as an accelerator to the iodo-bromine salt.[15]

In the field of photography we are indebted to Blanquart-Evrard for many improvements,[16] in particular for having introduced the developing process of iodide bromide (or silver chloride) paper by gallic acid as a rapid printing process for producing large editions of silver prints.

Blanquart-Evrard published, in 1852, a guide on Egypt, Nubia, Palestine, and Syria, photographically illustrated from Talbotype paper negatives.

Blanquart-Evrard's commercial success was considerable; he opened a photographic establishment for producing prints in large editions from photographic paper negatives at Lille, in 1851, and at the same time another, in Paris, through Chevardière, which he operated on a business basis. In England he later associated himself with Thomas Sutton[17] in establishing (1855), at the request and under the patronage of Prince Albert, a photographic printing establishment, where his rapid printing and developing process was carried on. At the same time he advanced photography by numerous contributions to technical publications.

In order to give a synopsis of the important features of Blanquart-Evrard's technique in printing, we particularize: The paper was first immersed for a few hours in a solution of one liter of water, 10 g. of gelatine, 10 g. of potassium iodide, and 2 ½ g. of potassium bromide, then dried and subjected under a glass bell to the vapors of hydrochloric acid for fifteen minutes. After its removal from these vapors it was immersed for another quarter of an hour in a 7 per cent silver bath, acidified with a few drops of nitric acid, whereby a mixture of silver iodide and silver bromide was formed in its texture. By placing the sensitive paper between two blotting papers and squeezing it, the excess of silver nitrate was absorbed and the silver paper, after being dried, now completely prepared and ready for use, was placed under the paper negative and exposed to light. Depending upon the density of the negative, the exposure lasted in diffused daylight for three to twenty seconds, when the image became slightly visible; it was then completely

developed in a gallic acid bath for about twenty minutes, but showed at first a very disagreeable color. The fixation was continued, without previously having rinsed off the developer, in two successive baths of five per cent of sodium-thiosulphate (hypo); during the first bath of five minutes a light toning took place (sulphur toning); the second bath lasted for twenty minutes, then the pictures were dipped into hydrochloric acid, which removed the yellow precipitate, and finally were washed and dried.

Calotypy had spread quite universally throughout Germany by 1842. Dr. F. A. W. Netto published a technical description in his *Die kalotypische Porträtkunst* (Quedlinburg and Leipzig, 2d ed., 1843, 5th ed., 1856), and A. Martin in his *Repertorium der Photographie* (Vienna, 1846-48, 5th ed., 1857).

W. E. Liesegang promoted calotypy in Germany by word and by the publication of articles. A portrait of Wilhelm Eduard Liesegang made at Elberfield was reproduced from a calotype on wax paper in 1929 by the firm which he founded, and which in the fifties sold appatus, chemicals, etc. for calotypy and the wet collodion process.[18]

Talbotypes were popular for portraits, landscapes, and architectural subjects in the middle of the last century, and were produced long after glass negatives had been introduced. Towards the end of the fifties they had to give way, finally, to the collodion process on glass.

Good Talbotypes were made in England in large numbers by P. H. Bird (1851), R. R. Turner, and others in the beginning of the fifties. A fine collection of calotype paper negatives, made by Charles Marville, France (1854), was presented by Mr. Pricam, of Geneva, to the Graphische Lehr- und Versuchsanstalt, Vienna, at the request of Dr. Eder. In size they average 27 x 36 cm. (10⅝ x 14¼ inches). Other Talbotypes were exhibited at the World Exposition of 1862, at London. Talbotypes were also made in other countries of Europe and even in the Orient.

About this time the French photographer Martens executed a panorama of Mt. Blanc, in fourteen parts, on Talbotype paper, taken at a height of 1877 meters (6,158 feet). This was probably one of the first panoramic views produced by this method.

While France and England were the centers for photography in western Europe, Vienna became the center in eastern Europe, where there arose amateurs, such as the librarian Martin, at the Polytechnikum, and the scientist Ettingshausen, at the University of Vienna.

It became, so to speak, the source from which numerous students of photography migrated to the eastern countries of Europe, in particular to the lower Danubian states, such as Serbia. A characteristic example of the work of one of these pupils is the halftone reproduction of a paper negative made by Jovanovits,[19] in Belgrade (1858). Specimens of such well-preserved Talbotype paper negatives are now very rare, since they were made in large numbers only in the fifties of the last century and were replaced as early as the end of the fifties and the early sixties by wet collodion negatives on glass. This process undoubtedly gave greater detail and softness; in recent years photography in its most modern form has reintroduced negative and positive emulsions on paper and film with undreamt-of possibilities in their practical application.

DEVELOPMENT WITH PYROGALLIC ACID BY REGNAULT AND LIEBIG (1851)

It must be emphasized that the methods of development employed at this time (gallic acid and silver nitrate) comprised only the so-called "physical development," that is, it consisted of pouring a solution of silver nitrate and gallic acid, which had a slow reducing action (especially following the usual acid treatment with acetic acid), on the exposed iodide-bromide (or chloride) of silver; this compound decomposed slowly, precipitating powdered metallic silver, which adhered in its nascent state to the portions which represent the image; this same principle applies to the collodion process.

The important observation that pyrogallic acid, discovered by Braconnot in 1831, is a much more energetic and rapid photographic developer than gallic acid was made by the physicist Regnault,[20] professor at the College of France, in Paris, and the chemist Justus Liebig, at the University at Giessen each independently from the other and simultaneously in 1851. Regnault developed his paper negatives with an aqueous pyrogallic acid solution (1:1,000), and exhibited his photographs early in 1851 at the "Société Héliographique," in Paris, where they attracted particular attention, owing to their vigor and the beautiful modulation of the middle tones.[21] Liebig attained the same results independently.[22] Thus was accomplished an important step in the shortening of exposure by the use of more energetic or "faster" developers.[23] Pyrogallic acid was used as a developer in Talbotypy and Niépceotypy and in the beginning of the wet collodion process. Later

it had to give way to the iron sulphate developer in the latter process; but it remained as an intensifier (see silver intensification of collodion plates) and gained increased importance later through its successful application as an alkaline developer in the dry-plate process.

APPENDIX

ROLL HOLDERS AND ROLLER DARK-SLIDES FOR NEGATIVE PAPERS

The frequent use of calotype paper in landscape photography brought the traveling photographer early to the use of rolled sensitive negative papers. Thus we find Captain Barr (1855) describing the roll-holder for sensitized paper of the Englishmen Joseph Blakey Spencer and Arthur James Melhuish (1854); also a similar holder by Relandin was exhibited to the Photographic Society, in Paris, 1855. This latter could be filled or loaded in daylight.

From this was developed Warnerke's roll-holder (1875), with a silver-bromide collodion stripping emulsion, and the "roll-holder" of Eastman-Walker for the bromo-silver gelatine stripping paper and, later, films (see Chapter LXVI).

Chapter XXXVIII. REACTION OF THE IN-VENTION OF THE DAGUERREOTYPE, THE TALBO-TYPE, AND THE EARLIER PHOTOMECHANICAL PROCESSES ON THE MODERN PROCESSES OF THE GRAPHIC ARTS

DAGUERREOTYPY produced merely single picture images, which could be multiplied only with the greatest difficulty; nevertheless, daguerreotypes of landscapes and architectural subjects were at first welcomed as original copy by illustrators, in particular for reproduction as lithographs and steel engravings. Such publications of the forties and the fifties of the last century are numerous, and they show a splendid schooling in the conception of perspective and true form.

It was the introduction of Talbot's negative process that made photographic illustrations and the reproductions of art subjects accessible to

the general public, because it facilitated a purely photographic reproduction process.

One of the first publications illustrated in a purely photographic way is Talbot's *The Pencil of Nature* (1844), with twenty-four photographic silver prints. In this publication Talbot made subjects of all kinds accessible to the reading public.

Blanquart-Evrard was the first to recognize that the process of making prints on silver chloride paper was too slow for illustrating books; he therefore introduced into practice the more rapid method, employing iodo-bromide paper with gallic acid development as better adapted for the production of prints in quantities.[1]

Blanquart-Evrard, jointly with an artist friend, Hippolyte Fockedey, published, in 1851, an *Album photographique de l'artiste et de l'amateur*. More important was the book on travel entitled *Egypt, Nubia, Palestine and Syria* (1852), photographically illustrated, for which Du Camp made the paper negatives and from which Blanquart-Evrard, in Lille, made the prints for the work. This incunabulum of photography, of which only twenty copies were printed, has long since disappeared from the book markets.[2] The positive paper pictures were developed by Blanquart-Evrard in Lille (1852) with the gallic acid developer, and today they are better preserved than other prints on silver chloride paper, which were produced by printing-out without development. A second work of Maxime du Camp, *Souvenirs et paysages d'Orient*, is still extant; it contains photographs and was published in 1851.

Another successful photograph is the picture of a Flemish windmill from a paper negative by Blanquart-Evrard, reproduced in *La Lumiére* (July, 1855, p. 115). These two examples suffice to illustrate the status of photography at this date.

At this time, also, August Salzmann, in Jerusalem, published a work on the Holy City and its monuments (Paris, Gide et Baudry), with one hundred and eighty full-page illustrations, for which credit is given to the "Imprimerie photographique" of Blanquart-Evrard, in Lille.[3]

Photographic illustrations for books and periodicals, of course, found their modern application only when the photomechanical process had been so far developed that they could be printed with printing ink on copperplate and, later, typographical presses.

We shall mention at once the beginning of book illustrations by the

photomechanical method, although in doing so at this time we anticipate the course of its historical development.

The first printed matter, known to us, illustrated by a photomechanical method is Berres's brochure on daguerreotype etching *Phototyp nach der Erfindung des Prof. Berres in Wien* (Vienna 1840), with five illustrations and two pages of text. It contains an illustration of the dome of the St. Stephan Church, in Vienna, and two other architectural views of it, a reproduction of a copperplate engraving, and a mezzotint.

This pamphlet, however, was printed in a small edition, because the plates could not stand more than two hundred impressions, and the size of the illustrations was small. On the other hand, the periodical founded by Paul Pretsch during his stay in London entitled *Photographic Art Treasures; or, Nature and Art, Illustrated by Art and Nature*, published by the Patent Photo-Galvanographic Company, London, December, 1856, was probably the first work of large size, illustrated by a photomechanical process and printed from intaglio copper printing plates. The size was enormous, considering the conditions then prevailing, that is, 38 x 55 cm. (15 x 21⅝ inches). I have before me two volumes (1856 and 1857) with nineteen full-page inserts of the most varied subjects, which are reproduced in an excellent manner by Pretsch's process of copperplate printing. I dare say it is probably the first experiment in publishing an illustrated periodical devoted to the arts, executed in de luxe style with inserts produced by photographic printing plates. The illustrations in the text, printed from plates made in the halftone manner, were successfully inserted in the type forms; many similar publications covering various fields soon followed, but this is not the place to go farther into this matter. The history of the invention of the photomechanical illustrating processes (Berres, Poitevin, Talbot, Pretsch, and others) is treated exhaustively in later chapters of this work.

Chapter XXXIX. BAYARD'S DIRECT PAPER POSITIVES IN THE CAMERA AND ANALOGOUS METHODS

HYPPOLITE BAYARD (1801-1887), amateur photographer and official of the Ministry of Finance at Paris, invented independently of Talbot, an original process on silver iodide paper, in May, 1839, a month before Daguerre made his invention public. It differed from Talbot's calotype process principally because it produced positive images directly in the camera.

The *Moniteur officiel* of June 24, 1839, contains a description of such pictures made by Bayard, in Paris;[1] one of these shown by Potonniée in his *Histoire* (1925, p. 207) gives Bayard's portrait and a description of his process, together with proofs of his work.

H. Bayard had occupied himself for a long time previously with experiments in photography and had published his photographic process, which produced direct positive images in the camera, after Arago had made his preliminary report on daguerreotypy in January, 1839. Talbot's process had not yet been made known. On February 5, 1839, Bayard showed some very crude specimens of his method to Desprets, member of the Academy, and to Biot on May 13, and to Arago a week later. He required an hour's exposure for the production of his paper images. Bayard kept his method secret then, but delivered a description of it to the Academy of Sciences in a sealed letter on November 11, 1839. The pictures themselves, which, of course, were not portraits, were exhibited by Bayard in Paris, June 24, 1839, and were favorably mentioned in the French journals of July and August, 1839. Some of his pictures are still preserved by the French Photographic Society, of which body he was for years the secretary.

Bayard's process was not made public until February 24, 1840 (*Compt. rend.*, 1840, I, 337). It consisted in exposing silver chloride paper which had been blackened by light and immersed in a 4 per cent potassium iodide solution, while still moist, in the camera; the portions acted on by the light would then be bleached (separaton of iodine from the potassium iodide and combination with the blackened silver image); thus a direct positive image resulted in the camera.

Bayard and his friends attempted to gain recognition from the government for his invention, but without success, because his process, though interesting in theory, could not compete with daguerreotypy. On the day that Bayard made his public announcement before the

Academy, Vérignon also brought before it the description of a similar process; and a few days later Lassaigne recalled to the members that a year earlier he had communicated this process to them. A controversy, in which Arago participated, started as to the rights of priority in the invention. He reported his conclusions on the history of this invention at the session of the Academy of March 16, 1840, and called attention to the fact that the photographic methods of Vérignon and Bayard do not differ from the same process of Lassaigne, which had been announced in the journal *L'Echo du monde savant* on April 10, 1839, and was described in the *Compt. rend.* (1840, pp. 336-37, 374, 478). An Englishman, Fyfe, also had described the same method before the Society for Arts, at Edinburgh, April 17, 1839 (*Edin. New Philos. Journ.*, 1839, p. 114). While Lassaigne and Bayard used silver chloride paper, Fyfe employed a paper prepared with chloride or phosphate of silver;[2] he blackened the paper in light and coated it with potassium iodide solution, 1:30; this faded in the light and the blackened silver coating of the paper showed a positive image when exposed under a copperplate engraving.

If priority of publication of the process is to decide whose claim is valid, Lassaigne must be mentioned first, then Fyfe, and only then Bayard and Vérignon. Hunt also studied this phenomenon later and a great deal more exhaustively than those named above.

Herschel also mentions a similar method. He prepared paper with lead acetate, potassium iodide, and silver nitrate, allowed it to blacken in the sun, and dipped it in a potassium iodide solution, whereupon the sun bleached the paper (*Phil. Trans.*, 1840, Article 48). Grove made the same observation with some of Talbot's blackened calotype paper; this method proceeded best, according to Hunt's statements, behind violet glass.[3] Poitevin also described this same bleaching method in October, 1859, using silver iodide wet collodion plates with numerous modifications (*Bull. Soc. franç. phot.*, 1859, p. 314). A composite report on this method is found in Martin's *Repertorium der Photographie* (1846, pp. 17, 25, 63, 74, and in later editions). A detailed description of the theory and practice of this and allied processes down to modern times is given in my *Handbuch* (1884, II, 47).

APPENDIX

Karl Emil Schafhäutl (1803-1890), Doctor of Philosophy and Medicine, who lived several years in England, announced a method which was supposed to lead to the production of direct positive photographs

in the camera; he allowed silver chloride paper to blacken in light, dipped it in a solution of mercuric nitrate, which was to produce bleached-out pictures (Dingler's *Polytechn. Journ.*, 1840, LXXVIII, 238).

The method is absolutely useless, which caused the present author to omit it from the previous editions of this history. It emerges, however, from the obscurity it deserves every once in a while in historical notes and without comment on its uselessness. It was discussed by Erich Stenger in *Phot. Ind.* (1926, No. 14).

Chapter XL. REFLECTOGRAPHY (BREYERO-TYPY) BY ALBRECHT BREYER, 1839

When the first news on Daguerre's invention reached Belgium, in 1839, Albrecht Breyer, of Berlin[1] a medical student at the University of Liège, occupied himself in finding a process for printing photographs. He did not so much intend to fix the photograph obtained in the camera, as to endeavor to obtain exact impressions from engravings, drawings, and pages printed on both sides, without the use of a camera. Five days before the memorable session at which Arago reported to the Paris Academy, on August 19, 1839, the detailed description of daguerreotypy, that is, on August 14, 1839, Breyer submitted his photographs to the Academy of Science in Brussels. It was not, however, until October 6, that Breyer's specimens were revealed to the session and not until November 9, 1839, that the original report of Breyer was made known to the Academy at Brussels.

Breyer, incited by the first general news of Daguerre's invention, immediately began to experiment with silver chloride paper, and he observed accidentally reflect manifestations. Placing a piece of silver chloride paper with its sensitive surface in contact with a printed page, he let the light shine through the back of the paper and was astonished to find the clear type reproduced in reversed position, that is, a negative impression, showing white lettering on a brownish black background. At the end of March, 1839, he succeeded in making "heliographic pages" of this kind, which he showed to different persons and were reported by the journal *L'Espoir*, April 9, 1839. It seems that he also fixed these silver chloride prints, for he mentions the usefulness

of these reflectographs for the multiplication of type matter and similar designs in considerable quantities, if one wished to use the first (negative) copy for this purpose. He was aware of the commercial value of his invention, and he emphasized the possibility of producing copies of written and printed matter, even on perfectly opaque pages, without the use of a camera.

He was also aware of the scientific basis for his process for he states in his report:

When heliographic papers are placed in a specific manner on the copies (drawings, etc.), the largest part of the light penetrates these papers . . . ; and, arriving at the opaque parts (of the type, etc.), is reflected by the white parts (of the paper) and absorbed by the black parts. It is by this combined action that I explain the phenomenon, which in this case makes the image appear on the inner surface of the heliographic papers.

This discovery of Breyer's was first briefly referred to by Helmer Bäckström in the *Nordisk Tidskrift för Fotografi* (Stockholm, 1923, VII, 36) and later in *Camera*, (Luzern, 1923, I, 218).

For the most thorough account of Breyer and the Breyertype experiments we are indebted to Erich Stenger (*Phot. Indust.*, 1925, No. 47, and 1926, No. 7). These early statements about Breyertypes were very vague and attracted very little attention, the more so because Breyer himself does not seem to have concerned himself further in the matter.

The records of the Academy at Brussels, however, prove indisputably that Breyer discovered, in 1839, this process of reflectography, which was later brought to practical use in playertype (with gelatine silver bromide)[2] and in the Manul[3] process (with chrome gelatine) and other various modifications, all of which are based on the principles of Breyer's method (*Handbuch*, 1922, IV(3), 386, "Heliogravure"), where the evolution of this process is described in detail.

F. N. Feldhaus questioned whether Breyer should not be regarded with Daguerre as the inventor of photography. The question must be definitely answered in the negative. He is not the inventor of photography, but undoubtedly the inventor of an important photographic method of obtaining facsimile copies of opaque designs without the use of the camera, and his invention has had many useful applications in modern photo-reproduction.

Chapter XLI. PHOTOGRAPHIC NEGATIVES
ON GLASS (NIEPCEOTYPES)

The art of producing images on glass was invented by Niepce de Saint-Victor, in 1847.[1] This method was called Niepceotypy in his honor, but the name "glass negatives" soon became more popular. When the completely transparent glass replaced paper, much more beautiful negatives were obtained than could be made on the more or less coarse-grained paper, for in the middle of the last century paper could not be manufactured with such a fine structure as at the present time.

Claude Felix Abel Niepce de Saint-Victor, born 1805, in Saint Cyr near Chalon-sur-Saône, was the cousin of Nicéphore Niépce, although he always addressed him as "uncle." He attended the school for cavalry at Saumur and became Lieutenant of Dragoons in 1842. The accidental discovery that a vinegar spot on his madder red uniform could be removed by ammonia and that the madder color was made brighter by the treatment interested him in dye experiments. As a result, he reported a simple receipt to the military authorities for the brightening up of faded red uniforms, and this brought official support to his experiments.

In 1845 he was transferred to the Paris Municipal Guard, quartered in the barracks of the suburb of Saint Martin, where he equipped a chemical laboratory. His first work, presented to the Academy of Sciences at Paris, October 25, 1847,[2] dealt with the condensation of iodine vapors on a copperplate engraving and the reproduction of the iodine vapor image onto metal.

He was evidently unaware of the earlier publication of J. J. Pohl's (Vienna) on the discovery of atmography with iodine vapors; in both cases the phenomena are similar, but Niepce de Saint-Victor carried his observation to a practical application (*Handbuch*, 1922, IV(3), 392, under "Atmographie, Heliogravure," etc).

Niepce de Saint-Victor made his important invention of photography on glass in 1847. The barracks in which he lived were burned in February, 1848, and his laboratory and all his apparatus was destroyed. He became Captain of his regiment in 1848, returned to Paris and the "Garde Republicaine" in 1849, was elected Chevalier of the Legion of Honor and received also a prize of two thousand francs from the Société d'Encouragement. He improved the asphaltum process of his cousin Nicéphore Niépce and greatly advanced photointaglio etching on steel. In his works *Recherches photographiques* and *Traité pratique*

de gravure héliographique sur acier et sur verre (Paris, 1858), are contained portraits of Niepce de Saint-Victor, etched on steel after Riffault's process. Urged by Alexander Edmond Becquerel (1848), he then took up heliochromie and heliogravure with asphalt (1853-1855). Appointed Squadron Leader and Commander of the Louvre in Paris, he now had time for his experiments and investigated, among other subjects, photography with uranium salts.[3] He was pensioned when Napoleon III came to the throne, and in his retirement he continued untiringly and unselfishly his researches in scientific photography; he died in 1870.

INVENTION OF PHOTOGRAPHY ON GLASS

Early in 1847 Niepce de Saint-Victor experimented with the use of starch paste on his glass plates as a binding substratum for the iodide coating, but he soon found that albumen was preferable; he also tried gelatine, but laid it aside because it came off in the aceto-silver nitrate bath. By a mixture of honey, syrup, or whey with the albumen, he increased, later, the sensitivity. He published his process on October 25, 1847, in the *Compt. Rend.*, and he soon had many followers. He also made many modifications.

De Brebisson added dextrine to the albumen and gum arabic, and many changes developed in the process (*Handbuch*, 1927, Vol. II, Part 3).

Niepce de Saint-Victor, after obtaining fresh albumen (white of egg), mixed with it potassium iodide, coated the plate and dried it, then immersed it in the silver nitrate bath, in which the albumen coagulated and remained on the glass as a homogenous coating. After exposing the plate, he developed it with gallic acid, for which he later substituted pyrogallic acid (*Handbuch*, 1927, II(3), 60).

These photographic "glass pictures," called "Niepceotypes," gave structureless, transparent negatives, and the process quickly became popular. Blanquart-Evrard[4] described, in 1849, a process very similar to that of Niepce de Saint-Victor, with minor changes, and called attention to the fact that the silver-iodized albumen could be used either moist or dry. He also invented the so-called "amphitype" process[5] and produced an underexposed Niepceotype on a dark background, which when looked at on the coated side showed as a positive, but from the back of the glass appeared as a negative. Blanquart-Evrard described his "epreuves amphi-positives" in *La Lumière* (September 3, 1856), and later in the *Bull. Soc. franç. phot.* (1860, p. 5).

Talbot modified the method for negative making in 1851. He first albumenized and silvered the glass plate; then, after flowing over it a second albumen solution, to which he added ferrous iodide, he dipped it again in a silver bath. He took out an English patent on this method, June 12, 1851. The sensitivity of the plate was so great that he was able to produce with it the image of a piece of printed matter pasted on a rapidly rotating disk with an instantaneous exposure by the light of an electric spark.

Le Moyne substituted iron vitriol (iron sulphate).[6] Le Gray[7] used neither iron sulphate nor pyrogallic acid. His publications disclose the considerable application of the albumen process by the early fifties to the production of stereoscopic glass positives and lantern slides.

Two German-American photographers, the brothers W. and F. Langenheim, of Philadelphia, were the first to introduce glass projection pictures or small transparencies (lantern slides); in 1846 they imported from Vienna a projection apparatus and slides. In the winter of 1846-1847 they remodeled their apparatus for the reproduction of daguerreotypes; these were illuminated by two oxygen burners, and the picture was projected onto the wall through large lenses. In 1849 they began to make their own slides, and they gave public exhibitions of their productions in Philadelphia in 1850 and 1851 (*Brit. Jour. Phot.*, 1865, p. 318). These slides were made by Niepce de Saint-Victor's albumen process, which they patented in the U.S.A. under the name of "hyalotypes," in 1850; they published a catalog of their diapositives in the same year. Robert Hunt approvingly discussed these Niepceotypes in the *Daguerreian Journal* (April 15, 1851). Soon afterward, in France and elsewhere, these glass diapositives, or others of a similar kind, were made by the Taupenot collodion albumen process (see Chapter XLVII), until all these earlier processes were superseded by the silver bromo-chloride and chloro-bromide silver gelatine emulsions after 1870.

Of interest here is the work of Alphonse Louis Poitevin, who worked along the line of introducing gelatine into the negative process, but unfortunately with such sensitive coatings as silver iodide and with a gallic acid developer, both of which are especially unfavorable in their behavior towards gelatine; he missed the importance in certain cases of gelatine as a binder for photographic silver salt coatings.

Poitevin coated a glass plate with a gelatine solution; after cooling it off, he dipped it in an acid solution of silver nitrate and dried it com-

pletely, while protected from light. Before exposure, it was subjected to iodine vapors, just as a daguerreotype plate would be; some time was allowed to pass, to enable the plate to become more light-sensitive, and then it was backed with a piece of black cloth and placed in the camera. The sensitivity of these coated glass plates was much less than that of the iodo-bromide daguerreotype plate. In order to make the images visible, the glass plate was immersed from one to one and a half hours in a 1/10 per cent solution of gallic acid or iron sulphate. It was fixed with sodium thiosulphate (*Compt. rend.*, XXXIII, 647; *Jahrb. f. Chem.*, 1850, p. 196; Poitevin, *Traité des impressions*, 1883, p. 53).

In itself Poitevin's negative method with gelatine coating was of no practical value, it is only of interest as the precursor of the modern gelatine plates.

All these methods soon disappeared again from photographic practice. They did not provide sufficiently sensitive material, did not reduce exposure to any extent in comparison with the daguerreotype, were cumbersome in their manipulation and uncertain in results. The albumen process lasted longest, not as a negative process, it is true, but for the production of transparencies and lantern slides. It is worthy of note that Lippmann, the inventor of photography in natural colors by the interference method, used the albumen process in his early experiments, on account of the fine grain of the silver image.

It was only when the wet collodion process developed that the method of making negatives was entirely transformed and daguerreotypy definitely displaced, not only on account of the shorter exposure made possible, but also owing to the extraordinary fineness of the detail obtained, and the possibility of rapid multiplication by photographic printing processes.

During this period of transition from daguerreotypy to photography with paper negatives and to the wet collodion process daguerreotypy died, without having had any influence in later years on the revolutionary changes in the progress and process of photography.

Chapter XLII. THE WET COLLODION PROCESS

HISTORY OF GUNCOTTON (PYROXYLIN) AND COLLODION

BEFORE THE PROPERTIES of pyroxylin were known, Braconnot had, in 1833, produced a highly inflammable substance, "xyloidin,"[1] by the action of nitric acid on starch.

Christian Friedrich Schönbein (1799-1868), at Basel, discovered guncotton in the beginning of 1846, when investigating the behavior of nitric acid towards organic substances.[2] Böttger, in Frankfurt a. M., heard of this preparation and in August, 1846,[3] arrived independently at the same process of producing guncotton as that of Schönbein. Schönbein and Böttger joined forces in order to utilize the practical advantages of the new substance.

Shortly thereafter Knop, in Leipzig,[4] and Kamarsch and Heeren[5] independently of him, found that in place of nitric acid a mixture of nitric acid with sulphuric acid could be used. Later Millon and Gaudin demonstrated[6] that in place of nitric acid a freshly prepared mixture of potassium or sodium nitrate with sulphuric acid could be used, and it was also found that other kinds of cellulose, such as paper,[7] linen fibers, straw, wood[8] and the skin of cactus[9] react in the same manner.

DISCOVERY OF SOLUBLE GUNCOTTON AND COLLODION

The solubility of certain kinds of pyroxylin was discovered first by Baudin, in 1846, but since he accomplished no practical results, his discovery was forgotten; it was rediscovered in 1847 by Flores Domonte and Ménard,[10] and probably at the same time by Meynard and Bégelow. The solution is named after the Greek word χολλαω, to stick or to adhere.

Louis Ménard is usually called the real inventor of collodion. He was one of the most genial and eccentric Bohemians of the Latin Quarter in Paris. Born in 1822, he entered the Ecole Normale, the school in which college professors were trained. Because Greek was not taught there, he left and wrote dramas on the ideology of ancient Greek life. Then he turned to chemical experiments and worked with guncotton with Flores Domonte. Jointly they discovered that certain kinds of guncotton were soluble in ether-alcohol, and in 1847 they invented collodion, which later became of the greatest importance in photography. They published their discovery in the French Academy of Sciences (*Compt.*

rend., XXIII, 1687; XXIV, 87, 390). Ménard placed little value on his invention and made no effort to realize on it, while an American student of similar name, Meynard, and an associate, Bégelow, made the same invention shortly after and used it with material success. Ménard entered politics in 1848, wrote poetry, and received his doctor's degree in philosophy at the Sorbonne in 1852. He disappeared from Paris and turned up in Barbizon at the school for painters, where Millet also worked. He took up landscape painting and carried it on for ten years. Then he turned back to the study of Greek, went to London, and twenty-five years later we find him again in Paris, where, through the influence of political friends, he was appointed professor of history. He published *Dreams of a Heathen Mystic*, of which a new edition appeared in 1911.[11] He moved through the streets of Paris dressed as a philosopher of the old Greek Cynic School, in wooden shoes, from which straw peeped out. In his last years he changed completely in his religious and political ideas and became a fervent Catholic, endeavoring to bring about a union between Christianity and hellenic paganism (*Le Temps*, 1911).

Andemaos, in Lausanne, discovered, in 1855, that thick collodion solutions were suitable for drawing out into threads (Br. pat., No. 283, 1855).

CHEMICAL COMPOSITION OF GUNCOTTON AND COLLODION COTTON

Domonte and Ménard gave, in 1847, the first information on the difference between the chemical composition of ordinary guncotton insoluble in ether-alcohol, and collodion cotton, which is soluble in it. Credit is due them for having recognized that the insoluble guncotton has a higher content of nitrogen than the soluble collodion cotton. Gaudin made the same distinction (*Compt. rend.*, XXIII, 980, 1099; *Journ. f. prakt. Chem.*, XL, 421).

Their analyses, however, were inexact and produced no useful formula. They were followed by the analyses of Schönbein, Pelouze, Peligot, Crum, Abel, Wolfram, and others, whose results, however, disagreed. J. M. Eder made, in 1879, a thorough investigation of the different kinds of guncotton or nitrocellulose, with particular reference to photographic collodion (*Sitzungsberichte d. Akadem. d. Wissensch. im Wien, Abteilg. II*, Vol. LXXIX, March, 1879).

The formula for cellulose was given at that time as $C_6H_{10}O_5$, and the

collodion cotton summed up as $C_6H_8O_3(NO_3)_2$. Eder demonstrated in 1879 that the formula for cellulose must be doubled, in order to explain the properties of the various kinds of nitrocellulose produced and used for collodion photography.

The analyses gave for the insoluble guncotton, the composition as cellulose hexanitrat, $C_{12}H_{14}O_4(NO_3)_6$; for nitrocellulose, difficult to dissolve, which produces a viscous collodion, the formula of pentanitrate, $C_{12}H_{15}O_5(NO_3)_5$; for the normal collodion cotton, cellulose tetranitrate, $C_{12}H_{16}O_6(NO_3)_4$; for collodion cotton rendering a very easy-flowing collodion, cellulosetrinitrate, which also plays a certain role in the collodion emulsion process; while cellulose dinitrate, $C_{12}H_{18}O_8(NO_3)_2$, gives useless brittle layers. In order to explain these various properties, we must accept the formula for cellulose as at least $C_{12}H_{20}O_{10}$. The author demonstrated that collodion containing ammonium iodide, and so forth, gradually denitrated and thus became a thin liquid which produced very brittle coatings. As a by-product, he called attention to a small amount of a gummy substance, soluble in water and containing nitrogen, which could influence the sensitivity of the collodion emulsion (*Handbuch*, 1927, II(2), "Kollodiumverfahren").

<center>THE COLLODION PROCESS IN PHOTOGRAPHY</center>

The history of the discovery of the photographic collodion processes was first written by the author of this work in its first edition (1884) on the basis of studies of the sources. Later historical descriptions were published by others, in which, among other subjects, the history of photography with collodion was wrongly described. Schiendl[12] reproduces the names of the inventors of collodion photography, as well as the surrounding circumstances, incorrectly. This makes it necessary to go here into this important period of the history of the development of photography more thoroughly.

In the field of photography Gustave Le Gray[13] was the first to employ, in June, 1850, a solution of collodion cotton in ether, which when poured on glass furnished a transparent film which served as a carrier for the photographic image. He describes this in a very obscure manner in his pamphlet, published in 1850, *Traité pratique de photographie sur papier et sur verre:*

I invented a method with collodion on glass with hydrofluoric acid methyl ether, potassium fluoride, and sodium fluoride dissolved in a 40° alcohol, mixed with ether and saturated with collodion; I then sensitized

with acid silver nitrate and obtained in this manner images in the camera obscura with twenty seconds exposure in the shade. I developed the image with a very weak solution of iron sulphate, and fixed with hyposulphite. I hoped to achieve with this process a very great sensitivity. By the use of ammonia and potassium bromide I obtained great variations in the results.

Le Gray's formula is practically impossible of execution, because potassium fluoride is not a photographic agent and hydrofluoric acid ether was not known at all. Therefore Le Gray has merely the distinction of having been the first to call attention to the possibility of the use of collodion in photography. It does not seem possible to obtain successful photographic results in accordance with the above statements of Le Gray.

Gustave Le Gray was a French painter who endeavored to improve his financial position by opening a photographic studio. Poitevin is supposed to have induced him to do this. While his atelier at the Barrière de Clichy did not prosper to any great extent, he spent a good deal of his time in producing negatives on glass and had the idea of substituting collodion in place of albumen or gelatine as a base for the silver iodide coating. Although his first directions for the collodion process were extremely uncertain, he succeeded shortly in producing thoroughly good collodion negatives with relatively short exposures; it appears that he soon worked with the improved iodide collodion, which he describes in the second edition of his book (1851).[14] His photographic studio did not succeed, owing to lack of business, and he gave it up. Leaving Paris, he went to Egypt, painted for some time, and finally became instructor of drawing in a Cairo school. Misfortune followed him; while riding on horseback, he was thrown off, broke a leg, and died shortly afterward, in 1882.

The credit for having been the first to make the collodion process known in an intelligent manner and to give practical directions for its use belongs to Frederick Scott Archer (1813-1857). He turned his attention to collodion in 1849 and published an article on the wet collodion process, as it is generally used today, in *The Chemist* (London), March, 1851. He produced a large number of very beautiful collodion negatives. Archer and Le Gray entered into a controversy as to their respective rights to priority in the invention of the collodion process, which dragged along for several years. Le Gray tried to establish his right to priority in the second edition of his *Traité pratique*

de photographie sur papier et sur verre (1851), by claiming that he had used collodion before Archer, but accident played him a mean trick. The typesetter read instead of "avant M. Archer," "avant de marcher," and so the world learned with astonishment that Le Gray used the collodion process before M. Archer could walk. Not until 1854 was Le Gray in the position to correct this printer's error.

Archer insisted strenuously on his rights to priority and tried to prove his claim in the *Liverpool and Manchester Photographic Journal*, (1857, p. 121),[15] in which he was supported by the testimony of his wife Fanny Archer.[16]

Archer's partisans gave the collodion process the name "Archerotypie" (or Archertype), proposed by Belloc.[17] At any rate, Archer, as well as later two other Englishmen, P. W. Fry and Robert J. Bingham, deserve credit for the introduction of the process into practice (see *Photogenic Manipulation* by Robert J. Bingham, 1850).

Bingham also, notwithstanding Le Gray's and Archer's superior claims, tried unsuccessfully to appropriate the priority for the discovery of the collodion process,[18] although later he claimed that he had worked with collodion since 1851. Notwithstanding this, great credit is due to Bingham for his article, "On the Use of Collodion in Photography," in which he impressively points out the photographic properties and advantages of collodion.[19] In 1851 he was sent by the British government to Paris to photograph the prize-winning industrial exhibit at the exposition of that year. He produced twenty-five hundred photographs in a very short time by the collodion process, which created such a sensation that all photographers hastened to throw aside daguerreotypy and to introduce the new process.[20]

F. Scott Archer also invented the stripping of collodion films by coating the negative with a rubber solution, which enabled the negative films to be preserved without the glass plate; he took out an English patent for this invention (August 24, 1855), which later found numerous varieties of application in heliogravure and for direct printing on metal for subsequent etching.

Frederick Scott Archer died in May, 1857, without leaving any material means, and his contemporaries in England raised a purse of seven hundred forty-seven pounds sterling by subscription for his wife and children, to which the government added an annual pension of fifty pounds sterling for the children. The motive is stated to be that their father "was the discoverer of a scientific process of great value to

the nation, from which the inventor had reaped little or no benefit" (Harrison, *A History of Photography*, 1888, p. 40).

Millet, in 1854, was the first to produce positives on enamel with collodion, which he exhibited at the French Academy of Sciences.[21]

As photography with the collodion process spread throughout the world, a great demand sprang up for guncotton and suitable iodide and bromide salts. The chemicals needed were at first purchased in apothecary shops, but gradually special business places for the sale of photographic materials were established. We mention here only the firm A. Moll, in Vienna, which was combined with the court pharmacy, and the firm Liesegang, in Germany, where also the old "Grüne Apotheke," in Berlin, sold photographic chemicals and which was in 1881 absorbed into the Schering's Chemical Company. This firm produced in 1878 a special grade of collodion cotton which corresponded to the cellulose nitrate, and which was purified by washing in diluted sulphurous acid (*Handbuch*, 1927, II, 30). The trade name given to this cotton was "Celloidin Cotton," and the name of the first German collodion silver chloride photographic printing papers was "Celloidin Papers" (*Handbuch*, 1928, IV(1), 228).

In 1856 Dancer, in Manchester, was the first to reproduce very small portraits and manuscripts legible only under the microscope by the collodion process.[22] Even before this, the collodion process was used in the production of photographic enlargements from microscopic originals.

During the fifties the collodion negative process spread to such an extent that it was generally practiced in the early sixties, together with the iron sulphate developer, which gave such splendid results in the collodion process and had forced into the background the pyrogallic acid developer, which had been suggested by Archer and was in general use during the early fifties.

At the London World Exposition of 1862 instantaneous exposures on collodion plates (ships, waves, clouds) were exhibited by English (Breese, Wilson) and French photographers (Ferrier, Warnod) and others, which attracted great attention.

"Wet collodion" dominated the photographic negative process from the sixties to the eighties of the last century. The manipulation of the process is by no means easy and requires a great deal of attention and experience. It was used in particular by professional photographers to the exclusion of all other methods in every branch of photography.

Chapter XLIII. BEGINNING OF PHOTOGRAPHY AS AN ART BY DAGUERREOTYPY, CALOTYPY, AND THE WET COLLODION PROCESS

As EARLY AS the reports of the French commissions on daguerreotypy in 1839, it was recognized that photography would have many useful applications in the arts and sciences. Its astonishing fidelity in reproducing natural forms and light and shade effects, together with the delicacy of the earliest daguerreotypes, made such an overwhelming impression on the celebrated painter Paul Delaroche that when leaving Daguerre's studio after a visit he exclaimed: "La peinture est morte à partie de ce jour.[1]" Delaroche, however, did not seem to have been quite serious when expressing this rather exaggerated opinion, for within the year he saw in Daguerre's invention, not an enemy of painting, but "a great advantage for art."

The great majority of artists, however, were of a different mind and viewed daguerreotypy at first as a serious competitor of the fine arts. But daguerreotypy was as yet far from justifying its entry among the arts.

It was Le Gray, both photographer and painter, who expressed in the fifties the following epigram: "La photographie est appelée à un grand rôle dans le progrès de l'art. Son resultat immédiat sera de détruire les inferiorités et d'élever les artistes de talent.[2]"

The Scottish painter David Octavius Hill made calotypes, in 1843 to 1849, of single-figure portraits as studies for his paintings. His conception of the composition, illumination, and treatment of the subject, analogous to the instructions which painters give to their models, is also quite the same as the viewpoint of modern artist photographers. Hill is considered the father of artistic photography. His works, many of which are still extant in collections, especially in Edinburgh, were gradually lost sight of, until they were again brought to light in 1900. They then had all the interest of a new discovery. In 1901 seventeen new prints from the original negatives preserved in Scotland were exhibited in the Royal Museum for Copperplate Engraving at Dresden, together with pictures dating from the fifties. Dr. Heinrich Schwarz, of the Modern Gallery, Vienna, brought (1929) a hundred and eighty extremely interesting photographs by Hill from Scotland to Vienna and staged an exhibit which fully sustained the outstanding reputation of Hill's work.

The catalog of the exhibition contains the following remarks on Hill by Dr. Schwarz:

David Octavius Hill, born at Perth, 1802, died May 17, 1870, at Edinburgh, studied at the Edinburgh Academy under Wilson, painted at first rural genre pictures and later turned to landscapes. He was a charter member of the Scottish Academy (1838), of which he was secretary until his death, and of the Scottish Art Union, the first society of its kind in the United Kingdom. On the occasion of the founding of Scottish Free Church (1843), Hill received a commission to commemorate the convention in a large painting containing four hundred and seventy individual portraits. While engaged with this picture, which he did not finish until 1866, Sir David Brewster suggested to him the use of the calotype process, recently invented and greatly improved by the English scientist Fox Talbot. He studied the new process and made numerous photographs of his models as an aid in portrait painting. In this way he photographed many famous Scotsmen and Scotswomen of that day. He also produced many landscapes and architectural photographs, all of them paper negatives by Talbot's calotype process. A technical aid, Robert Adamson, helped Hill so that he might be able to concentrate his attention on his models.

F. C. Tilney's *The Principles of Photographic Pictorialism* (1930) contained a full-page portrait of Principal Haldane from a calotype by Hill. The eighty full-page illustrations in this work showed the development of artistic photography from the middle of the last century to the present.

Another old master of the art of photography, equal to Hill in repute, was brought to the attention of the Royal Photographic Society at the session of December, 1922, by F. C. Tilney. This was Dr. John Forbes White (1831-1904), who took up photography when twenty-four years old; he was a pupil of the painters Reid, Chalmers, Israels, Leighton, Millais, and others (*Phot. Jour.*, 1923, p. 5).

Other English artists of note in photography during the years 1845 to 1848 were Mayall, Reilander, and Robinson.

H. P. Robinson (1830-1891) is generally recognized as the founder of the English School in pictorial photography. He used the wet collodion process from 1854, cultivated landscape photography successfully about 1860; he excelled chiefly in scenes with figures in the foreground, by a special method of combination printing from several negatives. He was an honorary member of the London Photographic Society from 1871. Many of his pictures were published as inserts in the journal of the society and other photographic periodicals. Of

course, Robinson's genre pictures came to their full development only when he made use of gelatine silver bromide plates, in the eighties.

The technique of Robinson's pictorial composition, which found many imitators, is suggested in an illustration which is reproduced in the author's *Die Momentphotographie* (2d ed., 1886), where Robinson's method of combination printing is described in detail. For forty years Robinson played a prominent role as an exponent and leader in pictorial photography, and he enriched photographic literature by several excellent publications.[3] *Naturalistic Photography for Students of the Art* (London, 1889), by Dr. P. H. Emerson, also exercised a great influence in this field.

The sculptor Adam Salomon, who later devoted himself to photographic portraiture in Paris, excited attention by his artistic conception of photography when he, in 1867, produced vivacious portraits, properly lighted and with balanced background effects.[4] He also contributed to publications on artistic photography.

In German technical literature, C. R. Wigand called attention in 1856 to the artistic possibilities in photographic portraiture and recommended to photographers the study of art.[5] British photographers felt and considered themselves artists at the end of the nineteenth century, as presented in the discussion by Alfred H. Wall on the relation of photography to art,[6] while on the other hand many art critics like B. Frank Howard opposed the claim of photography to be called an art.

The way for the introduction of the collodion process was smoothed by its close connection with the improvement of photographic technique in artistic photography. The large portraits by Mrs. Julia Margaret Cameron, exhibited at Paris in 1867, although not at all sharp, were of real artistic merit and were even then appreciated (*Phot. Archiv.*, 1867, p. 170); but it was not until many years later that they received the general recognition and praise they deserved.

Of course, for this enumeration completeness is not claimed, since numberless artistic photographs were made everywhere. Wide circles of art-loving amateurs took up the most varied problems of artistic photography after the introduction of gelatine silver bromide plates and other important improvements in photographic technique and applied photochemistry, because simplicity and ease of manipulation played a very important part in the popularization of the art.

The credit for establishing photography as a business, with the artistic viewpoint always in mind, is due incontestably to Disdéri at

Paris. He also merits the distinction of having developed the technique of photography, in particular that of professional portrait photography.[7]

André Adolphe Eugène Disdéri published, in 1853, his *Manuel opératoire de photographie*, in which he described the technical side of instantaneous photography. In 1855 he published a collection of photographs reproducing objects exhibited in the Palais de l'Industrie and the Palais des Beaux Arts. Disdéri dealt with the artistic side of photography in his *Renseignements photographiques*, 1855. In 1862 another book by him appeared, *L'Art de la photographie*.[8] Disdéri was considered the outstanding portrait photographer of his time in Paris. Napoleon III appointed him court photographer. In 1861 he instructed French officers in photography under orders from the minister of war. Disdéri's popularity is best shown by the fact that his character was introduced in 1861 as a star attraction on the stage of a small vaudeville theater in Paris by a realistic representation featuring his bald head and tremendous beard.

VISITING CARD PORTRAITS (CARTES-DE-VISITE)

The first mention of the introduction of portraits the size of visiting cards is found in *La Lumière*, October 28, 1854, where it is stated:

E. Delessert and Count Aguado had an original idea for the use of small portraits. Up to now visiting cards carried only the name, address, and sometimes the title of the person whom they represented. Why could not the portrait of a person be substituted for the name? This idea met with great approval, since the special purpose of a visiting card could also be expressed by the visiting card portrait. At ceremonial occasions the visitor was to be photographed, wearing gloves, the head bowed as in greeting, etc., as social etiquette requires; in inclement weather he was to be shown with an umbrella under his arm; when taking leave a portrait was furnished in traveling costume. From that time the term "carte-de-visite" came into general use for portrait photographs of this small size.

According to another version, it was the Duke of Parma, an ancestor of the Austrian ex-Empress Zita, who is to be regarded as the inventor of visiting-card photography, because he had photographic prints of his portrait pasted on his visiting cards instead of the printed name in 1857. The first photographer who made these small-size portraits is said to be Ferrier, in Nice, but they became fashionable only when Disdéri, as photographer to the court of Napoleon III, brought them

out. They were generally used in society at that time by persons who exchanged these visiting-card portraits instead of their name cards (*Camera*, 1922, I, 68).

This story, while rather interesting, is merely gossip and establishes no priority in the invention of the visiting-card portrait. Their introduction by Disdéri greatly increased the popular demand for them to the advantage of photographic studios everywhere in the world.

Disdéri conducted this business on a grand scale, selling these cards, not singly, but at first in lots of not less than fifty cards and later by the dozen, at twenty to twenty-five francs per dozen. He attained great popularity for himself and his product.

Dr. P. Ed. Liesegang[9] reports his visit to Disdéri's studio as follows:

At Disdéri's one finds truly a temple of photography, an establishment in which luxury and elegance stand out in a class by themselves. His daily output is figured at from three to four thousand francs. In the short time of our visit he photographed eight persons. Disdéri himself merely supervises the poses, etc. For our benefit he himself developed a negative (eight visiting-card exposures on one plate) all extraordinarily successful. He usually takes three to four persons on one plate, which he could easily do, because there were always people waiting. The entrance on the Boulevard des Italiens is decorated with many photographs in gilt frames; one mounts a stairway which is carpeted with red velvet and on its walls hang paintings. On arriving at the top of the stairs, one is directed by a richly dressed porter to the reception room, where three or four clerks are seated who enter the orders and receive the money. This room is furnished in the style (à la boule) Louis XIV. In the waiting room are the finest furnishings, but only one portrait, that of the emperor, in a gorgeous gold frame, a mantel with a Venetian mirror, and albums of portraits of high personages. The laboratory also is beautifully equipped; developing is done over a large deep sink.

Disdéri used in his later practice a multiple camera with four lenses (1862) in order to make several exposures at the same time. For the smallest sizes, postage-stamp size, a camera was used with twelve small lenses; one of these cameras dates from about 1865 and was exhibited at the time of the centenary celebration at Paris of the invention of photography by Niépce.

CARTES-DE-VISITE IN VIENNA

Photographic *cartes-de-visite* were introduced in Vienna by Ludwig Angerer in 1857. Ludwig Angerer, the son of a German Hungarian

forester, was born August 15, 1827. He was a pharmacist and an amateur photographer. His photographs made on a journey through the Danube states in 1854 attracted general attention. Encouraged by his success, he came to Vienna and opened in his residence a studio of the first class, and he also made group pictures in the adjoining beautiful garden. He also made large direct photographs by the collodion process and was one of the first in Austria to develop the artistic side of portrait photography. His studio was visited by the most fastidious class of society. He died May 12, 1879. His brother, Victor Angerer (1839-1894), was an officer in the engineer corps and occasionally worked in his brother's photographic studio. He opened a portrait studio in Ischl (Austria) after the campaign of 1859, entered his brother's firm as partner in 1873, and continued to conduct the business along the lines of his brother's ideas. We have already reported on Ludwig Angerer's work with the large Petzval lenses (see Chapter XXXIV). The heirs of Ludwig and Victor Angerer sold the property on which the photographic establishment stood to Baron Nathaniel Rothschild, who erected his palace on it.

Victor Angerer, together with the photographer Dr. Székely, erected a dry-plate factory at Vienna in the early eighties. This was for their own supply. The factory was closed up after a few years. He built a new house for himself, with a studio, in 1892 and died there on April 10, 1894. His son-in-law was the copperplate engraver Blechinger, who achieved a great reputation as a portrait photographer and landscape painter. His many services to photography were generally acknowledged. He published an extensive series of reproductions, among them all of the pictures of the painter Makart. Blechinger and Leykauf were the founders of the publishing business for color-heliogravure in Vienna.

Another well-known Austrian portrait photographer was Jagemann, who had studios in both Vienna and Ischl, where the Emperor Franz Josefs I had his summer residence. Jagemann, who died at the end of 1883, was the first official photographer appointed to the Imperial Austrian Court.

Other later well-known court photographers of the wet collodion period were Professor Fritz Luckhard, who made the best portraits of the Emperor Francis Joseph and was secretary of the Vienna Photographic Society and president of the Lower Austrian Trades Society; then, Josef Löwy, who in addition to his portrait studio

conducted an establishment for reproductive processes (halftone, gravure, and collotype) and was knighted; also, Charles Scolik, who was one of the first professional photographers to experiment with the production of gelatine silver bromide emulsions.

PHOTOGRAPHY FOR IDENTIFICATION PURPOSES

The first to propose the application of photography for the purpose of identifying persons was Verneuil in 1853 (*La Lumière*, 1853, p. 40). He advised that travelers' passports carry photographic portraits, which could be produced with little trouble by the wet collodion process and printed on silver chloride paper. Such portraits of identification were used at the photographic exhibition in Berlin in 1865 on season tickets.

OTHER PHOTOGRAPHIC SIZES

In addition to visiting-card photographs, "cabinet size" portraits were made in England about 1863 (*Phot. Archiv*, 1864, p. 26). Windsor and Bridge, in London, advertised this popular size (*Phot. Archiv*, 1866, p. 297). Photographs of the smallest size, in the form of postage stamps, were brought on the market as early as 1863 (*Phot. Archiv*, 1863, p. 99). In the fifties photographic prints were produced on silver chloride-starch paper with gilt borders, later exclusively on albumen paper.

INTRODUCTION OF NEGATIVE RETOUCHING

In the early days of photography only positives were retouched or colored, usually in a most inartistic manner. The invention of negative retouching by the photographer Emil Rabending, in Vienna (1860), was of great benefit to photography. Rabending, who died in Frankfurt a. M. in 1886, was the first who regularly retouched the negatives of his everyday output, but he avoided altogether retouching positives. The retouching and coloring of photographs, always difficult to do on albumen paper, became more and more difficult when the shiny albumen print, with its purple-violet tone, became the style. Later the albumen print was replaced by the modern emulsion, platinum, pigment, and gum prints.

PORTRAIT GALLERIES IN THE MIDDLE OF THE NINETEENTH CENTURY

At the time of the invention of daguerreotypy cameras were operated mostly on light terraces or balconies out-of-doors, but when the

exposure was cut down by the use of fast lenses, the studio came into vogue. They were usually located in painters' or sculptors' studios, generally equipped with plate glass windows and, after the specialization for photography, with skylights (so-called pult-ateliers), which were preferred; sometimes one found studios lighted by glass from both sides and even so-called tunnel studios.

Further information on this subject can be found in Bühler's *Atelier und Apparat des Photographen* (1869) and "Atelier und Laboratorium des Photographen," supplement to *Handbuch der Photographie* (1884, I, 461). The method of building portrait studios was first developed in Paris; a very good survey of this subject is furnished by Captain Henry Baden Pritchard's work *The Photographic Studios of Europe* (1882) of which a German edition was also published in 1882. Henry Baden Pritchard was the editor of the *Photographic News* at that time.

The portrait studio of Ch. Reutlinger in Paris, in which he worked the wet collodion process is illustrated in the 1932 German edition of this *History* (illus. 126). His specialty was the production and sale of photographs of actors, artists, and other Parisian personages in public life. It is typical in its northern exposure; the illustration shows the equipment customary in the studios of the sixties and seventies. A similar type of construction is Liesegang's "Pulpit Studio," in Elberfeld, built in 1857 (see 1932 German edition of this *History*, illus. 127). In this studio Liesegang conducted a school of photography.

BLUE GLASS IN STUDIOS AND DURING EXPOSURES

Draper, in his first portrait photographs with daguerreotype plates, used light blue glass (see note 4, Ch. xxxii) or liquid filters of a solution of ammonium copper sulphate in order to tone down the glare of sunlight on his models. The optically strong or visually bright rays were softened by this method or excluded; but the "chemically active" blue rays were not weakened very much. Guided by this idea, confirmed by Becquerel's theory that the blue rays were the "activating" rays, while the red ones were "antagonistic," photographers in the middle of the last century often used blue glass for their sky and side lights. Beard, an Englishman, took out an English patent in June, 1840, for glazing photographic studios with blue glass. The Frenchman Disdéri, in 1856, equipped his portrait studio with light blue glass and stated correctly that dark blue glass absorbed three times as much light in the collodion process. American photographers used blue

glass in their portrait galleries in 1862. The author remembers quite definitely having seen, in Krems on the Danube (Lower Austria), photographic galleries equipped with blue glass, which indicates how generally it had been adopted.

Of course, the use of blue studio glass was dropped because the lighting effects were later regulated by blue and other colored draperies and because the necessity for a glaring illumination, blinding to the eye, was no longer required in portraiture when the sensitivity of photographic plates had been increased.

It is interesting to note that the cinema lighting technique of modern times again introduced illuminating effects which are disagreeably blinding to the eye. Moving picture artists may be guarded to a certain degree against suffering from the influence of the glaring lights of electric arc lamps during exposures by inserting a blue glass filter in front of the lights. This will permit the actinic rays to pass through, while in the yellow and green zone of the spectrum to which the retina is particularly sensitive, it possesses a strongly diminished transmission capacity. George Jackel, of the Sendlinger optical glass works in Berlin-Zehlendorf applied for a German patent of this phenomenon based on "process for photographic exposures of persons with artificial light," dated March, 1926, which was granted September 6, 1928. The author pointed out that owing to previous publications relating to the use of identical blue glass filters this patent was not valid.[10] We must add that as early as 1851 Disdéri used in his studio blue muslin in order to soften the glare of the light, and in 1856 he employed light blue glass panes.

The interior equipment of the studio was very simple in the beginning of portrait photography, and it developed, with few exceptions, without the surplusage of the so-called artistic accessories of later years. The introduction of painted backgrounds into photographic practice was discussed in *The British Journal of Photography* of 1927 (p. 502). A book by G. T. Fischer, *Photogenic Manipulation* (1845, p. 24), mentions that this was first used by A. J. F. Claudet,[11] who was born in France in 1796, became a partner of the firm of Claudet and Houghton in 1834 at London, where he died in 1867. Robert Hunt wrote, in 1853, advising against a white background.

Chapter XLIV. PORTABLE DARKROOMS; THEORY AND PRACTICE OF THE WET COLLODION PROCESS

THE WET collodion plate had to be prepared immediately before using and placed in the camera while still moist.[1] It was necessary to develop it at once, and it usually was fixed immediately afterwards. Both manipulations required water. For this reason the traveling photographer needed a portable tent for a darkroom, or a wagon, and in both, of course, space and weight were reduced to a minimum.

These accessories were described and illustrated in the "Atelier und Laboratorium des Photographen," supplement to my *Handbuch* (1884, Vol. I). This reference contains illustrations of the apparatus referred to in the section following.

Sometimes the tent was stretched over a framework and held to the ground by pegs and ropes. An elastic opening permitted the passage of the upper part of the operator's body, as shown in Moignié's tent (Kreutzer, *Zeitschrift für Phot.*, 1861, III, 158; *Brit. Jour. Phot.*, VII, 177). Often the tents were of very simple construction (see illustration in *Handbuch* (1884, I, 519, or 1932, I, 495). A more elaborate form was a box, equipped with silver baths, rinsing sinks, etc., screwed on to the tripod used by Bourfield and Rouch (Kreutzer's *Zeitschr. für. Phot.*, 1861, III, 142; *Brit. Jour. Phot.*, VII, 275).

Smart's tent, invented in 1858 and improved in 1860, was very roomy. Over a frame a tent of double black canvas was stretched; it contained a work bench equipped with the necessary accessories.

Professional or commercial photographers, when engaged in outdoor work, employed two-wheeled hand-wagons on springs, easily pushed (see *Phot. Mitt.*, XVI, 316). Such photographic darkrooms on wheels could still be seen in the streets of larger cities in the sixties of the nineteenth century.

More ambitious photographers had substantial wagons built in such large dimensions that, when required, one could mount the roof by means of a small ladder in order to place the camera on it, so that the public was not disturbed during exposures of street scenes.

In order to make it possible while traveling to produce a large number of small pictures on a single plate in the camera, J. Duboscq devised, in 1861, his "polyconograph," a camera attachment containing a row of five double plateholders, which were movable, so that fifteen

exposures could be made on the one plate successively. Thence came the idea of a plate magazine for dryplates, and Léon Vidal, in 1861, constructed his "autopolygraph," a kind of a plate-changing holder, which was improved (1882) by Marion of Paris.

The wet collodion process was ill-adapted for work with small hand cameras, nevertheless much effort was made to overcome the difficulties. We cite as an example the pistol camera, or "pistolgraph,"[2] invented and patented in 1860 by Th. Skaife. It was constructed entirely of brass, was only three inches long and one and one-half inches wide. It was held in the hand like an ordinary pistol, and a trigger was pressed to make the exposure. However, the traveling photographer had to suffer the inconveniences of the wet collodion process and had to carry around with him a miniature darkroom for collodionizing with silver baths, etc. (Skaife, *Instantaneous Photography . . . the Manipulation of the Pistolgraph*, Greenwich, 1860). The work bag employed with this pistolgraph was constructed of elastic, airtight rubber cloth tubes, which could be inflated at will by means of a valve affixed to one of the four corners, where the tubes were fastened to the wooden base. The inflated bag was nine to ten inches high; the flat floor was about twelve inches square. In front was a circular opening covered by a tight-fitting flap, which was entirely closed during the manipulation.

From these simple beginnings developed later the many different devices for changing or developing dryplates without a darkroom.

The introduction of "instantaneous" photography was hastened by difficulties of the wet collodion process. Skaife, in the pamphlet mentioned, *Instantaneous Photography* (1860), states very appropriately: "Speaking in general, instantaneous photography is as elastic a term as the expression 'long and short.'"

Landscape photography, particularly alpine photography, in the fifties and sixties, involved very troublesome and daring expeditions, as the cameras, tents and darkrooms had to be hauled up high mountains. According to E. Stenger in "High Mountain Photography in the Last Century" (*Camera*, 1930, p. 8), Aimé Civiale was probably the first who, in 1857-1858 and later, photographed the Pyrenees and made large composite panoramas. He made exposures from Piz Lanquard (3,266 meters-10,715 feet), which he exhibited at the Academy of Science in Paris. Notwithstanding all the efforts made to simplify his equipment, the total weight reached about 250 kg. (551 lbs.) and

required twenty-five men and mules for its transportation. This achievement was far excelled by the French photographer August Bisson, who made photographs on the summit of Mont Blanc in 1861 under the greatest difficulties and was acclaimed a hero and a conqueror. He also required twenty-five carriers and guides.

Members of the Austrian Alpine Society arranged a photographic expedition to the Grossglockner in July, 1863, under the guidance of Jägermaier, the photographer, and Adolf Obermüllner, landscape painter. This photographic glacier expedition was celebrated as hazardous and especially glorious, and the satisfactory results obtained were highly praised. Eighty-four 14 × 17 inch negatives of alpine views were made. Later photographs of the Alps were made by Würthle of Salzburg. The photographer of today, working with a small hand camera and producing large prints from his small negatives without trouble, has no conception of the difficulties involved in these early expeditions. The difficulties encountered in military photography in the wars during the collodion period seem incredible today.

The first official war photographer was Roger Fenton, secretary of the Photographic Society of London, who was sent by the English government to make photographs of the Crimean battlefields in 1855. He traveled in a closed wagon, which also served as his darkroom. An album containing forty-nine silver prints of his war photographs now forms part of the historical collection of the Royal Photographic Society. Fenton also made numerous negatives for Paul Pretsch's heliographic reproductions.

The American photographer Matthew B. Brady was the next, who during the Civil War of 1861 to 1865 made thousands of photographs of war scenes; his pictures of the battle of Antietam, in Maryland, excited much attention at the time. Photographic exposures from balloons were also attempted, but with little success.

Photography for military purposes was introduced in the curriculum of the Royal Military Academy at Woolwich, England, by John Spiller in September, 1857 (*Phot. Archiv.*, 1861, p. 267; 1862, p. 88; and 1864, pp. 59, 134; *Phot. Mitt.*, 1864, p. 161).

FURTHER INVESTIGATIONS OF THE WET COLLODION PROCESS

The experience of the photochemical process gained in daguerreotypy was not easily adaptable for use in the collodion process, because this new method was quite different from the earlier one; it was, how-

ever, of great assistance in its development. Many books on the wet collodion process were published. One of the best of these was written by the English chemist T. Frederick Hardwich. It was particularly valuable because he treated photochemistry exhaustively and gave an original and very useful method for the production of photographic collodion cotton, in which he emphasized the definite advantage of a strong excess of sulphuric acid in the nitric mixture. He was a teacher of photography at King's College, London, when he wrote, in the fifties, his *Manual of Photographic Chemistry, Including the Practice of the Collodion Process.* The first and second editions were published in 1855; sixth edition, 1861, which was also translated into German (1863). He resigned from his position as teacher and became a preacher in one of the mining districts, where he was active until the middle of the sixties.[3]

Of the early books on the wet collodion process we mention Le Gray, *Photographie* (1850, 1852, 1854); Barreswil and Davanne, *Chimie photographique* (1854, 1858, 1864); Belloc, *Traité . . . de la photographie sur collodion* (1854); Belloc, *Les Quatre Branches de la photographie* (1855, 1858); Belloc, *Photographie rationelle* (1862); Bingham, *Instruction in the Art of Photography* (1855); Blanquart-Evrard, *La Photographie, ses origines, ses progrès . . .* (1869); Disdéri, *Manuel operatoire de photographie sur collodion* (1854); Disdéri, *L'Art de la photographie* (1862); Martin, *Handbuch der Photographie* (1851, 1857, 1865); Chevalier, *Photographie sur papier sec, collodion . . .* (1857); Legros, *Encyclopédie de la Photographie* (1856); Liesegang, *Handbuch der Photographie auf Kollodion* (3d ed., 1861); Liesegang, *Verfahren zur Anfertigung von Photographien, Ambratypen und Sanotypen* (1859, 1860, 1861, and other years). See the *Handbuch* (1927, II(2), 43) for other references.

PHOTOCHEMICAL OBSERVATION ON THE COLLODION PROCESS

Experimenters concerned themselves with the question whether the wet silver iodide collodion plate retains the latent image unchanged or whether it soon fades away as in daguerreotype plates. Latent light images on silver iodide collodion with excess of nitrate of silver, when stored away, do not fade, as Reissig was the first to observe (*Phot. Korr.*, 1866, p. 124; and 1867, p. 53). (In contrast to daguerreotype plates see Chapter XXXI). On the other hand, bathed collodion dry plates which liberate silver nitrate in washing and were preserved

with tannin, were subject to the deterioration of the latent image after a few months. Silver bromide collodion plates also do not retain the image, while silver bromide gelatine plates, as is well known, keep the latent image unchanged for a long time.

In applied photography with wet collodion the iodides were the only salts used. Soon it was discovered that in this process also, as in daguerreotypy, the iodine-bromide compound added great advantages in the matter of sensitivity and rendering of the middle tones of the image. Who first employed bromides in collodion became a burning question when Tomlinson, who had bought rights for the use and application of Cutting and Turner's (1854) United States patent covering the use of bromides in the production of photographic collodion, demanded fifty to two hundred dollars from every photographer and tried to enforce his demand with the aid of the courts. Since Cutting insisted that he had made his invention in the spring of 1852, it became important to prove that bromides had been used in photographic collodion before that year (*Phot. Archiv.*, 1860, p. 189; 1866, pp. 337, 396). This proof was adduced. In the second edition of *Chimie photographique*, by Barreswil and Davanne (Paris, 1851), the following statements are printed: "Some photographers added to their collodion bromine salts (cadmium, ammonium, or potassium-bromide) . . . Silver bromide reproduces the green better . . . The quantity is usually four parts iodide, one part bromide."

These statements of the Parisian scientists set the standard for later years, and the relation of bromides to iodides was generally observed in the proportions of 1 to 3-6; pure iodide collodion being used only for the slow-acting collodion of reproductive processes (*Handbuch*, 1927, Vol. II, Part 2).

Pure bromide collodions were not deemed advantageous for the photographic technique of the times; only when emulsion photography was introduced did their use follow.

The greatest improvement in the preparation of photographic collodion was the introduction of the use of iodide and bromide. At first iodide and bromide of potassium, as well as ammonium salts, were tried, but they were less permanent. An important step was the introduction of cadmium salts in preparing negative collodion by Laborde in 1853, especially in mixtures of alkaline iodides, by which lasting and sensitive collodions were obtained, and it was recognized empiri-

cally that cadmium and alkaline iodide (or bromide) had a favorable affinity for each other.

This mixture forms double salts. The chemical composition and the properties of cadmium double salts (complex compounds) of cadmium iodide and bromide with the alkaline salts were investigated by the author (*Phot. Korr.*, 1876, p. 92). He found new cadmium double salts which furnished a maximum of permanency and sensitivity. He was still a student at the Vienna Polytechnikum when he produced these double salts of cadmium; they found their way into practice when negative collodions prepared on this basis were used first in portrait photography and, later, in the halftone process. In the literature on the subject this collodion is designated as "Reproduction Collodion of the Graphische Lehr- und Versuchsanstalt," because the author introduced it there as "halftone collodion," but it is identical with his double-salt collodion of 1876. These double salts for negative collodion received a bronze medal at the Paris Exposition, in 1878, and the silver Voigtländer medal from the Vienna Photographic Society. Proprietors of large establishments in Vienna, such as Gertinger, Dr. Székely, and others, used this collodion for portraits, and Max Jaffé employed it in his collotype works.

MANIPULATION OF COLLODION PLATES

Iodized collodion was poured on the glass plates, and when the coating became firm, they were dipped in a strong silver-nitrate bath and exposed while still moist. In the very beginning iron sulphate, which had been recommended by Hunt for paper, was used as a developer. Archer, who was an orthodox calotypist, stuck to pyrogallic acid for developing (1851), but after a while he turned, like all other photographers, to iron sulphate developer, which permitted the shortening of the time of exposure. Archer already recognized the possibility of intensifying the collodion negatives before fixing with a developer of silver nitrate, or of developing further (1851). Archer was also the inventor of a collodion stripping film by coating with rubber (*Phot. Jour.*, 1855, II, pp. 262, 266); these were probably the first transparent photographic film negatives.

FIXATION OF WET COLLODION PLATES

The fixation of wet collodion plates was done at first entirely with sodium hyposulphite. It was not until 1853 that M. Gaudin published

the use of potassium cyanide, which acts more rapidly and contributes to clearing up of the negative. It is still used today, especially with halftone negatives.

INTENSIFICATION

Herschel was the first to announce the bleaching of silver images with mercury chloride under formation of mercurous chloride. The formation of this white precipitate on the collodion negative was applied as an intensifier by the first pioneers of the collodion process, in particular by Archer (1851). According to Horn's *Phot. Jour.* (1854, I, 91), credit is due to the Frenchman Lespiault for the invention of intensifying by blackening of the white precipitate with ammonia. The blackening of negatives bleached with chloride of mercury by hypo was reported by Archer as well as by Le Gray (1854); the yellowish-brown coloring with iodide of potassium was reported by Maxwell Lyte (1853); and intensification with uranium nitrate and potassium ferricyanide by Selle in 1865 (*Handbuch*, 1927, Vol. II, Part 2).

The mordant dye action of murexid[4] on the negative, bleached with chloride is reported by Carey Lea (1865), and he invented the first mordant dye picture.

A splendid intensifier of line negatives was that with copper chloride (bromide) and silver nitrate, suggested by Abney in 1877, which has since been largely employed by photoengravers (Eder, *Die Photographie mit Kollodiumverfahren*).

LEAD INTENSIFICATION AND INVENTION OF DARKENING OF SILVER
WITH FERRICYANIDES

The methods of intensification based on the reaction of ferricyanide on silver have a far-reaching importance in applied photography. The first and earliest application of a mixture of potassium ferricyanide with uranium nitrate for intensifying and brown coloring of collodion negatives was made by Selle in 1865 (*Phot. Archiv*, 1865, pp. 326, 393). This method met with little approval, and the progress of the chemical reaction on which this intensifying process is based was not investigated. In 1875 the author, together with Captain Victor Tóth, found that mixtures of potassium ferricyanide with lead salts deposit a precipitate of silver ferrocyanide and lead ferrocyanide. This caused a strong intensification, which, while giving a white color, could be

made by suitable reactions inactinic and protective. This was reported by them in a treatise, *Die Bleiverstärkung, eine neue Verstärkungs-methode*, to the Vienna Photographic Society on December 14, 1875 (*Phot. Korr.*, 1876, p. 10).

The bleached negatives were blackened with dilute ammonium sulphide. This was the strongest intensifier known at the time. It was also reported that Schlippe's salt (sodium sulphantimonate) darkened the negative "to a nice reddish brown" and intensified it. Eder and Tóth mentioned that "silver reduced the potassium ferricyanide, which changed to ferrocyanide of potassium," and that it formed with the lead salt an insoluble compound (ferrocyanide of lead).

The author[5] investigated the exact chemical theory of reaction by this group of ferricyanides on silver. The chemical equations were published and demonstrated by chemical analysis in his dissertation: "Die Reaktion von rotem Blutlaugensalz auf metallisches Silber," in the *Phot. Korr.* (1876, pp. 26, 172), as well as in the *Jour. f. prakt. Chemie* (1876). The author also stated that the same scheme operates in the darkening of silver images with uranium salts (reddish brown color). He concluded that "a mixture of ferricyanide and ferric oxide salts (ferrisulphate) behaved similarly; giving a beautiful blue precipitate, or prussian blue, which colored the negative a strong and distinct blue." This was the first description of blue toning, and thus was determined the chemical basis for coloring and intensifying methods.

A later dissertation by Eder and Tóth, entitled "Neue Untersuchungen über die Bleiverstärkung," was presented at the session of October 17, 1876, of the Photographic Society of Vienna (*Phot. Korr.*, 1876, XIII, 207, 221). At this time it is described also how white silver images intensified with lead could be turned yellow by a solution of potassium chromate (formation of chrome yellow) and how they could be colored brown by permanganate. On page 222 of that essay it is mentioned that such yellow silver images could be colored a beautiful green by pouring on them a solution of iron chloride (superimposition of chrome yellow and prussian blue); also, that the white ferrocyanide image turns reddish brown under uranium salts, but red under copper chloride copper ferrocyanide. It is also expressly emphasized that the basis of this photographic coloring method need not always be a lead precipitate.

In the footnote (*Phot. Korr.*, 1876, XIII, 223) it is stated: "The

action of metal chlorides on pure ferrocyanide of silver is quite similar; silver chloride and corresponding metal ferrocyanides form; thus iron chloride will color the image blue, copper chloride will color reddish-brown, etc." Coloring with cobalt and nickel salts is also referred to there. These statements all related, first of all, to collodion plates, and a large collection of these blue, yellow, green, and reddish-brown diapositives were exhibited in the Photographic Exhibition at Vienna in 1885. Today we need to consider chiefly silver images on gelatine emulsion, but in the author's *Die Photographie mit Bromsilbergelatine-Emulsion* (2d ed., 1883, p. 176), it is clearly stated that these ferri-cyanide methods are also applicable to gelatine silver bromide images. This publication made public the application of the methods of color-ing and intensifying for the whole field of photography, comprising toning in blue, green, yellow, orange, and brown with lead, copper, uranium, chromium, nickel, and cobalt salts. The outline of the his-torical development of this research must be taken into consideration in any evaluation of priority claims from other sides. For instance, one of the elements of numerous modern three-color methods consists in the production of diapositives or paper prints, which are colored with chrome yellow or with prussian blue according to the ferricyanide method. It must be pointed out, also, that the modern methods of bromoil printing with potassium ferricyanide, as well as the koda-chrome process and certain mordant dye toners, are all to be traced to the author's chemical formulas of the reaction of ferricyanide on silver, as can be fully understood when the secondary formation, determined by him, of potassium ferrocyanide and the reduction from chromic acid to chromic oxide as the decisive agent in the tanning of the gelatine are recognized (*Phot. Ind.*, 1925, p. 1355).

Victor Tóth, born 1846, in Hungary, was the son of an army surgeon. He studied at a military school, entered the army as officer of engineers, and was transferred to Krems on the Danube (Lower Austria) in 1870. In the same regiment served another officer, Guiseppe Pizzighelli, and both engaged in amateur photography with the wet collodion process, using Busch combination lenses for portraits and landscapes. They sought advice at the Military Geographical Insti-tute and from Professor Emil Hornig, who later became president of the Vienna Photographic Society. Tóth resigned from the army and in 1873 became attached to the general inspection service of the Austrian railroads. He equipped a private laboratory, where he con-

tinued his experiments and, in collaboration with the author, worked out the lead intensifier. About the discovery of the pyrocatechin developer by Eder and Tóth see Chapter LIX. Tóth died in Hungary, in 1898.

In modern times R. Namias, in Milan, used lead intensification for producing mordant dye pictures. He converted silver images into lead images with the Eder-Tóth lead intensifier and colored them yellow with chromates (chrome yellow); he converted them with sodium sulphate into lead sulphate, in which class fall directly various dyes (auranium saffranin, methylene blue, etc.); or he converted the lead image with alkali into lead oxide. In this manner he produced mordant dye pictures in various colors (*Brit. Jour. Phot., Color Supplement*, September, 1909).

The reaction, mentioned above, of chemically pure potassium ferricyanide on the fine grained metallic silver process under the formation of ferrocyanide of silver, which is soluble in hypo (Farmer's reducer is based on this). Lead intensifiers retained their place in photographic reproduction methods in the earlier wet collodion process and the modern halftone process with collodion emulsion (*Handbuch*, 1927, II(2), 121, "Photography mit Kollodiumverfahren").

ACTION OF THE SOLAR SPECTRUM ON COLLODION PLATES

Heinrich Jacob Müller was the first to photograph the solar spectrum on wet collodion plates, in 1856, together with Fraunhofer's lines (*Poggend. Annal.*, XCVII, 135). Müller, born in Cassel (Germany) in 1809, was a teacher of physics in Giessen and in 1844 professor of physics at the university. He is widely known for his publication in German of Pouillet-Müller's *Textbook on Physics;* the first edition appeared in 1856-1857, and there were many later editions.

Helmholtz also photographed the solar spectrum in 1857. Rutherford and Seely, in New York, produced a spectrum in fifteen sections, two meters (6 9/16 feet) long.[6] William Crookes used in his investigations on the photography of the solar spectrum (1855-1856) a quartz lens with two quartz prisms, and J. Müller also worked with quartz prisms (*Poggend. Annal.*, XCVII, 616). The astronomer William Huggins photographed the spectrum of stars with a prism of Iceland (calcareous) spar and two quartz lenses (*Handbuch*, 1884, I, 41).

J. Müller recognized wet silver iodide collodion plates as sensitive from the blue violet next to the Fraunhofer line G up to line Q

in the ultraviolet. Eisenlohr found a similar result with a difraction spectrum. According to Becquerel the action begins in the blue violet at G⅓ H, which later scientists elaborated and in a general way confirmed. All early scholars (Becquerel, Crookes, Schultz-Sellack, and others) found that silver bromide as used in the wet collodion process, with pyrogallic as well as with iron vitriol developer, is sensitive to the light blue and into the green and beyond (analogous to daguerreotype plates). Iodo-bromide of silver shows increased sensitivity in the wet collodion process towards the bluish green, in which it is similar to pure silver bromide. The most comprehensive investigations on the behavior of silver bromide, in the form of wet collodion plates, towards colored light are those of Crookes (1855). During his experiments in photography of the solar spectrum be observed a deeper action towards the green of the spectrum in silver bromide than in silver iodide. He examined the ability of a wet silver bromide plate, with iron vitriol development, to reproduce the color-tone values of variegated leaves of flowers and found the result more pronounced than when silver iodide was employed. Crookes improved the results he obtained by inserting a light filter of quinine sulphate in front of the lens, which absorbed the ultraviolet and part of the violet. In these experiments Crookes became the pioneer in the application of suitable light filters and the use of silver bromide in the photography of colored objects; he utilized spectrum photography as an alternate control with the photographic behavior in the photography of colored objects in nature (Horn's *Phot. Jour.*, 1855, p. 28).

SOLARIZATION, REVERSAL INTO POSITIVES

The wet collodion plate (silver iodide with silver nitrate bath) solarized under long exposure from the indigo to the violet of the solar spectrum, which Crookes had already recognized.

Seventy years ago Sabattier[7] observed the phenomenon of reversal, *i. e.*, the changing of a negative image on the wet collodion plate to a positive during the development when suddenly daylight shone on it (pseudo-solarization); lights changed into shadows, and after scarcely a minute it turned into a complete positive. Such positives by reversal Sabattier exhibited, in September and October, 1860, before the French Photographic Society in Paris (*Bull. Soc. franç. phot.*, 1860, pp. 285, 306, 312, also July, 1862; Horn's *Phot. Jour.*, XVIII, 50; XIX, 37). De la Blanchère, Rutherford, and Seely made the same observa-

tions. This Sabattier reversal phenomenon also played a part in photography with gelatine silver bromide, which Lüppo Cramer describes exhaustively in his "Grundlagen der phot. Negativverfahren" (in *Handbuch*, 1927, II(1), 623).

PICTURES CAPABLE OF DEVELOPMENT BY MECHANICAL PRINTING

The possibility of obtaining developable photographic images on silver iodide layers by mechanical printing was observed by Carey Lea (Silliman's *American Journal of Science*, 1866, Ser. 2, XLII, 198; *Phot. Archiv.*, 1866, p. 111); later, by Aimé Girard with collodion, tannin or albumen dry plates (*Bull. Soc. franç. phot.*, 1866, p. 88). Warnerke made detailed reports on gelatine dry plates (*Phot. Archiv.*, 1881, p. 120), which resulted later in further investigations by others and became of value in the film industry (*Handbuch* 1885, II, 18; 1890, III, 94).

DEVELOPMENT OF THE LATENT LIGHT IMAGE AFTER FIXATION

Y. Young was the first to make, in 1858, the theoretically important discovery that the latent photographic image on collodion dry plates (Taupenot plates) could be developed after fixation with physical developers,[8] and he reported it to the session of the Manchester Photographic Society, January 5, 1859 (*Brit. Jour. Phot.*, 1859, p. 20), describing it as "developing after fixing with cyanide." He found that the exposed plate could be developed after fixing, either at once or after a few days, with pyrogallol and silver nitrate, which was confirmed by numerous other scientists, such as Davanne and Bayard, in 1859. This phenomenon may also be easily observed in silver bromide gelatine films. In the World War the Secret Service seized photographs treated after this manner. On the fixed silver-bromide-paper pictures (silver bromide post cards) latent invisible letters were written in the white part of the sky,[9] which kept their properties a long time even in light and could not be made visible by any kind of chemical media, with exception of physical development, such as acid metol with silver nitrate.

RESOLVING POWER OF WET COLLODION PLATES

Wet collodion plates showed great capacity for resolving the fine details of the picture in a sharply ascending blackening curve with great clearness, which has kept for them a special usefulness until

modern times in the photomechanical processes. They had to give way with respect to sensitivity, in the reproduction of middle tones, to greater durability, and especially to the color sensitiveness in other photographic films in which, as Herschel prophesied, silver bromide played a dominant part.

Chapter XLV. DIRECT COLLODION POSITIVES IN THE CAMERA

THE PRODUCTION of direct positive images in the camera became a technical speciality of the collodion process. This was not a matter of employing any of those new photographic processes described in Chapter XXXIX, but dealt with ordinary negatives with white silver precipitate which were made very weak (light) with a solid black background that appeared under reflected light as positive images. This process was used at the time when the daguerreotype was already on the wane and led to ferrotypes and to pannotypes.

The starting point of all these methods is the observation that glass negatives made by the albumen or collodion process and developed will appear negative when looked through against the light, but positive when looked at against a dark background.

The originator of ferrotypes, which were produced on black lacquered tinned iron by the wet collodion process, was the Frenchman Adolphe Alexandre Martin (1824-1896), the only pupil of Léon Foucault; he was a college professor in Paris and interested himself in photography. In 1852 and 1853 he presented to the Société d'Encouragement and to the French Academy of Sciences two memoirs, in which he described a process for the production of direct positives: (a) on glass, the back of which was made opaque, and (b) on tinned iron, which was the starting point of ferrotypes and pannotypes. Martin's experiments to produce direct positives on glass are described in La Lumière (1852, pp. 99, 114), and on metal, in the same publication (1853, p. 70). Wallon, in his speech commemorating Martin's death, at the session of the French Society of Photography, December 4, 1896, confirmed the above statements, and at this session Martin's sons presented two early specimens of the process to the society (Bull. Soc. franç. de phot., 1896, pp. 314, 577).

Adolphe Martin also made experiments in the production of gun-cotton for photographic purposes. He took part personally in the construction of the large instruments for the Paris Observatory and constructed a reflection mirror of greater dimensions than had been achieved before that time. He published his procedure for silver plating of mirror surfaces with invert sugar and silver nitrate. He also interested himself in the calculation of photographic lenses and published his method in the *Bull. Soc. franç. de phot.* for 1892 and 1893.

Similar positive collodion images on black waxed linen were presented for the first time to the French Academy of Sciences by the firm of Wulff & Co., in 1853, which called them pannotypes (from the Latin *pannus* = cloth); the process was widely sold for one hundred francs. Pannotypes soon became generally known, and many professional photographers made commercial use of them, but they were displaced in studios and by itinerant photographers between 1859 and 1863 by ferrotypes and albumen prints. Very few specimens of pannotypes have been preserved, owing to the fragility of the black waxed linen which served as a base for the picture image.

In the production of direct positives in the camera the black lacquered galvanized iron or tinned plate gradually displaced all other materials. At first these collodion positives on black backgrounds were called "melainotypes."[1] They were very popular at the end of the fifties or at the beginning of the sixties and were commonly called "tintypes" or by the name which later became generally used, "ferrotypes."[2]

The black lacquered tinned plate had the advantage over other materials of being stiff and unbreakable and therefore easier to handle; it was easily cut up and could be easily fitted into brooches, lockets, and so forth.

Professor Hamilton L. Smith was the first to make ferrotypes in the United States, and he and Griswold, of Peekskill, New York, introduced them into the photographic industry.

Smith took out a patent for his processes, in which he specifies that he coated his tinned plate with a boiled mixture of asphaltum, linseed oil, and umber or lampblack; and on top of this the collodion image was exposed.

Peter Neff bought Smith's patent in 1857 and manufactured the plates until 1863. Griswold started to make them in the same year and sold them to the trade as "ferrotype plates." They were used by itinerant

photographers in Europe under the name "American instantaneous photography" (*Handbuch*, 1927, Vol. II, Part 2).

Later, around 1900, "dry" ferrotypes were introduced in the form of gelatine silver bromide plates and a special apparatus, so-called photographic automats were used, in which illumination (magnesium flashlight or electric light) development and fixation were operated automatically. These automats were used at expositions and fairs, but the results were of mediocre quality. Silver bromide prints displaced the ferrotypes even for the rapid process demanded for these incidental photographs..

Chapter XLVI. CHEMICAL SENSITIZERS FOR SILVER HALIDES

It must be mentioned briefly that Poitevin stated in 1863[1] that silver iodide formed with an excess of potassium, which is almost completely insensitive, becomes light-sensitive with tannin, gallic acid, or ferrous sulphate, just like silver nitrate. He attributed this to the reducing property of these sensitizers, while, on the other hand, H. W. Vogel recognized, correctly, that the action of the "chemical sensitizers" for halide combinations of silver salts (silver iodide, bromide, chloride) rests, in the first place, on their ability to combine iodine, bromine, or chlorine (acceptors of iodine, and so forth).

This theory of Vogel and its consequences for photographic practice became authoritative in the later development of photographic history and was supplemented by Vogel's discovery of "optical sensitizers."

Poitevin also presented a new dry-plate process. He washed collodion plates (silver iodide, dipped in silver-nitrate bath), and made them insensitive by immersing them in an excess potassium iodide solution. He again washed and sensitized them immediately before exposure by flowing over them a 5 per cent solution of gallic acid. He exposed and then developed them with iron sulphate under addition of silver nitrate. While this method achieved no practical use, it must be designated the precursor of the similar method of Russel (tannin dry plates).

Chapter XLVII. THE DRY COLLODION PROCESS AND THE INVENTION OF ALKALINE DEVELOPMENT

AFTER ALL that has been said, one can readily understand the desire of all photographers, especially when traveling, to have a dry process introduced in place of the wet method.

The pure albumen plate of Niepce de Saint-Victor could, it is true, be used dry, but it was exceedingly slow. Therefore all hope centered in the collodion plate, which, however, showed great sensitivity only in the wet state.

Since the silvered collodion-bath plate cannot be dried with the bath silver adhering to it, owing to corrosion of the coating, which is eaten away by the formation of silver crystals, and since it loses its sensitivity almost completely after washing it in water and drying, there began a search for "preservatives" which would retain sensitivity in the dry collodion film.

But all these experiments led to no lasting practical success. The Frenchman Taupenot succeeded in making the first real progress by inventing a combination of silver iodide collodion film, which he coated with albumen. Taupenot (1824-1856) was professor of chemistry and physics in the Prytanée Military Academy at La Flèche (Dept. of Sarthe).

At first the silver iodide film of the wet collodion plate was coated with honey in order to keep it moist and sensitive, which succeeded up to a certain degree. This was first suggested by Maxwell Lyte, on June 17, 1854, in *Notes and Queries*.

Maxwell Lyte, an amateur, deserves a great deal of credit for his activity in the development of photography. A biography of him may be found in the *British Journal of Photography* (1906, p. 206). His honey collodion process was one of the earliest phases of the dry collodion process. Lyte was a chemical engineer and one of the first to call attention to the danger that "antichlore" (hypo) in photographic mounts threatened the durability of silver images. He wrote many articles on photographic processes, for instance, on the intensification of negatives with mercury chloride and ammonium sulphide.

George Shadbolt preceded him by a few days in recommending honey as a preservative to the London Photographic Society, on June 6, 1854. But this method of preservation for collodion plates was un-

satisfactory, because the demand was for permanently dry collodion plates. Robiquet and Duboscq (1855), then the Abbé Desprats (1856), sought to accomplish this by addition of resin.

Taupenot's process consisted of washing the collodion film after it had been sensitized in a silver nitrate bath, coating it with albumen and drying it. The plates were once more dipped in the silver bath and dried again; they lasted for several weeks.

Taupenot published his collodio-albumen process at the end of 1855[1] and exhibited the first specimens of his work, which attracted attention and admiration on account of the fine quality of the image obtained; other examples of his process were exhibited at the London Exposition of 1862 as objects of interest.

Taupenot's process met with immediate favor as early as 1855; it placed in the hands of experienced photographers a practical method for obtaining good results and simplified outdoor photography, although, of course, it was necessary to give longer exposures than with wet collodion plates (often several minutes). For instance, the Frenchman A. Ferrier made a notable series of views of the Swiss lakes in 1857. In England, J. Mudd, J. Sidebotham, and others worked this collodio-albumen dry process with great success (1860-1870).

While Taupenot's process was largely used from the end of the fifties to the early sixties for landscape photography, it did not seriously interfere with the general use of the wet collodion process, but continued in favor for many years in conjunction with photomicrography. We cannot give all the various modifications of this process which have been published (*Handbuch*, 1927, Vol. II, Part 2).

In Germany the Desprats resin method of 1856 was employed at first. One of the first photographers to occupy himself with the production of iodine-bromide collodion bathed dry plates with high silver bromide content and the addition of resin (gum), who as early as 1856 produced beautiful landscape photographs (with pyrogallic acid silver nitrate developer), was Hermann Krone 1827-1916).[2] Later, Krone turned to Taupenot's albumen process and its modifications.

Richard Hill Norris, in England, was probably the first to recognize the advantage of using a coating of gelatine or gum arabic as a preservative for collodion dry plate. He patented his process September 1, 1856 (No. 2,029). He sensitized the iodized collodion with silver in the usual manner; this he then dipped in an aqueous solution of gelatine, gum, or some other viscous vegetable substance in order to keep the

pores of the collodion film open while drying and to keep the coating sensitive. He also recognized the fact that after coating with gelatine the collodion film could be stripped off the glass.

The Norris process is worthy of attention not only for its clear recognition of the value of gelatine and the role it plays in preserving the structure of the collodion film but also because this process was the beginning of the manufacture of photographic dry plates. V. von Lang, the official Austrian observer at the London World Exposition, in 1862, who later became professor at the University of Vienna, reports: "The dry plates, ready for use, manufactured by Norris are being sold in all the larger towns of England and are said to give good results."[3]

The collodio-albumen process was displaced by the tannin method of Major C. Russell (1861), because it was simpler and more certain in manipulation, and because the development brought out the image more rapidly and strongly. The sensitized collodion film was thoroughly washed in this process and, while still moist, flowed with a tannin solution, and then dried.[4] Beautiful specimens of this process were exhibited at the London World Exposition in 1862.

How difficult it was, with the means at hand at that time, to produce a dry plate which would be practical and satisfactory is shown by a competition organized by the Marseilles Photographic Society in 1862, in which a prize of five hundred francs was offered for a dry-plate process "which could produce a photograph in full sunlight of a street scene, including action and movement."

In the sixties and the seventies of the last century such collodion dry plates, produced by one or the other of the foregoing methods, were largely used in traveling or on excursions. They required very long exposure, with physical development, and gave very beautiful results, but made great demands on the operator's experience and skill. We cite two examples of the method of procedure in those days. The photograph taken in Nagasaki, Japan, in 1868, by W. Burger on his travels (reproduced in the 1932 ed. of the *Geschichte*, p. 521) on a tannin plate, which was prepared in Vienna and not exposed until nine months later in Japan. The time of exposure was seven minutes with a Voigtländer-Petzval portrait lens, working with a small aperture. Another tannin dry-plate photograph was made from a plate prepared by the same photographer in Vienna, April, 1872. He exposed it on a journey to Sibera with Count Wilczek in September, 1872. The exposure

took one and a half hours in sunlight, owing to the loss of sensitiveness due to long keeping. It was made by means of a Dallmeyer triplet lens with the smallest diaphragm opening and was developed at Vienna, in December, 1872, with pyrogallic acid and silver nitrate developer (reproduced in 1932 ed. of the *Geschichte*, p. 522).

In 1917 the tannin process was resurrected for the production of very small fine-grained diapositives (see Chapter LI on microphotography).

Russell's tannin process underwent numerous changes. Tannin was replaced by gallic acid; morphine and other alkalies were introduced as preservatives, and coatings of mixtures containing gum and sugar as well as coffee and tea decoctions, beer and albumen, were tried, without any essential progress being made.

The plates were developed at first (in the style of the old Talbotypes) with pyrogallic acid with addition of silver nitrate and citric or acetic acid and also by "physical development." It is important to note here the improvement in the development of such dry plates, which always contained iodo-bromo-silver; the greatest advance in the development of the negative was made by the introduction of the alkaline pyrogallol developer.

Wardley, an assistant of the English photographer Mudd, recognized that the collodion dry plate could be developed with pyrogallol, without the addition of silver nitrate.

In 1861 Mudd reported, for the first time, that collodio-albumen dry plates (with iodo-bromo-silver) could be developed in full detail with pure aqueous pyrogallic acid (½ per cent) without the addition of silver nitrate and acid (*Phot. News*, V, 386; Kreutzer's *Zeitschr.*, 1861, IV, 131). Later, however, the full credit for the discovery was given by Mudd to his assistant Wardley. Wharton Simpson, on October 23, 1861, called attention to the importance of this method of development, as proving that dry plates could be developed without the use of silver nitrate. The image developed on albumen plates rapidly and quite perfectly, but had to be intensified with pyrogallol, silver nitrate, and citric acid. According to Simpson this method of development is also applicable to Fothergill's plates, to tannin plates, and to Norris's dry plates; the latter do not contain any trace of free silver nitrate (*Brit. Jour.*, VIII, 376. Kreutzer's *Zeitschr.*, V, 102).

Anthony, in New York (1862), increased the sensitivity of dry collodion plates by subjecting tannin plates before exposure to dilute

ammonia vapors, while Glover did the same after the exposure. In the same year Major Russell[5] and Leahy, probably urged by the observations mentioned above, discovered the alkaline pyro-developer, which was superior to gallic acid or pyrogallol development; he used the pyro-ammonia developer with additions of potassium bromide. This furnished the most important improvement in the method of development, which did not reach its full use until the emulsion process began. Russell pursued his discovery with a definite purpose, and to his work is due the credit for the introduction of alkaline developers, without which modern photography with silver bromide emulsions could not have been accomplished in its initial period.[6]

In the second edition of Major C. Russell's work *The Tannin Process* (1863) we find described the action of ammonia in the developer, as well as the part which addition of potassium bromide plays as retarding agent; alkaline carbonates were also used in pyro-developers at that time. Especially remarkable is Russell's observation, which he made during the continued experiments with his alkaline developer and published later, that it is necessary to add ample bromine salts to the iodo-bromo collodion; in fact, he finally succeeded in producing a chemically pure bromine collodion (*Handbuch*, 1927, Vol. II, Part 2). He recognized, therefore, the superiority of silver bromide over silver iodide in the so-called "chemical development," an experience which later (in the emulsion process) was universally confirmed.

Chapter XLVIII. INVENTION OF COLLODION EMULSION

THE POSSIBILITY of making a light-sensitive emulsion with silver salt which would result in dispensing with the silver used for sensitizing bath was first suggested by M. Gaudin, in *La Lumière* (August 20, 1853). "The whole future of photography seemed to require a sensitive collodion which could be preserved in a flask and poured when required upon glass or paper and by the use of which, either at once or after the lapse of time, positive or negative pictures could be obtained." Even then he evidently had in mind the silver iodide or silver chloride emulsion, which he described in April, 1861, and called "photogen."[1] This he produced by mixing iodized collodion (or

chloro-ammonium collodion) with nitrate of silver or silver fluoride. The first collodion emulsion, in the real sense of the word, Gaudin found at times as sensitive as wet plates, and he believed that it could be used to especial advantage on paper in the camera. For silver chloride collodion, which he produced with ammonium chloride and silver nitrate, he visioned its use in place of ordinary silvered positive paper.

Shortly before this (March, 1861), Bellini had recommended to photographers, in the periodical *L'Invention*, an ether-alcohol shellac or sandarac solution, which contained iodo-bromo silver together with lactate of silver and iron iodide. At the same time, the emulsion process made its appearance in England, where it was kept secret. Sutton wrote repeatedly of the good results which were obtained by this process without a silver bath.[2] This process was patented in England, April 29, 1861,[3] by Captain Henry Dixon.

SILVER BROMIDE COLLODION EMULSION

A serviceable independent process introduced about this time was the silver bromide emulsion process with collodion ("photography without silver bath"), discovered in September, 1864, by B. J. Sayce[4] and W. B. Bolton[5] in Liverpool and described in detail later in the *Photographic News*. They used Russell's pyrogallol and ammonia developer. In a later, not essentially different, formula in 1865 Sayce enumerates almost all possible modifications of collodion emulsion. Sayce also, in 1865, put forward the idea of separately precipitating and washing the silver bromide and preparing the emulsion subsequently.

The American Carey Lea (1823-1897) made notable photochemical studies on collodion developers and, later, on various molecular states of silver. He joined the Chemical Section of the Franklin Institute, Philadelphia. Ill health interrupted his chemical work, and he was compelled to seek recovery by extended travel in Europe. He spent some time in Italy and in the Tyrolean Engadine. He was a lover of art, and on his travels he gathered examples of paintings which enabled him to have one of the finest art collections of that time in America. From 1864 he devoted himself zealously to photography, worked a great deal with the formation of silver bromide, with silver iodide and silver chloride by various developing substances, and studied the modifications of metallic silver.[6]

Silver bromide emulsion with excess of silver nitrate was always

combined in the early days with a preservative. Sutton published in 1871 a silver bromide collodion process[7] without a preservative, which consisted only of an unwashed emulsion produced with a slight excess of silver nitrate.

The discoverers of the silver bromide emulsion process had already used in their early experiments Russell's alkaline pyrogallic developer. In the *British Journal of Photography*, January 16, 1874, W. B. Bolton recommended washing silver bromide collodion by precipitating it in a great excess of water. Canon Beechey published, in the *British Journal of Photography*, October 1, 1875, a method of producing silver bromide collodion plates with pyrogallic acid as a preservative and arranged to have them manufactured for the market. These collodion dry plates, however, were only used for landscapes; they could not compete with the greater sensitivity of wet plates and therefore found no acceptance in portrait studios. No noticeable progress occurred in the years following, notwithstanding the many endeavors of the Englishman Abney, the American Carey Lea, the Russian Warnerke, then living in England, the Frenchman Chardon, and others to popularize the new plates. Nor were the prize competitions of different photographic societies and other encouragements of the art of any avail.

In 1874 Newton announced that an extract of mustard seed and mustard oil could be used in sensitizing silver bromide collodion plates. This observation, which remained at that time unnoticed, became later very important, when Sheppard, of the Eastman Kodak Research Laboratory, Rochester, U.S.A., recognized mustard oil and related sulphurous preparations as sensitizers for silver bromide gelatine and took out patents for this use of sulphurous compounds (*Handbuch*, 1927, II (1), 509). The increased sensitivity of silver bromide collodion by addition of ammonia was first published by the author in June, 1880 (*Phot. Korr.*, XVII, 146). Collodion emulsion was later displaced in portrait and landscape photography by gelatine dry plates.

In reproduction photography, however, new fields were opened for silver bromide collodion by Dr. Eugen Albert's invention of orthochromatic collodion emulsion, the production of which became an important industry with its origin in Albert's establishment at Munich.

Dr. Eugen Albert (1856-1929) was the son of Josef Albert, the inventer of collotype printing with cylinder machines. He studied

physics and chemistry in Munich and wrote a dissertation: "On the Change of Color Tones in Spectral and Pigment Colors under Diminishing Intensity of Light." In the very same year (1882) he perfected his experiments in the production of a highly sensitive silver bromide collodion emulsion to such an extent that he realized its excellent quality for the reproduction of paintings and its possession of a high sensitivity for colors such as had been unknown up to that time.

He had achieved this increased color-sensitivity with ethyl eosin silver nitrate. He founded the Munich art and publishing house of Dr. E. Albert & Co., in 1883. For reproduction he at first made use of platinum prints but later adopted Dujardin's heliogravure method (*Handbuch*, 1929, IV(3), 29). It was not until 1888 that he introduced on the market his washed silver bromide collodion emulsion, which he made highly sensitive with eosine silver (ethyl eosine) and demonstrated, by invitation of the author, on May 17, 1888 in the photographic studio of the Graphische Lehr- und Versuchsanstalt, Vienna. He there proved the high sensitivity of his emulsion by taking a portrait with an exposure which, though longer than on a gelatine silver bromide plate, was yet three times faster than the most rapid wet collodion plate. He used a washed silver bromide collodion emulsion, which was made up with an excess of alkaline bromide, but it was in no way more sensitive than the earlier emulsions of this kind. It received its enormous sensitivity for light and color only from the addition of the eosine preparation (*Handbuch*, 1927, II(2), 203).

This invention of Albert's "isochromatic collodion emulsion" proved to be of permanent value in certain classes of reproduction photography (paintings, three-color process, halftone negatives[8]; it has become a special branch of the photochemical industry, first in Munich and later in England. Unfortunately, these isochromatic collodion emulsions must be used moist, and the problem of finding a good sensitive dry plate was not solved by this method. The solution of that problem was found only in the gelatine silver bromide dry plate.

Chapter XLIX. INVENTION OF COLLODION LAYERS FOR THE PRODUCTION OF STRIPPING FILMS ON SPOOLS

THE PAPER HOLDERS for calotype photography must be regarded as the precursors of the roll holder. In the beginning of 1870 many investigators, trying to improve the collodion dry-plate process, sought a solution of their problem in the form of silver bromide collodion. L. Warnerke,[1] who experimented in the production of silver bromide collodion emulsion with an excess of silver nitrate, developed with pyrogallol and ammonium carbonate, received a prize (1877) from the Association Belge de Photographie (*Handbuch*, 1927, II(2), 200 and 311). He had in 1875 invented a film-roll holder. He produced in that year (*Phot. News*, 1875, Nos. 876, 877) silver bromide films on gelatinized paper and exposed them in roll holders. He used a base of alternate collodion and india rubber coatings, on which he flowed the collodion emulsion. When finished, he strengthened the film with a gelatine coating and stripped it off the paper. In this roll holder of Warnerke's it is easy to recognize the original model of the Kodak and other modern film-roll holders. Later, as we know, gelatine bromo-silver emulsion was also applied to paper and cardboard (Milmson, 1877, Ferran and Pauli, 1880, Lumière).

Warnerke's predecessors in the invention of the roller dark-slide were the Englishmen Melhuish and Spencer, who patented a "roll holder" May 22, 1854; this was intended for Talbotype negative paper. Warnerke was the first to use "stripping films" with a roller dark-slide. The Warnerke roller dark-slide is similar to the Eastman roll holder. This was not recognized by George Eastman (see *George Eastman*, by C. W. Ackerman, 1930, p. 50) when his attention was called to it.

But all these methods were displaced by the introduction of gelatine silver bromide and have only a historic interest. The Eastman Kodak Company's stripping roll-paper, with gelatine silver bromide emulsion, came into general use in 1884 under the name "stripping film" (*Handbuch*, 1930, III (2), 395).

Chapter L. STEREOSCOPIC PHOTOGRAPHY

WE HAVE ALREADY described the principles of stereoscopic vision in Chapter VI. Shortly before the invention of daguerreotypy (1838) Sir Charles Wheatstone (1802-1875) invented the mirror, or reflecting stereoscope. He tried to produce a relief impression by drawing, side by side, two dissimilar images of an object; one represented it as seen by the right eye, the other, as seen by the left. The experiment was successful. The figures were drawn by hand and consisted of simple lines and circles. It was more difficult, of course, to obtain stereoscopic pictures of persons and landscapes, but the invention of photography made this possible. The process of producing stereoscopic pictures by taking two views of the same object, of which the foci were to some extent equidistant from the median line, was announced in 1844 by Professor Ludwig Moser, of Königsberg. It was not discovered by J. Duboscq, as Moigno stated earlier (Dove, *Repert. d. Phys.*, 1856, p. 238; W. Dost, *Phot. Chronik*, 1928, p. 387).

David Brewster (1781-1868) replaced the mirrors by lens-shaped, curved prisms (1844); this produced a much handier stereoscope, which Helmholtz later improved.

In *The Times* of October, 1856, appeared letters from Wheatstone and Brewster on the history of the invention of the stereoscope provoked by an assertion made in this newspaper that James Elliot had invented the stereoscope as early as 1834, but had not constructed one until 1839. This took the form of two small openings in a card. Wheatstone, however, claimed the credit for the invention of the stereoscope and pointed to his publication in the *Philosophical Transactions* of 1838. Brewster maintained that Euclid, Galen, Porta, Aguilonius had asserted that the different images of an object created in the two eyes unite to produce a relief effect. Wheatstone, however, insisted on his claim to priority (Kreutzer's *Jahresbericht über Fortschr. d. Phot.*, 1857, p. 537).[1]

In the Wicar Museum at Lille can be found two pen and ink drawings which represent a young man seated on a bench drawing with compasses. These drawings are by Jacopo Chimeti, a painter of the Florentine School, 1554-1640. These two drawings represent the same subject from two different positions; one of them a little to the right, the other more to the left. Both pictures are of such identical dimensions that they can be united in a stereoscopic view of the whole; this would

lead one to believe that they were designed especially for this particular mode of viewing (*Phot. Korr.*, 1897, p. 554).

Brewster first described his lenticular stereoscope in April, 1844, before the Royal Society at Edinburgh, and had constructed a "double-eyed camera [binocular] for the taking of portraits and copying statues" in Edinburgh (1844). This attracted, at the time, very little interest. Only when Brewster, in 1850, brought to Paris a model of the instrument made in Scotland and demonstrated it to the Abbé Moigno, the distinguished author of the work *Antique moderne* and to the opticians Soleil and his son-in-law Duboscq was the value of his instrument fully recognized, as Brewster himself relates. Duboscq at once began to manufacture the lens stereoscope for the market, and he produced a series of most beautiful stereoscopic daguerreotypes of persons, statues, bouquets of flowers, and objects of natural history, which thousands of persons flocked to see.

Daguerreotypy was early used for the production of stereoscopic photographs, and they were subjects of production in many photographic studios at the end of the forties and in the beginning of the fifties of the last century. Small stereoscopic daguerreotype portraits were mounted on cardboard so that they could be set up opposite a pair of simple condensing lenses, which made the stereoscopic viewing of the pictures possible. The whole outfit could be folded into its case and took up no more space than a memorandum book.[2]

In England the stereoscope became popular after having been brought back from Paris in 1851.[3] It attracted the attention of the queen at the Crystal Palace Exposition, London, 1851, and in consequence the demand for the stereoscopes rose enormously. An illustrated announcement of a sale of stereoscopic pictures in 1848 demonstrates the zeal employed in Paris in the popular distribution of stereoscopic pictures[4] (reproduced in 1932 ed. of *Geschichte*, p. 535).

Stereoscopic pictures were also produced on Talbotype paper in the fifties, but daguerreotypes, owing to the skilled technique then prevailing in that art, far excelled them in beauty and therefore found more favor with the public.

The introduction of the collodion process made possible the mass production of stereoscopic pictures. In particular, it was the English Photographic and Stereoscopic Company which had the monopoly of photographing art and industrial objects of the London World Exposition of 1862, and they disseminated beautiful stereoscopic pictures

in all stores of Europe. The further introduction of stereoscopic photography was later materially advanced by the invention of silver bromide dry plates, and stereoscopy found many applications in the various branches of arts and sciences, of which we only mention its use in microscopy, photogrammetry, radiography, and the experiments for the introduction of stereoscopy in the projection process.[5]

Among modern types of stereoscopic apparatus which have appeared may be mentioned Stolze's orthostereoscope,[6] Schell's universal stereoscope, and Zeiss's stereoscope.

Referring to stereoscopic projection, Brandner calls attention to the early publication of Tissandier's *Merveilles de la phot.* (Paris, 1858), to Claudet's *Le Stereoscope*, and to Blanchere's *Monographie du stereoscope* in which Claudet's "monostereoscope" is described (*Brit. Journ. Phot.*, 1907, p. 246).

F. P. Liesegang, in *Prometheus* (1911, p. 588), writes on the history of stereoscopic projection: D'Almeida[7] reported in 1858 a stereoscopic process which consisted in producing the component pictures in complementary colors (for instance, red and green), and viewing them through spectacles with glasses colored similarly, looking through the red glass upon the green picture and through the green glass on the red one. He supplemented this by giving a method of combining stereoscope with the phenakistiscope, a precursor of the cinematograph, in which small electromagnets screened the eye intermittently. The idea came to the surface again in later years, when two complementary stereoscopic pictures were thrown on a screen by two projection lanterns, so that they appeared to the eye in rapid succession by means of rotating shutters. Each person in the audience received a spectacle-like instrument, which also at equal speed covered first the right and then the left eye, exposing to view only the respective complementary stereoscopic half of the picture. This process of stereoscopic projection was elaborated by W. B. Woodbury (1881), A. Stroh (1886), F. C. Porter (1897), August Rateau (1899), who tried to make cinematographic projections of this kind; then by Doyen, Schmidt, and Dupuis, who employed, in 1903, rotating mirrors for the same purpose, and then by Jäger, in 1905, who used rotating diaphragms, and finally by M. Topp, in 1911.

"Parallax stereograms" are credited by Clerc (*Brit. Jour. Phot.*, 1926, p. 88) and in earlier publications by E. J. Wall, to H. Berthier, 1896. They are later contained in a patent by Jacobsen (1899). Frederic

Eugene Ives reports that he made this invention as early as 1885 (documentary evidence for this not available), but that he did not use it commercially until 1902, in which year he patented it; he was unaware of Berthier's work (*Brit. Jour. Phot.*, 1926, p. 218). At any rate, F. E. Ives deserves credit, more than any other, for the introduction of the parallax stereogram.

[A further development of the use of gratings to produce photographs exhibiting stereoscopic relief is the "parallax panoramagram" which exhibits a picture which continuously changes its appearance throughout a wide range of observing angles and positions. Such pictures were first made by C. W. Kanolt (U. S. Pat. 1,260,682, Mar. 26, 1918) by using a camera which moved through a wide arc during exposure. This form of relief picture has been exhaustively studied by Herbert E. Ives, who developed a number of methods of making them, particularly by single exposures with a large diameter lens or concave mirror (*Journal of the Optical Society of America*, 1928 et seq.). He has projected a series of such pictures on a lenticular rod screen, thereby achieving experimentally the projection of motion pictures in relief without resort to apparatus at the eyes of the observers (*Journal Soc. Motion Picture Engineers*, July, 1933). Translator's addition.]

INVENTION OF ROENTGEN STEREOSCOPY

It is not generally known that the Austrian physicist Ernst Mach[8] is the inventor of Roentgen stereoscopy. Roentgen rays and Roentgen photography were discovered in December, 1895, by the physicist W. C. Roentgen (1845-1923), who received the Nobel prize in 1901. In the spring of 1896 Professor E. Mach, while inspecting Eder and Valenta's work in Roentgen photography at the Graphische Lehr-und Versuchsanstalt, in Vienna, suggested, in a conversation with the above-named workers, the production of stereoscopic Roentgen photographs by shifting the Roentgen tubes. Upon this suggestion they acted in collaboration with E. Mach. In the richly illustrated work *Versuche über die Photographie mit Röntgenstrahlen* (Vienna, 1896) Eder and Valenta published their work. We quote from this first monograph on Roentgen photography, from which several full-page illustrations are republished in Meyer's *Konversationslexikon* (6th ed.).

The images obtained in the manner described by the aid of Roentgen rays, are silhouettes, which show, as already mentioned, a certain degree of apparent relief, because the varying degrees of transparency of the layers are expressed in the picture. In order to attain completely this relief

effect we experimented with stereoscopic exposures, employing Roentgen rays according to Dr. E. Mach's advice. For this purpose the object, a mouse, was placed on a piece of mica stretched over two strips of wood on a table, and the plate, wrapped in black paper, was slid under it, until it touched the mica, but enabled the plate to be exchanged without moving the object lying on the mica. Then a ruler was fastened to the table parallel to the edge of the plate, and the table was marked 10 cm. [about 4 inches] to the left and to the right of the center of the plate. The light source, about 30 cm. [about 12 inches] above the object, was placed at first so that its center registered with one of these marks on the table; then its axis was turned toward the object, and an exposure taken. The plate under the object was now changed, and the light was moved so that its center registered with the other mark, and the procedure was repeated. The two pictures, viewed as diapositives in a mirror stereoscope, showed a stereoscopic picture in astonishing relief of the skeleton of the mouse. This method of photography may find approval after some improvements in the apparatus are made, in particular when dealing with objects of natural history. E. Mach was the first or at any rate one of the first, who thought of Roentgen stereoscopy, and the first practical experiment was made in the Eder and Valenta photochemical laboratory. Later Roentgen stereoscopy became of unexpected importance in surgery.

Chapter LI. MICROPHOTOGRAPHY

OF THE MANY scientific applications of photography which followed the improvement of the negative process, we mention in the following chapters only a few characteristic branches: microphotography, photogrammetry, and balloon photography.

Microphotographs, that is, enlargements of microscopically small objects, were first projected by Wedgwood, in 1802, on light-sensitive silver paper by sunlight. These, however, he was unable to fix. The earliest permanent (fixed) microphotographs on silver chloride paper were probably made by J. B. Reade, of London, in the middle of 1839. He used hypo as fixing agent; for instance, he made an enlarged photograph of a flea and sold such pictures.[1] These enlargements were very imperfect.

Arago had pointed out the possibility of microphotography in his report on Daguerre's invention to the Chamber of Deputies, in 1839.

In that year the French scientist Alfred Donné took up this idea, and, working with a microscope and daguerreotype plates in sunlight,

he made enlarged pictures of the eye of a fly, specimens of which he presented to the Academy of Science, Paris, in October, 1839.[2] In February, 1840, Donné published other "microscope-daguerreotypes," made with a microphotographic apparatus introduced by the Paris optician Soleil.

Alfred Donné (1801-1878), doctor of medicine, was head of the clinic at the Charité in 1829, became subinspector of the administration of mineral water establishment at Enghien; general inspector of the medical faculty and rector of the Academy at Strassburg, and finally at Montpellier. He published *Cours de microscopie complem. d'études medic. suivi d'un atlas* (Paris, 1845).

In March, 1840, Chevalier also showed microphotographs (*Compt. rend.*, 1840). Later progress in this field is reported by Monpillard in his: "Notes sur l'histoire de la photomicrographie" (in *Musée retrospectif de la classe 12. photographie; rapport du Comite d'Installation de l'Exposition universelle, Paris, 1900*).

Donné later employed a vertical microscope of Chevalier's, by which the emerging rays were projected by a prism with total reflection horizontally into the photographic camera. In order to attain greater sharpness, he inserted blue glass (to correct focal differences). He also used a concave lens as projection-ocular in order to increase the magnification (see Monpillard, cited above).

At about the same time, Dr. Josef Berres, professor of anatomy at the University of Vienna, took up the use of the microscope for the production of enlarged photographs on daguerreotype plates, and he was probably one of the first to use artificial light in microphotography. He obtained, as early as 1840, a microphotograph of the cross section of a plant, made with Drummond's calcium light; he reproduced this by a process of etching daguerreotype plates, which he had invented, and obtained prints with fatty inks on a printing press. He wrote about his experiment in the *Vienna Zeitung* of April 18, 1840 (p. 737).

Josef Berres (1796-1844) was an assistant to a barber surgeon, never acquired a doctor's degree, and was called "doctor" only in an honorary sense. When twenty-one years old he became professor of anatomy at the University of Lemberg, where he distinguished himself by the production of many instructive anatomical preparations. In 1830 he came to Vienna in the same capacity and published various works on anatomy, the most important of which is his *Anatomie der mikroskopischen Gebilde des menschlichen Körpers* (Vienna, 1837-

1843). He used Plössl's instruments, was a skillful draftsman, and drew the illustrations for his books himself. As soon as Daguerre's invention became known in Vienna, he acquainted himself with this novel process and made use of it (Wurzback, *Biogr. Lex.*, I, 333).

Donné, with Léon Foucault[3] as collaborator, published his *Atlas d'anatomie microscopique* in 1844. They made the original exposures in Paris with the solar microscope on daguerreotype plates; but Donné had to make drawings from these originals, because at that time it was impossible to reproduce the photographs.

About the same time J. B. Dancer, in London, produced enlarged objects by microphotography with the aid of the solar microscope, and in 1841 Richard Hodgson also made good daguerreotype microscopic enlargements.

Bertsch, of Paris, introduced, in 1851, the horizontal microphotographic apparatus. The Parisian optician Nachet also engaged in microphotography, about 1854, and produced (1856), with the collaboration of Foucault and Duboscq, among other subjects, a microphotograph of the blood of a frog on daguerreotype plates, which, by its extremely fine definition, attracted much attention at the Paris Exposition of 1900.[4]

When Talbot's paper negative process became known and silver chloride positives (prints) could be produced in any desired number, this process was applied to microphotography. Carpenter is said to have presented such microphotographs on paper (Talbotypes) to the session of the British Association as early as 1847.[5] These, however, were unsatisfactory, because the coarse grain of the paper negatives interfered with the faithful reproduction of the delicate microscopic structure. It was not until the introduction of photography on glass (albumen and collodion processes) that photography became an important aid in microscopic research. As early as 1853 J. B. Dancer produced microphotographic diapositives on collodion plates, which he described in the *Manchester Guardian*. He was an optician in Manchester and exhibited in his house microphotographic diapositives, some of which he had colored and are reputed to have been of an excellent quality (*Phot. Jour.*, 1922, p. 497).

In the middle of the last century Professor J. J. Pohl, of the Polytechnikum at Vienna, engaged in microphotography, which he called "megatypy." Others who worked along this line were Weselsky, in Vienna, and in England, Hodgson, Shadbolt, Kingsley, Huxley, and

Allen Wenham, whose progress kept pace with the general development of optics and photography. All these men contributed greatly to the highly important achievements of later years.

It was especially the introduction of the very completely corrected apochromatic lenses and projection oculars of the optical establishment of C. Zeiss, Jena, that enormously increased the efficiency of the microscopic lens system. Orthochromatic gelatine silver bromide plates and light filters of various kinds were also used in microphotography at the end of the nineteenth century with great success; green, yellow, and blue light filters were introduced, and photographs were taken for special work with small spectral zones in the optically light part of the spectrum. A. B. Stringer[6] used light of the extreme violet and ultraviolet for special microphotographic exposures, which he exhibited to the Royal Microscopic Society in April, 1903. In 1904 A. Kohler,[7] of the staff of Carl Zeiss, developed a valuable method of photomicrography by means of monochromatic ultraviolet radiations which were isolated from spark discharges spectroscopically, so that they were free from light of other wave lengths.[8]

The progress of microphotography in recent years is recorded in Eder's photographic annuals (*Jahrbuch für Photographie*); also in the work of Dr. Richard Neuhauss *Die Mikrophotographie* (Halle, 1894) and his *Lehrbuch der Mikrophotographie* (2d ed., 1898); Dr. Kaiserling, *Lehrbuch der Mikrophotographie* (Berlin, 1903); Marktanner-Turneretscher, *Die Mikrophotographie als Hilfsmittel naturwissenschaftlicher Forschung* (Halle, 1890); Pringle, *Practical Photomicrography* (3d ed., London, 1902); Monpillard, *La Microphotographie* (Paris, 1899); and Mathet, *Traité practique de photomicrographie* (Paris, 1900).

Chapter LII. PHOTOMICROGRAPHY AND PROJECTION

THE EXTREMELY SHARP definition of collodion images made possible the production by Dancer of microscopically reduced pictures (photomicrographs) in 1856, as well as by Dagron, in Paris, about 1860.

Dagron, made his microscopically reduced pictures with apparatus constructed by the French optician Duboscq. These extremely minute photographs were made with Taupenot's albumen-collodion

dry-plate process and developed by the physical method. This method of development gives extremely fine-grained images, which were examined with a magnifying glass. The "photographic magnifying-glass pictures" were produced in France until the present day and were called "Stanhopes." "Stanhopes" were called after the English scientist Lord Charles Stanhope (1753-1816), who published many useful technical inventions; for instance, Stanhope's typographical printing press, improvements in the stereotyping process, and, among other things, the "Stanhope microscope lens," which is still manufactured and is used in small sizes for viewing the microscopic pictures under discussion (see Kuchinka, in *Phot. Korr.*, 1907, p. 409).

The minute photographs made by very few firms for sale under this name are well known; they are mostly mounted in ornaments, watch keys, etc., and they became mass products in commerce. The collodion albumen process was used in this method. The manufacture of these photographs spread widely, but in the sixties already complaints were heard in Paris because they were employed for obscene pictures (*Phot. Arch.*, 1864, p. 138). The method of production of these "Stanhopes" has changed only in some small particulars up to the present time.[1]

John Benjamin Dancer was a prominent English worker in this field and made a record in 1861 in the production of microscopically small pictures when he succeeded in making a microphotograph of a family group of seven persons on the head of a pin and taking ten thousand images on a square inch (Brewster, *Phot. Jour.*, 1862 p. 127).

The ingenious Paris photographer Dagron made a reputation for himself not only by his microphotographs but also, during the Franco-German War of 1870, through courageous balloon trips and the organization of a mail service carried on by means of carrier pigeons to and from Paris during the siege of that city by the Germans. In this service he made an ascent from Paris with the balloon "Niépce," landed in Tours, and organized a carrier pigeon service, which delivered hundreds of thousands of messages to beleaguered Paris. The news to be transmitted was printed on large sheets of paper, these were pieced together, and a sharp negative on glass was made from the printed matter. This was again reduced by the Dagron microphotographic method on a gelatine film, measuring only six square centimeters (about 2⅓ square inches). This tiny film, carrying the message, was rolled up and inserted in a quill, which was fastened to the wing of a carrier pigeon and was then sent from Paris to Tours. There,

as well as later in Bordeaux, similar gelatine films were made and transmitted by the carrier pigeons returning to Paris (Lafollye, *Dépêches par pigeons voyageurs pendant le siège de Paris*, Tours, 1871). In Paris the dispatches were considerably enlarged in a darkroom with Duboscq's apparatus, projected on a white wall and deciphered. A number of clerks were engaged in copying the contents of the photographic communications and dispatching them from there through the open postal channels. All photographic government and private dispatches which Dagron prepared at Tours and Paris were completed for each carrier pigeon flight in two hours. Each film carried copies of twelve to sixteen reduced folios and contained on an average from three thousand to four thousand dispatches. The material used in this correspondence was so light that one pigeon carried eighteen films, which contained altogether about sixty thousand dispatches and had a total weight of less than one gramme. In Paris and Tours the dispatches arriving from both sides were copied, and millions of copies were forwarded to the proper parties.

About 1898 Dr. Neubronner, court pharmacist, at Cronberg, Bavaria, installed a carrier pigeon mail service for the transmission of medical prescriptions between the hospital at Falkenstein and his pharmacy. He employed also a carrier pigeon photographic apparatus and a portable dovecote. This small camera, for from two to eight exposures, was attached to the breast of the pigeon and acted automatically during the flight of the bird in making photographs. This invention was tested at the carrier pigeon station of the Ministry of War at Spandau, but was found without practical value and is mentioned here merely as a curiosity ("Münch. neueste Nachrichten," in *Phot. Chronik*, 1898, p. 377).

Louis Jules Duboscq (1817-1886), to whom we owe numerous progressive steps in the field of photography, also constructed an apparatus for enlarging by electric light and presented it before the Paris Photographic Society, February 15, 1861.

Duboscq also equipped a projector with a device for the projection of horizontal objects by transmitted light, thus making them suitable to the so-called vertical projection. He used this apparatus for the demonstration of all kinds of physical and chemical experiments; magnetic lines of force, magnetic needles, crystallizations, etc. The Duboscq vertical device was imperfect inasmuch as he applied the mirror, which diverted the illuminating rays in the converging cone rays in

front of the condenser, which narrowed the range of vision. Professor
Henry Morton, of Philadelphia, improved this apparatus in the early
seventies.

M. Reiner, of Vienna, described, in 1890, the electric "epidiascope"
in his book published by Alfred Hölder, in Vienna, *Arbeiten aus dem
Institute für allgemeine und experimentelle Pathologie des Prof. Dr.
S. Stricker*. The name "epidiascope" was given by this university pro-
fessor of medicine, and the apparatus was constructed after his specifi-
cations. He used it with great success in his lectures at the university.
In the same publication mentioned above appears an article by Stricker
"Über das elektrische Mikroskop mit auffallendem Lichte." This made
the epidiascopic projection suitable for scientific lectures. The optical
works of Carl Zeiss, at Jena, produced, in 1898, an epidiascope con-
structed by the engineer Edward Richter. In 1903 August Kohler
reported on an appliance for microprojection, manufactured by Zeiss.
This topic is dealt with in *Zentral-Zeitung für Optik und Mechanik*
(1928, No. 25).

Chapter LIII. THE SOLAR CAMERA

THE EARLIER METHODS for the production of negatives on glass per-
mitted only exposures on paper or glass plates of small size, and enlarge-
ments were made from them on paper, linen, glass, and so forth.
The photographic papers and the other materials had only a limited
light-sensitivity; for this reason enlarging cameras were used with
direct sunlight and were called "solar cameras." These enlarging cam-
eras were constructed after the principle stated by Davy in Chapter XV
and later described in Chapter LI.

Gatel made enlargements in July, 1854 (*Gazette du midi*, July 8,
1854; *Bull. Soc. franç. phot.*, VI, 70), in the following manner. He
inserted the negative in the camera, set up a reflecting screen and placed
the lens so close to the negative that he obtained an enlarged picture.

The American J. J. Woodward, in Baltimore, was the first to con-
struct, in 1857, a well-designed enlarging apparatus in which he collected
sunlight by means of a plano-convex lens and used this condensed light
for the production of enlarged positives from small negatives. He
patented the apparatus in England (Sept. 22, 1857, No. 2459) and
brought it to the attention of the photographers in Paris and London in

1859. The design of this apparatus was followed in all later solar cameras. This theory was studied by Claudet (*Bull. Soc. franç. phot.*, 1860, p. 249) and Léon Foucault (*Bull. Soc. franç. phot.*, 1861, VII, 1; Kreutzer's *Zeitschr. f. Phot.*, 1861, III, 214); and others (for further details see *Handbuch*, 1892, II (1), 662).

Wothly, a photographer in Aachen, made a practical improvement on Woodward's solar camera in 1860 and exhibited portraits almost life size, which had been enlarged with a solar camera, at the session of the French Academy of Sciences, October 8, 1860 (*Compt. rend.*, LI, 558), attracting much attention thereby. Disdéri, in Paris, acquired this process for twenty thousand francs in the same year, with the privilege of being its sole user in France. This type of solar camera consisted in the separation of the reflector from the apparatus, which did away with the vibration caused by the turning of the mirror during the exposure (illustrated in the 1932 ed. of the *Geschichte*, p. 550).

In the *Deutsch. phot. Ztg.* (1909, p. 453) it is mentioned that Wothly had traveled to Aachen as an assistant to a bearkeeper, then turned to photography and acquired great wealth and position. He was an ardent equestrian, and on one occasion he was thrown from his horse and broke his leg. He recovered, retired from business, and entrusted his large fortune to a banker, who failed during Wothly's absence on a trip. He did not long survive this blow of fate. Wothly's character was dramatized in Speilhagen's novel *Der Sturmvogel*.

Wothly's solar camera was very large. The condenser had a diameter of one meter (39.37 inches) and a focus of two meters (about 6½ feet). The sunlight was reflected on it by a large mirror. The author acquired such an original apparatus in 1890; it was in a workable condition and was installed as an historic relic on the flat roof of the Graphische Lehr- und Versuchsanstalt, Vienna, under his direction. The enormous heat of the condensed rays of the sun made it necessary to cool the rays with systematically arranged parallel water troughs.

With such solar apparatus all enlarging was done in the sixties and the seventies. Generally the process introduced by Talbot and improved by Blanquart-Evrard was employed in the preparation of the paper, with solutions of iodides (possibly mixed with bromides or chlorides). The paper was then dried, sensitized in a silver bath containing citric acid, and exposed from several minutes to a half-hour, the faint image being developed with gallic or pyrogallic acid, with the addition of citric acid, lead acetate, and so forth; or the enlargements

were made on albumen paper, sometimes also on paper treated with a pigment (about 1870 and later) which required several hours in the solar camera; or a weak print was made on salted paper (silver chloride), which was used by artists and painters as a base for drawing or painting, the parts not so covered being subsequently bleached out with mercury bichloride.

Bertsch improved Woodward's condenser (1860), which consisted of one collecting lens, by the addition of a second one; likewise Monckhoven (1864), who called his apparatus "dialytic enlargement apparatus," improved it. In Vienna the court photographer, F. Luckhard, successfully employed such an apparatus in his studio.

We have treated this chapter somewhat in detail, because this phase of the development of applied photography, long since forgotten, was considered worth remembering.

The solar camera later disappeared entirely from the photographic industry and was replaced by enlarging cameras with arc lamps. Owing to the increased sensitivity of the silver bromide papers, other sources of artificial light, still weaker, could be used.

Chapter LIV. BALLOON PHOTOGRAPHY

THE FIRST SUGGESTION of photography from a balloon in the air appeared as a joke in a French lithographed caricature. Some years later a satire was published by Andraud: *Une Dernière annexe au Palais d'Industrie* (Paris, Guillaumin, 1855), in which the possibility was pointed out for the first time that bird's-eye views could be made by photography from a captive balloon. Andraud confined himself solely to the expression of what then seemed a purely fantastic idea, without dreaming that it would ever be realized.[1]

Without having any knowledge of this book, the photographer Gaspard Félix Tournachon, of Paris, who called himself Nadar,[2] decided, in 1858, to ascend in a captive balloon in order to obtain photographic bird's-eye views of the earth. He planned to produce an exact topographic map by photography from his captive balloon at a height of several hundred meters. In order to secure for himself the fruits of his project, Nadar applied for patents in France, England,[3] and other countries.

In carrying out his plans for photography from a balloon Nadar

met with many difficulties; he used the wet collodion process and tried to prepare his plates in a small photographic darkroom, lighted by an orange-colored linen window in the balloon; the hydrogen gas with which the balloon was inflated contained hydrogen sulphide, and this and other defects had a bad effect on the silvered collodion plates. Notwithstanding all this, he succeeded in making a photograph of the village of Petit Bicêtre, in which, despite spots and small defects in the negative, the houses can be clearly recognized.

CARICATURE OF BALLOON PHOTOGRAPHY

Honoré Daumier, the artist, one of the best-known Paris person-alities of his time, was urged by the balloon ascensions of the photog-rapher Nadar, in 1862, to draw a caricature of the balloons with the caption that Nadar had elevated photography to the "highest" art. This was later printed in *Paris photographe*, a journal published by Nadar's son.

Nadar was requested, in 1859, to make balloon photography ser-viceable for military purposes during the Franco-Italian War, but on the one hand he did not have sufficient confidence that his process could be successfully operated in the campaign, while on the other, being a radical republican, he did not care to follow Napoleon III in his expedition.

The first successful photographs from a captive balloon were made in America, in October, 1860, by the aeronaut Professor Samuel A. King and the photographer J. W. Black, employees of a Boston firm, who photographed the City of Boston from a height of 1,200 feet on wet collodion plates and under great difficulties, but with success, as reported in the *Boston Herald*, October 16, 1860. An especially suc-cessful balloon photograph by King and Black, dated 1861,[4] was preserved and was reproduced twenty-two years later in the *Photo-graphic News*, June 29, 1883.

In the American Civil War, however, the balloon was successfully operated (1861) in finding the enemy's positions, after General McClellan had succeeded in employing the balloonists La Montain and Allon. In 1862 the Union Army also used photography for recon-naissance from a balloon,[5] during the siege of Richmond, Virginia. From the negative of the terrain two prints were made, and each was cut up into sixty-four numbered squares, of which one copy was left with General McClellan, while the other was given to the balloonists.

They ascended on June 1, 1862, to three hundred and fifty meters (about 1,378 feet) over the battlefield, got into telegraphic communication with headquarters, and reported the exact position and movement of the enemy on the numbered squares of the map. General McClellan's success was greatly aided by the use of the balloon for photography and telegraphy.

King and Black, of Boston, photographed their city as early as 1860-1861 from a captive balloon. This photograph has been preserved and is reproduced in the 1932 ed. of the *Geschichte* (p. 554). Negretti photographed a London surburb in 1863 from a captive balloon.[6]

Later the English physicists Glaisher and Coxwell made meteorological and photometrical experiments in high air strata and investigated the speed of the blackening of photometric silver chloride paper in order to gain important data for photometry.

James Glaisher (1809-1903), director of the magnetic and meteorological branch of the Greenwich Observatory, made several ascents in the sixties in a free balloon. On one of these, in 1862, he was the first to use collodion dry plates for his aerographic pictures (*Photographic News*, Sept., 1862). These dry plates were made by Hill Norris, of Birmingham, according to his method of "preservation of the sensitivity in collodion plates," by coating them with a thin gelatine solution (to keep them porous) and then drying them. The sensitivity was sufficient for instantaneous exposures, which overcame the difficulty of the swaying and turning of the balloon. Glaisher ascended, in 1863, to a height of 2,000 feet and also used the Norris collodion dry plates.

In 1868 Nadar resumed his experiments at the Hippodrome in Paris and used Henri Giffard's balloon, guided by Arnaud, the balloon being raised to two hundred meters (about 660 feet). Nadar succeeded in making a brilliantly defined photograph of the Arc de Triomph, with its details, from this balloon. These are among the best results obtained in this field with wet collodion process.

When gelatine dry plates were introduced, the working procedure became more simple. The first trials with such plates from a free balloon were made by Triboulet, over Paris, on July 8, 1879, at a height of five hundred meters (1,640 feet); unfortunately, the officials at the octroi office (city tollgate) opened the plate holders in order to inspect the contents and thus destroyed his exposures. The first successful photographs on gelatine silver bromide plates from a free balloon were made by Desmarets, June 14, 1880, who obtained excellent negatives

with a lens of twenty-four cm. (about 9½ inches) focus and instantaneous shutter. Desmarets photographed, in 1880, the earth from a height of 1,100 metres (about 3,609 feet), and, with a camera pointed skyward, the clouds from 1,300 metres (about 4,265 feet). This remarkable photograph is to be found in the Museum of Arts and Trades in Paris. Then followed Cecil V. Shadbolt and W. Dale (1883), in England, V. Silberer, in Vienna (1885),[7] and others. A. Batut experimented (1887) in aerial photography by means of a kite to which a camera was attached, the exposure being made when it arose into the air,[8] and numerous experiments of the most recent times followed in the wake.[9]

Cecil V. Shadbolt undertook, in 1883 and 1884, numerous ascents in England with his balloon "Monarch," photographing on gelatine silver bromide plates. The camera was fastened to the gondola in a most primitive manner.

Gaston Tissandier, editor of *La Nature*, made a balloon ascent near Paris on June 15, 1885, with Jacques Ducom, an accomplished amateur. The photographic apparatus was fixed to the edge of the gondola; size of plates, 13 × 18 cm. (about 5 × 7 inches); rectilinear lens of thirty-five cm. (about 13¾ inches) focus; exposures, one-fiftieth of a second.

The tragic fate of S. A. Andrée's balloon expedition to the North Pole in 1897 is well known. The balloon was destroyed and all its passengers perished. The relics of this expedition were found thirty-three years later in the icy waste of White Island. The Kodak film rolls, which had been buried under ice and snow, were developed into serviceable negatives by John Hertzberg, in Stockholm.

E. Dolezal reports on the history of balloon photography in the annals of the Society for the Dissemination of Knowledge in Natural Science, Vienna, 1910. Further numerous reports on this subject are contained in the author's *Jahrbuch für Photographie*.

Thiele, in Moscow (1903), constructed a combination of seven cameras for panoramic exposures from balloons. In the balloon cameras of Müller and Klein (German patent No. 204915) the lens tilted downward and described a circle during the panoramic exposure. In the aerial photography of the past half century the airplane has largely displaced balloon and kite. This use of the airplane was first attempted about 1910 and was intensively developed in the World War 1914-1918; since then it has found increasing use in the making of topographical and commercial surveys (see Chapter LV).

Professor Karl Gunther, of Vienna, was the first to suggest the use of a small captive balloon carrying, not a person, but only a photographic camera; he desired to photograph the terrain and intended to control the exposure from the earth by an electrical device.

Walter B. Woodbury proposed, in 1877, this same method, in which also the opening and closing of the lens was to be controlled by an electric instantaneous shutter and long guide wires from the ground. He constructed this camera; it weighed, with accessories, about 6 kg. (about 13¼ lbs) and carried four photographic plates on a disk. These were exposed by a one-quarter turn. A small electromagnet set the instantaneous shutter, and another set in motion the disk with the plates.

The English military authorities interested themselves in Woodbury's apparatus, and Lieutenant Baden-Powell lectured, in 1883, before the Royal United Service Institution in London, but the idea was never applied in practice. Woodbury constructed only one camera for himself, which he never put into practical use (*Photographic News*, 1883, p. 400).

Kites were employed as early as the eighteenth century for scientific purposes (Wilson, 1748; Franklin, 1752). Photography with unmanned kites was tried by A. Batut, in 1887, and improved by the Russian R. Thiele. The use of a rocket camera was proposed by the Frenchman Denisse, in 1888; the German engineer Alfred Maul carried out the rocket apparatus in practice and was granted a German patent No. 162433, June 3, 1903.

The world record in photography from a balloon was achieved by Professor August Piccard, born in Zurich, Switzerland (1884). In 1915 he became assistant professor and in 1917 full professor at the Technical College, Zurich. In 1922 he was appointed professor of physics to the University of Brussels. His principal scientific investigations were in the field of magnetic and radio active measurements, as well as the action of the rays or their penetration, which can only be observed at great altitudes. For this study Piccard undertook his famous flight into the stratosphere. He achieved an altitude of more than 16,000 meters. He used a spherical hermetically enclosed gondola of aluminum constructed in Augsburg (Bavaria). He ascended from there on May 27, 1931, and landed on a glacier in Tirol. For his photographic exposures he used panchromatic dry plates made by Perutz, in Munich.

Piccard's second flight, on August 18, 1932, in which he used a spherical gondola constructed in Belgium, was made from Zurich, and he landed near the Lake of Garda, in upper Italy. Piccard's original reports appeared in the *Compt. rend.* (1932, Vol. CXCV; see also *Die Naturwissenschaften,* 1932). In the summer of 1932 Piccard traveled by way of France to the United States in order to prepare for other ascents. A modern French caricature shows the famous Piccard, balloonist to the stratosphere, leaving for America. Thus history repeats itself.

Here must also be mentioned the physicist Erich Regener, Technical High School, Stuttgart, who made, in 1932, measurements with small unmanned rubber balloons, which rose to a height of 20,000 meters. The measurements were automatically registered by photography. Regener furnished the exact proof that the intensity of the rays in great altitudes, contrary to earlier opinions, is considerably reduced in altitudes higher than 12,000 meters.

Chapter LV. PHOTOGRAMMETRY

THE FUNDAMENTAL mathematical idea of constructing geometrical plans from correctly drawn landscapes in perspective was first announced by Lambert (d. 1772) in Strasbourg. The Frenchman Beautemps-Beaupré in the year 1791-1793, executed topographical maps (freehand drawings) of a strip of the coast of Van Diemen's Land and of the Island of Santa Cruz, which he visited at the time. When later, 1837-1840, a French expedition was sent by Dumont-d'Urville commanding the corvettes "L'Astrolabe" and "Zélée," Beautemps-Beaupré had already worked out, in 1835, instructions to the naval officers and the hydrographic engineers, in which were laid down the principles of the picture-measuring method. Thus, the process of making measurements from pictures was known before the invention of photography.

When Arago (1839), in his memorable address on the discovery of daguerreotypy, spoke of the remarkable possibilities of the new art, he mentioned "the rapid method which topography might borrow from the photographic process."

As a scientific method, photogrammetry was first developed and introduced into practice about 1851 by Aimé Laussedat, an officer in the French Engineers' Corps, who later became colonel and honor-

ary director of the School for the Arts and Trades, Paris. We may call him the father of this process.

Laussedat's first important publication on the principles of photogrammetry appeared in 1854 under the title "Mémoire sur l'emploi de la chambre claire dans les reconnaissances topographiques." It was published in *Mémorial de l'officier du génie (No. 16)*; *rédigé par les soins du Comité des fortifications*, which report was continued in No. 17 (Paris, 1864). In Nadar's *Paris photographe* (1891-1893) Laussedat himself relates the history of his work.[1] Numerous excellent illustrations of his early photogrammetric instruments, as well as the first photographic exposures made in France, can be found there.

The first simple model used by A. Laussedat, in 1859, for photogrammetric exposures was constructed by the mechanic Brumer, in Paris. The French government purchased five of these cameras.[2] A map of the village of Buc, near Versailles, was made photogrammetrically in May, 1861, on the scale of 1:2,000.[3]

Laussedat took photographs of parts of Paris, in 1861, from the roof of the Polytechnical College and from the church of St. Sulpice and drafted plans from them which in exactness were in no manner inferior to the existing plans; in this one perceives the beginning of photogrammetry for architectural subjects. The Ministry of War took up the method for the French government, which was the first of all nations to introduce it.

We quote from the biography of Laussedat written for the author's *Jahrbuch* (1907, p. 217) by E. Doležal, professor of photogrammetry at the Technical College, Vienna:

Aimé Laussedat was born in Moulins, France, on April 18, 1819, and died in Paris, March 18, 1907. He became an officer, served with the engineers, and eventually became a colonel.

As an officer in the Technical Corps he devoted himself largely to geodetic work and turned to topography which attracted him greatly. As early as 1850 he made his first experiments in applying photography to ground maps, after he had already greatly improved the camera lucida. He is the inventor of a telemetrograph for great distances (1850), which he used during the War of 1870. In 1860 he constructed his horizontal photoheliograph.

Laussedat became professor of practical geometry at the Conservatory for the Arts and Trades and professor of topography at the Polytechnical College, Paris. He was director of the first-named institution from 1881-1890.

Laussedat was very prolific in his literary work; from his pen came numerous publications on photogrammetry, geodesy, astronomy, and aeronautics; his works are to be found in the *Compt. rend.*, the official organ of the Paris Academy, and in other photographic journals and independent publications.

His labors received due acknowledgment in the many honors bestowed upon him; we mention only that in 1879 he was made a Commander of the Legion of Honor, that he was elected a member of the Academy in 1883, and that the government entrusted him during his long life with many state and scientific missions. A monument erected to him at his birthplace, Moulins (Allier), was dedicated on October 15, 1911 *(Bull. Soc. franç. phot.*, 1911, pp. 287, 367).

Colonel Laussedat was for decades the interpreter of all the practical applications of photogrammetry to topography in architecture, meteorology, aeronautics, and of all efforts tending toward this use; even in his last years he permitted no chance to pass without pointing out to his countrymen, in lectures and articles, the progress of photogrammetry and of stereophotogrammetry.[4]

In Germany Albrecht Meydenbauer (1834-1921) devoted himself to the application of photogrammetry for the preservation of historical monuments. He was a civil engineer and architect. The war department, on the recommendation of General Wasserschleben, entrusted him, in 1867, with the project of experimental photographic work and placed at his disposal the necessary means. He made photographs of Freyburg and its environments and became (1885) the head of his own photogrammetrical institute ("Preussische Messbildanstalt"), which was supported by the Prussian department of education and directed by him until 1909. In the archives for historical monuments at this institute Meydenbauer recorded one thousand monuments in Prussia by the photographic method, working along the lines of historic art and archeological science. He later introduced successfully the method of "stand development" associated with his name. In this method a very dilute developer is employed, especially advantageous for interior exposures with great light contrasts; he used pyrogallol and later rodinal.

In Italy Professor Porro worked from 1855 on the improvement of photogeodesy. In 1875 mapmaking was done in Italy by the general staff (Lieutenant Manzi, later by Paganini). Then followed, in Austria, Vincent Pollack, chief engineer of the state railroads, Professor Schell, at the Technical College in Vienna, in particular Professor Doležal,

at the Mining Academy at Leoben, later at the Technical College in Vienna, who was also the founder of the International Archives for Photogrammetry, then Colonel Baron Arthur von Hübl of the Military Geographic Institute, at Vienna; in Germany Professor Koppe, at Brunswick, and others. England, as well as other countries followed with the introduction of photogrammetry.[5]

Photography from airplanes, photographs by flyers, and aerophotogrammetry found their most extensive use and an unexpected importance in the World War. They are also extraordinarily important in mapmaking and surveys during times of peace. Photographs from airplanes are usually distorted by the tilting of the camera (the inclined axis of the camera). These distortions must be rectified or corrected so that the photographs, when worked out, correspond to views taken vertically. In all these exposures the optical apparatus for the correction of distortion followed the principle of oblique correction introduced by Captain Theodor Scheimpflug and became very efficient.

Theodor Scheimpflug (1865-1911) studied at the Austrian Naval Academy, in Pola, and became lieutenant in the navy in 1898. He devoted himself to photography and allied sciences. Hoping to find recognition for his scientifically based ideas, he applied, in 1897, for transfer to the Military Geographic Institute, in Vienna. There he studied geodesy and photogrammetry under Professor Doležal, was definitely transferred to the army as captain in 1898, and detailed to the institute. Unfortunately, he found no real sympathy for his ideas dealing with the photographic correction of oblique pictures by the transformation of the aerophotogramme. He found so little support that he applied to the director of the Graphische Lehr- und Versuchsanstalt, in Vienna for an opportunity to do his experimental work there, which was granted. He carried on his research independently. In 1906 he invented the photo-perspectograph and the first rectification apparatus, developed the theory of photographic maps, and published it in his dissertation *Die Herstellung von Karten und Plänen auf photographischem Wege*, which he read before the Vienna Academy of Sciences in 1907. All this was of no avail; his work found no recognition from the military authorities. Fortunately, having private means, he continued his research. He wrote "Die Luftschiffahrt im Dienste des Vermessungswesens," in Hörne's *Buch des Fluges* (1911, Vol. I).

Theodor Scheimpflug recognized the importance of photogrammetry in conjunction with his process for land surveys and wrote on

the technical and economic possibilities of an extended survey of the colonies in the "Denkschrift der ersten Internationalen Luftschiffahrts-ausstellung" at Frankfurt a. M., 1909 (*Wissenschaftliche Vorträge*, Berlin, 1910, Vol. I).

Captain Scheimpflug's work was that of a pioneer in the technique of aerophotography and its scientific foundation; he received little personal glory, and the recognition due him was not bestowed upon him until after his death (see Doležal, "Th. Scheimpflug, sein Leben und seine Arbeiten," *International Archiv für Photogrammetrie*, 1911; Moffit, "A Method of Aerographic Mapping," *Geog. Review*, 1920). The Aero Club affixed a memorial tablet to his paternal home in Vienna.

Stereoscopy was applied in photogrammetry by Dr. C. Pulfrich, of the scientific department of the Carl Zeiss works at Jena, in 1901, and marked a great advance in photogrammetry. He constructed the stereocomparator, in which two stereophotographs of the two ends of one base could be viewed stereoscopically, by which the position and height of all those points of territory included in both photographs could then be determined.

Carl Pulfrich (1858-1928), the son of a teacher, studied physics and mathematics in Bonn, established himself there in experimental physics and constructed his well-known refractometer for chemists; Abbe engaged him as collaborator, in 1890, for the Carl Zeiss works (department for optical measuring instruments). In 1899 Pulfrich constructed a stereoscopic range finder, and, after extended studies, devised the stereocomparator in 1901 (*Zeitschr. f. Instrumentenkunde*, 1902). He also worked with the astronomer M. Wolf, of Heidelberg, in the field of astronomy, and demonstrated that the mountains and valley of the moon could be really recognized as such and measured with his instruments. The development of the stereoscopic measuring method became of great importance in surveying; he improved the stereocomparator and perfected the stereoautograph (automatic measuring apparatus) invented by E. von Orel. His studies are collected in his work *Die Stereoskopie im Dienste de Photometrie und Pyrometrie* (1923). Professor Dr. E. Doležal writes: "Pulfrich became the benefactor of photogrammetry through his stereocomparator; the method of stereophotogrammetry originated by him has found a wide-spread application and the instruments constructed by him for stereophotogrammetric use enjoy general favor and esteem."[6]

First Lieutenant E. von Orel, while working in the cartographic

division of the Military Geographic Institute, at Vienna, in 1905, invented the photogrammetric stereoautograph; by its aid contour lines could be drawn mechanically (automatically). The movements of the stereocomparators connected with it can be transferred with a pencil by a pantograph-like line system. His apparatus was constructed at Jena with the co-operation of Pulfrich. It was then tested in the Military Geographic Institute, at Vienna, under the supervision of Lieutenant Field Marshal A. von Hübl and found widespread use. This idea was later carried out for the mechanical reproduction of maps from aerial pictures (see H. Hugersdorff, *Autocartograph*, by the firm of Zeiss, at Jena, also *Zeitschr. f. Instrumentenkunde*, 1931, p. 214).

E. von Orel left Vienna after the collapse of Austria following the World War and moved to Switzerland, where he follows his vocation.

Chapter LVI. MODERN PHOTOGRAPHIC OPTICS

PETZVAL'S LENS met the requirements for portraits perfectly, but his orthoscope had not a sufficiently large field of view for landscapes and architectural subjects and was not suitable for reproduction work, because it was not wholly free from distortion. Many opticians and photographers experimented with many kinds of new lenses (see *Handbuch*, 1911, I (4), "Die photographischen Objektive").

A new era in lens construction began in 1865 with the calculation and construction of aplanatic lenses by the ingenious optician Dr. Adolph Steinheil, of Munich. His activities made Munich for many years the center for the improvement of photographic lenses.

Dr. A. Steinheil was born at Munich, April 12, 1832, the son of the celebrated physicist Karl August Steinheil.[1] He studied in Munich and Augsburg and moved to Vienna in July, 1850, where his father had been called for the installation of telegraphy. He continued his studies in Vienna and was employed, in 1851, as assistant in the telegraph department of the government.

Adolph Steinheil returned to Munich in November, 1852, and devoted himself to optics because his father was charged by King Maximilian II with the task of preserving the reputation of Bavaria for optical achievement that had been gained by Fraunhofer. During

1853-1855 he took part in the preliminaries for the establishment of the Optical Institute, which was opened in May, 1855.

His principal work during the next few years consisted in finding a method of calculations for two image points, one in the optical axis, the second lying laterally from the axis. During the calculation of the laterally lying image points it was demonstrated that, in addition to the pencils of rays outside the optical axis, the rays in the axial plane must also be calculated. Steinheil the elder requested Professor von Seidel (1864) to study this problem, and Seidel developed and placed at their service formulas for the investigation of any rays by a system of central spherical areas. These figures made it possible to produce an optical system by calculation alone.

The first photographic lens calculated by Steinheil was the "periscope," for which he, jointly with his father, took out a patent in 1865. The Steinheil periscope consisted of two symmetrical single (flint-glass) menisci of one and the same kind of glass and showed 100° field angle free of distortion, but it possessed a different focus. The Steinheil wide-angle lens, having been introduced into practice, came to the notice of the American optician Zentmayer, in Philadelphia, and he constructed an analogous wide-angle lens with two single flint-glass menisci of the same kind of glass, but he made the lens unsymmetrical with a smaller front lens (1866). The Zentmayer lens, which had to be diaphragmed down to f/40 when in use, soon disappeared from the market after Steinheil, in 1866, brought out his "aplanat," which, based on the periscope, was made achromatic.

In the same year Dr. Adolph Steinheil purchased the optical works and associated with him his elder brother Edward,[2] who looked after the business affairs. Using the symmetrical periscope as a starting point, Adolph Steinheil calculated his aplanat, which has become famous; the construction of this symmetrical, achromatic, and aplanatic double lens after an original drawing by Dr. Steinheil is reproduced in the 1932 ed. of the *Geschichte* (p. 566).

On July 26, 1866, Adolph Steinheil sent his first specimen (proof of which is available) to Monckhoven, in Belgium, who was writing a book on photographic lenses. Steinheil was granted a patent in Bavaria on January 14, 1867, for his optical system (*Handbuch*, 1884, I, 228). The first aplanatic lenses had an aperture 1/7 and a angle of view of 60°. This lens was made for landscape and architectural subjects and groups taken in the open, for which wet collodion plates had sufficient rapidity.

At the Paris Exposition of 1867 Adolph Steinheil received the gold medal in the division of optics for correctly drawn constructions (aplanats, magnifying glasses, oculars, and field-glass lenses) and in the photographic division, in which the aplanats were passed unnoticed, a bronze medal for the first wide-angle lens for landscapes. (This lens was later listed in series V of his price list.)

In 1868 he constructed, on an order from the Military Geographic Institute, in Vienna, wide-angle lenses for reproduction purposes, with which cartographic reproductions could be produced without distortion up to about a square meter (39.37 inches square). He constructed wide-angle and landscape aplanats and in 1881 the first aplanatic lens sets. Steinheil brought examples of this latter construction to Captain Pizzighelli, who was in charge of the photographic department of the Technical Military Committee, in Vienna, where they were tested. These landscape aplanats had a field of view of 80° with adjustable focus. They were deemed the best of the period, came into general use, and were quickly imitated by foreign opticians. Following long studies on the influence of the thickness of lenses, Steinheil was granted a patent in 1874 for portrait aplanats and in 1879 for group aplanats. In 1881 he was granted a patent for antiplanats, after having made a series of lengthy calculations, disregarding symmetry, and after having made a partial compensation of the astigmatism.

Adolph Steinheil collaborated with the author in his work on "Die photographischen Objective," published in the *Handbuch* (1884, Vol. I), and generously supplied the optical data of his lens constructions for publication (radii of curvature, qualities of glass); these are the only original construction data of that time for Steinheil lenses. Adolph Steinheil was on friendly terms with Abbe, who originally calculated accurately only microscope lenses and joined Steinheil at Munich in order to learn from him the mathematical calculations for photographic lenses with large lens apertures as Steinheil executed them. Abbe found in Steinheil the necessary encouragement. Steinheil was in no way a secret monger and published, with Professor Ernst Voigt, of Munich, *Handbuch der angewandten Optik* (Leipzig, 1891); however, only one volume appeared. Owing to his protracted labors, Steinheil lost the sight of one eye, which had to be removed in order to save the other; he had one artificial eye during the last years of his life. He died in Munich, Nov. 4, 1893. His son Dr. Rudolf Steinheil (1865-1930), became the head of the firm after his father's death and

introduced new anastigmats. With Dr. Rudolf Steinheil the male line of this famous family of opticians came to an end. The firm was changed into a stock company owned by the heirs (five daughters), and one of Steinheil's sons-in-law, the engineer L. Franz, became the manager of the company.

PATENT LITIGATIONS BETWEEN STEINHEIL AND DALLMEYER

A few months after Adolph Steinheil sent to Monckhoven the first specimen of his aplanats, which in this way became known, John Henry Dallmeyer, who had emigrated to London from Germany, came out with an analogous aplanatic construction. He used flint crown glass with the flint-glass lens on the outside, instead of Steinheil's heavy and light flint glass. Dallmeyer was granted an English patent (No. 2502) on September 27, 1866, for his "rectilinear." From this arose a controversy about the priority rights. Dallmeyer attacked (*Brit. Jour. Phot.*, 1874, p. 584) the originality of the construction with weak arguments, but the controversy ended in favor of Steinheil. He had already, in 1865, published the construction with flint on the outside in the *Nachrichten von der k. Gesellschaft der Wissenschaften an der Universität zu Göttingen*. (See also Steinheil's earlier statements in the *Phot. Korr.*, 1869, p. 97.) Steinheil's victory over Dallmeyer was complete from a scientific standpoint, but in a commercial way he lost, since, owing to the incapacity of his legal representative in England, Steinheil was deprived of the financial returns from his invention in that country.

Dallmeyer was connected by marriage with the family of the well-known optician Ross. The firm of Dallmeyer was founded with the support of the Ross family and produced not only portrait lenses, named after Dallmeyer (according to the Petzval system), but also aplanatic lenses (Steinheil system), which found great favor in England.

J. H. Dallmeyer died in the early eighties, and his son Thomas Rudolf Dallmeyer took his place. The old firm of Ross resumed later the commercial production of lenses with renewed vigor and entered actively into competition. The French opticians also constructed aplanat sets according to Steinheil's type: for instance, Français in Paris and then Suter in Switzerland (*Handbuch*, 1884, Vol. I).

FURTHER APPLICATIONS OF APLANATS

A. Steinheil's invention of the aplanat was of no less importance for

the photography of architectural subjects, landscapes, interiors, reproduction processes, and group pictures than the Petzval lens was for portrait photography.

The considerable speed of aplanatic lenses and the sharp and correct delineation to the edges and the lack of stray light due to internal reflections were their most valuable advantages.

Aplanats of medium rapidity were followed by landscape and wide-angle aplanats with 80° to over 100° angle of view by Steinheil, while Voigtländer, in Brunswick, constructed according to the aplanatic system his "euryscope," which was somewhat faster (1/6) than the ordinary aplanatic lenses.

Voigtländer brought the first two examples of this lens personally to Vienna, in 1886, one to the portrait studio of the court photographer Josef Löwy, another to the author; these lenses were nameless at the time and were only subsequently called euryscopes. They could be used with silver bromide gelatine plates for instantaneous exposures (Eder, *Momentphotographie*, 2d ed., 1887). Aided by the calculations of his stepson, Hans Sommer, Voigtländer increased the speed of his euryscope to such a degree that he relegated the earlier Petzval construction for ordinary portrait lenses to the background and centered his attention on speed lenses and projection lenses. At the foundation of the Graphische Lehr- und Versuchsanstalt, at Vienna, Fr. von Voigtländer presented a valuable collection of all his lenses produced up to that date. This is the most complete collection of its kind. Voigtländer was knighted for this and other services.

INVENTION OF ANASTIGMATS

Aplanatic and similar lenses suffered from the imperfect elimination of astigmatism on the edges of the picture; Steinheil attempted in 1881 to overcome this defect by antiplanat (with thick glass) along new lines. The antiplanat was extensively used in the eighties for instantaneous and group photography until it was displaced by the anastigmatic lens. Rudolf Steinheil worked also much later in the modern construction of lenses. He calculated with Dr. Karl Strehl the orthostigmat lens of his firm and the quadruple lens combination "unofocal."

Following Steinheil, the physicist Ernst Abbe devoted himself to theoretical and applied optics.

Dr. Ernst Abbe (1840-1905) was professor at the university in Jena, director of the observatory, 1878-1889, joined the optical works of Carl Zeiss, 1866, became a partner in the firm, 1875, and gave his

share in the business to the Carl Zeiss foundation. He achieved distinction in the construction of microscopes, field glasses, and photographic lenses and invented numerous optical apparatus (for his biography see *Ernst Abbe*, by Felix Auerbach, 1918; also numerous publications of Von Rohr; Auerbach also wrote, in 1903, on the Carl Zeiss Foundation).

Only a very limited number of varieties of glass ("crown and flint") were suitable for lens systems in mathematical optics up to the eighties. In 1884 a glass works was established by Dr. Otto Schott, at Jena, supported by the German government, which furnished, with Professor Abbe's collaboration, the material for new lens systems. This Jena glass was produced by the application of new combinations (by addition of barium, zinc, phosphoric acid, boric acid, and so forth),[3] which permitted the attainment of better achromatism, a more extended field of view, and other advantages. The introduction of these new kinds of glass, beginning from 1886 and 1888, stimulated the production of photographic lenses. Thus A. Steinheil, in 1886, produced and delivered an aplanat (No. 16147) made from special glass; the firm of Voigtländer & Son, Brunswick, in 1888, made public the first euryscope (aplanatic type) constructed from special Jena glass.

Professor Abbe called in the clever mathematical optician Dr. Paul Rudolph (born 1858),[4] on the results of whose calculations he himself reported in the *Jahrbuch für Photographie* (1891, p. 225; 1893, p. 221). The first anastigmats, according to Rudolph's calculations and produced from the new Jena glass, were patented by the firm of Carl Zeiss, April 3,1890 (No. 56109). As early as May 30, 1890, the first examples of the anastigmatic lenses completed by the firm were sent for tests to the Graphische Lehr- und Versuchsanstalt, Vienna. These specimens were as follows: a triple lens with the relative opening 1:6.3 and a 90° angle of view; an anastigmat 1:6.3 with 85° view angle (this was a double lens system consisting of five lenses); an anastigmat 1:10; an unsymmetrical double lens system for wide-angle exposures and for reproductions; and an anastigmat wide angle having 110° view and also a double-lens system consisting of four lenses. All these lenses[5] were unsymmetrical, with excellent correction of astigmatism, permitting a great extension of the field of view with uniform sharpness in every portion of the plate. Dr. Paul Rudolph was justly called the first inventor of the modern "anastigmat." After having been granted the patent of May, 1890, the firm of Carl Zeiss forthwith produced

six series of different relative proportions of apertures—from 1:4.5 up to 1:18. The anastigmats 1:4.5 up to 1:9 were of the doublet type, five-lens system; those 1:12.5 and 1:18 were of the four lens unsymmetrical type, which Dr. Rudolph illustrated in the author's *Jahrbuch* (1893, p. 226).

The glass used for those lenses was the new Jena glass (Barita flint and light crown glass). The oldest types of Zeiss lenses were called "protar" (Eder, *Phot. Objektive*, 1911, p. 128). In 1895 the double protars were added to the list (doublets, each of four cemented lenses).

This modern type of lens construction has been increasingly followed since 1890. Later the new construction of tessar lenses (German patent 142,294, April 25, 1902) made their appearance, the rear lens consisting of two connected elements and the front lens of two elements which are separated. They were introduced in different series for instantaneous and reproduction photography, which chapter of modern optics we shall not further discuss here.

About 1920 Dr. Rudolph calculated a new six-lens double objective, in which each two lenses were sealed together and each single lens was left separate; he called these lenses "doppel-plasmat." When he found that the Zeiss works did not show sufficient interest to suit him, he entrusted the production of this lens to the optician Hugo Meyer, in Görlitz, who had already constructed other lenses (aristostigmat, and others).[6]

One of the outstanding personalities in the field of modern photographic optics was Carl Paul Goerz (1856-1930), who succeeded in working his way up from the most modest beginnings to head of a gigantic enterprise.[7] After being graduated from the high school, Goerz became an apprentice in the employ of Emil Busch, at Rathenow. He worked later in different optical establishments, founding in 1886 his own business at Berlin, which, as the Goerz optical works, became well known in every part of the world. He supported the work of Anschütz and others.

In 1886 he took over a firm dealing in mathematical, drawing implements, and so forth, which he sold to schools. Recognizing the importance of photography, he added photographic apparatus to his stock and began in 1888 to make them in his own shop; in 1890 he joined Anschutz in the construction of the Goerz-Anschutz cameras for instantaneous photography, for which he furnished the optical equipment. At first Goerz produced only known types of photographic

lenses;[8] for instance, the triplet landscape lens of Dallmeyer in a some-
what altered form; then, following Steinheil's aplanats, he successfully
brought out, at the end of the eighties, his "lynkeyoskope." One day
Goerz received a visit from the mathematical optician E. von Hoegh,[9]
at that time wholly unknown, who informed Goerz that he had cal-
culated a new symmetrical lens system, which was very well corrected
anastigmatically. Goerz made tests and recognized with clear fore-
sight the importance of this new construction. He took out a German
patent, in 1893 (No. 74,437) for this symmetrical, anastigmatic,
double lens system, which he named "double-anastigmat"[10] with an
aperture of 1:7.7. Later, finding that the name was not protected by
law and was also used by others, he renamed the lens "Dagor," and
increased its speed to 1:6.8, producing them with enormous success.

At the World's Fair in Chicago, Goerz's double anastigmat attracted
great attention, and the sales increased tremendously. The thirty
thousandth lens of this type was furnished by Goerz in 1896.

The Goerz double anastigmat was patented at once in all countries,
but Goerz forfeited his French patent rights, owing to the error of
having imported one of these lenses into France before the patent was
applied for. When the patent expired in Germany and other countries,
the production of Goerz, Steinheil, and Zeiss lenses became common
property. The Goerz-Hoegh double anastigmat was based on the
symmetrical six-lens reproduction aplanat of Steinheil, but it attained
greater luminosity and better anastigmatism by means of the new Jena
glass used in its production. Dr. Rudolf Steinheil, in Munich, worked
at the same time and independently on a similar construction, but
Goerz-Hoegh had applied for their patent in Germany several weeks
earlier. Steinheil, however, succeeded in getting a patent, but only after
a long dispute with Goerz's firm on a second type of the six-lens aplanat
with the new Jena glass. This new anastigmat he called "orthostigmat."
Soon after the publication of the orthostigmat, the firm of Voigtländer
contended that theirs was the prior right to use the Steinheil type,
since they had made all necessary preparations of the invention when
Steinheil applied for his patent, and they compromised by agreeing
that Voigtländer, in Brunswick, would be permitted to manfacture
this lens, which he called "collinear."

Dr. H. H. Harting calculated the "heliar" of Voigtländer. This lens
was offered for sale in 1902, and the patent was applied for far ahead of
that of the Zeiss tessar, which appeared on the market at the same time

(1902). In the construction of the heliar, magnalium an alloy of magnesium and aluminum, which is much lighter than brass, was used by Voigtländer for the lens tube. Later the "dynar" and "oxyn" lenses, calculated by Dr. Harting, were made and sold by Voigtländer.

The optical works of C. P. Goerz at Berlin-Friedenau were very successful commercially. They supported scientific investigations in the various branches of applied optics, and C. P. Goerz was awarded the honorary degree of Doctor *honoris causa*. Goerz also established a factory for the manufacture of gelatine silver bromide films for cinematography, constructed projectors for photographic projection, for automobiles, and for military use, and invented carbons with electrolytic deposited copper for electric lamps. In 1925 the firms of Goerz, Ica, Ernemann, and Contessa-Nettel were consolidated, and on September 15, 1926, they were merged with the firm of Zeiss. The consolidation was known as Zeiss-Ikon-A.-G. The former Goerz works in Berlin were continued and carried on under the name of Zeiss-Ikon-A.-G. Goerz-Werk.

This subject is too broad to be dealt with in further detail here, and we must confine ourselves to mentioning the old and reputable optical establishments of Busch, of Rathenow, Meyer, of Görlitz, Rodenstock, of Munich, Rietschel Reichert, of Vienna and Suter, of Basel. Dennis Taylor, in London, calculated the triplet "Cooke lens" which Voigtländer improved as the heliar.

In recent years the rapidity of lenses for making the small negatives of motion pictures has been enormously increased, so that we now have lenses with apertures of about 1:1.6 to 1:2, of which details may be found in the author's *Jahrb. f. Phot.*

Reginald S. Clay delivered a lecture on the history of photo-optics in London, in which he gave due credit to the German scientists and optical establishments (*Opt. Rundsch.*, 1923, p. 907). Clay arrives at the most interesting conclusion that most of the better-known lenses constructed by English opticians were calculated by Germans and that the Cooke lens of Harold Dennis Taylor (1893) was to be regarded as the only really good true English type. The Ross lenses come from Schroeder; the Ross "homocentric" is the "aristostigmat" of Meyer, calculated by Kollmorgen; the Ross "telecentric" goes back to Bielicke; "teleros" comes from Hasselkus, who also calculated the "Ross-combination" lens. The "aviar," of Warmisham, produced by the optical works of Taylor, Taylor and Hobson, is the same as

"dogmar," but is less efficient; the Ross "xpress" is a poor Zeiss tessar.

For the most recent history of photographic optics, the specialized literature of the subject should be consulted.

Chapter LVII. FURTHER DEVELOPMENT OF PHOTOCHEMISTRY AND PHOTOGRAPHIC PHOTOMETRY

AFTER THE PUBLICATION of the process of daguerreotypy there followed an expansion of knowledge of the chemical action of light on organic substances, due to the fact that in 1839 Jean Baptiste Dumas produced synthetically trichloracetic acid by the interaction of chlorine on acetic acid in sunlight. This was the beginning of a series of photosyntheses (*Annal. chim. et phys.; Jour. f. prakt. Chemie*, XVII, 202).

In 1848 Anton V. Schrötter (1802-1875), professor of chemistry at the Vienna Polytechnikum, discovered amorphous red phosphorus and described it as a new allotropic form of phosphorous. The priority of his discovery was established by a committee of the Academy of Science, in Vienna (regardless of the claims of the physician Dr. Joseph Goldmark, brother of the famous composer Carl Goldmark). His bust is placed in the Technical Museum, Vienna.

In the middle of the last century a new era of scientific photochemistry began with the investigation on the formation of explosive chlorine detonating gas under the action of light, by Bunsen and Roscoe. The starting point of these experiments was a mixture of chlorine gas and hydrogen; the combination through light action in hydrogen chloride was known for a long time. J. W. Draper, of New York, had tried in 1843 to utilize this light reaction for measuring the chemical or active power of the sunbeam by employing as a photometrical criterion the diminution of volume which takes place in the formation of hydrochloric acid when this gas mixture is exposed to light (Draper's tithonometer).

Wittwer, in 1855, commenced his experiments on the decomposition of chlorine water by light (Poggendorff's *Annal.*, XCIV, 597) and calculated the experimental results. They indicated that the decomposition of chlorine water by light followed the law of mass action of

Guldberg and Waage. He entered into a controversy with Bunsen and Roscoe, improved his method in 1858, and continued his research in 1865. His labors received due recognition later from Nernst. This is gone into more exhaustively in Plotnikow's *Allgemeine Photochemie* (Berlin and Leipzig, 1920, pp. 96, 133, 369). See also Berthollet's (1785) and Saussure's (1787) earlier work on the sensitivity of chlorine water to light.

Bunsen and Roscoe, in 1854, entered on investigations of chlorine detonating gas and recognized that Draper's tithonometer was not suitable for accurate light measurements, due to many basic errors. They therefore sought a different method of experimentation which would eliminate these basic faults. After many and tedious attempts, they succeeded in constructing their chlorine detonating gas photometer, which enabled them to exclude all disturbing influences from their measurements. This made it possible to record the chemical action of light, not only as a relative quantity but also as an absolute measurement. With these classical investigations on the action of light on chlorine detonating gas the period of scientific photochemistry was begun. Their work was the first photochemical measurement and focussed the attention of scientists on the nature of the reaction producing the effects of the light rays. Robert Wilhelm Bunsen (1811-1899) collaborated at the University of Heidelberg with the English chemist Henry Enfield Roscoe (1833-1915). The dissertations appeared under the title, "Photochemische Untersuchungen," in Poggendorff's *Annal.*, 1855-1859 (reprinted in Ostwald's, *Klassiker der exacten Wissenschaften*, pp. 34, 38). They determined the phenomena of induction, deduction, and extinction. They found that the beginning of light reaction takes place at first very slowly and that the velocity increases gradually until it attains a constant value, observing also that steam accelerates the action and that air retards it. Although this interpretation of the action of light received later a different theoretical conception, their investigations were nevertheless epoch-making.

"Photochemical induction" was the name given by Bunsen and Roscoe to the phenomenon which they first observed in chlorine detonating gas, namely, that the speed of reaction is slow in the beginning, increases in proportion to the length of exposure, and then maintains a uniformly steady course.

Bunsen and Roscoe found that within the field in which the so-called induction disappears the changed quantity of the light-sensitive sub-

stance (chlorine detonating gas) per time unit is in direct proportion to the incident light intensity (Bunsen and Roscoe, *Reziprozitäts-Gesetz*).[1]

However one may evaluate the phenomenon of "photochemical induction" observed first by Bunsen and Roscoe in chlorine detonating gas, theoretically its importance for practical applied photochemistry consists in the fact that a certain initial action of light is essential in order that a normal sequence of the photographic effect may be obtained.

The wet collodion process had already demonstrated that an initial action of a not-altogether-too-weak light is essential in order to obtain normal negatives, and this applies also to the gelatine silver bromide process, which was probably first determined by the author in 1881 (Eder, *Die Photographie mit Bromsilbergelatine-Emulsion*, 1881; *Phot. Arch.*, 1881, p. 109).

Bunsen and Roscoe also found that the light absorption by chlorine in a mixture of chlorine detonating gas was greater than by chlorine alone. The difference of the absorbed light quantities seems to be taken up by the chemical energy necessary to the reaction (" photochemical light absorption").

With the aid of the chlorine detonating gas photometer, Bunsen and Roscoe conducted a series of measurements of the chemical intensity of the direct, as well as of the diffused, sunlight. The determination of the relationship of the intensity of light to the position of the sun was established by Bunsen and Roscoe on a clear day (June 6, 1858), on the summit of the Gaisberg, near Heidelberg (375 meters - 1,230 feet). On the basis of the formula given by them, the chemical illuminating power of a clear sky could be calculated for any definite geographical place at any given time (altitude of the sun). They also found that the chemical action of the atmosphere's diffusion of light was very irregular, particularly when the blue sky was overcast by mist or clouds. These tables and formulas are the public property of the photographic world and have served as the basis of all subsequent exposure tables.

LAW OF PHOTOGRAPHIC RECIPROCITY AND PHOTOMETERS

The first photometer to record photographically was invented by Landriani.

At the time of daguerreotypy Faustino Jovita Malagutti attempted

to determine the intensity of daylight by means of the darkening of silver chloride paper to a certain predetermined standard point; his object was to measure in this manner the corresponding time of exposure.[2] He accepted in 1839 the hypothetical law of blackening in which, $i \cdot t = $ constant. Malagutti was born at Bologna, in 1802, studied in Paris, was Pelouze's assistant in Gay-Lussac's laboratory and later Professor of chemistry at Rennes. He wrote numerous chemical works and investigated also the law of absorption of ultraviolet rays (Poggend., *Annal.*, XLIX, 567).

While Malagutti set up the "Law of Reciprocity" in a speculative manner, he failed to give the precise proofs of his assertions. Bunsen and Roscoe gave proofs of their theory, and the law is justly named after them in the later technical literature. Continuing their work Bunsen and Roscoe in 1862 occupied themselves with the exposure relationship of silver chloride paper by direct exposure (Poggend., *Annal.*, XXVII, 530). They perfected photometry on an exact basis by the use of photographic silver chloride paper and established experimentally the law of photographic reciprocity, which within certain limits (see "Die Sensitometrie und photographische Photometrie," in *Handbuch*, 1930, III (4), 13) is valid in this and in the allied methods for the measurement of the intensity of "chemical rays" at different times of day and year. All exposure tables in use today by photographers are based on Bunsen and Roscoe's measurements. These subjects are fully covered in the different parts of the *Handbuch* and are generally known and employed in scientific photography, therefore we shall not deal with them here in further detail.

Bunsen and Roscoe introduced a standard gray for silver chloride paper (one part pine soot, 1,000 parts zinc white, and some gelatine). The number of seconds necessary for the attainment of the standard gray by silver chloride paper were designated by Bunsen and Roscoe as the light unit.

It was an auspicious coincidence when three of the leading scientists of the middle of the last century, Bunsen, Kirchhoff, and Roscoe, met at the University of Heidelberg.

Robert Wilhelm Bunsen (1811-1899) was called in 1852 from the University of Breslau to Heidelberg. His outstanding investigations in the domain of chemistry and physics cannot be discussed in detail here. Those best known are his investigations in spectrum analysis which he made jointly with the physicist Gustav Robert Kirchhoff

(1824-1887), who was called to Heidelberg in 1854. Bunsen and Kirchhoff laid the foundation for spectrum analysis in 1860. Kirchhoff went to Berlin in 1875. He was in poor health for years and was compelled to use crutches for a time. His colleague Bunsen enjoyed life for many years.

We quote from *The Life and Experiences of Sir Henry Enfield Roscoe* (1906, p. 47), written by himself:

Bunsen's Laboratory was a quaint one. It had been an old monastery. The high-roofed refectory had been fitted up with work benches, whilst the chapel became the storeroom. The increasing number of students, however, made it necessary to enclose the cloisters with glass windows, in front of which a series of work benches were arranged. . . . Of course, we had neither water nor gas. We used Berzelius' spiritlamps, and drew our water from the pump. All our combustions were of course, made with charcoal and the evaporation of the wash waters of our analysis was carried out over charcoal fires.

Notwithstanding this primitive equipment, excellent experimental work was carried on there by Bunsen and his students. It was not until 1853 that a new chemical laboratory was built and equipped with gas, after the demolition of the old monastery.

While Bunsen and Roscoe carried on their experiments on the photochemistry of chlorine and hydrogen gases, only wooden shutters in the roof were at their disposal for their observations of the actinism of the sun rays. Roscoe suffered greatly from the summer heat, but did not allow this to interfere with his work.

The Englishman Roscoe was graduated from the University of London, 1835, with the degree of Bachelor of Arts. He went to Heidelberg in the same year for a postgraduate course in chemistry with Bunsen, who soon made him an assistant in his scientific work. They began in 1854 their investigations of the chemical action of light on a mixture of chlorine and hydrogen as mentioned above. Roscoe received his doctorate in Leipzig and became in 1857 professor of chemistry at the University of Manchester. He often returned to his beloved teacher Bunsen, and he spent his summer vacations in Heidelberg until 1863, when he married. The most important results of their joint work are their photochemical investigations. Later Roscoe worked independently and published, in 1865, the *Method of Meteorological Registration of the Chemical Action of the Total Daylight*, in which he recommended employing silver chloride paper; further dissertations on this

subject followed in 1870; most of them are published in the *Philosophical Transactions*.

Julius von Wiesner (1838-1916), professor at the University of Vienna, employed the Bunsen silver chloride paper photometer in his extensive light measurements in botany, plant physiology, and meteorology (1893-1906). This method of measurement, however, furnishes only qualitative results of relatively short exposures.

A new era in photographic photometry commenced with the introduction of step wedge photometers. The first idea of the use of several layers of thin paper for testing chemical light intensities was that proposed by Senebier in 1782, but his experiments were extremely primitive (see Chapter XIII).

The modern paper-scale photometer, by gradations of transparent strips of paper, was introduced by Lanet de Limenci, 1856. It was intended at first for visual observation of the intensity of illumination. When this instrument was presented to the Paris Photographic Society, February 15, 1856, the chemist Henri Victor Regnault pointed out that the photographic and the visual degrees of luminosity are not identical, but that one could place a piece of silver chloride paper behind the scale and thus measure the chemical intensity of the light (*Handbuch*, 1930, III(4), "Sensitometrie," p. 3). This photometer was very widely used in photographic printing with pigments, especially in the form given it by H. W. Vogel.

The standard color photometer, with sporadic light measurements at certain times of day, yielded no accurate average of the total radiation during a day, which is important in the study of botany and the cultivation of plants. This induced the Benedictine monk Benedict John Kissling, at Göttweig on the Danube (Lower Austria), to study the connection between a continuous light measurement and vegetation. Kissling was born in 1851, studied at Krems at the same time as the author, entered his novitiate in 1872, became a priest in 1877, and died in 1926.

Kissling specialized in botany and studied especially the connection between vegetation and meteorological conditions and the prevailing light intensity. He took into consideration for his purpose, the determination of the total volume of light on a certain day. Kissling chose for his measurements, on the author's advice, a calibrated Vogel paper-scale photometer with potassium monochromate paper (dipped in 5 percent solution), which is more suitable for protracted measurements

than silver chloride paper, owing to its slight sensitivity. Graduated ground glass was also used for the softening of the light. These photometer degrees he reduced to Bunsen light units, and he carried out numerous measurements. Kissling must be regarded as the first to introduce into botany exact continuous light measurement within the limits of error of the method.[3]

In 1895 he collected his observations, covering many years, in his pamphlet *Beiträge zur Kenntnis des Einflusses der chemischen Lichtintensität auf die Vegetation.*

The light-sensitivity of a mixture of a solution of mercury chloride with ammonium-oxalate (separation of a precipitate of mercurous chloride) for photometric use was proposed by Fowler in 1858; he failed, however, to take into consideration the influence of the concentration and temperature. Eder's investigations in this field produced the "mercury-oxalate-photometer" (reported to the Academy of Science, Vienna, October, 1879); he recognized that it possessed the dominant sensitivity in the ultraviolet; he also determined the course of the reaction.

With this mixture of mercury chloride and ammonium-oxalate of a fixed concentration, called briefly "Eder's photometric solution," many experiments were undertaken.

It is worthy of notice that the author determined for the first time in 1879 the so-called photochemical coefficient of temperature, in his dissertation mentioned above, which he found to be 1.19.[4]

He was also the first to determine that for silver bromide gelatine plates differences in temperature from 5° to 25° C. have no influence on the formation of the latent photographic image, which means that the coefficient of temperature equals 1 or lies very near 1, which was confirmed by subsequent investigations (*Sitzungsberichte, Akad. d. Wiss. in Wien, Abt. II*, April 8, 1880, Vol. LXXXI).

BASIC LAWS OF PHOTOCHEMISTRY

The Faraday Society of London invited to Oxford for October 1 and 2, 1924, photochemists of all countries for a debate on the photochemical law of Einstein and the properties of light reactions in general. In *Camera* (1925, IV, 114) Dr. J. Plotnikow prints the report which he rendered at this congress. In this lecture he treated the question which photochemical practices must be considered as fundamental laws. One hundred years ago Theodore Grotthuss (1817) declared

that only the light absorbed by a substance can act photochemically, and since that time until today we know of no case where this rule did not operate. A phenomenon or a rule of such an inclusive character must be called a basic law. There also exists a quantitative relation between the transformed amount of material and the absorbed light energy. If we designate the speed of the light reaction (that is, the amount of material transformed per time unit) as v and the absorbed light energy as A, we arrive at the general equation $v = F (A)$. This formula is of a general character and says not a thing about the function, F. Van't Hoff expressed the idea (1904) that there must exist here a simple linear proportionality, that is, that the quantitative expression of Grotthuss's law must have the following form: $v = kA$, in which k represents the constant chemical speed of the individual light reaction. The direct examination, as well as a series of consequences which result from this formula, confirmed its correctness. We can justly accept it as a quantitative extension of the original law and combine them as the Grotthuss-Van't Hoff photochemical law of absorption. The revolutionary changes which physics has undergone in the last decades could not remain without influence upon photochemistry, which is on a borderline between physics and chemistry. In the nineties Lenard and Hallwachs discovered and investigated the photoelectric phenomena. It developed the fact that the energy of motion of electrons ejected by light is related to the frequency of vibration of the light waves. In 1900 Professor Max Planck demonstrated that the absorption and emission of light, which is of a photoelectric nature, takes place in so-called quanta (in numerous minute quantities of energy).

Professor Albert Einstein, born March 14, 1879, applied (1905-1912) Planck's quantum theory to the absorption of light and to the photochemical reaction resulting from it in order to create a basis for the system of the quantitative course of chemical light actions. He formulater this in the so-called "Einstein's photochemical principle of equivalence," $Q = Nhv$. This refers to the absorbed energy, Q, the vibration frequency of the absorbed light, v, the quantum of energy, h, to the molecules split by the light, N. In the direct application of this formula to photochemical reaction difficulties were encountered. Numerous scientists, such as E. Warburg, W. Nernst, M. Bodenstein, F. Weigert, J. Stark, and others, worked on the further extension and adaptation of Einstein's law and continued experiments and observations.

In the light of the recent physicochemical conception, the reaction

which takes place in the formation of a photographic image consists in the transfer of an electron from a brom ion to a silver ion (*Handbuch*, 1927, I (1), 633-35). On the relation to the quantum theory, S. E. Sheppard reported to the Seventh International Congress of Photography, at Dresden, in 1931. On electrons, atoms, and light quanta and the historical development of the respective theories see Arthur Haas, *Atomtheorie* (1929).

Chapter LVIII. PHOTOELECTRIC PROPERTIES OF SELENIUM

RECENT EXPERIMENTS for transmission of the photographic image were directed to the construction of telegraphic printing apparatus and the like, where one or more light-sensitive cells are installed at the receiving end. This apparatus was based on the change of electrical resistance, on photoelectricity and on radiophone action. The historical development was described by R. Ed. Liesegang, in his *Beiträge zum Problem des elektrischen Fernsehens* (1899). We will here merely relate the curious behavior of selenium toward light. Of particular interest is the discovery of the influence of light on the electrical conductivity of selenium and other substances, which made possible television. The transmission of an optical lens image over long distances was anticipated by Goethe in the tenth canto of his *Reinecke Fuchs*. "Hear now further of the mirror, in which the glass is replaced by a beryl of great clearness and beauty; everything in it is reproduced, even if happening miles away, be it day or night." This dream of Goethe's came true in the nineteenth century through the finding of selenium.

Selenium was discovered by Berzelius in 1817. It exists in several allotropic forms, namely, as glassy or amorphous and as crystalline selenium. It occurs as an amorphous reddish powder and also in shiny thin sheets, which are transparent red. When heated, it forms the crystalline black selenium which possesses a mat, metallic surface resembling lead.

The German physicist J. W. Hittorf[1] (1851) demonstrated that the metallic form exhibits a curious behavior toward the electric current and conducts electricity. He also observed that sunlight had a great influence on the transformation of the amorphous, hydrous se-

lenium precipitated from an aqueous solution into the crystalline metallic form. Hittorf, however, considered selenium insensitive to light, but credited the change which red selenium undergoes from the rays of the sun to the temperature.

Willoughby Smith utilized selenium in 1873 on account of its high resistance in a method for measuring and signaling during the laying of a submarine cable. Experiments proved that selenium offers the required resistance in full measure; a resistance equal to that of a telegraph wire reaching from the earth to the sun. Since it was found, however, that the resistance was extraordinarily variable, it became necessary to make tests in order to ascertain the cause of this variability. During this test, May, an assistant to Willoughby Smith, discovered that the resistance of selenium was less when it was exposed to light than in the dark.[2]

Thus he found that light influences electric conductivity and that modern electrotechnology, for instance, the telephone, could be served by the action of light. The first successful tests of this kind moved Smith, in 1873, to the following enthusiastic expression.

Mr. Preece related to us that with the aid of the microphone the running of a fly could be heard so loud that it resembled the trampling of a horse on a wooden bridge, but I can tell you a story which I think is still more wonderful, namely, that I heard with the aid of a telephone a ray of light fall on a metal plate.

Werner Siemens[3] found that there are certain forms of selenium which are so extremely sensitive to light that quite minute light intensities were sufficient to increase considerably the conductivity of selenium for the electric current. In more recent times very sensitive selenium cells were constructed which were very suitable for photometry, electric transmission of light effects, photophones, and the recording of sound films.[4]

Chapter LIX. GELATINE SILVER BROMIDE

POITEVIN'S EXPERIMENTS (1850) to utilize gelatine as a binding agent for silver salts in the negative process were not wholly successful. Years passed before the idea, proposed by Gaudin in 1853, of producing emulsions with different binding agents, among others with gelatine, was realized. First it had to be learned that silver bromide (not silver

iodide) must form the principal part of such emulsions and, further-
more, that the great light-sensitivity of silver bromide becomes effec-
tive only by chemical processes of development, for instance, with
alkaline pyrogallol. Only when this was known did the use of gelatine
(in place of collodion) as a colloid medium in the emulsification of
silver bromide meet with complete success. But this vital perception
was gained only after many experiments had failed.

The Englishman W. H. Harrison published (*Brit. Jour. Phot.*,
January 17, 1868), in a short article entitled "The Philosophy of Dry
Plates," an account of his half successful experiments with silver bromo-
iodide (with use of cadmium iodide and cadmium bromide), which
he emulsified in a very weak gelatine solution. He coated plates with
this emulsion, which he dried, exposed, and developed with pyro-
gallol. He remarked that the image appeared quickly and was of great
intensity, but it was useless, owing to the rough and uneven surface
of the film. He attempted to improve his emulsion by increasing the
gelatine content, but then failed to obtain an image, proof that his
experimentation was faulty. Apparently discouraged, he discontinued
further trials with gelatine emulsion after the publication of his failure.
In these circumstances he can hardly claim consideration as a pioneer,
still less the inventor of gelatine silver bromide emulsions.

W. Jerome Harrison mentions, with great accuracy, in his *History
of Photography* (1888, p. 59) these unsuccessful fledgling experiments
by W. H. Harrison with gelatine silver bromo-iodide. He can be called,
therefore, only an experimenter who stopped after his initial attempt.

The experiments of W. H. Harrison so discouraged all other photo-
graphic experimenters that for the five years following no one took up
the use of gelatine as a binding agent for silver bromide; then Dr. R. L.
Maddox independently succeeded in obtaining the first satisfactory
images on gelatine silver bromide, which resulted in further progress.
This English amateur photographer must be recognized as the inventor
of the first serviceable gelatine silver bromide emulsion.[1] Richard L.
Maddox (1816-1902) studied medicine in England, followed his pro-
fession for several years in Constantinople, and married there in 1849.
In 1875 he practiced in Ajaccio (Corsica) and in Bordighera (Italy),
and later he returned to England. He devoted himself to photography
as early as the fifties and received medals for his microphotographs in
1853 from the Photographic Society of London and in 1865 at the
Dublin International Exhibition. While practicing medicine in Eng-

land, Maddox worked diligently as an amateur photographer. He worked a great deal with albumen films on glass plates, Niepceotypy (*Brit. Jour. Phot.*, VIII, 386); also Kreutzer's *Zeitschr. Phot.*, 1862, V, 58). The editor of the *British Journal of Photography* was his friend, and he wrote other articles on photographic subjects for this periodical. His most important contribution, however, was the successful experiment with gelatine silver bromide emulsion.

On September 8, 1871, Maddox sent the first notice on the preparation of gelatine silver bromide emulsion to the *British Journal of Photography*, under the title "An experiment with Gelatine-Bromide," and at the same time handed to Taylor, the editor of the *Journal*, some negatives of landscapes, views and so forth produced by the new process, representing the first successful photographs made with gelatine silver bromide dry plates.

Dr. Maddox, in the course of his experiments, was influenced by the Niepceotype process and the wet collodion process, to which he had become accustomed in his younger years, and so started with the physical development (nitrate of silver and pyrogallol) of his gelatine silver bromide plates, thus permitting the silver nitrate to predominate. His modesty caused him to use the expression that he "did not assume to have proposed something new," when he replaced collodion by another binding agent, namely, gelatine, though in fact it introduced a new epoch in photography. He found that the suitable, relatively great concentration of the gelatine solution, which produced smooth films on glass as well as on paper, did no injury to the silver bromide layer in drying.

It is very characteristic in the evaluation of this scientist, as he himself stated, that his investigations were by no means concluded, but that he made them public to point the way, as he did in a most admirable manner, and that they ought to be followed by the further elaboration of the gelatine emulsion process. He advised the study of the proportion of bromide to silver nitrate, of the kinds of soluble bromide which could replace the cadmium bromide which he had used, and he recommended also the study of the kind of developer. It is therefore established without doubt that Maddox invented and documented with good proofs photography with gelatine silver bromide on glass as applied to negative and positive processes, as well as gelatine silver bromide papers in their initial stages.

He states at the end of his communication to the *British Journal of*

Photography, 1871: "as far as may be judged at present, the process seems worthy of further and carefully carried out experiments; if found advantageous, progress in photography will be promoted by it."

Certainly he did not realize that the bromide should predominate when mixed with silver nitrate and that it was necessary to wash the emulsion in order to obtain more sensitive and more permanent silver bromide plates, a fact which was published only in 1873 by J. Johnston.

The famous negatives sent by Maddox in 1871 to Taylor for his examination were later sent to the present author in the eighties. They were small, delicate, completely detailed brown negatives. Later, in 1900, I received from Maddox a portrait made about that time which is reproduced in the 1932 German edition of the *History* (p. 591).

Dr. Maddox derived no pecuniary returns from his invention and passed his last years in anything but easy circumstances. In 1892 the photographers in England, France, Germany, and America and amateurs subscribed for him a sum of over five hundred pounds. In recognition of the value of his work, he earned the grateful appreciation of his professional colleagues, which was expressed in particular in the presentation of the "Progress Medal" of the Royal Photographic Society in 1901.[2] Dr. Maddox died May 11, 1902, at Southampton, in his eighty-sixth year.[3] It was not until two years later that Maddox's invention was taken up again and improved by others.

The Englishman J. Burgess, in July, 1873, offered for sale in London the first gelatine emulsion; it was advertised in the *British Journal of Photography* (July 18, 1873). Burgess never disclosed his formula for this emulsion, but he undoubtedly used the soluble bromide in excess in preparing the emulsion, since he used an alkaline pyro developer. To him is due the merit of having been the first actually to produce gelatine emulsions in a practical and suitable quality for the trade. This emulsion was, of course, hardly as sensitive as a wet collodion plate, but even this was a great deal at that time. Burgess, however, achieved no commercial success, and the emulsion itself gradually dropped out of the market.

J. King, on November 14, 1873, gave a more detailed description of the gelatine emulsion process (*Brit. Jour. Phot.*, 1873, p. 542, and 1874, p. 294; *Phot. Korr.*, 1874, p. 125), and he introduced the washing out of the soluble salts from the gelatine emulsion. In the same issue of the *British Journal of Photography* J. Johnston recommended the use of

soluble bromide in excess in the emulsion mixture and the washing of
the gelatine emulsion. This improvement, that the bromide must be in
excess of the silver nitrate, was recognized later as highly important
and adopted as a rule for the preparation of gelatine emulsions.

As early as 1873 an anonymous writer, who only signed himself
"Contributor," in the *British Journal of Photography* (1873, p. 73),
reported that a gelatine silver bromide emulsion could be prepared by
dissolving precipitated and washed silver oxide or silver carbonate in
ammonia and mixing it with a gelatine solution containing ammonium
bromide, but no attention was paid to this vague remark about the use
of ammonia.

Richard Kennett, an amateur photographer in London, on Novem-
ber 20, 1873, took out an English patent (No. 3782) on the preparation
of stable "sensitive pellicles" (foils) of dried gelatine silver bromide,
which were commercially used for a short time. After being softened
in water and melted, this dried gelatine silver bromide served for
coating glass plates (*Brit. Jour. Phot.*, 1874, p. 291). He also sold
ready-made gelatine silver bromide plates on glass in 1874 on a small
scale for special orders; but they contained silver bromide of poor
sensitivity.

In 1873 W. B. Bolton made public his method, which consisted in
emulsifying the silver bromide at first with very small amounts of
gelatine and later adding more gelatine, a procedure which was sub-
sequently recognized as especially important.

In 1874 Peter Mawdsley mentioned in the *Year-Book of Photog-
raphy* (pp. 115-116 of that year) the applicability of gelatine silver
bromide paper, with development for the production of negative and
positive prints, and founded the Liverpool Dry-Plate and Photographic
Printing Company. It was the first establishment to produce gelatine
dry plates and photographic papers in fairly large quantities for com-
mercial use; but the business did not meet with success.

J. Johnston described, in 1877, the use of ammonia for ripening
gelatine silver bromide emulsions (*Brit. Jour. Phot. Almanac*, 1877,
p. 95), a process which later was investigated more closely and per-
fected by Monckhoven. In the middle seventies gelatine silver bromide
plates, which at that time were not very rapid, equaling in sensitivity
only a wet collodion plate, were used in England experimentally for
landscapes and here and there by itinerant photographers for portraits.

In 1877 the world's attention was directed to dry plates by Pope

Leo XIII. One of the first practical accomplishments of the gelatine silver bromide photography was the taking of a photograph of Pope Leo and his entourage in the Vatican garden at Rome on such a plate, with an exposure of one second. The picture was so satisfactory to the Holy Father that he paid it the distinction of expressing his pleasure in the following Latin poem, which he sent to Princess Isabella of Bavaria.[4] It reads:

ARS PHOTOGRAPHICA

Expressa solis speculo
Nitens imago, quam bene
Frontis decus, vim luminum
Refert et oris gratiam!

O mira virtus ingenii!
Novumque monstrum! imaginem
Naturae Apelles aemulus
Non pulchriorem pingeret.

It may be translated as follows:

THE ART OF PHOTOGRAPHY

Breathed on by the mirror of the sun,
A brilliant image appears
How beautifully it reflects the forehead,
The light of the eye, the charm of the mouth.

Oh marvelous power of the mind,
Nature's new creation
Not even the hand of Appeles, the Master,
Could have produced it more effectively.

In the meantime the chemical processes involved in the production of gelatine silver bromide emulsions and the means for increasing their sensitivity were studied more closely.

As a fundamental observation on the possibility of increasing the sensitivity of gelatine silver bromide, Charles Bennet published, on March 29, 1878, in his article "A Sensitive Process," in the *British Journal of Photography* (1878, p. 146; 1879, p. 133; *Phot. Jour.*, 1879, p. 68; *Phot. Korr.*, 1878, p. 21, and 1879, p. 86) that gelatine silver bromide greatly gains in sensitivity when it is prepared with an excess of potassium bromide and heated for a long time (five to ten days) at $32°$ C. Certainly the gelatine underwent a partial change, or it fermented and lost its firmness, but it was improved, according to the

procedure, earlier demonstrated by Bolton, of reserving a part of the gelatine and adding fresh gelatine at the end of the "ripening process of the silver bromide." Thus a method was provided for the commercial production of dry plates, although the sensitiveness of the first examples offered for sale was still far behind our modern rapid plates. The road was opened to portrait photography and also to landscape and instantaneous photography. This ripening by heat was subsequently varied, by permitting the action to take several hours at 60° to 80° C. or a half hour at near the boiling point, but the principle remained the same.

It was not easy to prepare gelatine silver bromide emulsion in the primitive darkroom laboratories of the professional photographer, equipped as they were at that time for the still-prevailing wet collodion process, and every effort was exerted to produce a large number of dry plates on a commercial scale, keep them in stock, and introduce them on the market ready for use. This brought about the commercial manufacture of sensitive dry plates, which originated in England, as did the entire gelatine silver bromide process.

The firm of Wratten and Wainwright[5] put on the market in London in April, 1878, gelatine silver bromide plates of greater sensitivity; this firm did an extensive export business to the continent, and their plates were the first to be used in Vienna, through the agency of the Vienna Photographic Society under the presidency of Dr. E. Hornig, and later in Berlin.

The "Liverpool Dry-Plate Co." (Peter Mawdsley) produced in the same year plates of even greater sensitivity, which they called "Bennet plates" and sold at three shillings a dozen (size about 3¼ × 4⅜ inches).

In 1879 the English firm of Mawson and Swan entered the field with gelatine silver bromide plates (Sir Joseph W. Swan was formerly a manufacturer of pigment papers). The firm was the first to manufacture, in addition to portrait and landscape plates, "photomechanical plates" for the reproduction processes and to prescribe their development with hydroquinone and caustic potash (about 1890), which is still used today.

In 1879 the Belgian chemist and photographer Dr. van Monckhoven devoted himself to the development of the dry-plate manufacture.

Van Monckhoven, in August, 1879,[6] stated that the increase in sensitivity of the silver bromide emulsion under continued digestion was

connected with molecular changes.[7] He cited on this occasion the earlier statement of Stas (1874) on the various modifications of silver bromide[8] and made the far-reaching discovery that the ripening of silver bromide was greatly accelerated by ammonia.

Supplementing this, Monckhoven published in the *Photographisches Archiv* (1879) an ingenious emulsion process which did away with the washing of the emulsion. The silver was precipitated as carbonate of silver, washed and mixed with a gelatine solution and converted by the aid of hydrobromic acid into silver bromide. This process, though practical, was not generally adopted, and Monckhoven himself emulsified later in the usual manner with excess of potassium bromide, but ripened the emulsion with ammonia, in order to obtain a greater sensitivity, and afterwards washed as was then the general custom. Further details of the method he used are not known, because he kept it secret. He and his sister-in-law produced the gelatine silver bromide emulsions for the trade in his laboratory at Ghent.

Monckhoven prepared only the emulsion and sold his product to two plate factories, namely, Bernaert, in Ghent, and Palmer Descamps in Courtrai, for use in coating the plates. He used in the early eighties 120 kg. (about 264.6 lbs.) of silver nitrate monthly, which he bought in Frankfurt a. M. Bernaert coated daily 1,300 plates (on Belgian glass); some of these plates found daily use, about 1880, in the portrait studio of the court photographer, Jos. Löwy, of Vienna. It was there that the author familiarized himself with these plates and found their sensitivity about 20° to 30° on the Warnerke sensitometer (which is equal to 8°-10° on the Scheiner). These Monckhoven-Bernaert plates became great favorites, owing to their clearness, fine rendering of the middle tones, and brilliancy, but the more sensitive English product replaced them later.

Dr. Désiré Charles Emanuel van Monckhoven (1834-1882) was one of the most versatile and zealous representatives of scientific and applied photography in the latter half of the last century. He came from the Flemish race and spoke German fluently, although his daily conversation was carried on in French. He studied chemistry, did not engage in a business or profession, lived at Ghent, and devoted himself early in life to photographic studies. In his eighteenth year he published his *Traité général de photographie*, of which seven editions were published and which was translated into French, German, Italian, and Russian. His other well-known publication was *Traité populaire de*

photographie sur collodion (Paris, 1862). Of importance were his introduction of the dialytic enlarger and an improvement of Woodward's solar camera for enlarging, in 1864, as well as his appliances for the improvement of artificial illumination which he made known in 1869. He spent also a great deal of time in the study of photographic optics. His *Photographische Optik* was published at Vienna, in 1866, and an English translation, in 1867. He erected in Belgium an establishment for the manufacture of pigment papers, which contributed greatly to the spread of this process.

In 1867 he moved to Vienna and aided the portrait photographer Rabending (inventor of negative retouching) in establishing an imposing studio, which excited great curiosity at the time on account of its peculiar construction (large broad front light, with small side light), which, while it realized all expectations as far as optical considerations were concerned, permitting short exposures, did not fully meet artistic requirements. Although he was quite happy in the gay Viennese life, he returned to Ghent in the autumn of 1870. The medal bestowed upon him by the Vienna Photographic Society in 1871 had to be sent to him there.

In 1879 he erected at Ghent a completely equipped laboratory, in which he carried on later his famous experiments in the ripening of gelatine silver bromide and so forth. *Instruction sur le procédé au gélatino-bromure d'argent* (1879) and *Du gélatino-bromure d'argent* (1880) appeared at this time.

We have already reported above on the emulsion factory established by him. In this laboratory, as a hobby, he made spectral analyses for the investigation of the sensitivity of plates, photographed the spectrum of hydrogen in special vacuum tubes, which had to be used longitudinally and were named after him, occupied himself a great deal with astronomy, and had an observatory in his own house at the Rue de l'Hôpital in Ghent, which was purchased by the government after his death.

The ammoniacal ripening method of Monckhoven was further developed by the author, whose investigations in 1880 resulted in the method of ammoniacal silver oxide and its introduction to emulsion practice. The author also made public in the same year the favorable influence of ammonia and ammonium carbonate on the ripening of emulsion in the cold. The ammoniacal method is used at present for different kinds of emulsions. For extra rapid emulsion, the neutral boiled

emulsion, with a very small gelatine content, became of great importance during the process of ripening. It consisted in treating the silver bromide mixture with very weak gelatine solutions, then allowing it to ripen for half an hour at about 90° C., and only then adding the larger amount, left over, of the gelatine solution. The proportion of bromide to silver nitrate is important, and only a small excess of soluble bromide occurs in this process. The impetus to this improved method was given by the investigations of William de Wiveleslie Abney, Burton, and others (*Handbuch*, 1927, II(1), by Lüppo-Cramer, and II(2), by Eder).

Soon the number of factories, at first limited, increased in all countries, and as early as the eighteen-eighties highly efficient dry-plate factories sprang up which developed into an industry in which millions were invested.

At this time (about 1880) wet collodion plates disappeared almost completely from the portrait and landscape studios and were used only in photomechanical establishments.

We mention some of the earliest technical literature on gelatine silver bromide: Abney, *Emulsion Processes in Photography* (London, 1878); Abney, *The Practical Working of the Gelatine Emulsion Process* (*London*, 1880); Burgess, *The Argentic Gelatino-Bromide Worker's Guide* (Greenwich, 1880); Chardon, *Photographie par émulsion sensible; bromure d'argent et gélatine* (Paris, 1880); and Monckhoven, *Instruction sur le procédé au gélatino-bromure d'argent* (1879).

The first German textbook on the preparation of gelatine silver bromide emulsions based on original investigations appeared in January, 1881, written by the author, *Theorie und Praxis der Photographie mit Bromsilbergelatine.*

The author's experiments for the preparation of ammoniacal gelatine silver bromide emulsions were connected with Monckhoven's studies (addition of ammonia to the mixed emulsion). He collaborated at that time with Captain Giuseppe Pizzighelli, in Vienna, began the tests in 1880 for the preparation of emulsions with the use of ammoniacal silver nitrate, investigated accurately its modes of use, unknown at that time, with regard to the proper proportions of the mixture and its temperature, and summarized the detailed results in his dissertation "Beiträge zur Photochemie des Bromsilbers (*Sitzungberichte, Akadem. d. Wis-*

sensch., Wien, April 8, 1880, LXXXI, 679, also *Phot. Korr.*, June, 1880, p. 144), and in his monograph mentioned above. In the same year appeared an enlarged English edition of that book: *Modern Dry Plates; or, Emulsion Photography*, ed. by H. B. Pritchard (London, 1881), and later a French edition (Paris, 1883). These directions for the work with ammoniacal silver nitrate, through the mild digestion temperature and the rapid working, produced clear and strong gelatine silver bromide plates and opened the way for the commercial production of emulsions. They were used by almost all the older factories in Germany and Austria, for instance, by Haack,[9] Dr. Heid, Schattera in Vienna, Schleussner in Frankfurt a.M., and others. They harmonized well with the new iron oxalate developer which came into vogue at that time, as well as with the alkaline pyro developers which had replaced the ammoniacal pyro developer. The "hard" brands of gelatine, especially suited for this process, were first successfully produced on advice of the author in 1881 by the gelatine factory of Winterthur, which was directed at that time by Simeons.[10]

The industrial development of the manufacture of dry plates had its beginning in England. From April, 1878, a large volume of dry plates were exported by Wratten and Wainwright, London, the Liverpool Dry-Plate Co., Mawson and Swan, and others. In Holland, Wegner and Mottu made dry plates for portraiture in 1877 and 1878 which were sold by Schippang in Berlin from January 1878. Their sensitivity was four times greater than that of the wet collodion plate (Wilh. Dost, *Phot. Chronik*, 1928, p. 376).

In Austria (Vienna) Carl Haack was the first to produce gelatine silver bromide plates and offer them for sale, October, 1879 (*Phot. Korr.*, 1879, p. 193).[11]

In Vienna the chemist Dr. Heid started, in 1880, a dry-plate factory; later followed Victor Angerer and Dr. Székely. Löwy and Plener, in 1884, were the first to employ contrifuged silver bromide from ripe gelatine emulsions, and they were also the first to produce and to employ in Löwy's graphic art and reproduction establishment the orthochromatic gelatine silver bromide emulsions with erythrosin according to the author's directions. Later Schattera started under the direction of Perlmann a dry-plate factory in Vienna, which merged with the factory run by Ferdinand Hrdlička[12] under the name "Herlango," which joined the dry-plate factory of Professor Alex. Lainer.

In Germany the firm of John Sachs & Co. erected in March, 1879, the first dry-plate factory in Berlin under the firm name Glaserei für photographische Trockenplatten. This firm coated the plates with emulsion by machinery. Its first advertisement appeared July 29, 1880, in the *Photographisches Wochenblatt*. These plates were four times more sensitive than wet plates. The production of gelatine dry plates was begun in November, 1879, by F. Wilde, at Görlitz; in 1884 by Dr. Schleussner, at Frankfurt a. M.; later by Hauff, at Feuerbach,[13] John Herzog at Hemelingen, near Bremen (1888), and others. In 1893 the company, Allgemeine Gesellschaft für Anilin Fabrikation, at Berlin (later called "Agfa") introduced the manufacture of dry plates under the direction of the chemist Dr. Andresen, from which developed gradually this firm's great factories for the production of dry plates and later of films at Wolfen.

The manufacture of dry plates in the United States is closely interwoven with the name of George Eastman; Eastman offered his gelatine silver bromide plates for sale in 1880, as described in detail in Chapter LXIV. In France silver bromide plates were produced very early; the most important firm in this line was that of Lumière.

The manufacture of dry plates was started in 1882 by Antoine Lumière, at Lyon, with a daily output of sixty dozen plates. The firm later grew considerably, under the co-operation and direction of his sons, Auguste and Louis Lumière, and achieved a triumph in photochemical practice in 1907 through the invention of autochrome plates.

The entire recent development of the dry-plate industry is described by Dr. Wentzel in the *Handbuch* (1930, Vol. III, Part 1).

DEVELOPER FOR GELATINE SILVER BROMIDES

Chemical developers (such as pyrogallol solution) proved at an early stage more advantageous for silver collodion emulsion as well as gelatine silver bromide plates than the physical developers of the old wet collodion process.

At first the gelatine silver bromide dry plates which came on the market were developed exclusively with pyro-ammonia developer which had been brought over from the collodion process.

The work was done with a solution of pyrogallol and dilute ammonia, with the addition of ammonium bromide or potassium bromide, and the results were delicate, but these negatives had a yellowish or brownish stain, which coloring often unfavorably influenced the whole

gelatine layer of the image; these developers were also difficult to keep.

H. B. Berkeley,[14] in 1882, radically improved the pyrogallol developer by the addition of sodium sulphite, which protected the aqueous solutions of pyrogallol from rapidly turning brown and kept the negatives developed with pyro from yellow stain. This was an enormous advance, which affected not only the pyro developer but also, what is more important, all modern organic developing substances (hydroquinone, pyrocatechin metol, etc.).

Herbert Bowyer Berkeley (1851-1891) was the son of the Reverend Conyers Berkeley, attended Uppingham College and devoted himself in particular to chemistry, which he combined with his private studies in photography; he wrote many papers for the technical journals. Berkeley later entered the employment of the Platinotype Co. (1879) and remained there until six months before his death. He contributed greatly to the improvement of platinotype and had a large share in bringing about its popularity among photographers. He is best known for having introduced sodium sulphite in the pyrogallol developer (1882), which preserved it from oxidation and improved the quality of the negative. It was not long before Berkeley's discovery was applied to all other developers. Berkeley was an excellent photographer whose work was admired in many exhibitions. He had the courage of his convictions and was a good debater at society meetings, but was often too aggressive to make friends. His health declined in the last years of his life, and he went to Algiers, where he died in 1891 (*Phot. Jour.*, February 20, 1891).[15]

Mawson and Swan introduced potassium metabisulphite for preserving pyrogallol solutions, in 1886, and for hydroquinone developers.

IRON OXALATE DEVELOPERS

Carey Lea[16] experimented in 1877 with various developing substances for iodine bromo-silver chloride negative papers and found potassium ferrous oxalate especially effective. He dissolved precipitated ferrous oxalate in a boiling potassium oxalate solution and stated that solutions of ferrous sulphate with potassium oxalate were less to be recommended. Later, in 1880, he suggested various complicated iron developers, which contained, besides oxalate, also phosphates, sulphates, borates, etc. It escaped him that the best results could be obtained with the simple potassium iron oxalate developer.[17]

The author demonstrated this[18] and introduced the iron oxalate

developer by mixing two cold solutions of ferrous sulphate and potassium oxalate. This developer produced brilliant grayish-black negatives which offered great advantage over the yellowish-brown and often foggy pyro-ammonia negatives of that time. The introduction of the author's iron oxalate developer greatly aided the general use of gelatine dry plates, which is particularly emphasized by H. W. Vogel in his report to the Vienna *Photographische Notizen* (1880, p. 1).

ORGANIC DEVELOPER SUBSTANCES

W. de W. Abney published the alkaline hydroquinone developer for gelatine silver bromide negative making in 1880. In the same year the author and V. Tóth, of Vienna, discovered that pyrocatechin was suitable as an alkaline developer for dry plates. On this occasion they gave precise data on the influence of isomerism in the bihydroxyl derivatives of benzol. They observed that the para position in the bivalent phenols, which is present in the hydroquinone, shows a very strong action in the alkaline developer on silver bromide; furthermore, that the position given in the pyrocatechin causes a great developing power, while resorcin (meta position) has no energy as a developer.

This rule for the developing strength of phenol derivatives was later found correct also for other derivatives, for instance, paramidophenol.

The history of substances for the organic photographic developers is briefly as follows: in 1880 hydroquinone (Abney) and pyrocatechin (Eder and Tóth) became known as developers; then followed, in 1884, hydroxylamine (Carl Egli and Arnold Spiller); in 1885 phenylhydrazine (Jacobsen). In 1888 Andresen was granted a patent for use of p-phenylendiamine as developer; in 1889 Andresen recognized the adaptability of certain naphthalene derivatives (eikonogen), and in 1891 he announced paramidophenol (rodinal) which is still generally used.

To the chemist Dr. M. Andresen, who directed the company for manufacture of aniline in Berlin, we are indebted for numerous progressive steps in the chemistry of developer substances, also for the advance in other photochemical fields and for improvements in the manufacture of dry plates.

Dr. Momme Andresen was born October 17, 1857, the son of Andreas Christian Andresen, the owner of an estate on the west Schleswig coast, went to elementary school at Risum, his birthplace, later to

the Wilhelm School at Niebüll. He studied natural sciences from 1875 to 1880, principally at the technical college in Dresden and at the universities of Jena and Geneva. Between 1887 and 1911 he was employed as chemist by the company for aniline manufacture in Berlin (Agfa) and as technical and scientific director of the photographic department. Since 1911 his connection with the firm has been that of scientific collaborator.

Andresen took part in the successful investigation of the constitution of quinone chloramides (*Journal f. prakt. Chemie*, XXIII, 167, 435; XXIV, 426; XXVIII, 422), as well as the constitution of safranine (*Berlin Ber.* 1886, p. 2212). He discovered the α-napththol-ε-disulpho acid (German patent, No. 45776), which is also called Andresen acid.

Andresen recognized the great importance which belongs to the ammonia residue NH_2 as an "effective group" among organic developer substances, and he discovered paraphenylendiamine (German patent No. 46495, of January 8, 1888), Eikonogen (No. 50265, October 2, 1889), paramidophenol (rodinal) (No. 60174, January 27, 1891). He investigated the action of light on the diazo combinations of naphthylamine, from which sprang a new diazotype process (*Phot. Korr.*, 1895; *Jahrbuch*, 1896, p. 260).

In 1898 he demonstrated that "permanent direct printing papers" could be produced which possess, owing to an addition of dyes, the maximum sensitivity in any chosen region of the spectrum from the red end into the blue. He supplemented this with an investigation "Zur Aktinometrie des Sonnenlichtes" (*Phot. Korr.*, September, 1898).

Andresen is the author of *Das latente Lichtbild, seine Entstehung und Entwicklung* (1913). and the *Agfa-Photo-Handbuch* (1922). He wrote the section "Entwickler-Substanzen," for the 5th and 6th editions of the *Handbuch* (1930, Vol. III, Part 2).

Very important was the discovery of metol, amidol, and glycin as developers by the chemist Dr. A. Bogisch in the photographic department of the chemical factory of J. Hauff, Feuerbach, near Stuttgart. The metol developer is especially important for the rapid development of instantaneous exposures and is very widely used in a mixture with hydroquinone (metol-hydroquinone). It was introduced into practice about 1893 for both negatives and positives.[19]

In 1899 Dr. Lüppo-Cramer, who was at that time connected with the chemical factory of Schering, in Berlin, made the observation that a substitution bromo- or chloro-hydroquinone increased the strength

of the developer over the hydroquinone in alkaline developer, and he called his product "Adurol."

Great merit was achieved by Lumière brothers and Seyewetz in the photochemical laboratory of their dry-plate factory at Lyon. They introduced "metochinon" (a complex compound of metol and hydroquinone), diamidoresorcin, hydramin (combination of hydroquinone with para-phenylendiamine), and have published many research papers on the theory of developer substances (*Handbuch*, 1930, Vol. III).

UTILIZATION OF TANNING PHOTOGRAPHIC GELATINE SILVER BROMIDE
FILMS BY PYROGALLOL DEVELOPERS FOR REPRODUCTION PHOTOGRAPHY

Gelatine silver bromide films present the image as a swelled relief after development with alkaline pyrogallol without sulphite. The author pointed out in 1881, in the English edition of his *Modern Dry Plates* (p. 124), that this relief could be made sufficiently high so that a mold could be made from the swelled gelatine image and used as photomechanical printing plates (see also *Handbuch*, 1922, IV (3), 304).

Leon Warnerke, a Russian living in England, made in that same year a much more important report on the property of the gelatine film tanned with pyro developer, namely, that only those parts which had not been exposed to light were soluble in warm water, while the exposed parts, tanned by exposure, remained insoluble (*Phot. News*, 1881; *Phot. Mitt.*, XVIII, 65, 98, 235).

These relief images can be produced with fixed, as well as with unfixed, silver bromide paper prints, and they can be transferred in the manner of pigment prints to other surfaces, as described in the sections "Pigmentverfahren," in *Handbuch* (1926, IV(2), 293, 395), and "Heliogravüre," in *Handbuch* (1922, IV(3), 306).

This process was thoroughly elaborated by the ingenious amateur photographer Warnerke and demonstrated by practical proofs. The Royal Photographic Society of London awarded him a prize for the process, but it met with no success commercially. He extended his experiments by introducing the "silver pigment process" for intaglio etching of copper plates, but was no more successful in this than in the earlier process. Warnerke's work became more important, however, when the original developing method found practical application through the introduction of pyrocatechin in different forms by Gustav Koppmann (1907); all this is exhaustively treated in the *Handbuch* (1926, IV (2), 294).

FIXATION OF GELATINE DRY PLATES

Gelatine dry plates were always fixed with "hypo" (sodium thio-sulphate). The organic developers, pyrogallol, hydroquinone, and eikonogen sometimes indicated a so-called fogging tendency, which had to be eliminated by immersion in acid-fixing solutions, alum baths, and so forth,[15] in order to obtain clear negatives. The acidulation of fixing baths with acids prevented the rapid decomposition of the fixing salts.

In 1889 Professor Alex. Lainer, of Vienna, during his work at the Graphische Lehr- und Versuchsanstalt, found that sulphites could be mixed to a clear solution with fixing baths and that in this manner fixation and removal of the fog were obtained in one manipulation. He published this in the April number of the *Phot. Korr.* (1889, p. 171). This was quite important in the use of the new developing agents that made their appearance at that time.

Alexander Lainer (1858-1923) studied chemistry at the technical college in Vienna, in 1882 taught physics, chemistry, and optics in the photographic department of the government trade school at Salzburg, and was called to the newly founded Graphische Lehr- und Versuchs-anstalt, in Vienna, as professor of chemistry and physics (1888-1900). He wrote, in 1889, a textbook of photochemistry, *Lehrbuch der pho-tographischen Chemie* (1890; 2d ed., 1899); he published *Vorträge über photographische Optik* (1890); and *Photoxylographie* (1894); and wrote on the utilization of the residue of precious metals and nu-merous articles for photographic periodicals. During the course of his studies on photographic developers he discovered that under certain conditions the action of the developer is accelerated by the addition of potassium iodide[20] (in contrast to potassium bromide), which in the technical literature was designated as the "Lainer effect" and was the starting point of many investigations (*Handbuch*, 1927, II (1), 223, by Lüppo-Cramer). He resigned from the institution in 1900 in order to establish his factory for photographic papers and plates, which later became so well known. After his death, in 1923, his son Oscar took over the business and merged it with that of Hrdlička.

It was just at this time that M. Andresen, in Berlin, invented the eikonogen developer which the Agfa Co. brought into the market. This developer tended greatly to the formation of fog, but this was eliminated by Lainer's acid fixing bath, by which clear, gray-black negatives were obtained. A few months after Lainer's article in the

Phot. Korr. on his acid fixing bath, Andresen prescribed, in the directions for the use of eikonogen, under the title "Fixierbad für Platten, welche mit Eikonogen entwickelt sind," the use of the acid fixing bath. It consisted of 250 g. of hypo, 50 g. sodium bisulphite dissolved in 1,000 parts water. These salts were later put on the market, in anhydrous state in the shape of cartridges.

The generally used "acid sulphite solution" of today for the acidulation of fixing baths, consisting of sodium bisulphite with excess of sulphurous acid, was introduced by the author in August, 1889 (*Phot. Korr.*, 1889, p. 200; *Handbuch*, 1930, III (2), 200).

REDUCTION OF GELATINE SILVER BROMIDE IMAGES

The reduction of both negatives and positives was carried on during the years of the Talbotype and of the collodion process according to various methods, which are described in special chapters of the *Handbuch* (Vols. II and III).

After the publication by the author of the mechanism of the reaction of potassium ferricyanide on silver, in 1876, it was known that ferrocyanide of silver is formed by this procedure. This is soluble in hypo. The reduction by the treatment of silver images with potassium ferricyanide and subsequent fixation is based on this reaction.

The English worker E. Howard Farmer was the inventor of this mixed reduction bath, consisting of hypo with the addition of potassium ferricyanide (1883). The reduction occurs in one bath and is therefore more easily controlled. This Farmer's reducer became very important in photochemistry.[21] Reduction with potassium permanganate was invented by Namias (see Chapter XCVI). The reduction with ammonium persulphate (1898) and also cerisulphate (1900) were found by Lumière and Seyewetz (*Handbuch*, 1903, III, 556, 558).

Intensification of gelatine silver bromide images followed methods analogous to those employed with collodion negatives.

Chapter LX.. GRADUAL INCREASE IN SENSITIVITY OF PHOTOGRAPHIC PROCESSES FROM 1827 UNTIL THE PRESENT TIME

A REVIEW of the gradual increase in sensitivity of the photographic processes from the invention of photography until the present time is very interesting.[1]

	Year	Exposure
Engraving with asphalt	1827	6 hours
Daguerreotypy with silver iodide	1839	30 minutes
Talbotype with gallic acid developer	1841	3 "
Wet collodion process	1851	10 seconds
Collodion silver bromide emulsion	1864	15 "
Gelatine silver bromide at the time of invention	1878	1-1/200 second
Gelatine silver bromide	1900	1/1000 "

The spectral sensitivity of the daguerreotype plate was very limited, extending from the beginning of the ultraviolet to the blue, and embraced only a small part of the visible spectrum. The use of quartz (rock crystal) lenses broadened the field into the invisible ultraviolet[2] and the use of optical sensitizers far into the dark red.[3] Later investigations produced sensitizers which reached into wavelengths of 900 or 1,000 into the infrared.[4] A diagram in the 1932 German ed. of this *History* (p. 611) shows this development clearly.[5]

Chapter LXI. GELATINE SILVER BROMIDE PAPER FOR PRINTS AND ENLARGEMENTS

THE MODERN photographic printing method on gelatine silver bromide paper was begun in England, even as the entire technique of gelatine emulsions was evolved there. As early as 1874 Peter Mawdsley, the founder of the Liverpool Dry-Plate Co., pointed out, in the *Yearbook of Photography* (1874, p. 116), the possibility of utilizing gelatine silver bromide papers for photographic printing. He advertised this manufactured article and called attention to its adaptability for the enlargement of negatives by the projection apparatus, emphasizing the fact that such silver bromide prints were very suitable to being painted over. Nevertheless he died unsuccessful and very poor.

Sir Joseph Wilson Swan, co-inventor with Edison of the carbon filament bulb for electric illumination and inventor of the pigment process, was more successful in the following year. He was a manufacturer of importance, who in 1879 undertook the manufacture of "bromide printing paper" on a large scale, and applied for an English patent (No. 2986, 1879) on his product. This patent was granted because of the peculiar patent laws in England, which require no proof of originality. While it is unjust to call him the inventor of this positive printing paper, it was he who introduced it into practice. He foresaw clearly that this process, for which a short exposure in weak artificial light sufficed, would attain universal use.[1] All this, however, must not interfere with Peter Mawdsley's priority rights to the invention.

About the same time as Swan, E. Lamy entered the field in France and manufactured silver bromide paper successfully, erecting an efficient factory at Courbevoie (Seine). Later, factories were started in England by Morgan and Kidd, at Richmond, by Marion, and others.

The first textbook concerning the photographic silver bromide printing paper process came from the pen of John Burgess, under the title *The Argentic Gelatino-Bromide Worker's Guide, with Instruction for Use for Rapid Positive Printing* (1880). It was illustrated with a silver bromide print by Morgan & Co., of Greenwich. After seven years experience in the production of gelatine dry plates, Burgess, jointly with W. T. Morgan and assisted by his manager, R. L. Kidd, successfully introduced the manufacture and sale of silver bromide papers.

Silver bromide paper, as a medium for rapid printing with artificial light and for enlargements, was generally adopted about 1880. When, in 1884, the American firm of Eastman and Co. at Rochester constructed the first efficient emulsion coating machine to coat negative paper and films, the joint work of Walker and Eastman, a large industry in this field came into existence, which naturally first revolutionized the photographic printing process in the United States and later brought this technical process to a complete success.

The scientist Dr. F. Stolze, of Berlin (the inventor of the gelatine neutral tint wedge and editor of the *Photographisches Wochenblatt*), was the first manufacturer of silver bromide paper in Germany. He started the production of silver bromide paper in Berlin on a small scale, but could produce only a relatively small amount; in 1894 he still could not make more than one hundred meters (about 328 feet) a week.

For mass production the invention of the printing automat (rapid printing machine) was important. The first to construct a printing automat which satisfied the practical demands was the engineer Schlotterhoss,[2] in Vienna (1852-1892). In 1883 he patented an exposure automat in which the sensitized paper was advanced and exposed by clockwork and which could be used in artificial light or daylight.

By the use of the less sensitive silver chloride paper Schlotterhoss could produce in diffused daylight and in electric light four hundred to five hundred prints in an hour; in gaslight, sixty prints; and thirty cyanotype and platinum prints an hour in direct sunlight. They were then developed and fixed. Schlotterhoss erected his machine in Dr. E. Just's[3] photographic paper factory, Vienna, and produced experimentally large editions of serial pictures on both gelatine silver bromide and silver chloride paper. The invention, however, met with no appreciation at that time, since there existed no market for large editions of such pictures, no matter how beautiful they were. Just as unsuccessful was the application for the first time, by Schlotterhoss, in 1883, of the rapid photographic printing process to criminal photography, although police headquarters at Vienna had succeeded that year in identifying and arresting the dangerous anarchist Stellmacher through the work of Schlotterhoss, who printed photographically in one night the illustrated notices for the criminal's apprehension. While greatly pleased, the Vienna police authorities of that time failed to introduce the process, and it did not take its proper place in criminal procedure until 1890, when Alphonse Bertillon brought it to the front. Art dealers were indifferent at that time to this novel and rapid method, and, sadly enough, the engineer Schlotterhoss, who had sacrificed his whole fortune to this invention, died in poverty.

Photographic printing machines on a large scale were successfully introduced by Arthur Schwarz, who founded (1893-1894) in Berlin the Neue Photographische Gesellschaft (N. P. G.), for the production of the so-called "kilometer photography" for illustrating purposes, with which he combined his large art and picture postcard business.

Arthur Schwarz (b. 1862) was active in the photographic business from 1887 in London and New York, where various machines for printing silver bromide paper in large rolls were then in operation. In 1892 A. Schwarz, with Benjamin Falk, took over Urie's patent for an automatic printing machine for silver bromide paper in rolls. They started an establishment for this purpose in New York City and per-

fected this process by adding a developing and finishing machine. With the first specimen prints from this machine on paper rolls, Schwarz came to Germany and founded, in Berlin, July 4, 1894, the Neue Photographische Gesellschaft. When he found himself unable to buy the necessary silver bromide paper in sufficient quantity for his printing and developing automats, he erected a factory and made the paper himself. In January, 1895, the manufacture was started with the first machines, which were built in the United States.[4] To Arthur Schwarz must be credited the first practical introduction of the modern mechanical silver bromide printing process in Germany.

The silver bromide papers produced by the Neue Photographische Gesellschaft were offered for sale in 1894 in a variety of weights and surface textures (mat and glossy). The Neue Photographische Gesellschaft was incorporated in 1899, having established in 1898 a branch, the Société Photographique, in Rueil, France, and the Rotary Photographic Co. in London.

Glossy papers were produced on a base of permanent white (Ba SO_4) and on somewhat hardened gelatine. In the first eighteen years in the Berlin factory, Arthur Schwarz emulsified forty million meters (about 131 million feet) of paper and produced twenty-eight million meters (65½ million feet) of pictures. These large figures caused him to use the name "kilometer photography," or, as we would say, "photography by the mile." After the World War the Berlin Neue Photographische Gesellschaft merged with the Dresden Ika Co.

The Eastman Kodak Co. was followed in 1900 by a long list of well-known firms, of which many still exist today in England as well as in Germany and France; a new industry for the production of printing and developing papers was started, and also an industry which dealt with their use by automatic machines (Wentzel, *Handbuch*, 1930, Vol. III).

MAT SILVER BROMIDE PAPERS

Mat surfaced silver bromide papers were produced by Pauli and Ferran by the use of starch in place of gelatine (*Phot. News*, 1879, p. 439). G. J. Junk used a starch paste for making mat silver bromide prints on paper and linen (D. R. P. October 19, 1893), while the Eastman Kodak Co. produced, in 1894, a mat silver bromide paper called "platino," by emulsifying silver bromide in gelatine and adding starch flour in a nonpasty condition.

These mat silver bromide papers displaced to a large extent the glossy papers then generally used, such as the earlier printing-out papers (albumen paper, mat albumen, pigment prints, platinum printing) in the everyday business of commercial and artistic photography; they were also extensively used in the illustration of periodicals, scientific works (Roentgen photography, microphotography, astrophotography), but in many of these uses glossy papers reappeared, owing to their sharp delineation of detail.

Chapter LXII. THE DISCOVERY OF GELATINO-SILVER CHLORIDE FOR TRANSPARENCIES AND POSITIVE PAPER IMAGES BY CHEMICAL DEVELOPMENT (1881); ARTIFICIAL LIGHT PAPERS

THE PRODUCTION of diapositives and positive paper prints with gelatine silver chloride emulsion and chemical development was invented and published by the author and G. Pizzighelli, in Vienna (1881).[1] Until that time only the production of gelatine silver chloride papers with excess silver nitrate and the development with gallic acid, etc., after the manner of the Talbotype process, was known in photographic practice.

In the seventies of the last century attention was centered only in gelatine silver bromide emulsions, and it was natural that ideas turned to the making of silver chloride emulsions. W. de W. Abney attempted to develop gelatine silver chloride emulsion plates with ferrous oxalate (*Brit. Jour. Phot.*, 1879, p. 614). He found that these were much less sensitive to light than were silver bromide plates, but were easier to reduce, which caused a strong formation of fog. Abney deserves credit for having demonstrated that gelatine silver chloride emulsions were unsuitable for negative making; the fogged, grayish-black images were useless. No one knew at that time, not even Abney, that with chemical development gelatine silver chloride emulsions could produce beautiful diapositives in warm colors as well as photographic prints. The failure of his experiments had a discouraging effect on other research workers.

Two years later the author was busy with gelatine silver halide emulsions. In 1881 he was assistant to Professor J. J. Pohl, in chemical

technology, at the technical college at Vienna. There was only a small darkroom and no studio at the college, and his photographic experiments were made with prints from negatives. This experiment led the author to discover the very favorable behavior of silver chloride with the weak reducing ammonium-ferro-citrate developer and the weak alkaline hydroquinone developer; in these experiments he used gelatine silver chloride emulsions made with an excess of sodium chloride. For subsequent work he joined with his friend Captain Giuseppe Pizzighelli; the latter was director of the photographic branch of the army commission on technical administration, at Vienna, and had at his disposal spacious working facilities, as well as studios and technical assistants. It was there that the photographic work with the gelatine silver chloride emulsions was further elaborated.

The author and Pizzighelli recognized the superiority of gelatine silver chloride emulsions chemically developed over the earlier silver chloride emulsions which had been prepared with other binding agents, and they perfected methods by which, depending on the mode of development, prints of variable colors (red, yellow, violet, and brown) could be obtained, in contrast to the grayish-black color of silver bromide prints. They also realized the extreme fineness of the gelatine silver chloride grain.

They reported their work briefly to the Vienna Academy of Sciences, January 13, 1881 (LXXXIII, 144), and in *Phot. Korr.* (1881). There was also published a pamphlet by Eder and Pizzighelli: *Die Photographie mit Chlorsilbergelatine und chemischer Entwicklung nebst einer praktischen Anleitung zur raschen Herstellung von Diapositiven, Stereoskopbildern, Fensterbildern, Duplikat-Negativen, Vergrösserungen; Kopien auf Papier* ... (Vienna and Leipzig, 1881).

In this pamphlet they described for the first time the method of production of gelatine silver chloride emulsions with excess of chloride and suggested the development, heretofore unknown, of clear silver chloride images with ammonium-ferrocitrate and organic developers (alkaline hydroquinone and others). They also showed that the latent silver chloride image can be transformed to a latent silver-bromide image, capable of development, in the usual way by treatment with soluble bromides. The results of the experiments with pure gelatine silver chloride emulsions were satisfactory. In order to obtain specimens for exhibition, the author and Pizzighelli made diapositives from original portrait negatives (collodion) taken by the court photog-

rapher, Victor Angerer, of Vienna, and exhibited the finished results in a series of diapositives at the International Exposition, on the occasion of the twentieth anniversary of the Photographic Society of Vienna, in 1881. There for the first time were shown silver chloride developed photographs in tones of various warm colors unknown up to that time. The warmest bright red shades were developed with hydroquinone and ammonium carbonate, the brownish tones with ammonium-ferro-citrate, the greenish brown tones with alkaline gallic acid solution, and so forth. The beautiful effect of the toning of such developed pictures by thiocyanogen gold baths could be seen before fixation, which produced the warm, violet-black transparent color,[2] while silver bromide prints do not change their cold black tone in gold baths. This diapositive exhibit was awarded the gold-enamel medal by the Vienna Photographic Society.

In the same year the author sent some of these gelatine silver chloride diapositives, chemically developed, to Captain Abney at London, who presented them to the South Kensington Museum. The English technical societies also took an interest in this, and the Royal Photographic Society of Great Britain, in 1884, awarded to the author its "Progress Medal."

Others who occupied themselves with the new diapositive process were Cowan, in London, and Scolik and Schattera, in Vienna (1891), Unger and Hoffmann, in Dresden (1892), Perutz in Munich, Edwards, at the Britannia Works in Ilford, England (1893), Mawson, Swan, Cadett, and Neal, in England, and others.

Of greater importance, however, was the production of positive paper prints by means of the gelatine silver chloride developing process, which was first described in 1881 in the above-mentioned pamphlet by the author and Pizzighelli.

The manufacture of gelatine silver chloride development paper on a large scale, based on the publications of the author and Pizzighelli, was first taken up in Vienna, by Dr. E. Just, at the end of 1882. Dr. Just was the first to employ one of Schlotterhoss's printing automats, then newly invented. He printed long strips of negatives on gelatine silver chloride paper, which he preferred to silver bromide paper. A large number of such pictures were made for publication and presented to the Vienna Photographic Society; a series of these prints belonging to the author have been preserved in the Technical Museum at Vienna. Most of them were developed with ferro-acetate. Dr. Just recognized

also the influence of the time of exposure and development on the tone or color of the developed silver chloride prints, which he graphically demonstrated by systematic grouping. Such a group is preserved in the Graphische Lehr- und Versuchsanstalt, in Vienna, a gift of Dr. Just to the author.

Dr. E. Just, born 1846, in Saxony, was a chemist who came to Vienna and founded a factory for the manufacture of photographic papers (albumen paper, silver printing paper, etc.). He learned of gelatine silver chloride emulsions on glass and paper at the lectures by the author and Pizzighelli before the Photographic Society, and began their manufacture according to the directions of the inventors, who received no financial recognition. Dr. Just also wrote two pamphlets: *Der Positive-Prozess auf Gelatine-Emulsions-Papier* (Vienna, 1885) and *Leitfaden für den Positiv-Entwicklungs-Prozess auf Gelatine Emulsionspapier* (Vienna, 1890).

Somewhat later than Dr. Just, L. Warnerke, in London, in 1889, took up the production of gelatine silver chloride paper. Warnerke realized the importance of this novel printing method, owing to the beauty of the results which could be obtained (warm tones in contrast with the cold tones of bromide pictures), and he called this process "the printing process of the future."

Notwithstanding all these successes, the great period of the general use of gelatine silver chloride papers had not yet arrived. The introduction of velox paper, accompanied by a tremendous advertising campaign, commenced the victorious course of the gelatine silver chloride printing process. Carrol Bernard Neblette, in his *Photography* (London, 1927, p. 32), describes the invention, but his statement is incorrect. He writes:

In 1893 Velox, the first of the "gaslight" papers, was introduced by the Nepera Chemical Company from the formula of Dr. Leo Baekeland. This is a chloride emulsion developing-out paper without free silver, which is very much slower than bromide paper and can be handled in a brighter light. Since the advent of Velox many other similar brands have appeared both in this country and England, and indeed all over the world, and are now by far the most widely used papers for positive printing.

This, however, is word for word a characteristic description of the process invented by the author and Pizzighelli in 1881, of gelatine silver chloride emulsion (produced with excess of sodium chloride) and chemically developed. Baekeland had copied the earlier process,

perhaps unconsciously, with his silver chloride paper and had given it a new name. It must be added that the Eastman Kodak Co. later took over the manufacture of velox paper, retaining the name of this gelatine silver chloride paper, and that these papers were also made by other manufacturers in enormous quantities and sold at great profits. This velox paper can be demonstrated to be nothing else than gelatine silver chloride paper, chemically developed. It is because of these earlier Eder-Pizzighelli gelatine silver chloride emulsions that the later inventors were not successful in patenting their productions and why the Ansco Co., and others also, were able to produce these papers. But the real inventors of this product, which became so profitable an investment, were never mentioned in America (*Phot. Jour.*, 1930; also *Phot. Indust.*, 1930).

Mr. Neblette loyally corrected his error in the second edition of his work (1931, p. 32).

Later, Liesegang, in Düsseldorf, put on the market "pan" paper, that is, gelatine silver chloride paper. In 1903 the use of the mechanical silver chloride printing process was revived by Linnekampf's Aristophot Co. for printing art subjects with warm red tones. At Vienna a rapid-printing concern, Kilophot, was started later by Aug. Leutner (1858-1927), which produced gelatine silver chloride papers in different grades: "normal" papers with silver chloride gelatine, "contrast" papers with iodide added according to the Eder-Pizzighelli directions, and "soft" papers with bromide added. Many other manufacturers followed this differentiation of papers by their scale of contrasts.

GELATINE SILVER BROMO–CHLORIDE EMULSIONS FOR PAPER PRINTS AND POSITIVE MOVING PICTURE FILMS

Gelatine silver bromo-chloride emulsions, which are more sensitive than pure silver chloride emulsions, but produce warmer (brown) tones than pure silver bromide emulsions, were first described by the author in 1883. He published the advantages of these bromo-chloride emulsions for paper prints and diapositives in the *Photographic News* (January, 1883, p. 98) in one original report. The author selected the English periodical edited by Baden-Pritchard, for whom he acted as Vienna correspondent, because as a weekly publication it offered an earlier means of publication than did the German technical journals, which reprinted this report on silver bromo-chloride emulsions somewhat later. By this invention the author created the large class of chloro-

brom silver "portrait" development papers and the chloro-brom-ciné positive films, which are produced in millions of feet. Chloro-brom plates for lantern slides and transparencies were first made on a large scale in England (*Handbuch*, 1903, Vol.III); while the author's chloro-brom paper was not manufactured wholesale and introduced into photographic practice until several years after its publication by the English manufacturer as "alpha" paper. Later it was manufactured in Germany as "tula" paper (Liesegang) and as "lenta" paper (Neue Phot. Co., in Berlin); still later as "clorona" paper (Ilford Co., London); and by many others (*Handbuch*, 1930, Vol. III, Part 1).

ERRONEOUS CONFUSION OF SILVER CHLORIDE EMULSIONS WITH CHEMICAL DEVELOPERS WITH THE PRINTING-OUT PROCESS USING SILVER CHLORIDE EMULSIONS WITH EXCESS OF SILVER NITRATE

The author wrote on this subject in *Phot. Industrie* (1930, XXVIII, 855) as follows:

Until the beginning of the present century the fact was recognized, in the history of photography, that the production of diapositives and positive paper prints with gelatine silver chloride emulsions and chemical development was first published in 1881 by the author and G. Pizzighelli in Vienna.

Later arose erroneous confusion of this process with the entirely different printing-out method with gelatine silver chloride emulsions with excess silver nitrate (aristo paper). This error led some historical writers into confusion, which necessitates that we enter into the facts here more closely. In C. B. Neblette's *Photography* (London, 1927, p. 31) it is stated: As early as 1866 Palmer and Smith showed a paper coated with an emulsion of gelatinochloride of silver for use in positive printing (*Phot. News*, 1865, pp. 613, 614, and 1866, pp. 24, 35, 36). Further details were given by this author and Captain Pizzighelli, Captain Abney, and W. T. Wilkinson in 1881.

This statement of Mr. Neblette's is erroneous; Palmer and Smith did not invent gelatine silver chloride emulsions with chemical development. Neither in the original publication by Palmer nor in that by W. H. Smith in 1866 is there to be found one word about gelatine silver chloride emulsions with chemical development.

This can be proved. Palmer wrote on "enlargements on canvas" (on the pages cited above in *Phot. News*) that he had suspended silver chloride in gelatine, but had coated the canvas "with such minute quantities" that neither heat nor moisture impaired or cracked it. He stated, "It is developed without gallic acid, neither gelatine nor any hygroscopic sub-

stance." This definition contained no word pointing to chemical development.

Now let us also examine closely the article by W. H. Smith in the *Photographic News* (1866, p. 36). There is no mention whatever by Smith of any development. Probably he refers to a direct printing-out paper, undeveloped, as the description of the print, "the colour is rich, delicate and transparent," seems to indicate. This entirely contradicts Neblette's statement quoted above.

Since English and American periodicals continued to describe incorrectly the history of the invention of silver chloride emulsions and of silver bromo-chloride emulsions, the author demanded the rights of priority for himself and Pizzighelli in the *Photographic Journal* of the Royal Photographic Society of Great Britain in August, 1930 (also *Photographische Industrie*, 1930, XXVIII, 855-56). This request resulted in Neblette's dropping the above-mentioned erroneous statement in the second edition of his *Photography*.

Chapter LXIII. CALCULATION OF EXPOSURE, DETERMINATION OF PHOTOGRAPHIC SPEEDS, SENSITOMETRY, AND THE LAWS GOVERNING DENSITY

THE REGISTERING photometer of Landriani is reported in Chapter XVII. Exposure meters which are based on the appearance of a standard tint of gray color on silver chloride paper were invented by Jordan and Malagutti (1839), Heeren (1844), Hunt (1845), Claudet (1848), and Schall (1853). Bunsen and Roscoe, however, in 1861, first brought order into this field by the introduction of their standard gray with one thousand parts of zinc oxide and one part soot ("Sensitometry," in *Handbuch*, 1930, Vol. III, Part 4).

Exposure meters with silver salt papers and normal gray tints with tables were introduced by Stanley (1886), Wynne (1893), Alfred Watkins ("Standard Exposure Meter") 1890, (W. G.) Watkins ("Beemeter"), and others.

Of purely optical exposure meters we mention only Decoudin, "Photomètre photographique" (with graduated paper scale, 1888), and Heyde, "Aktinometer" (1905), (*Handbuch*, 1912, I (3), 122).

A comprehensive collection of actinometers, exposure meters, and

sensitometers was arranged for exhibition by Walter Clark in the Museum of Science, South Kensington, London, in 1927, for the Royal Photographic Society of Great Britain. The list of the exhibits is printed in the supplement to the catalogue in the *Photographic Journal*. The author began a similar complete collection for the Graphische Lehr- und Versuchsanstalt, in Vienna, as a practical aid in his lectures.

The first exposure tables were published by C. F. Albanus (1844). A very complete set of tables was given by Hurter and Driffield ("Actinograph," 1888). All later tables of this kind are based on the measurements of Bunsen and Roscoe (1858) which connect the activity of sunlight with the position of the sun (time of the day and year).

From the fifties of the last century, when the daguerreotype process was being abandoned and the wet collodion process, collodion dry plates, and silver bromide collodion made their appearance, the wet collodion plate was the ideal of sensitivity in photographic plates, that is, the sensitivity of such a plate was regarded as normal. This standard of sensitometry, however, was very inexact, because it varied with the preparation of the collodion.

We shall pass over the earliest experiments in this field, which are exhaustively described in the *Handbuch* (1930, Vol. III, Part 4). Sensitometry became of actual value only with the invention of gelatine silver bromide plates with their different degrees of sensitivity.

The first practically serviceable device for measuring exposures was the sensitometer invented in 1880 by Leon Warnerke, which was placed on the market in its final form in England.[1] It was widely appreciated, because with its aid one could classify the sensitivity of the extremely variable sensitive silver bromide plates with sufficient exactness. This sensitometer consisted of a gelatine intensity scale marked with India ink in graduated spaces; the light source was a blue phosphorescent plate, which was illuminated, as required, by magnesium light.

Warnerke rendered a great service to dry plate manufacturers and photographers with his sensitometer, because previous to its introduction they had been obliged to rely on the uncertain estimate of sensitivity based on mere guesswork. Ten degrees of Warnerke's sensitometer were at that time considered to be equal to the average sensitivity of a wet collodion plate. The ideal of the eighties for silver bromide emulsions was the sensitivity of plates equal to the highest number (twenty-five degrees) of the Warnerke's sensitometer; this

corresponded approximately to sixty times greater sensitivity than a wet collodion plate. Ordinary portrait plates had, even around 1890, the medium sensitivity of twenty degrees, Warnerke, equal to ten degrees of the later sensitometer of Scheiner. Instantaneous plates had twenty-four to twenty-five degrees Warnerke (about sixteen to eighteen degrees Scheiner), which at that time was still considered a high degree of sensitivity. Today manufacturers supply plates of twenty-four to twenty-five degrees Scheiner, which are several hundred times more sensitive than wet collodion plates.

Warnerke's biography: Leon Warnerke was born in 1837 in Russia (some less reliable sources say in Hungary).[2] He was a civil engineer, but devoted himself entirely to photography. He spent his youth in St. Petersburg. He came to London in 1870, started a private photo-chemical laboratory, invented the roll holder with silver bromide collodion stripping paper. He worked a great deal with silver bromide collodion, received a prize from Belgium in 1877, for his work in this field, and in 1881 the Progress Medal of the Royal Photographic Society of Great Britain. He gave lectures before the photographic societies of England, France, Belgium, and Germany, but never came to Austria-Hungary.

At the end of the seventies he investigated gelatine silver bromide emulsions and discovered the tanning action of pyrogallol in the development of silver bromide plates. In 1880 he founded, at St. Petersburg, a photographic firm and a technical journal. He was also financially interested in the manufacture of dry plates in Russia. Later he produced in England gelatine silver chloride paper, which he had greatly improved. His actinometer and his sensitometer are well known (*Handbuch*, 1912, Vol. I, Part 3). It was Warnerke who personally introduced in England the Goerz double anastigmat constructed by the Berlin optician Goerz; he also was the first to demonstrate there the Lippmann color process, and in 1893 he also showed Lumière's autochrome process.

About 1898 Warnerke received a rather large sum of money (about 5,000 pounds) in Russian bank notes as payment on account of a photographic invention. When these notes were exchanged in France, some of them proved to be counterfeits. From a false sense of discretion he refused to disclose the party from whom he had received the notes and was convicted, not for counterfeiting, but for passing the counterfeit notes; sentence, however, was suspended. He

retired after this to Geneva and lived in almost complete solitude, dying there in straightened circumstances on October 7, 1900. After his death his sensitometer was no longer manufactured, and today specimens of it can be seen only in museums.

The English chemist Chapman Jones introduced, in 1901, a similar instrument with progressively graduated squares of neutral gray densities, numbered 1 to 25, in combination with gelatine color filters, which enjoyed wide popularity under the name "Chapman Jones plate tester." It is still used, but it furnishes no exact measurements. Jones also studied the chemical reaction equations in negative intensification with mercury bromide and sodium sulphite, as well as in intensification with mercury chloride and potassium cyanide.

Warnerke's sensitometer was displaced, in 1894, by sensitometers with rotating wheels. The first of these were made at the time of Bunsen and Roscoe (1862). Professor E. Mach constructed the first sensitometer of this kind (1865). In 1890 Hurter and Driffield used the rotating sector-wheel sensitometer in their extensive sensitometric investigations (*Handbuch*, 1930, Vol. III, Part 4).

The astronomer Dr. Julius Scheiner (1858-1913) constructed, in 1894, a more exact sensitometer of this kind. He was at first assistant at the observatory at Bonn, and in 1894 observer at the astrophysical observatory at Potsdam. In 1895 he was professor of astrophysics at the university at Berlin.[3] He made his sensitometer public in June, 1894, with continuous curved apertures and shuttered benzine light. The author gave the instrument the shape which was later generally adopted, having a series of steps standardized with the Hefner amylacetate standard lamp, and presented it before the International Chemical Congress at Vienna in 1898. Scheiner's sensitometer scale, reduced to candle power per second per meter, is still used today in German and Austrian industry and commerce. Following the suggestion by this author, given at the International Chemical Congress of Vienna, the Secco-Film Co. of Berlin (Dr. Hesekiel, Moh & Co.) was the first (March 6, 1899) firm to indicate the sensitivity of its films by Scheiner degrees printed on the package.

The principle of tube photometers was stated by Heinrich Wilhelm Dove in 1861 (Poggend. *Annal.*, 1861, CXIV, 145) and was later applied by Bunsen and Roscoe, then came Taylor (1869), Mucklow and Spurge (1881), H. W. Vogel and the author (*Handbuch*, 1930, Vol. III, Part 4), with various kinds of tube photometers.

The invention of the gelatine neutral gray wedge sensitometer in 1883, by the German scientist Dr. Franz Stolze (1830-1910), was important. Stolze lived in Berlin and published fundamental articles in this field (*Photographische Wochenblatt*, 1883, p. 17, edited by him).[4]

In 1911 Professor Emanuel Goldberg,[5] of Leipzig, published instructions for the production of an improved form of such wedges, which later found general use and is considered to be a very definite advance. Dr. F. Stolze's priority had been entirely forgotten, and the author had to take up the fight for the recognition of priority he deserved.

Notwithstanding the fact that the Stolze-Goldberg gray wedge had long been known, no sensitometers equipped with it were manufactured for industry and commerce. This actuated the author to bring out, in 1919, his "Eder-Hecht wedge sensitometer,"[6] which Goldberg had not done up to that time. This is shown by a letter of Dr. Eduard Schloemann, manager of the Kino Film Co., Düren, Germany, dated April 27, 1921, which reads:

With greatest interest I have followed your work on the Eder-Hecht wedge sensitometer, and I promise myself great advantages from the use of this instrument for the photographic industry. I welcome the appearance of your sensitometer so much the more, since the Goldberg wedge sensitometer never made its appearance in practical form. Notwithstanding repeated announcements and since I have been repeatedly consoled personally by Professor Goldberg with promises for a later date. . . . I have bought two of your sensitometers from the Herlango Co. and intend to have them used continually in our work.

[Signed:] Dr. phil. Ed. Schloemann.

The Eder-Hecht wedge sensitometer was provided with spectroscopically standardized color filters (red, yellow, green, blue) and a scale referring to candle-meter seconds by using a free-burning standard light source of 2 mg. of magnesium ribbon, standardized as a white light source (German Musterschutz, No. 155,306, January 8, 1921). For literature on this subject see the author's *Ein neues Graukeil-Photometer für Sensitometrie, photographische Kopierverfahren und Lichtmessungen* (1920); *Phot. Korr.* (September, 1919), and *Handbuch* (1930, Vol. III, Part 4).

The investigations of sensitivity by Hurter and Driffield were very successful. Ferdinand Hurter (1844-1898) was born in Switzerland, went to Manchester, England, in 1867, where he was employed by

the United Alkali Co. as chemist. Vero Charles Driffield (1848-1915) interested himself in photography and made Hurter acquainted with it in 1876. On May 7, 1890, they published jointly their fundamental work, *Photochemical Investigations and a New Method of Determination of the Sensitiveness of Photographic Plates*, in which they plotted curves having as coördinates, the logarithm of the light intensity and the density of the plate.

These investigations are described in detail in the *Handbuch* (1930, Vol. III(4), "Sensitometry"). The collected writings of Hurter and Driffield were published in *Memorial Volume* by the Royal Photographic Society of Great Britain in 1920. The further progress of sensitivity is recorded in the proceedings of the International Congress of Photography, London (1928), and Dresden (1931).

LAWS OF DENSITY FOR PHOTOGRAPHIC PLATES AND PAPERS

The reciprocity law of Bunsen and Roscoe is considered fundamental, and it is $E = i \cdot t$. However, it works only within certain limits, and the photographic process of intensification exhibits many deviations, which on their part again are subject to definite rules.

The astronomer P. J. C. Janssen stated, in 1881, that during the process of photographic development the action of light, E, does not grow in proportion to the intensity. Later, W. de W. Abney made very thorough studies of the exceptions to the law of reciprocity on silver bromide gelatine plates (1892-1894)[7] and measured the deviations. He asserted that the law broke down completely when dealing with very small light intensities.

Abney stated, in 1894, "that every plate had an intensity of its own, which exercises during a certain exposure a maximum action and that a deviation to either side from this maximum point, reduced the beneficial applied energy." The great amount of material observed by him confirmed the existence of deviations from the law of reciprocity, but Abney was unable to arrive in his fundamental work at the formulation of a law of density adjustable to these conditions, which only later was done by K. Schwarzschild and E. Kron.

Sir William de Wiveleslie Abney (1843-1920) was until 1877 instructor in chemistry at the military school in Chatham; from 1877 he was active in London in the Department for Science and Art. From 1900 he was director of secondary education for England and Wales and a member of the Royal Academy of Sciences, London. He occu-

pied himself a great deal with photography, photochemical processes, the chemistry of photographic developers and intensifiers, photometric investigations of the law of density of photographic plates, and spectro-analytical work. Important are his experiments on solarization and the connection of exposures and the intensification of photographic silver bromide gelatine plates.

Abney photographed on specially prepared silver bromide collodion plates the infrared of the solar spectrum, with new Fraunhofer lines up to 2,700 μμ.

We owe to him the first practical directions for the production of light-sensitive emulsions. In 1877 he invented copper-bromide silver-nitrate intensification for the wet collodion plates, introduced in 1880 hydroquinone as a developer for dry plates, and furnished the basis for the production of aristo paper. Abney was for years president of the Royal Photographic Society, London.

For a biography and a portrait of this excellent scientist, to whom we are indebted for much of the most valuable work in the field of photo-chemistry, spectroanalysis, and photography see *Phot. Jour.* (1921, p. 44; also *ibid.*, p. 29), the exhaustive biography by Chapman Jones, and the *Annual Report* of the Smithsonian Institution (1919, pp. 531-46).

SCHWARZSCHILD'S LAW OF DENSITY

The astronomer Karl Schwarzschild, in 1900, first stated the law, called after him, governing the density of photographic plates. The photographic action of light on silver bromide plates depends upon the product "It^p," where "I" is the light intensity, "t" the time exposure, and "p" a characteristic constant for the particular plate; "p" is in general less than "I." If p equals one, we have the simple reciprocity rule. Later investigations, carried out at Schwarzschild's suggestion by his assistant E. Kron, resulted in a more precise formula, based on the absolute light intensities.

Kron's law stated that for each kind of plate there is a certain light intensity at which the energy incident on the plate acts most favor-ably. This "optimal light intensity" is that at which the incident ray has a greater photographic activity than at any other light intensity (greater or less). Kron based upon this his strictly formulated mathe-matical law of density, in which the curve of density, brought into relation with the logarithm of exposure, is plotted in the form of a

hyperbola or a catenary curve. In Kron's law the condition is taken into account that Schwarzschild's exponent "p" becomes variable by very great light intensity, while the time scale is accepted as invariable.

Karl Schwarzschild was born in 1873 in Frankfurt a.M., studied in Strassburg and Munich, where he received his doctor's degree, and came in 1897 to the Kuffner Observatory, Vienna. While working in the author's photochemical laboratory, he commenced his studies in photographic sensitometry, which led to his law of density. He moved to Munich, where he joined the university staff in 1899; in 1900 he became director of the observatory and professor of astronomy in Göttingen, in 1909 director of the photoastrophysical observatory, and in 1912 member of the Berlin Academy of Sciences and honorary professor at the university. He died in 1916 from an incurable disease which he contracted during the World War.

Obituaries of Schwarzschild can be found in: *Quarterly of the Astronomical Society* (LVIII, 191-209), by Oppenheim, his colleague at the Kuffner Observatory; *Die Naturwissenschaften* (1916, No. 31), written by Sommerfeld, his companion during his Munich days; *Jahresbericht der Deutschen Mathematiker-Vereinigung* (1917, XXVI, 56-75), by Blumenthal, his brother-in-law.

Erich Kron[8] (1881-1917) was educated in Potsdam. He wrote, in 1906, an astronomical dissertation for his doctor's degree; became assistant and observer at the Potsdam astrophysical observatory where he carried on, urged and guided by Schwarzschild, his experiments on the laws of density of photographic plates. Kron's dissertation on the theory of density was published in 1913 in the *Publikationen des astrophysikalischen Observatoriums in Potsdam* (Vol. XXII). Kron's theory marks great progress in the scientific conception of the photographic phenomenon of density on gelatine silver bromide. This phenomenon was investigated further and studied particularly by American scientists (E. Halm, 1915, L. A. Jones, E. Huse, and V. C. Hall, 1926), whose work may all be traced back to Kron's investigations. He joined his regiment during the World War, was first lieutenant in the artillery on the Western Front, in Flanders, where he fell. Obituary in *Astronomischen Nachrichten*, 1917, CCV, 223.

Among the publications of the Potsdam observatory are two articles published by him, one on the light change of the short periodic "XX cygni"; the other on the law of density of photographic plates.

PHOTOGRAPHIC PHOTOMETRY FOR THE DETERMINATION
OF THE BRIGHTNESS OF CELESTIAL BODIES

Professor G. Eberhard of the astrophysical observatory in Potsdam covers this subject thoroughly in the *Textbook of Astrophysics,* by G. Eberhard, A. Kohlschutter, and H. Ludendorff (1931, II(2), 431-518). This work also contains a historical review on the work of Foucault and Fizeau. In 1858 Warren de la Rue made comparisons of the luminosity of the moon with that of Jupiter and Saturn, which were produced on wet collodion plates. In the same year the astronomer George Phillips Bond reported at the Harvard observatory, in Cambridge, Mass., his experiences with photographic measurements of stellar luminosity. He established first that increased exposures not only increase the density of the photographed stellar disks, but also the diameter of the disks, which can easily be measured by the aid of the microscope. Bond used this in his measurements of the luminosity of stars.

On the occasion of the proposed photographic chart of the whole heavens, which was resolved on, as an international undertaking, by the International Astronomical Congress at Paris in 1887, astronomers decided to organize their efforts along these lines. This work became extremely valuable to scientific astronomy.

Chapter LXIV. DISCOVERY OF COLOR-SENSITIZING OF PHOTOGRAPHIC EMULSIONS; IN 1873 PROFESSOR H. W. VOGEL DISCOVERS OPTICAL SENSITIZING

THE ACTION of the solar spectrum on photographic films was investigated soon after the discovery of daguerreotypy for both iodide and daguerreotype plates by Herschel in 1840 and 1842, by Draper in 1842, and by Hunt in 1843. Herschel found that silver bromide is more sensitive to green than is pure silver iodide. The physicist Crookes (1855), J. Müller (1856), Schultz-Sellack (1871), as well as others, investigated the behavior of collodion plates toward the spectrum.

All early experiments showed that principally blue and violet rays (also pigments) acted photographically on daguerreotype plates as

well as in the other photographic processes with silver iodide, silver bromide and silver chloride. Red, yellow, and deep green, however, acted little or not at all; thus, the daguerreotype and the dry collodion process, as well as the gelatine silver bromide were "color blind."

This was a great defect in photography and made the "color-correct" reproduction of paintings, and so forth, very difficult, necessitating the assistance of hand retouching—good or bad. The introduction of the theoretically conceived three-color photography was also arrested at first, because the photographic plates available lacked sensitivity for the optically active rays.

This defect was remedied by Professor Hermann W. Vogel, of Berlin, in 1873, by his discovery of color sensitizing with the so-called "optical sensitizers." This discovery opened a new era in photography and raised him to the position of the most important photochemist of the post-Daguerre period and also the most successful promoter of the technique of reproduction and scientific photography. He published his discovery in a well-elaborated form, quite in contrast to the treatment of many other photographic inventions, which gave scientists a great deal of work owing to their incoherent statements. Vogel's discovery met with much opposition on its first publication, and he had to fight before he managed to carry it through. In due time, however, the importance of Vogel's epoch-making discovery became clear, and so we shall devote more space here to a report on his life and works.

In 1873 Vogel busied himself with experiments[1] on the chemical action of the solar spectrum on silver iodide, silver bromide, and silver chloride, having received from the Berlin Academy of Sciences a small spectrograph for his work. He turned his attention to collodion silver bromide plates, which occupied at that time the foreground of interest, and the preparation differed from that of those produced commercially in England. The trade was chiefly concerned with the elimination of halation, a defect from which collodion plates suffered; they tried to overcome it by the addition of various coloring matters. Stuart Wortley manufactured in England such a collodion dry plate for the trade, which contained as a preservative rubber, gallic acid, and uranium nitrate, as well as a yellowish-red dye (corallin), to prevent the penetration of actinic light through the film and the formation of detrimental light reflections from the glass base. As a matter of fact, such plates, when used for landscapes, showed little halation.

H. W. Vogel observed in 1873 that such plates possessed a greatly increased sensitivity to the green of the spectrum, which was unknown until then. With great insight he grasped the significance of this phenomenon as a specific action, namely, as an increase in sensitivity by the admixed dye. He observed in the case of corallin that this dye (which absorbs yellow and green) also sensitizes for yellow and green silver bromide collodion dyed with it and that green aniline dyes sensitize silver bromide collodion into the red. Thus Vogel made the enormously important discovery of the "optical sensitizers" (as he called them), or as they are mostly called today, "color sensitizers." From Vogel's discoveries developed the new color-sensitive processes which permit photography with correct tone values and called forth an essential change in the photography of colored objects. This was fundamentally important not only for correct-color photography but also for three-color photography.[2]

Vogel published his discovery in 1873[3] and exhibited his first spectrum photographs on color-sensitized collodio-bromide plates at the session of the Berlin Society for the Promotion of Photography, October 17, 1873. He made comparative exposures with his small spectrograph in 1874, which confirmed his results of 1873 and furnished the proofs for his extensive dissertation in Poggendorff's *Annalen*. Reproductions of Vogel's spectrum photography, by which he demonstrated "the increase of light sensitivity of silver halides for certain colors by admixed absorption media (dyes)" are in the 1932 ed. of the *Geschichte* (pp. 638-39). Vogel followed up his discovery consistently and gave exact data in his article "Über die chemische Wirkung des Sonnenlichtes auf Silberhaloidsalze," in Poggendorff's *Annalen* (1874, CLIII, 218) on the behavior of pure silver bromide, silver iodide, and silver chloride collodion toward the solar spectrum. He also described the action of corallin, nephthalene red, aniline red, aniline green (methylros-anilinpicrate), and aldehyde green. These interesting and historically important photographs Vogel presented to the author of this book; they are preserved in the collection of the Graphische Lehr- und Versuchsanstalt, at Vienna, with Vogel's marginal notes, and it is doubtful whether any duplicates are in existence.

The diagrams of the curves of the action of the solar spectrum on silver halides in the collodion process and the description of the action of color sensitizers which Vogel published in his early reports, are of permanent interest; since he used a spectrograph with a thick direct-vision prism, the action of the ultraviolet solar spectrum is missing.

Vogel also discovered that cyanine is the most efficient sensitizer for orange-red in collodion plates, which later was recognized by V. Schumann as also an effective sensitizer for this spectral region in gelatine plates.

Vogel's important discovery was at first looked upon with a great deal of doubt, for instance, Monckhoven, in Ghent, repeated Vogel's sensitizing experiments with negative results. This failure aroused misgivings as to the correctness of Vogel's statements; it was later found that Monckhoven, who had at his disposal more powerful spectrographs, with greater dispersion, had worked with weak spectra, so that the action of the color sensitizers known at that time, which were not very strong, was not very prominent, while they showed plainly in Vogel's small direct-vision spectral apparatus, used in strong sunlight.

Carey Lea also achieved no better results when working with colored glass plates in repeating Vogel's sensitizing experiments.[4] Vogel entered into various controversies with Monckhoven, Lea, and Spiller, in which he defended the correctness of his statements (*Phot. Mitt.*, Vol. XI).

The first who came to Vogel's assistance with his endorsement was the famous French physicist E. Becquerel (*Compt. rend.*, 1874, LXXIX, 185), who, following along the lines of Vogel's theory on the connection of light absorption with the sensitizing of silver bromide collodion dyed with chlorophyll, found even more sensitivity bands. This ended the controversy in favor of Vogel.

H. W. VOGEL'S AZALINE PLATES (1884)

In his experiments with new dyes Vogel came across quinoline red, discovered in 1882 by Dr. E. Jakobsen, of Berlin, which is a splendid fluorescent basic dyestuff (from quinaldine and iso-quinoline). This dye was recognized by H. W. Vogel (1884) as an excellent sensitizer for green silver bromide emulsions. In itself quinoline red offered no advantages as a green sensitizer over the acid eosin colors. But it possessed the important property that it could be mixed without decomposition with the likewise basic quinoline blue (cyanine equals quinoline blue), and so it made possible a harmonious sensitizing for green, yellow, and orange. Thus, Vogel became the creator of the first panchromatic plate. He called this dye mixture "azaline" (*Phot. Mitt.*, 1884, XXI, 50, 60, 106) and offered it on the market, keeping his formula secret.

Professor Vogel visited Vienna in 1884 and brought some of his

azaline plates with him, where at the Löwy studio, in the presence of J. Löwy and the author, he successfully photographed paintings with the aid of strongly yellow-sensitive glass plates, in which negatives the red-orange was splendidly reproduced. This was rightly esteemed a great progressive step.[5] The developer, used at that time exclusively, was iron oxalate. The acid reaction of this developer destroyed the red sensitivity of the sensitizer (as was later found out, it contained cyanine), and it acted as a desensitizer in the development, therefore the negatives were clear. This first "panchromatic" plate was discussed by the Vienna Photographic Society and aroused a desire to discover the secret of its preparation. Dr. F. Mallmann, an amateur photographer, succeeded in this, in company with the professional photographer Charles Scolik, who reported to Vogel an offer from the United States, which expressed the desire to introduce his azaline there and promised large orders for the dye in solution. Vogel sent it to the United States, from where it was returned to Dr. Mallmann at Vienna; he had it analyzed in Berlin, where it was disclosed as a mixture of quinoline-red with cyanine (proportion 10:1); they then published the composition in photographic circles (*Phot. Korr.*, May,1886, pp. 331, 337, 372; see also Vogel, *Phot. Mitt.*, 1886, Vol. XXIII, and the report of the session of the Society for the Promotion of Photography, Berlin, September 17, 1886).

This, of course, greatly interfered with Vogel's exploitation of his invention, but the azaline solutions sold on the market found, notwithstanding, many kinds of application.

Not only were these azaline plates used in the reproduction processes but they also enabled the spectrum analyst, Professor Heinrich Kaiser (then at the technical college, Hanover) and Professor Runge to photograph from the red to the green spectral regions in their investigations in the bands of the spectra of alkalis and alkaline earths in 1888 and later. Lippmann, in Paris, also used azaline for sensitizing the dry plates used in his interference-photochromy. Azaline plates were also used in three-color photography.

Of course, azaline plates had their shortcomings, for they were feebly sensitive, less stable, and required strong light filters in order to subdue the blue. Nevertheless, azaline presented a remarkable progress; but it could not compete in orthochromatic photography with erythrosin and with the new sensitizers of the isocyanine series found by Miethe and E. König.[6]

BIOGRAPHY OF H. W. VOGEL[7]

Hermann Wilhelm Vogel was born March 26, 1854, and was destined to be a merchant. Having left school at 14, he worked for awhile in his father's store and as a clerk in Berlin and elsewhere. His desire to devote himself to the natural sciences after acquiring an education was opposed by his father, who saw no financial returns accruing to his son from science and refused him also the chance to become a mechanic. His father finally gave up all hope for him and allowed him to become a cabin boy on a boat. Fortunately, the young man became too ill to depart, for the whole crew perished from yellow fever during the voyage.

In the meantime he sought to enlarge his knowledge by reading and study, and finally, through the kind intervention of a friend, he received the parental consent to attend the trade school at Frankfurt on the Oder. He passed his examination so satisfactorily that he received a government scholarship of 600 talers to cover his expenses at the trade institute at Berlin. He moved to Berlin on March 2, 1852, studied chemistry and physics, and broadened his education in many directions. His examination paper was so successfully elaborated that it was published in Poggendorff's *Annalen der Physik*. After a short term of employment in a sugar refinery, Vogel became, in 1858, scientific assistant to Professors Rammelsberg and Dove, in Berlin, and in 1865 assistant at the mineralogical museum of the University of Berlin. Here he began his activity in photography, when required to reproduce enlarged rock sections. In 1862 he visited the World Exposition in London,[8] and in 1863 he received his doctorate for a dissertation *Über das Verhalten des Chlorsilbers, Bromsilbers und Jodsilbers in Licht und die Theorie der Photographie* (Berlin, 1863). In 1864 he invented his test for silver, that is, titration with iodide of potassium solution and starch paste as indicator.

In 1863 he founded the Photographic Society, at Berlin, from which started in 1869, under his direction, the Society for the Promotion of Photography. From which also sprang in 1887, the German Society of Friends of Photography, and in 1889 the Free Photographic Union, both at Berlin. Vogel's activities in societies were always brisk and many sided, but also controversial and hostile, involving him in many disputes. Vogel was also a charter member of the German Chemical Society (1867) and of the Union for German Applied Art (1878). In 1864 he founded the *Photogr. Mitteilungen,* a leading tech-

nical journal, which he edited until his death, after which it lost its importance. He also founded and directed a photographic laboratory at the Royal Trade Institute, Berlin, in 1864; when this was merged with the Technical College, in 1879, Vogel became ordinary professor of photochemistry and taught spectrum analysis[9] and principles of illumination in addition to scientific and applied photography.

Vogel was director of the first Berlin Photographic Exhibition, 1865,[10] also of the Berlin Jubilee Exhibition, 1889; he was also one of the judges of awards in the World Exposition at Paris, 1867, Vienna, 1873, Philadelphia, 1876, and Chicago, 1893. He visited America four times; the first time in 1870 as guest of the National Photographic Association, of which he was an honorary member; in 1893 he attended, upon invitation, the Photographic Congress in Chicago. Vogel participated as photographer in the North-German solar eclipse expedition to Aden, in 1868, to Sicily, in 1870, with the British expedition, in four editions,[13] and many of his articles were translated into foreign expedition, in 1888, to Jurgewetz on the Volga.[11]

His scientific activities were many-sided and prolific; his most important success, the color-sensitizing of photographic films, is dealt with in detail at the beginning of this chapter. The results of his investigations are reported in numerous separate publications, particularly in the *Photogr. Mitteilungen.*[12] His *Handbuch der Photographie* appeared in four editions,[13] and many of his articles were tranlated into foreign languages.

Vogel's services to photographic chemistry must be especially emphasized; he introduced the paper scale photometer,[14] which retains its importance today for its practical usefulness, particularly for carbon and pigment printing. He always stressed the use of the tube photometer, improved it, and was the first to recommend the burning magnesium ribbon, which is so similar to daylight, with the use of a white reflecting paper surface as an indirect normal light source (*Handbuch*, 1930, Vol. III(4), "Sensitometry").

During ten years, 1867-76, Vogel endeavored to obtain legal protection for photographs, which at times occupied him to the exclusion of everything else; his efforts were finally crowned with success by the German copyright law, which became effective July 1, 1876. He was always a follower and a lively defender of artistic photography. He received many honors, among them, in 1894, the gold medal of the Vienna Photographic Society.

Overwork caused Vogel to suffer from insomnia in his early years, and he was one of the first on whom Oscar Liebreich experimented with chloral hydrate, the soporific effect of which was discovered in 1869. In later years his suffering from lack of sleep made him irritated and suspicious, which tended to drive him into solitude. He suffered from diabetes from 1886 and died from an attack of influenza December 17, 1898.[15]

His son, Ernst Vogel, who had collaborated with his father in the field of graphic arts, became his successor in some respects; he continued along the lines which his father had established.

Ernst Vogel, born July 23, 1866, at Berlin, studied chemistry at the technical college in Berlin, devoted himself entirely to photochemistry, and was assistant to his father at the photochemical laboratory of the technical college (1890-93). He received his doctor's degree from the university at Erlangen, in 1891, for his thesis: *Beziehungen zwischen Lichtempfindlichkeit und optischer Sensibilisation der Eosinfarbstoffe*. On October 31, 1889, he applied for a German patent, which was granted in 1890 (No. 53078) for the use of collodion and gelatine films as substitutes for glass as a carrier for sensitive films. After having acquired during 1892 the necessary experience and practical training in New York in the plant of William Kurtz (a dear friend of his father's), he took an important part in the development of the three-color halftone process and, with Georg Büxenstein, founded in 1893 an establishment for photoengraving at Berlin, with particular attention to the practical application of his knowledge of color printing.

Ernst Vogel was editor of the *Photogr. Mitteilungen* from 1899 until his death, August 27, 1901.[16]

WATERHOUSE DISCOVERS THE SENSITIZING EFFECT OF EOSIN

Major J. Waterhouse, of Calcutta, made the important discovery in 1875 of the sensitizing action of eosin on silver bromide collodion dry plates in the green region of the spectrum. He published his findings in the *Brit. Jour. Phot.* (1875, p. 450; 1876, p. 23, 233, 304), as well as in the *Phot. Mitt.* (1876, XII, 17).

J. Waterhouse was born in England, June 24, 1842, and died September 28, 1922, a major general. This prominent scientist spent nearly forty years of his life in the army in India, being for some time chief of the Cartographic Service at Calcutta. In the eighties and nine-

ties he visited Carlsbad, where he took the cure; he always visited Vienna on such trips. Here he met the author of this history and justified the latter's respect and admiration for this noted scientist's knowledge of and service to photography. He contributed many valuable articles to the *Jahrbuch für Photographie*. Waterhouse returned from India in 1897 and became president of the Royal Photographic Society, London. His investigations in the field of photography we have reported elsewhere. In 1868 he worked on a photographic transfer process, studied in 1875-76 color sensitizers with the spectrograph and was the first in 1894 to start and carry out the three-color process of gravure printing in India.

DUCOS DU HAURON EMPLOYS COLOR SENSITIVE PLATES FOR THREE-COLOR PHOTOGRAPHY, 1875

It is most remarkable that Vogel's discovery of photographic color sensitizers were first utilized in photographic practice, not in Germany, but in France. The French scientists Ducos du Hauron and Cros anticipated the progress in the manufacture of light-sensitive plates with their ideas on three-color photography.

Louis Ducos du Hauron, born in 1837, in France, to whom is due great credit for the progress of three-color printing, applied himself successfully to the introduction of color-sensitizers into photographic practice. Hauron had interested himself in photography since 1859, when he tried to produce photographic images in series and invented a kind of cinematograph, which he protected by French patents of March 1 and December 3, 1864. He recognized even then the importance of the principles underlying three-color photography and applied, on November 23, 1868, for a patent on a photographic three-color process.

This process of Ducos du Hauron necessitated the making of three matrices, which were produced on collodio-silver bromide plates behind colored glass (filters), and which were supposed to reproduce not only the blue and the violet but also the yellow, red, and green of the original; it was only partly successful. This required plates which were very sensitive to green, yellow, and red, which were not available until after Vogel's discovery of optical sensitizers (1873), of which Ducos du Hauron soon made use. Ducos du Hauron dyed his plates accordingly and reported on September 6, 1875, to the Agricultural Society of Arts and Sciences that he used chlorophyll; Edmond Becquerel (1874)

had indicated its sensitizing effect for the red end of the spectrum. He also used Vogel's corallin as green sensitizer.

The brothers A. and L. Ducos du Hauron published in 1878 a pamphlet *Photographie des couleurs*. They phrased their directions for producing photographs behind green or orange colored glass filters as follows.[17] They stated that brominated collodion with eosin, as recommended by Waterhouse, permitted much shorter exposures than with chlorophyll and corallin, and gave a detailed description of their procedure. It consisted in salting the collodion with cadmium bromide, dyeing it with eosin, and then sensitizing it in a silver nitrate bath. The exposed plate was developed with iron sulphate. The history of three-color photography and the part which Louis Ducos du Hauron played in this process, as well as the invention of anaglyphs, is described in Chapter XCIV. We must mention here only that the work of this meritorious scientist had also a great influence on orthochromatic (correct-color) photography.

Chas. Cros[18] also published studies on the classification of colors and the means for the reproduction of all tones by three negatives (corresponding to red, yellow, and blue).

ADOLPH BRAUN EMPLOYS WET EOSIN SILVER COLLODIO-BROMIDE PLATES FOR CORRECT-COLOR TONE NEGATIVES OF ART SUBJECTS

The first who used these new wet eosin collodion plates, with acid iron sulphate developer, for the orthochromatic reproductions of paintings in color (for monochrome photography, in particular for pigment printing), was the Frenchman Adolph Braun at Dornach (Switzerland), who worked this process as early as about 1878.[19] His son, Gaston Braun (born 1845), who later became the head of the firm of Adolph Braun & Co., of Dornach and Paris, devoted himself from 1869 to experiments with three-color photography after the methods of Cros and Ducos du Hauron. He used the bromide collodion-bath process, dyed his plates with eosin, and developed them with acid iron sulphate for the reproduction of oil paintings (1878), using not the ordinary eosin, but ethyl eosin, which is more advantageous. In 1878 Gaston Braun reproduced for the first time with such orthochromatic collodion-bath plates the paintings in the galleries of Madrid and St. Peterburg. Their correct reproduction of the tone values of the yellow and blue excited the astonishment of the professional world.

Gaston Braun photographed, in 1880, many paintings in the museum

of the Hermitage at St. Petersburg, where he compared the superiority of the reproductions made with eosin silver bromide collodion-bath plates and the inferior results obtained by the old silver iodide wet collodion process. One of Braun's earliest reproductions is Gerard Dow's painting "The Reader," at the Hermitage Museum, which he made in 1880 with dyed bromide collodion, separate silver bath, and developed with acid iron sulphate developer.

On account of his complete silence about his method, however, none of those viewing Braun's reproductions had the idea of applying color sensitizers in practice for obtaining orthochromatic negatives, because it was believed that the superior effects obtained by Braun were due to the use of special bromine salts in his negative collodion. The art firm of Braun & Co. achieved their world-wide reputation because they were the first to introduce the orthochromatic process in the reproduction of paintings. This was followed at about the same time by Swan's improved pigment (carbon) process.

H. W. VOGEL'S AND E. ALBERT'S EXPERIMENTS WITH
EOSIN SILVER BROMIDE COLLODION

H. W. Vogel, the originator of color-sensitizers in photography, urged by Braun's performance, turned his attention, later, to the use of the eosin silver bromide process in obtaining color correct negatives when photographing colored objects, such as paintings and so forth. Vogel improved the wet bath process with eosin collodion, for which he received a prize of 1000 marks from the Society for the Promotion of Photography, Berlin. In 1884 he published his process, which was similar to that of Ducos du Hauron, in the *Phot. Mitteilungen* and pointed out to those engaged in photographic reproduction the advantages of this process, which, as we have said, was for many years employed by Braun of Dornach and Hanfstängl of Munich, but was later displaced by the "isochromatic collodion emulsions" of Dr. E. Albert.

E. ALBERT EXPERIMENTS WITH SILVER BROMIDE COLLODION
AND ADDITION OF EOSIN SILVER (1883)

Dr. Eugen Albert, at Munich, applied himself with great success in 1883 to the work of making a practical collodion emulsion for reproduction methods; he dyed his silver bromide collodion emulsions with eosin silver or similar eosin dyes in order to sensitize them for green

and yellow and employed alkaline development. Thus he adapted this method to the modern emulsion process and obtained greater sensitivity. His results, exhibited at the International Art Exhibition in Munich, in 1883, were the first to be publicly shown, and they attracted great approval. It was not until five years later that he offered his emulsion for sale (*Phot. Korr.*, 1888, p. 251).

The preparation of the eosin silver bromide emulsion itself was kept a secret by Albert. The method was not established and published until after many experiments by Dr. Jonas at the laboratory of the Graphische Lehr- und Versuchsanstalt in Vienna, and later[20] by Baron A. Hübl, of the Military Geographic Institute (*Handbuch*, 1927, Vol. II, Part 2).

SENSITIZING GELATINE SILVER BROMIDE PLATES

The optical sensitizers discovered in 1873 by H. W. Vogel worked quite satisfactorily in collodion plates; on the other hand, when used for gelatine silver bromide plates difficulties arose, because the latter reacted very little with the color sensitizers known at that time. Vogel considered this as a definitely unfavorable characteristic property of gelatine plates, so that he at first doubted whether they could be properly sensitized by dyes. In 1882 the Frenchman Attout, trading as Tailfer and Clayton, found that eosin (sodium salt of tetra-brom-fluorescein-natrium) made gelatine silver bromide plates highly sensitive to green; they took out a patent (French patent No. 152615, December 13, 1882), and offered dry plates prepared in this manner for sale in 1883-84. In the description of their patent they mentioned not only the addition of the dye to the emulsion itself, but also the subsequent bathing of the dry plate in the dye solution with the addition of ammonia and alcohol. They recognized that the dye combines thoroughly with the silver bromide emulsions and cannot be washed out.[21]

V. Schumann reported, shortly after, that cyanine (already known as a sensitizer for collodion through Vogel), also made gelatine plates sensitive to red, and Vogel combined quinoline red and cyanine (for quinoline blue; see earlier in this chapter).

EDER'S ORTHOCHROMATIC ERYTHROSIN PLATE (1884)

Attout's eosin plates had the disadvantage that in the reproduction of colored objects they rendered the green too light and the yellow too dark; Vogel's azaline plates, while qualitatively better sensitized for

the different colors were, however, reduced considerably in total sensi-
tivity by the cyanine in the dye used, which necessitated the use of
very dark yellow filters in order to compensate for the excessive blue
sensitivity and to increase the relative yellow sensitivity.

The author discovered in 1884, while systematically and spectro-
graphically investigating the dyes of the eosin group (the results of
which he published in the reports of the Vienna Academy of Sciences),
that erythrosin (potassium salt of tetraiodo-fluorescein)[22] has an es-
pecially favorable effect in the yellow and green.[23] Accordingly, in
the reproduction of colored objects, the relation between green and
yellow is rendered more correctly with erythrosin than with bromo-
eosin as used by Attout; at the same time the gelatine silver bromide
plates retain their high total sensitivity and can be used either without
or with light-yellow softening filters. He communicated his results
unselfishly to the scientific world[24] and so furnished the basis for the
general use of this sensitizer, which was quickly adopted by all manu-
facturers of dry plates. The first preliminary account by the author
in March, 1884, appeared in the April number of *Phot. Korr.* (pp. 95,
121, 311), also in number of August 12, 1884, where the advantage of
the addition of ammonia for the increase of color sensitivity was men-
tioned.

The experiments were carried on with a large Steinheil spectro-
graph equipped with three prisms, which he was able to procure from
a contribution by the government received through the kind inter-
cession of Professor Emil Hornig, the president of the Vienna Photo-
graphic Society. The well-defined spectrograms obtained in this man-
ner permitted an exact insight into the structure of the sensitizing
spectra.[24]

These spectrographs brought out the superiority of the iodo-eosin
(erythrosin) over the ordinary bromo-eosin or the substituted bromo-
eosin. The facsimile reproduction of the first spectrum-photo of the
comparative action of erythrosin and of eosin on gelatine silver bro-
mide plates is on p. 652 of the 1932 ed. of the *Geschichte*; it indicates
the superiority of the former.

Such erythrosin plates, made after the author's directions, were
first manufactured in the dry-plate factory of J. Löwy and J. Plener,
at Vienna (1884), and were called "orthochromatic plates"; from this
originate the terms "orthochromatic," "orthochromatism," and so forth.

With such orthochromatic erythrosin plates the author produced

reproductions of paintings (1884) and probably the first orthochromatic photographs of yellowed papyrus of old Egypt (for the "Papyros Rainer," which Professor Karabaček began to publish at that time). These erythrosin negatives were exhibited by him in Vienna (1884).

The first public demonstration in Germany of the excellent results of the orthochromatic erythrosin plates was made by the author on the occasion of his lecture before the Society for the Fostering of Photography and Allied Arts at Frankfurt a. M., September 10, 1884. The originals were there exhibited alongside the reproductions and were greatly appreciated. One of the first negatives made was of a colored embroidery and is preserved in the Technical Museum in Vienna.[25]

Owing to the greatly increased sensitivity of the orthochromatic plates in the yellow-green spectral region, they showed a relatively higher sensitivity to candle or gas light, and so forth, and permitted much shorter exposures than ordinary gelatine silver bromide plates in everyday photography. This the author first reported on April 23, 1885, to the Academy of Sciences at Vienna and elaborated further on December 17.

This naturally led to photographs of portraits and interiors by gas and electric-bulb lights, of which Charles Scolik, in Vienna, made use in 1886.

Orthochromatic erythrosin plates were soon manufactured in all dry-plate factories and are still considered the best in this class. It is well known that normal motion picture negative film is dyed more or less with erythrosin, because this improves the clearness of the image, aside from the greater sensitivity of the film to yellow-green, in daytime as well as in electric light, and because the films are very durable.

Later, numerous dyes were investigated for their properties as sensitizers. This information is collected in the *Handbuch*, 1903, Vol. III, and in Eder-Valenta's *Beiträge zur Photochemie und Spektralanalyse* (1904), as well as in the 1931 edition of the *Handbuch*.

Erythrosin plates were also found advantageous for photographing landscapes and clouds, in which field Obernetter-Perutz achieved great success with their eosin silver plates; they also contained iodo-eosin (erythrosin). About 1887 the Obernetter dry-plate factory, at Munich, offered orthochromatic plates with the addition of a yellow dye for depressing the blue sensitivity; then followed the similar perxantho plates of Hauff's dry-plate factory.

Erythrosin plates are not sensitive to red, which may be overcome to a certain degree by admixing cyanine; but the effect of this mixture (of which erythrosin is an acid dye, while cyanine is a basic one), does not work as well as a mixture of quinoline red and cyanine (Vogel's azaline), which are both basic dyes.

E. VALENTA INTRODUCES ETHYL VIOLET, GLYCIN RED FOR RED SENSITIZERS AS WELL AS WOOL-BLACK (1899)

E. Valenta, in 1899, found ethyl violet to be a splendid sensitizer for silver bromide collodion in making one of the color negatives of a color-separation set behind the orange filter. This was accepted according to his directions in the industry for the manufacture of emulsions, for direct three-color photography and in the three-color halftone process on the continent and in England.[26] The clarity and sharpness of the halftone dots of the screen negatives were excellent. The process worked also with gelatine silver bromide plates. Valenta found glycine red a good sensitizer, with approximately continuous effect in green, yellow, and orange red. Jointly with the author he applied this in photographing the weak spectra of bromine vapor in Plücker-tubes with a large grating spectrograph (presented before the Vienna Academy of Sciences, July 6, 1899); the spectrograms extended far into the orange red. Valenta wrote on glycine red in *Phot. Korr.* (1899, p. 539) and used this dye also for sensitizing the grainless plates employed in Lippmann's photochromy process. In wool-black he also found a red sensitizer sufficiently useful for the conditions of that period. He published an excellent analysis of the line group A of the solar spectrum (grating spectrographs) in Eder and Valenta's *Beiträge zur Photochemie und Spektralanalyse* (1904, table V, 3d part, p. 166).

Eduard Valenta was born in Vienna, August 5, 1857, studied chemistry, and became (1881-84) assistant in the faculty for chemical technology of organic compounds. Here he wrote his first book, entitled *Die Klebe- und Verdickungsmittel* (Cassel, 1884). He worked with the author on ferric oxalate and its double salts. Then Valenta joined the chemical factory of F. Fischer, of which he later became director.

Soon after the foundation of the Lehr- und Versuchsanstalt für Photographie und Reproduktionsverfahren, now the Graphische Lehr- und Versuchsanstalt, Vienna, he was employed there, January 1, 1892, where he remained until 1924, finally as director of the institute. As head of the photochemical department Valenta found a wide field of

activities to which he devoted himself assiduously. The results of his numerous investigations are published in the *Phot. Korr.* and in the *Jahrbücher*.

On Valenta's work covering silver chloride printing-out paper and silver phosphate emulsions see Chapter LXXIV; on the production of highly sensitive photographic tracing paper see Chapter LXXVI.

After the publication of Lippmann's interference–photochromy, Valenta also occupied himself with this interesting process and collected the results of his work in *Die Photographie in natürlichen Farben mit besonderer Berücksichtigung des Lippmann-Verfahrens* (Halle a.S., 1894). In this he described in detail for the first time the production of the "grainless" gelatine silver bromide plates, which were particularly suitable for the color process. Shortly after Rœntgen's discovery, Valenta, together with the author, published the illustrated work: *Röntgenphotographie*. In 1896 appeared: *Behandlung der für den Auskopierprozess bestimmten Emulsionspapiere;* in 1898-99 *Photographische Chemie und Chemikalienkunde*, now in its second edition. When the institute was enlarged by the addition of a typographical department, which brought with it the use of new materials, Valenta's activities were extended to the investigation of paper, printing inks, varnishes, gums, and so forth. These supplied the materials for the three-volume work *Die Rohstoffe der graphischen Druckgewerbe*, which deals exhaustively with the subject and is now in its second edition. Valenta constructed an apparatus for testing the jellying of glue, for the examination of the viscosity of collodion, and so forth, and he designed the viscosimeter named after him. In 1891 he originated a valuable method of sulphurization, in order to increase the sensitivity of asphalt in the reproduction processes.

The results of his investigations in the field of photochemistry and spectroanalysis appeared in collected form in the work published by Eder and Valenta: *Beiträge zur Photochemie und Spektralanalyse* (Vienna, 1904) and in the *Atlas typischer Spektren* (2d ed., 1924). Professor Valenta was an honorary member of the Vienna Photographic Society, the Royal Photographic Society, and of many other societies. He became director (1923-24) of the Graphische Lehr- und Versuchsanstalt when the author retired, and followed him also, after the author became professor emeritus, as lecturer on photochemistry at the technical college in Vienna until 1929.

He was the first who investigated, spectrographically and in a syste-

matic manner, the newly discovered isocyanine sensitizers of E. König (*Phot. Korr.*, 1903, p. 359).

His investigations in the field of the photographic tracing and printing processes, asphalt photography, and so forth are reported more fully on later pages of this work.

MIETHE AND TRAUBE INTRODUCE ETHYL RED FOR PANCHROMATIC PLATES (1902)

The new, strong color sensitizers which opened the way for the manufacture of panchromatic plates, as they are used today, were found and introduced into practice in 1902 by Professor A. Miethe and Dr. A. Traube, his assistant in photochemistry at the technical college in Berlin-Charlottenburg.

Traube proposed to Miethe that in view of the difficulties encountered in the use of the early cyanine they should produce other dyes of this class and test them spectrographically. After having made a series of experiments for the production of different dyes of this group, Traube found a readily-crystallizing red-violet dye, which Miethe and Traube later called "ethyl-red"; this proved to be an excellent sensitizer for yellow-green up to orange. Neither young Dr. Traube nor Professor Miethe knew at the time that the chemist Spalteholz had anticipated the discovery of this dye, but had not examined it for its photographic properties and therefore did not recognize them. Only later, after Traube had manufactured "ethyl-red" (in which quinaldine was used instead of lepidine), did they learn that this dye was produced long ago (in 1883, by Spalteholz) and therefore was not new. Yes, even in the description of the Miethe-Traube patent an erroneous name of the dye is given. Dr. König, in the *Phot. Korr.* (1903, p. 578), and the author, in *Jahrbuch für Photographie* (1903, p. 10), called attention to this misstatement. This German patent granted jointly to Miethe and Traube on May 6, 1903 (No. 142926), protected the use of ethyl red as sensitizer of gelatine silver bromide plates for yellow and orange (with a slight desensitizing action in the green); all this signified a tremendous advance in the manufacture of color-sensitive plates. The first dry plates sensitized with ethyl red (dyed in the emulsion) were made by Traube in conjunction with the dry-plate factory of O. Perutz, in Munich, and sold under the name "Perchromo-plates-Miethe-Traube." They probably also added some quinoline red to compensate for the desensitizing in the green,

and still later, as a red sensitizer, the pinacyanol of Homolka, but that belongs to a later period.

The joint intellectual ownership of Miethe and Traube of this discovery is proved by the patent papers. At any rate, ethyl red opened new avenues of usefulness in three-color photography.

Adolf Miethe, born April 25, 1862, in Potsdam, studied physics, mathematics, and astronomy in Berlin, spent some time in the institute for calculations at the observatory there, and entered, in 1887, the astrophysical institute at Potsdam in order to study special problems in the application of photography to astronomical observations. He concluded his studies in Göttingen, where he published the results of an investigation on the actinometry of astronomical photographic exposures of fixed stars. In 1891 he became a scientific associate of Professor Hartnack, at Potsdam; then he joined the optical works of Schulze and Bartels, in Rathenow; later he became associate and finally scientific codirector of the optical establishment of Voigtländer and Son, in Brunswick. He calculated an aplanat in 1888, and in 1891 introduced the teleobjective a few months after Dallmeyer and Duboscq. After Vogel's death he was called, in 1899, to the technical college at Berlin-Charlottenburg as professor of photochemistry and spectro-analysis and head of the photographic laboratory and astronomical observatory. He wrote in particular on the relation of diaphragms and light dispersion to the image, on astigmatism, and on exposures through small apertures. With Gaedicke he introduced the magnesium flash-light in photography, but the flashlight powder recommended by him was soon abandoned owing to its dangerous explosive composition (*Handbuch*, 1912, Vol. I, Part 3).

He became editor of the *Photographische Nachrichten* when the Photographic Society of Berlin started that periodical in 1889. He also edited the *Atelier des Photographen* published by W. Knapp at Halle.

His greatest achievement was the discovery, made jointly with his assistant Dr. Traube, of ethyl red as a sensitizer, which permitted in some measure the production of panchromatic plates. Miethe himself pursued the practical work necessary. He allied himself with the optician Goerz, in Berlin, who constructed a triple projection apparatus (Vidal system) for the production of three-color pictures, which projected the image in full color on a white linen screen (additive method). The three-color negatives (exposed behind orange, green, and blue filters) were made in a special camera, with a rapidly changeable

holder, built by Bermpohl; the use of the holder was demonstrated by the projection of pictures in full color at theaters.

He wrote several works on photographic optics, artistic landscape photography, three-color photography from nature (1908), and aerial photography. In 1916 he wrote, with Professor Mente, a textbook on applied photography, *Unter der Sonne Oberägyptens* (2d ed., 1924).

In 1924 he believed that he had found the secret of transmuting mercury into gold. He had noticed that mercury vapor lamps used for illuminating purposes, after long use, showed a gray deposit, and he had been able to isolate traces of gold in this residue. These experiments he made jointly with the chemist Dr. Stammreich in his laboratory at Berlin-Charlottenburg. Stammreich carried on principally the chemical and analytical part of the experiments and actually found traces of gold in the gray deposit of the lamps. This caused a great sensation, and Miethe was hailed as a successful alchemist. He himself affixed a memorial tablet in his laboratory at the technical college[27] which stated that here the transmutation of mercury into gold took place, for he was convinced of the inviolability of his discovery. But a strict examination by several competent persons demonstrated that the traces of gold were not formed new from mercury, but were contained in the mercury at the start and had collected in the gray deposit of the mercury lamps. Miethe was convinced of the transmutation up to his death and suffered severely from the general scientific rejection; he seldom appeared in public in the last years of his life and died at Berlin, after a severe illness, May 5, 1927.

Arthur Traube, born March 8, 1878, in Berlin, studied chemistry at the technical college in Berlin, worked with Professor Miethe, and received the degree of doctor for his *Photochemische Schirmwirkung*, which he worked out in Dr. Miethe's laboratory. He became first private assistant and later first scientific assistant to Dr. Miethe. Their joint work on ethyl red was carried on in 1902. In 1904 Traube managed the technical department of the dry-plate factory of O. Perutz, in Munich; he perfected at the same time the first panchromatic plates, sensitized with ethyl red. After his return to the Charlottenburg technical college in 1905, he developed the fotol print process, according to suggestions given by A. Tellkampf. After this followed his work on color photography, from which originated first diachromy, much later uvachromy, and then uvatype. In 1910 he re-

tired from the technical college, established his own photochemical laboratory, founded in Munich the Uvachrome Company, and incorporated it in 1922, of which company he is still the manager (1933).

MODERN COLOR SENSITIZERS OF E. KÖNIG, HOMOLKA, SCHULOFF, AND OTHER CHEMISTS AT THE HÖCHST DYE WORKS; CONFISCATION OF THESE PATENTS IN FOREIGN COUNTRIES

Ethyl red was soon outstripped by entirely new dyes, which Dr. Ernst König produced at the dye works of Meister, Lucius and Brüning, of Höchst a. M., as it was called then, and introduced to the trade as superior, while Miethe and Traube worked in vain to broaden the sensitivity band of their emulsion towards the red by changes in the amount of the alkyl in the employed alkyl iodide. König accomplished this result by the introduction of auxochrome groups in the benzene nucleus of the quinoline bases. Thus originated the famous and still unexcelled color sensitizers for green, yellow beyond orange to red and far into the infrared, which have become indispensable aids in orthochromatic photography, especially in the field of three-color photography. We mention here the first sensitizers produced by König: orthochrome, pinaverdol, pinachrome, pinachromviolet (with Stahlin), and dicyanine (with Philips). We cite also pinacyanol, a prominent red sensitizer, produced by the chemist Dr. Homolka in 1906 at the Höchst Works, then pinaflavol, a green sensitizer produced by Schuloff in 1919. Scientific photography, spectrography, and aerophotography also derived great advantages from these new sensitizers.

In addition E. König produced pure filter dyes (among others filter yellow and pyrazol yellow, 1908) and devoted himself to the investigation of desensitizers discovered by Lüppo-Cramer.

Ernst König was born in Schleswig in 1869, was employed by the Höchst Works in 1893, where he worked for thirty-one years and established a photographic department. He invented pinachromy by leuco bases and introduced "pinatype," invented by Didier, into practice. He died October 29, 1924, after a long illness, which he contracted in his work with injurious substances soon after the French occupation of the Höchst Works ended. The author wrote a full biography of König in the *Chemikerzeitung* (1924, p. 905).

König edited a new edition of Vogel's *Photochemie* (1906), then out of print, which unfortunately he did not complete; He published *Farbenphotographie;* the first edition appeared in 1904, and there were

three later editions; finally *Autochromphotographie* (1908) and *Arbeiten mit farbenempfindlichen Platten* (1909).

Before the World War practically all sensitizing dyes were produced and sold by the great German dye works, especially by those in Höchst a. M. When it became more and more difficult during the war for the Allied nations to procure sensitizers, it became necessary to imitate the German dyes or approximate them in Great Britain, France, and the United States. This was attempted by confiscating the German patents and producing the dyes after the patented formulas and descriptions, as well as from systematic analysis of the original German dyes. W. H. Mills and W. J. Pope reported this in 1920 to the Royal Photographic Society of Great Britain (*Phot. Jour.*, 1920, p. 183), enumerating the German patent papers covering such investigations. The patent rights having been declared enemy property by the government and the German patent rights voided, Mills and Pope furnished sensitizers to the English dry-plate factories. What they called "pinachrome," however, was not new, but corresponded with a dye made before the war by the Höchst Works especially for Wratten and Wainwright, in Croydon, and exported for them to England (from p-ethoxyquinaldinium iodide and p-methoxy quinolinium iodide with one ethoxy and one methoxy group),[28] whereas the dye for Germany and shipment from Germany under the name pinachrome was always the dye with two ethoxy groups. Pope himself admitted that some of his dyes were identical with those obtained formerly in Germany (*Phot. Korr.*, 1920, p. 313).

In the scientific laboratory of Lumière, at Lyon, H. Barbier also investigated isocyanine dyes which contain the diethyl- or dimethylamido groups (*Bull. de la Soc. chim. de France*, 1920). But the French chemist evidently was not aware that a dye of this group had been produced and sold on the market by the Höchst Works under the name "pinachromviolet" as a good red sensitizer, which Dr. E. König pointed out in *Phot. Korr.* (1920, p. 313; see also Wentzel, *Handbuch*, 1930, Vol. III, Part 1).

The great value of these red sensitizers (pinacyanol, pinachromviolet, and others) is that they enable aerophotography through fog and atmospheric haze ; they also play an important part in astronomical and spectroanalytical photography; also in moving picture photography by artificial light.

It should be mentioned here that in 1925 the Eastman Kodak Re-

search Laboratories, in Rochester, discovered the sensitizer neocyanine, which sensitizes from the red far into the infrared. The I. G. Farbenindustrie, in Berlin, found rubrocyanine[29] in 1928, and in 1929 allocyanine and other sensitizers for the red and infrared.

Chapter LXV. DISCOVERY OF DESENSITIZING

THE PHOTOCHEMISTS of the nineteenth century held the opinion that all substances which annihilate or greatly diminish the light sensitivity of silver bromide, etc., destroy also the latent photographic image, resulting from exposure and normally capable of development. It was not until 1901 that Dr. Lüppo-Cramer (*Phot. Korr.*, July, 1901) found that certain developers of the paramidophenol class, as well as ferrous oxalate, greatly reduce the sensitivity of unexposed silver bromide, without destroying its capability of developing the latent image. This action of certain organic developer solutions which reduces the light sensitivity was investigated later also by the brothers Lumière and A. Seyewetz, in Lyon, 1907.[1] But it was only the discovery of dyes which were able to act as "desensitizers" in the above-mentioned manner which led to a revolutionary change of the developing process of photographic plates by diffused light. This was of the greatest importance for the use of color-sensitized plates. For this discovery we are indebted to Dr. Lüppo-Cramer (at that time in Munich), who, on the basis of certain theoretical hypotheses, found desensitizers in the coal-tar dyes of the safranine and related groups, which acted much more satisfactorily in practice than did the oxidized developer substances.

Lüppo-Cramer's first article on desensitizing by dyes appeared in the Swiss periodical *Die Photographie* (October, 1920, Nos. 10-11) and in the *Phot. Korr.* (December, 1920, p. 311). The first-mentioned carried the title "Ein neues Verfahren, höchst-empfindliche und selbst farbenempfindliche Platten bei gewöhnlichem Kerzenlichte zu entwickeln." This method, so surprising in its extraordinary simplicity, of undertaking development without the slightest danger of fog in very clear yellow light, consists in either adding to the developer a solution of safranine dye (phenosafranine, a red dye of which the homologues, in particular safranine T, are used considerably in the textile industry) or by immersing the plate before development in a

bath containing the dye in solution. Methylene blue was also recognized by Lüppo-Cramer as a desensitizer which acts when enormously diluted, but causes fogging. Lüppo-Cramer published his investigations collectively in his book *Negativentwicklung bei hellem Lichte; Safraninverfahren* (Leipzig, 1921, 2d ed., 1922). Safranine dyes the silver bromide grain and acts as a desensitizer, or as it was called later, a "narcotic." Safranine proved its value, and Lüppo-Cramer's process excited the greatest attention in technical circles, because it was a basic step forward in the developing process, which had remained as a whole unchanged for forty years. Since the process was given free to the world and not patented, it was soon used everywhere.

Lüppo Hinricus Cramer (1871-1943), who writes under the pen name "Lüppo-Cramer," was born in East Friesland. He studied natural sciences in Munich, 1890-91, in Heidelberg, 1891-92, and in Berlin 1892-94. He received his doctor's degree in chemistry in 1894, under Emil Fischer, for his thesis on substitution products of caffein. He was employed as chemist with the firm of Schering, in Berlin, from 1894 to 1901, at first in the general scientific laboratory and after 1895 in their new photographic branch in Charlottenburg. During this period he attended also the scientific-photographic lectures and laboratory work under H. W. Vogel at the technical college at Charlottenburg. He found at this time that the halogen substituted polyphenols were specially energetic developers, which led to the introduction of bromo- and chloro-hydroquinone under the trade name "Adurol" (*Handbuch*, III (2), 121). From 1902 to 1918 Lüppo-Cramer was manager of the dry-plate factory of the Dr. C. Schleussner Co. at Frankfurt a.M., and in 1918-19 temporarily in the war industry in the chemical factory Griesheim-Elektron. From 1920 to 1922 we find Lüppo-Cramer as technical director of the dry-plate factory of Kranseder & Co., at Munich. It is there that this scientist discovered, in 1920, the process of developing in broad daylight with the use of desensitizers.

Lüppo-Cramer's technical publications in periodicals number already (1932) more than seven hundred. Some collected works must be mentioned: *Photographische Probleme* (1907); *Kolloidchemie und Photographie* (1908); *Kolloides Silber und die Photohaloide von Carey Lea* (1908); *Röntgenographie* (1909); *Das latente Bild* (1911); *Negativentwicklung bei hellem Lichte* (1921); "Grundlagen der photographischen Negativverfahren" in the *Handbuch* (1927), Vol. II (1).

In addition to the discoveries enumerated as of practical importance,

Lüppo-Cramer's studies, extending over ten years, on the significance of colloidal chemistry in photographic problems deserve the highest recognition. Lüppo-Cramer is an honorary member of the photographic societies of Vienna, Munich, and Frankfurt a.M. Since 1922 Lüppo-Cramer has been manager of the scientific photochemical laboratory of the German Gelatine Factory Co., in Schweinfurt. He was called by the faculty of the technical college of Vienna to a professorship in photochemistry, but declined in order to maintain his position in the photographic industry.

In competition with phenosafranine, found by Lüppo-Cramer, the "basic scarlet N" was produced by French photochemists (1925), but it turned out that this dye contained safranine (*Jahrbuch*, XXX, 645).

Worthy of mention also is the discovery by Zelger, at the Pathé-Cinema laboratory, Paris, of "protective dyes" against fog-creating desensitizers. For instance, the strong fog-producing, desensitizing dye, methylene blue, becomes through the addition of acridine yellow a desensitizer free from fog, which, however, is not so effective as pinakryptol-green (see below) or phenosafranine (see also Lüppo-Cramer's *Phot. Indust.*, 1925, No. 8).

Phenosafranine, which was the first desensitizing dye recommended by Lüppo-Cramer, answered perfectly as far as its effect as desensitizer was concerned, but it had the defect that it was difficult to wash out completely from the gelatine plates, and often there remained in the gelatine film a troublesome reddish stain, which could scarcely be removed by washing. Other safranine and azine dyes proved to have a similar defect on re-examination at the Höchst Dye Works.

Robert Schuloff at the Höchst Dye Works succeeded (1920) in producing a quite effective and very little colored desensitizer, by the introduction of a nitro group into the well-known green sensitizer "pinaflavol" found by him, namely, through condensation of m-nitro-p-dimethylamido-benzaldehyde with a-picolinium salts. Since, however, its action was still considerably weaker than that of phenosafranine, other more effective representatives of this group were sought, by preparing numerous similar combinations. A year after the discovery of phenosafranine as a desensitizer by Lüppo-Cramer, Schuloff succeeded in finding several almost colorless desensitizers among this group, which possessed great efficiency as desensitizers and had only the defect of being difficult to dissolve. One of these new desensitizers

was placed on the market in 1922 by the Höchst Works, under the name proposed by Schuloff, "pinakryptol." It is noteworthy that to the commercial article pinakryptol there was added from ten to twenty percent of pinakryptol-green in order to overcome the tendency of this desensitizer to retard development.

The numerous examples of this group of desensitizing dyes, to which pinakryptol also belongs, are the subjects of the German patent of the Höchst Works, No. 396402, dated May 1, 1922; they are all generally described by the inventor (Schuloff) as "pinakryptols."

In the further investigation of desensitizing the chemists Dr. E. König, Dr. Schuloff, and Dr. Homolka searched systematically for new desensitizers among the collection of dyestuffs in the Höchst Works. Dr. König and Dr. Schuloff engaged in constant and lively exchange of ideas with Dr. Homolka, whose collaboration they valued highly, owing to his unusual knowledge and his excellent personality. On the occasion of a conference between these three scientists Dr. Homolka offered to put at their disposal a green safranine which he had prepared experimentally in small quantities about sixteen years before according to the directions of Kehrmann. This dye is identical, as related by König to the author, with an isomer of phenosafranine designated by Kehrmann as "isophenosafranine" and differs from it only by a different position of an amido group, which is, as mentioned above, green in color and a good desensitizer. It has the advantage that it can be easily washed out from the gelatine film. This sensitizer, sold under the name "pinakryptol-green," was not protected by a patent.

After Schuloff left the Höchst Works, he continued his work at the Society for Chemical and Metallurgical Production, in Aussig (Czechoslovakia), where he acted as manager of the laboratory. He soon determined that homologues of isophenosafranine as well as numerous isomers of phenosafranine and their derivatives possess partly even better qualities than pinakryptol-green. The Aussig Chemical Society applied in 1925 for a patent on this invention. In the description of this patent the information is furnished that the position of certain amido groups is decisive for both the color and the desensitizing action of amido phenyl-phenazonium compounds. A particular case of these groups is pinakryptol-green, found by Homolka, from which the most effective representative of the desensitizers mentioned in the patent application of the Aussig Chemical Society differs only by an additional methyl group.

The corresponding German patent application was filed by Schuloff after leaving the employ of the Aussig Chemical Society and was designated as "Sch. 79634 of July 24, 1926."

Pinakryptol-yellow, commercially introduced by the Höchst Dye Works, is one of the best desensitizers and is distinguished by its almost complete lack of color in the solution ready for use. It was invented exclusively by Schuloff, and belongs to the large group of pinakryptols included by the Höchst Works in a German patent, I 26984 of December 11, 1925, applied for as an addition to patent 396402. The corresponding American application of December 11, 1926 was taken out in the name of Schuloff.

Biography of Schuloff: Dr. Robert Schuloff, born at Vienna, March 25, 1883, studied at the universities of Vienna, Geneva, Innsbruck, and others as a pupil of Graebe, Wegscheider, and Herzig. He received his doctor's degree at Vienna and became assistant to the chemist Paul Friedländer, the discoverer of thioindigo and of artificial "purple." In May, 1908, he was employed by the dye works of Meister, Lucius and Brüning, at Höchst a. M., where he remained until 1922. Here he worked in the laboratory for dye research and in the central scientific laboratory, particularly as collaborator of Dr. E. König. He found, independently, the green sensitizer pinaflavol, which comes under the German patent 394744 of May 23, 1922 (inventor Dr. Robert Schuloff). Although the patent application 395666 of the same date in the name of the factory specifies, for reasons which can only be conjectured, that Dr. König was the sole inventor, Dr. Schuloff felt justified, notwithstanding, to consider the invention as his exclusive property. The author has also before him the original of a letter from König to Schuloff, in which König, in reply to an inquiry from Schuloff about the above-mentioned position of the dye works, writes, among other matters, "that he would take care that the name of Dr. Schuloff, as inventor, should receive the recognition which was due him." About pinaflavol Dr. Schuloff writes:

I want to add that other representatives of the pinaflavol group deserve attention. For instance, the combination dimethylamido-benzaldehyde plus pyranton (i.e., 2-methyl-5-ethyl-pyridin-halogen-alkylate, e.g., ethylate). This combination is almost equivalent to dimethylamido-benzaldehyde plus alpha-picolinium salts (pinaflavol) and can replace it entirely.

Pinaflavol appeared at the end of 1920 as a green sensitizer, the chemical composition being kept secret by the Höchst Works. Its

spectrographic qualities were published almost immediately afterwards in the technical journals (*Phot. Korr.*, 1920, p. 304; and 1921, p. 29).

Dr. Schuloff writes further:

Finally it is not without interest that the patent for pinaflavol was first applied for by the Höchst Dye Works, in February, 1921 (F 48516 IV/22), but the application was withdrawn before publication, because at that time the patent situation was too uncertain, especially in Great Britain and the United States, where there was danger of confiscation. Thus it happened that shortly before the second application, in 1922, there appeared in the *Journal of the Chemical Society* an article by Pope and Mills on the combination: dimethylamido-benzaldehyde plus alpha-picoliniodomethylate, in which this combination was hailed as the first specific green sensitizer. I do not know whether these English gentlemen invented pinaflavol independently after "pinaflavol" had made its appearance on the market or arrived at the knowledge by analysis of the constitution of the commercial dye. In fact, I informed them on my behalf and that of Dr. König that our pinaflavol, which had been on the market for quite some time before the date of their publication, was identical with the dye described by them; but they refused to publish an explanation of this matter in the *Journal of the Chemical Society*.

It is also of interest to read in a letter from Schuloff to this author of the genesis of the invention of pinakryptol and many similar desensitizers:

I endeavored, after the discovery of "pinaflavol," by modifying the pinaflavol molecule to produce still better green sensitizers and introduced, among other things, the nitro group in the aldehyde component in the expectation of changing the specific color of pinaflavol still more towards the yellow. Much to my surprise, I obtained an almost colorless product from the introduction of the nitro group into the dimethylamido-benzaldehyde, and the combination m-nitro-p-dimethylamido-benzaldehyde plus alpha-picolin-iodoethylate proved itself, in contrast to the derivate free from nitro groups (pinaflavol), a strong desensitizer. After producing numerous derivatives (more than one hundred) the following combination, m-nitrobenzaldehyde plus beta-naphtoquinaldinium-dimethyl-sulphate, finally manifested itself as the most efficient desensitizer, equally as strong as safranine. In spite of its comparatively poor solubility, it was at first offered for sale as "pinakryptol," but was displaced later by the following product, which was more soluble: m-nitrobenzaldehyde plus quinaldinium salt, which, however, was not as active a desensitizer. A defect which attached to both products was their property to retard development. In order to eliminate this defect or at least to reduce it measurably,

I tried to combine them with other desensitizers. The addition of safranine brought no desired result, but the admixture of small amount of indulin scarlet, pinagreen, and other dyes was successful. These experiments also showed that the combination of pinakryptol had a potential effect with indulin scarlet and with pinakryptolgreen, but not with safranine, in which combination it had only an additive effect.

At the end of 1923 Schuloff joined the organic chemical scientific laboratory at the Aussig Society for Chemical and Metallurgical Production as manager, and in 1927 established himself at Vienna as consultant chemist, with other associates.

Biography of Dr. Homolka: Dr. Benno Homolka (born in Bohemia, 1860, died in 1925, at Frankfurt a. M.) was a prominent color technician and photochemist; he was manager of the dye works of Meister, Lucius and Brüning, in Höchst a. M., studied chemistry at Prague and Munich, was assistant 1882-86 of the famous chemist Adolph von Baeyer, of Munich, discoverer of eosin dyes and of artificial indigo, in the preparation of which he participated. He went to the Höchst Dye Works from here, where he specialized in dye chemistry, but he devoted himself later to photochemistry. Most of his results were published in the *Photographische Korrespondenz*, Vienna. Dr. Homolka came into contact with applied photography by his invention of the excellent red sensitizer pinacyanol, and the important desensitizer pinakryptol-green. He also invented a new photographic printing process, based on the sensitivity to light of the o-nitrodiaminotriphenyl methane bases, which was first published in the *Handbuch* (1926) Vol. IV; he published there also (on p. 492), articles on pinachromy and on the chromogenic development of gelatine silver bromide (p. 512). He set up the hypothesis that the latent silver bromide image is a combination of silver subbromide and silver perbromide (*Handbuch*, 1927, II (1), 160, 617), wrote on the fog along the edges of silver bromide plates (*ibid.*, p. 347) and on other subjects.

Only through the introduction of desensitizers by Lüppo-Cramer were the sensitizers for panchromatic and other color-sensitive plates enabled to reach their full measure of usefulness. Before that invention the developing of such plates, which could only be done in complete darkness or under the weakest kind of green light, was surrounded by great difficulties and very uncertain. Through the use of desensitizing dyes the development of plates or films of the highest color-sensitivity was made easy, so that they are now widely used in the mass production of motion picture films.

Chapter LXVI. FILM PHOTOGRAPHY AND THE RAPID GROWTH OF AMATEUR PHOTOGRAPHY

EASTMAN-KODAK; GOODWIN

THROUGH THE INTRODUCTION of flexible, light, unbreakable film,[1] amateur photography, travel photography, and motion picture photography were greatly advanced. On the road the weight and bulk of glass plates were extremely burdensome and added many difficulties to the work; the danger of breakage was undoubtedly another reason why a more suitable base or carrier for the light-sensitive material was sought as a substitute. The early "negative paper" employed by Fox Talbot, later improved in many particulars[2] offered undeniable advantages, owing to its light weight and small bulk. The "grain" or structure of the paper, discernible in the prints was discounted as a small fault and was eliminated later, when stripping films were introduced.

Warnerke, as early as 1875, produced dry collodion silver bromide films on chalk coated paper, which could be stripped (see *Handbuch* 1927, II (2), 310). Paper coated with silver bromide collodion, which could be stripped, by Milmson in 1877 (*Phot. Korr.*, 1877, p. 225) and by Ferran and Pauli in 1880 (*Phot. News*, 1880, p. 365) are reported in the *Handbuch* (1903, III, 593).

E. Stebbing produced a tanned gelatine film base between two collodion layers in order to obtain greater strength and toughness (*Brit. Jour.*, May 16, 1879; also 1884, p. 30). Wilde, a photographer in Görlitz, combined gelatine and collodion layers (*Phot. Korr.*, 1883, p. 162). G. Balagny, at Paris, combined alternate flexible layers of collodion, varnish, and gelatine (*Moniteur Phot.*, 1886, p. 9, 20; *Phot. Woch.*, 1886, pp. 302, 354; 1887, p. 67; *Phot. Korr.*, 1885, p. 98; 1886, pp. 361, 442).

The manufacture of machine-made papers having meanwhile made great progress, the production of gelatine silver bromide negative paper (analogous to silver bromide positive paper) was taken up by Morgan and Kidd (English patent of June 5, 1882), by Warnerke in London, by Moh in Görlitz (1897-98), by the Neue Photographische Gesellschaft in Berlin, and by others.

The use of celluloid as a film base was patented by Parkes in 1856 as "transparent support for sensitive coating," but he never was able

to use it photographically. Serviceable celluloid in sheets was first commercially produced by John W. Hyatt[3] at Newark, New Jersey. The brothers Hyatt were the first to produce, in 1869, negatives on semirigid celluloid sheets. Flat films on celluloid sheets, coated with gelatine silver bromide emulsion, were produced by Fortier and exhibited to the Paris Photographic Society, March 4, 1881, but the films were imperfect and streaky. Satisfactory flat films on clear celluloid were produced commercially by John Carbutt, in Philadelphia (1888). This firm developed the manufacture of flat films on a large scale and was the first to export films to Europe. Carbutt also used mat surface celloidin sheets as film carriers..

The Reverend Hannibal Goodwin, an Episcopal clergyman at Newark and an amateur photographer, applied for a United States patent on May 2, 1887, on a process which produced a mass, similar to celluloid for roll films, of suitable collodion mixtures. After prolonged delay, caused by "interferences" and the filing of new and amplified specifications, the patent was granted on September 13, 1898 (U. S. P. No. 610,861). We shall discuss this later in detail.

George Eastman was the pioneer in introducing the manufacture of roll films into the photographic industry and practice with complete success. The history of the manufacture of films and the use of roll films in suitable holders is closely interwoven with his name.

George Eastman[4] was born July 12, 1854, at Waterville, New York, a very small town with only a few hundred inhabitants. He was descended from an English family who settled in Massachusetts in 1638 and received land grants from the government. There the Eastman family lived for about two centuries, surviving the attacks of the Indians; they belonged to the pioneers of America. The house in which George Eastman was born was built in colonial style. When he was six years old his father moved to Rochester, where he conducted a commercial school. The father died two years later (April 27, 1862), and the widow and children lived for a time on the income from the school, but a few years later they met with reverses. The boy had to leave school when fourteen years old and work for three dollars a week in an insurance office. As the only son, he assisted his mother in the strenuous work of running a boardinghouse. Young Eastman slowly worked his way up in the business world until he earned six hundred dollars a year, which, at his age, was as much as he could expect for a long time to come. Later (1874) he succeeded in getting a

position in a bank with a salary of $1,400. This, of course, seemed a great income at that time. He had attained what he had set out to do; he was now independent and could support his mother. Now came the decisive change in his life. As he tells the story:

My Chief, whose assistant I was, left the bank. I had done a great deal of his work and was thoroughly familiar with it. All my fellow workers shared my expectation that I would be promoted to fill his position. I did not get it. Some relative of a director of the bank was appointed and put by my side. It was not just. That was not honest. It mocked all justice. I remained a short time, then I left. I now devoted myself entirely to my hobby, photography.

In the beginning Eastman worked with the troublesome wet collodion process, until he read of the new gelatine (silver bromide) dry plates. In 1877 he experimented in making these plates at home, following the methods of emulsion making found in the English technical journals. In this he had such success that he decided to start upon a new career as a dry-plate maker. Beginning in a small factory, he had worked out in June, 1879, a dependable formula for the production of emulsions, and he coated glass plates with them. Then he designed and built a machine for flowing the emulsion onto the glass plates, and patented it on July 22, 1879, in England, and on April 13, 1880, in the United States (No. 226503). Good photographs by Eastman made on such plates in the winter of 1879-80 have been preserved and one is reproduced in Ackerman's biography of Eastman.[4] In 1880 he improved this coating machine and thus was enabled to increase the output and the sale of Eastman dry plates very considerably. This necessitated the enlargement of his small factory.

In January, 1881, he associated himself with Colonel Henry Alvah Strong, in Rochester, who was interested in many industrial enterprises. Strong invested five thousand dollars in the joint enterprise. The product of the company was more widely introduced and found larger sales, until the monthly deliveries of plates were valued at four thousand dollars. Suddenly the company met with serious difficulties in the manufacture of their product; the plates suffered deterioration between factory and user and showed troublesome fog. Eastman and Strong went to England to seek advice.

Eastman succeeded in being permitted to spend two weeks in the plate factories of Mawson and Swan, of Newcastle, obtaining there information and processes which enabled him to remedy the defects

which had caused so much trouble. No longer than four weeks after the threatened catastrophy, manufacturing for the next season's needs was again in full swing at Rochester. Eastman had recognized that poor gelatine has the worst kind of influence on emulsions.

But business battles also had to be fought. When about 1884 the dry-plate trade in America was threatened by strong competition, it was necessary to find new ways of getting and increasing business. It was at this time that Eastman conceived the idea of roll films, which simplified photography and made it really popular, because it was no longer necessary to carry heavy plates or plate holders.

Then came paper films, that is the film consisted of paper coated with an emulsion. In order to make this process possible, it was necessary to coat the emulsion on long continuous widths of the paper, for which Eastman invented a special coating machine, which he patented in 1885. The paper sensitized in this manner was stored in a "roll holder," which could be attached to the back of the camera in the same manner as a plate holder. The "grain" of the paper, however, was so disturbing that it made paper negative film quite unsatisfactory. It was soon displaced by the so-called "stripping film," in which the paper served only as a temporary carrier for the emulsion layer. After exposure and development, the picture could be and was transferred to a glass plate, and the paper was stripped off by removing an easily soluble gelatine layer inserted between plate and film. This "stripping film" was patented (U. S. P. October 14, 1884, No. 306,594).

It now became necessary to invent a mechanism in order to keep the roll film firmly fixed in the camera in its proper position. For this purpose Eastman employed the camera manufacturer William H. Walker, who had discontinued his own business and started to work for Eastman in January, 1884. He solved the problem. From twenty-four to one hundred exposures could be made in a hand camera with such a stripping roll film. Eastman now planned the establishment of a new company, which started in October, 1884, under the name Eastman Dry Plate & Film Company of Rochester. The initial capital was two hundred thousand dollars. The officers of the new company were Henry A. Strong, president, J. H. Kent, vice-president, George Eastman, treasurer, and W. H. Walker, secretary.

When the Eastman-Walker holder for roll films appeared, attention was called from many sides to the older roll film holder of Warnerke and to the fact that Melhuish and Spencer, at a much earlier date, were

granted an English patent (May 22, 1854) on a roll-film holder for Talbotypes. But the mechanism of the Eastman-Walker roll-film holder was new, well designed for the use of the silver bromide films, and most generally used.

In January, 1885, the Eastman company started an advertising campaign on a large scale to promote the sale of the roll holder and film, and from this campaign dates the introduction of these inventions. For his handy camera, which combined within itself camera, roll holder, and stripping film, Eastman invented the name "Kodak," which was not trademarked in the United States until September 4, 1888.

On the origin of the word "kodak," George Eastman lifted the veil. The word "kodak" was thought out by Eastman himself in 1888, invented out of pure air, and signifies really nothing; it is simply a short, particularly pregnant trademark, known all over the world; it has passed even into literature. In *American Photography* (1924) Eastman, describing the origin of the word, concludes: "Philologically, therefore, the word 'kodak' is as meaningless as a child's first 'goo.' Terse, abrupt to the point of rudeness, literally bitten off by firm and unyielding consonants at both ends, it snaps like a camera shutter in your face. What more could one ask?"

This first kodak was a box camera equipped with two spools; it was placed on the market in 1888. The pictures taken with it were circular and had a diameter of 6.5 cm. (2½ inches). The first model of its kind, "Kodak No. 1," is reproduced in the 1932 German edition of this *History* (p. 679).[5] The apparatus measured 8 x 9 x 16 cm. (3 x 3½ x 6¼ inches), weighed 680 grams (1½ lbs.), and contained in the roll-film holder a strip of film sufficient for one hundred pictures.

Kodak No. 1 was very handy and achieved an enormous commercial success, owing to its simplicity and its low price. Soon other cameras followed, of various designs and equipment, with bellows, and so forth.

Stripping films were later displaced by the Eastman transparent films. These were produced by Eastman and the chemist Henry N. Reichenbach, March, 1889, by dissolving nitrocellulose in methanol with camphor, fusel oil, and amylacetate also present, which gave an entirely transparent film base. On December 10, 1889, patent No. 417,202 was granted to Reichenbach by the United States Patent Office, while on March 22, 1892, and July 19, 1892, two additional patents were granted to Eastman and Reichenbach. In the summer of 1889, Edison purchased from Eastman a $25 kodak, and this kodak was reconstructed by W.

K. L. Dickson and the Edison staff as the "first Edison motion picture camera."

Eastman early observed the electrical discharge phenomena of collodion films (nitro films); he tried to eliminate them by the addition to the support of hygroscopic salts (potassium nitrate or ammonium nitrate), Eastman patent No. 584,862, which was the first successful attempt of this kind. Later, backing the film with gum arabic was recommended or coating the nitro films with a very thin layer of acetylcellulose (Lovejoy, patent No. 1,232,702).

The modern daylight-changing roll-film system was invented by S. N. Turner, a camera-maker in Boston, who took a patent on it. Eastman first purchased license under the Turner patent and then purchased the patent outright along with the Boston Camera Co., owned by Turner, for $35,000. The actual cost to the company, however, was only $24,100 for the idea of packing the roll film with a backing of black paper.

According to Turner's invention, the strip of film was rolled on its spool in intimate contact with a longer strip of black paper, on the back of which numbers for each picture were printed, which could be read through a little window in the back of the camera as the roll was advanced. These statements[6] are supplemented by communications which were sent at the time by the Anthony and Scovill Company in New York to Eder.[7] According to these letters, Parker B. Cady, an employee of the Blair Camera Company, invented, about 1894 or 1895, a kind of daylight pack system for roll films, and that kind of celluloid films were made by the Blair Camera Company for the Boston Camera Company and introduced by them first on the American market, and in Europe by the European Blair Camera Company, London. The Eastman Kodak Company later acquired the Boston Camera Company, but continued the production and sale of their own films, which soon gained the approval of the public.

The Eastman Kodak Company offered orthochromatic roll films for sale before the end of the nineteenth century, later "verichrome" orthochromatic film. "Supersensitive" panchromatic film is another important product of the company.

In 1895 the Eastman Kodak Company introduced the "pocket kodak" of Frank A. Brownell, of which the first lot made ran up to twenty-five thousand. In 1898 a further important progressive step was taken in the construction of roll film cameras, when folding appara-

tus was constructed. The first of these was called the "folding pocket kodak"; in 1900 followed the Brownie camera, made especially for children, which sold at only one dollar. Still lower in price and very recent was the Hawkeye camera, which could be bought for eighty-nine cents.

After 1895 the business expanded enormously in the direction of the flourishing motion picture industry, which brought about the production of a special positive film for projection. The "non-curling film," with a gelatine coating on the reverse side, was made in 1903. The Eastman Kodak Company also produced before 1909 acetate cellulose films and others.

The growth of the Eastman Kodak Company seems like an industrial fairy tale. From a single associate with Eastman, the number of employees of the company increased to thirteen thousand, and from the primitive workshop grew ninety buildings. Kodak Park alone, with its seventy-five buildings, occupies four hundred acres, which does not include the other plants at Rochester and elsewhere throughout the world.

In 1912 Eastman installed at Rochester a splendidly equipped research laboratory under the direction of Dr. C. E. Kenneth Mees, who surrounded himself with many distinguished scientists, among them Dr. S. E. Sheppard, Dr. Walter Clark, L. A. Jones, J. G. Capstaff, C. J. Stand, J. I. Crabtree, and A. P. H. Trivelli. Later he established a research laboratory at the Kodak-Eastman Works at Wealdstone (Middlesex), England, under the direction of Dr. Walter Clark, who still later joined the research laboratory at Rochester. Their investigations are published in the *Abridged Scientific Publications* published yearly. In addition, the laboratory issues monthly the *Kodak Abstract Bulletin*, which gives abstracts of all papers of technical and scientific interest appearing in the United States and foreign countries in the photochemical field, including all patents. Eastman contributed largely to numerous scientific and educational institutions and donated nineteen and one-half million dollars to the Massachusetts Institute of Technology.

Eastman, who never married, was one of America's greatest philanthropists. By 1932 the sum known to have been given by him for charitable, educational, and other welfare work amounted to one hundred million dollars.

He surprised the inhabitants of Rochester, New York, with the gift of a theater with which a musical conservatory is connected. His

original gift to this institution was $3,520,000, which he supplemented a few months later by an additional million dollars for the equipment. The theater is most beautifully appointed and seats more than thirty-three hundred persons. There is also a small lecture hall completely equipped for the exhibition of motion pictures.

Eastman presented more than half his stock in the Eastman Kodak Company, valued at fifteen million dollars, and seven and one-half million dollars in addition to the University of Rochester.

Most of the employees of the company are stockholders in the enterprise, which increases their own interest in its success and promotes that of the company. At seventy-one years, Eastman still took an active and lively interest in the business. In 1925 Eastman retired from the active management. He left as his principal successors William G. Stubeer, president, and Frank W. Lovejoy, vice-president and general manager. After having given up the presidency, he remained as chairman of the Board of Directors until his death, which took place March 14, 1932. The value of Eastman's estate at this time was $25,561,640, of which an amount estimated at $19,287,143 went to the University of Rochester as residuary legatee, making his total gifts to that institution approximately $35,000,000.

GOODWIN'S PATENT SUIT AGAINST THE EASTMAN COMPANY

The American clergyman Reverend Hannibal Goodwin (1822-1900) of Newark, New Jersey, was the first to apply for an American patent on the production of light-sensitive celluloid strips (flexible transparent film), which later became so important in motion picture photography. This application by Goodwin, dated May 2, 1887, encountered "interferences" and was amended in its specifications, so that it was not granted until September 13, 1898 (U. S. P. No. 610,861).[8]

The Eastman Kodak Company, in the interval, had applied for two similar patents under the name of H. M. Reichenbach, which led to litigation lasting for years.

The experiments of Eastman and Reichenbach solved . . . the problem of making, on a commercial scale, transparent nitro-cellulose photographic rollable film. December 10, 1889, patent No. 417,202 was granted to Reichenbach by the U. S. Patent Office, while on March 22, 1892 and July 19, 1892, two additional patents were granted to Eastman and Reichenbach. (Ackerman, George Eastman, p. 62).

Fritz Wentzel writes in Eder's *Handbuch* (1930, Vol. III, Part 1) that this patent included not only the product but also the process itself, the underlying principle of which consisted in the introduction into the solution of a high-boiling solvent for nitrocellulose, which permitted the low-boiling solvent to evaporate first. The high-boiling solvent held the material moist and in a soluble state until it was completely evaporated; this prevented the separation of the nitro cellulose.

For more than eleven years the patent suit remained undecided by the Patent Office and the Federal courts, because the Eastman Kodak Company during this time employed every possible means to prevent the granting of the patent to Goodwin. Finally, however, on September 13, 1898, Goodwin was awarded the patent rights (U. S. P. 610,861). Shortly afterward Goodwin's patent rights were transferred to the Goodwin Film & Camera Company, controlled by the Ansco Company of Binghamton, who acted as plaintiff in the case against the Eastman Kodak Company. These legal proceedings, unique in the history of the patent suits of the time, were begun after Goodwin's death and, on account of the length of time involved, as well as the unusual amount of damages assessed, amounting to millions of dollars which the Eastman Kodak Company paid to the Ansco Company, occupied the time of the courts until March, 1914, when the final decree was entered in Goodwin's favor.

This gave definite recognition to Goodwin as the original and rightful inventor of the celluloid base for roll films. Unfortunately, Goodwin had died in 1900, but his wife and son, who survived him and lived in straightened circumstances, received a considerable part of the financial award. Goodwin also obtained a number of other patents for the production of photographic film bases, among them one which applied the valuable properties of amylacetate to his purpose.

Goodwin was extremely well liked and popular with the members of his congregation; he liked and enjoyed amateur photography, in which he also instructed the pupils of his Sunday School. He had a fairly accurate knowledge of the technical side of photography and was sufficiently familiar with chemistry to enable him to make his own experiments. This doubtless led him to the idea of the production of transparent celluloid films and their use in roll holders as simplifying photographic practice.

His experiments required constant and considerable expenditures, which he found it difficult to provide and which involved severe de-

privations. When the patent suit against the Eastman Kodak Company entered its more serious phase, it became impossible for him to obtain the necessary funds to meet the expense. He was forced to assign his patent rights to the predecessors of the Ansco Company, receiving therefrom a small amount of cash and a block of stock in the company, which became very valuable when the courts decided in his favor. Unfortunately, he did not live to see this change of fortune. The Essex Camera Club and his church friends erected in the Public Library at Newark, New Jersey, a tablet to his memory in 1914, with the following inscription:

APRIL 21, 1822 DEC. 31, 1900

REVEREND HANNIBAL GOODWIN
A DEVOTED PASTOR

His service in the church covering charges in this state and in California included the Newark parishes of St. Paul's and the house of prayer. He foresaw the possibilities of photography as an instrument of education and devoted his inventive talent to the improvement of that art in the rectory of the house of prayer at Broad and State Streets. His experiments culminated in 1887 in

THE INVENTION OF THE PHOTOGRAPHIC FILM

As a memorial to the inventor of the device that has proved so potent an agent for the instruction and entertainment of mankind this tablet is erected.

THE ESSEX CAMERA CLUB AND FRIENDS, 1914

The patent suit of Goodwin vs. Eastman had no influence on the growth of the Eastman Kodak Company, which developed its own methods and inventions and became the largest film manufacturer in the world.

Chapter LXVII. THE STROBOSCOPE AND OTHER EARLY DEVICES SHOWING THE ILLUSION OF MOVEMENT IN PICTURES

THE SILVER BROMIDE process made possible the easy production of instantaneous photographs and the manufacture of photographs in series and their projection, of which toward the end of the nineteenth century those made on long celluloid strips achieved the greatest success. The beginning of optical presentations of serial pictures reaches back far into the past.

Here, also, we find presentiments on the part of the early Romans, who were endowed with a strong sense of imagination. A quotation from the poetic writings of the Latin poet and scientist Lucretius Carus (96 B.C.-55 B.C.), *De rerum natura* (Book V, lines 768-73) was interpreted to indicate that he understood the synthesis of serial images.[1] The passage cited reads:

> Quod superest, non est mirum simulacra moveri
> Brachiaque in numerum jactare et cetera membra;
> Nam fit ut in somnis facere hoc videatur imago;
> Quippe ubi prima perit alioque est altera nata
> Inde statu, prior hic gestum mutasse videtur;
> Scilicet, id fieri celeri ratione putandum est.

In translation it reads as follows:

> And further 'tis not strange that images
> Are moved, and throw about their arms and limbs
> In rhythmic order: for in sleep sometimes
> An image seems to do so: when the first
> Has disappeared, and another comes
> In different postures, then the former seems
> To have changed its attitude. You must conclude
> That this is done with great celerity.
> Sir Robert Allison, London, 1919.

This vague statement of Lucretius Carus does not in any manner detract from the merit of Plateau and Stampfer, the later discoverers of stroboscopic viewing.

It is noteworthy that Plateau himself was familiar with the foregoing verse, because he published a note about it which reads, "On the passage in Lucretius, where it is believed one recognizes a description of the phantascope" (*Bibl. univ.*, 1852, ser. 4, Vol. XX).

The first device for serial pictures and their observation through stroboscopic viewing was invented by Joseph Antoine Plateau (1801-83), professor at Brussels and later (1835) professor of experimental physics and astronomy at Ghent. He was a distinguished scientist in the field of optics, although blind from his thirty-ninth year, a misfortune arising from the eyestrain due to his studies.

Plateau is looked upon as inventor of the so-called "zoescope."[2] He published the principle of his phantascope in his dissertation, *Sur quelques propriétés des impressions produites par la lumière* (Liége, 1829), but he gives the date of the stroboscopic wheel as January 20, 1833. His first idea was probably inspired by Faraday. He took up the subject of defining the apparent animate movement of objects from the inanimate and vice versa, and in 1831 he read a paper before the Royal Society on "A Peculiar Class of Optical Deceptions, Showing Wheel Phenomena." Plateau drew or painted pictures of the movements of a dancer on the circumference of a circular disk, cut vertical slits in the cardboard and looked through them at the disk, which revolved in front of a mirror; a specimen of these cartoons is still extant.[3]

About the same time Simon Stampfer, the son of an Austrian day laborer (1792-1864), independently invented this wheel showing life in motion. After a most difficult time in finishing his schooling, he first became professor of mathematics in Salzburg and then served for twenty years as professor of practical geometry and surveying at the Polytechnikum at Vienna.[4] He also received his impetus from Faraday's experiments. A detailed statement by Stampfer on this subject is printed in the eighteenth volume of the *Annals* of the Polytechnic Institute.[5] This was a reprint of the pamphlet which accompanied as explanatory text the second edition of stroboscopic disks sold by Trentsensky & Vieweg. In the Deutsches Museum at Munich, Stampfer's original stroboscopic disks are preserved.

Stampfer began his experiments for the production of stroboscopic disks in 1832, and by February, 1833, had completed six of them. He applied for an Austrian patent in April, 1833, which was granted May 7, 1833 (No. 1,920). These disks, with an explanatory description and a preface, were placed on sale in July, 1833.[6] It is worth noting that Plateau and Stampfer, independently of each other, made the same invention. The priority right may be questionable, but Plateau anticipated it by publishing his invention a few weeks earlier. (For particulars see F. Paul Liesegang, *Kinotechnik*, 1924, Nos. 19-20.)

That Plateau and Stampfer made the invention independently of each other was established by Poggendorff in his *Annalen* (1834, XXXII, 646-48). He remarks about the zoescope:

Without doubt Professor Stampfer of Vienna is its inventor. . . . Justly as his rights are established, there can be no doubt, however, that by a co-incidence not unknown before in the history of the sciences, he must divide the honor of the invention with another, namely, M. Plateau of Brussels. . . . At any rate, M. Plateau, in a letter to me in January of this year, has confirmed the fact that he received the first reliable information of stroboscopic disks and of their inventor from a casual notice in the *Annalen* (XXIX, 189). At his request for more information on these disks, which after hearing about them from a traveler, he had considered an imitation of his phantascope, I thereupon sent him a copy of the pamphlet by Professor Stampfer mentioned above. Considering all this, I believe, one cannot deny that both Professor Stampfer and M. Plateau are to be considered independent inventors of the stroboscopic disks, since their close contemporaneous ideas and the great distance between Vienna and Brussels preclude the presumption that either knew or could know of the other's invention.

Plateau at first gave no name to his invention; but when in 1833 an inferior imitation appeared in the trade, called phanakitiscope, he ordered disks made in London from his drawings, which at first were to be called "phantasmascopes," but were later named "phantascopes." Stampfer also proposed other forms of application for the disks, among others, their use for serial picture strips. He recognized that at the moment of viewing the picture should not be subjected to rapid movement.

Plateau's work in 1828-29 was not concerned with the subject of the zoescope and did not directly influence its development. Stampfer would have invented it without Plateau. He was urged by his experiments, however, to study Faraday's work and to elaborate on it. Only later, in 1849, his anorthoscopic experiments changed the form of the zoescope, because Plateau had applied the anorthoscopic principle.

The first to project serial picture images by means of a Stampfer "stroboscope" onto a wall and thus produce the illusion of motion pictures before a large number of onlookers at one time was Franz von Uchatius.[7] He later became a lieutenant-fieldmarshal and was the inventor of steel-bronze guns. He was captain of artillery in the campaign of 1848-49 and later taught physics at the Artillery School, Vienna. He employed the stroboscopic disks in order to demonstrate

to his class various motions, for instance, sound and light waves; it was necessary to pass the apparatus from hand to hand, since only one person could use it at one time, which, of course, delayed the lecture. Therefore Uchatius sought a method which would show various motions objectively so that they could be seen by all his students at the same time. He succeeded in this by projecting onto a white wall, by the aid of a magic lantern, pictures of successive instantaneous movements which had been painted on a transparent disk. The construction of these pictures was, of course, extremely difficult at that time, in the forties of the last century, when photography had not yet been applied to the taking of serial pictures.

Captain Uchatius presented, on April 4, 1853, to the Vienna Academy of Sciences (*Berichte*, 1853, p. 482) the results of the experiments which he had begun in 1845 by order of Colonel von Hauslab, who was the tutor of Archduke Franz Carl's sons.

Baron Franz von Uchatius was born in 1811 in Lower Austria, the son of a public road inspector. He volunteered for the army as private in the Artillery Corps (1829), studied mathematics, mechanics, and chemistry, attended the Polytechnikum at Vienna, was transferred in 1841 to the gun factory, invented "Uchatius steel" and introduced (1879) steel-bronze into the Austrian army. He was appointed major general and knighted. Unfortunately, the experiments to produce larger calibers out of steel-bronze met with difficulties, and the attempt to produce a 28 cm. (11 inch) cannon barrel for coast artillery made slow progress. These seeming misadventures and a communication from the War Office that no funds could be made available by the Reichstag for the production of large-caliber guns so distressed Uchatius that he shot himself on June 4, 1881 (see Oberst von Obermayer, *Geschichte der technischen Militär-Akademie*, 1904; also Alfred von Lenz, *Uchatius*, Vienna, 1904). For us the "apparatus for the presentation of motion pictures on the wall" is of particular interest; it was constructed after the principle of the stroboscopic disk and was published by Uchatius in 1853.

The pictures were, like Stampfer's, arranged on a circular disk, drawn freehand, but transparent and stationary. In front of each picture was a lens which projected it onto the wall as each successive picture image was illuminated by a light source (Drummond light), with a condensor which was turned around the circle by a crank handle. The apparatus was made and sold by the optician Prokesch in Vienna.[8]

The moving pictures so obtained were quite satisfactory and proved the possibilities of the method. With photographic serial pictures and instantaneous exposures the method could be perfected. Uchatius was, without doubt, the first to invent this kind of cinematography with drawn pictures. His motion pictures attained general approval.

At that time there lived in Vienna a well-known prestidigitator, Ludwig Döbler (1801-64), who dealt with natural magic on a physical basis and became famous as a juggler, traveling all over Europe as early as the thirties. He liked to offer surprising physical demonstrations with a projection microscope and a calcium light. He became also an itinerant lecturer. It was he who, in 1843, brought to Germany the "dissolving views" which had been shown in England a short time before.[9]

On the occasion of one of Döbler's performances at Vienna in 1853, Uchatius spoke to him about his projected moving pictures, which interested Döbler so much that he went to the barracks where Uchatius was stationed and, after having seen the apparatus demonstrated, asked the price. The astonished and modest Uchatius said "one hundred florins," whereupon Döbler placed the money on the table, packed up the apparatus, and loaded it with his own hands into his carriage.

By the purchase of the improved projection zoetrope, constructed in 1853 by Uchatius, Döbler was enabled ten years after "dissolving views" were taken to enlarge his program by a splendid number, which he entitled "Presentation of Living Pictures." Döbler acquired a large fortune, bought an estate, to which he retired in his last years and where he died,[10] while Uchatius, notwithstanding several inventions he made after this, remained without fortune until his sad end.

General Uchatius must be designated justly as the precursor of cinematography, because he was the first to project on a wall drawn stroboscopic pictures giving the illusion of motion. Directly, he has no share in cinematographic projection, since this is possible only by means of serial photographs, which were then unknown.

The thought that in order to obtain a good effect the living pictures should remain stationary for a short time had already been grasped by Stampfer. The realization of this idea, however, was first attained by Charles Wheatstone, who back in the fifties installed a cogwheel on the axle of the disk and ran it by the worm gear. Later (1852), the optician Duboscq, of Paris, combined the zoescope with the stereoscope. The movement of pictures by the action of springs we find

realized for the first time in the projection zoetrope of Beale's "choreu-toscope" (1866). According to the historical classification of F. Paul Liesegang, Horner, an Englishman, described in 1833-34 the "marvel drum." This well-known form of the zoetrope was later "invented" over and over again, but only came into general use about 1867. In 1869 the Scottish physicist Maxwell constructed a "marvel drum" with an optical adjustment for changing the pictures, by inserting concave lenses into the viewing slits of the drum. The Frenchman Reynaud arranged for (1877) a change of pictures by means of a mirror drum (praxinoscope) which he built in. The first mention of a rapidly chang-ing exposure interrupted by a rotating shutter, the picture plate being simultaneously interrupted, is found in American patent No. 92,594, of August 10, 1869, by A. B. Brown. This device corresponds to the Maltese cross of the modern motion picture apparatus and presents with it essential characteristics resembling the motion picture ap-paratus of today.

THE PRAXINOSCOPE OF EMIL REYNAUD

The praxinoscope of Emil Reynaud represents a combination of the magic latern and the zoetrope. He described it in the periodical *La Nature* (*Phot. News.*, 1882, p. 675; *Jahrbuch*, 1892, p. 363). This apparatus required only an ordinary lamp. There are two projection systems, and a single lamp is sufficient for both. One lens projected a landscape, and so forth, and the other a moving figure. When both lenses were directed onto the screen and the successive instantaneous pictures were projected, the figures moved and presented an animated scene in a somewhat jerky manner. Nevertheless, with such an appara-tus the correctness of Muybridge's exposures, which had been ques-tioned, was practically demonstrated (see Ch. LXVIII).

He took out a French patent (No. 194,482, December 1, 1888) for the invention of a perforated flexible picture strip to produce the illusion of motion. Edison and Lumière also had perforated strips of film. Reynaud used his apparatus for the pantomimes at the "Théâtre Optique," in Paris (1892), and the "Photopeinture Animée" at the same theater (1896).[11]

Emil Reynaud devoted himself in 1877 to the improvement of the stroboscope, using a rotating mirror drum in order to present princi-pally the images, optically stationary, to the spectator. He used the same arrangement later (1889) for projection also. Reynaud's *Erfin-*

dung des optischen Bildausgleiches inspired further applications (see F. Paul Liesegang, *Wissenschaftliche Kinematographie*, Düsseldorf, 1920). In Reynaud's model of 1882 the motion pictures were imperfect and appeared reversed, notwithstanding the continuing optic compensation, while the series were photographed with intervals too prolonged. Later this defect was corrected, and Reynaud made a real contribution for that period.

Chapter LXVIII. EADWEARD MUYBRIDGE'S MOTION PICTURE PHOTOGRAPHY

THE FIRST SERIAL PHOTOGRAPHS of human beings or animals in motion produced by successive exposures at regular intervals were made by the Englishman Edward James Muggeridge, known as Eadweard Muybridge.[1] He was born at Kingston-on-Thames, April 9, 1830. When still young, he emigrated to America, obtained a position as clerk, became a professional photographer, and received an appointment from the United States Government as director of the "Photographic Survey" of the coast of California. He was engaged in this work on the Pacific coast in the spring of 1872, when he attracted the attention of Governor Leland Stanford of California. The governor maintained a racing stable and had entered into an argument with a gentleman named Frederick MacCrellish over the question whether or not a horse when running at full speed at certain moments touches the ground with only one foot. The Frenchman Dr. Jules Marey had taken up this question some time before.[2]

Dr. Konrad Wolter describes this in detail in *Filmtechnik:*[3]

A long time before these happenings Jules Marey had considered how the motions of a horse trotting or galloping could be accurately registered so that the period during which each foot of the horse touched the ground could be automatically recorded. In order to accomplish this he inserted firmly in the hollow of each hoof, which was surrounded by the horseshoe, a rubber ball from which a long rubber hose led to an inked pen, which drew a line on a piece of paper stretched around a continually rotating metal drum whenever the horse put its foot down and thereby increased the air pressure of the rubber ball. This registering instrument, into which four tubes were inserted and had four corresponding pens, which were arranged one above the other, was carried in the horse-

back rider's hand. The length of time, as well as the coincidence or the succession of these strokes, on the registration paper showed the time lapsed and the reciprocal relation between the lowering and the rise of each of the four feet of the horse. By the aid of this method, which Marey called "chronography," he succeeded, among other things, in demonstrating that the horse when galloping supports itself first on one foot, then on three, then on two, and again on one only. Captain Duhousset, who was not only a fine horseman and lover of horses but also a clever artist, was so fascinated with these experiments, that he made drawings for Marey from the chronographs he had made showing the respective positions of the horse in motion.

These drawings by Duhousset, which had their origin in Marey's chronographs, were reproduced, and copies came into the possession of Governor Leland Stanford, of California, an enthusiastic friend of horses and owner of a racing stable. Governor Stanford believed these drawings to be very questionable.. He was particularly skeptical of the drawing which depicted the galloping horse touching the ground with only one forefoot. Stanford believed this to be impossible; he discussed the matter with his friend MacCrellish, and out of the discussion came the happy idea, so momentous for the future, to settle the matter in dispute by the aid of photography, an idea at once strange and novel, considering contemporary photographic technique. Marey had never thought of such a possibility up to that time. Stanford gave Muybridge an order for the carrying out of this experiment, which, as we know, led Muybridge to devote his whole life to the perfecting of serial photography in the analysis of movement. This had another consequence: Stanford entered into direct communication with Marey in Paris and informed him also of his experiment. This called Marey's attention to the possibilities which photography offered, which he exploited later with such skill and ingenuity in his chronophotography. Marey, of course, communicated with Muybridge, who kept him informed on the progress of his work and the splendid success which attended his work in America in the production of serial photography of fast-moving objects. In due time Marey received from Stanford and from Muybridge, full confirmation of the correctness of his own chronographic equestrian pictures. Muybridge's photographs made at Palo Alto, California, at Stanford's request in 1872 furnished the proof of the drawings made from Marey's serial chronographs.

Muybridge ordered a horse to be ridden on a race track at Palo Alto, alongside of which he set up from twelve to thirty cameras side by side, but spaced slightly apart. The track was covered with rubber matting, and strings were stretched across the ground which led to the instantaneous shutter of the cameras, which functioned automatically.

When he began his first experiments, Muybridge had only wet collodion plates at his disposal and obtained only weak outlines of the horse passing in front of the camera.

In May, 1872, he constructed instantaneous shutters for short exposures and made his first experimental negatives at the race course in Sacramento, Cal. The imperfect pictures were sufficiently sharp to show the silhouette of the trotting horse; some, indeed, indicated that the trotter undoubtedly raised all four feet simultaneously from the ground. Marey's drawings were examined and found correct.

The first photographs, however, lacked continuity and showed only accidental, isolated positions of the trotter. Muybridge conceived the idea of obtaining a connected record of all phases of the motion of the horse in exactly regulated time spaces. He interested Governor Stanford in this idea, so that he put at his disposal the thoroughbreds at his racing stables at Palo Alto, Cal. This location is now occupied by the buildings of the Leland Stanford University. There Muybridge set up his battery of twenty-four cameras in a row parallel to a white wall. At first he tried to obtain the exposures automatically by mechanical means of stretching across the track wires which led to the lens shutters. Later he operated the shutters at exactly determined time intervals, by means of an electrical device, which functioned automatically. This arrangement was described in the *Proceedings of the Royal Institution of Great Britain*, March 13, 1882.

Instantaneous photographs of the racing horse "Sallie Gardner," which ran at the rate of 52½ feet per second and was photographed at successive intervals of 1/25 of a second are reproduced in the 1932 German edition of this *History* (p. 296). In the original, however, the contours are not so sharp as in the reduced illustration.

In 1878 Muybridge published a pamphlet under the title *The Horse in Motion*, which he copyrighted. In a second publication (a quarto of 203 pages) appear numerous illustrations depicting athletes, horses, dogs, and other animals in motion. The *Scientific American Supplement* (1879, No. 158, p. 2509) printed several similar pictures.

The obvious idea occurred to Muybridge to stretch his long strips of photographically produced serial motion pictures in the long-known American "wonder drum." He also tried to frame stereoscopic serial pictures in two of these drums, which were fixedly combined with each other and, with a simple mirror device (after the manner of Wheatstone's reflex stereoscope), gave the illusion of a seemingly corporeal small trotting horse in action.

In 1879 Muybridge invented the zoopraxiscope. It consisted of a revolving tin disk, in which were inserted one or more concentric rows of glass diapositives in a certain order; they passed through a projection apparatus. The disks carried a collection of as many as two hundred single views. These serial pictures Muybridge exhibited with his projection-stroboscope before large audiences.

Muybridge gave the first performance with his zoopraxiscope in Palo Alto, in 1879, and in 1880 he gave one before a large circle of persons in San Francisco. In the middle of 1881 Muybridge went to Europe with his serial-diapositives and the zoopraxiscope. He gave his first lecture in September, 1881, in the laboratory of the physiologist Professor E. J. Marey, who was very enthusiastic over this new invention and was incited by it to employ photography also in his similar investigations, which led him later to his "chronophotography." From Paris Muybridge went to London (March, 1882), and there, as at Paris, he achieved extraordinary success. Up to now his work had been done with wet collodion plates. This period ended in 1879. Later he took his work up again, using gelatine silver bromide plates, when Dr. William Pepper, president of the University of Pennsylvania, Philadelphia, urged him to continue his investigations there on a broader basis. With this most encouraging support he began, in the spring of 1884, his most fruitful activities, which ended in the fall of 1885 as far as photographic exposures were concerned. During these one and one-half years he used more than one hundred thousand Cramer dry plates. The time intervals of a series were always measured by a chronograph and graphically recorded.[4]

The material gathered from his photographic exposures was published in 1887 under the title *Animal Locomotion: an Electro-photographic Investigation of Consecutive Phases of Animal Movements, University of Pennsylvania, 1872-85* (London, Eadweard Muybridge, 10 Henriette Street, Covent Garden, c. 1887). The large edition of this work embraces eleven volumes, with 781 large mezzotint gravure inserts, illustrating more than 20,000 single successive phases of locomotion (price 110 guineas), while the small edition, with selected illustrations, cost 20 guineas.[5] The book contains serial pictures of human beings and animals (horses, donkeys, steers, dogs, cats, lions, elephants, camels, birds and so forth).

Muybridge found it unexpectedly difficult to sell enough of these expensive books to justify their publication and came, in 1891, even

to Austria in order to find subscribers. He also visited the author and presented him with some of the illustrations. He also gave numerous lectures in Germany in 1891-92 and sold a number of copies of his works to German libraries.

The invention of the above-mentioned zoopraxiscope by Muybridge was of the greatest importance. To him belongs the priority right for the invention of the zoetrope projection with glass diapositives and counterslotted disks, which dates from 1879. Muybridge himself, in March, 1882, projected his pictures before the Royal Society in London by the use of such an apparatus illuminated by electric lights. In 1891 he exhibited these pictures also in Vienna and Berlin.

The great progress which these pictures showed astonished all who saw them. That they had defects did not remain undiscovered, but these notwithstanding, Muybridge's projected serial photographs were a pioneer's work. Muybridge was well aware of the importance of his invention, for he remarked about his zoopraxiscope that it was "the first instrument which was ever constructed or invented to show by synthetic reconstruction motions which had been photographed from life." Therefore Muybridge must be recognized as the real inventor of the first projected animated photograph from life.

In 1893 he had his own exposition building at the Chicago World's Fair, which he called "Zoopraxographical Hall." On this occasion he published two textbooks: E. Muybridge, *Descriptive Zoopraxography; or, The Science of Animal Locomotion*, University of Pennsylvania, 1893, and E. Muybridge, *Popular Zoopraxograph; the Science of Zoopraxography*, published at the Zoopraxographical Hall of the World's Columbian Exposition, 1893.

With this the successful life work of Muybridge was completed; he never went beyond the use of glass negatives and diapositives, nor did he ever turn to the production of serial photographs on films or paper. In 1900 he returned to his birthplace in England and retired from business. He died on May 8, 1904, and bequeathed his zoopraxiscope to the public library of his native town. Leland Stanford, Jr., University, at Palo Alto, California, honored him in 1929 by erecting a bronze tablet to his memory.

Chapter LXIX. PHOTOGRAPHIC ANALYSIS OF MOVEMENT BY JANSSEN AND MAREY

THE FRENCH ASTRONOMER Professor Pierre Jules César Janssen[1] (1824-1907) employed photography in 1874 to obtain a chronographic photo-record of the positions of the planet Venus during its transit across the face of the sun. He invented a special "photographic revolver" for this purpose, with which forty-eight instantaneous exposures in juxtaposition were taken around the edge of a circular, rotating light-sensitive plate in rapid succession.[2] A series of photographs of Venus during its passage in front of the sun at intervals of seventy seconds, photographed by Janssen, is reproduced in Marey's *Développement de la méthode graphique* (Paris, 1884).

The photographic apparatus of Janssen was based on the principle that the sensitive plate moved forward at certain intervals, but remained stationary during the exposure. He employed in this the Maltese cross, which later played an important role in motion picture photography. Janssen had an excellent astronomical observatory at Meudon, where he lived until his death; his lectures were delivered in Paris.

The palace in Meudon, used by the Empress Marie Louise and later by Prince Napoleon as a summer residence, was destroyed in the Franco-Prussian War of 1870-71. Restored by the Republic, it was equipped as an observatory for Janssen. On a visit of this author in the spring of 1889, on the occasion of the International Conference for the Production of Photographic Celestial Maps,[3] he found that Janssen had produced the granulation of the sun's surface in very large size on wet collodion plates. Janssen also demonstrated the absorption spectrum of water in very long tubes in calcium light. In 1880 Janssen had obtained in the strongest sunlight (with refractors), while working with gelatine silver bromide plates, as well as on collodion-tannin-dry-plates, a repetition of the solarization phenomena. The different phases through which the picture passes are: (1) a negative; (2) neutral condition (total intensification); (3) a positive; (4) a second neutral condition, in which the plate becomes uniformly light in the developer; (5) a negative of the second order; (6) a third neutral condition of uniform intensification (Janssen, *Compt. rend.*, June, 1880, XC, 1447, and XCI, 199). He also worked on the laws of density in normal negatives.

JULES MAREY

The French physician Etienne Jules Marey (1830-1904), professor at the College of France, devoted himself particularly to the physiology of motion of men and animals and the scientific possibilities of motion pictures. After the work of Janssen and Muybridge became known, he analysed the phenomena of motion in men and animals by photographic methods, for which he constructed his own chronographic apparatus. He invented a series of registering appliances to serve as exact aids independent of the individuality of the observer, for the analysis of very complicated and fleeting physiological functions; for instance, the heart action, with the aid of the sphygmograph, the gait of horses and dogs, the flight of birds, and so forth.

Marey employed for his motion studies apparatus with movable photographic plates and also stationary plates on which the instantaneous pictures appeared next to each other on a single plate. His apparatus equipped with movable plates followed closely the earlier photographic revolver and followed exactly Janssen's astrophotographic telescope.

Marey's photographic gun for taking serial pictures of birds in flight was equipped with a sight and a clock movement; it permitted twelve exposures in a second, each exposure occupying 1/720 of a second of time of exposure on Monckhoven's gelatine silver bromide plate. Photographs of a gull in flight are reproduced in the *Handbuch* (1893, I (2), 582-84). Marey mounted the serial pictures thus obtained on a stroboscopic disk, where, notwithstanding their small size, the phenomena of motion could be observed.

Jules Marey[4] was assistant surgeon in a Paris hospital in 1855, then he took up the science of human and animal physiology and the animated motion of the body. He became professor of medicine at the University of Paris; in 1872, a member of the Academy of Medicine; and in 1876, a member of the Academy of Sciences. He founded the Institute for Physiology (Institut Marey) at Paris. In all his researches after 1882 Marey employed the systematic methods of serial photography.

He invented, in 1888, the "chronophotograph" from which later was developed the modern cinematograph. Marey was for many years president of the Société Française de Photographie and took a lively interest in the arrangement of the photographic division of the Paris

Exposition of 1900. His scientific friends and admirers presented to him (1902) an artistic plaque which shows his portrait and a symbolic design of the different apparatus and the results of his investigations.[5]

Marey's chronograph with stationary plates was installed in a movable roomy darkroom (wagon). It consisted of a large rotating disk of 4¼ feet diameter with a slot opening on the circumference. The slot measured a one-hundredth part of the periphery of the disk, so that when the disk turned ten times in a second, each exposure took one-thousandth of a second.

Marey had his actors clothe themselves in white and had them pass in front of a black background; he used only one camera and one lens. The speed of the rotating disk was controlled by a round dial with a shining movable hand which was fastened on a dark background. For special motion studies Marey clothed the actors in black and fastened bright metal bands on their hands, legs, and so forth, in order to indicate more plainly the movements in the photographs. In another series of experiments the clothes worn were half white and half black, so that, for instance, when walking, only one side of the body was visible.

Later, Marey greatly improved his apparatus (Marey, *La Photographie du mouvement*, Paris, 1892). After 1890 he used a new serial apparatus, the photochronograph, in which was used a strip of negative paper, moved by a spring which was 3½ inches wide and not more than 157½ inches long. The strip was not perforated, winding iself continuously from spool to spool and remaining stationary for a moment during the exposure. The instantaneous shutter consisted of two slotted disks, rotating closely behind each other, one of which turned five times as fast as the other; when two of the slits cut in the periphery coincided, the exposure took place.

These photographs were not suitable for projection, owing to the unequal distances between pictures ("steps"). There were also lacking at that time a transparent film suitable for projection. About the same time Marey invented an instrument for making serial micro-photographs and subsequently also high-frequency-current serial negatives, with electric arc lamps, at the rate of 120 pictures a second. Thus, in 1890 Marey photographed with his chronograph not only persons in motion but also jellyfish, fish, insects, and the movements of blood corpuscles in the capillary vessels.

In 1893 George Demeny, in Paris, who assisted Marey in his experiments, built an apparatus arranged for taking and projecting serial

photographs with a beater ("*Schläger*") carrier inserted; this beater was, much later, frequently employed in cinema projection. This invention lay unemployed until exploited in 1896 by Gaumont (at first with a film 2 ⅜ inches wide) after Edison and Lumière had made their "cinematoscope" public.

Many admirers and friends of Marey regarded him as the real inventer of modern cinematography, while generally the brothers A. and L. Lumière were recognized as its creators. A movement in protest against the designation of the brothers Lumière as the inventors of cinematography developed in France, proceeding mostly from Marey's pupils, which we report below because the document describes Marey's services comprehensively.[6]

Protest against the Serious Injustice Committed against the Eminent French Physiologist E. J. Marey, by Those Who Desire to Contest His Right to the Invention of the Cinematographic Process and of Having Constructed the First Cinematograph.

All we former pupils of E. J. Marey consider it our imperative duty solemnly and energetically to express our firm conviction that the cinematographic process and the first cinematograph are the work of Marey and represent the crowning result of his labors, extending over almost half a century. The automatic and true-to-nature delineation of motion in all its forms, particularly of all animated phases of life, was the task to which he devoted himself without cessation.

From 1858 to 1882 the simple graphic method or chronostylography, after the description of his friend and collaborator Chauveau, formed the essential tools in his work.

Thus came into existence successively the sphygmograph, the cardiograph, the myograph, the several registering devices with movable plates or rotating cylinders, the odograph, the chronograph, etc., all of which are apparatus of classical importance, which have been described in scientific literature and have become indispensable elements of the equipment of every biological research laboratory.

In the pursuit of this object, clearly tending toward one definite goal, Marey, since 1882, was convinced that chronostylographs did not suffice to disclose the several phases of the complex manifestations which are presented by the motions of men and animals, the flight of birds and insects.

From this period on he sought a new method, and thus photography became his favorite pursuit, to which he devoted until the end of his life his scientific activities and his remarkable gift for invention.

It was he who created animated photography, or cinematography.

Since Marey's death (1904) the brothers Lumière have asserted that they are the inventors.

A simple comparison between the work of Marey and that of the Lumière brothers, by means of the development of the facts and their chronological succession, suffices to show in relief and in a striking manner Marey's priority rights.

Marey's Work on the Animated Picture

1882: Marey invents a chronophotographic apparatus with stationary plates and chronographic disk shutter, which produced in equal time intervals pictures of successive phases of motion of objects on black background (*Compt. rend.*, August 7, 1882, Vol. XCV).

1882 and subsequently: Marey endeavors to eliminate the necessity of the black background and constructs the photographic gun, an apparatus with movable plates and rotating mirror.

1888: Marey substitutes in place of the stationary plate of his chronograph of 1882 a strip of light-sensitive paper and drops the regular intermittent movement in the picture plane of the lens. The paper strip remains stationary during the time of the opening of the disk shutter (*Compt. rend.*, October 15 and 29, 1888, Vol. CVII). Here the basic principle is for the first time expressed and materialized which forms the real foundation of cinematography.

1889: The International Photographic Congress adopts Marey's recommendation of the term "chronophotography" for describing the several methods which serve to obtain the photography of motion.

Marey induces Balagny, of Paris, to introduce strips of emulsion coated celluloid, which advantageously displaced the light-sensitive paper of 1888.

1890: Marey describes, in a report to the Academy of Sciences, his new apparatus equipped with a transparent light-sensitive film. This is the first cinematograph for taking animated pictures.

1892: Marey constructs, according to the reversible principle of the chronophotograph, an apparatus for the projection on a screen of series of pictures taken by the afore-mentioned apparatus and thus realizes the photographic synthesis of motion (*Compt. rend.*, May 2, 1892).

1893: Marey becomes conscious of the fact that his process promises to have far-reaching application and decides to apply for a patent (June 29, 1893). Unfortunately, the principle of animated photography on flexible, transparent film suitable for rapid intermittent movement had become public knowledge since his report of 1890, and the law denies all rights to industrial and economic ownership of an invention which has been made public before application for a patent. An unjust and unfair law! The industrial and financial advantage can accrue, therefore, to the

originator of a single improvement, which is all he needs to patent in order to reap the result of the original invention, in which he had no part.

1894: Marey publishes his book *Le Mouvement*, which collected his earlier work and contains the history of the invention of cinematography.

The Work of Messrs. Lumière on the Animated Picture

1895: A. and L. Lumière patent an "apparatus for the taking and projection of chronophotographic pictures" (February 13, 1895).

They open a showroom in Paris, December 28.

Marey's work shows clearly the thread leading to cinematography, an invention which since 1892 is perfected and final in its basic elements. Messrs. Lumière have evidently done nothing more than add a technical improvement to this basic invention.

In place of the name given to it by Marey, which was adopted by Lumière, "chronophotography," the term "cinematography," introduced by Léon Bouly, has been accepted and brought into general use. But this is only a change of names. Marey is and remains, for the impartial expert, the creator of animated photography and of the chronophotographic analysis and synthesis of motion on a flexible transparent film, in a word, of cinematography.

The protest is signed by:

R. Anthony (professor at the Museum of Natural History); J. Athanasiu (professor in the University of Bucharest; formerly subdirector of the Institute Marey); L. Bull (subdirector of the Institute Marey); L. Camus (member of the Academy of Medicine, director of the Institute Superieur de Vaccine); F. Cellerier (director of the Research Laboratory at the Conservatoire Nationale des Arts et Métiers); G. Contremoulins (chief of the Main Laboratory for Radiography at the Hospitals); A. Doléris (member of the Academy of Medicine); E. Gley (professor of the Collège de France, vice-president of the Academy of Medicine); L. Hallion (member of the Academy of Medicine); L. Manouvrier (professor at L'Ecole d'Anthropologie); R. Marage (professor at the Sorbonne); M. Mendelssohn (ex-professor University of St. Petersburg, member of the Academy of Medicine); P. Noguès (laboratory director of the Institute Marey); Dr. Felix Regnault; Ch. Richet (member of the Institute, professor on the Faculty of Medicine, director of Institute Marey); G. Weiss (dean of medical faculty, Strassburg, member of Academy of Medicine, former subdirector of the Institute Marey).

For comparison we print below an article from *Science, technique, et industries photographiques*, May, 1926 (p. 55), which refers to the foregoing protest and shows how divided opinions are, even in France. The article reads:

It was inevitable that the dedication of the Lumière commemorative tablet would arouse again a new clamor among the people who are more Marey'istic than Marey himself and have made it their affair to twist the facts, without submitting to a discussion. In the Paris *Soir*, March 24, we learn that the Lumières have robbed Deménÿ or something of the sort. This is a new version. Formerly the followers of Marey, of which anyhow some have patented and exploited their inventions in this field, could find no words harsh enough to censure Demeny's action, who constructed an apparatus for chronophotographic exposures (but without projection) and had the temerity to turn it to his own account instead of yielding the paternity to his master. At present there is being disseminated a polemic of Dr. Richet, who seems to have forgotten that he himself had admitted, in a letter to the late E. Wallon, the correctness of the record taken during the course of a discussion in which he participated, in which he was clearly determined that there was no foundation whatever for the campaign against the brothers Lumière, which was carried on under his leadership.

For further information see Chapter LXXI and following.

Chapter LXX. OTTOMAR ANSCHUTZ RECORDS MOVEMENT BY INSTANTANEOUS PHOTOGRAPHY AND INVENTS THE ELECTROTACHYSCOPE (1887)

GREAT MERIT for the progress of serial photography, as well as for that of instantaneous exposures in general, must be accorded to O. Anschütz, of Lissa and later of Berlin (*Handbuch*, 1892, I (2), 592).

Ottomar Anschütz (1846-1907) was a professional photographer in Polish Lissa.[1] He perfected instantaneous photography by the introduction of the focal-plane shutter (although it was not invented by him), which was attached immediately in front of the photographic plate. Anschütz made, in 1882, single instantaneous exposures and attracted attention in 1884 with his instantaneous exposures of pigeons and storks in flight, which possessed sharpness and considerable size, which had not been attained before that time.[2] His photographs furnished exceedingly valuable material for the study of animal life and the mechanics of flying. One of these original photographs, which

pioneered the further improvement of instantaneous photography, is reproduced in the 1932 German edition of this *History* (p. 718).

From 1885 Anschütz devoted himself to the pictorial presentation of animals and human beings in motion by continuous series of exposures. On orders from the Prussian government, horses in different gaits (24 exposures in ¾ second) were photographed; the original photographs were very small (¾ x 1 ½ inches) and were later enlarged. Anschütz was far more successful and more precise in obtaining the optical synthesis of these serial photographs into "moving pictures" than all his predecessors. He also used transparencies, which, however, he did not project on a wall, but which could be "looked through" by a large number of people simultaneously. In the first form of the "electric rapid viewer," which Anschütz invented in 1887 and exhibited in Berlin and Vienna, the serial pictures (glass diapositives) were arranged in a circle on a steel disk.[3] At the lightest point was an opal glass, behind which the illumination of the field of the picture took place with the aid of an instantaneous flashing Geissler tube in corresponding intervals of time.

The original form of the "electric rapid viewer of Anschütz was exhibited on the invitation of the author in 1887 at the Vienna Graphische Lehr- und Versuchsanstalt. This was the first apparatus which presented, in a perfect manner to a small circle of onlookers, animated photographs, employing photographic serial pictures (glass diapositives). This presentation excited great attention at the time.

This kind of electric illuminating device was retained also in the later form of Anschütz's electrotachyscope (1890), while the form of the stroboscope was changed; in place of the rotating disk, a rotating drum (a kind of wheel) was used, which made the apparatus easier to handle and less bulky and also permitted the showing of various pictures next to one another, while with the disk form only one series could be observed, and then the diapositive had to be changed (*Handbuch*, 1893, I (2), 396).

The electrotachyscope consisted of a rapidly moving drum to which were attached a number of transparent gelatine silver bromide prints (on flexible paper). The light source (Geissler tube) was installed behind the diapositive, and a ground glass inserted between the light and the diapositive softened the flashlight of the Geissler tube through which the electric current flowed.

This kind of stroboscopic "rapid viewing"[4] is of only historic inter-

est. Modern cinematography turned to flexible strips of transparent film, both for the taking of the negative as well as for the projection of the positive picture.

Chapter LXXI. DEVELOPMENT OF CINEMATOGRAPHY

CINEMATOGRAPHY had its beginning in stroboscopic vision and the subsequent connection with moving pictures, which we have described before.

A comprehensive description of the history of the art of projection and cinematography is presented by F. Paul Liesegang in the *Liesegang-Mitteilungen*, October, 1928. The history of the development of cinematography is depicted in a diagram which shows that the cinematograph (1895) evolved from the combination of three inventions, the magic lantern (1660), the stroboscope, or "wheel of life" (1832), and photography (1839).

HISTORY OF THE PERIOD PRECEDING MODERN CINEMATOGRAPHY

Ducos du Hauron had already conceived the principle of the idea for the construction of cinema apparatus in 1864, but he did not execute it. His invention was not made public, and he cannot, therefore, be accorded any part in the realization of this idea.

Ducos du Hauron patented in France, March 1, 1864, his apparatus (No. 61,976) for taking moving pictures with optical equalization under the title "Apparatus Having for Its Purpose the Photographic Reproduction of Any Kind of a Scene, with All the Changes to Which It Is Subjected during a Specified Time." He also took out a supplementary patent, December 3, 1864. The apparatus was never constructed, the description of the patent was never published, and his directions remained unknown at that time. In his supplementary patent application he substituted a light-sensitive strip for the rigid photographic plates. For the projection of the picture an artificial light with a condenser was used. Ducos du Hauron's idea was far ahead of his time. The battery of stationary lenses and the passing shutter proposed by him was put into practice by Humbert de Molard in 1867, and the arrangement of rotating lenses described in the additional patent was

realized thirty years later by the American Jenkins, who had no knowl-
edge of the earlier work of Ducos du Hauron.[1]

A strong impulse came from Marey, who by 1888 had already con-
structed his apparatus for the production of serial photographs with
negative paper strips and was therefore repeatedly called the "founder
of modern cinematography.[2] But Marey's apparatus lacked character-
istic elements of the modern cinema apparatus; he used no transparant
films, no perforation of the film strips, which render the single ex-
posures equidistant, no intermittent forward movement, but an elec-
tromagnetic arresting adjustment, and no sufficiently large size of
picture ($3\frac{1}{2}$ x $3\frac{1}{2}$ inches). Marey therefore cannot be recognized as
the inventor of modern cinematography.[3]

CINEMA CAMERAS WITH STRIPS OF FILMS OF FRIESE-GREENE
(1889) AND SIMILAR APPARATUS

Friese-Greene[4] and the engineer Mortimer Evans invented, in 1889,
a camera for making rapidly successive series of photographs on a long
unperforated strip of celluloid film, which they patented on June 21,
1889. The film remained stationary during the time of exposure and
was moved only afterward. The movement was effected by a handle
turned by hand, which also caused the instantaneous shutter to func-
tion. The film strip contained enough material for three hundred
pictures, ten every second.

Friese-Greene first demonstrated this camera in 1890 before the
Photographic Society at Bath; and in July of the same year, at the
Photographic Convention at Chester. At this time he had also con-
structed a projection apparatus for it.

Friese-Greene was led to his invention by J. A. Roebuck Rudge of
Bath in 1882. The latter worked at that time on the production of
serial photographs on a glass disk, naming the apparatus "bio-phanta-
scope." After Rudge's death Friese-Greene continued the experiments,
at first with glass plates and intermittent exposures, whereby the serial
pictures were rolled off spirally (1885). In 1889 he started the use of
celluloid films, and on June 21, 1889, he took out, jointly with Evans,
who had assisted him in building his cinema camera and his projection
apparatus, a patent for cinema celluloid films. The city of Bath erected
in 1927 a memorial tablet to Rudge and Greene. Edison had founded the
Motion Picture Trust of America against Greene and others, but
Greene's patent remained valid. At any rate, Edison is considered

the first to introduce the perforated motion picture film on a practical scale. In August, 1889, W. Donisthorpe and W. C. Croft took out an English patent on an arrangement quite the same as that of Greene (No. 19,912), and L. Breeman was granted a similar patent with paper bands on February 18, 1890. Demeny patented, on September 1, 1892, a "photoscope," and on December 19, 1893, on a process of chronophotography. Demény accomplished the electrical connection by the "punch," which later occupied a prominent position, but was then displaced by the Maltese cross.

[The following paragraph was sent to the translator by the author.]

C. Francis Jenkins played a noteworthy role in the introduction of motion picture photography in America. He constructed, in 1893, a motion picture projection apparatus called a "phantascope" and a "phantascope camera," for which a U. S. patent was granted, January 12, 1894. The intermittent motion was accomplished by perforated films. The machine was first exhibited to the public at the Atlanta Exposition, October, 1894; the projector had no intermittent shutter. This apparatus is exhibited at the National Museum in Washington. Jenkins was the founder of the Society of Motion Picture Engineers of America. Although he made no particularly important inventions, his activity in America was so highly regarded that he was awarded the Gold Medal by the Franklin Institute in 1925.

Louis Aimé le Prince (1842-1890), a Frenchman who lived most of his time in either England or America, must be included among the precursors of motion pictures. He studied in France and also in Leipzig, went to Leeds (England) in 1866, took out on November 2, 1877, an American patent, No. 376,247, and on January 10, 1888, an English patent on motion pictures and their projection. In 1888 he produced twenty serial pictures per second with a one-lens-perforated-film camera and projected his pictures at Leeds. An English Committee convinced of his priority rights, erected a memorial tablet to him at Leeds, 1931 (*Phot. Jour.*, May, 1930; *Kinotechnik*, 1931, p. 224). Le Prince arranged a motion picture presentation on March 3, 1890, at the Paris Opera House. When traveling in France, at the time at which he was to prove the functioning of his apparatus to the French Patent Office, he disappeared, leaving no trace behind him (1890),

[The remainder of this section was sent to the translator by the author.]

William Friese-Greene (1855-1921) learned photography in his

early years and was employed in 1882 by J. A. Rudge in Bath, England, who at that time was occupied with the production of serial photographs on glass plates on which the serial images were rolled spirally under intermittent exposures. This apparatus Rudge called "biophantascope." After Rudge's death Friese-Greene continued these experiments and demonstrated his apparatus in 1885 and 1887 before the Photographic Society of Great Britain. He established, in 1888, a photographic business, which he neglected, however, and produced motion pictures on photographic paper strips. They were impregnated with oil and thus made semitransparent. In January, 1888, he used perforated paper rolls for both the taking and the projecting camera. In 1888 he substituted film rolls for paper, which caused him a great deal of difficulty, for he succeeded in producing some strips of emulsionated films. The films were perforated only on the corners and were propelled by rollers. The mechanism of his apparatus Friese-Greene constructed, together with his friend Mortimer Evans, and they took out a patent on June 1, 1889, which subsequently became of great importance.

According to this patent the film was not in motion during the exposure, and only then resumed its motion. The motion was accomplished by a crank, moved by hand between the rollers, which also caused the instantaneous shutter to function. The cameras produced 300 pictures at about 10 per second.

The first scene was filmed in October, 1889, by Friese-Greene in Hyde Park Corner, and it was projected at the Photographic Convention in the Town Hall in Chester in 1890 (*Scientific American Supplement*, April 19, 1890, No. 746). In a later camera, constructed by the mechanic Lege, made for Greene at the end of 1889, the films were already perforated on both sides (Will Day, *Phot. Jour.*, 1926, p. 359).

Friese-Greene devoted himself also with great skill to the field of stereoscopic motion picture and color photography. We learn from the *British Journal of Photography* (1921, p. 281) that Friese-Greene possessed an extraordinary talent for inventions and a superior skill for mechanics, although he never rose above an elementary conception of chemistry and physics. Fortunate though he was in his inventions, he died in straightened circumstances, having expended all his means on an invention for printing without inks by electricity and on other inventions. A memorial tablet was erected to Rudge and Greene in 1927 at Bath.

Edison and Friese-Greene started a patent suit. Edison had founded the Motion Picture Trust of America in order to combat those parts of Greene's patents which interfered with his own. Friese-Greene succeeded in having Edison's claim for a patent rejected by the United States Supreme Court, which declared Friese-Greene's patent the master patent of the world in cinematography.

Notwithstanding this, Edison is considered the first to introduce the perforated motion picture film into practice.

EDISON'S KINETOGRAPH AND KINETOSCOPE (1891)

The many-sided inventor Thomas Alva Edison (1847-1931), conceived the idea in 1889 of taking serial photographs and had a camera for this purpose, which he called the "kinetograph," constructed by the Eastman Kodak Co. in Rochester in that year. Eastman also furnished the film. The apparatus for viewing the pictures Edison called the "kinetoscope."[5]

In July, 1891, the daily papers carried the news of this most ingenious invention made by Edison. Accompanied by an extended advertising campaign, Edison described his invention, claiming that he would present animated scenes through serial pictures and that he would also reproduce musical performances, speeches, and so forth through a combination with the phonograph.[6]

The kinetoscope was offered for sale in 1893. It was an apparatus for viewing pictures, with a continuous moving strip, 35 mm. (1⅜ inch), which in construction was not superior to the early stroboscope. But of the greatest importance was the use of perforated celluloid film strips for serial exposures, of which the measurements were later generally adopted. R. W. Paul constructed such kinetoscopes in England in 1894.

Edison's patent of 1891, which was not published until 1897, referred to a camera for taking the pictures and to a perforated strip of film. Edison later claimed the sole right for the use of perforated motion picture films. The patent suit, however, led in 1912 to a denial of Edison's claim.

In 1893 the Edison Company exhibited serial photographs through their viewing apparatus in many places. Edison was the first to introduce the very small picture sizes (still in use today) and made with an attached electric motor 46 exposures a second, also in half a minute about 1,400 small pictures on a perforated strip of film 49¼ feet long.

For the presentation a sort of peep box was used (kinetoscope), which had an eyepiece attached on top. After the money was deposited in a slot, a lamp lit up, and the motion mechanism presented the pictures in a life-like manner. The apparatus made its appearance in the spring of 1895 at a show called "Venice in Vienna" in the Prater, and in Berlin somewhat later.[7]

Edison's photographic studio was very simple and unattractive. An illustration in *Die Phantasiemachine*, by René Füllöp-Miller (c. 1931), shows the first of Edison's film studios, which at that time (the end of the 19th century) was called "the Black Maria." As a counterpart of this primitive studio of the early times, a picture of the modern thirty-story skyscraper, which houses the offices of the Paramount Pictures Corp. and the Paramount Theater, is shown by Füllöp-Miller.

The American Le Roy saw one of these kinetoscope exhibitions in December, 1893, which induced him to construct a projection apparatus. With such an apparatus, invented by him, and with Edison's kinetoscope films, which were then on sale, Le Roy exhibited on June 6, 1894, in the store of an optician named Riley, in New York, projected motion pictures to an audience consisting of theatrical agents. It is maintained by Americans that this was the first objective motion picture projection (E. Lehmann, "Zur Geschichte der Kinematographie," in *Kinotechnik*, 1931, XIII, 223-28).

Edison later projected his serial photographs with his own apparatus, but all these preliminary experiments and inventions were excelled by the cinematograph of the brothers A. and L. Lumière at Lyon; they must be considered the creators of modern cinematography. The Lumières also used from the start the word "cinématographe," although this term had been used by others for other apparatus.[8]

THE BROTHERS LUMIÈRE INVENT, IN 1895, THE MODERN CINEMATOGRAPH

The brothers Auguste and Louis Lumière, owners of a large dry-plate factory at Lyon, constructed and offered for sale under the name "cinématographe" their remarkably simple and efficient apparatus for taking and reproducing serial pictures, in which for the first time the perforated film strip was held and moved by a gripper (French pat., February 13, 1895; German pat., April 11, 1895).[9] The first apparatus was constructed by Carpentier in Paris. Lumière's "cinématographe" had an overwhelming success, and from this dates the modern advance of motion picture technique.

The first presentation of Lumière's cinematograph took place on December 28, 1895, on the ground floor of the Grand Hotel, Paris. A memorial tablet affixed to this house was dedicated on March 17, 1926, and reads: "Here on December 28, 1895, took place the first public projection of animated photography by the aid of the cinematograph apparatus invented by the brothers Lumière."

The enormous spread of the motion picture, with its far-reaching economic consequences, brings along with it France's claim that this invention was originated by Frenchmen. This was agitated by the "Chambre Syndicale des Directeurs de Cinema," the Municipality of Paris, and the Commission for Old-Paris. The detailed report is given in *Bull. Soc. franç. phot.* (August, 1921, ser. 3, VIII, 225-49). The discussion was reopened in October, 1925, as to whether the brothers Lumière or Marey was to be considered the real inventor of cinematography. This brought about a meeting of the Photographic Society of Paris, at which the members approved of the text inserted on the tablet, but the wish was expressed that a memorial tablet be also affixed to Marey's workshop at 11 Boulevard Delessert, Paris (*Bull. Soc. franç. phot.*, 1929, ser. 3, XVI, 33, 137). The society added that Marey deserved the fullest appreciation as inventor of chronophotography, but that cinematography was actually born on the day when long series of animated photographs were presented for the first time to a large audience. These conditions were fulfilled first, with great success, on December 28, 1895, by Messrs. A. and L. Lumière, with the aid of the apparatus invented and named by them "cinématographe."

The Lumières had started the manufacture of celluloid film for motion pictures in 1887 and had bought the celluloid from the Celluloid Company of New York. Later, Eastman began the manufacture of motion picture film at Rochester and developed such a large industry that his company today supplies the greatest part of the world consumption of motion picture film. He had also supplied Edison with films for his "kino" apparatus from the start. The largest European film factory was erected by the company for anilin manufacture (I. G. Farbenindustrie A. G.) in Berlin; this has been moved to Wolfen (Kr. Bitterfeld). The C. P. Goerz factory in Dresden, Zeiss-Ikon, must also be mentioned. Louis Lumière was elected a member of the French Academy of Sciences in 1920.

In 1896 Lumière-Casler brought out the "kinora," which produced a continuous serial picture when the prints, on paper, were moved

rapidly from the lower unbound edge of the pack; they soon stopped producing them.

The firm Lumière, at Lyon, shortly afterward put on the market their kino projection apparatus with a small number of positive films. They were equipped with gelatine silver bromide diapositives on celluloid strips about 4¼ feet long and 0.1375 inches thick.

The life work of the brothers Lumière is covered in an interesting survey in the *Bull. Soc. franç. phot.* (1921, p. 225). Their work in photochemistry and research, their accomplishments in the technical industry, in the field of color photography, in cinematography, and more, is described and substantiated by numerous citations giving the original sources.

Lumière's cinema apparatus was presented at London on December 28, 1895. In the German countries it was first introduced at Vienna on March 20, 1896. Then it appeared at Berlin, and soon it had spread all over the world. At the World Exposition at Paris, 1900, the brothers Lumière projected their motion pictures on large wall surfaces and proved their capability for mass production. These pictures, of which the author saw a presentation at that time, were perfect in every way. They also showed the first educational films for medical men and surgeons; in one of them they represented the amputation of a leg by a celebrated surgeon—in all its gruesome details.

The first presentation of the Lumière cinematograph at Vienna demonstrated the beginning of this new technique, which makes the following detailed description of historic interest.

At the beginning of 1896 Lumière sent a projection apparatus and camera to the author in Vienna, who demonstrated the astonishing results at the Graphische Lehr- und Versuchsanstalt before an invited audience, who were delighted with them. The cinema apparatus consisted of a small wooden box, in which the film roll was drawn intermittently in front of the lens of an electric projection apparatus by the aid of wheels, rolls, and by turning a handle, the film falling into a basket; the fire hazard was entirely neglected. The condenser of the electric light consisted of a glass ball (Bohemian glass) filled with water, in which hung a piece of charcoal to eliminate the disturbing air bubbles.

The films used at that time were at the most fifty feet long and the performance lasted about one minute. The whole program at these first presentations comprised no more than nine of these picture series,

namely, a gateway of the Lumière factory at Lyon, a carnival at Nice, the arrival of a railroad train and of a steamship, the beach of a seashore resort, children at play, and so forth.

Shortly after the appearance of the Lumière "cinématographe," Gaumont-Demeny, in Paris, Pathé, and others constructed similar apparatus.

Motion picture films were manufactured in France by Pathé-Cinéma at Vincennes (Seine) among other manufacturers; they later became the Kodak-Pathé Soc. Anon. Franç., Paris.

The establishment Gaumont introduced various types of cinematographs, such as small cinema apparatus and amateur cinematoscopes. Gaumont also showed, in November, 1902, after Decaut's specifications, a synchronized phono-cinematograph at Paris. In England R. W. Paul constructed the first commercial cinematograph in March, 1896, and presented it at the Alhambra, London.

At the turn of the nineteenth century many applied themselves to the improvement of motion picture apparatus. The first to show projected film pictures in Germany was Max Skladanowsky in 1895.[10] The American Jenkins, who had constructed a compensating camera with rotating lenses in 1894, provided in 1895 a gear single-tooth cogwheel, with a cross consisting of many parts, for moving the film. The multipartite Maltese cross appeared first in November, 1896, in a French patent of Bunzli and Continsouza. It was later introduced by Robert Paul in London ("theatrograph") and by Oskar Messter, in Berlin, who used before this a seven-part and a five-part cross, respectively. The American Casler, the inventor of the "mutoscope" (1894), a viewing apparatus with a picture cylinder, introduced in 1896 in his "biograph" the "cam change," which has meanwhile died out (F. Paul Liesegang).

About 1900, laws were passed (presumably first in England) for the management of motion picture theaters and for fire prevention, due to a horrible conflagration in a Paris theater which cost many human lives.

Later, priority claims sprang up for the invention of motion picture apparatus and their first presentation. We mention here the work of the Viennese photo-technician Theodor Reich.

According to the statement of Professor Karl Albert,[11] backed by letters and documents, Reich had already, in May, 1895 (a half year before Lumière), produced in London the first perfect films and had

projected them in private circles, but nothing had been published about them. He did not apply for an English patent until June, 1896, which was granted on June 3, 1896 (No. 1228) under the title "Improvements in apparatus for making or exhibiting zoetropic and similar pictures." Since the English Patent Office does not examine, when a patent application is received, whether the invention is novel or not, and since the publication of Reich's patent did not take place until after that of Lumière, the latter's priority can hardly be contested.

The history of the subject is exhaustively dealt with by G. M. Coissac in his *Histoire du cinématographe* (Paris, 1925).

TIME LAPSE AND SLOW MOTION PICTURES

For the history of time-lapse photographs it must be mentioned that the Austrian physicist Professor Ernst Mach, in Prague, was the first to express, in 1888, the thought (*Jahrbuch*, 1888, p. 286) that through the accelerated stroboscopic reproduction of very slow serial exposures, lasting for days or months, previously unknown laws of metamorphoses might be discovered; for instance, in the growth of plants,[12] in the development of an embryo, or in the laws of nature, and so forth. He also mentioned how instructive it would be if the course of the planets could be reduced as to space and time, ideas which were realized (Zeiss's Planetarium) only much later by those who had no knowledge of Mach's earlier work. Much later, not until 1896, Georges Gueroult attracted attention when he caused to be opened a letter deposited on June 11, 1889, with the Paris Academy of Sciences, which contained the same idea of time-lapse.

The "slow motion" represents the opposite procedure and is used for the analysis of motion. Several thousand motion pictures are taken in a second and then projected at the normal speed of sixteen per second.

The frequency is limited in the case of intermittent film changing with special claw construction. Up to 250 pictures a second have been attained. With higher frequencies it is necessary to use optical compensation for the movement of the image. A practical compensating arrangement using mirrors was invented by August Musger (1869-1929). Musger was born in Styria, was educated for the priesthood, and became also a professor of drawing and mathematics. He constructed mirror cinema-apparatus, received a German patent on it in 1905, exhibited his apparatus in 1907 before the University of Graz

(Styria), and thus became the founder of an entirely new construction of film apparatus. The exploitation of Musger's world patents was to be carried out by a company in Ulm (Germany), but they met with financial reverses, and the patents expired. Musger applied later for various new patents. Dr. H. Lehmann, a film technician in Dresden, took up Musger's patent, coined the name "Zeitlupe" (slow motion) for this apparatus, and the firm of Ernemann, in Dresden, marketed it. The rights to the invention Lehmann gave to Musger unreservedly. Musger was never financially successful, but worked with self-denial as teacher and inventor (a biography by Albrecht Graf von Meran is in *Filmtechnik*, 1929, p. 503).

<div align="center">SMALL FILMS</div>

The normal size of motion picture films was standardized by Edison as 35 millimeters (negative size 18×24 mm.). After many experiments the Eastman Kodak Company brought out, in 1923, small films of 16 mm. and Pathé (Paris) put out films of 9.5 mm. widths (H. Pander, *Filmtechnik*, 1931, No. 15).

Chapter LXXII. PHOTOGRAPHING PROJECTILES IN FLIGHT AND AIR EDDIES

THE FIRST ATTEMPTS to enlist photography in the service of military technique dates back to the middle of the last century. The tests were carried on especially at the arsenal at Woolwich, by Marey at Paris and by Ottomar Anschütz in Germany. For ballistic purposes it was sought to obtain pictures of the projectile in its flight. Sunlight and automatic instantaneous shutters with complicated arrangements were adopted for this purpose. The results were useful to some extent.

As early as 1866 a cannon ball in flight was photographed by the ordinary method of instantaneous photography at the Woolwich arsenal in England.

Perfect pictures, however, were attained only after 1884, when Professor E. Mach, in Prague, introduced the electric spark as the light source.

This ingenious method Ernst Mach[1] first worked out in 1884 and completed in his Physical Institute at Prague in the years 1885 to 1887. He caused the projectile shot from a pistol or a gun to cut through

wires enclosed in glass tubes; this released a strong electric spark which furnished the illumination for the compressed air wave ahead of the projectile, the whirl of the air behind it, and the cloudy appearance in the firing line (Geitel, Max, *Siegeslauf der Technik*, Stuttgart, 1910, III, 655). Especially important is Mach's original report in *Jahrbuch* (1888, p. 287).

Ernst Mach, physicist and philosopher (1838-1916), was professor of physics at the University of Graz (Styria), then in Prague, and from 1895 to 1901 professor of philosophy at the University of Vienna. In his work on physics he often referred to photography, and he worked out the first apparatus for the measurement of sensitivity by means of rotating sector wheels. He also devoted himself with re- markable success to the study of the flight of projectiles and the re- sulting air eddies by means of instantaneous photography.

On these experiments Professor Anton Lampa writes in the Vienna *Neue Freie Presse*, July 28, 1926:

Of Mach's physical experiments the best known are probably his studies of flying projectiles. They have recorded his name in the history of bal- listics, a science in which he had no fundamental interest. It was not his intention to serve ballistics as a military science, which enlisted his co- öperation, but the purely technical interest of the scientist whose atten- tion had been drawn accidentally to a phenomenon in the ballistic field. Mach himself relates that in 1881 he attended a lecture in Paris by the Belgian expert in ballistics, Melsen, who expressed the opinion that pro- jectiles at a high velocity push ahead of them a volume of compressed air; he believed that he thus could explain certain explosive effects of penetrating projectiles. Melsen's explications aroused in Mach the desire to investigate this conception by experiments, because the experimental method was in principle ready at hand.

It was brought to the highest perfection by Professor August Toepler, 1865, in his method of investigating air eddies, which can be traced back to Huygens. This is based on the natural phenomenon which we may ob- serve occasionally in bright sunshine out-of-doors, in the air eddies which are generated in the surrounding cooler air by the warm air rising from hot surfaces; it is a fact that air of different densities presents different properties of light refraction (see Mach's popular lecture on his experi- ments, given November 10, 1897, before the Vienna Society for the Dis- semination of Knowledge in the Natural Sciences under the title "Er- scheinungen an fliegenden Projektilen"; also the 4th ed. of Mach's popu- lar scientific lectures published in Leipzig, 1910).

The first experiment was made in 1884 with a target pistol. The missile

itself started the illuminating spark when it reached the middle of the field of vision of the photographic apparatus. The picture of the missile was obtained without difficulty; very delicate pictures of sound waves, generated by the illuminating spark, appeared on the dry plates, but the air compression which it was hoped to record did not show. Mach searched at once and in the right direction for the explanation of the failure. He determined the velocity of his missile and found it to be 240 mm. (787.4 feet) per second; therefore, considerably less than the velocity of the sound. He quickly recognized that under these circumstances no appreciable compression could take place, since it advances with the velocity of the sound (340 mm./sec.; 1,115 feet per second) and thus is in advance of the projectile and escapes.

He was so firmly convinced of the existence of air eddies (formed by air compression in advance of flying projectiles), at a velocity of the projectile greater than 1,115 feet per second, that he requested Professor Dr. Salcher, of the Naval Academy in Fiume (Austria), to carry out the experiment with a projectile of correspondingly high velocity. Salcher made such tests in the summer of 1886, exactly according to Mach's directions, and the expected result was at once obtained. The result coincided exactly in its form with the sketch which Mach had previously drawn. Further tests by Salcher with a cannon and Mach's own trial with a big gun supplied by Krupp furnished additional progress which, however, confirmed Mach's conviction that "really good results are only obtainable by the most careful execution of the tests in a laboratory suitably equipped for this purpose." He therefore continued his experiments in his laboratory (Physical Institute of the German University of Prague), which was possible, because the size of the projectile was of no consequence, since small ones show the same phenomena as large ones. He was assisted by his son Ludwig in this work, and the most successful experiments were later executed by Ludwig alone. The phenomena surrounding the projectile flying at a velocity in excess of that of sound resemble the phenomena in the water surrounding a ship proceeding at high speed.

Professor Lucien Bull, Marey's successor in Paris, applied Mach's principle of illumination by an electric spark in such a way that he succeeded in obtaining oscillating spark discharges (2,000 discharges per second) and thus exposures at the speed of 2,000 in one second. He photographed with this, among other subjects, the movement of the wings of insects.

Still higher velocities were reached by Professor C. Cranz, in Berlin (1909), with a ballistic cinematograph. As light source he used a high-frequency machine with alternating current. He improved the

process for ballistic military purposes in Germany. Some years later Cranz's method was introduced into the Austrian army.

In Mach's process only a single exposure of the projectile was possible. Professor C. Cranz, of Berlin, succeeded in 1909 in constructing a ballistic cinematograph (*Zeitschr. für das Gesamte Schiess- und Sprengstoffwesen*, 1909, IV, 17), which enabled him by an exposure which lasted one-tenth of a second, to take 500 photographs, which followed each other in a time interval of one five-thousandth of a second.

About 1909 Dr. Cranz began his work on the photographic method of measurement of the velocity of infantry projectiles and tested the use of a direct-current spark discharge interval for motion pictures of ballistic and physical phenomena, and so forth, which is reported in *Jahrbuch* (1910, pp. 159, 232; 1911, p. 533). Cranz was able to take a great number of pictures per second with his apparatus and produced photographs of projectiles in flight and of the effect of shots. These pictures were exhibited publicly at the International Photographic Exhibition in Dresden in 1909. He also made serial pictures of air eddies with the aid of electrical sparks. Later, Cranz became director of the Institute for Technical Physics at the Technical College, Berlin. He presented a survey of his sound and ballistic photographs at Dresden, 1931.

Paul Schrott also used cinematography of air eddies for further studies (*Kinotechnik*, 1930, p. 40).

In Austria, Major Franz Duda devoted himself to the construction of apparatus for serial photographs of cannon projectiles in flight in daylight, in order to determine the course of the flight. Owing to his scientific knowledge, he was attached to the technical administrative military committee, where he made his investigations. The author was fortunate to see splendid proofs of such serial photographs in 1913. The World War saw Duda an officer of heavy field artillery in Serbia and Galicia; he was recalled to Vienna during the war and worked on all the proving grounds with his measurement apparatus.

He had built three serial apparatus for the serial photography mentioned. The last one and the most perfect was no longer of any use in the new Austria, and Duda, who had to pay for the mechanical work out of his own pocket, was compelled to sell his apparatus abroad in order to pay the accumulated bills. We hear that his ideas have

been taken up in Germany, England, and America. Chronic throat trouble necessitated an operation from which he died in 1928.

Chapter LXXIII. ARTIFICIAL LIGHT IN PHOTOGRAPHY

THE PHYSICIST Seebeck observed in 1812 that Bengal fire emits strong actinic light and that it explodes detonating chlorine gas. The first photographic reproduction obtained on daguerreotype plates by the light of an ordinary oil lamp was probably made by the brothers Natterer, 1841.

"Oxyhydrogen calcium light," which is produced by heating a lime cylinder under an oxygen blast to white heat, which then gives a glaring white light, was known long before the time of the daguerreotype under the name "Drummond lime light." Thomas Drummond is called the inventor of calcium light in most literary sources (1826),[1] which, however, is erroneous. This question of priority was agitated during Drummond's lifetime, and it is due to Drummond's fairness that we are able to produce a written, authentic statement of the case. It was Sir Galsworthy Guerney (1793-1875) who discovered the calcium light, which was named after Drummond because he used it first in public, in 1826-27, for his trigonometric work in Ireland. Drummond himself admitted that he had no claim to the invention. The inventor, who demonstrated his light before the Earl of Sussex and the Earl of Kendal (later King Leopold of Belgium) was then honored with a medal (*Jahrbuch*, 1902).

The strong chemical action of the electric arc light on chlorine detonating gas was recognized by Brandes (*Annales de chimie et de physique*, Vol. XIX). It seems that Silliman and Goode were the first to use the arc light for daguerreotypes. In November, 1840, they photographed a medal by an electric arc light of 90 Daniell elements. Berres had also used it in 1840 for microphotography.

Fizeau and Foucault demonstrated, in 1844, that the chemical illuminating power of the Drummond calcium light was less than that of an electric arc light of forty galvanic elements. They compared the luminosity of calcium light, electric light, and sunlight, optically and photographically, on daguerreotype plates, and were the first to find that the chemical and optical luminosities of the light source were

not proportionate to each other (*Annal. de chim. et de phys.*, ser. 3, XI, 370). This was also determined later by Bunsen and Roscoe (1859) in their studies on the action of illuminating gas and carbon monoxide flames on chlorine detonating gas.

Drummond's calcium light and Talbotype paper were used by David Octavius Hill experimentally for his portraits in 1841. He used blue muslin to soften the harsh light and exposed for one-half minute (*Daguerrean Jour.*, 1851, I, 217). This experiment was, however, never repeated. Calcium light was later used only for enlarging and projection, and eventually it went out of use, being displaced by the electric arc light.

The electric carbon arc light could be produced at first only with galvanic batteries. In November, 1840, Silliman and Goode[2] used it in making daguerreotypes; they employed the electric arc from 90 Daniell elements. By this light they made with a single lens a daguerreotype of a medallion in twenty seconds. Similar experiments were made by De Monfort, 1846, also by Gaudin, 1853.

The practical application of an electric arc lamp for photographing people seems to have been inaugurated by Aubree, Millet, and Leborgne in 1851 (*Compt. rend.*, XXXIII, 501); they used fifty Bunsen galvanic elements. Lucenay devoted himself, in 1852, to this kind of portrait photography.

Gaudin and Delamarre patented, in France, in 1854, without regard to the priority claims of their predecessors, the use of electric arc lights and of Bengal light in portrait photography. They applied a novel illuminating device by bringing the light into the focus of a parabolic silver-plated copper mirror. The eyes of the sitter were protected from the glare of the illuminating source by inserting a small spherical mirror in front of the arc light, which reflected the light back into the parabolic mirror. In addition there was a blue glass inserted before the arc, and the studio skylight was covered with blue paper.

Nadar, in 1861 and 1862, photographed, with great difficulty the famous underground catacombs in Paris by the light of a galvanic arc light. The results aroused great excitement at that time.

At the December 21, 1863, session of the Paris Photographic Society, Nadar exhibited portraits taken by electric light. He exposed his wet collodion plates 60 to 85 seconds, using a white-painted reflector.

Adolf Ost, in Vienna, also used electric light in taking portraits and exhibited satisfactory pictures on May 17, 1864, at the Vienna

Photographic Society (*Phot. Korr.*, 1864, p. 11). He used two big batteries, one of which, with 80 Bunsen elements, furnished the principal light, while the smaller one, of 40 elements, served to illuminate the shadows. Blue-glass globes were employed to soften the glaring light.

In 1866 Saxon & Co., Manchester, used old-style electromagnetic generators of Wilde, London, for the carbon arc light in making enlargements (Talbotypes), and were proud when they produced twenty life-size photographs in one evening (*Phot. Archiv,* 1866, p. 385; and 1867, p. 338).

But not until the introduction of the dynamo was the general utilization of the electric arc light made possible. Van der Weyde[3] introduced "photography at night" (1876-78) and carried on a regular portrait studio by electric light at the Paris Exposition of 1878; then A. Liébert, in Paris, followed. He established, in 1879, a night studio, using electric light generated by a Gramme dynamo, and made photographs of full figures by the aid of large white reflectors.

Later, in 1903, Liébert perfected his technique by surrounding a a large arc lamp with a reflector shade, to which he added a circle of electric bulbs. This produced a softer and more harmonious illumination, while permitting short exposures. Electric lighting in photography found later extensive application in the reproduction processes, in printing negatives and enlarging them.[4] The details of these various processes for photography by artificial light are reported in the *Handbuch* (1892, Vol. I, Part 2 and 1912, Vol. I, Part 3).

Magnesium light began to compete with the electric light. Bunsen and Roscoe, at Heidelberg, pointed out, in 1859, the considerable chemical action of burning magnesium. Almost at the same time William Crookes, in London, made the same observation and immediately tried to employ magnesium light in photography. About 1864 magnesium was used in large measure in photography, because in the meantime it became available on the market in larger quantities.

Magnesium light was successfully used in photography by Brothers, at Manchester (1864). He photographed Faraday in the presence of the audience after a lecture at the Royal Institution. In Berlin (July, 1864) the first successful trials were made about the same time by H. W. Vogel in the presence of Carl Suck, Réméle, and Poggendorff. Vogel took a portrait of I. C. Poggendorff on wet collodion plates, exposing fifty-five seconds.

The Royal Astronomer of Scotland and director of the Edinburgh Observatory, C. Piazzi Smyth (1819-1900), made interesting photographs of the interior of the Great Pyramid (Egypt) with burning magnesium wire in 1865; Brothers also did this in mines in 1864 (*Phot. Archiv*, 1865, p. 330). As early as 1864 Sonstadt, in London, used magnesium light in the course of his portrait photography (*Phot. Archiv*, 1864, p. 209). The Magnesium Company, Boston, recommended in 1865 the use of smoke bags for catching the fumes emitted by the burning magnesium wire. The bags were kept from collapsing by crinoline hoops (*Phot. Arch.*, 1896, p. 340). Magnesium lamps equipped with wires on spools wound off by hand originated with W. Mather, of Salford, and F. W. Hart, of Kingland. Alonzo Grant, in America, was probably the first to use a clock movement to wind the wire (*Phot. Arch.*, 1865, p. 377). On the Perkins magnesium lamp see *Phot. Korr.* (1889, p. 229); this lamp furnished the basis for the Böhm lamp, which came later.

Nadar, who was the first to photograph the Paris catacombs with electric light, later used magnesium light, owing to its simplicity, in photographing subterranean canal construction. The amateur photographer Leth, of Vienna, photographed the sarcophagus of Empress Maria Theresa in the imperial burial vault about 1865, and Fr. von Reisinger, professor at the Polytechnikum in Lemberg (Galicia), in 1867 photographed reliefs on stone and sarcophagi in the Lemberg catacombs also by magnesium light.

The interior of the stalactite cave at Adelsberg (Austria) was photographed on wet collodion plates by Em. Mariot, of Graz (Styria), in 1868, by the light of a burning magnesium strip. These prints have become very rare; they are reproduced in the 1932 German edition of this *History* (p. 743).

The first directions for preparing rapidly burning fuse compounds with magnesium powder, which was later called flashlight powder, originated with Traill Taylor in 1865[5] (mixture of magnesuim powder and potassium chlorate, sulphur, and antimony sulphide). These experiments led, however, to no practical results in photographic portraiture and so forth, because of the slight sensitivity of the wet collodion process, then generally used, and on account of the high price of magnesium powder. Traill Taylor's experiments were therefore soon forgotten. Equally unsuccessful was the attempt of Larkin to burn magnesium powder in lamps (1866).

G. A. Kenyon, in 1883, followed with experiments employing mixtures of magnesium powder with pure potassium chlorate and observed the powerful photographic effect produced by burning magnesium wire in an atmosphere of oxygen. He also made portraits by such a light, and noticed at the time that mixtures of magnesium powder and potassium chlorate could be used to produce a brilliant light. The resultant smoke prevented him from further pursuit of this observation (*Brit. Jour. Phot.*, 1883, p. 61).

Photography with magnesium powders in the form of "flashlight," as it is called, was notably advanced by the work of J. Gaedicke and A. Miethe, at Berlin (1887),[6] and soon came into general use everywhere, because the explosive mixtures recommended by them for these magnesium powders (magnesium, potassium chlorate, antimony, sulphide, and later other mixtures) as a fact burn as fast as a flash and make instantaneous pictures of persons, groups, and so forth, possible on gelatine silver bromide plates.

The use of Gaedicke-Miethe's magnesium flashlight powder, which contained an explosive mixture of potassium chlorate and antimony sulphide, was discontinued later, owing to the danger of explosion. It was displaced by the so-called "harmless" flashlight mixtures of magnesium with manganese peroxide, strontium and thorium nitrate (Agfa flashlight), etc. This is reported in detail in *Handbuch* (1912, Vol. I, Part 3).

Bunsen and Roscoe, in Heidelberg, determined in 1859 the high actinism of magnesium light; Schrötter of Vienna recognized the richness of magnesium light in ultraviolet radiation. The spectra of magnesium light and of the various flashlight mixtures were given by Eder and Valenta, *Atlas typischer Spektren* (Vienna, 1928). A spectral comparison of Drummond's calcium light with sunlight by the author (*Denkschriften der Wiener Akad. d. Wissenschaft*, 1892) was published in Eder and Valenta's *Beiträge zur Photochemie und Spektralanalyse* (1904).

Photometric investigations on the chemical luminosity of burning magnesium, aluminum, and phosphorus were published by the author in the *Sitzungsberichte* of the Vienna Academy, 1903 (*Handbuch*, 1912, Vol. I, Part 3). He also determined the color temperature of the various light sources used in photography.

In the eighties of the last century the superior properties of pure magnesium powder, burned in a flame, became known, which furnished

ample illumination for instantaneous photographs on gelatine silver bromide plates. Shortly after the publicizing of Gaedicke-Miethe's flashlight powder, T. N. Armstrong pointed out that pure magnesium powder blown through a flame gives an intensive light (*Brit. Jour. Phot.*, 1887, p. 77). A large number of different magnesium flashlight lamps were manufactured after these directions, which are described, together with experiments with aluminum flashlight, in another volume of the *Handbuch*.

The flashlight candles for interior photography were anticipated by the slow-burning fireworks.[7] They were introduced into modern photographic practice by York Schwartz, of Hanover (1887), (*Apollo*, December, 1887). There were many varieties of magnesium flashlight (*Handbuch*, 1912, Vol. I, Part 3).

Photography by gas light was made practical only by the introduction of orthochromatic plates. The use of Auer's incandescent light advanced photography temporarily.

Incandescent gas light was invented by Carl Auer von Welsbach in 1885 and improved by the introduction of thorium. The use of ligroin gas with compressed air instead of illuminating gas for Auer's incandescent mantles in photographic enlarging and printing was invented by the mechanic Fabricius, in Vienna (1889).

Mercury light with an electric arc was known as early as the sixties (*Handbuch*, 1912, Vol. I, Part 3). The first practical mercury-vapor lamp was constructed by Leon Arons, of Berlin, in 1892.[8] These mercury lamps were perfected in 1901 by the American Cooper-Hewitt (1860-1921). By the use of special glass (ultraviolet previously) the "uviolglass-mercury lamp" of Schott (Jena) came into existence. This was followed by the mercury quartz lamp of Heraeus (Hanau), in 1903.

The mercury light and the improved arc light have recently been partially displaced by the modern gas-filled, metal-wire incandescent lamps, which, in combination with highly color-sensitive plates, have been increasingly used for photography of all kinds. The greatest development in the technique of artificial illumination in photography is found in the motion picture studios.

Chapter LXXIV. PRINTING-OUT PROCESSES WITH SILVER SALTS

THE PRINTING-OUT PROCESS with paper made light-sensitive with silver salts reaches back in its first beginnings to Hellot, 1737, Scheele, 1777, and Wedgwood and Davy, 1802. Talbot described silver chloride paper for photographic printing, which he prepared by first "salting" the paper with a common salt and sensitizing with a silver nitrate solution. He was the first to carry out, following Herschel's direction, the fixation of prints with sodium thiosulphate. Talbot also found that silver bromide paper was suitable for the printing-out process (1839), but silver chloride paper persisted, because it gave a stronger black color.

Talbot and Herschel therefore laid the foundation for our modern photographic printing-out process on silver chloride paper. To these two Englishmen belongs the merit of having made possible photographic printing on paper and of having found the best medium for fixing, namely, hypo.

Talbot also recognized the great importance of these photographic printing processes for those purposes which we call, in short, "photographic tracing." He not only produced in 1839 prints of drawings but also sent, on March 23, 1840, to the French Academy of Sciences facsimile photographic copies of old manuscripts and documents made in printing frames. Their accuracy and legibility met with the highest approval of the members of the Academie des Belles-Lettres.[1]

Daguerre recommended a method for the preparation of silver chloride paper. Biot reported this method, which Daguerre supposedly had known since 1826, to the French Academy of Sciences on February 18, 1839.[2] He saturated paper with "hydrochloric acid ether," then with silver nitrate. The prints were imperfectly fixed by washing in water. Daguerre's method was, however, not accepted in photographic practice.

Since the history of printing on silver paper is given in detail in *Handbuch* (1928, Vol. IV, Part 1), the author confines himself here to the most important points.

Taylor reported in 1840 that an improved paper for photographic printing could be obtained if paper salted with common salt was impregnated with ammonio-nitrate of silver;[3] Talbot described in 1844 a similar preparation.[4] In modern times (1903) Valenta used ammoniacal silver in the silver chloride collodion emulsion for celloidin

paper and found that this was especially suitable for celloidin-mat paper for platinum toning.[5]

To Blanquart-Evrard we are indebted for the coating of paper with substances which overcome the roughness and porosity of the paper surface and thus produce a greater fineness in silver prints. He devoted himself to Niepce's negative process, published in 1847, with albumen or starch coating on glass and found in 1850 that albumen and milk serum act favorably on negative paper development as well as on positive-printing-out paper. Blanquart-Evrard presented his method with albumen paper for positive prints to the French Academy of Sciences, May 27, 1850 (*Compt. rend.*, 1850, XXX, 663), and described the preparation of positive paper with albumen, which he salted with sodium chloride and sensitized with a concentrated silver solution (1 : 4).[6]

Thus the methods for preparing positive paper with albumen, starch, and gelatine were known in the early fifties; attention was also already directed to the addition of organic acids in the preparation of silver print paper. In 1856 T. F. Hardwich investigated more closely the behavior of silver citrate in the positive printing process (*Jour. Phot. Soc.*, London, 1857, III, 6; Kreutzer, *Jahresbericht f. Phot.*, 1856, p. 23). He prepared paper with a mixture of sodium citrate, ammonium chloride, and gelatine, and sensitized it in a bath of silver nitrate solution. Hardwich found that the silver citrate which formed in sensitizing with silver influenced the image favorably.

The use of starch paste added in the salting of the printing paper was introduced by De Brebisson (Horn's *Phot. Jour.*, 1854, II, 6 and 47). He coated paper with a boiled tapioca starch, to which he added chlorides.

All these photographic printing processes were later practically applied. At first the starch-filled silver chloride paper was preferred, then, in the sixties, first the single- and later the twice-albumenized paper. The gelatine papers, as well as those prepared with chloro-citrate, were then abandoned.

Adolf Ost, of Vienna, invented in 1869 the permanent silver print paper which was produced by addition of a great deal of citric acid to the silver bath.

After the silver print papers (especially albumen papers) which are sensitized in a bath had maintained their leadership for twenty-five to thirty years, they met with strong competition because of the intro-

duction of permanent emulsion print papers. The strongest impulse was given by the work (1864-65) of G. Wharton Simpson, who elaborated the collodio-chloride silver emulsion printing process, later called "celloidin process." Of great importance were the experiments (1867 and 1868) of J. B. Obernetter, of Munich, who was the first to manufacture collodion paper on a large scale. Adolf Ost introduced a collodio-chloride paper which permitted the picture image to be transferred to other supports.

The Bavarian photochemist J. B. Obernetter (1840-87), who applied his inventive genius to numerous branches of photographic reproduction technique,[7] was not only the first to manufacture collodio-chloride papers on a commercial scale but also the first to use it in printing large editions for the illustration of German photographic technical journals. He called attention to the sharpness of definition in the prints and proved that collodio-chloride prints surpassed albumen prints in permanency. Nevertheless, professional photographers used albumen prints until about 1890 for all kinds of portrait and landscape subjects and accepted the yellowing of the prints as a necessary evil.

The widespread popularity of amateur photography following the introduction of gelatine silver bromide dry plates urged the necessity for permanent and easily workable printing papers. About 1890 gelatino-chloride silver emulsion papers ("aristo" papers) and collodion silver chloride papers ("celloidin" papers) captured the market to such an extent that the consumption of these papers soon surpassed that of the earlier albumen and starch papers. It was Abney who brought about the manufacture of modern gelatine chloro-citrate printing papers, in 1882.[8] Emil Obernetter, of Munich, son of J. B. Obernetter, manufactured gelatino-chloride paper on a large scale from 1884 and thereby laid the foundation for the later commercial production of these papers in England and France. Later, many factories for the manufacture of these papers came into existence.[9]

The first large celloidin paper (with baryta coating) factory in Germany was probably that built by Kurtz in Wernigerode (1890).

The emulsions cited (celloidin, zelloidin, and aristo) contained, in addition to the colloid, silver chloride, silver nitrate, silver citrate or tartrate, also free citric or tartaric acid.

The composition of these celloidin papers was varied to meet special requirements. Professor Ferdinand Hrdlička, of the Graphische Lehr- und Versuchsanstalt, Vienna, manufactured patented special print

papers for weak negatives, obtaining a reduction of the gradation by adding chromate to the silver chloride celloidin. E. Valenta[10] investigated the effect of various admixtures on the gradation of print papers and introduced for this purpose (1895) uranyl- and copper salts. He softened too strongly contrasting emulsions by adding a silver phosphate emulsion.[11] At the same time Valenta investigated the developing processes for prints on silver phosphate papers,[12] after having described, in 1893, the development of collodio- and gelatino-chloride silver emulsion papers with acid developers.[13]

Another progressive step was the introduction of vegetable albumen free from sulphur in the production of "protalbin paper" (with vegetable albumen bodies soluble in alcohol), by Dr. Leon Lilienfeld, in Vienna (German patent, April 21, 1897), which increased the permanency of the prints. Lilienfeld, however, discontinued the manufacture of this paper later, when he made the important invention of ethyl cellulose as a motion picture film base and for artificial silk, and when he became connected with the Eastman Kodak Co.

"Casoidin paper" (casein emulsion), made from casein preparations, was invented by Dr. Otto Buss (1871-1906) in Switzerland in 1903. These emulsions were supplied in glossy and mat varieties, but did not meet with favor (Handbuch, 1928, IV (1), 193).

Positive prints on silver chloride papers usually show an unpleasant brick-red tone. The beautifying (making them "look pretty") and deepening of the color tones (toning) was done with sulphur, which with the silver formed dark silver sulphide.

In the forties this sulphur toning of paper positives, the result of sulphide of silver in the hypo bath, formed by the liberation of sulphur, owing to the decomposition of the hypo, was the only method known. Old fixing baths gradually toned the prints brown.

Toning positive silver prints with gold salts was introduced between 1847 and 1850. The method of toning silver chloride prints with *sel d'or* (sodium-auro-thiosulphate), the use of which for toning daguerreotypes was suggested by Fizeau (1841) is supposed to have first been introduced by P. E. Mathieu, who published his method in a pamphlet entitled *Auto-photographie* in 1847.[14]

Le Gray also recommended, in his booklet *Traité pratique de photographie* (Paris, 1850), toning positive silver chloride prints with a solution of gold chloride in hypo. Humbert de Molard was the first to describe, in 1851, separate gold baths (solution of chloride of gold and

chalk); he first immersed the print in the gold bath and after that used hypo (*Handbuch*, 1928, Vol. IV, Part 1). Waterhouse, of Halifax, used in 1858 a gold chloride bath which had been made mildly alkaline by adding sodium carbonate or sodium bicarbonate. In January, 1859, Maxwell Lyte reported to the French Photographic Society the method of toning with gold chloride and sodium phosphate. The chemist John Spiller (1833-1921), one of the directors of an English chemical color factory, was the first to indicate the possibility of admixing gold chloride with silver chloride collodion emulsions for printing-out papers, which was the start of the much later commercial manufacture of self- toning printing papers. For a biography and portraits of Spiller see *Phot. Jour.* (1922, p. 23) and *Brit. Jour. Phot.* (1921, p. 673).

The first mention of the addition of gold salts to aristo paper was made by the English scientists Ashman and Offord, who published in the *Phot. News* of July 24, 1885, the admixture of gold combinations to a gelatino-chloride emulsion, which accelerated the toning process considerably. As a matter of fact, they did not recognize that a subsequent toning process became thus superfluous. This seems to have been first published by D. Bachrach three years later (*Brit. Jour. Phot.*, 1906, p. 319; 1908, p. 781).

In 1898 self-toning papers were manufactured in America with gold chloride and ammonia (fulminating gold). In Germany, Oskar Raethe introduced the admixture of the double salt, gold chloride-barium chloride (1898), which was later adopted by Kraft and Steudel in Dresden for their "cellofix" paper (*Phot. Ind.*, 1925, p. 232). For details see Wentzel (*Handbuch*, 1928, Vol. IV, Part 1).

E. de Valicourt[15] recommended, in 1851, the addition of lead salts to the fixing baths, which also played a part later in the mixed toning fixing baths for celloidin and aristo papers; he observed that hypo mixed with lead acetate caused the formation of violet tones in silver chloride prints, which Henderson[16] confirmed in 1862.

The way chemical processes combined in fixing and toning silver prints with gold and hypo was shown in the intensive investigations of Alphonse Davanne[17] and Jules Girard in their *Recherches théoriques et pratiques sur la formation des épreuves photographiques positives* (Paris, 1864).

Meynier introduced cyanogen sulphide, especially of potassium thiocyanate and ammonium thiocyanate, into toning and fixing baths

in 1863 (*Handbuch*, 1928, Vol. IV, Part 1). Thiocyanates have proved their value in photographic practice, especially for gold toning baths in modern emulsion print-out papers, not only in the separate toning and fixing process but also sometimes as an addition to the combined gold toning-fixing baths, in which hypo acts as the principal factor in the fixation process.

Acid thiocarbamide gold toning baths were introduced by Hélain[18] and Valenta.[19] Other improvements of the toning process belong to recent times and need not be mentioned here. By introducing toning-fixing cartridges and ready-mixed "toning baths" the manipulation has been extremely simplified (*Handbuch*, 1928, Vol. IV, Part 1).

Chapter LXXV. MORDANT-DYE IMAGES ON A SILVER BASE; UVACHROMY AND ALLIED PROCESSES

THE BASIC IDEA in all processes of producing photographic mordant-dye images is the conversion of the silver image into another substance, which is capable of acting as a mordant on solutions of dyes. This action deposits organic dyes on the image and colors the particles of the silver image more or less strongly, about in proportion to the quantity of the silver precipitate, and this creates half tone color pictures. Silver bromide layers also develop and fix, but printed-out silver chloride layers are used mostly.

The history of the mordant-dye process reaches far back into the last century. The American Carey Lea was probably the first to try, in 1865, to color a silver image with an organic dye in the sense of the mordant-dye process, when he dyed a collodion negative, which had been bleached with mercuric chloride with murexide, which is a purple red dye prepared from uric acid (*Phot. Archiv*, 1865, p. 184). This experiment was forgotten until thirty years later, when Georges Richard (1896) published the general application of dyeing silver images, which hold suitable mordant media, to the production of vari-colored pictures (*Compt. rend.*, 1896, p. 609; *Jahrbuch*, 1915-20). This information also led to no practical use, and only in the twentieth century were practical methods found and perfected for producing mordant-dye photographs, used especially in connection with three-color pictures.

The first use of mordant-dye pictures, which were colored directly on silver iodide and used for three-color photography (diapositive on glass), originated with Dr. Arthur Traube, in Berlin. He called his process "diachromy" and took out a patent on it in 1906; the patent application is accompanied in a practical manner by splendidly executed proofs. Traube converted fixed gelatine silver bromide images on glass into yellowish silver iodide by means of an iodine-potassium-iodide solution. He treated them with solutions of basic dyes, which all combine well directly with silver iodide, or with the acid dyes, eosin or triphenylmethane dyes. After the dye was washed out from the gelatine, the silver iodide was dissolved out with a hypo solution which contained tannin. Colored images remain, and red, blue, and yellow pictures of this sort can be combined in three-color diapositives (*Jahrbuch*, 1907, p. 103; 1912, p. 362; 1915-20, p. 171; *Phot. Korr.*, 1920, p. 103). These particular processes met with no lasting success, because other silver combinations are more suitable for this purpose than is silver iodide.

The Italian photochemist Namias pointed out in his speech before the Congress of Applied Chemistry in 1909 that a silver image which is changed by the Eder-Tóth lead intensification to lead ferrocyanide and silver ferrocyanide absorbs many dyes very satisfactorily from their aqueous solutions; for instance, chrysoidine, rhodamine, methylene blue, victoria green (*Brit. Jour. Phot., Col. suppl.*, 1909, p. 68; *Jahrbuch*, 1910, p. 525; 1915-20, p. 172).

Namias also tried toning with copper (1909), but, as he states himself, with little success; he had not yet recognized the advantage of copper ferrocyanide for the mordant-dye process. The following articles by Namias refer to the history of the invention of mordant-dye pictures: "The Fixation of Coaltar Dyestuffs on Metal Compounds by Which the Silver Image Is Substituted" (*International Congress for Applied Chemistry*, London, 1909); "The Fixation of Colors on Copper-Ferrocyanide Images and Its Application to Trichromy" (*International Congress of Photography*, Rome, 1911). Here was mentioned the production of red diapositives by fixation of fuchsin red on copper ferrocyanide. Biography of Namias and further details are given in Chapter XCVI.

It is to Dr. Traube's credit that he recognized the great advantage of copper ferrocyanide as mordant for dyes. Somewhat later Crabtree and Frederick E. Ives made similar observations. Traube based on this

an excellent process for producing three-color diapositives true to nature. He found in 1916 that the well-known copper toning bath (potassium ferricyanide, copper sulphate, and potassium citrate, tartrate, or oxalate) which deposits on metallic silver images a reddish brown precipitate of copper ferrocyanide (with silver ferrocyanide) is especially suitable for the production of mordant-dye images. Traube founded the Uvachrome Company at Munich and a branch at Vienna for the exploitation of his process, on which he had several patents. Beautiful specimens of the uvachrome process were exhibited before the Vienna Photographic Society on November 9, 1920 (*Phot. Korr.*, 1920, p. 301). The name "uvachrome" is derived from the Latinized name of the inventor, *uva* meaning *Traube* (grape).

The manipulation begins with the printing of the delicate diapositives on silver bromide celluloid films from three-color negatives, previously made on panchromatic dry plates behind orange, green, and violet-blue color filters.

After development the diapositives are fixed, washed, dried, and then immersed in the uvachrome bath, which consists of copper sulphate, ferricyanide of potassium, and tri-basic potassium citrate.

Transparencies and projection diapositives (lantern slides) produced by the uvachrome process are extremely brilliant in color and more transparent than autochromes, therefore very suitable for the reproduction of subjects dealing with art, the natural sciences, and technical advertising.

Traube patented[1] his processes in England and America,[2] as well as in Austria (patent No. 87,807). Priority for the English claim is dated as of February 1, 1916, and for the other claims, December 3, 1918. He had French patents and also others. In Germany his first patent was contested on the ground of a previous publication of Namias. The patent process before the German Patent Office resulted in the annulment of the general claim for the use of copper baths in the production of mordant-dye images.

The subject of a supplementary patent was the production of highly transparent pictures. It was granted a German patent under the number 403,428 ("Verfahren zur Herstellung von Farbstoffbildern aus Kupferbildern").

Not only copper ferrocyanide but also cupric thiocyanate may be used for the mordant-dye process. F. J. Christensen transformed the silver image into cuprous thiocyanate, for instance, bleaching the silver

image in a bath of copper sulphate-potassium thiocyanate, potassium citrate, and some acetic acid (German patent No. 319,459, September 7, 1918; English patent No. 132,846, 1918; *Phot. Korr.*, 1919, p. 274) and dyed them with acid rhodamine, fast green, and so forth. This was followed by many other varieties of mordant-dye images, which are described in *Handbuch* (1926, IV (2), 412).

These processes were used profitably not only in three-color photography (as represented by the uvachrome method) but also for toning diapositives and especially motion picture films.

Chapter LXXVI. PRINTING METHODS WITH IRON SALTS; PHOTOGRAPHIC TRACING METHOD (BLUE PRINTS, ETC.); PLATINOTYPE

THE SENSITIVITY TO LIGHT of certain iron salts (iron oxide salts), especially iron chloride when mixed with organic substances, was known long ago, as we have already mentioned in Chapter VIII. Doebereiner (1831) was the pioneer in this field, since he discovered the light-sensitivity of ferric oxalate (see Chapter XVII).

Organic ferri-salts (especially citric iron oxide and potassium ferri-cyanide), which were later so generally used in photographic printing processes, were first successfully tried by Sir John Herschel in 1842,[1] and were described in detail by him; the printing processes founded upon these salts, especially the cyanotype or blueprint process were very important for the photographic tracing method.

Herschel observed and described the light-sensitivity of papers coated with ferri-citrate and tartrate; he used in particular the brown ammonium ferri-citrate, and he determined its photochemical reduction to the ferro-salt. He showed that the unexposed ferric salts do not turn blue with potassium ferricyanide, but turn blue when the ferri-salt is exposed. For the principle of the photographic tracing method of cyanotype see *Handbuch*, 1929, Vol. IV, Part 4. Potassium ferro-cyanide gives by this method positive photographic tracings (Herschel), a method which was used by Pellet in his gum arabic iron photographic tracing method in 1877 (see *Handbuch*, 1929, Vol. IV, Part 4). The great capacity for reaction of iron salt prints was recognized by Herschel, who determined that the ferrous salt formed by

light liberates metallic precipitates from solutions of precious metal salts (silver, gold). With this he laid the foundation for the so-called "argentotype" process of 1842, which in 1889 came up again with small changes in England as "kallitype" process and was used later also for the "sepia paper" (sepia iron tracing paper) introduced by Arndt and Troost (1895) in practical form. The time for printing argentotypes, as well as for photographic tracing, was greatly reduced in modern times by the substitution of green ammonium ferri-citrate for the brown salt by E. Valenta, 1897.[2]

The different reactive capacities of ferric and ferrous salts toward tannin, gallic acid, and so forth, led to the production of the so-called "ink pictures" by ferrogallic printing processes, the beginning of which can be traced back to Poitevin's publication in the *Bull. Soc. franç. phot.* (May 20, 1859). It led, about 1880, to the large-scale production of ferrogallic prints with black lines on a white ground (*Handbuch*, 1929, Vol. IV, Part 4).

The fact, discovered by Garnier-Salmon, that ferricitrate changes its hygroscopic properties in light (1858) met with little application, although it was hoped to carry out powder processes and photographic pigment processes with it. The effect was worse than by the powdering process based on the light-sensitivity of the chromate sugar layers.

The above-mentioned idea of Herschel, however, to precipitate precious metals by exposing ferric salts on those parts of the image where ferrosalts form achieved great importance in artistic photography when platinum salts were introduced into this process. Platinotypes are based on the use of a mixture of ferric oxalate with platinum salts, preferably with potassium platinous chloride.

Platinotypes were invented by William Willis in England and patented June 5, 1873 (No. 2,011), as a new "photographic printing process." He described his process as the coating of paper, wood, etc., with a mixture of ferric oxalate or tartrate with platinum, iridium,[3] or gold salts, which, after exposure under a negative, was immersed in a solution of potassium oxalate or ammonium oxalate, in which the picture was developed. The platinum salt he used was potassium platinous chloride, or potassium platinum chloride, or platinum bromide. Willis took out patents for improvement, July 12, 1878 (No. 2,800), for the addition of lead salts to the iron platinum mixture; the exposed paper was developed in a mixture of potassium oxalate with potassium platinous chloride. In his later patent of March 15, 1880

(No. 1,117), Willis omitted all these additions of lead salts, etc., to the sensitive layer; he increased the content of platinum salt in the sensitive iron platinum mixture, and avoided thus the admixture of this salt in the developer. For other changes and improvements in platinum prints see *Handbuch*, 1929, Vol. IV, Part 4.

William Willis (1841-1923) was the elder son of the well-known engraver of landscapes William Willis. After finishing his schooling he worked in practical engineering at Tangyes, Birmingham, which proved valuable to Willis in later years, enabling him to solve the mechanical problems which arose when platinotypes were introduced commercially. A new avenue opened to him when he entered the then Birmingham and Midland Bank, where he rapidly advanced. He was so well liked by the staff that when he left the bank they presented him with a memorial and with a collection of works on chemistry. He joined his father, who had invented the anilin printing process for the reproduction of technical designs and drawings (Brit. pat., No. 2,800, Nov. 11, 1864). (*Handbuch*, 1926, IV(2), 454).

Willis recognized that silver images were not permanent. He therefore decided to find a more stable metal, and chose platinum. Then followed the wearing task of overcoming the many opposing difficulties. He made innumerable experiments before he was able to announce the process commercially. Finally, however, he earned his well-deserved success with his platinotype printing. His first patent, granted in 1873, carried the curious title: "Perfection in the Photomechanical Process." The mat surface, the neutral black tone, the extraordinary permanence of the image, consisting of precious metal, brought many supporters to this process; further improvements, such as the sepia platinum prints and cold development, were patented in 1878 and 1880. The Platinotype Co., founded by Willis, manufactured platinum papers for the trade and was most successful in maintaining their uniform quality. In later years, when the high price of platinum caused difficulties, Willis worked out two similar processes, satista paper, a silver-platinum paper, and palladiotype paper, of which the substance of the image consisted of palladium.

Willis received the Progress Medal of the London Photographic Society in 1881, and in 1885 the gold medal of the International Inventions Exhibition. It was established that Willis was the first to produce photographic prints in metallic platinum, and the first to employ platinum salts in combination with light-sensitive ferric salts and to use

neutral potassium oxalate for developing these papers. He manufactured not only mat black but also sepia platinum papers. One of his chief assistants in the factory was Berkeley, who, among other things, first proposed the use of sodium sulphite in developer solutions (*Phot. Jour.*, June, 1923).

During the late seventies, under the guidance of the inventor, beautiful photographs were produced in London by the platinotype printing method, but a reliable process for the individual preparation of the sensitive platinum paper was not then known. Only through a dissertation by the Austrian army officers G. Pizzighelli and Arthur, Baron v. Hübl, which had been awarded a prize by the Vienna Photographic Society and was published in 1882 (*Die Platinotypie*, 2d ed., 1883), was the process made generally available.

Captain Pizzighelli was at that time chief of the photographic department of the army technical administration, and Captain von Hübl, later field marshal and head of the Military Geographical Institute at Vienna until the end of the World War, attended scientific lectures at the Vienna Technical College. In their joint experiments they closely followed Willis's principle to prepare the platinum paper with ferric oxalate and potassium platinous chloride and develop it in a potassium oxalate solution. They had at that time no success with the use of double salts of the ferric oxalate. In 1887, however, Pizzighelli found the conditions under which ferric oxalate double salts were serviceable in the preparation of platinum paper and observed that a black platinum image is obtainable[4] by the addition of sodium oxalate to the preparatory solution, whereby the reducing strength of the ferrous oxalate, which had been formed by light, is increased to such a degree that no further development is required. Captain Pizzighelli had meanwhile been transferred to Bosnia, where he made the first experiments with the "direct platinum printing-out process" without developing and whence he sent the first successful "direct platinum prints" to the author in 1887. Further improvements in platinum printing were the result of investigations of A. Lainer,[5] Hübl,[6] and others.

The first platinum papers were offered for sale (1880) by the Platinotype Co., London. At first they were "hot developer papers"; they were followed in 1892 by "cold developer papers." Later on, platinum paper was also manufactured in Austria (Dr. Just, 1883) and in Germany (Hesekiel, Jakobi, and others). In these commercial platinum papers the strength and texture of the paper (smooth, more

or less rough, thick water-color paper, pyramid-grain paper, etc.) were given consideration and thus they met the demands of artistic photography, especially for large pictures. It was soon noticed that although the platinum papers were, to be sure, very beautiful, they were cold and grayish black, so that ways and means were sought to vary the color of platinum prints (partly by certain admixtures to the preparation of the sensitive coating, partly by toning processes) into brown or other shades (*Handbuch*, 1929, Vol. IV, Part 4).

Platinum printing was employed before the World War chiefly for the production of the highest class of portraiture and documentary photographs, owing to its exquisite quality and permanency. The author made photographs of contemporary portraits and historic paintings for the government library by the platinum process. One of these subjects was the statue of Paracelsus on the house at Salzburg in which he resided.

Owing to the World War and the increased cost of platinum, platinotype papers disappeared almost entirely from the professional photographic field and were replaced by mat silver bromide and "gaslight" papers.

Giuseppe Pizzighelli (1849-1912), son of an Austrian military surgeon, was educated at a military academy and came to Krems, near Vienna, as lieutenant, in 1869, where he devoted himself to photography and often worked with one of his colleagues, V. Tóth. He was appointed captain and director of the photographic branch of the military technical administration in Vienna (1878). Here, in 1880, he published an article on "fotantracografia," invented in 1879 by Alexander Sobbachi, in a book entitled *Anthrakotypie und Zyanotypie*. In 1881 he worked jointly with the author on gelatine silver chloride emulsions with chemical development, and in 1882 he wrote, with A. von Hübl, *Platinotypie*. In 1884 he was transferred to Bosnia as the chief engineer, where he remained until 1893. This is where he worked out his direct printing-out platinum paper. He was then transferred to Graz (Styria) as major, later to Przemysl (Galicia), and he retired as a colonel in 1895. He moved with his family to Florence, where he built a villa in the Via Militare, continued his photographic studies, and became president of the "Societa Fotographica Italiana." He was also an honorary member of the Vienna Photographic Society and received many prizes. He died in Florence. We mention only his independent photographic works: *Handbuch der Photographie für*

Amateure und Touristen (Halle, 1891); in 1887 appeared his *Anleitung zur Photographie für Anfänger* which was read widely; he also wrote various books in Italian and articles for the *Bulletino della Societa Fotografica Italiana*, which he edited. A biography and portrait may be found in *Phot. Korr.* (1912, p. 199).

Baron Arthur von Hübl was born in 1852, a descendant of an Austrian officer's family. He received his education at the military academy and became an officer of artillery. He was sent to the technical college at Vienna for further study of chemistry, and there he attended the lectures on photochemistry by this author. In the laboratory for technical chemistry he worked out a method of fat analysis with iodine (Hübl's iodine number), and then joined Pizzighelli in the study of platinotype.

Hübl entered the technical branch of the Military Geographic Institute in Vienna and modernized its photographic management, at the same time devoting himself almost entirely to photogrammetry. He wrote numerous works on photographic procedure, for instance, silver bromide collodion (1894); the development of gelatine silver bromide plates after dubious exposure (1889); silver prints (1896); three-color photography with special regard to three-color printing and photographic pigment pictures in natural colors (1897), all of which were issued in several editions. He also wrote *Die Reproduktionsphotographie im k.und k.Militärgeographischen Institute* (1889); *Die photographischen Reproduktionsverfahren* (1898), and numerous scientific articles, which are reviewed in the *Jahrbücher*. He introduced and advanced the stereoscopic measurement process invented in Germany at the Military Geographic Institute. As colonel, he equipped the new building of the institute. During the World War, Hübl, who had now been advanced to the rank of a Lieut. Field Marshal, directed the enormous distribution of maps for the army and managed the technical section splendidly.

He also published works on sensitometry and the combination of neutral tint wedges with color light filters (*Handbuch*, 1930, Vol. III, Part 4).

After the collapse of the monarchy the temporary wave of communism in Vienna also attacked the Geographic Institute. The destruction of the army destroyed respect for the authorities and also for the authority of the last commander of the institute, Lieutenant Field Marshal Kaiser. The workmen elected soldier's councils, who demand-

ed and forced the resignation of the chief. They joined the dangerous communistic regime which had formed and which used the presses of the institute for printing its placards. The authorities later regained control, and the communistic element was eliminated. But the new Republican government took no interest in the institute, and the Ministry of War recommended that it should be liquidated and completely dismantled. A conference was held at the War Department, to which were invited army officers, professors of geography and cartography, reproduction technicians, and others. The majority of those present supported this author in his recommendation for the continuation of the institute and its transfer to the Ministry of Public Works. This proposal was accepted, and the institute became the now greatly reduced Cartographic Institute of the Republic; its pioneer work and numerous contributions to science and the arts being thus ended.[7]

Notwithstanding the post-war troubles, foreign countries watched these proceedings, and in 1920, when the confusion was at its height, the ambassador from Brazil to Vienna engaged Hübl and a selected group of assistants, in behalf of his government, for the purpose of making a survey and topographical maps of his country. The company departed in September, 1920, for Rio de Janeiro, but met with great difficulties in their work. After four years Hübl returned, suffering from troubles brought on by the climate. In his later work he was able to employ what was left of his research laboratory at the Cartographic Institute, but he retired in 1930, broken in health. The surplus inventory of the old laboratory was transferred to the collection of the Graphische Lehr- und Versuchsanstalt.

Among other honors, the degree of honorary doctor was given to Hübl by the technical college in Vienna. He was also an honorary member of the Vienna Photographic Society, where he had been a member of the board of management for many years.

Chapter LXXVII. FOTOL PRINTING (1905) AND PRINTING PHOTOGRAPHIC TRACINGS [BLUE-PRINTS, BROWN PRINTS, AND OTHERS] ON LITHO-GRAPHIC PRESSES (1909)

"FOTOL" PRINTING, or "cyanotype gelatine" printing, belongs to the group of photographic tracings and is based on squeegeeing ordinary, unwashed cyanotypes (blueprints) on moist gelatine layers; this makes it possible to obtain with greasy printer's ink several impressions of the tracings, in which the original negative blueprints appear as positive prints in black lines on a white ground.

This process was invented in 1905 by Adolf Tellkampf and Arthur Traube. Tellkampf continued to apply himself successfully to improvements of these photographic-tracing methods (*Handbuch*, 1929, Vol. IV, Part 4). He was not a chemist by training, but nevertheless developed his photographic processes with a practical understanding of the scientific problems.

His co-worker in working out fotol printing was the photochemist Dr. Arthur Traube, the well-known joint inventor of the first panchromatic sensitizer, ethyl red, and inventor of the uvachrome process. The German patent for fotol printing granted to Tellkampf and Traube bears the date of August 10, 1905 (No. 201,968). The inventors coined the name "fotol printing."

L. P. Clerc, in his book *La Technique photographique* (1927, II, 564) credits the brothers F. and J. Dorel (1905) with the invention, but we cannot recognize this claim for priority, because no documentary evidence is presented.

R. J. Hall, of London, called fotol printing "ordoverax" (1907), but it is the same process. To this class belongs also "fulgur" printing of Peukert, at Munich (*Jahrbuch*, 1911, p. 538). Henri Brengou curved the gelatinized zinc plate around a press cylinder in order to attain greater speed in printing (French patent, January 17, 1913, No. 265,760; *Jahrbuch* 1914, p. 399, with illustration of cylinder press).

On August 20, 1921, L. Daniel and R. Dumont received a French patent (No. 539,639) for a gelatine mass, which gave a closer and more intimate contact with the cyanotype. Nothing essentially new is contributed to the patent of Tellkampf or the publications of Fishenden and August Albert on the subject.

Fotol printing is a valuable method for the production of small editions of positive tracings with printing ink; but for the production of larger editions it has been displaced by another invention by Tellkampf, for printing from tracings with chromated gum. Tellkampf invented, in 1909, the making of photographic tracings on chromated rubber in connection with an acid developer containing glycerine; in this process those parts of an image on a zinc plate which were washed out by this development take the rolled-on printer's ink and can be used like flat zinc plates, from which can be printed much larger editions on a lithographic press than it is possible to print with the fotol process.

These tracings printed by lithography (the method of printing from flat zinc plates without photography) have become the common property of all larger establishments for printing photographic tracings. They often employ the second Tellkampf process in the analogous form of the "Douglasgraph-process";[1] details of this process are reported in *Handbuch* (1929, IV(4), 220).

Chapter LXXVIII. PHOTOGRAPHIC PRINTING METHODS WITH LIGHT-SENSITIVE DIAZO COMPOUNDS: DIAZOTYPY, PRIMULINE PROCESS, OZALID PAPER

DIAZO COMPOUNDS are organic compounds which contain two nitrogen atoms in a particular combination. They form a large class of substances of special scientific and technical importance. These compounds, which are also capable of forming numerous dyes, were discovered by the chemist P. Griess in 1860. Diazo compounds usually decompose very easily (on heating and sometimes when exposed to light, whereby the nitrogen is displaced). They very readily react with certain other organic compounds (amines, phenols, etc.) to form fast dyes.

The light-sensitivity of diazo compounds can be employed in the production of photographic prints which are called "diazotypes" on paper and cloth of all kinds. A photographic process of this kind was invented by Dr. Adolf Feer (German patent, December 5, 1889). His diazotype paper, after five minutes' exposure in sunlight, formed

an insoluble dye on the exposed parts; the prints were fixed by washing in water. This process met with no practical application.

Of greater importance were the primuline processes, which were patented in Germany by Cross and Bevan, September 2, 1890. According to the choice of reactive organic substances, the inventors obtained red or orange colored and brownish-black prints (positive images from positive copies). The primuline process was the precursor of later printing processes. There followed Andresen (1894), Schön (1899), and Homolka (*Handbuch*, 1926, Vol. IV, Part 2, and 1929, Vol. IV, Part 4).

The most notable success in the use of light-sensitive diazo compounds was achieved by Gustav Kögel, when he found in the diazo anhydrides a new group of light-sensitive and more stable substances, which he used for the production of positive photographic dye pictures. Thus, he created the widely used modern photographic-tracing process which he called "ozalid process." In order to produce these photographic-tracing papers commercially he joined the dye works of Kalle at Biebrich on the Rhine, which took over his German patents of June 1, 1917, and November 20, 1920, on the dry-photographic-tracing paper process. The development of the diazotype paper, which has been exposed to light under the copy to be reproduced, is carried out by fuming it with ammonia, without the use of wet baths of any kind. This process which produces in the most simple manner positive photographic tracings from reddish violet to black brown in color, has displaced almost all other photographic-tracing processes, with the exception of the photomechanical methods. The oxalid paper factory in Biebrich has become the largest manufacturer of photographic-tracing paper in the world.[1] The foundation of later printing processes with diazo compounds can be traced to Feer, Cross, and Bevan.

Gustav Kögel, born 1882, at Munich, after passing his early studies, joined the Benedictine Order in Brazil. He continued his studies in Pernambuco, Rome, and Leyden. He devoted himself to photography, for instance, to reflectography (Breyertypy, see Ch. XL) in which he employed the Eder-Pizzighelli gelatine silver chloride papers (typon process).

Kögel introduced the use of ultraviolet fluorescent light in palimpsest photography (*Sitz.-Ber. preussisch Akad. d. Wissensch.*, 1914), and later, in criminal investigation photography; he also experimented

in the bleaching processes for the production of color prints. Kögel's
ozalid process is reported above. During the World War he worked
at the Technical College at Munich; in 1922 he received the degree of
Doctor of Technical Science from the Technical College at Vienna.
After the war, the Benedictine Order to which he belonged was partly
dissolved, and Kögel left it. Since 1921 he has been professor of tech-
nical photochemistry at the Technical College in Karlsruhe.

Chapter LXXIX. DISCOVERY OF THE PHOTO-GRAPHIC PROCESSES WITH CHROMATES BY PONTON (1839) AND OF THE LIGHT-SENSITIVITY OF CHROMATED GELATINE BY TALBOT (1852)

VAUQUELIN discovered in 1798 that chromic acid forms with silver
a carmine red salt which turns darker in light. Professor Suckow was
the first to observe, in 1832, that chromic acid salts mixed with organic
substances are light-sensitive even in the absence of silver. But it was
not until after the invention of the daguerreotype and much experi-
menting with light-sensitive salts that the Englishman Mungo Ponton[1]
attempted, in 1839, evidently following Vauquelin's statements, to
employ the light-sensitivity of silver chromates photographically. He
observed during his experiments that paper dipped in bichromate of
potassium (even in the absence of silver salts) was colored brown by
the rays of light. Ponton described these experiments in 1839 in his
report to the Royal Society of Scottish Artists.[2] The image was "fixed"
by mere rinsing, because salt colored by the sun becomes insoluble
in water (*Handbuch*, 1926, Vol. IV, Part 2).

These statements prove that Ponton discovered the change of color
of the bichromated paper, although his conception of the nature of
the chemical reaction was quite incorrect. Ponton failed to realize
the much more important light-sensitivity of mixtures of potassium
bichromate with gelatine, rubber, etc. This discovery was not made
until later.[3]

Becquerel tried to improve Ponton's process and worked along the
lines of using starch paste and treating the chromate image with iodine,
in order to make the print clear and more visible (*Comp. rend.*, 1840,
X, 469).

Hunt's experiments (1843) to find[4] a better printing-out method on paper by the use of a mixture of potassium bichromate and copper sulphate (so-called "chromatype process") led to no practical results, nor did his "chromo-cyanotype" process, in which Hunt coated paper with a mixture of potassium bichromate and potassium ferricyanide.[5]

Talbot was the discoverer of the light-sensitivity of a mixture of potassium bichromate and gelatine. He took out an English patent on October 29, 1852, for the production of photographic etchings on steel by the aid of this chromate mixture and published his method in detail in the *Comp. rend.* (1853). He published the fact that chromated gelatine becomes insoluble in light,[6] that is, it loses its capacity of swelling in cold water. In this particular article, which is entitled "Gravure photographique sur l'acier," Talbot describes the light-sensitive coating as a glue solution with potassium bichromate, with which he coated a polished steel plate and dried it over an alcohol lamp; he laid his diapositive on the coated side, printed a few minutes in the sun, until a visible image appeared "yellow on brown background." The plate was then washed with water, after which the light image (after Talbot's detailed description) "appeared somewhat prominent, since the water washed away the chromium salt from the parts affected by light and swelled the glue coating somewhat." Talbot etched through the coating with a solution of platinum perchloride. In order to get a half tone effect, Talbot interposed fine black gauze between the diapositive and the coated layer, thus laying the basis for the later screen process; he remarked that photographic prints on zinc and photolithographs could also be obtained by this process, and mentions this in his patent description.

Talbot's observations on the property of chromated gelatine to swell in water after exposure to light were utilized by Paul Pretsch (1854), of Vienna, for a gravure process. He coated a plate with glue, potassium bichromate, and silver compounds, exposed to light, washed in water, and electrotyped or stereotyped the relief thus obtained. His English patent (No. 2,373) is dated November 9, 1854; Pretsch did not receive his French patent until July, 1855.

POITEVIN DISCOVERS COLLOTYPE AND PIGMENT PRINTING (1855)

The Frenchman Alphonse Louis Poitevin achieved great merit for introducing photography with chromates. He studied the reaction of chromates with organic substances in light very successfully and in-

vented collotype (1855) as well as pigment printing. At first Poitevin took out an English patent, December, 1855, for a new photographic printing process, which in its specifications presents the principles of collotype.

In his patent Poitevin recommends a mixture of "albumen, fibrine, gum arabic, gelatine, and other similar substances with potassium bichromate" to print an image on this coating, to dampen the plate and roll it up with greasy ink, "which only adheres to the parts exposed to light." The print thus obtained could remain on this first produced image coating or it could be used in the manner of lithographs by transferring to different bases, like lithographic stones, metal, glass, wood, and so forth, for the production of pictures. Poitevin goes on to remark in this description of his patent that colored prints could be obtained if a dye (pigment) were added to any of the above-mentioned mixtures and the portions not changed by light were washed away after exposure.

Poitevin exhibited photographic prints made according to this patent[7] at the Paris "Exposition Universelle" in 1855. These methods and the principles expressed in the patent description undoubtedly represent the foundation of collotype and of pigment printing, and we must honor Poitevin[8] as one of the distinguished inventors of these photographic methods, next to Talbot and Pretsch.

Alphonse Louis Poitevin (1819-82)[9] studied chemistry and mechanics and received a diploma in 1843 as a civil engineer. He entered the government service as chemist at the "National Salt Mines in the East," where he commenced his photographic experiments in 1848. His first result was the "galvanography" on daguerreotype plates, then he found a photochemical engraving process on metal coated with gold, also one for daguerreotypes, for which he received the silver medal of the Société d'Encouragement des Arts. He entered the employment of the factory of Pereire, in Lyon, in 1850, as engineer and went to Paris the same year. He devoted himself to a thorough study of the photographic properties of chromated glue and discovered the principles of collotype and of pigment printing, (French license, August 6, 1855). Pretsch antedated him in the invention of photo-galvanography by a few months only. He gave much attention to direct photolithography in halftone on grained stone coated with chromated albumen. In October, 1855, he erected a photolithographic printing establishment; the enterprise did not succeed very well, be-

cause Poitevin had not sufficiently mastered lithographic technique. He therefore joined the famous Paris lithographer Lemercier, in Paris, to whom he sold his patents, and in this roundabout way he was successful in introducing his invention into practice. Later, Poitevin published numerous important improvements in the field of photography with chromates, photography with iron salts, photochromy with silver photochloride, and so forth. For his invention of photography with chromates (carbon prints) he received 10,000 francs from the fund donated by the wealthy art lover the Duke of Luynes, but this irregular income was insufficient to offset the considerable sacrifices required to carry out his inventions, and in 1869 he found himself again compelled to take a position as civil engineer. He managed glass works at Folembran, traveled to Kefoun-Theboul in Africa to exploit silver mines, and after the death of his father returned to his birthplace Conflans (Sarthe), where he lived modestly.

At the International Exposition in Paris (1878) Poitevin was honored with the title "Collaborateur Universel" and was presented with a gift of 7,000 francs and a gold medal in appreciation of his services for the progress of photography. This money, however, seems never to have been paid to him.[10] The Société d'Encouragement des Arts, of Paris, more than once gave him financial aid and finally granted him 12,000 francs, a prize founded by the Marquis d'Argenteuil. In 1880 he suffered an attack of brain trouble and died at Conflans. A monument to him has been erected at Saint Calais, the county seat of the Department of Sarthe.

PRIZE COMPETITION OFFERED BY THE DUKE OF LUYNES

Poitevin's photographic prints with printer's ink exhibited in 1855, imperfect though they were, attracted the attention of the Duke of Luynes in Paris, who recognized in them the possibility of photographically producing permanent prints at a low cost. In order to hasten the solution of this problem, the Duke offered, in 1856, money prizes of 8,000 and 2,000 francs, respectively, and thus encouraged the production of permanent photographic prints[11] (see *Handbuch*, 1926, IV(2), 56).

The chemist H. V. Regnault, as chairman of the Paris Photographic Society, prefaced the prize offer in the following words:

Of all the elements with which chemistry has acquainted us, carbon is the most permanent, and the one which withstands most all chemical re-

agents at the temperature of our atmosphere. The present condition of old manuscripts indicates that carbon in the form of lampblack on paper remains unchanged for hundreds of years. If we could therefore make it possible to reproduce photographic images in carbon, we should have a basis for their permanency, as we now have in our books, and that is as much as we may hope for and wish.

This gave direction and impetus to the work on printing methods with carbon or printer's ink, which was not without influence on the development of these methods, among which was pigment printing. Up to 1859 several entries for the Luynes prize were received: (1) from Testud de Beauregard; (2) Garnier and Salmon; and (3) Pouncy.

Testud de Beauregard exhibited some good proofs, but for reasons unknown broke off the practical demonstration of his method before the commission, and his application was no longer considered. Messrs. Garnier and Salmon successfully carried out a demonstration with a dusting-on or powder method before the commission, and Pouncy's work was examined according to his directions by the commission, since he was unable to appear personally.

Incidentally, the jury appointed by the Paris Photographic Society declared that Poitevin was the real father of all these competing methods by his new processes mentioned above.

Therefore Poitevin received the gold medal and Garnier and Salmon, as well as Pouncy, were each awarded a silver medal.

FURTHER INFORMATION ON PIGMENT PRINTING

The Englishman John Pouncy exhibited in 1858 before the London Photographic Society pigment prints (*Jour. Phot. Soc.*, December, 1858, p. 91). At first he kept the method of production a secret, but later divulged his method in detail. However, he took out at the same time an English patent on this process (April 10, 1858, No. 780), from which it appears that he used "vegetable carbon, gum arabic and potassium bichromate" as coating in the preparation of his paper or that he substituted bitumen or other pigments for carbon, in order to obtain permanent photographs. That Pouncy's gum prints were actually produced by this method is shown by a letter from his assistant Portbury, published in the *Photographic News* (November 23, 1860). This pigment process with gum arabic and chromates had already been mentioned, however, by Poitevin, and "Pouncy's pigment process" is covered by Poitevin's patent specifications.[12] Nevertheless, Pouncy

received part of the money prize of the Duke of Luynes's contest, owing to the excellent execution of his pictures. At any rate, Pouncy may be considered the practical founder of printing with gum bichromate.

Garnier and Salmon were considered in the distribution of prizes,[13] owing to a method of dusting-on the paper with chromates, sugar, albumen or rubber and carbon powder, the description of which they deposited on June 30, 1858, in the hands of the secretary of the Paris Society and which was actually original.[14] The contest was extended, and in 1862 Poitevin received the prize of 2,000 francs.

Notwithstanding these prize competitions of 1858, it was not possible to reproduce halftone negatives satisfactorily by Poitevin's pigment process; it was limited to the reproduction of outline drawings.

The reason for the destruction of the halftones in Poitevin's pigment process and similar methods, in which the image is created on the coated surface and where the image is fixed by washing away the unchanged particles, was first recognized by Abbé Laborde.[15]

After Laborde had discovered why the halftones were destroyed in Poitevin's pigment process, J. C. Burnett proposed a remedy in the *Photographic Journal* (November 22, 1858, V, 84). He remarked that the pigment paper was to be exposed through the back of the paper in order that the pigmented portions of the image would adhere to the base. This laid the ground for the use of transparent celluloid sheets as carriers for pigment coatings; they were proposed in 1892 (*Jahrbuch*, 1892, p. 454), then in 1893, anonymously, probably Friedlein, of Munich, in *Phot. Korr.*, 1893; see Hans Schmidt in *Jahrbuch*, 1909, p. 46. This method was later applied by Robert Krayn (Neue Phot. Gesellsch., Berlin) for three-color photography with superimposed pigment diapositives (1903).

INVENTION OF THE TRANSFER METHOD IN PIGMENT PRINTING

None of these methods in which exposure had to be made through the paper resulted in the desired smoothness and sharpness of the picture, which gave Fargier the idea to transfer the exposed chromate-pigment coating face down on another base and thus to firmly fix the surface image. Fargier's pigment printing process,[16] patented in France, September, 1860, consisted in exposing to light the gelatine pigment film sensitized with chromate, then flowing collodion on it and immersing the plate in warm water. The unexposed parts of the gelatine dissolved,

while those parts of the pictures which had become insoluble by exposure to light adhered to the collodion with all their detail and halftone structure. This detached itself from the original base and was transferred to another, let us say, to a piece of paper.

Fargier repeatedly exhibited proofs of his pigment process before the Paris Photographic Society (1861), and in 1862 he received from it for his investigations in the field of pigment printing and for the ingenious improvements of his method a prize of 600 francs (*Bull. Soc. franç. phot.*, 1862, p. 101).

An important step in the development of the pigment process was the contribution of the Englishman J. W. Swan, who introduced the transfer process. Joseph Wilson Swan (1828-1914)[17] improved the pigment process and worked with untiring perseverance on the perfecting of this method; thus, a large part of the practical success which was later achieved in the pigment process was due to Swan's labors, for it was he who introduced the single and double transfer method of pigment pictures to glass and paper (*Handbuch*, 1926, Vol. IV, Part 2). He later established jointly with Mawson one of the first gelatine silver bromide dry-plate factories in England. Swan also invented the electric-bulb lamp with a twisted carbon filament. He was knighted by King Edward VII in 1904 for his services in science and industry.

Swan devoted himself from 1864 to the pigment process,[18] which he patented in England February 29, 1864 (No. 503). An excellent pigment picture from the double transfer (rubber and paper) made by him in 1866 is reproduced in the 1932 German edition of this *History* (p. 779). Swan's original prints of the early period have become very rare, because his workshop and collections were destroyed by fire at the end of the nineteenth century. W. Benyon Winsor, of London, bought Swan's patent and started the English Autotype Company, which manufactured and sold pigment papers exclusively.

Adolph Braun, of Dornach (Alsace), at that time reproduced the sketches of old masters at the Louvre and endeavored to represent the various colors (brown, red, and gray) of the originals by a photogravure process invented by Rousseau. Swan explained to him that he, by his pigment printing method, could not only imitate the colors of the originals but also produce the actual and exact paints which had been used by the artist. He showed Braun a reproduction of an original executed in a red crayon with actual red chalk (sanguine), and excited his admiration for his method to such an extent that Braun used Swan's

process in making his reproductions of the works of the old masters, which today have a world-wide reputation in all art schools.

Edgar Hanfstängl (son of the founder of the art publishing house of Franz Hanfstängl) was the first to introduce pigment printing on a large scale in Germany for art-print publishing at Munich; he also manufactured pigment papers for the trade (*Handbuch*, 1926, Vol. IV, Part 2) and employed all modern photographic processes.[19]

After this time the pigment process reached its height and became one of the most important methods for reproducing art subjects and also for artistic photography. Braun in Dornach, Hanfstängl in Munich, Autotype Co. in London, Goupil (Boussod, Valadon & Co.) in Paris and others used this process.

The superior beauty of carbon prints on glass led to the application of the carbon process for the production of transparencies and for making duplicate negatives.

Swan also employed the pigment print process for the production of copperplate printing plates on which rest two methods, namely, the process of etching in which a pigment image (negative) acts as an etching ground and the other, especially developed by Swan and Woodbury, in which the relief of a positive pigment image serves as a matrix for an electrotype (see Klič's photogravure and photoelectrotypes in Ch. XC).

THE CHEMICAL BASIS OF PHOTOGRAPHY WITH CHROMATES

The chemical reaction of light on chromates in the presence of organic substances, notwithstanding manifold practical uses of the glue chromatic process, had been in the beginning hardly investigated, which prompted the Photographic Society of Vienna to offer, in 1877, a prize of 140 ducats for a critical study on the light reaction of the chromates on albuminoids, gelatine, and so forth. The prize was awarded, in 1878, to the competitive work of this author.[20] The tanning action of the chromi-chromate (chromium dioxide = CrO_2) formed by light was determined as the cause for the insolubility of the chromated gelatines, and so forth.

The results of the investigations were published in the *Phot. Korr.* (1878), and in a somewhat more detailed form as a separate pamphlet: *Über die Reaktionen der Chromsäure und der Chromate auf Gelatine, Gummi, Zucker und andere Substanzen organischen Ursprungs in ihren Beziehungen zur Chromatphotographie* (Vienna, 1878).[21] A short digest appeared in the *Journal f. praktische Chemie*, (1879, XIV, 294).

Since this pamphlet had been out of print for decades and was in great demand, the Graphische Lehr- und Versuchsanstalt, in Vienna, printed a new edition in 1916 (see also *Handbuch*, 1926, Vol. IV. Part 2).

Chapter LXXX. GUM PIGMENT METHOD

GUM PRINTING does not offer the precise reproduction of the fine details of pictures given by Swan's pigment process, but splendid results can be obtained by it for larger pictures with breadth of light and shade effects. After Pouncy, the method had become forgotten; Bollmann's suggestions for gum-pigment pictures (1863) also met with no success (*Handbuch*, 1926, Vol. IV, Part 2). Victor Artigue first directed in 1889 attention to direct halftone printing method by recommending a "velvet carbon paper" (Charbon velours) (*Handbuch*, 1926, Vol. IV, Part 2). But this was no real "gum print."

The modern revival of gum printing for pictorial photography was begun by the French amateur photographer A. Roullé-Ladevèze, who presented such prints first at the exhibition of the Photo Club, Paris, in January, 1884. He was very successful with his pictures in sepia and red chalk toning. He described his process in a pamphlet in 1894 (*Handbuch*, 1926, Vol. IV, Part 2). The English amateur Alfred Maskell saw these prints by Ladevèze at Paris and brought them to London in October, 1894, for exhibition at the Photographic Salon of that year. Later, Robert Demachy, of Paris, brought gum printing to high perfection (exhibition at Paris Photo Club in 1895). He sent some of his prints to the Photographic Salon, London, where one of them was purchased by the amateur photographer Dr. Henneberg, of Vienna, who also obtained information on the technique of the process, and who introduced gum printing at Vienna. This gum-print method was then called "gum-bichromate process" or "photo-aquatint."

The earlier Ladevèze's publication on gum prints was printed in June, 1894, in the *Photographische Blätter* of the Vienna Camera Club.

This caused several members of the Vienna Camera Club to take up experiments with gum printing, and they obtained good results, but they have no claim to priority for the invention of this process. When such claims were made, this author established the truth of the matter in the *Phot. Korr.* (1914, p. 116), under the title "Die Erfinder

des Gummidruckes" (see also *Handbuch*, 1926, Vol. IV, Part 2).

The surprinting of several impressions in order to obtain better halftones (multiple gum printing) was first published by Hübl, March, 1898, in the *Photogr. Blätter*, Vienna. This method improved considerably the gradations of tones. A question of priority raised by Heinrich Kühn was decided in favor of Hübl (*Phot. Korr.*, 1919, pp. 100, 133; also *Jahrbuch*, 1915-20, p. 473).

Modern gum printing in France was well represented by Demachy and Puyo, who call gum printing with a single gum-chromate layer "French gum printing" and the method with two or three thin gum layers and multiple printing the "Vienna method." A retrospective exhibition of gum prints was held at Paris in 1931 (*Revue française de phot.*, 1931, p. 33). Dr. Henneberg, in Vienna, was the first to produce two-color gum prints; then follow polychrome gum prints after the three-color method.

The effective combination of platinotypes with gum printing was first executed by Professor H. Kessler at the Graphische Lehr- und Versuchsanstalt, in Vienna, and such prints were exhibited by the institute at the Paris Exposition of 1900.

Gum printing later spread extensively in artistic photography to all countries, was written about in numerous books, and was well represented at all exhibitions. Lately it has lost more and more ground, perhaps because its procedure is somewhat troublesome and requires more artistic skill than other printing methods.

Chapter LXXXI. PIGMENT IMAGES BY CONTACT; MARION (1873); MANLY'S OZOTYPE (1898); OZOBROME PROCESS (1905); CARBRO PRINTS

A. Marion reported, in 1873, to the Paris Photographic Society that exposed bichromate pigment paper prints when put in contact under pressure with another piece of unexposed pigment paper would transfer the insoluble light images to a certain degree onto the second paper. He exhibited some of these "Mariotypes by contact" in the spring of 1873 before the Photographic Society of London. The process could not compete, however, with the ordinary pigment process.

Thomas Manly, in England, improved the method in 1898 and was

granted a patent (No. 10,026); he called his process "ozotype" (*Handbuch*, 1926, IV(2), 281).

The working directions for ozotype were afterwards modified by Manly himself, also by Hübl, in Vienna (1903), H. Quentin, in Paris (1903), and others, but the method failed to attain popularity or practical application in photography.

In 1905 Manly described his "ozobrome" process, in which a gelatine silver bromide image is transferred by contact to pigment paper. Baths containing potassium ferricyanide and bichromates were used. The amateur photographer H. F. Farmer[1] worked out empirically new directions for Manly's "ozobrome" process in 1919 and coined a new name for it, that is, "carbro" prints. The London Autotype Company introduced this method on the market. H. F. Farmer's process consisted in the use of a solution of ferricyanide of potassium, bichromate, potassium bromide, and potassium bisulphate, in which the silver bromide image and the pigment paper is bathed and then put in contact in a printing frame. After the reaction has taken place, which is analogous to that of bromoil printing, a pigment image is obtained, which can be developed in warm water. These methods were used especially for enlargements.

Although H. F. Farmer cannot be designated as the sole inventor of this method, he must be given the credit of having been the one who made "carbro" printing a practical and easily workable method (see *Handbuch*, 1926, IV(2), 312).

Chapter LXXXII. OIL PRINTING

CHROMATED GELATINE when in contact with a negative exposed to light and immersed in cold water will take up greasy colors on the exposed parts. This observation was first made by Poitevin in 1855, who produced such light images in greasy colors. This is the basis of collotype, photolithography, and so forth.

The picture rolled up with printer's ink can be used itself as original. The Austrian photographer Emil Mariot of Graz (Styria), later connected with the Military Geographic Institute, Vienna, described this process in 1866 in the *Phot. Korr.* (1866, p. 79) and called it "oleography." He stated that the image could be transferred to another paper and exhibited such pictures before the Vienna Photographic

Society, but the time for such photographic methods had not then arrived, and his method went into desuetude (*Handbuch*, 1926, IV(2), 318).

W. de W. Abney was probably unaware of Mariot's publication when, in 1873, he described his "papyrograph," which was nothing else than the use of chromated gelatine paper exposed to light under a negative, washed, rolled up with greasy ink, applied to printing on plain paper (*Handbuch*, 1926, IV(2), 331).

It was much later that another Englishman, G. E. Rawlins, of Waterloo, Liverpool, again called attention to such greasy ink pictures. He recognized, in 1904, the importance of this process as a new vehicle for artistic photography, offering remarkable possibilities of individual treatment and control and giving excellent results with skill and experience. Rawlins[1] manufactured and sold gelatine papers and other materials for the process. The gelatine papers were sensitized by baths in a bichromate solution, exposed to light under a halftone negative, and softened in water, after which the oil color was applied by a roller (1905) or a camel's hair brush (1906). Rawlins published his working procedure (*Photography*, 1905, XX, 490) and propagated the method by exhibits before amateur circles, where his oil prints excited a great deal of attention. C. Puyo, in Paris, wrote the booklet *Procédé Rawlins à l'huile* (Paris, 1907), which was also translated into German, and after that time such oil prints were shown at all photographic exhibitions.

No great inventive genius was required for the production of so-called "oil transfers" on ordinary paper on a handpress and to obtain in some degree a limited number of impressions (mat paper prints), for it was really nothing but an inferior type of the long-known collotype printing. Of course, collotypes were printed from a glass base on special presses, while oil prints required no special mechanical equipment and were easily practicable for amateurs.

The transfer of oil prints was published in 1873 by W. de W. Abney. The modern transfer method in oil printing was introduced by M. R. Demachy in Paris in the spring of 1911. Oil printing had the disadvantage that it demanded very strong light (daylight or electric arc light); see *Handbuch*, 1926, IV(2), 331.

Bromoil printing therefore soon displaced it, for the gelatine silver bromide paper required only a very brief exposure to light to give a developable image and furnished a greater and better range of tone gradations.

Chapter LXXXIII. BROMOIL PROCESS

BROMOIL PRINTING had its beginning in a curious manner; at first, in theoretical deliberations. E. Howard Farmer, head of the photographic department at the Regent Street Polytechnic, London, must be considered an original investigator of this and other similar methods. He published in Eder's *Jahrbuch* (1894, p. 6; and 1895, p. 419) the observation that the gelatine film of an ordinary fixed silver bromide image in a bath of 20 percent solution of ammonium or potassium bichromate becomes insoluble (catalytic action) in the silver portions of the print. The image of tanned gelatine obtained in this manner can be developed in the same manner as pigment pictures in warm water or can be colored like an oil print at ordinary temperature (*Handbuch*, 1926, IV(2), 293).

On this basis Riebensahm and Posselt invented their silver pigment process (German patent, November 6, 1902), which was improved by Gustav Koppmann in 1907. Koppmann sold his process to the Neue Photographische Gesellschaft, in Berlin, which patented it on February 27, 1907 (No. 196,769).

Along a different road Farmer's discovery led to bromoil printing. The Englishman E. J. Wall,[1] who lived at that time in London, published in the *Photographic News* (April 12, 1907, p. 299) the following idea:

Suppose we enlarge direct on to bromide paper and develop with a non-tanning developer, such as ferrous-oxalate, we should obtain an image in the ordinary way in metallic silver. If this image were treated with a bichromate, the gelatine should be rendered insoluble in proportion to the amount of silver present, just as though exposed to light. One would then only have to dissolve out the unaltered bromide and the metallic silver with hypo and ferricyanide to obtain an image in insoluble gelatine, to which the ink or pigment should adhere precisely as in the original oil process. If this would work, there is no reason why any bromide or gaslight print should not be "oil-printed," though I have no doubt that a special emulsion would have to be used on account of the difference in the gelatines.

Thus Wall invented bromoil printing without having engaged in the actual execution of the process.

Wall's basic idea led the Englishman C. Welborne Piper to practical success in the introduction of the bromoil process. He made his results public on August 16, 1907, in the *Photographic News* (p. 115), under

the title "Bromoil, the Latest Printing Process, a Remarkable Method of Turning Bromide Prints and Enlargements into Oil-Pigment-Prints." These first directions for the production of such pictures were rather complicated, but a few weeks later Piper announced a simplified method (*Phot. News.*, September 12, 1907). He treated the silver bromide prints with a solution of potassium bichromate and potassium ferricyanide, which forms ferrocyanide, according to the reaction formulated by the author, which brings the bichromate to a much more energetic tanning of the gelatine (formation of chromic oxide) than the pure bichromate solution used by Farmer. Thus Piper became the inventor of the modern bromoil process, which met with an enormous success.

The year 1911 brought another and safer method of bleaching and tanning gelatine silver bromide pictures. F. J. Mortimer, in *Amateur Photographer*, introduced a mixture of potassium bichromate, copper sulphate, and potassium bromide as the best bleaching bath. By the use of this mixture cuprous bromide forms on the silver portions of the image, which in contact with the admixed bichromate, by energetic reduction to chromic oxide, brings about the tanning of the image in the silver bromide gelatine. He published this improvement in his *Amateur Photographer* (1911, p. 577). The bromoil process first became popular in amateur circles, but later Continental professional photographers also employed the process to great advantage.

The lawyer Dr. Emil Mayer, of Vienna, greatly advanced bromoil printing with copper baths. Dr. Mayer, president of the Society of Amateur Photographers, in Vienna, produced very beautiful pictures, which he showed at exhibitions. He lectured on the process and wrote a manual *Das Bromölverfahren* (1st ed., 1912; Halle, 8th and 9th eds., 1922; and an English ed., see also *Handbuch*, 1926, IV(2), 362).

Bromoil transfers were first publicized by C. H. Hewitt in the *Amateur Photographer* (March 2, 1909, p. 199) which spurred Demachy to the introduction of the analogous oil-transfer process in 1911.

Chapter LXXXIV. PHOTOCERAMICS, ENAMEL PICTURES WITH COLLODION, AND DUSTING-ON METHODS

THE PARIS PHOTOGRAPHER Lafon de Camarsac first published, in 1855, the fact that the silver image (collodion film) produced by the wet collodion process (with development) should be treated with a gold chloride or platinum chloride solution, in order to introduce gold or platinum metal through chemical substitution in the picture film, which when burned in on enamel gives darker shades of colors than silver, which yields yellow tones (*Comp. rend.*, XL, 1266; Dingler's *Polytechn. Journ.*, CXXXVII, 271).

Camarsac improved his process further and exhibited at the Paris Exposition of 1862 "permanent photographic images on enamel and vitrified porcelain, resembling Sèvres paintings."[1]

C. M. Tessié du Motay and Maréchal made later by the same process photographic pictures on enamel (burnt in, in a porcelain kiln) which they exhibited in Paris (*Bull. Soc. franç. phot.*, March 3, 1865, pp. 59, 175).

Grüne, in Berlin (1868), also employed the principle of burning in gilt and platinized collodion images and used also iridium and palladium chloride solutions for the substitution of silver images in order to change the tones of burned-in pictures on glass, enamel, and porcelain (*Phot. Mitt.*, V, 20).

A peculiar photochemical reaction of iron salts was discovered in 1858 by Henri Garnier and Alphonse Salmon (of Chartres). They observed that ferric citrate, exposed to light, changes its solubility and hygroscopic properties.[2] They based on this the first dusting-on process, with which they produced prints on paper and on glass, which they exhibited before the Paris Photographic Society. They called the method "Procédé au charbon." They stated that ferric citrate on paper as well as on glass showed less solubility in water, or in water containing alcohol or glycerine, in the parts affected by light. They laid on the print with a tampon pine soot or some other colored dry powder or metallic salt which adhered only to the unexposed tacky portions, and assisted the process by breathing on the print. The image was fixed by rinsing in water, during which the iron salt dissolved and the dusted-on powder adhered rather well to the paper. Finally, this carbon image was coated with a rubber solution.

Poitevin employed this same principle in 1860 and found that a mixture of iron chloride and tartaric acid could also be used for dusted-on pictures. He used this not only for ordinary powdered dyes but also for metallic oxides (ceramic dyes). The dusted-on picture was detached from its temporary base by flowing it with raw collodion and burnt in on porcelain (*Bull. Soc. franç. phot.*, 1860, pp. 147, 304).

The dusting-on process with hygroscopic iron salts found little application in photography. Much more successful proved the dusting-on processes with the aid of hygroscopic gutta percha, honey, and sugar mixtures with chromates. Garnier and Salmon, in 1859, abandoned the use of light-sensitive iron salts in the dusting-on process and employed as hygroscopic layer a mixture of ammonium bichromate and sugar (*Bull. Soc. franç. phot.*, 1859, pp. 135, 357).

After this important discovery of the chromate dusting-on method, it became obvious to employ metal oxides and ceramic dyes for dusting-on images, which could be burnt in on enamel and glass in porcelain kilns.

Dr. F. Joubert was the first to take up this idea, and he announced a method with a layer of ammonium bichromate, honey, and albumen (English patent, January 20, 1860, No. 149). He dusted with powdered enamel, rinsed, fixed, dried, and burnt in, with due regard to certain precautionary measures.[3] The method was announced subsequently (*Phot. News*, 1862, p. 125) and was imitated in numerous varieties.

J. Wyard was the first, in 1860, to exploit the chromate dusting-on process commercially in London, and he produced by this method lovely pictures with enamel colors on glass and English porcelain as an article of trade.

J. B. Obernetter elaborated the dusting-on process with chromate-gum (1864) (*Handbuch*, 1926, IV(2), 434). The amateur photographer Justus Leth, of Vienna, was especially successful, in 1864, in obtaining very beautiful photographic pictures on porcelain by the dusting-on process.[4]

At the present time photoceramics have become a branch of industry which is practiced in Czechoslovakia, Saxony, France, England, and other countries; often a kind of pigment process is employed.

Burnt-in enamel pictures found a singular application, worthy of mention for its cultural historic significance, in that they are enclosed, along with the customary documents, in the cornerstones of monumental structures in order to preserve for later generations imperish-

able photographs. This proceeding may have been instituted for the first time in Vienna, when an excellent portrait of Emperor Francis Josef I, burnt in on porcelain by J. Leth, was immured[5] in the cornerstone of the Museum for Art and Industry on September 1, 1871. A duplicate of this photoceramic portrait was presented by the artist to this author and is preserved in the collection of the Graphische Lehr- und Versuchsanstalt, Vienna.

Chapter LXXXV. ELECTROTYPES; AUER'S NATURE PRINTS

THE EARLIEST ATTEMPTS at nature prints were discussed in Chapter IV. Not until the introduction of electrotyping by Moritz Hermann von Jacobi (1801-74) in 1837 was the molding of natural objects such as plants made possible, that is, their impressions in copper by electrolysis.

Jacobi was a physicist and an engineer. He devoted himself at first to architecture at Königsberg; in 1835 he was called to Dorpat as professor of architecture, where he investigated the action of the galvanic current and invented electrotyping in 1837.

As early as 1836 De la Rive observed that copper deposited on the copperplate of a Daniell element can be separated (stripped) and that it represents a very exact reproduction of the surface of the plate. Jacobi made the same observation in 1837 and built on it a process for molding various objects by the aid of the galvanic current. Murray found, in 1840, that nonconducting surfaces can be made suitable for galvano-plastic reproduction (electrotyping) by rubbing them with graphite.

In 1837 Jacobi was called to St. Petersburg by the Russian government. He introduced electrotyping there, wrote his book *Die Galvano-plastik* in 1840, made great efforts to construct electromagnetic machines, and made experiments on a large scale with electric light. Jacobi wrote numerous scientific articles for the *Memoirs* of the Academy of Sciences at St. Petersburg. He was accorded great honors, became a member of the Russian Academy of Sciences, a state councillor, and was knighted.

ALOIS AUER EMPLOYS ELECTROTYPING FOR NATURE PRINTS

Court Councillor Alois Auer, director of the Government Printing

Office at Vienna, is the inventor of the process for the use of electrotyping in the production of nature prints. A conversation with several members of the Academy of Sciences first interested him in making experiments, June 14, 1849, with some fossils. The foreman of the galvanoplastic department, Andreas Worring, made electrotypes of them and delivered perfect impressions. Auer perfected this process in its complete practical manipulation, and as early as 1852 he reproduced numerous plastic objects, principally laces, plants, and insects, by nature prints. He made an impression of the object in lead and from this depressed matrix an electrotype was made for intaglio printing. An impression from this electrotype on a copperplate printing press naturally presents the same relief effect as the original, which was molded into the lead, and therefore an exact facsimile is obtained. For further details see Auer's *Die Entdeckung des Naturselbstdruckes* (Vienna, 1853); also Auer's polygraphic illustrated journal, *Faust* (1854). In 1853 there arose a claim for priority with regard to this invention, when a notice appeared in some German newspapers that the nature printing process, alleged to have been invented in Vienna, had been discovered twenty years before in Copenhagen by goldsmith Peter Kyhl and that a complete description of the method with forty-six illustrations had been placed in the Royal collection of copper etchings at Copenhagen. Auer replied to this by having printed at the Government Printing Office, "Disputes about the Ownership of New Inventions," which was accompanied by a separate supplementary volume containing twenty-five full-page illustrations reproduced from Kyhl's originals in facsimile: "A convincing proof of the impossibility of comparing the process of the goldsmith Kyhl, owing to its defects, with the nature printing of the Government Printing Office in Vienna."[1]

Auer must indeed be called the inventor of galvanoplastic nature printing, and he brought the method to a perfection which has not been reached elsewhere. Two examples are shown in the 1932 German edition of this *History* (p. 798) which illustrate the beauty of the intaglio electrotypes from molds of leaves and permit the appreciation of the delicate structure. These are still more soft in the original copperplate prints than in our halftone reproductions. Just as remarkable is the nature print of a fern shown on page 800 of the 1932 German edition.

The different many-colored leaves, blossoms, seaweeds, and so forth,

Auer had imitated by the use of corresponding printing inks. By rolling several colors on the copper printing plate, he produced polychrome nature prints. A reproduction of this kind of nature print in colors (1853) is shown in Table II at the end of the 1932 German edition. We see anticipated in this the later color gravure.

Great astonishment was excited when Auer presented the first proofs of nature printing, in February, 1853, through Anton Ritter von Perger, to the Zoologic-Botanical Society, in Vienna. These prints appeared very true to nature and were printed in their true colors from the gravure plate. Several excellent works on botany were produced at the Government Printing Office by this method; for instance, the *Physiotypia Plantarum Austriacarum*, by Pokorny and Ettingshausen (1856),[2] the skeletons of dikotyledon leaves, by Ettingshausen, and various other works of a similar nature. Five more volumes of physiotypia, which appeared in 1873, were probably a last attempt to save this technique, which at one time showed so many well-earned successes, from entire oblivion. The photomechanical processes, then rapidly developing, had outstripped this nature printing.

AUER'S BIOGRAPHY

Alois Auer (1813-69) was apprenticed to a printer in his native town of Wels, Upper Austria. According to Auer's own story, he devoted himself with great zeal to the study of languages, and his extensive knowledge, together with examinations which he passed, opened his road out of the composing room. In his twenty-fourth year he became teacher of Italian in the college at Linz. In the same year (1837) he submitted a petition to the "all highest source" at Vienna, recommending the establishment of a Polygraphic Institute. His plans were so well elaborated in technical detail that he was appointed director of the Government Printing Office founded in 1804. Formerly this office was a small printing shop, and when Auer took it over it had old wooden presses and forty-five workmen with little work on hand. He introduced modern printing presses, worked out a typometric system, and ordered type of many different ancient and modern languages. He also introduced an electrotype foundry and proved to be a constructive genius. His invention of nature printing made him known everywhere.

He did not confine himself, however, to this method alone, but cultivated all the graphic methods known at that time. The exhibit of the

Government Printing Office at the Great Exhibition at London, in 1851, was so extensive that it received the great medal of the council, the only award in Class XVII. Thus, Austria occupied a leading position in the whole domain of the printing craft and of the graphic arts.

Auer published, in 1844, the Lord's Prayer in 608 languages and dialects in Latin characters, and in 1847 in their national alphabets; *Das typometrische System in allen seinen Buchstabengrössen* (1845); *Geschichte der Hof und Staatsdruckerei* (1851) and the polygraphic apparatus of the same. For his services in promoting the printing of works in oriental languages at Vienna he was appointed, by the Emperor Ferdinand, a member of the Vienna Academy of Sciences.

His untiring diligence and zeal, as well as his intellectual ability, created a great reputation for the establishment, which he directed from 1841 to 1868. It flourished under his management and became a world-renowned institution, where the progress of the graphic arts, of the printing craft, electrotyping, and photography in connection with the printing industry were co-ordinated, investigated, and promoted. His versatility brought about his appointment as general director of the government paper mill, and in 1862 he also took over the management of the imperial porcelain factory at Vienna for two years. Auer was held in great esteem by the government, was appointed court councillor, and was knighted with the title "von Welsbach." He retired in 1868.

Auer's many experiments were expensive, but the funds for them at first were always at his disposal; and his printing plant, employing about a thousand men, was extremely efficient. But the introduction of nature printing caused a deficit.[3] For instance, the copperplates for the *Physiotypia Plantarum*, of Ettingshausen, with its fifteen hundred full-page illustrations, cost 40,000 florins, which the sale of the book failed to cover. The government caused him to undertake many unprofitable printing orders. The Academy of Sciences also was privileged to have its printing done there practically without charge. In 1849 a law gazette was created by the government and ordered to be distributed with indiscriminate liberality to the governments of all countries, free of charge. It was printed in the ten languages of as many countries, with the German text opposite. It cost the mere sum of one million florins. At the normal cost of printing, the production was worth 1,600,000 florins and would have earned a profit, but under the circumstances, it resulted in a heavy loss.

The volume of these printed journals, which soon had no other value than that of waste paper, had accumulated to such an extent from 1849 to 1852 that placed on top of each other they would have been sometimes higher than Vienna's tallest church (St. Stephen's).

Auer also engaged in the invention of a speed printing press with self-feeder, invented the production of paper from cornstalks, and made many other improvements, which brought him no gain, but more or less loss.

This unfortunate financial condition brought about attacks on Auer, who, however, successfully defended himself, because after all he showed a favorable balance sheet. The accounting department of the court and Minister Baron von Bruck supported Auer, expressed to him the appreciation of the government, and procured his appointment as court councillor, with a salary of 4,000 florins.

At the height of his career Auer published a pamphlet printed as a facsimile of his manuscript *Mein Dienstleben* (Part I, March, 1860) which reflected the appreciation extended to him by his patrons, Prince Metternich, Count Kolowrat, Baron Kübeck, and Baron von Bruck.

In contrast to this was the end of his government service, when the minister of finance, Von Plener, treated Auer in a most disagreeable manner. Plener was extremely parsimonious; Auer's budget for the institution was cut down[4] in an unfortunate and categorical, almost insulting, way. Auer became greatly depressed by the cares of procuring the funds necessary for the printing and publishing establishments; these worries increased in the beginning of the sixties, when he found it necessary to pay the accumulated bills. The harsh restrictions of the finance ministry irritated him, and he felt impelled to write his defense and accusations: *Mein Dienstleben* (Part II, 1864). He had it printed privately and supported his statements with numerous official documents. The edition of the pamphlet, the submission of which to the ministry was an official duty, on coming to the knowledge of the ministry was ordered destroyed by the government before publication. Auer was also forced, under threat of a disciplinary trial and loss of his pension, to surrender his manuscript and galley proofs. Thus it happened that his family knew nothing of this pamphlet, as his son Dr. Carl von Auer stated to this author. Decades passed, and it seemed as if the pamphlet had been forgotten. In 1919 the son of the printer of the galley proofs of the booklet, which the father had retained, gave the proofs to this author. With the consent of the minister, En-

gineer Truka, who sympathized with correct historical presentation, the pamphlet was reprinted at the Graphische Lehr- und Versuchsanstalt. It was printed for private circulation, with a preface by this author, and sent to the Auer family, libraries, and other interested persons. Further search revealed that a second complete copy, with all the original documents, was preserved in the Imperial private library, as the chief librarian, Court Councillor Dr. Payer von Thurn, related to this author. Evidently this "duty copy" was delivered before it was known that the police were endeavoring to seize it.

When Dr. Carl von Auer learned of the existence of this copy, he reprinted a small edition, edited by Payer von Thurn. Both editions have become very rare, but they belong to the most interesting documents of the battle of an inventive fiery spirit against bureaucracy.

On Auer's 100th birthday a memorial tablet was erected in his birthplace in Wels (Upper Austria). His son Dr. Carl Auer von Welsbach (1858-1929) invented the incandescent gaslight, named after him, as the outcome of his investigation of alkaline earths in 1885. He invented the osnium incandescent lamp and the pyrophoric cerium iron.[5]

Alois Auer, the father, is of special importance in the history of photography, owing to his invention of a nature printing process which is practical and thoroughly elaborated, because of the closely connected photoelectrotyping process, worked out by his employee Paul Pretsch. Under Auer's supervision was also produced the first Pretsch gravure cylinder for rotary printing. Auer's desire for the promotion of all the reproduction processes of his time led to the acquisition of the largest Petzval orthoscope lenses for reproduction purposes at that time known in Vienna.

Auer's nature printing method must be called the precursor of the Woodburytype process. Woodbury employed the same principle of relief molding in lead, but used photographic glue reliefs instead of natural objects.

Chapter LXXXVI. ELECTROTYPES AND GALVANIC ETCHINGS

"ELECTROTYPES" closely follow nature prints. They were invented and made public by Franz von Kobell, at Munich, in March 1840. He presented his first example of the electrotypic reproduction of paintings in water color to the Bavarian Academy of Sciences, and later (1842) he described his method in a pamphlet[1] with several illustrations. He painted with oil of spike and porcelain colors on metal plates, with the design in strong relief, and electrotyped the plates. Kobell obtained intaglio printing plates without etching, which could be printed on a copperplate printing press and resulted in prints like water color drawings.

Dr. Franz von Kobell (1803-75) became professor of mineralogy at the University of Munich in 1826 and did splendid work in the field of crystallography and mineralogy, as well as in analytical chemistry. He was also artistically inclined, published poetry in the Bavarian dialect,[2] and joined K. A. Steinheil, in 1839, in photographic work. The daguerreotype camera, constructed by them jointly in April, 1839, is on exhibition in the German museum at Munich (*Zeit. f. wiss. Phot.*, XXX, 212). Kobell also was quite familiar with the graphic arts, which led him to the idea of electrography, which attracted general attention and was introduced in the reproductive processes.[3] In his later years Kobell gave up his work in the graphic arts and returned to his mineralogical studies.

Kobell published several examples of galvanography in his pamphlet *Die Galvanographie* (1842), which demonstrated that in painting for electrotyping purposes the artist could work with a certain freedom; notwithstanding all his technical skill, Kobell's method never reached practical perfection.

Independently of Kobell, but not until August 7, 1840, Jacobi exhibited to the Russian Academy at St. Petersburg electrographs produced after the same principle as Kobell's.[4] Hoffmann, in Copenhagen, later announced this same method. The credit for having elaborated this method as an artistic reproduction process and for having introduced it into the art trade, belongs to two young Munich artists, Schöninger and Freymann, who improved the process and published in 1843 their first successful electrograph, a Titian portrait. Schöninger joined Franz Hanfstängl's establishment at Munich in 1849.

The famous painter and lithographer Professor Franz Hanfstängl (1804-77), worked in lithography from 1819 and established his own lithographic establishment in Munich in 1834.[5] In 1848 or 1849 he installed Kobell's electrography. He operated a large art publishing business, where until 1853 a great number of originals and reproductions of art subjects were produced by this method and published. Among these was an electrograph of Ruben's "Columbus" measuring 19⅝ × 26 inches and one of Fluggen's "Court Decision," which included forty figures, measuring 21⅝ × 28 inches. The competitive success of the new methods of photomechanical reproduction induced Hanfstängl,[6] in 1853, to discontinue his lithographic and galvanographic establishment, although it was conducted with a high degree of perfection. He started in that year his photographic art publishing house at Munich, which he handed over to his son Edgar in 1868.

Electrographs were also produced by Auer at the Government Printing Office, in Vienna, of which his *Faust* contains very nice examples, especially of the work of the painter Ranftl; one of these original electrographs was exhibited in 1883. F. Theyer,[7] in Vienna (1843), and Würthle, in Salzburg, devoted themselves temporarily to this process, which around the end of the fifties of the last century was discontinued, when the photographic reproduction processes were taken up. Thus died out a technique[8] which no doubt represented the first application of reproduction by electrotyping designs in relief and is of interest as the forerunner of photoelectrotyping.

When the essential features of Kobell's electrographing method, in which drawings in relief are made on plain copper plates, electrotypes, and then printed on gravure presses, are compared with the principle underlying the subsequent photoelectrotyping process, the full analogy of this graphic art method with the later photomechanical process is recognized. Kobell's method reminds us especially of the principle of Woodbury's photoelectrotypes (the molding of a pigment relief produced on a copper plate, washed in hot water) and secondly in 1854 of Pretsch's photoelectrotypes (the molding of a swelled glue relief, hardening it, and using an electrotype from this relief as a printing plate).

Electroetching, or the electroengraving process, rests on the phenomenon that when immersed in an electrolytic bath, a metal plate (copper, steel, etc.) dissolves rapidly at the positive pole. When such

metal plates are coated with an etching ground on which designs are engraved and immersed in an electrolytic bath, etched plates are produced for relief or intaglio printing.

The first attempts to etch with a galvanic current were made public by an Englishman, Spencer, in 1841. G. W. Osann, professor of physics at the University of Würzburg, invented independently the same process and published it on June 7, 1841, in the *Würzburger Zeitung* and in a pamphlet: *Anwendung des hydroelektrischen Stromes als Ätzmittel* (Würzburg, 1842). A sample of an electrically etched intaglio print may be found in *Handbuch* (1922, Vol. IV, Part 3).

Georg Ludwig von Kress devoted himself successfully to galvanic etching and wrote a chapter on it in his book *Die Galvanoplastik für industrielle und künstlerische Zwecke* (Frankfurt a. M., 1867).

ETCHING OF PHOTOGRAPHIC IMAGES WITH GALVANIC CURRENT

As early as 1841 experiments were made with the etching of daguerreotype plates by galvanic currents. Baldus was the first to cover copper plates with a light-sensitive asphalt coating, and he etched them in 1854 in a galvanic bath. *La Lumière* of 1854 contains prints from such Baldus etchings. Gillot, the Paris photoengraver, reproduced one of these prints by "paniconography."

Lyons and Mittwald used galvanic etching in 1848 on copper and brass cylinders for rotary printings. Later, photographic chromate gelatine pictures were etched by this method on zinc, copper, steel, and so forth.

Paul Schrott, of Vienna, reverted in 1920 to galvanic etching on steel engravings for the production of matrices for postage and revenue stamps, as well as for printing paper money and embossing dies produced by photography with albumen or glue chromates, as a substitute for steel. He carried on his experiments in the Government Printing Office at Vienna, where he was employed as engineer (*Archiv für Buchgewerbe*, 1920, LVII, 75; *Jahrbuch*, 1915-20, p. 540; *Handbuch*, 1922, IV, Part 3).

Chapter LXXXVII. PHOTOGRAVURE WITH ETCHED OR GALVANICALLY TREATED DAGUER-REOTYPE PLATES

AFTER NIÉPCE's early experiments in etching photographic asphaltum images on metal plates and thus producing printing plates for graphic reproduction, no progress ensued in the field of photomechanical processes until the success of the daguerreotype awakened the attention of physicists. Several of them interested themselves in the problem "to produce engravings on metal plates by the sole aid of the action of light in combination with chemical processes."

Two scientists, Dr. A. Donné, in Paris, and Dr. Josef Berres, in Vienna, began experiments, independently of each other, to etch daguerreotypes for intaglio printing. To Berres belongs the priority of publication, while Donné kept his invention a secret. Donné presented to the Paris Academy of Sciences, early in 1840, proofs of daguerreotype plates etched by him, but did not disclose his process. Daguerre criticized the performance adversely and remarked at the session of the institute that nothing approaching perfection could be obtained by etching his pictures and printing them on paper.

At the same time Berres, professor of anatomy at the University of Vienna, undertook similar experiments, and he produced, on April 5, 1840, his first fairly satisfactory etching of a microphoto of a section of a plant photographed by Drummond's calcium light. He announced his successful results to the scientific world in the *Wiener Zeitung* of April 18, 1840 (p. 737), and presented proof on April 30, 1840, of his process to the Vienna Medical Society. Donné meanwhile allowed nothing to be known of his method, while Berres published a booklet on August 3, 1840, *Phototyp nach der Erfindung des Professors Berres*, in which he speaks of his invention as offering usefulness in the arts and sciences. This rare publication, with five sample illustrations, is preserved in the Graphische Lehr- und Versuchsanstalt, Vienna.

Berres's etchings were later more deeply re-etched in further experiments by the copper etcher Jos. Axmann, of Vienna, and worked up to artistic perfection.[1] According to A. Martin, Berres etched at first with nitric acid and later with electric current.[2] He worked untiringly in the pursuit of his object and obtained very splendid results.

Grove, who had a great deal of experience in galvanic etching and had worked out a method for galvanic etching of daguerreotype

plates, recognizes Berres as the first to publish a process of etching photographic images, i. e., daguerreotype plates. Berres's photogravures were considerably better than Donné's (Dingler's *Polytech. Jour.*, 1841, XLI, 156).

Berres's proofs demonstrate that he had progressed relatively very far with his etching method, farther than any investigator working along these lines, which is proven by the silver medal awarded him by the Société d'Encouragement. From his plates more than two hundred impressions were printed.[3] These proofs (photos from nature) are, of course, imperfect if judged by modern standards, but they show, nevertheless, an exact reproduction of the outlines and somewhat also the middle tones. They are remarkable achievements, if one considers that the photographs were made in the camera obscura direct from nature and were at once, without any transfer process, etched on metal, a problem, which even to this day has not been satisfactorily solved.

Berres, however, spent no more time on his invention. He wrote: "As a practicing physician, active professor, and journalist, I can no longer devote more than passing moments to my creation and am forced, if only for pecuniary reasons, to recommend it to and leave its cultivation to the craftsmen in the industry."

Fizeau, as well as Claudet after him and then Grove (with photo-galvano-caustic etching in 1841), experimented with the etching of daguerreotype plates.

A richly illustrated work comprising views of important monuments, architectural subjects, and landscapes was published at Paris in 1842 by the optician Lerebours jointly with Rittner and Goupil, and Bossange, under the title *Excursions daguerriennes; vues et monuments les plus remarquables du globe*.[4] Most of the full-page illustrations are lithographed from daguerreotypes, some engraved on copper and some etched by hand. There are others, however, which are produced by Fizeau's direct-etching process on metallic daguerreotype plates, although in part very extensively worked over by a copperplate engraver. One of these which shows little retouching is reproduced in halftone in the 1932 German edition of this *History* (p. 818), and shows a bas-relief of Notre Dame. It is one of the few illustrations produced by Fizeau's daguerreotype etching process. The page containing this illustration also gives a description of the procedure which Fizeau used in transforming the daguerreotype into a gravure plate. Fizeau etched the daguerreotype, produced on a silvered plate, with a

mixture of nitric and hydrochloric acid or with a warm solution of copper chloride; the silver chloride formed in the etching, which retarded the action of the acid, was removed with ammonia. The etched plate thus obtained was altogether too shallow for printing, whereupon Fizeau brushed the plate with linseed oil, wiped it carefully from the surface, permitting it to remain in the etched parts. He then placed the plate in a galvanic gold bath, in which the gold deposited only on the clean surface. The gold top formed an effective protection for the ensuing deep etching, which gave it the depth required for printing on a copperplate press and for reproduction similar to a copperplate engraving.

A very remarkable improvement in etching daguerretoype plates was introduced by Paul Pretsch (the inventor of photoelectrotypes). In the report of the Society of Arts, London, April 25, 1856, there is a supplement by Pretsch, in which are announced new methods of photographic etching on metal and which is accompanied by examples of well-printed proofs. He had printed these in the Vienna Government Printing Office. The article is headed: "Photogalvanographie; or, Engraving by Light and Electricity."

Pretsch's method of etching daguerreotype plates consisted in coating them with a solution of gum arabic and then spraying them through a fine-pointed glass tube, with an etching solution consisting of nitric acid with sodium chloride and sodium nitrate. He obtained in this manner a kind of retouching during the etching, and the plates thus treated naturally showed a grain, which assisted the printing with greasy inks. Pretsch therefore appears to be the inventor of the "spray" method of etching, which was later used in etching machines for the halftone process.

Since the original report has become very rare[5] and seems of great importance, we reprint it here:

I have here another specimen of an etched daguerreotype picture, executed in 1854 in the same establishment.[6] A perfect picture is taken upon silvered copper or upon real silver; the four edges are bent up for convenience in manipulation, and the picture is fixed in the common way by hyposulphite of soda. From this time until the end of the etching process the plate must not be allowed to become dry. When fixed, the plate is placed upon a stand in a horizontal position and warmed until what remains of the hyposulphite of soda begins to evaporate. The solution is then poured off, and the plate is washed several times with distilled water,

which must also be heated. Then a weak solution of gum arabic is poured upon the plate, to which is added the etching mixture consisting of two solutions, *viz.*, one part of pure nitric acid 45° Beaumé and eleven parts of water; two parts of pure chloride of sodium, one part pure nitrate of potash and forty parts of water. Of these solutions take nine parts of the diluted acid and one part of the solution of salts. This etching liquid must be well distributed over the gum solution upon the plate, which may be done by using a pointed glass tube and by sucking in and blowing out the fluid.

Not only chemical etching with liquids, but electrotyping also was repeatedly combined with daguerreotypes. Fizeau was the first to try it (1841) by copperplating a daguerreotype on a silvered plate and detaching the copper shell; this produced a copy of the daguerreotype image which was not very suitable for printing.[7] Beauvière sought unsuccessfully to improve this process (1850).

Poitevin observed in 1847, that with a copper sulphate (blue vitriol) galvanic bath, copper will deposit first on those portions of non-fixed daguerreotype plates which are covered with amalgam (but not as rapidly on the silver iodide surface). He obtained in this manner a detailed red copper image.[8]

Poitevin used such a copper picture for printing. He fixed the galvano-deposited daguerreotype plate with hypo, washed and dried it, then heated it until the copper image began to oxidize. He poured mercury on it, which was repelled by the copper oxide, but adhered to the bright silver metal, laid gold leaf on it, which adhered to the amalgam and on renewed heating formed a gold top. Then he etched with nitric acid through the copper surface and through the underlying silver metal, so that only the gilt top remained. In this manner Poitevin obtained his first "gravure photochimique," in 1847, which was printed as an intaglio printing plate on a copperplate printing press. It was submitted on February 7, 1848, to the Paris Academy with other similar etched plates.[9]

Poitevin's etched plates reproduced only outline drawings and fell short of Berres's early work. Poitevin himself soon gave up this method and used, later, the chromate process. Gradually Berres's process and the other related methods were forgotten. The period of the photomechanical printing process had not yet arrived. Interest in it had not been awakened, since all attention was focused on the perfection of the photographic process proper.

Chapter LXXXVIII. INVENTION OF PHOTO-ELECTROTYPES FOR COPPERPLATE PRINTING AND TYPOGRAPHIC REPRODUCTION

PRODUCTION OF PHOTOGRAVURES BY PHOTOELECTROTYPES FROM GLUE CHROMATE RELIEF IMAGES

ALL METHODS of photoelectrotyping rest on the principle of molding a photographic relief picture and can be traced to the underlying method of Kobell's electrography. While Kobell produced graduated, balanced relief pictures with a brush in a freehand manner on silver plated copper plates and by a galvanic deposit obtained an intaglio printing plate, in the photographic processes the relief picture was produced by the action of light. The invention of making a mold from the reliefs which are produced photographically with chromated glue or gelatine chromate and by a galvanic deposit, and their application to intaglio and typographic printing must be credited to the Viennese Paul Pretsch.

Paul Pretsch (1808-73)[1] was the son of the goldsmith Johann Pretsch, of Vienna. He learned the printing trade (1822-27) at Vienna from the master printer Anton von Haykul, in whose employment he remained until the death of his father, in 1831. He worked his way to Munich, Augsburg, Ulm, Stuttgart, Karlsruhe, and along the Rhine to Cologne, from there to Brussels, Amsterdam, Hamburg, and finally returned to Vienna (1839-41). He learned electrotyping for the printing trade, went to Jassy (Rumania) as manager of a business, and returned to Vienna, where Director Auer employed him in the Government Printing Office as foreman, and, owing to his linguistic knowledge, as proofreader. In February, 1850, he was ordered to study the application of photography to the graphic arts, the Government Printing Office being at that time equipped with an efficient photographic studio where the Talbotype and later wet collodion processes were employed. Here were produced fine photographic views of the city of Vienna, Schönbrunn, and other places, which were exhibited with great success. Pretsch was sent several times in 1850 as an expert in forgery cases to London and Paris, and in 1851 as director of the affairs of the Government Printing Office to the World Exhibition, London.[2] He made connections there which greatly influenced his future. After nine months he returned to Vienna and elaborated his idea to electrotype the relief picture of bichromated glue which had been exposed

to light and which had swelled in cold water, according to Fox Talbot's process.[3]

In the late fall of 1854 he gave up his secure employment at the Government Printing Office, Vienna, and went to England, where he remained for nine years and carried out his ideas for linking photography to the printing press. He is the inventor of what he called "photogalvanography." He took out a British patent (No. 2,373), on November 9, 1854, under the title "Production of Copper and Other Printing Plates," which formed the basis for his French "privilege" of June 1, 1855, and for the Austrian patent of 1866, eleven years later. A later English patent (No. 1,824) of August 11, 1855, entitled "Obtaining Cylindrical and Other Printing Surfaces," had as its subject the use of a photoelectrotype copper cylinder for rotary printing on textiles. Pretsch realized his ideas and experiments by their introduction into practice and started, in 1855, at Islington, London, the Patent Photo-Galvanographic Company. This company issued, in 1856, a serial work *Photographic Art Treasures*, in large size, of which five numbers appeared, each with four illustrated pages. This was the first periodical devoted to artistic reproduction that was illustrated by a photomechanical process (in this case intaglio copper plates). A large house was rented, and the work was assisted by experienced copperplate engravers, who retouched the plates. Numerous reproductions were turned out in 1856 and 1857—many photographs taken from nature, for which the photographer Roger Fenton made the negatives. The company was dissolved after two years, and Pretsch carried on the business alone. Although Fox Talbot had an old patent on an invention for etching photographic images, he took no steps to prosecute Pretsch for his infringement. The process which Pretsch employed, the details of which are not within the limitations of this work, had nothing in common with Talbot's method of etching.

A young man named Campbell Duncan Dallas was assigned to the position of managing partner, and Pretsch initiated him in all the details of the process, which otherwise were carefully kept secret. This Dallas made himself extremely undesirable. As early as June 5, 1856, he applied for a British patent in his own name (No. 1,344) on "Improvements in Chemical Preparations Applicable to the Photographic and Photogalvanic Processes," but he was unable to furnish the detailed specification within the required time, and the patent was therefore not issued. This left Pretsch's original patent standing as the only

valid one, but it also expired on February 2, 1858, because Pretsch personally had no money to pay the patent fee and the company for the exploitation of his process had gone out of business. This made the process public property, but it was protected in some measure owing to the lack of knowledge for the manipulation of the method. Now Dallas started the process on his own part and called it "Dallastypy." He went so far as to contest his teacher's priority rights and to represent himself as the inventor. He refused to demonstrate, however, in what his "Dallas" process differed from that of Pretsch. Subsequently Dallas failed in his efforts to establish his fraudulent claims, because outstanding experts like Anton Martin, in Vienna, Scamoni of the Imperial Russian Bureau of Engraving, as well as Leipold (Pretsch's only pupil) of the Government Printing Office in Lisbon, and others ranged themselves on Pretsch's side (*Phot. Mitt.*, 1874, II, 107; also *Phot. Korr.*). Pretsch had meanwhile suffered mentally and physically and was unable to plead his own case.

Major General J. Waterhouse wrote a most interesting and comprehensive survey on the history of photoelectrotyping and its inventor Paul Pretsch for *Penrose's Pictorial Annual* (1911, p. 157; see also *Le Procédé*, 1911, p. 161).

The 1932 German edition of this *History* (p. 825) shows a halftone reproduction of a photograph by Cundall and Howlett, London, portraying English grenadiers at the time of the Crimean War. The original reproduction, in *Photographic Art Treasures* (1856), was about 8 x 10 inches. It is obvious that Pretsch required a great deal of retouching by copperplate engravers for his photoelectrotype plates, especially in the shadows, nevertheless the delicate middle tones must be acknowledged as an accomplishment in photographic processes. At any rate, the photogravure plates, though more or less re-engraved by hand, were superior to similar products of that time and more artistic in effect than Talbot's later copper etchings. Since, however, Talbot's copper etchings required less handwork and marked a great advance in the technique of photogravure, photoelectrotypes were displaced for halftone pictures at the beginning of the sixties of the last century by the etching process, while for line and map work photoelectrotypes held their precedence.

At the London World Exhibition of 1862 Pretsch exhibited not only intaglio photoelectrotypes but also "halftone" plates for typographic printing, which had been made by the glue-chromate process and

electrotypes. The results were very mediocre, but they are worthy of note as early attempts of utilizing the natural grain structure of gelatine chromate layers. Pretsch received the only medal in this class of exhibits for his prints by photoelectrotyping on gravure and typographic presses. All this notwithstanding, he could not make a living in London and had to contend with persistent worries and misery. He returned to Vienna the following year, where he was very ill for a long time. For several years nothing was heard of Pretsch's invention, but in 1865 *Die ungarischen Nachrichten* and the *Neue freie Presse* printed the news that Pretsch had succeeded, after numerous and laborious experiments in 1864, in improving his process, and that he was giving all his time and efforts to the production of copper plates for printing on typographic presses. The principle of the production of photoelectrotypes for typographic printing consisted in making molds of the bichromate images on a glue top, which had produced a swelled relief picture in cold water. He endeavored to obtain the greatest possible relief and separation of the swelled portions, because the reticulation promoted the formation of halftones.

Pretsch also succeeded in interesting the English scientist De la Rue (1815-89) in his invention, especially in his "photographic electrotypes." De la Rue was well known by his work in astronomy, chemistry, and especially in the application of photography to the observation of astronomical phenomena.[4] He joined Pretsch temporarily, and several landscapes and pictures of statues and paintings (electrotypes in relief) were produced photographically, signed "De la Rue and Pretsch." But the connection met with no success. In 1865 Pretsch received a subsidy from the Austrian government in consideration of the importance of his invention and to enable him to perfect his experiments. His process was also recommended for trial to larger institutions issuing illustrated publications. He made experiments at the Military Geographic Institute in the production of maps on typographic presses, but his method was not practical for this purpose. Pretsch was now thoroughly discouraged, but again he found employment at the Government Printing Office. His shattered health, however, kept him from efficient work and from attaining satisfactory results, so that finally he confined himself to proofreading.

Pretsch's invention found many imitators. Dallas, in London, and Nègre, in Paris,[5] worked along the same lines (electrotypes from gelatine chromate plates in relief). Nègre seems to have been the first to

transfer the coarse-grained gelatine chromate images to zinc plates and make them suitable for printing by etching them according to Gillot's "zincotype" process.

Poitevin also had the idea to model the swelled relief chromate glue tops in plaster of Paris or to mold them for electrotypes and use them as printing plates. He worked with the process, first invented by Pretsch, without seeming to have had any knowledge of it and took out a French patent August 26, 1855, for his "helioplastie" as he named his process (*Handbuch*, 1922, Vol. IV, Part 3). On the occasion of the World Exposition of 1855 Poitevin exhibited several of his heliotypes for relief and intaglio printing. Poitevin made no further progress in this process, especially in the development of the halftone process.

Poitevin declared erroneously that his process of photoelectrotyping differed in principle from Pretsch's method, because he claimed that Pretsch washed away the unexposed portions of the gelatine chromate so that the exposed portions remained representing the image, while as a fact he (Poitevin) used swelled reliefs (Poitevin, *Traité de l'impression photographique sans sels d'argent*, Paris, 1862, p. 5). This statement of Poitevin is, however, incorrect, because Pretsch also used swelled reliefs, so that both processes were really identical. Pretsch, having taken out his patent first, is therefore entitled to claim priority. Pretsch arrived in London with his completed photoelectrotype process in October, 1854, and at once took out a British patent, dated November 9, 1854. Poitevin's "brevet d'invention" is dated August 27, 1855; he was not granted a British patent for photoelectrotyping on account of Pretsch's priority. Pretsch defended his unquestionable priority rights in an article in Horn's *Phot. Jour.*, 1857.

Pretsch's photoelectrotyping process suffered because a swelled glue relief had to be molded, in which the portions in relief were formed by glue which had not been tanned; therefore the glue swelled greatly in water, while the low portions were formed by the glue that had been hardened by light. The portions in relief were naturally very easily injured, which made it difficult to handle them.

After Pretsch's death the process was further improved by his former pupil and colleague Joseph Leipold, who was employed at the Vienna Government Printing Office and later directed the Department of Gravure and Photoelectrotyping at the Government Printing Office in Lisbon. To him we are indebted for publishing directions for manipulating Pretsch's process in the *Phot. Korr.*, 1874, p. 180.

Georg Scamoni,[6] chief of the photogravure and lithographic department of the Imperial Russian Bureau of Engraving at St. Petersburg in the seventies, also promoted photoelectrotyping from swelled reliefs. He reported his success in results in his basic, beautifully illustrated *Handbuch der Heliographie* (St. Petersburg, 1872). He also attempted to model gelatine chromate swelled reliefs in plaster of Paris and wrote useful directions for the method.

Pretsch's process of molding swelled reliefs for typographic printing was used by Wegner and Mottu in Amsterdam, who published prints in *Phot. Korr.* (1874), but Pretsch's achievements remained unexcelled.

The molding of glue reliefs (swelled process) in plaster of Paris, which had appeared on the scene repeatedly (Poitevin, Eng. patent No. 2,816, December 13, 1855; *Handbuch*, 1922, IV(3), 267, 832), was again taken up by Gustav Re, of Jeletz (Russia), in 1878. He called his process "helioprint," but it was hardly practical as a graphic method, although he presented good-looking proofs. This method continued to make periodical appearances for industrial uses as in the production of designs on ceramics, glazed tiles, and so forth, but only to disappear again.

PHOTOELECTROTYPES FROM HARDENED GELATINE CHROMATE
RELIEFS PRODUCED BY WASHING OUT WITH WARM WATER

Fontaine, in Marseille,[7] in 1862 changed Pretsch's process by washing out with warm water the gelatine chromate copperplates after exposure, instead of producing swelled gelatine plates in cold water; the method proved unsuitable in this form for the reproduction of the middle tones.

Joseph Wilson Swan, to whom pigment printing is indebted for its greatest advancement, invented a photomechanical method in which the transfer process of the pigment image, shortly before invented by Woodbury, played a role. He took out a patent (Eng. patent, No. 1,791) on July 6, 1865, on a "photo-mezzotint process," in which pigment images were transferred to glass or metal, developed in warm water, and the hardened pigment relief electrotyped. He produced thus halftones for lithographic and typographic presses, which could be printed with ordinary greasy printing inks. This method, however, never achieved its desired object; the results were unsatisfactory, owing to the lack of grain formation in the halftones, and Swan soon turned to other photomechanical methods.

INVENTION OF WOODBURYTYPES OR PHOTOGLYPTY

The photomechanical processes received a great impetus, especially for the production of delicate halftone plates, from the work of Walter Bentley Woodbury in the beginning of the sixties of the last century. Woodbury (1834-85) was born at Manchester. He led a life of adventure in his youth and went to the gold fields of Australia when fifteen years old, but had no luck. He became a professional photographer in 1855. In 1859 he went to Java, where he successfully worked the wet collodion process. He returned to England in 1863, where he devoted himself to the development of photomechanical processes, took out no less than twenty patents, of which the "Woodburytype" met with enormous success. He died at Margate.[8]

Woodbury[9] changed the relief method, probably without knowing anything of Fontaine's somewhat similar, but very imperfect procedure, by coating the chromated gelatine on collodion film, exposed from the back of a negative, then washed the exposed film (just as in the pigment process) with warm water. Thus he removed the unchanged gelatine on the portions not affected by light, so that the raised portions, the relief, were formed by the chromated gelatine hardened by the light. By this method of exposure to light all middle tones were retained on the film, which was a decided advance over Fontaine's method. These reliefs were better able to offer resistance to the mechanical pressure, as well as to chemical actions. Recognizing this fact, Woodbury, with Ashton, took out a patent (Eng. patent, No. 2,338, September 23, 1864) in which he described the electrotyping of such reliefs and the printing of impressions from these intaglio plates with transparent ink (for instance, china ink and gelatine). In later patents (January 12, 1866, No. 105; February 11, 1866, No. 505; May 8, 1866, No. 1,315; July 24, 1866, No. 1,918; and others) he improved this invention and finally perfected his method, which was introduced to the photographic industry as photoglypty, or Woodburytype. He left the electrotyping of the pigment reliefs behind and turned to molding his glue reliefs by hydraulic presses in sheets of lead producing printed impressions with liquid gelatine china ink from these lead intaglio molds, in which the halftones of the pictures were obtained with great perfection. Because of their softness, fine definition, and absence of grain or halftone screen effects, Woodburytypes met the most severe requirements. In the seventies Woodburytypes were made and used extensively in England, France, and Belgium. The delicacy of

these reproductions and their durability are unexcelled. As late as 1884 many establishments for the printing of Woodburytypes (lead matrices) were in full swing. The impossibility of incorporating Woodburytype illustrations in the text of periodicals and books,[10] however, and the slowness of their production gave the ascendancy to gravure (rapid-press printing), which displaced Woodburytypes toward the end of the last century.

Woodbury patented, in 1872, a method of producing photographic printing plates (by the Woodburytype process) for cylinders and made them thus suitable for rotary printing (Eng. patent, No. 3,654, December 4, 1872).

Woodburytypes, molded by hydraulic presses in lead sheets, furnish fine impressions, printed with transparent gelatine printing ink, not only on paper but also on wood, ivory, and glass, and from 1870 to 1880 stereoscopic pictures on glass were put on the market by Wilson and others in the United States.

Woodbury sold his patent to Disdéri & Co., in England, who, however, did not pay the fees; whereupon the rights reverted to him. He founded, in 1868, the Photo Relief Printing Company, which undertook the business of printing Woodburytypes and followed it successfully for years. In France, Goupil & Co., Paris, bought the process and employed it in their works at Asnières. Goupil's building was badly damaged during the Franco-German War in 1870, but was soon reerected. Director Rousselon continued its use until the modern reproduction processes displaced the Woodburytype.

In addition to the firm of Goupil, which later was succeeded by Boussod and Valadon, Lemercier & Co., in Paris, used Woodburytypes in their original form (with hydraulic presses) on a large scale. The Paris photographer and art dealer Braun, at his works in Dornach (Alsace), also bought the rights for the use of Woodbury's process, but he employed it very little in his reproduction of paintings, because it was not as suitable as the pigment printing process, for the large sizes required in reproductions of art subjects. This author, on a visit to Braun's works at Dornach, saw there the complete equipment for printing Woodburytypes with hydraulic presses, turntables, and a number of small printing presses using gelatine printing inks. He succeeded in acquiring the equipment for the Graphische Lehr- und Versuchsanstalt, in Vienna, where it was installed, and for decades it was the last of its kind for teaching this particular technique of printing.

Later, interest in this process waned, and in 1928 the Woodbury-type press was sold as scrap iron. Thus, the last witness of a one-time extremely valuable photomechanical reproduction method passed into oblivion; but the educational courses in the graphic arts relating to Woodburytype were continued.

In Belgium, until the beginning of the eighties, the Woodburytype process dominated the photographic reproduction methods to a great degree. For instance, on the occasion of the wedding of Crown Prince Rudolph of Austria to the Belgian Princess Stephanie, in 1881, thousands of Woodburytype portraits of the bride were sold in Austria.

For the first edition of this author's *Handbuch* (1884, Vol. 1), the Woodbury Permanent Printing Company, London, furnished an insert for the edition of 2,000 copies from an instantaneous exposure, then still very rare, by Marsh Brothers in England. Woodburytypes were not used industrially to any extent in Austria and Germany, because the demand could be satisfied by the heliotype process, which even at that time was quite well developed.

But even in England, France, and Belgium, Woodbury's process disappeared entirely from the graphic field in the nineties, displaced by heliogravure, the halftone process, Klič's rotogravure, and intaglio rapid-printing presses. These processes are capable of producing large editions in a very short period of time, and require no cutting and pasting of individual pictures on pasteboard; they permit the incorporation of illustrations in the text and allow the execution of large sizes; but they have never been able to attain the soft gradations, the superb rendering of middle tones and modulated shadows characteristic of the Woodburytype.

PHOTOELECTROTYPES FROM PIGMENT (HARDENED) RELIEFS

A success equally as great as that of the production of the intaglio lead plates molded by hydraulic presses was attained by Swan's and Woodbury's process of photoelectrotype heliogravure for intaglio printing on a copperplate printing press.

Schielhabel, called Mariot,[11] a photographer in Graz (Styria), recognized in the earlier photoelectrotype method of Swan an excellent aid for photographic copperplate printing. In 1867 he produced sample plates by electrotyping pigment pictures, evidently inspired by Swan's and Woodbury's inventions (already known at the time), and sent a proof of the subject photographed from nature, as well as a reproduc-

tion of an outline drawing, to the Military Geographic Institute, Vienna. The importance of this process for the production of maps was at once recognized there, and Mariot was called to Vienna and in 1869 began the making of maps on a large scale for the General Staff of the army by "heliogravure," as this photoelectrotype process was subsequently named. The Austrian government was the first to put this process into practical use for map making, and used it with the greatest success for the unusually rapid and precise production of military maps.

The Military Geographic Institute, Vienna, played an important role in the history of the graphic reproduction processes. It was founded in 1806 as a printing office and enlarged in 1818 by the addition of a lithographic department. In 1839 the Military Geographic Institute at Milan (which then belonged to Austria) was merged with it. In 1862 Baron Schönhaber introduced photography, and in 1865 photolithographs were printed there on rapid-printing presses. Mariot introduced (1869-91) heliography and photoengraving. Heliography was made usable for general photographic practice by Wilhelm Roese (1781-1883). The outstanding merit for the promotion of the scientific side of photography at this institute belongs to O. Volkmer and Lieutenant Field Marshal Baron Hübl.

Later the photoelectrotype-heliographic process was greatly improved by Roese, who was section chief at the institute, and during his time reproductions of numerous art subjects were made for sale. Roese was called in 1885 to the Government Printing Office at Berlin, where he introduced this method and Klič's process. The Austro-Hungarian Bank employed, from 1877 to 1903, electrotypes of photographic pigment reliefs for the production of banknotes,[12] but in 1903 this method was again abandoned and the government returned to copperplate engraving for this purpose. In the reproduction of art subjects the method also lost ground in the same degree as heliogravure by the etching process gained favor.

Chapter LXXXIX. PRODUCTION OF HELIO-GRAVURES BY MEANS OF THE ASPHALTUM METHOD; BEGINNING OF HALFTONE STEEL ETCHING

THE FIRST attempts to etch heliogravure prints on steel were based (with the exception of etching daguerreotype plates) on the use of light-sensitized asphaltum as an etching top.

Niepce de Saint-Victor, the cousin of Nicéphore Niépce, continued in 1853 the experiments begun in 1814 by the latter of etching heliogravures on metal by the asphalt process. He was convinced that the etching of daguerreotype plates presented too many difficulties. Niepce de Saint-Victor joined the Parisian engraver Lemaître, and they substituted steel plates[1] for pewter and copper, which Nicéphore Niépce used in the beginning. On May 23, 1853, Niepce de Saint-Victor presented his first dissertation on his improvement of the asphaltum process[2] before the Academy in Paris. At first he could only reproduce outline drawings on steel and therefore progressed really no further than his cousin.

But in 1883 he presented to the public halftone etchings from photographs taken from nature, which unquestionably were the most beautiful examples of halftone etching on metal (for intaglio printing presses) offered at the time, showing a surprising perfection in the delicate middle tones. Niepce de Saint-Victor's achievement in connection with his heliographic halftone steel etchings consisted in introducing into photographic technique the old aquatint grain, well known to artists, to which the delicate middle tones were due.

Niepce de Saint-Victor combined the asphalt prints on steel with the dusting-on and melting in of powdered resin along the line of the aquatint method.[3] This fine grain he declared to be indispensable in making halftone pictures suitable for heliogravure printing (intaglio plates), which he expressly pointed out in his publication on heliogravure (1856).[4] Niepce de Saint-Victor built a box in which the aquatint grain was produced by whirling around the powdered resin blown on by a bellows. He laid the steel plate on a shelf in the grain box, the agitated resin dust deposited on it and was then melted in. Thus fine halftones and good printing plates were obtained by deep etching of the low portion of the plates.

After Niepce de Saint-Victor's report on May 23, and another of October 21, 1853, several persons devoted themselves at Paris to the

practical exploitation of heliogravure on steel, among whom were especially Charles Nègre[5] and Baldus. Benjamin Delessert (exhibited at the World Fair at Paris, in 1855, reproductions of Dürer) and Riffaut[6] were masters of this process. The detailed description of the method is contained in Niepce de Saint-Victor's *Traité pratique de gravure héliographique sur acier et sur verre.*

L. Cremière, the court photographer of Napoleon III, was very successful in the use of the steel etching method; the plates made in his studio were printed by Sarazin.

Proofs of heliographic etchings on steel (evidently by the asphaltum process) by Baldus, Riffaut, and Nègre can be found in *La Lumière* (1854, pp. 67, 159, 167, 203; 1855, p. 67).

Charles Nègre of Paris was one of the first painters to employ photography for artistic reproduction. In January, 1854, he joined Niepce de Saint-Victor for study and in the same year published a lovely album of halftone pictures reproduced by the heliogravure on steel process (asphaltum method).[7]

Baldus, about 1854, used Niepce de Saint-Victor's asphalt method for producing a print (from a diapositive) on copper, but he did not etch with acid or anything like it, but in a galvanic bath. He suspended the copper plate, on which was the print on aquatint grained asphaltum ground, at the positive pole of a galvanic battery in a salt solution; this caused the metal at the anode to dissolve, that is, it was etched. By painting in the halftone portions of the plate the etching could be done in graduated stages. A greater or lesser distance of the electrodes (curving of the cathode) was also employed to regulate the graduated depths of the etchings.[8]

Those using heliogravure later overlooked the enormously important influence of the aquatint grain on printing on a copperplate printing press, and even Talbot seems to have been unaware of this favorable effect, while making his first photogravure etchings on copper; at least, he writes nothing about it in his earliest publications on photographic steel engraving, and, as appears in his printed proofs, he had not used aquatint grain in the sixties. Yet this is of basic importance for good printing of heliogravure halftone etchings.

ETCHING ON RUSTLESS STEEL

In modern times rustless steel (alloys of steel with chromium, nickel, chromium tungsten, etc.) has been produced, which is more difficult to

etch than ordinary steel. Alois Schäfer, for many years a photoengraver in Vienna, succeeded in 1929 in etching such steel objects for decorative purposes, using a photographic chromate etching ground. He produced portraits with delicate halftones on rustless steel, which remind one to some degree of daguerreotypes; they offer great resistance to atmospheric and mechanical influences and open new possibilities for photographic steel etching.

Chapter XC. HELIOGRAPHIC STEEL AND COPPER ETCHING WITH THE CHROMATED GLUE PROCESS; KLIČ'S PHOTOGRAVURE; PRINTING WITH THE DOCTOR; ROTOGRAVURE

TALBOT'S PHOTOETCHINGS ON STEEL AND COPPER

Fox TALBOT discovered the light-sensitivity of potassium bichromated gelatine and the change of solubility (swelling) in water after exposure. He drew at once the conclusion from this observation that exposed chromated gelatine layers on metal plates must act as protecting tops against aqueous etching solutions. In 1852 he invented the first such photoetching method by producing images with chromated gelatine on steel plates, etching them with a solution of platinum chloride, and thus obtaining an intaglio surface from which impressions could be made on a copperplate printing press.

He took out an English patent in 1852 on this steel etching process, and in the following year he presented to the Paris Academy of Sciences not only his specifications but also printed specimens from his etched steel plates (*Handbuch*, 1922, IV(3), 22).

Later Talbot recognized that iron chloride furnished a better and cheaper etching medium than platinum chloride for steel and in particular for copper. Iron chloride also offers the advantages that it leaves the insoluble portions of the chromated gelatine prints unharmed and that even when in greatly concentrated solutions it has a tanning effect on the gelatine. Talbot worked out on this basis a new copper etching process for images that gives a better rendering of the halftones.

One of the earliest proofs made by this process appeared in the *Photographic News* (1858, Vol. I, No. 10), and while imperfect, it is very interesting for the history of photogravure.

Still very imperfect, but greatly improved, is a photogravure, or, as Talbot called it, "photoglyph," made by "Talbot's patented process" in 1859,[1] of the Tuileries in Paris (from nature) that appears as an insert to the *Photographic News* of September, 1859. This photogravure shows delicate middle tones without handwork, but the printed proofs lack strength in the shadows, because the aquatint grain is missing.

Talbot had mastered the manipulation of the iron chloride solutions of different strengths and therefore easily obtained soft gradations in his etched plates, which was uncertain or impossible without additional handwork before Talbot's invention. The introduction by Talbot, in 1852, of these processes giving intaglio engravings on copper plates with bichromated gelatine as light-sensitive etching ground, with iron chloride in varied strength as etching fluid, opened the road for modern photogravure.

Talbot's outstanding merit is his invention of the bichromated gelatine process for the production of halftone photogravure plates not only on steel but also on copper, and the specification of iron chloride as the best etching medium for this purpose.

In his early publications on photoetchings Talbot mentions nothing of a dusted-on and melted grain, but recommends that a piece of gauze (crossed lines) be inserted between the negative and the metal plate. This would unquestionably give Talbot the credit of being the forerunner of the later process of photogravure with a screen for intaglio printing plates, for this furnished the basis for the breaking up of images by a screen into lines and dots, so important in the halftone process and for screen photogravure printing with a "doctor."

At the London Exposition of 1862 the earlier photoelectrotype process of Pretsch was threatened with serious competition by Fox Talbot's intaglio photoetchings. Talbot's photogravures, mostly landscapes and architectural subjects, even at that early stage of his process presented soft gradations of tones and met with great success. His contemporaries were liberal in their appreciation of his work. "Talbot has opened a new field for photography and the graphic arts by his heliogravure (halftone copper etching for gravure presses) and he has justly earned the prize which the jury has awarded him," writes H. W. Vogel, one of the official reporters at the exposition. In fact, the further progress of photogravure is directly traceable to Talbot's invention.

The sale of art subjects reproduced by photogravure (intaglio engravings printed on copperplate printing presses) flourished especially in France because of the work of Lemercier, Nègre, Garnier, and other Paris photographers, as was demonstrated at the Paris Exposition of 1867.

Numerous variations of Talbot's method of etching were employed, especially and with great artistic success by Garnier, in Paris, who received the Grand Prix[2] at the Paris Exposition in 1867 for an excellent photogravure of the Palace Maintenon, and by Dujardin, also in Paris, who independently following Garnier's results improved the method and published many beautiful photogravures in the seventies.

The Garnier-Dujardin etching method was complicated and difficult to manipulate. A copper plate was grained with finely powdered resin in a grain box and the resin melted in (aquatint grain), then it was coated in a whirling apparatus with a thin layer of chromated gelatine and dried. A halftone diapositive was then printed on the coated plate and the image thus obtained (of partially insoluble gelatine) was etched with iron chloride. This first bite furnished monotone and delicate impressions. In order to get more contrast and improve the middle tones, the plate was thoroughly cleaned, again grained with powdered resin, coated with another chromated gelatine solution, and another diapositive was printed in exact register and etched again. For the third bite, to intensify the shadows, a diapositive with strong contrasts was used; when the plate was finished and printed on a copperplate printing press, splendid photogravures, with the full range of tones, were obtained. The method required long experience and the assistance of trained engravers, which the Paris firms employed. The process was kept secret, and the manipulation did not become known until much later, in the nineties (*Handbuch*, 1922, Vol. IV, Part 3). Art prints made by this method were produced by Goupil (later Boussod and Valadon), of Paris, both for sale in art stores and for book illustrations. Dr. Eugen Albert, of Munich, employed this Dujardin progressive etching method and the platinotype process in the early eighties[3] for the production of his art prints. Later, however, he adopted Klič's process and other modern methods.

All these methods, however, were surpassed by the photogravure process invented by Karl Klič, at Vienna, in 1879, based on the pigment process, by which at least equally beautiful results were obtained

in a simpler and more certain manner. Klič transferred a pigment image onto a grained copper plate, developed the print in warm water (wash-out process), and then etched with iron chloride solutions of varying strength. The pictures thus obtained showed particular sharpness, rich detail, and halftones. They control the art trade of modern times as far as photographic intaglio printing is concerned.

KLIČ'S METHOD OF PHOTOGRAVURE (1879)

The zenith of heliogravure by the etching method for beauty of results, as well as for sureness and rapidity of production, was reached by the painter and newspaper artist Karl Klič, at Vienna, who combined the pigment transfer process on grained copper plates with the etching process, and thus outstripped his predecessors.

Klič is the creator of modern photogravure with aquatint grain on copper plates by means of the transfer of a pigment image and etching in iron chloride baths of various strengths, in which he etched the half-tone picture to different graduated depths. He was also the first to introduce rotogravure printing with the doctor in graphic art techniques, for which he also used the pigment process, but without grain, for which he substituted a copied crossline screen. Both methods were of fundamental importance, differed essentially from Talbot's process, and are entirely original.

Karl Klič (as the name is spelled in Czechish) or Karl Klitsch (in German) was born on May 31, 1841, in Arnau, a small town, predominantly German, in the district of Hohenelbe, Bohemia; he died Nov. 14, 1926, in Hietzing, a suburb of Vienna. The spelling of his name is specified legally in the book of vital statistics in the local vicarage. It is there registered that to Karl Klitsch, foreman of the paper factory, at No. 71 in Arnau, was born a son "Karl Klitsch." The same document testifies that his grandfather "Georg Klitsch" served as captain in the Infantry Regiment Fürst Reissklau. There is no other documentary record of the spelling of the name other than "Klitsch." Therefore this is the official way of spelling, since the Austrian military formula recognizes no other spelling of this name. It was the father of our subject who during the awakening of Czechish nationalism allied himself with that movement, dropped his German connections, and accepted the Czechish spelling of his name, "Klič," thus disregarding the spelling of the family name by his ancestors. He induced his son, our inventor, to follow him in this. The polyglot

nationalities of the Austrian Empire overlooked and accepted without protest many of these variable spellings. With filial consistency and a patriotic spirit the inventor Karl Klič, whose native language was Czechish, signed all his original drawings, designs, gravures, and contracts with the Government Printing Office, Vienna (1881-82), with the name "Klič." His gravure establishment was officially registered under the title "Klič's Photochemische Werkstätte, Wien IV, Belvederegasse 22."

We tarry longer on the discussion of the spelling of his name, because during the latter days of the inventor a confusion arose about this question, for which, however, Klič himself was largely the cause. In the latter years of the last century (see below) he lived for many years in England. English people found the Czechish pronunciation of his name difficult and called him "Mr. Klik," which annoyed him greatly. This caused him to call himself in England "Klietsch," as he related to this author in Vienna, which he had left as "Klič" and returned to as "Karl Klietsch," director of the Rembrandt Intaglio Printing Co., Ltd. This new spelling of his name was, of course, contrary to the official records.

The new spelling was announced to this author by a visiting card. Klič's Vienna relatives accepted this spelling (Klietsch), while those in Brünn declined it, since it was not according to the official documents. This erroneous spelling "Karl Klietsch" is unfortunately found on his tombstone, at Hietzing, as well as in the otherwise excellent biography by Professor Karl Albert, of Vienna. This spelling is, however, incorrect and was invented by Karl Klič only during a playful mood.

This is difficult to understand without going into the meaning of the Czechish word "Klič." According to the Czechish grammar the letter "i" (carrying a dot) is pronounced short, while with an accent, "í," it sounds soft (long). The Czechish word "Klič" in English means "key," which tickled our inventor's risibility, and he often signed himself as a key or hook. The long "i" appears in German writing as "ie" and Klič's sense of humor caused him to sign his name as "Klietsch," distorting it still more. This is accurately proved by the author in *Phot. Korr.* (June and August, 1928). The historian therefore must spell the name either according to the Czechish manner "Klič" or following the German "Klitsch," but never "Klietsch." We are bound above all to respect the use of his Czechish name "Klič," which he as

inventor of the modern rotogravure printing process, as business man, and as artist chose during his most active period. It is this spelling of his name by which he introduced himself internationally. [The translator was told on a visit to Mr. Klič that he insisted on the Czechish spelling of his name.]

Karl Klič showed a great talent for drawing in his youth and he went to Prague to study under Professor Engerth. His father moved to Brünn (Moravia), where he started a photographic studio in which his son had to assist him. But young Klič was more interested in drawing and lithography and drew cartoons and caricatures for the newspapers. His work attracted attention, and he was called to Budapest in 1867 as a newspaper artist. Later he went to Vienna and became a favorite caricaturist for comic journals. He drew with so-called chemical india ink on zinc plates which were etched in photoengraving shops in Vienna. Then he learned zinc relief etching, and from 1873-74 he made his own line plates. During all this time he looked for a method for better halftone reproduction by experimenting with the pigment process and the transfer to copper plates.

He began experiments with photographic copper etching in 1875, and had so far progressed in 1879 that he was able to apply his process practically, exhibiting his photogravures in October of that year at a general meeting of the Vienna Photographic Society. He made the short announcement that his "heliogravures" (beautiful halftone pictures on paper, printed on an ordinary copperplate printing press) "were produced on solid copper by etching." At the same meeting Klič exhibited cotton cloths which had been printed by the photogravure process from cylinders prepared by him. In November, 1880, Klič again exhibited at the Vienna Photographic Society a collection of his photogravure reproductions of portraits and other subjects from nature. Other early prints of Klič's photogravures are to be found in *Photographische Korrespondenz*, at the Graphische Lehr- und Versuchsanstalt, and in the Technical Museum at Vienna.

Klič produced his photogravures from diapositives on coffee-collodion dry plates, which he at first had made by Victor Angerer in Vienna. Later, Klič made his own diapositives on tannin-collodion dry plates, but he soon turned to the production of glass diapositives by the pigment process.

His work soon became well known, because Klič made single gravures to order, published them, and also delivered heliographic copper plates. Since he worked either alone or with only a few trustworthy

men, owing to his desire to keep his manipulation a secret, his output was small and reached only a limited circle of art lovers; beyond the borders of his own country his process and its advantages remained unnoticed. Klič did not apply himself very intensively, even leaving uncompleted an order for the imperial collection. The English journals published Klič's invention in 1881. The editor of the *Photographic News* and of the *Yearbook of Photography*, London, Captain Baden-Pritchard, requested this author to order from Klič a heliogravure of Mungo Ponton's portrait and 2,000 impressions from it. This work appeared as an insert to the *Yearbook* for 1882 with the credit line, "Heliogravure by Klič, Vienna." This was Klič's debut in England, and it made the craftsmen there acquainted with his work.

Klič had decided to leave Vienna, and he sold licenses for the rights to his process, with the provision of secrecy,[5] to several interested parties, one of which was the Government Printing Office, which made a contract with him on January 1, 1881, and paid him 2,000 florins. Others who bought the process were Jos. Löwy and Victor Angerer.[6] The clients were taught at the small "Klič Photochemical Works."

Then Klič sold licenses for his process in Germany to Hanfstängl, E. Albert, and Bruckmann, in Munich, Meisenbach and Riffarth, in Berlin, Braun, in Dornach, and others. He also licensed some firms in France and England, where he introduced his process personally.

He brought to England his process of rotary photogravure (rotogravure) with etched cylinders for machine printing. He remained in England until 1899 and earned sufficient money there to be able to retire to his own villa at Hietzing, one of Vienna's residential suburbs. Here he died in November, 1926.

Color photogravure (after the style of English color prints from eighteenth century copperplate engravings), produced by tamping colored inks on the copper plate with small printer's balls (tampons), was first attempted by Boussod and Valadon, of Paris, about 1880; later by Blechinger and Leykauf, at Vienna, about 1893, and still later by the Government Printing Office at Vienna.

KLIČ INVENTS (1890) ROTOGRAVURE PRINTING FROM CYLINDERS ON FAST PRESSES WITH THE USE OF CROSSLINED SCREEN; USE OF THE DOCTOR IN FINE PRINTING, AS WELL AS FOR PRINTING ON FABRICS AND WALLPAPER

Photogravure reached its full capacity for mass production only with the introduction of cylinders for intaglio printing, for which, how-

ever, specially constructed presses were required. Such a press for re-productions of outline drawings, and copper and steel engravings, was constructed in practical form in 1877 by Const. Guy, of Paris. This press was equipped with an automatic cleaning and wiping device for use on rotating cylinders. But this press was useless for halftone photo-gravures.

Another idea for the rapid production of these delicate photo-gravures from the ordinary flat copper plates, by a method similar to lithography (lithographic rapid presses), also originated in France (*Handbuch*, 1922, IV(3), 83).

At the Paris Exposition of 1889 the press-builder Marcilly exhibited a kind of lithographic rapid-printing press for ordinary halftone photo-gravures and printed on it some of Dujardin's grained halftone photo-gravure plates. Both Guy and Marcilly accomplished the mechanical wiping of the copper plates by cloths moving in a straight line, which resulted in uneven impressions. Lavière, in Paris, improved this press in 1894 by equipping it with rotating balls for wiping the flat copper plates.

For the rapid printing of large editions the adaptation of photo-gravure to rotary cylinder presses was of great importance. It is known that Pretsch, then Swan, and also Woodbury had this idea in mind, but their plans proved unsuitable for practical execution.

J. F. Sachse expressed himself most clearly in the matter of produc-ing etched photomechanical printing cylinders by etching bichromated gelatine prints.

Sachse, who had previously taken out several patents for textile printing (Brit. patent No. 2,724, July 4, 1879), was granted a British patent (No. 1,909, May 10, 1880), on a process of coating a metal cylinder with bichromated gelatine, printing a positive on it by elec-tric light, the cylinder being slowly turned during the exposure and the print being subsequently etched with iron chloride. Sachse also described the transfer of the photographic print from the bichromated gelatine paper (pigment paper) to the cylinder, the washing out, and the etching. He does not mention the crossline screen, nor had he been able to use halftone images.

Klič recognized in 1890 that for photogravure printing from rotary-press cylinders a screen formation was more suitable than the aquatint grain. He became acquainted with the use of the doctor[7] employed in ordinary rotary intaglio printing at the textile print works at Neun-

kirchen (Lower Austria), where textiles and wallpapers were printed (*Handbuch*, 1922, Vol. IV, Part 3). He grasped the great advantage of the continuous delivery by rotary intaglio presses over that from flat-bed presses. Klič improved on Talbot's awkward interposition of black nets and avoided the breaking up of the image, as practiced in the halftone process, into lines and dots of various sizes. He printed a positive crosslined screen with transparent lines and opaque dots on the pigment image to be transferred on the cylinder, which resulted in producing a delicate screen structure with raised lines on the pigment gelatine top. When the doctor passed over these raised lines, it removed the excess of printing ink from the surface of the plate and allowed it to remain in the sunken parts of the plate, which had been etched to varying depths and represented the picture. Klič named the beautiful halftone intaglio impressions so obtained, "Rembrandt intaglio prints."

Viewed through a magnifying glass, the Rembrandt prints (Klič process) show white thin crossed lines, which break up the picture. These white lines stand out from the dots, etched to varying depths, and are found almost altogether on the surface of the copper plate.

It is on this foundation that Klič introduced his process at Lancaster, England, where he became a partner in the Rembrandt Intaglio Printing Co., which he and Samuel Fawcett started in August, 1895, and which was financed by Storey Brothers. This company kept the process secret and expanded its use extensively. Their large editions, in 1895 and later, of screen photogravures for the art trade, periodicals, and Christmas cards attracted much attention. The process was used not only in the arts and commerce, but also by weekly journals such as the *Illustrated London News*. Subsequently they opened a branch in London.

ADOLF BRANDWEINER, INDEPENDENTLY OF KLIČ, INVENTED INTAGLIO PRINTING CYLINDERS WITH CROSSLINE SCREEN IMAGES AND PUBLISHED THIS PROCESS, IN 1892, IN THE PHOTOGRAPHISCHE KORRESPONDENZ

Adolf Brandweiner[8] made the photographic part of his experiments at the Graphische Lehr- und Versuchsanstalt, Vienna, with asphaltum, but employed also pigment paper transfers, used a screen in printing on metal and a doctor for the removal of the ink from the surface of the cylinder. He realized the importance of the raised screen lines for

intaglio printing with a doctor. At this time Klič's process was kept strictly secret, and Brandweiner could not have known anything about it. He produced in 1891 at the Graphische Lehr- und Versuchsanstalt steel cylinders, prepared according to his idea, for the cotton-printing firm Cosmanos, in Joseftal (Bohemia); these cylinders are preserved in the technical museum at Vienna. While Brandweiner probably mentioned the use of this process for printing on paper, he did not pursue it in this direction. Brandweiner's rights to priority, as far as the publication of this invention is concerned, are today fully established, and they played a great role in later patent suits (*Handbuch*, 1922, IV(3), 94; and *Jahrbuch*, 1906, p. 581). In fact, neither Klič nor the Rembrandt Company ever patented their process or initiated court proceedings, but contented themselves with keeping their method secret.

Theodor Reich, a technician in the reproduction processes, born at Vienna, in 1861, lived in 1895 in London, where he was employed. The Rembrandt screen rotary photogravures came early to his attention, and by careful consideration of the formation of the light screen cross lines in these photogravures, he arrived at the correct method of producing these printing plates. Without further knowledge of Klič's secret manipulation, he succeeded in producing such photogravure copper plates. He did not, however, print these plates on a rotary press, but worked with flat copper plates, printed on a sort of lithographic press, using the doctor for the removal of the superfluous printing ink. This allowed an increased speed in production greater than the early Klič method with aquatint grain and the slow wiping with pads and tampons. The method was quite adaptable for small runs, but of course it could not compete with the large production of rotary intaglio printing. He therefore reconstructed his lithographic presses.

Reich first introduced the method invented by him in England, where he founded the Art Photographic Company, Limited, which he managed from 1897 to 1903.

He sold his process ("mezzo-tinto-gravure") in 1903 to Bruckmann, in Munich, and introduced it in 1904 to the Wiener Kunstdruck Aktien-Gesellschaft,[9] formerly J. Löwy, as well as in firms in France and America.[10]

The manipulation in Reich's method is relatively simpler than rotary printing, but the latter is much faster and later entirely displaced the printing of flat-plate gravure plates when large editions were demanded.

PATENT DISPUTES OVER ROTARY INTAGLIO PRINTING WITH PHOTOGRAPHIC
CROSSLINE SCREEN PRINTING CYLINDERS; AWARD OF PRIORITY TO
BRANDWEINER BY THE GERMAN SUPREME COURT AND ANNULMENT
OF MAEMECKE-ROLFF'S PATENT

Klič's invention was used in England on a large scale, but the mode of procedure was never made public. Adolf Brandweiner, while having assured to himself the claim of being the first to publish his similar invention in detail in the technical publications, had disappeared from the field of its practical application.

Klič became rather disturbed when other inventors, especially Rolff, took out English patents on the use of crossline screens for rotogravure printing from cylinders; he questioned the ability of others for independent invention and claimed that he was being "spied upon." He kept his silence, however, because he felt that these patents would not interfere with his work and that he could, when necessary, establish his claims of prior practical use of the method. But no legal difficulties of this sort arose.

At that same time Dr. Ernst Rolff, a German textile printer, without having knowledge of Brandweiner's publications, took up the idea of producing cylinders for textile printing, employing the doctor, by the photochemical process. This idea came to his mind on reading an article referring to this problem in the program of the Industrial Society of Mulhouse, May 18, 1898. Dr. Rolff applied for a German patent covering this subject on June 13, 1899, under the name of his lawyer, Dr. Maemecke, and for an English patent under his own name. The English patent was granted on November 9, 1899 (No. 22,370).

The German Patent Office delayed issuing the patent, contesting its originality, owing to Brandweiner's publication. In fact, they had before them only an incomplete extract of Brandweiner's publication contained in the book by Wilhelm F. Toifel, *Handbuch der Chemigraphie* (1896, 2d ed., p. 197). The examiner accepted Dr. Rolff's viewpoint that Brandweiner spoke of the use of a line screen, not of a cross-line screen, and granted the patent on June 15, 1899 (No. 129,679) for the use of the cross-line screen in rotary intaglio printing, which seemed to imply a kind of monopoly for the use of cross-line screens for rotary intaglio cylinders in Germany, England and other countries.

Dr. Eduard Mertens, chemist and technician in the graphic arts, who worked along the same lines quite independently of Rolff, saw that

Rolff's patent stood in his way and therefore joined him, so that both might improve their work.

Dr. Mertens had started an attack on Rolff's patent, but the suit was dropped on the basis of the joint exploitation of the patent. For several years it seemed that the patent was incontestable, but events took a different course; for the earlier claims of Brandweiner to the invention were much more comprehensive than was assumed, because of the lack of familiarity with the original publication of Brandweiner (*Phot. Korr.*, 1892, p. 1).

The publishing house F. Bruckmann A.-G., Munich, and the firm Meisenbach, Riffarth & Co., Berlin-Schöneberg, brought suit before the Patent Office at Berlin for annullment of the Maemecke (Rolff) patent (No. 129,679 of June 15, 1899) on the ground of several previous publications. With its decision of March 4, 1909, the Patent Office acquiesced in the petition and annulled the patent.

Ernst Rolff appealed this decision to the Supreme Court; the joint owner of the patent, Dr. Mertens, did not participate in the appeal. At the session of November 26, 1910, the court confirmed the decision of the Patent Office, and the contested patent was definitely annulled.

In this judgment the publication of Brandweiner in the *Photographische Korrespondenz* (1892, p. 1) played a decisive part, and the very exhaustive opinion of the court definitely established the priority claim of Brandweiner to the invention, which had been conceded for a considerable time previously in technical circles.

The reasons upon which the court based its judgment, in its thorough objectivity, are of such interest for the history of rotary intaglio printing that the author printed them in his *Handbuch* (1922, IV(3), 105).

It follows primarily from the consideration of the contents of Brandweiner's article in the *Photographische Korrespondenz* (1892, p. 1). . . It was in no way Brandweiner's opinion that the intaglio cylinder for photomechanical textile printing required a single-line screen. On the contrary, he advocated for this purpose the underlying idea, which is claimed as the essence of the Maemecke-Rolff patent, namely, the application of a cross-line screen. This follows without question from the original publication, where it is clearly stated that the halftones must be broken up into lines or dots; but cannot be formed with a single-line screen. It further follows from the fact testified to by Dr. Miethe that the use of the single-line screen had been entirely abandoned before 1902 and that every expert employed the term "screen" as meaning "cross-line screen" unless otherwise specified.

The system of crossed lines which stand out in relief on the surface of the plate and over which the doctor passes thus had been described by Brandweiner. . . . However, in this case it must be considered that the particular adaptability of the cross-line screen as the surface for the attack of the doctor had already been known. It is not only the last-cited British patent, No. 1,791, by Swan, in 1865, which goes into this matter in great detail. As has been explained by the expert, a cross-line screen was also used by textile printers in the sixties and seventies of the last century. Those earlier printers, who engraved with the roulette, used, of course, copper printing cylinders. On the other hand, Swan's description, while it refers to flat-bed printing, takes the photomechanical screen as a basis. But the idea that a cross-line screen was pre-eminently suitable for the use of the doctor was common property in the industry.

Under these circumstances it may appear strange that a cylinder prepared photomechanically with a cross-line screen, was not used, as far as we know, for intaglio printing before the contested patent was taken out. One may speculate as to the reasons which might give an explanation for this, but this cannot alter the decision. The patent is declared null and void, not on account of prior use, but on account of prior publication. This cannot be denied in the face of Brandweiner's article when properly interpreted. . . . Rolff's appeal is denied.

This exhaustive argument of the court unquestionably proves that Adolf Brandweiner was the first, in 1892, independently to invent rotary intaglio printing (rotogravure) with a crossline screen and doctor and to make this process public. This decision by the highest court removed the threatened monopoly in the manufacture of photomechanical intaglio printing cylinders with a screen.

INTRODUCTION OF ROTARY INTAGLIO PRINTING (ROTOGRAVURE)
FOR NEWSPAPERS BY EDUARD MERTENS

Dr. Eduard Mertens (1860-1919), studied chemistry and physics at Berlin, Kiel, and Geneva and received his doctor's degree in philosophy at Berlin in 1888. About the same time as Rolff he investigated, independently and alone, the same problem of photomechanical printing with the use of a doctor. He started a concern for engraving and printing near Berlin in 1889, and published elaborate museum catalogues. In 1897 he merged a rotary gravure business with his own establishment and commenced experiments with rotary photogravure along the lines of Klič's method (which the latter used in England as a secret) under the name "Graphische Gesellschaft in Berlin von Dr. E. Mertens & Co."

In 1900 Dr. Martin Schöpff joined Mertens, and between 1903 and 1905 they transferred screen images from gelatine-bichromated paper (pigment paper) to cylinders with great success. Mertens's personal desire, however, held fast to the use of direct photographic printing on a cylinder, coated with a bichromated glue solution. In 1902 Mertens etched a halftone diapositive of the Emperor's portrait on the seamless cylinder of a rotary press at a wallpaper factory, and in 1903 and 1904 he contracted for the construction and delivery of rotary intaglio printing presses. The Alsace Printing Machinery Co., Mülhausen, exhibited in Mertens's laboratory in 1904 a special rotogravure press for illustrations and text, with three thousand revolutions per hour.

Dr. Mertens's achievement lies in the ingenious construction of the mechanical parts of the rotary gravure press, by which it was made possible for newspaper presses to print gravure plates at a high speed, thus paralleling the slower gravure presses for finer grades of illustrations as Klič used them.

In 1904 Mertens elaborated his combination of typographic and gravure printing in one printing operation for newspapers. The first attempt of newspaper gravure printing, in which halftone pictures and text were delivered from one and the same printing cylinder, was produced by Dr. Mertens in part of the newspaper *Der Tag* of April 26, 1904. The author, who has seen this copy, must pronounce it perfectly successful. Dr. Mertens was the first to print illustrated papers and newspapers on fast gravure printing presses, and without doubt we are indebted to him for rotary gravure printing at high speed.

The Mertens's German company, in Freiburg (Deutsche Mertensgesellschaft), which he founded, worked in the whole field of book and newspaper printing. The so-called Mertens process consisted of a combination of rotary intaglio ond typographical cylinder printing presses. The first of these tandem presses was erected at Freiburg in 1910, for which the Alsace Printing Machinery Company delivered the gravure presses, and Voigtländer, the typographic rotary press. The publisher of the *Freiburger Zeitung*, Max Ortmann, and later the firm of Schmidt Brothers, participated in the production of rapidly drying printing ink.

On April 1, 1910, appeared on Easter the first number of the *Freiburger Zeitung* printed in a combination of typography and gravure at the rate of ten thousand impressions per hour. This was the first time

a large illustrated newspaper was produced in such a large edition. The illustrations were etched by photogravure, using a screen on a cylinder, and the text was set up in the usual typographic manner; the printing was done on a cylinder press and a rotogravure press coupled together in tandem. This newspaper edition, which is historically so original and important as the first printing of rotary photogravure on ordinary cheap newspaper stock, also contained a description of the process. The costly and complicated installation of the tandem typographic and gravure cylinder presses forced illustrated newspaper plants to replace the Mertens combination printing method with the printing of both text and illustrations from one and the same cylinder.

Rotary gravure printing has certain advantages over halftone relief printing, which rest in particular on the possibility of using inferior uncoated paper. The method of preparing printing cylinders with halftone screen formations, using the doctor and carbon tissue, as well as the transfer of the pigment images onto the cylinder, corresponds completely to the early Klič "intaglio process," which originally had been kept a strict secret. Although for a long time this fact seemed wrapt in mystery, the historical truth eventually came into its own (*Handbuch*, 1922, Vol. IV, Part 3).

USE OF GELATINE SILVER BROMIDE PAPER IN PLACE OF PIGMENT PAPER
FOR THE TRANSFER OF IMAGES SUITABLE FOR ETCHING TO COPPER
PLATES

Silver bromide papers, which can be printed much more rapidly, can be used for photogravure in place of pigment paper if the image is prepared according to Warnerke's process or along the lines of bromoil prints. In this manner resist transfers on copper can be produced which are suitable for photogravure etching with iron chloride.

In 1891 Oskar Pustet, of Salzburg, described his experiments with a photographic etching method, in which he was the first to use Warnerke's transfer method for a gelatine silver bromide image, developed with pyrogallol after the manner of pigment printing, on copper and etched grained photogravures (*Jahrbuch*, 1891, p. 195). Then Warnerke himself mentioned this method of "photogravure" (*Jahrbuch*, 1899, p. 587). This is the procedure given for the use of the gelatine silver bromide images, tanned in the silver portions of the picture by suitable developers. While Pustet and Warnerke developed with pyrogallol, Gustav Koppmann later used the alkaline developer pyro-

catechin, which acts similarly, for the transfer of gelatine silver bromide images to copper plates (after the manner of carbon prints) for photographic etching. But this method was never employed in photographic practice.

The bromoil process also starts with gelatine silver bromide paper, because the developed silver bromide images are tanned in their silver parts in a bath of bichromate and potassium ferricyanide or copper bromide. These layers can then be etched along the lines of photogravure, or they can be transferred to copper plates by the carbon printing method and etched in combination with crossline screens. This method of screen photogravure was published in April, 1914, by Paul Schrott, who took out an Austrian patent (No. 72,450) and a German patent (No. 303,136). The practicability of this method Schrott[11] demonstrated by a screen photogravure, which he produced at the Graphische Lehr- und Versuchsanstalt, Vienna, and which appeared in 1918 in the *Photographische Korrespondenz* (1918, No. 695; see also *Handbuch*, 1922, IV(3), 134).

Thus the historical development of the application of gelatine silver bromides, which can be printed so fast and are so adaptable to the direct enlargement or reduction of pictures for photolithography and collotype, had also come to photographic copper printing; of course, for the latter purpose gelatine silver bromide could not take the place of the earlier method with pigment paper in practice.

Chapter XCI. PHOTOLITHOGRAPHY; ZINCOGRAPHY; ALGRAPHY

WE SHALL leave out of consideration the fact that in his experiments with light-sensitive resins in 1815 and 1816 Nicéphore Niépce used lithographic stones. While he thus attempted photolithography, he attained no practical results and dropped the method in favor of what he called "heliographic etching on metal. It is, therefore, difficult to justify the claim sometimes made, that he should be called the inventor of photolithography. It is true, however, that long after Niépce's death the starting point for the production of photolithographs was the heliographic asphaltum process invented by him.

The first successful attempts to produce halftone photolithographs by the asphaltum process were made by Lemercier, Lerebours, Barres-

wil and Davanne in Paris, who published the first experiments in 1852. Lemercier was a famous Paris lithographer, and Lerebours the well-known photographic optician in Paris; the other two were chemists and amateur photographers. The right kind of men had associated themselves for joint work, and they soon produced fine photolithographs. They coated grained lithographic stones with asphaltum, exposed under a paper negative, washed with turpentine, and obtained photolithographs[1] ready for printing by the ordinary method on lithographic presses.

They published a now very rare collection[2] of these direct asphalt photolithographs in 1853, entitled *Lithophotographie; ou, Impressions obtenues sur pierre à l'aide de la photographie*, by M. M. Lemercier, Lerebours, Barreswil and Davanne. The first number contained photolithographs, size 40 × 57 cm. (about 15¾" × 22½"), showing architectural subjects of Strassburg (negatives 1851), of Chartres (negatives 1852), Neuviller, Beauvais, and other places. This publication, which has entirely disappeared from art and book stores, is the earliest portfolio of photolithographs in the halftone manner. These asphaltum "lithophotographs" show remarkable strength, with a somewhat coarse grain in the middle tones. We must consider them the first successful attempts at printing on lithographic presses halftone photographs copied directly on stone.

The uncertain manipulation and the washing of the large stones with turpentine, which was rather expensive at that time, were a hindrance to the spread of the method, but it was reintroduced later with great success by other photographers.

Poitevin's invention of the bichromated albumen process on stone, however, soon relegated the asphaltum process to the background, because Poitevin's method was more certain, required a shorter exposure, and needed only water for washing, advantages which soon attracted attention.

In the early months of 1855 Poitevin discovered the property that mixtures of potassium bichromate with gelatine, albumen, gum arabic, and other substances, after exposure to light have of retaining greasy printer's ink, while rejecting water in the exposed parts, the unexposed parts retaining their solubility or ability to swell in water. Poitevin, with great vision, at once recognized the far-reaching importance of his observation and thus invented the principle underlying collotype, photolithography with chromate layers, as well as pigment printing.

The first practical application of a potassium bichromated gum mixture for direct prints on stone for the production of photolithographs is supposed to have been made, according to several statements, by the American Joseph Dixon (1841), in Massachusetts (Harrison, *History of Photography*, 1888, p. 99); but the first published account of the process did not appear until 1854, in the *Scientific American*, and did not become known or adopted in practice.

Poitevin patented his process in August, 1855, in France and other countries,[3] and then devoted himself entirely to the perfecting of photolithography and the halftone process on grained stone. In order to exploit his process, he sold all his patents for 20,000 francs in October, 1857, to the well-known Paris lithographer Lemercier, in whose lithographic plant subsequently many photolithographs in line as well as in halftone from photographs made from nature were produced.

Poitevin coated the stone (grained for halftone pictures) with a solution of potassium bichromate and albumen, equalized the coating with a tampon, dried, exposed under a negative, washed with water, rolled up with greasy ink (or rolled up first and then washed), which only adhered to the parts which had become insoluble by exposure to light, but did not adhere to the moist parts. The stone was then etched and printed by the usual lithographic method.

Fine photolithographs were thus obtained; the halftone pictures on grained stones were beautiful, so delicate in the middle tones and deep in the shadows that even modern craftsmen are surprised by the excellence of these photolithographs of Poitevin, printed by Lemercier, which have now become so rare. Lemercier is said to have printed seven hundred impressions from such a photolithographic stone before witnesses.

Ernst Conduche expressed the theoretical view that in the practice of Poitevin's process the stones are soon worn out by the mechanical wear and tear on the bichromated albumen picture-images and that photolithographs have the proper resistance in printing only when the lithographic or greasy soap comes in direct contact with the lithographic stone;[4] he advanced practical recommendations along these lines.

Lemercier seems to have made his largest photolithographic publications only with Poitevin's chromated albumen method. Numerous photolithographic halftone pictures still exist from the fifties, signed "mise sur pierre par Lemercier (procédé Poitevin)."

Lemercier exhibited before the Paris Photographic Society, July 20, 1860, as a novelty photolithographs which had been printed from two stones (halftone and keyplate).

Poitevin, in his *Traité de l'impression photographique* (1862, p. 79), cites numerous publications by Lemercier, produced by Poitevin's process on grained stones. At the Paris Exposition in 1862 Lemercier exhibited photolithographs made by both the asphaltum process and the chromated albumen method of Poitevin.

Niepce de Saint-Victor also produced a sort of intaglio design for ornaments by engraving on lithographic stones by the asphaltum process, to be printed on a lithographic press (*Compt. rend.*, 1856, XLIII, 874, 912; Kreutzer, *Jahresbericht*, 1856, p. 120).

In 1855-56 Macpherson also recognized and published the importance of grained stones in asphalt-photolithography. This method was later improved and used commercially, especially by Karl von Giessendorf, at Vienna, who devoted himself exhaustively to Lemercier's asphaltum process. Giessendorf was employed in the Government Printing Office, Vienna, at the end of the fifties, but found himself with time on his hands. He improved the method of making asphaltum prints on grained stone by the halftone method in the early sixties and introduced the process in the lithographic plant of Reiffenstein and Rösch, Vienna, and in 1864 he showed such prints at the Vienna Photographic Exhibition. After the death of Giessendorf, in 1866, Reiffenstein[5] far excelled his teacher, but notwithstanding its excellence his work (in which he was later joined by L. Schrank, editor of the *Photographische Korrespondenz*) was not appreciated at the time and gradually disappeared; even Reiffenstein's photolithographic color prints, made by this method in 1866, were produced only for a short period.

This is historically noteworthy, because this method was the basis for the later "Orell-Füssli process," which also employed color photolithographic printing according to the halftone asphaltum process (although with much handwork by the artist), a method by which enormous editions (especially of town views) were distributed.

A direct reproduction method on grained stone with gum arabic, sugar, and potassium bichromate was brought out by J. A. Cutting and L. H. Bradford in Boston, 1858.[6] They printed from a diapositive, directly on the stone coated with bichromated gum arabic; washed in soapsuds, which removed the unexposed gum arabic and made the

stone capable of absorbing the greasy ink on these parts; then the exposed gum arabic was washed off with hot water, and the positive image produced by the action of the soapsuds was printed on a lithographic press. Snelling's *Photographic and Fine Art Journal* (1858, pp. 117, 254, 289, 321) has good examples of this remarkable method, which, however, was soon forgotten.

For the invention of zincography with chromated albumen or gum arabic by A. and L. Lumière, of Lyon (1892), which produces a positive print from a positive, see *Handbuch* (1922, IV(3), 11). Here must also be mentioned the light-tracing method from zinc prints (see also Karl Albert's *Lexikon der graphischen Techniken*, 1927).

The photolithographic transfer process from chromated papers was invented by Eduard Isaak Asser (1809-94), in 1857, at Amsterdam. Asser studied law and received his doctorate in law in 1832. He became interested in Daguerre's process, went to Paris to purchase photographic apparatus, experimented with Niepce de Saint-Victor's photographic asphaltum process, and was familar with Poitevin's chromated albumen printing method on stone. He was the first to make photographic prints with greasy ink on paper coated with starch paste and sensitized with bichromate for transfer on stone, proofs of which he sent in 1859 to the Paris Photographic Society. Later he exhibited his improved process at Paris, Vienna, and Amsterdam and received numerous medals.[7]

Shortly after Asser, J. W. Osborne, of the Survey Office of Victoria, at Melbourne, reported to the Philosophic Society of Victoria (Australia) that photolithographs could easily be produced with photolithographic transfer papers, which are coated with bichromated gelatine, albumen, gum arabic, or asphaltum, and on which a greasy color print is produced. He recommended especially albumen paper, coated with potassium bichromate and gelatine, dried, printed, rolled up with greasy lithographic transfer ink and developed with a wet sponge. Osborne received one thousand pounds sterling from the government of the State of Victoria, because his process was of great value for the production of maps. Osborne considered this process, which he improved in 1863, novel, but mentioned that Asser also had invented a transfer method. Osborne's method, however, was taken up more intensively for practical use, especially since he made transfers, in 1860, on zinc plates, which had been given a slight bite or which were grained with sand.

A. Wood called attention to the fact, in 1863 (*Phot. News*, 1863, p. 154), that it is not necessary to treat the greasy photographic image on chromated gelatine with hot water, but that it suffices to place the exposed paper rolled up with greasy ink in cold water and wipe it with a sponge, which removes the greasy ink in the white parts, while the parts representing the picture hold the lithographic transfer ink.

Photolithography was soon extensively employed, particularly for the reproduction of plans, maps, and outline drawings, in conjunction with printing on rapid lithographic printing presses, this method developed one of the lowest priced branches of lithography suitable for mass production in the lithography trade. We cannot enter here into further details and improvements of the photolithographic transfer process; but we must mention that frequently halftone images were transferred—for instance, from collotype plates or from grain paper to smooth lithographic stones. This was proposed in 1897 by August Albert, of Vienna, who transferred a collotype from a smooth photolithographic gelatine paper to a grained lithographic stone. For a description of these various methods refer to August Albert's *Verschiedene Reproduktionsverfahren mittels lithographischen und typographischen Druckes* (1899).

Experiments were also made to print a worm-like grain (collotype grain) photographically on stone, for instance, by E. Mariot, of the Military Geographic Institute, Vienna. He made a photographic enlargement six times the size of a natural grain collotype plate, transferred the enlargement onto a smooth lithographic stone, composed several such pieces on a large sheet, and again printed the composite image on stone. From this a film negative was made, used as a screen between a continuous tone negative and photographic chromate gelatine transfer paper. Or he placed the grain negative in contact with the continuous tone negative and made a diapositive (*Phot. Korr.*, 1884, p. 3).

The impetus for direct photolithographic transfers from negatives on glass to lithographic stones was given by engineer Carl Aubel in 1875. So-called Aubel prints were produced by coating a collodion negative with chromated gelatine, drying it and exposing it through the glass, then the print was washed like a collotype plate, dried, dampened, and inked and either printed directly or transferred to paper and printed from stone. The German firm of Aubel & Kaiser used this method for a number of years. Fine line reproductions were

produced with great precision, and the photographic journals of that period contain good proofs made by this method.

G. Pizzighelli made prints directly from gelatine silver bromide plates with greasy ink at Vienna, in 1881, and he published his process with proofs in the *Photographische Korrespondenz* (1881, No. 214).

A gelatine silver bromide negative, after having been developed with oxalate of iron, fixing, washing, and drying, was bathed in a potassium bichromate solution, dried, and exposed through the glass, as in the Aubel method. The black lines in the negative prevented the light from penetrating, and these parts took on water when the greasy transfer ink was rolled on, so that the printing ink was retained only on the transparent parts of the negative. This greasy picture could be printed directly or transferred to a lithographic stone. Pizzighelli reports in his article all the details of the procedure for this method, which reproduce the image in its original size, while transfer papers dampened with water will shrink or stretch and thus alter the original dimensions.

PLANOGRAPHIC PRINTING FROM ZINC; PHOTOZINCOGRAPHY

To Sir Henry James and J. W. Osborne we are indebted for the introduction of photo-planographic printing[8] from zinc plates, so called "zincography," by which impressions are produced analogous to those obtained by printing from a stone on a lithographic press. The English Colonel Henry James made the first successful attempts, at Southampton, in 1859, to transfer a greasy ink print produced on chromated gelatine or gum to zinc,[9] which he mentions[10] in the preface which he wrote for A. C. Scott's *Photozincography* (1862).

James copied for Mr. Gladstone some old manuscripts and documents, and in 1859 he inserted in his annual report the reproduction of a small document of the time of Edward I, which he followed with other works. About this time James learned that Osborne had applied for a patent on his process of photolithography. He convinced himself that the principle was the same as that of his photozincography, of which he had stated in his report that the method could be applied to zinc or stone. Since James had made his report public in print and since this report had been widely distributed among English engineers and officials, James must be credited with being the first to publish photozincography by transfer.

In September, 1861, James delivered a lecture on photozincography

before the British Association.[11] A gum arabic bichromate print made on paper with greasy ink was transferred to zinc (or stone), etched with gum arabic solution and phosphoric acid. This method was then in use at the Ordnance Survey at Southampton.

The English Cartographic Institute, through James, produced successfully many old and valuable manuscripts by photozincography. Captain Scott, in his book on photozincography mentioned above, says that in 1862 gum arabic was no longer employed in this method and that gelatinated paper had taken its place for the transfer of the greasy ink pictures. The method was quite similar to that of Osborne. Scott also mentions that one or more impressions of these greasy ink pictures could be made on another piece of paper by placing them in contact on a press. This was probably one of the starting points of the later "oil print."

About 1865 Colonel Sir James introduced planographic printing from photographic zinc plates, besides photolithography, at Southampton and in the New Zealand Survey Office and later also in the Government Survey Office at Calcutta.

James's photozinc prints were splendidly represented at the Paris Exposition of 1867 by reproductions of national manuscripts, a facsimile of an old Shakespeare manuscript, a survey of Jerusalem, and other reproductions.

Planographic printing from zinc displaced the use of litho stones more and more in the whole field of lithography, especially in photographic printing, the stones being difficult to obtain in large sizes. In printing light tracings, also, zinc was largely used.

The ease with which thin zinc plates can be curved around the cylinder of a rotary printing press opened the way for the rapid printing of large editions.

USE OF ALUMINUM PLATES FOR LITHOGRAPHIC PRINTING (ALGRAPHY)

When advancing engineering skill made possible the production of thin aluminum sheets, it turned the thoughts of reproduction technicians to their use analogous to that of zinc plates. John Mullay and Lothrop L. Bullock, of New York, wrote in 1891 that they had found a method in which pure aluminum sheets served as substitutes for the lithographic stone and that this metal is treated in the same manner as the stone.[12] But in practice no one succeeded in printing from aluminum when the ordinary etching fluids applied in lithography were used.

The correct treatment of aluminum for printing was invented first by Joseph Scholz, at Frankfurt a. M., who was granted a patent September 18, 1892 (No. 72,478), on his "Verfahren der Zubereitung von Aluminiumplatten." He correctly states in the introduction to his patent application:

Up to this time it has not been possible to prepare aluminum plates in a suitable manner for lithographic printing. All attempts were frustrated by the use of the etching fluid ordinarily applied to stone. This mordant did not achieve the desired result, because it could not create a sufficiently adhesive layer on the bare metal which would prevent the spread of the printing ink.

Scholz etched with phosphoric acid, hydrofluoric acid, fluosilic acid, etc. The method of printing from aluminum sheets, so-called "algraphy," was quite successful,[13] both with and without the use of photography, but it did not entirely displace zincography.

OFFSET PRINTING, OR INDIRECT PRINTING, FROM RUBBER BLANKETS

In offset printing, or indirect printing, the image produced by the relief, planographic, or intaglio process is transferred from the printer's form to a printing cylinder covered with sheet rubber and from this the impression is printed onto the paper. The rubber blanket, imprinted with the greasy ink impression of the image which it is to transfer, makes perfect contact with rough and grained paper, and large editions are rapidly delivered by rotary presses. Since the offset process lends itself very successfully to multicolor printing, it has found wide application in this field. Being concerned with the history of photography only, we cannot enter into details of the many applications of this process.

ETCHING ON GLASS AND HYALOGRAPHY

The method of engraving based on the etching of glass with hydrofluoric acid through a wax coating was invented in 1670, by Heinrich Schwanckhardt, a glass cutter of Nuremberg. Glass is coated with wax or a similar etching ground, the design engraved with a graver (burin) and etched with aqueous or gaseous hydrofluoric acid, as described by Professor Lichtenberg in 1788 (Güttle, *Die Kunst in Kupfer zu stechen*, 1795, p. 337). The first to produce printing plates for typographic or copperplate presses by etching on glass was probably Hann, at Warsaw (1829), who called his process "hyalotype,"[14] Professor

Böttger, of Frankfurt a. M., and Dr. Bromeis, of Hanau a. N. (1844), as well as C. Piil, at Vienna, improved "hyalography" (1853), all of which is detailed in *Handbuch* (1922, IV(3), 318).

Of special importance was the use of the lithographic transfer process for the etching of ornaments on flat glass sheets with hydrofluoric acid or sodium fluoride. The first technically complete description we owe to Karl Kampmann (1889),[15] who by the addition of soft gum elemi to the greasy lithographic transfer ink increased the resistance of the picture transferred on the glass to the etching fluid. Kampmann also brought photolithography to the service of this process. With aqueous hydrofluoric acid he etched the glass for depth, retaining a smooth and clear surface, whereas hydrofluoric acid more or less neutralized with soda produces a finer or coarser mat surface. By the use of flashed glass beautiful results can be obtained which find extensive industrial application. Details of this method are described in Karl Kampmann's *Die Dekorierung des Flachglases durch Ätzen und Anwendung chemigraphischer Reproduktionsverfahren für diesen Zweck*, Halle a. S., 1889.

Chapter XCII. COLLOTYPE

THE IDEA underlying "collotype" we find described as early as 1855 by Poitevin. He recognized that a plate coated with bichromated gelatine, after exposure to light under a negative and after being rolled up with water, is capable of accepting greasy ink only on the exposed parts, which makes it possible then to produce direct prints from the gelatine coating. It took a relatively long time, however, before this process was introduced into practical printing. Photolithography, zincotypy, and photogravure were all used on a practical scale before collotype or printing direct from chromated gelatine was practiced.

It was not until 1865 that the Frenchmen C. M. Tessié du Motay and Ch. Raph. Maréchal, in Metz (Lorraine), employed chromated gelatine coatings on a copperplate base under the name "phototype," and at that only temporarily, because the gelatine top on the copper base did not adhere sufficiently for printing large editions and peeled off quickly. At any rate, they produced collotypes of good quality in small editions for their own use, as samples for their painted glass, and very few of these prints were known to the public.[1] These first

practical collotypes, or "photo-gelatine" prints, suffered chiefly in the reproduction of the middle tones, and these incunabula of collotypes therefore show hard half tones, but they must nevertheless be considered quite respectable achievements.

Collotype[2] did not become a practical and productive process until Josef Albert, a photographer of Munich (1825-86), contributed his important improvements. He employed plate glass as the base for the chromated gelatine and attained the adhesion of the gelatine top by preparing the glass with an original gelatine chromate layer that had been exposed to light. Josef Albert aroused the interest of the whole craft by the exhibition of his prints at the Third German Photographic Exposition, in Hamburg, 1868. They were generally called "Albertotypes."

Josef Albert, the son of an engineer at Munich, studied at the Polytechnikum, Munich. He learned the daguerreotype process and opened a photographic studio. There he produced (about 1869) large photographic reproductions of paintings for the art trade, and in the middle of the sixties turned his whole attention to the photomechanical process, which led him to the improvement of collotype. His efforts found favor at the Royal Bavarian Court, and he was rewarded with orders and numerous prizes at exhibitions. He was also the first to carry out successfully practical three-color collotype. His wife continued the business after his death. His son Eugen Albert devoted himself primarily to photogravure and the three-color halftone process, and he introduced orthochromatic collodion emulsion into the reproductive process.

A drawing teacher in Prague, Czechoslovakia, Professor Jakob Husnik played an important part in the practical development of collotype, for he achieved, as early as 1868, such noteworthy success in publishing art subjects by this method that Josef Albert found himself compelled to buy Husnik's process and incorporate its advantages with his own.

Jakob Husnik (1839-1916) was born near Pilsen (Czechoslovakia), studied at the academy for painters in Antwerp, became professor of drawing in his native town and later in Prague. In the seventies the director of the Government Printing Office invited him to continue his experiments on collotype at the department's plant and to improve photozincotype, photographic etchings on copper, photogravure, and so forth. Husnik accepted the invitation and published his results in

several books.³ He was also the founder and the expert advisor of a company in Prague which dealt mostly in halftone engravings. After having been pensioned, in 1889, he became a partner in the firm of Husnik and Häusler in Prague (*Phot. Korr.*, 1916, pp. 141, 170).

About the end of 1868 Max Gemoser, a lithographer at Munich, introduced collotype on lithographic stone as base and called the process "photolithography." He joined (1860) the firm of Ohm and Grossmann, at Berlin, in order to exploit the process in business, and designated the process then as "Lichtdruck," which name became generally adopted in the German-speaking countries. Gemoser asserted that he was the inventor of collotype, but Josef Albert established his claim to priority successfully.⁴

In the beginning Josef Albert did his printing entirely by hand, and his collotypes in the larger sizes were artistically executed and made the process popular. The production of collotype prints on hand presses was too slow for large editions; Josef Albert conceived the idea of employing rapid-printing presses and took as his model the rotary lithographic processes which were then in use. He ordered from Faber & Co. (later Faber & Schleicher, in Offenbach on the Main), according to his specifications, the first rotary collotype press, which was in operation in 1873 and made collotype possible in large editions.

J. Löwy introduced collotype, in Vienna, in 1872, and erected the first rotary collotype press in 1881.⁵ He was followed by the collotype establishment of Max Jaffé, Vienna.

Ernest Edwards seems to have been the first to practice collotype printing from several plates and in more than one color, a process which he patented in England, December 8, 1869 (No. 3,543). He also added alum to the printing top in order to harden it and took out another patent, later, on color collotype.

Woodburytypes were gradually displaced by collotypes; in neither method can the picture be incorporated in the text, but must be printed seperately from the type. The advantage of collotype consists in the possibility of printing it on paper with any desired amount of margin, while Woodburytypes had to be "bled" and mounted to give them the margins required. This made collotype more suitable for book illustration. The method was faster and replaced Woodburytypes entirely at the end of the nineteenth century. The use of collotype for typographic printing met with little success.⁶

The best history of the collotype process is found in August Albert,

Die verschiedenen Methoden des Lichtdruckes (1900), from which the short outline given above is taken.

August Albert (1854-1932) was born at Vienna, studied drawing and painting at the academy, and devoted himself to the technique of printing and reproduction. He did practical work in different establishments in his own country and in foreign countries, and invented, in 1888, a photolithographic transfer paper, still in use and known to the trade as "Albert's Autotypie-Hochglanzpapier." In 1877 Albert undertook the management of the department for collotype, photolithography and line etching for the firm Max Jaffé, Vienna, and in 1890 became the technical director of the firm of J. Löwy of the same city. In 1894 he was called to the Graphische Lehr- und Versuchsanstalt as professor, where he introduced collotype in colors. He was made section chief and later government councillor and retired in 1922. He also introduced other new processes, such as a combination of color collotype with photogravure (*Phot. Korr.*, 1900, p. 564), typographic collotype (*Typogr. Jahrbücher*, 1906, No. 10, p. 75), printable pencil drawings on aluminum (*Das Aluminium in seiner Verwendung für den Flachdruck*, 1902), and published his experiences in various periodicals and books: "Die Fehlertabellen für Lichtdruck," in *Jahrbuch* (1895); *Der Lichtdruck an der Hand- und Schnellpresse* (1898, 2d ed., 1906); *Verschiedene Reproduktionsverfahren* (1899); *Verschiedene Methoden des Lichtdruckes* (1900); *Der Lichtdruck und die Photolithographie* (1906); *Technischer Führer durch die Reproduktionsverfahren* (1908); and *Die Reflektographie* (1923).

Karl Albert, his son, born in 1878, succeeded him as professor at the Graphische Lehr- und Versuchsanstalt, Vienna. He studied at the Graphische Lehr- und Versuchsanstalt and did practical work in graphic establishments in Prague, London, and as director of establishments in St. Petersburg and Budapest. In 1920 the printing-ink manufacturing firm of Professor A. Albert & Son was founded. Karl Albert was professor at the Graphische Lehr- und Versuchsanstalt from 1921 to 1927, when he was appointed government councillor and resigned his professorship in order to act as technical advisor to industrial firms. He wrote, in 1926, the *Lexicon der graphischen Techniken*, and in 1927 the biography of Karl Klič, published by the Graphische Lehr- und Versuchsanstalt. The Vienna family of August and Karl Albert are not related to the family of the Munich phototechnicians Josef and Eugen Albert.

August Albert of Vienna introduced, in 1896, thin aluminum sheets as a substitute for glass base for the collotype film. Much later Maclure, in Paris, also printed his collotypes from aluminum bases (*Jahrbuch*, 1911, p. 276).

Transfers of collotypes on aluminum were also first employed with cylinder presses by Professor August Albert at the Vienna Graphische Lehr- Versuchsanstalt (*Phot. Korr.*, 1899, pp. 37, 112).

Chapter XCIII. PHOTOGRAPHIC ETCHING ON METAL FOR TYPOGRAPHIC PRINTING, ZINCOGRAPHY, COPPER ETCHING, AND THE HALFTONE PROCESS

THE USE of zinc for relief etching was known as early as 1822, but after that time zinc plates were also used largely for intaglio printing. The obvious idea of applying the modified principle of lithography to zinc relief etching[1] was probably first advanced by Blasius Höfel, of Vienna (1840), who worked out the idea as a practical method and offered it for sale to the Austrian National Bank, but without success. It was not until 1850 that Firmin Gillot, of Paris, brought zincography into practice. He named his zinc relief etchings "paniconographs," which name soon went out of use, and the method of etching in relief designs transferred to zinc was called "gillotage," after the inventor.

In 1850 Gillot employed the photographic asphaltum method on zinc plates for making photozincotypes. He took out a French "privilege" on March 21, 1850, with a supplement March 15, 1851. The original "paniconography" employed greasy ink transfers from lithographs, autographs, copperplate engravings, or wood engravings onto zinc plates, which were etched in relief with nitric acid after the so-called French zinc relief etching process (see August Albert, *Technischer Führer durch die Reproduktionsverfahren*, 1908, p. 184).

Firmin Gillot (1820-72), a peasant's son, had only an elementary education, but was blessed with a healthy mind and ambition for work, and having learned lithography, soon became one of the best workers in his line at Chartres (France). He went to Paris in 1844 as a lithog-

rapher, and after 1850 devoted himself untiringly to the improvement of the process named after him. Gillot's first idea was the transformation of a lithographic print into a typographic printing plate. He succeeded in this by making a transfer with greasy ink on zinc from an engraving or lithograph, etching the plain portions with acid, leaving the greasy parts intact; thus he obtained a relief, and the zinc plate became a typographic printing plate.

The *Journal avantscène*, realizing the great advantage which this process offered to illustrated papers, gave up its wood-engraving department and entrusted Gillot with the reproduction of all drawings. "Gillotage" soon penetrated so deeply into the practice that very many illustrations which were formerly cut on wood were now produced by the photoetching process. Charles Gillot, his son, continued the traditions of his father by improving the process invented by him.

The firm F. Gillot introduced in the sixties the commercial production of photographic prints in greasy ink on chromated gelatine paper and their transfer onto zinc plates, which were etched in relief and printed typographically.

In 1872 Charles Gillot turned from the photographic transfer process to a large degree and printed directly on zinc with albumen and bichromate. The zinc plates coated with sensitized top were printed under a negative, rolled up with greasy ink, developed in water, and etched, after being dusted with resin.

During the years after 1850 Gillot instructed many pupils in zinc etching at his establishment, and these spread his method more or less intelligently.

Gillot printed not only from lithographs and intaglio copper etchings on zinc for relief etching but also thin line prints from intaglio etched steel plates produced by the photographic asphaltum process and etched in a galvanic bath, as Baldus, in Paris, made them in 1854; an example of this method was given in *La Lumière* of 1854.

Nègre, in Paris, was the first to make experiments in the production of halftone pictures in zincography by transferring photographic prints onto coarse-grained chromated gelatine tops (transfer with greasy ink). He joined Gillot, who transferred these collotypes[2] with greasy inks onto zinc plates and etched them for typographic printing. The first example of Nègre-Gillot's halftone zincography was printed in *La Lumière*, May 5, 1856, but was described in error by the editor, Lacan, as made by the asphaltum process; it shows a grain re-

minding one somewhat of the coarse, worm-like collotype grain, and on the other hand of the structure which forms in coating fissured asphaltum layers.

Nègre called his method "gravure paniconographique en relief," and it seems that he produced them for Gillot, who called his zinc relief etchings generally "paniconographs." In these plates one readily recognizes the worm-like grain of Pretsch's process, although the grained chromated gelatine picture was not electrotyped, but was transferred with greasy ink to zinc and etched in relief by Gillot's method. Thus one recognizes in these "paniconographs" the earliest methods of the photographic halftone process on zinc with a natural grain in the picture. Very few of these zinc etchings were produced, because the method was, on the one hand, too complicated for practical use, and, on the other, the pictures appeared too coarse.

At Vienna, in the early fifties, Karl von Giessendorf and the copper-plate printer Tomassich (1859 or 1860), at the Government Printing Office under Auer, made experiments in etching on zinc, at first by drawing with lithographic greasy ink on paper and transferring it on zinc. In 1865 Giessendorf produced for the first time halftone etchings in relief from asphaltum prints on grained zinc,[3] but the tones were coarse and the plates difficult to print.

The painter and photographer Karl Bapt. v. Szathmary, who had produced an atlas of Rumania in which Carl Angerer (who was at the time artist and technician at the Military Geographic Institute) collaborated, must be mentioned as one of the first to practice zincography for printing maps (1862).

Carl Angerer, of Vienna, was of great service in introducing and perfecting zincography. The fashion journal *Iris*, published in Vienna in 1865 or 1866, was illustrated by "decalcography" by Carl Angerer and Hugo Würbel, a pupil of Giessendorf. This method was simple and permitted designs to be made on zinc. The zinc plates were black leaded and coated with thin white gum arabic. The design was scratched in through the greasy ink, and benzine was poured over the plates. They were treated with water, dusted in with asphaltum, which was melted, and then the design was etched on them. The journal ceased publication; zincographs did not appeal to the illustrated comic papers of the time. Carl Angerer, who was an excellent topographical draftsman, went abroad, worked at Gillot's, and returned to Vienna in 1869 to practice zincography.

Angerer, following Gillot, used prints on chromated paper for transfers in greasy inks onto zinc plates, but he changed Gillot's method of etching the photographic greasy ink images. In 1870 he introduced in his plant this new etching method, called it "chemigraphy," and employed it for the reproduction of outline drawings.

Angerer's etching process was later designated[4] as the "Vienna etching method" by several technical writers. In his method Angerer departed from the lithographic manner of treatment of wet zinc plates; he etched very deeply on the first bite, and worked on a dry top, dusting it with resins of different melting points.

For the production of halftone printing plates by zincography Angerer employed at first designs on a grained or cross-line paper, suitable for transfer, drawn with a kind of lithographic crayon. This author had to have recourse to such pictures, drawn on grained paper, which were then etched on zinc, for the first edition of his book *Die Moment-photographie in ihrer Anwendung auf Kunst und Wissenschaft*, Vienna, 1884, and partly also for the second edition of this book, because at that time no one in Vienna was properly equipped to make halftone zincographs.

Until the end of the eighties it was customary to make photozincographs from prints on bichromated gelatine paper, which were transferred from greasy ink prints on zinc. The little-sensitive asphaltum process was seldom used. Angerer also used this transfer method, which is particularly adapted to outline drawings, but less to the halftone process. At this time the news came from America of the use of the Levy cross-line screen and of direct printing from screen negatives on zinc plates. The work was done either with chromated albumen solutions or with the then novel American enamel-top method. Angerer studied the process at the Central Bureau of Engraving in New York (later owned by the translator) under F. J. M. Gerland, who patented, on October 3, 1893, the first high-light process. Angerer introduced in his establishment in Vienna screen negatives printed on chromated albumen enamel tops, because glue tops, necessitating great heat in burning, were not suitable for the soft Belgian and Silesian zinc. [In America a hard zinc was used.—Translator.]

Angerer, one of the most successful pioneers of zincography, was born the son of an innkeeper at Vienna, 1838; he learned lithography and printing, and experimented early with the etching of zinc printing plates. In 1859, while serving in the army, he was assigned to duty at the

Military Geographic Institute, Vienna, where he worked as artist, lithographer, and copperplate engraver. After leaving the institute he went to France and Belgium, where he studied the chemigraphic methods. After his return to Vienna he founded, in 1871, his chemigraphic establishment, in which he introduced photozincography and photolithography with the transfer method then customary. His brother-in-law, Alexander Göschl (died 1900) entered the firm in 1874 as business manager. The firm was granted the title Court Art Institute and became famous in the development of photomechanical processes. Imperial Councillor Carl Angerer was an honorary member of the Photographic Society of Vienna. He died in 1915, at Vienna.[5] His son, Commercial Councillor Alexander Angerer, continued the business of the firm Angerer & Göschl.

When Meisenbach invented his halftone process, Carl Angerer recognized its importance and improved on it, taking out patents which involved him in a patent suit with Meisenbach. But this method was soon surpassed by the halftone process with the cross-line screen (Ives, Levy), which Carl Angerer introduced in masterly fashion in his plant, which soon became one of the largest in Europe. He possessed the splendid ability, at a time when there existed no technical schools for this craft, to educate his workmen in his plant to such competence that many of his apprentices later entered business for themselves, like Patzelt, Andreas Krampolek, and others.

Without doubt the greatest influence on illustrations for use with all forms of printed matter was contributed by photography through the invention of halftone printing plates, which could be incorporated into the text in printing forms. The purely photographic methods of this kind, which were known in the seventies, were so imperfect that it was preferred to make drawings on so-called "scratchboard" with transfer ink, greasy crayons, or india ink, after which the drawings were mechanically transferred to zinc and etched. Such scratchboard was put on the market by the English firm Maclure and Macdonald of London, about 1870, for lithographic purposes. Carl Angerer improved the paper, and it is due to him that crayon and scratchboard drawings were introduced in book illustration. He took out, on July 5, 1877, an Austrian "privilegium" on his scratchboard method, which was and still remains the best of its kind, and many artists of that period (Katzler, Klič, Juch, Weixelgärtner, and others) made use of such paper for their drawings.

In 1880 Angerer first offered for sale scratchboard with cross-line ruling, especially suitable for drawings to be reproduced for printing plates. As late as 1880 it was the preferred method, in illustrating the text of books and periodicals, for making drawings of photographs and pictures of all sorts on grain, screen, or scratchboard with greasy crayon, transferring them onto zinc, thus producing chemigraphic relief etchings.

The technique of these halftone drawing methods furnishes the transitory period of photoengraved halftone plates, originating from redrawn copies on scratchboard, to the modern purely photographic halftone process for typographic printing, called on the Continent "autotype."[6]

INVENTION OF THE HALFTONE PROCESS

The breaking up of pictures into halftones by the use of meshes or screens was hardly considered in the middle of the nineteenth century, although the ingenious Talbot recommended in 1852 the printing of a mesh between the negative and the heliographic plate in order to obtain halftone printing plates (*Handbuch*, 1899, IV, 497). In Talbot's patent there are mentioned glass plates and woven meshes with fine opaque lines or very fine grain, and therefore the honor of the invention of a gauze line or grained screen belongs to Talbot (1852).[7] Talbot also mentioned that his heliographic etching and screen process could be employed on zinc or lithographic stone as well as on steel.

Single-line screens are described in the French patent of M. Berchtold, December 14, 1857.[8] He used glass plates coated with an opaque substance, through which the parallel lines were scratched. Either the glass plates were placed on the metal coated with light-sensitive asphaltum and crossed after half the exposure, or a copy was made by a double exposure of the lines to get the cross-line effect, and from this cross-line dry plate the screen was printed on the metal. J. C. Burnett reported in 1858 methods of line screen photography with single-line and cross-line screens.[9] The use of a woven mesh for producing the screen effect on halftone printing plates was mentioned in Talbot's patent of 1852; he used copied meshes. Silk gauze, canvas, mosquito nets, wire nets, etc., are mentioned as suitable for screens by several early experimenters.[10]

An English patent (No. 2,954) was granted on November 17, 1865, to the brothers Edward and James Bullock. They first made a dia-

positive, placed it in contact with the screen (for instance, gauze), and then photographed the image which had been broken up by the combination of positive and screens. These "reticulated negatives" were printed on transfer paper (bichromated gelatine method), and from this they produced printing plates for any of the known processes. They also used the single-line screen for exposures in the camera.

A method, which is not quite clearly described, for the production of screen images for printing plates was announced by Frederik von Egloffstein in his British patent of November 28, 1865 (No. 3,053);[11] he also took out a patent in America;[12] it seems that he used a steel plate on which very fine lines were engraved, which probably were too fine to be employed with success.[13]

A great impetus was given to the process of making typographical printing plates by J. W. Swan, who makes the following important statements in the patent specifications[14] of his "photomezzotint prints": In order to obtain from an ordinary negative halftone printing plates with a chromated glue top and an electrotype in relief, he (Swan) provides the surface of the plate with a series of parallel, equidistant lines or lineatures which cross each other, for the purpose of enabling the surface of the plate, thus broken up into numerous lines and dots, to retain the printer's ink.

He states elsewhere: These lineatures or dots which must be equidistant or nearly so "I make in or on the negative itself" or "I make these lines or dots on the collodion film on which the chromated glue relief is produced." This demonstrates that Swan went beyond Talbot's recommendation and had in mind the production of screen negatives; he also mentions that he produced lineatures with a machine on a glass plate coated with an opaque ground and "from it produced a negative in the ordinary manner"; furthermore, he also mentions grain plates (instead of lineatures) obtained with powdered resin. However, he does not speak in this discussion of the importance of such glass screens or their insertion in the path of the light in the camera in front of the sensitive plate.

Waterhouse experimented with photo-zincographic halftone printing plates in 1868, making prints on chromated gelatine paper with greasy printing ink and transferring them to grained zinc.[15]

William August Leggo and George E. Desbarats printed a negative on a grained film, which they then transferred on stone or zinc (British patent, May 25, 1871, No. 1,409). The *Daily Graphic* of New York

used "leggotypes" for illustrated inserts in 1873; they were made by printing the negative on a mesh film and transferring it onto zinc. By another method, which was called "helio-engraving" or "photo-engraving" and was practiced from 1873 in America, it is asserted that the screen was placed before the negative plate during the original exposure, but the author was not able to present proofs of this claim. By the end of the last century various kinds of screen and grain methods for photographic typographic printing plates had been invented.

APPLICATION OF THE SCREEN PRINTING PLATE TO NEWSPAPER PRINTING

The brothers Moritz and Max Jaffé, of Vienna, turned back to Talbot's gauze, which they interposed in the camera in front of the sensitized plate. On March 1, 1877, they were given a "privilegium" for a photo-zincographic process using such a screen, in which they expressed the idea of producing screen negatives in the camera by stretching miller's gauze in the plateholder close in front of the silvered plate during the photographic exposure.

It must be stressed that the brothers Jaffé produced in 1877 these halftone printing plates for newspaper printing, exhibited proofs of them, and made them public. Stephen H. Horgan, New York, claims priority in the production of the first halftone printing plate for newspaper printing as of March 4, 1880, but the brothers Jaffé preceded him by three years. The use of these gauzes and nettings, however, furnished only mediocre results. Moritz Jaffé, the business manager of the firm, died in 1880, and Max Jaffé continued the business, extending it considerably for photogravure, zincography, photolithography, and three-color collotypes.

Max Jaffé was born in 1845 in Mecklenburg-Schwerin.[16] He was the son of a merchant, finished Latin school in his home town, and studied drawing and painting in 1864 at Nuremberg (Bavaria). He went to Paris in 1865, where he worked with the photographer Reutlinger and in other studios for several years. At Hamburg he worked from 1868 to 1869, where he designed a new construction for portrait and sculptors' studios.[17] Then he went to Vienna, worked in Löwy's and Rabending's photographic galleries, and established his own plant for the photographic reproduction processes. He was the first to produce in Austria and Germany (1877) halftone screen printing plates for typographic presses with negatives from nature. With August Albert, at Vienna, he manufactured a photolithographic gelatine transfer paper

(1886). They published, probably were the first to publish, the addition of acetone to the bichromate bath used for sensitizing gelatine paper, in order to accelerate the drying (*Phot. Mitarbeiter*, 1886, p. 90).

After the Graphische Lehr- und Versuchsanstalt, Vienna, was founded, Jaffé served there as lecturer and demonstrator of the reproduction processes until 1889. He wrote many technical articles. In 1893 Jaffé invented "Weitraumphotography" (*Phot. Korr.*, 1904, 1918), and in 1918 the "Akaustisches Verfahrens," in which planographic printing is executed from lithographic stone or metal without etching or similar means.

VARIOUS EXPERIMENTS FOR THE PRODUCTION OF HALFTONE RELIEF PRINTING PLATES

Charles Petit, at Paris (died 1921), and F. E. Ives (1856-1937), at Philadelphia, invented at the same time a process for the production of halftone printing plates (from halftone negatives and chromated gelatine reliefs, plaster of Paris casts, and ruled with a wedge-shaped tool). Petit was granted a patent in 1878 and Ives eight days later.

The early process of Petit was soon dropped by him, but the name "similigravure,"[18] coined by him, is still used in France for those methods, which they also call "photogravure à demiteintes," while in Germany the name "Autotypie" is used.

Swan received an English patent in 1879 for a new process in relief. He broke up the halftone either by a screen printing method or by exposure with the screen placed in front of the sensitive plate or in front of a diapositive. In every case the screen was crossed at a certain angle during the exposure. This method was recommended by Swan also for the chromate process on zinc, copper, and so forth.

For further details concerning the various earlier but now obsolete halftone processes, such as Ives's photoblock method (patent 1878), Mosstypes, Petit's similigravure, see *Jahrbuch* (1887, p. 332) and Grebe in *Zeitschrift für Reproduktionstechnik* (1899, p. 19).

Horgan introduced a process for making photographic halftone plates for newspaper printing, at New York, in 1880. He was employed as photographer by the New York *Daily Graphic* and had devoted himself to the photomechanical processes since 1875. He covered a sheet with cross lines and placed it between the halftone negative and photolithographic chromated gelatine paper, washed it, rolled it up with photolithographic ink, transferred it to zinc, and etched the plate

to type height. The *Daily Graphic* printed, March 4, 1880, a portrait from life of Henry J. Newton, president of the American Institute. This was one of the earliest applications of this method to newspaper printing.

In the *Inland Printer* of 1924 we find an article: "The Beginnings of Halftone, from the Note Books of Stephen H. Horgan," by Lida Rose McCabe. There is a reference to Horgan's first cross-line plate by an interposed screen of "A Scene in Shantytown, New York," which was printed in the *Daily Graphic* on March 4, 1880. According to *Anthony's Photographic Bulletin* (1880, p. 123) this invention was presented at a meeting of the Photographic Section of the American Institute. But the screen halftone printing plate of Horgan was no "Halftone plate" in the strictly technical sense of the word.

A remarkable attempt at cross-line or grain screen printing on unexposed gelatine silver bromide plates before exposure in the camera for making the negative we owe to Brunner & Co. in Winterthur, Switzerland, (German patent, No. 31,537, Jan. 29, 1884).

The inventors hoped to place every photographer in a position in which he could make screen negatives with the ordinary photographic equipment and thus be able to produce halftone printing plates. Such gelatine silver bromide plates were actually produced for the market. These Brunner silver bromide plates hardly fulfilled their purpose, because printing of the screen cross lines in close contact with the gelatine silver bromide film produced no proper breaking up of the screen image into dots of different sizes. The method was more suitable for grain screens, which required no screen distance, but the method soon went into disuse.

GEORG MEISENBACH'S HALFTONE PROCESS (1882)

Meisenbach, of Munich, achieved great success with his "Autotypie."[19] He eliminated the defects caused by the irregularities of the earlier used lineatures by (German patent, No. 22,444, May 9, 1882) making a diapositive from the copy, bringing it in contact with a parallel single-line transparent screen, turning the plate when half-exposed ninety degrees, and finishing the exposure, which produced cross-lines on the negative. Later, Meisenbach also made halftone negatives direct from the copy by the interposition of a single-line screen in front of the sensitized glass plate and crossing it after a half-exposure at 90° (*Phot. Korr.*, 1883 and 1884); but this last procedure of mak-

ing halftone negatives is not contained in the patent specification. Meisenbach's methods, which he introduced into practice after he had equipped an establishment for "Autotypie" in Munich, contributed greatly to the progress of the halftone process for typographical printing. To his partner, Baron Schmädel, we owe the name, "Autotypie" which has become the everyday trade name.

At first Meisenbach made his single-line screen photographically on wet collodion plates from a copperplate print of a ruled copper plate. Baron Schmädel succeeded, in 1884, in ruling the first glass screen (with a specially constructed ruling machine) directly in the black coating of a glass plate, and from this time dates the success of Meisenbach's autotype. The Meisenbach patent was sold in the same year in England, and a branch of the Meisenbach Company was established in London.

Georg Meisenbach was born in 1841 at Nuremberg, Bavaria, and became a copperplate engraver. As such he achieved success, especially with his architectural subjects. In 1873 he moved to Munich, founded there the first zincographic etching shop, and began in 1879 his experiments with the direct reproduction of halftone pictures with a screen. After the year 1889 all halftone negatives at Meisenbach's plant were made with cross-line screens, although nothing was published about this, because at that time the working procedure was still kept secret as much as was possible.

In the spring of 1891 Meisenbach retired, owing to ill health, and the business was continued by his son and Baron Schmädel. In 1892 came the merger of Meisenbach's Autotype Company with H. Riffarth & Co., Berlin.[20] Meisenbach withdrew to his country estate, near Munich, where he died December 12, 1922.

Meisenbach's halftone, "Autotypie," was the first photographic halftone process for book printing which was made commercially practicable. The use of it continued until about the end of the eighties in its original form, when it was definitely displaced by Ives's halftone process with cross-line screens.

PATENT SUIT MEISENBACH – C. ANGERER

Angerer and Göschl, Vienna, invented at the same time a halftone method which was simpler and cheaper than the original Meisenbach method. They produced by this method, in 1879, relief printing plates from photographs and wash drawings. They interposed during

the exposure the single-line glass screen in front of the sensitive plate in the camera, turning it by 90° after half of the exposure. By this manipulation they undoubtedly produced directly a cross-line negative, without first making a screen diapositive, thus simplifying the process.

Angerer patented his halftone method in Austria, France, and England in 1884; in Germany the patent was denied, owing to Meisenbach's objection, who proved that he had previously invented this simplication and had practiced it.[21]

IVES INTRODUCES MODERN CROSS-LINE SCREENS ON GLASS FOR MAKING HALFTONE NEGATIVES (1886)

In 1886 the American Frederic Eugene Ives introduced the modern cross-line screen on glass for the production of halftone negatives for halftone relief printing plates and captured with it permanently the field of the halftone process. Ives devoted himself from 1878 to experiments for the production of halftone relief printing plates, and ruled his plates in the beginning mechanically.[22] He became dissatisfied with this mechanical method of halftone etching and commenced in 1881 experiments to produce ruled printing plates by the optical method with single lines.

Ives promoted the halftone process by basically correct methods and is considered the founder of the modern halftone process. For a short period he used the single-line screen, and he exhibited in 1885 such pictures at the Novelties Exhibition in Philadelphia, in which the single-line lineatures produced lights and shadows by their varying thickness. In 1894 Ives recommended this procedure for the three-color halftone process, although he had long since worked with cross-line screens.

Ives had recognized in 1886 the advantage of two single-line screens, superimposed on each other so that the lines crossed at 90° and cemented together. He made them at first on a photographically blackened collodion plate with a ruling machine.

By the interposition of crosswise superimposed and cemented single-line glass screens in front of the photographic plate in the camera Ives produced screen negatives, from which etched copper relief printing plates by the glue enamel process were made.[23]

These halftone relief printing plates were quite practical for printing on rapid typographic presses, but the cross-line screens required

improvement. Max Levy, also of Philadelphia, succeeded in 1890 in perfecting glass screens. Levy coated glass plates with an etching ground, in which he ruled parallel lines with a ruling machine; he etched the lines rather deeply with hydrofluoric acid, removed the ground, filled in the etched lines with a black resin, and polished the surface. The line screen appeared sharp and clear. Two such single-line screens were placed at right angles and cemented together. These Levy screens met with great success in the halftone process. They were put on the market in 1888 with rulings of various degrees of fineness, proved to be the best of their kind, and achieved general use and approval.

Max Levy, born in Detroit (1857) of German-Bohemian parentage, was a photographer who went to Baltimore, where he established, jointly with his brother Louis Edward Levy (d. 1919), in 1875, a photographic plant for reproduction processes. From 1881 to 1885 they made zincographs by direct printing on the bichromated albumen coated metal and etching it. Then Meisenbach's single-line screens were introduced. Max Levy improved in 1888 the ruling machine, producing perfect cross-line screens, etched in glass (halftone screens) in various finenesses of lines for sale. Max Levy at first ruled the glass plates diagonally in order to have as little waste as possible. The brothers Levy also invented an etching and powdering machine for zinc line plates and later an etching machine for halftone plates. One of the zinc etching machines was exhibited at the Paris Exposition of 1900.[24] Max Levy took out numerous patents, among them one for a four-line screen.

The American cross-line screens were brought by Fritz Goetz to Europe in 1890. They were first introduced by Meisenbach, Munich, then by Angerer and Göschl, Vienna; E. Albert, Munich; Husnik, Prague; and by others for practical use in the halftone process.

Frederic Eugene Ives was born in 1856 in Litchfield, Conn., and died at Philadelphia in 1937, at the age of eighty-one. He learned the printing trade, was employed in a printing plant at Ithaca, N. Y., where he devoted himself to amateur photography, and when only eighteen years of age he became the official photographer (1874) of Cornell University, Ithaca, New York, where he remained until 1878, after which he turned to the development of the photomechanical processes. He began at first to resolve the photographic chromate gelatine reliefs into lines and dots by a mechanical method and introduced this

into practice at the Crosscup and West Engraving Company in Phila-
delphia, where he also produced halftone plates for printers; later he
pioneered the improvements of the halftone process with the cross-
line screen (optical resolution of tone pictures into lines and dots). He
invented the burning-in method of chromate glue (American enamel
process) for copper halftone plates. He made public his three-color
process ("composite heliochromy") in 1888, which he patented in
1890. Later he went to England and visited also Vienna; while there he
made Europe acquainted with his "photochromoscope," which was
the first instrument producing really good results by the additive three-
color process. He made apparatus not only for projection but also for
direct vision, so that we may say that he improved all forms of three-
color photography.

His son, Dr. Herbert E. Ives, of New York City, himself a promi-
nent scientist in the field of photographic physics, founded in 1928,
in honor of his father, an honor medal for the American Optical
Society, to be awarded for distinguished work in the field of optics
(*Journal of the Optical Society of America*, 1930, XX, 161).

Many years passed before Europe could produce screens as excellent
as those of Max Levy (J. C. Haas, at Frankfurt a. M., E. Gaillard, at
Berlin, and others). The cross-line screen can only attain its full effect
and properly resolve the picture into harmonious lines and dots when it
is used at the right "screen distance" from the sensitive plate and when
the lens is properly diaphragmed. It is only when the pertinent optical
conditions are correctly known, considered, and applied that satis-
factory halftone negatives can be produced, such as are demanded for
the process of today. Although empiric experience gradually led to the
proper use of diaphragms and screen distances, a scientific system was
only attained when the correct theory of the process was established.
The first thorough study of the theory of the halftone screen in pure
geometric presentation we owe to the Surveyor General of Canada,
E. Deville, who lectured before the Royal Society of Canada on May
17, 1895, on the "Theory of the Screen in the Photomechanical Pro-
cess"; the lecture was published in the journal of the society.[25]

During the first stage of Meisenbach's halftone process the work
was done with the zincographic transfer method (from chromated
gelatine paper); but this transfer image was not sharp enough when
fine screen lines were used. America undoubtedly turned first to direct
printing on metal. The asphaltum process was not sufficiently sensitive

and was abandoned for the chromate process. An improvement in precision of the etching procedure was brought about by the introduction of the enamel process, which could be executed easily and with certainty.

Ives is acknowledged as the inventor of the American enamel process. In this process a copper plate is coated with bichromated glue solution, which is dried, printed under a cross-line screen, developed in water, dyed in a methyl violet bath, burned, and etched with iron chloride. It is in this method that Levy screens achieved their best effect.

Before the introduction of his enamel process at the Crosscup and West plant in Philadelphia, Ives made relief copper printing plates with cross-line screens (1888) and started a plant for their production, printing negatives directly on glue tops,[26] burning-in the prints, and etching them with iron chloride. H. W. Hyslop[27] claimed priority in the invention of the copper enamel process, but it seems that Ives achieved practical results from this process earlier than others.

The American copper-enamel process with Levy screens was soon practiced in Europe by many establishments; we cite, for instance, Boussod and Valadon in Paris (1886).

Copper and brass plates resist the burning-in of the bichromated glue image better than other metals and therefore were preferred for the process. Zinc plates often become crystallized during the burning-in, do not etch well, and are too soft to be printed from directly, which for a time relegated zinc to the background, until a cold enamel was introduced much later. However, through the introduction of a cadmium zinc alloy and a suitable nitric acid solution, zinc plates were eventually adapted to the halftone enamel process. Professor Franz Novak of the Graphische Lehr- und Versuchsanstalt, Vienna, experimented[28] with this metal and found that some kinds of American zinc contained the right amount of cadmium for this use, but that any zinc might be adapted for the process by making an alloy of zinc with small amounts of cadmium. The trade, however, never used this discovery.

It is quite possible to produce any kind of fine screen halftones on polished zinc plates without the burning-in over great heat, by using an albumen ammonium bichromate top. Such prints on zinc are rolled up with greasy ink and developed in water. This produces a somewhat sticky image, which is dusted with resin and heated slightly until the resin melts. The structure of the zinc is not changed by this operation,

and halftone prints of finest screens can thus be etched on zinc without difficulty. This method also started in America and was probably well known to Ives.

<p style="text-align:center">HALFTONES WITH GRAIN SCREENS</p>

The use of a grain on prints from negatives or diapositives for halftone printing is very old. When the method used in the halftone process, interposing a screen during the exposure of the negative in the camera, became known, the old idea of using grain screens turned up again. Several of these experiments were carried on at the turn of the nineteenth century with more or less success.

Max Perlmutter, a photoengraver at Vienna, made grain halftone plates by melting an aquatint grain of powdered asphaltum on a glass plate, or by a transfer from a fine grained lithographic stone with greasy ink on glass and then dusting it in with the finest possible asphaltum powder. These grained glass plates were interposed closely in front of the collodion plate during the exposure of the negative, just as in the halftone process. Perlmutter exhibited successful prints from such grain halftone plates at the Paris Exposition of 1900. The method found only a limited application, because the grain plates were more difficult to print than halftone plates. The method, however, was still in use in 1910. The firm J. Löwy, of Vienna, used this method in producing a brass halftone plate with Perlmutter's grain screen, which was printed in the *Phot. Korr.*, 1910.

The firm of J. C. Haas, Frankfurt a. M., introduced in 1900 a grain screen made by them independently from asphaltum powder. *Jahrbuch* for 1901 shows proofs of such screens.

But the reproduction of the halftones by these grain screens was never as satisfactory as reproduction with the Levy cross-line screens.[29]

A remarkable substitute for the above-mentioned black grain screens was invented by the Englishman J. Wheeler, who took a patent (Brit. patent, No. 12,017, May 14, 1897) on such uncolored grain screens etched in glass ("mezzograph screens"). They were produced by subjecting glass plates to the smoke of smouldering birchbark, which formed a deposit of fine drops on the surface of the glass. Etching with hydrofluoric acid produced a delicate, irregular grain structure on the glass, owing to the differing resistance of these drops. The inventor at first used this mezzograph screen only for graining halftone silver chloride prints. The first halftone mezzotint printing plates

were made at the Graphische Lehr- und Versuchsanstalt, Vienna, with one of these screens, brought to the author by the inventor, and a print is shown in *Phot. Korr.* (1899, p. 717). The Wheeler mezzograph screen appears almost smooth to the touch, but when interposed close to the photographic plate during exposure, it produces a grain negative, which when printed on metal can be etched to a printable depth. Of course, printing these plates on both flat and cylinder presses requires a great deal of careful manipulation.

Husnik and Häusler's phototechnical art establishment at Prague (Czechoslovakia) carried out the same idea as that of Wheeler. They printed a worm-like grain from collotype plates on plate glass, which produced black grain screens, but which did not satisfy Husnik.[30] When Husnik and Häusler, however, etched the worm-like grain with hydrochloric acid into glass, and, after removal of the black film, interposed this seemingly almost smooth glass screen during exposure in the camera, they obtained fine, printable grain halftones similar to those produced with Wheeler's "mezzograph" screen.

Here must also be mentioned the halftone typographic printing plates produced with powdered asphaltum, according to Klič's photogravures; they were made in the same manner by the transfer of a pigment image, with the difference that he printed from a negative. Klič produced such plates on copper, called "cuprotypes," about 1880. About 1886 Roese made such plates at the Government Printing Office, Berlin, on brass and named the method "chalkotype" (*Handbuch*, 1922, IV(3), 67).

The artist and painter Emanuel Spitzer, at Munich, applied in 1901[31] for a patent, which was not granted until July 7, 1905 (No. 161,911), for a process under the title "Spitzertype." He had observed that in certain circumstances light-sensitive layers are formed by mixtures of glue and gum arabic with bichromates, which form automatically after drying a hardly perceptible grain internally. When direct prints on such tops, from ordinary halftone negatives (without first washing them in water), are etched in the copper plate, they show underneath a so-called "automatic" or "spontaneous" grain and can be printed on typographic presses.

Emanuel Spitzer (1844-1919) was a clever illustrator who went to Paris in 1864 and was stimulated by the work of P. Gavarni and H. Daumier. He moved to Munich in 1869, where he was employed as illustrator on the *Fliegenden Blätter*, a comic journal, and later turned

successfully to painting. His work was frequently printed in periodicals, and because the reproduction did not always satisfy him, he devoted himself intensively to the problem of reproduction. This resulted in his invention. He founded, with Dr. Robert Defregger, the Spitzer Company, at Munich, which in a publication *Die Spitzertypie, ein neues Reproduktionsverfahren* (Munich, 1905) printed fine specimens of the process. In 1907 this company produced their first three-color prints. The method must be considered the simplest process for the production of halftone printing plates from continuous tone negatives (*Handbuch*, 1922, IV(3), 63).

Spitzer was not able to enjoy the fruits of his invention undisturbed. In addition to Dr. Defregger, another associate joined them, Dr. Hans Strecker, who engaged his friend Karl Blecher as manager of the laboratory. Strecker and Blecher elaborated a process under the name "stagmatype," which they patented on November 26, 1908 (No. 231,813). The claim described a method of producing printing plates with grainy structure by etching with iron chloride a bichromated glue top on metal, such as copper, which was exposed to light, but not washed in water. This same matter is also described in the English patent of H. Strecker-Aufermann (*Brit. Jour. Phot.*, 1910, p. 179; *Eder's Jahrbuch*, 1910, p. 574), without adding any essential new feature to the Spitzertype method.

This author proved that Spitzertypes and stagmatypes are essentially identical. A distasteful controversy between Strecker and Spitzer, during which Strecker played a questionable role, established the right of Spitzer's priority. (*Phot. Korr.*, 1912, p. 101; 1913, pp. 330, 389, 464; 1917, p. 247; *Zeitschr. f. Reproduktionstechnik*, 1912, pp. 69, 107; see also, *Handbuch*, 1922, IV(3), 65). This litigation in the courts forced the Spitzer Company into liquidation in 1909. Spitzer was taken ill and lost the strength which would have been necessary to improve and exploit his process. His invention remained unused and forgotten for years, but a short time ago his wife and daughter sought to revive it.

In order to complete the record it must be mentioned that according to L. P. Clerc, Paris, H. Placet announced in 1877 that mixtures of glue, gum arabic, and bichromate show a grain formation when thin layers of the mixture dry out. Clerc refers to L. Vidal's book *Photogravure* (Paris, 1900, p. 350). But we must call attention to the fact that Placet was not aware or at least did not mention the possibility of producing halftone printing plates on copper by etching such print tops with iron chloride.

Chapter XCIV. THREE-COLOR PHOTOGRAPHY

PRINTING BOOKS IN COLOR reaches back to 1457 and was used by Peter Schöffer (1425-1502), Mainz, assistant to Gutenberg and Fust, who employed it for his Psalter, but it was replaced in later years by hand painting, owing to the inefficient accessories. Of course this color printing, or rather variegated printing, was at first only a printing next to each other of colors, not a superimposed printing.[1] Ever since Senefelder invented lithographic printing, color printing was carried on almost entirely by lithography; colors were printed on top of each other as well as next to each other. The knowledge of the so-called primary colors led gradually to modern color printing.

The first statements on primary colors, which are the basis of all our sensitivity to color,[2] were made by Antonius de Dominis in his dissertation *De radiis visus et lucis in vitris perspectivis et iride* (Venice, 1611). He observed that colors result from the absorption of white light. Black is the absence of light, he states, and red, green, and violet are the primary colors, of which all other colors are composed (the still valid color system of complementary three-color synthesis).

The Jesuit Franciscus Aguilonius, who published a dissertation on optics in 1613, drew a kind of color scheme, taking as a basis the primary colors, red, yellow, and blue, showing the basic colors in circles, half of which showed them in combination, thus indicating the synthesis. The Englishman Waller made investigations in 1686 in subtractive color syntheses, that is, mixing pigment colors. Sir Isaac Newton, as is well known, dissected light in the color spectrum and added red, yellow, and blue in order to produce white (additive color synthesis).

The first practical three-color printing with red, yellow, and blue inks was done by Jakob Christoph Le Blon, born at Frankfurt a. M., in 1667. He studied painting and copperplate engraving under Carlo Murates, went to Rome, and later to Amsterdam. Here he devoted himself, incited by Newton's theory, to the task of printing copperplate engravings in color, by using seven plates successively on top of each other in Newton's colors (red, orange, yellow, green, blue, indigo, violet). Naturally this lengthy procedure must have caused Le Blon great difficulties, and he endeavored therefore to reduce the number of printing plates. Finally, he arrived at the conclusion that all possible shades of color could be obtained by printing from only three plates, using red and yellow and blue printing inks. He went to London and published, in 1722, the first report on his color printing process under

the title, *Il coloritto; or, The Harmony of Colouring in Painting, Reduced to Mechanical Practice under Easy Precepts and Infallible Rules.* Le Blon's announcement, however, met with little success, probably because his statements were rather obscure. It was only after he moved to Paris, in 1737, that he found a number of pupils and a public which was intensely interested in his efforts. In 1740 the king of France granted him a subsidy under the condition that he should demonstrate his method before a commission, engrave and print the plates in their presence, and reveal all the secrets of his art. Le Blon died in 1741 at Paris, 74 years of age, after having devoted his whole life, full of anxiety and labor, to his invention of three-color printing.

Color printing (chromolithography, etc.) which started to flourish again at the beginning of the nineteenth century, reattracted attention to the laws of combining colors. Heinrich Weishaupt printed, in 1835, after many years of experiments, the first three-color lithograph ("Head of Christ," by Hamling).

Blasius Höfel, at Vienna, introduced in the middle of the 1820's book printing in colors by means of several woodcuts. He was followed by Heinrich Knöfler, in Vienna (1868), who used as many as fourteen to twenty woodcuts (Friedrich Jasper, "Der Farbendruck in Österreich," *Neue Freie Presse*, July 12, 1930).

Another primary-color system, consisting of red, green, and violet on the basis of additive mixture tests was introduced by Chr. Wünsch, in 1792,[3] which became the foundation of the famous theory of color sensation by Thomas Young.[4] Young asserted that the normal human retina possesses three different kinds of nerves, which, when stimulated, cause a reflex of the respective nerve elements sensitive to red, green, and violet. This theory was developed further by Helmholtz,[5] Maxwell, A. König, Franz Exner, and others.

Another direction was taken by Sir David Brewster,[6] who, led astray in 1831 by color tests on a subtractive basis, proposed the theory that only three homogenous colors exist in the spectrum—"red, yellow, and blue"—and that each of these lights gave rays of each, refrangible within the limits of the spectrum. This view was, however, soon scientifically disproved, especially by Helmholtz,[7] but printers accepted Brewster's colors in practice, because in the present state of color ink manufacture only yellow, red, and blue produce suitable mixtures, especially in the yellow shades.

The famous English physicist J. Clerk Maxwell was the first to

think of color reproduction by means of three-color light filters, and he published his idea in a lecture "On the Theory of the Three Primary Colours" before the Royal Institution, London, May 17, 1861.[8] He discussed Young's theory of the so-called primary colors, which in various combinations give all the colors of the spectrum. Among his experiments Maxwell made a projection of partly drawn and partly photographically produced diapositives behind red, green, and blue light filters:

Three photographs of a coloured ribbon taken through three coloured solutions, respectively, were introduced into the lantern, giving images representing the red, the green, and the blue parts separately, as they would be seen by Young's three sets of nerves, respectively. When these were superposed, a coloured image was seen, which, if the red and green images had been as fully photographed as the blue, would have been a truly coloured image of the ribbon. By finding photographic materials more sensitive to the less refrangible rays, the representation of the colours of objects might be greatly improved.

This demonstrates that Maxwell (1861) was the first to prove the possibility of reproducing colors by photographic three-color negatives made through color filters. Although his experiments confined themselves principally to diapositives, he also mentioned explicitly colors laid on paper, stating that "by means of the colour scale (Young's primary colours) one could obtain colour equations for coloured paper . . . which present the numerical value of the whole of each colour in the proportion in which it was admixed."

James Clerk Maxwell (1831-79)[9] studied at Trinity College, Manchester, until 1854, became professor at Aberdeen in 1856, at King's College, London, in 1860, resigned in 1865, and retired to his estate in Scotland until he was called to the University of Cambridge in 1871 as professor for experimental physics, where he died. He devoted himself to astronomy, electricity, magnetism, and optics, and his scientific works have become of the utmost importance.[10] Maxwell has become famous especially through the establishment of his electromagnetic light theory. According to the undulation theory of light, light waves are caused by elastic vibrations of the ether. According to the electromagnetic light theory light waves are not of an elastic but of an electromagnetic nature. The first indication of a relationship between the motion of light and electromagnetic phenomena were found in the facts that the ratio of an electromagnetic to an electrostatic unit of

current represents a size equal to the dimension of velocity and that the value of this velocity equals that of the transmission of light. Maxwell demonstrated by his mathematical theory of electromagnetic phenomena, following the ideas of Faraday, that the above-mentioned ratio represents the velocity with which an electromagnetic disturbance must extend in free space. This theoretical result formed the foundation for his electromagnetic light theory, in which light is considered as a periodical electromagnetic process. The investigations of Hertz,[11] in the first place, the actual production of rapid electromagnetic vibrations, and the experimental demonstration of their wave-like spread with a velocity equal to that of light, and, furthermore, the subsequent tests, which showed that the behavior of light and that of electromagnetic waves are the same in every respect, have proved the Faraday-Maxwell theoretical results so convincingly that no doubt of their correctness is possible. Maxwell's fundamental work, *Treatise on Electricity and Magnetism*, was published in 1873. His electromagnetic theory is now being used, especially in the mathematical formula given it by Heaviside[12] and Heinrich Hertz.[13] This theory revived also those early electric light theories, for which probably Grotthuss laid the first foundation.

Henry Collen, teacher of painting to Queen Victoria, proposed in 1865 a method for the production of three-color plates; he recommended making three negatives in "Brewster's primary colors" (red, yellow, and blue light) from these color diapositives, which he would superimpose one on the other.[14]

Baron Ransonnet, of Vienna, in the same year, also conceived the idea of producing three-color prints with the three primary colors photographically,[15] but was discouraged from further experiment by the lack of color-sensitivity in collodion plates. He does not seem to have gone beyond the idea of manual photolithographic three-color printing,[16] which he executed in some printed proofs. He also employed a graytone plate (key plate), thus accomplishing a four-color result.

LOUIS DUCOS DU HAURON (1868)

Two Frenchmen, Louis Ducos du Hauron and Charles Cros, independently of each other and without either one knowing anything of the other's work, outlined, in 1868 and 1869, the idea of reproducing objects in their natural colors by the superimposition of three photographically produced pictures (blue, yellow, and red). Their work

greatly promoted the possibilities of practical results in this field. Du Hauron's idea consisted in making three diapositives in the primary colors and combining these part-pictures in a peep box, where the polychrome effect could be seen.

He presented a written and illustrated statement through Lélut, a member of the Paris Academy of Sciences, but the Academy did not include this statement in its reports. Many years later, in 1897, this historically important document of Du Hauron was printed and published (E. J. Wall, *History of Three-Color Photography*, 1925, p. 104).

Not until 1865 did Du Hauron turn to practical photographic experiments; he worked with silver bromide collodion and colored light filters, producing three-color pictures with red, yellow, and blue colored pigment diapositives. He achieved his first satisfactory proofs in 1868, when he applied for a French "privilege," November 23, 1868, under the title "Les Couleurs en photographie, solution du problème," and announced it on May 7, 1869, to the French Society of Photography. Incidentally, Charles Cros, in the same year, independently reported on his own work on the same principles of three-color printing. At that time Du Hauron wrote several articles on his method of three-color photography, which are reported in the *Bulletin de la Société française de photographie* and *Photographische Korrespondenz*. These articles on the first work of Du Hauron are collected in his *Les Couleurs en photographie* (Paris, 1869).

Later publications of Du Hauron were written partly in collaboration with his brother Alcide, such as *Traité pratique de photographie des couleurs* (Paris, 1878). They refer there to Vogel's discovery of color sensitizers during exposure of the separation negatives. Other publications by the brothers Du Hauron are: Alcide Ducos du Hauron, *Les Couleurs en photographie et en particulier l'heliochromie au charbon* (Paris, 1870); *Photographie des couleurs* (*Algier*, 1891); and *La Triplicité photographique des couleurs et l'imprimerie* (Paris, 1897); Louis Ducos du Hauron, *La Photographie indirecte des couleurs* (Paris, 1900).

Du Hauron's influence on the progress of three-color photography was important; he made the first successful experiments in photographic three-color printing and exhibited his work at the Paris Photographic Society May 7, 1869. It was stated: "The picture of the spectrum presented as proof is certainly far from perfect, nevertheless it substantiates his statements." Du Hauron, in his experiments, made three negatives

by the method now generally known, behind blue, green, and orange colored light filters; after that, monochrome complementary red, yellow, and blue pigment prints were made and combined by superimposition to the polychrome picture. This is analogous to the modern three-color printing which has grown so mightily. In 1869 Du Hauron announced a practical and perfect photochromoscope with three-color diapositives, which projected the picture by means of lenses and mirrors on the retina of the eye and formed additive color effects. In the same year he also outlined the projection of pictures in colors by throwing three-color diapositives in the primary colors on a white screen by means of a triple projection lantern and uniting them in one polychrome picture.

In 1869 Ducos du Hauron wrote in his work *Les Couleurs en photographie* (p. 54) that the synthesis of the three-color separations could be changed by the use of a stereoscope, which would permit on one hand the red and yellow separation to reach the eye additively, while the third (blue) separation reached it through the second lens of the stereoscope. The physiology of the human eye would render it possible then to unite all three colors, forming a polychrome picture. This idea did not prove successful in practice and was soon abandoned. But this in no way deterred later inventors from reconsidering it.

Du Hauron also experimented in 1869 with the bleaching process of producing color pictures. He wrote:

We must find a substance which has the property of undergoing a modification by the influence of light, which is analogous to that of the simple and composite rays acting upon it, that is, a substance which will turn red when exposed to red light, green when exposed to green light, and under the action of white light turns white.[17]

He then cites the work of Becquerel, Niepce de Saint-Victor, and Poitevin and states:

Instead of causing the sun to create colors, could it not be employed for the diffusion of color? Instead of searching for a simple preparation which in some way absorbs and holds fast, on every point of its surface, the color rays acting upon it, could we not subject to the action of light a combined and polychromatically prepared surface? Or at least a substance which, as far as possible, contains all shades of color and which is composed exclusively of already known and commercially produced colors, spread equally over all points of the photogenic surface, so that beneath each of the simple or composite rays acting upon it, the corres-

ponding simple or composite color will become fixed, while the other colors would be eliminated by the action of the same rays? In this idea is found the basis for the later production of pictures by the so-called "bleaching process."

It must be emphasized that Du Hauron was the first to describe the screen color-plate process. He also pointed out the necessity of adjusting the screen by such an arrangement of color elements that it would appear gray and show no excess of any color whatsoever. He states in his French patent specification of 1869 (No. 83,061): "We imagine the whole surface of a piece of paper covered alternately with extremely fine lines of red, yellow, and blue of equal size, with no space between them; when viewed at close range the three-color system of the lines can be distinguished, but seen from a distance they merge into a single color tone, which, when viewed by looking through a transparent medium, will appear white, but when viewed on an opaque background will show gray if none of the three colors predominates."

In 1874 Du Hauron made use for his three-color process of the color sensitizing discovered by H. W. Vogel.[18] Before Vogel's discovery of color sensitizing for the visually bright color rays, three-color photography could not be carried out successfully in practice. After the publication of Vogel's discovery, Du Hauron applied this knowledge by sensitizing his silver bromide collodion plate with Vogel's coralline for green and with chlorophyll, as recommended by Becquerel, for red.[18]

Du Hauron also invented a three-color camera, in which the three-color separations could be made simultaneously by a single exposure behind complementary light filters. He was granted a French patent (December 15, 1874, no. 105,881) for a "camera heliochromatique" or a "photographic apparatus for the purpose of taking at one time three pictures from one and the same object." He writes:

1. We obtain by the aid of the photographic camera three negatives of the same object, the first negative through a green colored glass, the second negative through a violet colored glass, and the third negative through orange-red glass.

2. Then transparent positives are made by the pigment or a similar process by the aid of chromolithography, Woodburytype, or by a toning process. From the first negative a red print is made, from the second a yellow print and from the third a blue print. When the three mono-

chromes are superimposed and thus combined, we obtain a finished print, which is a polychrome reproduction of nature. . . . [Du Hauron at that time knew only coralline as green and chlorophyll as red-sensitizers.]

Supposing that better sensitizers are found, it will then be desirable to construct an apparatus with which the three pictures simultaneously and without the interference of perspective can be photographed.

In order to obtain this result I have considered the following arrangement, in order to photograph an object geometrically correct with a single exposure.

The light rays coming from the subject to be reproduced are received on a clear glass with parallel planes inclined at approximately 45 degrees and are partially reflected towards the first lens. The greater part of these rays penetrate the first glass and are received by a second clear glass, with parallel planes also inclined at 45 degrees, and these light rays coming from the same object are here further split up, and a part is here reflected towards a second lens. The remaining light rays penetrate through this second glass and are collected directly by a third lens or by means of reflection from a glass or metal mirror . . .

In general, this description of a heliochromatic camera with two or more reflectors agrees with the requirements demanded today.[19] Almost all Ives's chromoscope cameras depend on the above basic suggestions.

Blanquart-Evrard, of Lille, wanted to exploit Du Hauron's process and establish, in 1870, a three-color printing establishment. Du Hauron had already furnished a set of three-color negatives for this purpose, but, alas, the Franco-German war forced the postponement of the project until 1871. Unfortunately, Blanquart-Evrard died in April, 1872, but he had reported the process to the Society of Sciences at Lille. Du Hauron now confined himself, during 1873, to the use of his process for photolithography and showed portions of a color transparency. He founded a company in 1876 for the production of three-color prints by photoglypty (Woodburytype), but it was extremely difficult to register the three separations by this process, although he exhibited a dozen such color impressions at the Paris Exposition of 1878. His brother Alcide happened to be in Paris when the inventor of the power press collotype process, Josef Albert, of Munich, visited the exposition. Albert proposed to combine their work for Germany and France, calling attention to his own success with three-color collotype prints, which he had produced since 1874. Du Hauron declined the offer and joined Guisac-André, who had a collotype plant in Toulouse. Later he often exhibited three-color prints.

From 1874 Du Hauron made use of Vogel's invention of color sensitizers.[20] By the addition of dyes to silver bromide collodion he obtained practical three-color separation negatives, the results of which he exhibited at the Paris Exposition of 1878, and again in 1892 and 1894 at the exhibition of books. His brother Alcide was appointed a court official in Algiers, and Louis lived there also from 1884 to 1896.[21]

Josef Albert, at Munich, had long before this (1874) produced good three-color collotypes, working with the then generally known principles of the process and using Vogel's color sensitizers. He began his work with a collotype hand press and continued in this manner until 1877 (Husnik, *Phot. Korr.*, 1879, p. 1).

The first color collotypes of Josef Albert, made in 1874, were a sample of a striped carpet, which was printed in the order of yellow, blue, and red; and a reproduction of a picture in colors by Frik, of Munich, showing a child of the Empress Frederick, to whom Josef Albert presented them in 1879. These, with an autograph on the reverse side, are preserved in the Phot. Lehranstalt des Lette-Hauses, Berlin.

At the Graphische Lehr- und Versuchsanstalt, Vienna, and in other places examples of Josef Albert's color collotypes may be seen; they were also published as inserts in the *Photographische Korrespondenz*, Vienna, and in the *Photographische Mitteilungen*, Berlin.

Three-color collotype printing was carried on at Vienna by the firms J. Löwy, Max Jaffé, at the Government Printing Office, and at the Graphische Lehr- und Versuchsanstalt; also in Berlin and by the experimental staff of the Imperial Printing Office at St. Petersburg. For later developments see K. Albert, *Lexicon der graphischen Techniker* (1927).

Du Hauron announced in 1897 a process for the production of three-color negatives by means of three plates or films placed one behind the other and in one single exposure. On top he placed (glass side toward the lens) a perfectly transparent ordinary gelatine blue sensitive silver bromide plate (Lippmann emulsion), then a thin film sensitive to green, then a red filter, and finally an emulsion sensitized for red; thus he obtained with one exposure the separations for the yellow, red, and blue plates.[22] This superimposition of three-color films, one behind the other, was later called "tripack." This early method was recognized as worthy of attention and further elaborated by employing thin films by the so-called "tripack process" by the English Colour Snapshot Co., Ltd., and used for additive color projection (F. J. Tritton, *Phot. Jour.*, 1929, p. 362).

Du Hauron placed the so-called "anaglyphic process" on the market at Paris (*Jahrb.*, 1895, p. 404). Dr. du Bois-Reymond wrote in regard to this (*Phot. Rund.*, 1894, p. 199) that in 1853 W. Rollmann described in Poggendorff's *Annal.* (XC, 186) exactly the same process, although for drawings only. Rollmann also laid out the pictures around a common center, while Du Hauron shifted them a little. J. C. d'Almeida, at Paris, also published, in 1858, his method of projecting stereoscopic pictures. He placed in his magic lantern a red and green glass and projected with each a steroscopic view; the audience put on spectacles of red and green glass in order to see the picture stereoscopically.[23]

Du Hauron wrote several basic works on color photography: *Les Couleurs en photographie* (1869); *L'Héliochromie* (1875); *Traité pratique de photographie des couleurs* (1878). Compare further Eugéne Dumoulin, *Les Couleurs reproduites en photographie* (1876). In his last work, *Photographie indirecte des couleurs* (Paris, 1900), with his portrait, he collected his practical experiences with three-color photography, and on page 44 of this book he gives proof of his rights to the patents which he was granted.

Louis Ducos du Hauron derived no material benefits from his inventions, and his old age was not free from care. The French government awarded him the modest pension of 1,200 francs annually (at that time about $240) in appreciation of his services. Thus was the scholar and scientist rewarded. The Vienna Photographic Society presented Du Hauron, in December, 1904, with a gift.[24]

CHARLES CROS

Charles Cros (1842-88) was a very versatile, ingenious man, who at one time devoted himself to mechanics with the talking machine and photography and at another time became prominent as poet and painter.

It is curious that he, at the same time as Du Hauron and absolutely independently, worked on three-color photography. On December 2, 1867, he presented to the French Academy of Sciences a sealed package, containing a report of his experiments, which had as their object the production of the three separation negatives and their synthesis for three-color photography.[25] He kept his process secret, however, until it became known that Du Hauron had patented his

three-color process on November 23, 1868. It was only after Du Hauron published the first of a series of articles in the journal *Le Gers* (March, 1869) on this same subject of three-color photography that Cros was induced to make his findings public.

On February 25, 1869, Cros published in the French journal *Les Mondes* an article on the solution of the problem of photography in colors, (entitled "Solution du problème de la photographie des couleurs"), which also appeared as a pamphlet. He accepted red, yellow, and blue as the primary colors and started from three complementary negatives. For their production Cros used light filters of colored glass or liquid filters, just as in the later usual method. He also mentioned the illumination of objects by colored lights during exposure. He also proposed another way—by projecting red, yellow, or blue light into the camera by prisms—and described clearly and in detail the "prismatic dispersion process." Cros in this anticipated the dispersion processes of Wordsworth Donisthorpe (1875) and K. J. Drac (1904, 1906). For the color synthesis of these negatives Cros emphasized the additive method of observation, along the lines of the chromoscope; but he also mentioned the viewing in the phenakistoscope or zoetrope.

Cros described in 1879 and exhibited before the Paris Photographic Society an apparatus which he called "chromometer," which contained orange-red, green, and blue-violet light filters and composed the complementary diapositives with the aid of transparent plate glasses in the eye of the observer. [A diagram of his chromometer is reproduced in the 1932 German edition of this *History* (p. 941)]. This was the basis of later photochromoscopes of Ives and others.

On this basis Charles Cros constructed a camera for three-color photography, which his brother A. H. Cros patented in 1889 in France and England. Cros is also the inventor of the production of color pictures by the "Absauge" method. He coated a glass plate with bichromated gelatine, exposed under a glass diapositive, washed with water, and soaked the coating with suitable dye solutions, which were absorbed only in the nonexposed parts. Thus he obtained diapositives in color, which he called "hydrotypes" (*Moniteur de la phot.*, 1881, p. 67). This was the basis for a method by Selle (*Phot. Korr.*, 1896, pp. 192, 294, 442) and the "pinatypy," by L. Didier in Xerligny, France, which was further elaborated by Dr. E. König of the Höchst Dye Works

in 1905 (German patent, no. 176,693; see also *Handbuch*, 1926, IV (2), 377).

Charles Cros studied medicine and philology. He was both a scientist and a poet; also a member of the "Collège Libre de Medicine," Paris. Cros worked on the invention of an autographic telegraph instrument (1867), a phonograph (1879), wrote on the means of communication with the planets by optical telegraphy (1869) and also a medical work on the mechanics of the brain (1880).

Personal communications by M. Potonniée to this author call attention to a collective description of Cros's scientific plans in Cros's book *Le Collier de griffes*, which appeared under the pen name "Emile Gauthier." It contains the statement that Cros was making investigations into the synthesis of precious gems, the radiometer, and the photophone. He also occupied himself with electricity, musical stenography, which was realized by others under the name "melotrope," and also with the autographic industry (Potonniée).

Cros's poetical works are, according to M. Potonniée, as follows: *Le Coffret de santal* (Paris, 1873; 2d ed., 1902); *Le Fleuve* (Paris, 1874); and *Le Collier de griffes* (Paris, 1908). The last-mentioned was published after his death by his son Guy Charles Cros.

In 1874 Cros published *Revue du monde nouveau*, of which only three numbers appeared. For the history of photography his work, *Solution générale du problème de la photographie des couleurs* (Paris, 1869) is particularly valuable. *Note sur l'action des différentes lumières colorées sur une couche de bromure d'argent imprégné de diverses matières colorantes organiques* (Paris, 1879) we shall refer to more in detail later in this book.

Cros delivered his first lecture on color photography before the French Society of Photography, Paris, May 7, 1869; all his articles referring to photography are printed in the bulletin of this society. They are also extensively published in the *Photographische Korrespondenz*, edited by E. Hornig.

With respect to the role Cros plays in the history of photography, it is of interest to consider his part in the invention of the phonograph. France contested the priority rights of Edison, who was everywhere called the inventor of the phonograph (1877), in favor of Cros. The Academy of Sciences in Paris celebrated the jubilee of the invention by Cros in April, 1877, while the Americans exalted Edison as the real inventor on August 10, 1927. The New York correspondent of

the Paris *Matin* interviewed the great inventor Edison, who stated:

The phonograph was fifty years old on August 10, 1927. On this date, fifty years ago, I ordered one of my mechanics to construct the first apparatus according to my specifications. It took thirty hours to do this. In the forenoon of August 12, 1887, the voice of a phonograph was heard for the first time in my laboratory. The apparatus was then already so perfect, that it differed only in quite unessential details from the general type of phonograph as it is used today.

"How do you explain the fact," asked the reporter, "that the French physicist, Charles Cros, who then claimed the authorship of the invention, is today still considered in France the real inventor of the talking machine?"

It is certain [replied Edison] that in July 1877, I conceived the idea of constructing a talking machine, as I said before, I ordered the first apparatus built on August 10, 1877. Cros, probably without question, transmitted somewhat earlier, that is, on July 30th of the same year, a sealed envelope with the plan of his phonograph to the Academy of Sciences, at Paris, but the envelope was not opened until December 3, that is, at a time when my machine had been in use for a long time. A comparison of his plan with my apparatus demonstrated that Cros had in mind an entirely different manner of the realization of a talking machine. At any rate, his plan was never executed up to the present time. Whatever may be thought of the paternity of the idea for a talking machine, the fact remains that the first machine which really talked was my work, and this ought to decide the contention finally! There is no doubt, of course, that Charles Cros had a great and original mind; he thought and found the correct solutions in many other technical fields, but unfortunately he always lagged in their execution. Thus he gave an important impetus to color photography by his statements, which others took hold of, realized and made money out of. This tardiness was in a certain measure his tragedy. He was inconsistent, sought immortality at one time as poet and at other times strove for the painter's laurels, and thus he lacked that peculiar ability of concentration and inner composure, without which nothing great and permanent can be created.

In the history of three-color photography Louis Ducos du Hauron and Charles Cros must be put in the first place side by side. At the session of the Paris Photographic Society on May 7, 1869, Davanne verified the fact that both inventors, at the same time and independently of each other, worked on the same subject.[26] Cros made his experiments in the studio of a rich amateur, the Duke of Chaulnes. The

famous Paris collotyper Dujardin occupied himself (1878) with making collotype printing plates for the reproduction of Cros's negatives from colored objects.[27] Du Hauron knew only the method of using three-colored glass plates for negatives, while Cros had already considered the production of three-color negatives by means of monochromatic illumination of the originals during exposure.[28] Du Hauron, on the other hand, as Davanne stated, had presented to the Paris Photographic Society on May 7, 1869, the first more or less successful, and in fact practical, three-color photographs (colored spectrum, see earlier in this Chapter) and by this had won precedence over Cros.

In the meantime the above-mentioned publications by Du Hauron appeared and at the end of the seventies Cros[29] published studies on the classification of colors and the means by which all shades could be reproduced by three negatives (red, yellow, and blue). Cros wrote:

I have been busy for some time trying to find photographic films which are sensitive to rays of all colors, especially to orange-red, green, and violet. In order to obtain these rays, I use transparent troughs (cells) filled with salt solutions, which filter the composite light.

Du Hauron carried on three-color printing more persistently than Cros, and his numerous publications were especially stimulating and advancing. In the *British Journal of Photography* (1906, p. 7) the patents of Du Hauron and Cros are published chronologically and with illustrations.

The real progress of three-color printing came only with the discovery of optical sensitizers by Vogel. Du Hauron dyed his plates according to Vogel's method and announced on September 6, 1875, to the Society of Agriculture, Sciences and Arts, Agen, that he used chlorophyll, the sensitizing effect of which for the red end of the spectrum was discovered by Edmond Becquerel. The silver bromide plates can be sensitized with dyes, however, for red, yellow, and green, which Vogel pointed out.

Du Hauron continued his experiments with color-sensitive plates and announced in 1878[30] that all photographic processes could be adapted to three-color printing. "We can choose," Du Hauron states, "between the pigment process, Woodburytype, collotype, the dusting-in process, or the silver chloride method, with the use of suitable toning baths, etc." He preferred at the time the pigment process with three colors, namely, carmine, prussian blue, and chrome yellow, although he had great difficulty in registering the prints. Du Hauron made not

only three-color pigment prints on paper but also polychrome pictures on glass, windows, and so forth.[31] He anticipated the principles underlying practically all varieties of three-color prints, which appeared with the later improvement of the reproduction processes by many inventors and experimenters.

The brothers Alcide and Louis Ducos du Hauron gave the fruits of their experience in their *Traité pratique de photographie des couleurs* (Paris, 1878),[32] in which they used the orthochromatic collodion process for making their negatives behind green and orange filters and introduced eosin collodion. At the First International Exhibition for Color Photography, at Paris, in 1904, such three-color photographs by Du Hauron, of the seventies, taken partly from nature, were shown.[33]

Léon Vidal, of Paris, also worked successfully with the production of three-color pigment pictures during the seventies of the last century. He was the first to produce color combination prints of chromolithographs with a brown pigment picture, especially he combined chromolithographs with a black Woodburytype printed last, which gave, owing to its transparency, excellent fine effects in reproductions of the work of goldsmiths (set with jewels) on a gold bronze background. The technique, which has been entirely discontinued, owing to the difficulty in reproduction, is unexcelled for this purpose.[34]

In the eighties Angerer and Göschl, at Vienna, as well as Goupil, of Paris (now Boussod & Valadon), produced four- and five-color zincographs, without achieving very much color separation in a purely photographic manner; good color prints were obtained, but only by the aid of a great deal of retouching by hand.

Photographic three-color printing attained a new impulse from the energetic invention of Vogel in 1891, especially after he devoted himself with all his zeal to the reproduction side of three-color printing.

Vogel had broadened, in 1885,[35] the theory of three-color printing. Emil Ulrich, a Berlin lithographer, experimented in 1890 with color collotype following these principles[36] and exhibited proofs at the Photographic Congress of Berlin (1890), as well as to the Society for the Advancement of Photography; he printed a fourth collotype plate in black as a key plate. He joined Ernst Vogel, the son of H. W. Vogel, in order to exploit this "four-color collotype printing," and the firm of William Kurtz, New York, offered to buy the process and adapt it for halftone relief printing, which seemed much more practical for book illustrations than the collotype process.

Ernst Vogel tried out different color filters and systems in Berlin and then went to New York, where he and Kurtz, employing azaline plates, made the first artistic and really satisfactory three-color prints, in 1892. They published a three-color halftone in the January, 1893, number of the *Photographische Mitteilungen* (signed E. Vogel-Kurtz). The firm Büxenstein, at Berlin, took up later the production and printing of three-color process plates on the advice of E. Vogel.

In the meantime Eugen Albert, at Munich, had also taken up the three-color process with Levy screens. He took out a German patent (No. 64,806) on May 9, 1901, for halftones and photolithographs in two and more colors. He patented the turning of the screen during exposure behind red, green, and blue violet light filters, at an angle of 30 degrees, in order to avoid a pattern (moirée) when the yellow, red, and blue impressions of the plates were printed on top of each other.[37] Buxenstein acquired this patent later, but it was not sustained and therefore did not interfere with the progress of reproduction technique.

Others who worked at three- and four-color processes intensively were Angerer & Göschl, Vienna; Husnik and Vilim, Prague; Meisenbach and Riffarth, Berlin, and many other men and establishments.

THREE-COLOR COLLOTYPE

It is worthy of notice that the English officer James Waterhouse was the first to employ three-color photography, in 1894, in Calcutta, assisted by A. W. Turner, a collotyper there. He printed collotype intaglio plates in order to obtain reproductions in natural colors by red, yellow, and blue inks, which he also applied to printing maps in colors (*Jahrbuch*, 1895).

Three-color collotype printing gives very pleasing effects. Artistic reproductions of oil paintings in large sizes were[38] probably first made by this method in 1904, at the Graphische Lehr- und Versuchsanstalt, Vienna, under the direction of Professor G. Brandlmeyer.

VARIOUS THREE-COLOR PHOTOGRAPHIC PRINTING PROCESSES

The production of polychrome pictures by photographic printing processes based on the subtractive three-color method was successfully accomplished. Both gum printing (repeated sur-printing of yellow, red, and blue films) and pigment printing were employed. In the latter case three films, yellow, red, and blue, either pigment tissues

or chromated gelatine prints tinted by immersion in dye solution (hydrotype of Cros), were superimposed. We mention, for example, here the work of G. Selle[39] and that of the brothers Lumière (*Handbuch*, 1926, Vol. IV), as well as that of Krayn (Neue Photographische Gesellschaft, Berlin). The pinatype method was and still is largely employed in the production of three-color pictures, both for diapositives and for paper prints. For the production of tanned gelatine films, which, impregnated in dye solutions, are absorbed by gelatine or collodion paper pressed against them, not only the pinatype method is adaptable, but also the so-called "Jos-Pé" method of Koppmann (1925) with tanned prints and pyrocatechin development (*Handbuch*, 1926, IV(2), 402) and several newer processes.

Here belongs also the kodachrome process (not to be mistaken for kodacolor) of the Eastman Kodak Company, which is based on mordant dye processes, as well as the excellent diapositive method "uvachromy," of A. Traube, which was also successfully used for polychrome paper prints (uvatypes) (see also Namias in ch. lxxv, and *Handbuch*, 1926, Vol. IV, Part 2).

The ordinary photoprinting methods used for making blue prints, also color toning of silver prints in baths for blue, yellow (lead intensification and subsequent chromium baths), and orange-red (toning with uranium and mordant dyes), were employed for these subtractive color prints. To enumerate them all would take too long, and we cite only one simple example: A. Gurtner produced color prints with the two-color system (orange and blue), using for it the usual toning methods for silver prints, namely, toning the blue in a ferricyanide-iron chloride bath and by making an untoned strippable print on celloidin paper, which is a brick-red color and is superimposed on the blue component of the picture (German patents, 1902, Nos. 146,149 and 146,150). These and numerous other such methods are described in Wall's *History of Three-Color Photography* (1925, p. 155), and all kinds of color toning methods appertaining to this in the issues of Eder's *Jahrbuch*.

COMBINATION OF COLOR PROCESSES

In many cases various photomechanical or other printing processes were combined. For very large editions (picture postcards and such) color lithography or color woodcuts were used with the halftone process. For art subjects, color lithography, algraphy, photogravure,

and collotype were employed in various combinations. The first impetus in this direction was probably given by prints made by a combination of color lithography and collotype by H. Ecker and A. K. Koppe, at Prague, in 1873. Otto Troitzsch and E. Gaillard, at Berlin, were very successful in 1877 with this combination printing, which had been used only in an experimental manner by the firm at Prague. They called it "heliochromy" (also "Troitzschotypie"). This combination of several printing methods was subsequently often employed. Among others, good prints of this sort were made by J. Löwy, Vienna, by Meissner & Buch, Leipzig, and by the Government Printing Office, Vienna, which cultivated especially the combination of chromolithography (six or more plates), and later algraphy with collotype or with photogravure. A great advance over these earlier methods is shown by the art prints which Professor Brandlmeyer produced in 1897, at the Graphische Lehr- und Versuchsanstalt, which combined for the first time pure three-color collotype with photogravure and later three-color lithographic algraphy with photogravure.

THREE-COLOR PROJECTION

Prompted by Maxwell's suggestion of color projection, Du Hauron studied and described in his *Les Couleurs en photographie* (Paris, 1869) the principle of three-color projection, but he never demonstrated his theory in practice. Léon Vidal elaborates on this in the author's *Jahrbuch* (1893, pp. 4, 302). It may be said without in any way diminishing the rights of later inventors that all the different experiments of this kind can be traced back to the basic ideas of Maxwell, Du Hauron, and Cros.

The first practical and successful color projection of three diapositives on a screen seems to have been made by the American Frederic Eugene Ives. He projected at Philadelphia, in 1888, such three-color pictures by means of a triple projection lantern and three different diapositives, backed with red, green, and violet glass. This public demonstration is reported in the *Journal of the Franklin Institute* (1889, p. 58).

Ives patented his method in America on February 7, 1890, (No. 432,530), describing it as a projection of three diapositives, made behind red, green, and violet filters to the same spot on a white wall in register, on top of one another by means of a triple projection lantern illuminated with red, green, and blue-violet light. Ives called

his apparatus a "triple projection lantern" and with it he was the first to achieve satisfactory results from this method.

Léon Vidal, at Paris, also carried out the same ideas and presented (similar to Ives) colored projections with three separately functioning projection lanterns, with three-color diapositives and colored illumination, on February 7, 1892, at a lecture before the "Conservatoire Nationale des Arts et Métiers," where he was professor of photography. He repeated this illustrated lecture on March 4, 1892, before the Paris Photographic Society. He sent his pictures to Vienna, where E. Valenta showed them in the projection room of the Society for the Propagation of Knowledge in Natural Sciences. Vidal's lectures caused the optician C. Nachet, in Paris, to construct a "stereo-photochromoscope" in 1894.

Professor A. Miethe, in Berlin, used, in 1903, the same idea as Ives and Vidal for the additive color projection of three-color positives, which had been made with the use of his panchromatic ethyl-red plates from nature. The apparatus used by Miethe was constructed by the Goerz Optical Works. This apparatus differed very little from Ives's "triple lantern"; in the Miethe-Goerz apparatus the lanterns were placed one above the other instead of side by side. Miethe inserted red, green, and blue-violet liquid filters in glass cells, which contributed a cooling effect in the path of the rays from the electric projection lamps. With this apparatus colored pictures by additive synthesis were shown on large projection screens at Berlin in 1903. The negatives from nature were made with a camera provided with a long strip of an ethyl-red plate enclosed in a falling plate holder which moved the negatives downward in rapid succession, while a pneumatic shutter made very short exposures possible. This camera ("Miethe-Bermpohl-Kamera") was built by Bermpohl, Berlin, in 1902.

For the purpose of making the rapidly successive exposures of the separation negatives for the three-color process, especially constructed motion picture cameras were also employed. B. J. Mroz, at Vienna, patented in 1922 a three-color pocket camera for use with panchromatic motion picture films. The simple movement of a lever opened the lens shutter, moved the strip of film, inserted the colored light filter, so that in the space of four seconds the three separations, properly divided, were obtained (*Jahrbuch*, XXX, 144).

Many different kinds of cameras for making three-color negatives were constructed; most of them sought to attain a simultaneous ex-

posure of the subject to be photographed. The important point was the necessity of avoiding parallax. Many types of construction used the method, laid down by Du Hauron, of using reflecting plate glass which reflected the light in part, but permitted it to penetrate somewhat, and thus produced in this manner three-color separations behind red, green, and blue filters. Ives called this kind of camera "chromoscope" and later also "photochromoscope cameras."

These types of construction were essentially the same as Du Hauron's camera. Du Hauron, however, described them only for use in making subtractive three-color photographs. Ives specified his camera also for additive three-color synthesis, and was the first to achieve practical results.

Ives's first English patent on three-color cameras is that of 1892 (No. 4,606); later he took out various other patents in 1895 and 1899 on similar types of construction. Concerning the controversy of Ives vs. Pfenninger relative to these patents see *British Journal of Photography* (1907, p. 54, and 1914, p. 61).

Later followed British patents by Edwards (1895, No. 3,613) and by White (1896, No. 8,663). In the *British Journal of Photography* (1906, p. 178) the further course of these inventions and patents by other scientists (Bennetto, Butler, etc.) was published.

Ives also made three-color projection serviceable for motion picture photography in 1897 and recommended a projection lantern with movable color filters. Then followed W. Friese-Greene, 1898; Turner, 1899; and others. J. Gaumont, at Paris, produced motion picture projectors for three-color pictures. In this system the film images were so small that all three took up no more space than two ordinary film pictures. These he projected additively by means of an ingenious triple projection lens.

The history of motion picture projection in colors is described by Otto Pfenninger (*Jahrbuch*, 1910, p. 29) and exhaustively up to present time by Wall, *History of Three-Color Photography* (1925).

Ives himself (1888) did not consider the practical method of three-color projection by three projection lanterns as final. The necessary projection lanterns, difficult and costly to procure, prevented the spread of the art. He therefore continued his work in this field and constructed next a special camera for taking the three-color separations ("chromoscope camera," 1891). The usual diapositives made from these separations were illuminated in a different novel arrangement

by appropriate red, green, and blue glasses, and were brought together in a small diascope in ordinary daylight for optical superposition and synthesis of the colors. They presented to the observer a reproduction true to nature in light, shade and color. This apparatus, which Ives called "heliochromoscope," was equipped with reflecting plate glass as mentioned above and was very original in its construction. Ives described his "heliochromoscope" (or "photochromoscope") in the *Journal of the Society of Arts* of May 27, 1892 (also in the *Jahrbuch*, 1894, pp. 217, 457). He demonstrated it in London in the autumn of 1893 with great success. On December 18, 1894, Ives was granted an American patent (No. 531,040) for his photochromoscope. One of the first examples of his photochromoscope was presented by Ives to this author, who demonstrated and described it in detail before the Vienna Photographic Society (*Phot. Korr.*, 1893).

Ives's photochromoscope incited others to construct similar apparatus. Karl Zink, of Gotha, constructed in 1893 his "photopolychromoscope,"[40] which, however, is not so compendious as Ives's apparatus, and there were other attempts along the same lines.

TETRACHROMY

Tetrachromy for the production of color photographs is based on the division of the spectrum into four color zones which border on each other (red, yellow, green, and blue). This system was first proposed and described in detail in a lecture before the Society for the Propagation of Knowledge in the Natural Sciences in Vienna by the author (*Vereins-schriften* of the Society, XXXVI, 235; *Phot. Korr.*, 1906, p. 231; *Jahrbuch*, 1907, p. 245). Ten years later, Zander applied in England for a patent on exactly the same subject, thinking that he had made a new invention. The patent was refused in Germany, because this author proved the lack of originality. At any rate, this tetrachromy which Zander attempted to introduce into the printing industry has no commercial advantages over the more simple and therefore more efficient three-color process, which makes this matter merely of historical interest.

FOUR-COLOR PROJECTION

A. Scott sought to improve on Ives's three-color projection by a four-color projection (purple, yellow, green, blue) with a quadruple projection lantern illuminated by a single light source, but he was unable to obtain any superior results (*Jahrbuch*, 1892, p. 433).

The Japanese Katsujro Kamei also invented a similar method of four-color projection (English patent No. 143,597, February 19, 1919).

For two-color projection bluish-green and orange-yellow light filters are employed, which by additive projection give an illusion of true colors in photographs taken from nature. The first practical results were exhibited by B. Jumeaux and W. W. L. Davidson at Paris, in 1904, and at the Photographic Convention at Southampton (England) in 1906. Their English patent (No. 3,729) is dated 1903.

C. A. Smith constructed a two-color apparatus ("kinemacolor") with red and green sectors and opaque interval sectors. He was granted an English patent (No. 26,671) in 1906, which was annulled in 1915. His cinema color was presented for a time (1907 until about 1914) quite frequently (see Liesegang, *Wissenschaftliche Kinematographie,* 1920, p. 167).

Bernard's two-color films (additive system) was worked out by the Raycol British Corporation, Ltd., according to the English patent, No. 329,438 (*Brit. Jour. Phot.,* November 7, 1930; *Kinotechnik,* 1930, p. 625).

A typical two-color projection film by the subtractive method was worked out by J. G. Capstaff in the research laboratories of the Eastman Kodak Co.[41] The silver image for the red and green components is produced on gelatine silver bromide films by means of the mordant dye process, and these two-color images are photographed on both front and back of the film in register. Similar methods were announced by other inventors. On two-color printing from twofold printing forms see Karl Albert, *Lexikon der graphischen Techniken* (1927, pp. 45, 270).

When small red, green, and blue color elements of pictures are placed in juxtaposition and observed visually, they merge into a color picture. This kind of additive color synthesis was considered by Du Hauron as early as 1868, but was never carried out by him in practice.

Independent experiments of this kind were made by J. W. McDonough in 1892, and he was granted in that year both an English patent (No. 5,597) and American patents (Nos. 471,186 and 471,187)

on his invention. At first he employed color-screen plates with granular powder in the three primary colors. For this purpose he first coated a glass plate with a sticky layer, on which he applied a mixture of very small colored red, green, and blue particles, like resin or such. On top of this color screen he flowed the emulsion, and the exposure was made through the color film. The idea was a good one, but the execution very difficult, and McDonough's invention was not successful in practice.

In the meantime the Englishman John Joly, of Dublin, had carried on experiments with color screens which he produced with a rather coarse line grating on glass, which consisted of red, green, and blue lines 0.12mm. wide next to each other. The color sensitized plate was exposed behind this three-color line screen. The negative showed naturally a color separation. The diapositives made from these negatives were viewed through such a color screen and presented to the observer a polychrome picture. The first English patent of Joly is dated 1893 (No. 7,743).

Notwithstanding their coarse lines, Joly's color screen pictures achieved a great success, and quite a large number of them were sold; but it often became necessary to realign from time to time the photographic diapositive with the three-color line screen, which was inconvenient and disagreeable. The screens of Joly, although merely temporary, induced McDonough to drop his earlier grain screen method. He turned to a screen similar to Joly's, but used finer lines (British patent, 1896, No. 12,645). We will discontinue the consideration of the line color screen, because the grain screens have achieved now a victorious precedence.

Here must also be mentioned the English patent No. 8,390 (German patent No. 96,773) granted in 1896 to Brasseur and Sampolo, who produced their color-screen plates with colored transparent celluloid grain or other transparent substances. In some of his patents A. Brasseur mentioned the possibility of the use of such color films for motion picture photography, but he was unable to introduce them into practice.

The first real and lasting success was achieved by the brothers A. and L. Lumière, of Lyons, in 1903, by their autochrome process. The production on a large scale of autochrome plates was extraordinarily expensive, which difficulty was not overcome until 1907, when they succeeded in placing the first perfect and efficient plates of this kind on the market. The autochrome plates carry on a glass plate mixed

red, green, and blue starch grains, on which a thin film of panchromatic gelatine emulsion is applied. The exposure takes place through the glass and the color grain base.

Lumière's autochromes found general and permanent favor. Equal to them are the German color screen plates made by "Agfa"; both have been often described.

Colored diapositives were not considered as an end even at the time of the first autochrome plates, and the idea was conceived to produce with their aid color prints on paper. The most efficient way turned out to be the making of separation negatives from autochrome diapositives, from which three-color process plates were made for typographic printing.[43]

Autochromes were, of course, also used as color guides for collotypes, uvachromes, and pinatypes in colors. Color proofs on paper from autochromes were attempted by E. C. G. Caille (English patent, 1908, No. 15,050); similar attempts are published in the *Jahrbuch* (1910, p. 387; 1911, p. 371; 1912, p. 372; 1913, p. 301). The method was not successful.

The color-screen method was also made to serve for projection in color. Thus Dufay's omnicolor plate was developed into the English Spicer-Dufay color cinema film and successfully projected in the summer of 1931 at London. They produced on a strip of film a red, blue, and green mosaic light filter from a lineature, and by reversal, turned the film negative into a positive which could be rapidly printed and thus reproduced. Thorne Baker reported on this at the Photographic Congress of 1931 at Dresden (*Brit. Jour. Phot.*, 1931, No. 3,790). The Agfa Company also exhibited narrow films with a three-color screen system (reversible films) at that Congress, where J. Eggert gave a demonstration of other noteworthy color film systems of the time.

JAN SZEPANIK'S THREE-COLOR WEAVING

The Austrian Pole Jan Szepanik (1872-1926) was an amateur photographer who built his own cameras. In 1896 he attracted public attention with his process of producing weave patterns for Jacquard looms by photography. Baron Ludwig Kleinberg, a countryman of Szepanik, backed him financially, and in 1896 an Austrian patent was granted them jointly for an "electric Jacquard machine" and for a "process for the production of a pattern for electrically driven looms"

and finally for a "method and installation for the production of weave patterns by photography." Szepanik elaborated Joly's color photography with three-color line screens to such an extent that he was able to weave pictures in natural colors. Two monochrome examples of large size (the portrait of Emperor Francis Joseph) as well as a silk gobelin, 148 × 120 cm. (about 4 × 5 ft.) were presented by the inventor to this author and are preserved at the Graphische Lehr- und Versuchsanstalt, Vienna.

An efficient designer, working by hand, would have required several years for the production of the patterns for a silk gobelin, while Szepanik's machine will accomplish the work in a few hours. In order to enable him to distort designs according to any requirement, Szepanik used a Zeiss anamorphot equipment. In a subsequent patent he published an arrangement for multiplying pictures with the aid of perforated cards and peculiar diaphragms, which might also be employed in the production of background and border designs for bonds, banknotes, and certificates. The photographic weaving process did not meet with general acceptance in practice; the establishment at Barmen (Germany) was closed in 1902, and the Vienna factory, in 1903. Szepanik invented, in 1902, an arrangement for the simultaneous exposure of the color separation in three-color photography.[44] He also announced at the same time a modification of Worel's bleaching process, in which he worked with three superimposed bleaching layers. After autochrome plates appeared commercially, Szepanik turned to screen plate color photography and worked out a color screen after new principles, which he later improved jointly with Dr. Hollborn, in Dresden, and sold in the market for a short time as "veracolor plates." During the World War he returned to Galicia (Austria), where he made his last invention, namely, an arrangement for motion pictures in natural colors, of which a model was built by the Emil Busch Company, Rathenow. This is described in detail in *Photographische Industrie* (1925). Although Szepanik was unsuccessful commercially, his inventions proved his genius and pointed out the road along which other inventors could proceed with greater success. Szepanik's numerous works are described in detail in issues of the *Jahrbuch*, in *Phot. Korr.* (1919, p. 331), and in Wall's *The History of Three-Color Photography* (1925). Poland acclaimed him as one of its greatest inventors, hailed him as the "Polish Edison," but his ingenious inventions have thus far been only ephemeral.

We have reported here only in rough outline the history of three-color photography. The field has grown enormously by the advent of color projection, motion picture photography, and other processes with two or more colors. The most exhaustive work to date on the historical development of these processes is E. J. Wall's *History of Three-Color Photography* (1925). E. Matthews published still later developments in his article "Processes of Photography in Natural Colors" in the *Journal of the Society of Motion Picture Engineers of America* (1931, XVI, 188, 219). Also see *Jahrbuch*, Vols. XXXI-XXXII.

Chapter XCV. PHOTOCHROMY; COLOR PHOTOGRAPHY WITH SILVER PHOTOCHLORIDE; LIPPMANN'S INTERFERENCE METHOD AND "PHOTOGRAPHIE INTEGRALE"; KODACOLOR; BLEACHING-OUT PROCESS

THE FIRST INDICATION of the origin of natural colors by the action of light was given by Senebier in 1782, when he announced the observation that silver chloride took on in violet light more of a hue towards blue, but lighter shades towards the other end of the spectrum.

But the physicist Seebeck, in Jena, was the first to determine, in 1810, exactly and in detail that the solar spectrum produces shades of color on silver chloride paper similar to those colors of the spectrum which strike it.

Sir John Herschel made further observations in this direction; he observed in February, 1840, that paper treated with silver chloride and darkened in sunlight takes on, under the influence of the rays of the spectrum, in red, green, and blue light, the analogous colors. These experiences found as little appreciation, however, as those of Seebeck, because the whole world was convinced of the impossibility of the problem's solution. The fact observed by Herschel was considered a mere accident.[1]

The results of the investigations of Edmond Becquerel on photochromy (1847, 1848, and 1855) surpassed all those preceding them. He prepared his sensitive film by polishing a silver plate and immersing

it in a metal perchloride solution or in chlorine water; a violet film of silver subchloride formed, which under the influence of colored glass or of the spectrum takes on the impression received and which retains this color photograph as long as subsequent light action is avoided.

Niepce de Saint-Victor devoted himself from 1851 to 1866 to Becquerel's method of heliochromy with chlorinated silver plates, inproved the process, and obtained more brilliant and more vivid colors than those of his predecessor.[2] When a blank polished silver plate is coated by the action of chlorine with a thin coating of silver subchloride (silver photochloride), it changes under the influence of the solar spectrum in such a way that the affected parts show shades of color similar to the color rays by which they were struck. The "chlorinating" of the silver plate was made by different methods with various degrees of success.

The silver plate was immersed in a solution of iron chloride or copper chloride (Becquerel), a mixture of both, or in a warm solution of potassium chloride with copper sulphate, washed after a few seconds and dried;[3] or it was held over chlorine water until it showed a whitish faintly pink color (Becquerel).

Becquerel preferred chlorination by the galvanic process. The silver plate was immersed as the positive pole in weak hydrochloric acid (1:8), the negative pole being a platinum sheet. Within the space of a minute the silver plate takes on gradually a gray, yellowish, violet, bluish color, which repeats itself in the same sequence; at the moment before the violet changes for the second time to blue, the process is interrupted, and the plate is rinsed and dried over an alcohol flame. This silver plate now renders all colors of the spectrum; the blue and violet strongest, the yellow weakest. Heating to 100 degrees, during which the film turns pink, increases its sensitivity, especially for yellow.[4] The sensitivity of the silver chloride layer to colored light depends upon the thickness of the layer and the strength of the chlorinating solution, also on the purity of the silver, which should not contain even 10 percent copper.[5] Copper chloride imparts to the colors greater liveliness than chlorine water alone. When weak chlorine is used, the yellow in particular is reproduced, while concentrated chlorine water renders especially the red and the orange. A mixture of magnesium chloride and copper sulphate seemed advisable.[6] Later Niepce de Saint-Victor chlorinated with chloride of lime; this alkaline bath gives less sensitive layers, but is very simple. The most pleasing

photochromes made on chlorinated silver plates are the work of Niepce de Saint-Victor, who exhibited them at the Paris Expositions of 1862 and 1867.[7]

One of these Niepce heliochromes (a colored example) of 1867 came into the possession of this author from Ludwig Schrank; after sixty years it still presents unchanged a remarkable liveliness of color. It is protected by a mixture of lead chloride and dextrin. These original photographs in natural colors on metallic silver plates are now extremely rare, which is the reason the author ordered one of them reproduced in facsimile by chromolithography, as a remarkable document of the history of photography, for the third German edition of this *History*. Insert III in that edition shows a halftone reproduction of this original heliochrome by Niepce de Saint-Victor.

This at the same time establishes the fact that direct heliochromes on silver subchloride do not fade by themselves, although they turn gray rapidly in light; they cannot be fixed.

Poitevin experimented especially with the production of photochromes with silver subchloride on paper. He turned back to the earliest form of Seebeck's experiments[8] and observed that by suitable admixtures, especially oxygen containing salts, the violet silver chloride on paper gives better color images.

He produced on ordinary unprepared photographic paper first a silver chloride layer, by floating it on a solution of common salt, then on a silver nitrate solution. After washing out the free silver nitrate, the paper was placed in a very weak stannous chloride solution; the tray was then exposed to diffused daylight for from five to six minutes, when the paper was taken out and thoroughly washed. In order to increase the sensitivity of the violet silver subchloride which had formed on the paper, it was treated with a mixture of potassium bichromate and copper sulphate. The paper, dried in the dark, developed under colored paintings on glass or by a projection apparatus, gave colored impressions which could be fixed to some degree with sulphuric acid.[9] Later Saint-Florent[10] especially occupied himself with similar experiments. Raphael Kopp[11] (died 1891) followed Poitevin's method and improved the reproduction of the colors by adding mercury nitrate to the preparation of the paper,[12] employing the bath method.

Silver chloride emulsion papers are also suitable for the reproduction of colors. The first obscure statements on this subject come down to us from the year 1857. Colored images were sometimes obtained on

collodion silver chloride; after fixation with potassium cyanide the colors are supposed to appear[13] when subjected to the action of iodine chloride vapors. More precise is the statement of Wharton Simpson, who observed that collodion silver chloride paper (which we now call "celloidin" paper), which under light had turned a slate gray, turns under different varieties of colored glass to various colors. Under ruby glass it turns red, and under an aniline green filter, green, and so forth.[14] This statement was found much later to be true for all modern collodion and gelatine silver chloride printing-out papers (collodion and gelatine printing-out papers).[15]

Dr. Wilhelm Zenker,[16] of Berlin (1829-99), collected in his *Lehrbuch der Photochromie* (Berlin, 1868) all the material published on the subject up to that time, and he was the first to advance the theory, which later became so important, that stationary light sources produce the colors of thin laminae (layers); Rayleigh (1887) also explained the origin of Becquerel's color photography by stationary waves.

It was not until 1889 that Professor Otto Wiener (1862-1927) succeeded in experimentally and definitely demonstrating stationary light waves. He gave, also, by his discerning study, "Farbenphotographie durch Körperfarben und mechanische Farbenpassung in der Natur" (1895)[17] an incontestable explanation of the creation of colors when silver subchloride papers are exposed to light. He demonstrated that Zenker's explanation of the theory of stationary light sources does not hold good for all these processes. In Becquerel's method (with silver plates and a homogenous layer of silver chloride, containing subchloride) stationary waves act in combination with so-called pigments, while in Seebeck's and Poitevin's paper images the colors of the image are exclusively pigmentary.

The "pigments" originate in light, according to Wiener, in the following manner: a light-sensitive substance can be changed only by the color rays which it absorbs. Light-sensitive red matter, therefore, is not changed by red rays, because it repels them, and likewise light-sensitive yellow and blue matter remains unchanged in yellow and blue light, respectively. When, therefore, a light-sensitive substance is capable by the action of light of assuming different colorings, it will under the influence of red, yellow, and green rays change so long, until it has turned red, yellow, and green, and the color remains during further exposure. This property is inherent in Poitevin's silver subchloride, and this explains the origin of the colors; but none of these

silver subchloride photochromes can be fixed, because the fixative destroys the colors.

In consequence of these premises the investigations in photochromy had to be pursued along two different directions: 1st, photochromy according to the interference method, which leads to Lippmann's method and, 2d, photochromy by the bleaching-out process.

LIPPMANN SOLVES THE PROBLEM OF FIXABLE DIRECT PHOTOCHROME EXPOSURES BY THE INTERFERENCE METHOD (1891)

The greatest recognition for having produced and fixed photochromes by direct exposure from nature is due to the physicist Gabriel Lippmann, of Paris (1845-1921). Lippmann studied in Heidelberg, received his doctorate in philosophy in 1873, went to Paris in 1875, where he continued to study until 1878, when he became professor of physics at the Sorbonne. His work dealt especially with the field of electricity, to which he gave his "capillary electrometer," a most valuable instrument. He also contributed important studies on thermodynamics and optical phenomena. Lippmann presented to the Paris Academy of Sciences on February 2, 1891, his report on photochromy, in which he described his famous method of photography in colors, the so-called "interference" method, based on the action of stationary waves (*Compt. rend.*, 1891, CXII, 274). His first experiments were carried on with silver bromide albumen plates sensitized for color with cyanine. His successful experiments in the reproduction of the solar spectrum in its colors aroused much attention in the scientific world, because he had solved the problem of direct photography in natural colors on silver haloid layers and the fixation of the color images.

In Lippmann's method[18] a glass plate was coated with a "grainless" (as fine grained as possible) color-sensitive film of albumen containing potassium bromide, dried, sensitized in the silver bath, washed, flowed with cyanine solution, dried, and then brought into optical contact with a reflecting surface; the back of the plate is then flowed in a plate holder of special form with pure mercury and exposed in the camera through the glass side of the plate, so that the light rays which strike the transparent light-sensitive film, are reflected in themselves and create interference phenomena of stationary waves.

Then followed the development of the latent image, during which the formation of silver as white as possible was striven for. After fixation with potassium cyanide solution and the drying of the image, a

brilliant picture in colors appeared when viewed in reflected light.

Lippmann produced by his process such photochromes of the solar spectrum and of the spectrum of an electric arc light. These color images of the spectrum were only a few centimeters long and showed good reproduction of color from blue to red.

As a light-sensitive material Lippmann used the albumen process, along the lines of the old Niepce de Saint-Victor method, but employed in place of silver iodide, silver bromide, and he sensitized with cyanine.

Such a color image of the spectrum Lippmann sent to this author, who loaned it to the Technical Museum for Industry and Trade, Vienna. The detailed description of the procedure is taken from a letter from Lippmann to this author, dated June, 1892.

This letter discloses that Lippmann employed that particular process which, among the processes known at the time, produced the finest grain, namely, the albumen-bath process, omitting silver iodide from his preparation and substituting pure silver bromide, thus ensuring a more favorable color sensitizing. Owing to the extremely low light-sensitivity of this method Lippmann confined himself to the photography of the most luminous spectra. In 1892 Lippmann started on a series of important experiments; he produced photochromes of natural objects, such as paintings on glass, flowers, parrots, a landscape with green trees and blue sky, on which work he reported on May 2, 1892 (*Jahrbuch*, 1893, p. 426).

Lippmann also made experiments for the production of photochromes by his interference method without the use of silver salts. He presented to the Paris Academy of Sciences on October 24, 1892, color photographs in which albumen or gelatine with addition of bichromates was used as the sensitive film.[19]

In 1908 he conceived an idea which was as bold as it was original. He proposed the production of photographic plates constructed in imitation of an insect's eye, on which plates a negative would be formed without the use of a photographic lens, and the positive of which would give a stereoscopic impression (Lippmann, in *Compt. rend.*, 1908; *Jahrbuch*, XXX, 1170; also, Lippmann, in *Journal de phys.*, 1908, VII, 821; *Bull. Soc. franç. phys.*, *Proc. verbaux*, 1911, p. 69). Lippmann called this method "photographie intégrale."

Following this method, E. Estanave experimented with it and described further details (*Compt. rend.*, CLXXX, 1255; 1930, XXIV, 1405). Dr. Herbert E. Ives wrote on "Optical Properties of a Lipp-

mann Lenticulated Sheet," *Journal of the Optical Society of America* (1931, p. 171).

Lippmann was a member of the French Academy of Sciences and was awarded the Nobel prize for 1908. He died in 1921 on board the S/S La France, returning from Canada, where he had gone as a member of a French mission. He died from an illness which he incurred owing to the hardships of the trip. An exhaustive biography of Gabriel Lippmann is printed in the *Bull. Soc. franç. phot.* (1921, pp. 299, 325).

INTRODUCTION OF "GRAINLESS" SILVER BROMIDE GELATINE FOR THE PRODUCTION OF LIPPMANN PHOTOCHROMES BY THE BROTHERS LUMIÈRE AND E. VALENTA (1892)

At first Lippmann worked with albumen plates, which were not very sensitive. In 1892 the brothers Lumière, in Lyons, produced their first satisfactory Lippmann photochromes on fine-grained gelatine silver bromide plates. They reported their method March 23, 1892, to the "Société des Sciences Industrielles" at Lyons,[20] but this local publication was not transmitted to the technical journals and therefore remained unknown in larger circles. Valenta, at Vienna, worked independently on the same method and published the process almost at the same time.[21]

The first publication by the Lumières was written in general terms and contained no detailed statement on the preparation of the gelatine silver bromide emulsion suitable for Lippmann's photochromes. This description is first given by Valenta in September, 1892. The gelatine silver bromide must be prepared and applied at a very low temperature in order that the "ripening" and accompanying enlargement of the silver bromide grain is avoided (Valenta, *Die Photographie in natürlichen Farben*, 2d ed., 1912).

The light-sensitivity of these "grainless" gelatine silver bromide films was essentially greater than that of the earlier albumen films, but still very much less than those of ordinary gelatine silver bromide plates. From this time on only gelatine emulsions were used for the Lippmann process. The Lumière brothers were the first to take the portrait of a living person in natural colors, in the summer of 1893, which they showed at the International Photographic Exhibition in Geneva. It was a photograph of a girl, resting her head on her arm at a table with a green background of grape vines and a glass of red wine

on the table. This photochrome possesses particular interest as the first photographic image of a human face in natural colors, taken directly from nature.

The Paris Exposition of 1900 brought many such beautiful photochromes from nature by Lippmann, Lumière, and Neuhauss, of Berlin, among them photographic portraits in everyday attitudes.

In 1893 Hermann Krone, at Dresden, demonstrated that Lippmann photochromes can also be obtained without mercury mirrors by mere reflection from glass.

Dr. R. Neuhauss,[22] at Berlin, who devoted himself very successfully to photochromy, was the first to demonstrate, in 1897, by the aid of microphotographs of cross-sections, that at a two thousand times magnification the lamellae of the silver precipitate become visible in the interference image of the spectrum. In the same year he showed that "grainless" emulsions, after developing and fixing, possess silver grains of about 0.005 mm. in diameter.

For further development of interference color photography we are indebted to Dr. Hans Lehmann (died September 19, 1917, at Dresden,)[23] who, in 1905 and the following years, occupied himself successfully with these methods at the Zeiss works, Jena. Here he also constructed improved apparatus with mercury holders for taking interference photochromes, as described in his *Beiträge zur Theorie und Praxis der direkten Farbenphotographie nach Lippmanns Methode* (1906) and in *Photographische Rundschau* (1909). Lehmann made, in 1906, microphotographs of the lamellae of photochromes, of monochromes as well as of mixed colors at a 7000 times magnification, which he reproduced by Spitzertype (see ch. xciii).

Lehmann kept secret his good formula for the production of "grainless" and correct-color-sensitive gelatine silver bromide plates, made for him by Richard Jahr, the dry-plate manufacturer at Dresden, and only long after Lehmann's death, in 1925, did Jahr reveal the preparation, for which the modern color sensitizers, pinacyanol, orthochrome, and acridine orange were used.[24] With Lehmann the technique of Lippmann's photochromy reached its highest point.

In 1907 Lehmann made a color photograph of an oil painting (a sample is reproduced as insert IV in the 1932 German edition of this *History*). This was the first reproduction of a Lippmann photochrome by the three-color halftone process. The plates were made by Schelter and Giesecke, in Leipzig, and printed in Germany and England

(Valenta's *Photographie in natürlichen Farben,* 1909, Penrose's *Year-book,* 1907-8, and others). We are indebted to the Carl Zeiss Works, of Jena, for the electrotypes.

Lehmann's work ended abruptly in 1909, because in the meantime A. and L. Lumière had commercially introduced their autochrome plates. They had solved the problem of photography in natural colors in a more convenient and comparatively cheaper manner and accomplished the result with shorter times of exposure.

Although Lippmann's interference photography has disappeared from photographic practice, it still remains the culminating point of the scientific solution of the problem of photography in natural colors by direct exposure in the camera.

FROM LIPPMANN'S "PHOTOGRAPHIE INTÉGRALE" TO THE KODACOLOR
PROCESS FOR COLOR MOTION PICTURE PROJECTION

The ingenious idea of Lippmann to provide the back of the photographic film with very many small lenses, analogous to the faceted eyes of insects[25] was taken up by Albert Keller-Dorian, whose patents go back to 1908.[26] The small lens-like raised parts ("wart lenses") are impressed on the back of the film with steel embossing cylinders. At first the Keller-Dorian establishment made these with fifty-two cells to the square centimeter, later the lens pattern was made much finer, to about twenty-two on a square millimeter. The other side of the film is coated with a panchromatic emulsion. A divided three-color light filter (blue, green, red) is inserted. The small facets, or wart lenses, of the embossed film project an image of the color light filters on the panchromatic photographic film. From the film negative thus produced diapositives are made with the use of acid permanganate or bichromate baths (similar to the autochrome process) and they furnish motion picture projections in color.

The firm Keller-Dorian belonged later to Berthon, in Mulhouse (Alsace), who improved the method further for motion pictures in color. He succeeded, in 1922, in producing a good experimental film of short length, and in 1923 he produced in the south of France a long color cinema film suitable for color projection. The method was called in short the "K. D. B. process" (Keller, Dorian, Berthon).

Soon Berthon left the company, the reasons for this step not being made public. Keller-Dorian died in 1924, and Brosse, another stock-holder, also left, with two young engineers, and founded another

company, the "Société d'Etudes." Berthon joined this company in 1926, while the Keller-Dorian company continued along the same lines (*Filmtechnik*, 1928, No. 7).

The rights for the Keller-Dorian-Berthon process were bought in 1928 by the Eastman Kodak Company, which, with its tremendous resources, improved the process to a high degree. The Kodak Company introduced special photographic and projection apparatus for the practice of the process, giving it the trade name "kodacolor," and in the same year put on the market films for amateur motion pictures in color,[27] and widely advertised them.[28]

The motion picture photographic lens (Ciné-Kodak) has a light intensity of f. 1.9. The colored light filter placed over the lens consists of three filters next to each other (red, green, blue). The kodacolor film bears twenty-two facet lenses on one square millimeter. The small facet lenses, embossed on the film, act like photographic lenses and photograph the object with a three-color filter through the film carrier onto the light-sensitive film, which is strongly panchromatic. When the exposed film is reversed, the light can penetrate the film only in those parts where an exposure has taken place, and since an exact repetition of the ray direction during exposure takes place in reversed sequence, a picture in the natural color of the object is produced on the screen.

PHOTOCHROMES THROUGH COLOR SELECTION BY THE BLEACHING-OUT PROCESS

Color-printing methods, or photochromy, by the bleaching-out process are based on the fact that light-sensitive substances are bleached out only by those kinds of light which they absorb, while they are not destroyed by light of their own color. Vogel (1813) and Grotthuss had experimented with bleaching organic dyes in varicolored light (see ch. xvii).

Herschel studied, in 1842, "the action of the rays of the solar spectrum on vegetable colors"[29] and determined on the basis of his observations that coloring matter is destroyed as a rule by those color rays which possess the color complementary to the former. He cited the example that orange-yellow dyestuffs are destroyed mostly by blue rays; blue coloring matter by red, orange, and yellow light; purple and carnation red dyes by yellow and green light.

But these observations were forgotten until Otto Wiener's thorough

investigations placed them again in the foreground and determined the theory of the origin of pigmentary colors by the action of light.

Regarding the historical development of the bleaching-out process, it seems that the publications of Raphael Ed. Liesegang in this field are not yet fully appreciated. In the *Photographisches Archiv*, published by him, he recommended as early as 1889 (No. 633, p. 328) that the primary colors, red, yellow, and blue, be mixed on paper and that for this purpose fugitive coloring matter be employed. At the same time he gives a perfectly correct explanation of the process by which in such color mixtures the colors of the light source (for instance, from paintings on glass) are reproduced.

In his *Photographische Almanach für 1891*, Liesegang broadened his statement by adding: "The (bleaching-out) process proceeds more rapidly in oxygen." A few years later Liesegang published[30] a series of experiments which relate to the acceleration of the bleaching-out of different aniline colors by the addition of various chemicals (stannous chloride, oxalic acid, hydroxylamin, ammonium sulphocyanide, lead acetate, tartaric acid, sodium carbonate, soap, etc.).[31]

Incited by Wiener's investigations, E. Vallot, in 1895, produced for the first time photochromes by the so-called "bleaching-out process."[32] He mixed (led by the idea of applying three-color printing to the bleaching-out method) fugitive red, yellow, and blue coal-tar dyes (aniline purple, curcuma, and Victoria blue), and spread them on paper, which now appeared black. This coating turned in sunlight under colored transparencies blue in blue light, yellow in yellow light, and red in red light, because red light, for instance, bleaches out the blue and yellow coloring matter and permits, thus, only red to remain. Unfortunately, this process of Vallot suffered greatly from lack of sensitivity.

Ministerial Councillor Karl Worel, at Graz (Styria), as well as Dr. R. Neuhauss, at Berlin, endeavored to shorten the required time of exposure by searching for oxidizing substances which would accelerate the bleaching-out of the coloring matter (and thus act as sensitizers) and could be removed after exposure.

Worel used essential oils, especially one of the components of aniseed oil (anethol) for admixture to red, yellow, and blue coal-tar colors, and while he failed to obtain a high sensitivity, he was able to use this method for photography. He exhibited a collection of photographs in pigmentary colors (made both in the camera and by contact print-

ing) at the Amateur Photographic Club of Graz, November 12, 1901, and published his method March 13, 1902, in the *Bulletin* of the Academy of Sciences at Vienna.[33]

At about the same time Neuhauss published his process in the *Photographische Rundschau* (January, 1902) and stated that he mainly used oxidizing substances, like hydrogen peroxide, persulphate, etc., as an addition to the color mixture and that he had in this way accomplished a very considerable increase in light-sensitivity, providing that the colors were transferred with gelatine on glass and that this film was exposed while still moist.[34] Lumière and Jougla at Lyons used for the same purpose hypochlorides, and so forth (1913).

J. Szepanik, at Vienna, in 1902, also used three different dyes, but not in a mixture; he applied them, with a suitable binding substance (gelatine, collodion, etc.), in layers on top of each other, to paper.[35] Other photographic printing methods for the production of pictures in color, such as those with leuco bases (D. Gros, 1901; E. König, 1904), the katatype invented by W. Ostwald (1902), and others, are described in *Handbuch* (1926, Vol. IV, Part 2, and Vol. IV, Part 4). All these methods, however, are at this time (1932) practically incomplete, and all we can record is their origin.

Dr. J. H. Smith and Dr. W. Merkens, at Zurich, elaborated Worel's work and produced "utocolor paper" for the bleaching-out process, which was prepared with a mixture of the primary colors and with the addition of anethol as sensitizer; it was placed on the market in 1907.

In 1910 Dr. J. H. Smith improved his utocolor paper, employing new sensitizers for photochemical bleaching-out by using thiosinamine and other combinations. With this improvement he participated in its exploitation by the "Société Anonyme Utocolor" (La Garenne Colombes, Paris), which in 1911 made extensive efforts to introduce the bleaching-out process as a printing method into general practice. The firm produced beautiful picture folders with proofs on paper (from autochromes, etc.) and improved the manipulation of utocolor papers.[35] The factory continued to work for several years, but all bleaching-out methods for color selection, on which so much hope had been placed, could not fulfill the expected results.[36]

Chapter XCVI. PHOTOGRAPHIC TECHNICAL JOURNALS, SOCIETIES, AND EDUCATIONAL INSTITUTIONS

FOR THE SURVEY, incomplete as it must necessarily be, owing to lack of space, of the influence which the early photographic journals, societies, and educational institutions have exerted on photography, we append a few statements.[1]

FRANCE

The first notices in France on the daguerreotype were published in the *Comptes rendus de l'Academie de sciences*. Subsequently the growing interest in photography in the middle of the last century caused the creation of photographic societies and technical journals. In 1851 was founded the "Société Heliographique de Paris" (by de Monfort), who had as his cofounders Niepce de Saint-Victor, Ed. Becquerel, Chevalier, Le Gray, Regnault, and others. The journal of the society was *La Lumière*, of which twelve numbered volumes appeared,[2] which are important for the history of that time.

The Société française de Photographie was founded November 15, 1854, at Paris. The history of this society is published in a pamphlet by Pector (*Notice historique*, 1905), with portraits of its presidents Regnault, Balard, Peligot, Janssen, Marey, Lippmann, Laussedat, Davanne, and Sebert. An exhibition of artistic photographs is held regularly as "Salon International d'Art Photographique de Paris" by the Société française de Photographie and the Photo Club.

This Paris photographic society soon outstripped all other earlier photographic societies in France, and it achieved, through its *Bulletin*, which has been printed since 1855 and is still being published, as well as through its prize competitions, a great and lasting influence on the progress of photography. It also awarded honor medals, such as the "Peligot-Medaille," founded by the chemist Peligot, which bears the portraits of Niépce and Daguerre.

We must mention here the successful prize competitions and the great encouragement given by this society. Most successful were those of the Duke of Luynes, in 1856. The duke had seen the first photographic prints of Poitevin produced with printer's ink, which were exhibited in 1855, and in view of the, to be sure, still imperfect examples desired to hasten the solution of the problem of the production of

permanent photographic prints. He donated, in 1856, through this society, two prizes, which led to the invention of pigment printing, gum printing, photolithography, and collotype.

In the last century was established at Paris a technical school on a large scale, the "Ecole Municipale Estienne,"[3] or "Ecole de Livre," which is the oldest of its kind. Typographic printing, lithography, and the photomechanical processes were taught here. The photographic department was directed by the excellent technician in reproduction and technical writer L. P. Clerc. The school receives great encouragement from the city authorities because of its services to the growing generation in the printing industry.

At the old and extensive "Ecole des Arts et Métiers," at Paris, L. Vidal, who has been referred to many times in this *History*, taught for many years as professor of photography.

Although in various places in France the subjects of photography, photographic optics, and the technique of reproduction had been taught for many years, a special school devoted to photography and cinematography was not established until a commission of French technical experts had visited other national institutions for this purpose, among them the Graphische Lehr- und Versuchsanstalt in Vienna, and had made themselves acquainted with their organization. An educational institute for photography and cinematography was opened in Paris on November 15, 1926, and was directed by L. P. Clerc and Paul Montel.[4] Both theory and practice were taught there.

The first journal devoted to the application of photography in medical science was the *Revue médico-photographique des hôpitaux de Paris*, founded in 1869 by Dr. de Montméja. It was richly illustrated with Woodburytypes as early as 1875.

Of the many photographic societies in Paris we mention also the "Photo-Club de Paris," the "Société française d'Amateurs Photographiques," and the "Stereo-Club de Paris." An exhaustive list of French photographic societies is contained in the *Agenda Lumière* (1930).

ENGLAND

Of the English scientific photographic technical societies, the London Photographic Society, founded in 1853, achieved special importance in the development of photography. The Royal Photographic Society of Great Britain grew from the meetings of a few photog-

raphers, who used to come together during 1851 and 1852 in the rooms of the *Art Journal*. The foundation of this photographic society took place on January 20, 1853, at the clubhouse of the "Society of Arts." At that meeting some members offered a resolution to found, not a new society, but only a branch of the Society of Arts; but the motion failed to pass and thus this photographic society was founded, with Sir Chas. Eastlake as its first president. The first photographic exhibition took place on January 3, 1854, which Queen Victoria and the Prince Consort Albert attended with their retinue; from that time the interest of the royal family in photography never waned. The society's journal, *The Photographic Journal*, appeared in March, 1853, but met with financial difficulties and ran into debt which amounted to £335 in 1860. In 1890 the number of members had so increased and the financial condition was so satisfactory that the society was able to move into its own quarters at 35 Russell Square, London. In 1894 Queen Victoria granted it the title "Royal Photographic Society of Great Britain."

The society founded in 1878 its silver "Progress Medal," awarded annually. This medal was bestowed in the first years of its existence upon W. de W. Abney, 1878; W. Willis, 1881; L. Warnerke, 1882; W. B. Woodbury, 1883; J. M. Eder, 1884; Abney, 1890; J. Waterhouse, 1891; P. H. Emerson, 1895; Thomas R. Dallmeyer, 1896; G. Lippmann, 1897; Hurter and Driffield, 1898; Louis Ducos du Hauron, 1900; R. L. Maddox, 1901; Joseph Wilson Swan, 1902; Frederic Eugene Ives, 1903; Paul Rudolph, 1905; Janssen, 1906; E. Sanger-Sheppard, 1907; John Sterry, 1908; A. Lumière and his sons, 1909; etc.

Photography is taught in almost all the large cities of Great Britain; for instance, at the Municipal College of Technology in Manchester, where there is a department of photographic technology, where the well-known phototechnicians R. B. Fishenden and Charles W. Gamble taught (until 1932).

The Photomicrographic Society, founded at the turn of the 19th century, devotes itself specially to its own field and has published, since 1915, its own journal.

A very exhaustive list of the numerous photographic societies in Great Britain is published in the *British Journal Photographic Almanac* (1931, p. 144).

The photographic societies of England, previously associated in local or sectional groups, for the promotion of their interests formed in 1891 "The Affiliation of Photographic Societies" with the Royal

Photographic Society of Great Britain, which was reorganized in 1930 as "The Photographic Alliance," comprising (1932) about 300 societies in Britain and overseas, with 22,000 members. *The Photographic Red Book*, first issued in 1900, is the official yearbook of the Alliance and lists all the federated societies and their activities.

In Scotland a photographic society under the patronage of Prince Albert was founded in 1856. Sir David Brewster was its first president.[5] Many other small societies started in various places and functioned for a longer or shorter time (see footnote 3, ch. xliv).

In Bombay, India, a photographic society also was founded in 1855, which published the *Journal of the Photographic Society of Bombay*.

In 1854 the *Liverpool Photographic Journal* was founded, which was merged in 1856 with the great London publication *The British Journal of Photography*, which still exists. *The British Journal Photographic Almanac* was first published in September, 1859, as a supplement to the *British Journal*. It has appeared annually since then. In the *Almanac* of 1931 (p. 140) the succession of editors is enumerated. In 1856 *The Photographic News* was founded at London.

AMERICA

The first photographic technical journals in the world were published in America. The first of these devoted especially to photography appeared in Boston under the title *The Daguerreotype; a magazine of foreign literature and science, compiled chiefly from the periodical publications of England, France and Germany*, in 3 volumes from 1847 to 1849. [*The Daguerreotype* quoted was not a photographic journal, but was devoted to general literature. There is also in the Epstean Library, Columbia University, a three-volume journal entitled, *Il dagherotipo* (Turin, 1840-42). In the preface of Volume I the editor gives a reference to the daguerreotype and illustration of a daguerreotyper's outfit. The journal described immediately following was really the first periodical devoted to photography in the world. Translator's note.]

S. D. Humphrey, at New York, founded *The Daguerreian Journal; Devoted to the Daguerreian and Photogenic Art*.[6] It made its appearance in November, 1850, changed its title in 1853 to *Humphrey's Journal of the Daguerreotype and Photographic Arts and the Sciences and Arts Pertaining to Heliography* (8 volumes, V-XII, 1853-62); and from that time it was published as *Humphrey's Journal of Photography*

and the Allied Arts and Sciences (1862-1870) edited by John Towler. *Humphrey's Journal* was not without competition. H. H. Snelling published, in 1851, *The Photographic and Fine Art Journal*, New York, of which the first series ran until 1853, the second from 1854 until about 1860. Snelling died in 1897, eighty years old, at St Louis, Missouri.

In America not only was the practical side of photography taken up but also it was promoted by scientific investigation, which is evidenced by the Franklin Institute at Philadelphia, founded in 1824, where Elliot Cresson, a wealthy promoter of science donated, in 1848, funds for a gold medal of honor, which has been awarded by the institute in all fields of science, including photochemistry. The fund and the award is managed by the institute.

INTERNATIONAL EXHIBITIONS AT LONDON AND PARIS

The progress of photography was presented to the general public for the first time at the International Universal Exposition at London (1851), and at Paris (1855).[7] These were followed by numerous exhibitions of photography at London, Paris, Birmingham (September, 1857), Vienna, Berlin, etc., and brought forward many valuable improvements in the art.

GERMANY AND AUSTRIA

In German literature Dingler's *Polytechnisches Journal* the most important technical organ, collected reviews from French, English, and German photographic publications from 1839, and as late as the 1880's still printed comprehensive reports.

The first photographic journal in German was published in 1853 by the photographer, painter, and technical government official, Wilhelm Horn, at Prague. The first number appeared in December, 1853 *Horn's Photographisches Journal; Magazin usw. für Photographen, Maler, Zeichner und Freunde dieser Kunst.* It appeared twice a month (1854-65, Vols. I-XXIII), and printed articles only on daguerreotypy and collodion. In the fifties it was of great importance, but it soon lost its reputation and it ceased publication in 1865.

The first German textbook on photography, *Repertorium der Photographie* (Vienna, 1846) was written by A. Martin, librarian of the Polytechnical Institute, Vienna. Martin, from the discovery of photography, was one of the first amateur photographers and promoted

photography at the Polytechnikum, Vienna. During the years 1855-57, urged by Martin, Karl Josef Kreutzer,[8] of the library of the Polytechnikum, edited the *Jahresbericht über die Fortschritte und Leistungen im Gebiete der Photographie mit genauer Nachweisung der Literatur*, Vienna, and he founded, in 1860, the *Zeitschrift für Photographie und Stereoskopie*.

Both Kreutzer's *Jahresbericht* and his *Zeitschrift* contain exhaustive references to contemporary technical literature and are rich sources for the historian.

The photographer M. Weingartshofer published, in 1857, at Vienna, the periodical *Photographisches Album*, which was distinguished as the foremost illustrated technical journal by its excellent photographic inserts and other illustrations. The periodicals mentioned above were followed by the important publication *Photographisches Archiv*, founded in 1860 and edited until 1896 by Paul E. Liesegang, and by R. E. Liesegang until 1897; also by H. W. Vogel's, *Photographische Mitteilungen;* and then by *Photographische Korrespondenz* and numerous other technical journals.

The Photographic Society of Vienna is the oldest organization of its kind in German countries. It was founded in 1861 by the Friends of Daguerreotypy, who met in 1840 at the home of Karl Schuh, in Vienna. The founders were representatives of professional photography and men of science and art.[9] Regular meetings provided contact between the members of the circle, who kept themselves informed in this manner about the progress of photography at home and abroad. Small exhibitions and a *Wanderalbum* (circulating portfolio), which was also sent to the provinces, propagated interest in photography in wider circles. The first president of the society was the librarian A. Martin (1861-66), and the Academy of Sciences placed a hall in its building at the disposal of the society for its monthly meetings, which courtesy it enjoyed until May, 1931. Martin's successor as president was Dr. Emil Hornig (1828-90), the son of Professor Dr. Josef Hornig of the University of Vienna. He studied chemistry at the technical college, and in the fifties became professor of chemistry at the government technical high school, Vienna. Here he had a small chemical laboratory at his disposal for photographic experiments. He furnished the inspiration for the promotion of scientific endeavor in the photographic society, initiated prize essays on work in this field, and edited his journal, the *Photographische Korrespondenz*, along these lines.

After the death of Dr. Hornig, in 1890, Ottomar Volkmer, director of the Government Printing Office, became president of the Vienna Photographic Society, a position which he occupied until his death, in 1901. He was succeeded by the author of this *History*. During the latter's incumbency (1906) the society was granted the title "Imperial and Royal Photographic Society," with the privilege of using the imperial eagle as coat of arms in recognition of its public service, a right which, after the Republic came into existence, was confirmed as far as the use of the coat of arms was concerned. The society was also honored by the city of Vienna, under the mayor Dr. Neumeyer, by the bestowal of the Gold Salvator Medal. The Photographic Society of Vienna awards several medals of honor for outstanding achievements. The earliest award was established by Baron Friedrich von Voigtländer, who donated on May 7, 1868, a capital of 4,500 florins for members of the society.

President Hornig founded, in 1876, the Medaille der Wiener photographischen Gesellschaft, which may be awarded also to nonmembers for distinguished efforts in the field of photography.

The Josef Löwy Foundation, amounting to 10,000 kronen, was given by Mrs. Mathilde Löwy (died 1905) in 1904 as a prize for outstanding work in the field of photography.

The official publication of the society was at first Kreutzer's *Zeitschrift für Photographie;* after 1864 Ludwig Schrank's *Photographische Korrespondenz,* which is the only German photographic technical journal which has been published regularly.

The *Photographische Korrespondenz* was edited from 1864 to 1870 and from 1884 to 1905 by Ludwig Schrank (1828-1905). He was not a professional photographer, although temporarily he had charge of a studio in Vienna. He was an accountant in the Ministry of Agriculture, the department for direction of sales for mine production. At that time Austria still had a lively mining output, which the government had developed—for instance, the mercury mines in Istria, the silver and uranium mines in Joachimstal (Bohemia), the salt mines in Galicia, etc.

Schrank was an ingenious, many-sided man, a composer and a witty journalist. He kept in close touch with all the members of the society. In the sixties he engaged for a short time in photolithography (*Phot. Korr.*, June, 1905). This is where he realized the desire of the professional photographers for a practical technical journal, satisfying the

daily requirements of the craft. Kreutzer's journal had become out of touch with the practical needs of the time, and the necessity for a new photographic journal became obvious. Ludwig Schrank brought the *Photographische Korrespondenz*, and the first number appeared in July, 1864, to a high level of efficiency, and he was successful in finding competent contributors. This journal contains a great deal of information for historical studies. In 1870 Professor Hornig bought the periodical from Schrank, and he managed it from 1871 to 1884. Hornig applied himself especially to the scientific and technical side of photography and showed great interest in silver bromide emulsions, which then had just made their appearance in the development of the photomechanical processes. In 1882 the Frankfurt Verein zur Pflege der Photographie (founded 1874) selected the *Photographische Korrespondenz* as its official organ. In 1884 Professor Hornig, whose health was failing, presented the journal as a gift to the Vienna Photographic Society. The society again entrusted Ludwig Schrank with its management, which he continued until his death, in 1905.[10] The *Photographische Korrespondenz* became of greater importance when, after 1889, it became the official publication for the reports of the Graphische Lehr- und Versuchsanstalt, Vienna.

The Vienna Photographic Society arranged an international photographic exhibition May 17, 1864, at Vienna, the first of its kind in German countries,[11] and this was as fruitful in its way for the further development of photography as the exhibitions of the photographic societies of England and France had been.

Two years after the foundation of the Vienna Photographic Society followed that of the Photographic Society of Berlin, brought about on November 18, 1863, by Professor H. W. Vogel, who was its first chairman. After some time, many members, including Vogel, who had become dissatisfied, resigned and organized the Society for the Fostering of Photography, which also elected Vogel as president, while Dr. Franz Stolze took over the direction of the older society. In the course of time the Photographic Society of Berlin became a trade association, which is still in existence and which awards a Daguerre-Medaille in recognition of services rendered in the field of photography. The Society for the Fostering of Photography created in 1908 the Association of German Amateur Photographic Societies and changed after the World War to the German Society of Friends of Photography, which since 1924, jointly with several large amateur photographic societies,

has formed the German Photographic Society (Deutsche Photographische Gesellschaft).

The official organ of the Society for the Fostering of Photography was the *Photographische Mitteilungen;* the first number, edited by H. W. Vogel, appeared in April, 1863. This journal became important, for in it was published the work of the department of photochemistry, which Vogel directed.[12] This society organized the first International Photographic Exhibition at Berlin in 1865, which brought as good results as the one in Vienna in 1864.

The Berliner deutsche Photographen Verein had at first chosen the journal *Das Licht* as its public organ, which had no great influence. In 1865 Dr. Stolze founded the *Photographisches Wochenblatt,* which was very valuable, but ceased publication years ago.

The interests of the technical workers engaged in the field of reproduction were carried on by the Verband der Chemigraphischen Anstalten Deutschlands und der Tiefdruckereibesitzer.

The trade paper for those engaged in manufacture and sale of photographic equipment, *Die photographische Industrie*, Berlin, managing editor Karl Weiss, was founded in 1902 and became an important vehicle for phototechniques.

To the above-mentioned publications must be added the German periodicals for scientific photography, for photogrammetry, for motion picture and film technique, and others representing special fields.

AMATEUR SOCIETIES

The development of artistic photography was in a great measure due to the amateur photographic societies formed during the last decade of the nineteenth century, especially to those at London, Vienna, and Paris. The exhibitions of these societies, as well as the impetus which they gave to pictorial photography by their enthusiasm and official publications, acted as a guide and inspiration for the progress of photography, the youngest of the arts. Several of these amateur clubs issued periodicals, such as the Paris Photo-Club, which has published its *Bulletin* since 1890, the Vienna Camera Club, and many others.

The first of these amateur societies in a German country was the Club of Vienna Amateur Photographers, later called the Vienna Camera Club. It was founded March 31, 1887, and soon gained great importance (*Phot. Korr.*, 1887, p. 226). It was one of the first of its kind on the Continent. From September to October, 1888, it arranged

an international exhibition, which presented the progress of amateur photography and its importance in art, science, and industry. The Vienna Camera Club published the *Wiener Photographische Blätter* (1894-98), which devoted itself especially to the artistic side of photography and was notable for its beautiful illustrations. This organ was supported by substantial contributions from wealthy amateurs, but it ceased publication after a few years.

Other amateur societies at Vienna were the Photo Club (since 1899, founded in 1897 as the Amateur Photo Club), and the Vienna Club for Amateur Photographers, founded in 1903, under whose president, Dr. Emil Mayer (1907-27), a prominent amateur and attorney-at-law, the bromoil and bromoil transfer printing processes were popularized by publications, lectures, and exhibitions. The Society for Photographic Art and the Wiener Lichtbildner-Klub, founded in 1911, must also be mentioned.

These and other similar Austrian societies united in the Federation of Austrian Amateur Photographers, just as happened in other countries.

PHOTOGRAPHIC EDUCATIONAL INSTITUTIONS

The earliest private photographic school in Germany was probably that established by Dr. Julius Schnauss (1827-95) at Jena. On May 1, 1855, he opened his school with twelve pupils; he directed it for fifteen years and taught the current practical methods, especially the wet collodion process, which was not generally known at that time, for a fee of 20 to 25 thaler ($15 to $18.50). The biography of this distinguished teacher of photography may be found in *Phot. Korr.* (1895, p. 365).[13]

Another private school was established by W. Cronenberg, in 1858, at Schloss Grönenbach, Bavaria. This was a boarding school where instruction was given in the different branches of photography and later in the technique of reproduction. This school was very successful, and it did not close until 1900. Cronenberg then moved to Munich, where he started a reproduction establishment; he died there soon afterward. He wrote numerous articles for the *Jahrbuch* and an excellent handbook entitled, *Praxis der amerikanischen Photogravure* (1899), which was translated into French by G. Fery.

Owing to the lack of schools for teaching photography in most of the industrial centers, the larger firms dealing in supplies for photog-

raphers did not stop at merely presenting their wares for sale, but also instructed buyers in using and manipulating them. We have already referred in Chapter XLIII to such a studio, conducted by the firm of Wilhelm Eduard Liesegang, at Elberfeld (Germany), in 1857.

Seventy years ago the teaching of photography was confined to the wet and dry collodion processes, to some photographic printing and light-tracing methods, and to elementary photochemistry. In order to present a view, we add to the above-mentioned (Schnauss, Krone, Cronenberg), a survey of educational facilities in 1863.

Vienna: University, W. Burger.

Berlin: H. W. Vogel commences photographic courses at the trade school.

Leipzig: University, Dr. Weiske.

Stuttgart: Royal Württemberg Center, Dr. Haase.

Marseille: Public lectures, Léon Vidal.

Gent (Belgium): Public lectures, Prof. de Vylder.

London: Kings College, Hardwich, Sutton and Dawson.

Paris: Ecole Impériale des Ponts et Chaussées and Ecole Impériale du Genie Maritime.

The importance of photography for professional use, as well as for the graphic arts, trades, and science, was also recognized by the introduction of a lecture course at the higher governmental educational institutions.

In Germany a professorship was first established in 1864 at the Trade Academy in Berlin, to which Dr. Vogel was called as instructor; he was made full professor in 1873. After the establishment of the Technical College at Berlin-Charlottenburg in 1879, Professor Vogel received the professorship for photochemistry and scientific photography and was provided with suitable laboratories and photographic studios. There he successfully promoted photography and instructed a large number of students. Vogel was succeeded, after his death (1898), by Professor Dr. A. Miethe. After Miethe, who died in 1927, Professors Dr. Erich Stenger, Dr. Erich Lehmann, and O. Mente continued the instruction.

Another deserving earlier protagonist in photographic education in Germany must be mentioned here. In 1853 Hermann Krone (1827-1916), who had worked at photography, suggested to the Saxon government the establishment of a professorship for scientific photography, but the petition was denied "owing to lack of funds." Per-

sisting in his efforts, Krone succeeded in being called to the Polytechnikum at Dresden as instructor of photography 1870-71. There he worked for the first nine years without any financial support from the government. For the next twelve years he received 300 marks ($75) annually. In 1898 Krone was appointed assistant professor of photography at the Technical College, Dresden, and later full professor. He retired in 1907, 80 years old, with distinguished honors. After Krone's retirement the Saxon government had to provide the necessary funds, largely exceeding the inadequate remuneration so modestly accepted by Krone. It is said that Heinrich Ernemann, the head of a great industrial concern, intervened with the government and induced the Ministry to provide the sum required to establish a full professorship, to which Professor Dr. Robert Luther (born in Moscow, 1868), photochemist, pupil of Ostwald and former assistant professor for physical chemistry at Leipzig, was appointed in 1904. The new building of the Scientific Photographic Institute at the Technical College at Dresden was opened in October, 1913.

At the University of Berlin Professor John Eggert lectured (1930) on the "Basis and Uses of Photography," the practical work being done in the former "Agfa" photochemical laboratory.

Today Professor Dr. Fritz Weigert lectures at the University of Leipzig; at the University of Giessen, Professor Dr. K. Schaum; at the Technical College in Darmstadt, Professor Dr. Fritz Limmer; at the Technical College in Karlsruhe, Professor Fritz Schmidt on photography (since 1888) and Professor Dr. J. Kögel (since 1921) on photochemistry. Raphael Ed. Liesegang presents photochemistry at the Institute for the Physical Basis of Medicine at Frankfurt a. M.

PHOTOGRAPHIC EDUCATION IN VIENNA; FOUNDATION OF THE GRAPHISCHE LEHR- UND VERSUCHSANSTALT

As early as 1858 Dr. J. J. Pohl, professor of chemical technology, lectured from time to time on photography and microphotography at the Vienna Polytechnikum. At the University of Vienna the photographer Wilhelm Burger taught photographic practice for a few terms in the 1860's to the students of the Institute for Physics, which had been located in a private house since 1851.[14]

Professor Dr. Josef Stefan (1835-90), the famous physicist, was the director of the institute. Wilhelm Burger gave his photographic course, with Stefan's permission, at the institute. The classes were

held in a few small rooms, next to a water tower tank into which the water used at the institute was pumped; a large garden was also at his disposal. The subjects taught were chiefly the wet and dry collodion processes. While there was no studio with a skylight, there was a great opportunity for photography in the open air. Here Burger carried on the preparations for his subsequent photographic expeditions, which are reported on in Chapter XLVII. After Burger's departure from Vienna these photographic lecture courses were interrupted, about 1865; they were not resumed until thirty years later, by the lecturer Hugo Hinterberger at the University of Vienna.[15] After Burger's return he opened a photographic studio, was appointed court photographer and acted as secretary of the Vienna Photographic Society and editor of the *Photographische Korrespondenz* (obituary, *Phot. Korr.*, 1920, p. 135).

About the same time (1864) Dr. Emil Hornig lectured on photography for one term at the Technical College, Vienna, but he did not continue. He acted as president of the Vienna Photographic Society and in later years did much for the development of photography. In June, 1880, this author took up his residence at the Technical College as private lecturer on photochemistry. He was at that time assistant to Professor Pohl of the faculty of chemical technology, and he began his lectures in the winter term of 1880-81.

At this time Dr. Hornig, as president of the Vienna Photographic Society, directed the attention of the Ministry, in a petition, to the necessity of fostering the new growth of photography by the establishment of an experimental institution. The government also granted a subsidy for the purchase of apparatus for this purpose. These, together with the spectrographs purchased on the recommendation of this author, were turned over to him as chief of the Government Chemical Laboratory at the higher technical school.

ESTABLISHMENT OF THE FIRST INDEPENDENT GOVERNMENTAL EDUCA-
TIONAL INSTITUTION DEVOTED ESPECIALLY TO PHOTOGRAPHY AND THE
REPRODUCTION PROCESSES IN COMBINATION WITH A SCIENTIFIC PHOTO-
CHEMICAL EXPERIMENTAL LABORATORY

Dr. Hornig's petition met with favorable consideration by the Austrian government.

This author explained the extensive plans for the establishment of an institute for photographic education and research at a lecture held

on January 29, 1885. The scheme of operation evolved by him recommended to the Ministry of Education a comprehensive combination of an educational institution for photography together with scientific laboratories and a department for the cultivation of the graphic arts. The Minister of Education, Baron Paul Gautsch von Frankenthurm, and Count Vincent Baillet-Latour took great interest in the matter and called a conference at which it was decided to accept the report of this author for a three-year course in photography and reproduction technique, in combination with a scientific technical experimental station, a photographic library, and a museum for graphic collections. It was now necessary to find a suitable building. The city government offered one of its school buildings, erected in 1859 and rebuilt in 1880, which was enlarged and equipped with photographic studios by the city building department. The Imperial and Royal Institute for Teaching and Experimentation in Photography and the Reproduction Processes was established on August 27, 1887, as a governmental institution directly responsible to the Ministry of Education and was commanded to open its work in March, 1888, under the direction of this author. He called outstanding men as teachers to the institute (*Jahrbuch*, 1889, p. 322; 1890, pp. 260 ff.).

The history of the origin and growth of the Graphische Lehr- und Versuchsanstalt, Vienna, was described on the occasion of the fortieth anniversary of the institution by the president of the Technical Experimental Station, Dr. Wilhelm Fr. Exner (1840-1931) from his own recollections.[16]

It is interesting to note how this institute has grown from small beginnings and how it has become world famous. I was privileged to observe its growth. What were the educational conditions prevailing in this field in the eighties of the last century, when photography, a new art, began its victorious course in all fields of human endeavor? The Technical College at Berlin had at that time a long-established course in photochemistry, given by the famous Professor H. W. Vogel. The student was therefore well provided for, but for the technician and the working man there was no trade school either at Berlin or elsewhere. At the Salzburg Government Trade School, about 1880, a photographic studio for teaching photography for reproduction was built in the attic, and there demonstrations were given. Neither experimental research nor artistic photography was represented. Another drawback was the lack of a local phototechnical industry. This photographic school could not last in such a primitive form, and in 1887 it was discontinued. At Vienna the assistant for chem-

ical technology, Dr. J. M. Eder, had established residence as lecturer in photochemistry in 1880 at the Technical College. Dr. Eder had come in contact with photography through his study of the photochemical properties of chromates. His investigations were awarded a prize by the Vienna Photographic Society. Further scientific studies on silver bromide emulsions and color sensitizers were made possible for him by a government subsidy for the purchase of spectrum apparatus, granted, to him on the petition of the Vienna Photographic Society. Thus modern photographic spectrum analysis was created in Austria by him, which subsequently became of such great importance for applied photography and the production of motion films, as well as for the exact sciences.

Thus a foundation was laid for the later experimental institution. Then Dr. Eder conceived the idea of gathering together under one roof scientific photochemistry, applied photography, and its artistic development, in a center for all Austria. The plan met with an enthusiastic reception. As director of the Technological Museum for Industry, I recommended, jointly with Hornig, that a section of this institute and one in his be set aside for Dr. Eder's projected institute, of which he was to be the director. The Minister of Education, however, after hearing the report of his referee Dr. Sonntag, stated: "Since the organization and the director are ready at hand, the government will proceed with the undertaking if the city authorities will provide a suitable building for its use," which is what happened. The Minister then entrusted Professor Eder with the drawing up of the final plan of organization and with the starting of the activities of the Lehr- und Versuchsanstalt für Photographie und Reproduktionsverfahren. The institute, which in March, 1888, was conducted by Dr. Eder alone, was further extended after a few years by the appointment of the chemist Professor Valenta. Later the school was enlarged by the addition of a section for typographic printing as well as by the inclusion of photogravure, copperplate printing, copper and wood engraving, and the installation of modern power presses. Dr. Eder directed the institute from 1888-1923 and gave it a world-wide reputation. Both at home and abroad there is a keen appreciation of the accomplishments of the institute in scientific investigation, in education, in technical literature, and in the presentation of its work at international exhibitions. The institute was so well organized by its founder and so firmly anchored in the scientific, industrial, and artistic world, that it has weathered all the storms of war and postwar times and is now able to celebrate its fortieth anniversary in the well-earned joy of its labors. Director Eder was succeeded by Professor E. Valenta, who for years had supervised the experimental section, but who soon retired.

May these lines awake the recollection of the work of those meritori-

ous pioneers of old Austria, who created an institution of which we may well be proud, which has served as an example for all later establishments of its kind and has surpassed even the older Paris school, Ecole du Livre (Estienne).

In 1892 a separate course for photochemistry was initiated at the Technical College of Vienna, to which this author was appointed professor, retaining his position as director of the Graphische Lehr- und Versuchsanstalt, where the university lectures and practical photographic work were held once a week. The personal union created thus between the two institutions brought about a close scientific relationship, which contributed greatly to the well being of the institute.

On the petition of the Association of Printers at Vienna, the establishment of a section for printing and illustration was decided upon, and the enlarged institute was designated as "Graphische Lehr- und Versuchsanstalt" (1897), comprising now four sections: the first, the educational section for photography and reproduction processes; the second, the educational branch for the book and illustrating trades; the third, the laboratories; and the fourth, the graphic and apparatus museum and the technical library.

The institute trained many capable students. Their numerous accomplishments in the field of photomechanical investigation are incorporated in many contributions to the literature of the craft. The results in the field of applied photography and the photomechanical reproduction processes have been made public by many proofs, and the artistic side was carefully fostered. This gained for the Graphische Lehr- und Versuchsanstalt prizes at many exhibitions, for example, at Paris, 1900, at St. Louis, 1904, at Dresden, 1909, at Leipzig, 1914, not only as an educational institution but also in competition in the field of graphic practice and in scientific technical investigation.[17]

In 1913 the Graphische Lehr- und Versuchsanstalt celebrated its twenty-fifth anniversary and published a richly illustrated history of the institute, consisting of 127 pages and 56 inserts. All the work contained in this volume, both printing and illustrations, was executed at the institute. The artistic inserts represent distinctive achievements in the fields of scientific, technical, and artistic photography and reproduction processes and are an excellent testimony to the teaching staff.

For the study of the history of photography our interest lies especially in the historic collections relating to photography and the

photomechanical processes, the collection of lenses and apparatus, and an extensive technical library started by this author and managed with expert knowledge by his colleague the custodian of the collections, Eduard Kuchinka. Here we wish to pay a special tribute to Eduard Kuchinka, a valued contributor to this history of photography; unfortunately he died suddenly before this new edition was published. [The translator, who knew Mr. Kuchinka personally, joins in this tribute of respect for his specialized intelligence and all-embracing knowledge in his field of endeavor.]

Eduard Kuchinka (1878-1930), born in Bohemia, was a grandson of the well-known portrait photographer Carl Kroh, of Vienna. He went to school in Vienna and learned photography in his grandfather's studio. He attended and finished the course for photography at the Graphische Lehr- und Versuchsanstalt and then went into the photographic business.

In 1898 this author appointed him an official in the administrative department of the institute, and later he became custodian of collections and library. His knowledge of the history of photography was very extensive and thorough, and he was one of the few who knew the early, now unused and practically forgotten, photographic processes and apparatus.

He wrote the monograph *Die Photoplastik* (1926) and, jointly with this author, *Daguerreotypie, Talbotypie und Niepçotypie* (1927); also numerous historical articles for the *Jahrbuch*, *Photographische Korrespondenz*, etc.

Kuchinka served in the World War, first on the Eastern front and later on the Italian border. He returned to Vienna and in 1930 died suddenly from heart failure (obituary in *Jahrbuch*, Vol. XXXI). His successor as librarian is Adolf Schwirtlich.

Professor Valenta was succeeded as director of the institute by Professor Dr. Rudolf Junk, with Professor Otto Krumpel at the head of the laboratories and Dr. Jos. Daimer as professor of chemistry (*Jahrbuch*, 1921-27, XXX, 2).

LATER GERMAN PHOTOGRAPHIC SCHOOLS

The Lehr- und Versuchsanstalt für Photographie, Lichtdruck und Gravüre, at Munich, was founded by the Photographic Society of Southern Germany, with the support of the city and the state, and opened in October, 1900.

The first director, G. H. Emmerich, conducted a business in photographic equipment and consequently had a wide acquaintance in the profession. He organized the school and directed it until 1919. He was succeeded by Professor Hans Spörl, with Professor W. Urban teaching photochemistry.

In 1906 the study of collotype and photogravure was added, and the name of the school was changed to "Lehr- und Versuchs-Anstalt für Photographie, Lichtdruck und Gravüre." In 1909 the school received without cost a former hospital building for its use, which was opened in May, 1911.

The government did not take over the school until July 1, 1921, when the name was changed to "Higher Professional School for Phototechnique." Soon afterward a branch was added for motion picture technique (Professor Konrad Wolter).

In 1924 the section for photoengraving and collotype, which had been in existence for a number of years, was discontinued as no longer successful and because the photoengravers and lithographers of Munich refused financial support for its continuation. The rooms vacated by this section were then used by the motion picture department. Finally the school was called "Bavarian Government Institute for Photographic Procedure (Lichtbildwesen) at Munich."

In 1893 the very old Leipzig Art Trades Academy and Art Trades School, founded in 1764, added a department for photomechanical reproduction processes, directed by Dr. G. Aarland. In 1901 it received the title "Royal Academy for the Graphic Arts and the Book Industry of Leipzig"; it was devoted entirely to the graphic printing process.

The photographic school of the Lette Society for Fostering the Education and Practical Training of Women, Berlin, was founded in 1890 under the direction of Dr. Dankmar Schultz-Henke (died 1913), a former assistant of Dr. H. W. Vogel. It is now a government technical high school under the direction of Marie Kundt and one of the largest trade schools of its kind in Germany.

GOVERNMENT AND INDUSTRIAL UNDERTAKINGS AS PATRONS OF PHOTOGRAPHY; ARCHIVES FOR THE HISTORY OF PHOTOGRAPHY

The publications of the great governmental and private industrial graphic institutions were of great importance for photography. This was recognized especially by A. Auer von Welsbach, director of the Government Printing Office at Vienna, in the fifties of the last century.

Then followed the publications of the British Cartographic Institute at London, Calcutta, and elsewhere, as well as by French institutions, which are reported on different pages of this *History*. The photographic reproduction processes were carried on extensively and successfully, especially at the Military Geographical Institute, Vienna. It is true that here the methods of procedure employed were, until the beginning of the seventies, kept more or less secret; thus, while officers were permitted to copy the formulas for collodion photography and reproductive processes, nothing was permitted to be published. This rule was broken by the section chief Ottomar Volkmer and his successor Baron A. Hübl. This plan was also followed by Volkmer when he became director of the Government Printing Office and was continued by the vice-director, George Fritz. In recent years this activity has been eliminated. The Government Printing Office at Berlin also followed this example.

These reports and publications of the great government departments proved to be important contributions to the general progress of photography which in turn worked to the great advantage of the government. In later years government departments for research in physics included photography among their subjects. We mention only the Physikalische Reichsanstalt, Berlin; the National Physical Laboratory, Teddington (England); analogous institutes in France, including the Institute d'Optique, Paris, under Director M. Ch. Fabry; and the United States Bureau of Standards, Washington, D. C., under Director George K. Burgess, which issues its own *Bulletin*.

Of the many publications of the U. S. Bureau of Standards we mention only the *Standards Yearbook*, which contains all the more important international standardizations and the monthly reports on commercial standards. In the "Miscellaneous Publications" of the bureau, No. 114, we find basic investigations on light filters for the production of artificial daylight (for sensitometry) by Raymond Davis and K. S. Gibson (*Handbuch*, 1930, Vol. III, Part 4). This department added to its activities in the first decade of the present century spectroscopy and the measurements of the wave length of light (Dr. Burns, Dr. Meggers, and others). All these bureaus of research devoted themselves to the study of normal light sources for photometry and sensitometry ("Sensitometry," in Eder, *Handbuch*, 1930, III(4), 339).

For institutes of research pure and simple see: *Die Forschungsinstitute, ihre Geschichte, Organisation und Ziele*, by L. Brauer, A.

Mendelssohn-Bartholdy, Ad. Meyer, and J. Lemcke (Hamburg, 1930). Extremely valuable for the study of photographic science were the reports of the private industrial research laboratories. One of the first of these was established at the dry-plate factory of Schleussner, Frankfurt a. M., from which were published the first investigations of Dr. Lüppo-Cramer. Since 1922 Lüppo-Cramer has had the active direction of the scientific photochemical laboratory of the Deutsche Gelatinefabrik A. G., Schweinfurt.

The dry-plate factories of O. Perutz, Munich, of J. Hauff, Feuerbach, near Stuttgart (Württemberg), and others added scientific research laboratories to their industrial undertakings. Pre-eminent is the laboratory in the photographic department of the Berlin A. G. für Anilinfabrikation ("Agfa"; see Andresen, ch. lix). No less important are the publications of the dyeworks of Meister, Lucius & Brüning, Höchst a. M. (König, Homolka, etc., chs. lxiv-lxv). We must also mention the publications of the Carl Zeiss Works, at Jena, and those of the Optical Works of Steinheil, Munich; Voigtländer, Braunschweig; Emil Busch, Rathenow; Goerz, Berlin; Zeiss-Ikon A. G., Dresden, among others.

After the merger of Germany's great dye works into the Deutsche I. G. Farbenindustrie A.-G., their research laboratories were also combined. The scientific photographic central laboratory was moved to Wolfen under the direction of Professor Dr. John Eggert; in 1930 appeared the first volume of the research reports of this central laboratory of the "Agfa."

Important German trade papers, such as the *Photographische Industrie*, Berlin, and *Photographische Chronik*, and *Filmtechnik*, Halle a. S., installed private laboratories for the investigation of photographic materials (Dr. Kurt Jacobsohn, Berlin, and C. Emmermann, Halle).

Earlier, at the end of the last century, the brothers Lumière, at Lyons, published their researches in collaboration with Dr. Alphonse Seyewetz. The firm Lumière, Lyons, has published the *Agenda* for photography annually since 1905; later Lumière combined with Jougla of Paris as Union Photographique Industrielle, which continued the publication. Its scientific photographic investigations proved highly valuable; they are recorded in the *Jahrbücher*.

The Photographic Research Laboratories of the Eastman Kodak Company, Rochester, New York, are conducted on an unusually large scale, having enormous financial resources. George Eastman called a

number of eminent physicists and photochemists to Rochester. The director of the Kodak Research Laboratories is the English photochemist Dr. C. E. Kenneth Mees, who in 1921 received an honorary doctor's degree from the University of Rochester. The extensive and important research work of these laboratories that the Eastman Kodak Company published is in part summarized in the *Abridged Scientific Publications from the Research Laboratories of the Eastman Kodak Company;* the first volume appeared 1913-14, and it has been published annually, with a wealth of valuable information. In various parts of this publication articles by the scientific staff are printed. In the first volume we find contributions by C. E. Kenneth Mees, P. G. Nutting, L. A. Jones, J. I. Crabtree, Frank E. Ross, S. E. Sheppard, A. P. H. Trivelli, and others. Since 1915 the laboratories have also published the *Monthly Abstract Bulletin of the Kodak Research Laboratories,* which contains short abstracts of all pertinent publications in the field of photography and the allied branches of science and industry. The Optical Society of America, which also publishes an important journal, came within the circle of influence of the Eastman Co. The Eastman Kodak Co. very generously assisted the scientific workers of European countries which, because of the World War, were entirely cut off from all technical publications issued outside their own countries by making available to interested technical circles on the Continent their valuable original publications and exhaustive references of the war years. For this aid Continental scientists owe them a lasting indebtedness.

There is also a research laboratory connected with the Kodak Works at Wealdstone (Middlesex), England, which is directed by Dr. W. Clark. At Vienna, the research laboratory of Dr. Leon Lilienfeld is in contact with the Eastman Kodak Works.

COLLECTIONS AND ARCHIVES FOR THE HISTORY OF PHOTOGRAPHY; DOCUMENTS OF PHOTOGRAPHY

Very little attention was paid by individuals in the last century to collecting photographic products with an eye to their preservation for historic reasons. But since the middle of the last century the early large photographic societies in London, Paris, and Vienna have preserved in the archives of their meeting rooms documents for the "History of Photography." The Vienna collections were kept at first in the home of the editor, Ludwig Schrank, of the *Zeitschrift der photographischen Gesellschaft.* After his death this publication was taken

over by the author for the Graphische Lehr- und Versuchsanstalt, to which he added his own collection. Other photographic objects of historical interest are preserved at the Technical College, Vienna, and in the Historical Museum of Austrian Industry (Technological Trade Museum), founded by Wilhelm Exner. The Technical Museum for Industry and Trade was founded in 1918 by Wilhelm Exner,[18] and its first director was the engineer Ludwig Erhard. The graphic section was organized by the author with the co-operation of an active committee. The collections at the Graphische Lehr- und Versuchsanstalt were under the management of the custodian, Ed. Kuchinka,[19] and were used in the writing of this *History*.

Under the direction of the engineer Oskar von Miller the famous Deutsches Museum was founded, in 1903, at Munich. Rooms 322 and 323 contain a large collection relating to the history of photography. A short history of photography by Professor Dr. Erich Stenger, published in 1929 by the Deutsches Museum, gives some very good historical explanations. This museum has also housed, since 1931, the collection pertaining to the history of motion pictures donated by Oskar Messter, of Berlin.

In the Hamburg Museum for Art and Industry are found large collections of daguerreotypes, first begun by the photographer Wilhelm Weimar, and at the Book Trade Museum of Leipzig, founded in 1885, photography was included at the end of the nineteenth century. About this time there was also opened in Leipzig a great museum for the book trade and literature. There are also historical photographic collections to be found in some German high schools—Berlin, Dresden (Krone Collection).

Of private collections covering the history of photography and motion-picture photography in Germany that of Dr. Stenger must be mentioned and also that established by Wilhelm Dost, the recording secretary of the Photographic Society, Berlin. Dost also wrote a brief *Geschichte der Kinematographie* (1925) and several articles on historical photographic subjects.

At Paris there are large collections important for the history of photography at the house of the Société française de Photographie, also at the Museum Dantan, as well as that of G. Cromer. In addition there are photographic collections at some educational institutions and a collection of the history of cinematography at Lyons. The Niépce Museum, at Chalon, has been reported earlier in Chapter XIX.

In London there is the museum of the Royal Photographic Society of Great Britain, which is particularly noteworthy. The South Kensington Museum, London, contains not only historical photographic subjects but also a rich collection of motion picture apparatus. In other localities in Great Britain there are to be found interesting historical photographic objects in public and private collections. We have already mentioned those relating to Talbot, Hurter and Driffield, and Abney.

The Society of Lithographers and Lithographic Printers, Stockholm, owns a large collection appertaining to the history of photography and the photomechanical reproduction processes.

In the United States there was added about 1908 a photographic museum to the Smithsonian Institution, Washington, D. C. The National Museum at Washington has a rich collection of photographs, supervised by A. J. Olmsted, chief of its photographic studio; this museum acquired in 1931 large additions of historic and modern material, portraits of inventors and scientists, artistic photographs, also two motion picture projectors by Woodville Latham, one of which was constructed in 1895 by the inventor in New York.

The Eastman Kodak Company, Rochester, N. Y., possesses a photographic museum, with large collections of historical interest, including early American apparatus and the inventions introduced by Eastman in the past fifty years.

At the International Photographic Congress in Chicago, 1893, W. Jerome Harrison recommended the establishment of a collection of so-called "documented photographs." Professor Léon Vidal, of Paris, a member of the committee at the congress, put this idea into effect by founding the Association du Musée des Photographies Documentaires in Paris. In 1903 this association owned 80,000 documented photographs; the classification and registry followed the subject represented (history, natural science, religion, law, military, art, sports, etc.).

This enormous mass of material necessitated a further division, corresponding to the broad field of the applications of photography. Sometimes under government direction there were gathered collections of educational diapositives for the study of art history; for medical use, including Roentgen photography, for anthropology; for criminal investigations; for the history of civilization; and so forth.

These various collections of "documented photographs," important for all fields of scientific research and artistic endeavor, were supplemented in modern times by the "documented film." The collections

present an impressive picture of the immense importance of photography in all fields of human activities.

ITALY

Scientific life in Italy was nurtured in numerous age-old academies. We mention here the Academy of Sciences in Florence (founded in 1560), the Academia Secretorum Naturae, of which Jean Baptist Porta was one of the founders, and the academies at Rome, Venice, Bologna, and other places.

It was in Italy that the "phosphorescent Bologna stone" was discovered, which played a great role in the history of photography. The discoverer of the light-sensitivity of silver chloride, Beccaria, was a member of the Academy at Bologna. For daguerreotypy in Italy see Chapter XXXIII; for photogrammetry in Italy by Porro (1855) see Chapter LV; for Malagutti see Chapter LVII.

Historical reports on the development of photography in upper Italy were published by Enrico Unterveger in *Il corriere fotografico* (1922, No. 12). Wilhelm Dost mentions this in his booklet *Vorläufer der Photographie* (Berlin, 1931, p. 30), and he adds a necessary criticism.

Let us turn to modern photochemistry. At the turn of the nineteenth century fundamental investigations on the photochemistry of organic compounds were carried on in Italy by Professor Dr. Giacomo Ciamician (1857-1922), at the University of Bologna. He had studied chemistry at Vienna at the university and at the Technical College and was appointed professor of general and biological chemistry at the University of Bologna. He was one of the most prominent chemists of his time in Italy and devoted himself to physicochemical work and also to photochemistry. He was a member of the Vienna Academy of Sciences. Ciamician's researches on the chemical action of light on organic compounds ("Azioni chimiche della luce"), which he carried on in part jointly with P. Silber, are of the greatest importance. They are printed in the *Mem. Accadem. Bologna*, principally from 1900 to 1902, and were also translated into German technical literature (*Photochemie*, in the *Handbuch*, 1906, Vol. I, Part 2). His publications are registered in Poggendorff's biographical pocket dictionary. Ciamician's article "Photochemistry of the Future" was translated into German in 1913.

Another notable worker in this field was Professor Carlo Bonacini, at the University of Parma.

In Florence there was the Societa Fotografica Italiana, a leading body; G. Pizzighelli was a director until his death. This society published a notable journal. Both were dissolved in 1912. The most important photographic journals of the present time are *Progresso fotografico*, founded at Milan in 1894 and edited by Professor Namias; *Il Corriere Fotografico*, founded at Turin in 1905; also *La Rivista fotografica italiana* founded in 1915 at Vicenza; and finally *La gazzetta della fotografica*, founded in 1926 at Palermo.

Photographic societies exist in Milan, Bologna, Turin, and so forth. There are no schools of photography at present.

Namias was very active in the field of photography and is considered the most eminent representative of applied photochemistry in Italy.

Professor Rodolfo Namias (born 1867), after his college years, studied technical chemistry at the Polytechnikum at Turin. He commenced his career in the Stabilimento Acciaierie of Terni and then became director of the chemical laboratories of the Milan steel foundry. Later he taught chemistry in the Italian secondary schools, but he left the educational field and opened in Milan a laboratory for technical chemical research. Here he established his journal *Progresso fotografico*, which developed into the most important Italian technical periodical. In 1913 he enlarged his research laboratory to the Istituto Chimico e Fotochimico and added an educational laboratory for photochemistry, applied photography, microphotography, and metallography.

He has published the following independent photographic works: *Manuale teorico-practico di chimica fotografica* (2 vols.); *La fotografia in colori, ortocromatismo e filtri di luce; I processi di illustrazione grafica;* and others.

He has also written many research papers: "Direct Toning of Silver Images with Copper Ferrocyanide and Ferrous Ferrocyanide" (*Phot. Korr.*, 1894); "Photochemistry of Mercury Salts" (*ibid.*, 1895); "Direct Positives by Reversal with Potassium Permanganate and Reducing Negatives with It" (*Intern. Congress for Applied Chemistry*, Paris, 1900); "Influence of Alkaline Salts of Organic Acids on the Permanency of Bichromate Preparations" (*ibid.*, Berlin, 1903). On mordant dye pictures: "Fixation of Coaltar Dyestuffs on Metal Compounds, by Which the Silver Image Is Replaced" (*ibid.*, London, 1909); "Fixation of Colours on Copper Ferrocyanide Images and Ap-

plication to Trichromy" (*ibid.*, Rome, 1911); Namias, "Processo di resinotypia" (*Progresso fotografico*, 1922) is a resin-pigment method (*Jahrbuch*, XXX, 1163).

The photographic reproduction processes were actively employed in Italy before the end of the last century. In Florence the establishment Fratelli Alinari, founded in 1854, introduced color collotype printing on power presses about 1891 for their art publishing works, under Arturo Alinari, who was a pupil of August Albert at the Graphische Lehr- und Versuchsanstalt, Vienna. Later the firm Danesi in Rome also produced color collotypes. At present all types of photochromy and of reproduction processes are largely employed in Italy.

The graphic arts, the printing of books, and copperplate engraving flourished for centuries in Italy. The use of photomechanical processes in the publishing of photographic art subjects, however, developed there later than in other European countries. Although there were famous Italian portrait and landscape photographers at the time of the wet collodion process and silver bromide gelatine plates were known early in Italy, in the beginning of the twentieth century the publishers of postcard views and of art subjects obtained their silver bromide paper prints chiefly from the large Neue Photographische Gesellschaft, Berlin. Later there sprang up in Italy factories for silver bromide plates, films, and paper, as well as extensive motion picture studios; photogrammetry and aerial photography for civil cartography and military purposes have also attained great perfection.

SWEDEN

The history of daguerreotypy in Sweden, where it took hold very early, is reported in Chapter XXXIII. The subsequent history of photography in Sweden was treated exhaustively by Dr. Helmer Bäckström,[20] of Stockholm, in the *Nordisk Tidskrift för Fotografi* (1919 ff.). See *Jahrbuch*, XXX, 38, 43, 46, 52, 60.

Information on the Swedish scientist G. Scheutz reported in Chapter XVII and for the introduction of the diorama into Sweden see Chapter XXI.

In the fifties Talbotypes were introduced into Swedish studios, and soon thereafter, the wet collodion process. At about the same time the first stereoscopic photographs were shown in Stockholm. Noteworthy is the reproduction by the wet collodion process, in 1856, of the "Codex argenteus," Ulfila's Gothic translation of the Bible, which is preserved

at Upsala. Textbooks on photography in Swedish were published by C. P. Mazér, 1864, C. S. Mylbäus (1874), and others.

The first large Swedish photographic exhibition was held in 1866;[21] it was followed by collective exhibits of Swedish photographers at Copenhagen (1872) and Vienna (1873).

The first gelatine silver bromide dry plates imported into Sweden came from Wratten and Wainright, London; they were soon followed by other products. Azaline plates, as well as orthochromatic erythrosine plates from Dr. Schleussner's factory in Frankfurt a. M., came to Sweden in 1887. On balloon photography in Sweden see Chapter LIV.

In 1888 the Swedish Amateur Photographers' Society was founded by Tore Ericsson, teacher of history of art at Stockholm; later a branch of this society was started at Upsala. In 1889 professional photographers were admitted to membership, and the name was changed to The Photographic Society; it is still in existence. There are photographic societies in Gotenburg (1888), in Sundsvall (1893), in Lund (1893), and other places.

The official organ of The Photographic Society, the *Nordisk Tidskrift för Fotografi*, founded in the same year in Stockholm, is at present edited by John Hertzberg and Helmer Bäckström.

The Photographic Society in Stockholm is the trustee for awarding the honor medal founded in 1904 by Claes Adolf Adelsköld for meritorious service in the field of photography.[22]

Major C. A. Adelsköld (1824-1907), officer of the engineer corps for railroad construction, planned and built a great part of Sweden's first railroads. He was a prominent amateur photographer, from 1897 an honorary member of the Swedish Photographic Society and often selected as judge of awards at exhibitions.

The Swedish high schools teach photography and photochemistry. At the technical college in Stockholm assistant professor and court photographer John Hertzberg (born 1871) devotes himself to the field of scientific photography; at Vienna he studied photography, photochemistry, and the technique of reproduction.

At the University of Stockholm the scientist Dr. T. Svedberg teaches photochemistry. He received the Nobel prize for his research on the development of the latent light image on silver bromide gelatine plates. On his work in this field he reported in the *Handbuch* (1927, II(1), 292) published by Lüppo-Cramer and the author.

A large collection pertaining to the history of photography and the reproduction processes is at the Lithographtruste, Stockholm.

HOLLAND

For the invention of the magic lantern by the famous Dutch physicist Huygens see Chapter VII. For Asser and his starch transfer process see Chapter XCI. Modern photography was well cultivated in Holland.

The oldest photographic society in Holland is: "De Nederlandsche Amateur Fotografen Vereeniging, Amsterdam. This society is almost forty-five years old and has rendered great service in the field of photography. It was formerly almost the only important Dutch photographic society, although there existed societies in smaller cities. About 1925 there was formed at Amsterdam also the Amsterdamsche A.F.V., as well as at Rotterdam, at The Hague, and at Arnhem.

The photographic journal *Lux* was first published about 1888; later it was combined with *De Camera* (founded 1908), published by Ellermann Harms & Co., Amsterdam.

The photographic technical journal *Focus* was established in 1914 and is today (1932) probably the leading Dutch periodical for amateur photographers. For the professional photographer there is the *Bedrijfsphotographie* (since 1928), which is the official organ of the Nederlandsche Fotografen Patroons Vereeniging. *De Fotohandel* and the *Fotovreugde* must also be mentioned. There are no special schools for photography in Holland.

BELGIUM

For the inventions of Breyerotypes see Chapter XL. Belgium, at the time of Van Monckhoven, was prominently active in the field of photography (see Chapter LIX). The Association Belge de Photographie, founded at the end of the eighties, was an influential photographic society; it published a valuable periodical, the *Bulletin de l'Association belge de photographie*, of which the first volume appeared in 1889. Another still older Belgian photographic journal was the *Bulletin belge de photographie*, which was first published at Brussels in 1861. The Photoclub de Belgique published the periodical *Bulletin* from 1896.

Scientific photography also was cultivated in Belgium.

DENMARK

The earliest photographic society in Denmark was Den fotografiske

Forening, founded January 20, 1863. Beginning in 1865, the society published *Den fotografiske Forenings Tidende*, but the society and its organ lasted only a few years.

On April 5, 1879, the *Dansk fotografisk Forening* was founded; it still exists. In October, 1879, the *Beretninger fradansk fotografisk Forening* appeared, first quarterly, then monthly, continuing after January 1, 1903, as *Dansk fotografisk Tidskrift*.

A course in photochemistry was established at the technical college of Copenhagen in 1912, broadened to include scientific photography in 1914, and merged with the independent photochemical laboratory at the same college in 1917. A full professorship of scientific photography was instituted in 1919, now under the direction of Professor Dr. Chr. Winther.

<div align="center">SWITZERLAND</div>

In Switzerland many eminent men devoted themselves to the development of photochemistry and photography. We have already mentioned the activities of the learned professor Konrad Gesner at Zurich; the inventor of the first chemical photometer, Saussure, at Geneva; and the photochemical work of the Geneva scientist Senebier.[23] For Chr. Friedr. Schönbein see Chapter XLII.

The invention of daguerreotypy soon came to Switzerland. The first daguerreotype from Paris was sent to the painter and copperplate engraver Johann Baptist Isenring (1796-1860) at St. Gallen, where he was established as an art publisher.

Isenring was a skilled artist who published a series of aquatint views of towns and often colored his copperplate prints. Shortly after daguerreotypy became known, he bought a Daguerre-Giroux camera in Paris; he photographed architectural subjects as early as December, 1839. The light in the Swiss Alps, sometimes very actinic, enabled him, in March, 1840, to take portraits with the optically weak apparatus of the first daguerreotype cameras. Although they have not been preserved, these early portraits are fully described in the St. Gallen newspapers of that time. The pictures were taken in sunlight with long exposures, showed sharp, deep shadows, and the eyes of the sitter were indistinct or appeared closed, owing to the long exposure, wherefore the copperplate engraver Isenring retouched them on the silvered copperplates. Isenring, who was adept at coloring copperplate prints, conceived the idea of coloring daguerreotypes also. In this he was

very successful, and his work attracted public attention. He exhibited, from September to November, 1840, many examples of his light-pictures at Zurich, Munich, Augsburg, Vienna, and in July, 1841, at Stuttgart and Munich. At this time Isenring established the first Heliographic Atelier for daguerreotypy at Munich, with great success, examples of his work being exhibited at the gallery of the Munich Art Society.

In July, 1841, Isenring returned to St. Gallen, where he arranged an exhibition of daguerreotypes at his shop, among them, according to the Munich newspapers of October 8, 1841, daguerreotypes 3 x 4 inches in size of the colorful scenes at the October fair there, made in one second (undoubtedly with a Petzval-Voigtländer lens). See also the remarks about the first instantaneous daguerreotype exposures in Chapter XXXII.

When, in 1843, many other daguerreotypists entered the field, Isenring returned to St. Gallen, where he remained in very modest circumstances until his death. Isenring's house, in which the first photographic studio in Switzerland was established, no longer exists. A few years ago the city of St. Gallen honored his memory by naming a road after him, "Isenring-Weg."

Dr. E. Stenger has given us an interesting historical study of the *Daguerreotypist J. B. Isenring* in an illustrated booklet, published privately at Berlin, 1931, from which the above biographical details are taken.

From these beginnings photography was developed as time went on by the introduction of the calotype, the collodion and the gelatine silver bromide processes; all were used especially for Alpine photography. The growth of the photographic industry kept pace with this.

In 1897 a department was established at the municipal trade school at Zurich for training apprentices in photography; R. Ganz was the director.

In Switzerland the first course in scientific photography having both lectures and practical demonstrations, was started toward the end of the nineteenth century at the technical college at Zurich under Professor Dr. Barbieri, who died in 1926, 75 years old.

Camera, an illustrated monthly journal founded in 1921, published by C. J. Bucher A.-G., Luzerne, and edited by Adolf Herz, stands out as the Swiss photographic periodical which has won an important place as far as artistic and scientific photography is concerned.

RUSSIA

To give an adequate account of the development of photography in Russia is impossible, owing to lack of space and because the recent political changes have made it extremely difficult to obtain the necessary facts and data for such a survey. We must therefore be content to record only the characteristic events in the development of photography in Russia.

The Imperial Russian Academy of Sciences at St. Petersburg (Leningrad), founded two hundred years ago by Peter the Great, who housed it in a magnificent building, turned its attention at an early date to the chemical action of light, as demonstrated by the prize competition which it held in 1804 on the "Nature of Light," which led to the award to Link and Heinrich for their basic dissertation on the subject (see Chapter XVI). This was printed in German at St. Petersburg, in 1808, and gives a clear and splendid review of the knowledge of photochemistry at the beginning of the nineteenth century.

Peter the Great founded the academy upon the advice of the famous German scientist G. W. Leibnitz. The plan of organization was drawn by Leibnitz, who took the older academies at Paris, London, and Berlin (of the latter he was president) as his model. The Academy of Sciences at St. Petersburg was not formally opened until after the death of Peter the Great, when it was opened by his successor the Empress Catherine, January 7, 1726. The Russian czars zealously fostered the Academy of Sciences, and the present government continues it as the Soviet Academy of Sciences in Leningrad. The stately edifice of the Academy of Sciences at St. Petersburg[24] included not only studios and laboratories for scientific work and investigations but also living quarters for the academicians, who were appointed by the czars.

Gottfried Wilhelm Leibnitz (1646-1716), the famous scientist who induced Peter the Great to found the academy, was enabled to accomplish this owing to his connections at the Russian and the Prussian courts. Leibnitz was appointed a member of the St. Petersburg Academy, which at the beginning numbered among its members the French astronomer Jos. Nic. Delisle, the mathematician Joh. B. Bernoulli, and the German philosopher of the Leibnitz school Georg Bernh. Bilfinger. Later, in 1733, the famous German mathematician Leonhard Euler was also called to the academy, which always kept up pleasant relations with German scientists.

We must also mention here the Academy of Arts and the Society

for the Advancement of the Graphic Arts at St. Petersburg. Here the graphic arts were cultivated, to which soon was added, in accordance with the times, photographic technique.

On the "iron tincture" produced by the Russian Chancellor Bestuscheff in 1725 by the action of light see Chapter VIII. See also Chapter XVII on Brandenburg and on the work of Von Grotthuss; Chapters LXXXV and LXXXVI on Jacobi; and Chapter LXXXVIII on Gustav Re.

The correspondence mentioned in footnote 14 of Chapter XIX proved the great interest shown by the Russian government in the earliest work of Niépce.

Photography was closely watched in St. Petersburg by the court authorities from the invention of the daguerreotypy in 1839, and experiments were ordered to be made after Daguerre's directions, at first from landscapes and architectural subjects.

The traveling daguerreotypist Josef Weninger, of Vienna, came to St. Petersburg in August, 1841, by way of Stockholm and Finland (as Bäckström relates), and he was the first to bring a Petzval portrait lens and daguerreotype plates prepared after the more sensitive Vienna method, thus opening the road in Russia for the practice of daguerreotypy and portrait photography.

When Talbot's calotype process made its appearance there were already in Russia amateur photographers, for instance, the Prince Paul Trubetzkoy at Odessa, who in 1851 made sixteen paper negatives, which he exhibited at the Moscow Photographic Exhibition of 1889, as reported by Scamoni in his description of the exhibition. Subsequently the wet collodion process was adopted. In 1851 H. Denier, the Imperial Court photographer, who later became very famous, established himself in St. Petersburg; he played a leading role there for several decades and also received high awards at the Vienna International Exhibition of 1873 for his artistic accomplishments in photography.

In 1859 the photographer Migursky published a textbook on photography in Russian, which had a large sale. There existed also an old Russian technical journal, *Photograph*, which was edited about 1865 by Friebes.

The development of portrait and landscape photography, as well as amateur photography, in Russia was rapid and considerable. The Russian general Count Nostitz of St. Petersburg was an earnest amateur

photographer about the middle of the last century. He participated in a campaign against Schamyl, the last independent chief of the Circassians, who was defeated in 1859. At the time of the collodion process Count Nostitz took photographs in the Caucasus of the country and of its inhabitants. At the Moscow Photographic Exhibition of 1889 he showed fifty-two photographs, representing portraits of members of the imperial family, castles, battleships, groups and landscapes of the Crimea and of Little Russia. Some of these were shown to the author by Count Nostitz when he visited Vienna.

The seasonal change of light conditions at St. Petersburg prompted experiments with artificial lights in photographic studios. The photographer Lewitsky opened in 1881 a portrait studio (after Liébert's system, Chapter LXXIII) equipped with such strong arc lights that he was enabled to take portraits on wet collodion plates in four seconds. Dutkiewicz, in Warsaw, conducted at about the same time a similar business in his night studio and praised the easy method, since electric light, acting as a constant source of light, obviated errors in the length of exposure.

Gaston Braun, of Paris, was called to St. Petersburg in 1880 to reproduce paintings at the Hermitage picture gallery. Braun had at that time taken the first orthochromatic photographs of paintings with eosine wet collodion plates for art dealers and had reproduced them by the pigment printing process. Many of these art prints appeared in the art stores at St. Petersburg and at Paris.

Gelatine silver bromide dry plates were at first imported from London to St. Petersburg, seemingly by an arrangement with Warnerke, who kept up an active connection with London, Brussels, and St. Petersburg.

The first Russian gelatine dry-plate factory was erected by A. Felisch in 1881. Then Warnerke, with Sresnowsky, established a gelatine silver bromide plate factory in St. Petersburg, to which he later added the manufacture of gelatine silver chloride papers.

In Moscow also photography received a good deal of attention, which is proved by the great photographic exhibition of 1889, under the protection of Archduke Alexis Alexandrowitsch, where there was also a historical section (*Phot. Korr.*, 1889, pp. 199, 243).

The photomechanical processes were intensively cultivated, especially at St. Petersburg. On electrotyping, photoelectrotyping, and so forth we have reported in Chapter LXXXV. Photolithography,

collotype, and zinc etching developed parallel with the industry in other countries. It is noteworthy, in reference to the general interest in the photographic processes in Russia, that A. Jedronoff, a naval officer, worked at collotype from 1872, but he applied the chromated gelatine, not in the usual manner to glass plates, but to copper plates. In 1885 he printed his collotypes on a typographical press ("Typographischer Lichtdruck," *Phot. Korr.*, 1885, p. 80).

The tempestuous political conditions during the czarist monarchy and the large amount of propaganda material, printed mostly in underground printing shops, caused the most rigorous supervision of all printing presses by the government, which was a great hindrance to the spread of the technique of reproduction.

Officially photography was advanced especially by the Imperial Russian Technical Society at St. Petersburg, which consisted of several sections, each of which dealt with one of the different technical fields as its subject proper.

Urged by Warnerke, the fifth group of the society, "The Photographic Section," was established in 1880. It became the important center of the photographic industry and of the various branches of industrial, artistic, and scientific photography. From here were published the reports of the "Office for the Production of Government Papers," St. Petersburg, and of the cartographic section of the General Staff, which had in its service studios and efficient reproduction technicians. Here were produced the microphotographs of the botanical section of the university (1884). Constantin Schapiro, appointed in 1880 special photographer to the Academy of Fine Arts, distinguished himself especially in the field of portrait photography and made many recommendations, on which Scamoni reported in *Phot. Korr.* of 1883 and later.

The government's central institution for the graphic arts was the "Imperial Russian Office for the Production of Government Papers," St. Petersburg. Here were produced the Russian bonds, ruble notes, stock certificates, and valuable printed matter of all sorts; but artistic printing and book illustrations were not neglected.[25] The photographic processes found an eminent representative there in the person of Scamoni.

Georg Scamoni (1835-1907) was born in Würzburg, Bavaria, the son of a town councillor. He learned lithography, was employed at the printing house of C. Neumann, Frankfurt a. M., and was called

in 1863 to the Office for Production of Government Papers at St. Petersburg. He introduced there with great success photolithography, collotype, gravure, and so forth, acted as chief of the section until 1898, was overwhelmed with honors, and died at St. Petersburg.

This Office for Production of Government Papers was of great importance at the time of the Russian monarchy. Prominent statesmen such as Prince Golitzin acted as president, and the famous Minister of Finance Count S. J. Witte kept this government printing office under his personal supervision. The demand for the product of this department frequently became so great that the private art printing concern of Policke and Wilborg, St. Petersburg, was often given emergency orders for printing.

Bruno G. Scamoni, son of Georg Scamoni, who received his training at the Graphische Lehr- und Versuchsanstalt, Vienna, became technical director of the printing firm of Policke and Wilborg. To this establishment Karl Albert was called from Vienna, in 1903, to install Klič's heliogravure; he remained there until 1909. After the Russian revolution the firm lost its importance. Director Scamoni had to leave Russia and went to Berlin by way of Finland.

Before the World War the Russian printing office kept in close touch with the government printing offices in Berlin and Vienna. Conferences of the managers of these institutions were held annually at one of three capitals for discussing preventive measures against counterfeiting.

The World War brought these meetings to an end, but in 1930-31 the League of Nations resumed the conferences. An international convention for the prevention of forgery and counterfeiting of government securieties was called and joined by sixteen countries. The first meeting took place on March 4, 1931, at Geneva, under the protection of the League of Nations. The board of examiners is located at Vienna.

In 1886 the Russian printing office called the Vienna phototechnician and engineer A. Nadherny to be chief of the engraving section. Nadherny, in 1890, called to St. Petersburg the copperplate engraver Gustav Frank and in 1891 the photochemist Wilhelm Weissenberger;[26] both were Austrians. The office employed all modern reproduction methods, including three-color process printing, with splendid results. Nadherny returned to Vienna in 1901 as director of the securities printing department of the Austro-Hungarian Bank (now National

Bank). Frank resigned in 1913, having been appointed state councillor, and went to Leipzig, where he joined Schelter and Giesecke, manufacturers of security and banknote papers. Weissenberger remained in St. Petersburg until he was able to leave Russia in 1920, when he went to Germany.

Photographic education was available in old Russia in various places. The Imperial Russian Technical Society at St. Petersburg included in its section for photography a course, with lectures and demonstrations, which for many years before the World War rendered great service to industry and science. But it was much later that the teaching of photochemistry as a separate subject was introduced into the curriculum of colleges.

The first chair for photochemistry in Russian colleges was filled by Professor J. Plotnikow a few years before the World War, at the University of Moscow. Here Plotnikow began an active career in the scientific field, which the Russian Revolution abruptly terminated. The history of Plotnikow's professorship, as described in the preface of his book *Allgemeine Photochemie* (Berlin-Leipzig, 1920) might well be cited in this work, which has set itself the task not only of the narrower technical history of photography but also of presenting the history in relation to the course of events during its development.[27]

Plotnikow was born on December 4, 1878 (still living in 1932), in one of the central regions of Russia, the son of a well-to-do engineer and architect. After leaving college in 1897, he studied mathematics and physics and was graduated from the University of Moscow in 1901. From there he went to Leipzig in order to study physical chemistry under W. Ostwald (1901-7), where he received a doctor's degree in philosophy. After the retirement of Professor Ostwald, Plotnikow left Leipzig and returned to Moscow, where he taught photochemistry at first as lecturer in 1910, as assistant professor in 1912, and as full professor in 1916. In 1913 he equipped at his own expense the first Russian photochemical laboratory. He owned a large country estate, where he spent his summer vacations. He was discharged in 1917 by the Kerensky government, and his chemical laboratory was destroyed. He retired to his country place, which also met destruction by the peace-loving peasants, who were ordered by the government to destroy it.

Soon after Plotnikow had found a position in the scientific photochemical laboratory of the "Agfa" at Berlin, he was called to the Zagreb

University (Jugoslavia). This institution was established in the early days of the monarchy and was housed in beautiful buildings.[28] When taken over after the World War by Jugoslavia, it was enlarged by the addition of a technical faculty, and Plotnikow was appointed professor of physics, chemistry, and photochemistry. He became director of the physicochemical institute and is now the leading scientific representative of photochemistry in the Balkan States (*Phot. Korr.*, 1929-30; and the *Jahrbücher*).

Better than the photochemical institute at Moscow, fared the industrial government printing institutions and the government printing office for securities, because the Soviet Union required them as much as the czarist government. The former imperial printing office was moved, with its machines and equipment, to Moscow and continued in full working order, while the paper factory connected with it remained in Leningrad. The military cartographic institute at Leningrad was continued, with most of its staff, after the revolution, but was transferred to Moscow and placed under the People's Commissar for the Army.

According to the reports of the embassy of the Union of the Socialist Soviet Republics at Vienna (1931) there are located at Moscow: (1) The Printing Office for the Production of Government Securities (Gosznak); (2) The Military Photographic Institute (Rewwensoet); (3) The Government Publication Office of the Soviet (Gosizdat); (4) The All-Russian Society of Photographers (W.O.F.).

The Soviet authorities established various photographic sections in the government service—for instance, at the Aeronautical Institute (section for aerial photography),[29] at the Geological Institute (geological committee),[30] and at the Technological Institute and the agricultural section connected with it, all of which are located at Leningrad.

Occasionally, when the necessity arises, photography is employed by the different scientific institutes at Leningrad,[31] in Moscow, and at the universities of Irkutsk, Kasan, Minsk, Odessa,[32] Tomsk, and the Ukrainian Chamber of Weights and Standards at Charkow.[33]

After the revolution considerable attention was paid to photography in Russia. In 1917 a Government Photographic College was established, and Popowitzky, the former chief of the Government Printing Office was appointed rector (president). Probably "college" does not correspond to the meaning the title implies in Germany or elsewhere, but it offers an opportunity for the study of and development in the field

of photography. A "Technikum" for motion picture photography (1927) and a special institute for optics were established under the direction of Professor Rostjestvenski.

The publishing house Ogoniok (1929), in Moscow, publishes the journal *Soviet-Photo;* one of its issues describes the organization and activities of a photographic union in Russia.

The Society for Cultural Relations between the Soviet Union and foreign countries, which fosters intellectual interchange, is located at Moscow. The academies of sciences at Vienna, Berlin, and elsewhere exchange their scientific publications with those of the various Russian academies, universities, scientific bodies, and technical educational institutions.

From the information at hand, it appears that the Soviet government controls all these institutions and, of course, also those touching on and dealing with photography; even the distribution of photographic cameras to labor organizations is a governmental function. Private activity in the field of photography, we suppose, is very difficult, because the economic organization of the Soviets has taken over the trade in everything, which includes, naturally, photochemical supplies, cameras, and accessories. Amateur photography in Russia is practically extinct, owing to the risk the photographer incurs, in awakening distrust of political motives and having to face awkward consequences.

Notwithstanding these regrettable circumstances, we must acknowledge and appreciate the work and results brought to us by the official Soviet scientific and technical journals, which are full of unusually splendid photographs, reproductions, and scientific research.

JAPAN

According to a report[34] in the *Deutsch-japanische Post*, Yokohama, August 19, 1911, the draftsman and painter Renjyo Shimooka (1823-1914) was the first native of Japan to carry on the art of photography in the Far East. He still lived in 1911, 88 years old, and he related how with a great deal of trouble and difficulty he had seen how photographs were made when an American warship arrived in the harbor. He succeeded in opening a photographic studio in Yokohama, but encountered the superstition of his countrymen that having one's picture taken meant an early death. His first customers were sailors from foreign warships, who enjoyed being photographed in company with Japanese girls. Gradually the people overcame their

prejudices, took pleasure in being photographed, and many studios made their appearance in Tokyo, Yokohama, and all other large cities, probably as early as the sixties of the last century.

The Japanese All Kanto Photographic Association arranged in 1928 the erection of a memorial tablet in Szimoda Izu, the native town of the pioneer in photography Renjyo Shimooka (*Japan Photographic Annual*, 1928-29, p. 1).

Until the eighties the wet collodion method dominated in Japan. Gelatine silver bromide plates were introduced into Japan largely through the influence of the English amateur photographer and scientist W. K. Burton (1835-99). He lived in London in the eighties and wrote a number of articles and books, mostly on silver bromide emulsions.[35] He was by profession a sanitary engineer and was called in 1887 by the Japanese government to the Imperial College at Tokyo as professor of sanitary engineering. His excellent knowledge in the field of applied photography undoubtedly had something to do with his appointment. He had at his disposal in Tokyo two large photographic studios, where native and foreign visitors were always given a wholehearted reception. The Englishman T. B. Blow told this author that during several visits to Japan (1896 and 1898) he was given the use of the available facilities for his photographic work. Burton also introduced platinotypes into Japan and was a silent partner in the first Japanese collotype establishment of Ogawa, which had attained much commercial importance at the end of the last century. Burton owned a rich collection of large negatives of Japanese scenes and photographs taken in Formosa. He attempted also to produce gelatine silver bromide plates in Japan, but encountered great difficulty in finding suitable glass. Japanese houses had at that time only paper windows, and the small amount of imported window glass was of the cheapest quality and unfit for the manufacture of dry plates. In addition he had to overcome trouble in drying the emulsion-coated plates during the hot weather and immediately following the rainy season, when the atmosphere is saturated with humidity. Burton therefore made the dry plates needed for his own use, but never manufactured any for the trade. Burton died in Tokyo, and George E. Brown wrote his obituary article in the *British Journal of Photography* (1899, p. 603).

At first dry plates and other photographic requirements were imported by Japan from England, which had a monopoly of this trade for years, but later the United States has shared in the trade.

Photography has been a subject in the curriculum of the Japanese high schools for a long time; for instance, Professor Yasugi Kamada lectured on photochemistry at the university at Senday from 1916 until 1922, when a course in photography and reproduction was established at the Tokyo Polytechnic College (Tokyo Kogei Gakka), to which Professor Kamada was appointed.

A medal for services in the field of photography shows a picture of Fujiyama penetrating the clouds, the high volcanic cone on the Japanese Island of Nippon. It is considered a national shrine and as such a favorite motive for Japanese art.

In 1930 the medal was awarded by the Friends of Photography, presided over by Professor Y. Kamada, to this author. The mountain on this medal was modeled from a photograph by Kamada, who had taken it with infrared light filters on neocyanine plates at a distance of 68 kilometers (42½ miles).

The translation of the text on the reverse side of this medal reads: "As a remembrance of the seventy-fifth birthday of Prof. Dr. J. M. Eder, in gratitude for and appreciation of his great services in photography and the art of printing, his Japanese colleagues respectfully present him with this medal of honor, Tokyo, December, 1930."

Only very lately were modernly equipped factories for silver bromide gelatine plates and papers of all kinds established: the Oriental Photo Industrial Co., Ltd., Tokyo (founded in 1920); the Tokyo Dry Plates Co., Ltd., Tokyo, Kampan Kabushiki-Kaisha; Nihon Photo Industrial Co., Ltd.; and the Asahiphoto Industrial Co., Ltd., which was started in 1908. The firm Rokuosha, among others, also manufactures cameras. Because of the great number of professional and amateur photographers in Japan it is easy to understand that there exist many societies. The best known is that of the professional photographers, Nihon Shashinshi Rengo Kyokai. A number of photographic societies united in arranging the first Japanese exhibition of amateur photography, in 1927, at Tokyo and Osaka, which was called the International Photographic Salon.[36] Then followed exhibitions of "Japanese artistic photographs." Since 1911 exhibitions by the Tokyo Photo-Research Society and by the Manchurian Artistic Photographs group show annually the result of their work.[37] The Osaka Industrial Experimental Station works for industrial purposes. In Tokyo was founded, in 1929, the Amateur Cinema Club. The Tokyo Scientific Photographic Society was founded in 1926 and numbered more than 100

members in 1931 (president, General Lieutenant Hitoshi Omura; director, Professor Y. Kamada).

The Japanese government gave special attention to photography at the beginning of this century and sent painters, photographers, phototechnicians, and scientists to Europe to be educated in the field of photography. A number of these studied at the Graphische Lehr- und Versuchsanstalt, Vienna—among them Takheri Kamoi, now at the University of Tokyo, Major Hitoshi Omura, the painter Seiichi Oka, and the cartographer K. Ogura, who was detailed to the Military Geographic Institute, Vienna, and also visited the section on reproduction of the Graphische Lehr- und Versuchsanstalt. He returned to Japan before the outbreak of the Russo-Japanese War (1904) and introduced map printing by means of photoalgraphy at the Military Geographic Institute, Tokyo, with the result that the Japanese army and navy in the above-mentioned war were equipped with excellent maps of this kind.

Ogura sent to this author in 1904 an original war map from the theater of war in Manchuria, printed on thin waterproof paper by algraphy, which presents very precise execution (*Jahrbuch*, 1908, p. 132). An example of these Japanese war maps of 1903-4 is preserved in the Technical Museum for Industry and Trade, Vienna. Ogura was chief of the Military Geographic Institute at Tokyo until 1928.

The *Japan Photographic Annual* has been published since 1925 by the Asahi Shimbun Publishing House, Tokyo and Osaka. The preface is in English, the balance in the Japanese language and script, and it is richly illustrated.

In portrait and landscape photography the production of postcard views and the photomechanical illustration of books and periodicals in halftone, collotype, rotogravure, etc. Japan has become independent of the outside world.

As far as the author is able to ascertain, Japan seems to be superior to China in the field of modern illustration. The Academia Sinesica at Nanking founded there the Metropolitan Museum of Natural History, which since 1930 has issued a journal printed in English and Chinese script by means of the earlier graphic processes (lithography, etc.). The illustrations are not particularly noteworthy examples of photography.

Chapter XCVII. SUPPLEMENT TO THE CHAPTERS ON DAGUERREOTYPY AND CINEMATOGRAPHY

A. To Chapter XXIV, p. 228: The quotation from Liebig, *Cornhill Magaz.* (1865) XII, 303, is taken from an address of Liebig that he made March 28, 1865, at a session of the Academy of Sciences at Munich; it is reprinted in *Reden und Abhandlungen von Liebig*, Leipzig, 1874, p. 296 (see E. Stenger, *Phot. Korr.*, 1931, p. 225).

B. To Chapter LXXI, p. 516: Among the pioneers in motion picture photography the Frenchman Le Prince is mentioned. A committee was formed at Leeds, England, to honor his services and to preserve his memory. The committee requested subscriptions for a "Memorial to L. A. A. le Prince, Father of Kinematography," to be affixed to his residence at Leeds. The inscription reads: "Louis Aimé Augustin le Prince had a workshop on this site, where he made a one-lens camera and with it photographed animated pictures. Some were taken at Leeds Bridge in 1888. Also he made a projecting machine and thus initiated the art of kinematography. He was assisted by his son and by Joseph Whitley, James Wm. Longley, and Frederic Mason of Leeds. This tablet was placed here by public subscription."

L. A. A. le Prince (1842-90) was the son of a French officer; he studied chemistry and physics at Paris and Leipzig, and painting under Billeuse at Paris, where he met the Englishman John R. Whitley, who invited him to Leeds, where both devoted themselves to painting. Le Prince married Whitley's sister and settled at Leeds. In 1881 he went to the United States in order to stage panoramic paintings in New York, Washington, and elsewhere. There he learned of Muybridge's serial photographs, which at that time attracted great attention. This led him to construct a camera for the production of motion pictures, which he patented on January 10, 1888 (U. S. patent No. 376,247), describing it as the "method of, and apparatus for, producing animated pictures." On his return to Leeds in 1887 he completed the practical construction of his apparatus, and he patented it in England (November 16, 1888) as well as in Austria and other countries. In 1889 he used long perforated and transparent strips of film.

On a business trip to Paris, in 1890, Le Prince visited friends in Dijon, and he was last seen on September 16, 1890, boarding the Dijon-Paris train. Since that time he has disappeared completely, and his

family, who engaged a number of French and English detectives, never was able to find a trace of him again. His heirs and friends had seen his presentations, and some knew all the details of the construction of his apparatus, but no one was able to utilize it practically.

C. To Chapter LXVI, p. 489, and Chapter LXXI, p. 518: Thomas Alva Edison (1847-1931) was born at Milan, Ohio. His father came from an old Dutch family of millers, who had emigrated a hundred years earlier. He had to help earn his living when eleven years old by selling newspapers on railroad trains. Then he became a telegraph operator, but his mind was always occupied with inventions, and he made several successful inventions in the field of telegraphy.

In 1876 he started a laboratory at Menlo Park, New Jersey, near New York City, where he worked on the improvement of the telephone. Two years later he invented his phonograph, which made his name known throughout the world. In 1879 he invented the carbon filament incandescent lamp; in 1881, the Edison dynamo; at that time he began the erection of powerhouses for electric illumination. In 1887 Edison erected large works, mostly for research and testing purposes, at West Orange, New Jersey. We are interested here only in those of his numerous inventions which his successful activities developed in the field of photography.

The various attempts of Muybridge and others to produce photographic serial pictures did not escape Edison's attention. He conceived the idea of constructing a film camera for serial instantaneous pictures, and in 1889 he entrusted the Eastman Kodak Co., Rochester, with an order for a "motion picture camera," for which he furnished complete working plans. This camera (kinetograph) Edison equipped with films especially manufactured by the Eastman Company. The box in which the observer viewed the living pictures he called "kinetoscope."

For a long time Edison kept the construction of the kinetoscope secret. Later it became known that in the final models the intermittent motion of the film was obtained by friction (C. Forch, "Edison and His Connection with Cinematography," *Kinotechnik*, 1931, p. 397). Edison applied for patents on these apparatus on August 24, 1891. The patent on the kinetoscope was granted on March 14, 1893, but that on the kinetograph was strongly contested, and Edison was forced to divide this patent into three parts; on these, patents were not granted until 1897. It is noteworthy that Edison's kinetoscope was arranged for only a single observer to view the subject—a peep box. The posi-

tive film was continuously moved in front of the window in the box by an electric motor. A continuous rotating disk, with slits, exposed each image of the film to the observer for a short time.

The kinetoscope films, easily obtainable on the market, prompted further experiments. We have mentioned that Le Roy, in 1894, projected motion pictures on a wall with such films by means of a special apparatus of his own. On May 20, 1895, Major Woodville Latham also presented such projections of kinetoscope films with his "panopticon." A few months earlier the Lumière brothers in Lyons had taken out a French patent on their "cinematograph." Thomas Armat had also shown film projections in Washington, D. C. Along the lines of these experiments Edison produced his "vitascope," which was used for kino-projection at New York City in April, 1896.

Later Edison combined these projection apparatus cleverly with his phonograph ("kinetophone") and thus produced the first practicable, though imperfect, tone film. The kinetoscope and the kinetophone could be seen for some time in all the great cities of the world, but they were displaced by Lumière's cinematograph and other modern apparatus.

Edison's work in this field was without doubt a decisive step along the road of modern motion picture technique. He died on October 18, 1931, at West Orange, New Jersey.

Biography OF JOSEF MARIA EDER, BY HINRICUS LÜPPO-CRAMER

JOSEF MARIA EDER, son of Josef Eder, a judge of a county court, was born March 16, 1855, at Krems on the Danube. His mother, Caroline, was the daughter of Ludwig von Borutski, legal advisor (district captain and judge) of Tulln, Lower Austria. Ludwig von Borutski was of Polish origin, his family having emigrated after the third partition of the Kingdom of Poland. Eder attended the old Piarist preparatory school at Krems from 1864 to 1872; after that he entered the University of Vienna. There he specialized in the study of the natural sciences. At the same time he pursued studies at the technical high school, where he came in contact with the pioneers of photography, such as the Librarian Martin, Professor Pohl, Professor Hornig, Angerer, and others. In addition to these important professional photographers, there were also a number of amateur photographers in Vienna, among whom was Captain Victor Tóth, who later married Eder's sister Caroline.

While in Vienna, Eder published several works on chemistry; namely: *Die Bestimmung der Salpetersäure* (1876); *Untersuchungen über Nitrozellulose;* "Analysen des chinesischen Tees," in Dingler's, *Polytechnisches Journal; Bleichen von Schellack;* etc. While at the university he specialized in the study of the chemical foundation of photography and investigated the double salts of cadmium bromide and iodide in their relation to negative collodion. With Tóth he announced a lead intensifier and investigated the methods of dyeing photographic silver plates with the aid of ferricyanides, which were later to become very important.

About that time the Photographic Society of Vienna held a competition to further the study of the chemical principles underlying color photography, which undoubtedly had a determining influence on the course of scientific study later pursued by Eder. Eder's treatise, *Über die Reaktionen der Chromsäure und Chromate auf Gelatine, Gummi, Zucker und andere Substanzen organischen Ursprunges in ihren Beziehungen zur Chromatphotographie* (1878) was awarded the first prize in the competition. This work evidences a thorough understanding of the technique of reproduction and is a classic in its field.

For a time Eder worked in the Austrian State Mining Laboratory

under the chief mining engineer, Pattera, and later he became assistant to J. J. Pohl, professor of chemical technology in Vienna. In 1879 Eder published *Die chemischen Wirkungen des farbigen Lichtes,* which was translated into French and English. With E. Valenta, also a student under Professor Pohl, he investigated the composition and method of producing iron oxalate and its compounds, then little known, which later became important in connection with platinotype and other iron-printing processes.

During the year in which Eder substituted for Dr. Hein, professor of chemistry at the technical high school at Troppau, he completed his report on the mercuric-oxalate photometer, which he started to write in Vienna. He was the first to establish the dominating sensitiveness of the ultraviolet and the coefficient of light reaction.

Dr. Eder then returned to the technical high school in Vienna, and in June, 1880, he was appointed associate professor of photochemistry and scientific photography. In this office the young scientist was supported by the Vienna Photographic Society, which welcomed this revival of photochemical research.

The introduction into England (1871-74) of silver bromide gelatine emulsions, of which little was then known, attracted the attention of Eder, who directed all his energies to this promising field. In 1880 he published in the *Photographische Korrespondenz* a series of basic experimental studies, which later appeared as a monograph under the title *Theorie und Praxis der Photographie mit Bromsilbergelatine;* this was also translated into French and English. In the same year appeared his treatises on the dissociation of ammonium bromide solutions, and in 1881, on the chemical analysis of gelatine and collodion emulsions.

As early as 1879 Eder published the fact that for developing the newly discovered gelatine dry plate the ferric-oxalate developer offered definite advantages over the pyro-ammonia developer, the only one in use up to that time. Together with G. Pizzighelli, Eder developed a silver chloride gelatine process. Following this up, Eder alone discovered the silver chloride bromide gelatine process, which he unselfishly offered to the public for use in photography. As a result of these two discoveries a great industry for the manufacture of photographic art paper and of positive films for motion pictures developed and spread throughout the world.

Meantime the Photographic Society of Vienna considered establishing a photographic research institute, but the road toward the realiza-

tion of this plan was long and difficult. In 1882 Dr. Eder was appointed professor of chemistry and physics at the trade high school in Vienna. Here he had well-equipped laboratories at his disposal, and from here he published his well-known researches on the reaction of the silver halide compounds to the solar spectrum and on the action of dyes and other substances on photographic emulsions. These articles appeared in the reports of the Academy of Sciences of Vienna. Dr. Eder's experiments establishing the superiority of iodo-eosin (erythrosin) over eosin (bromeosin), heretofore used exclusively, were of practical value. Following that discovery erythrosin has been used exclusively by the manufacturers of orthochromatic plates. In 1881 Eder published his spectral-analytical investigations on light sources for photographic use, and later he continued these researches. His treatises and reports on researches and experiments in the field of photochemistry, photometry, sensitometry, on photographic objectives, etc., are too numerous to mention.

Instantaneous (snapshot) photography, which was rapidly growing in importance, was ably dealt with by Eder in his monograph *Die Momentphotographie* (1st ed., 1880; 2d ed., 1883), which was also translated into French. All Eder's works had one common purpose—practical application without regard to the pursuit of extraneous objects.

During the early period of his photographic researches Eder was greatly handicapped by the fact that the meager literature of photochemistry of that time was scattered throughout a vast body of scientific and technical publications and difficult to find. No comprehensive and scientific work on the subject similar to Gmelin's *Handbuch der Chemie* was available to the photographic student. This gave him an incentive to create such a work. Having assembled and arranged his data, he was able, in 1884, to complete the first volume of his widely-known *Ausführliches Handbuch der Photographie*, which was subsequently followed by many other volumes and passed through several editions. This standard work arises above a mere compilation of data because of the volume of original investigation and research by Eder included in it. Of no less importance was Eder's *Jahrbuch für Photographie und Reproduktionstechnik*. This is the most comprehensive review we have of the development of photography from 1887 to the present time.

In 1888 efforts were renewed to found an institute in Vienna for the study and research of the graphic arts. This was finally accomplished

through the Ministry of Education under the name "Graphische Lehr-
und Versuchsanstalt," according to Eder's original plans for its or-
ganization. In 1889 he was appointed director of this institution, the
history of which has been outlined in Chapter XCVI.

The studies covered the entire field of photography, in its application
to portraiture, landscape and scientific photography as well as its use
in the photomechanical processes (heliogravure, photolithography,
line etching, halftone, and both hand photogravure and rotogravure,
etc.). Adequately equipped studios and printing plants were installed.
In order to systemize an intelligent and uniform method of study for
both the teacher and the student of photography, Eder prepared his
*Rezepte, Tabellen und Arbeitsvorschriften für Photographie und Re-
produktionstechnik*, first published by W. Knapp in Halle (1889);
it has since gone through many editions.

At the time of founding the institute, photography was passing
through a stage of transition from the use of a collodion to a gelatine
plate, from printing on albumin paper to collodion and gelatine silver
chloride (printing-out), silver bromide and silver chloride (develop-
ment) papers. Amateur photography made unprecedented strides and
blazed the trail also for professional photography. New types of lenses
and other appliances and devices were placed on the market. Tests for
the usefulness of these appliances were made in Eder's laboratory and
proved of great value to the profession. Numerous improvements and
new working methods, as well as the results of extensive experiments,
were published from time to time by Eder and his associates in the
technical journals and were included in the lecture to the students of
the institute by practical demonstrations. Many exhibitions were or-
ganized along these lines. A special department of this institution, under
the personal direction of Eder for a number of years, has been devoted
to the investigation of forged legal and other documents.

Eder was very active in promoting the application of photography
to all branches of science. Physicists, chemists, astrophysicists, geode-
sists, geographers, archaeologists, zoologists, botanists, physiologists,
anthropologists, hygienists, many of them celebrities (for instance,
Ernst Mach) visited him from all parts of the world and found him
always ready with assistance and inspiration. His varied and thorough
knowledge, his keen insight, and his gift of quick perception enabled
him to give counsel and point the way out of many difficulties. In his
laboratory Lieutenant Scheimpflug perfected the methods of aerial

photography used in cartography and surveying. As is well known, in 1896 Dr. Leopold Freund, of the University of Vienna, perfected the use of X rays in therapy at Eder's photochemical laboratory. Together with Dr. Freund, Eder discovered in the naphtoldisulfonic salts, which rapidly absorb the ultraviolet light, a protection against sunburn, which, patented in 1923 under the trademark "Antilux," became very popular.

Eder was particularly attracted to the study of sensitometry, actinometry, spectral analysis, and spectrography. Then he studied the action of the solar spectrum on photographic emulsion by means of a glass spectrograph, and in 1889 he constructed a quartz spectrograph, through which he was the first to establish the ultraviolet emission spectrum of burning carbohydrates and that of the ammonium-oxygen flame (1890-92); he also investigated the reaction of the Bunsen burner in ultraviolet, the absorption of various kinds of glass, the emission spectrum of mercury light, and magnesium light, etc. In 1895 he received from Rowland in Baltimore large diffraction gratings for spectrography, which he used for wave-length measurements of the spark and arc spectra of elements. He was in constant communication with Carl Auer Von Welsbach, who separated the supposed element into its true elements praseodymium, and neodymium, ytterbium, and thallium. Eder took wave-length measurements of the elements cassiopeium, yttrium, samarium, gadolinium, europium, dysprosium, and terbium, and so forth, which ranged from the deepest ultraviolet to red, resulting in many conclusions reported by Professor Heinrich Kayser, of Bonn, spectral analyst, in his *Handbuch der Spectroskopie*. Dr. Eder, with Valenta, made careful wave-length measurements of the spectra of sulphur, chlorine, and bromine in vacuum tubes under various pressures. These spectral-analytical investigations by Eder were published with excellent photogravure illustrations in the records by the Academy of Sciences of Vienna; the wave-length measurements of the rare elements by Auer are published in the reports of the sessions of the academy.

Most worthy of mention is the *Atlas typischer Spektren*, by Eder and Valenta, published by the Academy of Sciences of Vienna (1st ed., 1911; 3d ed., 1928). It presents the spectra of the rare elements based on first-hand observations and contains many valuable spectral photographs. A summary of the photographic, photochemical, and spectral-analytical investigations made by Eder and Valenta is found in the now-scarce voluminous work *Beiträge zur Photochemie und Spek-*

tralanalyse (Vienna and Halle, 1904, 786 pages, 93 illustrations in the text, and 60 full-page plates).

Eder wrote the monographs *Quellenschriften zu den frühesten Anfängen der Photographie* (1913) and *Johann Heinrich Schulze* (Vienna, 1917). He urged the publication of the monographs on A. Martin, 1921 (by Professor A. Bauer) and on Karl Kampmann. The richly illustrated historical work *Uber Schloss Münichau bei Kitzbühel in Tirol* (1915) and the work on Kissling, *Beiträge zur Kenntnis des Einflusses der chemischen Lichtintensität auf die Vegetation*, were also written by him.

He collaborated in many collective scientific works, such as: "Licht, chemische Wirkungen," in Fehling's *Neues Handwörterbuch der Chemie* (1886, Vol. IV); Meyer's *Grosses Konversations-Lexikon* (6th ed., 1902-8); Otto Lueger's *Lexikon der gesamten Technik* (1st and 3d eds.); and Max Geitel's *Der Siegeslauf der Technik* (3d ed., 1928).

Eder was also associate editor of the retrospective catalogue of the Austrian Exhibit at the World's Fair at Paris, in 1900, to which he contributed the "Geschichte der Oesterreichischen Industrien."

In addition to writing on the history of photography, he presented collections of examples, by photographic processes, typical apparatus, and so forth, to the Graphische Lehr- und Versuchsanstalt, to the Technisches Museum für Industrie und Gewerbe, Vienna, and to the Deutsche Museum, Munich.

Eder attended numerous congresses and exhibitions. In 1887, at the invitation of the French Academy of Sciences, he became a member of the First International Congress on Astrophotography. He participated in the International Congresses of Applied Chemistry, which met at Vienna, 1898, at Berlin, 1904, and at Rome, 1906. He organized a large exhibition of scientific photography at the Vienna University, on the occasion of the eighty-fifth annual meeting of German naturalists and physicians at Vienna (September, 1913). Due to his able direction, the exhibit of the Lehr- und Versuchsanstalt attracted conspicuous attention at the World's Fair at Paris in 1900, at St. Louis in 1904, at the International Photographic Exhibition, Dresden, in 1909, and at the Leipzig World's Fair of the Book and Graphic Industry, 1915.

Eder assisted the Austrian legislature in drafting a bill for the protection of the rights of inventors in the field of photography; the law

went into effect in 1895 and was warmly welcomed by professional photographers. As a result the Austrian government appointed him court expert in the field of the graphic industry and chairman of the government department of experts on patent rights; he served as a member of this commission for a number of years.

On the occasion of the twenty-fifth anniversary of the establishment of the Graphische Lehr- und Versuchsanstalt Eder was honored by the faculty, who presented him with a silver plaque bearing his portrait.

The history of the Graphische Lehr- und Versuchsanstalt was published by the institute in 1913 as a memorial. It was executed in the institution and illustrated with 63 full-page plates. Artistically and technically it represents the height of accomplishment and demonstrates the excellent and varied activities engaged in by this institution of learning under Eder's guidance.

In addition Eder lectured for many years as professor of photochemistry at the technical high school in Vienna, where in 1892 he became assistant professor and in 1902 full professor. In 1925, having reached the age of retirement, he withdrew from teaching, showered with many honors. In 1930 he was awarded the honorary degree of Doctor of Philosophy and Science at the technical high school in Vienna. He is a member of the "Kaiserlich Leopoldinisch-Carolinischen deutschen Akademie der Naturforscher" and of the Academy of Sciences at Vienna; honorary president of the Photographic Society, Vienna; honorary member of the Association of Austrian Chemists and of many amateur and professional photographers' associations in Austria, Germany, England, Belgium, France, Sweden, Denmark, and America, as well as of the former Imperial Russian Technical Society of St. Petersburg and the former Imperial Society of Physicians in Vienna.

Dr. Eder received many decorations from the rulers of prewar Europe. He was Knight of the Imperial Austrian Order of the Iron Cross, Knight of the Leopold Order, Commander of the Austrian Francis-Joseph Order, of the Saxon Albrecht Order with Star, officer of the French Legion of Honor, and commander of the Swedish Wasa Order. During the World War he was decorated by Emperor Carl with the gold war cross for his civil services and by the Austrian Republic with the great decoration for distinction. Of the numerous medals of honor which Eder received, we mention only: The Elliot

Cresson gold medal of the Franklin Institute in Philadelphia; the gold medal of the Vienna Photographic Society, also their Voigtländer medal; the gold Swedish Adelsköld medal; the Plössl medal; the Petzval medal; the Maria Theresa medal of the Vienna Camera Club; the Daguerre gold medal of the Photographic Society in Berlin; that of the Amateur Photographer's Club of Vienna; the Wilhelm Exner medal of the Lower Austrian Trade Associations in Vienna; the Senefelder medal of the Gremium of Lithographers and Copper Printers of Vienna; the progress medal of the Royal Photographic Society of Great Britain; the Peligot medal of the Société française de Photographie; and the Japanese medal of honor of the Friends of Photography in Tokyo.

Eder's personality has been aptly described in the following words by one of his colleagues, Professor Dr. Alfred Hay, of Vienna (1892-1931), in the *Phot. Korr.* (April, 1930, Vol. LXVI, "Zum 75. Geburtstage Eder's"):

The three most outstanding qualities in Eder's work are: the purely scientific ability to sense relationships and adjust them; the ability of the technician to subserve scientific findings to technical aims; and finally, the ability of the organizer to direct and guide his co-workers with a deep psychological understanding of their individual capabilities.

Eder was able through his insight into human thought to develop both men and their labors, and he often succeeded in difficult situations, where others would have failed, because of his personal charm and sympathetic approach. It may be conceded that although he fought vigorously many an opponent, he never used unfair means.

Eder's favorite subject has been and still is the history of photography. For this fascinating study he is especially well equipped by his comprehensive knowledge of the subject and his extraordinary memory.

Eder represents the type of scientist who has become more rare every day. By this I mean a man of great learning, sound judgment, and—what is more important than learning—human sympathy and tact.

This pen picture of Eder would not be complete were we to present him merely as a scientist and scholar, omitting the man. However, to relate his human qualities is both a pleasant and an enjoyable task.

Notwithstanding his serious conception of life's problems, his is a genial and joyful nature. The passing years have left no traces upon him; he keeps a young heart and such a youthful spirit that the younger generation may well envy him.

From nature, which he loves above everything else, Eder has

gathered for years strength and inspiration, thus keeping his body and spirit young and buoyant. It is indeed a great delight to observe our master wandering about in the garden of his beloved estate, "Villa Anna," in Kitzbühel, Tyrol, among his exotic plants, examining beetles and butterflies, watching his meteorological and photometric instruments, and with a hearty "Hello" extending a welcome to an unexpected visitor with the old-time Viennese cordiality. All at once the solitary student of nature in his peasant's blouse is transformed into the man of the world, and the visitor is carried away by the charm of his host. This happens daily, because scientists, friends, and acquaintances come from all parts of the world to seek his counsel or the warm hospitality of his cheerful household. Eder is most happy when at Kitzbühel. His country home, named "Villa Anna" after his wife, is his refuge from the din and turmoil of the big city. Here he has installed a comfortable workshop, fully equipped with the necessary paraphernalia for his studies.

Eder may well look back upon his life's work and accomplishments with pride and with the rare satisfaction of having earned the respect and appreciation of the scientific world, as well as the love and admiration of those who have had the privilege of knowing him intimately.

Notes

CHAPTER I

1. For a more extensive treatment of the subject see Wiedemann, *Annalen*, XXXIX (1890), 470.

2. See also Ferd. Rosenberger, *Geschichte der Physik in Grundzügen mit synchronistischen Tabellen* (Brunswick, 1882).

3. After Aristotle's death his whole library, including his manuscripts, was left to his successor, the Greek philosopher Theophrastus (390-286 B.C.). After the latter's death the library changed hands many times by inheritance. It is said that later, for a period of a hundred years or more, they lay hidden in a cellar to prevent their being stolen and were eventually completely forgotten. About 100 B.C., Appellikon of Teos, a wealthy bibliophile, is said to have discovered them and brought them to Athens, where they were published. In 87 B.C., when Sulla took Athens, he had them brought to Rome. About 70 B.C. Andronikus of Rhodes rearranged the manuscripts and made a catalogue of them. In this order they have remained to the present day.—*Metaphysik*, by Aristotle, Kirchmann ed., 1871, 5).

4. For criticisms as to whether this work is genuine see Wilde, *Geschichte der Optik* (1838), I, 9.

5. In 1792, in the *Annals of Botany*, by Usteri, St. 3, p. 237, Von Humboldt called attention to this statement of Aristotle; he, however, made Aristotle say more than the latter really did utter, since Heinrich points out in his *Von der Natur und den Eigenschaften des Lichtes* (1808), p. 33, that Goethe, in his *Geschichte der Farbenlehre* (Hempel ed., XXXVI, 22) gives a translation of this passage from the Greek original.

6. For further notes on earlier historic research data on the previous conceptions of the development of the various colors of the skin of the human race see Landgrebe, *Über das Licht* (1834), p. 373; see also Ebermaier, *Versuch einer Geschichte des Lichtes und dessen Einfluss auf den menschlichen Körper* (1799), pp. 183, 199; Latin edition of the latter, *Commentatio de lucis in corpus humanum efficacia* (1797); see also Horn, *Über die Wirkungen des Lichtes auf den lebenden menschlichen Körper mit Ausnahme des Sehens* (1799).

7. In this note the reference to the "silver plate" is erroneous, for the original mentions a "gold plate."

8. Pliny frequently does not properly discriminate between minium, mercuric sulphide, and ocher.

9. See Magnus, *Die geschichtliche Entwicklung des Farbensinnes* (1877), p. 14; see also Wiegmann, *Die Malerei der Alten in ihrer Anwendung und Technik* (1836), p. 210.

10. Experiments were made and reported on by Chaptal (*Annales de Chimie*, 1809, Vol. LXX); Davy (*Philos. Transact.*, 1815); Gilbert (*Annal. f. Physik*, 1816); Geiger (*Magazin für Pharmazie*, XII, 135); Junius (*Von der Malerey der Alten*, 1770); Schafhäutel (Dingler's *Polytechn. Journ.* XCV, 76); Artus (*Der Technolog*, 1877, I, 25). Compiled in Keim, *Die Mineralmalerei* (1881) and Wiegmann, *Die Malerei der Alten* (1836). As source material on the colors among the ancients see Rochette, "De la peinture sur mur chez les anciens," in *Journal des savants* (1833); Roux, *Die Farben, ein Versuch über Technik alter und neuer Malerei* (1824); Böttiger, *Ideen zur Archäologie der Malerei* (1811); Walter, *Alte Malerkunst* (1821); Fernbach, *Die enkaustische Malerei* (1845); Rhode, *Über die Malerei der Alten* (1787); Fiorelli, *Kleine Schriften* (1806); Grund, *Die Malerei der Griechen* (1810). There were continuous controversies over the technique of the paintings in Pompeii, Herculaneum, and Stabiae, following the publication of the *Pitture antiche d'Ercobano e contari* (1757) and up to the publication of Helbig's *Wandgemälde der vom Vesuv verschütteten Städte Campaniens* and Donner's treatise *Über die antiken Wandmalereien in technischer Beziehung*, which were settled by the last-mentioned work, 1868.

CHAPTER II

1. Only in the twentieth century was it discovered that light had the property of developing magnificent dyes of all kinds through photooxidation of colorless leuco-base pseudo-dyestuffs.

2. Dr. Dedekind, Vienna, wrote an excellent historical essay on purple and its sensitivity to light. This study was published in French also: Dedekind, *La Pourpre verte [!] et sa valeur pour l'interprétation des écrits des anciens*, Paris, 1899.

3. H. Flach, *Die Kaiserin Eudoxia Makrembolitissa, eine Skizze aus dem byzantinischen Gelehrtenleben des XI. Jahrhunderts*, Tubingen, 1876.

4. Krumbacher, *Geschichte der byzantinischen Literatur von Justinian bis zum Ende des oströmischen Reiches (527-1453)*; 2d ed. (1897), p. 578, n. 240.

5. Cole's letter "Observations on the Purple Fish" was published in *Phil. Trans.* (XV, 1278) in 1685; also, in a French translation in *Journal des Savants* (1686), p. 356.

6. *Histoire de l'Académie Royale des Sciences* (Paris, 1711), p. 6.

7. In his *Geschichte der Optik*, to which reference will be made frequently later, Priestley names Duhamel du Monceau as the first who realized

"that in the light some things change color and structure." According to my research on the history of photochemistry this statement is not correct, for we owe to other scientists the priority of the discovery of chemical light effect. See statements of various authors on purple in Dedekind's exhaustive monograph *La Pourpre*, footnote 2, *supra*.

8. *Histoire de l'Académie Royale des Sciences* (Paris, 1736), p. 49. It is difficult to locate this treatise for references to it are both infrequent and brief. In Ebermaier and in Heinrich's otherwise very carefully edited *Von der Natur und den Eigenschaften des Lichtes* (a prize-winning work at Petrograd in 1808), the references (1711 and 1746) are also incorrect. This erroneous data we wish to correct here. See also Landgrebe, *Über das Licht* (1834), p. 471, where there is a detailed description of Duhamel's experiments.

9. ". . . ce qui prouve que le Soleil agit d'une façon très singulière et très efficace sur le suc colorant dont il s'agit."

10. See P. Friedländer, *Über den antiken Purpur von Murex brandaris*. Report of the Akademie der Wissenschaften, Vienna, June 6, 1907. See also a paper read before the Chem. Phys. Ges. on January 26, 1909, in *Öst. chemiker-Zeitung* (1909).

11. Soon after the publication of the above-mentioned studies, which aroused so much attention, Professor P. Friedländer left Vienna and accepted an appointment in Germany.

CHAPTER III

1. According to Wiegleb, *Geschichte des Wachstums der Chemie* (1792), p. 52. Wiegleb adds: "Kircher points out that in the original manuscript of Firmicus's works in the Vatican Library there is no mention of the word 'alchemy.' It seems probable that the insertion was made deliberately by copyists in order to favor falsely 'alchemy.' *Mundus subterraneus*, II, 235."

2. Kallid Rachaidibis, "Güldenes Buch der dreyen Wörter," published as an appendix to Geber's *Chymischen Schriften* (Vienna, 1751), p. 222.

3. Our author mentions three constellations: the first when the sun has entered Ram and is in ascension; the second, when the sun has approached the Lion, and the third when the sun has reached Sagittarius.

4. Printed in Schröder, *Neue alchimistische Bibliothek* (1774), IV, 222.

5. *Ibid.*, p. 159.

6. Schmieder (*Geschichte d. Alchemie*, 1832, p. 30), who copies the inscription from *Theatrum chemicum*.

7. See Kopp, *Beiträge zur Geschichte der Chemie* (1869-1875), p. 383.

8. *Ibid.*, p. 385.

9. Dierbach, *Beiträge zur Kenntnis des Zustandes der Pharmazie im 16.*

und 17. Jahrhundert; Kastner, *Repertorium f. d. Pharmazie* (1829), XXXII, 52.

10. Gerber, *Curieuse vollständige chymische Schriften* (Vienna, 1751), p. 17.

11. See Schmieder elsewhere.

12. *Ibid.,* p. 287.

13. Morhoffi, *Oratio de laudibus.* Aurip. 21.

14. Friedrich Geissler's *Baum des Lebens; oder Bericht vom wahren Auro potabili,* p. 21, para. 14, and Johann Christophorus Steeb, *Elixir solis et vitae,* para. 20.

15. *Ibid.,* p. 56.

16. See *Theatrum chemicum,* Vol. VI; also Becher, *Chymische Concordanz* (Leipzig ed., 1755), p. 146.

17. *Ibid.,* p. 135. Spies adds in his *Concordantzs* "This shows how the dew, the rays of the sun, the influence of the planets are also instruments and means through which the heavenly energies combine with that of the earth."

18. Becher, *Chymische Concordanz,* pp. 152, 155.

19. *Ibid.,* pp. 164, 175.

20. An element could be depicted by a series of different symbols, as shown in the table on p. oo, but no other signs can be applied to designate this element.

21. A. Bauer, *Wiener numismatische Zeitschrift,* XXIX, 323; A. Bauer, *Chemie und Alchimie in Österreich bis zum Beginn des 19. Jahrhunderts* (Vienna, 1883, R. Lechner, pub.); A. Bauer, *Die Adelsdokumente Österreichischer Alchimisten und die Abbildungen einiger Medaillen alchimistischen Ursprungs* (Vienna, 1893, Hölder, pub.).

22. Christian Wilhelm Baron von Kronemann, under the pretext of being able by use of alchemy to turn quicksilver into silver and gold, deceived his sponsor with his alleged processes—as Köhler puts it—as long as "the Ducal silver dishes and the money advanced by the first court chaplain, Dr. Lilien, lasted." When his fraudulent practices were discovered, he was imprisoned in the Red Tower of the Fortress Plassenburg. He did not, however, stop experimenting even there, using silver he secured by forcefully opening cupboards and stealing old silver, "gift cups." With the stolen silver a soldier named Hans Poltzen provided him with a red uniform. In this disguise he fled to Bamberg, where he was arrested on the bishop's order, returned by escort to the Fort in Kulmbach. There he was hanged in his stolen red uniform.

23. Geber, *De inventione veritatis sine perfectiones incerto interprete alchemia Geberi cum reliquiès* (Bernae, 1545); Gmelin, *Geschichte der Chemie* (1797), I, 19; Schmieder, *Geschichte der Alchemie* (1832); Kopp,

Geschichte der Chemie; M. Berthellot, *Die Chemie im Altertum und Mittelalter* (Leipzig and Vienna, 1909). Of especial importance is Edmund O. von Lippmann's *Entstehung und Ausbreitung der Alchemie* Vol. I, 1919, Vol. II, 1931.

24. Albert the Great, under the heading "Ignis volans," describes also in his treatise *De mineralibus mundi* gun powder and its production from sulphur, coal, and saltpeter. Incidentally, he also remarks that the studies of his contemporary Roger Bacon also include definite traces of his knowledge of gun powder; see Wiegleb, *Geschichte des Wachstums und der Erfindung der Chemie* (1792). I, 137. See "Albertus Magnus von Köln als Naturforscher und das Kölner Autogramm seiner Tiergeschichte" (*Österr. chemiker-Zeitung,* 1908, p. 274).

25. According to tradition, Basilius Valentinus differentiated with chemical symbols bismuth and zinc and produced pure mercury, discovered muriatic acid, ammonia, gold fulminate, and acetate of lead. It was he who determined the precipitation of silver solutions by sodium chloride and copper. The most voluminous edition of Basilius Valentinus's collected papers which was greatly improved by some old MSS added to from the Preface of Doctor Petraeus, was published by Gottfried Richter, Hamburg (1717 and 1740). Later research, however, indicated that the publisher of the first edition of the legendary Basilius Valentinus was J. Thölde, the secretary of the Rosicrucian Order, who was also a partner in some salt mines.

26. I follow, in this narrative of the writings of Basilius Valentinus, mainly the information kindly presented to me and put directly at my disposal by Dr. Franz Strunz, retired professor of history of natural sciences at the Vienna Institute of Technology (1929). His information to me concludes by referring me to the *Buch grosser Chemiker.*

27. The exact title of this work is *Osualdi Crollii, Veterani Hassi Basilica chymica continens; philosophicam propria laborum experientia confirmatam descriptionem et usum remediorum chymicorum selectissimorum è lumine gratia et naturae desumptorum* (Frankfort, 1609). This first edition is very rare, and this author found a copy in the Wiener Hofbibliothek. B. Poggendorff, in his otherwise complete *Biographisch-literarisches Lexikon* (1863), does not mention this oldest edition of Crollius.

28. In Basel (1570) Risner published the work *Thesaurus opticae,* in which the then-known Arabic scientists and their knowledge on the subject of light are recorded (Fiedler, *De lucis effectibus chemicis,* 1834, p. 2).

29. See Felix Fritz, *Chemiker-Zeitung* (1914, No. 22); *Phot. Rundschau* (1914, p. 221, and 1915, p. 30); Eder, *Quellenschriften zu den frühesten Anfängen der Photographie* (1913), p. 173; Eder, "Zur Geschichte der Lichtempfindlichkeit der Silbersalze," *Photo. Industrie* (1925, No. 37).

CHAPTER IV

1. Feldhaus, *Leonardo der Techniker und Erfinder* (Jena, 1913), pp. 71, 72.

2. La Hyre's work was published in 1711 (*La Lumière*, 1855, p. 150).

3. In English: Natural and Original Drawings Dedicated to His Holy Imperial Majesty Leopold I, the Undefeated and Indefatigable Champion of the Catholic Religion.

4. The work, printed in 1748 in Nuremberg by the copper engraver M. Seligmann, contains illustrations of plants, as imprinted by nature herself. The method of production is exactly described in the work by Ernst Martius (Wetzlar, 1784) and Joh. Conr. Gütle (1793), p. 119.

CHAPTER V

1. M. von Rohr wrote in *Zentralztg. f. Opt. und Mech.* (1925), pp. 233 ff., an extensive historical description of the development of the camera obscura. He describes it as a showroom, a portable aid to drawing, a peep-box, and so forth, and presents interesting old illustrations of such apparatus.

2. See Priestley, *Geschichte der Optik* (1772); Fischer, *Geschichte der Physik 1801 bis 1806;* Waterhouse, *The Phot. Journal* (1901), XXV, 270, also *The Journal of the Camera Club* (1902), XVI, 115; Eugène Müntz, *Prometheus* (1899), p. 204, publications of the French Academy of Sciences. The original passages from related works of Roger Bacon, Caesariano, Porta (1558 and 1589), Barbaro, and so forth, are reprinted in Waterhouse, "Notes on the Early History of the Camera Obscura," *The Phot. Journ.* (1901), Vol. XXV, No. 9).

3. The 33d volume of the "Künstler-Monographien" of H. Knackfuss (1898), published by Velhagen & Klasing, deals with Leonardo da Vinci. See Feldhaus, *Leonardo der Techniker und Erfinder* (pub. Eugen Diederich, Jena, 1913), p. 102. O. Werner, *Zur Physik Leonardo da Vinci* (Erlangen, 1910), p. 114. Da Vinci is also looked upon as the founder of modern anatomy; see Rudolf Disselhorst, *Berichte der Kais. Leopoldinischen deutschen Akademie der Naturforscher* (1929), V, 51, "Das biologische Lebenswerk des Leonardo da Vincis." Otto Werner compiled an extensive description of the publications *Zur Physik Leonardo da Vinci* (Internationale Verlagsanstalt für Kunst und Literatur, Berlin). He describes in this work at great length the famous painter's research on the theory of vision, also through binoculars and stereoscopes, optical mirages, diffusion of light, camera obscura, and images through noncircular apertures, catoptrics, dioptrics, acoustics, heat, magnetism. He also gives a thorough account of the physical science of those days.

4. Waterhouse, *The Journal of the Camera Club* (1902), p. 124.

5. The earliest copy (French), dated 1588, preserved in the Bibliothèque Nationale in Paris, is a second edition of Porta's *Magia naturalis*. Its title is: *Jo. Bapt. Portae, Neapolitani magiae naturalis libri xx, ab ipso autore expurgati et super aucti, in quibus scientiarum naturalium divitiae et delitia demonstrata Neapoli DDXXXVIII*. Another edition is dated 1589 and contains Porta's portrait with the inscription "anno aetatis quinquagesimo."

6. "Die Camera obscura bei Porta," *Mitteillungen zur Geschichte der Medizin und der Naturwissenschaften* (1919), XVIII, No. 1.

7. Priestley, *Geschichte der Optik*. German edition, 1776, p. 30.

CHAPTER VI

1. Sutton, *Phot. Notes* (Sept. 15, 1858), III; also *Phot. Journ.* (1862), p. 362.

2. See Brewster, *The Stereoscope* (London, 1850).

CHAPTER VII

1. Rosenberger, *Geschichte der Physik*, II, 120. For the genesis and the first demonstration of the magic lantern refer to the following treatises of F. Paul Liesegang: "Der Ursprung des Lichtbilderapparates,"*Die Umschau*, (1919, No. 7), p. 107; "Die ältesten Projektionsanordnungen," *Centralztg. f. Optik u. Mech.* (1918, Nos. 35-36, pp. 345, 355); "Der älteste Projektionsvortrag," *Phot. Ind.* (1919, No. 4); "Die Camera obscura bei Porta," *Mitteilungen z. Geschichte der Medizin u. d. Naturwissenschaften*, (1919, Nos. 80-81); "Schaustellungen Mittels der Camera obscura in früheren Zeiten," *Opt. Rundsch.* (1919, Nos. 31-33); "Die Camera obscura und der Ursprung der laterna magica," *Phot. Ind.* (1919, Nos. 31-33, and 1920, p. 197); "Die Projektionsuhr; eine Erfindung aus der Kindheitszeit der laterna magica," *Süddeutsche Uhrmacher-Ztg.* (1920, No. 9). See also: "Vom Geisterspiegel zum Kino" (No. 927 of Ed. Liesegang's *Lichtbildervorträge*, Düsseldorf).

2. Priestley, *History and Present State of Discoveries Relating to Vision, Light and Colours* (1772).

3. Athanasius Kircher mentions nothing in the first edition of his *Ars magna lucis et umbrae* (1646) concerning the magic lantern; only the second edition, published in 1671, contains a description and illustration of it.

4. Reinhardt, "Über den Erfinder des Projektionsapparates," *Prometheus* (1904), p. 314.

5. Evidently this is the same ingenious Dane who was quoted by De

Monconys under the name "Welgenstein" and demonstrated in Rome about 1660 the nature print.

6. In the original drawing this lens is described as CB, obviously due to an error on the part of the wood engraver.

CHAPTER VII REWRITTEN

1. F. Paul Liesegang, "Die camera obscura und der Ursprung der laterna magica," *Photographische Industrie* (1920), p. 197.

2. F. Paul Liesegang, *Vom Geisterspiegel zum Kino* (Düsseldorf, 1918); *Die Umschau* (1919), XXIII, 107; *Prometheus*, 1919, XXX, 345; *Central-zeitung für Optik und Mechanik* (1922), No. 5; M. von Rohr, *Zeitschrift der Deutschen Gesellschaft für Mechanik und Optik* (1919), pp. 49, 61; F. Paul Liesegang, *Zahlen und Quellen zur Geschichte der Projektions-kunst und Kinematographie,* (Düsseldorf, 1926).

3. F. P. Liesegang, *Photogr. Industrie* (1919), p. 39; *Deutschösterreich. Centralzeitung für Optik und Mechanik* (1919, Nos. 1-2).

4. F. P. Liesegang, *Deutsche optische Wochenschrift* (1919), V, 152, 165.

5. *Deutsche optische Wochenschrift* (1920), VI, 337, 355; (1921), VII, 20.

6. *Photograph. Korrespondenz* (1918), p. 349.

7. Reinhardt, *Prometheus* (1904), XV, 314.

8. F. P. Liesegang. *Deutsche optische Wochenschrift* (1921), VII, 180.

9. *Centralzeitung für Optik und Mechanik* (1919), XL, 77, 85; (1922) XLIII, 475.

10. *Deutsche optische Wochenschrift* (1923), IX, 2.

11. *Süddeutsche Uhrmacherzeitung* (1920, No. 9), XXXI.

12. *Centralzeitung für Optik und Mechanik* (1921), XLII, 99, 111.

13. *Der Bildwart* (1924), II, 237.

14. *Vom Geisterspiegel zum Kino* (1917), p. 30.

15. *Centralzeitung für Optik und Mechanik* (1921), XLII, 522; *Deutsche optische Wochenschrift* (1924), X, 187, 207.

16. Niemann, *Archiv für die Geschichte der Naturwissenschaften und der Technik* (1914), V, 202.

17. F. P. Liesegang, *Licht und Lampe* (1925), p. 265.

18. *Centralzeitung für Optik und Mechanik* (1928, No. 23).

19. *Photographische Industrie* (1923), p. 423.

20. *Centralzeitung für Optik und Mechanik* (1928, No. 23).

CHAPTER VIII

1. Ray, *Historia plantarum* (London, 1686), I, 15. He ascribes the cause of the plant's loss of green color in darkness more to the absence of light

than the action of air and heat. To quote his words: "Nobis tamen non tam aër quam lumen luminisve actio coloris in plantarum foliis viridis causa esse videtur . . . Ad hunc autem colorem inducendum non requiritur calor." For detailed description of these experiments see Bancroft, *Färbebuch* (German edition, 1817), I, 86.

 2. Goethe, *Geschichte der Farbenlehre* (ed. Hempel), XXXVI, 191.

 3. *Ibid.*, XXXVI, 284.

 4. Lémery, *Histoire de l'Académie Royale des Sciences* (Paris, 1707), p. 299.

 5. *Histoire de l'Académie Royale des Sciences* (Paris, 1722), p. 129. See also Crell, *Chemische Annalen*, II, 136.

CHAPTER IX

 1. Placidus Heinrich, *Die Phosphoreszenz der Körper; oder, Die im Dunkeln bemerkbaren Lichtphänomene der anorganischen Natur.* (1811), p. 9.

 2. J. Fr. Gmelin, *Geschichte der Chemie seit dem Wiederaufleben der Wissenschaften bis ans Ende des 18. Jahrhunderts* (Göttingen, 1798), II, 117.

 3. Landgrebe, *Wirkungen des Lichtes* (1834), p. 125.

 4. Ch. Ad. Balduini, *Aurum superius et inferius aurae superioris et inferioris hermeticum et phosphorus hermeticus; sive, Magnus luminaris* (Frankfurt and Leipzig, 1675); Kunckel, *Laboratorium chymicum* (1716). p. 656; *Ephem. med. phys. nat. curios.* (Ann. IV in app.), p. 91; Wiegleb, *Geschichte des Wachstums und der Erfindungen in der Chemie* (1790), Vol. I, Part 2, p. 40. Kunckel in error cites 1677 as the date for the discovery of Balduin's phosphorus; this, however, is a slip of the pen, for Balduin, in the quoted paper, described the preparation in 1675.

 5. ". . . vitrum pro maxima sui parte opacis corporibus obtegerem relicta exigua portione, quae liberum luci accessum permitteret. Sic non rara nomina vel integras sententias chartae inscripsi et atramento notatas partes scalpello acuto caute exscidi, et sic chartam hoc modo perforatam vitro, mediante cera, affixi. Nec longa mora fuit, quum radii solares, qua parte per apertam chartam vitrum testigeret, illa verba, illasve sententias sedimento cretaceo tam accurate et distincte inscriberent ut multis curiosis, experimenti autem nesciis, ad nescio quod artificium rem hanc referendi occasionem subinde dederim." Owing to the difficulty of accessibilty to the source of this work, I cite this important passage here fully.

 6. Schulze's treatise dated 1727 in *Acta physicomedica Academiae Caesareae Leopoldino-Carolinae naturae curiosorum exhibentia ephemerides; sive, Observationes historiae et experimenta a celeberrimis Germaniae et exterarum regionum viris habita & communicata singulari studio collecta,*

(Nuremberg, 1727), Vol. I, is quoted in full in Eder, *Quellenschriften zu den frühesten Anfängen der Photographie bis zum XVIII. Jahrhundert;* mit 5 heliographischen Porträten, 2 Lichtdrucken und diversem Buchschmuck, 179 pages. You will find there not only the original Latin text but also its literal German translation. Considering these original sources, which are made generally accessible, all objections must subside, since they are probably founded more on ignorance than on malice. The precise biography of Schulze was written by Eder in his profusely illustrated book *Johann Heinrich Schulze; der Lebenslauf des Erfinders des ersten photographischen Verfahrens* (Vienna, 1917; agent W. Knapp, Halle).

7. *The history and Present State of Discoveries* (London, 1772).

8. The first confirmation published by Eder, *Photographische Korrespondenz* (1881), p. 18.

CHAPTER XI

1. Neumann, *Praelectiones chymicae* (published by Zimmermann, Berlin, 1740), p. 1612.

2. *Histoire de l'Académie royale des sciences* (1737), p. 101. The passage referring to silver solution reads: "La dissolution de l'argent fin dans l'eau forte, qu'on a affaiblie ensuite par l'eau de pluye distillée, fait aussi une écriture invisible, qui tenue bien enfermée ne devient lisible qu'au bout de trois ou quatre mois; mais elle paroît au bout d'une heure si on l'expose au soleil, parce qu'on accélére l'évaporation de l'acide. Les caractères faits avec cette solution sont de couleur d'ardoise, parce que l'eau-forte est un dissolvant toujours un peu sulphureux et que tout ce qui est sulphureux noircit l'argent."

3. *Histoire de l'Académie royale des sciences* (1737), p. 253. This quotation is found in Berthollet, *Eléments de l'art de la teinture* (Paris, 1791).

4. "Heraclius," in *Quellenschriften zur Kunstgeschichte*, 1873, Vol. IV.

5. "Cennino Cennini," in *Quellenschriften zur Kunstgeschichte*, 1871, Vol. I.

6. *Quellenschriften zur Kunstgeschichte*, Vol. V.

7. Beccarius et Bonzius, "De vi quam ipsa per se lux habet, non colores modo, sed etiam texturam rerum salvis interdum coloribus immutandi." *De Bononensi scientiarum et artium institutio atque Academia commentarii* (1757), IV, 74.

CHAPTER XII

1. Wallerius is also quoted in Macquer, *Chymisches Wörterbuch* (German tr. by Leonhardi, 1772), V, 46 *n*. Eder mentioned these works of Wallerius in the third edition of his *Geschichte der Photographie* (1905),

p. 64; Helmer Bäckström, in *Nord. Fidskr. f. Fot.* (1920), p. 43, also referred to them.

2. Also published in *Taschenbuch für Scheidekünstler und Apotheker für 1781*, p. 46.

3. German edition of Priestley's *Geschichte und gegenwärtiger Zustand der Optik;* tr. and annotated by Klügel (1776). Klügel's numerous annotations enhance the value of the German edition in comparison with the English original.

4. Priestley, *Experiments and Observations Relating to Various Branches of Natural Philosophy* . . . (London 1775), I, 33; II, 61. Further research on the action of light on plants (especially Bonnet, 1778, Duhamel, Tessier, 1783, Senebier, 1782-91, and others) are not included in this historical essay, for they belong to the science of plant physiology. See Landgrebe, *Über das Licht* (1834), p. 320.

5. Also quoted in Macquer, *Chymisches Wörterbuch* (German tr. by Leonhardi, 1782), IV, 165; Bergman, *Opuscula physica et chemica* (6 vols., Upsala, 1779-84).

6. Torberni Bergman, *Opuscula physica et chemica* (6 vols., 1779-90). German edition: Bergman, *Kleine physische und chemische Werke;* published after the author's death by Hebenstreit from the Latin by Tabor (Frankfurt on the Main, 1782-88).

7. The title of the Latin edition reads: Scheele, *Aeris atque ignis examen chemicum* (Upsala et Leipzig, 1777), p. 62. The title of the German edition reads: *Chemische Abhandlung von der Luft und dem Feuer von Carl Wilhelm Scheele Apotheker zu Köping in Schweden, der Königl. Akademie der Wissenschaften zu Stockholm, Akademie zu Turin, der Churfürstlichen Maynzischen Akademie nützlicher Wissenschaften zu Erfurth und der Gesellschaft naturforschender Freunde* . . . (Mitglied. Upsala und Leipzig, 1777; 2d ed., 1782). The German edition of Scheele's *Sämtliche Werke* ed. by Hermbstädt (Berlin, 1793), pp. 131ff. J. M. Eder printed a verbatim copy in its proper place for the "History of Photography," in *Quellenschriften zu den frühesten Anfängen der Photographie* (Halle on the Saale, 1913). See *C. W. Scheele ett minnesblad på hundrade årsdogen of hans död*, by Cleve, with portrait and facsimile; also Scheele, *Nachgelassene Briefe und Aufzeichnungen*, published by Nordenskiöld; with portrait and facsimile (1892).

8. Landgrebe, in his famous book *Über das Licht* (1834), p. 3; Becquerel, *La Lumière* (1868), II, 45; Hardwich, *Manual der photogr. Chemie* (1863), p. 6; Muspratt, *Enzyklopädisches Handbuch der technischen Chemie*, arranged by Kerl and Stohmann (1878), V, 1077ff.

9. The priority of this discovery is not infrequently ascribed to Priestley. However, it seems that Scheele and Priestley at the same time and

independent of each other experimented with this property of nitric acid. Hunt erroneously dates this discovery in his *Manual of Photography* (1834, p. 335) as the year 1786 which error was reprinted in *Abridgments of Specifications Relating to Photography*, issued by Great Britain, Patent office (1861), Vol. V.

10. This means that red vapors of nitrogen tetroxide (nitric dioxide) developed.

11. Scheele, *Sämtliche Werke*, German edition by Hermbstädt, p. 132, par. 61.

12. *Ibid.*, p. 141, par. 66.

CHAPTER XIII

1. Priestley, *Experiments and Observations on Different Kinds of Air* (London, 1775-77). Vol. III, sec. 23; *Experiments and Observations Relating to Various Branches of Natural Philosophy* (London, 1789). Vols. I and III, sec. 22; *Philosoph. Transact.* (1799) II, 139; Gren, *Journal der Physik*, II, 94, 350; abstract from *Über die Natur des Lichtes* (1808), p. 36, and Heinrich, *Von der Natur des Lichtes* (1808), p. 79.

2. Opoix, *Observations physico-chymiques sur les couleurs* (Paris, 1777); German edition: *Physikalischchemische Beobachtungen über die Farben* (Vienna, Leipzig, 1785), p. 65. There it states: "colored bodies discolor little by little in the air and after a certain time sustain complete loss of their color. However, it is easily demonstrated that it is not the air which produces the change in colored bodies, for colors remain perfect in a dark, well-aired place . . . it is not the air, but the light which destroys color."

3. *Neue Beiträge zur Natur und Arzneiwissenschaft* (Berlin, 1782), p. 200. This quotation is taken from Ebermayer, *Versuch einer Geschichte des Lichtes*, (1799), and Fischer, *Geschichte der Physik*, Vol. VII.

4. He states: "Organization, sensation, arbitrary motion, life, exist only on the surface of the earth and in places where light penetrates. One might say that the myth of the fire of Prometheus is the expression of a philosophical truth which, indeed, did not originate with the ancients. Nature in the absence of light was without life, dead, without soul. A good God created light, and through it he dispersed on the surface of the earth order, sensation, and thought."

5. Lavoisier, *System der antiphlogistischen Theorie*, German tr. by Hermbstädt, 1792, I, 228; originally published in French, 1789.

6. *Taschenbuch für Scheidekünstler und Apotheker auf das Jahr 1784*, p. 160.

7. Selles, *Neue Beiträge zur Natur und Arzneiwissenschaft* (1782); Gmelin, *Geschichte der Chemie* (1799), III, 790; *Taschenbuch für Scheidekünstler auf 1784*, p. 160.

8. Crell, *Chemische Annalen* (1784), p. 341; *Taschenbuch für Scheide-künstler und Apotheker auf das Jahr 1786*, p. 46.

9. Crell, *Neueste Entdeckungen in der Chemie* (1782), V, 70.

10. Senebier, *Mémoires physico-chimiques sur l'influence de la lumière solaire pour modifier les êtres des trois règnes de la nature* (Geneva, 1782); German edition, Leipzig, 1785. Excerpt by Crell in *Neueste Entdeckungen in der Chemie* (1783), XI, 211.

11. Senebier (German edition) *Physikalisch-chemische Abhandlungen über den Einfluss des Sonnenlichtes*, II, 212.

12. Aromatic gum from hymenoca Courbail (letter from Eder to Translator, Dec. 5, 1932).

13. Senebier, *Physikalisch-chemische*, III, 12, 82, 92, 104, 108.

14. *Ibid.*, p. 94.

CHAPTER XIV

1. "Giovanni Antonio Scopoli, born near Trentino, doctor of medicine, at first physician in the mercury mine at Idria (Austria), then mining councillor and professor of mineralogy at the Academy of Mines in Schimnitz (Hungary), 1777, professor of chemistry and mathematical sciences at Pavia, died 1788" (letter from Eder to Translator).

2. Crell, *Die neuesten Entdeckungen in der Chemie* (1783), VIII, 1.

3. Berthollet, *Histoire de l'Académie royale des sciences* (Paris, 1785), p. 290. *Lichtenberg's Magazin*, IV, 2, 40.

4. Scheele, "Observation sur l'air qui se dégage de l'acide nitreux exposé au soleil," *Journal de physique*, XXIX, 231; Crell, *Chemische Annalen* (1786), IV, 332.

5. Berthollet, *Journal de physique* (1786), XXIX; *Lichtenberg's Magazin*, IV, 2, 40.

6. Berthollet, *Essai de statique* (1803); excerpt from Landgrebe, *Über das Licht* (1834), p. 7.

7. Bindheim, *Chemische Annalen* (1787); see also *Taschenbuch für Scheidekünstler und Apotheker auf das Jahr 1788*, p. 23. This passage refers only indirectly to photography. I refer to it here because there is a connection with the spoiling of the silver baths by bad filter paper.

8. Robison, in Buchner's and Kastner's *Repertorium für die Pharmazie* (1822), XIII, 44, from Black's *Lectures*, I, 412. Robison further states: "It might be useful to compare the blackening property of the sun rays after passing through nitric acid with that of the rays having passed through the same quantity of water. The rays have a stronger effect upon the nitric acid than on water." Robison's experiments were not published until about forty years after he made them. John Robison: "On the Motions of Light, as Affected by Refracting and Reflecting Substances, Which Are Also in

Motion," *Trans. Soc. of Edinburgh*, II, 83; Reuss, *Repert. Commentationum*, IV, 255. [Letter from Eder to Translator.]

9. "Jean Antoine Claude Chaptal (1765-1832), chemist and statesman, was director of a saltpeter factory at Grenoble, simplified the manufacture of niter; later professor at Montpellier. He improved the manufacture of nitric acid, alumina, and soda and introduced production of Turkish red in France. He was secretary of the interior (1800-1804) and was made Count de Chanteloup by Napoleon in 1811; after the restoration of the Bourbons he retired to private life, but was elected to the Chamber of Peers in 1819. [Letter from Eder to Translator.]

10. Chaptal, "Observations sur l'influence de l'air et de la lumière dans la végétation des sels," *Journal de physique* (1788). XXXIII, 297; *Lichtenberg's Magazin*, VII, 153.

11. Dizé, "Sur la cristallisation des sels par l'action de la lumière," *Journal de physique* (1789), XXXIV, 105; *Voigt's Magazin*, VII, 61.

12. Priestley, *Philosophical Transactions* (1879), p. 134; Gren, *Journal der Physik* (1790), II, 94, 350.

13. Dorthes, *Annales de chimie* (1790), II, 92; Gren, *Journal der Physik* (1790), I, 497. Crell, *Chem. Annal.* (1790), I, 546. He also observed that a frog kept in darkness takes on a green of a deeper hue.

14. Saussure, "Effets chimiques de la lumière sur une haute montagne, comparés avec ceux qu'on observe dans les plaines," *Mémoires de l'Académie de Turin* (1790), IV, 44; Crell, *Chemische Annalen* (1796), I, 356.

15. Eder, *Photogr. Korrespondenz* (1881), p. 128. Later C. Chistoni wrote a historical essay on Saussure and actinometry (*Beiblätter z. d. Annal. d. Physik.*, 1903, p. 386).

16. Senebier, *Annal. de Chim.*, II, 89; Crell, *Chemische Annalen* (1796), I, 71.

17. German translation by Göttling under the title *Handbuch der Färbekunst* (Jena, 1792). Second French edition 1804 and its German translation (by Gehlen), Berlin, 1806.

18. Berthollet's discovery of bleaching by chlorine was of the greatest consequence in the development of bleaching industry. I mention here an unimportant detail, which has only a slight bearing on photography; the bleaching of old corroded copper engravings, and so forth, which were to be reproduced photographically. Göttling, in 1791, and Madame Masson, in 1795, discovered this (Scherer, *Allgemeines Journ. d. Chemie*, 1799, II, 2, 500; *Handbuch für Fabrikanten, Künstler, Handwerker . . . oder, Das Neueste und Nützlichste der Chemie . . .*, 1799, II, 12). Under the heading "Anwendung der dephlogistinierten Salzsäure zum Bleichen der Kupferstiche, alten Bücher . . ." the procedure is described in detail. The illustration was immersed in chlorinated water. After ¼-½ hour it

was carefully taken out, passed through clean water, and dried between blotting paper and placed between boards. This procedure was later rediscovered time and again.

19. Hahnemann's exact prescription is published in Crell, *Chemische Annalen* (1790), p. 22.

20. Fourcroy, "Sur les différents états du sulfate de mercure, sur la précipitation de ce sel par l'ammoniaque . . ." *Annales de chimie* (1791), X, 293, 312.

21. The relevant passage by Fourcroy reads: "Lorsqu'on verse de l'ammoniaque dans une dissolution de sulfate (oxyduls) de mercure neutre et bien pur, on obtient un précipité gris très-abondant, qui, exposé sur son filtre aux rayons du soleil, se réduit en partie en mercure coulant; une autre portion de ce précipité reste en poudre grise foncée, sans se reduire: cette dernière se redissout complétement dans l'ammoniaque Ce dépôt composé . . . n'a lieu ou ne se présente dans cet état et ainsi mélangé, que lorsqu'on ne met que peu d'ammoniaque dans la dissolution de sulfate mercuriel bien neutre. Si au contraire on met beaucoup de cet alcali, on a un précipité . . . beaucoup plus noir et qui se reduit complettement par le contact de la lumière et sur-tout lorsqu'on l'expose aux rayons du soleil."

22. Vasalli, *Mémoires de l'Académie royale des sciences de Turin* (1790-91), p. 186. Crell, *Chemische Annalen* (1795), II, 80; Trommsdorff, *Journal der Pharmazie* (1796), III, 337.

23. Vasalli states: "That much is evident; light in the process of combustion colors the chloride of silver equally as sun light, differing only in the longer time consumed by the former and producing a lack of density in color by the later . . ."

24 Vasalli, *Mémoires de l'Académie royale de Turin* (1793), p. 287; Crell, *Chemische Annalen* (1795). II, 142.

25. Trommsdorff, *Journal der Pharmazie* (1793), I, 174.

26. Buonvicino, *Mémoires de l'Académie royale de Turin* (1793), p. 297. It is possible that Buonvicino confused it with Fourcroy's light-sensitive mercurous-oxide salt.

27. Humboldt, *Versuche über die Zerlegung des Luftkreises* (1799), p. 234.

28. Göttling, *Beitrag zur antiphlogistischen Theorie* (1794), p. 51; see also Heinrich, *Über das Licht* (1808), p. 89.

29. Gren, *Neues Journal der Physik* (1795), II, 492.

30. Böckmann, *Versuche über den Phosphor . . .* (1800), p. 264.

31. Lentin, Göttingen, 1798, translated Mme Fulhame's paper into German. This is condensed in Scherer's *Allgemeines Journal der Chemie* (1798). I, 420. See Heinrich, *Von der Natur und den Eigenschaften des*

Lichtes (1808), p. 106. An article: "Neue Versuche mit der Reduktion der Metalle in Beziehung auf Färbekunst," in *Handbuch für Fabrikanten, Künstler, Handwerker* . . . (1800), III, 54, without reference to author or source, mentions the same experiments as those performed by Mme Fulhame and Rumford, namely, the reaction of gold and silver solutions under action of light or hydrogen gas.

32. Fischer, *Geschichte der Physik* (1806), VII, 12.

33. Juch, *Versuch über die Wiederherstellung des Goldes;* Scherer, *Journal der Chemie* (1799), III, 399; Landgrebe, *Über das Licht* (1834), p. 16.

CHAPTER XV

1. Vauquelin, "Du plombe rouge de Sibérie, et expérience sur le nouveau métal qu'il contient."

2. Vauquelin, in Scherer's *Journal der Chemie* (1798), II, 2, 717; and Trommsdorff's *Journal der Pharmazie* (1800), VII, 95.

3. Fabroni, *Di unatinta stabile che qui suo entrarci dall'aloc soccotorima* (Florence, 1906).

4. Scherer, *Journal der Chemie* (1798), II, 2, 544. Also condensed without giving source in *Handbuch für Fabrikanten, Künstler* . . . *oder, Das Neueste und Nützlichste der Chemie, Fabrikwissenschaft* . . . (1799), II, 109.

5. Euler, *Letters on Various Subjects;* new translations with annotations and additions by Kries (1792), I, 204, 42d letter.

6. Davy, "An Essay on Heat, Light and the Combinations of Light," *Nichols. Jour.* (1799), IV, 395; Gilbert, *Annalen* (1802), XII, 574.

7. Gilbert, *Annalen*, XII, 574, 581.

8. Abildgaard, "Über die Wirkung des Lichtes auf das rote Quecksilberoxyd," *Annalen* (1800), IV, 469; *Annales de chimie*, XXXII, 193.

9. Böckmann, *Versuche über das Verhalten des Phosphors in verschiedenen Gasarten* (Erlangen, 1800); Scherer, *Journal der Chemie*, V, 243.

10. Voigt, *Magazin für den neuesten Zustand der Naturkunde* (1800), IV, 121; see also Landgrebe, *Über das Licht*, p. 71.

11. Trommsdorff, *Journal der Pharmazie* (1800), VIII, 163.

12. See also Scherer, *Allgemeines Journal der Chemie* (1802), VIII, 14.

13. *Ibid.* (1800), IV, 2, 549.

14. Subtitle: "Das Neueste und Nützlichste aus der Chemie, Fabrikwissenschaft, Apothekerkunst . . ." III, 9.

15. Ritter, *Versuche über das Sonnenlicht;* Gilbert, *Annalen* (1801), VII, 527 (short note); 1802, XII, 409. Dealt with exhaustively in Landgrebe, *Über das Licht*, p. 28.

16. Trommsdorff, *Journal der Pharmacie* (1801), IX, 164, from *Journ. de la Soc. de pharm. de Paris*, III, 433.

17. *London Medical Review and Magazine*, V, 1801; see also Nicholson, *Journal of Natural Philosophy, Chemistry and the Arts* (1802), V, 545.

18. This is explicitly mentioned here because Hunt insisted that the priority is entirely due to Harup; he also errs in calling Boullay (1803) the first who discovered the light sensibility of calomel.

19. I follow here Fiedler's statement *De lucis effectibus chemicis* (1785), p. 6, without having checked it with the quoted original byWeiss, since this work was not accessible.

20. Desmortiers, *Recherches sur la décoloration spontanée du bleu de Prusse* (Paris, 1801); Gilbert, *Annalen*, X, 363; Scherer, *Journal der Chemie*, X, 114.

21. Desmortiers ascribed also the secondary blue result to the action of light.

22. *Das Neueste und Nützlichste der Chemie, Fabrikwissenschaft, Apothekerkunst* . . . (1801), IV, 135. The original article is unknown to me. The cited journal, which was very poorly edited, was especially lacking in its quotation of sources.

23. Gilbert, *Annalen der Physik* (1811), XXIX, 291.

24. Rumford, "An Inquiry into the Chemical Properties That Have Been Attributed to Light," in his *Philosophical Papers*, (1802), I, 341-65 (letter from Eder to translator).

25. Nicholson, *A Journal of Natural Philosophy, Chemistry and the Arts* (1802), V, 245.

26. Charles R. Gibson, *Die Photographie in Wissenschaft und Praxis* (German translation, A. Hay, Leipzig-Vienna, 1929), p. 10.

27. Notwithstanding the fact that the English original on the method of Wedgwood and Davy was published in 1802, almost all German translations give 1803 as the publication date. See Meteyon, *Wedgwood and His Works* (1874); E. Mehegard, *Memorials of Wedgwood* (1870); Smiler, *Josiah Wedgwood* (1894).

28. For Davy's biography see Thorpe, *Humphry Davy, Poet and Philosopher* (Cassel & Co., Lim., London, 1901), and A. Bauer, *Humphry Davy* (1778-1829), Lecture in *Ver. zur Verbr. naturw. Kenntnisse* (Vienna, 1904) Vol. XLIV, No. 5.

29. R. B. Litchfield wrote a book about Tom Wedgwood, in which he hailed him as the first photographer—*Tom Wedgwood, the First Photographer* (London, 1903). Litchfield, in discussing Eder's fundamental description of Schulze's experiments, p. 103, is of the opinion that those experiments were so imperfect in the results at that time that they could not be referred to as photography. Litchfield endeavors to ascribe to

Wedgwood and Davy the merit of discovering photography. The author, in the third edition of his *Geschichte*, p. 104, remarks that it is true that Schulze had no knowledge of fixation. Neither had Wedgwood and Davy; nevertheless, they had always been called by various authors the first discoverers of photography (without fixation). Due to my historic research Wedgwood and Davy must cede to Schulze this priority, and to him must be given the credit for having made the first photograph. The priority of the discovery of the above-mentioned photographic light images on silvered paper, of silhouettes, and of solar-microscope pictures belongs without doubt to Wedgwood and Davy.

CHAPTER XVI

1. Scherer, *Allgemeines Journal der Chemie*, X, 115; Tilloch's *Philosoph. Magaz.*, XIII (No. 49), 42.

2. Gehlen, *Journal*, II, 91.

3. Berthollet's statement that a current of air blackened silver chloride is, according to Ritter, due to a mere coincidence, for a draught was caused by a bellows having been used before which discharged coal dust (Fischer, *Über die Wirkung des Lichtes auf Hornsilber*, 1814, p. 26).

4. Thomas Young (1773-1829) was a practicing physician in London and an eminent scientist. From 1801 to 1804 Young was professor of natural sciences at the Royal Institution. In his work *Syllabus; a Course of Lectures on Natural and Experimental Philosophy with Mathematical Demonstrations of the Most Important Theorems in Mechanics and Optics* (1802), he gave for the first time an explanation of the most important phenomena of vision and of the interference of light, based on the wave theory. He concluded that the color sensitivity in the human eye can be traced to the three primary colors, red, green, and violet, which are perceived by the retina on three corresponding sensitive kinds of fibers. This theory was elaborated by the German physicist Hermann von Helmholtz (1821-94) into the so-called "Young-Helmholtz Theory of Color Sensitivity." [This footnote was added to this edition by Dr. Eder.]

5. Poggendorff, *Geschichte der Physik* (1879), p. 646.

6. *Philosoph. Transactions of the Roy. Soc. of London*, 1804. German: Gilbert, *Annalen* (1811), XXXIX, 262, 282.

7. For instance, Fischer, in Breslau (Kastner, *Archiv f. gesamte Naturkunde*, 1886, IX, 345).

8. Eder wrote this in the first ed. of his history (1881).

9. Nicholson, *Journal*, II, 117; Gilbert, *Annalen*, XVI, 245.

10. Gehlen, "Über die Farbenveränderung der in Äther aufgelösten salzsauren Metallsalze durch das Sonnenlicht," *Neues allgemeines Journal der Chemie*, III, 566.

11. *Disputatio chemica-phisica inauguralis, de atmosphaera, ejusque in colores actione* (1805); translated in Trommsdorf, *Journal der Pharmacie* (1809), XVIII, 221.

12. Pfaff, in Gehlen, *Journal der Chemie* (1805), V, 500.

13. Ritter, *loc. cit.*, 1806, VI, 157.

14. Gehlen, *Journal für Chemie und Physik* (1808), VI, 659; Landgrebe, *Über das Licht* (1834), p. 33.

15. From this remark of Ritter's it seems obvious that he had no knowledge of Saussure's experiments with his chemical photometer.

16. Ritter mentions here Gilbert's experiment in which in a vacuum silver chloride kept all of its white. This statement by Gilbert is incorrect. Senebier had long ago discovered this property of chloride silver to change color even in a vacuum.

17. "Dissertation chemico-pharmaceotique sur la graisse, et sur quelques médicaments qui en dérivent"; read before the Société de pharmacie de Paris 1806, Trommsdorff, *Journal der Pharmacie* (1807), XVI, 1, 173.

CHAPTER XVII

1. Later he moved to Bayreuth and Nuremberg. From 1818 he was a member of the Berliner Akademie der Wissenschaften; then he resided in Berlin, where he died in 1831.

2. "Zur Farbenlehre," in Goethe's *Werke*, Tübingen, Cotta'sche Buchhandlung, 1810 (ed. Hempel, Berlin, XXXVI, 431).

3. Silver chloride.

4. Seebeck, "Über die ungleiche Erregung der Wärme im prismatischen Sonnenbilde" (presented before the academy in Berlin in March, 1819; *Journal für Chemie und Physik*, by Schweigger (1824), XL, 146). Hessler carried out in 1835 more thoroughgoing experiments on the influence of the properties of the prism on the spectrum. He studied the action of the solar spectrum obtained through various liquid and glass prisms on paper coated with a rubberized water solution and sprinkled with silver chloride. Certain differences appeared in the extent of the blackening as well as in the location of the maximum darkness and the time in which it occurred. With water and alcohol it was approximately 0; with flintglass, 2.3 min.; with crownglass, 1.5 min.; with turpentine and cassia oil, 12-13 minutes. In the spectrum of water the maximum of the darkening lay in the middle of the violet close to the blue, while in the spectrum of the "water" [sic] in the center of the violet, while in the cassia oil it was found 23 lines outside of the violet range *(Annal. d. Phys. u. Chem.*, Poggendorff, 1835, XXXV, 578).

5. When in 1830 Schopenhauer was about to publish the Latin edition of his *Farbenlehre*, he consulted Dr. Seebeck of the academy in Berlin,

who at that time was considered Germany's greatest physicist. Schopenhauer asked his opinion on the dispute between Goethe and Newton. Seebeck "was extremely cautious; he made me promise that I would publish no part of our conversation; and finally, after strong pressure from me, he confessed that Goethe was quite right, in fact, and Newton wrong—which, however, was not his business to publish to the world." On this Schopenhauer comments: "He has since died, that old coward ... Truth in this vicious world occupies a hard position and progresses with difficulty ... " (Schopenhauer, *Über das Sehen und die Farben*, Frauenstädt's Preface to the 3d ed., 1870, p. xv).

6. Schweigger, *Journal*, 1811, II, 262.

7. *Ibid.*, 1812, V, 233.

8. See also Schweigger, *Journal für Chemie und Physik* (No. 219), V, 233.

9. "Oil-forming gas and gases which develop from alcohol when it is disintegrating in glowing tubes or from vegetable or animal substances in dry distillation."

10. Gilbert, *Annalen* (1811), XXXIX, 291.

11. Ruhland, in Schweigger, *Journal für Chemie und Physik* (1811), I, 470.

12. Young, in Gilbert, *Annalen* (1811), XXXIX, 156.

13. Fresnel, see Poggendorff, *Geschichte der Physik* (1879), p. 646.

14. David, in Schweigger, *Journal für Chemie und Physik* (1813), IX, 199.

15. A. Vogel, *op. cit.* (1812), p. 404.

16. *Ibid.*, VII, 95.

17. A. Vogel, in *Annales de chimie* (1813), LXXXIV, 225; Trommsdorff, *Journal der Pharmacie*, XXII, 2, 209; Schweigger, *Journal für Chemie und Physik* (1813), VII, 95. See also Brugnatelli (Schweigger, *Journ.*, 1813, VII, 98).

18. Ruhland, in Schweigger, *Journal für Chemie und Physik* (1813), IX, 229.

19. *Ibid.* (1813), VII, 21.

20. See also Gilbert, *Annalen* (1814), XVIII, 375.

21. Dr. A. Vogel may well be called the precursor of the modern photographic bleaching process, owing to his knowledge of bleaching of organic pigments under exposure to light with complementary colors and their consistency behind glass (see later chapters).

22. N. W. Fischer's treatise was read before the medical section of the Silesian Gesellschaft für vaterländische Kultur, on April 25, 1812. Schweigger, *Journal für Chemie und Physik* (1813), IX, 403. Nicolas Wolfgang Fischer (b. 1782, in Gross-Meseritz, Moravia; d. 1850, in Bres-

lau) practiced medicine in Breslau, first as assistant, later as full professor at the university in Breslau, where he lectured on chemistry.

23. Consequently, he calls melted silver chloride "Hornsilber," the precipitated "silver hydrochloride."

24. The German chemists disagreed in the definition of chlorine and iodine. Some called it "die Chlorine," "die Jodine," others, "das Chlorin oder Jodin" or "das Chlor oder Jod." They soon abandoned the feminine gender, particularly after the vigorous protest which Buchner directed against the anomaly created by the idioms and analogies in German and in foreign languages (Buchner, *Repertor. Pharm.*, 1823, XIV, 456). Later the terms "das Chlor und Jod" became general.

25. Davy, in Schweigger, *Journal für Chemie und Physik* (1814), XI, 68; from Thomsen, *Annals of Philos.* (1814); *Phil. Trans.* (1814), CIV, 74.

26. Schweigger, *Journal für Chemie und Physik* (1814), XI, 133.

27. *Journal de Pharmacie* (1815), p. 49. See also Trommsdorff, *Journal der Pharmacie*, XXV, 1, 195.

28. Brandenburg, in Schweigger, *Journal für Chemie und Physik* (1815), XIV, 348.

29. Schweigger, *op. cit.*, p. 377.

30. Evidently containing sulfate of manganic oxide with "oxydul."

31. Fromberg, in Schweigger, *Journal*, 1824, XLI, 269.

32. Pelletier and Cavetou, in *Journal de Pharm.* (1817), Vol. XI; Buchner, *Repertorium für die Pharmacie* (1818), IV, 394; *Annales de chimie et de physique* (1818), Vol. IX.

33. Buchner, *Repertorium für die Pharmacie* (1818), IV, 396.

34. *Annales de chimie et de physique* (1818), VIII, 201; Schweigger, *Journal für Chemie und Physik* (1818), XXIV, 309.

35. For biography and the works of Grotthuss see monographs by R. Luther and also Oettingen, "Abhandlungen über Elektrizität und Licht von Theodor Grotthuss," Leipzig, 1906 (No. 152 of Ostwald's *Klassiker der Naturwissenschaften*).

36. Schweigger, *Journal für Chemie und Physik* (1818), XX, 240.

37. Extract from Gilbert, *Annal. Phys.* (1819), LXI, 50.

38. See Grotthuss, *Physisch-chemische Forschungen* (Nuremberg, 1820).

39. This reaction was later recognized as due only to the escape of iodine under heat. Therefore, the example is irrelevant.

40. See Traube, *Grundriss der physikalischen Chemie* (1904).

41. See Fr. Limmer, in *Phot. Korresp.* (1911), No. 608, on the history of the bleaching process, particularly on the contributions of Worel and Neuhauss.

42. J. M. Eder, *Phot. Indust.* (1930), p. 1392.

43. *Annals of Philos.* (January, 1821); Schweigger, *Journal für Chemie und Physik* (1821), XXXI, 490.

44. Schweigger, *Journal für Chemie und Physik* (1821), XXXIII, 231.

45. *Annals of Philos.* (September, 1821); Schweigger, *Journal für Chemie und Physik*, XXXIII, 233.

46. Buchner and Kastner, *Repertorium für die Pharmacie* (1822) XIII, 44.

47. Buchner, *Repertorium für die Pharmacie* (1823), XIV, 467.

48. Water, resp. carbonic acid, must have been polluted by organic substances.

49. Schweigger, *Journal für Chemie und Physik* (1823), XXXVIII, 298.

50. Kastner, *Archiv für die gesamte Naturlehre* (1824), I, 257.

51. *Chemical News* (1909), XCXI, 205.

52. See Balard's portrait in Pector, *Notice historique*, Gauthier-Villars, Paris, 1905. See also *Chemiker-Zeitung*, 1909; *Repert.*, p. 261, by F. D. Chataway.

53. Kastner, *Archiv für die gesamte Naturlehre* (1826), IX, 345.

54. *Journal de Pharmacie* (April, 1826), p. 209; Trommsdorff, *Neues Journal der Pharmacie* (1826), XIII, 216. It must not be forgotten that a great role has been played by the stronger reducing action of alkaline tannic elements (when alkaline development was introduced) in photography.

55. Trommsdorff, *Neues Journal der Pharmacie* (1826), XII, 100.

56. Wetzlar, in *Journal für Chemie und Physik*, by Schweigger-Seidel (1828), XXV, 467.

57. Wetzlar, in Schweigger's *Journal für Chemie und Physik* (1827), pp. 51, 371.

58. Mitscherlich, in Poggendorff's *Annalen* (1827), IX, 413; Berzelius, *Jahresbericht über die Fortschritte der physischen Wissenschaften*, VIII, 183.

59. Hess, in Poggendorff's *Annalen* (1828), XII, 261.

60. Henry and Peisson, *Journ. de Pharmac.* (1829), p. 390.

61. Rose, in Poggendorff's *Annalen* (1830), XIX, 153.

62. Stromeyer, in Schweigger's *Journal* (1830), LVIII, 128.

63. Sérullas, *Annales de chimie et de physique* (1831), XLVI, 392.

64. Berzelius, in Poggendorff's *Annalen* (1835), XXXVI, 27.

65. Pelouze, Gay-Lussac, *Annal. de chimie et de physique* (1833), LII, 410.

66. Löwig, in Poggendorff's *Annalen* (1828), XIV, 485.

67. Carbonell, *Journal de Pharmacie* (1833); Buchner's *Repertorium für die Pharmacie* (1834), XLVII, 71.

68. Garot mentioned earlier (*Journ. de Pharmacie*, 1826, p. 454) the light sensitivity of mercury oxide acetate.

69. Carbonell, *Archiv d. Pharmacie* (1836), LV, 246.

70. Burkhardt, "Über Verbindungen der Quecksilberoxyde mit organischen Säuren," Brandes, *Archiv d. Pharmacie* (1837), II, 250.

71. Doebereiner, in Schweigger's *Journal für Chemie und Physik* (1828), LIV, 414, 416.

72. Doebereiner, in Schweigger's *Journal* (1831), LXII, 86.

73. Suckow (*Über die chemischen Wirkungen des Lichtes*, 1832, p. 27) performed experiments on the decomposition of ferric oxalate in colored light. He found that decomposition takes place most quickly in white and violet light, less rapidly in blue, and slowest in green light. Yellow and orange-red light produced no change.

74. Braconot, in Schweigger's *Journal* (1831), LXII, 455; *Annal. de chimie et de physique*, XLVI, 206.

75. Liebig, *Annalen der Pharmacie*, V, 290; Erdmann, *Journal für technische und ökonomische Chemie* (1883), XVIII, 348.

76. Torosiewicz, in Buchner, *Repertorium für die Pharmacie* (1836), LVII, 335.

CHAPTER XVIII

1. Schübler, *Annal. de chimie et de physique*, XXVIII, 440; Kastner, *Archiv für die gesamte Naturlehre* (1825), VI, 33.

2. S. Landgrebe, *Über das Licht*, p. 276.

3. *Journal de Pharmacie* (May, 1826), p. 276; Buchner, *Repertorium für die Pharmacie* (1826), XXIV, 284

4. Sérullas, first in *Annal. de chimie et de physique* (1827), XXXV, 291, then more extensively, *op. cit.* (1828), XXXVIII, 371.

5. Sprengel, in Erdmann, *Journal für technische und ökonomische Chemie* (1828), III, 413.

6. The chapter referring to "Vom Licht" is also in Erdmann, *Journal für technische und ökonomische Chemie* (1830), p. 172.

7. Lampadius, in Erdmann, *Journal für technische und ökonomische Chemie* (1830), VIII, 322.

8. Robiquet, in *Journ. d. Pharmacie* (March, 1831); Erdmann, *Journal für technische und ökonomische Chemie* (1831), X, 417.

9. Zier, in Erdmann, *Journal für technische und ökonomische Chemie* (1832), XIV, 33.

10. Lampadius, in Erdmann, *Journal* (1832), XIV, 455. See for further information on this bleaching process: Michaelis, in Poggendorff, *An-*

nalen, XVII, 633 (also Erdmann, *Journal* (1833), XVII, 219), in which he precedes the bleaching by light by one of sulphur.

11. Merck, in Buchner, *Repertorium*, XLVI, 8; Berzelius, *Jahresbericht*, XIV, 324.

12. Trommsdorff, *Annalen der Pharmacie* (1834), XI, 190.

13. Buchner, *Repertorium für die Pharmacie* (1835), LI, 27.

14. Berberine is the yellow-coloring substance of the barberry bush.

15. Buchner, *Repertorium für die Pharmacie* (1835), LIV, 371.

16. *Journal de Pharmacie* (1836), No. 12; Dingler, *Polytechnisches Journal* (1837), LXV, 433.

17. Berzelius, in *Jahresbericht über die Fortschritte der physischen Wissenschaften*, XVII, 300.

18. Chevreul, in *Journal de chimie médicale* (1837), p. 92; Dingler, *Polytechnisches Journal* (1837), LXV, 63—ten essays (1837-54).

CHAPTER XIX

1. The style of writing Niépce with an accent was used by Nicéphore himself in his letters; Fouque also, in his work, *La Vérité sur l'invention de la photographie*, continued it. On the contrary, Niepce de Saint-Victor, descendant of a branch of the same family, wrote the name "Niepce" without accent in his own case as well as when referring to "Nicephore Niepce." Therefore, the family Niepce seemed to have laid very little stress on the accent. Daguerre also, in his well-known pamphlet of 1839, wrote "Niepce" without accent, which is another evidence of the lack of importance attached to a uniform mode of spelling the name. The spelling "Nièpce" is sometimes found; it is wrong. The proper spelling is "Niépce."

2. The source material on Niépce most frequently used is Fouque, *La Vérité sur l'invention de la photographie* (1867). In this work the archives of the family Niépce and the correspondence and the contracts were published, thus revealing the great contribution of Niépce to the invention of photography. Another biography we owe to Ernest Lacan, who added valuable biographical data in the periodical *La Lumière* (1856), pp. 151, 154, 167, 179. Niépce's correspondence with Lemaître on his discoveries was published in *Brit. Journ. Phot.* (1864), p. 531, and (1865), pp. 5, 44. In 1925 Georges Potonniée published an exhaustive biography of Nicéphore Niépce, in his *Histoire de la découverte de la photographie* (Paris); Isidore Niépce also published a pamphlet, *Historique de la découverte improprement nommée daguerréotype* (Paris, 1841). Niépce's son Isidore donated a great number of his father's letters to the museum at Chalon. This was done at the time of the erection of the statue of the inventor on one of the prominent places in Chalon on June 21, 1885. In the *Bull. Soc.*

franç. de phot. (1913), p. 143, is the following genealogy of the family Niépce.

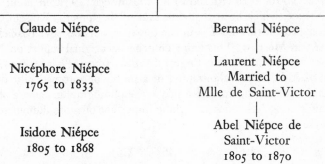

Bernard Niépce, 1671 to 1766

Claude Niépce	Bernard Niépce
Nicéphore Niépce 1765 to 1833	Laurent Niépce Married to Mlle de Saint-Victor
Isidore Niépce 1805 to 1868	Abel Niépce de Saint-Victor 1805 to 1870

3. S. Fouque, *La Vérité sur l'invention de la photographie* (1867), p. 49.

4. They are published in Fouque, *La Vérité sur l'invention de la photographie* (1867).

5. Böckmann is the first to note this, in 1800; more exhaustive research was undertaken by A. Vogel in 1812.

6. It is interesting to note that Poirson, in 1886, rediscovered this method of copying on a layer of phosphorus (on stone) and the fixation of the image by red phosphorus with carbon disulfide.

7. I mention here the names of the later scientists: Senebier (1782), Wollaston (1802), to whom I have previously referred, and others.

8. See an exhaustive essay by F. Paul Liesegang in *Zentralblatt für Optik und Mechanik* (1930).

9. G. Cromer, Paris, procured in 1921 a letter from Nicéphore Niépce, dated May 26, 1826, in which he reports on his photographic experiments; it is reproduced in facsimile in *Bull. Soc. franç. d. phot.* (1922), p. 71.

10. Fouque, *La Vérité sur l'invention de la photographie*, p. 108; also Chevreul, "La Vérité sur l'invention de la photographie" (*Journal de savants*, 1873).

11. Isidore Niépce's letter to Fouque, March 10, 1867, i.e., forty years later (Fouque, p. 122).

12. It does not seem to be a mere accident that Nicéphore Niépce used just Dippel's animal oil as a solvent (this oil is obtained from bones, by dry distillation); it is more than likely that he was familiar with the observations of prior chemists on the light-sensitivity of this oil (Swindern in 1805 and Link in 1808); it was not much later that the light-sensitivity of this oil was recognized, with that of asphalt.

13. *Rapport du Comité d'installation; Musée rétrospectif de la Classe 12 Exposit. universelle 1900* (Paris, 1903), p. 11.

14. A Russian professor, N. E. Yermilow, reported in the *Sowjet Photo-Almanach* for 1929 (Moscow) on a manuscript, written about 1828 by Nic. Niépce, which he at that time sent to the Imperial Russian Government; at present this letter is in the possession of the Soviet Academy of Sciences, in Moscow. This letter contains an original report on Niépce's work and was published in English by *Brit. Journ. Phot.* (1930), p. 603, under the title, "On Heliography, or a means of automatically fixing by the action of light the image formed in the photographic camera obscura." This interesting MS contains nothing important or more illuminating than our present knowledge of the subject.

CHAPTER XX

1. This "prisme ménisque," invented by the brothers Chevalier, was an optical instrument consisting of a lens which was on one side concave and on the other side convex.

CHAPTER XXI

1. For Daguerre's biography see also Colson, *Mémoires originaux des créateurs de la photographie* (Paris, 1898); Blanquart-Evrard, *La Photographie, ses origines* (Lille, 1870); Mentienne, *La Découverte de la photographie en 1839* (Paris, 1892); in Poggendorff, *Biogr.-liter. Handwörterbuch zur Geschichte der exakten Wissenschaften* (1863, I, 509), Daguerre's date of birth is erroneously given as 1789.

2. The statement that Daguerre's parents were peasants in Normandy is incorrect.

3. Robert Fulton (b. 1765, in Little Britain, Pennsylvania, d. 1815) built the first practical steamboat which sailed up the Hudson, in 1807. He was a skilled goldsmith, went to London, was a mechanic, together with Rumsey, traveled to Paris, where he constructed panoramas for Barlow.

4. See Potonniée, *Histoire de la découverte de la photographie* (1925), p. 124.

5. In *Bull. Soc. franç. de phot.* (1924), p. 52. G. Cromer publishes documents on the history of photography and reports particularly on the "Artist Daguerre and his diorama" and on the painter Charles Maria Bouton, Daguerre's collaborator in this enterprise; Cromer's statements are based partly on Potonniée's historical research; he stresses more exact data on Daguerre's career. We learn from this that Daguerre in his youth worked for Degotti, the painter of scenes at the Opera in Paris. He also created, with Ciceri, a famous landscape painter of his time, the decora-

tions for the play "The Magic Lamp," as well as various decorations for the Ambigu Theater.

6. Mentienne, *La Découverte de la photographie en 1839* (Paris, 1892); G. E. Brown, *The Amateur-Photographer* (1904), XXXIX, 411.

CHAPTER XXII

1. A "ligne" is a French unit of length=2.256 millimeters.
2. This article was written in December.
3. This remark of M. Niépce was merely hypothetical, and experience has shown that the achromatic camera obscura, although it made the image more distinct, did not procure the perfect sharpness which M. Niépce hoped to obtain. (Note by Daguerre.)
4. I want to call attention to the fact that the prints of which M. Niépce speaks were produced by contact with copper engravings which were placed in contact with the impregnated material. Also that the use of the wax of which he speaks neutralized the action of the bitumen of Judea solution in the camera obscura, where the action of the light was very much diminished; the mixture with the wax, however, was not a serious obstacle to obtaining his prints, because he exposed them for three to four hours to the full sunlight. (Note by Daguerre.)
5. It is important to mention that M. Niépce's use of iodine for blackening his plates proves that he had no knowledge of the property of this substance to decompose when exposed to light in contact with silver. This is also proven, because on the contrary he cites iodine as a means for the fixation of his prints. (Note by Daguerre.)

CHAPTER XXIII

1. Daguerre, *Historique et description des procédés du daguerréotype* (1839).
2. Daguerre, who had no educational background in natural sciences, was not familiar with Davy's discovery of the light-sensitivity of silver iodide in 1814.
3. Daguerre, *Geschichte und Beschreibung des Verfahrens der Daguerreotypie und des Dioramas*, translated from the original French into German (Karlsruhe, 1839), p. 72.

CHAPTER XXIV

1. See A. Davanne, *Nicéphore Niépce, inventeur de la photographie; conférence faite à Chalon-sur-Saône, pour l'inauguration de la statue de Nicéphore Niépce, le 22 juin, 1885* (Paris, Gauthier-Villars, 1885).
2. This is a polemical pamphlet against Daguerre and emphasizes the

claim of Niépce as the real inventor of photography; the pamphlet sharply criticizes the suppression of Niépce's name in the publication of the joint invention under the title "Daguerreotypy," although the latter had already permitted this in the agreement of 1837. Later, Isidore Niépce emphasized that he did this under the pressure of circumstances, because Daguerre knew all Niépce's secret process.

CHAPTER XXV

1. Daguerre, having demonstrated to Arago the results of his invention, also showed them to the French physicist and astronomer John Baptiste Biot (1774-1862) and to the famous German scientist, Alexander von Humboldt, who at that time resided in Paris. The complete procedure was confided only to Arago, the Secretary of the Academy of Sciences in Paris. It was not until January 7th that Arago made his report to the Paris Academy of Sciences.

CHAPTER XXVI

1. *Compt. rend.* (1839), IX, 250.
2. The members of this commission were Baron Athalin, Besson, Gay-Lussac, Marquis de Laplace, Viscount Simeon, Baron Thénard, and Count of Noe.

CHAPTER XXVII

1. *Paris photographe* (1891), p. 24.

CHAPTER XXVIII

1. George E. Brown, in *The Amateur Photographer*, 1904, p. 411; an illustrated article: "The Last Days of Daguerre; Some Notes on a Visit to Bry-sur-Marne."
2. *Handbuch* (2d ed., 1892), Vol. I, Part 1, Plate 1.
3. *Bull. Soc. franç.* (1897), pp. 308, 320.

CHAPTER XXIX

1. An original Daguerre-Giroux camera, which Eder acquired for the collections of the Graphische Lehr- und Versuchsanstalt in Vienna in 1890, is at present exhibited in the Technical Museum, Section for Photography, in Vienna. Dost and Stenger, *Die Daguerreotypie in Berlin, 1839-1860*, 1922, also contains a good illustration of such a camera.
2. The well-known Paris optician Chevalier adapted Wollaston's concave-convex periscopic meniscus to the first lenses which he made for Niépce's and Daguerre's experiments. Wollaston invented and described

the fundamental principle of his invention on June 11, 1812, and emphasized the advantages of this type of lens over the former biconvex lens. The concave side of the lens was turned to the object to be photographed. It was exactly this type of meniscus lens Chevalier chose for the daguerreotype camera in 1839. He had pointed out the fact in several addresses at the Société d'Encouragement, Paris. The apparatus constructed for the daguerreotype by Giroux, as well as the first Austro-German lenses produced by Simon Plössl, of Vienna, followed this form of lens. The achromatic single lenses Daguerre had used earlier usually had an aperture of three inches and about sixteen-inch focus; this opening, however, was reduced to one inch by placing a diaphragm in front of it at a distance of three inches. Daguerre frequently exposed with two-inch lenses, in 1839, for about ten to twenty minutes. At this time Townson had already suggested the use of a lens of a greater diameter and a more precise correction of the focal distance in order to eliminate the chromatic aberration. It is these lenses that Draper used for his portraits, in New York, in 1840. These portraits, taken with enormously long exposure, were not sharp, owing to the imperfection of the lens and the inevitable restlessness of the sitters. For Chevalier's lens, see M. von Rohr, *Theorie und Geschichte des photographischen Objektivs* (1893), p. 89.

3. At first only silvered copper plates were used; since 1845 the less expensive copper plates on which the silver had been deposited by the *galvano* process were found usable. The Berlin chemist A. Lipowitz offered in his book *Die Daguerreotypie* (1845) a process for the production of such plates for five thalers (Wilh. Dost. *Phot. Chronik*, 1925, p. 391; see also Kilburn, *Phot. Magaz.*, XXXII, 541; *Fortschr. d. Physik*, 1848, p. 196; Boué, *Compt. rend.*, XXIV, 446). In some cases silver foil mounted on cardboard was used for the production of daguerreotypes (Raife, *Compt. rend.*, 1840; Dingler, *Journ.*, LXXVII, 159).

4. For further details see Eder and Kuchinka, *Die Daguerreotypie* (1927). *Handbuch*, Vol. II, Part 3.

5. *Musée retrospectif de la Classe 12, Photographie. Rapport du Comité d'installation* (Paris, 1903).

6. Sir John Frederick William Herschel, b. 1792, d. 1871, in London, son of the famous astronomer Friedr. Wilhelm Herschel, who died in 1822, devoted himself first to the study of astronomy and optics; later he engaged in chemical and physical experiments and also gave some time to photochemical investigation.

7. Many years later it was said that Herschel had forgotten his twenty-year-old observation on the solubility of chloride of silver in sodium hyposulphite. But it was published in W. T. Brande's *Chemistry* and that is where Joseph Bancroft Reade found it in 1839 while he was engaged

in photographic research. He had the apothecary Hodgson of the Apothecaries Hall, in London, prepare some sodium hyposulphite for him. He successfully experimented in fixing silver chloride paper images and informed Herschel of it. The latter originally used hyposulphite of ammonia as the fixing agent; but then he adopted Reade's sodium salt. This chemical thereafter became generally used under the name "fixing sodium." This was reported in *Phot. Journ.*, 1928, pp. 305-11, with Reade's portrait. There is at this time no way of verifying this belated story.

8. Hippolyte Louis Fizeau (b. 1819, in Paris, d. 1896), together with Foucault and other scientists, was engaged in experiments in physics; after 1843 he successfully turned to photography, which owes to him many improvements.

9. The earlier history of the panorama camera is (with many illustrations) published in the first edition of Eder's *Handbuch* (1884), p. 412.

CHAPTER XXXI

1. In the early period of the daguerreotype the latent image was called the "dormant image."

2. This experiment of Draper is, however, proof only that no free iodine escapes; yet it is separated, changing to metallic silver in the inner stratum.

3. *Compt. rend.*, 1843, XVI, 25; XVII, 4.

4. L. Lewandowsky, a student at the Polytechnikum, in Vienna, invented, in 1843, his "iodine-and-exposure-meter" for daguerreotype, which permitted the correct control of the iodization and proportionate exposure (*Handbuch*, 1930, Vol. III, Part 4). Later, Claudet's "photographometer" (1848) is also described in the same place.

5. Here should be mentioned the magic photographs by W. Grüne, in Berlin, produced by the smoke of a cigar containing ammonia (1866).

6. E. Becquerel, when only nineteen years old, described a method for an electrochemical actinometer (*Compt. rend.*, 1839, p. 145).

7. For the Becquerel phenomenon and its importance for modern photochemical research see Lüppo-Cramer, *Handbuch* (1927), II(1), 315. The photographical "Becquerel-phenomenon" occurs also in silver bromide gelatine; see Lüppo-Cramer, *Die Grundlagen deer photographischen Negativverfahren*, 1927, p. 285 (Vol. II(1) of the *Handbuch*). See also Erich Stenger, *Zeitschr f. wissensch. Phot.* (1930), XXIX, 44.

8. *Compt. rend.*, XXIII, 679; *Fortschr. d. Phys.*, 1846, p. 235.

9. *Philos. Magaz.*, XXXII, 199.

10. *Phot. Korr.*, 1874, p. 68; *Fortschr. d. Physik*, 1874, p. 507.

11. Pohl, *Phys.-chem. Notizen*, II series, p. 19.

12. E. Arago, *Astronomie populaire* (1855), Vol. II, Book xiv, chap. 22.

CHAPTER XXXII

1. John William Draper, M.D. (b. May 5, 1811, near Liverpool, England). Since 1836 professor of chemistry and physics at Hampden Sidney College, Va., later (1839) professor at New York University. He died in 1882. See biography with portrait in *The American Journal of Photography* (1861), p. 238; also *Phot. Times* (1882), p. 1.

2. Harrison, *History of Photogr.* (1888), p. 26.

3. An illustration of the first daguerreotype camera constructed in the U. S. A. is found in *American Photography* (1911), p. 516. This camera is now in the photographic section in the National Museum, Washington, where numerous other photographic incunabula are collected. These are, for instance, two daguerreotypes made in 1839 by the inventor; a heliograph by Niépce, of 1824; a silverprint by Fox Talbot, of 1839; and other documents of the development of photography. The different processes are not only represented by the results but also shown by specimens of the apparatus by which they were produced. There are about 250 apparatus, which make it possible to study almost every step in the progress of construction from the beginning. The collection was started in 1876, and it is surprising to find it much more extensive than similar ones in Europe which had only been begun in the course of the last decades *(Phot. Ind.,* 1911, No. 39, p. 1358; *Phot. Korresp.,* 1911, p. 637).

4. In 1840 W. Draper, of New York, stated that it is possible to make portraits in full sunlight, using mirrors as light reflectors. "But in the reflected sunshine, the eye cannot support the effulgence of the rays. It is therefore absolutely necessary to pass them through some blue medium, which shall abstract from them their heat and take away their offensive brilliancy. I have used for this purpose blue glass, and also ammoniaco-sulphate of copper, contained in a large trough of plate glass, the interstice being about an inch thick" *(Philosoph, Magaz.,* Sept., 1840, p. 217; Dingler, *Polytechn. Journ.,* LXXVIII, 120).

5. Werge, *The Evolution of Photography* (1890), p. 79. J. F. Sachse erroneously confuses Dr. Paul Beck Goddard, professor at the University of Pennsylvania, who occupied himself somewhat with daguerreotypy, with the inventor of the iodo-bromide plates, John Frederick Goddard *(Jahrbuch f. Phot.,* 1894, p. 258). Werge published John Frederick Goddard's portrait in his *The Evolution of Photography,* p. 27; one of Dr. Paul Beck Goddard is to be found in *American Journal of Photography* (July, 1883), p. 308.

6. According to his contemporary Berres, in Vienna (Dingl. *Polytechn. Journ.,* 1841, LXXXI, 151).

7. *Wiener Zeitung,* January 19, 1841, p. 139.

8. One of the brothers, Johann Natterer, M.D. (1821-1900), was the

inventor of the compression pump for the liquefaction of carbonic acid and was well known in the history of chemistry. *(Cf.* Natterer's biography by A. Bauer, published in the *Chemiker Zeitung*, 1901; also *Jahrb. f. Phot.*, 1891. The Viennese geologist Professor Ed. Suess (president of the Academy of Science) was a brother-in-law of the brothers Natterer.

9. J. M. Eder donated these originals from his own private collection to the Graphische Lehr- und Versuchsanstalt in Vienna.

10. *Rapport du Comité d'installation Musée retrospectif de Photogr. Exposition universelle Paris 1900* (issued 1903).

11. For instance, Claudet's publications on iodo-bromide of June 10, 1841 *(Philosoph. Magaz.*, 1841, 3d ser., XIX, 167), are credited unjustly by some authors with the priority of the introduction of the combination of bromide with iodine for the sensitization of silver plates.

12. Must not the outstanding celebrated scientists be recognized as incontestable witnesses?

13. Charles R. Gibson, in Chapter I, "The History of Photography," of the work entitled *Photography as a Scientific Implement*, 1923, p. 30 (German translation by Alfred Hay, pub. by Fr. Deuticke, 1929, p. 23) writes: "The daguerreotype plates were made more sensitive by the application of bromine, which was added by Goddard in 1840; this was enhanced further by Claudet's introduction of chlorine along with iodine." He does not mention Kratochwila and the Natterer brothers. Evidently he was unfamiliar with the technical literature of 1840, and on the whole he seems to write very objectively.

CHAPTER XXXIII

1. E. Stenger, *Camera*, 1930, VIII, 193.

2. From 1815 Prechtl was director of the Polytechnische Institut, Vienna, which he organized and over which he presided until 1849. The *Technologische Enzyklopädie* (20 vols., 1830-1855), edited by him, is well known. Also his *Praktische Dioptrik*, which he published in 1828, is of interest for us. He promoted photography and photographic optics.

3. Conventionsmünze: 20 gulden conventionsmünze=10 thaler (1 thaller equals 3 German marks).

4. The Waldstein family of opticians appears first in Arnold Waldstein (b. Würtemberg, 1787; d. Vienna, 1853). He was an optician in Munich and founded there a factory for grinding glass; he met Fraunhofer and opened a branch office in Vienna in 1842 (see biography of the Waldstein family in *Österr. Zentralzeitung f. Optik. u. Mechanik*, 1927, No. 10).

5. *Phot. Korresp.*, 1908, p. 578.

6. Abstract, *Journal of the Franklin-Institute*, October, 1908, p. 315.

CHAPTER XXXIV

1. Dr. Otto Waldstein, *Österr. Zentralzeitung f. Optik u. Mechanik*, 1926, No. 14.

2. See footnote 3 for Chapter XXVIII.

3. Dr. Erményi published in *Phot. Zentralblatt* (VIII, 247) an exhaustive biography of J. Petzval. See also his *Petzvals Leben und Verdienst* (1903). Until then little was known about him. Even the date of his birth was disputed; in the obituary Professor E. Suess in the Imperial Academy of Sciences, Vienna (Petzval was a member of the Imperial Academy of Sciences), called attention to the contradictory available data *(Almanach Wien, kais. Akad. d. Wiss.*, 1892, XLII, 182). But the data given by Eder proved to be correct. Eder mentioned several times that it was Petzval himself who, emphasizing the fact that he was the son of German parents, had made him put down in writing explicitly the day and year of birth, namely, January 6, 1807; this date, which Eder had also published in the first edition of his *Handbuch der Photographie* (I(2), 40), had been doubted by some persons, since there exists documentary evidence that January 6, in other years, is also the birthday of his two brothers; it was held to be most improbable that all three sons of one family were born on the same day of the year, on Epiphany. But Dr. Erményi's research, made in Petzval's city of birth itself, in Szepes-Béla, District of Zips, Hungary, confirmed that in the parochial vital statistics Petzval's date of birth was registered as January 6, 1807; thus this question is settled for good. Among friends the three brothers Petzval had the nickname "The Three Magi," alluding to their birthday January 6. Dr. Erményi publishes in his Petzval biography, a work worthy of highest appreciation, various authentic facts of Petzval's life and his scientific work *(Phot. Korresp.*, 1902, p. 395). For Petzval's work on the subject of optics see also M. von Rohr, *Theorie und Geschichte des photogr. Objektives*, (1899). Zips, in the former Austro-Hungarian monarchy, was a Hungarian county in Northern Hungary on the Galician border, with a mixed population and some German settlements. After World War I, when Austria-Hungary was dismembered, it was assigned to Czechoslovakia, together with the most beautiful parts of the High Tatra.

4. Joseph Petzval correctly remarked, in his *Bericht über die Ergebnisse einiger dioptrischer Untersuchungen* (1843, p. 26): "Lens combinations are quite moody and refractory objects, which, when placed in a certain rotation, do not produce at times any kind of a decent image, sometimes an inevitably crooked or distorted one; this is entirely due to general basic laws which are deeply seated in the construction of their complicated functions. . . . The practical scientific optician will reach the

peak of his art only through the closest kind of an association with intense research in the science."

5. *Akademiker Dr. Petzval beleuchtet vom Optiker Voigtländer*, Brunswick, 1859.

6. A study, important for the history of optics, is Harting's "Zur Geschichte der Familie Voigtländer, ihrer Werkstätte und ihrer Mitarbeiter" *(Central-Zeitung für Optik und Mechanik*, 1924/25). This study was also published as a separate pamphlet by Aktiengesellschaft Voigtländer & Sohn, (Brunswick, 1925). M. von Rohr has added to this significant essay valuable source material; in the *Zeitschrift für Instrumentenkunde* (1925, XLV, 436, 470) he gave a summarizing account of the Voigtländer optical workshop and its environment. An excerpt of it by F. P. Liesegang is published in *Centralzt. f. Opt. u. Mech.* (1926).

7. The illustration of this medal in the 1932 edition of this *History* was reproduced from the collection of medals awarded to the author.

8. See Claudet's later essays *(Compt. rend.*, October 18 and December 20, 1847, and 1851, XXXII, 130); also *Recherches sur la theorie des principaux phenomènes de photographie* (Paris, 1849); *Nouvelles recherches sur la différence entre les foyers visuels et photogénique et sur leur constante variation* (Paris, 1851); and Claudet's report in *Revue photographique* (1857), p. 250.

9. These first Petzval-Dietzler portrait lenses, constructed under Petzval's supervision, were excellent and were used successfully in first-class portrait studios in Vienna until the end of the nineteenth century; an old Dietzler objective was continually used for half-length portraits in the portrait studio of the renowned photographer Dr. Székely, Vienna, holding its own during the collodion method and until that of silver bromide gelatine. The author witnessed these changes. He also started a collection of good Dietzler lenses at the Graphische Lehr- und Versuchsanstalt, Vienna.

10. At that time, beside the Viennese optician Dietzler, other professionally skilled opticians established themselves who also copied portrait lenses, such as Eckling, Prokesch, Waibl, and Weingartshofer; Kuchinka reports on that exhaustively in his "Geschichte der photographischen Optik in Wien" *(Phot. Korr.*, 1927).

11. See Dr. L. Erményi, "Theorie der Tonsysteme von Petzval," in *Zeitschr. Math. u. Physik* (Vol. LI); also Petzval's work on the *Theorie der Schwingungen gespannter Seiten* (1858).

12. Erményi's writings, in chronological order, are: "Dr. Josef Petzvals Leben und wissenschaftliche Verdienste," *Photographisches Zentralblatt*, 1902, VIII, 247-278; *Dr. Josef Petzvals Leben und Verdienste*, 2d ed., essentially enlarged, with eleven pictures and two figures (1903).

"Nachträgliches über Petzval," *Photographisches Zentralblatt*, 1904, X, 239-245. See also M. von Rohr, "Über ältere Porträtobjektive," *Zeitschr. f. Instrumentenkunde* (1901), XXI, 49; M. v. Rohr, "Die optischen Systeme aus Petzvals Nachlass," *Phot. Korresp.* (1906), p. 266; J. M. Eder, "Petzvals Orthoskop," in his *Jahrbuch* (1900), XIV, 108.

13. See *Phot. Korresp.* (1902), p. 756. Eder, *Jahrb. f. Phot.*, (1904), p. 249.

14. Until now it has been only once awarded, namely, at the end of Eder's honorary year of service as professor at the Technische Hochschule, when he was 70 years of age (1925). The "Staatliche Lichtbildstelle" was, after the breakdown of Austria, no longer a state institution and was continued as "Österreichische Lichtbildstelle."

15. Friedrich's death urged W. F. Voigtländer to establish a Voigtländer-Foundation of the Viennese Photographic Society. A portrait of Friedrich taken by A. Mutterer is in the collection of the Graphische Lehr- und Versuchsanstalt, Vienna.

16. Collection of the Wiener photographische Gesellschaft.

17. See also Rohr, *Zeitschr. f. Instrumentenkunde* (1925), XLV, 436, 470; (1926), XLVI, 76.

18. This lens was one of the chief attractions at the Münchener Gewerbeausstellung in December, 1819, and brought to the manufacturer a medal, awarded on that occasion for the first time.

19. The way the production of these Benediktbeurener lenses came about was as follows: Georg von Reichenbach established, in 1804, together with Utzschneider and Liebherr, a mechanical institute. Then, in 1809 Reichenbach founded, with Fraunhofer and Utzschneider, in Benediktbeuren, the optical institution which became so famous. It was in this institution that Fraunhofer ground and produced the lenses.

20. Professor Ernst Voit, Munich, published, with Dr. Adolph Steinheil, the *Handbuch der angewandten Optik* (1891).

21. A. Rogers was an astronomer at Harvard University, Cambridge, Mass. From 1877-1886 he was observer. Later he was professor of astronomy and physics at Colby College, Waterville, Me.

22. The British patent No. 329144, of May 3, 1929, registered by A. Warmisham and Kapella for modified "Petzval-Cine-Lenses" of the enormous intensity of light $f/1.8$ proves that Petzval's masterly achievement in constructing his portrait lens was the incentive for calculating objective constructors far into the twentieth century.

CHAPTER XXXV

1. *Derniers perfectionnements apportés au daguerréotype*, by Gaudin and Lerebours (3d ed., Paris, 1842).

2. *Traité de photographie, derniers perfectionnements apportés au da-guerréotype,* by N. P. Lerebours (Paris, 1843).

3. *Traité de photographie,* by Lerebours and Secretan (5th ed., Paris, 1846).

4. Prints made in the studios of Lambert, Paris, Lerebours and Secretan, Paris, of the painter Martin Theyer, Vienna, are in the department of mechanical technology at the Technische Hochschule, Vienna; other large collections of early daguerreotypes are in the Graphische Lehr- und Versuchsanstalt and in the Technisches Museum, Vienna.

5. In the collection of the Graphische Lehr- und Versuchsanstalt, Vienna.

CHAPTER XXXVI

1. Instructions for the coloring of daguerreotypes published in the *Neueste Ratgeber für Daguerreotypie* (see Lerebours), 4th ed., Leipzig, Fr. Volkmar, 1843.

2. Dingler, *Polytechn. Journ.,* LXXXVII, 316.

3. Martin, *Repertorium der Phot.* (1846-1848), II, 98. Martin, *Handbuch d. Phot.* (1854), p. 296.

CHAPTER XXXVII

1. Poggendorff, *Biograph, literarisches Handwörterbuch* (1863) II, 1066.

2. C. H. Talbot, Talbot's son, lived there in 1905. The author owes to his kindness three very beautiful Talbot copper heliogravures.

3. *Compt. rend.* (1839), VIII, 341.

4. Seventy-five years later potassium ferrocyanide was discovered as a fixing agent by N. Sulzberger, who took out a German patent. Eder proved that this was nothing new and that it was invented by Talbot and published in *Compt. rendus* (1839), p. 341. See also E. Valenta, *Phot. Korresp.* (1916), p. 199, and Eder, *Jahrbuch* (1916), p. 415.

5. Dingler, *Polytechn. Journ.,* LXXXI, 356, 363; *Philosoph. Magazin* (1841), p. 88. A pamphlet was published on Talbot's calotype process: *Lichtbilder (Porträts) auf Papier in ein bis zwei Minuten darzustellen, von Talbot, Physiker in London* (Aachen, 1841).

6. William Henry Fox Talbot applied for the grant of a patent for his invention of the Calotype process in England on February 8, 1841; it was signed on July 29, 1841, and sealed on August 17 of the same year. The *Liverpool Photographic Journal* published it exhaustively in 1857, p. 114, as a historically important document. It was reprinted from there in other periodicals (for instance, Dingler, *Polytechn. Journ.,* LXXI, 468).

7. Waxing of papers. *Repert. of pat. invent.,* January, 1844, p. 47; Dingler, *Polytechn. Journ.,* XCII, 94.

8. *Phot. Archiv* (1877), p. 169. *Camera obscura* (1901), II, 840; also *British Journ. of Phot.* (1877)

9. This is, moreover, inadmissible, because Reade obtained images only with silver nitrate and gallic acid. The method of developing the latent image, later discovered by Talbot, refers, however, to the image produced with silver iodide, silver bromide, or silver chloride.

10. *Encyclopaedia Britannica*, 8th edition, article on "Photography," p. 545; also published in Harrison, *History of Photography* (1888), p. 31, and copied without giving the source in Schiendl, *Geschichte der Photographie;* John Werge treated this work exhaustively in his *Evolution of Photography* (1890), where he reproduced also a portrait of Reverend J. B. Reade, who died December 12, 1870. See also *Brit. Journ. Phot. Almanac,* (1931), p. 156.

11. Blanquart-Evrard, *Traité de photographie sur papier* (Paris, 1851).

12. Published in the *Comptes rendus*, XXIV, 117; Dingler, *Polytechn. Journ.*, CIV, 32, 275; CVI, 365; CVII, 193. Martin, *Handbuch der Photographie* (1851), p. 187; proven formula by Martin, see Martin, *Handbuch d. Phot.* (1865), p. 281. See Eder's *Handbuch* (1927), II, 3.

13. Dingler, *Polytech. Journ.*, XCII, 367, from *Philos. Magaz.* (1844). Martin, *Handb. d. Photographie* (1851), p. 201.

14. Le Gray, *Photographie* (1852), p. 24.

15. *Journ. Phot. Soc.* (London, 1856), p. 65; Kreutzer, *Jahrb. Photogr.* (1856), p. 19. Later, Parr found that it is best to treat the silvered paper with sodium acetate (formation of silver acetate).

16. Blanquart-Evrard, *Procédés employés pour obtenir les épreuves de phot. sur papier* (1847); *Traité de phot. sur papier* (1851); and other publications.

17. Thomas Sutton was an accomplished English photographer, distinguished also by numerous publications in technical journals. He wrote: *The Calotype Process; a Hand-Book to Photography on Paper* (London, 1st ed., 1855; 2d ed., 1856). Sutton and Dawson, *A Dictionary of Photography* (London, 1st ed., 1858; 2d ed., 1867). This publication and others are good descriptions of the state of photography of the time.

18. The apothecary A. Moll, Vienna, started the manufacture of chemicals for photography in 1854.

19. Anastas Jovanovits, b. 1817, in Bulgaria, was at one time High Steward of Prince Michael Obrenowitz of Serbia, assassinated in 1868. He lived mostly in Belgrade, often visited Vienna, where he died in 1899, 82 years old. He was one of the first amateur photographers who had become familiar with photography around 1840 in Vienna through the librarian Martin; later he introduced photography into Serbia and Montenegro *(Phot. Korresp.* (1899), p. 731).

20. A portrait of Regnault, see Pector, *Notice historique*, (Paris, 1905).

21. See *La Lumière* (February, 1851), p. 3.

22. Dingler, *Polytechnisches Journal*, CXXIII, 158.

23. See Eder, *Phot. Korresp.* (1891), pp. 153, 256.

CHAPTER XXXVIII

1. "Elles resultaient de ce que l'image était combinaison d'argent et d'acide gallique" (Blanquart-Evrard, *La Photographie, ses origines* . . . 1870, p. 187).

2. The Library of Lille has supposedly a copy (Blanquart-Evrard, *La Photographie, ses origines* . . . 1870, p. 187). I saw only one page of it.

3. In 1854 Blanquart-Evrard was already in a position to publish a remarkable catalog of his photographic art publications; this firm, however, does not seem to have existed very long.

CHAPTER XXXIX

1. See *Bull. Soc. franç. d. phot.* (1887), pp. 167, 174; see also Colson, *Mémoires originaux des créatures de la phot.* (Paris, 1898).

2. In 1839 Fyfe had also discovered the good qualification of silver phosphate for photographic copying paper. He treated paper either successively with a solution of sodium phosphate and silver nitrate or prepared it with a solution of silver phosphate in ammonia or ammonia carbonate. Fyfe fixed the photographs thus made with ammonia *(Edinb. New Philos. Journ.* (1839), p. 144; Dingler, *Polytechn. Journ.*, LXXIV, 55; Eder, *Handbuch* (1887), IV, 6, 34). He produced also photographs on canvas by this process. M. Lyte used silver phosphate also on albuminized paper and fixed with diluted nitric acid *(Journ. Phot. Soc.*, III, 50; Kreutzer, *Jahrb. f. Phot.* (1856), pp. 27, 28; (1857), p. 58).

In 1844 Hunt mentioned that photographs on silver-phosphate paper are well suited for development with gallic acid + silver nitrate (see Eder, "Photochemie," *Handbuch*, 1906, I(2), 302; see also Eder, "Silberkopierverfahren," in *Handbuch*, 1896, Vol. IV). Johann Meyer, Brooklyn, applied it successfully in the "printing-out" process *(Brit. Journ. Phot.*, 1899, pp. 714, 721; 1900, pp. 132, 134; Eder, *Jahrb. f. Phot.*, 1900, pp. 636, 1901, p. 660). E. Valenta (Eder, *Jahrb. f. Phot.*, 1901, p. 130) described the use of silver phosphate colloidine paper without silver chloride ("printing-out" process); the result produced beautiful, durable papers, which are exhibited in the technical museum in Vienna (photography section).

3. This refers primarily to the photochemical decomposition of the potassium iodide, which shows its greatest effect in the short-wave spectrum.

CHAPTER XL

1. E. Stenger publishes a more extended biography of A. Breyer in *Phot. Ind.* (1926), p. 155. Friedrich Wilhelm Breyer's father, b. 1787, in Hirschberg, Upper Silesia, Germany, studied medicine in Berlin. His eldest son, Albrecht Breyer (b. October 16, 1812, in Berlin, d. August 9, 1876, in Brussels) studied medicine in Liège; he graduated there in 1839 and moved later to Brussels, where he practiced as general physician, surgeon, and obstetrician. He never again referred to his earliest publication on the process of copying of opaque objects. He died August 9, 1876, in Brussels.

2. The typon process is the recent application of this method.—Note by William Gamble.

3. Invented by Max Ullmann, of Zwickau (Sacheen), in 1913 (*Handbuch*, 1922, IV(3), 387).

CHAPTER XLI

1. Niepce de Saint-Victor used no accent on the first "e" in his name, as mentioned in Chapter XIX.

2. *Compt. rend.* (Oct., 1847), XXV, 586, and XXVI, 637; Dingler, *Journ.*, CVII, 58, and CIX, 48; *Jahrb. f. Chemie* (1848), p. 232.

3. Gehlen (1804) discovered the light-sensitivity of uranium chloride in alcoholic solution. Burnett, an Englishman, invented, 1857, a photographic process of copying on paper which was impregnated with uranium nitrate; he recognized the photochemical reduction of uranous salt (also tartaric acid and citric acid uranous salt) to oxide (uranous salt), the copies were made visible, among other ways, by treatment with silver nitrate or potassium ferricyanide (*Photogr. Notes*, 1857, p. 97, see also *Handbuch* 1927, IV(4), 159, under "Lichtpauserei"). Only later, in the period between 1858 and 1860, Niepce de Saint-Victor also engaged in the process of copying by means of uranium. Niepce de Saint-Victor elaborated on this basis processes of copying photographs (submitted to the French Academy of Sciences in March, 1858), having, however, the earlier preliminary work of Burnett, of 1857, at his disposal. The articles of Niepce de Saint-Victor on the photographic application of uranium salt (1858-1860) were published in the *Compt. rend.*, XLVI, 448, 449; XLVII, 860, 1002; XLVIII, 470; XLIX, 815; in German, Dingler, *Polytechn. Journal*, CXLVIII, 126; CLI, 130, 435; CLVI, 456.

4. *Compt. rend.* XXIX, 215; *Annal. Chem. und Pharmac.*, LXXII, 179. Dingler, *Journ.*, CXIV, 123. For other modifications see Blanquart-Evrard, *Traité de photogr.* (1851). The spelling "Blanquard" is wrong; "Blanquart" is correct.

5. From the Greek "amphi"=both, because the image appears positive on one side and negative on the other.

6. *Compt. rend.*, XXXVII, 305.

7. Le Gray, *Traité*, new ed., p. 117.

CHAPTER XLII

1. *Annal. chim. phys.*, LII, 290; Poggend., *Annal.*, XXIX, 176.

2. Poggend., *Annal.*, LXX, 320; *Compt. rend.*, XXIII, 678; John, *Chem. Schrift.*, IV, 204.

3. *Ibid.*

4. *Compt. rend.*, XXIII, 808.

5. *Handwörterb. Chem.* (1854), VI, 724.

6. *Compt. rend.*, XXIII, 980, 1099; *Journ. f. prakt. Chem.* (1847), XL, 193, 418.

7. Pelouze, *Compt. rend.*, VII, 713; *Journ. f. prakt. Chem.*, XVI, 168.

8. Bley, *Compt. rend.*, XXIII, 809; Bonjeon, *Compt. rend.*, XXIV, 190.

9. Payen, *Compt. rend.*, XXIII, 999; XXIV, 81.

10. Domonte and Ménard, *Compt. rend.*, XXIII, 1087; XXIV, 87, 390; abstract, *Journ. f. prakt. Chemie.* (1847), XL, 421.

11. Louis Ménard wrote a booklet, *De la moral avant les philosophes* (1860), in which he refers (p. 104) to the mythology of the ancient Greeks and suggests: "At that time one was not more annoyed with the thousands of hymns to Zeus and Aphrodite than one is nowadays, when assuming that oxygen had become immoral because of its union with all elements."

12. Schiendl, *Geschichte der Photographie*, 1891 (see also the criticism of this work in *Phot. Korresp.*, 1891, pp. 148, 254).

13. The popular spelling "Legray" is wrong.

14. Aside from the book mentioned, Gustave Le Gray wrote also *Traité nouveau théorique et pratique* (1853; 2d ed., 1854).

15. Also Snelling, *Phot. Journ.* (1857), p. 256; Kreutzer, *Jahrber. f. Phot.* (1857), p. 506. It was Archer who first obtained beautiful effects on collodion negatives through treatment with chloride of mercury (Horn, *Phot. Journ.*, XV, 36). To him is also due the credit for the invention of the chemical intensification of the collodion negatives. Archer's earliest writings are published in *Chemist* (1851), *Athenaeum, La Lumière* (1851 and 1852), *Humphrey's Journal* (1851 and ff.), and others.

16. *Revue photogr.* (1857), II, 207; Kreutzer, *Jahrber. f. Phot.* (1857), p. 506.

17. Belloc, *Les Quatre Branches de la phot.* (Paris, 1858), p. 165.

18. Bingham's letter to *La Lumière* of 1854; Horn, *Phot. Journ.* (1854), I, 43.

19. *Compt. rend.* (May, 1854), No. 19; Dingler, *Polyt. Journ.*, CXXV, 28.

20. H. W. Vogel, *Die Photographie auf der Londoner Weltausstellung*, (1863), p. 32.

21. Millet, *Cosmos* (March, 1854), p. 261; Dingler, *Polyt. Journ.*, CXXXI, 467. Nevertheless, Glover and Bold, of Liverpool, secured a patent on the identical process on February 20, 1857 (Dingler, *Polyt. Journ.*, CXLVII, 157).

22. *La Lumière* (1856), p. 16. Kreutzer, *Jahrber. f. Phot.* (1856), p. 188.

CHAPTER XLIII

1. *Paris photographe* (1892), p. 329.

2. *Ibid.*, p. 328.

3. H. P. Robinson, *Pictorial Effect in Photography* (London, 1869) with specimen illustrations; Robinson, *Picture Making by Photography* (London and New York, 1884); Robinson, *Art Photography in Short Chapters* (London, 1890). A portrait of Henry Peach Robinson will be found in *The Photographic Times* (1897), p. 255; also his autobiography, p. 497.

4. See H. P. Robinson, *Yearbook of Phot.* (1871).

5. Horn, *Photogr. Journ.* (1856), V, 88; VI, 7.

6. Read before the London Photogr. Society on December 15, 1859.

7. Bruno Meyer, *Phot. Korresp.* (1895), p. 442.

8. Disdéri, *L'Art de la photographie; avec une introduction par Lafan de Camarsc.* (Paris, 1862). Disdéri, *Die Photographie als bildende Kunst*, German translation by Weiske (Düsseldorf, 1864).

9. In the memoir *Die Geschichte der Firma Ed. Liesegang* (Düsseldorf, 1929), p. 8.

10. J. M. Eder, "Blaues Licht für Porträtaufnahmen bei künstlichem Lichte; Vorschaltung von Kobaltgläsern usw. in der Atelier-beleuchtung," *Die Kinotechnik* (1929), XI, 259.

11. Claudet claimed priority for the use of backgrounds in daguerreotype photography (see Brit. Pat. No. 9193, for 1841).—Note by William Gamble.

CHAPTER XLIV

1. See also E. Stenger, *Der Landschaftsphotograph und seine Arbeitsbehelfe zwischen 1860 und 1880*, reprinted from Matschoss, *Beiträge zur Geschichte der Technik und Industrie* (1930).

2. It is remarkable that in 1930 Willesden constructed a camera especially for amateur flyers, the "Pistol Aircraft and General Utility Camera";

the camera was made entirely of metal and used as a matter of course all the advantages of dry plates *(Brit. Journ. Phot.* (1930), p. 107).

3. Hardwich's successor at King's College was Thomas Sutton, and after him George Dawson. Sutton, an outstanding photographic expert, was a successful experimenter and technical writer. With Dawson he published the *Dictionary of Photography* (London, 1858; 2d ed., 1867). As an author he wrote, probably the first photographic novel, which appeared from January 1, 1865, serially in the *Photographic Notes*, the organ of the Photographic Society of Scotland and Manchester, which Thomas Sutton had edited from its beginning in 1856.

4. A purple artificial dyestuff made from uric and nitric acids and subsequently treated with ammonia was discovered by Liebig and Wöhler in 1839.

5. Eder, "Über die Einwirkung von Ferrizyaniden auf metallisches Silber," *Journal f. prakt.* Chemie (1877); previous excerpt in *Chem. Zentralbl.* (1876), p. 569. Eder's equation of reaction is as follows:

$$Ag_4 + 4Fe(CN)_6K_3 = 3Fe(CN)_6K_4 + Fe(CN)_6Ag_4$$

or

Silver + potassium ferricyanide = potassium ferrocyanide + silver ferrocyanide.

6. Rutherford and Seely, in Seely, *Am. Journ. of Phot.*, II, 251. Kreutzer, *Zeitschr. f. Phot.* (1861).

7. "Sabatier," as it is frequently spelled (also in Potonniée, *Histoire de Phot.)*, is incorrect.

8. Eder reports this in detail in *Handbuch der Phot.* (1884), II, 20, as well as in the new edition of his *Photographie mit Bromsilbergelatine.*

9. To produce such secret writing the negative of a landscape with a cloudy sky was copied on silver bromide gelatine card, then developed and washed; after this the secret writing was copied on the white part of the sky and immediately fixed. Thus the secret writing remained invisible and latent. It could only be developed physically.

CHAPTER XLV

1. From the Greek *mela*=black. In this category belong the collodion prints on blackened glass or collodion-development-images, which when viewed appear, owing to the black layer, on the back as positives.

2. From the Latin *ferrum* (iron).

CHAPTER XLVI

1. Poitevin, *Bull. Soc. franç. d. phot.* (1863), p. 306.

CHAPTER XLVII

1. *Compt. rend.* (1855), XLI, 383; *La Lumière* (September 8, 1855).

2. In 1853 Krone published *Album der Sächsischen Schweiz* (36 photographs in quarto) which attracted attention. This was commemorated in 1857 by a tablet on the Basteibrücke (Stenger, *Phot. Rundschau*, 1931, p. 158).

3. Austrian report on the London World Exhibition, 1862, section 14.

4. *Phot. News* (1861), p. 135.

5. *Brit. Journ. of Phot.* (November 15, 1862).

6. Of Leahy nothing more was heard, nor do we know who he was.

CHAPTER XLVIII

1. *Phot. News* (1861), V, 403, and *Phot. Notes* (1861), VI, 156, according to *La Lumière* (April 15, 1861). Gaudin gave before this suggestions for the production of photogen with collodion and gelatine.

2. *La Lumière* (1861), p. 37.

3. Patent No. 1074. *Abridgements of Specifications Relating to Photography*, Part II, p. 26.

4. B. J. Sayce was an amateur photographer, later president of the Liverpool Amateur Photographic Association. He died 1895 (See obituary, *Brit. Journ. of Phot.*, 1895, p. 340).

5. W. B. Bolton (b. 1848 in York, d. May, 1899). For his biography see *Brit. Journ. Phot. Alman.* (1900), p. 683; his portrait is in *Brit. Journ. of Phot.* (May 19, 1899).

6. See Lea's biography in *Brit. Journ. of Phot.* (1897), p. 312; *Phot. Mitt.*, XXXIV, 104. Carey Lea's photochemical research covers many fields of photography. Of special scientific interest are his investigations on red and purple silver chloride, silver bromide and iodide, on heliochromy and the latent photographic image; on the allotropic forms of silver. In 1908 Dr. Lüppo-Cramer published, under the title *Kolloides Silber und die Photohaloide von Carey Lea*, a German edition of these important articles which had appeared in the English language in various periodicals (published by Theodor Steinkopff, in Dresden, with Carey Lea's portrait).

7. *Brit. Journ. of Phot.* (1871), p. 312.

8. In 1908 Stenger reports the frequent use of di-iodofluorescin as sensitizer for silver bromide collodion halftone negatives (*Handbuch*, 1927, II(2), 247).

CHAPTER XLIX

1. For Warnerke's biography see Chapter LXIII.

CHAPTER L

1. See Poggendorff, *Biograph.-literarisches Handwörterbuch.* A portrait of Wheatstone is in *Brit. Journ. Phot.* (1868), p. 74. In October, 1925, a bronze portrait plaque of Sir Charles Wheatstone was affixed to his birthplace in Gloucester, England. He invented, in 1838, the mirror for the stereoscope (illustrated in *Phot. Journ.*, 1925).

2. I. F. Mascher, Philadelphia, obtained, in 1853, an American patent on folding stereo-viewing apparatus. It is questionable whether he was the first to invent it.

3. Brewster, *The Stereoscope* (London, 1850; German ed., Weimar, 1862). A synopsis of the sources for the history of stereoscopic projection is published by F. P. Liesegang in *Zahlen und Quellen zur Geschichte der Projektionskunst und Kinematographie* (1926), p. 106.

4. *Paris photographe* (1894), p. 24.

5. On the progress of stereoscopy in recent years see Eder, *Jahrbücher für Photographie.*

6. Stolze, *Die Stereoskopie* (1908), p. 132.

7. Joseph Charles d'Almeida (1822-1880) was a professor of physics in Paris. He founded the *Journal de physique* and was a charter member of the Société de Physique, Paris. His dissertation, "Nouvelle appareil stéreoscopique," appeared in *Compt. rend.* (1858).

8. Ernst Mach (b. February 18, 1838, Tucas, Moravia; d. February 19, 1916, Haar, near Munich) was an outstanding physicist and philosopher. He was professor of physics at the German university in Prague; 1895-1901, professor at the university in Vienna. On the occasion of E. Mach's death Eder, in the *Neues Wiener Tagblatt*, February 24, 1916, again called attention to the fact that Mach was the inventor of Roentgen stereoscopy; this fact was mentioned also in German technical periodicals, but was disregarded during World War I.

CHAPTER LI

1. C. H. Oakten, who reports on it *(Brit. Journ. Phot.*, 1926, p. 91) dates the first publication erroneously as 1837; it probably should be 1839 because the sodium thiosulphide did not become generally known until the publications by Talbot and Daguerre.

2. Heinrich Robert Goeppert (b. 1800, d. 1884) and Gebauer, Breslau, are reported to have shown microphotographs on daguerreotype plates with detonating gas on November 29, 1839 (E. Stenger, *Geschichte d. Photogr.*, 1938, p. 109).

3. Léon Foucault (1819-1868) was the son of a bookseller in Paris. This great physicist is widely known through his famous pendulum ex-

periment (to demonstrate the rotation of the earth) and through his determination of the speed of light. He made daguerreotypes approximately from 1843 and, with Donné, constructed an apparatus for microscopic demonstrations (*Compt. rend.*, 1844).

4. See *Recueil des travaux scientifiques de Léon de Foucault*, by C. M. Gabriel and Bertrand (Paris, 1878), and Sturmey, *Phot. Annual* (1898), p. 176. Foucault, with Donné, described an electrical photomicroscope.

5. J. Gerlach, *Die Photographie als Hilfsmittel mikroskopischer Forschung* (Liepzig, 1863); Moitessier, *La Photographie appliquée aux recherches micrographiques* (Paris, 1866; German ed., 1868).

6. *The Amateur Photographer* (April, 1903), p. 349.

7. *Physikalische Zeitschrift* (1904), p. 666.

8. Following Köhler's investigations in 1926, C. E. K. Mees suggested the use of the ultraviolet silver mercury line 365 mm. for microphotography. [Translator's note: Dr. Mees wrote to the translator "I have no recollection at all of Köhler's research in 1926."] A. P. H. Trivelli and L. V. Forster investigated this further in the Eastman Kodak Research Lab. (*Journ. Optic. Soc. Amer.*, February, 1931, Vol. XXI. See also Trivelli, *Kodak Scientific Papers*, No. 434, and *Phot. Indust.* (1931), p. 161.

CHAPTER LII

1. A. Miethe, for instance, used the old Taupenot silver iodide albumen process for photomicrography (*Zeitschrift f. Instrumentenkunde*, 1912, p. 190); E. Goldberg used Russell's tannic collodion dry process (*Phot. Indust.*, 1917, p. 448) and later fine grain silver chloride printing-out emulsions on glass (*Phot. Indust.*, 1926, p. 579) which require an especially intensive illumination for the microscope. Eder-Pizzighelli's silver chloride gelatine with chemical development were used for photomicrography (micrometer scales), owing to their superior fine grain.

CHAPTER LIII

1. Later J. J. Woodward wrote a paper, *Heliostat for Photomicrography* (1869).

CHAPTER LIV

1. On the history of photography from a balloon see Gaston Tissandier, *La Photographie en ballon* (Paris, 1886).

2. Nadar, "Artiste en daguerreotypie," as he called himself, had his studio in Paris, 113 Rue St. Lazare, in the second half of the past century. He died in 1910, in Paris, when 90 years old. Nadar published also *Petits albums pour rire, No. 1* (title in woodcut and 224 anecdotal illustrations

on 56 pages). Nadar's son later was a famous portrait photographer in Paris.

3. Nadar's British patent is number 2,425 for his balloon photography and is dated October 29, 1858.

4. John A. Tennant, in his monthly periodical *Photo-Miniature* (July, 1903, V, 145-173), published an article "Aërial Photography" on the work of Samuel A. King and J. W. Black with numerous illustrations. For earlier publications on this subject see A. Batut, *La Photographie aérienne par cerf-volant* (Paris, 1890); and H. Meyer-Heine, *La Photographie en ballon* (Paris, 1899); also the articles by the Reverend J. M. Bacon in the periodical *Photography* (London), April and May, 1893.

5. See Tissandier, p. 655.

6. See *Phot. Archiv* (1862), pp. 97, 99; (1863), p. 172; (1864), pp. 134, 409.

7. *Phot. Korresp.* (1885), p. 388. In Vienna, *Allg. Sportzeitung*, (September 25, 1885), No. 39, p. 895, as well as in its supplement attached to November 28, 1886, No. 48, pp. 1-4. V. Silberer, the editor, defends his priority with regard to the making of the first balloon photograph in Austria (see *N. Wiener Journal*, 1900, XXV, 9).

8. *La Nature* (February 26, 1887).

9. Miethe, *Photogr. Aufnahmen vom Ballon aus.* (1917).

CHAPTER LV

1. Laussedat's portrait in *Paris photographe* (1892), p. 241.

2. A. Laussedat, *Paris photographe* (1892), p. 471.

3. Chevalier also constructed in the 50's an attachment for photographic measurements of which an example was preserved in the military-technical collection in Vienna (see Pollack, *Mitteilung der k. k. geographischen Gesellschaft in Wien*, 1891, No. 4; see also Eder, *Jahrb. f. Phot.*, 1897, p. 506).

4. Obituary on Colonel Laussedat, see *La Phot.* (1907), p. 94, with portrait; *Le Mon. de la phot.* (1907), p. 25, as well as Eder, *Jahrbuch* (1907), p. 217.

5. See Laussedat, *Recherches sur les instruments, les méthodes et le dessin topographiques* (Paris, 1903); Laussedat, *La Métrophotographie* (Paris, 1899); V. Pollack, "Über photographische Messkunst" in *Mitteilungen der k. k. geographischen Gesellschaft in Wien* (1891); Paganini, *Fotogrammetrie* (Milan, 1901); C. Koppe, *Photogrammetrie und internationale Wolkenmessung* (Brunswick, 1896); C. Koppe, *Die Photogrammetrie oder Bildmesskunst* (Weimar, 1889); Meydenbauer, *Das Denkmälerarchiv und seine Herstellung durch das Messbildverfahren. Memoir.* (1896); Ed. Doležal, *Die Anwendung der Photographie in der*

praktischen Messkunst (Halle on the Saale, 1896); Ed. Doležal, *Die Photographie und Photogrammetrie im Dienste der Denkmalflege und das Denkmälerarchiv* (Halle on the Saale, 1899).

6. Eder, *Jahrbuch f. Phot.* (1910), p. 643.

CHAPTER LVI

1. Karl August Steinheil (b. 1801, Rappoldsweiler, Alsace; d. 1870, Munich) studied astronomy in Göttingen and Königsberg; he became professor of physics and mathematics in Munich, 1832; he occupied himself with work in telegraphy. In 1849 he entered the service of Austria as head of the Department for Telegraphy in the Ministry of Commerce, where he organized the telegraphic system in the Austrian monarchy. In 1851 he did the same in Switzerland, after which he was called as ministerial counselor to Munich; in 1854 he founded an optic-astronomical institution which produced excellent instruments. Karl August Steinheil is considered to be the scientific founder of electromagnetic telegraphy. He is said to have made the first daguerreotype in Germany.

2. Ed. Steinheil died 1878 on a trip to South America.

3. Moritz von Rohr, *Zur Geschichte der Zeissschen Werkstätte bis zum Tode Abbes, Forschungen zur Geschichte der Optik, Beilage zur Zeitschrift für Instrumentenkunde* (1930, Vol. I).

4. Dr. Paul Rudolph was a pupil and collaborator of Abbe's at Jena. The anastigmatic principle, determined by Rudolph in 1889, acknowledged the importance of high refractoring barium lenses for photooptics. During the first years the Zeiss-Rudolph anastigmats found only a rather unresponsive audience in Germany, whereas in France and Russia they were received enthusiastically. Rudolph remained with Zeiss, Jena, until 1910, when he resigned because of poor health. At the outbreak of World War I he was recalled to Zeiss for civilian service and calculated a strong teleobjective for balloon photographs. Released from this service, he calculated a new anastigmat, which is described later in this chapter. P. Rudolph's biography is to be found in Dr. von Rohr's *Theorie und Geschichte der photographischen Objektive* (1899), dedicated to him. Rudolph gives an account of his later activity in his writings: *Neue Gesichtspunkte für Anastigmate* (lecture delivered in Stuttgart on May 12, 1920), "Der Raumzeichner und die Zonenkreise sphärischer Korrektion" (in the periodical *Die Kinotechnik*, 1929, p. 339) and in a manuscript, "Dr. Paul Rudolph in eigener Sache," dated August, 1920. These writings of P. Rudolph are in the library of the Technische Hochschule, Vienna.

5. These are preserved in the Graphische Lehr- und Versuchsanstalt, Vienna.

6. The "plasmat" lenses belong in the group of "anastigmatic sphero-achromatic objectives" (German patent, No. 420, 223, of 1924 and 1925; and No. 426, 912, of 1926).

7. A description of Goerz's career will be found in the *Goerz-Festschrift*.

8. For a description of these earlier types of Goerz objectives see my manual *Photogr. Objektive* (1911); the author has placed the originals in the collection of the Graphische Lehr- und Versuchsanstalt, Vienna.

9. Emil von Hoegh (b. May, 1865, in Löwenberg, Silesia; d. January, 1915) was a descendant of a very old Danish aristocratic family. He had his first technical education in Karl Bamberg's precision workshops for optics and mechanics in Berlin, where the impulse to take up the study of optical instruments was awakened in him. He applied at the firm Carl Zeiss, Jena, by offering his coöperation on the basis of his theoretical research which he had carried on privately. He was engaged, but later the contract was canceled, probably at Bamberg's instigation. The latter had informed Zeiss that Hoegh often enough had proved that he did not have the slightest notion of the simplest mathematical principles. At first Hoegh was dependent entirely on himself, working in small shops in Southern Germany, working manually wherever he could find a job (M. v. Rohr, *Theorie und Geschichte des phot. Objektives*).

While laboring manually during the day, he continued way into the night his theoretical studies. He called one day on C. P. Goerz (see *Goerz-Festschrift*, the article by W. Zschokke) who at first treated him coldly; but Hoegh, sketching various forms of lenses on paper, continued: "I have in mind to calculate a symmetrical objective, in which the anastigmatic leveling of the image field is accomplished with a light intensity which at least equals that of lynkeioscopes. . . . If you want to assist me, I promise to submit to you the final calculation of the objective within a few weeks." In November, 1892, a model of the first double anastigmat was ready, and a patent for it was filed by Goerz in December 20, 1892, which was granted on May 5, 1893. Hoegh worked with Goerz until the middle of 1903; because of poor health he moved then to Rostock, later to Goslar (Harz), where he remained until he died. His biography may be found in *Phot. Korr.*, 1915, p. 85, and 1916, p. 6; portrait, same source, 1915, p. 133. Baltin in *Phot. Ind.*, 1930, p. 582, reports on this ingenious man's irregular mode of life.

10. For the history of the name "doppel-anastigmat" as applied to the Goerz objective see Léon Christman (*Phot. Indust.*, 1930, p. 904).

CHAPTER LVII

1. Lately Chapman (1924) and Kronfeld (1925) confirmed the validity of the law of reciprocity by Bunsen-Roscoe in mixtures free from

induction (see Eder, "Sensitometrie," in *Handbuch*, 1930, Vol. III, Part 4). The mystic nature of the "photochemical induction" kept many photochemists busy. R. Luther and E. Goldberg demonstrated in 1926 that traces of oxygen retarded the action of light when present in a chlorine detonating gas mixture. Since the oxygen acts as a negative catalyzer in photochemical chlorinations, it is only when the oxygen is exhausted that the photochemical reaction occurs undisturbed. It is thus that the phenomenon of induction is explained (Plotnikow, *Allgemeine Photochemie*, 1920, p. 94). The many investigations into the photochemical chlorine detonating gas reaction in reference to the kinetic reaction to the Einstein equivalence law and to the modern quantum theory, are exhaustively treated in Nathaniel Thon's report, "Die Chlorknallgasreaktion" *(Fortschritte der Chemie, Physik und physikalischen Chemie*, 1928, XVIII, No. 11; with a foreword by Max Bodenstein).

2. Eder, *Handbuch* (1884), I, 174 where also similar experiments made by Jordan, 1839, Hunt, 1845, Herschel, 1840, Claudet, Heeren, 1844, Schall, 1853, are described. Malagutti published the mentioned study in *Annal. de chim. et phys.*, LXXII, 5.

3. See Walter Hecht, "Das Graukeil-Photometer im Dienste der Pflanzenkultur; eine neue Methode zur kontinuierlichen Messung der Lichtintensität," *Sitzungsberichte, Akad. d. Wiss. in Wien, Math-Sc. Class IIa* (1918, CXXVII, 2283). Kissling's merits are there acknowledged and the more exact methods of photometry of the grayscale-photometer instead of the less exact paperscale photometers are defined.

4. Plotnikow erroneously reports in his *Allgemeine Photochemie* (1920), p. 64, that Eder and Valenta, in 1904, had found in a mixture of oxalic acid + mercury silver chloride the photochemical coefficient temperature as 1.19. The error was due to the fact that Eder's *Akademieabhandlung vom Jahre 1879* was published in Eder-Valenta, *Beiträge zur Photochemie*, in 1904, quoting, however, the original source. Because of the confusion between the years in Plotnikow's *Photochemie*, p. 61, E. Goldberg is mentioned as the first who, in 1902, called attention to these lowest photochemical coefficient temperatures; Eder's statement, however, was made some years earlier.

CHAPTER LVIII

1. *Annal. d. Physik u. Chemie* (1851), XXIV, 218.

2. See Sale, *Proceed. of the Royal Soc.*, XXI, 283; Poggend., *Annal.* CL, 333.

3. *Reports of the Berlin Academy*, 1875, p. 280; 1876, p. 95.

4. [The selenium cell is now regarded as out of date and has been replaced by various forms of photoelectric cells. Note by William Gamble.]

CHAPTER LIX

1. For Dr. R. L. Maddox and the invention of gelatine-emulsion plates see also *Photography* (1901), p. 56 and portrait; W. Jerome Harrison, *A History of Photography* (Bradford, 1888); *Brit. Journ. of Phot.* (1901), p. 425; Richard Jahr in *Handbuch* (1930), Vol. III, Part 1, ch. 1.

2. Maddox's fellowcountrymen also shared the opinion that it was he who invented the silver bromide gelatine plate. The president of the Royal Photographic Society of Great Britain proposed at the meeting of August 1, 1901, that the Progress Medal be awarded to Dr. R. L. Maddox as "the inventor of the gelatine silver bromide dry plates, causing a revolution in photography and its application," which was accepted unanimously. This distinction, bestowed upon Dr. Maddox as the inventor of the silver-bromide gelatine plate, is all the more important since it was awarded to him by British experts, his contemporaries, who were the best judges of the conditions. I should like to point this out to those who have doubts as to Maddox's share in this invention.

3. See Maddox's complete biography in *Brit. Journ. Phot.* (1902), pp. 425, 427; and obituary, *Brit. Almanac* (1903).

4. *Photographisches Archiv* (1881), XXII, 120.

5. The founder of the firm Wratten & Wainwright was F. C. L. Wratten; he died April 8, 1926, in London at the age of 86.

6. *Bull. Soc. franç. d. phot.* (1879), p. 204; also *Phot. Korresp.* (1879), XVI, 149.

7. According to W. Ostwald's later theory of ripening, the larger silver bromide particles increase at the expense of the smaller ones which are more soluble (see Lüppo-Cramer in *Handbuch*, 1930, III(1), 47). For W. Ostwald's theory of the chemical development of the latent image see his *Lehrbuch der allgemeinen Chemie* (1893), II, 1078; also Eder, *Handbuch* (1903), III, 871.

8. The hypothesis as to the formation of three silver bromide modifications to which J. S. Stas referred in his determination of atomatic weight and which Monckhoven used for the explanation of the "ripening process" are not sufficient. J. M. Eder was the first to point this out, in June, 1881 (*Phot. Arch.*, 1881, p. 109); he was of the opinion that in the process of ripening silver bromide gelatine the silver bromide was reduced very little and that these traces of silver are involved with the increase of the sensitivity. Thus the silver bromide of the ripe emulsion must contain a minimal surplus of silver. Weigert and F. Lühr, as well as H. H. Schmidt and F. Pretschner, confirmed this much later by chemical quantitative analysis (see Eder, "Das Reifen der Bromsilbergelatine," *Zeit. f. wissensch. Phot.*, 1930). The later theory of electronics also adopts Eder's opinion of the development of free silver during the ripening of the silver

bromide gelatine; S. E. Sheppard at the 8th International Congress for Photography, Dresden, 1931 (see *Phot. Indust.*, 1931, p. 905), reported on this. See *Handbuch* (1927), II(1), 9.

9. In 1883 Carl Haack, Vienna, sold a dozen dry plates, size 19 x 12 cm. for 1 gulden 30 kreuzer, plates size 18 x 24 cm. for 4 gulden 80; silver bromide gelatine in the shape of noodles, preserved in alcohol, for 14 gulden per kilogram.

10. Director Simeons moved later to London, where the gelatine factory "Simeons" still exists to this day. The factory in Winterthur continued to produce its own kind of gelatine.

11. Carl Haack (b. 1842, Schwerin; d. 1908) came to Vienna in 1865. As chemist he devoted himself to photography, especially to reproduction photography, and worked in his own studio for the photoengravers Angerer and Göschl (Vienna III, Landstrasse, Hauptstrasse) until they opened their own studio. In 1888 he sold his dry-plate factory, started in 1879, in which he had first introduced the fulminating silver method, in 1881, to Engelhardt and Schattera (later Langer & Co.). He then moved to Dresden, where he painted landscapes. Biography and portrait are in *Phot. Korresp.* (1909), p. 585.

12. Professor Ferd. Hrdlička and Professor Alexander Lainer were teachers at the Graphische Lehr- und Versuchsanstalt, to which they had been called by Director Eder. Engineer-chemist Ferdinand Hrdlička (b. 1860), the son of an estate-manager in Moravia, attended the German Staatsrealschule in Brünn, graduated from the chemical training school of the Technische Hochschule, in Vienna, in 1882. He worked for one year as chemist in a sugar refinery. After this he worked with the inventor of the collotype process, Professor Husnik, in Prague, studying various techniques of reproduction; in 1884 he started a photoengraving establishment in Vienna, where he produced collotypes and zinc etchings. In 1889 he was called as teacher to the Graphische Lehr- und Versuchsanstalt; in 1893 he resigned, however, to start a factory in Vienna for the production of photographic paper, where he also introduced (1895) his invention of "Rembrandt-celloidin-papers"; his business grew and produced finally all kinds of photographic paper commonly used in the trade, as well as all sorts of photographic plates. He is still active today after having combined with the photographic works of Professor Alex. Lainer as partner in the firm Lainer & Hrdlička.

13. The factory for dry plates and films, Hauff, in Feuerbach, near Stuttgart, developed from the chemical works which Julius Hauff established in 1870 for the production of fatty preparations; he produced there pure phenol, salicylic, and picric acid for the armed forces (1888), etc. After his death his son, Dr. Fritz Hauff, produced, among other

items, also by-products for the coal-tar industry and photographic preparations. As early as 1890 they attempted the production of dry plates. At that time more stress was laid on the production of developer preparations. Dr. A. Bogisch, the chemist with the firm of Hauff, was extremely successful in this field (metol, amidol, glycin, ortol, etc.). In the early years of the 20th century the production of dry plates and films on a large scale was taken up in Feuerbach.

14. Berkeley, *Phot. News.* (1882), p. 41; *Phot. Korresp.* (1882), p. 47.

15. Berkeley, *Phot. News* (1882), p. 41; he also drew attention to the use of acidulous alum baths as agents for the prevention of yellow fog on negatives *(Brit. Journ. Phot.,* 1881, p. 59).

16. Carey Lea, *Brit. Journ. Phot.* (1877), pp. 192, 304; also *Phot. Archiv* (1877).

17. Carey Lea, *Brit. Journ. Phot.* (1880); *Phot. Archiv* (1880), p. 104.

18. *Phot. Korresp.* (1879), p. 223. In a letter of May 7, 1880, to the *Brit. Journ. Phot.* Carey Lea admits that Eder's mixture of ferro-vitriol and potassium oxalate is preferable to other, more complicated ferro developers.

19. According to a statement of L. Tennant Woods *(Brit. Journ. Phot.,* 1927), Dr. Baekeland is supposed to have been the first to introduce the metal-hydroquinone developer for developing positive paper images (for "the velox paper invented by him" in 1893). This statement must be closely examined, because historical data quoted from this source are questionable. The "invention" of the velox paper is also erroneously credited to the same Mr. Baekeland by these sources. This does not differ from the invention of Eder and Pizzighelli of silver chloride gelatine with chemical development. When the Eastman Co., in 1899, took over Baekeland's plant, they also continued the metal-hydroquinone developer as standard for their silver bromide gelatine films.

20. It was first Carey Lea (in his article "Comparative Influence of Soluble Chlorides, Bromides and Iodides on Development," *Brit. Journ. Phot.,* 1880, p. 304) and Dr. Székely, of Vienna, in *Phot. Korresp.* (1882), p. 57 (Eisenoxalat-entwickler), who in their experiments added potassium iodide to the ammonia pyrogallic developer for the purpose of retarding development without, however, achieving the so-called "Lainer effect."

21. The basic invention which made the bromoil print possible also originated from E. Howard Farmer's research.

CHAPTER LX

1. S. E. Sheppard of the Eastman Kodak Research Institute in Rochester published such a diagram in the *Journal of Chemical Education,* 1927, Nos. 3-6.

2. For further progress of photography into the ultraviolet see Guthrie lecture, Society of Physics, by Professor M. Siegbahn, *Studies in the Extreme Ultra Violet and the Very Soft X-Ray Region* (1933).

3. "The Infra-red Content of Daylight," G. B. Harrison, Ph.D., and "Development in Infra-red Photography," Olaf Block, F.I.C., *Phot. Journal* (August, 1932, and April, 1933).

4. "Recent Advances in Sensitizers for the Photography of the Infrared," by Brooker, Hamer, and Mees in *Abridged Scientific Publications from the Kodak Research Laboratories*, 1933-1934 (XVI, 75, Communication No. 513).

5. Taken from "Fifty Years of Photography," by C. E. K. Mees, printed in *Industrial and Engineering Chemistry* (1926), XVIII, 916.

CHAPTER LXI

1. A biography, *Sir J. W. Swan, a Memoir*, by Mary Edmonds Swan and K. R. Swan, is published by Ernest Benn, 1929.

2. *Phot. Korresp.* (1883), p. 332; (1884), p. 330. German patent (D.R. P.) No. 26,620, April 15, 1883. Schlotterhoss exhibited his automaton for copying in the Electrical Exhibition, 1883, in the Rotunde, Vienna.

3. The chemist Dr. E. Just was the first manufacturer of silver bromide and chloride gelatine in Vienna. About 1880-83 he produced only albumen paper, which at that time was the predominantly used copying-out paper. In 1883 he took up the production of gelatine emulsion developing paper.

4. The first automaton for copying used by the Neue Photographische Gesellschaft, Berlin, is illustrated in Eder's *Jahrbuch* (1896), p. 479.

CHAPTER LXII

1. In Ludwig Darmstaedter's *Handbuch zur Geschichte der Naturwissenschaften und der Technik* (2d ed., Berlin, 1908, Julius Springer, p. 791) appears the following note: "1881, Eder and Pizzighelli discover the silver chloride gelatine paper as positive paper and the silver chloride gelatine emulsion process at which the image appears completely in the emulsion during the exposure, so that it need no longer be developed further, but needs to be only toned and fixed." This statement is erroneous. Eder's and Pizzighelli's silver chloride gelatine process concerns itself with the bringing forth of the latent light-image by means of chemcial developers, while on the other hand the silver bromide gelatine copying-out paper has been invented by Abney.

2. F. Stolze, who later in his small factory manufactured commercially silver bromide and silver chloride gelatine paper (the latter after Eder's and Pizzighelli's publication) introduced as a variation of the toning with gold the mixed gold fixing bath for toning such photographs, a process

which had been previously applied for collodion and aristo papers; it was a composition of sodium thiosulphate, alum, table salt, ammonium, sulpho-thiocyanate and some chloride of gold *(Phot. Wochenbl.,* 1887, p. 54).

CHAPTER LXIII

1. See Eder, "Sensitometrie," in *Handbuch* (1930), Vol. III, Part 4.

2. Josef Plener convinced this author that Warnerke was a Russian by birth. Plener was a Pole in czarist Russia and at that time involved in a Polish revolt against Russia. He fled to London as a Russian emigrant. He devoted himself to photography and invented his centrifugal machine for using silver bromide in the production of gelatine emulsions. In 1882 he came to Vienna to work in Eder's laboratory. Later he started the dry-plate factory Löwy-Plener, in Vienna, the firm which first manufactured Eder's orthochromatic erythrosin plates. In London, Plener had close personal contact with Warnerke, with whom he was able to converse in Russian, his mother tongue, and he always described Warnerke as a Russian.

3. Scheiner's complete biography is found in *Vierteljahresschrift der Astronomischen Gesellschaft,* 1914, Vol. XLIX.

4. Dr. Franz Stolze, son of Wilhelm Stolze (b. 1798, d. 1867), who was founder of a German shorthand system named for him. Dr. F. Stolze was a physicist and a chemist, and he turned successfully to photography about 1880. As early as around 1870 we find his articles in technical periodicals, mostly dealing with the collodion process. He joined an archaeological expedition to the ruins of Persepolis (equipped by the Prussian State) as a photographer; he used on this occasion silver bromide collodion plates with an alkaline solution of carmine sulphuric acid and a gum-sugar preservative. He achieved magnificent negatives *(Phot. Wochenbl.,* 1881, p. 245). He suggested the backing of the plates with auri-collodion to keep the images free from halo (1882); he started and ran a small factory for photographic paper in Berlin; he introduced the use of potash in pyrodeveloper for silver bromide gelatine plates; he found a method of photographic determination of location without a timepiece and the junction of the intersecting points (1893). He started the *Photographisches Wochenblatt,* a well-known periodical (1882-89), and the *Photographischer Notiz-Kalender* (1896), etc.; he wrote monographs on apparatus for panorama, enlargements, stereoscopes, etc. (W. Knapp, Halle). Of special importance are his experiments and publications on the determination of the sensitivity and graduation of photographic plates, reported in *Handbuch* (1930), Vol. III(4), "Sensitometrie." By profession Stolze was a teacher of shorthand at the University of Berlin and had the title professor.

5. Literature on the gray scale: Dr. E. Goldberg, "Die Herstellung neutral grauer Keile und veraufender Filter für Photometrie und Photographie" (*Jahrb.*, 1911, p. 149; see also *Zeitschr. f. wissensch. Phot.*, 1912, p. 238; *Phot. Korresp.*, 1917, p. 82); A. Hübl, "Die Bestimmung der farbenempfindlichen photographischen Platten," *Phot. Korresp.* (1918), p. 379; (1919), p. 363.

6. The controversy between Eder and Goldberg (*Phot. Ind.*, 1927, Nos. 11, 18; also Eder's "Sensitometrie," *Handbuch*, 1930, III(4), 396) determined Stolze's priority in the use of the gray scale in sensitometry.

7. Experiments by Janssen, Abney, and others are described in great detail in Eder's "Sensitometrie," *Handbuch* (1930), III(4), 174.

8. Dr. Kron's family left Potsdam after his death, and later inquiries remained fruitless.

CHAPTER LXIV

1. See *Phot. Korresp.* (1899), p. 68.

2. Schiendl, *Geschichte der Photographie*, described the invention of the color-sensitive process quite incorrectly. Owing to some sharp, though justified, criticisms on the part of H. W. Vogel (*Phot. Mitt.*), Schiendl became his personal antagonist. L. Schrank, of Vienna, his counselor, also had personal differences with Professor Vogel, a temperamental person who wrote the truth with a virulent, though justified, pen. This caused Schiendl to lose his clear and objective judgment of the situation. He states in his *Geschichte* (p. 169) that H. W. Vogel published in May, 1884, his (Vogel's) color-sensitive collodion process "on the basis of investigation published by Schultz-Sellack in 1871." Schiendl cites there the *Berichte der deutschen chemischen Gesellschaft* (1871) and *Pogg. Annal.* (1871). Strange to say, the source to which the author refers does not contain one single word justifying his denial of Vogel's independent discovery. If one studies the source to which Schiendl refers, one will find an article by Schultz-Sellack on the reaction of silver iodide, and so forth, to the spectrum; but this has no bearing whatever on Vogel's famous discovery of color-sensitive photography. H. W. Vogel increased the color-sensitivity—always keeping in mind the result which he wished to obtain—by adding dyestuffs to silver bromide. Schultz-Sellack used the old process of iodide-bromide and iodide-chloride collodion without the least addition of a sensitizing color substance. It is this which makes it quite useless for correct orthochromatic photography, while Vogel's discovery initiated a complete reversal in the photographic reproduction of colored objects. H. W. Vogel and Eder have corrected Schiendl's statement in *Phot. Korresp.* (1891), p. 154, and *Phot. Mitt.*, XXVII, 243, 325.

3. H. W. Vogel, *Ber. d. deutsch, chem. Ges.* (1873), VI, 1305, and (1875), 1635; *Phot. Mitt.*, IX, 236.

4. *Brit. Journ. of Phot.* (March, 1874); *Phot. Mitt.*, XI, 27, 97.

5. Azaline plates were hardly suitable for portrait photographs, because the cyanine reduced the entire sensitivity considerably.

6. H. W. Vogel was occupied in 1884 also with eosin plates, and by adding "eosin silver" to the silver bromide emulsion he produced ortho-chromatic plates which showed good color sensitization together with a greater general sensitivity. For the exploitation of this matter he sought collaboration with the Munich photo-technician J. B. Obernetter, who introduced the plates on the market as "Obernetter-Vogel-eosin-silver plates." After Obernetter's death, on March 12, 1887, Vogel was connected with the dry-plate factory of Otto Perutz. It may be mentioned here briefly that the early Obernetter-Vogel-eosin-silver plates proved perishable, due to the predominance of silver salt, which led to complaints. They avoided this objection later by limiting themselves in neutralizing the disturbing excessive potassium bromide, which was characteristic of the washed emulsion, by adding silver nitrate or eosin silver.

7. The author, who was connected with Dr. Vogel in constant scientific and personal relations, possessed a broad basis for a historical record of his life and career. In addition to this Professor E. Stenger, one of Vogel's successors at the Berlin Technische Hochschule, sent the author further interesting data and also a portrait of young Vogel (1865). Stenger also enriched the biographical material very appreciably.

8. H. W. Vogel, *Die Photographie auf der Londoner Weltausstellung 1862* (Brunswick, 1863); also in Bollmann, *Photogr. Monatshefte* (1862), Nos. 6-9.

9. Vogel, *Praktische Spektralanalyse irdischer Stoffe*, was published in 1877, and a second edition in 1889.

10. The seemingly common use of photographs on cards of identification, passports, etc., probably was due to a suggestion of H. W. Vogel, who initiated them on the admission tickets to the Berliner photographische Ausstellung, in 1865, which was a matter for ridicule in the *Brit. Journ. Phot.* (1865), p. 227.

11. Two books, *Vom indischen Ozean bis zum Goldlande* (Berlin, 1877), and *Lichtbilder nach der Natur* (Berlin, 1879), contain popular-scientific descriptions of his travels and of his research work.

12. Everywhere Vogel found recognition, even abroad; notwithstanding this, France calls him in a special issue of the *Figaro Photographe* (1892), on the occasion of a photographic exhibition on the Champ-de-Mars, in four places the "Autrichien," and the "Viennois," respectively; and in addition a portrait appears there of a bearded man who is not Vogel at all! (Stenger)

13. First in serials 1867-70; then in the 2d ed., 1874; 3d ed., 1878; 4th ed., in several volumes, 1890-99; only under his name, but completely revised, the work was published, 1925-28, in Berlin (ed. by E. Lehmann); Ernst König had already issued in 1906 a 5th ed. of the volume *Photochemie und photographische Chemikalien*. Anyone who wants to know H. W. Vogel more thoroughly needs to read the earlier original editions.

14. *Phot. Mitt*, 1868, IV, 293, 320.

15. See autobiography in Brockhaus, *Konversationslexikon* (13th ed., 1887), p. 305, where he is said to have edited all technical terms in photography; also *Photogr. Rundschau* (1895), IX, 62.

16. For necrology on Vogel and his portrait see *Phot. Mitt.*, 1901, XXXVIII, 279.

17. Also published in *Phot. Archiv* (1878), p. 109.

18. *Compt. rend.*, LXXXVIII, No. 3, p. 119; No. 8, p. 378; *Phot. Korresp.* (1879), p. 107.

19. Ducos du Hauron does not seem to have appreciated the importance of the orthochromatic process (for instance, the eosin collodions) for true color values of monochrome reproductions, but had always in mind only its application to the three-color process.

20. See Eder and Valenta, *Beiträge zur Photochemie und Spektralanalyse* (Vienna and Halle a. S., 1904), III, 131; *Phot. Korresp.* (1899), p. 336.

21. See Eder. *Phot. Korresp.* (1904), p. 215.

22. Eder defended his claims to priority for the discovery of erythrosin as a sensitizer in a controversy directed against Mallmann and Scolik; see his "Zur Geschichte der orthochromatischen Photographie mit Erythrosin," *Phot. Korresp.* 1890), p. 455; also Eder and Valenta, *Beiträge zur Photochemie und Spektralanalyse* (1904), III, 78.

23. *Sitzungsberichte d. kais. Akad. d. Wiss.* (Vienna, 1884), XC, 1097.

24. Eder's original study was published under the title "Über das Verhalten der Haloid-Verbindungen des Silbers gegen das Sonnenspektrum und die Steigerung ihrer Empfindlichkeit durch Farbstoffe," *Sitzungsberichte d. kais. Akad. d. Wiss.* (Vienna, December 4, 1884); printed in Eder and Valenta, *Beiträge zur Photochemie und Spektralanalyse* (1904).

25. In the periodical *Graphische Künste* (Vienna, 1885), Eder published a profusely illustrated study on the use of erythrosin plates for the reproduction of paintings. The reproduction on p. 653 of the German edition is made from an orthochromatic negative on erythrosin-cyanide plates and shows a preponderance of red.

26. Valenta's red color sensitization of silver bromide collodion with ethyl violet was introduced in all classes at the Graphische Lehr- und Versuchsanstalt, Vienna (1898). Guido Raubal, who studied there in

1898-99, learned of it. When he was employed by the British factory making silver bromide collodion he brought with him the ethyl violet which had been given to him. It had been unknown there as a sensitizer up to this time, and it was he who introduced it successfully into manufacture. At the outbreak of the World War Raubal returned to Austria; he fell in Galicia. Paul Szulmann, assistant at the Graphische Lehr- und Versuchsanstalt (b. January 25, 1887, in Budapest) introduced ethyl violet in France, in the engraving establishment of Louis Geissler, Paris; he used ethyl violet in combination with Albert's silver bromide collodion; Szulmann went later to Belgium; he served in the World War as an officer in the reserve, and in 1919 took a position with Ullmann in Berlin; later with W. Büxenstein in Berlin.

27. This memorial tablet was removed after his death.

28. Pope took this product erroneously for Höchster pinachrom, which contains two ethoxy groups. The constitution of the British dyestuff is 6'-methoxy-6-ethoxy-1-1'-diethylisocyanineiodide; that of the Höchster product, 6'-ethoxy-6-ethoxy-1-1'-diethylisocyanineiodide (bromide).

29. On rubrocyanine see Eder, "Sensitometrie," Handbuch (1930, III(4), 242), and Dieterle, in Handbuch (1932, Vol. III, Part 3).

CHAPTER LXV

1. Lüppo-Cramer defends his claims to priority against Lumière and Seyewetz in his book, "Die Grundlagen der photographischen Negativverfahren," in Handbuch (1927, II(1), 678).

CHAPTER LXVI

1. The term "film" originates in the Anglo-Saxon word "filmen," i.e., the scum which forms on boiled milk.

2. Handbuch (1927), Vol. II(3).

3. John W. Hyatt, the inventor of celluloid (see Eder, Jahrbuch, 1915-20, p. 21), died, 82 years old in June, 1920, at Newark.

4. Eastman's biography and the growth of the Eastman Kodak Company is exhaustively described in the work, George Eastman, by Carl W. Ackerman (1930); also, "George Eastman und sein Lebenswerk," by Dr. Fritz Wentzel, of Binghamton, N. Y., in Phot. Korresp. (1927), pp. 161-67, and various articles in photographic almanacs and periodicals. (See also Epstean in Photo-Engravers Bull. Sept. 1935, pp. 10-27).

5. See Photogr. News (1888), p. 578; also described in detail in Eder, Handbuch (1892), I(2), 545, illus. 711. The manipulation of this hand camera with the fixed focus and good, inexpensive objectives, with two symmetrical lenses like the Steinheil periscopes, the focal difference which

is calculated in the permanent focal fixation, was simple, and the developing and loading of the camera was done by Eastman Dry Plate and Film Company, which was then the official name. At that time was coined the slogan, "You press the button, we do the rest," which was painted in big letters on the face of the Eastman Company building and which every dealer in photographic materials appropriated for his own.

6. *Everybody's Magazine* (New York, June, 1926), p. 24; F. Wentzel, *Phot. Korresp.* (1927), p. 161.

7. Eder *Jahrb. f. Phot.* (1903), p. 475.

8. *Phot. Archiv* (1893), p. 522; *Phot. News* (1894), p. 469; *Phot. Wochenbl.* (1901), p 312; *Deutsche Phot. Ztg.* (1901), p. 849.

CHAPTER LXVII

1. Sacher, *Phot. Korresp.* (1897), p. 1; F. Paul Liesegang, *Kinotechnik* (1919), No. 4.

2. J. Plateau, "The Inventor of the Stroboscope," in *Bull. de l'Académie royale de belgique*, 1883, 3d ser., Vol. VI, Nos. 9-10.

3. A complete description of Plateau's disk, together with a sample table, is found in the Göttingen University Library, Section Phys. Math., II, 3620. The illustration of Plateau's stroboscope shows a diameter of 24 cm. F. Paul Liesegang, to whom we are indebted for the most detailed history of the invention of the stroboscope (see *Die Kinotechnik*, 1924, Nos. 19-20), illustrates the first table of Plateau with the stroboscope disk.

4. See Biography by J. Herr, "Simon Stampfer, eine Lebensskizze," in *Almanach der Kaiserlichen Akademie der Wissenschaften* (Vienna, 1865), XV, 189-216. On pages 212-16 we find Stampfer's various writings listed. The passage on the stroboscopic disks reads: "In passing we mention only . . . his stroboscopic disks, which made his name known everywhere."

5. "Über die optischen Täuschungs-Phänomene, welche durch die stroboskopischen Scheiben hervorgebracht werden" in *Jahrbücher des k. Polytechnischen Institutes in Wien* (1834), XVIII, 237-58. The insert issued with the 2d ed. of the tables is entitled: *Die stroboskopischen Scheiben; oder, Optischen Zauberscheiben, deren Theorie und wissenschaftliche Anwendung, erklärt von dem Erfinder S. Stampfer.*

6. Stampfer's description of his Austrian patent for the stroboscope, in which the first attempts at cinematography are based, reads as follows: "Application for a two-year privilege of Simon Stampfer, professor at the k. k. Polytechnisches Intitut, and of Mathias Trentsensky, both of Vienna, on the invention of the stroboscopic disks. Granted May 7, 1833; expired 1835. The principle on which this device is based is that any act of vision which creates a conception of the image seen is divided into a suitable number of single moments; these present themselves to the eye in rapid

succession, so that the ray of light falling on the change of the images is interrupted, and the eye receives only a momentary visual impression of each separate image when it is in the proper position. The easiest way is to draw these images on cardboard or any other suitable material on the periphery of which are pierced a sufficient number of openings for viewing—depending on the number and the speed of the images. Revolving these disks on their axes rapidly in front of a mirror the animated images are seen in the mirror through the openings." (For a description of the invention and improvements for which the Austrian patent was granted see the official patent office publications Vol. 1, covering 1821-35 (Vienna, Government Printing Office, 1841).

7. See O. Volkmer, *Wiener phot. Blätter* (1897), p. 92; Sacher, "Zur Geschichte der objektiven Darstellung von Reihenbildern," *Phot. Korr.* (1897), p. 1.

8. For an illustration of both apparatus see F. Paul Liesegang, "Uchatius und das Projektions-Lebensrad" in *Kinotechnik* (1920), Vol. II, Nos. 7-8.

9. See F. Paul Liesegang, *Kinotechnik* (1921), No. 1.

10. Eder, *Jahrbuch f. Phot.* (1912), p. 288; Wilhelm Dost, *Geschichte der Kinematographie* (1925), p. 13.

11. The motion picture periodical, *Le Cinéopse* (1924), p. 449.

CHAPTER LXVIII

1. For Muybridge's biography see Sir Sidney Lee, *Dictionary of National Biography* (London, 1912), 2d Suppl., II, 668-69; Konrad Wolter, *Filmtechnik* (1928), IV, 239, 258, 281; Wolter and Seeber, *Filmtechnik*, special issue on the occasion of the Leipzig Spring Fair (1930), p. 1.

2. Marey's report, *La Chronophotographie* (Paris, 1899), p. 6.

3. K. Wolter and Guido Seeber, "Zwei Hundertjährige," in *Filmtechnik* (1930), Vol. VI, Part 5, p. 2.

4. K. Wolter describes Muybridge's technique of exposure in Pennsylvania precisely in *Filmtechnik* (1928), IV, 258.

5. A copy of this work is in the library of the Höhere Staatsgewerbeschule, Vienna I, now called Technischgewerbliche Bundeslehranstalt. A new edition, illustrated with halftones, appeared under the title, *Animals in Motion*, London, 1899, a copy of which is in the library of the Graphische Lehr- und Versuchsanstalt, Vienna.

CHAPTER LXIX

1. Janssen was an astrophysicist and director of the Astrophysical Observatory, Paris; he discovered the possibility of observing the protuberances on the sun even when there was no solar eclipse; he had an obser-

vatory established on Mont Blanc for investigating the influence of the atmosphere on the solar spectrum reaching the earth. His bust was unveiled in Meudon, October 31, 1920.

2. W. Campbell constructed an incomplete "photographic pistol" with a rotary plate in 1861.

3. The conference was presided over by Admiral Mouchez, at the time director of the Paris observatory. The Austrian government was represented by Professor Dr. E. Weiss, director of the university observatory, Vienna, the German by Professor Dr. H. C. Vogel and Dr. O. Lohse, Potsdam.

4. On Marey see *Die Filmtechnik*, 1930, special issue for the spring fair in Leipzig; also obituary by R. du Bois-Reymond, *Naturw. Rundschau*, XIX, 904.

5. Marey wrote a number of works on motion: *Physiology médicale et la circulation du sang; Du mouvement dans les fonctions de la vie; La Machine animale locomotion terrestre et airienne; Développement de la méthode graphique par la photographie* (Paris, 1884); *Le Vol des oiseaux; La Locomotion et la photographie* (Paris, 1886); *Le Mouvement* (Paris, 1894); *La Chronophotographie* (Paris, 1899); *Fonctions et organes* (Paris, 1902).

6. From a pamphlet distributed in Paris in 1926; published by Eder in *Kinotechnik*, 1926.

CHAPTER LXX

1. Ottomar Anschütz's biography (d. May 28, 1907, Berlin), written by his son in *Umschau* (1927), p. 483.

2. Anschütz took also photographs of military maneuvers; on Krupp's shooting range at Meppen near Essen he tried to take photographs of projectiles. The shutter was closed over the plate through its own weight (exposure one-millionth of a second). The shutter was released electrically by the shell itself, which broke the current connected with the camera.

3. Eder, *Jahrbuch f. Phot.* (1888), p. 176; (1891), p. 35.

4. See Eder's *Handbuch* (1893), I(2), 592.

CHAPTER LXXI

1. For further information see F. Paul Liesegang, *Phot. Ind.* (1915), p. 330; *Zahlen und Quellen zur Geschichte der Projektionskunst und Kinematogr.* (Düsseldorf, 1926), p. 67.

2. Henry V. Hopwood, in his book *Living Pictures* (1889).

3. The French motion picture periodical *Le Cinéopse* opposes strongly a committee of the Société Franç. de Phot. assembled March 31, 1924, which consisted, not of practical experts in motion picture photography,

but of physicians, etc., who unjustly intended to attribute to the physician Marey the priority in the invention, which was not due to him.

4. Friese-Greene (b. 1855 in Bristol, d. May 5, 1921, as he was about to address a meeting) devoted himself with great skill to the field of stereoscopic and color motion picture photography (see *Brit. Journ. of Phot.*, 1921, p. 281). He had an extraordinary talent for invention and exceptional dexterity in mechanics, although he was unable to surmount even the elements of chemistry and physics. Effective as he was as an inventor, he died in poverty, having sacrificed most of his money on the invention of printing electrically without inks (*Phot. Korr.*, 1921, p. 208).

5. C. W. Ackerman, *George Eastman* (1930).

6. The synchronized combination of film with the gramophone, attempted by Edison, could not be made practical for the cinema industry until the electrical sound transmission was possible through the invention of the "amplified tubes." This invention is to be credited mainly to Philipp von Lieben, of Vienna, and his collaborators Reiss and Siegmund Strauss, who, independently of but simultaneously with the American Lee de Forest, had in 1910 constructed the first tubes of this kind. This step opened the way to the sound film.

7. The detailed description of construction of Edison's kinetoscope is to be found in Eder, *Jahrb. f. Phot.* (1896), p. 389.

8. The term "cinématographe" was used by Bouly in a French patent application as early as February 12, 1892. From this term the abbreviation "cinéma" was derived.

9. See *Phot. Korresp.* (1896), p. 217. Lumière's first patent was later followed by supplementary patents.

10. Max Skladanowsky showed on November 1, 1895, in the Berlin Wintergarten filmstrips, which he had taken with an apparatus invented by him. These "bioscope" performances were presented as rather unimportant interludes between two numbers in a variety show. These projected motion pictures were primitive; they showed dancers, acrobats, and the like. The filmstrips were very short; it did not take longer than six seconds to show one of them. This was why they were glued together in rolls and projected successively without interruption in the same way as were picture strips in the earlier marvel drum. The positives of the film strips were perforated at the margin, and metal eyelets were inserted. The projected images flickered considerably. Skladanowsky produced only eight images per second. Two projection apparatus, which contained the same film rolls and worked simultaneouslsy, were used for each projection. During intervals of darkness in one apparatus, the other was kept projecting to fill the pause. There were always two identical images projected on the screen in order to achieve a frequency of sixteen images per second.

Skladanowsky had this projection apparatuss patented, D.R.P. No. 88,599, November 1, 1895. The Skladanowsky brothers intended to show this method in Paris in spite of its imperfections. They arrived in Paris at the end of December, 1895, and made a contract with the Folies Bergères according to which the "biograph" should be put on the program for January, 1896. But there the Lumière brothers got ahead of them with a performance of their "cinèmatographe" which was by far superior to that of the Skladanowsky brothers. While the Folies Bergères paid the Skladanowsky brothers the stipulated fee, they canceled the show. ("Diskussion um Skladanowsky," by Guido Seeber and Konrad Wolter, in *Filmtechnik*, 1931, VII, 1).

11. K. Albert, *Neues Wiener Tageblatt* (July 19, 1924); Beranek, in *Filmtechnik* (1925), p. 296, with illustrations of Reich's apparatus.

12. Ludwig Mach, Ernst Mach's son, carried through in practice the cinematographic time lapse photography of plant growth *(Phot. Rundschau, 1893, p. 121).*

CHAPTER LXXII

1. Ernst Mach, *Phot. Korresp.* (1884), p. 282; E. Mach, "Beitrag zur Mechanik der Explosionen" (*Sitzber. d. Akad. Wiss.* Vienna, July, 1885); E. Mach, *Die spektrale und stroboskopische Unterscheidung tönender Körper* (Prague, Calve, 1873); Eder, *Jahrbuch* (1888), p. 286.

CHAPTER LXXIII

1. *Edinburgh Journ. of Science* (1826), p. 319.
2. *Handbuch* (1912), I(3), 432.
3. On Van der Weyde see *Handbuch* (1912), I(3), 439, where also Liébert's night studio is described.
4. The first establishment equipped for the extensive commercial production of enlarged photographs on linen was started by M. L. Winter (1824-99) in Vienna in 1877.
5. *Phot. News* (1865), p. 550; *Phot. Wochenbl.* (1883), p. 79.
6. See P. Baltin's memoirs (*Phot. Rundschau*, 1930, p. 74). It had been mentioned earlier that Trail Taylor had used and described such lycopodium.
7. Capt. Botton and Colomb constructed magnesium flares for night signaling in the merchant marine; these flares burned for 3, 5, 8, 12, or 15 minutes *(Phot. Archiv,* 1865, p. 381).
8. See *Jahrb. f. Phot.* (1896), pp. 26, 423.

CHAPTER LXXIV

1. *Compt. rend.,* X, 485.

2. *Ibid.*, 1839, VIII, 246.

3. *Athenaeum*, No. 670; Dingler, *Polytechn. Journ.*, LXXVII, 467.

4. *Repert. of Pat. Inv.*, Jan., 1844, p. 47. Dingler, *Polytechn. Journ.*, XCII, 44.

5. *Photogr. Korresp.*, 1903, p. 230.

6. Blanquart-Evrard is also the inventor of albumen papers for photographic prints. This is erroneously ascribed to Le Gray or Talbot by writers not familiar with the facts.

7. Eder, *Jahrb. f. Phot.*, 1888, p. 440 (with portrait).

8. *Phot. News*, 1882, p. 300.

9. An exhaustive history of celloidin and aristo paper is published in *Handbuch*, 1928, Vol. IV, Part 1 (Fritz Wentzel).

10. *Handbuch*, 1928, IV(1), 144.

11. *Photogr. Korresp.*, 1900, p. 317.

12. E. Valenta, *Phot. Korresp.*, 1900. York Schwartz, in Hanover, applied for a German patent on April 6, 1902, for a printing-out paper with a silver phosphate emulsion.

13. Eder, *Jahrb. f. Phot.*, 1893, p. 53.

14. I copy here the statement in Blanquart-Evrard's *La Photographie, ses origines, ses progrès, ses transformations* (Lille, 1870), p. 182. Ignorant of this source, I cited Le Gray's priority in 1850 for the gold toning of paper copies, in *Handbuch*, 1899, IV, 6.

15. Valicourt, *Manuel de Phot.*, 1851, p. 345.

16. Eder, *Jahrbuch f. Phot.*, 1895, p. 484.

17. Alphonse Davanne (b. 1843, d. 1912) was distinguished by his research in the field of photography. He was an amateur photographer with a studio in his own private house. He laid the basis for our knowledge of the chemical changes during the photographic copying process with silver chloride. He was active in the progress of photolithography, a founder of the French Photographic Society, one of the presidents of the International Congress for Applied Chemistry in Vienna, 1898 (Photographic Section) and of the French Photographic World Exposition. He wrote: *La Photographie; traité théorique et pratique* (1886-88); on Nicéphore Niépce (1885); on Poitevin (1882); on Gillot (1883); report on the World Exposition in Vienna (1873), etc.; with Louis Barreswil and others *Handbuch d. Phot.* (1854, German ed., 1863-64).

18. *Bull. Soc.. franç.*, 1902, p. 223.

19. *Photogr. Korresp.*, 1902. p. 650.

CHAPTER LXXV

1. Engl. patent, No. 100,098; *Brit. J. Phot.*, 1917, p. 303.

2. Traube's English patents are: Nos. 147,005; 163,336; and 163,337. Traube's American patent is No. 1,093,503, dated 1914.

CHAPTER LXXVI

1. John Herschel, "On the Action of the Solar Spectrum," *Phil. Trans.* 1842; also *Photogr. Archiv,* 1864, p. 467.

2. *Photogr. Korresp.,* 1897, p. 78.

3. According to Pizzighelli and Hübl *(Die Platinotypie,* 1883) the salts of iridium produce no image with this process, while with palladium salts nice brown pictures are obtained.

4. *Phot. Korresp.,* 1887 and 1888.

5. *Phot. Korresp.,* 1894, p. 518.

6. Hübl, *Der Platindruck,* 1895; also *Phot. Korresp.,* 1894, p. 555.

7. Wilhelm Glotz contributes to the *Kartographische Zeitschrift* (Vienna), 1922, Vol. X, an article on the centenary (1818-1918) of the Vienna Military Geographic Institute.

CHAPTER LXXVII

1. G. Douglas elaborated photographic tracing on zinc plates in 1920 at the English-Egyptian Cartographic Institute, Cairo, and published the details of what was called the "Douglasgraphy."

CHAPTER LXXVIII

1. The chemical factory of Van der Grinten, in Holland, also produced black tracing papers with special diazo mixtures; they were patented in England and France (March 23, 1927), but not in Germany, owing to precedence of Kalle's patents (see Eder and Trumm, "Lichtpausverfahren," in *Handbuch,* 1930, IV(4), 230).

CHAPTER LXXIX

1. Mungo Ponton, b. 1801, d. August 3, 1880, in Clifton, England.

2. *Edinb. New Philosoph. Journ.,* 1839, p. 169.

3. In making this statement we must consider many superficial and erroneous reports of the historical development of photography with chrom salts, which state that Ponton is called the discoverer of the sensitivity of gelatine chromate to light. Many errors of this sort, relating to the use of chromates in photography, are copied by some writers from other authors and so disseminate the errors in literature by repetition. This incorrect statement is printed in the unreliable *Geschichte der Photographie* (1891), by Schiendl, which Eder properly corrected in *Photogr. Korrespondenz* (1891, p. 151).

4. Hunt's *Researches on Light* (1854), p. 175; *Athenaeum* (1843), No. 826; Dingler, *Polytechn. Journ.,* XC, 413.

5. See Hunt, *Manual of Photogr.* (1854).

6. *Compt. rend.*, XXXVI, 780; Dingler, *Polytechn. Journ.*, CXXVIII, 296.

7. India ink was known as a dyestuff (see Simpson, *Swan's Pigment-druck.*, German ed. by Vogel, Berlin, 1868, p. 10).

8. Poitevin, we must note, also applied for a patent, December 13, 1855, for his photogalvanic method—manifestly later than Pretsch.

9. A portrait of Alphonse Louis Poitevin appeared in *Paris-Photographe* (1892).

10. *Phot. Archiv* (1882), p. 94; *Phot. Korresp.* (1882), p. 94; also, Poitevin, *Traité des impressions photogr.* (Paris, 1883, 2d ed.).

11. *Bull. Soc. franç. phot.* (1856), p. 214.

12. Seely, the publisher of the *American Journal of Photography*, also proposed the use of chromated gum (1858) without adding anything new to the problem.

13. *Bull. Soc. franç. phot.* (1862), p. 99.

14. Eder, *Handbuch* (1926), IV(2), 38.

15. *Bull. Soc. franç. phot.* (1858), p. 213; Liesegang, *Der Kohledruck* (1884), p. 8.

16. *Bull. Soc.. franç. phot.* (1860), p. 314. Poitevin sued Fargier, or rather the licensee Charavet, for infringement on his patent and won the suit *(Brit. Journ. Phot.*, 1865, p. 304).

17. Obituary in Eder's *Jahrb. f. Phot.* (1915-20), p. 22.

18. See Swan, "Mein Anteil am Verfahren zur Herstellung von Kohle-bildern" *(Jahrbuch f. Photographie*, 1894, p. 275). For the biography of Swan see *Brit. Journal* (1904), p. 990; also, the monograph on the life and works of Swan.

19. Edgar Hanfstängl (b. July 15, 1842, in Munich, d. in Munich May 29, 1910) owned from 1868 the "Franz Hanfstängl, kgl. bayr. photographische Hofkunstanstalt und Kunstverlag in München." He was one of the first to use the eosin silver wet collodion process as practiced with A. Braun's or H. W. Vogel's bath methods for his reproductions of paintings. He used a large turntable for his exposures, which he preferred to make by direct sunlight. See Ch. LXXXVI regarding Edgar's father (Franz Hanfstängl).

20. The jury which awarded this prize consisted of: the president of the Vienna Photogr. Gesellschaft, Regierungsrat Professor Dr. Emil Hornig; the vice-president of the society, Von Melingo; Schriftführer Hofphotograph Professor Fritz Luckhard; Hofphotograph Viktor Angerer; Supervisor Franz, of the Banknotenfabrikation der Österreichisch-ungarischen Bank, Vienna; also Captain G. Pizzighelli, photographer and chemist, Dr. Szekely, in Vienna, kais. Rat Anton Martin, the chemistry professor Dr. Alexander Bauer of the Technische Hochschule, Vienna, the re-

production technician Professor J. Husnik, Prague, Jos. Leipold, supervisor of the government institution for cartography (reproduction section), and G. Scamoni of the Imperial Russian delegation for the production of government securities in St. Petersburg.

21. The sensitivity to light of gelatine chromate in the spectrum (maximum 470 to 430 in blue and violet) was determined later by Eder (*Zeitschr. f. Physik*, 1920, XXXVII, 235).

CHAPTER LXXXI

1. H. F. Farmer, mentioned here, who died January 4, 1926, is not to be confused with E. Howard Farmer (Ch. LIX and Ch. LXXXIII) who at this time (1931) lives in London, about 70 years of age. The note in *Jahrb. f. Phot.* (1921-27), p. 105, is due to a mistake in names. H. F. Farmer spent a great deal of his life in Patagonia, but returned later to London, where he worked assiduously in photography.

CHAPTER LXXXII

1. Rawlins was born in 1876, in Liverpool, where he received his scientific education at the university; afterward he devoted himself to sculpture. He took an early interest in photography. He exhibited his work often at the Photographic Salon in London.

CHAPTER LXXXIII

1. E. J. Wall was a chemist who occupied his time intensively with photography. He spent his early years in London, where he published, in 1889, a photographic technical journal, *The Photographic Answers*. In this periodical he undertook, among other subjects, to translate Eder's *Photographie mit Bromsilbergelatine* (Vol. III of Eder's *Handbuch d. Phot.*, chapter "Herstellung von Emulsion"). He also translated into English the work of Fritz, *Lithographie*, E. König's *Farbenphotographie*, and Mayer's *Bromöldruck*. He was the publisher of the *Photographic News* from 1896. Later Wall became teacher of three-color photography at the London Council School of Photo-engraving. He was also active in the photographic industry. He came to the United States in 1910, engaged by the Fire-proof Acetylcellulose Co., Rochester, worked with Technicolor Motion Picture Co., Boston. In his last years he worked exclusively in publishing photographic literature. He was assistant editor of *American Photography*, Boston, where he built up the most important photographic publishing house in the United States. Wall's most important works are *The History of Three-Color Photography* (1925, 732 pages); *Practical Color Photography* (Boston, 1922, 1928); *Photographic Emulsions*

(1929); *Photographic Facts and Formulas* (1929), and other works. He died in Boston (Mass.), October 13. 1928.

CHAPTER LXXXIV

1, Compare Lafon de Camarsac, *Application de l'héliographie aux arts céramiques aux émaux, à la joaillerie, aux vitraux ou transformation des dessins photographiques; memoire présenté à l'académie des sciences* (Paris, 1855); Lafon de Camarsac, *Portraits photographiques sur émail,* (Paris, 1868).

2. *Bull. Soc. franç. phot.* (July, 1858), p. 220.

3. See Martin, *Handbuch der Emailphot.* (1867), p. 49.

4. On modern methods see Schwier, *Handb. d. Emailphotographie,* 3d ed. (Weimar, 1885).

5. Compare *Phot. Korresp.* (1871), p. 55, and (1895), p. 544.

CHAPTER LXXXV

1. Other unsubstantiated claims for priority were fought by Auer in his brochure, *Das Benehmen eines jungen Engländers* (Vienna, 1854). He discusses there the fact that in 1852 the Englishman Henry Bradbury had learned to know from Auer, in Vienna, the process of nature prints and then illegally claimed for himself the priority for the invention (see Wurzbach, *Neue freie Presse,* from July 30, 1869).

2. See the publication on the occasion of the celebration of the centenary of the Government Printing Office, Vienna, 1904; for the biography of Auer see Professor Arthur W. Unger's, *Die Geschichte der k. k. Hof- und Staatsdruckerei, Archiv f. Buchgew.* (1905) February and March issues; and Wurzbach in *Neue freie Presse* of July 30, 1869.

3. In the Vienna Hof- und Staatsdruckerei appeared the following works illustrated with nature prints: C. v. Ettingshausen, *Photographisches Album der Flora Österreichs, zugleich ein Handbuch zum Selbstunterricht in der Pflanzenkunde,* with 173 tables (Vienna, 1864). *Die Blatt-Skelette der Dikotyledonen mit besond. Rücksicht auf Untersuchung u. Bestimmung d. fossilen Pflanzenreste,* with 276 physiotypes printed in the text and a map with 95 color charts and 1,042 nature prints (Vienna, 1861); *Üb. Castanea vesca u. ihre vorwelt. Stammart,* with 17 tables of nature prints (1872); Ettingshausen and Pokorny, *Physiotypia plantarum austriacarum. Der Naturselbstdruck in sein. Anwendung auf d. Gefässpflanzen d. Österreichisch. Kaiserstaates, mit besonderer Berücksichtigung der Nervation in den Flächenorganen der Pflanzen,* Vols. I-V, tables 1-500 (Vienna, 1856).

4. Freiherr Ignaz von Plener was an influential Austrian official of the Department of Finance, who became later the head of it; still later he be-

came minister of commerce and member of the upper house of the Legislature. During the time when this party was in power the Government Printing Office was greatly cramped in its efficiency, but it survived. The famous old Imperial Vienna Porcelain Factory, more than 100 years old, fared worse. This was entirely discontinued, much to the sorrow of later generations. It was not until after the World War that the factory was rebuilt.

5. Carl Auer von Welsbach (b. September 1, 1858, in Vienna, d. August 4, 1929, in Schloss Welsbach) achieved the invention of the incandescent gas light in 1885, based on his studies of alkaline earths. He invented the osmium incandescent lamp and the pyrophore cer-iron. His biography, written by Eder, appeared in the *Zeitschrift des niederösterr. Gewerbevereins*, Vienna (1929), a society of which Auer was an honorary member. It was Eder who undertook the spectrum analysis research of Carl Auer's cracked and decomposed alkaline earths.

CHAPTER LXXXVI

1. Franz von Kobell, *Die Galvanographie, eine Methode, gemalte Tuschbilder durch galvanische Kupferplatten im Drucke zu vervielfältigen* (Munich, 1842; 2d ed., Munich, 1846). See also the discussion of Kobell's inventions in Martin's *Repertorium der Galvanoplastik und Galvanostegie* (1856). Also Eder's *Handb. d. Phot.*, 1922, Vol. IV, Part 3.

2. See Alois Dreyer, *Franz von Kobell, sein Leben und seine Dichtungen*, Munich, 1904.

3. Martin, *Repertorium der Galvanoplastik und Galvanostegie* (Vienna, 1856), p. 123.

4. See Martin.

5. Franz Hanfstängl advanced lithography in Germany to its great development; he published many lithographs, designed and drawn on stone by his own hands; he reproduced 190 large paintings of the Dresden museum at government expense. In 1848 he devoted himself zealously to the electrotyping process named after him.

6. For biography of Franz Hanfstängl with portrait see *Leipziger Illustrierte Zeitung* (March 10, 1904).

7. Franz Theyer, of Vienna, exhibited electrotypes at the 21st meeting of German scientists and physicians in Graz. With Dr. E. Weidele he established, 1842, in Vienna a laboratory for galvanoplastic (electrotyping-plating). See *Verzeichnis der bei der 21. Versammlung deutscher Naturforscher und Ärzte in Graz ausgestellten Produkte der Galvanoplastik aus Theyers Laboratorium.*

8. "Versuch der Wiederbelebung durch Hubert Herkomer und Henry Thomas Cox," in Eder, *Jahrb. f. .Phot.* (1897), p. 479.

CHAPTER LXXXVII

1. In Vienna are preserved such etched daguerreotype gravure plates, dating from 1843 (reproduction of the painting "Palace with Ornamentations"), signed: "After Prof. Berres's etched daguerreotype by Jos. Axmann." For more information about Axmann see Bodenstein, *Hundert Jahre Kunstgeschichte Wiens in den Regesten,* 1898.

2. A. Martin, *Repertorium der Photographie* (1846), II, 75.

3. In the 1905 German edition of this *History* a facsimile in gravure is bound in as Table III. In the 4th German edition (1932) this is reproduced in halftone.

4. *Excursions daguerriennes* consisted of 114 illustrations, which cost 114 francs; each of the prints could be purchased separately for one franc.

5. The attention of the author was called to this article by Pretsch by Mr. Edgar Hunter, managing director of the Printing Press Firm, London, 26-29 Poppings Court, Fleet Street, in a letter dated June 20, 1908.

6. Government Printing Office.

7. See Fizeau, *Vervielfältigung der Lichtbilder durch Abziehen einer galvanischen Kopie eines Daguerreotyps;* Martin, *Repertorium der Phot.* (1846), I, 120; (1848), II, 100; also Dingler, *Polyt. Journ.,* LXXX, 155; XCIII, 216.

8. In 1848 Becquerel *(Compt. rend.,* XXVII, 13) made the same observation.

9. Poitevin, *Traité de l'impression photographique* (Paris, 1862), pp. 4-9.

CHAPTER LXXXVIII

1. See Wurzbach, *Lexikon,* XXIII, 280; also Fritz, *Festschrift zur Enthüllungsfeier der Gedenktafel für Paul Pretsch* (Vienna, 1888, printed privately by the "Verein der Wiener Buchdrucker und Schriftsetzer Wiens"), *Phot. Korr.,* 1874, p. 47.

2. This London World Exhibition included for the first time exhibitors from different countries.

3. Pretsch never published the details of his method. However, we know them accurately from the publications of his pupil Leipold, Director of the Government Printing Office in Lisbon *(Phot. Korresp.,* 1874, p. 180; compare also *Phot. Korresp.,* 1874, p. 46).

4. De la Rue was the first to use the collodion process in photography successfully during the eclipse of the sun, on July 18, 1860.

5. Nègre's photogalvanographs were exhibited at the London World Exposition, but they were then imperfect, showing hard edges and coarse middle tones (H. W. Vogel, *Die Photographie auf der Londoner Weltausstellung, 1862,* Brunswick, 1863, p. 38).

6. Georg Scamoni's biography is printed in Chapter XCVI. It is of historical interest to note the helio-galvanoplastic process which he used. This process depended on collodion negatives strongly intensified with mercury chloride, silver nitrate, and pyrogallic acid. Scamoni's predecessor, the Englishman Osborne, used this process and produced such photographic reliefs, silver plated with tinfoil *(Phot. Archiv,* 1864, p. 271).

7. *Bull. Soc. franç. phot.* (1862).

8. Harrison, *A History of Photography* (London, 1888), p. 135; see also *British Journal of Photography* (1885), pp. 167, 581, 596, and *The Photographic News* (1885), pp. 578, 600.

9. J. W. Swan had the same idea and at about the same time withdrew his claim; however, he accorded Woodbury priority because the latter had first made his invention public (see *Phot. News,* 1865, pp. 387, 397, 489, 502, 512).

10. It was necessary to trim Woodburytypes and to mount them on cardboard, owing to the adhering smudgy edges.

11. Emil Mariot was born January 7, 1825, in Kromau, Moravia, and died in Vienna on August 7, 1891. His portrait and biography are published in Hornig's *Jahrb. f. Phot.* (1885). Obituary, *Phot. Korresp.* (1891), p. 398 (with picture), also *Phot. Rundschau* (1891), pp. 107, 383.

12. The Austrian one hundred and one thousand gulden banknotes, as well as the later twenty kronen notes (1900), and other banknotes, were printed from electrotypes.

CHAPTER LXXXIX

1. Steel plates were used as early as 1820 for steel engravings by the Englishman Charles Heath. Same size reproductions on steel (after the manner of litho-transfers and their etching method) were probably described first by Jonas, in *Frankfurter Gewerbefreund* (1842).

2. See *Handbuch* (1922), Vol. IV, Part 3.

3. Aquatinta-Manier: Joh. Heinr. Meynier states in his *Anleitung zur Ätzkunst* (1804) about this: "The Aquatinta-Manier differs from the ordinary art of etching and crayon manner in that the shading is not produced either by cross-hatching or stippling, but, if I may be permitted to say so, by a ground of rosin, with which the plate is dusted and which forces the acid to bite the copper to quite a rough surface. Stopping out (covering) varnish and rosin varnish are painted on to permit the acid work only where shading is to be," etc. At first the rosin was dusted on the plate through an ordinary sieve, and therefore Meynier claims to have been the first to have used the so-called "dusting box." He himself states, however: "I have my doubts that I may justly claim the invention of this machine, for I learned subsequently that other workers in aquatint use

similar boxes although I never saw one." This so-called dust grain has lately been used on collotypes. See also K. Kampmann, "Titel und Namen der verschiedenen Reproduktionstechniken," in *Österr.-ungar. Buchdruckerzeitung* (1891).

4. Niepce de Saint-Victor, *Traité pratique de gravure héliographique* (Paris, 1856), p. 44.

5. Nègre also invented the decorations for and on metal (sort of damascene lace effect) by photography. He copied designs on metal, coated with asphalt, developed them and goldplated them galvanoplastically. He also produced in the same manner intaglio plates *(Bull. Soc. franç. phot.,* 1856, p. 334; Kreutzer's *Jahresber.,* 1856, p. 119).

6. See *La Lumière* (1854), pp. 159, and (1885), p. 43.

7. *La Lumière* (October 21, 1854), p. 165. A beautiful collotype by Ch. Nègre appears in Monckhoven, *Traité général de photographie* (2d ed., 1856).

8. Cosmos, *Revue encyclopéd.,* III, 615; Liebig's *Jahresbericht* (1854), p. 202; Kessler, *Photographie auf Stahl, Kupfer usw.* (Berlin, 1856).

CHAPTER XC

1. In the previous edition of this *History* (3d ed.) Talbot's "Photoglyph" (illus. 299) is reproduced by collotype. In the 4th ed., on page 850, a halftone plate is printed.

2. See *Handbuch*, IV, 499; also *Phot. Korresp.* (1867), pp. 191, 193. H. Garnier exhibited collotype copper etchings made by the chromate process, which he kept secret. He probably proceeded along the way prescribed by Talbot (chromated gelatine plates etched in iron chloride), with some improvements; also, probably he introduced the double or multiple copying of lights and shadows of the image and the multiple etching process, however, this author can only conjecture this.

3. This coincides with the introduction of silver bromide collodion emulsion for orthochromatic negatives.

4. Karl Klič's name is not on the official list of regular students at the Academy of Fine Arts in Prague.

5. The licensed firms which had purchased Klič's process kept it very secret, but the manipulation of the method gradually filtered through the workmen into public knowledge. In 1886 Hans Lenhard, an employee of J. Löwy, in Vienna, who was not connected with the collotype department, but achieved inside information from workmen, published the details of the process in the periodical edited by him, *Der photographische Mitarbeiter*. This was followed in the publication by Rudolf Maschek of the Military Geographic Institute in Vienna of the Klič process in Eder's *Jahrb. f. Phot.,* 1887 and 1891, and soon after this date other publicity followed (see *Handbuch,* 1922, Vol. IV, Part 3).

6. In 1881 Victor Angerer, who conducted a large art institute in Vienna, introduced Klič's process, producing collotypes for the annual report of the Imperial Art Collections. His son-in-law, the copper etcher Blechinger, increased the business considerably, with V. Angerer in the following year, and alone after 1886. In 1893 Blechinger (with Leykauf and later with Raimund Rapp) introduced collotypes with great success, which until that time were produced by Boussod and Valadon in Paris, almost alone.

7. The German word *Rakel* ("doctor," in English) is derived from the Low German *rak* which means *straff* (taut). A tightly stretched, thin steel band with a knife edge is attached on rotogravure presses and removes from the surface of the gravure cylinder any excess of printing ink. The doctor was first used in printing of textile goods, carpets, and wallpaper. In modern speed printing presses for rotogravure, the doctor is decidedly important.

8. Adolf Brandweiner (b. February 26, 1866, in Suchenthal, Bohemia) attended a technical school at Salzburg, 1883-84. He was then employed in the Rentsch reproduction establishment, Dresden, and in Sach's Engraving Company, and in Manchester. Later he assisted in the introduction of the rotogravure process in the cotton print factory Cosmanos, in Josefstal, Bohemia. During the summer of 1891 he was a student at the Graphische Lehr- und Versuchsanstalt in Vienna, where he perfected his process of employing the "doctor" in rotogravure and where he also presented his results before the Vienna Photographische Gesellschaft (*Phot. Korresp.*, January, 1892).

9. The president of the Vienna Kunstdruck A. G. was Kommerzialrat Albert Rott (d. May 27, 1931) the director of the factory, Kovac. The building was erected in the garden of the former plate factory of J. Löwy fronting on Parkgasse 15-19.

10. In his last years Th. Reich was employed by *Wiener Bilder* as superintendent of the rotogravure printing plant. His portrait was printed in that periodical on October 4, 1931.

11. The process consisted in copying a positive on silver bromide gelatine paper by exposing it for a few seconds under an electric light. Then a screen was copied on it, the print was developed in amidol, immersed as in the bromoil process in a bleaching bath. It was then squeezed onto the copper plate, and the insoluble silver image was brought out with warm water. It was etched in perchloride of iron acid solution.

CHAPTER XCI

1. The detail of this method was published by Lemercier, Lerebours, Barreswil, and Davanne in February, 1854, in *Bulletin de la Soc. d'En-*

couragement (1854, p. 84); see also *Handbuch*, 1922, IV(3), 356; also Dingler, *Polytechn. Journ.*, CXXXII, 65, and especially Barreswil and Davanne, *Die Anwendung der Chemie auf die Photographie* (German by Schmidt, 1860), p. 461.

2. An example is preserved in the collection of Graphische Lehr- und Versuchsanstalt in Vienna.

3. See Poitevin, *Traité de l'impression photogr. sans sels d'argent* (Paris, 1862), p. 79. Poitevin, *Bull. Soc. franç. de phot.* (February, 1857). English patent, February 23, 1858, No. 357; Snelling's *Photographic and Fine Art Journal* (1858), p. 337.

4. *La Lumière* (1856), p. 54; Horn, *Phot. Journ.* (1856), VI, 10.

5. Gottlieb Benjamin Reiffenstein (b. Sept. 10, 1822, at Cölleda, near Erfurt; d. March 27, 1885, in Vienna) frequented the Royal Art School at Erfurt. He came to Vienna in 1842, found a position in the studio of the professor of architecture, Ludw. Förster, where he worked on drawings and copper etchings for Förster's published works. With Ludw. Rösch he bought the lithographic business of Joh. Rauh, Vienna, which soon prospered as Reiffenstein & Rösch, owing to the former's artistic talent and Rösch's business ability. In the early sixties he became interested in photography, and with Karl von Giessendorf he endeavored to introduce photolithography, especially by the asphalt process, into his company. His splendid success is shown by the examples exhibited at the first photographic exhibition in Vienna (1864). After Giessendorf's death, in 1866, he continued the work in the same field with Ludwig Schrank. Uninterruptedly the asphalt process was carried on; the half-tone process was elaborated into the manufacture of three-color plates after the system of Ducos du Hauron. The difficulties which he met owing to insufficient prevailing knowledge of color filters seemed insurmountable and were so discouraging that Reiffenstein turned, aided and abetted by his artistic staff, entirely to manual chromolithography. His work stands eminent in the reproduction of the old and modern masters of fine arts, true to the original paintings and as commercially required by the taste of that period.

6. See Kampmann, "Geschichte der Photolithographie mittels Umdruckpapieres" (Eder, *Jahrbuch f. Photogr.*, 1896, p. 293).

7. *Annuaire général et international de la photogr.* (1895), p. 141.

8. History of zinc plates for flat press printing, see Kampmann, *Phot. Korresp.* (1890), pp. 267 ff.

9. Paper was coated with chromated gelatine, on which a negative was copied, rolled up with greasy ink, and developed in water with a sponge. There remains the image in greasy transfer ink of the portions exposed to light.

10. See the periodical *Engineering* (June, 1888); Eder, *Jahrbuch f. Phot.* (1889), p. 67.

11. See British Association, *Report of the Meeting* (1861), p. 263; also *Brit. Journ. Phot.*, VII, 240; Kreutzer's *Zeitschrift f. Phot.* (1861), III, 24.

12. Eder, "Beiträge zur Geschichte und Theorie der Algraphie" (Eder, *Jahrb. f. Phot.*, 1908, p. 132).

13. The process of copying halftone negatives directly onto aluminum plates coated with albumen or chromated fish glue ("algraphische Autotypie") was first completed by Regierungsrat Fritz, assistant director of the Government Printing Office in Vienna and published in *Phot. Korresp.*

14. Langenheim's so-called "hyalotype" process (Ch. xli) is not related in any way to that of Hann.

15. Karl Kampmann came from a middle-class Viennese family. He was the son of a master glazier, Lorenz Kampmann, born July 8, 1847. He worked at lithography and etching on glass and studied at the Graphische Lehr- und Versuchsanstalt in Vienna, to which Director Eder later appointed him teacher of photolithography. He wrote many articles on lithography, photolithography, zincography, and on nature prints, which he first published in Eder's *Jahrb. f. Photographie*. His publications include: *Die graphischen Künste* (Leipzig, 1898); *Die Literatur der Lithographie von 1798 bis 1898; Titel und Namen der verschiedenen Reproduktionstechniken* (Vienna, 1891); *Geschichte der Lithographie und der Steindrucker in Österreich* (1898). He retired in 1909, moved to Baden near Vienna, where he died July 12, 1913. His biography, entitled *Karl Kampmann*, by J. M. Eder, and examples of his lithographic works were published in 1918 by the Graphische Lehr- und Versuchsanstalt in Vienna.

CHAPTER XCII

1. See *Phot. Korresp.* (1868), p. 274.

2. The history of the invention of the collotype process and its variations is treated exhaustively in the brochure by August Albert, *Die verschiedenen Methoden des Lichtdruckes* (1900).

3. J. Husnik and Carl Klič applied for an Austrian patent for the production of printing plates for securities which could not be counterfeited, on October 31, 1875 (Kl. IX, 234. N).

4. *Phot. Mitteil.* (1868 and 1870).

5. See *Die Grossindustrie in Österreich*, Vol. VI; *Geschichte der Photographie und der photomechanischen Verfahren*, by J. M. Eder (1900).

6. Concerning "collotype by letterpress" see Arthur W. Unger, *Phot. Korresp.* (1902), p. 152; *Österr.-Ung. Buchdr.-Ztg.* (1902), p. 181; *Ar-*

chiv f. Buchgew. (1902), p. 182. A. W. Unger, professor at the Graphische Lehr- und Versuchsanstalt in Vienna, referred in his writings also to "Duplexlichtdruck" (duplex collotypes), as well as to the use of stereotypes as carriers of the collotype gelatine.

CHAPTER XCIII

1. Relief etchings on copper, or ektypography, was the name which A. Dembour, an engraver in Metz (Lorraine), called the relief process invented by him in 1834. He made drawings on copper plates with greasy varnish and etched away the bottom, which was not covered by the varnish. This is perhaps one of the first publications on the so-called relief etching for letter press printing (German by H. Meyer, 1835, with 8 illustrations). The use of galvanic baths for depositing metal, as an etching ground, came from the Dane C. Piil. He called his process "chemitypy," which he described as follows in his work of 1846: "Zinc is a positive metal. I cut or etch a design on such a polished zinc plate, and the depression created is filled in (melted in) with a negative metal. The original positive zinc plate is now deepened by etching with a certain acid, and the design, which at first seemed below the surface, appears now as a raised die. This is possible only because the melted metal composition, owing to the galvanic action agitated between the two kinds of metal, is not affected by the acid, which attacks only the positive zinc." Nègre invented, in 1867, a process in Paris, by which a steel plate, coated with asphalt or bichromate of glue and having a photographic image copied on it, was gold-plated in a galvanic bath. The gold, of course, was deposited only on the bare portions of the plate; after the asphalt or glue ground were removed. The gold image on the metal could be etched with the proper acid *(Phot. Archiv, 1867, p. 171).*

2. As late as 1878 Mörch proposed a similar way, trying to copy a halftone gravure plate on a grained transfer paper, which he proposed again to transfer on zinc or stone *(Phot. News, 1886, p. 761).*

3. A. Albert, *Verschiedene Reproduktionsverfahren* (1900).

4. C. Angerer never published his process of etching zinc according to what was called "nach der Wiener Methode." It is, however, described in exact detail in Mörch's *Handbuch der Chemigraphie und Photochemigraphie* (Düsseldorf, 1886) alongside the French method, which was somewhat different. The history of C. Angerer and Göschl, an engraving firm, was published as a memorial on the 50th anniversary, 1871-1921.

5. The family of Carl Angerer in Vienna is not related to the brothers Ludwig and Viktor Angerer, who are mentioned in Chapter XLIII.

6. The process of transferring drawings on metal for etching is still used, especially for industrial designs.

7. C. Grebe, "Geschichte der Raster," *Zeitschr. f. Reproduktionstechnik* (1899), p. 19; see also Gamble, in *The Photographic Journal* (1897), p. 126.

8. *Bull. Soc. franç. phot.* (1859), pp. 116, 211, 265; Grebe (note 7 above), p. 21.

9. Burnett, *Journ. Phot. Soc.* (London, 1858), No. 74, p. 98.

10. Mathey (1864), Kiewic (1866), see *Jahrbuch f. Phot.* (1892), p. 474; also in Woodbury's patent of December 4, 1872 (No. 3659), in which negatives of mosquito netting were used: Jaffé (1877), Thevoz, Gamble (see Grebe, *Zeitschr. f. Reproduktionstechnik*, 1899, p. 19); also with crossed copper wire (*ibid.*, p. 20). Woodbury discontinued the experiment with mosquito netting.

11. Egloffstein, *Abridgement of Specification Relat. to Phot.* (London, 1872), p. 127.

12. Grebe; see note 7 above.

13. See Anthony's *Photographic Bulletin* (1895), p. 136; Eder, *Jahrb.* (1896), p. 470.

14. Swan, *Phot. Korresp.* (1866), p. 155.

15. *Phot. News* (1868), p. 355.

16. [Max Jaffé died December 14, 1938, at the age of 93. An American branch of the Vienna firm was established and incorporated at 40 East 49th Street in New York City under the name of Arthur Jaffé, Inc.–Translator.]

17. On Jaffé's construction of a glass studio see *Handb.* (1893, Vol. I, Part 2), and supplementary volume, p. 34, illus. 40-41; also *Phot. Korresp.* (1871), p. 57.

18. The history of "similigravure" is printed in *Le Procédé* (1928), p. 48.

19. The term "autotypie," designating the halftone letterpress process, is not used in England, where it is called "halftone process"; in France it is called "photogravure à demi-teintes" or "similigravure"; in Italy, "mezzotinta." For "Raster" the English use the name "screen," the French "trame," the Italians "reticola."

20. Heinrich Riffarth, the founder of the Berlin firm Meisenbach, Riffarth & Co., was born on August 10, 1860, in Munich-Gladbach, where his father was a publisher. After having been graduated from the gymnasium, he studied chemistry in the laboratories of Vienna and Salzburg at the government technical high schools. The writings of Ducos du Hauron, Tessié du Motay, and others urged him to proceed farther into photochemical research, and he became one of the first pioneers and a famous promoter of the photochemical reproduction technique in Germany. He died January 21, 1908.

21. *Phot. Korresp.* (1884), p. 180, and 1885, p. 454; *Phot. Mitteil.*, XXI, 198.

22. The earlier process, which Frederick Ives patented August 12, 1878 (see *Phot. News*, 1883, p. 498), consisted in blackening evenly a photographic chromo-gelatine relief, which was transferred onto a raised or grained paper; it then presented the appearance of a chalk drawing and was again transferred to metal and worked up for letter press printing. Proofs of this process of Ives are shown in *Jahrbuch* (1889), Vol. II.

23. For useful receipts see Eder's *Rezepte und Tabellen* (6th ed., 1905).

24. The use of etching machines in the graphic arts is very old. In Diderot's great *Encyclopédie* of 1767 will be found the description of a machine for copper etchings, in which the etching tub was agitated by a clock movement. In 1856 Pretsch etched metal plates by blowing the acid on them. Louis Levy sprayed the acid vertically onto flat plates. Later other varieties of etching machines were put on the market.

25. *Transactions of the Royal Society of Canada* (1895), Vol. I, section iii, p. 29; also *Phot. Mitteil.*, XXXVI; Eder, *Handb. d. Phot.* (1928, Vol. II, Part 4, "Autotypie" by Eder and Hay).

26. American fish glue is soluble in cold water and is produced from the refuse of fish.

27. To complete the record: H. W. Hyslop, in *American Journ. of Phot.*, 1896, p. 362, claimed the priority for the copper enamel process. His first publication and the description of the fish glue method appeared in *Artist Printer*, Chicago, in October, 1892. S. H. Horgan, in *Inland Printer*, 1929, LXXXIII, 107, took his part and believed Hyslop to be the inventor of the fish glue enamel process.

28. *Phot. Korresp.* (1900), p. 562.

29. See Eder's *Jahrb. f. Phot.* (1901), p. 222; also A. C. Angerer, "Über Kornätzung," *Phot. Korresp.* (1921), p. 251; R. B. Fishenden, *Process Engraver's Monthly* (1909), p. 226; and the same in *Process Year Book* (1917) Vol. XIX and (1920) Vol. XXII.

30. Husnik and Häusler, *Kornautotypie mit ungefärbtem Glasraster* (February, 1901); see also *Jahrbuch* (1901), p. 222.

31. Emanuel Spitzer applied for a patent (1901) in Berlin for his invention, describing the development of an "Eigenkorn" (specific grain) which is produced in the light-sensitive bichromate glue top. According to later investigations, small drops of glue solution are segregated, which enter and dry in minute particles in the "top" and during the etching process form with the perchloride of iron a grain in the printing surface. The patent office informed the inventor a short time after his application: "There can be no mention of an 'Eigenkorn' (a specific grain), therefore, the term 'Korn' (grain) must not be used in the patent

application." Spitzer fought for three years without result for his viewpoint; his financial conditions forced him to give way in order to have granted to him in 1905 what he dubbed his "mangled" patent. He etched with iron chloride solutions.

CHAPTER XCIV

1. Georg Fritz, "Die Vorläufer des Dreifarbendruckes und der Farbenheliogravure," in Eder's *Jahrb. f. Photogr.* (1902), p. 44, gives a history of the beginnings of three-color printing. Typographical printing in color dates back to the 16th century.

2. We follow here C. Grebe's "Zur Geschichte der Dreifarbensynthesen," in *Zeitschr. f. Reproduktionstechnik* (1900), p. 130.

3. Gilbert, *Annal.* (1792), XXXIV, 10.

4. Helmholtz, *Handbuch der physiologischen Optik* (2d ed., 1896), p. 364.

5. Poggendorff, *Annal.*, LXXXVII, 45.

6. Brewster, *Introd. ad. philos. natur.* (1820).

7. Helmholtz, in Poggendorff, *Annal.*, LXXXVI, 501.

8. Maxwell, see *Brit. Journ. of Phot.* (1861), p. 270; Kreutzer's *Zeitschr. f. Photogr.*, V, 143.

9. The centenary of the birthday of Maxwell was celebrated festively at Cambridge University.

10. See *Life of Maxwell* by Campbell & Garnett (London, 1882); Poggendorff, *Biograph.-literar. Handwörterb.* (1898), III, 889.

11. Wiedemann, *Annal. d. Phys.* (1888 and 1892).

12. *Philosoph. Magazine* (1888), Ser. 5, Vol. XIX.

13. Hertz, *Göttinger Nachrichten* (1890).

14. Collen, *Brit. Journ. of Phot.* (October 27, 1865), p. 547.

15. Schrank, *Phot. Korresp.* (1869), pp. 199, 333.

16. Eder, *Jahrb. f. Photogr.* (1895), p. 329.

17. S. Wall, Eder's *Jahrb.* (1914), p. 127.

18. Ducos du Hauron reported on September 6, 1875, to the Society of Agriculture, Science and Arts in Agen that he made silver bromide collodion plates sensitive to red with chlorophyll. He related that Edmond Becquerel declared, following Vogel's publication, that chlorophyll showed a sensitizing action in the red end of the spectrum.

19. Otto Pfenninger (Eder, *Jahrb. f. Phot.*, 1911, p. 11).

20. Potonniée, the French authority on the history of photography, in his biography of Ducos du Hauron, leaves out of account the part which H. W. Vogel played in the invention of three-color photography and without which Du Hauron would not have been able to achieve success.

21. For Ducos du Hauron's patent for a camera intended to photo-

graph simultaneously three images of one and the same object see Otto Pfenninger in Eder's *Jahrbuch f. Phot.* (1911), p. 11.

22. The principle of the superimposition of several sensitive films or films with impregnated dyes was often used in different forms. E. J. Wall, in his *History of Three-Color Photography* (1925), p. 152, reports on this in his chapter on "Bi-packs and Tri-packs." We mention here only G. Selle's patent (1899); Dr. R. Stolze's German patent, No. 179,743 (1905); O. Pfenninger's English patent (1906); and F. E. Ives' English patent (1908). The "bi-pack" is of interest in Gurtner's two-color system (blue and orange), see German patent, Nos. 146,149 and 146,150 (1902), and 146,151 (1903); also Eder's *Jahrbuch für Phot.* (1904), pp. 18, 207.

23. The anaglyph principle led also to the realization of the plastic film production. The onlooker wears spectacles fitted with glasses with complementary colors for each eye. Two stereoscopic pictures are projected on the screen through the same color filters. Although these exhibitions were repeatedly offered in public places, the process was too awkward and troublesome for the spectator and did not become popular.

24. *Phot. Korresp.* (1905), p. 24.

25. *Bull.. Soc. franç. phot.* (1869), p. 177.

26. *Ibid.*, p. 123.

27. *Phot. Korresp.* (1879), p. 107.

28. *Bull. Soc. franç. phot.* (1869), p. 179.

29. *Compt. rend.*, LXXXVIII, No. 3, p. 119; No. 8, p. 378; *Phot. Korresp.* (1879), p. 107.

30. See Ducos du Hauron's brochure, *Les Couleurs en photographie* (1869); also in German translation *Phot. Archiv* (1878), p. 132.

31. *Phot. Archiv* (1878), p. 162.

32. Also printed in *Phot. Archiv* (1878), p. 109.

33. *Phot. Korresp.* (1904), p. 251.

34. Vidal's classical example in this field was acquired by Dr. Eder for the collection of the Graphische Lehr- und Versuchsanstalt in Vienna.

35. H. W. Vogel, *Die Photographie farbiger Gegenstände* (Berlin, 1885).

36. *Phot. Mitt.*, XXVIII, 201; XXIX, 85; *Phot. Korresp.* (1893), p. 125.

37. E. Albert's patent brought in its train protracted difficulties. See *Phot. Korresp.* (1898), p. 107; also Bruno Meyer's *Sachverständiger und deutsches Reichspatent 64806* (Weimar, 1902).

38. *Phot. Korresp.* (1904), p. 369. For the production of large color gravures the contact paper had to be reinforced by wire netting in order to insure register.

39. Dr. G. Selle was a practicing physician in Berlin, had studied in Vienna, Paris, and London. He became interested in three-color photog-

raphy. In order to achieve the final color composition result, after making the three separations, he poured chromated gelatine on collodion films, exposed through the back and then immersed them in cold water. Then he put them through their respective complementary color solutions, which penetrated into the layers unaffected by light. These films he then superimposed. He recommended several variations for the dyeing of the three-color separation positives, which he patented, as well as a chromoscope (1903). In order to promote the commercial exploitation of his process, he started the Graphische Kunstanstalt for polychrome photography in Berlin, where he, about 1895, advertised his "Sellechromie," which at first attracted great attention. Although he received the Order of the Red Eagle from Kaiser Wilhelm II for his achievements, his process never went beyond the experimental stage, nor did it result in any commercial profit. Selle died June 8, 1907.

40. Eder, *Handbuch* (1903) III, 710.

41. Capstaff's English patent was acquired by the Eastman Kodak Co. and patented by them in 1915 (No. 13,429).

42. For more concerning this see Valenta, *Die Photogr. in natürlichen Farben* (1912, W. Knapp); also Wall, *History of Three-Color Phot.* (1925), pp. 475, 503, and Raphael Ed. Liesegang, "Zur Geschichte der Farbenrasterplatten," in *Jahrb. f. Phot.*, 1908, p. 147.

43. The first reproductions of autochromes by the three-color halftone process were probably ordered to be made by the firm Lumière in Paris. In Germany the first reproduction of an autochrome (portrait) by the three-color halftone process was made by the "Graphische Kunstanstalt Joh. Hamböck," Munich. This was exhibited on October 2, 1907 (Eder's *Jahrb. f. Phot.*, 1918, p. 401). The journal *Schweizer Graph. Mitt.* of April 15, 1908, published the reproduction of an autochrome portrait subsequent to the one by Hamböck. The reproduction of autochromes by photoengravers became soon universal.

44. Concerning the camera and the projector for three-color cinematography according to the system Szepanik see Spanuth and Honnhold, *Phot. Korresp.* (1925), p. 12; S. Szepanik, "Cinematography in Natural Colors," *(Brit. Journ., Colour Suppl.,* October 2, 1925, p. 38).

CHAPTER XCV

1. See *Philosoph. Transact.* (1840), p. 28; *Athenaeum*, No. 621.

2. *Compt. rend.* (1851, 1852, 1859, and ff.).

3. Niepce de Saint-Victor, *Compt. rend.*, XXXI, 491.

4. For fuller details see also the report of Becquerel in the meeting of the French Photographic Society on December 18, 1857; also Heinlein,

Photographikon, p. 384; Dingler, *Polytechn. Journ.*, CXXXIV, 123; *Phot. Arch.* (1868), p. 300.

5. Niepce; also Martin, *Handbuch d. Photogr.* (1857), p. 311, 1st and 2d treatise.

6. *Compt. rend.* (1862), LIV, 281, 299; Kreutzer, *Zeitschrift f. Photogr.*, III, 5; also Heinlein, mentioned above.

7. See *Phot. Korresp.* (1867), p. 190.

8. Pure silver chloride becomes distinctly violet in ultraviolet, but in the visible spectrum, it gradually turns to a gray-violet. However, if it is first exposed to diffused daylight (the violet subchloride is thus produced) it will then reproduce the spectral colors, although yellow and green will certainly be pale and barely visible (Becquerel, *Phot. Arch.*, 1868, p. 300).

9. De Roth, *Fortschritte der Photogr.* (1868), p. 22; *Compt. rend.* (1866), LXI, 11.

10. *Bull. Soc. franç. phot.* (1874); *Photogr. Korresp.* (1874) XI, 65.

11. Concerning R. Kopp's invention see Eder's *Jahrb. f. Phot.* (1892; and 1893, p. 432).

12. Eder's *Jahrb. f. Phot.* (1893), p. 432.

13. Experiment of Beauregard, Kreutzer, *Jahresber. Photogr.* (1857), p. 302; *Bull. Soc. franç. phot.* (1857), p. 116; see also Diamond, Heinlein, *Photographikon*, p. 390.

14. Simpson, *Photogr. Korresp.* (1866), III, 100.

15. See E. Valenta, *Die Photographie in natürlichen Farben mit besonderer Berücksichtigung des Lippmannschen Verfahrens* (1894, 2d ed., 1912); see also Eder's *Jahrbüch f. Photogr.* (1891), pp. 538, and (1892), p. 332; see also *Handbuch* (1927) II(1), 183 ff., where an exhaustive study on "photochromy" by Lüppo-Cramer will be found.

16. Portrait and short biography of Wilhelm Zenker is found in *Phot. Rundschau* (1895), p. 91.

17. O. Wiener's treatise was printed in *Annalen der Physik*, n.f. Vol. LV; also in Vogel's *Phot. Mitteilungen*, Vol. XXXII; L. Weickmann delivered a memorial address on O. Wiener before the Saxony Academy of Science, 1927.

18. See E. Valenta, *Photographie in natürlichen Farben* (1912).

19. See Eder's *Jahrb. f. Photogr.* (1892), p. 326 (with illus.).

20. Eder, *Jahrb. f. Phot.* (1894), p. 450.

21. E. Valenta, *Phot. Korresp.* (Sept., 1892), p. 435.

22. Professor Dr. Richard Neuhauss (b. October 17, 1855, at Blankenfelde) studied medicine at Heidelberg and Berlin, made in 1884 a trip around the world for anthropological studies. When he returned he began practice as physician in Gross-Lichterfelde and took up photography.

NOTES TO PAGES 671 - 673　　　　811

From 1894 to 1904 he edited the *Photogr. Rundschau*, after which he made a long trip to German New Guinea. At the outbreak of World War I he volunteered in the Medical Corps, was infected while active in diphtheria barracks, and died in Berlin-Lichterfelde on February 9, 1915. Among his works are: *Photographie auf Forschungsreisen* (1894); *Anleitung zur Mikrophotographie* (2d ed., 1908); *Die Farbenphotographie nach dem Lippmannschen Verfahren* (1898); *Lehrbuch der Mikrophotographie* (3d ed., 1907); and *Lehrbuch der Projektion* (2d ed., 1907). Of especial importance were his works on "Farbenphotographie" (bleaching-out process and Lippmann process). His many publications in technical journals are listed in Eder's *Jahrbuch für Photographie*. His portrait is published in *Photographische Korrespondenz* (1915), p. 95.

23. Dr. Hans Lehmann, physicist and photochemist, devoted himself to the development of interference photography according to Lippmann's procedure. He invented various apparatus, constructed by Zeiss in Jena. Later he became scientific collaborator at Ernemann-Werke in Dresden. His specialty was scientific construction for cinematography; he constructed the "time expander," an addition to cinema apparatus called by its manufacturers, the Ernemann-Werke, "Zeitlupe" (ch. lxxi). He wrote *Die Kinematographie* (1911).

24. See Eder, *Jahrb. f. Photogr.* (1921-27), p. 482. The description of this procedure of H. Lehmann-Jahr is found also in *Handbuch* (1930), III(1), 161. H. Lehmann wrote often concerning the Lippmann procedure; for example, Lehmann, "Beiträge zur Theorie und Praxis der direkten Farbenphotographie nach Lippmann und Lumière," *Verhandlungen, Deutsch.-Physik. Gesellsch.* (1907), Vol. IX, No. 26; "Interferenzfarbenphotographie mit Metallspiegel," *ibid.* (1909), Vol. XI, No. 20; "Die Praxis der Interferenz-Farbenphotographie," *Phot. Rundschau* (1909).

25. See also the early works of Szepanik (also *Phot. Korresp.*, 1925, p. 12).

26. Later patents by Keller-Dorian are the British patent, No. 246,908, of Dec. 23, 1914, and the French patent No. 52,336, of Jan. 20, 1920. See also the reports of the "K. D. B.-Film" in the *Bull. Soc. franç. phot.* (1923), p. 26, with colored table, in the *Brit. Journ. of Phot.* (1923), *Color Suppl.*, p. 10, and more recent references in *Filmtechnik* and *Kinotechnik* concerning kodacolor. See also Dr. Grote, "Geschichte des Linsenrasterfilmes," *Phot. Indust.* (1931), p. 1342.

27. J. G. Capstaff and M. W. Seymour, "The Kodacolor Process for Amateur Color Cinematography," *Transact. Soc. Motion Picture Engineers*, (1928), No. 36, XII, 940; also C. E. K. Mees, "Motion Pictures in Natural Colors," *Camera Craft* (1928), XXXV, 305) and Mees, "Ama-

teur Cinematography and the Kodacolor Process," *Journ. Franklin Instit.* (Jan., 1929). The description of this process for the demonstration of surgical operations and so forth is given by H. B. Tuttle in *Journ. Soc. Mot. Pict. Engin.* (Aug. 1930), XV, 193.

28. A kodacolor film was produced in the Vienna Photogr. Gesellschaft on Jan. 27, 1931.

29. Herschel, "On the Action of the Rays of the Solar Spectrum on Vegetable Colours," *Philosophic. Transact.* (1842); see also Hunt, *Researches on Light* (1844), p. 170.

30. *Photogr. Archiv* (1893), Nos. 729-730.

31. Neuhauss, *Phot. Rundschau* (1903), p. 258.

32. *Moniteur de la Phot.* (1895); *Jahrb. f. Phot.* (1896), p. 499.

33. See *Jahrb. f. Phot.* (1902), p. 544; *Phot. Korresp.* (1902).

34. See *Jahrb. f. Phot.* (1903), p. 48.

35. *Phot. Korresp.* (1902).

36. F. Limmer, *Das Ausbleichverfahren* (Verlag W. Knapp), 1911.

CHAPTER XCVI

1. The early photographic literature of the craft from 1839 to 1860 was recorded by Ernst Amandus Zuchold, editor and publisher, in his *Bibliotheca photographica* (Leipzig, 1860). His data are unfortunately not very dependable, especially regarding the earliest publications. Hornig, in his *Photograph. Jahrbuch* (1877 ff.), lists the literature up to the eighties of the 19th century. The meritorious president of the Vienna Photographische Gesellschaft, Regierungsrat Professor Dr. E. Hornig, spent a great deal of time and labor in collecting this data. We are indebted to Professor Erich Stenger, Berlin, for a complete enumeration of the photographic literature from 1839 to 1870 in the German, French, and English languages. The list appeared serially in *Die photographische Industrie.*

2. Complete set of this publication was procured by Dr. Eder for the library of the Graphische Lehr- und Versuchsanstalt in Vienna.

3. The name comes down from the famous French Estienne family of printers and scientists, whose printing shop was established in 1501. The last of this printer family, which became extinct in the 18th century, was Antoine Estienne (1592-1674).

4. Paul Montel is the publisher of the *Revue française de photographie et de cinématographie*, Paris, and of other photographic publications. L. P. Clerc is the editor of *La Technique photographique* and editor-in-chief of the most important French authoritative photographic periodical, *Science & industrie photographiques*, both published by Montel.

5. *Journ. Phot. Soc.* (London, 1856), III, 48.

6. Concerning *The Daguerreian Journal*, Vol. I, 1850, see Canfield, in *Phot. Times* (1887), p. 648; it came into the possession of Humphrey in 1852. Elsewhere the contents of the *Journal* are discussed.

7. The report of the jury for the section "Photography" at the Universal Exhibition in Paris, 1855 (reporters Benj. Delessert and Louis Ravené) was published in 1857 (see *La Lumière*, 1857, pp. 43 ff.). Fritz Hansen also reported on the exhibition, in *Phot. Korresp.* (1921), p. 176.

8. K. J. Kreutzer was called to Graz in his later years as librarian, where he committed suicide during a mental disorder in 1863. The library official Lukas of the Wiener Polytechnik continued to edit the periodical started by Kreutzer, with whom he had previously worked on it. The publication ceased in 1864.

9. For the history of the Photographic Society see *Phot. Korresp.* (1911). There the charter members are listed and the portraits of the following gentlemen are printed: Petzval, Voigtländer, Anton Martin, Joh. Bauer, E. Hornig, O. Volkmer, Fritz Luckhard, Ludw. Schrank, Ludw. Angerer, Carl Angerer, Max A. Davanne, J. M. Eder, Wilh. Burger, A. v. Obermayer, J. Hofmann, v. Hübl, Perlmutter, Alex. Angerer, M. Frankenstein, E. Förster, C. Pietzner, O. Prelinger, E. Sieger, F. Hrdlička, H. Kosel, W. Müller, E. Valenta, Mathilde Löwy, Prof. Berlin, Albert Freiherr v. Rothschild, E. Bondy, and C. Seib.

10. Obituary of Ludwig Schrank in *Phot. Korresp.*, June, 1905.

11. As a memory of the first German photographic exhibition (1864) the Wiener Photograph. Gesellschaft organized, forty years later, a great exposition in the Austrian Museum for Art and Industry. The last great international photographic exhibition before World War I took place in Dresden in 1909. This was followed by an International Exposition for the Book-publishing Trade and the Graphic Arts (Bugra) in Leipzig in 1914. This was greatly curtailed by the outbreak of the war.

12. After the death of H. W. Vogel the *Photographische Mitteilungen* were merged with the *Photographische Rundschau* published by W. Knapp (the latter was originally edited by Charles Scolik in Vienna).

13. The textbooks edited by Dr. Julius Schnauss were very popular. We cite here the most important: Schnauss, *Photograph. Lexikon für den praktischen Photographen*, Leipzig, (1st ed., 1860; 3d ed., 1868); *Katechismus der Photographie*, Leipzig (1st ed., 1861; 4th ed., 1888); *Das einfachste und sicherste Trockenverfahren der Gegenwart* (1863), (Kollodiumbadeplatten mit einem Präservativ von Rosinen-Absud.); *Der Lichtdruck und die Photolithographie* (3d ed., 1886; 7th ed., revised by August Albert, 1905).

14. The *Geschichte der Wiener Universität von 1848-1898* (pub. by Alfred Hölder, Vienna), issued by the Academic Senate in 1895, states

that the University Institute for Physics moved in the fall of 1851 to the House Erdberg, Hauptstrasse 104. When the streets in Vienna were zoned differently, the house mentioned (built in 1777) was renumbered Bezirk III, Erdbergerstrasse, No. 15. The house belonged at that time to a citizen by the name of Kier Tuberius. According to the directory of the city of Vienna of 1875, the subsequent owner was recorded as the photographer Josef Löwy. It was here that the dry-plate works of J. Löwy (d. March 24, 1902) and of J. Plener were housed and that the first Eder orthochromatic eosine plates were produced. It was here also that H. W. Vogel introduced his azaline plates in Vienna. Later their own building was constructed, adjoining in the Parkgasse, in which the successors to the Löwy firm, as Wiener Kunstdruck A.-G, Vienna III, Parkgasse 13-15, carried on their photoengraving business.

15. *Jahrb. f. Photogr.* (1897), p. 263.

16. W. Exner in the *Neue Freie Presse* of March 21, 1928; also *Phot. Rundschau* (1928), p. 195.

17. Most of the reports of the Institute were published in the *Phot. Korresp.* The purely scientific research in photochemistry and spectro-analysis by Eder and Valenta will be found in the reports of the sessions and the memoirs of the Vienna Academy of Sciences (class for mathematics and natural sciences). The collected works of J. M. Eder and E. Valenta, *Beiträge zur Photochemie und Spektralanalyse* (Vienna, 1904) were printed and published by the institute.

18. See Wilhelm Exner, *Erlebnisse* (Vienna, 1929).

19. Eduard Kuchinka, "Die Sammlungen der Graphischen Lehr- und Versuchsanstalt in Wien," *Phot. Korresp.* (1928).

20. Dr. Karl Gustav Helmer Bäckström was born September 8, 1891, at Stockholm, where he studied physics and chemistry at the university. He was an assistant at the technical high school there (1917-25), and since 1929 teacher at the Royal Seminar for Female Teachers. With Hertzberg he edited the *Nordisk Tidskrift för Fotografi;* since 1923 he has written several widely circulated Swedish books on photography.

21. The statement in *Jahrbuch f. Phot.*, (XXX, 47) that the first photographic exhibitions in Sweden took place in 1843 is a typographical error.

22. *Phot. Korresp.* (1924), p. 22.

23. From Fritz Köhler, *Forscher- und historische Bildnisse*, 1911-1928, Leipzig.

24. An illustration of the Academy of Science is in A. B. Grenville, *St. Petersburg; a Journal of Travels to and from that Capital* (London, 1828).

25. See the report by A. Nadherny and Weissenberger in *Phot. Korr.* (1893).

26. W. Weissenberger of Vienna reported in 1886 a method for sensitizing bromosilver gelatine plates by adding a cyanide solution, decolorized with acetic acid; this caused the plates to show their sensitivity to colors only after being dried (*Phot. Korresp.*, 1886, p. 591; and 1896, p. 131). This process was taken up later again in the methods for sensitizing with isocyanide, sensitive to acids (see W. Dieterle, this *Handbuch*, 1932, III(3), 191-242, "Die Herstellung farbenempfindlichen Schichten"). Weissenberger also recommended the use of chrome baths containing manganese sulphate (1888); see *Handbuch* (1926), Vol. IV(2).

27. "The transcript of this work," writes Plotnikow, "and the arrangement of the material which it has taken years to gather was begun in the summer of 1917 on my estate 'Schwarzer See' in the Department of Riasan. All about us stormed the masses of the Russian people who had torn themselves loose from all human and cultural ties, having been overwhelmed by a mania for destruction. Day after day I had to witness powerlessly the destruction and sacking of my country property, which I had labored with such difficulty, toil, and expense of money to bring to its high economic standard. Finally, in November of the same year, I lived to see my estate leveled to the ground. The library of my country house passed into the making of cigarette papers. In Moscow the writing of my book was continued. There, in a few wretched rooms, my family found shelter, amid the volleys of continuous cannon and guns of Bolshevik revolts. The frightfulness of the terrorist government which followed was added to by the lack of food. Grievous and distressing were the few hours left for my work. My library in Moscow, which I had collected for years with such love and labor, diminished constantly under the necessity of bartering the books in exchange for food in order to snatch my wife and child from the danger of starvation. From the position of professor at the university I was discharged in the first days of the Revolution, on March 20, 1917, by the arbitrary, illegal, and violent proceedings of the Minister of Education, Cadet Manuiloff, who tolerated only members of his own party. The first Russian photochemical laboratory, which I had installed laboriously and partly from my own funds, was also liquidated. As the problem of providing food became more and more acute and the sources dwindled, we fled in peril of our lives in the fall of 1918 from this socialistic paradise to relatives in Ukraine. It was in Charkoff that the mathematical part of my *Allgemeine Photochemie* (Berlin-Leipzig, 1920) was written. The bolshevist waves of blood and hunger continued to approach, closer and closer, the rich and beautiful Ukraine; they threatened to engulf it and to cut me off anew from the world of culture. In the name of the new "Soziale Gerechtigkeit' I was reduced to the state of an itinerant mendicant, while oth-

ers, stronger physically, enriched themselves at my expense. They robbed me even of my scientific haven. Whether fate has in store for me another such opportunity, where I might continue in peace my scientific research, is at this writing very problematical. Unfortunately scientists, more than elsewhere, depend on the consideration of party, nationality, and prejudice. My position was desperate. However, then came the long-hoped-for assistance out of Germany. I am indebted to the German men of science and industry, for through their timely intervention I was permitted to spend Christmas 1918 in Leipzig with my friends and patrons. Unfortunately, my wife and child had to be left behind in Charkoff for two years; during that time I was unable to communicate with them, owing to the shortsightedness and naïve politics of the 'Entente.'

"On German soil, so fertile for every scientific research, I was able to conclude my work *Allgemeine Photochemie*. Thus came into being a textbook which, I believe, contains at least sufficient material offered to our present generation in research to make possible a further successful development in this interesting scientific, practical, and gratifying field.

. . .

"Hunger, misery, and bitter necessity, extraordinary personal insecurity, often bordering on the danger of one's life, were constant companions during my hours of study."

At the end of this dramatic statement Professor Plotnikow, who had found a temporary position at Agfa in Berlin through the recommendation of Professor W. Nernst and the general director, F. Oppenheim, thanks his friends who had stood by him during this trying time of his life.

28. Dr. Janecek, born in Prague, became first assistant to Professor Pohl of the Technische Hochschule in Vienna, was called to Agram by the Banus of Croatia, where he was the first professor in the 1870's to introduce a department for chemistry at the university.

29. The Russian Professor Samoilowitsch contributed numerous aerophotographic and photogrammetric exposures taken during the voyage of the Graf Zeppelin on its polar trip in 1931. The German scientists Dr. Aschenbrenner (Munich), Dr. Basse (Berlin), and Dr. Gruber (Jena) carried out the scientific cartographic results of Samoilowitsch's photographic work (*Forschungen und Fortschritte*, 1932, p. 23).

30. L. Scharlow, working in the Geologic Committee in Leningrad, published a formula for the production of silver bromide gelatine by precipitation of silver bromide, washing and the following emulsification in gelatine, which results in clear, less sensitive emulsions for silver bromide papers (*Phot. Indust.*, 1924, p. 233).

31. A. Walenkov, also A. Denisoff, "Physikalisches Institut der Universität Leningrad," *Zeitschr. f. wissensch. Phot.* (1929), Vol. XXVII.

32. A. Kirilow, "Physikalisches Institut in Odessa," *Zeitschr. f. wissensch. Phot.* (1929), Vol. XXVI.

33. N. Barascheff and B. Semejkin, *Zeitschr. f. wissensch. Phot.* (1930-31), Vol. XXVIII.

34. See *Jahrbuch für Photographie* (1912), p. 294.

35. See *Handbuch* (1930), III(1), 172, "Die Photographie mit Bromsilber-und Chlorsilbergelatine," by Eder und Lüppo-Cramer, and elsewhere in this work. Several of Burton's works have been translated into German (*Das ABC der modernen Photographie*, 3d ed., Düsseldorf, 1887) and into French (*Fabrication des plaques au gelatinobromure*, Paris, 1901). Exposure Tables (1882) of W. K. Burton are reported in *Handbuch* (1893), II, 263-64.

36. The intense interest taken by the Japanese in the "Photographic Salon" (1929) was best shown by the 1700 photographic entries of which 400 took prizes (*Japan Photographic Almanac*, 1928-29, p. 2). The exhibit at the "V. Internationale Photographische Salon" in Tokyo was sent to Vienna and shown there by the "Wiener Photoklub," in December, 1931, where it excited great interest.

37. Production statistics are published in Japanese photographic annuals (1929-30), giving figures covering manufacture of photographic merchandise made in Japan. Cameras, etc., 2,000,000 yens, plates and papers about 3,000,000 yens, against an import of photographic items amounting to 8,000,000 yens. Important information on photographic trade statistics in Japan are found in *Phot. Chronik* (1932), p. 6.

INDEX

Aarland, G., 693

Abbe, Ernşt, 402, 405, 407

Abildgaard, 121, 129; "Über die Wirkung des Lichtes auf das rote Quecksilberoxyd," 744

Abney, Sir William de Wiveleslie, 363, 430, 434, 443, 454-55, 563, 781; *Emulsion Processes in Photography*, 430; *The Practical Working of the Gelatine Emulsion Process*, 430

Absorption, photochemical: Grotthuss's law of, 166-68, 418-19

Accum, *Chemische Unterhaltungen*, 106

Achromatic lens, 50, 133, 251, 290, 292, 294, 298; *see also* Aplanatic lens

Achromatism, 50, 149-50, 251, 298

Ackerman, Carl W., *George Eastman*, 380, 487, 492, 786

Adams, Charles M., *xiii*

Adamson, Robert, 327, 349

Adelsköld, C. A., 702

Aerial photography, 393-98, 401-3

Agenda Lumière, 677, 695

Agfa Company, 432, 435, 437, 662, 695

Agricola, Georg, 24, 25

Aguado, Olympe, Count, 307, 351

Aguilonius, Franciscus, 381, 639

Air eddies, photographic study of, 525-27

Airy, G. B., 45

Aktinometer, 449

Albanus, C. F., 450

Albert, August, 549, 613, 620, 621, 628; *Verschiedene Reproduktionsverfahren mittels lithographischen und typographischen Druckes*, 613, 620, 804; *Die verschiedenen Methoden des Lichtdruckes*, 620, 803; "Die Fehlertabellen für Lichtdruck," 620; *Der Lichtdruck an der Hand- und Schnellpresse*, 620; *Der Lichtdruck und die Photolithographie*, 620; *Technischer Führer durch die Reproduktions-verfahren*, 620, 621; *Die Reflektographie*, 620

Albert, Eugen, 378-79, 595, 599, 620, 633, 654, 808; invention of isochromatic collodion emulsion, 379, 467-68, 618; "On the Change of Color Tones in Spectral and Pigment Colors under Diminishing Intensity of Light," 379

Albert, Josef, 378, 618, 619, 620, 646, 647

Albert, Karl, 522, 597, 620, 710; *Lexicon der graphischen Techniken*, 620, 647, 660

Albertus Magnus, 23, 57; *Compositum de compositis*, 24; *De mineralibus mundi*, 733

Albinos, 126

Albumen: use on glass negatives, 339-41; use on collodion plates, 372-73, 375; print paper prepared with, 535, 536, 781, 792; use in photolithography, 609, 610, 611

Alchemic medals, *see* Medals, Alchemic

Alchemists, 15-33; production of silver chloride by wet process, 27-29; study of phosphorescence by, 57-60

"Alcmäon," epithet bestowed on J. H. Schulze, 72-73

Algraphy, 615-16, 803

Al Husen (Ibn al Haitam), 1

Alinari, Arturo, 701

Allgemeine Gesellschaft für Anilin Fabrikation, *see* Agfa Company

Allon, 394

Almeida, Joseph Charles d', 383, 648, 772; "Nouvelle appareil stéréoscopique," 772

Alpha papers, 448

Alpine photography, *see* Mountain photography

Alsace Printing Machinery Co., 606

Aluminum: use for lithographic printing, 615-16, 803; use in collotypy, 621

Amboise, Cardinal Georges d', 204, 207

America, *see* United States

Amici, 290

Ammonia: use in developers, 376; emulsions ripened with, 425, 428-31

Ammonium oxalate, mixed with mercuric chloride: light-sensitivity of, 164-65

Amphitype process, 339

Anastigmatic lens, 407-10, 775, 776

Andemaos, 343

Andraud, *Une Dernière Annexe au Palais d'Industrie*, 393

Andrée, S. A., 396

Andresen, Momme, 432, 434-35, 437-38, 551; "Zur Aktinometrie des Sonnenlichtes," 435; *Das latente Lichtbild*, 435; *Agfa-Photo-Handbuch*, 435; "Entwickler-Substanzen," 435

Angerer, Carl, 623-26, 632, 804
Angerer, Ludwig, 304, 305, 306, 352, 353
Angerer, Victor, 353, 431, 445, 598, 599, 801
Angerer & Göschl, 625, 631, 633, 653, 654, 804
Anglada, 173
Animal locomotion: photographed by Muybridge, 501-5; photographed by Marey, 507
Anschütz, Ottomar, 409, 512-13, 789
Ansco Company, 447, 493, 494
Antiplanat lens, 407
Anthony, 375
Anthony and Scovill Company, 490
Antilux, 724
Aplanatic lens, 403-7, 408
Aqua fortis, see Nitric acid
Aqua rubi, 17
Aquatint grain, 591, 594, 595, 596, 600, 799
Arago, François Jean, 25-26, 157, 202, 243, 259, 270, 334-35, 398; report on daguerreotypy to French Academy of Sciences, 140, 141, 230, 245, 252, 287, 310-11, 756; report on daguerreotypy to French Chamber of Deputies, 232-41, 242, 258, 385; "La Daguerreotypie," 252
Archaeology, benefits of daguerreotypy to, 234
Archer, Frederick Scott, 299, 345-47, 362, 363, 768
Archertype, 346
Argentotype process, 543
Aristo papers, 448, 536, 538
Aristostigmat lens, 409, 411
Aristotle, 1, 2, 3, 36, 57, 729; views on color, 3-4, 10; Metaphysik, 729
Armat, Thomas, 719
Armstrong, T. N., 533
Arndt and Troost, 543
Arons, Leon, 533
Arrowsmith, Charles, 209
Arsenic disulphide, light-sensitivity of, 142
Arsenic sulphide, light-sensitivity of, 146
Artigue, Victor, 560
Art Photographic Company, Limited, 602
Arts, relation of photography to, 235, 242-43, 314, 348-51
Arts, graphic: contribution of early photographic inventions to, 331-33
Artus, 730
Artus, Willibald, 177
Asahiphoto Industrial Co., Ltd., 715
Aschenbrenner, Dr., 816
Ashman, 538
Ashton, 587
Asphalt, light-sensitivity of, 103

Asphaltum process, 611; use by Niépce, 197, 199-203, 204, 206, 207, 218-23, 250, 608; improvement by Niepce de Saint-Victor, 591-92; use in photolithography, 608
Asser, Eduard Isaak, 612, 703
Association Belge de Photographie, 703
Association du Musée des Photographies Documentaires, 698
Astigmatism, 45
Astrology, speculations of alchemists in, 15-21
Astronomical photography, 269-70, 584, 798
Astronomy, value of daguerreotypy to, 237
Atelier des Photographen, 474
Atmography, discovery of, 268, 338
Attout, 468, 469
Aubel, Carl, 613
Aubel & Kaiser, 613
Aubree, 529
Auer, Alois (von Welsbach), 36, 568-73, 575, 693; "Disputes about the Ownership of New Inventions," 569; Die Entdeckung des Naturselbstdruckes, 569; Geschichte der Hof und Staatsdruckerei, 571; Das typometrische System in allen seinen Buchstabengrössen, 571; Mein Dienstleben, 572; Das Benehmen eines jungen Engländers, 796
Auerbach, Felix, Ernst Abbe, 408
Auer von Welsbach, Carl, 533, 572, 573, 724, 797
Aufermann, 638
Aussig Chemical Society, 481, 484
Austria: early interest in daguerreotypy in, 245, 246-48, 280-84; photography in, ix, 680-92, 694
Autochrome process, 661-62, 672, 809
Automats, photographic (so-called), 371
Automats, printing, 441, 445
Autopolygraph, 358
Autotypie, 626, 629, 630-31, 805; see also Halftone process
Averroës (Ibn Ruschd), 2
Aviar lens, 411
Avicenna, 1
Axmann, Jos., 577
Azaline plates, 460-61, 468, 784

Bache, Alexander Dallas, 288
Bachrach, D., 538
Bäckström, Helmer, xi, 214, 283, 287, 337, 701, 702, 814
Bacon, Francis (Baron Verulam), 125; Sylva sylvarum, 125

Bacon, Roger, 2, 28, 29, 31, 37, 38, 733, 734
Baden-Powell, Lt., 397
Baden-Pritchard, Captain, 447, 599
Baekeland, Leo, 446, 780
Baeyer, Adolph von, 484
Baker, Thorne, 662
Balagny, G., 485, 510
Balard, Antoine Jerome, 172, 173
Balduin, Christoph Adolph (Baldewein), 30; study of phosphorescence by, 57-60, 61, 73, 737; *Miscellanea curiosa medico-physica Academiae naturae curiosorum*, 58; *Aurum superius et inferius aurae superioris et inferioris hermeticum et phosphorus hermeticus*, 737
Baldus, 576, 592, 622
Ballistic photographs, 524-27
Balloon photography, 393-98; *see also* Aerial photography
Bamberg, Karl, 776
Barascheff, N., 817
Barbaro, Daniel, 734; *La prattica della perspettiva*, 42
Barbier, H., 477
Barbieri, 705
Barium sulphide, luminosity of, 57; *see also* Bologna stone
Barker, Robert, 209
Barr, Captain, 331
Barreswil and Davanne, 608, 609; *Chimie photographique*, 360, 361; *Die Anwendung der Chemie auf die Photographie*, 802
Basilius Valentinus (pseudonym), 27-29, 733; *Ein kurtz summarischer Tractat Fratris Basilii Valentini des Benedicter Ordens, von dem grossen Stein der Uralten*, 27; *Von den natürlich und obernatürlichen Dingen*, 27; *De occulta Philosophia*, 27; *Haliographia*, 27; *Triumph-Wagen Antimonii Basilii Valentini* 27; *Das letzte Testament des Basilius Valentinus*, 28; *Chymischen Schriften des Basilius Valentinus*, 28
Basse, Dr., 816
Batut, A., 396, 397; *La Photographie aérienne par cerf-volant*, 774
Baudin, 342
Bauer, Alexander, 20; *Die Adelsdokumente österreichischer Alchimisten*, 21, 732; *Wiener numismatische Zeitschrift*, 732; *Chemie und Alchimie in Österreich*, 732; *Humphry Davy*, 745
Bauer, Francis, 198, 206, 207
Bauerle, Adolf, 287
Bavarian Government Institute for Photographic Procedure (Munich), 693

Bayard, Hyppolite, 334, 335, 368
Beale, 500
Beard, 280, 315, 355
Beauregard, Testud de, 556, 810
Beautemps-Beaupré, 398
Beauvière, 580
Beccarius (Giacomo Battista Beccaria), 62, 86-87, 89, 93, 98; light-sensitivity of silver chloride discovered by, 86-88, 93, 140; *Treatise on Artificial Electricity*, 87; "De vi quam ipsa per se lux habet," (with Bonzius), 738
Becher, *Chymische Concordanz*, 732
Beck, Viennese daguerreotypist, 281
Becquerel, Antoine Henry, 265
Becquerel, Edmond, 264-65, 267-68, 367, 552; *La Lumière, ses causes et ses effets*, vi, 26, 265, 266; studies action of red rays of spectrum (Becquerel phenomena), 265-66, 355, 758; discovers sensitizing effect of chlorophyll at red end of spectrum, 460, 465, 645, 652, 807; investigations in photochromy, 664-65, 667
Becquerel phenomena, 265-66, 355, 758
Bedrijfsphotographie, 703
Beechey, Canon, 378
Beemeter, 449
Beer, 284
Bégelow, 342, 343
Belgium, photography in, 703
Bellini, 377
Belloc, 346; *Traité ... de la photographie sur collodion*, 360; *Photographie rationelle*, 360; *Les Quatre Branches de la photographie*, 360, 768
Benedetti, Giovanni Battista, 42
Benediktbeurener lens, 308, 763
Bennet, Charles, "A Sensitive Process," 426
Bennetto, 658
Bentiviglio, Conte, 325
Benzelstierna, Lieutenant, 287
Bérard, 185
Berberine yellow, 752; light-sensitivity of, 189
Berchtold, M., 626
Beretninger fradansk fotografisk Forening, 704
Bergman, Torbern Olof, 95, 96; *De acido sacchari*, 95; *Opuscula physica et chemica*, 95, 739
Bergström, J. W., 287
Berkeley, Herbert Bowyer, 433, 545
Berlin Photographic Society, 683
Berliner deutsche Photographen Verein, 684
Bermpohl, 475
Bernaert, 428

Bernard, 660

Berres, Josef, 386, 528, 577, 578, 580; *Anatomie der mikroskopischen Gebilde des menschlichen Körpes*, 386; *Phototyp nach der Erfindung des Professors Berres in Wien*, 333, 577

Berry, Miles, 251

Berthier, H., 383, 384

Berthollet, Comte Claude Louis, 107-9, 114, 143-44; experiments with silver chloride, 101, 109, 143-44, 158, 160, 161, 162; experiments with chlorine water, 107-9, 112, 114, 152, 413, 742; *De l'influence de la lumière*, 108; *Eléments de l'art de la teinture*, 114; *Essai de statique chimique*, 143, 741; *Histoire de l'Académie royale des sciences*, 741

Berthollet, M., *Die Chemie im Altertum und Mittelalter*, 733

Berthon, 672

Bertillon, Alphonse, 441

Bertrand, *Recueil des travaux scientifiques de Léon de Foucault* (with Gabriel), 773

Bertsch, 387, 393

Berzelius, 167, 168, 176, 190, 420

Bestuscheff, Count, 56, 101, 707

Bevan, 551

Bezzenberger, "Ein angeblicher Vorgänger Daguerres," 182

Bichloride of mercury, light-sensitivity of, 143

Bichromates, light-sensitivity of, 178-79

Bielicke, 411

Bindheim, 109; *Chemische Annalen*, 741

Bingham, Robert J., 307, 346; *Photogenic Manipulation*, 346; "On the use of Collodion in Photography," 346; *Instruction in the Art of Photography*, 360

Binocular vision, 45-46

Biograph, 522

Biondo, M. A. B., *Traktat von der hochedlen Malerei*, 85

Bio-phantascope, 515, 517

Biot, John Baptiste, 278, 320, 334, 534, 756

Biotar lens, 298

Birckbeck, 54

Bird, P. H., 329

Bischoff, J., 88-89; *Versuche einer Geschichte der Färbekunst*, 10, 89

Bishop, Joaquim, 288

Bisson, August, 359

Black, J. W., 394, 395

Blacklock, H. H., xi

Blair Camera Company, 490

Blanchère, de la, *see* La Blanchère, de

Blanquart-Evrard, 327-29, 332, 339, 392,

535, 646, 792; *Album photographique de l'artiste et de l'amateur* (with Fockeday), 332; *La Photographie, ses origines, ses progrès . . .*, 360, 754, 766, 792; *Procédés employés pour obtenir les épreuves de phot. sur papier*, 765; *Traité de photographie sur papier*, 765

Bleaching, 187-92; early theories on causes of, 55, 85, 86, 100, 740; Saussure studies action of light on colored materials, 112-13; Berthollet discovers bleaching with chlorine, 114, 742; development of photographic bleaching-out process, 159, 168, 263, 673-75, 748, 749

Blecher, Karl, 638

Blechinger, 801

Blechinger and Leykauf, 353, 599, 801

Bloch, Elsa, 249

Block, Olaf, "Development in Infra-red Photography," 781

Blow, T. B., 714

Blue glass, use in photography, 355-56

Blueprints, 549

Blumenbach, 125

Boccone, Silvio, "Disegni naturali et originali," 35

Bock, Emil, *Die Brille und ihre Geschichte*, 2

Böckmann, 116, 121, 136, 158; *Versuche über das Verhalten des Phosphors . . .*, 743, 744

Bodenstein, Max, 419, 777; *Hundert Jahre Kunstgeschichte Wiens in den Regesten*, 798

Bogisch, A., 435, 780

Bois-Reymond, Dr. R. du, 648, 789

Bollmann, 560

Bologna stone, 57, 58, 60

Bollstädt, Count Albert von, *see* Albertus Magnus

Bolton, W. B., 377, 378, 425, 771

Bombay, *Journal of the Photographic Society of*, 679

Bonacini, Carlo, 699

Bond, George Phillips, 457

Bond, W. C., 270

Bone, Homberg's experiments with, 31, 92

Bonzius, 87, 88, 89, 93, 100; "De vi quam ipsa per se lux habet . . ." (with Beccarius), 738

Boston Camera Co., 490

Böttger, 342, 617

Böttiger, *Ideen zur Archäologie der Malerei*, 730

Botton, Captain, 791

Boullay, Pierre François Guillaume, 143, 164, 745

Boulton, Matthew, 100, 134, 135
Bouly, Léon, 511, 790
Bourfield and Rouch, 357
Boussingault, Jean, 187
Boussod and Valadon, 588, 599, 635, 801
Bouton, Charles Maria, 209, 210, 214, 754
Boutron-Chalard, A. F., 190
Boyle, Robert, 29; *Experiments and Considerations upon Colours*, 30, 67; *The Systematic Cosmos*, 44
Braconnot, Henry, 178, 330, 342
Bradbury, Henry, 796
Bradford, L. H., 611
Brady, Matthew B., 359
Brand, 59
Brandau, *Universal Medicine*, 18
Brande, W. T., *Chemistry*, 757
Brandenburg, Friedrich, 165, 707
Brandes, Rudolf, 171, 174, 528
Brandlmeyer, G., 654, 656
Brandner, 383
Brandweiner, Adolf, 601-2, 603, 604, 605, 801
Brasseur, 661
Brauer, L., *Die Forschungsinstitute, ihre Geschichte, Organisation und Ziele*, 694
Braun, Adolph, 466, 558, 559
Braun, Gaston, *viii*, 466-67, 588, 599, 708
Breath pictures (Hauchbilder), 260
Brebisson, de, 339, 535
Breeman, L., 516
Brengou, Henri, 549
Brewster, Sir David, 271, 349, 381, 382, 640, 679; *Optics*, 157; *The Stereoscope*, 735, 772; *Introd. ad. philos. natur.*, 807
Breyer, Albrecht, 336, 337, 767
Breyertypes, 336-37
Breysing, 209
British Cartographic Institute, 694
British Journal of Photography, 356, 679
British Journal Phot. Almanac, 678, 679
Bromeis, 617
Bromides, use in wet collodion process, 361
Bromine: discovery of, 172-173; sensitivity of daguerreotype plates increased with addition of, 265, 275-78
Bromoil process, 564-65, 607-8, 780, 801
Bromo-iodide, light-sensitivity of, 276
Brongniart, 262
Brooker, "Recent Advances in Sensitizers for the Photography of the Infra-red" (with Hamer and Mees), 781
Brothers, 530, 531
Brown, A. B., 500
Brown, George E., *viii, xiii*, 249; "The Last Days of Daguerre...," 756
Brownell, Frank A., 490

Brownie camera, 491
Brucke, E., 125
Bruckmann A.-G., F., 599, 602, 604
Brugnatelli, Luigi Gasparo, 166
Brunner & Co., 630
Buchholz, 120, 146, 157, 160, 161
Buchner, Eduard, 258
Buchner, Johann Andreas, 166, 189; *Reportium für die Pharmacie*, 187, 749, 750, 752
Bühler, *Atelier und Apparat des Photographen*, 355
Bull, Lucien, 526
Bulletin belge de photographie, 703
Bulletin de l'Association belge de photographie, 703
Bullock, Edward, 626
Bullock, James, 626
Bullock, Lothrop L., 615
Bülow, Leonhard, 304
Bunsen, Robert Wilhelm, 152, 412-16, 449, 450, 452, 529, 530, 532; "Photochemische Untersuchungen" (with Roscoe), 413
Bunzli and Continsouza, 522
Buonvicino, 116
Burger, Wilhelm, 374, 686, 687, 688
Burgess, George K., 694
Burgess, John, 424, 440; *The Argentic Gelatino-Bromide Worker's Guide*, 430, 440
Burkhardt, E. G., 177; "Über Verbindungen der Quecksilberoxyde mit organischen Säuren," 751
Burnett, J. C., 557, 626, 767
Burns, Dr. 694
Burton, W. K., 714; *Das ABC der modernen Photographie*, 817; *Fabrication des plaques au gelatinobromure*, 817
Busch, Emil, 270, 304-6, 307, 365, 409, 411, 695
Büsch, Georg, 45
Buss, Otto, 537
Butler, 658
Büxenstein, Georg, 464, 654

Cadett, 445
Cady, Parker B., 490
Caesariano, Caesare, 38, 734
Caille, E. C. G., 662
Calotype process, 317, 322, 323, 327, 329, 348, 349, 764; *see also* Talbotypes
Camarsac, Lafon de, 566; *Application de l'héliographie aux arts céramiques aux émaux*, 796; *Portraits photographiques sur émail*, 796
Camera: invention of photography in, by Niépce, 193, 195, 197-98, 200-3, 250;

Camera (*Continued*)
commercial introduction by Daguerre and Giroux. 250-56, 756

Camera, De, Amsterdam, 703

Camera, Luzerne, 705

Camera obscura: 36-45, 272-73, 734, 755; described by Leonardo da Vinci, 38-40; described by Porta, 40-41; experiments by Wedgwood and Davy with, 137, 318; used by Niépce, 198, 220, 234; used by Daguerre, 214, 250; used by Talbot, 317, 319

Cameras, enlarging, 391-93; *see also* Enlargements

Cameras, pistol, 358, 770

Cameras, portable, first mention of, 43

Cameras, three-color, 657-58

Cameron, Mrs. Julia Margaret, 350

Camp, Maxime du, 332; *Souvenirs et paysages d'Orient,* 332

Campbell, *Life of Maxwell* (with Garnett), 807

Campbell, W., 789

Campeel, 147

Capstaff, J. G., 491, 660, 809; "The Kodacolor Process for Amateur Color Cinematography" (with Seymour), 811

Carbon, use in photographic printing, 554-59, 566-67

Carbonell, 177

Carbon perchloride, 171

Carbro prints, 562

Carbutt, John, 486

Cardano, Girolamo, *De subtilitate,* 40

Carpenter, 387

Carpentier, 519

Carrier pigeons, photomicrographs sent by, 389-90

Carry, 54

Cartes-de-visite, *see* Visiting card portraits

Casaseca, J. L. 174

Casciorolo, 57

Casler, 522

Casoidin papers, 537

Castel, 85-86; *Die auf lauter Erfahrungen gegründete Farbenoptik,* 85

Catalysotype, 326

Caustic stone, 23

Cavetou, 165

Celestial photography, *see* Astronomical photography

Cellio, Marco Antonio, 45

Cellofix papers, 538

Celloidin papers, 347, 536

Celluloid, used as film base, 485-86, 489-91, 492-93

Cellulose, 342, 343-44

Cennini, Cennino, *Buch von der Kunst; oder, Traktat der Malerei,* 85

Cerargyrite, *see* Hornsilver

Chalkotype, 637

Chapman, 776

Chaptal, Jean Antoine Claude, 110, 111, 730, 742; "Observations sur l'influence de l'air et de la lumière dans la végétation des sels," 742

Chardon, 378; *Photographie par émulsion sensible . . . ,* 430

Charles, Jacques Alexandre César, 141, 142

Charlieu, Millet de, 249

Chauveau, 509

Chemical rays, 131, 146-47, 149-50, 157; *see also* Solar spectrum

Chemicals, photographic, sale of, 347

Chemigraphy, 624

Chemitypy, 804

Chevalier, optical firm of Paris, 198-99, 207-8, 290; lenses constructed by, 279, 289, 290, 291, 295, 298, 310

Chevalier, Charles Louis, 132, 207-8, 214, 251, 253, 255, 294-96, 299, 386; *Sur une modification apporté au doublet de Wollaston,* 208; *Nouvelles instructions sur l'usage du daguerréotype,* 208; *Mélanges photographiques,* 208; *Sur quelques modifications apportées à des instruments optiques,* 208; *Photographie sur papier, verre et metal,* 208; *Méthodes photographiques perfectionnées,* 208; competition with Voigtländer over lenses, 294-96; *Photographie sur papier sec, collodion . . . ,* 360

Chevalier, Jacques Louis Vincent, 207, 208

Chevalier, Louis Marie Arthur: *Méthode des portraits des grandeur naturelle et des agrandissements photographiques,* 208; *Etude sur la vie et les travaux scientifiques de Charles Chevalier,* 208

Chevreul, Michel Eugène, 131, 190, 192

Chevrier, 204

Childe, 53

Chimenti, Jacopo, 46, 381

Chisholm, 135

Chistoni, C., 742

Chlorine, increased sensitivity of daguerreotype plates by use of, 276-78, 665

Chlorine detonating gas, light-sensitivity of, 151-53, 155, 413, 777

Chlorine water, light-sensitivity of, 107-9, 112, 152, 412

Choiselat, 260, 261

Choreutoscope, 500

Christensen, F. J., 541

Christman, Léon, 776

Chromates: light-sensitivity of, 179, 552-54, 559, 593; photographic processes with, 552-59, 793; Poitevin introduces photography with, 553-57; Eder studies chemical reactions of, 559; use in photoceramics, 567
Chromium, discovery of, 119
Chromometer, 649
Chromoscope cameras, 646, 649, 658
Chronographs, 502, 504, 507, 508, 510
Chronophotography, 504, 507, 510, 511, 516, 520
Chrysotype, 264
Ciamician, Giacomo, 699; "Azioni chimiche della luce," 699; "Photochemistry of the Future," 699
Ciceri, 754
Ciné-Kodak, 673
Cinéma, origin of term, 790
Cinematograph, ballistic, 526-27
Cinematography: forerunners of, 495-500, 501-5, 506-13; controversy over invention of, 509-12; development of, 514-24, 717-19
Cinéopse, Le, 789
Cinnabar, effect of light on, 6-8
Citric acid, 119
Civiale, Aimé, 358
Civil War, American: Matthew Brady's photographs of, 359; balloon photography used in, 394-95
Clark, Walter, xiii, 450, 491, 696
Clauder, G., "Treatise on the Philosopher's Stone," 15
Claudet, A. J. F., 251-52, 280, 298, 314, 449, 578; studies action of spectrum on daguerreotype plates, 263, 267; investigates use of bromo-iodide and iodochloride in daguerreotypy, 276, 278, 760; uses painted backgrounds in daguerreotype studio, 356, 769; Le Stereoscope, 383; Recherches sur la theorie des principaux phenomènes de photographie, 762; Nouvelles recherches sur la différence entre les foyers visuels et photogénique, 762
Claudet and Houghton, 356
Clay, Reginald S., 411
Clément, 163
Clerc, Louis-Philippe, xiii, 383, 638, 677, 812; La Technique photographique, 549
Cleve, C. W. Scheele ett minnesblad på hundrade årsdogen of hans död, 739
Clorona papers, 448
Cochineal papers, 182
Coindet, Dr., 164

Coissac, G. M., Histoire du cinématographe, 523
Cole, William, 11-12; "Observations on the Purple Fish," 730
Coleridge, Samuel Taylor, 135
Collen, Henry, 642
Collinear lens, 410
Collodion emulsions, 376-79
Collodion process, dry, 372-76, 382, 395
Collodion process, wet: 326, 341; early history of, 342-47; theory and practice of, 357-69; disadvantages of, 357-59; early books on, 360; intensification methods used in, 363-66; photography of solar spectrum by, 366-67; direct positives in camera with, 369-71
Collotypes, 554, 563, 617-21; three-color, 646-47, 654; four-color, 653
Colomb, 791
Color photography, see Photography, three-color
Colors: Aristotle's views on, 3-4; used by ancients, 6-8, 730; action of light on, 13, 85-89, 100, 112-13, 129, 149, 153-55, 187, 740; fastness of organic, 120; Goethe's studies on, 153-55; theories of primary, 639-41, 746; see also Light; Solar spectrum
Color sensitizers, 459, 460, 465-78, 480, 482-83, 645, 646, 647, 783, 815; see also Desensitizing
Colson, R., Mémoires originaux des Créateurs de la photographie, vii, 27, 754
Comptes rendus de l'Academie de sciences, 676
Conduche, Ernst, 610
Contessa-Nettel, 411
Cooke lens, 411
Cooper, 54
Cooper-Hewitt, 533
Copper plates, 262; Niépce's use of, 205; photoetchings on, 593-94, 595, 598
Copyrights for photographs, 463
Cornelius, Robert, 272, 274, 275, 288, 289
Corriere Fotografico, Il, 700
Corti, Count Egon, 318
Corti, Count Hugo, 318
Corvinus, Andr. Albr., 64, 65, 72
Cotton, colloidion, see Collodion process
Courtois, Bernhard, 162, 163, 173
Cowan, 445
Coxwell, 395
Crabtree, J. I., 491, 540
Cramer, Lüppo Hinricus, see Lüppo-Cramer
Cranz, C., 526, 527
Creiling, 53

Crell, *Die neuesten Entdeckungen in der Chemie,* 741

Cremière, L., 592

Croft, W. C., 516

Crollius, (Oswald Croll) 28; *Basilica chymica,* 29, 733

Cromer, G., 697, 753, 754; *Revue française de photographie,* 255

Cronenberg, W., 685; *Praxis der amerikanischen Photogravure,* 685

Crookes, William, 264, 366, 367, 457, 530

Cros, A. H., 649

Cros, Charles (Emile Gauthier, pseud.), 465, 466, 642, 643, 648-652, 656; "Solution du problème de la photographie des couleurs," 649; *Le Collier de griffes,* 650; *Solution générale du problème de la photographie des couleurs,* 650; *Note sur l'action des differentes lumières colorées,* 650

Cross, 551

Cruickshank, W., 151

Crum, 343

Crusius, C. G. Baumgarten, *De Georgii Fabricii vita et scriptis,* 26

Crystalli Dianae, 23

Crystallization, 147

Cundell, 298, 328, 583

Cuprotypes, 637

Curie, Marie, 265

Curie, Pierre, 265

Cussel, 206

Cutting, J. A., 611; patent with Turner, 361

Cyanometer, 112

Cyanotype, 178, 542, 549

Dagherotipo, Il, 679

Dagon lens, 410

Dagron, 388, 389, 390

Daguerre, Eulalia (Madame Courtin), 248

Daguerre, Louis Jacques Mandé, 209-15, 233-54, 272-73, 279-80, 534; use of iodized silver plates by, 139, 164, 223-26, 250, 253, 261-62, 269, 271; use of fixatives by, 170, 176, 250, 254; invention of daguerreotype process by, 181-82, 193, 203, 250; agreement with Nicéphore Niépce, 199, 215-17, 233; meeting with Niépce, 205, 207-8, 215; description of diorama invented by, 209-14; *Historique et description des procédés du daguerréotype et du diorama,* 218, 252, 755; contracts with Isidore Niépce, 226-29, 233; use of mercury vapors for development, 227-28, 250, 253, 325; sale of invention to French government, 230-32, 245;

manufacture of cameras with Giroux, 250-51; *Geschichte und Beschreibung des Verfahrens der Daguerreotypie und des Dioramas,* 755

Daguerreian Journal, 340, 679, 813

Daguerreotype, The, 679

Daguerreotypes: first portraits with, 271-77; coloring of, 315-16; spectral sensitivity of, 439; etching of, 577-80, 591; historical collections of, 764

Daguerreotypy, 193, 253; sale of invention to French government, 230-32, 245; Arago's report on invention to French Chamber of Deputies, 232-41; Gay-Lussac's report on invention to French Chamber of Peers, 241-45; publication of processes used in, 245, 252; caricatures about, 256-57; theories on chemical basis of, 259-68; early exploitation of, 279-89; as a profession, 313-15; disadvantages of, 316; displaced by wet collodion process, 341, 346; relation to arts, 348; used in stereoscopic photography, 382

Dahlström, C. A., 214

Daily Graphic (New York), 627-28, 629-30

Daimer, Jos., 692

Dale, W., 396

Dallas, Campbell Duncan, 582, 583, 584

Dallmeyer, John Henry, 307, 406, 410, 474

Dallmeyer, Thomas Rudolf, 406

Dancer, John Benjamin, 299, 347, 387, 388, 389

Danesi, 701

Daniel, L., 549

Dansk fotografisk Forening, 704

Dansk fotografisk Tidskrift, 704

Darkrooms, portable, 357-59

Darmstädter, Ludwig, *Handbuch zur Geschichte der Naturwissenschaften und der Technik,* 25, 781

Darwin, Erasmus, 100, 135

Daumier, Honoré, 394

Davanne, Alphonse, *viii,* 368, 651, 652, 792; *Chimie photographique* (with Barreswil), 360, 361; *Recherches théoriques et pratiques sur la formation des épreuves photographiques positives* (with Girard), 538; *Nicéphore Niépce,* 755; *La Photographie,* 792; *Die Anwendung der Chemie auf die Photographie* (with Barreswil), 802

Davidson, W. W. L., 660

Da Vinci, *see* Leonardo da Vinci

Davis, Raymond, 694

Davy, Sir Humphry, 136-42, 730, 745; as forerunner of photography with Wedg-

wood, 63, 107, 140, 318-19, 745-46; collaboration with Wedgwood, 92, 136-42, 203; studies chemical action of light, 120, 157, 158, 167; "An Account of a Method of Copying Paintings upon Glass and of Making Profiles by the Agency of light" (with Wedgwood), 136-38; produces enlarged images with solar microscope, 139, 140, 391; experiments with silver iodide, 139, 163-64; *Elements of Chemical Philosophy*, 158; "Some Experiments and Observations on a New Substance Which Becomes a Violet Coloured Gas by Heat," 163; "An Essay on Heat, Light and the Combinations of Light," 744

Dawson, George, 686; *A Dictionary of Photography* (with Sutton), 765, 770

Decalcography, 623

Decaut, 522

Dechales, Claude François Milliet, 49, 52; *Cursus seu mundus mathematicus*, 49

Decoudin, 449

Decourdemanche, 187

Dedekind, Alexander, 9, 10, 11; *Ein Beitrag zur Purpurkunde*, 10, 13; *La Pourpre verte*, 730, 731

Defregger, Robert, 638

Degotti, 209, 754

Delamarre, 529

Delaroche, Paul, 235, 348

Delessert, Benjamin, 592, 813

Delessert, Edouard, 307, 351

Della Rovere, 286

De Lucs, *see* Lucs, de

Demachy, Robert, 560, 561, 563, 565

Demaria, Jules, viii

Dembour, A., 804

Demény, George, 508, 512, 516

Democritus, 1

Denier, H., 707

Denisoff, A., "Physikalisches Institut der Universitat Leningrad" (with Walenkov), 816

Denisse, 397

Denmark, photography in, 703-4

Density, laws of: for photographic plates, 454-56

De Roth, *Fortschritte der Photogr.*, 810

Desbarats, George E., 627

Descartes, 50

Descamps, Palmer, 428

Desensitizing, 478-84

Desmarets, 395, 396

Desmortiers, 130, 131, 146; *Recherches*

sur la décoloration spontanée du bleu de Prusse, 745

Dosormes, 163

Desprats, Abbé, 373

Desprets, 334

Deutsche Gelatinefabrik A. G., 695

Deutsche I. G. Farbenindustrie A.-G., 695

Deutsche Mertensgesellschaft, 606

Deutsche Photographische Gesellschaft, 684

Developers, 219, 432-36; Daguerre's use of mercury vapor, 227-28, 250, 253, 325; gallic acid, 322, 327-30, 339 340, 341; iron sulphate, 325-26, 347, 362; pyrogallic acid, 330, 347, 375; alkaline, 375-76, 434, 750; pyrogallol, 375-76, 432-33, 436; iron oxalate, 433-34; organic, 434-36, 444-45, 478

Development: physical, 330, 368, 375, 432; chemical, 376, 432, 443-45; stand, 400; with use of desensitizers in light, 478-79, 484

Deville, E., 634; "Theory of the Screen in the Photomechanical Process," 634

Diachromy, 540

Dialytic photographic lens, 300

Diamond, 810

Diaphanometer, invented by Saussure, 113

Diaphragms, 298-99; Niépce's construction of iris, 198, 299

Diapositives, 443-45, 540-42

Diazo compounds, use in producing diazotypes, 550-51

Dickson, K. L., 490

Didier, L., 649

Dierbach, *Beiträge zur Kenntnis des Zustandes der Pharmazie*, 731

Dietzler, construction of lenses by, 300-303, 304, 307, 762

Dioptrics, 302

Diorama, 209-14; invented by Daguerre, 209-11; Lewald's impressions of Daguerre's, 211-14; spread from Paris to other countries, 214; sale of process to French government, 231

Dioscorides, *De materia medica*, 8

Direct positives in the camera, 369-71

Disdéri, André Adolphe Eugène, 307, 325, 350, 352, 355, 356, 392; *Manuel opératoire de photographie*, 351, 360; *Renseignements photographiques*, 351; *L'Art de la photographie*, 351, 360, 769; *Die Photographie als bildende Kunst*, 769

Disdéri & Co., 588

Disks, stroboscopic, 496, 497, 498, 504, 507, 513, 787-88

Disselhorst, Rudolf, "Das biologische Lebenswerk des Leonardo da Vincis," 734

Dissolving views, 53, 499

Distillation, sun, 16-17

Dixon, Henry, 377

Dixon, Joseph, 610

Dizé, 111, "Sur la cristallisation des sels par l'action de la lumière," 742

Döbbelin & Remelê, 305

Döbler, Ludwig, 499

Doctor: use in photogravure printing, 594, 596, 600-2, 605, 801; origin of term, 801

Doebereiner, Johann Wolfgang, 160, 172, 177, 178, 186, 542; *Pneumatischen Chemie*, 172; *Zur chemischen Kenntnis der Imponderabilien in der anorganischen Natur*, 177

Dogmar lens, 412

Doležal, Ed., 396, 399, 400, 401, 402; "Th. Scheimpflug," 402; *Die Anwendung der Photographie in der praktischen Messkunst*, 774; *Die Photographie und Photogrammetrie*, 775

Dollond, John, 50, 251

Dominis, Antonius de, *De radiis visus et lucis in vitris perspectivis et iride*, 639

Domonte, Flores, 342, 343

Donisthorpe, Wordsworth, 516, 649

Donné, Alfred, 54, 259, 260, 385, 386, 577, 578, 773; *Cours de microscopie complem. d'études medic. suivi d'un atlas*, 386; *Atlas d'anatomie microscopique* (with Foucault), 387

Donner, *Über die antiken Wandmalereien in technischer Beziehung*, 730

Dorel, F., 549

Dorel, J., 549

Dorffel, T., 285

Dorpat telescopic lens, 308

Dorthes, 111, 742

Dost, Wilhelm, 697; *Vorläufer der Photographie*, xi, 699; *Die Daguerreotypie in Berlin 1839 bis 1860* (with Stenger), 284-85; *Geschichte der Kinematographie*, 697

Double-anastigmat lens, 410, 776

Douglas, G., 793

Douglasgraph process, 550, 793

Dove, Heinrich Wilhelm, 452

Doyen, 383

Drac, K. J., 649

Draper, Henry, 270

Draper, John William, 110, 166-67, 260, 261, 269-70, 272, 412-13, 759; studies

action of solar spectrum on daguerreotype plates, 263, 264, 267, 457; makes first daguerreotype portraits, 271-72, 273, 274, 355, 759

Dresden Ika Co., 442

Dreyer, Alois, *Franz von Kobell...*, 797

Driffield, Vero Charles, 450, 452, 453-54; *Photochemical Investigations and a New Method of Determination of the Sensitiveness of Photographic Plates* (with Hurter), 454

Drummond, Thomas, 528

Drummond's calcium light, 386, 528-29

Drums, used in early motion pictures, 500, 504, 513

Dry plates, *see* Plates, dry

Dschâbir ibn Hajjam, *see* Geber

Duboscq, Louis Jules, 54, 357, 373, 381, 382, 387, 388, 390, 474, 499

Duchâtel (French Minister of the Interior), 230, 231, 232

Ducom, Jacques, 396

Ducos du Hauron, Alcide, 646, 647, 653; *Traité pratique de photographie des couleurs* (with Louis Ducos du Hauron), 466, 643, 648, 653; *Les Couleurs en photographie et en particulier l'heliochromie au charbon*, 643; *Photographie des couleurs*, 643; *La Triplicité photographique des couleurs et l'imprimerie*, 643

Ducos du Hauron, Louis, 465, 467, 514-15, 642-49, 651-53, 658, 785, 807; *Traité pratique de photographie des couleurs* (with Alcide Ducos du Hauron), 466, 643, 648, 653; *Les Couleurs en photographie*, 643, 644, 648, 656, 808; *La Photographie indirecte des couleurs*, 643, 648; *L'Héliochromie*, 648

Duda, Franz, 527

Dufay, 662

Dufay, Captain, 85, 100

Duhamel du Monceau, 12-13, 93, 730, 731; *Quelques expériences sur la liqueur colorante que fournit le pourpre...*, 12

Du Hauron, *see* Ducos du Hauron

Duhousset, Captain, 502

Dujardin, 379, 595, 652

Dulk, Friedrich Philipp, 180-81; *De lucis effectibus chemicis*, 180

Dumas, Jean Baptiste, 192, 224, 262, 272, 412

Dumont, R., 549

Dumoulin, Eugéne, *Les Couleurs reproduites en photographie*, 648

Dunker, J. H. A., *Pflanzenbelustigung*

oder Anweisung, 34
Dupuis, 383
Dusting-on processes, 566-67, 591
Dutkiewicz, 708
Dyeing: purple, 8-14; experiments in, 92-93, 114, 115, 188, 189, 190-92
Dyes: used in color-sensitizing, 457-61, 464-78; confiscation of German patents for, 477; used as desensitizers, 478-84; produced with diazo compounds, 550-51
Dyes, mordant, *see* Mordant-dye process
Dynar lens, 411

Earinus, 5-6
Eastlake, Sir Charles, 321, 678
Eastman, George, 380, 432, 440, 486-92, 520, 695, 786
Eastman Dry Plate & Film Company, 440, 488
Eastman Kodak Company, 442, 447, 490-94, 518, 524, 655, 673, 698, 718; *Abridged Scientific Publications from the Research Laboratories*, 696; *Monthly Abstract Bulletin of the Kodak Research Laboratories*, 696
Eastman Kodak Research Laboratory, xi, 378, 478, 695-96
Eberhard, G., 457
Ebermaier, Johann Edwin Christof, 122, 123, 124, 126, 127; *Versuch einer Geschichte des Lichtes*, v, 122, 146, 729; *Commentatio de lucis in corpus humanum vivum praeter visum efficacia*, 122
Ecker, H., 656
Ecole des Arts et Métiers, 677
Ecole Municipale Estienne, 677, 812
Ectypa, 35
Eder, Josef Maria, 682, 688-91, 720-28; *Geschichte der Photochemie*, vi; *Ausführliches Handbuch der Photographie*, vi, vii, 722; *Geschichte der Photographie*, vii, viii, ix, xi, xiii, 26; investigations in spectroscopy, 14, 472, 532, 724; *Quellenschriften zu den frühesten Anfängen der Photographie*, 25-26, 30, 63, 724, 733; *Johann Heinrich Schulze*, 63, 73, 83, 724, 738; investigations in photometry, 165, 418, 452, 453, 721, 722, 783; *Die Daguerreotypie und die Anfänge der Negativphotographie auf Papier und Glas* (with Kuchinka), 252, 316, 757; investigation of nitrocellulose, 343-44; investigation of cadmium double salts, 362, 720; *Die Photographie mit Kollodiumverfahren*, 363; *Die Bleiverstarkung, eine neue Verstarkungsmethode* (with Tóth), 364; investigation of

intensifiers, 364-66, 720; "Die Reaktion von rotem Blutlaugensalz auf metallisches Silber," 364; "Neue Untersuchungen über die Bleiverstarkung," (with Tóth), 364; *Die Photographie mit Bromsilbergelatine-Emulsion*, 365, 414; investigations in Roentgen photography, 384-85; *Versuche über die Photographie mit Röntgenstrahlen* (with Valenta), 384-85; *Jahrbuch für Photographie und Reproduktionstechnik*, 388, 722; "Die photographischen Objective" (with Steinheil), 405; *Momentphotographie*, 407, 624, 722; investigations in ammoniacal ripening of emulsions, 429-30, 778; *Theorie und Praxis der Photographie mit Bromsilbergelatine*, 430, 721; "Beiträge zur Photochemie des Bromsilbers," 430; *Modern Dry Plates*, 431; introduces iron oxalate developer, 433-34, 721, 780; introduces pyrocatechin developer, 434; introduces chemical development of gelatine silver chloride emulsions, 443-45, 447, 721, 780, 781; *Die Photographie mit Chlorsilbergelatine* (with Pizzighelli), 444; introduces gelatine silver bromo-chloride emulsions, 447, 721; *Ein neues Graukeil-Photometer für Sensitometrie*, 453; introduces orthochromatic erythrosin plates, 469-70, 722, 785; *Beiträge zur Photochemie und Spektralanalyse* (with Valenta), 470, 471, 472, 532, 724, 814; *Röntgenphotographie* (with Valenta), 472; *Atlas typischer Spektren* (with Valenta), 472, 532, 724; investigation of photography with chromates, 559, 795; *Über die Reaktionen der Chromsäure und der Chromate auf Gelatine, Gummi, Zucker und andere Substanzen*, 559, 720; "Die Erfinder des Gummidruckes," 560; *Daguerreotypie, Talbotypie und Niepçotypie* (with Kuchinka), 692; *Die chemischen Wirkungen des farbigen Lichtes*, 721; *Die Bestimmung der Salpetersäure*, 720; *Untersuchungen über Nitrozellulose*, 720; "Analysen des chinesischen Tees," 720; *Bleichen von Schellack*, 720; *Rezepte, Tabellen und Arbeitsvorschriften für Photographie und Reproduktionstechnik*, 723, 806; *Über Schloss Münichau bei Kitzbühel in Tirol*, 725; *Beiträge zur Kenntnis des Einflusses der chemischen Lichtintensität auf die Vegetation*, 725; "Licht, chemische Wirkungen," 725; "Geschichte der Oester-

Eder, Josef Maria (*Continued*)
reichischen Industrien," 725; "Petz-vals Orthoskop," 763; "Blaues Licht für Porträtaufnahmen bei künstlichem Lichte," 769; "Über die Einwirkung von Ferrizyaniden auf metallisches Silber," 770; "Das Reifen der Bromsilbergelatine," 778; "Zur Geschichte der orthochromatischen Photographie mit Erythrosin," 785; Über das Verhalten der Haloid-Verbindungen des Silbers...," 785; "Versuch der Wiederbelebung durch Hubert Herkomer und Henry Thomas Cox," 797; "Beiträge zur Geschichte und Theorie der Algraphie," 803; *Karl Kampmann,* 803

Edison, Thomas Alva, 489-90, 500, 509, 515, 518-19, 650-51, 718-19

Edwards, B. J., 445, 658

Edwards, Ernest, 619

Eggert, John, 662, 687, 695

Egli, Carl, 434

Egloffstein, Frederik von, 627; *Abridgement of Specification Relat. to Phot.,* 805

Egypt, Nubia, Palestine and Syria, 332

Ehrenberger, 53

Einstein, Albert, photochemical law of, 418-19

Eisenlohr, 367

Ektypography, 804

Electrochemical theory, Berzelius', 167

Electrography, 260, 268, 574, 575, 581

Electrotachyscope, 513

Electrotyping, 568, 569, 574-75; *see also* Photoelectrotypes

Element, defined by Boyle, 30

Elliot, James, 381

Ellis, Joseph, 206, 207

Emerson, P. H., *Naturalistic Photography for Students of the Art,* 350

Emmerich, G. H., 693

Empedocles, 3

Emulsions, collodion: 376-79; silver bromide, 377-79; orthochromatic, 378; isochromatic, 379

Emulsions: gelatine silver bromide, 421-38; gelatine silver chloride, 443-49; gelatine silver bromo-chloride, 447-48; "grainless," 668, 670-71

Enamel, positives on, 347, 566-67

Enamel process, halftone, 635, 806

Endlicher, 245, 281

Energiatype, 326

England, photography in, 677-79

English Autotype Company, 558, 559

English Cartographic Institute, 615

English Colour Snapshot Co., Ltd., 647

Engravings: Niépce's method of copying, 221-22; as book illustrations, 33

Enlargements, 271, 324, 391-93

Eosin, sensitizing effect of, 379, 464, 466-68, 784; *see also* Erythrosin

Epicurus, 3

Epidiascope, 391

Episcopic projection, 54, 55

Erdmann, Friedrich Andreas, *Gründlicher Gegensatz auff das Gründliche Bedencken und physicalische Anmerckungen von dem tödtlichen Dampfe der Holtz-Kohlen,* 71

Ericsson, Tore, 702

Erményi, L., 761; *Petzvals Leben und Verdienste,* 303, 761, 762; "Theorie der Tonsysteme von Petzval," 762; "Nachträgliches über Petzval," 763

Ernemann, 411, 524

Ernemann, Heinrich, 687

Erythrosin, use in color-sensitizing, 469-71, 785

Eschinardi, Francesco, *Centuriae optical pars altera,* 52

Estanave, E., 669

Etching: galvanic, 576, 577-79; of daguerreotypes, 577-80, 591; Talbot's invention of photographic, 582, 583, 593-94; on steel, 591-94; on glass, 616-17; on zinc, 621-25, 635

Etching, heliographic, *see* Heliogravure

Etching machines, 633, 806

Ethyl red, as a sensitizer, 473-76

Ettingshausen, Andreas Freiherr von, 245, 280, 281, 290, 293, 296, 311, 329

Ettingshausen, C. V., *Physiotypia Plantarum Austriaearum* (with Pokorny), 570, 571, 796; *Photographisches Album der Flora Österreichs,* 796; *Die Blatt-Skelette der Dikotyledonen...,* 796

Euclid, 1, 45, 46, 581

Eudoxia Macrembolitissa, 10-11

Euler, Leonhard, 54, 120, 123, 130, 144, 706; *Letters on Various Subjects,* 744

Euryscope lens, 407, 408

Evans, Mortimer, 515, 517

Excursions daguerriennes, 279, 578, 798

Exhibitions, photographic, 676, 680, 683, 684, 685, 702, 708, 715, 725

Exner, Wilhelm Fr., 689-91, 697; *Erlebnisse,* 814

Exposure, length of: in heliography, 223, 234; in daguerreotypy, 236, 254, 271, 275-78; in other photographic processes, 439

Exposure meters, 449, 758; *see also* Photometers

Exposure tables, 415, 450

Faberius, 7

Fabre, C., *Traité encyclopédique de photographie*, 26

Fabricius, 533

Fabricius, Georg, 24, 25, 26; *De metallicis rebus*, 25

Fabroni, Giovanni Valentino Mattia, 119; *Di unatinta stabile che qui suo entrarci dall'aloc soccotorima*, 744

Fabry, M. Ch., 694

Falk, Benjamin, 441

Faraday, 171, 642

Fargier, 557, 558

Farmer, E. Howard, 438, 564, 565, 780, 795

Farmer, H. F., 562, 795

Farmer's reducer, 366, 438

Fawcett, Samuel, 601

Feer, Adolf, 550, 551

Fehling, *Neues Handwörterbuch der Chemie*, 725

Feldhaus, F. N., 337; *Leonardo der Techniker und Erfinder*, 734

Felisch, A., 708

Fenton, Roger, 359, 582

Ferdinand I, Emperor of Austria, 246, 247

Fernbach, *Die enkaustische Malerei*, 730

Ferran, 442, 485

Ferricyanides, use in intensification, 364, 365

Ferrier, A., 347, 351, 373

Ferrotypes, 326, 369, 370, 371

Feuerbach, 780

Fiedler, J., 183-84; *De lucis effectibus chemicis in corpora anorganica*, v, 62, 183

Field, George, 186; *Chromatographie*, 187

Figuier, Louis, *Exposition et histoire des principal découvertes scientifiques modernes*, 223

Film, origin of term, 786

Film-roll holder, *see* Roll holder

Films, 452, 485-94: stripping, 346, 362, 380, 485, 488, 489; celluloid, 485-86, 489-91, 492-93; roll, 486, 488-90; paper, 488; transparent, 489

Films, motion picture: 470; use of perforated, 518; standard sizes of, 524

Filmtechnik, 695

Filters, 367, 388, 465-66, 469, 641; blue glass, 355, 356; complementary light, 645-46; *see also* Photography, three-color

Fiorelli, *Kleine Schriften*, 730

Firmicus Maternus, Julius, 15, 731

Fischer, Carl, *Geschichte der Physik*, v, 734; *Physikalisches Wörterbuch*, v

Fischer, F., 471

Fischer, G. T., *Photogenic Manipulation*, 356

Fischer, Nicolas Wolfgang, 160-62, 163, 164, 173, 176, 181, 748-49; "Kritik der von dem Herrn Professor David Hieron Grindel fortgesetzten Versuche über die künstliche Bluterzeugung," 160; *Über die Wirkung des Lichtes auf Hornsilber*, 160; "Über die Ausscheidung des Silbers aus dem Chlorsilber durch Zink," 162; *Über die Natur der Metallreduktionen*, 176

Fishenden, R. B., 549, 678

Fixatives: lack of knowledge of, 97, 137, 139, 140, 141, 180, 182, 195, 196, 199, 254; hyposulphites as, 170, 254, 757-58; Talbot's use of, 319-21, 323; development after use of, 368

Fixing baths, 254, 538-39; for gelatine dry plates, 437-38

Fizeau, Hippolyte Louis, 270, 457, 578, 580, 758; gold toning of daguerreotypes by, 254, 537; studies varied effects of light on daguerreotype plates, 266-67, 269, 528; *Vervielfältigung der Lichtbilder durch Abziehen einer galvanischen Kopie eines Daguerreotyps*, 798

Flach, H., 11; *Herr Wilamowitz-Möllendorf und Eudokia*, 11; *Die Kaiserin Eudoxia Makrembolitissa*, 730

Flashlight powders, magnesium, 474, 531-33

Flower infusions, light-sensitivity of, 159

Fluorotype, 326

Fockeday, Hippolyte, *Album photographique de l'artiste et de l'amateur* (with Blanquart-Evrard), 332

Focus, 703

Fontaine, 586, 587

Forch, C., "Edison and His Connection with Cinematography," 718

Fordos, Mathurin Joseph, 254

Forest, Lee de, 790

Forster, J. R., 98, 99

Forster, L. V., 773

Fortier, 486

Fothergill, 375

Fotografiske Forening, 703-4

Fotografiske Forenings Tidende, 704

Fotohandel, 703

Fotel printing, 549-50

Fotovreugde, 703

Foucault, Léon, 54, 387, 772-73; studies varied effects of light on daguerreo-

Foucault, Léon (*Continued*)
type plates, 266-67, 269, 528; experiments in astrophotography, 270, 392, 457; *Atlas d'anatomie microscopique* (with Donné), 387
Fouque, S., 195, 200, 201-2, 204, 205, 206; *La Vérité sur l'invention de la photographie*, vi, 199, 201, 752, 753
Fourcroy, A. Fr. de, 115, 124, 152; "Sur les différents états du sulfate de mercure," 743
Fowler, R. J., 306, 418
Fox Talbot, *see* Talbot, William Henry Fox
Foye, 270
Français, 406
France, photography in, x, 676-77
Franciscus Maurolycus, *Photismi de lumine et umbra*, 43
Francke, August Hermann, 64, 65, 72
Frank, 187
Frank, Gustav, 710
Frankfurt Verein zur Pflege der Photographie, 683
Franklin, Benjamin, 87, 100, 397
Franklin Institute at Philadelphia, 680
Franz, L., 406
Fraunhofer, Joseph von, 50, 132-33, 251, 290, 292, 298, 308-11, 763
Fraunhofer lines, 132, 133, 264, 267
Freiburger Zeitung, 606
Fresnel, 157
Freund, Leopold, xi, 127, 723; *Vergessene Pioniere der Lichttherapie*, 123
Freymann, 574
Friebes, 707
Friedländer, P., 14; *Über den antiken Purpur von Murex brandaris*, 731
Friedlein, 557
Friedrich, Anton, 304, 763
Friese-Greene, William, 515, 516, 517, 518, 658, 790
Frisius, Gemma, 40
Fritz, Felix, 23, 28, 32, 67, 68, 81
Fritz, Georg, 803; *Festschrift zur Enthüllungsfeier der Gedenktafel für Paul Pretsch*, 798; "Die Vorläufer des Dreifarbendruckes und der Farbenheliogravure," 807
Fromberg, 165
Fry, P. W., 346
Fulgur printing, 549
Fulhame, Mrs., 116-17, 118, 743-44; *An Essay on Combustion*, 116
Fülöp-Miller, René, *Die Phantasiemachine*, 519
Fulton, Robert, 209, 754

Funke, C. R., 36
Fyfe, 335, 766

Gabriel, C. M., *Recueil des travaux scientifiques de Léon de Foucault* (with Bertrand), 773
Gaedicke, J., 474, 532
Gaillard, E., 634, 656
Galen, 46, 381
Gallic acid, 339, 340, 341; use of, by Talbot, 322-23
Galvanography, 574
Gamble, Charles William, 678
Gamble, William, xiii, 767, 769, 777, 805
Ganz, R., 705
Garnett, *Life of Maxwell* (with Campbell), 807
Garnier, Henri, 543, 556, 557, 566, 567, 595, 800
Garot, 751
Gatel, 391
Gaudin, Alexis, 255
Gaudin, Marc Antoine, 266, 278, 314, 342-43, 376-77, 421, 529, 763, 771; *Derniers perfectionnements apportés au daguerréotype* (with Lerebours), 763
Gaumont, J., 509, 522, 658
Gaumont-Demény, 522
Gauthier, Emile, *see* Cros, Charles
Gay-Lussac, Joseph Louis, 151-53, 155, 156-57, 158, 163-64, 176; "De la nature et des propriétés de l'acide muriatique," 152; *Recherches physico-chimique*, 156; report on daguerreotypy to French Chamber of Peers, 153, 232, 241-45
Gazzetta della fotografica, La, 700
Gebauer, 772
Geber (Gâbir), 17, 22, 29; *De inventione veritatis*, 22, 732; *Curieuse vollständige chymische Schriften*, 732
Gehlen, Adolph Ferdinand, 120, 147, 148, 767; *Physikalisches Wörterbuch*, 120; Über die Farbenveränderung der in Äther aufgelösten salzsauren Metallsalze durch das Sonnenlicht," 746
Geiger, 730
Geissler, Friedrich, *Baum des Lebens*, 732
Geitel, Max, *Der Siegeslauf der Technik*, 725
Gelatine: early failures with, 339, 340, 421-22; use on collodion plates, 373-74; use in emulsions, *see* Emulsions
Gelatine silver bromide, 425-32, 432-36, 439-43; firms producing plates, 427, 428, 430, 431-32; technical literature on, 430; developers for plates, 432-36; printing papers, 439-43, 607-8

Gélis, Amadée, 254

Gemoser, Max, 619

Gerlach, J., *Die Photographie als Hilfsmittel mikroskopischer Forschung*, 773

Gerland, F. J. M., 624

German Society of Friends of Photography, 683

Germany: early interest in daguerreotypy in, 284-86; photography in, 680, 683-87

Gerson, Levi ben (Leon de Bagnois), "De sinibus, chordis et arcubis," 38

Gertinger, 362

Gesner, Konrad, 704; *De onmi rerum fossilium genere, gemmis, lapidibus, metallis*, 24

Gibson, Charles R., 63, 92, 317, 319; *Photography as a Scientific Implement*, 322, 760

Gibson, K. S., 694

Giessendorf, Karl von, 611, 623, 802

Gilbert, 161, 730, 747

Gillot, Charles, 622

Gillot, Firmin, 576, 585, 621-22, 623, 624

Gillotage, 621, 622

Giphantie, 89, 90

Girard, Aimé, 368

Girard, Jules, *Recherches théoriques et pratiques sur la formation des épreuves photographiques positives* (with Davanne), 538

Giroux, manufacture of cameras with Daguerre, 250-52

Giroux et Cie., 281, 285

Girtaner, 121; *Anfangsgründe der antiphlogistischen Theorien*, 117

Glaisher, James, 395

Glaserei für photographische Trockenplatten, 432

Glass, 155, 185-86, 309; reproduction of designs on, 135-39, 222; negatives on, 338-40, 344-45, 369, 485; direct positives on, 369; types used in lenses, 408-10; etching on, 616-17

Glauber, Johann Rudolf, 23; *Explicatio miraculi mundi*, 23; *Opera chymica*, 23, 106

Glotz, Wilhelm, 793

Glover, 376

Glover and Bold, 769

Gmelin, J. Fr., *Geschichte der Chemie, v*, 722, 732, 737

Gobelins tapestry, 190

Goddard, John Frederick, 265, 275, 276, 278, 288, 759, 760

Goddard, Paul Beck, 265, 288, 759

Goeppert, Heinrich Robert, 772

Goerz, 695

Goerz, Carl Paul, 409, 410, 411, 474, 520, 776

Goerz-Festschrift, 776

Goethe, 37-38, 153-54, 177, 748; *Geschichte der Farbenlehre*, 37, 153-54, 729; studies on science of color, 153-55; *Reinecke Fuchs*, 420

Goetz, Fritz, 633

Gold: alchemists' work with, 15-22; use in toning-fixing baths, 254, 537-38, 781-82; Miethe's attempts to transmute mercury into, 475

Goldberg, Emanuel, 453, 773, 777; "Die Herstellung neutral grauer Keile und verlaufender Filter für Photometrie und Photographie," 783

Goldmark, Joseph, 412

Gold salts, light-sensitivity of, 18, 22

Goode, 528, 529

Goodwin, Hannibal, 486, 492-94; suit against the Eastman Company, 492-94

Goodwin Film & Camera Company, 493

Göttling, 101, 116, 742; *Beitrag zur antiphlogistischen Theorie*, 743

Gould, 270

Goupil, Adolphe, 279, 559, 595, 653

Goupil & Co., 588

Government departments, as patrons of photography, 694-95, 709-10, 712

Government Printing Office (Vienna), 568-72, 581, 656, 693, 694

Graff, 186

Grant, Alonzo, 531

Graphische Gesellschaft in Berlin von Dr. E. Mertens & Co., 605

Graphische Lehr- und Versuchsanstalt (Vienna), 471, 677, 683, 688-92, 723, 725

Graumüller, *Neue Methode von natürlichen Pflanzenabdrücken in- und ausländischer Gewächse*, 35

Gravesande, s', *Physices Elementa Mathematica*, 53

Grebe, C., 629; "Geschichte der Raster," 805; "Zur Geschichte der Dreifarbensynthesen," 807

Greene, William Friese-, see Friese-Greene, William

Gren, 116

Grevius, *Anatomia plantarum*, 55

Griendel, Franciscus, 53

Griess, P., 550

Grimaldi, Francesco Mario, 144

Grindel, 173

Grinten, van der, 793

Griswold, 370

Gropius, Carl, 214

Gros, Baron, 279

Gros, D., 675

Grotthuss, Theodore von, 166-68, 642, 673, 707; *Über die chemische Wirksamkeit des Lichtes*, 167; law of photochemical absorption, 166-68, 418-19; *Physisch-chemische Forschungen*, 749

Group pictures, taken by Daguerre, 315

Grove, 268, 335, 577, 578

Gruber, Dr., 816

Grund, *Die Malerei der Griechen*, 730

Grüne, W., 566, 758

Guaiacum, 102, 157, 197

Guericke, Otto von, 31

Guerney, Sir Galsworthy, 528

Gueroult, Georges, 523

Guinand, P. L., 309

Guisac-André, 646

Guldberg, 413

Gum printing, *see* Printing, gum

Guncotton, 342-44, 347

Gun powder, 733

Gunther, Karl, 397

Gurney, 54

Gurtner, A., 655, 808

Gütle, J. Conr., *Über die Kupferstecherei*, 34

Guy, Const., 600

Haack, Carl, 431, 779

Haas, Arthur, *Atomtheorie*, 420

Haas, J. C., 634, 636

Haase, Dr., 686

Haensch, 55

Hagemann, A., 102, 103, 197; *Zufällige Bemerkung, die blaue Farbe des Guajacgummis betreffend*, 102

Hahnemann, 115

Halation, 458

Halftone etchings, 583, 591-95, 596, 598

Halftone pictures, 586, 587, 589, 609-13, 622

Halftone process, 623-38; early experiments in producing, 626-30; Meisenbach's use of single-line screen for, 630-32; Ives' use of cross-line screen for, 632; Levy's use of improved cross-line screen for, 633-35; use of grain screens for, 636-38

Hall, R. J., 549

Hall, V. C., 456

Halle, Joh. Sam., *Magic*, 106

Hallwachs, 419

Halm, E., 456

Hamböck, Joh., 809

Hamer, "Recent Advances in Sensitizers for the Photography of the Infra-red" (with Brooker and Mees), 781

Hanfstängl, Edgar, 467, 559, 575, 599, 794

Hanfstängl, Franz, 559, 574, 575, 794, 797

Hann, 616, 803

Hansen, Fritz, 813; *Die ersten Anfänge der Photographie in Berlin*, 284

Hardwich, T. Frederick, 360, 535, 686; *Manual of Photographic Chemistry*, 360

Hare, Robert, 288

Harff, 177

Harrison, C. C., 302

Harrison, G. B., "The Infra-red Content of Daylight," 781

Harrison, W. H., "The Philosophy of Dry Plates," 422

Harrison, W. Jerome, 422, 698; *History of Photography*, vi, vii, 276, 347, 422, 759, 765, 799

Hart, F. W., 531

Harting, H. H., 297, 298, 310, 410, 411; "Zur Geschichte der Familie Voigtländer," 762

Hartmann, Franz, *Cosmology*, 21

Harup, Robert, 129, 133, 134, 745

Hasselkus, 411

Hauff, Fritz, 779-80

Hauff, Julius, 432, 435, 470, 695, 779

Hauler, Edmund, 4, 5, 6

Hauron, Ducos du, *see* Ducos du Hauron

Hawkeye camera, 491

Hay, Alfred, 727

Heat, effect distinguished from action of light: 32, 60, 117-18, 124, 133-34; by Schulze, 62, 74-75, 77, 82; by Scheele, 98; by Berthollet, 143; by Gay-Lussac and Thénard, 152, 156-58; by Fiedler, 183-84

Heath, Charles, 799

Heaviside, 642

Hecht, Walter, "Das Graukeil-Photometer im Dienste der Pflanzenkultur," 777

Heeren, 342, 449, 777

Heid, 431

Heinlein, *Photographikon*, 809

Heinrich, Placidus, 57, 122, 125, 147, 157, 160, 161; *Über die Natur des Lichtes* (with Link), v, 145; *Von der Natur und den Eigenschaften des Lichtes*, 729, 731; *Die Phosphoreszenz der Körper*, 737

Hélain, 539

Helbig, *Wandgemälde der vom Vesuv verschütteten Städte Campaniens*, 730

Helcher, Hans Heinrich, *Aurum potabile*, 17

Heliar lens, 410, 411

Heliochromatic camera, 645-46

Heliochromoscope, *see* Photochromoscope

Heliochromy, 656, 665, 666

Helio-engraving, 628

Heliogravure (heliography): Niépce's invention of, 193, 195, 218-23, 608; Talbot's method of, 204-5, 593-94; Breyer's method of, 336-37; photoelectrotype process of, 589-90; asphaltum method of, 591-92; Klic's improved method of, 596-99

Helioplastie, 585

Helioprint, 586

Hellenbach, Lazar Freiherr von, 19

Hellot, Jean, 63, 84, 88, 105, 106, 140, 534; *Sur une nouvelle encre sympathique*, 84

Helmholtz, Hermann von, 366, 381, 640, 746; *Handbuch der physiologischen Optik*, 807

Henderson, 538

Henneberg, 560, 561

Hennicke, 181

Henry, 6

Henry, C., 190

Henry, Etienne Ossian, 176

Henry, William, 171

Heraclius, *Von den Farben und Künsten der Römer*, 85

Heraeus, 533

Herlango, 431

Hermagis, 304, 305, 307

Hermbstädt, *Bulletin des Neuesten und Wissenswürdigsten aus der Naturwissenschaft*, 151

Hermes Trismegistos, 16, 18, 29

Herodotus, 4

Herr, J., "Simon Stampfer, eine Lebensskizze," 787

Herschel, Sir Friedrich Wilhelm, 128, 131, 135, 136, 146, 757

Herschel, Sir John Frederick William, 262-64, 335, 363, 542, 543, 673, 757-58, 777; discovers use of hyposulphites as fixatives, 170, 254, 319, 320, 534, 757-58; coins word "photography," 258; studies effect of solar spectrum on silver papers, 262-64, 457, 664; "On the Chemical Action of the Rays of the Solar Spectrum on Preparations of Silver," 263; "On the Action of the Rays of the Solar Spectrum on Vegetable Colours," 263, 793, 812

Herschel effect, 263-64

Hertz, Heinrich, 642; *Göttinger Nachrichten*, 807

Hertzberg, John, 396, 702, 814

Herz, Adolf, 705

Herzog, John, 432

Hesekiel, 545

Hess, Germain Henri, 176

Hessler, 747

Hewitt, C. H., 565

Heyde, 449

Hill, David Octavius, 327, 348, 349, 529

Hill, Levi, 316

Hillotype, 316

Hinterberger, Hugo, 688

Hipparchus, 3

Hirsch, *Biographisches Lexicon der hervorragenden Ärzte aller Zeiten und Völker*, 80

Hittorf, J. W., 420, 421

Höchst Dye Works, 476, 477, 480, 481, 482, 483, 484

Hodgson, Richard, 387

Hoegh, Emil von, 410, 776

Höfel, Blasius, 621, 640

Hoff, F. van't, 167, 419

Hoffmann, 574

Hoffmann, Friedrich, influence on Schulze, 66-71, 72, 73; *Friderici Hommanni observationum physico-chymicarum*, 67; *Eines berühmten Medici gründliches Bedenken und physikalische Anmerkungen*, 70-71; *De diaboli potentia in corpora*, 71

Hoffmeister, Philipp, 181-82, 286; "Von den Grenzen der Holzschneidekunst," 181

Holland, photography in, 703

Hollborn, 663

Hollenstein (caustic stone), 23

Homberg, Wilhelm, 31, 32, 33, 60

Homocentric lens, 411

Homolka, Benno, 474, 476, 481, 484, 551

Honey, use on collodion plates, 372

Hooke, Robert, 45, 53

Hooper, W., *Rational Recreations*, 45, 94; plagiarizes Schulze, 94-95

Hopwood, Henry V., *Living Pictures*, 789

Horgan, Stephen H., 628, 629, 630, 806

Horn, Ernst, 122-24, 125-27; *Über die Wirkungen des Lichtes*, v, 729

Horn, Wilhelm, 680

Horner, 500

Hornig, Emil, 365, 427, 469, 681, 682, 683, 688, 812; *Photograph. Jahrbuch*, 812

Hornsilver, 24, 25, 28, 150, 176; *see also* Silver chloride

Horn's Photographisches Journal, 680

Horses in motion, photographic study of, 501-3, 513

Hossauer, 285

Howard, B. Frank, 350

Howlett, 583

Hrdlička, Ferdinand, 431, 437, 536, 779

Hübl, Arthur, Baron von, 401, 403, 468, 545, 547-48; *Die Platinotypie* (with Pizzighelli), 546, 793; fosters graphic reproduction processes at Military Geographic Institute, Vienna, 547-48, 561, 562, 590, 694; *Die Reproduktionsphotographie im k. und k. Militärgeographischen Institute*, 547; *Die photographischen Reproduktionsverfahren*, 547; "Die Bestimmung der farbenempfindlichen photographischen Platten," 783; *Der Platindruck*, 793

Hufeland, 127

Hugersdorff, *Autocartograph*, 403

Huggins, William, 366

Humboldt, Alexander von, 116, 756; *Versuche über die Zerlegung des Luftkreises*, 743

Humphrey, S. D., 679

Humphrey's Journal of Photography and the Allied Arts and Sciences, 679-80

Hunt, Robert, 325, 326, 340, 356, 362, 449, 457, 553, 745, 777; *Researches on Light*, vi, 269, 326, 793, 812; *A Popular Treatise on the Art of Photography*, 326; *A Manual of Photography*, 326, 740, 793; *The Practice of Photography*, 326; *Poetry and Science*, 326

Hunter, Edgar, 798

Hurter, Ferdinand, 450, 452, 453-54; *Photochemical Investigations and a New Method of Determination of the Sensitiveness of Photographic Plates* (with Driffield), 454

Huse, E., 456

Husnik, Jakob, 618, 633, 803

Husnik and Häusler, 619, 637; *Kornautotypie mit ungefärbtem Glasraster*, 806

Husnik and Vilim, 654

Huxley, 387

Huygens, Christian, 31, 47, 50, 52, 120, 123, 144, 703

Hyalography, 616-17

Hyalotypes, 340, 803

Hyatt, John W., 486, 786

Hydrotypes, 649

Hypo, 319, 320, 538, 539

Hyposulphites, property of, as fixatives, 170, 254, 757-58

Hyre, de la, *see* La Hyre, de

Hyslop, H. W., 635, 806

Ibn al Haitam (Al Husen), 1, 2; "On the Form of the Eclipse," 37, 38

Ibn Ruschd (Averroës), 2

Ica, 411

Ichwân Al Safâ (Lautere Brüder), 2

Iconographs, *see* Medals

Identification photography, 354

Idzerda, *Leerbock der algemeene Fotografie*, 249

I. G. Farbenindustrie A. G., 478, 520

Illustrations: engravings as, 33; nature printing used for, 33-36; photographs as, 324, 331-33; Woodburytypes as, 588, 589, 619, 799; printing of newspaper, 605-7; collotypes as, 619; halftone printing of photographs for, 625

Imperial and Royal Institute for Teaching and Experimentation in Photography and the Reproduction Processes, *see* Graphische Lehr- und Versuchsanstalt (Vienna)

Imperial and Royal Photographic Society, *see* Vienna Photographic Society

Imperial Russian Academy of Sciences, 145, 706

Imperial Russian Office for the Production of Government Papers, 709

Indigo, purple dye a derivative of, 14

Induction, photochemical, 413, 777

Infrared rays, 128, 146; chemical action of, 155

Ingenhousz, Jan, 94, 125

Ink pictures, *see* Printer's ink, photographic printing with

Instantaneous photography, 358, 370, 503, 506, 507, 508, 512, 524, 525

Institute d'Optique (Paris), 694

Intaglio printing, *see* Photogravure

Intensification, 265-66, 363-66

Interference-photochromy, 341, 461, 472, 668-72

Iodine, 162-64, 749; discovery of, 162; properties of, 163, 164; use by Niépce of, 220, 222, 223, 755

"Ionia," 10-11

Iris, 623

Iron salts: light-sensitivity of, 56, 542; printing methods with, 542-43

Isenring, Johann Baptist, 315, 704-5

Isochromatic collodion emulsions, 379

Istituto Chimico e Fotochimico, 700

Italy: early interest in daguerreotypy in, 286; photography in, 699-701

Ives, Frederick Eugene, 384, 629, 632, 633-35, 656, 658-59, 806, 808

Ives, Herbert E., 384, 634; "Optical Properties of a Lippmann Lenticulated Sheet," 669-70

Ivory: effect of silver nitrate on, 118; light-sensitivity of, 151

Jackel, George, 356
Jacobi, Moritz Hermann von, 568, 574, 707; *Die Galvanoplastik*, 568
Jacobsen, 383, 434
Jacquard looms, photographic production of patterns for, 662-63
Jacquin, J. Fr. v., 289, 309
Jaffé, Arthur, Inc., 805
Jaffé, Max, 362, 619, 628, 629, 647, 805
Jaffé, Moritz, 628
Jagemann, 353
Jäger, 383
Jäger, Daniel, 121
Jägermaier, 359
Jahn, Johann Quirin, "The Bleaching and Purification of Oils for Oil Painting," 143
Jahr, Richard, 671
Jahresbericht über die Fortschritte und Leistungen im Gebiete der Photographie, 681
Jakobi, 545
Jakobsen, E., 460
James, Sir Henry, 614, 615
Jamin, 299
Janecek, Dr., 816
Janssen, Pierre Jules César, 454, 506, 507, 788-89
Japan, photography in, 713-16, 817
Japan Photographic Annual, 714, 716
Japanese All Kanto Photographic Association, 714
Jasper, Friedrich, "Der Farbendruck in Österreich," 640
Jedronoff, A., 709
Jena Christmas Eve tragedy, 69-70
Jena glass, 408, 409, 410
Jenkins, C. Francis, 515, 516, 522
Jermesite, light-sensitivity of, 180
Johnston, J., 424, 425
Joly, John, 661, 663
Jonas, 468, 799
Jones, Chapman, 452
Jones, L. A., 456, 491
Jordan, 449, 777
Joubert, F., 567
Jougla, 675, 695
Journal avantscène, 622
Journals, photographic, 676-713
Jovanovits, Anastas, 330, 765
Juch, 118; *Versuch über die Wiederherstellung des Goldes*, 744
Julius Pollux, *Onomasticon*, 10
Jumeaux, B., 660
Junius, *Von der Malerey der Alten*, 730
Junk, G. J., 442
Junk, Rudolf, 692

Just, E., 441, 445, 446, 545, 781; *Der Positive-Prozess auf Gelatine-Emulsions-Papier*, 446; *Leitfaden für den Positiv-Entwicklungs-Prozess auf Gelatine Emulsionspapier*, 446

Kaiser, Heinrich, 461
Kaiserling, *Lehrbuch der Mikrophotographie*, 388
Kalle, 551, 793
Kallitype process, 543
Kamada, Yasugi, xi, 715, 716
Kamarsch, 342
Kamei, Katsujro, 660
Kampan Kabushiki-Kaisha, 715
Kampmann, Karl, 34, 617, 803; *Die Dekorierung des Flachglases*, 617; "Titel und Namen der verschiedenen Reproduktionstechniken," 800; "Geschichte der Photolithographie mittels Umdruckpapieres," 802; *Die graphischen Künste*, 803; *Die Literatur der Lithographie von 1798 bis 1898*, 803; *Geschichte der Lithographie und der Steindrucker in Österreich*, 803
Kannegiesser, 285, 286
Kanolt, C. W., 384
Karabaček, 470
Karsten, 260, 268; "Literaturbericht der Photochemie," vi
Kasteleyn, 121
Kastner, 171, 188; *Gewerbefreunde*, 188
Kayser, Heinrich, *Handbuch der Spectroskopie*, 724
Kehrmann, 481
Keim, *Die Mineralmalerei*, 730
Keller-Dorian, Albert, 672, 673, 811
Keller-Dorian-Berthon process, 672-73
Kelly, *Life of John Dollond*, 251
Kennett, Richard, 425
Kent, J. H., 488
Kenyon, G. A., 532
Kepler, Johannes, 31, 44
Kessler, H., 561
Kiewic, 805
Kilophot, 447
Kinetograph, 518, 718
Kinetoscope, 518, 519, 718-19, 790
King, J., 424
King, Samuel A., 394, 395
Kingsley, 387
Kinora, 520
Kircher, Athanasius, 44, 46, 48-49, 51, 731; *Ars magna lucis et umbrae*, 44, 48, 51, 52, 735
Kirchhoff, Gustav Robert, 415, 416
Kirilow, A., "Physikalisches Institut in

Kirilow, A. (*Continued*)
 Odessa," 817
Kirwan, Richard, 98; *On Phlogiston*, 99
Kissling, John, 417, 777; *Beiträge zur kenntnis des Einflusses der chemischen Lichtintensität auf die Vegetation*, 418
Kite, aerial photography from, 396, 397
Klaproth, Martin Heinrich, 101, 197
Klein, 396
Kleinberg, Ludwig, Baron, 662
Klič, Karl (Karl Klitsch), 596-601, 637, 803; biography of, 596, 598-601; spelling of name, 596-98; method of photogravure invented by, 596-99, 800; rotogravure invented by, 599-601; firms using processes of, 599, 601, 801; secrecy of processes, 602, 603, 605, 607
Klič Photochemical Works, 597, 599
Klitsch, Karl (Kleitsch), *see* Klič, Karl
Klügel, 739
Knapp, Wilhelm, xi, 813
Kniphof, Joh. Hieron, 36
Knirim, *Die Malerei der Alten*, 186
Knöfler, Heinrich, 640
Knop, 342
Kobell, Franz von, 286, 574, 575, 581; *Die Galvanographie*, 574, 797
Kodachrome process, 655
Kodacolor, 673
Kodak, 489-91; origin of word, 489; pocket, 490; folding pocket, 491; *see also* Eastman Kodak Company
Kodak Abstract Bulletin, 491
Kodak-Eastman Works (Eng.), 491, 696
Kodak-Pathé Soc. Anon. Franç., 522
Kögel, Gustav, 551, 552
Kögel, J., 687
Kohler, August, 388, 391, 773
Köhler, Fritz, *Forscher- und historische Bildnisse*, 814
Kollmorgen, 411
König, A., 640
König, Ernst, 461, 473, 476, 477, 481, 482, 649, 675; *Farbenphotographie*, 476; *Autochromphotographie*, 477; *Arbeiten mit farbenempfindlichen Platten*, 477
Kopp, H., *Geschichte der Chemie*, 24, 732; *Beiträge zur Geschichte der Chemie*, 24, 731
Kopp, Raphael, 666
Koppe, A. K., 656
Koppe, C., 401; *Die Photogrammetrie oder Bildmesskunst*, 774; *Photogrammetrie und internationale Wolkenmessung*, 774
Koppmann, Gustav, 436, 564, 607, 655
Kraft, 59
Kraft and Steudel, 538

Krampolek, Andreas, 625
Kranseder & Co., 479
Kratochwila, Franz, 262, 265, 275-76, 278
Krayn, Robert, 557, 655
Kress, Georg Ludwig von, *Die Galvanoplastik für industrielle und künstlerische Zwecke*, 576
Kreutzer, Karl Josef, 681, 682, 683, 813
Kries, 120
Kron, Erich, 454, 455, 456
Krone, Hermann, 373, 671, 686-87; *Album der Sächsischen Schweiz*, 771
Kronemann, Christian Wilhelm, Baron von, 20, 732
Kronfeld, 776
Krumbacher, Karl, 11; *Geschichte der byzantinischen Literatur*, 730
Krumpel, Otto, 692
Krüss, 54
Kuchinka, Eduard, 304, 692, 697; *Die Daguerreotypie und die Anfänge der Negativphotographie auf Papier und Glas* (with Eder), 252, 316, 757; *Die Photoplastik*, 692; *Daguerreotypie, Talbotypie und Niepçotypie* (with Eder), 692; "Geschichte der photographischen Optik in Wien," 762; "Die Sammlungen der Graphischen Lehr- und Versuchsanstalt in Wien," 814
Kühn, Heinrich, 561
Kunckel, Johann, 59; *Laboratorium chymicum*, 737
Kurtz, 536
Kurtz, William, 464, 653, 654
Kyhl, Peter, 569

Laborde, Abbé, 361, 557
La Blanchère, de, 367; *Monographie du stéréoscope*, 383
Lacan, Ernest, 622, 752; *Esquisses photographiques à propos de l'Exposition universelle*, 279
Lucaze-Duthiers, H. de, 13; "Memoire sur la pourpre," 13
Lafollye, *Dépêches par pigeons voyageurs pendant le siège de Paris*, 390
La Galls, Ad. Jul. Caesar, *De phenomenis in orbe lunae*, 60
La Hyre, de, 34, 734
Lainer, Alexander, 431, 437, 545, 779; *Lehrbuch der photographischen Chemie*, 437; *Vorträge über photographische Optik*, 437; *Photoxylographie*, 437
Lainer effect, 437, 780
Lambert, 398
La Montain, 394
La Motte (Lamotte), de, 56, 101

Lampa, Anton, 525

Lampadius, W. A., 189; *Über die durch Imponderabilien bewirkte Veränderung . . .*, 188

Lamps, types used in projection apparatus, 53-55; *see also* Light, artificial

Lamy, E., 440

Landerer, 189

Landgrebe, George, *Über das Licht*, v, 180, 729, 731

Landriani, Count Marsiglio, 169, 170, 414, 449; "Di due termometri," 169

Landscape photography, 299-300, 358

Lang, V. von, 374

Langenheim, Friedrich, 289, 340

Langenheim, Wilhelm, 289, 340

Langenheim brothers, 340, 803

La Payre, 127

Lard, action of light on, 151

La Rive, de 568

Larkin, 531

La Rue, Warren de, 270, 457, 584, 799

Lassaigne, 335

Lasteyrie-Dussaillant, Count Charles Philibert de, 194

Latent images: discovery by Talbot, 321-23; development after fixation, 368

Latham, Woodville, 719

Laussedat, Aimé, 398, 399, 400, 774; "Mémoire sur l'emploi de la chambre claire dans les reconnaissances topographiques," 399; *La Métrophotographie*, 774; *Recherches sur les instruments, les méthodes et le dessin topographiques*, 774

Lavière, 600

Lavoisier, 100, 101, 144; *System der antiphlogistischen Theorie*, 740

Lea, Carey, 250, 261, 368, 377, 433, 460, 771; mordant-dye pictures made by, 363, 539; "Comparative Influence of Soluble Chlorides, Bromides and Iodides on Development," 780

Leahy, 376

Lealand, 290

Leather bellows, Niépce's construction of, 198

Le Blon, Jakob Christoph, 639, 640; *Il coloritto*, 640

Leborgne, 529

Lebrun and Maës, portrait lens by, 307

Lechs, Etienne, 315

Le Comte, 127

Leggo, William August, 627

Leggotypes, 628

Le Gray, Gustave, 328, 340, 344, 345, 348, 363; *Traité pratique de photographie sur papier et sur verre*, 344, 345, 537,

768; *Photographie*, 360, 765; *Traité nouveau théorique et pratique*, 768

Legros, *Encyclopédie de la Photographie*, 360

Lehmann, Erich, 686; "Zur Geschichte der Kinematographie," 519

Lehmann, Hans, 524, 671, 672, 811; *Beiträge zur Theorie und Praxis der direkten Farbenphotographie nach Lippmanns Methode*, 671; *Photographische Rundschau*, 671; "Beiträge zur Theorie und Praxis der direkten Farbenphotographie nach Lippmann und Lumière," 811; "Interferenzfarbenphotographie mit Metallspiegel," 811; *Die Kinematographie*, 811; "Die Praxis der Interferenz-Farbenphotographie," 811

Lehr- und Versuchsanstalt für Photographie, Lichtdruck und Gravüre (Munich), 692

Leibnitz, Gottfried Wilhelm, 72, 706

Leipold, Joseph, 583, 585, 798

Leipzig Art Trades Academy and Art Trades School, 693

Lemaître, 199, 201, 204, 205, 206, 217, 591, 752

Lemercier, 555, 608, 609, 610, 611

Lemercier & Co., 588

Lémery, 30, 31, 59, 60; *Cours de chymie*, 30, 60

Lémery, the younger, 111

Le Moyne, 340

Lenard, 419

Lenhard, Hans, 800

Lenses, 289-313, 403-12, 761; used by ancients, 2; used with camera obscura, 42-45, 198, 207, 214; used with projection apparatus, 47-54; used in Daguerre-Giroux cameras, 251, 253, 255, 279; Petzval's portrait, 275, 290-97, 300-1, 304-6, 311-13; used by daguerreotypists, 280-89; Petzval's orthoscopic, 291, 292, 300, 301-2, 313, 403; construction of large-size portrait, 304-7; construction of aplanatic, 403-7; construction of anastigmatic, 407-10, 775, 776

Lenta papers, 448

Lenz, Alfred von, *Uchatius*, 498

Leo XIII, Pope, 426

Leonardo da Vinci, 33, 34, 40, 46, 734; on nature printing from plants, 33; "Codex Atlanticus," 33, 39; description of camera obscura by, 38-40

Le Prince, Louis Aimé Augustin, 516, 717

Lerebours, N. P., 263, 298, 314, 315, 608, 609; *Historique et description de la daguerréotypie*, 259; *Excursions da-*

Lerebours, N. P. (*Continued*)
guerriennes; vues et monuments les plus remarquables du globe (with Rittner, Goupil, and Bossange), 578, 798; *Derniers perfectionnements apportés au daguerréotype* (with Gaudin), 763; *Traité de photographie* (with Secretan), 764
Leroux, 129
Le Roy, 519, 719
Leslie, John L., 170
Lespiault, 363
Leth, Justus, 531, 567, 568
Lettelier, Augustin, 13
Leuco bases, 675, 730
Leutner, Aug., 447
Levy, Louis Edward, 633, 806
Levy, Max, 633, 634, 635
Lewald, August, 211-14; *Gesammelte Schriften*, 211
Lewandowsky, L., 758
Lewis, William, 92, 107, 135; *Commercium philosophico-technicum*, 92
Lewitsky, 708
Licht, Das, 684
Lichtdruck, *see* Collotypes
Lichtenberg, 126, 616
Lieben, Philipp von, 790
Liébert, A., 530
Liebig, Justus, 180, 276, 278, 330, 717, 770
Liebreich, Oscar, 464
Liesegang, Franz Paul, xi, 51, 55, 195, 205, 383, 447, 448, 496, 500, 514, 522, 787; "Ausführungen," 41; "Schaustellungen mittels der camera obscura in früheren Zeiten," 42, 735; "Über Christian Huygens und die Zauberlaterne," 47; *Wissenschaftliche Kinematographie*, 501; "Die Camera obscura bei Porta," 735; "Der Ursprung des Lichtbilderapparates," 735; "Die ältesten Projektionsanordnungen," 735; "Der älteste Projektionsvortrag," 735; "Die Camera obscura und der Ursprung der laterna magica," 735, 736; "Die Projektionsuhr ...," 735; *Vom Geisterspiegel zum Kino*, 736; *Zahlen und Quellen zur Geschichte der Projektionskunst und Kinematographie*, 736, 772; *Licht und Lampe*, 736; "Uchatius und das Projektions-Lebensrad," 788
Liesegang, Paul Edward, 352, 681
Liesegang, Raphael Ed., 674, 681, 687; *Beiträge zum Problem der elektrischen Fernsehens*, 420; *Photographisches Archiv*, 674; *Photographische Almanach für 1891*, 674; "Zur Geschichte der Farbenrasterplatten," 809

Liesegang, Wilhelm Eduard, 329, 355, 686; *Handbuch der Photographie auf Kollodion*, 360; *Verfahren zur Anfertigung von Photographien, Ambratypen und Sanotypen*, 360
Light: early theories on nature of, v, 98-99, 120-21, 123-25, 129-30, 144-47, 157; definition of, 1; study of, by ancients, 1-8, 31; effect on colors used in painting, 6-8, 85, 89, 186; effect in purple dyeing, 8-14; wave theory of, 50, 120, 123, 144, 157, 641-42; Bonzius' experiments with effect on colored ribbons, 88; biological effects of, 122-127; discovery of law of interference of, 144, 746; Link's and Heinrich's dissertations on, 145-47; electric transmission of, 420-21; electromagnetic theory of, 641-42; *see also* Phlogiston theory of light
Light, artificial: 53-55, 528-32; calcium, 53-54, 386, 528, 529, 532; first photograph made by, 277, 288-89, 528; magnesium, 474, 530-31, 532; Bengal, 528, 529; electric arc, 528, 529, 530; incandescent gas, 533, 573, 797; mercury-vapor, 533; electric incandescent, 533
Light, chemical action of: 145-47, 178-79, 180-81, 183-84; early theories on, 91, 101, 129-30, 150-51; Priestley's observations on, 93, 99-100; Scheele's experiments with, 96-99; Grotthuss's theories on, 166-68; Fiedler's digest of discoveries on, 183-84; *see also* Heat, effect distinguished from action of light
Light absorption, photochemical law of, 166-68, 418-19
Light intensity, measurement of, 112-13, 414, 415, 454-56; *see also* Photometers
Light reaction, photochemical measurement of, 413-14
Lilienfeld, Leon, 537, 696
Limenci, Lanet de, 417
Limewater, blackening of chemical compounds by, 91
Limmer, Fritz, 687, 749; *Das Ausbleichverfahren*, 812
Linen: photographs on, 325, 791; positive images on, 370
Link, Heinrich Friedrich, 125, 145, 146, 147, 157, 160, 163, 164; *Über die Natur des Lichtes* (with Heinrich), v, 145; *Beiträge zur Physik und Chemie*, 117
Linnekampf's Aristophot Co., 447
Linography, 325
Lipowitz, A., *Die Daguerreotypie*, 757
Lippmann, Edmund O. von, *Entstehung und Ausbreitung der Alchemie*, 733

Lippmann, Gabriel, 341, 461, 472, 668-70, 671, 672

Litchfield, R. B., *Tom Wedgwood, the First Photographer*, 135, 745

Lithographtruste (Stockholm), 703

Lithography, 194, 550, 609, 613, 639, 797; see also Photolithography

Lithophotographie; ou, Impressions obtenues sur pierre à l'aide de la photographie, 609

Lithophotographs, see Photolithography

Littrow, von, 289, 290

Liverpool Dry-Plate and Photographic Printing Co., 425, 427, 431

Liverpool Photographic Journal, 679

London Autotype Company, 562

London Photographic Society, 677

Lovejoy, Frank W., 492

Löwenstjern, Johann Kunckel von, 58-59

Löwig, 176

Löwy, Josef, 353, 407, 428, 461, 599, 602, 619, 636, 647, 656

Löwy-Plener, 431, 469, 782

Lucenay, 529

Luckhard, Fritz, 353, 393

Lucretius Carus, 495

Lucs, de, 124

Lueger, Otto, *Lexikon der gesamten Technik*, 725

Lühr, F., 778

Lumière, La, 676

Lumière, Antoine, 432

Lumière, Auguste, 432, 511, 519

Lumière, Louis, 432, 511, 519

Lumière and Seyewetz, 436, 438, 478

Lumière brothers, 432, 436, 612, 655, 670-71, 675, 695; inventions in cinematography, 500, 509, 510, 511, 512, 519-23, 719, 791; invention of autochrome process, 661-62, 672, 809

Luminosity: disparity of optical and chemical, 269, 529; of celestial bodies, measurement of, 457

Luminous minerals, 57-60, 73; action of solar spectrum on, 154

Luna cornea, 24, 28; see also Silver chloride

Lunar Society, 134, 135

Lüppo-Cramer (Lüppo Hinricus Cramer), xi, 435, 476, 478-80, 484, 695; "Grundlagen der photographischen Negativverfahren," 263, 368, 479, 786; "Ein neues Verfahren, höchst-empfindliche und selbst farbenempfindliche Platten bei gewöhnlichem Kerzenlichte zu entwickeln," 478; *Negativentwicklung bei hellem Lichte, ...,* 479; *Photographische Probleme,* 479; *Kolloidchemie*

und Photographie, 479; *Kolloides Silber und die Photohaloide von Carey Lea,* 479, 771; *Röntgenographie,* 479; *Das latente Bild,* 479; biography of Eder, written by, 720-28

Luther Robert, 26, 687, 749, 777

Lüttgens, J., 325

Lux, 703

Luynes, Duke of, prize competition by, 555-57, 676

Lynkeyoskope lens, 410, 776

Lyons, 576

Lyte, Maxwell, 363, 372, 538, 766

McCabe, Lida Rose, "The Beginnings of Halftone, from the Note Books of Stephen H. Horgan," 630

McDonough, J. W., 660-61

Mach, Ernst, 452, 523, 525, 772; invention of Roentgen stereoscope by, 384-85, 772; photographic study of projectiles by, 524-26, 527; "Erscheinungen an fliegenden Projektilen," 525; *Die spektrale und stroboskopische Unterscheidung tönender Körper,* 791; "Beitrag zur Mechanik der Explosionen," 791

Mach, Ludwig, 526, 791

Maclure, 621

Maclure and Macdonald, 625

Macpherson, 611

Maddox, Richard L., 422-24, 778

Maedler, Johann von, 259; *Geschichte der Himmelskunde,* 259

Maemecke, 603, 604

Magic, application of chemical phenomena to field of, 105

Magic lantern, 46-50, 51-55, 735; see also Projection apparatus

Magic photographs, 264, 758

Magisterium argenti, 23

Magnesium Company, 531

Magnesium light, 474, 530-33

Magnus, Hugo, *Die geschichtliche Entwicklung des Farbensinnes,* 730

Malagutti, Faustino Jovita, 414, 415, 449

Mallmann, F., 461, 785

Malone, 324

Maltese cross, use in motion picture photography, 500, 506, 516, 522

Manchurian Artistic Photographs group, 715

Manganic salts, light-sensitivity of, 165

Manly, Thomas, 561

Manul process, 337

Maps, reproduction of, 590

Maps, photographic, see Photogrammetry

Marcilly, 600

Marcy, 54

Maréchal, Ch. Raph., 566, 617

Marey, Etienne Jules, 501-2, 507-12, 515, 520, 524, 789, 790; *Développement de la méthode graphique*, 506, 789; *La Photographie du mouvement*, 508; *Le Mouvement*, 511, 789; *La Chronophotographie*, 788, 789; *Du mouvement dans les fonctions de la vie*, 789; *La Machine animale locomotion terrestre et airienne*, 789; *Physiology médicale et la circulation du sang*, 789; *Le Vol des oiseaux*, 789; *La Locomotion et la photographie*, 789; *Fonctions et organes*, 789

Marggraf, *Mémoires de Berlin*, 93

Marion, A., 358, 440, 561

Mariot, Emil (Schielhabel), 531, 562, 563, 589, 590, 613, 799

Mariotte, Ed., *Traité de la nature des couleurs*, 55

Marktanner-Turneretscher, *Die Mikrophotographie als Hilfsmittel naturwissenschaftlicher Forschung*, 388

Marsh Brothers, 589

Martens, Friedrich von, 255, 329

Martin (professor), 54

Martin, Adolphe Alexandre, 369, 370

Martin, Anton, librarian at Vienna Polytechnikum, 252, 280-81, 282, 293, 298, 312, 329, 680, 681; *Repertium der Photographie*, 245, 329, 335, 680, 798; *Handbuch der Photographie*, 360; *Handbuch der Emailphot.*, 796; *Repertorium der Galvanoplastik und Galvanostegie*, 797

Martius, Ernst Wilhelm, *Neueste Anweisung, Pflanzen nach dem Leben abzudrucken*, 34

Marvel drum, 500

Marville, Charles, 329

Maschek, Rudolf, 800

Mascher, I. F., 772

Maskell, Alfred, 560

Mason, A., 288

Masson, 742

Mather, W., 531

Mathet, *Traité practique de photomicrographie*, 388

Mathey, 805

Mathieu, P. E., 537; *Auto-photographie*, 537

Matschoss, *Beiträge zur Geschichte der Technik und Industrie*, 769

Matthews, E., "Processes of Photography in Natural Colors," 664

Maul, Alfred, 397

Maurisset, 256

Mawdsley, Peter, 425, 427, 439, 440

Mawson and Swan, 427, 431, 433, 445, 487, 558

Maxwell, James Clerk, 500, 640-42, 656; "On the Theory of the Three Primary Colours," 641; *Treatise on Electricity and Magnetism*, 642

Mayall, J. E., 249, 314, 349

Mayer, *La Photographie considérée comme art et comme industrie* (with Pierson), 90

Mayer, Emil, 565, 685; *Das Bromölverfahren*, 565

Mazér, C. P., 702

Meade, Charles, 249

Medals: alchemic, 19-21; commemorative, 80, 249, 303; as photographic awards, 294, 676, 678, 680, 682, 683, 702, 715, 763

Medicines, preservation in colored bottles, 185-86

Mees, C. E. Kenneth, xiii, 491, 696, 773; "Fifty Years of Photography," 781; "Recent Advances in Sensitizers for the Photography of the Infra-red" (with Brooker and Hamer), 781; "Motion Pictures in Natural Colors," 811; "Amateur Cinematography and the Kodacolor Process," 811

Megascope, 198

Megatypy, 387

Meggers, 694

Mehegard, E., *Memorials of Wedgwood*, 745

Meisenbach, Georg, 625, 630-34

Meisenbach's Autotype Company, 631

Meisenbach, Riffarth & Co., 599, 604, 654, 805

Meissner, Traugott, 169, 170; *Handbuch der allgemeinen und technischen Chemie*, 169

Meissner & Buch, 656

Meister, Lucius & Brüning, 695; see also Höchst Dye Works

Melainotypes, 370, 770

Melhuish, Arthur James, 331, 380, 488

Melsen, 525

Ménard, Louis, 342; *Dreams of a Heathen Mystic*, 343; *De la moral avant les philosophes*, 768

Meniscus lens, 45, 132, 207, 294, 754, 756-57

Mente, O., 686; *Unter der Sonne Oberägyptens* (with Miethe), 475

Mentienne, *La Découverte de la photographie en 1839*, 754

Meran, Albrecht Graf von, 524

Merck, C., 189

Mercuric sulphate, 116

Mercury bromide, light-sensitivity of, 176

Mercury oxides, light-sensitivity of, 121, 129, 133
Mercury salts, light-sensitivity of, 83, 91, 114-15, 177
Mercury vapors, development by: 259, 260, 262; invented by Daguerre, 227-28, 250
Merkens, W., 675
Mertens, Eduard, 603, 604, 605, 606
Merz, George, 290
Messter, Oskar, 522, 697
Metal chlorides, light-sensitivity of, 147
Metallic cloths, 116-18
Metals, alchemists' attempts to transmute base into precious, 15, 17, 21, 475, 733
Meteoric waters, investigation of, 172
Meters, exposure, *see* Exposure meters
Meteyon, *Wedgwood and His Works*, 745
Metternich, Clemens, prince, 245, 246, 247, 280, 318
Meydenbauer, Albrecht, 400; *Das Denkmälerarchiv und seine Herstellung*, 774
Meyer, Bruno, *Sachverständiger und deutsches Reichspatent*, 808
Meyer, Hugo, 409, 411
Meyer, Johann, 766
Meyer, Jos. Fr., *Chymische Versuche zur näheren Erkenntnis des ungelöschten Kalches*, 91; investigation of caustic substances, 91
Meyer-Heine, H., *La Photographie en ballon*, 774
Meyers Grosses Konversations-Lexikon, 384, 725
Meynard, 342, 343
Meynier, 538
Meynier, Joh. Heinr., *Anleitung zur Ätzkunst*, 799
Mezzograph screens, *see* Screens, grain
Mezzo-tinto-gravure, 602
Microphotography, 385-88, 389, 508; *see also* Photomicrography
Microprojection, 391
Microscope, projection, 54, 390-91
Miethe, Adolf, 461, 473, 474, 476, 532, 604, 657, 686, 773; *Unter der Sonne Oberägyptens* (with Mente), 475; *Photogr. Aufnahmen vom Ballon aus.*, 774
Migursky, 707
Military Geographic Institute (Tokyo), 716
Military Geographic Institute (Vienna), 547-48, 584, 590, 694
Military photography, *see* War photography
Millet, 347; 529
Millon, 342

Mills, W. H., 477, 483
Milmson, 485
Mirror writing, used by Leonardo da Vinci, 39, 40
Mitscherlich, Eilhard, 176
Mittwald, 576
Mizaldi, Antonio, 35
Moestlin, 40
Moffit, "A Method of Aerographic Mapping," 402
Moh, 485
Moignié, 357
Moigno, Abbé, 296, 381; *Antique moderne*, 382
Moisture, effect on dyestuffs, 190-92
Moitessier, *La Photographie appliquée aux recherches micrographiques*, 773
Molard, Humbert de 514, 537
Moll, A., 347, 765
Molybdic acid, light-sensitivity of, 121
Molyneux, 50; *Treatise of Dioptrics*, 53
Monceau, Duhamel du, *see* Duhamel du Monceau
Monckhoven, Désiré Charles Emanuel van, 393, 404, 425, 427-29, 460, 703, 778; *Traité général de photographie*, 428; *Traité populaire de photographie sur collodion*, 428; *Photographische Optik*, 429; *Instruction sur le procédé au gélatino-bromure d'argent*, 429, 430; *Du gélatino-bromure d'argent*, 429
Monconys, M. de, 34, 736
Monfort, de, 529, 676
Monochromata, 7-8
Monpillard, *La Microphotographie*, 388; "Notes sur l'histoire de la photomicrographie," 386
Mons, Jean Baptiste van, 150
Montabert, *Traité complet de la peinture*, 186
Montel, Paul, 677, 812
Montgolfier, 142
Montméja, de, 677
Moon, photographing the, 269
Mörch, 804; *Handbuch der Chemigraphie und Photochemigraphie*, 804
Mordant-dye process, 363, 366, 539-42
Morgan and Kidd, 440, 485
Morhoffi, *Oratio de laudibus*, 732
Morienus, 29
Morse, Samuel Finley Breese, 272, 273, 274, 289
Mortimer, F. J., 565
Morton, Henry, 391
Moser, Ludwig Ferdinand, 260, 266, 268, 381
Motay, C. M. Tessié du, 566, 617

Motion pictures, *see* Cinematography; Serial photography

Motion Picture Trust of America, 515, 518

Motte, de la, *see* La Motte, de

Mountain photography, 358-59

Movement, photographic analysis of: by Muybridge, 501-5; by Janssen, 506; by Marey, 507-12; by Anschütz, 512-13; with slow motion pictures, 523

Mroz, B. J., 657

Mucklow, 452

Mudd, J., 373, 375

Muggeridge, Edward James, *see* Muybridge, Eadweard,

Mullay, John, 615

Müller, 396

Müller, G. A., 214

Müller, Heinrich Jacob, 366, 457

Munich: photographic lens production in, 403; teaching of photography in, 692-93

Müntz, Eugène, 39

Murdoch, William, 135

Muriatic acid, 161

Murray, 568

Murray (professor), 101

Murray, Sir James A. H., 258

Musée Dantan; galerie des charges et croquis des célébrités de l'époque, 257

Museums, *see* Photography, historical collections of

Musger, August, 523, 524

Mustard oil, 378

Mutoscope, 522

Muybridge, Eadweard, 500-5, 507, 717, 718; *The Horse in Motion*, 503; *Animal Locomotion*, 504; *Descriptive Zoopraxography*, 505; *Popular Zoopraxograph*, 505; *Animals in Motion*, 788

Mylbäus, C. S., 702

Nachet, 387

Nachet, C., 657

Nadar (Gaspard Félix Tournachon), 257, 393-94, 395, 529, 531, 773-74; *Paris photographe*, 399

Nadherny, A., 710, 814

Namias, Rodolfo, 366, 540, 541, 700; "The Fixation of Coaltar Dyestuffs on Metal Compounds," 540, 700; "The Fixation of Colors on Copper-Ferrocyanide Images," 540, 700; *Manuale teorico-practico di chimica fotografica*, 700; *La fotografia in colori, ortocromatismo e filtri di luce*, 700; *I processi di illustrazione grafica*, 700; "Direct Toning of Silver Images with Copper Ferrocyanide and Ferrous Ferrocyanide,"700;

"Photochemistry of Mercury Salts," 700; "Direct Positives by Reversal with Potassium Permanganate," 700; "Influence of Alkaline Salts of Organic Acids on the Permanency of Bichromate Preparations," 700

Narbutt, Johannes, *Über den Herschel-Effekt*, 264

National Museum (Washington, D. C.), 698, 759

National Physical Laboratory (Teddington, England), 694

Natterer, Johann, 276, 759

Natterer, Joseph, 276-77

Natterer brothers, 275, 276-77, 278, 289, 528, 760

Nature-printing, 33-36, 568-73; *see also* Electrotyping, Woodburytypes

Neal, 445

Neblette, Carrol Bernard, *Photography*, 446, 447, 448, 449

Nederlandsche Amateur Fotografen Vereeniging, 703

Nederlandsche Fotografen Patroons Vereeniging, 703

Neff, Peter, 370

Negatives, photographic: invention by Talbot, 316, 321-23, 340; experiments with transparent glass for, 338-41, 344-45

Nègre, Charles, 584, 592, 595, 622, 623, 798, 800, 804

Negretti, 395

Nepera Chemical Company, 446

Nernst, W., 413, 419, 816

Nero, 2

Netto, F. A. W., 256; *Vollständige Anweisung zur Verfertigung daguerrescher Bilder*, 252; *Die kalotypische Porträtkunst*, 329

Neubronner, 390

Neue Photographische Gesellschaft (N. P. G.), 441, 442, 485, 564

Neuhauss, Richard, 671, 674, 675, 749, 810-11; *Lehrbuch der Mikrophotographie*, 388; *Die Mikrophotographie*, 388; *Photographie auf Forschungsreisen*, 811; *Anleitung zur Mikrophotographie*, 811; *Die Farbenphotographie nach dem Lippmannschen Verfahren*, 811; *Lehrbuch der Projektion*, 811

Neumann, August, 281

Neumann, Kaspar, 83; *Praelectiones Chymicae*, 738

Newspapers: introduction of rotogravure for, 605-7; halftone printing plates for, 628, 629-30

Newton, 378

Newton, Sir Isaac: emission theory of light advanced by, 31, 50, 98, 120, 123, 144; theory of solar spectrum advanced by, 153, 221, 309, 639, 748

Nicotine, light-sensitivity of, 190

Niépce (colonel), 207-8

Niépce, Claude, 193-96, 199-200, 205, 206, 207

Niépce, Isidore, 193, 195, 200-2, 204-5, 230, 752, 753, 755-56; succeeds his father to contract with Daguerre, 226-29, 233; *Historique de la découverte improprement nommée daguerréotype*, 227, 752; attempt to sell daguerreotype by subscription, 229, 230; sale of daguerreotype invention to French government, 230-32, 245; life pension from French government to, 232, 240-41

Niépce, Joseph Nicéphore, 102, 182, 193-207; asphaltum process used by, 103, 197, 199, 200-4, 218-23, 250, 608; experiments with fixatives, 170, 197, 199; early life of, 193-94; lithographic experiments of, 194-95, 608; cameras used by, 195-96, 197; experiments with lenses, 198-99; produces first photograph in camera, 200-3; heliographic reproductions on metal invented by, 204-7, 218-23, 250, 591; "Memoire," 205, 206; collaboration with Daguerre, 207-8, 215-17, 224-26, 233; "Notice sur l'héliographie," 218; death of, 226; Daguerre's use of inventions by, 226-29; "On Heliography," 754; *see also* Daguerre

Niépce-Daguerre Company, 201, 216-17

Niepce de Saint-Victor, Claude Felix Abel, 338-39, 591-92, 611, 665-66, 752, 767; invention of glass negatives by, 338-39, 372, 535; *Recherches photographiques*, 338; *Traité pratique de gravure héliographique sur acier et sur verre*, 338, 592, 800

Niepceotypy, 338-40

Nihon Photo Industrial Co., Ltd., 715

Nihon Shashinshi Rengo Kyokai, 715

Nitric acid, 22; experiments by Priestley with, 99; experiments with, 108-9

Nitrocellulose, 343, 344; use in making transparent film, 489, 492-93

Nordisk Tidskrift för Fotografi, 701, 702, 814

Norris, Richard Hill, 373, 374, 375, 395

Nostitz, Count, 707-8

Nottone, 299

Novak, Franz, 635

Numismatics, 20, 79

Nützlicher und curieuser Künstler, 34

Oakten, C. H., 772

Obermayer, Oberst von, *Geschichte der technischen Militär-Akademie*, 498

Obermüllner, Adolf, 359

Obernetter, Emil, 536

Obernetter, J. B., 536, 567, 784

Obernetter-Perutz, 470

Objectives, *see* Lenses

Oehme & Graff, 286

Oettingen, "Abhandlungen über Elektrizität und Licht von Theodor Grotthuss," 749

Offord, 538

Offset process, 616

Ogura, K., 716

Ohm and Grossmann, 619

Oil prints, 562-63, 564-65; transfer of, 563

Oils, action of light on, 113, 130, 131, 143, 188, 189, 753

Oleography, 562

Olmsted, A. J., 698

Omura, Hitoshi, 716

Onesicritus, 4

Opoix, 100; *Observations physico-chymiques sur les couleurs*, 740

Oppenheim, 456

Oppenheim, F., 816

Optical firms, *see* Lenses

Optical sensitizers, 458, 459, 465, 468, 652; *see also* Color sensitizers

Optical Society of America, 696

Optics: study of, by Greeks, 1-3; Vienna's importance in history of, 307-13; modern photographic, 403-12; *see also* Lenses

Ordoverax, 549

Orel, E. von, 402, 403

Orell-Füssli process, 611

Oriental Photo Industrial Co., Ltd., Tokyo, 715

Orthochromatic collodion emulsions, 378

Orthochromatic film, 490

Orthochromatic photography, 378, 459, 466, 469-70, 783

Orthochromatic plates, 469-70

Orthoscopic lens, 291, 292, 300-2, 313, 403

Orthostigmat lens, 407, 410

Ortmann, Max, 606

Osaka Industrial Experimental Station, 715

Osann, G. W., 576; *Anwendung des hydroelektrischen Stromes als Ätzmittel*, 576

Osborne, 799

Osborne, J. W., 612, 614

Ost, Adolf, 529, 535, 536

Ostanes, 16

Ostwald, Wilhelm, 113, 675, 711; *Far-*

Ostwald, Wilhelm (*Continued*)
beñatlas, 113; *Lehrbuch der allgemeinen Chemie,* 778
Oxalates, light-sensitivity of metal, 95, 177-78, 751
Oxygen, 116; Berthollet's studies of, 107-109, 114; importance to health, 127; importance in dyeing, 190-92
Oxyn lens, 411
Ozalid process, 551
Ozobrome process, 562
Ozotype, 562

Paganini, *Fotogrammetrie,* 774
Painters, use of photography by, 348-49
Paintings: effect of light on colors used in, 6-8, 85, 89, 186; reproduction of, 466-67, 469-70, 558-59, 574, 654, 802
Palaeokappa, Constantin, 11
Palladiotype papers, 544
Palmer, 448
Panchromatic film, 490
Panchromatic plates, 460-61, 473, 474, 475
Paniconographs, 576, 621, 623
Pannotypes, 369, 370
Panopticon, 719
Panorama camera, 255-56, 758
Panoramic photography, 255-56, 329, 396; *see also* Diorama
Panselenus, 250
Papers: production of printing and developing, 439-42, 445-47, 485-86, 534-37, 542-46, 551; gelatine silver bromide, 439-43, 607-8; mat silver bromide, 442-43, 546; gelatine silver chloride, 445-47; chloro-brom, 447-48; albumen, 535, 536, 792; collodion, 536-37; silver-phosphate, 537, 766; self-toning, 538; photographic tracing, 543, 551; platinum, 544-46
Papnuzio, Dom (Panuce), 38, 40
Papyrograph, 563
Paracelsus, Theophrastus, 27, 28, 29
Parallax stereograms, 383, 384
Paris, early center of photographic industry, 279
Paris, Derville de, 287
Parkes, 485
Parma, Duke of, 351
Parr, 328, 765
Parrot, 121
Pathé, 522
Pathé-Cinéma, 522
Patzelt, 625
Paul, Robert W., 518, 522
Pauli, 442, 485
Pector, *Notice historique,* 676
Pedemontese, Alessio (Alexis Pedemonta-

nus), "Ectypa plantarum," 34
Peisson, 176
Peligot, Eugene Melchior, 249, 343, 676
Pellet, 542
Pelletier, J., 165
Pelouze, 176, 343
Pepper, William, 504
Percy, 260
Perger, Anton Ritter von, 570
Periscope lens, 404
Perlmutter, Max, 636
Pernety, *Dictionnaire portatif de peinture,* 89
Perutz, O., 397, 445, 473, 475, 695
Petit, 52
Petit, 56, 111
Petit, Charles, 629
Petzval, Josef Max, 54, 251, 255, 275, 281, 289-313, 761, 763; invents portrait lens, 275, 290-97; Voigtländer constructs lenses designed by, 291-95; designs orthoscopic lens, 291, 292, 300-2, 403; *Bericht über die Ergebnisse einiger dioptrischer Untersuchungen,* 292, 761; breaks with Voigtländer, 297; Dietzler constructs lenses designed by, 300-2; controversy with Voigtländer over rights to orthoscopic lens, 301-2; *Theorie der Schwingungen gespannter Seiten,* 762
Peukert, 549
Pewter plates, heliographic: used by Niépce, 204, 205
Pfaff, Christian Heinrich, 149, 155; *Newton's Farbentheorie, Herr von Goethe's Farbenlehre,* 155
Pfenninger, Otto, 658, 808
Phantascope, 497, 516
Phavarinus, 11
Phenakistiscope, 383
Phenosafranine, use as a desensitizer, 478-80
Philipsthal, 53
Philosopher's stone, 15, 58, 59
Philostratos, *Imagines,* 10
Phlogiston theory of light: early supporters of, 96, 97-98, 99, 100, 101, 102, 116, 169; refuted by Berthollet, 108-9
Phonograph, controversy over invention of, 650-51
Phosphorescence, discovery of, 21, 57-60
Phosphorus: Balduin's, 58, 59, 74; discovery of production of, 59; derivation of word, 74; light-sensitivity of, 121, 158, 189; Niépce's experiments with, 197
Photo-aquatints, 560
Photoceramics, 566-68

Photochemistry: laws of, 418-19; Fiedler's analysis of chemical actions of light and heat, 183-84

Photochromoscope, 634, 644, 649, 658, 659

Photochromy: by interference method, 341, 461, 472, 668-72; early studies in, 664-68; by bleaching-out process, 673-75

Photochronograph, 508; see also Chronophotography

Photoclub de Belgique, 703

Photo-Club de Paris, 677, 684

Photoelectric currents, see Photometers

Photoelectricity, 420-21

Photoelectrotypes, 581-90; invented by Pretsch, 581-85; from glue chromate relief images, 581-86

Photo-engraving, 628

Photogalvanic currents, see Photometers

Photogalvanography, 579, 582

Photogen, 376, 771

Photogeodesy, 400

Photoglypty, see Woodburytypes

Photogrammetry, 398-403

Photograph, 707

Photographic Alliance, 679

Photographic and Fine Art Journal, 680

Photographic Answers, 795

Photographic Art Treasures, 333, 582, 583

Photographic Journal, vii, 678

Photographic News, 355, 679, 795

Photographic Red Book, 679

Photographic Society of Southern Germany, 692

Photographie intégrale, 669, 672

Photographische Chronik, 695

Photographische Industrie, 684, 695, 812

Photographische Korrespondenz, vi, vii, 598, 681, 682, 683, 688

Photographische Mitteilungen, 681, 684, 813

Photographische Nachrichten, 474

Photographischer Notiz-Kalender, 782

Photographische Rundschau, 813

Photographisches Album, 681

Photographisches Archiv, 681

Photographisches Wochenblatt, 684, 782

Photography: historical collections of, viii, 207, 696-98, 759; fanciful prophecies about, 5-6, 89-90, 495; invention of, 62-63, 83, 98, 134, 140, 181-82, 193, 203; first use of word, 258-59; scientific basis of, 259-71; as a profession, 313-15; scientific applications of, 385-403; teaching of, 677, 678, 685-93, 702, 704, 705, 711-12, 715

Photography, artistic, see Arts, relation of photography to

Photography, motion picture, see Cinematography

Photography, orthochromatic, see Orthochromatic photography

Photography, portrait, see Portrait photography

Photography, serial, see Serial photography

Photography, three-color, 465-66, 474, 476, 539-42, 634, 639-64; Du Hauron's contributions to, 642-48, 651-53; Cros' contributions to, 648-52; projection of, 656-59; use of screens in, 660-62; see also Photochromy

Photography, visiting-ccard, 351-52

Photography as a Scientific Implement, 63, 92

Photogravure, 593-605; Talbot's work with, 593-94; Klič's method of, 595-99

Photolithography, 554, 608-17, 619; see also Lithography

Photomechanical processes, color printing by combination of, 655-56; see also Printing, photomechanical

Photomechanical reproduction, see separate processes, e.g. Photogravure, Rotogravure, etc.

Photometers, 112, 165, 178, 267-68, 412-18; chlorine detonating gas, 152, 413, 414; invention of recording, 169-70; paperscale, 417, 463; step wedge, 417; tube, 452, 463; see also Exposure meters; Sensitometry

Photo-mezzotint process, 586, 627

Photomicrographic Society, 678

Photomicrography, 347, 388-91; see also Microphotography

Photo Relief Printing Company, 588

Photoscope, 516

Phototypes, see Collotypes

Photozincography, 614-15, 624, 628; see also Zincography

Photozincotypes, 621

Physics, value of daguerreotypy to, 238, 242

Physikalische Reichsanstalt (Berlin), 694

Piccard, August, 397, 398

Pickering, *Stellar Photography*, 270

Pierson, *La Photographie considérée comme art et comme industrie* (with Mayer), 90

Pigment printing, see Printing, photographic : pigment process

Pigments, see Colors

Pill, C., 617, 804

Pinachrome, 476, 477, 786

Pinaflavol, use as sensitizer, 480, 482-83

Pinakryptol, use as desensitizer, 481-82, 483
Pinatypy, 476, 649, 655
Pinhole camera, *see* Camera obscura
Piper, C. Welborne, 564; "Bromoil, the Latest Printing Process," 565
Pistolgraph, 358
Pius VII, Pope, photograph of, 200, 202, 204
Pizzighelli, Giuseppe, 365, 405, 430, 545-47, 614, 700; produces gelatine silver chloride emulsions with chemical development, 443-46, 448-49, 721, 780, 781; *Die Photographie mit Chlorsilbergelatine* (with Eder), 444; *Die Platinotypie* (with von Hübl), 546, 793; *Handbuch der Photographie für Amateure und Touristen*, 546-47; *Anleitung zur Photographie für Anfänger*, 547; editor of *Bulletino della Societa Fotografica Italiana*, 547
Placet, H., 638
Plagniol, portrait lens by, 307
Planche, L. A., 165; "Experiments on the Reciprocal Action of some Ammonia Salts," 164
Planck, Max, 419
Planets, alchemists' belief in influence of, 15
Planographic printing, 614-15
Planté, 95
Plants: importance of sunlight in growth of, 3, 55-56, 94, 187-88, 736-37; green coloring matter of, 3, 55, 93-94, 165, 736-37; nature printing from, 33-36
Plateau, Joseph Antoine, 495, 496, 497; *Sur quelques propriétés des impressions produites par la lumière*, 496; "A Peculiar Class of Optical Deceptions, Showing Wheel Phenomena," 496; "The Inventor of the Stroboscope," 787
Plates: Niépce's use of, for heliographic etching, 204-7, 218-23, 236; copper, 205, 262, 593-94, 595, 598; glass, 339-41, 344-45, 362; dry, 369-71, 374, 375, 378, 488; gelatine silver bromide, 425-32, 432-36; azaline, 460-61, 468, 784; panchromatic, 460, 461, 473, 474, 475; eosin, 464, 466, 467, 468; orthochromatic, 469-70; erythrosin, 469-71
Platinic chloride, light-sensitivity of, 172
Platinotype Co., 544, 545
Platinotypes, 433, 543-47, 561
Platinum chloride, light-sensitivity of, 177, 178
Platinum salts, 543, 544
Plato, 1, 3
Playertype, 337

Plener, Ignaz von, 572, 796-97
Plener, Josef, 431, 469, 782
Pliny, 2, 7, 8, 57, 729; *Historiae naturalis*, 7
Plössl, Simon, 281, 289, 290, 308, 309, 310, 311, 757
Plotnikow, J., 167, 418, 711, 815-16; *Allgemeine Photochemie*, 413, 711, 777, 815, 816
Plutarch, 3
Poggendorff, *Annalen der Physik*, 459, 462, 497
Pohl, J. J., 245, 268, 338, 387, 443, 687, 688
Poirson, 753
Poisson, Albert, *Collection d'ouvrages relatifs aux sciences hermétiques*, 21
Poitevin, Alphonse Louis, 335, 371, 553-55, 567, 580, 617, 666, 794; introduces gelatine into negative process, 340-41; introduces photography with chromates, 553-56, 562, 585, 609; invents pigment printing, 554, 555, 556, 557, 676; invents bichromated albumen printing method on stone, 554-55, 609-10, 612; *Traité de l'impression photograpique sans sels d'argent*, 585, 611, 798, 802
Pokorny, *Physiotypia Plantarum Austriaearum* (with Ettingshausen), 570, 571, 796
Pollack, Vincent, 400; "Über photographische Messkunst,". 774
Pollitzer, Adam, 300
Polyconograph, 357
Polytechnisches Journal, 680
Pompeii, 8
Poncet de Maupas (general), 200, 201, 202, 204
Ponton, Mungo, 119, 269, 552, 793
Pope, W. J., 477, 483, 786
Popowitzky, 712
Poppe, *Neuer Wunder-Schauplatz*, 106
Porro, 400
Porta, Johann Baptista, 31, 40-43, 46, 48, 51, 381; description of camera obscura by, 40-41, 735, 739; *Magiae naturalis*, 40, 41, 42, 43, 46; *La fisonomia dell' huomo et la celeste*, 41
Porter, F. C., 383
Portrait photography, 293, 294, 295, 348-56; first use of daguerreotypes in, 271-77; use on visiting cards, 351-52
Positives, *see* Printing, photographic
Positives, direct, in the camera, 334, 369-71
Posselt, 564
Potassium bichromate: light-sensitivity of, 119, 179, 552-53, 593; use in photolithography, 609, 610, 611
Potassium cyanide, as fixative, 363

Potassium ferrocyanide, 320, 764; light-sensitivity of, 107, 147
Poterius, Peter, *Pharmacopoea spagirici*, 60
Potonniée, Georges, *Histoire de la découverte de la photographie*, x, xi, 26, 63, 200, 249, 277, 752; views on origins of photography, 26, 62-3, 200-3, 277-78, 807; views on invention of photographic lenses, 290, 296
Pouncy, John, 556, 557
Powell, 290
Praxinoscope, 500
Prechtl, Johann Joseph Ritter von, 262, 280, 293, 308, 310, 311, 312, 760; *Technologische Encyclopädie*, 308; *Praktische Dioptrik*, 309, 760
Prelinger, O., 209, 211
Pretsch, Paul, 553, 573, 575, 579, 581-86, 594, 600, 794, 798, 806; *Photo-galvanography*, 36; "Photogalvanographie; or, Engraving by Light and Electricity," 579
Pretschner, F., 778
Preussische Messbildanstalt, 400
Prévost, 209
Priestley, Joseph, 62, 92, 99-100, 109, 111, 134, 739, 742; *History and Present State of Discoveries Relating to Vision, Light and Colours*, v, 92, 93, 95, 100, 135; *History and Present State of Electricity*, 100; *Experiments and Observations Relating to Various Branches of Natural Philosophy*, 739, 740; *Experiments and Observations on Different Kinds of Air*, 740
Primuline process, 551
Pringle, *Practical Photomicrography*, 388
Printer's ink, photographic printing with, 543, 554-56, 562, 586; *see also* Carbon
Printing, photographic: 368, 448-49, 534-39, 542, 552-59, 566-67, 614-15; Blanquart-Evrard's improved process of, 328-29, 332, 535; Breyertype process of, 336-37; on gelatine silver bromide paper, 439-43; on gelatine silver chloride paper, 443-47; photographic tracing processes, 534, 542, 549-50, 551; on platinum paper, 543-46; with diazo compounds, 550-51; pigment process, 554-59, 561-62, 586, 589; gum printing process, 550, 556, 560-61; oil printing process, 562-63, 564; bromoil process, 563, 564-65
Printing, photomechanical: 331-33, 553, 568-638; *see also* separate processes, e.g., Electrotyping, Photogravure, Rotogravure, etc.
Printing, rotary intaglio, *see* Rotogravure

Printing, three-color: invented by Le Blon, 639-40; experiments by Du Hauron, 642-47, 652; subtractive method of, 654-55; *see also* Photography, three-color
Printing machines, photographic, 441-42
Printing-out processes, *see* Printing, photographic
Pritchard, 54
Pritchard, Henry Baden, 355; *The Photographic Studios of Europe*, 355
Pritschow, Karl, 299
Progresso fotografico, 700
Projectiles, photographic study of, 524-27, 789
Projection: stereoscopic, 383, 808; vertical, 390-91; beginning of motion picture, 497-501; of Muybridge serial photographs, 504-5; of Marey's serial photographs, 510; of animated photography by Lumière brothers, 519-21; of colored pictures, 644, 656-60, 808; *see also* Cinematography
Projection apparatus, 46-50, 51-55, 340, 474, 519
Prokesch, 498
Protalbin papers, 537
Protar lens, 409
Prussian blue, light-sensitivity of, 130, 146
Ptolemy, 1, 2
Pulch, "Die Pariser Handschriften des Honnus Abbas und Eudoxia," 10; *Konstantin Palaeokappa*, 11; *Jonia der Eudokia*, 11
Pulfrich, Carl, 402, 403; *Die Stereoskopie im Dienste de Photometrie und Pyrometrie*, 402
Purple dyes, 8-14, 93
Purpuric acid, light-sensitivity of, 166
Pustet, Oskar, 607
Puyo, C., 561; *Procédé Rawlins à l'huile*, 563
Pyrogallic acid, 178; as developer, 330, 347, 375
Pyrophilus, 30
Pyroxylin, 342; *see also* Guncotton

Quantum theory, 419-20, 777
Quentin, H., 562
Quinet, 299

Rabending, Emil, 354, 429
Rachaidibis, Kallid, 15; "Güldenes Buch der dreyen Wörter," 731
Radnitzky, C., 294
Raethe, Oskar, 538
Raimundus Lullius, 29
Ransonnet, Baron, 642

Rateau, August, 383
Ratel, 260, 261
Raubal, Guido, 785-86
Ravené, Louis, 813
Rawlins, G. E., 563, 795
Ray, 55; *Historia plantarum*, 736
Rayleigh, 667
Re, Gustav, 586, 707
Reade, Joseph Bancroft, 325, 385, 757-58, 765
Realgar, light-sensitivity of, 142-43
Réaumur, René Antoine Ferchault de, 12; *Sur une nouvelle pourpre*, 12
Reciprocity, law of photographic, 414-15, 454
Rectilinear lens, 406
Reduction baths, 438
Reeves, John, 47, 53
Reflectography (Breyerotypy), 336-37
Refraction of light, law of, 50
Refrangible rays, *see* Chemical rays
Regener, Erich, 398
Regnault, Henri Victor, 330, 417, 555
Reich, Theodor, 522, 602, 801
Reichenbach, Georg von, 308, 763
Reichenbach, Henry N., 489, 492
Reichert, Rietschel, 411
Reiffenstein, Gottlieb Benjamin, 802
Reiffenstein and Rösch, 611, 802
Reilander, 349
Reimann, 174
Reiner, M., *Arbeiten aus dem Institute für allgemeine und experimentelle Pathologie des Prof. Dr. S. Stricker*, 391
Reinhardt, 48, 49, 50; "Über den Erfinder des Projektionsapparates," 735
Reinhold, of Saxony, 288
Reinhold, Erasmus, 40, 288
Reisinger, Fr. von, 531
Reiss, 790
Reisser, 283
Reissig, 360
Relandin, 331
Relief pictures, 621, 622, 804; electrotyping of, 553, 574-75, 581, 584-86, 587
Rembrandt Intaglio Printing Co., Ltd., 597, 601, 602
Rembrandt prints, 601, 602
Research laboratories, photographic, 694-96
Resins: light-sensitivity of, observed by Senebier, 102, 103; use on collodion plates, 373
Retouching, negative: introduction of, 354
Reutlinger, Ch., 355
Revue du monde nouveau, 650
Revue française de photographie et de cinématographie, 812
Revue médico-photographique des hôpitaux de Paris, 677
Reynaud, Emil, 500, 501; *Erfindung des optischen Bildausgleiches*, 500
Rhode, *Über die Malerei der Alten*, 730
Richard, Georges, 539
Richet, Dr., 512
Richter, D., 65; *Lehrbuch einer für Schulen fasslichen Naturlehre*, 88
Richter, Edward, 391
Riebensahm, 564
Riffarth, Heinrich, 599, 805
Riffaut, 592
Rigling, Alfred, 288
Rigny, de, 211
Riley, 519
Risner, *Thesaurus opticae*, 733
Ritter, J. W., 128, 131-32, 136, 145, 149-51, 160, 747; *Beweis, dass ein bestandiger Galvanismus den Lebensprozess im Thierreich begleitet*, 128; "Remarks on Wünsch's Dissertation on Herschel's Experiments with the Separation of Light Rays," 150; *Versuche über das Sonnenlicht*, 744
Rittner, 578
Rive, de la, *see* La Rive, de
Rivista fotografica italiana, La, 700
Robertson, 53
Robinson, Henry Peach, 349, 350; *Pictorial Effect in Photography*, 769; *Picture Making by Photography*, 769; *Art Photography in Short Chapters*, 769
Robiquet, Pierre Jean, 188, 373
Robison, John, 109, 110, 171, 741; "On the Motions of Light," 741
Rochas, Henricus de, 18
Rochester, N. Y., photographic industry at, 491-92
Rochette, "De la peinture sur mur chez les anciens," 730
Rodenstock, 411
Rodman, G. H., 317, 324
Roentgen, W. C., 384
Roentgen stereoscopy, 384-85
Roese, 637
Roese, Wilhelm, 590
Rogers, A., 309, 763
Rohr, Moritz von, 45, 298, 307, 308, 734; *Theorie und Geschichte des photographischen Objektivs*, 298, 757, 775; *Zeitschr. f. Instrumentenkunde*, 304; account of Vienna's place in precision optics by, 307-13; "Über ältere Porträtobjektive," 763; "Die optischen Systeme aus Petzvals Nachlass," 763;

Zur Geschichte der Zeisschen Werkstätte bis zum Tode Abbes, 775
Rokuosha, 715
Rolff, Ernst, 603, 604, 605
Roll holder, 331, 380, 486, 488, 489
Rollmann, W., 648
Rösch, Ludw., 802
Roscoe, Sir Henry Enfield, 412-16, 449, 450, 452, 529, 530, 532; "Photochemische Untersuchungen" (with Bunsen), 413; The Life and Experiences of Sir Henry Enfield Roscoe, 416; Method of Meteorological Registration of the Chemical Action of the Total Daylight, 416
Rose, Heinrich, 176
Rosenberger, Ferd., Geschichte der Physik in Grundzügen mit synchronistischen Tabellen, 729
Rospini, 282
Ross, 290, 307, 406, 411, 412
Rosse, Lord, 321
Rostjestvenski (professor), 713
Rotary Photographic Co., 442
Rotogravure, 599-607; introduction of, in newspaper printing, 605-7
Rott, Albert, 801
Roullé-Ladeveze, A., 560
Rousselon, 588
Roux, Jacob, Die Farben, ein Versuch über Technik alter und neuer Malerei, 186, 730
Rovere, Della, see Della Rovere
Rowland, 270, 724
Royal Photographic Society of Great Britain, xi, 677, 678, 698
Rubber blankets, offset printing from, 616
Rubens, Peter Paul, 186
Rudge, J. A. Roebuck, 515, 517
Rudolph, Paul, 408, 409, 775; Neue Gesichtspunkte für Anastigmate, 775; "Der Raumzeichner und die Zonenkreise sphärischer Korrektion," 775; "Dr. Paul Rudolph in eigener Sache," 775
Rue, Warren de la, see La Rue, Warren de
Ruhland, 159; "Fragmente zu einer Theorie der Oxydation," 157; Über den Einfluss des Lichtes auf die Erde, 159
Rumford, Count, 106, 117, 118, 133, 134, 744; "An Inquiry into the Chemical Properties That Have Been Attributed to Light," 745
Runge, 461
Russell, C. (major), 374, 375, 376, 377, 378; The Tannin Process, 376
Russia, photography in, 706-13
Rutherford, Lewis Morris, 270, 366, 367

Sabattier, 367, 368
Sachs, John, & Co., 432
Sachse, Julius F., 94, 274, 600, 759; "Philadelphia's Share in the Development of Photography," 274
Sachse, L., 284, 285
Safranine dyes, use as desensitizers, 478-81, 483-84
Sage, Balthazar George, 142, 146
Saint-Florent, 666
Saint-Victor, Niepce de, see Niepce de Saint-Victor
Sala, Angelo, 22; Opera medica chimicae, 23; Septem planetarum terrestrium spagirica recensio, 23
Salcher, 526
Salmon, Alphonse, 543, 556, 557, 566, 567
Salomon, Adam, 350
Salt vegetations, Chaptal's experiments with, 110-11
Salzmann, August, 332
Samoilowitsch, 816
Sampolo, 661
Santonin, light-sensitivity of, 189
Sarazin, 592
Satista papers, 544
Saussure, Horace Benedict de, 94, 108, 112-13, 413, 704; first chemical photometer invented by, 112, 747; "Effets chimiques de la lumière sur une haute montagne," 742
Saxon & Co., 530
Saxton, Joseph, 274
Sayce, B. J., 377, 771
Scamoni, Bruno G., 710
Scamoni, Georg, 583, 586, 709, 799; Handbuch der Heliographie, 586
Schäfer, Alois, 593
Schafhäutel, 730
Schafhäutl, Karl Emil, 335
Schade, 177
Schall, 449, 777
Schapiro, Constantin, 709
Scharlow, L., 816
Schattera, 431, 445
Schaum, K., 687
Scheele, Carl Wilhelm, 96-99, 102, 109, 739; Aeris atque ignis examen chemicum, 96, 739; experiments with silver chloride, 97-98, 139-41, 161, 162, 176; studies photochemistry of solar spectrum, 98, 131, 136; Chemical Observations and Experiments on Air and Fire, 99; Traité de l'air et du feu, 131; Sämtliche Werke, 739, 740; Nachgelassene Briefe und Aufzeichnungen, 739; "Observation sur l'air qui se dégage de l'acide nitreux

Scheele, Carl Wilhelm (*Continued*) exposé au soleil," 741

Scheimpflug, Theodor, 401, 402, 723; *Die Herstellung von Karten und Plänen auf photographischem Wege*, 401; "Die Luftschiffahrt im Dienste des Vermessungswesens," 401; "Denkschrift der ersten Internationalen Luftschiffahrtsausstellung," 402

Scheiner, Julius, 451, 452

Scheldracke, 131

Schell, 383

Schell, 400

Scherer, *Nachträge zu den Grundzügen der neuen chemischen Theorie*, 117

Schering, 479

Schering's Chemical Company, 347

Scheuchzer, J. J., *Physica*, 86

Scheutz, Georg, 170, 701

Schielhabel, *see* Mariot, Emil

Schiendl, 344, 783; *Geschichte der Photographie*, 768, 783, 793

Schippang, 431

Schleussner, 431, 432, 695

Schlippe, 364

Schloemann, Eduard, 453

Schlotterhoss, 441, 781

Schmädel, Baron, 631

Schmidkunz, Fritz, *xi*

Schmidt, 55, 383

Schmidt, Fritz, 687

Schmidt, H. H., 778

Schmidt Brothers, 606

Schmieder, *Geschichte d. Alchemie*, 731, 732

Schnauss, Julius, 685, 813; *Photograph. Lexikon für den praktischen Photographen*, 813; *Katechismus der Photographie*, 813; *Das einfachste und sicherste Trockenverfahren der Gegenwart*, 813; *Der Lichtdruck und die Photolithographie*, 813

Schnitzer, 302

Schöffer, Peter, 639

Scholz, Joseph, 616

Schön, 551

Schönbein, Christian Friedrich, 342, 343, 704

Schönhaber, Baron, 590

Schöninger, 574

Schools, photographic, *see* Photography, teaching of

Schopenhauer, 747; *Über das Sehen und die Farben*, 748

Schöpff, Martin, 606

Schott, Caspar, 51; *Magia universalis naturae et artis*, 43

Schott, Otto, 408, 533

Schrank, Ludwig, 611, 666, 682-83, 696, 783, 802, 813

Schröder, *Neue alchimistische Bibliothek*, 731

Schroeder, 411

Schröpfer, Georg, 53

Schrott, Paul, 527, 576, 608

Schrötter, Anton V., 169, 412, 532

Schubler, 187

Schuh, Karl, 282, 681

Schuloff, Robert, 476, 480-83

Schultner, 245

Schultz, 367, 783

Schultz-Henke, Dankmar, 693

Schultz-Sellack, 260, 457

Schulze, Friedrich, 283

Schulze, Johann Heinrich, 60-63, 64-83; discovers chemical action of light on silver salts, 32-33, 60-63, 73-77, 82-83, 140; invents photographic copying of stencils with silver salts, 61-62, 75-77, 82-83, 140, 745-46; life of, 64-83; influence of Friedrich Hoffmann on, 66-71; *Dissertatio inauguralis de athletis veterum, eorum diaeta et habitu*, 71; "Scotophorus pro phosphoro inventus," 74; *Historia medicinae a rerum initio*, 78; interest in numismatics, 79, 81; *De nummis Thasiorum*, 79; *Compendium historiae medicinae*, 80; *Dissertationum academicarum ad medicinam*, 80; *Commentarius de vita Friderici Hoffmanni*, 80; *Chemische Versuche*, 81, 82, 83; use of discoveries by later investigators, 89, 92, 93, 96, 98, 105, 106, 135

Schumann, V., 468

Schwaiger, A., 309

Schwanckhardt, Heinrich, 616

Schwartz, York, 533, 792

Schwarz, Arthur, 441, 442

Schwarz, Heinrich, 348-49; *David Octavius Hill*, 327

Schwarzschild, Karl, 454, 455, 456

Schweigger, 165

Schwier, *Handb. d. Emailphotographie*, 796

Schwirtlich, Adolf, 692

Science & industrie photographiques, 812

Scientific Photographic Institute (Dresden), 687

Scolik, Charles, 354, 445, 461, 470, 785, 813

Scopoli, Giovanni Antonio, 107, 147, 741

Scotophorus, 74, 82-83; *see also* Silver salts

Scott, A., 659

Scott, A. C., 615; *Photozincography*, 614

Scratchboard, 625, 626

Screens, 594, 805; photogravure with, 596, 602, 608; for rotogravure printing, 601, 603-5; patent disputes over, 603-5, 631-32; cross-line, 624, 625, 632, 633-35; early attempts to produce halftones with, 626-30; application to newspaper printing, 628, 629-30; single-line, 630-32; grain, 636-38; color, 645, 660-62

Sebron, Hippolyte, 209

Secco-Film Co., 452

Secretan, 298, 314; *Traité de photographie* (with Lerebours), 764

Secret writing, 368, 770

Seebeck, Johann Thomas, 105, 153-55, 528, 664, 666, 667, 747-48; *Wirkung farbiger Beleuchtung*, 154; *Von der chemischen Aktion des Lichtes und der farbigen Beleuchtung*, 154; "Über die ungleiche Erregung der Wärme im prismatischen Sonnenbilde," 747

Seely, 366, 367, 794

Seguier, Armand Pierre de, 255

Seidel, von, 404

Selenium, photoelectric properties of, 420-21, 777

Self-portraits, 274

Seligmann, M., 36, 734

Sellack, 260, 367, 457, 783

Selle, 101; *Neue Beiträge zur Natur und Arzneiwissenschaft*, 740

Selle, G., 649, 655, 808-9

Selle, Hermann, 363

Semejkin, B., 817

Sendivogius, 18

Senebier, Jean, 94, 102-5, 113, 197, 417, 704; *Essai sur l'art d'observer et de faire des expériences*, 102; experiments with silver chloride, 104-5, 140, 154, 664, 747; *Mémoires historiques sur la vie et les écrits de H. H. de Saussure*, 112; *Mémoires physico-chimiques sur l'influence de la lumière solaire*, 124, 741; *Sur la lumière*, 136; *Physikalisch-chemische Abhandlungen über den Einfluss des Sonnenlichtes*, 741

Seneca, 2

Senefelder, Alois, 194, 639; *Lehrbuch der Lithographie*, 194

Sensitizing, color, of photographic emulsions, 457-61, 464-78, 647, 783, 815; *see also* Color sensitizers

Sensitometers, 449-54

Sepia papers, 543

Serial photography, 506-11, 512-13, 515, 517, 518, 527; *see also* Cinematography

Sérullas, Georges S., 176, 187

Sevén, J. A., 287

Severin, Marc Aurel, 35

Seyewetz, Alphonse, 436, 438, 478, 695

Seymour, M. W., "The Kodacolor Process for Amateur Color Cinematography" (with Capstaff), 811

Shadboldt, George, 372

Shadbolt, Cecil V., 387, 396

Sharroc, *Histor. propagat. vegetabilium*, 55

Shaw, G., 260

Sheppard, S. E., 378, 420, 491, 779, 780

Shimooka, Renjyo, 713, 714

Shreiber, G. F., 289

Sidebotham, J., 373

Siegbahn, M., *Studies in the Extreme Ultra Violet and the Very Soft X-Ray Region*, 781

Siemens, Werner, 421

Silberer, V., 396, 774

Silhouettes, reproduction on light-sensitive paper, 137, 141

Silliman, 528, 529

Silver, volumetric examination of, 153

Silver albuminate: light-sensitivity of, 160; photochemical properties of, 173

Silver bromide emulsions, 377-79, 421-38

Silver bromide paper, 320, 439-43

Silver carbonate, light-sensitivity of, 120, 146

Silver chloride, 24; early ignorance of effect of light on, 7, 25, 30, 31, 67; wet process of producing, 27, 28, 29; light-sensitivity of, 87-88, 97-98, 104-5, 109, 115, 146, 164, 174-76, 743; action of solar spectrum on, 104-5, 128, 153-56, 664; Niépce's experiments with, 195, 196

Silver chloride paper: first production of, 139; used in recording photometer, 169-70; action of solar spectrum on, 263; used for prints by Talbot, 317, 319, 323; used for direct paper positives, 334-36; standard gray for, 415, 449

Silver chromates, light-sensitivity of, 119, 179, 552

Silver citrate, 119, 535

Silver compounds, light-sensitivity of, 160-62, 176

Silver halides, 261, 275; chemical sensitizers for, 371

Silver iodide: light-sensitivity of, 139, 163-64, 179, 203, 259-62, 319; Daguerre's use of plates coated with, 223-26, 250, 755

Silver muriate: effect of solar spectrum on, 136; compared with silver nitrate, 138

Silver nitrate, 22; light-sensitivity of, 23-24, 31-33, 84, 136-38, 173, 179; used by Lewis to produce designs, 91

Silver nitrate solutions, light-sensitivity of, 67-69, 171-72, 174, 179
Silver salts, light-sensitivity of, 22, 32, 60-63, 74-77, 82-83, 91, 93, 119
Silver subchloride, 161; Wetzlar's studies of, 174-76; influence of solar spectrum on, 665, 666, 667, 810
Simeons, 431, 779
Similigravure, 629, 805; see also Halftone process
Simonides, 250
Simpson, G. Wharton, 375, 536, 667; Swan's Pigmentdruck, 794
Skaife, Th., 358; Instantaneous Photography, 358
Skin, theories on color of human, 4, 125, 729
Skladanowsky, Max, 522, 790-91
Slides, see Projection apparatus
Slow motion pictures, 523-24, 811
Smart, 357
Smiler, Josiah Wedgwood, 745
Smith and Beck, English lens-makers, 290
Smith, C. A., 660
Smith, Hamilton L., 370
Smith, J. H., 675
Smith, W. H., 448, 449
Smith, Willoughby, 421
Smithsonian Institution, 698
Smyth, C. Piazzi, 531
Snails (purpura), purple dye produced from, 8-14
Snelling, H. H., 680
Snellius (Willebrord Snell van Roijèn), 50
Sobbachi, Alexander, 546
Societa Fotografica Italiana, 700
Société française d'Amateurs Photographiques, 677
Société française de Photographie, xi, 676, 697
Société Heliographique de Paris, 676
Société Photographique, 442
Societies, photographic, 676-715
Society for Chemical and Metallurgical Production, see Aussig Chemical Society
Society for Photographic Art (Vienna), 685
Society for the Fostering of Photography, 683
Sodium thiosulphate, 320; see also Hypo
Solar cameras, 391-93; see also Solar microscope
Solarization, 367-68, 506
Solar microscope, production of enlarged images with, 137, 139, 387
Solar spectrum: experiments with, 98, 104-

5, 128, 131-33, 136, 747; chemical action of, 154-55, 158, 159, 262-63; photographic study of, 264-67, 366-67, 457-61, 469, 471, 669; bleaching action of, 673
Soldi, E., 249
Soleas, Nikolaus, 27, 28; Ein Büchlein von dem Bergwergk wie man dasselbig nach der Rutten und Witterung bawen soll sehr dienstlich, 28
Soleil, 382
Sommer, Hans, 407
Sommerfeld, 456
Sonstadt, 531
Sophocles, 5; "Trachinierinnen," 4-5
Sotheran, 124
Sound film, 790
Soviet-Photo, 713
Sowjet Photo-Almanach, 754
Spain, early interest in daguerreotypy in, 287
Spalteholz, 473
Spectacles, early mention of, 2
Spectroanalysis, 133; see also Solar spectrum
Spectrographs, 469
Speilhagen, Der Sturmvogel, 392
Spencer, Joseph Blakey, 331, 380, 488, 576
Spies, Pater, 18; Concordantzs, 732
Spiller, Arnold, 434
Spiller, John, 359, 460, 538
Spitzer, Emanuel, 637, 806-7
Spitzer Company, Die Spitzertypie, ein neues Reproduktionsverfahren, 638
Spitzertype, 637
Spörl, Hans, 693
Sprengel, C., 187, 188; Chemie für Landwirte Forstwirte und Kammeralisten, 187
Spurge, 452
Sresnowsky, 708
Stagmatype, 638
Stahl, Georg Ernst, 65, 67, 73, 82
Stammreich, 475
Stampfer, Simon, 308-9, 311, 312, 495, 496-97, 499, 787; Die stroboskopischen Scheiben, 787; "Über die optischen Täuschungs-Phänomene," 787
Stand, C. J., 491
Stanford, Leland, 501, 502, 503
Stanhope, Lord Charles, 389
Stanley, 449
Stark, J., 419
Starke, 308
Stars, alchemists' belief in influence of, 15, 17
Stas, J. S., 428, 778
Statius, Publius Papinius, 5, 89; "Silvae," 5-6

Stebbing, E., 485
Steebr, Johann Christophorus, *Elixir solis et vitae*, 732
Steel, etching on, 591-94
Steffens, Henrik, 163, 164
Steinheil, Adolph, lenses constructed by, 403-5, 407, 408, 410, 695; "Die photographischen Objective" (with Eder), 405; *Handbuch der angewandten Optik* (with Voit), 405, 763; litigations with Dallmeyer, 406; *Nachrichten von der k. Gesellschaft der Wissenschaften an der Universität zu Göttingen*, 406
Steinheil, Edward, 404, 775
Steinheil, Karl August, 262, 268, 284, 313, 403, 404, 775
Steinheil, Rudolf, 405, 406, 407, 410
Stenger, Erich, *xi*, 258, 336, 337, 686, 697, 771, 784, 812; *Daguerre's Diorama in Berlin*, 214; *Die Daguerreotypie in Berlin 1839 bis 1860* (with Dost), 284-85; "High Mountain Photography in the Last Century," 358; *Daguerreotypist J. B. Isenring*, 705; *Der Landschaftsphotograph und seine Arbeitsbehelfe*, 769
Stereoautograph, 402, 403
Stereo-Club de Paris, 677
Stereocomparator, 402, 403
Stereo-photochromoscope, 657
Stereoscopes, 381-85, 644, 648
Stereoscopic photography, 282, 381-85; application to photogrammetry, 402-3
Stereoscopic vision, 45-46
Stereoscopy, Roentgen, 384-85
Stokes, 264
Stolze, Franz, 440, 453, 683, 684, 781, 782, 783
Stolze, R., 383, 808; *Die Stereoskopie*, 772
Stops, *see* Diaphragms
Strauss, Siegmund, 790
Strecker, Hans, 638
Strehl, Karl, 407
Stricker, S., "Über das elektrische Mikroskop mit auffallendem Lichte," 391
Strieder, *Gelehrtenlexikon*, 181
Stringer, A. B., 388
Stroboscope, 495-500, 513
Stroh, A., 383
Stromeyer, Friedrich, 176
Strong, Henry Alvah, 487, 488
Strumpff, 81, 82
Strunz, Franz, 733
Stubeer, William G., 492
Studios, daguerreotype, 280-89, 313-14
Studios, photographic: lighting of, 355-56, 530, 533
Sturm, Johann Christoph, 52-53: *Collegium experimentale sive curiosum*, 52

Suck, Karl, 306
Suckow, Gustav, 119, 174, 179, 180, 185, 552, 751; *Commentatio physica de lucis effectibus chemicis, v; De lucis effectibus chemicis in corpora organica et organis destituta*, 174, 178; *Die chemischen Wirkungen des Lichtes*, 178, 179
Sulzberger, N., 764
Sun: alchemists' belief in influence of, 15-21; effect of light and heat not differentiated by alchemists, 16, 32
Sunlight: early observations on effect of, 3-8; effect in purple dyeing, 8-14; effect on plants, 55, 94; effect on wood, 103, 122; measurement of chemical intensity of, 414; *see also* Light
Suter, 406, 411
Sutton, Thomas, 328, 377, 378, 686; *The Calotype Process*, 765; *A Dictionary of Photography* (with Dawson), 765, 770
Svedberg, T., 702
Swan, Sir Joseph Wilson, 427, 440, 558; pigment process improved by, 467, 558, 560; electrotyping of pigment images by, 559, 586, 589, 799; use of screens by, 605, 627, 629; "Mein Anteil am Verfahren zur Herstellung von Kohlebildern," 794; *see also* Mawson and Swan
Swan, Mary Edmonds, *Sir J. W. Swan, a Memoir* (with K. R. Swan), 781
Sweden: early interest in daguerreotypy in, 287; photography in, 701-3
Swedish Photographic Society, 702
Swindern, Theodorus von, *On the Atmosphere and Its Influence on Colors*, 149
Switzerland, photography, in, 704-5
Symbols, alchemists', 19, 732
Sympathetic ink, 84, 106
Szathmary, Karl Bapt. v., 623
Székely, 353, 362, 431, 762, 780
Szepanik, Jan, 662, 663, 675
Szepanik, S., "Cinematography in Natural Colors," 809
Szulmann, Paul, 786

Tacquet, Andreas, 51, 52
Tailfer and Clayton, 468
Talbot, M., 324
Talbot, William Henry Fox, 63, 139, 258, 316-25; invents negative photography in the camera, 63, 321-25, 327, 340, 485; *The Pencil of Nature*, 139, 317, 318, 323, 332; experiments with fixatives, 170-71, 254, 319-20, 323, 534; experiments with developers, 262, 321-22; discovers light-

Talbot, William Henry Fox (*Continued*)
sensitivity of chromated gelatine, 269,
553, 593, 595; *Sun Pictures in Scotland*,
317, 324; *Some Account of the Art of
Photogenic Drawing*, 320; experiments
with printing papers, 320, 323, 534; in-
vents heliographic etching with chro-
mated gelatine process, 553, 582, 583,
592, 593-94, 595, 626; "Gravure photo-
graphique sur l'acier," 553
Talbotypes, 324, 327, 329, 330; used in
stereoscopic photography, 382
Tannin process, 374, 375
Taupenot, 340, 372, 373, 388
Taylor, 452, 534
Taylor, Harold Dennis, 411
Taylor, John Traill, 423, 424, 531
Technique photographique, La, 812
Telecentric lens, 411
Teleros lens, 411
Tellkampf, Adolf, 475, 549, 550
Tennant, John A., *xiii*; section of text
written by, 272-75; "Aërial Photog-
raphy," 774
Tessar lens, 409, 410, 412
Testelin, *Essai de théorie sur la forma-
tion des images photographiques*, 261
Tetrachromy, 659
Textiles: printing of, 598, 600, 602, 603,
605; photographic production of color-
ed weave patterns for, 662-63
Thénard, Louis Jacques, 151, 155, 156, 157,
158, 174; "De la nature et des propriétés
de l'acide muriatique," 152; *Recherches
physico-chimique*, 156
Theophrastus, 3, 729
Therapy, light, 123, 126
Thevoz, 805
Theyer, Franz, 575, 797
Theyer, Martin, 282
Thiele, R., 396, 397
Thölde, Johann, 27, 733
Thompson, W., 307
Thon, Nathaniel, "Die Chlorknallgas-
reaktion," 777
Thorpe, *Humphry Davy, Poet and Phil-
osopher*, 745
Tilney, F. C., *The Principles of Photo-
graphic Pictorialism*, 349
Time-lapse photographs, 523, 791
Tintypes, 370, *see also* Ferrotypes
Tiphaigne de la Roche, 89; *Giphantie*,
89-90
Tippmann, xi
Tissandier, Gaston, 141-42, 396; *Les Mer-
veilles de la photographie*, 141, 210, 383;
*A History and Handbook of Photog-
raphy*, 321; *La Photographie en ballon*,
773
Titereon, 279
Tithonometer, Draper's, 412, 413
Toepler, August, 525
Toifel, Wilhelm F., *Handbuch der Chemi-
graphie*, 603
Tokyo Amateur Cinema Club, 715
Tokyo Dry Plates Co., Ltd., 715
Tokyo Photo-Research Society, 715
Tokyo Scientific Photographic Society,
715
Tomassich, 623
Tomlinson, 361
Toning, 540-42, 655; use of gold baths in,
254, 445, 537-39, 781-82; use of sulphur
in, 537
Topographical maps, application of photo-
graphy to, 398-401
Topp, 383
Torosiewicz, Theodor von, 185
Tóth, Victor, 363, 365, 366, 434, 720; *Die
Bleiverstarkung, eine neue Verstar-
kungsmethode* (with Eder), 364; "Neue
Untersuchungen über die Bleiverstär-
kung" (with Eder), 364
Tournachon, Gaspard Félix, *see* Nadar
Townson, 298, 757
Tracing, photographic, 534, 542, 549-50,
551
Transfer process: in pigment printing,
557-59, 586, 607-8, 624; in photolithog-
raphy, 612, 613, 614, 617
Transparencies, 541
Traube, Arthur, 473, 476, 540, 541, 549,
655; *Photochemische Schirmwirkung*,
475
Trentsensky & Vieweg, 496
Triboulet, 395
Tripack process, 647, 808
Tripod, introduction of, 255
Trivelli, A. P. H., 263, 491, 773
Troitzsch, Otto, 656
Trommsdorff, Herman, Jr., 189
Trommsdorff, J. R., 116
Trubetzkoy, Paul (prince), 707
Tula papers, 448
Turner, A. W., 654
Turner, E. R., 658
Turner, R. R., 329
Turner, S. N., 490
Tuttle, H. B., 812
Typon process, 767

Uchatius, Franz, Baron von, 497, 498, 499
Ullmann, Max, 767
Ulrich, Emil, 653

Ultraviolet rays, 128, 144-45, 146; see also Solar spectrum
Unger, 445
Unger, Arthur W., 803-4; Die Geschichte der K. K. Hof- und Staatsdruckerei, 796
Union Photographique Industrielle, 695
United States: early interest in daguerreotypy, 271-75, 288-89; photography in, 679-80
Unofocal lens, 407
Unterveger, Enrico, 699
Uranium salts, light-sensitivity of, 148, 339, 767
Urban, W., 693
Urie, 441
U. S. Bureau of Standards, 694; Standards Yearbook, 694
Utocolor paper, 675
Uvachrome Company, 476, 541
Uvachrome process, 475, 541, 655

Valenta, Eduard, xi, 384, 471-73, 539, 690, 721; Versuche über die Photographie mit Röntgenstrahlen (with Eder), 384; Beiträge zur Photochemie und Spektralanalyse (with Eder), 470, 471, 472, 532, 724, 814; investigates color sensitizers, 471, 785; Die Klebe- und Verdickungsmittel, 471; Die Photographie in natürlichen Farben, 472, 670, 672, 809, 810; Röntgenphotographie (with Eder), 472; Behandlung der für den Auskopierprozess bestimmten Emulsionspapiere, 472; Photographische Chemie und Chemikalienkunde (with Eder), 472; Die Rohstoffe der graphischen Druckgewerbe, 472; Atlas typischer Spektren (with Eder), 472, 532, 724; investigates printing-out papers, 534, 537, 543
Valicourt, E. de, 296, 538; Manuel de Phot., 792
Vallot, E., 674
Varnish, Hoffmeister's description of, as a fixative, 181-82
Vasalli, 115, 160, 743
. Vauquelin, Louis Nicolas, 119, 179, 552; "Du plombe rouge de Sibérie," 744
Vegetable substances, reactions on, 174
Velox papers, 446, 780
Veracolor plates, 663
Verband der Chemigraphischen Anstalten Deutschlands und der Tiefdruckereibesitzer, 684
Verichrome film, 490
Vérignon, 335
Verne, Jules, 89

Vernet, Horace, 279
Verneuil, 354
Vidal, Léon, viii, 358, 653, 656, 657, 677, 686, 698, 808; Photogravure, 638
Vienna: progress of daguerreotypy in, 280-84; development of percision optics in, 307-13; photography in, 329, 680-92, 694; portrait photography in, 352-54; Graphische Lehr- und Versuchsanstalt, 471, 677, 683, 688-92, 723, 725; Military Geographic Institute, 547-48, 584, 590, 694; Government Printing Office, 568-72, 581, 656, 693, 694
Vienna Camera Club, 684-85
Vienna Club for Amateur Photographers, 685
Vienna Photo Club, 685
Vienna Photographic Society, 282, 303, 681, 682, 683, 688, 720, 721, 813
Viewing, stroboscopic, 495, 496
Villoisin, Anecdota Graeca, 10
Vinci, Leonardo da, see Leonardo da Vinci
"Violarium," see "Ionia"
Viscosimeter, 472
Vision, theories of, 1-3, 45-46
Visiting card portraits (Cartes-de-visite), 351-52
Vitascope, 719
Vitruvius, 6, 7; Treatise on Architecture, 6, 38
Vogel, Ernst, 464, 653, 654; Beziehungen zwischen Lichtempfindlichkeit und optischer Sensibilisation der Eosinfarbstoffe, 464
Vogel, Henri August, 151, 158, 159, 166, 197, 673, 748; "Dissertation on Lard," 151
Vogel, Hermann Wilhelm, 417, 452, 458-64, 530, 683, 684, 686, 689, 783-85; discovery of color sensitizers, 371, 458-61, 465, 468, 643, 645, 652, 653, 783, 807; "Über die chemische Wirkung des Sonnenlichtes auf Silberhaloidsalze," 459; azaline plates made by, 460-61; biography of, 462-64; Über das Verhalten des Chlorsilbers, Bromsilbers und Jodsilbers in Licht, 462; Handbuch der Photographie, 463; use of eosin silver bromide, 467, 784; Photochemie, 476; Die Photographie auf der Londoner Weltausstellung, 769, 784, 798; Praktische Spektralanalyse irdischer Stoffe, 784; Vom indischen Ozean bis zum Goldlande, 784; Lichtbilder nach der Natur, 784; Die Photographie farbiger Gegenstände, 808

Voigtländer, Friedrich Ritter von, 294, 407

Voigtländer, Johann Friedrich, 293-94, 308

Voigtländer, Peter Wilhelm Friedrich von, 255, 281, 291-302, 304-6, 307, 313; construction of Petzval lenses, 291-95, 297, 301-2, 311-13; competition with Chevalier lenses, 294-96; competition with Dietzler lenses, 301

Voigtländer & Son, 408, 410, 411, 695, 762

Voit, Ernst, 309; *Handbuch der angewandten Optik* (with Steinheil), 405, 763

Volkmer, Ottomar, 590, 682, 694

Volpicelli, 268

Vossius, *De lucis natura et proprietate*, 55

Vylder, de, 686

Waage, 413

Wagner, Julius, 287

Waibl, portrait lens by, 307

Waldstein, optical firm of Vienna, 282, 290, 760

Waldstein, Arnold, 760

Waldstein, Jacob, 310

Walenkov, A., "Physikalisches Institut der Universität Leningrad" (with Denisoff), 816

Walgenstein, Thomas, 34, 47, 49, 50, 52, 53, 736

Walker, William H., 440, 488

Wall, Alfred H., 350

Wall, E. J., 383, 564, 795; *History of Three-Color Photography*, 643, 655, 658, 663, 664, 795, 808, 809; *Photographic Emulsions*, 795; *Practical Color Photography*, 795; *Photographic Facts and Formulas*, 796

Waller, 639

Wallerius, Johann Gottschalk, 93; *Chemia physica*, 93

Wallon, 369

Walter, *Alte Malerkunst*, 730

Warburg, E., 419

Wardley, 375

Warmisham, 411, 763

Warnerke, Leon, 368, 378, 436, 446, 450-52, 485, 607, 708, 782; invents film-roll holder, 331, 380, 451, 488

Warnod, 347

War photography, 359, 394

Waterhouse, James, viii, 27, 44, 299, 464-65, 466, 538, 627, 654; "Notes on the Early History of the Camera Obscura," vi, 734; "Notes on Early Tele-Dioptric Lens-Systems and the Genesis of Telephotography," vi; "Historical Notes on Early Photographic Optics," vi; "The History of the Development of Photography with the Salts of Silver," vi

Watkins, Alfred, 449

Watkins, W. G., 449

Watt, James, 100, 134

Wawra, 245

Weaving, three-color photographic, 662-63

Weber, Hieronymus Wilhelm von, 77

Wedge sensitometers, 453

Wedgwood, Josiah, 92, 100, 134, 135

Wedgwood, Thomas, 134-42, 385, 745-46; as forerunner of photography, 107, 182, 203, 318-19, 745-46; "An Account of a Method of Copying Paintings upon Glass and of Making Profiles by the Agency of Light" (with Davy), 136-38

Wegner and Mottu, 431, 586

Weickmann, L., 810

Weidele, E., 797

Weigert, Fritz, 419, 687, 778

Weimar, Wilhelm, 697; *Die Daguerreotypie in Hamburg*, 286

Weingartshofer, M., 681

Weishaupt, Heinrich, 640

Weiske, 686

Weiss, Christian Samuel, 129-30, 166; *Betrachtung eines merkwürdigen Gesetzes der Farbenänderung organischer Körper*, 129

Weiss, Karl, 684

Weissenberger, Wilhelm, 710-11, 814, 815

Weixelgärtner, 625

Welgenstein (Welkenstein), *see* Walgenstein, Thomas

Wells, 262

Welsbach, Carl Auer von, *see* Auer von Welsbach, Carl

Wenham, Allen, 388

Weninger, Josef, 283, 284, 287, 707

Wentzel, Fritz, *xiii*, 432, 493; "George Eastman und sein Lebenswerk," 786

Wenzel, *Lehre von der Verwandtschaft der Körper*, 101

Werge, John, *Evolution of Photography*, vii, 274, 759, 765

Werner, Otto, *Zur Physik Leonardo da Vinci*, 734

Weselsky, 387

Wet collodion process, *see* Collodion process, wet

Wetzlar, Gustav, 174, 176, 181; *Beiträge zur chemischen Geschichte des Silbers*, 174

Weyde, van der, 530

Wheatstone, Sir Charles, 381, 499, 771

Wheel, stroboscope, 496, 514

Wheeler, J., 636, 637
White, 658
White, John Forbes, 349
Wide-angle lens, 404, 405
Wiedemann, Eilhard, 36; *Geschichte der Lehre vom Sehen*, 1
Wiegleb, *Natürliches Zauberlexikon*, 105, 106; *Geschichte des Wachstums der Chemie*, 731
Wiegmann, Rudolph, *Die Malerei der Alten in ihrer Anwendung und Technik*, 730
Wiener, Otto, 667, 673, 674; "Farbenphotographie durch Körperfarben und mechanische Farbenpassung in der Natur," 667
Wiener Kunstdruck Aktien-Gesellschaft, 602
Wiener Lichtbildner-Klub, 685
Wiener Photographische Blätter, 685
Wiener Photographischen Gesellschaft, *see* Vienna Photographic Society
Wiesner, Julius von, 417; *Jan Ingenhousz: sein Leben und Werken*, 94
Wigand, C. R., 350
Wilamowitz-Möllendorf, *Die deutsche Literaturzeitung*, 11
Wilde, 530
Wilde, Emil, *Geschichte der Optik*, 2, 729
Wilde, F., 432, 485
Wilkinson, W. T., 448
Willesden, 769
Willis, William, 543, 544, 545
Wilson, 347
Wilson, 397
Wilson, 588
Winckelmann, Johann Joachim, 79
Windsor and Bridge, 354
Winsor, W. Benyon, 558
Winter, 306
Winter, Chr., "Über den Becquerel-Effekt," 268
Winter, M. L., 791
Winterthur, 431
Winther, Chr., 704
Witting, Ernst, 171
Wittwer, 112, 412
Wöhler, 276, 278, 770
Wolf, M., 402
Wolfram, 343
Wollaston, William Hyde, 131-32, 214, 290, 294; invents improved meniscus lens, 45, 251, 294, 756-57; study of solar spectrum by, 131-32, 136, 145, 157, 158
Wolter, Konrad, 501, 788
Wonder camera, 54
Wood, A., 613

Wood, effect of light on, 103, 122
Woodbury, Walter Bentley, 383, 397, 586-89, 600, 805; produces photoelectrotypes from pigment reliefs, 559, 575, 589, 799; produces intaglio lead plates molded by hydraulic presses (Woodburytypes), 573, 587-89
Woodbury Permanent Printing Company, 589
Woodburytypes, 587-589, 619
Woods, 326
Woods, L. Tennant, 780
Woodward, J. J., 391, 392, 393; *Heliostat for Photomicrography*, 773
Wooton, Sir Henry, 44
Worel, Karl, 663, 674, 675, 749
Worring, Andreas, 569
Wortley, Stuart, 458
Wothly, 392
Wratten and Wainwright, 427, 431, 477, 778
Wulff & Co., 370
Wünsch, Christian Ernst, 150, 640
Würbel, Hugo, 623
Würthle, 359, 575
Wurtz, Karl Adolph, 172
Wyard, J., 567
Wynne, 449

Xpress lens, 412
Xyloidin, 342

Yearbooks, photographic, 678, 679, 681
Yermilow, N. E., 754
Young, Thomas, 123, 141, 144, 157, 640, 641, 746; *Experiments and Calculations Relative to Physical Optics*, 144; *Syllabus*, 746
Young, Y., 368

Zahn, Johann, 43, 44, 48, 53; *Oculus artificialis teledioptricus*, 43, 48, 53
Zalento, Petrus de, 15
Zamboni, Philippo, 286
Zander, 659
Zeiss, Carl, optical works, 55, 383, 388, 391, 407, 408-9, 410-12, 695
Zeiss-Ikon-A.-G., 411, 520, 695
Zeiss Planetarium, 523
Zeitlupe (slow motion), 524, 811
Zeitschrift der photographischen Gesellschaft, 696
Zeitschrift für Photographie und Stereoskopie, 681, 682
Zelger, 480
Zenker, Wilhelm, 667, 810; *Lehrbuch der Photochromie*, 667

Zentmayer, 404
Zentral-Zeitung für Optik und Mechanik, 391
Zier, Konrad, 189
Zimmermann, Wilhelm L., 171, 172, 174
Zinc, planographic printing from, 614-15
Zincography, 612, 614-15, 622, 623, 624
Zincotype process, 585

Zinc plates, photographic etching on, 621-25, 635-36
Zink, Karl, 659
Zinke-Sommer, 298
Zoescope, 496, 497, 499
Zoetrope projection, 499, 500, 505
Zoopraxiscope, 504, 505
Zuchold, Ernst Amandus, Bibliotheca photographica, 812

A CATALOGUE OF SELECTED DOVER BOOKS
IN ALL FIELDS OF INTEREST

A CATALOGUE OF SELECTED DOVER BOOKS
IN ALL FIELDS OF INTEREST

THE NOTEBOOKS OF LEONARDO DA VINCI, edited by J.P. Richter. Extracts from manuscripts reveal great genius; on painting, sculpture, anatomy, sciences, geography, etc. Both Italian and English. 186 ms. pages reproduced, plus 500 additional drawings, including studies for Last Supper, Sforza monument, etc. 860pp. 7⅞ x 10¾. USO 22572-0, 22573-9 Pa., Two vol. set $15.90

ART NOUVEAU DESIGNS IN COLOR, Alphonse Mucha, Maurice Verneuil, Georges Auriol. Full-color reproduction of Combinaisons ornamentales (c. 1900) by Art Nouveau masters. Floral, animal, geometric, interlacings, swashes — borders, frames, spots — all incredibly beautiful. 60 plates, hundreds of designs. 9⅜ x 8¹/₁₆. 22885-1 Pa. $4.00

GRAPHIC WORKS OF ODILON REDON. All great fantastic lithographs, etchings, engravings, drawings, 209 in all. Monsters, Huysmans, still life work, etc. Introduction by Alfred Werner. 209pp. 9⅛ x 12¼. 21996-8 Pa. $6.00

EXOTIC FLORAL PATTERNS IN COLOR, E.-A. Seguy. Incredibly beautiful full-color pochoir work by great French designer of 20's. Complete Bouquets et frondaisons, Suggestions pour étoffes. Richness must be seen to be believed. 40 plates containing 120 patterns. 80pp. 9⅜ x 12¼. 23041-4 Pa. $6.00

SELECTED ETCHINGS OF JAMES A. McN. WHISTLER, James A. McN. Whistler. 149 outstanding etchings by the great American artist, including selections from the Thames set and two Venice sets, the complete French set, and many individual prints. Introduction and explanatory note on each print by Maria Naylor. 157pp. 9⅜ x 12¼. 23194-1 Pa. $5.00

VISUAL ILLUSIONS: THEIR CAUSES, CHARACTERISTICS, AND APPLICATIONS, Matthew Luckiesh. Thorough description, discussion; shape and size, color, motion; natural illusion. Uses in art and industry. 100 illustrations. 252pp.
21530-X Pa. $3.00

TEN BOOKS ON ARCHITECTURE, Vitruvius. The most important book ever written on architecture. Early Roman aesthetics, technology, classical orders, site selection, all other aspects. Stands behind everything since. Morgan translation. 331pp.
20645-9 Pa. $3.75

THE CODEX NUTTALL. A PICTURE MANUSCRIPT FROM ANCIENT MEXICO, as first edited by Zelia Nuttall. Only inexpensive edition, in full color, of a pre-Columbian Mexican (Mixtec) book. 88 color plates show kings, gods, heroes, temples, sacrifices. New explanatory, historical introduction by Arthur G. Miller. 96pp. 11⅜ x 8½. 23168-2 Pa. $7.50

JEWISH GREETING CARDS, Ed Sibbett, Jr. 16 cards to cut and color. Three say "Happy Chanukah," one "Happy New Year," others have no message, show stars of David, Torahs, wine cups, other traditional themes. 16 envelopes. 8¼ x 11.
23225-5 Pa. $2.00

AUBREY BEARDSLEY GREETING CARD BOOK, Aubrey Beardsley. Edited by Theodore Menten. 16 elegant yet inexpensive greeting cards let you combine your own sentiments with subtle Art Nouveau lines. 16 different Aubrey Beardsley designs that you can color or not, as you wish. 16 envelopes. 64pp. 8¼ x 11.
23173-9 Pa. $2.00

RECREATIONS IN THE THEORY OF NUMBERS, Albert Beiler. Number theory, an inexhaustible source of puzzles, recreations, for beginners and advanced. Divisors, perfect numbers. scales of notation, etc. 349pp. 21096-0 Pa. $4.00

AMUSEMENTS IN MATHEMATICS, Henry E. Dudeney. One of largest puzzle collections, based on algebra, arithmetic, permutations, probability, plane figure dissection, properties of numbers, by one of world's foremost puzzlists. Solutions. 450 illustrations. 258pp. 20473-1 Pa. $3.00

MATHEMATICS, MAGIC AND MYSTERY, Martin Gardner. Puzzle editor for Scientific American explains math behind: card tricks, stage mind reading, coin and match tricks, counting out games, geometric dissections. Probability, sets, theory of numbers, clearly explained. Plus more than 400 tricks, guaranteed to work. 135 illustrations. 176pp. 20335-2 Pa. $2.00

BEST MATHEMATICAL PUZZLES OF SAM LOYD, edited by Martin Gardner. Bizarre, original, whimsical puzzles by America's greatest puzzler. From fabulously rare Cyclopedia, including famous 14-15 puzzles, the Horse of a Different Color, 115 more. Elementary math. 150 illustrations. 167pp. 20498-7 Pa. $2.50

MATHEMATICAL PUZZLES FOR BEGINNERS AND ENTHUSIASTS, Geoffrey Mott-Smith. 189 puzzles from easy to difficult involving arithmetic, logic, algebra, properties of digits, probability. Explanation of math behind puzzles. 135 illustrations. 248pp. 20198-8 Pa. $2.75

BIG BOOK OF MAZES AND LABYRINTHS, Walter Shepherd. Classical, solid, and ripple mazes; short path and avoidance labyrinths; more — 50 mazes and labyrinths in all. 12 other figures. Full solutions. 112pp. 8⅛ x 11. 22951-3 Pa. $2.00

COIN GAMES AND PUZZLES, Maxey Brooke. 60 puzzles, games and stunts — from Japan, Korea, Africa and the ancient world, by Dudeney and the other great puzzlers, as well as Maxey Brooke's own creations. Full solutions. 67 illustrations. 94pp. 22893-2 Pa. $1.50

HAND SHADOWS TO BE THROWN UPON THE WALL, Henry Bursill. Wonderful Victorian novelty tells how to make flying birds, dog, goose, deer, and 14 others. 32pp. 6½ x 9¼. 21779-5 Pa. $1.25

CREATIVE LITHOGRAPHY AND HOW TO DO IT, Grant Arnold. Lithography as art form: working directly on stone, transfer of drawings, lithotint, mezzotint, color printing; also metal plates. Detailed, thorough. 27 illustrations. 214pp.
21208-4 Pa. $3.50

DESIGN MOTIFS OF ANCIENT MEXICO, Jorge Enciso. Vigorous, powerful ceramic stamp impressions — Maya, Aztec, Toltec, Olmec. Serpents, gods, priests, dancers, etc. 153pp. 6⅛ x 9¼.
20084-1 Pa. $2.50

AMERICAN INDIAN DESIGN AND DECORATION, Leroy Appleton. Full text, plus more than 700 precise drawings of Inca, Maya, Aztec, Pueblo, Plains, NW Coast basketry, sculpture, painting, pottery, sand paintings, metal, etc. 4 plates in color. 279pp. 8⅜ x 11¼.
22704-9 Pa.$5.00

CHINESE LATTICE DESIGNS, Daniel S. Dye. Incredibly beautiful geometric designs: circles, voluted, simple dissections, etc. Inexhaustible source of ideas, motifs. 1239 illustrations. 469pp. 6⅛ x 9¼.
23096-1 Pa. $5.00

JAPANESE DESIGN MOTIFS, Matsuya Co. Mon, or heraldic designs. Over 4000 typical, beautiful designs: birds, animals, flowers, swords, fans, geometric; all beautifully stylized. 213pp. 11⅜ x 8¼.
22874-6 Pa. $5.00

PERSPECTIVE, Jan Vredeman de Vries. 73 perspective plates from 1604 edition; buildings, townscapes, stairways, fantastic scenes. Remarkable for beauty, surrealistic atmosphere; real eye-catchers. Introduction by Adolf Placzek. 74pp. 11⅜ x 8¼.
20186-4 Pa. $3.00

EARLY AMERICAN DESIGN MOTIFS. Suzanne E. Chapman. 497 motifs, designs, from painting on wood, ceramics, appliqué, glassware, samplers, metal work, etc. Florals, landscapes, birds and animals, geometrics, letters, etc. Inexhaustible. Enlarged edition. 138pp. 8⅜ x 11¼.
22985-8 Pa. $3.50
23084-8 Clothbd. $7.95

VICTORIAN STENCILS FOR DESIGN AND DECORATION, edited by E.V. Gillon, Jr. 113 wonderful ornate Victorian pieces from German sources; florals, geometrics; borders, corner pieces; bird motifs, etc. 64pp. 9⅜ x 12¼.
21995-X Pa. $3.00

ART NOUVEAU: AN ANTHOLOGY OF DESIGN AND ILLUSTRATION FROM THE STUDIO, edited by E.V. Gillon, Jr. Graphic arts: book jackets, posters, engravings, illustrations, decorations; Crane, Beardsley, Bradley and many others. Inexhaustible. 92pp. 8⅛ x 11.
22388-4 Pa. $2.50

ORIGINAL ART DECO DESIGNS, William Rowe. First-rate, highly imaginative modern Art Deco frames, borders, compositions, alphabets, florals, insectals, Wurlitzer-types, etc. Much finest modern Art Deco. 80 plates, 8 in color. 8⅜ x 11¼.
22567-4 Pa. $3.50

HANDBOOK OF DESIGNS AND DEVICES, Clarence P. Hornung. Over 1800 basic geometric designs based on circle, triangle, square, scroll, cross, etc. Largest such collection in existence. 261pp.
20125-2 Pa. $2.75

HOUDINI ON MAGIC, Harold Houdini. Edited by Walter Gibson, Morris N. Young. How he escaped; exposés of fake spiritualists; instructions for eye-catching tricks; other fascinating material by and about greatest magician. 155 illustrations. 280pp. 20384-0 Pa. $2.75

HANDBOOK OF THE NUTRITIONAL CONTENTS OF FOOD, U.S. Dept. of Agriculture. Largest, most detailed source of food nutrition information ever prepared. Two mammoth tables: one measuring nutrients in 100 grams of edible portion; the other, in edible portion of 1 pound as purchased. Originally titled Composition of Foods. 190pp. 9 x 12. 21342-0 Pa. $4.00

COMPLETE GUIDE TO HOME CANNING, PRESERVING AND FREEZING, U.S. Dept. of Agriculture. Seven basic manuals with full instructions for jams and jellies; pickles and relishes; canning fruits, vegetables, meat; freezing anything. Really good recipes, exact instructions for optimal results. Save a fortune in food. 156 illustrations. 214pp. 6⅛ x 9¼. 22911-4 Pa. $2.50

THE BREAD TRAY, Louis P. De Gouy. Nearly every bread the cook could buy or make: bread sticks of Italy, fruit breads of Greece, glazed rolls of Vienna, everything from corn pone to croissants. Over 500 recipes altogether. including buns, rolls, muffins, scones, and more. 463pp. 23000-7 Pa. $4.00

CREATIVE HAMBURGER COOKERY, Louis P. De Gouy. 182 unusual recipes for casseroles, meat loaves and hamburgers that turn inexpensive ground meat into memorable main dishes: Arizona chili burgers, burger tamale pie, burger stew, burger corn loaf, burger wine loaf, and more. 120pp. 23001-5 Pa. $1.75

LONG ISLAND SEAFOOD COOKBOOK, J. George Frederick and Jean Joyce. Probably the best American seafood cookbook. Hundreds of recipes. 40 gourmet sauces, 123 recipes using oysters alone! All varieties of fish and seafood amply represented. 324pp. 22677-8 Pa. $3.50

THE EPICUREAN: A COMPLETE TREATISE OF ANALYTICAL AND PRACTICAL STUDIES IN THE CULINARY ART, Charles Ranhofer. Great modern classic. 3,500 recipes from master chef of Delmonico's, turn-of-the-century America's best restaurant. Also explained, many techniques known only to professional chefs. 775 illustrations. 1183pp. 6⅝ x 10. 22680-8 Clothbd. $22.50

THE AMERICAN WINE COOK BOOK, Ted Hatch. Over 700 recipes: old favorites livened up with wine plus many more: Czech fish soup, quince soup, sauce Perigueux, shrimp shortcake, filets Stroganoff, cordon bleu goulash, jambonneau, wine fruit cake, more. 314pp. 22796-0 Pa. $2.50

DELICIOUS VEGETARIAN COOKING, Ivan Baker. Close to 500 delicious and varied recipes: soups, main course dishes (pea, bean, lentil, cheese, vegetable, pasta, and egg dishes), savories, stews, whole-wheat breads and cakes, more. 168pp.
 USO 22834-7 Pa. $2.00

EAST O' THE SUN AND WEST O' THE MOON, George W. Dasent. Considered the best of all translations of these Norwegian folk tales, this collection has been enjoyed by generations of children (and folklorists too). Includes True and Untrue, Why the Sea is Salt, East O' the Sun and West O' the Moon, Why the Bear is Stumpy-Tailed, Boots and the Troll, The Cock and the Hen, Rich Peter the Pedlar, and 52 more. The only edition with all 59 tales. 77 illustrations by Erik Werenskiold and Theodor Kittelsen. xv + 418pp. 22521-6 Paperbound **$4.00**

GOOPS AND HOW TO BE THEM, Gelett Burgess. Classic of tongue-in-cheek humor, masquerading as etiquette book. 87 verses, twice as many cartoons, show mischievous Goops as they demonstrate to children virtues of table manners, neatness, courtesy, etc. Favorite for generations. viii + 88pp. 6½ x 9¼. 22233-0 Paperbound **$2.00**

ALICE'S ADVENTURES UNDER GROUND, Lewis Carroll. The first version, quite different from the final *Alice in Wonderland,* printed out by Carroll himself with his own illustrations. Complete facsimile of the "million dollar" manuscript Carroll gave to Alice Liddell in 1864. Introduction by Martin Gardner. viii + 96pp. Title and dedication pages in color. 21482-6 Paperbound **$1.50**

THE BROWNIES, THEIR BOOK, Palmer Cox. Small as mice, cunning as foxes, exuberant and full of mischief, the Brownies go to the zoo, toy shop, seashore, circus, etc., in 24 verse adventures and 266 illustrations. Long a favorite, since their first appearance in St. Nicholas Magazine. xi + 144pp. 6⅝ x 9¼. 21265-3 Paperbound **$2.50**

SONGS OF CHILDHOOD, Walter De La Mare. Published (under the pseudonym Walter Ramal) when De La Mare was only 29, this charming collection has long been a favorite children's book. A facsimile of the first edition in paper, the 47 poems capture the simplicity of the nursery rhyme and the ballad, including such lyrics as I Met Eve, Tartary, The Silver Penny. vii + 106pp. (USO) 21972-0 Paperbound **$2.00**

THE COMPLETE NONSENSE OF EDWARD LEAR, Edward Lear. The finest 19th-century humorist-cartoonist in full: all nonsense limericks, zany alphabets, Owl and Pussycat, songs, nonsense botany, and more than 500 illustrations by Lear himself. Edited by Holbrook Jackson. xxix + 287pp. (USO) 20167-8 Paperbound **$3.00**

BILLY WHISKERS: THE AUTOBIOGRAPHY OF A GOAT, Frances Trego Montgomery. A favorite of children since the early 20th century, here are the escapades of that rambunctious, irresistible and mischievous goat—Billy Whiskers. Much in the spirit of *Peck's Bad Boy,* this is a book that children never tire of reading or hearing. All the original familiar illustrations by W. H. Fry are included: 6 color plates, 18 black and white drawings. 159pp. 22345-0 Paperbound **$2.75**

MOTHER GOOSE MELODIES. Faithful republication of the fabulously rare Munroe and Francis "copyright 1833" Boston edition—the most important Mother Goose collection, usually referred to as the "original." Familiar rhymes plus many rare ones, with wonderful old woodcut illustrations. Edited by E. F. Bleiler. 128pp. 4½ x 6⅜. 22577-1 Paperbound **$1.50**

HOW TO SOLVE CHESS PROBLEMS, Kenneth S. Howard. Practical suggestions on problem solving for very beginners. 58 two-move problems, 46 3-movers, 8 4-movers for practice, plus hints. 171pp.
20748-X Pa. $3.00

A GUIDE TO FAIRY CHESS, Anthony Dickins. 3-D chess, 4-D chess, chess on a cylindrical board, reflecting pieces that bounce off edges, cooperative chess, retrograde chess, maximummers, much more. Most based on work of great Dawson. Full handbook, 100 problems. 66pp. 7⅞ x 10¾.
22687-5 Pa. $2.00

WIN AT BACKGAMMON, Millard Hopper. Best opening moves, running game, blocking game, back game, tables of odds, etc. Hopper makes the game clear enough for anyone to play, and win. 43 diagrams. 111pp.
22894-0 Pa. $1.50

BIDDING A BRIDGE HAND, Terence Reese. Master player "thinks out loud" the binding of 75 hands that defy point count systems. Organized by bidding problem—no-fit situations, overbidding, underbidding, cueing your defense, etc. 254pp.
EBE 22830-4 Pa. $3.00

THE PRECISION BIDDING SYSTEM IN BRIDGE, C.C. Wei, edited by Alan Truscott. Inventor of precision bidding presents average hands and hands from actual play, including games from 1969 Bermuda Bowl where system emerged. 114 exercises. 116pp.
21171-1 Pa. $2.25

LEARN MAGIC, Henry Hay. 20 simple, easy-to-follow lessons on magic for the new magician: illusions, card tricks, silks, sleights of hand, coin manipulations, escapes, and more —all with a minimum amount of equipment. Final chapter explains the great stage illusions. 92 illustrations. 285pp.
21238-6 Pa. $2.95

THE NEW MAGICIAN'S MANUAL, Walter B. Gibson. Step-by-step instructions and clear illustrations guide the novice in mastering 36 tricks; much equipment supplied on 16 pages of cut-out materials. 36 additional tricks. 64 illustrations. 159pp. 6⅝ x 10.
23113-5 Pa. $3.00

PROFESSIONAL MAGIC FOR AMATEURS, Walter B. Gibson. 50 easy, effective tricks used by professionals —cards, string, tumblers, handkerchiefs, mental magic, etc. 63 illustrations. 223pp.
23012-0 Pa. $2.50

CARD MANIPULATIONS, Jean Hugard. Very rich collection of manipulations; has taught thousands of fine magicians tricks that are really workable, eye-catching. Easily followed, serious work. Over 200 illustrations. 163pp. 20539-8 Pa. $2.00

ABBOTT'S ENCYCLOPEDIA OF ROPE TRICKS FOR MAGICIANS, Stewart James. Complete reference book for amateur and professional magicians containing more than 150 tricks involving knots, penetrations, cut and restored rope, etc. 510 illustrations. Reprint of 3rd edition. 400pp.
23206-9 Pa. $3.50

THE SECRETS OF HOUDINI, J.C. Cannell. Classic study of Houdini's incredible magic, exposing closely-kept professional secrets and revealing, in general terms, the whole art of stage magic. 67 illustrations. 279pp.
22913-0 Pa. $3.00

THE RED FAIRY BOOK, Andrew Lang. Lang's color fairy books have long been children's favorites. This volume includes Rapunzel, Jack and the Bean-stalk and 35 other stories, familiar and unfamiliar. 4 plates, 93 illustrations x + 367pp.
21673-X Paperbound $3.00

THE BLUE FAIRY BOOK, Andrew Lang. Lang's tales come from all countries and all times. Here are 37 tales from Grimm, the Arabian Nights, Greek Mythology, and other fascinating sources. 8 plates, 130 illustrations. xi + 390pp.
21437-0 Paperbound $3.50

HOUSEHOLD STORIES BY THE BROTHERS GRIMM. Classic English-language edition of the well-known tales — Rumpelstiltskin, Snow White, Hansel and Gretel, The Twelve Brothers, Faithful John, Rapunzel, Tom Thumb (52 stories in all). Translated into simple, straightforward English by Lucy Crane. Ornamented with headpieces, vignettes, elaborate decorative initials and a dozen full-page illustrations by Walter Crane. x + 269pp.
21080-4 Paperbound $3.00

THE MERRY ADVENTURES OF ROBIN HOOD, Howard Pyle. The finest modern versions of the traditional ballads and tales about the great English outlaw. Howard Pyle's complete prose version, with every word, every illustration of the first edition. Do not confuse this facsimile of the original (1883) with modern editions that change text or illustrations. 23 plates plus many page decorations. xxii + 296pp.
22043-5 Paperbound $4.00

THE STORY OF KING ARTHUR AND HIS KNIGHTS, Howard Pyle. The finest children's version of the life of King Arthur; brilliantly retold by Pyle, with 48 of his most imaginative illustrations. xviii + 313pp. 6⅛ x 9¼.
21445-1 Paperbound $3.50

THE WONDERFUL WIZARD OF OZ, L. Frank Baum. America's finest children's book in facsimile of first edition with all Denslow illustrations in full color. The edition a child should have. Introduction by Martin Gardner. 23 color plates, scores of drawings. iv + 267pp.
20691-2 Paperbound $3.00

THE MARVELOUS LAND OF OZ, L. Frank Baum. The second Oz book, every bit as imaginative as the Wizard. The hero is a boy named Tip, but the Scarecrow and the Tin Woodman are back, as is the Oz magic. 16 color plates, 120 drawings by John R. Neill. 287pp.
20692-0 Paperbound $3.00

THE MAGICAL MONARCH OF MO, L. Frank Baum. Remarkable adventures in a land even stranger than Oz. The best of Baum's books not in the Oz series. 15 color plates and dozens of drawings by Frank Verbeck. xviii + 237pp.
21892-9 Paperbound $2.95

THE BAD CHILD'S BOOK OF BEASTS, MORE BEASTS FOR WORSE CHILDREN, A MORAL ALPHABET, Hilaire Belloc. Three complete humor classics in one volume. Be kind to the frog, and do not call him names . . . and 28 other whimsical animals. Familiar favorites and some not so well known. Illustrated by Basil Blackwell. 156pp.
(USO) 20749-8 Paperbound $2.00

VISUAL ILLUSIONS: THEIR CAUSES, CHARACTERISTICS, AND APPLICATIONS, Matthew Luckiesh. Thorough description and discussion of optical illusion, geometric and perspective, particularly; size and shape distortions, illusions of color, of motion; natural illusions; use of illusion in art and magic, industry, etc. Most useful today with op art, also for classical art. Scores of effects illustrated. Introduction by William H. Ittleson. 100 illustrations. xxi + 252pp.

21530-X Paperbound $2.50

A HANDBOOK OF ANATOMY FOR ART STUDENTS, Arthur Thomson. Thorough, virtually exhaustive coverage of skeletal structure, musculature, etc. Full text, supplemented by anatomical diagrams and drawings and by photographs of undraped figures. Unique in its comparison of male and female forms, pointing out differences of contour, texture, form. 211 figures, 40 drawings, 86 photographs. xx + 459pp. 5⅜ x 8⅜.

21163-0 Paperbound $5.00

150 MASTERPIECES OF DRAWING, Selected by Anthony Toney. Full page reproductions of drawings from the early 16th to the end of the 18th century, all beautifully reproduced: Rembrandt, Michelangelo, Dürer, Fragonard, Urs, Graf, Wouwerman, many others. First-rate browsing book, model book for artists. xviii + 150pp. 8⅜ x 11¼.

21032-4 Paperbound $4.00

THE LATER WORK OF AUBREY BEARDSLEY, Aubrey Beardsley. Exotic, erotic, ironic masterpieces in full maturity: Comedy Ballet, Venus and Tannhauser, Pierrot, Lysistrata, Rape of the Lock, Savoy material, Ali Baba, Volpone, etc. This material revolutionized the art world, and is still powerful, fresh, brilliant. With *The Early Work,* all Beardsley's finest work. 174 plates, 2 in color. xiv + 176pp. 8⅛ x 11.

21817-1 Paperbound $4.00

DRAWINGS OF REMBRANDT, Rembrandt van Rijn. Complete reproduction of fabulously rare edition by Lippmann and Hofstede de Groot, completely reedited, updated, improved by Prof. Seymour Slive, Fogg Museum. Portraits, Biblical sketches, landscapes, Oriental types, nudes, episodes from classical mythology—All Rembrandt's fertile genius. Also selection of drawings by his pupils and followers. "Stunning volumes," *Saturday Review.* 550 illustrations. lxxviii + 552pp. 9⅛ x 12¼.

21485-0, 21486-9 Two volumes, Paperbound $12.00

THE DISASTERS OF WAR, Francisco Goya. One of the masterpieces of Western civilization—83 etchings that record Goya's shattering, bitter reaction to the Napoleonic war that swept through Spain after the insurrection of 1808 and to war in general. Reprint of the first edition, with three additional plates from Boston's Museum of Fine Arts. All plates facsimile size. Introduction by Philip Hofer, Fogg Museum. v + 97pp. 9⅜ x 8¼.

21872-4 Paperbound $3.00

GRAPHIC WORKS OF ODILON REDON. Largest collection of Redon's graphic works ever assembled: 172 lithographs, 28 etchings and engravings, 9 drawings. These include some of his most famous works. All the plates from *Odilon Redon: oeuvre graphique complet,* plus additional plates. New introduction and caption translations by Alfred Werner. 209 illustrations. xxvii + 209pp. 9⅛ x 12¼.

21966-8 Paperbound $6.00

THE FITZWILLIAM VIRGINAL BOOK, edited by J. Fuller Maitland, W.B. Squire. Famous early 17th century collection of keyboard music, 300 works by Morley, Byrd, Bull, Gibbons, etc. Modern notation. Total of 938pp. 8⅜ x 11.
ECE 21068-5, 21069-3 Pa., Two vol. set $15.00

COMPLETE STRING QUARTETS, Wolfgang A. Mozart. Breitkopf and Härtel edition. All 23 string quartets plus alternate slow movement to K156. Study score. 277pp. 9⅜ x 12¼.
22372-8 Pa. $6.00

COMPLETE SONG CYCLES, Franz Schubert. Complete piano, vocal music of Die Schöne Müllerin, Die Winterreise, Schwanengesang. Also Drinker English singing translations. Breitkopf and Härtel edition. 217pp. 9⅜ x 12¼.
22649-2 Pa. $5.00

THE COMPLETE PRELUDES AND ETUDES FOR PIANOFORTE SOLO, Alexander Scriabin. All the preludes and etudes including many perfectly spun miniatures. Edited by K.N. Igumnov and Y.I. Mil'shteyn. 250pp. 9 x 12.
22919-X Pa. $6.00

TRISTAN UND ISOLDE, Richard Wagner. Full orchestral score with complete instrumentation. Do not confuse with piano reduction. Commentary by Felix Mottl, great Wagnerian conductor and scholar. Study score. 655pp. 8⅛ x 11.
22915-7 Pa. $11.95

FAVORITE SONGS OF THE NINETIES, ed. Robert Fremont. Full reproduction, including covers, of 88 favorites: Ta-Ra-Ra-Boom-De-Aye, The Band Played On, Bird in a Gilded Cage, Under the Bamboo Tree, After the Ball, etc. 401pp. 9 x 12.
EBE 21536-9 Pa. $6.95

SOUSA'S GREAT MARCHES IN PIANO TRANSCRIPTION: ORIGINAL SHEET MUSIC OF 23 WORKS, John Philip Sousa. Selected by Lester S. Levy. Playing edition includes: The Stars and Stripes Forever, The Thunderer, The Gladiator, King Cotton, Washington Post, much more. 24 illustrations. 111pp. 9 x 12.
USO 23132-1 Pa. $3.50

CLASSIC PIANO RAGS, selected with an introduction by Rudi Blesh. Best ragtime music (1897-1922) by Scott Joplin, James Scott, Joseph F. Lamb, Tom Turpin, 9 others. Printed from best original sheet music, plus covers. 364pp. 9 x 12.
EBE 20469-3 Pa. $7.50

ANALYSIS OF CHINESE CHARACTERS, C.D. Wilder, J.H. Ingram. 1000 most important characters analyzed according to primitives, phonetics, historical development. Traditional method offers mnemonic aid to beginner, intermediate student of Chinese, Japanese. 365pp.
23045-7 Pa. $4.00

MODERN CHINESE: A BASIC COURSE, Faculty of Peking University. Self study, classroom course in modern Mandarin. Records contain phonetics, vocabulary, sentences, lessons. 249 page book contains all recorded text, translations, grammar, vocabulary, exercises. Best course on market. 3 12" 33⅓ monaural records, book, album.
98832-5 Set $12.50

CONSTRUCTION OF AMERICAN FURNITURE TREASURES, Lester Margon. 344 detail drawings, complete text on constructing exact reproductions of 38 early American masterpieces: Hepplewhite sideboard, Duncan Phyfe drop-leaf table, mantel clock, gate-leg dining table, Pa. German cupboard, more. 38 plates. 54 photographs. 168pp. 8⅜ x 11¼. 23056-2 Pa. $4.00

JEWELRY MAKING AND DESIGN, Augustus F. Rose, Antonio Cirino. Professional secrets revealed in thorough, practical guide: tools, materials, processes; rings, brooches, chains, cast pieces, enamelling, setting stones, etc. Do not confuse with skimpy introductions: beginner can use, professional can learn from it. Over 200 illustrations. 306pp. 21750-7 Pa. $3.00

METALWORK AND ENAMELLING, Herbert Maryon. Generally conceded best all-around book. Countless trade secrets: materials, tools, soldering, filigree, setting, inlay, niello, repoussé, casting, polishing, etc. For beginner or expert. Author was foremost British expert. 330 illustrations. 335pp. 22702-2 Pa. $4.00

WEAVING WITH FOOT-POWER LOOMS, Edward F. Worst. Setting up a loom, beginning to weave, constructing equipment, using dyes, more, plus over 285 drafts of traditional patterns including Colonial and Swedish weaves. More than 200 other figures. For beginning and advanced. 275pp. 8¾ x 6⅜. 23064-3 Pa. $4.50

WEAVING A NAVAJO BLANKET, Gladys A. Reichard. Foremost anthropologist studied under Navajo women, reveals every step in process from wool, dyeing, spinning, setting up loom, designing, weaving. Much history, symbolism. With this book you could make one yourself. 97 illustrations. 222pp. 22992-0 Pa. $3.00

NATURAL DYES AND HOME DYEING, Rita J. Adrosko. Use natural ingredients: bark, flowers, leaves, lichens, insects etc. Over 135 specific recipes from historical sources for cotton, wool, other fabrics. Genuine premodern handicrafts. 12 illustrations. 160pp. 22688-3 Pa. $2.00

DRIED FLOWERS, Sarah Whitlock and Martha Rankin. Concise, clear, practical guide to dehydration, glycerinizing, pressing plant material, and more. Covers use of silica gel. 12 drawings. Originally titled "New Techniques with Dried Flowers." 32pp. 21802-3 Pa. $1.00

THOMAS NAST: CARTOONS AND ILLUSTRATIONS, with text by Thomas Nast St. Hill. Father of American political cartooning. Cartoons that destroyed Tweed Ring; inflation, free love, church and state; original Republican elephant and Democratic donkey; Santa Claus; more. 117 illustrations. 146pp. 9 x 12.
22983-1 Pa. $4.00
23067-8 Clothbd. $8.50

FREDERIC REMINGTON: 173 DRAWINGS AND ILLUSTRATIONS. Most famous of the Western artists, most responsible for our myths about the American West in its untamed days. Complete reprinting of *Drawings of Frederic Remington* (1897), plus other selections. 4 additional drawings in color on covers. 140pp. 9 x 12.
20714-5 Pa. $5.00'

DECORATIVE ALPHABETS AND INITIALS, edited by Alexander Nesbitt. 91 complete alphabets (medieval to modern), 3924 decorative initials, including Victorian novelty and Art Nouveau. 192pp. 7¾ x 10¾. 20544-4 Pa. $4.00

CALLIGRAPHY, Arthur Baker. Over 100 original alphabets from the hand of our greatest living calligrapher: simple, bold, fine-line, richly ornamented, etc. —all strikingly original and different, a fusion of many influences and styles. 155pp. 11⅜ x 8¼. 22895-9 Pa. $4.50

MONOGRAMS AND ALPHABETIC DEVICES, edited by Hayward and Blanche Cirker. Over 2500 combinations, names, crests in very varied styles: script engraving, ornate Victorian, simple Roman, and many others. 226pp. 8⅛ x 11. 22330-2 Pa. $5.00

THE BOOK OF SIGNS, Rudolf Koch. Famed German type designer renders 493 symbols: religious, alchemical, imperial, runes, property marks, etc. Timeless. 104pp. 6⅛ x 9¼. 20162-7 Pa. $1.75

200 DECORATIVE TITLE PAGES, edited by Alexander Nesbitt. 1478 to late 1920's. Baskerville, Dürer, Beardsley, W. Morris, Pyle, many others in most varied techniques. For posters, programs, other uses. 222pp. 8⅜ x 11¼. 21264-5 Pa. $5.00

DICTIONARY OF AMERICAN PORTRAITS, edited by Hayward and Blanche Cirker. 4000 important Americans, earliest times to 1905, mostly in clear line. Politicians, writers, soldiers, scientists, inventors, industrialists, Indians, Blacks, women, outlaws, etc. Identificatory information. 756pp. 9¼ x 12¾. 21823-6 Clothbd. $30.00

ART FORMS IN NATURE, Ernst Haeckel. Multitude of strangely beautiful natural forms: Radiolaria, Foraminifera, jellyfishes, fungi, turtles, bats, etc. All 100 plates of the 19th century evolutionist's Kunstformen der Natur (1904). 100pp. 9⅜ x 12¼. 22987-4 Pa. $4.00

DECOUPAGE: THE BIG PICTURE SOURCEBOOK, Eleanor Rawlings. Make hundreds of beautiful objects, over 550 florals, animals, letters, shells, period costumes, frames, etc. selected by foremost practitioner. Printed on one side of page. 8 color plates. Instructions. 176pp. 9³/₁₆ x 12¼. 23182-8 Pa. $5.00

AMERICAN FOLK DECORATION, Jean Lipman, Eve Meulendyke. Thorough coverage of all aspects of wood, tin, leather, paper, cloth decoration — scapes, humans, trees, flowers, geometrics — and how to make them. Full instructions. 233 illustrations, 5 in color. 163pp. 8⅜ x 11¼. 22217-9 Pa. $3.95

WHITTLING AND WOODCARVING, E.J. Tangerman. Best book on market; clear, full. If you can cut a potato, you can carve toys, puzzles, chains, caricatures, masks, patterns, frames, decorate surfaces, etc. Also covers serious wood sculpture. Over 200 photos. 293pp. 20965-2 Pa. $3.00

MOTHER GOOSE'S MELODIES. Facsimile of fabulously rare Munroe and Francis "copyright 1833" Boston edition. Familiar and unusual rhymes, wonderful old woodcut illustrations. Edited by E.F. Bleiler. 128pp. 4½ x 6⅜. 22577-1 Pa. $1.50·

MOTHER GOOSE IN HIEROGLYPHICS. Favorite nursery rhymes presented in rebus form for children. Fascinating 1849 edition reproduced in toto, with key. Introduction by E.F. Bleiler. About 400 woodcuts. 64pp. 6⅞ x 5¼. 20745-5 Pa. $1.50

PETER PIPER'S PRACTICAL PRINCIPLES OF PLAIN & PERFECT PRONUNCIATION. Alliterative jingles and tongue-twisters. Reproduction in full of 1830 first American edition. 25 spirited woodcuts. 32pp. 4½ x 6⅜. 22560-7 Pa. $1.25

MARMADUKE MULTIPLY'S MERRY METHOD OF MAKING MINOR MATHEMATICIANS. Fellow to Peter Piper, it teaches multiplication table by catchy rhymes and woodcuts. 1841 Munroe & Francis edition. Edited by E.F. Bleiler. 103pp. 4⅝ x 6. 22773-1 Pa. $1.25

THE NIGHT BEFORE CHRISTMAS, Clement Moore. Full text, and woodcuts from original 1848 book. Also critical, historical material. 19 illustrations. 40pp. 4⅝ x 6. 22797-9 Pa. $1.35

THE KING OF THE GOLDEN RIVER, John Ruskin. Victorian children's classic of three brothers, their attempts to reach the Golden River, what becomes of them. Facsimile of original 1889 edition. 22 illustrations. 56pp. 4⅝ x 6⅜. 20066-3 Pa. $1.50

DREAMS OF THE RAREBIT FIEND, Winsor McCay. Pioneer cartoon strip, unexcelled for beauty, imagination, in 60 full sequences. Incredible technical virtuosity, wonderful visual wit. Historical introduction. 62pp. 8⅜ x 11¼. 21347-1 Pa. $2.50

THE KATZENJAMMER KIDS, Rudolf Dirks. In full color, 14 strips from 1906-7; full of imagination, characteristic humor. Classic of great historical importance. Introduction by August Derleth. 32pp. 9¼ x 12¼. 23005-8 Pa. $2.00

LITTLE ORPHAN ANNIE AND LITTLE ORPHAN ANNIE IN COSMIC CITY, Harold Gray. Two great sequences from the early strips: our curly-haired heroine defends the Warbucks' financial empire and, then, takes on meanie Phineas P. Pinchpenny. Leapin' lizards! 178pp. 6⅛ x 8⅜. 23107-0 Pa. $2.00

ABSOLUTELY MAD INVENTIONS, A.E. Brown, H.A. Jeffcott. Hilarious, useless, or merely absurd inventions all granted patents by the U.S. Patent Office. Edible tie pin, mechanical hat tipper, etc. 57 illustrations. 125pp. 22596-8 Pa. $1.50

THE DEVIL'S DICTIONARY, Ambrose Bierce. Barbed, bitter, brilliant witticisms in the form of a dictionary. Best, most ferocious satire America has produced. 145pp. 20487-1 Pa. $1.75

THE ART DECO STYLE, ed. by Theodore Menten. Furniture, jewelry, metalwork, ceramics, fabrics, lighting fixtures, interior decors, exteriors, graphics from pure French sources. Best sampling around. Over 400 photographs. 183pp. 8⅜ x 11¼.
22824-X Pa. $4.00

THE GENTLEMAN AND CABINET MAKER'S DIRECTOR, Thomas Chippendale. Full reprint, 1762 style book, most influential of all time; chairs, tables, sofas, mirrors, cabinets, etc. 200 plates, plus 24 photographs of surviving pieces. 249pp. 9⅞ x 12¾.
21601-2 Pa. $6.00

PINE FURNITURE OF EARLY NEW ENGLAND, Russell H. Kettell. Basic book. Thorough historical text, plus 200 illustrations of boxes, highboys, candlesticks, desks, etc. 477pp. 7⅞ x 10¾.
20145-7 Clothbd. $12.50

ORIENTAL RUGS, ANTIQUE AND MODERN, Walter A. Hawley. Persia, Turkey, Caucasus, Central Asia, China, other traditions. Best general survey of all aspects: styles and periods, manufacture, uses, symbols and their interpretation, and identification. 96 illustrations, 11 in color. 320pp. 6⅛ x 9¼.
22366-3 Pa. $5.00

DECORATIVE ANTIQUE IRONWORK, Henry R. d'Allemagne. Photographs of 4500 iron artifacts from world's finest collection, Rouen. Hinges, locks, candelabra, weapons, lighting devices, clocks, tools, from Roman times to mid-19th century. Nothing else comparable to it. 420pp. 9 x 12.
22082-6 Pa. $8.50

THE COMPLETE BOOK OF DOLL MAKING AND COLLECTING, Catherine Christopher. Instructions, patterns for dozens of dolls, from rag doll on up to elaborate, historically accurate figures. Mould faces, sew clothing, make doll houses, etc. Also collecting information. Many illustrations. 288pp. 6 x 9. 22066-4 Pa. $3.00

ANTIQUE PAPER DOLLS: 1915-1920, edited by Arnold Arnold. 7 antique cut-out dolls and 24 costumes from 1915-1920, selected by Arnold Arnold from his collection of rare children's books and entertainments, all in full color. 32pp. 9¼ x 12¼.
23176-3 Pa. $2.00

ANTIQUE PAPER DOLLS: THE EDWARDIAN ERA, Epinal. Full-color reproductions of two historic series of paper dolls that show clothing styles in 1908 and at the beginning of the First World War. 8 two-sided, stand-up dolls and 32 complete, two-sided costumes. Full instructions for assembling included. 32pp. 9¼ x 12¼.
23175-5 Pa. $2.00

A HISTORY OF COSTUME, Carl Köhler, Emma von Sichardt. Egypt, Babylon, Greece up through 19th century Europe; based on surviving pieces, art works, etc. Full text and 595 illustrations, including many clear, measured patterns for reproducing historic costume. Practical. 464pp.
21030-8 Pa. $4.00

EARLY AMERICAN LOCOMOTIVES, John H. White, Jr. Finest locomotive engravings from late 19th century: historical (1804-1874), main-line (after 1870), special, foreign, etc. 147 plates. 200pp. 11⅜ x 8¼.
22772-3 Pa. $3.50

COOKIES FROM MANY LANDS, Josephine Perry. Crullers, oatmeal cookies, chaux au chocolate, English tea cakes, mandel kuchen, Sacher torte, Danish puff pastry, Swedish cookies — a mouth-watering collection of 223 recipes. 157pp.

22832-0 Pa. $2.25

ROSE RECIPES, Eleanour S. Rohde. How to make sauces, jellies, tarts, salads, potpourris, sweet bags, pomanders, perfumes from garden roses; all exact recipes. Century old favorites. 95pp.

22957-2 Pa. $1.75

"OSCAR" OF THE WALDORF'S COOKBOOK, Oscar Tschirky. Famous American chef reveals 3455 recipes that made Waldorf great; cream of French, German, American cooking, in all categories. Full instructions, easy home use. 1896 edition. 907pp. $6\frac{5}{8}$ x $9\frac{3}{8}$.

20790-0 Clothbd. $15.00

JAMS AND JELLIES, May Byron. Over 500 old-time recipes for delicious jams, jellies, marmalades, preserves, and many other items. Probably the largest jam and jelly book in print. Originally titled May Byron's Jam Book. 276pp.

USO 23130-5 Pa. $3.50

MUSHROOM RECIPES, André L. Simon. 110 recipes for everyday and special cooking. Champignons à la grecque, sole bonne femme, chicken liver croustades, more; 9 basic sauces, 13 ways of cooking mushrooms. 54pp.

USO 20913-X Pa. $1.25

THE BUCKEYE COOKBOOK, Buckeye Publishing Company. Over 1,000 easy-to-follow, traditional recipes from the American Midwest: bread (100 recipes alone), meat, game, jam, candy, cake, ice cream, and many other categories of cooking. 64 illustrations. From 1883 enlarged edition. 416pp.

23218-2 Pa. $4.00

TWENTY-TWO AUTHENTIC BANQUETS FROM INDIA, Robert H. Christie. Complete, easy-to-do recipes for almost 200 authentic Indian dishes assembled in 22 banquets. Arranged by region. Selected from Banquets of the Nations. 192pp.

23200-X Pa. $2.50

Prices subject to change without notice.
Available at your book dealer or write for free catalogue to Dept. GI, Dover Publications, Inc., 180 Varick St., N.Y., N.Y. 10014. Dover publishes more than 150 books each year on science, elementary and advanced mathematics, biology, music, art, literary history, social sciences and other areas.